History of

MODERN ART

Painting Sculpture Architecture Photography

H. H. Arnason

History of

MODERN ART

Painting Sculpture Architecture Photography

Third Edition

Revised and Updated by Daniel Wheeler

Harry N. Abrams, Inc., Publishers, New York

For Elinor

Frontispiece: PABLO PICASSO. *Man, Guitar, and Bird-Woman.*
1970. Oil on canvas, 63¾ × 51⅛″. Estate of the Artist

Project Director: Margaret L. Kaplan

Editor: Anne Yarowsky

Designer: Dirk Luykx

Photo Research: Pamela Phillips

Library of Congress Cataloging-in-Publication Data
Arnason, H. Harvard.
 History of modern art.
 Bibliography: p. 699
 Includes index.
 1. Art, Modern—20th century—History. I. Wheeler,
Daniel. II. Title.
N6490.A713 1986 709′.04 86–1167
ISBN 0–8109–1097–7

Times Mirror Books

Printed and bound in Japan

Contents

Preface and Acknowledgments

First and Second Editions

The arts of painting, sculpture, and architecture are arts of space. For this reason it is essential to approach these arts in the twentieth century, or in any other period, through an analysis of the artist's attitude toward spatial organization. Since space is normally defined as extension in all directions, this attitude can be seen relatively easily in architecture and sculpture, which traditionally are three-dimensional masses or volumes surrounded by space and, in the case of architecture, enclosing space. Architecture is frequently defined as "the art of enclosing space," a definition which gives primary importance to the interior space, despite the fact that many architectural styles throughout history have been largely concerned with the appearance of the exterior, or the organization of outdoor space.

The Classic and Romantic eclecticism of the nineteenth-century academic styles in architecture added nothing new to the history of architectural spatial experiment. The development of reinforced concrete and structural steel, however, provided the basis for a series of new experiments in twentieth-century architecture. The most significant product of steel construction is, of course, the skyscraper, which in its characteristic spatial development is perhaps more interesting as an exterior form than as an interior space (if one excepts the new interior space effects resultant from the all-glass sheathing). It is in the flexible material of reinforced concrete that many of the most impressive twentieth-century architectural-spatial experiments have been realized, as well as in the use of new structural principles such as those embodied in Buckminster Fuller's geodesic domes.

Until the twentieth century a work of sculpture has characteristically been a three-dimensional object existing in surrounding space. The formal problems of the sculptor have thus involved the exploitation of his material (bronze, clay, stone, etc.), the integration of the sculptural elements with their environment, and the relation of these elements to surrounding space. In the various broad cycles of sculptural history—ancient, medieval, Renaissance, Baroque—the development of sculpture has tended to follow a pattern in which the early stages emphasized frontality and mass, and the later stages, openness and spatial existence.

In the twentieth century, sculpture has continued in one way or another most of the sculptural-spatial tendencies of the past. Modern experimental sculptors have also made fundamental new departures, particularly in the exploration of sculpture as construction or as assemblage; in experimentation with new materials; and in sculpture as enclosing space. Partly as a result of influence from primitive or archaic art, there has also been a contrasting abandonment of the developed systems of full spatial organization in favor of a return to frontality achieved through simplified masses.

It is probably more difficult for the spectator to comprehend the element of space in painting than in either architecture or sculpture. A painting is physically a two-dimensional surface to which pigments, usually without appreciable bulk, have been applied. Except insofar as the painter may have applied his paint thickly, in impasto, the painting traditionally has no projecting mass, and any suggestion of depth on the surface of the canvas is an illusion created through various technical means. The instant a painter draws a line on the blank surface he introduces an illusion of the third dimension. This illusion of depth may be furthered by overlapping or spacing of color shapes, by the different visual impacts of colors—red, yellow, blue, black, or white—by different intensities or values, and by many other devices known throughout history. The most important of these, before the twentieth century, were linear and atmospheric perspective (discussed in Chapter 1).

Perspective, although known in antiquity, became for the Renaissance a means for creating paintings that were "imitations of nature"—visual illusions that made the spectator think he was looking at a man, a still life, or a landscape rather than at a canvas covered with paint. Perhaps the greatest revolution of early modern art lay in the abandonment of this attitude and the perspective technique that made it possible. As a consequence, the painting—and the sculpture—became a reality in itself, not an imitation of anything else; it had its own laws and its own reason for existence. As will be seen, after the initial experiments carried out by the Impressionists, Post-Impressionists, Fauves, and Cubists, there has been no logical progression. The call for a "return to nature" recurs continually, but there is no question that the efforts of the pioneers of modern art changed modern artists' way of seeing, and in some degree, modern man's.

The principal emphasis of this book revolves around this problem of "seeing" modern art. It is recognized that this involves two not necessarily compatible elements: the visual and the verbal. Any work of art history and/or criticism is inevitably an attempt to translate a visual into a verbal experience. Since the mind is involved in both experiences, there are some points of contact between them. Nevertheless, the two experiences are essentially different and it must always be recognized that the words of the interpreter are at best only an approximation of the visual work of art. The thesis of this book, insofar as it has a thesis, is that in the study of art the only primary evidence is the work of art itself. Everything that has been said about it, even by the artist himself, may be important, but it remains secondary evidence. Everything that we can learn about the environment that produced it—historically, socially, culturally—is important, but again is only secondary or tertiary evidence. It is for this reason that an effort has been made to reproduce most of the works discussed. For the same reason a large part of the text is concerned with a close analysis of these works of art—and with detailed descriptions of them as well. This has been done in the conviction that simple description has an effect in forcing the attention of the spectator on the painting, sculpture, or building itself. If, after studying

the object, he disagrees with the commentator, all the better. In the process he has learned something about visual perception.

This book is intended for the general reader and the student of modern art. As the title suggests, the emphasis is on the development of modern painting, sculpture, and architecture, although there is reference to the graphic arts—drawing and printmaking—and to the arts of design, when these are of significance in the work of an artist or of a period. The book deals predominantly with twentieth-century art, but attention has been paid to the nineteenth-century origins of modern painting. Whereas modern sculpture and architecture saw their beginnings at the end of the nineteenth century with a small number of pioneers, such as Auguste Rodin in sculpture and Louis Sullivan in architecture, the sources of modern painting must be traced much further back in the century.

A discussion of some changes in attitudes toward pictorial space and subject matter around 1800 is followed by a brief summary of Romanticism, aspects of the academic, Classic tradition, and an account of Courbet's approach to reality, both in subject and in materials. With Édouard Manet and the Impressionists the account becomes more explicit in the examination of individual artists, their works, and the movements with which they were associated. It is, nevertheless, still necessarily selective, since only the major figures of Impressionism, Post-Impressionism, and Neo-Impressionism can be discussed in any depth. Although there were many other excellent Impressionist and Post-Impressionist painters, and some of these are mentioned, the main emphasis is on the artists of greatest stature. Another feature of the book should be mentioned at this point: every effort has been made to place the black-and-white illustrations as close as possible to the accompanying text. The colorplates are grouped with the chapters they illustrate.

Emphasis is placed on these matters of physical makeup because they are obviously important to any student, and because the approach used makes them important in a very particular sense. The main body of the book deals with the twentieth century, for the earlier part of which—up to 1940—the works and the attitudes of the pioneers of modernism are examined at length. In discussing their works, the approach is primarily the close examination of the works as aesthetic objects in which problems of space, color, line, and the total organization of the surface are studied. Iconography—the meaning of and attitude toward subject matter—significant in many phases of modern art such as Expressionism, Surrealism, and Pop Art, is given appropriate attention. Also, it is recognized that a work of art or architecture cannot exist in a vacuum. It is the product of a total environment—a social and cultural system—with parallels in literature, music, and the other arts, and relations to the philosophy and science of the period. Aside from being a broad, analytical survey of modern art and architecture, the book is conceived as a dictionary in which much factual information is included. This is particularly true of the latter part, art since 1950. As we approach our own time it is possible to discuss at length only a minority of the talented artists who are creating the art and architecture of the future. Thus, the accounts of these, with a few exceptions, are summary and factual, intended to suggest the main directions of contemporary art and architecture rather than to pretend completeness.

Since this is a history of international modern art and architecture, the criterion for inclusion has been art and architecture which have in some way had international implications. In the late nineteenth and earlier twentieth centuries the emphasis is largely on French, German, and Italian developments. In architecture, further accent is placed on English and American experiments, since these did have some international impact. Other national movements—De Stijl in Holland, Suprem-

atism and Constructivism in Russia—are also discussed in detail for the same reasons. However, painting and sculpture in the United States and in England before World War II are discussed only briefly, since, despite the presence of many talented artists in these countries, they cannot be said to have affected the international stream of modern art until mid-century. For the same reason, Abstract Expressionism in the United States in the 1940s and 1950s, as well as British and American Pop Art, are treated at some length, as a consequence of their worldwide dispersion.

My primary acknowledgment is to Charles Rufus Morey (1875–1955), even though he might not have approved of the subject matter. I am indebted to Robert Goldwater for reading the manuscript and correcting numerous errors of fact. Needless to say he is in no sense responsible for opinions expressed by the author.

At The Solomon R. Guggenheim Museum, my thanks are due to: Anna Golfinopoulos, my research assistant, who achieved miracles of efficient organization under extreme pressure. Also to Susan Earl, research assistant during the first stages of the book; Joan Hall, librarian; Robert Mates and Paul Katz, photographers; Darrie Hammer, and Ward Jackson—all for aid beyond the call of duty.

At Harry N. Abrams, Inc., my thanks are due to: the late Milton S. Fox, whose sensitivity, perception, and humor were a constant delight and whose premature death was to me a great personal tragedy. Also to the late Sam Cauman, who read the manuscript; Barbara Lyons, Director, Photo Department, Rights and Reproductions; Mary Lea Bandy, Mr. Fox's assistant; and to all the other members of the Abrams firm who worked so hard on this project.

A particular note of appreciation goes to all the collectors, museums, art galleries, and other institutions who so kindly granted permission to reproduce works of art and provided photographs or color transparencies.

In this context it will be obvious that I have drawn heavily on the resources of a few museums and collectors: first, The Museum of Modern Art, New York; then other New York museums such as The Solomon R. Guggenheim Museum and The Whitney Museum of American Art. For sculpture I have drawn heavily on the collection of the Hirshhorn Museum and Sculpture Garden in Washington, D.C. The reasons I have used these collections so intensively are: 1) They are among the greatest collections of modern art in existence. Taken together (and with the modern and American collections of The Metropolitan Museum of Art) they constitute the most comprehensive collections of modern painting and sculpture to be found in any one area. 2) I am most intimately familiar with the paintings and sculpture in these museums. 3) For the student who may wish to secure slides or additional research material, these institutions have extensive facilities. Again, my thanks to all who have helped me so generously.

For the 1976 edition, my particular appreciation, aside from that already expressed, goes to my assistant Dorothy Anderson. Thanks are also due to Francis Naumann, who gave me valuable assistance, particularly in the fields of Conceptualism and other recent movements. The list of those at Harry N. Abrams, Inc., who have worked untiringly on the many tasks involved in revising this work and making it current has been greatly enlarged from those already mentioned. My gratitude goes particularly to: Edith M. Pavese for her capable editing and thoughtful supervision; Margaret L. Kaplan, Executive Editor, for skillful coordination of the various phases of what proved to be a complicated undertaking. H. H. A.

Third Edition

In the Third Edition presented here, the story of contemporary art and architecture has been brought up-to-date right through the mid-1980s. Since so much of the new art produced during the 1970s and thereafter represents some form of reaction against the whole modernist tradition that went before—or at least against its culminating phase in 1960s Minimalism—the earlier chapters have received almost as much fresh attention as the new chapters addressed to the various forms of Conceptual Art, to Photorealism, Pattern, Decoration, and the New Imagery, to Neo-Expressionism and, finally, a resurgent, albeit radically altered, abstraction. This was done not only to incorporate recent research and to realize a clearer, more cohesive organization, but also to provide firm antecedents for the numerous references, positive as well as negative, made to earlier modernism by artists of the so-called "Post-Minimal" age, a *fin-de-siècle* period of broad revisionist and retrospective thinking. Among the older chapters, those that have been rather substantially rewritten are Cubism and Fauvism. Throughout the pre-1970 material, however, readers familiar with the old editions will find some new writing, as well as fresh illustrations, even in the section devoted to Minimalism. They will also discover that the history of photography has been introduced and interwoven with the ongoing history of painting and sculpture. This particular expansion of the book has been undertaken not only to acknowledge the aesthetic importance of the work realized in the medium of photography, but also to provide a background for photography's current ubiquitous presence among the mix of media increasingly favored, by all manner of artists, for their endless capacity to yield new figurative, formal, and expressive effects. In architecture, too, the recent trend has been revisionist, and so, along with a very modest amount of new text and reorganization in the original material on architecture, there is an additional chapter entitled "Post-Modernism," touching on the various forms of reaction manifested against the International Style dominant during the century's third quarter.

For the 1986 edition of *History of Modern Art,* the first acknowledgment must go to H. H. Arnason, who not only created the book in the first place, but then generously allowed another person to revise the text once he found it impossible, for reasons of health, to carry out the task himself. As the writer to whom this privilege passed, I met with Arnason on several occasions, and was fortunate enough to benefit from his general advice before circumstances forced him to withdraw from all further participation in the development of the present volume. Still, he must have been very much with us in spirit, if not in fact, for just as these acknowledgments were being assembled—always the final event before a book goes on press—the publisher and I learned that Arnason had died. It was as if he had held fast just long enough to *will* us safely clear of a thousand hurdles. And so in gratitude for his confidence and aid, both tangible and intangible, I want to dedicate my own sections in the new edition to the memory of Harvey Arnason, scholar, teacher, critic, curator, and administrator, an art historian as much at ease with archival research as with artists in their studios, with collectors as much as with students, with specialized monographic writing as much as with the broader statements needed in a general survey.

In preparing the 1986 edition of Arnason's *History of Modern Art,* I have attempted not so much to "present" new material as to discover it, as the curious viewer/reader himself might in the act of following contemporary art through its present and ongoing processes of unforesee-able, yet ultimately logical, development. Consequently, I write not as an authority but rather as a student of modern art, albeit a serious—even passionate—one of some years standing. Moreover, in discovering, studying, or revealing works of art and architecture, I have carefully avoided the role of critic, as well as that of theorist. Rather than engage in speculative value judgments, or some narrowly defined ideological approach, I invariably find it more rewarding and instructive—for myself and I hope for readers—to remain open to the distinctive qualities of each work or trend, to learn its special language, and to allow the particular truth this conveys to unfold. And since art, like poetry, almost always seeks a deeper, less obvious reality, the challenge of that reality can be further enriched by the findings of those who have interviewed the artist, observed his work at length, and commented upon its possibilities in a knowing, constructive manner. Once the art has been experienced from these several perspectives, criticality emerges, as problems are posed, resolved, and assessed, like a cat's cradle of checks and balances, woven by the competing interests of time, place, personal circumstance, and sociocultural context. Thus, what I have wanted to offer is a balanced view of recent events in the visual arts—a view balanced, that is, between the subjective vision of the artist himself, an objective, informed consideration of what that vision produced, and my own keen sense of identification with both.

To obtain such a synthesis, I have, of course, incurred a very great many debts, all of which I am eager to acknowledge with the warmest feelings of gratitude. For present purposes, my most immediate recognition must go to the nearly countless writers cited in the bibliography, whose books, articles, reviews, monographs, and catalogues provided not only information, concepts, and artists' statements, but even the essential nomenclature and style of address without which the sort of broad, integrated survey I have attempted would not be possible. However, a still more primary debt of gratitude is the one I owe to the distinguished faculty who first taught me art history and how to think as well as write about it. At New York University's Institute of Fine Arts these were Professors Colin Eisler, Robert Goldwater, Jim Jordan, Theodore Reff, Robert Rosenblum, William Rubin, and Gert Schiff. Here, however, I must reserve a special place for Robert Rosenblum and Gert Schiff, to acknowledge the gentle persistence of their urging that I cease editing other people's books and undertake one of my own. In venturing this partial, if not altogether first, step in that direction, I have been long about it, long enough certainly for my mentors to be absolved of all blame for the present consequences of their well-meant encouragement. Quite particular to the enterprise at hand has been the spirited interest and active support offered by Dr. Ruth Kaufmann, the kind of friend that only the lucky can boast and a specialist whose knowledge of current art is peerless. Another informed guide who tried to set me off in the right direction across the largely uncharted terrain of the new is Charles Stuckey, now of the National Gallery in Washington, D.C. I have also been the beneficiary of advice from Dr. Anthony F. Janson of the John and Mabel Ringling Museum of Art in Sarasota, Florida, on how to cut or shrink the old text in order to permit the inclusion of another fifteen years of art, in addition to the history of photography, without making the book an object that only a weight-lifter could handle. If I have managed to find my way through the maze of fresh knowledge concerning the Russian avant-garde, it is thanks to the generously shared scholarship of Dr. Marian Burleigh Motley, a friend at Princeton University. Professor Ursula Meyer interrupted her own writing and quite literally went out of her way to clarify ideas and lend illustrations for the section on Conceptualism, as did Sidney Geist when I approached him about Brancusi. While Sabine Rewald of New York's Metropolitan Museum of Art helped me with Balthus, Dr. Madeleine Fidell

Beaufort in Paris answered my frantic call for assistance in obtaining documents on a key Matisse in the Soviet Union. In the course of adding photography to the text, I sought aid and received it from many able and selfless individuals, among them Peter Galassi of The Museum of Modern Art in New York, Sam Wagstaff, John Waddell, Pierre Apraxine, Frau Monika Schmela in Düsseldorf, Christine Faltermeier, Maria Morris Hambourg at The Metropolitan Museum, Beth Gates-Warren of Sotheby's in New York City, and Gerd Sander of the Sander Gallery, also in New York. And in speaking of museums and galleries, the author of a book like this could scarcely be too extravagant in voicing thanks for the patience with which such institutions—here cited either in the captions or in the Photo Credits—endure what must seem interminable requests for facts and images. At Harry N. Abrams, I have been remarkably fortunate in my sponsoring editor, Margaret Kaplan, a professional par excellence and graceful about it. May her trust in me not have been misplaced! Other members of Abrams's capable staff who overcame terrible difficulties to bring off this complex project are Barbara Lyons, director of the Photo Department, Pamela Phillips, photo researcher, and Pamela Bass, photo assistant. They all have my sincere thanks. And so does my "other" publisher, Alexis Gregory of The Vendome Press, without whose tolerance I could not have stayed so long at a different well.

D. W.

Unless otherwise noted, all paintings are oil on canvas. Measurements are not given for objects that are inherently large (architecture, architectural sculpture, wall painting) or small (drawings, prints, photographs). Height precedes width. A probable measuring error of more than one percent is indicated by "c." A list of credits for the illustrations appears at the end of the book.

The Prehistory of Modern Painting

Various dates are used to mark the point at which modern art supposedly began. The most commonly chosen, perhaps, is 1863, the year of the Salon des Refusés in Paris, where Édouard Manet first showed his *Déjeuner sur l'herbe* (plate 6). But other and even earlier dates may be considered: 1855, the year of the Exposition, in which Courbet built a separate pavilion to exhibit *The Painter's Studio* (fig. 1); 1824, when the English landscapists John Constable and Richard Parkes Bonington exhibited their brilliant, direct-color studies from nature at the Paris Salon; or even 1784, when Jacques-Louis David finished his *Oath of the Horatii* (fig. 2) and the Neoclassical movement began to assume a position of dominance in Europe and the United States.

Each of these dates has significance for the development of modern art, but none categorically marks a completely new beginning. For what happened was not that a new outlook suddenly appeared; it was that a gradual metamorphosis took place in the course of a hundred years. It embodied a number of separate developments: shifts in patterns of patronage, in the role of the French Academy, in the system of art instruction, in the artist's position in society, and, especially, in the artist's attitude toward artistic means and issues—toward subject matter, expression, and literary content, toward color, drawing, and the problem of the nature and purpose of a work of art.

Pictorial space is the first matter to be considered. Neoclassicism has at times been called an eclectic and derivative style that perpetuated the Classicism of Renaissance and Baroque art, a Classicism that might otherwise have expired. Yet in Neoclassical art a fundamental Renaissance tradition was seriously opposed for the first time—the use of perspective recession to govern the organization of pictorial space. Indeed, it may be argued that David's work was crucial in shaping the attitudes that led, ultimately, to twentieth-century abstract art. David and his followers did not actually abandon the tradition of a pictorial structure based on linear and atmospheric perspective. They were fully wedded to their idea that a painting was an adaptation of Classical relief sculpture (fig. 3); they subordinated atmospheric effects, emphasized linear contours, arranged their figures as a frieze across the picture plane, and accentuated that plane by closing off pictorial depth through the use of such devices as a solid wall, a back area of neutral color, or an impenetrable shadow. The result, as seen in *The Oath of the Horatii*, is an effect of figures composed along a narrow stage behind a proscenium, figures that exist in space more by the illusion of sculptural modeling than by their location within a pictorial space that has been constructed according to the principles of linear and atmospheric perspective.

Perspective space, the method of representing depth against which David was reacting, had governed European art for the preceding four hundred years. Its basis was single-point perspective, perfected in early fifteenth-century Florence and the logical outcome of the naturalism of fourteenth-century art: a single viewpoint was assumed, and all lines at right angles to the visual plane were made to converge toward a single

1. GUSTAVE COURBET.
The Painter's Studio (Atelier).
1854–55. 11'10" × 19'7".
The Louvre, Paris

2. JACQUES-LOUIS DAVID. *The Oath of the Horatii.* 1784. 10′10″ × 14′.
The Louvre, Paris

3. ROMAN. The Ara Pacis, Imperial Procession Frieze (detail).
13–9 B.C. Rome

point on the horizon, the vanishing point. These mathematical-optical principles were discovered by Filippo Brunelleschi before 1420, after which they were applied by Masaccio in his fresco *The Holy Trinity* in 1425, and then written down by Leone Battista Alberti about 1435. Fifteenth-century artists used perspective to produce the illusion of organized depth by the converging lines of roof beams and checkered floors, to establish a scale for the size of figures in architectural space, and to give objects a diminishing size as they recede from the eye.

Nowhere in the Early Renaissance did this science receive a more lucid or poetic expression than in the painting of Piero della Francesca (fig. 4). Mystically convinced that a divine order underlay the surface irregularities of natural phenomena, this mathematician-artist endowed his forms with ovoid, cylindrical, or cubic perfection, fixed their rela-

4. PIERO DELLA FRANCESCA. *Flagellation.* c. 1450. Panel, 23¼ × 32″. Galleria Nazionale delle Marche, Palazzo Ducale, Urbino, Italy

tionships with exact proportionality, and further clarified all these geometries with a suffusion of cool, silvery light. Such is the abstract wonder produced by this conceptual approach to perceptual reality that it would prove irresistible to a whole line of modern artists, beginning with David and Ingres and continuing through Seurat and Picasso. Piero and his fifteenth-century peers in Italy elaborated the one-point perspective system by shifting the viewpoint to right or left along the horizon line, or above or below it. Atmospheric perspective, another fifteenth-century technique and one developed in Flanders rather than Italy, added to the illusion of depth by progressively diminishing color and value contrasts relative to the presumed distance from the viewer (fig. 5). With these as their means, Renaissance painters attained control over naturalistic representation of man and his environment.

Early in the sixteenth century, the Renaissance conception of space reached a second major climax in such works as Raphael's *School of Athens,* where the nobility of the theme is established by the grandeur of the architectural space (fig. 6). For this supreme masterpiece of the High Renaissance (1500–1520), Raphael employed both linear and aerial perspective not only as devices for unifying a vast and complex pictorial space but also as a metaphor of the period's longing for the harmonious unification of everything—the divergent philosophies of Plato and Aristotle, upon whose images Raphael made all lines converge, the human and the divine, the ancient and the modern, and, perhaps most of all, the searing divisions that afflicted Christendom on the eve of the Protestant Reformation.

So exquisite was the balance struck by Raphael and his contemporaries, among them Leonardo da Vinci, Michelangelo, Titian, and Correggio, that the succeeding generation of painters gave up studying nature in favor of basing their art on that of the High Renaissance, an art that had already conquered nature and refined away its dross element. Thus, whereas the older masters had looked to nature and found their grand harmonious style, the new artists sought a style and discovered what the sixteenth century would call a "manner" *(maniera).* Mannerism came forth as a kind of overelaboration that often follows in the wake of balanced, monumental simplicity (fig. 7). On this occasion it consisted of figural grace exaggerated into extreme attenuation and

5. Jan van Eyck. *The Madonna of Chancellor Rolin.* c. 1435. Oil on panel, 26 × 24⅜". The Louvre, Paris

6. Raphael. *School of Athens.* 1510–11. Fresco. Stanza della Segnatura, Vatican Palace, Rome

Isenheim in Alsace, Grünewald's *Crucifixion* was part of an elaborate polyptych designed to offer example and solace to the sick and the dying. With its contorted forms, dissonant colors, passionate content, and spiritual purpose, the *Isenheim Altarpiece* stands near the apex of

7. Angelo Bronzino. *An Allegory of Time and Love.* c. 1546. Panel, 61 × 56¾". The National Gallery, London

twisting, choreographic poses, jammed, irrational spaces or distorted perspectives, shrill or even "shot" colors, scattered compositions, imagery cropped at the edges, polished surfaces, and an atmosphere of glacial coolness, even in scenes of high, often erotic emotion or violence. In their preference for allowing the ideal to prevail over the real, the Mannerists can be seen as forerunners of the bent toward abstraction that would become a dominant trend in modernist art, whether pursued for reasons of objective formal analysis or to express some inner, subjective state of emotional or spiritual necessity.

Emotional or spiritual necessity lay at the core of the *Isenheim Altarpiece* painted by Raphael's great German contemporary Mathis Gothardt Neihardt (d. 1528), generally known simply as Grünewald, the creator of what may well be the most harrowing Crucifixion ever painted (fig. 8). In this dreadful scene, set against a darkening wilderness and floodlit with a harsh, glaring light, the tortured body of Christ hangs so heavy on the rude cross that the arms seem all but wrenched from their sockets, while the hands strain upward like claws frozen in rigor mortis. Under the fearsome diadem of brambles, the head slumps with eyes closed and the mouth twisted in agony. Supporting the lacerated, gangrenous body are the feet crushed together by an immense, heavy spike. As the ghostly pale Virgin swoons in the arms of Saint John, Mary Magdalene falls to the ground wringing her hands in grief, while John the Baptist points to the martyred Christ with a stabbing gesture, as if to re-enact the violence wrecked upon the Savior. Here, the unity of the human and the divine has been sought not in harmonious perfection of outward form, such as that realized by Raphael, but rather in an appalling image of spiritual and physical suffering, an experience shared by God with humanity when He became man. Placed upon the high altar in a hospital chapel in the monastery of Saint Anthony at

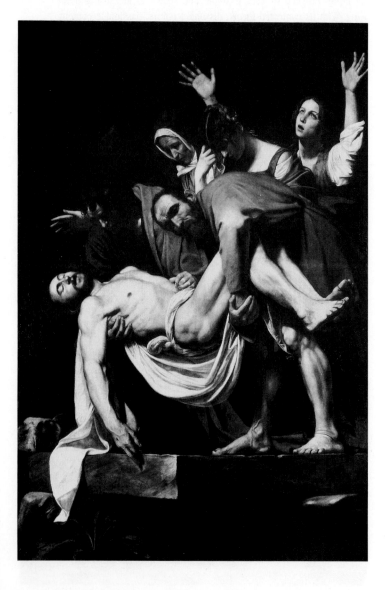

a long tradition that would prove resurgent in the Expressionist art of twentieth-century Europe.

In the seventeenth century, along with the religious Counter-Reformation, came an aesthetic reform designed to cleanse art of Mannerism's self-referring excesses and reinvigorate it with something of the broad, dramatically communicative naturalism realized in the High Renaissance. It began with one of the most revolutionary and influential painters in all of history, Michelangelo da Meresi (1572–1610), known simply as Caravaggio for his native town in northern Italy. Singlehandedly and still in his twenties, Caravaggio introduced a blunt, warts-and-all kind of naturalism that, with its histrionic effectiveness in making the greatest mysteries of the Christian faith seem present and palpable, became a tradition equal to and running parallel with Renaissance-derived Classicism (fig. 9). Once enhanced by the artist's sense of authentic gesture and his bold light-dark contrasts—the famous Caravaggesque *tenebrism*—full-bodied illusionistic painting assumed an optical and emotive power never before seen in European art. Its impact would be felt with stunning force in the Spain of Velázquez and The Netherlands of Rembrandt.

The innovations of Caravaggio issued in the age of the Baroque, whose reaction against Mannerism also gave rise to such decorators as Pietro da Cortona and, during the eighteenth century, Giovanni Battista Tiepolo (fig. 10), in whose hands perspective painting became an expressive instrument that was blended with architecture and sculpture in the creation of gigantic symphonies of space organization, a dynamic world of illusion alive with sweeping, rhythmic movement. Every trompe-l'oeil trick of perspective and foreshortening learned in two centuries of experimentation was resorted to. The opening up of illusionistic recession away from the plane continued to the end of the eighteenth century, notably with the deep-perspective Venetian scenes by Canaletto and Guardi. Only with the advent of Neoclassicism at the end of the eighteenth century was there a halt in representing the expansion of space, a desire to limit it severely.

David's followers in the first half of the nineteenth century were increasingly concerned with placing an emphasis on art of ideal subject matter rendered in abstract line. Both Neoclassicism and Romanticism were flights from the immediate world, to a reality evoked from impressions of the Orient, Africa, or the South Seas; or, to a fictional world derived from the art and literature of Classical antiquity, the Middle Ages, and the Renaissance. The differences between the two schools lay partly in the particular subjects selected, the Neoclassicists obviously leaning to antiquity and the Romantics to the Middle Ages or the exotic East. Even this distinction was blurred as the century wore on, since Ingres, the Classicist, made rather a speciality of Oriental odalisques, and Delacroix, the Romantic, at various times turned to Greek mythology. The approach to subject matter is even more similar. David's *Horatii* (fig. 2) emotionalizes in a Romantic manner closer to the stage tradition of Racine than to that of Classical Greek sculpture. Delacroix's

above: 8. MATTHIAS GRÜNEWALD. *Crucifixion* from the *Isenheim Altarpiece* (closed). c. 1512–15. Panel (with frame), 9′9½″ × 10′9″. Musée Unterlinden, Colmar, France

left: 9. CARAVAGGIO. *The Entombment of Christ*. 1602–4. 9′10¼″ × 6′8″. Pinacoteca Vaticana, Rome

Michelangelo, brooding in his studio, has a close spiritual affinity to David's Brutus mourning the death of his sons.

The clearest distinction between Classicism and Romanticism in the nineteenth century may be seen, perhaps, in the approaches to plastic form and techniques of applying paint. The Neoclassicists continued the Renaissance tradition of glaze painting to attain an effect of uniform surface, whereas the Romantics revived the textured surface of Rubens, Rembrandt, and the Rococo (fig. 11). Neoclassicism in painting established the principle of balanced frontality to a degree that transcended even the High Renaissance or the classical Baroque of Poussin (fig. 12). Romanticism reverted to the formula of asymmetry, diagonal recession in depth, and indefinite, atmospheric-coloristic effects more appropriate to the expression of the inner imagination.

In analyzing Classic, Romantic, and Realist painting throughout the first part of the nineteenth century, a number of factors other than attitudes toward technique or spatial organization must be kept in mind. The Neoclassicism of David and his followers involved specifically moralistic subject matter related to the philosophic ideals of the French Revolution and based on the presumed stoic and republican virtues of early Rome. Yet the painter was hampered in his pursuit of a truly Classical art by the lack of adequate prototypes in ancient painting. There was, however, a profusion of ancient sculpture, and thus it is not surprising that Classical paintings such as David's *The Oath of the Horatii* should emulate sculptured figures in high relief within a restricted stage (fig. 2). The "moralizing" attitudes of the figures make the stage analogy particularly apt, for the almost abstract simplification of the composition results from the artist's attitude toward his subject—a deliberate attempt to replace eighteenth-century royalist elaboration with republican simplification and austerity.

One of David's greatest paintings, *The Death of Marat* (fig. 13), contains all the elements referred to—spatial compression, sculptural figuration, highly dramatized subject. But it also reminds us of David's power of realistic presentation, which forms a link between the French portraitists of the eighteenth century and the nineteenth-century Realist tradition of Courbet and his followers. And, although painted as early as 1793, the *Marat* also anticipates the more macabre elements that were to permeate the Romantic movement in the second and third quarters of the nineteenth century.

JEAN-AUGUSTE-DOMINIQUE INGRES (1780–1867) Another Classicist of paramount importance to the development of modern painting was Jean-Auguste-Dominique Ingres, a pupil of David who during his long life remained the exponent and defender of the Davidian Classical tradition. Ingres's style was essentially formed by 1800 and cannot be said to have changed radically in works painted at the end of his life, but although he was a vociferous opponent of most of the new doctrines of Romanticism and Realism, he did introduce certain factors that affected the younger artists who opposed in spirit everything he stood for.

above: 10. GIOVANNI BATTISTA TIEPOLO. *Translation of the Holy House to Loreto.* 1744. Ceiling fresco (destroyed 1915). Church of the Scalzi, Venice

right: 11. JEAN-HONORÉ FRAGONARD. *The Meeting.* 1771–73. 10'5" × 8'.
©Frick Collection, New York

12. NICHOLAS POUSSIN. *Mars and Venus*.
c. 1630. 61 × 84". Museum of Fine Arts,
Boston. Augustus Hemenway Fund, Arthur
Wheelwright Fund

Indeed, while Ingres produced his complement of elaborate Classical "machines," he represented in a greater degree than did David the influence of Renaissance Classicism, particularly that of Raphael. Although David was a superb colorist, he tended to subordinate his color to the Classical ideal except when he was carried away by the pageantry of the Napoleonic era. Ingres, on the contrary, used a palette both brilliant and delicate, combining Classical clarity with Romantic sensuousness, often in liberated, even atonal harmonies of startling boldness (plate 1).

The sovereign quality that Ingres brought to the Classical tradition was that of drawing, and it was his drawing, his statement of line as an abstract quality—coiling and uncoiling in self-perpetuating complications that seem as much autonomous as descriptive—which provided the link between his art and that of Degas and Picasso.

FRANCISCO DE GOYA (1746–1828) The art of the twentieth century involves fundamental changes in attitude toward the subject as well as toward the form of painting. Movements such as late nineteenth-century Symbolism and early twentieth-century Expressionism and Surrealism all may be traced in one form or another to aspects of early nineteenth-century Romanticism, fantasy, and Realism. It is always possible, of course, to find historical prototypes for anything in contemporary art. Thus twentieth-century experiments in the fantastic have been related to the apocalyptic dramas of Hieronymus Bosch (1450/60–1516) and Pieter Brueghel the Elder (1525/30–1569), and the visionary paintings of William Blake (1757–1827). Much of modern Expressionism seems to have been anticipated by the ecstatically religious paintings of El Greco (1541–1614).

One of the major figures of eighteenth- and nineteenth-century art, who had a demonstrable influence on what occurred subsequently, was the Spaniard Francisco de Goya. The long-lived Goya carried his art through many stages, but in his middle and late periods he was particularly concerned with the inherent evil and insane cruelty of mankind. The artist expressed this black vision in terms of monstrous images that

13. JACQUES-LOUIS DAVID. *The Death of Marat*. 1793. 65 × 50½". Musées Royaux des Beaux-Arts, Brussels

were yet rooted in the most precise and penetrating Realism (figs. 14, 15). During his lifetime Goya was not very well known outside Spain, despite the final years he spent in voluntary exile in the French city of Bordeaux, but once he had been rediscovered by Édouard Manet at mid-century his art made a strong impact on the mainstream of modern painting.

EUGÈNE DELACROIX (1798–1863) The French Romantic movement really came into its own with the arrival of Eugène Delacroix—through his exploration of exotic themes, his accent on violent movement and intense emotion, and, above all, through his reassertion of Baroque color and emancipated brushwork (plate 2). The intensive study that Delacroix made of the nature and capabilities of full color derived not only from the Baroque but also from his contact with English color painters, such as Constable, Bonington, and Turner. His greatest originality, however, may lie less in the actual freedom and breadth of his touch than in the way he juxtaposed colors in blocks of mutually intensifying complementaries, such as vermilion and blue-green or violet and gold, arranged in large sonorous chords or, sometimes, in small independent, "divided" strokes. Either way, the technique and its effect would have a profound influence on the Impressionists and Post-Impressionists, particularly Van Gogh (who made several copies after Delacroix) and Cézanne.

15. FRANCISCO DE GOYA. Plate 30 from *The Disasters of War* series. 1863 edition. Etching. Hispanic Society of America, New York

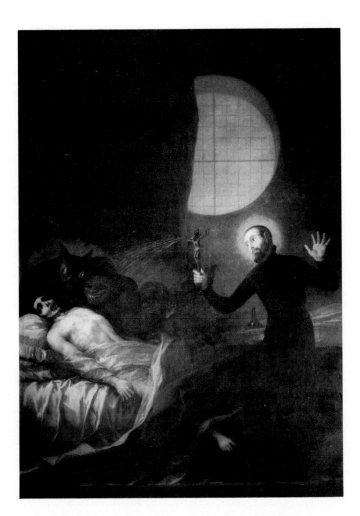

14. FRANCISCO DE GOYA. *St. Francis Borgia Exorcising an Impenitent.* 1788. Figures lifesize. Valencia Cathedral, Barcelona

Northern Romanticism

If Romanticism can be defined as the supremacy of emotion over reason, it found its most characteristic manifestation in Germany rather than in France. Indeed, although the main lines of twentieth-century painting and sculpture are traditionally traced to French Neoclassical, Romantic, and Realist art, there is now an increasing awareness of the impact of Northern Romanticism—that is, the Classic-Romantic strain that was dominant in Germany, England, Scandinavia, and the Low Countries throughout much of the nineteenth century. One may, in fact, trace an almost unbroken Romantic tradition in Germany and, deriving in considerable degree from the German, in the Scandinavian countries—a legacy that extends from the late eighteenth century through the entire nineteenth century to the Expressionist fantasy of Edvard Munch and the fantastic Realism of the twentieth-century German Expressionists.

Twentieth-century painting, sculpture, the graphic arts, and even architecture may be divided into the Classic wings that led to Cubism and abstraction, and the Romantic wings that led to Symbolism, Expressionism, Surrealism, and certain phases of Abstract Expressionism. The latter strains have immediate ancestors in the Romanticism of the Germans Caspar David Friedrich (1774–1840), Philipp Otto Runge (1777–1810), the Danish-German Asmus Jacob Carstens (1754–98), and two Englishmen: William Blake (1757–1827) and Joseph Mallord William Turner (1775–1851). All of these Romantic painters, active at the beginning of the nineteenth century, were involved in a form of visionary art expressing a new religious sense based on the vastness and mystery of nature rather than on any formula of traditional Christianity. A direct line may be traced from these early nineteenth-century visionary landscapes and genre paintings through concepts of the mysteries of nature that express themselves in later nineteenth-century European and American landscapes, from John Constable, Thomas Cole, Millet, and the Barbizon School through Gustave Courbet, James Abbott McNeill Whistler, to the Impressionists, Vincent van Gogh, Gauguin, Cézanne, and the early landscapes of Piet Mondrian. Implicit in this Romantic, Symbolist vision of nature is a sense of mystery, at times

religious in a formal context, at times broadly pantheistic. Nineteenth-century Romanticism was also specifically concerned with the mystery and the alienation of the individual, aspects that are evident in Romantic portraits, from those of Friedrich and Goya at the beginning of the century to the works of Vincent van Gogh and Edvard Munch at its end.

In Friedrich, the leading German painter of Romantic landscape, the image of open nature was by definition a statement of the sublime, of the infinite and the immeasurable. The emphasis on landscape itself marks a departure from Classicism, where, with one or two notable exceptions, the natural scene played a subordinate role. In the landscapes of Friedrich, filled with mysterious light and vast distances, the human beings, when they appear, occupy a subordinate or purely contemplative place (fig. 16).

16. CASPAR DAVID FRIEDRICH. *Cloister Graveyard in the Snow.* 1819. 48 × 67″. Staatliche Museen, Berlin

Romantic Landscape and the Barbizon School

Although landscape painting in France during the first part of the nineteenth century was a relatively minor genre, certain close connections with the English landscapists of the period would have crucial effects. The watercolorist Richard Parkes Bonington (1801–1828) lived most of his brief mature life in France and was close to Delacroix. Many of the English landscapists—including not only Bonington and Constable but also Crome, Cotman, and others—visited France frequently and exhibited in the Paris Salons. Delacroix spent time in England and learned from the direct color painting of the English landscapists (plates 3, 4).

17. THEODORE ROUSSEAU. *The Forest in Winter at Sunset (La Forêt en hiver au coucher du soleil).* 5′2″ × 8′6⅜″. The Metropolitan Museum of Art, New York. Gift of P. A. B. Widener, 1911 (11.4)

18. JEAN-FRANÇOIS MILLET. *The Gleaners*. Salon of 1857. 33 × 44″. The Louvre, Paris

The principal French school of Romantic landscape, that of Barbizon, drew more directly on the seventeenth-century Dutch landscape tradition than it did on that of England (fig. 17). In this, the emphasis continued to be on unified, tonal painting rather than on free and direct color. It was the "interior of the forest" of Fontainebleau, rather than the brilliant sunlight of the seashore, that appealed to the Barbizon masters. This in itself could be considered a Romantic interpretation of nature, as the expression of intangibles through effects of atmosphere. The Romantic landscape of the Barbizon School merged into a kind of Romantic Realism in the paintings of Jean-François Millet (1814–1875), who paralleled Gustave Courbet in his passion for the subject of peasants at work but whose interpretation, with primary emphasis on the simplicity and nobility of agrarian experience, was entirely different in manner (fig. 18). As if to redeem the grinding poverty of unpropertied farm life, he shaped his field laborers with Michelangelesque monumentality and integrated them into compositions of Poussin-like grandeur and calm. It must also be noted that Millet was Van Gogh's first influence, perhaps because of his reverence for the peasant as symbol of the original natural man.

Another painter vigorously at work in the French rural scene was Rosa Bonheur (1822–1899), as liberated as her contemporary George Sand and certainly the most internationally known woman artist of her time (fig. 19). And Bonheur could produce Salon machines with the best of them, realizing tremendous success at it, mainly because her essentially Romantic, grandly scaled, photographically precise conception proved irresistibly persuasive, all the while that it saved viewers from the harsher, more threatening realities of country life.

CAMILLE COROT (1796–1875) The most important French landscapist of the nineteenth century before Impressionism was Camille Corot. Only peripherally associated with the Barbizon School, Corot ranged between Classicism and Romanticism in landscape. His studies of Roman scenes have a Classical purity of organization comparable to Poussin, and a clarity of light and color similar to that of the English watercolorists (fig. 20). These small landscapes, which seem so traditional, did in fact exert a great influence on the development of the Impressionism and Post-Impressionism of Monet and Cézanne. From the Classical architectural landscapes of the Roman period, Corot turned to a Romantic form in delicate woodland scenes composed in tones of silvery gray, Arcadian landscapes sometimes populated by diminutive figures of nymphs and satyrs (fig. 44). His late portraits and figure studies, on the contrary, are solidly realized and beautifully composed, works that are closely related to the studio scenes and figures of Post-Impressionist, Fauve, and Cubist tradition.

19. ROSA BONHEUR. *The Horse Fair*. 1853–55. 8′¼″ × 16′7″. The Metropolitan Museum of Art, New York. Gift of Cornelius Vanderbilt, 1887

20. CAMILLE COROT. *View of Rome: The Bridge and the Castle of Sant' Angelo with the Cupola of St. Peter's.* 1826–27. Oil on paper mounted on canvas, 8⅝ × 15". The Fine Arts Museums of San Francisco. Collis Potter Huntington Memorial Collection

The Academic School: The Salon

Since a large part of this book is concerned with revolts by experimental artists against the "academic system," a brief summary of the Academy of Art, particularly as it existed in the mid-nineteenth century, is in order.

The term "academy," in the sense of a school of arts, letters, philosophy, or science, may be traced back to Plato and Athens in the fourth century B.C. It was revived in the latter fifteenth century A.D. with the recrudescence of Platonism in Italy. During the Middle Ages and much of the Renaissance and Baroque periods, guilds were organized chiefly to protect artists' rights as craftsmen rather than as creative artists. The origin of the modern academy of art is associated with Leonardo da Vinci at the end of the fifteenth century, after which the idea gained strength in Italy during the sixteenth century as painters and sculptors sought to elevate their position from the practical to the liberal arts. The academy in its modern sense really began in the seventeenth century, when academies of arts and letters and science were established in many countries of Europe. The French Académie des Beaux-Arts was founded in 1648 and, in one form or another, dominated the production of French art until the end of the nineteenth century. The French Academy was under royal patronage until the Revolution and then again with the Bourbon Restoration. An artist's survival could depend on his acceptance in the biennial Salons. Indeed, during the eighteenth century it is difficult to find a painter or sculptor who is well recognized today who was not an academician and did not exhibit in the Salons.

During the nineteenth century, the Salons occupied an even more influential place. In contrast to previous centuries, the Salons now became vast affairs in which thousands of paintings were hung and thousands rejected, for the revolutionary attempt to "democratize" the academic Salon resulted in a mélange that contrasted sharply with the relatively small invitational exhibitions of the eighteenth century. Although the new Salons were selected by juries, presumably competent and occasionally distinguished, they reflected the taste or lack of taste of the new bourgeoisie. This might not have been pernicious in itself, except insofar as the authority of the academic tradition persisted, but the reputation, and even the livelihood, of artists continued to be dependent upon acceptance in these official exhibitions.

The typical Salon painting ranged from pseudo-Classical "machines," whose scale illustrated the tendency to attention-gaining vast-ness, to the photographic history illustrations of Jean-Louis Ernest Meissonier (1815–1891). Other genres on which the largely second- and third-rate artists of the Salon depended ranged through the entire history of art, but particularly popular were works of extreme sentimentality combined with extreme realism, such as the wounded boy in *An Accident* by Pascal-Adolphe-Jean Dagnan-Bouveret (1852–1929), or pseudo-Classical, erotic compositions like *The Birth of Venus* by Alexandre Cabanel (1823–1889) and *Return of Spring* by Adolphe William Bouguereau (1825–1905; fig. 21).

Although the revolution of modern art was, as we have seen, in large degree the revolt against this cumbersome academic Salon system, it must be remembered that the leading artists of the nineteenth century participated gladly in the Salons—indeed, they could rarely afford not to. The famous Salon of 1855 devoted a room each to Delacroix and Ingres, and both were awarded grand medals of honor. Courbet may have built a separate pavilion to show *The Painter's Studio* (fig. 1), which had been rejected, but he also had other works in the official Salon. Not only did many of the Romantics, Realists, and Impressionists whom we now regard as pioneers of modern art exhibit regularly or irregularly in the Salon, but there was certainly a number of "Salon painters" of distinction, among them Henri Fantin-Latour and Puvis de Chavannes (fig. 61). It is also true that Corot, Manet, Odilon Redon, Degas, and many other artists highly regarded today, were, to one degree or another, successful Salon painters.

21. ADOLPHE WILLIAM BOUGUEREAU. *Return of Spring (Le Printemps).* 1886. 84½ × 50". Joslyn Art Museum, Omaha. Gift of Francis T. B. Martin, 1951

Realism and Impressionism

The Invention of Photography and the Rise of Realism

The French Revolution, as we have seen, was essentially a bourgeois affair, having little to do with the proletariat, and, followed as it was by the industrial expansion of the nineteenth century, the new and prosperous middle class assumed a larger and larger part in every phase of European and American life. Although governmental patronage of the arts still persisted, and in some cases even expanded over that of the eighteenth century, the new patrons were the newly rich bourgeoisie. Being fundamentally materialistic in its values, this increasingly dominant segment of society had less interest in the vagueness and fantasy of Romantic art than in a kind of pictorial verisimilitude that could convey meticulous visual facts verifiable in the external world of here and now. Since the interest was primarily in such facts for their own sake, quite apart from whatever role they might play in expressing some higher meaning, as in the elevated realism of the Renaissance and Baroque eras, it served as an all-important stimulant to the research that finally brought about the invention of photography. And from the time it was publicly demonstrated in early 1839 that a new mechanical technology had been discovered for resolving and permanently fixing upon a flat surface and in minute detail the exact tonal, if not full-color, image of the three-dimensional world, rarely would a Western painter ever again be able to create without some consciousness of the special conditions introduced by the new medium. Nor, it should be added, would photographers ever feel altogether free to work without some awareness of the rival aesthetic standards, qualities, and prestige imposed by the age-old, handwrought image-making processes of painting and drawing.

True enough, painters had already anticipated, long before anyone had ever seen a daguerreotype, almost every salient characteristic of photographic form: a snapshot-like cutting off or cropping of figures by the framing edges, a feature especially pronounced in sixteenth-century Mannerism (fig. 7); motion arrested or frozen in full flight or mid-step to reveal its physiognomy in a way seldom perceptible to the naked eye; a related "stop-action" informality of human pose and gesture; ghostly residual or afterimages left in the wake of speeding objects; imagery defined purely in terms of tone, free of bounding contour lines; wide-angle views and exaggerated foreshortenings; and, perhaps most of all, a generalized flatness of image even where there is depth illusion, an effect produced in normal photography by the camera's relative consistency of focus throughout the field and its one-eyed or monocular view of things. None of these characteristics, however, would become a commonplace of painting style until the mass proliferation of photographic imagery made them an ubiquitous and unavoidable feature of modern life. The most immediate and obvious impact on art can be seen in the work of Realists eager to achieve a special kind of optical veracity un-

known until the advent of photography, a trend often thought to have culminated in the "instantaneity" of Impressionism, only to become resurgent in the Photorealism of the 1970s. Other artists, however, or even the same ones, took the scrupulous fidelity of the photographic image as good reason to work imaginatively or conceptually and thus liberate their art from the dictum of perceptual truth. Some indeed saw the aberrations and irregularities peculiar to photography as a source of fresh ideas for creating a whole new language of form, thus accelerating the movement toward abstraction. Initially, however, photography, quite apart from its role as a model of pictorial mimesis, served painters mainly as a shortcut substitute for closely observed preparatory drawings and as a vastly expanded repertoire of reliable imagery, drawn from whatever remote, exotic corner of the globe into which adventurous photographers had been able to lug their cumbersome nineteenth-century equipment.

Meanwhile, photographers found themselves no less symbiotically involved with painting than their rival image-makers, the painters, were bound up with photography. Buoyed by pride in their technical superiority, photographers even felt compelled to match painting in its artistic achievements. Painters, albeit unequal to camera operators in their ability to produce a certain indiscriminately objective imitation of nature, enjoyed the freedom to select, synthesize, and emphasize at will and thus attain not only the poetry and expression thought to be essential to art but also a higher order of visual, if not optical, truth. In the earliest known photograph, Louis Jacques Mandé Daguerre (1789–1851), an artist already famous for his immense, sensationally illusion-

22. LOUIS JACQUES MANDÉ DAGUERRE. The earliest surviving Daguerreotype. Taken in the artist's studio, 1837. Daguerreotype. Courtesy Société de Photographie, Paris

above: 23. OSCAR G. REJLANDER. *The Two Ways of Life*. 1857. Combination albumen print. Courtesy the International Museum of Photography at George Eastman House, Rochester, New York

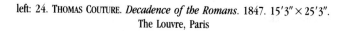

left: 24. THOMAS COUTURE. *Decadence of the Romans*. 1847. 15'3" × 25'3". The Louvre, Paris

above: 25. H. P. ROBINSON. *Sketch for Carrolling*. 1887. Pencil on paper. The Royal Photographic Society, Bath, England

below: 26. H. P. ROBINSON. *Carrolling*. 1887. Combination albumen print. The Royal Photographic Society, Bath, England

istic dioramas, had sought to emulate art as much as nature, since the reality he chose to record was that of a still life arranged in a manner conventional to painting since, at least, the seventeenth century (fig. 22). This was a daguerreotype, a one-of-a-kind metal plate that became a photograph once the inventor had succeeded in sensitizing it with silver, exposing the plate to light reflected from the subject through the lens of a camera, and, most important of all, arresting the action of light, thereby *fixing* the image it had reflected on the sensitized focal plane. This was a negative image, which became positive when viewed so that the mirror-bright plate reflected a dark field.

Simultaneously in England, the photographic process became considerably more versatile when William Henry Fox Talbot (1800–1877) discovered a way of fixing a light-reflected image on the silver-treated surface of paper. For the image stopped on this matte support to assume the chiaroscuro variations of its subject, Talbot had to rephotograph, develop, and arrest it, once again on sensitized paper, thereupon producing what its creator called a "calotype." By this means Talbot converted a negative into a positive, a procedure that remains funda-

27. LOUIS JACQUES MANDÉ DAGUERRE. *Boulevard du Temple, Paris*. c. 1838. Daguerreotype. Bayerisches Nationalmuseum, Munich

mental to photography even now. Because the two-step reversal technique made it possible for the image to be replicated ad infinitum, unlike the daguerreotype, painting-conscious photographers, such as Oscar G. Rejlander (1813–1875), could assemble elaborate, multifigure compositions in stagelike settings. They pieced the total image together from a variety of negatives made independently of one another and then orchestrated them, before negative-positive reversal, rather in the way contemporary history painters prepared their grand narrative machines for the Salon (figs. 23–26). And indeed Rejlander emulated not only the artistic methods and ambitions of academic masters like Thomas Couture (1815–1879), but also their pretensions to high moral purpose.

But just as the Realist spirit inspired a number of progressive painters to seek truth in a more direct and simplifying approach to both subject and medium, many enlightened photographers sought to purge their work of the artificial, academic devices seen here and concentrate on what photography then did best—report the world and its life as candidly as possible. While painters might create coherence, photographers would learn to discover it within the apparent disorder of external reality. The practitioners of "straight" photography would thus allow art and expression to occur naturally, through the choice of subject, view, framing, light, and the constantly improving means for controlling the latter—lenses, shutter speeds, plates, processing chemicals and equipment. The trend began early, even in the work of Daguerre

28. WILLIAM HENRY FOX TALBOT. *Trafalgar Square, London, During the Erection of the Nelson Column*. 1843. Salt print from a paper negative. Collection, The Museum of Modern Art, New York. Gift of Warner Communications, Inc.

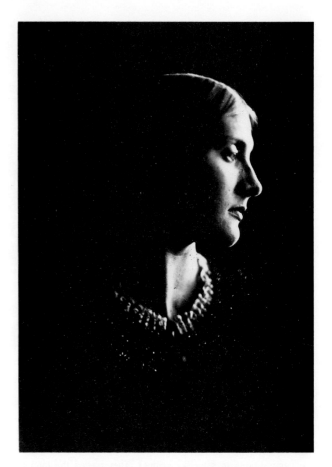

29. FÉLIX NADAR. *Portrait of Sarah Bernhardt.* 1859. Photograph. Courtesy the International Museum of Photography at George Eastman House, Rochester, New York

30. JULIA MARGARET CAMERON. *Mrs. Herbert Duckworth as Julia Jackson.* 1867. Albumen print. Collection, the International Museum of Photography at George Eastman House, Rochester, New York

and Talbot (figs. 27, 28), whose first street scenes already have the oblique angles and random cropping of snapshots, if not the bustling life, which moved in and out of range too rapidly to be caught by the slow photosensitive materials of the 1830s and 1840s. Contemporaries called Daguerre's Paris a "city of the dead," since the only human presence it registered was that of a man who stood still long enough for his shoes to be shined and, coincidentally, his picture to be taken.

The first great successes in straight photography came from the portraitists, foremost among them France's Félix Nadar (1820–1910) and England's Julia Margaret Cameron (1815–1879), whose own powerful personalities gave them access to many of the most illustrious people of the age and the vision necessary to render these with unforgettable forthrightness and penetration (fig. 29). A prolific writer, as well as caricaturist, balloon photographer, and dynamic man about Paris, Nadar wrote in 1856:

Photography is a marvellous discovery, a science that has attracted the greatest intellects, an art that excites the most astute minds—and one that can be practiced by any imbecile.... Photographic theory can be taught in an hour, the basic technique in a day. But what cannot be taught is the feeling for light.... It is how light lies on the face that you as artist must capture. Nor can one be taught how to grasp the personality of the sitter. To produce an intimate likeness rather than a banal portrait, the result of mere chance, you must put yourself at once in communion with the sitter, size up his thoughts and his very character.

At the same time that Cameron liked to dress up her friends and family and reenact scenes from the Bible and Tennyson's *The Idylls of the King* as photographed costume dramas, styled in a late-Romantic Pre-Raphaelite manner (plate 5; fig. 40), she also approached portraiture with an intensity that simply swept away all staginess but the drama of character and accentuated chiaroscuro (fig. 30). Throughout her work, however, she maintained, like the good Victorian she was, only the loftiest aims. Answering the complaint that her pictures were always out of focus, Cameron said:

What is focus—who has a right to say what focus is the legitimate focus—My aspirations are to ennoble Photography and to secure for it the character and uses of High Art by combining the real & ideal & sacrificing nothing of Truth by all possible devotion to Poetry & Beauty—

In the age of Realism, fantasy too found itself well served by the representational integrity available in straight photography, especially when adventurous individuals dragged their heavy paraphernalia high up among the gargoyles of Paris's Notre Dame Cathedral (fig. 31) or into the unimaginably strange environments of the American Far West and the exotic back streets of Old China (fig. 32).

When it came to war, however, photography ruthlessly disallowed fantasy and robbed armed conflict of the operatic glamour often given it by traditional painting. This first became evident in the photographs taken by Roger Fenton in the Crimea, but it had even more shattering

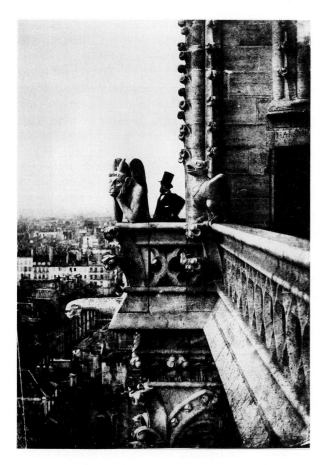

31. CHARLES NÈGRE. *The Gargoyle of Notre Dame*. 1840s–50s. Photograph. The Metropolitan Museum of Art, New York. Rogers Fund, 1962

32. JOHN THOMPSON. *Physic Street, Canton*. c. 1868. Carbon print in *Illustration of China and Its People* (London: 1873). Courtesy Peabody Museum of Salem

effect in the work of Mathew Brady (1823–1896) and such associates as Alexander Gardner (1821–1882), who bore cameras onto the body-strewn fields in the wake of battle during the American Civil War (fig. 33). Now that beautifully particularized, mutely objective—or indifferent—pictures disclosed all too clearly the harrowing calm brought by violence, or the almost indistinguishable likeness of the dead on either side of the conflict, questions of war and peace took on a whole new meaning.

As a medium of communication, as well as expression, photography was both the product and the agent of the powerful social changes that had been taking place in Western civilization since the revolutions of the late eighteenth century. Along with photography, and its popularization of pictorial imagery, came the immense expansion of journalism, as newspapers and periodicals were in some measure liberated from the tight and often punitive censorship of the *ancien régime*. A new kind of journalism, and a new kind of critical writing as well, were everywhere evident. Many of the leading authors and critics of France and England wrote regularly for the new popular reviews.

HONORÉ DAUMIER (1810–1879) The changes in attitude are perhaps best seen in the emergence of the caricature—the satirical comment on life and politics which became a standard feature of journals and newspapers (fig. 34). Although visual attacks on individuals or cor-

33. MATHEW BRADY. *Gathered for Burial at Antietam After the Battle of September 17, 1862*. 1862. Photograph. The Library of Congress, Washington, D.C.

34. HONORÉ DAUMIER. *Battle of the Schools: Idealism vs. Realism.* 1855. Lithograph. Bibliothèque Nationale, Paris

35. HONORÉ DAUMIER. *The Third Class Carriage.* c. 1860–62. 25¾ × 35½". The Metropolitan Museum of Art, New York. The H. O. Havemeyer Collection. Bequest of Mrs. H. O. Havemeyer, 1929

Paris, and his satire is thus rooted in realistic observation, he cannot be called only a Realist. His paintings dealing with themes from Cervantes and Molière, like for example his interpretations of Don Quixote, put him in the camp of the Romantics not only for his use of literary subject but also for the dramatic chiaroscuro he employed to obtain his effects. This drama of light and shade transforms even seemingly mundane subjects, such as *The Third-Class Carriage* (fig. 35) or his studies of theater audiences, from simple illustration to scenes of pathos or high comedy.

Daumier's caricatures, which reached a vast audience partly because of the development of lithography in the nineteenth century, were at times so biting in their attacks on the Establishment that censorship was applied. For a caricature he did of Louis-Philippe, Daumier was imprisoned for six months. The profundity of Daumier's horror at injustice and brutality is perhaps best illustrated in the famous lithograph *Rue Transnonain* (fig. 36), which shows the dead bodies of a family of workers who were murdered by the civil guard during the republican revolt of 1834. This is a work comparable to Goya's *Disasters of War* (fig. 15).

Daumier's studies of the theater, of the art world, and of politics and the law courts run the gamut from simple commentary to perceptive observation to bitter satire. Taken together they give us a picture of French life in the mid-nineteenth century comparable to that which Balzac shows us in his *Comédie Humaine.*

The chronological sequence of Neoclassicism, Romanticism, and Realism is, of course, only a convenient stratification of movements or tendencies so inextricably bound up with one another and with preceding movements that it is impossible to tell where one ended and another began. All three had renewed roots in the remote past, from antiquity to the Baroque, as well as continuity with the immediate past of the eighteenth century—that compound of sentimental naturalism and decorative-coloristic expression drenched by a tidal wave of archaeological Classicism. Romanticism and Realism emerged without appreciable interruption from Rousseau's notion of the "noble savage," Chardin's description of bourgeois life, and Greuze's exaltation of peasant virtues. David's late "neoclassic" portraits are masterpieces of specific realistic observation. Courbet's "realistic" self-portraits are very early instances of the modern formula of the artist as the Romantic individual, the genius touched with divine madness.

36. HONORÉ DAUMIER. *Rue Transnonain, April 15, 1834.* 1834. Lithograph, 11½ × 17½". Albertina, Vienna

rupt economic or political systems have always existed, and artists such as Goya have been motivated by a spirit of passionate invective, drawings that ranged from gentle amusement to biting satire to vicious attack now became a commonplace in every part of Europe and America. Just as the rise of Realism in art and the seemingly opposed expansion of the inflated Salon picture were closely allied to the emergence of large-scale bourgeois patronage, so were the expansion of the newspaper and journal and the popularity of the daily or weekly caricatures of the problems—and sometimes the tragedies—of everyday life.

The greatest of the satirical draftsmen to emerge in this new environment was Honoré Daumier, who, although best known for some four thousand drawings he contributed to different journals such as *La Caricature* and *Le Charivari*, was also a major painter and sculptor. But while Daumier was concerned with all the details of everyday life in

37. GUSTAVE COURBET. *Funeral at Ornans*. 1849. 10′3½″ × 21′9″. The Louvre, Paris

GUSTAVE COURBET (1819–1877) Gustave Courbet exhibits the three-way conflict of past, present, and future more clearly than any other artist of his time. Today secure in his place as the father of modern Realism, he alternated all of his life among pedantic Classicism, an erotic academicism that anticipated Bouguereau, and an atmospheric-romantic interpretation of the artist's world. Almost incidentally, he also produced more telling, unsentimentalized records of contemporary life than any other artist since the seventeenth century. And, most notably in a number of his key landscape studies, he made highly explicit statements of the realities that were to dominate so much of twentieth-century painting: the reality of the picture plane, the reality of the material with which he painted—oil paint itself. It is questionable whether Courbet ever understood that in his paintings he was mounting a revolution far greater than the political revolution that caused him to flee from France in 1873.

Funeral at Ornans (fig. 37) is of significance in the history of modern painting for its restatement of Neoclassic delimitation of illusionistic depth and its reiteration of the picture plane. In his assertion of the paint textures, the artist drew on and amplified the intervening experiments of the Romantics, although with a different end in view. Whereas the Romantics used broken paint surfaces to emphasize the intangible elements of the spirit, Courbet employed them as analogies of the most tangible aspects of ordinary, everyday life, commonplace but nevertheless profound in the statement of the realities of life and sorrow and death. The *Funeral* documents the artist's realization that his concern would be the facts of the world as he himself experienced it. Even more significant, it is one of the first documents of the artist's understanding that a painting is in itself a reality—a two-dimensional world of stretched canvas defined by the nature and textural consistency of oil paint—and that the artist's function is to define this world. The work established Courbet's position not only as a founder of modern Realism but also as a pioneer experimenter in the kind of abstract design generally considered to be the antithesis of Realism.

In a group of landscapes of the 1850s and 1860s, *The Source of the Loue* among them (fig. 38), Courbet experimented with a form of extreme close-up of rocks abruptly cut off at the edges of the painting to create the effect of a photographic detail. Such paintings probably owe something to the emerging art of photography, both in their fragmentary impression and in their frequently subdued, sometimes almost monochromatic color. Analogies may be seen in photographs of the time, for example, some of Louis J. M. Daguerre's intimate studio views and Fox Talbot's architectural details (figs. 22, 28). The rock land-

38. GUSTAVE COURBET. *Source of the Loue*. c. 1862. 23⅜ × 28¾″. The Metropolitan Museum of Art, New York. Bequest of Mrs. H. O. Havemeyer, 1929

39. GUSTAVE COURBET. *The Waves*. c. 1870. 12¾ × 19″. Philadelphia Museum of Art. The Louis E. Stern Collection

Realism in England: The Pre-Raphaelites

On the English side of the Channel, the social and artistic revolution that fueled the Realist movement in France assumed truly religious zeal, as a group of young painters rebelled against what they considered the decadence of current English art and called for renewal modeled upon the piously direct, primitive naturalism practiced in Florence and Flanders prior to late Raphael and the High Renaissance. Somewhat like the German Nazarenes thirty years earlier, William Holman Hunt (1827–1910), John Everett Millais, and Dante Gabriel Rossetti joined with several other sympathetic spirits to form a secret, reform-minded artistic society, this time called the Pre-Raphaelite Brotherhood. The ardent, if not monkish, PRB determined to eschew all inherited Mannerist and Baroque artifice and to search for truth in worthwhile, even Christian subject matter presented with naïve, literal fidelity to the exact textures, colors, light, and, above all, the outlines of nature. For *The Hireling Shepherd* (plate 5) Hunt pursued "truth to nature" in Surrey, where he spent months throughout the summer and autumn working *plein air*, or out-of-doors, to set down the dazzling effect of morning sunlight flooding onto a meadow next to an oak grove flanked by corn and wheat fields. Reviving the techniques of the fifteenth-century Flemish masters, Hunt laid on a white wet ground glaze after glaze of jewellike, translucent color and used the finest brushes to limn every last wild-flower blossom and blade of grass, the microscopic, almost magical detail enough to satisfy both botanists and those persuaded of the divine presence within nature. And such sacred or scientific concern for rendering reality did indeed suggest that this pastoral scene represented something more than a summer's idyll. Late in life, Hunt asserted that his "first object was to portray a real Shepherd and Shepherdess ...sheep and absolute fields and trees and sky and clouds instead of the painted dolls with pattern backgrounds called by such names in the pictures of the period." But it seems that originally he was also profoundly motivated to create a private allegory of the need for mid-Victorian spiritual leaders to cease their sectarian disputes and become true shepherds tending their distracted flocks. Thus while the shepherd, ruddy-faced from beer in his hip keg, pays court to the shepherdess, red-clad like the first Roman Catholic Cardinal to be named in Britain since the Reformation, the lamb on her lap makes a deadly meal of green apples, just as the sheep in the background succumb from being allowed to feed on corn. Gone are the smooth chiaroscuro elisions, rhythmic sweep, and gestural grace of old, replaced by a fresh-eyed, if somewhat ungainly and sunburnt naturalism, its uniform attention to detail serving to collapse near and far, as if to declare even the artist's own painstaking illusionism a falsehood.

While the repressed sexuality of Hunt's themes and symbols usually remained covert within the overwhelming innocence of their naturalistic treatment, this ever-present handmaiden of passionate Victorian morality played a far more explicit or even sultry role in the art of Dante Gabriel Rossetti (1828–1882), a preeminent poet of Italian descent as well as a Pre-Raphaelite painter. For Rossetti, "truth to nature" meant saturating the crystal-clear realism of his imagery with an electric charge of sensuously romantic, semimystical fantasy. In *Venus Verticordia*, for instance (fig. 40), he rendered his floral motifs and female model, a voluptuous, long-necked, heavy-tressed type adored by the PRB, with near-biological accuracy, but then nimbed the pagan deity with a Christian halo and positioned her flaming love barb as if it were

scapes of Courbet, however, combined a sense of observed reality with an even greater sense of the elements and materials with which the artist was working: the rectangle of the picture plane and the massed texture of the oil paint, which asserted its own nature at the same time that it was simulating the rough-hewn, sculptural appearance of exposed rocks.

Courbet, in his later career, experimented with as many different approaches to the subjects of landscape, portrait, still life, or figure as there were tides of fashion. Nevertheless, his fascination with a type of realism in which precise observation of nature is combined with the aggressive, expressive statement of the pictorial means continued, and was climaxed in a group of seascapes of the late 1860s. In *The Waves* (fig. 39) he appears deliberately to have selected an unrelieved expanse of open sea in order to demonstrate his ability to translate this subject into a primarily two-dimensional organization in which the third dimension is realized as the relief texture of the projecting oil paint.

Courbet's contribution to painting is revealed when such landscapes as *The Source of the Loue* and *The Waves* are compared with a landscape by John Constable, *The Hay Wain* (plate 3). The paintings of the English colorists Constable, Turner (plate 4), and Bonington had a profound influence on the French Romantics and particularly on the Barbizon School of landscapists. Constable's textural statement of brush gesture was well adapted to Romantic narrative and landscape, out of which Courbet's painting emerged. The radiant color used by both the Englishmen was a revelation. Its sun-filled naturalism, however, although it may have affected the course of French Impressionist painting, was premature for the French Realists and Romantics. With the exception of Delacroix, they continued to prefer the more subdued color harmonies and the less vivid light of the studio when painting the out-of-doors. The paint texture of Constable's *Hay Wain* is direct and unconcealed to a degree rarely observed in painting before his time, but his landscapes are still seen with the eyes of the Renaissance-Baroque tradition. Space opens up into depth, and paint is converted into fluffy, distant clouds, richly leaved trees, and reflecting pools of water. Not only does Courbet's assertion of a unified picture plane and of paint texture contribute to the abstract quality of *The Waves*, but so does even its unified, subdued color palette.

40. DANTE GABRIEL ROSSETTI. *Venus Verticordia*. 1864–68. 26¾ × 31⅞". Russell-Cotes Art Gallery and Museum, Bournemouth, England

Catholicism's symbol of the Sacred Heart. Given this, every form suddenly seems redolent of hidden meaning, as in the emblem-rich, minutely particularized pictures of the fifteenth-century Flemish primitives, albeit now for the sake of private sexual longings remote from the genuinely spiritualized past. To Rossetti, the roses stood for sensual love, as did the foreground honeysuckle, since its flowers attract bees. As the butterflies draw near the fiery halo and dart, like the souls of men risking death for love, the Venus with the Virgin's nimbus emerges as a *femme fatale*, an early example of the morbidly erotic conception whose conflation of pagan and Christian themes shocked Victorians, but survived to dominate the male imagination throughout much of the later nineteenth century.

Impressionism

ÉDOUARD MANET (1823–1883) Manet's *Déjeuner sur l'herbe* (plate 6), rejected by the Salon of 1863, created a major scandal when it was exhibited in the Salon des Refusés. Although the subject was based on such respectable academic precedents as Giorgione's *Pastoral Concert* (1510) and a detail from an engraving by Marcantonio Raimondi of *The Judgment of Paris* (c. 1520) after a lost cartoon by Raphael, popular indignation arose because the Classic, pastoral subject had been translated into contemporary terms. Raphael's goddesses and Giorgione's nymphs had become models, one naked, one partially disrobed, relaxing in the woods with a couple of respectably dressed but "obviously" dissolute bohemian artists. At this level, Manet's departure seems to have been made in terms of the Realist conviction that the artist had to paint the world of his own experience, the world as he saw it. Venus or Danaë or even the Romantics' odalisque had to become a seated nude or woman bathing.

The *Déjeuner sur l'herbe* places the figures in the same sort of sealed forest setting, although the center is opened up to a limited depth, and the bending woman in the middle distance acts as the apex of the classical triangle of which the three foreground figures serve as the base and sides. In his abandonment of Courbet's impasto, Manet had moved a step further toward the assertion of a painting as a two-dimensional surface that the artist had the duty of reiterating in all elements of the work. This conception as well as the sketchiness of technique infuriated the professional critics, almost as though they sensed in this work the prophecy of a revolution that was to destroy the comfortable world of secure values of which they felt themselves to be the guardians.

Manet's *Olympia* (fig. 41), painted in 1863 and exhibited in the Salon of 1865, created an even greater furor than the *Déjeuner*. Here, again, the artist's source was exemplary: Titian's *Venus of Urbino*, itself stemming from Giorgione's *Sleeping Venus*. The *Olympia*, however, was a slap in the face to all the complacent academicians who regularly presented their exercises in scarcely disguised eroticism as virtuous homage to the gods and goddesses of Classical antiquity. Venus reclining has become simply a reclining nude—"obviously" of somewhat doubtful morals—who stares out at the spectator with an impassive boldness that bridges the gap between the real and the painted world in a startling manner and effectively shatters any illusion of sentimental idealism in the presentation of the nude figure. The *Olympia* is a brilliant design in black and white, with the nude figure silhouetted against a dark wall enriched by the red underpainting that creates a Rembrandtesque glow of color in shadow. The black maidservant acts as a transition from dark to light and provides a classical balance to the inclined torso of the nude. The volume of the figure is created entirely through its contours—again, the light-and-dark pattern and the strong linear emphasis annoyed the critics as much as the shocking subject matter. Even Courbet, who dared every reality—aesthetic, social, or political—found *Olympia* so unsettling in the playing-card flatness of its forms, all pressed hard against the frontal plane, that he likened the picture to "a Queen of Spades getting out of a bath."

41. ÉDOUARD MANET. *Olympia*. 1863. 51 × 74¾". The Louvre, Paris

Colorplate 1. JEAN-AUGUSTE-DOMINIQUE INGRES. *Odalisque with Slave*. 1842. 30 × 41½″. Walters Art Gallery, Baltimore

Colorplate 2. EUGÈNE DELACROIX. *The Lion Hunt*. 1861. 30⅛ × 38¾″. Art Institute of Chicago. Potter Palmer Collection

Colorplate 3. JOHN CONSTABLE. *The Hay Wain*. 1819–21. 51¼ × 73″. The National Gallery, London

Colorplate 4. J. M. W. TURNER. *The Burning of the Houses of Parliament*. 1834–35. 36½ × 48½″. The Cleveland Museum of Art. John L. Severance Collection

Colorplate 5. WILLIAM HOLMAN HUNT. *The Hireling Shepherd*. 1851. 30¹⁄₁₆ × 43⅛″. Courtesy Manchester City Art Gallery, England

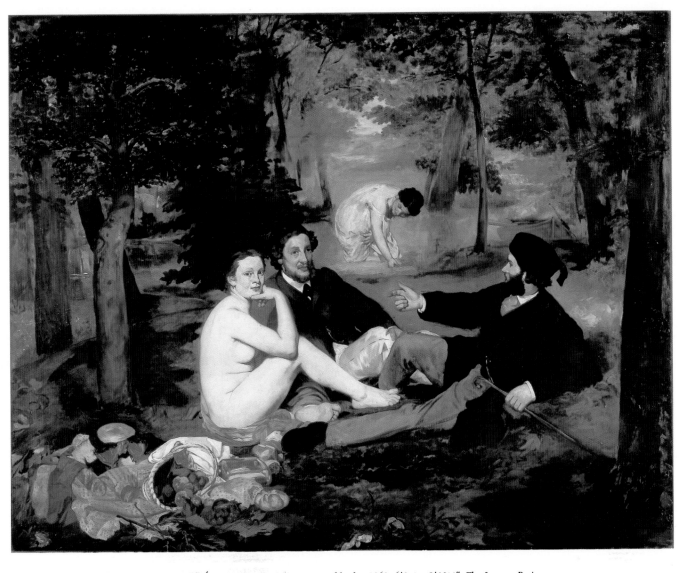

Colorplate 6. ÉDOUARD MANET. *Déjeuner sur l'herbe*. 1863. 6′9⅛ × 8′10¼″. The Louvre, Paris

Colorplate 7. EISHI. *Evening Under the Murmuring Pines*. c. 1800. Color woodcut. Reproduced by courtesy of the Trustees of the British Museum, London

Colorplate 8. JAMES MCNEILL WHISTLER. *Symphony in White No. II: The Little White Girl*. 1864. 30⅛ × 20⅛″. The Tate Gallery, London

Colorplate 9. CLAUDE MONET. *Impression, Fog (Le Havre)*. 1872. 19½ × 25½″. Musée Marmottan, Paris

Colorplate 10. CLAUDE MONET. *Bridge at Argenteuil*. 1874. 23⅝ × 31½″. The Louvre, Paris

Colorplate 11. AUGUSTE RENOIR. *Moulin de la Galette*. 1876. 51½ × 69″. The Louvre, Paris

left: Colorplate 12. EDGAR DEGAS. *A Ballet Seen from an Opera Box*. 1885. Pastel on paper, 25⅛ × 19¼″. John G. Johnson Collection, Philadelphia

above: Colorplate 13. MARY CASSATT. *Little Girl in a Blue Armchair*. 1878. 35 × 51″. National Gallery of Art, Washington, D.C. Collection Mr. and Mrs. Paul Mellon, 1983

above: Colorplate 14.
GEORGES SEURAT.
*A Sunday Afternoon
on the Island of
La Grande Jatte*.
1884–86.
6′9½″ × 10′1¼″. Art
Institute of Chicago.
Helen Birch Bartlett
Memorial Collection

left: Colorplate 15. PAUL
CÉZANNE. *The Bay from
L'Estaque*. 1886.
31½ × 38½″. Art
Institute of Chicago.
Mr. and Mrs. Martin
A. Ryerson Collection

Colorplate 16. PAUL CÉZANNE. *Still Life with Basket of Apples*. 1890–94. 24⅜ × 31″. Art Institute of Chicago. Helen Birch Bartlett Memorial Collection

Colorplate 17. PAUL CÉZANNE. *Boy in a Red Vest*. 1890–95. 36¼ × 28¾″. Collection Mr. and Mrs. Paul Mellon, Upperville, Virginia

Colorplate 18. PAUL CÉZANNE. *Mont Sainte-Victoire*. 1904–6. 25⅝ × 31⅞″. Collection Mr. and Mrs. Louis C. Madeira, Gladwyne, Pennsylvania

Colorplate 19. PAUL CÉZANNE. *The Large Bathers*. 1898–1905. 82 × 98″. Philadelphia Museum of Art. Wilstach Collection

Colorplate 20. ODILON REDON. *Roger and Angelica*. c. 1910. Pastel,
36½ × 28¾″. Collection, The Museum of Modern Art, New York. Lillie P.
Bliss Collection

Colorplate 21. PAUL GAUGUIN. *Vision After the Sermon*. 1888. 28¾ × 36¼″. National Gallery of Scotland, Edinburgh

Colorplate 22. PAUL GAUGUIN. *The Day of the God (Mahana No Atua)*. 1894. 27⅜ × 35⅝″. Art Institute of Chicago

Colorplate 23. VINCENT VAN GOGH. *The Night Café*. 1888. 27½ × 35″. Yale University Art Gallery, New Haven, Connecticut. Bequest of Stephen C. Clark

Colorplate 24. VINCENT VAN GOGH. *The Starry Night*. 1889. 29 × 36¼″. Collection, The Museum of Modern Art, New York. Acquired through the Lillie P. Bliss Bequest

above left: Colorplate 25. PAUL SÉRUSIER. *The Talisman (Landscape of the Bois d'Amour)*. 1888. Oil on cigar box cover, 10½ × 8⅜″. Mme. Denis-Boulet, Clermont d'Oise, France

above: Colorplate 26. EDOUARD VUILLARD. *Self-Portrait*. 1892. Oil on board, 14 × 11″. Collection Mr. and Mrs. Sidney F. Brody, Los Angeles

left: Colorplate 27. PIERRE BONNARD. *Dining Room on the Garden*. c. 1933. 50⅛ × 53½″. The Solomon R. Guggenheim Museum, New York

Colorplate 28. GUSTAV KLIMT. *Death and Life*. 1908–11. 70⅛ × 78″. Collection Frau Marietta Preleuthner, Vienna

Colorplate 29. EDVARD MUNCH. *The Dance of Life*. 1899–1900. 49½ × 75½″. National Gallery, Oslo

Colorplate 30. JAMES ENSOR. *The Entry of Christ into Brussels in 1889*. 1888. 8′5″ × 12′5″. Collection Colonel L. Frank, London. On loan to Koninklijk Museum voor Schone Kunsten, Antwerp

42. ÉDOUARD MANET. *Portrait of Émile Zola.* 1868. 57⅛ × 44⅞". The Louvre, Paris

43. JAMES McNEILL WHISTLER. *Nocturne in Black and Gold: The Falling Rocket.* c. 1874. 23¾ × 18⅜". The Detroit Institute of Arts. Gift of Dexter M. Ferry, Jr.

The *Portrait of Émile Zola* (fig. 42), an informal genre portrait, not only continues the Realists' attack on the academic concept of the grand and noble subject but, moreover, carries the attack several steps further in its emphasis on the plastic means. Manet painted into the work what are manifestly credos of his own in addition to those of the writer who had so brilliantly defended him. The bulletin board at the right holds a small print of the *Olympia*, behind which is a reproduction of Velázquez's *Bacchus*. Beside the *Olympia* is a Japanese print, and behind Zola's figure is seen part of a Japanese screen. The Japanese print and screen are symptomatic of the growing enthusiasm for Oriental and specifically Japanese art then spreading among the artists of France and other parts of Europe. This enthusiasm resulted from the fact that in the art of the Orient experimental French painters found formal qualities that, consciously or unconsciously, they were seeking in their own work.

After photography, the most powerful and pervasive influence on the nineteenth-century advance of modernist form may have come from Oriental art, especially the color woodcut prints that began flowing West shortly after Commodore Matthew Perry had forced open the ports of Japan in 1853 (plate 7). With their steep and sharply angled views, their bold, snapshot-like croppings, and their flat-pattern design of brilliant, solid colors set off by the purest of contour drawing, the works of such masters as Utamaro, Hokusai, and Hiroshige struck susceptible eyes as supremely confident statements of the growing belief that pictorial truth lay not in illusion but in the intrinsic qualities of the artist's means and the opaque planarity of his painting surface.

The attraction of this art for Manet is evident in every aspect of the *Portrait of Zola.* Henri Fouquier denounced the picture in *Le National,* declaring: "The accessories are not in perspective, and the trousers are not made of cloth." The stupid phrase contained a remarkable truth: the trousers were not made of cloth; they were made of paint.

By 1870 Manet had turned his attention to *plein air* painting in which he sought to apply his brush-sketch technique to large figure compositions and to render these in full color that caught all the lightness and brilliance of natural sunlight. He had been in touch with the Impressionists Monet, Renoir, Pissarro, Bazille, and Sisley, and had been their spiritual leader since the exhibition of *Déjeuner sur l'herbe* in 1863.

JAMES ABBOT McNEILL WHISTLER (1834–1903) Closely allied to Manet in his search for a new pictorial reality suitable for "a painter of modern life" was the American expatriate artist James Abbot McNeill Whistler. Much more than Manet, however, Whistler transformed his Japanese sources into an emphatic, even dominant aestheticism, although the artist, in an authentic Realist manner, consistently painted only what he had actually observed. The shift in emphasis was evident, moreover, in the early 1860s when he did pictures like *Symphony in White No. II: The Little White Girl* (plate 8), where *japonisme* makes its presence felt not only in the obvious décor of a blue-and-white porcelain vase, painted fan, and cherry blossoms, but also in the more subtle, and more important, flattening effects of the nuanced, white-on-white rendering of the model's dress and the rectilinear, screenlike

44. CAMILLE COROT. *Ville d'Avray.*
1871–74. 21⅝ × 31½". The
Metropolitan Museum of Art, New
York. Bequest of Catherine Lorillard
Wolfe, 1887

45. UNIDENTIFIED PHOTOGRAPHER (LOUIS-DÉSIRÉ BLANQUART-EVRARD CAHIERS).
Forest Scene. c. 1851–55. Calotype. Courtesy the International Museum of
Photography at George Eastman House, Rochester, New York

divisions of the architectural framework. Further reinforcing the sense
of an overriding formalism is the off-center composition, with its result-
ing crop of the figure along the edges of the canvas. As if to emphasize
his commitment to the principle of art for art's sake—of the painting as
an oasis of beauty and refinement remote from the world of coarse
reality—Whistler gave his pictures musical titles, thereby analogizing
them to a more immaterial, evocative, and nondescriptive kind of po-
etry. By the mid-1870s, when the artist had settled permanently in Lon-
don, his painting came to seem so purely abstract that *Nocturne in
Black and Gold: The Falling Rocket* prompted John Ruskin to accuse
Whistler openly of "flinging a pot of paint in the public's face" (fig. 43).
The irascible Whistler brought a libel suit against his critic and won a
token judgment, for indeed he had worked from a subject—a noctur-
nal fireworks display—carefully chosen to allow him the delight of
demonstrating his skill at capturing the glow-worm evanescence of fiery
bursts and glittering sparks sprayed over a midnight sky.

A great part of the struggle of nineteenth-century experimental paint-
ers was an attempt to recapture the color and light of nature that had
been submerged in the studio gloom of academic tonal formulas. The
color of the Neoclassicists had been defined in local areas but modified
with large passages of neutral shadows to create effects of sculptural
modeling. The color of Delacroix and the Romantics flashed forth pas-
sages of brilliant blues or vermilions from an atmospheric ground. As
Corot and the Barbizon School of landscape painters sought to approxi-
mate more closely the effects of the natural scene with its natural light,
they were almost inevitably bent in the direction of the subdued light of
the interior of the forest, of dawn, and of twilight. Color, in their hands,
thus became more naturalistic, although they did choose to work with
those effects of nature most closely approximating the tradition of stu-
dio light. However, the increasingly delicate and abstract, almost mono-
chromatic tonality of the post–1850 landscapes painted by Corot (fig.
44), so different from the clear colors and structural firmness of his
earlier Italian work (fig. 20), may well have been an attempt to imitate
the seamless, line-free value range of contemporary photography (fig.
45). In their smoky tissues of feathery leaves and branches, the moody,

46. EUGÈNE BOUDIN. *On the Beach at Trouville*. 1863. 10 × 18″. The Metropolitan Museum of Art, New York. Bequest of Amelia B. Lazarus, 1907

autumnal parklike scenes painted by the aging Corot now seem a proto-Symbolist, painterly counterpart of the blurred and halated landscape photographs made with the period's nonpanchromatic emulsions.

One of the few landscapists of the mid-century determined to work away from the forest in full sunlight was Eugène Boudin (1824–1898), who painted the sea and shore around Le Havre with a direct, on-the-spot brilliance that fascinated both Courbet and the poet Charles Baudelaire (fig. 46). It inspired Claude Monet and, through Monet, the movement of Impressionism.

Impressionism in French painting, and its expansion throughout the world, has long been thought of as an ultimate refinement of Realism. The more the Realist artists of the mid-nineteenth century attempted to reproduce the world as they saw it, the more they understood that reality rested not so much in the simple objective nature of the natural phenomena—in mountains or trees or human beings or pots of flowers—as in the eye of the spectator. Landscape and its sea, sky, trees, and mountains in actuality could never be static and fixed. It was a continuously changing panorama of light and shadow, of moving clouds and reflections on the water. Observed in the morning, at noon, and at twilight, the same scene was actually three different realities—or, if the time or spectators were varied, a hundred different realities. Further, as painters moved from the studio out of doors they came to realize that nature, even in its dark shadows, was not composed of black or muddy browns. The colors of nature were blues, greens, yellows, and whites, accented with notes of red and orange.

In the sense that the artists were attempting to represent specific aspects of the observed world more precisely than any artists before them, Impressionism can be labeled as a kind of super Realism, a specialized view of the world in terms of intense observation as well as of new discoveries in the science of optics. This view of Impressionism, however, is only partial, and puts an undue emphasis on what is perhaps its least important aspect. In this sense it could be regarded as the end of a great tradition of realistic painting extending from antiquity through the eighteenth century and gradually narrowing its focus in the landscapists and genre painters of the mid-nineteenth. But Impressionism was much more than this. Behind the landscapes of Monet and the figure studies of Renoir lay not only the Social Realism of Courbet and the Romantic Realism of Corot and Daubigny but also the more significant sense of abstract structure that had appeared with David and Ingres and developed into a new aesthetic with Courbet and Manet.

CLAUDE MONET (1840–1926) The term "impressionism" was the achievement of Louis Leroy, the facetious critic for *Le Charivari*, who found this apt epithet for the "outrageous" experiments submitted to an exhibition at the gallery of the great photographer Nadar in the title of a painting by Monet (plate 9). The work in question offers a romantic harmony of sky and water, an example of the type of atmospheric dissolution later developed further by Whistler in his Nocturnes (fig. 43). It is a thin veil of light gray-blue shot through with the rose-pink of the rising sun. Reflections on the water are suggested by short, broken brushstrokes, but the painting as a whole has nothing of the quality of optical, scientific color analysis that critics and historians were soon to attach to the movement. The original Impressionists—Monet, Auguste Renoir, Camille Pissarro, Alfred Sisley, and, for a time, Paul Cézanne—were less interested in scientific theories of light and color than in the simple but overwhelming experience of the natural world seen directly in all the splendor of full sunlight or in the cool and magical mystery of dawn or twilight. Not until later did the Neo-Impressionists—Georges Seurat, Paul Signac, and, briefly, Pissarro—become fascinated with some of the new discoveries in scientific color perception. The *Impression, Fog*, for Monet, was an attempt to capture the ephemeral aspects of a changing moment, more so, perhaps, than any of his paintings until the late Venetian scenes or *Waterlilies* of 1905. *The Bridge at Argenteuil* (plate 10) might be considered a more typical or even a more classic version of developed Impressionism, a work that glistens and vibrates and gives the effect of brilliant, hot sunlight shimmering on the water. The water itself is rendered in positive color. Nevertheless, there is no uniform pattern of brushstroke to define the surface: the trees are treated as a fluffy and relatively homogenous mass; the foreground blue of the water and the blue of the sky are painted quite smoothly and evenly; the boats and the bridge are drawn in with firm, linear, architectural strokes. In other words, Monet here demonstrates an attention to the different aspects of the scene in many respects comparable to that in the early paintings of Camille Corot (fig. 20). The differences, however, which are quite apparent, represent revolutionary changes. The complete avoidance of blacks and dark browns and the assertion of modulated hues in every part of the picture introduce a new world of light-and-color sensation. And even though distinctions are made among the textures of various elements of the landscape—sky, water, trees, architecture—all elements are united in their common statement as paint. The overt declaration of the actual physical texture of the paint

left: 47. CLAUDE MONET. *Boulevard des Capucines, Paris (Les Grands Boulevards)*. 1873–74. 31¼ × 23¼". The Nelson-Atkins Museum of Art, Kansas City, Missouri. Acquired through the Kenneth A. and Helen F. Spencer Foundation Acquisitions Fund

above: 48. EDWARD ANTHONY. *A Rainy Day on Broadway, New York*. 1859. One half of a stereograph. From the series "Anthony's Instantaneous Views." Courtesy the International Museum of Photography at George Eastman House, Rochester, New York

itself, heavily brushed or laid on with a palette knife, derives from the broken paint of the Romantics, the heavily modeled impasto of Courbet, and the brush gestures of Manet. But now it has become an overriding concern with this group of young Impressionists. The point has been reached at which the painting ceases to be solely or even primarily an imitation of the elements of nature. The experiments in limited picture-space organization pursued in other ways by Courbet and Manet have now been carried further. In *The Bridge at Argenteuil* Monet arranges all his elements in a careful grid. He closes the background in with the horizontal mass of trees and the architecture of the bridge. The staccato color strokes that make up most of the water have themselves the effect of limiting and defining depth and expressing recession as areas of color parallel to the picture plane.

In this work, then, Impressionism can be seen as an ultimate refinement of optical Realism, a statement of visual reality not simply as the persistent surface appearance of natural objects but as a never-ending metamorphosis of sunlight and shadow, reflections on water, and patterns of clouds moving across the sky. This is the world as we actually see it: not a fixed, absolute perspective illusion in the eye of a frozen spectator within the limited frame of the picture window, but a thousand different glimpses of a constantly changing scene caught by a constantly moving eye.

Monet's intuitive grasp of the reality of visual experience becomes particularly evident when a work like *Boulevard des Capucines, Paris* (fig. 47)—painted from a window in the upstairs studio of the photographer Félix Nadar (fig. 29), where the Impressionists would hold their first exhibition—is compared with the contemporary photographs of a similar scene (figs. 27, 48). Whereas both camera-made images show Paris as a "city of the dead," one because its slow emulsion could record virtually no sign of life and the other because its speed froze every horse, wheel, and human in mid-movement, Monet used his rapidly executed color spotting to express the dynamism of not only the bustling crowd but also the flickering, light- and mist-suffused atmosphere of a wintry day, the whole perceived within an instant of time. Still, far from allowing his broken brushwork to dissolve all form, he so deliberated his strokes that simultaneously every patch of relatively pure hue represents a ray of light, a moment of perception, a molecule of atmosphere or form in space, and a brick within the mosaic structure of a surface design. With its decorative clustering of color touches, its firm orthogonals, and its oblique Japanese or photographic view, the picture emerges as a statement of the artist's sovereign strength as a pictorial architect. Such a scene served as a reaction not only against the worn-out formulas but also against the sobriety of past landscape painting. Not even Watteau, Turner, or Constable ever painted a world so secure within its bath of light and coloristic gaiety.

More significant still, Impressionism also marks the moment at which a group of artists began, half-unconsciously, to assert the identity of a painting as a thing, a created object in its own right, with its own structure and its own laws beyond and different from any property it might have as illusion or as imitation of the world of man and nature. It may thus at one and the same time be regarded as the end of the Renaissance tradition of illusionistic Realism and the major beginning of twentieth-century exploration of expressive color, Cubism, and abstraction.

AUGUSTE RENOIR (1841–1919) The artists associated with the Impressionist movement were a group of diverse individuals, all united by common interest, but each intent on the exploration of his own separate path. Auguste Renoir was essentially a figure painter and one of the great colorists of all time. He applied the principles of Impressionism in the creation of a lovely dreamworld, a new Isle of Cythera that he then transported to the Paris of the late nineteenth century. The *Moulin de la Galette* (plate 11), painted in 1876, epitomizes his most Impressionist moment, but it is an ethereal fairyland in contemporary dress. Baudelaire had preached the doctrine of a heroic Realist or Romantic painting of the actual world in which the artist lived, with heroes dressed in top hats, or boaters and heroines in crinolines and bustles. In the *Moulin de la Galette* the commonplace scene of an outdoor bohemian dance hall is transformed into a color-and-light-filled reverie of fair women and gallant men. The lights flicker and sway over the color shapes of the figures—blue, rose, and yellow—and details are blurred in a romantic haze that softens and enhances the beauty of all the delightful people. This painting and his many other comparable paintings of the period are so saturated with the sheer joy of a carefree life that it is difficult to recall the privations that Renoir, like Monet, was suffering during these years.

The art of the Impressionists was largely urban. Even the landscapes of Monet had the character of a Sunday in the country or a brief summer vacation. But this urban art commemorated a pattern of life in which the qualities of insouciance, charm, and good living were extolled in a manner equaled only by certain aspects of the eighteenth century. Now, however, the good life was no longer the prerogative of a limited aristocracy; even the most poverty-stricken artist could participate in it. This was, of course, another form of Romanticism, since the moments of carefree relaxation were relatively rare and spaced by long intervals of hard work and privation for those artists who, unlike Cézanne or Degas, were not blessed with private incomes.

EDGAR DEGAS (1834–1917) Born into a family with some pretensions to aristocracy, Degas thought of himself as a draftsman in the tradition of Ingres. Nevertheless, he seems to have had little interest in exhibiting at the Salon after the 1860s or in selling his works. On the contrary, he took an active part in the Impressionist exhibitions between 1874 and 1886, in which he showed his paintings regularly. But while associated with the Impressionists, Degas did not share their enthusiasm for the world of the out-of-doors. Still, the racehorse scenes of the late 1860s and early 1870s involved Degas with open-air subjects— which however he painted in his studio—and lightened his palette, but only in about the same degree as Boudin's. To draw horses and people

49. EDGAR DEGAS. *The Jockey*. 1889. Pastel on paper, 12½ × 19¼". Philadelphia Museum of Art. W. P. Wilstach Collection

50. EADWEARD MUYBRIDGE. *Horse in Motion*. 1878. Wet plate photographs. Courtesy the International Museum of Photography at George Eastman House, Rochester, New York

51. EDGAR DEGAS. *The Tub*. 1886. Pastel on cardboard, 23⅝ × 32⅝".
The Louvre, Paris

zation, an interest that arose from his enthusiasm for the world of the theater, the concert hall, and the ballet, it was in terms of dramatic indoor effects. Theater and ballet gave him unequaled opportunities for the exercise of his brilliant draftsmanship and for the exploration of a kind of arbitrary, artificial, dramatic, and romantic light, which served as a means of divorcing the scene from actuality and finding an essentially abstract organization in the motions of ballet dancers. The importance of Degas, perhaps above the Impressionists, lies in his sense of abstract form and color. He was a student of Japanese prints and was strongly influenced by their patterns. He was also an accomplished photographer, and earlier than almost any other painter, he discovered how to use photography as a means for developing a fresh, original, even oblique vision of the world. *A Ballet Seen from an Opera Box*, for instance, could be a photographic fragment translated into a coloristic pattern (plate 12). This dance scene, like many others created by Degas during the 1880s and 1890s, is presented from above, with the woman in the loge acting as the observer who also becomes a part of what is observed. The performers in blue in the background are abruptly decapitated and the bowing ballerina in the foreground is seen in a truncated version, from the knees up. The movement from dense but colored shadow in the foreground figure, first to the illumination of the middle ground and then to the diminishing light intensity of the dancers in the background, creates a further sense of strangeness that takes the scene out of real time and place.

After the mid-1870s Degas increasingly turned to pastel or combinations of pastel and gouache for his ballet scenes, for he realized that his concern was with arbitrary rather than naturalistic color, and that in the medium of pastel he could best achieve the nondescriptive effects he sought.

remained his primary interest, and his drawing style continued to be more precise than that of Manet's comparable racetrack subjects. This was particularly true in later works, where Degas became one of the first artists to exploit the new knowledge of animal movement recorded in the 1870s and 1880s by Eadweard Muybridge (1830–1904) in a series of stop-action photographs (figs. 49, 50), images that made forever obsolete the "hobbyhorse" attitude—legs stretched forward and backward—long conventional in paintings of running beasts.

When Degas became really interested in light and color-light organi-

52. BERTHE MORISOT. *Hide and Seek*.
1873. 17¾ × 21¾". Collection Mrs.
John Hay Whitney

Increasingly, during the 1880s and 1890s, Degas also chose commonplace subjects: milliners in their shops; exhausted laundresses; simple bourgeois women occupied with the everyday details of their toilets: bathing, combing their hair, dressing, or drying themselves after the bath. Subjects such as these constitute a further development of the Realist experiments of Courbet and Manet, but with a difference particularly apparent in the studies of nudes. In a work like *The Tub* (fig. 51) Degas goes beyond any of his predecessors in presenting the nude figure as part of a scene, of an environment in which she fits with unconscious ease. Here the figure is beautiful in the easy compact sculptural organization, but the routine character of the accessories takes away any element of the erotic just as the bird's-eye view and the cut-off edges translate the photographic fragment into an abstract arrangement reminiscent of Japanese prints.

Two painters who showed regularly with the Impressionists and who identified strongly with the Manet-Degas orbit were the Frenchwoman Berthe Morisot (1841–1895) and the American Mary Cassatt (1845–1926). While Morisot joined Monet and Renoir in banishing black from her palette, she accepted the authority of line from Manet, her brother-in-law, and Degas, using it in tangled skeins to realize scenes and figures as materializations of light and color (fig. 52). The Philadelphia-born Cassatt, who arrived in Paris with her wealthy family in 1866, also had an almost Japanese love of line, but often used it with the painterly freedom of Manet and the high-keyed colorism of the *plein-air* Impressionists. In her skewed perspectives, intimate views, and photographic cropping, however, she was at one with Degas, her closest artistic associate (plate 13). Cassatt, like Morisot, generally kept to the mother and child subjects still considered appropriate for women, but the sensuous immediacy and directness with which she treated them betrayed the daring modernity of her whole approach to art.

By the mid-1880s, the Impressionists discovered that their once innovative procedures had also become automatic and repetitious, with instantaneity and directness producing not so much freshness as mere formlessness. This was the so-called "crisis of Impressionism," which prompted Monet and his circle to move in various directions to renew their art once again, some by reconsidering aspects of traditional drawing and composition, others by enlarging or refining the premises on which they had been working. Foremost among the latter stood Monet, who remained true to visual experience, but with such intensity, concentration, and selection as to push his art toward antinaturalistic subjectivity and pure decorative abstraction. In series after series he withdrew from the urban and industrial world, once so excitingly consistent with the nineteenth century's positivist, materialist concept of progress, and looked to unspoiled nature, as if to record its scenes quickly before science and technology could destroy them forever. Thus motivated, Monet so magnified his sensations of the individual detail perceived in an instant of time that instead of fragmenting large, complex views like that in *Boulevard des Capucines, Paris* he broke up simple, unified subjects—poplars, haystacks, the façade of Rouen Cathedral—into representations of successive moments of experience, each of which, by its very nature, assumed a uniform tonality and texture that tended to reverse objective analysis into its opposite: subjective synthesis. In a long, final series, painted at Giverny, Monet retired to an environment of his own creation, a water garden, where he found a piece of the real world—a sheet of clear liquid afloat with lily pads, lotus blossoms, and reflections from the sky above—perfectly at one with his conception of the canvas as a flat, mirrorlike surface shimmering with an image of the world as a dynamic materialization of light and atmosphere (fig. 53). In these late, deeply pondered masterpieces, Monet's empirical interest in luminary phenomena had become a near mystical obsession, its lyrical poetry often expressed in the monochrome blue and mauve favored by the introspective, *fin-de-siècle* Symbolists. As single, all-over, indivisible images, they also looked forward, from 1926 when the long-lived Monet died, to the late 1940s and 1950s, the time of the New York Abstract Expressionists, who would produce a similarly "holistic" kind of painting, environmental in its scale but now entirely abstract in its freedom from direct reference to the world outside.

53. CLAUDE MONET. Left third of *Les Nuages (Clouds)*. 1916–26. Each panel 6′6¾″ × 13′11⅜″. Musée de l'Orangerie, Paris

Post-Impressionism

So various and distinctive were the reactions against the largely sensory nature and so-called "formlessness" of Impressionism that Roger Fry, the English critic who was the first to take a comprehensive look at these developments, could do no better than characterize them with the essentially nondefining, umbrella designation "post-impressionism." The sheer inadequacy of the term is borne out by the fact that, unlike "impressionism," it did not enter the language until a quarter of a century after the inception of the artistic phenomena it purported to describe. Still, Post-Impressionism, a coinage of 1910, does offer the virtue of specifying the one element that Seurat, Cézanne, Gauguin, and Van Gogh all had in common—their determination to move beyond the relatively passive registration of perceptual experience and give formal expression to the conceptual realm of ideas and intuitions.

In view of this objective, it could also be said that the Impressionists were themselves the first Post-Impressionists, for, by the early 1880s, Renoir, Monet, and Degas, as we have seen, were all beginning to reconsider their painting in the light of their own altered consciousness. Far from mindless or uncritical portrayers of bourgeois ease and pastoral pleasures, as the Impressionists have sometimes been called, these artists were all intelligent beings vibrantly in tune with their times, which by the 1880s had begun to change rapidly in ways that could only distress a Europe imbued with the nineteenth-century positivist belief in ever-accelerating progress under the impetus of science and industry. As industrial waste combined with expanding commerce to destroy the unspoiled river and meadow sites so often painted by Monet, the master withdrew ever deeper into his "harem of flowers" at Giverny, a synthetically natural world of his own creation and so bound up with his late painting as to be virtually inseparable from it. And as rising socioeconomic expectations met with conservative backlash, which in turn brought anarchist violence, as scientists broke down the theories of classical physics, chemistry, and psychology, as Nietzsche declared God dead and saw truth less in reason than in the irrational, the most advanced artists of the period found little to satisfy their needs in the optimistic utilitarianism that had dominated Western civilization since the Enlightenment-spawned French Revolution and Napoleonic era (1789–1815). Gradually, therefore, they abandoned the Realist tradition that, beginning with Daumier, Courbet, and Manet, had opened such a rich vein of aesthetic exploration, climaxing in the Impressionism of the 1870s, and sought to discover, or recover, and evince a new and more complete reality, one that would encompass the inner world of mind and spirit as well as the outer world of physical substance and sensation.

Inevitably, this produced paintings that seemed even more shocking than Impressionism in their violation of both academic principles and the mirrorlike veracity desired by eyes now thoroughly under the spell of photography. And so, just as Monet and Renoir were beginning to enjoy a measure of critical and financial success, the emerging painters who would inspire the rubric Post-Impressionist reopened the gap, wider than ever before, that separated the world of advanced art from that of society at large. And it would never close in their lifetimes, for unlike the relatively healthy, stable, extroverted, long-lived Impressionists, Seurat and Cézanne, Gauguin and Van Gogh remained troubled and isolated to the end, which came prematurely for all—even tragically in the cases of Seurat, Gauguin, and Van Gogh—in large part because of what they endured for the sake of exploring beyond the known, wherever this might lead them into the realms of both objective and subjective analysis. And so great were the differences in their approaches and aims, tastes, ideas, and characters that they could offer little, if any, support even to one another, which denied them the comforts of the camaraderie enjoyed by the Impressionists. Here indeed was the beleaguered avant-garde, rejected and counter-rejecting, which set a pattern that would be repeated with bruising regularity throughout much of the history of modernist art, until quite recent times. Whatever their divergences, however, the Post-Impressionists would all bring heightened tension and excitement to art by reweighting their values in favor of the ideal or romantic over the real, of symbol over sight, of concept over percept. Never would they work other than in direct contact with perceptual reality, if only through the medium of photography, but increasingly perception and its translation into art would cease to be an end unto itself and become a means toward the knowledge of form in the service of expressive content. In arriving at their antinaturalism, moreover, all would depend upon and counterbalance the dualities of mind and spirit, thought and emotion. Along the way, however, Seurat and Cézanne tended to proceed primarily through the intellect, while Gauguin and Van Gogh placed their trust more in feeling and intuition.

GEORGES SEURAT (1859–1891) Of the four figures who inspired the term Post-Impressionism, Georges Seurat may be the least known, seemingly the one most isolated from the others, and at the same time the closest in spirit to twentieth-century geometric abstraction. Trained in the academic tradition of the École des Beaux-Arts, he was a devotee of Classical Greek sculpture and of such Classical masters as Piero della Francesca, Poussin, and Ingres. He also studied the drawings of Holbein, Rembrandt, and Millet, and learned principles of mural design from the academic Symbolist Puvis de Chavannes (fig. 61). He early became obsessed with theories and principles of color organization, which he studied in the paintings of Delacroix and the scientific treatises of Eugène Chevreul, O. N. Rood, Herman von Helmholz, Charles Henry, and James Clark Maxwell. Seurat, indeed, was the first of a new breed of artists born of the scientific revolution: the artist-scientist. Working with his younger friend and disciple Paul Signac, he sought to synthesize the color experiments of the Impressionists and the Classical structure inherited from the Renaissance, combining the latest concepts of pictorial space, traditional illusionistic perspective space, and the

54. GEORGES SEURAT. *The Couple, Study for La Grande Jatte.* 1884–85. Conté crayon, 11½ × 9″. Private collection

55. GEORGES SEURAT. *Study for Le Chahut.* 1889. 21⅞ × 18⅜″. The Albright-Knox Art Gallery, Buffalo. General Purchase Funds, 1942

newest scientific discoveries in the perception of color and light.

For all his theoretical apparatus, the incredible thing is that Seurat produced such a body of masterpieces in so short a life (he died at thirty-one). His greatest work, and one of the landmarks of modern art, is *A Sunday Afternoon on the Island of La Grande Jatte,* more briefly known as *La Grande Jatte* (plate 14). Seurat worked for two years on this monumental painting, preparing for it with at least twenty preliminary drawings and forty color sketches (fig. 54). In these preparatory pieces, ranging from studies of individual figures to oils that laid in most of the final composition, he analyzed, in meticulous detail, every color relationship and every aspect of pictorial space. The color system that Seurat propagated was based on the Impressionists' intuitive realization that all nature was color, not neutral tone. Impressionism, for the most part, had involved no organized, scientific effort to achieve an optical impact through the placement of primary colors in close conjunction on the canvas and their fusion on the retina of the eye as glowing, vibrating patterns of mixed color. This optical effect appears in many paintings by Monet, as anyone realizes who has stood close to one of his works, first experiencing it simply as a pattern of color strokes, and then moving gradually away from it to observe all the elements of the scene come into focus.

Seurat, building on Impressionism and nineteenth-century scientific studies of optical phenomena, constructed his canvases with small brushstrokes of generally complementary colors—red-green, violet-yellow, blue-orange—with white. The intricate mosaic produced by his painstaking and elaborate technique was somewhat analogous to the

actual medium of mosaic in its glowing depth of luminosity that gave an added dimension to color experience. The significance of Seurat's method, to which the various names "divisionism," "pointillism," and Neo-Impressionism have been given, in great measure resides in the creation of an ordered, geometric structure closely approximating the pure abstract art of the twentieth century.

In *La Grande Jatte* Seurat began with a simple contemporary scene of Parisians relaxing along the banks of the Seine. What drew him most strongly to the particular scene, perhaps, was the manner in which the figures arranged themselves in diminishing perspective on the grass under the trees along the banks of the river. At this point in the picture's evolution the artist was concerned as much with the re-creation of a fifteenth-century exercise in linear perspective as with the creation of a unifying pattern of surface color dots. Through many preliminary experiments, the figures were composed across the surface of the canvas and in calculated, mathematical diminution and repetition in depth. Broad contrasting areas of shadow and light, each built of a thousand minute strokes of juxtaposed color-dot complementaries, carry the eye from the foreground into the beautifully realized background. In a certain sense the painting might be considered a spatial departure from David, Courbet, Manet, and Monet, all of whom, in one form or another, were concerned with the assertion of the picture plane. Certainly, Seurat was here deliberately attempting to reconcile the Classic tradition of Renaissance perspective painting and modern interest in light, color, and pattern.

More important in the painting than depth or surface pattern is the

magical atmosphere that the artist was able to create from the abstract patterns of contemporary bourgeois Parisians. Seurat's figures are like those of a mural by Piero della Francesca in their quality of mystery and of isolation one from another. In all the accumulation of commonplace details there is a total effect of poetry that makes of the whole a profoundly moving experience. The fascinating fact about Seurat's paintings is that they anticipate not only the abstraction of Mondrian but also the Surrealist strangeness of Giorgio de Chirico and René Magritte. Thus the most scientific and objective of all the painters of his time becomes, by a curious inversion, one of the most poetic and mysterious.

La Grande Jatte was almost an isolated experiment in its illusion of perspective depth, and even there the broad landscape planes of color, light, and shadow close and flatten the picture space. In the drawings and sketches preceding it, and in the paintings following it, everything tends to come back to the surface of the picture, to emphasize and reiterate the two-dimensional plane of which it is constructed. *La Parade* (1887–88) is a luminous façade in which the silhouettes of the figures are arranged across a shelf of space formed out of light and color. The landscapes are all organized as horizontal planes made up of color-dot tesserae. In some of the later works, such as the *Study for Le Chahut* (fig. 55), we see the color dots increase in scale to a point such that the figures and their spatial environment are dissolved in a pattern of large-scale units that cling to the surface of the picture, an image of movement as frozen as Muybridge's new stop-action photographs (fig. 56). At this point in the evolution of modern painting the transition from a representation of natural objects in terms of color-dot pattern to an abstraction composed of color-dot and flat, curvilinear pattern was almost complete. The next stage would be the color-line experiments of the Fauves and the Cubists.

56. EADWEARD MUYBRIDGE. *Animal Locomotion*. 1887. Photograph. Courtesy the International Museum of Photography at George Eastman House, Rochester, New York

Seurat's chief colleague and disciple was Paul Signac (1863–1935). Signac followed Seurat in painting landscapes involving industrial scenes. In his later, highly coloristic seascapes, he provided a transition between Neo-Impressionism and the Fauvism of Matisse and his followers. And through his book, *D'Eugène Delacroix au Néo-impressionisme*, he was also the historian of the movement. His portrait of the critic Félix Fénéon (fig. 57), who had been the first to refer to "neo-impressionism," is a fascinating example of the decorative formalism to which Seurat's immediate followers tended.

Seurat's technique in the hands of other disciples too often declined into a decorative formula for use in narrative exposition. This was also the fate of Impressionism proper as it became first accepted and then immensely popular throughout the world. Unfortunately, the color and light, initially so shocking to the world, were all too quickly discovered

57. PAUL SIGNAC. *Against the Enamel of a Background Rhythmic with Beats and Angles, Tones and Colors, Portrait of M. Félix Fénéon in 1890*. 1890. 29½ × 36⅝". Formerly Foundation Emil Bührle, Zurich

to be charming, endearing, and capable of every kind of vulgarization, until redeemed by the more stringent endeavors of the Abstract Expressionists and the Color Field painters following World War II. Seurat's divisionism, on the other hand, affected not only Fauvism and certain aspects of Cubism in the early twentieth century, but also some Art Nouveau painters and designers, and many German Expressionists. The art of Seurat, the least known of the four great founders of twentieth-century painting, has made itself felt, through one of its phases or another, in almost every major experimental wing of that painting until the present day.

PAUL CÉZANNE (1839–1906) Of all the nineteenth-century painters who might be considered prophets of twentieth-century experiment, the most significant for both achievement and influence was Paul Cézanne. Cézanne was a solitary who struggled throughout his life to express in paint his ideas about the nature of art, ideas which, at the same time, in their very inclusiveness, were among the most revolutionary in the history of art. Son of a well-to-do Aix-en-Provence merchant turned banker, he had to resist parental disapproval to embark on his career, but once having won the battle, unlike Monet or Gauguin, he did not need to struggle for mere survival. As we view the splendid control and serenity of his mature paintings, it is difficult to realize that he was a man of violent disposition, given to sudden rages and, on occasion, to hallucinatory dreams. This aspect of his character is evident in some of his early, mythological figure scenes, which were baroque in their movement and excitement. At the same time he was a serious student of the art of the past, one who studied the masters in the Louvre, from Veronese to Poussin to Delacroix.

Cézanne's unusual combination of logic and emotion, of reason and unreason, represented the synthesis that he would seek in his paintings. All artists before him, at least since the Renaissance, had been faced with the dilemma of nature versus art—even when they did not realize it was a dilemma. Painting itself from the seventeenth to the nineteenth century had increasingly become a power struggle of drawing versus color: in the seventeenth century the Poussinists against the Rubenists; in the nineteenth century the Neoclassicists against the Romantics, Ingres versus Delacroix. This dichotomy had been exaggerated during the nineteenth century as a result of over two centuries of the influence of the art academies. With the rise of the concept of official art in the seventeenth century, with the development of organized art criticism in the eighteenth century and of art history in the nineteenth, and with the expansion of official art schools, there came inevitably a consolidation of theory about art, the hardening of dogmatic lines on what was proper and good. The result was that the nineteenth-century rebels against the establishment quite logically took positions at the opposite end of the spectrum from the academicians. If the academy insisted on an ideal subject taken from antiquity and presented in meticulous drawing, perspective, and oil glazes, Courbet gave them nineteenth-century French peasants frontalized and roughly modeled, presented with no effort to conceal the texture of oil paint. The Impressionists, in the 1870s, largely abandoned traditional drawing in their effort to state their visual discovery—that objects in nature are not seen as isolated phenomena separated from one another by defined contours. In their desire to realize the observed world through spectrum colors in terms of which the spaces between objects are actually color intervals like the objects themselves, they tended to destroy the objects as three-dimensional entities existing in three-dimensional space, and to re-create solids and voids as color shapes functioning within a limited depth. It was this destruction or at least subordination of the distinction between the illu-

sion of three-dimensional mass and that of three-dimensional depth that led to the criticism of Impressionism as formless and insubstantial. Even Renoir felt compelled to restudy the drawing of the Renaissance in order to recapture some of that "form" which Impressionism was said to have lost. And Seurat, Gauguin, Van Gogh, each in his own way, consciously or unconsciously, was seeking a kind of expression based on, but different from, that of the Impressionists.

Certainly, Cézanne's conviction that Impressionism had taken a position excluding qualities of Western painting important since the Renaissance prompted his oft-quoted and frequently misunderstood remark that he wanted to "make of Impressionism something solid like the art of the museums." By this, obviously—as his paintings document—he did not mean to imitate the Old Masters. And he had no thought that the Renaissance or Baroque masters were primarily concerned with simple imitation of the observed natural world. He realized, quite correctly, that in their paintings artists like Veronese or Poussin had created a world similar to but quite distinct from the world in which they lived (fig. 12). Veronese in fact transposed the village world of Christ into the urban sophistication of sixteenth-century Venice. Rather, the painting resulting from the artist's various experience emerged as a separate reality in itself. This kind of reality, the reality of the painting, Cézanne sought in his own works. As he felt progressively that his sources must be nature, man, and the objects of the world in which he lived rather than stories or myths from the past, these were the sources that he wished to transpose into the new reality of the painting. For this reason he expressed his desire "to do Poussin over again from nature."

58. PAUL CÉZANNE. *Uncle Dominic as a Monk.* c. 1866. 25⅝ × 21¼".
Collection Mrs. Ira Haupt, New York

59. PAUL CÉZANNE. *Bacchanal (La Lutte d'amour)*. 1875–76. 15 × 18½". Collection the Honorable and Mrs. W. Averell Harriman

Cézanne's mature position was arrived at only after long and painful thought, study, and struggle with his medium. The theoretical position that, late in his life, he tried so inarticulately to express in words, was probably achieved more through the discoveries he made on his canvas with a fragment of nature before him than through his studies in museums. In the art of the museum he found corroboration of what he already instinctively knew. In fact, what he knew in his mature landscapes is in many ways already evident in such an early work as *Uncle Dominic as a Monk* (fig. 58). Uncle Dominic, his mother's brother, is painted in the white habit of the Dominican order, modeled out from the blue-gray ground in sculptured paint laid on in heavy strokes with the palette knife. The sources in Manet and Courbet are evident, but the personality revealed by the portrait—the spirit of the artist himself—is different from either of his predecessors. The painting, which is not so much a specific portrait as a study of passion held in restraint, belongs to both the Classic tradition of the withdrawn, generalized type, and the Romantic tradition of the involved, intense, and particularized individual. This painting may have been one of the first attempts to establish a balance or control over the baroque violence that permeated his early

figure studies. Cézanne attempted his own *Déjeuner sur l'herbe* in heavy-handed variants on Manet's painting, also with reminiscences of Titian. He exorcised his own inner conflict in scenes of murder and rape. After his exposure to the Impressionists, particularly to Pissarro, with whom he studied during 1872 at Auvers-sur-Oise, he returned to the violence of these essays in his *Bacchanal* (fig. 59). Here he has moved away from the somber tonality and sculptural modeling of the 1860s into an approximation of the light blue, green, and white of the Impressionists. Nevertheless, this is a painting remote from Impressionism in its effect. The artist subdues his greens with grays and blacks, and expresses an obvious obsession with the sexual ferocity he is portraying, different from the stately bacchanals of Titian, and more intense even than the comparable scenes of Rubens. At this stage he is still exploring the problem of integrating figures or objects and surrounding space. The figures are clearly outlined, and thus exist sculpturally in space. However, their broken contours, sometimes seemingly independent of the cream-color area of their flesh, begin to dissolve solids and integrate figures with the shaped clouds that, in an advancing background, reiterate the carnal struggles of the bacchanal. The *Bacchanal*

is a transitional work, but nevertheless one of tremendous power in itself and of significance in suggesting the direction in which Cézanne was moving. In it the solidity of the art of the museums is reappearing already—with a difference.

In the 1880s all of Cézanne's ideas of nature, man, and painting came into focus in a magnificent series of landscapes, still lifes, and portraits. During this period he was living at Aix, largely isolated from the Impressionist and Post-Impressionist experiments in Paris, but nevertheless affecting them like some mysterious legend. *The Bay from L'Estaque* (plate 15) today is a work so familiar from countless reproductions that it is difficult to realize how revolutionary it was at the time of its execution. The scene was also viewed from the high vantage point familiar in the sixteenth-century landscapes of Brueghel, and revived in early Impressionist landscapes. However, the space of the picture does not recede into a perspective of infinity in the Renaissance or Baroque manner. Buildings in the foreground are massed close to the spectator and presented as simplified cubes with the side elevation brightly lighted, which gives them a prominence asserting their identity as frontalized color shapes parallel to the picture plane rather than at right angles to it. The foreground buildings and intervening trees are composed in ocher, yellow, orange-red, and green, with little distinction in definition as objects recede from the eye. Although the elements of the foreground—houses, rooftops, chimneys, trees—are perfectly recognizable as such, it is difficult to think of them as objects existing in natural space. If we try to envisage the space and air surrounding the solid objects, such as houses and chimneys, we realize that there is no empty space. The trees to the right of the foreground house, which should be some distance behind it in depth, are actually a variegated color shape beside it. Cézanne wished to re-create nature with color, feeling that drawing was a consequence of the correct use of color. In *The Bay from L'Estaque*, contours are the meeting of two areas of color. Since these colors vary substantially in value contrasts or in hue, their edges are perfectly defined. However, the nature of the definition tends to allow color planes to slide or "pass" into one another, thus to join and unify surface and depth, rather than to separate them in the manner of traditional outline drawing. There is now apparent in the composition of this painting Cézanne's intuitive realization of the perceptual concepts that Seurat had studied so assiduously in scientific texts. For Cézanne the important point was the discovery that the eye took in a scene both consecutively and simultaneously, with profound implications for construction of the painting.

Cézanne was certainly the father of twentieth-century Cubism and the abstract art that developed therefrom. Yet he never, even at the end of his life, had any desire to depart entirely from nature. When he spoke of "the cone, the cylinder, and the sphere" he was not thinking of these geometric shapes as the end result, the final abstraction into which he wanted to translate the landscape or the still life. Abstraction for him was a method, a way station at which he stripped off the visual irrelevancies of nature in order that he could begin rebuilding the natural scene as an independent painting. Thus the end result was easily recognizable from the original motif, as extensive photographing of the scenes has proved, but it is essentially different: the painting is a parallel but separate and unique reality.

The middle distance of *The Bay from L'Estaque* is the bay itself, an intense area of dense but varied blue stretching from one side of the canvas to the other and built up of meticulously blended brushstrokes. Behind this is the curving horizontal range of the hills, and, above these, the lighter, softer blue of the sky, with only the faintest touches of rose, as though from a setting sun. The abrupt manner in which the

artist cuts off his space at the sides of the painting has the effect of denying the illusion of recession in depth. The blue of the bay asserts itself even more strongly than the ochers and reds of the foreground, with the result that space becomes both ambiguous and homogeneous. The painting must be read simultaneously as a panorama in depth and as an arrangement of color shapes on the surface.

Despite Cézanne's continual struggle, uncertainty, and dissatisfaction, in such a work as this there is no question that he succeeded superbly in what he set out to do. On the color and instantaneous vision of the Impressionists, on the discipline and solid structure of the Old Masters, and, above all, on the intense and sensitive perception of his own view of nature he was able to build a new conception of painting, one that has affected the course of twentieth-century art for the last eighty years.

Few if any artists in history have devoted themselves as intently as Cézanne to the separate themes of landscape, portrait, and still life. In order to understand this fact it is necessary to understand that to him these subjects involved identical problems. In all of them he was concerned with the re-creation, the *realization*, of the scene, the object, or the person. In *Still Life with Basket of Apples*, a work of 1890–94 (plate 16), as well as in many other still lifes, Cézanne succeeded in translating, even transcending, Balzac's verbal images. The fascination of the still life for Cézanne, as for generations of painters before him and after, obviously lies in the fact that it involves a subject delimited and controllable as no landscape or portrait sitter can possibly be. After he had carefully arranged his tilted basket of apples and wine bottles, scattered the other apples casually over the mountain peaks of the tablecloth, and placed the plate of *petit-pain* at the back of the table—which, vertically, is also the summit—he had only to look until all these elements began to transform themselves into the relationships on which the final painting would be based. The apple obsessed Cézanne as the three-dimensional form most difficult to control as a separate object and to assimilate into the larger unity of the canvas. To attain this goal and at the same time to preserve the nature of the individual object, he modulated the circular forms with small, flat brushstrokes, distorted the shapes, and loosened or broke the contours to set up spatial tensions among the objects and thereby unify them as color areas. By tilting the wine bottle out of the vertical, flattening and distorting the perspective of the plate, or changing the direction of the table edge as it moved under the cloth, he was able, while maintaining the illusion of real appearance, to remove the still life from its original environment of pictorial form, where not the objects but the relations and tensions existing between them become the significant visual experience. As we look at this work almost a century after it was painted, it is still difficult to express in words all the subtleties through which Cézanne gained his final result. However, we can now comprehend at many different levels the beauty of his achievement. He was one of the great constructors and one of the great colorists in the history of painting, one of the most penetrating observers, and one of the most subtle minds.

This still life, like all his still lifes, was a landscape. The ocher foreground, the light blue background, the "snowy peaks" of the tablecloth, the haphazard order of the apples flowing across the scene, all these take us back to *The Bay from L'Estaque* or to the many views of Mont Sainte-Victoire. The figure studies, such as the various versions of *The Card Players* (fig. 283), remind one in their massive, closed architecture of his paintings of quarries. So does the draped curtain enclosing the space of his *Boy in a Red Vest* (plate 17), a painting constructed as much by its network of broken lines as by the all-over tesselation of its flat, planar strokes. At the same time that the lines contour forms and

endow them with an unmistakable fullness, they also intersect and continue from edge to edge, across figure and ground alike, thereby integrating the whole of the field into a kind of asymmetrical armature. A similar equilibrium of volume and plane occurs in the brushwork, where the "constructive" strokes articulate the surface as a mosaic pattern of translucent, painterly slabs, all the while that the very richness of the color creates a sense of plenitude in the forms. Just as the firm, carefully deliberated architectonics brought the Classical tradition into the modern age, and made it ready for assimilation into the Cubism of Braque and Picasso, the dynamic counterbalancing of everything and the renewal of color as a potent means of both structure and expression prepared the way for Matisse and twentieth-century Expressionism.

After 1890 Cézanne's brushstrokes became larger and more abstractly expressive, the contours more broken and dissolved, with color floating across objects to sustain its own identity independent of the object. These tendencies were to lead to the wonderfully free paintings of the very end of the artist's life, of which the *Mont Sainte-Victoire* of 1904–6 is one of the supreme examples (plate 18). Here the brushwork acts the part of the individual musician in a superbly integrated symphony orchestra. Each stroke exists fully in its own right, but each is nevertheless subordinated to the harmony of the whole. This is both a structured and a lyrical painting, one in which the artist has achieved the integration of Classicism and Romanticism, of structure and color, of nature and painting. It belongs to the great tradition of Renaissance

60. GUSTAVE MOREAU. *Dance of Salome (L'Apparition)*. c. 1876. 21¼ × 17½". Fogg Art Museum, Harvard University, Cambridge, Massachusetts

and Baroque landscape, seen, however, as the eye actually sees, as an infinite accumulation of individual perceptions. Analyzed by the painter into their abstract components, these are then reconstructed into the new reality of the painting.

To the end of an anxiety-ridden life, Cézanne held fast to his dream of redoing Poussin after nature, a goal that long eluded him by reason, in part, of the problem of how to pose Classically, or heroically, nude figures in an open landscape. Moreover, Cézanne never overcame the difficulty of controlling his own emotions when in the presence of the unclothed human form. Finally, however, for the largest canvas he ever stretched, Cézanne worked as Poussin had done—that is, from his imagination—and simply relied on his years of *plein-air* experience to evoke Impressionist freshness. In this way he created *The Large Bathers* (plate 19), the product of a seven-year labor and a masterpiece in which the artist subsumed the rampant emotions expressed in the 1875–76 *Bacchanal* within the grandeur of his total conception. Thus, while the figures have been so formalized as to seem little more than part of the overall pictorial architecture, their erotic potential now charges that total scheme. It can be sensed as much in the high-vaulted stretch of the trees as in the sensuous, watercolor-like beauty of the brushwork, with its unifying distribution of rosy flesh tones and earthy ochers throughout the delicate, blue-green haze of sky and foliage. *The Large Bathers*, in its miraculous integration of Classical harmony and Romantic release, of linear structure and painterly freedom, of eye and idea, would provide the touchstone model for Fauves and Cubists alike—those yin-yang movements of early twentieth-century modernism—as well as the immediate antecedent for such landmark, yet disparate paintings as Matisse's *Joy of Life* and Picasso's *Les Demoiselles d'Avignon*.

Symbolism and Synthetism

The formulation of modern art at the end of the nineteenth century involved not only a search for new forms, a new plastic reality, but also a search for a new content and new principles of synthesis. As already noted, Courbet had tied his reality of subject to the equal reality of his medium of paint. The Impressionists, in seeking the very ultimate refinement of optical reality through color and light, had progressively diminished the illusion of the tangible object. Cézanne had returned with a new intensity to the study of nature, whether man, landscape, or still life, the better to abstract its essence and remake it as a painting. In general, the direction of Cézanne and the Impressionists, as well as of the early Seurat and the Neo-Impressionists, was toward the "non-subject," the subject sufficiently neutral and commonplace to serve simply as a point of departure for the artist. This can also be said about the later works of Degas, although Degas's obsession with the world of the theater and the ballet undoubtedly entailed elements of the exotic. Seurat's later works are marked, too, by an increasing symbolic-expressive quality.

The search for a new subject that would be meaningful in itself and not simply a continuation of outworn clichés taken from antiquity, French history, or Shakespearean drama would become, as we shall see, a conscious program in Gauguin's paintings, first at Pont-Aven in Brittany and then in the South Seas. In Brittany it was the peculiar individuality and intensity of the Christian belief which intrigued him and which he wanted to capture in such works as *The Yellow Christ* and *Vision After the Sermon* (plate 21). In Tahiti it was the mystery of a beautiful people living in an earthly paradise haunted by the gods and

61. PIERRE PUVIS DE CHAVANNES. *Summer.* 1891.
59 × 91½″. The Cleveland Museum of Art.
J. H. Wade Collection

spirits of their primitive religion (plate 22). In both cases the subjects he pursued were those of the Romantic tradition: the exotic, the other-worldly, the mystical. In this, Gauguin and the artists who were associated with him at Pont-Aven and later at Le Pouldu in Brittany, as well as very different painters like Odilon Redon and Gustave Moreau, were affected by the Symbolist spirit, which, in poetry and criticism, stemmed from the reaction against Realism in literature and against industrialization in life.

Symbolism in literature and in art was in fact a direct descendant of the Romanticism of the eighteenth and the early nineteenth centuries. In literature, its founders were Charles Baudelaire and Gérard de Nerval; the leaders at the close of the century were Jean Moréas, Stéphane Mallarmé, and Paul Verlaine. In music, Richard Wagner was a great force and influence and Claude Debussy the outstanding master. Baudelaire had defined Romanticism as "neither a choice of subjects nor exact truth, but a mode of feeling"—something found within rather than outside the individual—"intimacy, spirituality, color, aspiration toward the infinite...." More narrowly defined, Symbolism was an approach to an ultimate reality, an "idea" in the sense of Platonic philosophy that transcended particular physical experience. As such, it not only reflected some of the ideas of the philosophers Hegel and Schopenhauer, but it also directly paralleled the contention of Henri Bergson that reality could be achieved only through intuitive experience expressed particularly in the work of art. The credo that the work of art is ultimately a consequence of the emotions, of the inner spirit of the artist rather than of observed nature, not only dominated the attitudes of the Symbolist artists but was to recur continually in the philosophies of twentieth-century Expressionists, Dadaists, Surrealists, and even of Mondrian and the abstractionists.

For the Symbolists the reality of the inner idea, of the dream or the symbol, could be expressed only obliquely, as a series of images or analogies out of which the final revelation might emerge. Symbolism led some poets and painters back to organized religion, some to religious cultism, and others to aesthetic creeds that were essentially anti-religious. During the 1880s, at the moment when artists were pursuing the idea of the dream, Sigmund Freud was beginning the studies that were to lead to his theories of the significance of dreams and the subconscious.

Paul Gauguin sought in his paintings what he termed a "synthesis of form and color derived from the observation of the dominant element." He advised his friend, the painter Émile Schuffenecker, not to "...copy nature too much. Art is an abstraction; derive this abstraction from nature while dreaming before it, but think more of creating than the actual result."

In these statements may be found many of the concepts of twentieth-century experimental painting, from the idea of color used arbitrarily rather than to describe an object visually, to the primacy of the creative act, to painting as abstraction. Gauguin's Synthetism also involved a synthesis of subject and idea with form and color, so that the *Vision After the Sermon* is given its mystery, its visionary quality, by its abstract color patterns.

Symbolism in painting—the search for new forms, antinaturalistic if necessary, to express a new content based on emotion rather than intellect or objective observation, and on intuition, inner force, and the idea beyond appearance—may be interpreted broadly to include most of the experimental artists who succeeded the Impressionists and opposed them. The broader definition would encompass not only Gauguin but also Van Gogh, Toulouse-Lautrec, and, in varying degrees, Seurat and Cézanne. However, all these artists met on common ground in their concern, each in his different manner, with problems of personal expression and pictorial structure.

In this the great Post-Impressionists were anticipated, inspired, and abetted by two older academic masters—Moreau and Puvis de Chavannes—and also by Odilon Redon, an artist born into the generation of the Impressionists, only to attain his artistic maturity, like Cézanne, much later than his exact contemporaries.

GUSTAVE MOREAU (1826–1898) Gustave Moreau had been a recluse until he was appointed professor at the École des Beaux-Arts in 1892. Here, during his last years, he displayed remarkable talents as a teacher, numbering among his students Henri Matisse and Georges Rouault, as well as others who were to be associated as the Fauves, or "wild beasts," of early modern painting. The art of Moreau himself exemplified the spirit of end-of-the-century melancholy, combining morbid subject matter, meticulous draftsmanship, and jewellike color and paint texture (fig. 60). Moreau's spangled, languidly voluptuary art also did much to glamorize decadence in the form of the *femme fatale*, that obsessive love-death image of woman as an erotic and destructive force, a concept fostered by Baudelaire's *The Flowers of Evil* (1857) and the mid-century pessimistic philosophy of Arthur Schopenhauer. Already seen in the Pre-Raphaelite work of Dante Gabriel Rossetti (fig. 40), the *femme fatale* emerged as a lurid invention serving to counterbalance the no less bizarre male fantasy of woman as pure virgin and nurturing mother. She would become a veritable goddess of sex and mysticism in the work of such composers as Wagner and Richard Strauss, writers on the order of Joris Karl Huysmans, Oscar Wilde, and Marcel Proust, and a great number of artists, ranging from Rossetti and Moreau to such *fin-de-siècle* figures as Redon, Aubrey Beardsley, Edvard Munch, and Gustave Klimt. Moreover, the deadly temptress would thrive well into the twentieth century, as she resurfaced savagely or beguilingly in Picasso's *Les Demoiselles d'Avignon*, the paintings and drawings of Egon Schiele, and the *amour fou* art of the Surrealists.

PIERRE PUVIS DE CHAVANNES (1824–1898) Although Puvis de Chavannes, with his simple, naïve spirit, bleached colors, and near archaic handling, would seem to have stood at some polar extreme from the elaborate, overly sophisticated, hothouse art of Moreau, the two painters were alike in their neo-academicism and in the curious attraction

this held for the younger generation. With regard to Puvis, the reasons for such an anomaly can, in retrospect, be readily discerned in the painting seen here (fig. 61). The subject and its narrative treatment are sufficiently traditional, but the organization in large, flat, subdued color areas, and the manner in which the plane of the wall is respected and even asserted, embodied a compelling truth in the minds of artists who were searching for the new reality of painting. Although the abstract qualities of the murals are particularly apparent to us today, the classic withdrawal of the figures—as still and quiet as those in Piero della Francesca and Seurat—transforms them into emblems of that inner light which the Symbolists extolled.

ODILON REDON (1840–1916) Symbolism in painting found one of its earliest and most characteristic exponents in Odilon Redon, a painter of dreams who provides a direct link between nineteenth-century Romanticism and twentieth-century Surrealism. Like so many European artists in the second half of the old century, he was influenced by Oriental art and specifically by Japanese prints. His world, however, was one of dreams created from amorphous, flowing, and changing color, which itself had the character of a dream. He frequently found his subjects in the study of nature, at times observed under the microscope, but in his hands transformed into beautiful or monstrous fantasies.

Redon first studied architecture, but, failing his examinations, he turned to painting. In actuality the first twenty years of his career were devoted almost exclusively to drawing, etching, and lithography in black and white. His initial enthusiasms were for Renaissance masters of drawing: Albrecht Dürer, Hans Holbein, and Leonardo da Vinci. In Leonardo as well as in Rembrandt he was entranced by the expressive effects of light and shadow. Redon studied etching with Rodolphe Bresdin, a strange and solitary artist who created a graphic world of meticulously detailed fantasy based on Dürer and Rembrandt. Through him, Redon was attracted to these artists, but later he found a closer affinity with the graphics of Francisco Goya, the greatest master of fantasy of the early nineteenth century (fig. 15). Redon himself became one of the modern masters of the medium of lithography, in terms of which he created a world of dreams and nightmares based not only on the example of the past but also on his close and scientific study of anatomy and microbiology. It was this that made his monsters believable.

Redon's own predilection for fantasy and the macabre drew him naturally into the orbit of Delacroix, Baudelaire, and the nineteenth-century Romantics. In his drawings and lithographs, where he pushed his rich, velvety blacks to extreme limits of expression, he developed and refined the fantasies of Bresdin in nightmare visions of monsters, or tragic-romantic themes taken from mythology or Romantic literature. Redon was close to the Symbolist poets, and was almost the only artist who was successful in translating their words into visual experiences. He dedicated a portfolio of his lithographs to Edgar Allan Poe, whose works had been translated by Baudelaire and Mallarmé, and he interpreted in lithography Gustave Flaubert's *Temptations of St. Anthony* (fig. 62). The critic and novelist Huysmans reviewed Redon's exhibitions enthusiastically at the same time that he was himself moving away from Zola's naturalism and into the Symbolist stream with his novel *À Rebours (Against the Grain)*, in which he also discussed at length the art of Redon and of Gustave Moreau.

It was not until 1895 that Redon began to work seriously in color, but almost immediately he demonstrated a capacity for exquisite, original harmonies, in both oil and pastel, that changed the character of his art from the macabre and the somber to the joyous and brilliant. *Roger and Angelica* (plate 20), with little change or distortion other than the

62. ODILON REDON. *Anthony: What is the object of all this? The Devil: There is no Object.* Plate 18 from *The Temptation of St. Anthony*, third series. 1886. Lithograph, printed in black, composition 12¼ × 9⅞″. Collection, The Museum of Modern Art, New York. Gift of Abby Aldrich Rockefeller

use of intense color, becomes an object of overpowering sensuality.

During his lifetime, Redon had only a modest success with the general public, but his reputation among his younger colleagues grew constantly. The Nabis, as we shall see, paid homage to Redon, although they were only peripherally influenced by his painting. The most comprehensive tribute paid him during his lifetime came, perhaps, at the Armory Show in New York in 1913. In the entire movement of Symbolism in painting, which affected most of the progressive tendencies at the end of the nineteenth century and the beginning of the twentieth, there is, other than Gauguin, no more central figure.

PAUL GAUGUIN (1848–1903) One of the four great Post-Impressionists, Paul Gauguin was unquestionably the most powerful and influential artist to be associated with the Symbolist movement. But while he became intimate with Symbolist poets, especially Mallarmé, and enjoyed their support, Gauguin deplored the literary content and neotraditional form of such artists as Moreau and Puvis. Simultaneously, he also rejected the optical naturalism and middle-class values of the Impressionists, his initial inspiration, while retaining their rainbow palette and vastly extending its potential for purely decorative effects. For Gauguin, art was an abstraction to be dreamed in the presence of nature, not an illustration of nature but a synthesis of natural forms reinvented imaginatively. His purpose in creating such an anti-Realist art was to express invisible, subjective meanings and emotions experienced by a spirit freed from the corrupting sophistication of the modern industrial world, and renewed by contact with the innocence and sense of mystery enjoyed by children, peasants, and preliterate societies. He constantly used for painting the analogy of music, of color harmonies, of color

and lines as forms of abstract expression. In his search he was attracted, to a greater degree even than most of his generation, to Oriental, pre-Classical, and primitive art. In him we find the origins of modern primitivism, the desire to attain to a kind of expression that achieves truth by discarding the accumulation of Western tradition and returning to the elemental verities of prehistoric man and barbaric peoples.

Gauguin, more than any other artist of the nineteenth century, perhaps, has become a romantic symbol, the personification of the artist as rebel against society. After years of wandering, first in the merchant marine, then in the French Navy, he settled down, in 1871, to a prosaic but successful life as a stockbroker in Paris, married a Danish girl, and had several children. For the next twelve years the only oddity in his respectable, bourgeois existence was the fact that he began painting, first as a hobby and then with increasing seriousness. He even managed to show a painting in the Salon of 1876 and to exhibit in the sixth and seventh Impressionist exhibitions in 1881 and 1882. Then, in 1883, he suddenly quit his position to paint full time. By 1886, after several years of family conflict and attempts at new starts in Rouen and Copenhagen, he had largely severed his family ties, isolated himself, and become involved in the little world of the Impressionists, whom he first met through Camille Pissarro.

Gauguin seems almost always to have had a nostalgia for far-off, exotic places. This feeling ultimately crystallized in the conviction that his salvation and perhaps that of all contemporary artists lay in abandoning modern civilization and its encumbrance of Classical Western culture to return to some simpler, more elemental, primitive pattern of life. A desire to live like a savage resulted in 1887 in ill-fated trips to Panama and Martinique. Even earlier he had sought a less extreme version of the primitive life in the Breton village of Pont-Aven. He returned to Pont-Aven in 1888, after his stay in Martinique, and then went to Arles for the short but almost fatal visit with Van Gogh. After still another visit to Pont-Aven he tried Le Pouldu and, in 1891, following a further stay in Paris, sailed for Tahiti. After two years in Tahiti he went back to France, where he remained until 1895. He then returned to Tahiti. His final trip, in the wake of years of illness and suffering, was to the island of Dominique in the Marquesas, where he died in 1903.

The earliest picture in which Gauguin brought his revolutionary ideas to full realization is *Vision After the Sermon*, painted in 1888 on his return to Pont-Aven (plate 21). This is a startling work, a pattern of red, blue, black, and white tied together by curving, sinuous lines to create a Byzantine mosaic translated into a Breton peasant's religious vision. It is a document of the new creed of "synthetism," a concept evidently developed in association with the painter Émile Bernard (fig. 66) and destined to affect the ideas of younger groups such as the Nabis and the Fauves. Perhaps the greatest single departure is the arbitrary use of color in the dominating red field within which the protagonists (Jacob and the Angel) struggle. This painting was one of the first complete statements of color as an expressive end in itself and not as something that describes some aspect of the natural world. As such, it marks one of the great moments of liberation in the history of Western art. Also, in terms of abstract statement of pictorial means, Gauguin has here constricted his space to such an extent that the dominant red of the background visually thrusts itself forward beyond the closely viewed heads of the peasants in the foreground.

Gauguin's developed Tahitian paintings have no necessary consistency in plastic or spatial exploration. The artist's imagination was too filled with different concepts, visual and symbolic, each of which had to be given the plastic equivalent most appropriate to it. Thus, *The Day of the God* (plate 22) is in certain ways a traditional landscape organized

63. PAUL GAUGUIN. *Be in Love, and You Will Be Happy*. 1901. Painted wood relief. 58⅛ × 28¾". Private collection

in clear-cut recessions in depth. Its figures suggest the various non-Western influences that obsessed him, from ancient Egyptian to contemporary Polynesian. The "god" is a product of the artist's imagination. The mystery of the subject, of the devotions of the natives to the god, is very much on his mind, but he has integrated concern for mystical experience with concern for red, blue, and yellow color shapes, here framed in curving lines that move over the painting. In certain virtuoso passages, especially in the foreground, Gauguin broke free of description into pure design, consisting of lazy arabesques lovingly traced about large floral patches of the most daring color—off-key harmonies of blue, violet, chartreuse, orange, and rose. Wherever he improvised in this autonomous manner, the artist anticipated the Fauvism of Matisse and even looked beyond it to the totally abstract art of Vasily Kandinsky.

Meanwhile, Gauguin, ever in the spirit of the times, had turned his hand to relief carving (fig. 63) and ceramic design or painted vases, and had also become one of the leading masters in developing a new approach to woodcut—strong, contrasted, primitivist—that was to affect the course of German Expressionist graphic art in the twentieth century.

VINCENT VAN GOGH (1853–1890) Although the names of Gauguin and Vincent van Gogh are coupled as pioneers of modern Expressionism and as typical of the supreme individualism of the artist, it is difficult to envisage two personalities more different. Whereas Gauguin was an iconoclast, caustic in speech, cynical, indifferent, and, at times, bru-

above: 64. VINCENT VAN GOGH. *The Garden of the Presbytery at Nuenen, Winter.* 1884. Pen and pencil, 15¼ × 20¾". National Museum Vincent van Gogh, Amsterdam

right: 65. VINCENT VAN GOGH. *Self-Portrait.* 1888. 24½ × 20½". Fogg Art Museum, Harvard University, Cambridge, Massachusetts. Maurice Wertheim Collection

tal to others, Van Gogh was filled with a spirit of naïve enthusiasm for his fellow artists and overwhelming love for his fellow men. This love had led him, after a short-lived experience as an art dealer and an attempt to follow theological studies, to become a lay preacher in a Belgian coal-mining area. There he first began to draw in 1880. After study in Brussels, The Hague, and Antwerp, he went to Paris in 1886, where he met Toulouse-Lautrec, Seurat, Signac, and Gauguin, as well as members of the original Impressionist group.

In his early drawings, meanwhile, Van Gogh revealed his roots in traditional Dutch landscape, portrait, and genre painting (fig. 64). Works like the one seen here extol, through the same perspective structures, the broad fields and low-hanging skies that Hobbema had loved in the seventeenth century. Van Gogh never abandoned perspective even in later years, when he developed a style with great emphasis on the linear movement of paint over the surface of the canvas. For him—and this is already apparent in the early drawings—perspective depth took on an expressive, an emotional significance. In the struggle between illusionistic depth and flat surface pattern arises much of the feeling-filled tension in his paintings.

After his exposure to the Impressionists in Paris, Van Gogh changed and lightened his palette. Indeed, he discovered his deepest single love in color—brilliant, unmodulated color—which in his hands took on a character radically different from the color of the Impressionists. Even when he used Impressionist techniques, the peculiar intensity of his vision of man and nature gave the result a specific and individual quality that could never be mistaken.

Van Gogh's passion arose from his intense, indeed overpowering, response to the world in which he lived and to the people whom he knew. It was not the simple response of a primitive or a child. His letters to his brother Theo, which are among the most moving narratives by an artist, reveal a highly sensitive perception that is fully equal

to his emotional response. He was acutely aware of the effects he was achieving through his yellows, more brilliant and saturated than ever before in the history of painting, or his blues, as intense as the bottomless depth of infinity. "Instead of trying to reproduce exactly what I have before my eyes, I use color more arbitrarily," he wrote, "in order to express myself forcibly." As if to echo the Synthetist-Symbolist ideas of Gauguin, Van Gogh told Theo that he "was trying to exaggerate the essential and to leave the obvious vague."

Although most of his color perceptions had to do with his love of man and nature and his joy in the expression of that love, he was also sensitive to a darker side. Thus, of *The Night Café* (plate 23) he says: "I have tried to express the terrible passions of humanity by means of red and green." *The Night Café* is a nightmare of deep-green ceiling, blood-red walls, and discordant greens of furniture. The floor is a brilliant yellow area of directed perspective driving with incredible force into the red background, which, in turn, resists with equal force. The painting is a struggle to the death between perspective space and aggressive color attempting to destroy that space. The result is a terrifying experience of claustrophobic compression. This work anticipates the Surrealist explorations of perspective as a means to fantastic expression, none of which has ever matched it in emotive force.

The universe of Van Gogh is forever stated in *The Starry Night* (plate 24). This is visionary beyond anything attempted by Byzantine or Romanesque artists in their interpretations of the ultimate mystery of Christianity. The closeness of the exploding stars relates to the age of space exploration even more than to the age of mystical belief. Yet the vision is set down with a brushstroke of painstaking precision. When we think of Expressionism in painting, we tend to associate with it a bravura brush gesture, uncontrolled or flamboyant, arising from the spontaneous or intuitive act of expression and independent of rational processes of thought or precise technique. The anomaly of Van Gogh's

paintings is that they are supernatural or at least extrasensory experiences documented with a touch as meticulous as though the artist were painfully and exactly copying what he was observing before his eyes. In a sense this is what was actually happening, since Van Gogh was an artist who saw visions and painted what he saw. *The Starry Night* is both an intimate and a vast landscape, seen from a high vantage point in the manner of the sixteenth-century landscapist Pieter Brueghel the Elder, although certain Impressionist landscapes were a more immediate source. The great poplar tree looms and shudders before our eyes; the little village in the valley rests peacefully under the protection of the church spire; and over all the stars and planets of the universe whirl and explode in a Last Judgment, not of individual human beings but of solar systems. This work was painted in June 1889 at the sanatorium of Saint-Rémy, where he had been taken after his second mental breakdown, during one of the many lucid but emotionally charged intervals in which he continued to paint. The color is predominantly blue and violet, pulsating with the scintillating yellow of the stars. The foreground poplar, in its deep green and brown, suggests the darkness of the night about to encompass the world.

Vincent van Gogh was one of the few artists of his generation who carried on the great tradition of portraiture. His passionate love of mankind made this inevitable, and he studied people as he studied nature, from his first essays in drawing to his last self-portraits painted a few months before his suicide in 1890. The portrait seen here is a profoundly disturbing work that records the frightening intensity of the madman's gaze (fig. 65). Yet it is impossible for a painting as masterful and accomplished as this to have been executed by a madman or by anyone not in control of whatever he was doing. The beautifully sculptured head and the solidly modeled torso are silhouetted against a vibrant field of linear rhythms in gradations of blue. Everything in the painting is blue or blue-green, with the exception of the white shirt front and the red-bearded head of the artist. The coloristic and rhythmic integration of all parts, the careful progression of emphases, from head to torso to background, all demonstrate an artist in superb control of his plastic means. It is as though Van Gogh, for the moment completely sane, was able to record with scrupulous accuracy the vision of himself insane. "In a picture," he wrote to Theo, "I want to say something comforting as music. I want to paint men and women with that something of the eternal which the halo used to symbolize, and which we seek to give by the actual radiance and vibration of our colorings."

The Nabis

Although the origins of twentieth-century painting are to be found specifically in the ideas and achievements of the great masters of the late nineteenth—in particular Cézanne, Gauguin, Van Gogh, and Seurat—these ideas were transmitted in large degree through many lesser artists associated with the dominant trends in art at the turn of the century—Neo-Impressionism, Symbolism, Art Nouveau, and the Nabis. Neo-Impressionism, created by Seurat and Signac, made its appearance in 1884, when a number of artists who were to be associated with the movement exhibited together at the Groupe des Artistes Indépendents in Paris. Later in 1884 the Société des Artistes Indépendents was organized through the efforts of Seurat, Henri-Edmond Cross, Redon, and others, and was to become important to the advancement of early twentieth-century art as an exhibition forum. Also important were the exhibitions of Les XX (Les Vingt, or "The Twenty") in Brussels. Van Gogh,

Gauguin, Toulouse-Lautrec, and Cézanne exhibited at both the Indépendents and Les XX. James Ensor, Van de Velde, and Jan Toorop exhibited regularly at Les XX and its successor, La Libre Esthétique, whose shows became increasingly dominated first by the attitudes of the Neo-Impressionists and then of the Nabis.

The Nabis were a somewhat eclectic group of artists whose principal contributions—with two outstanding exceptions—lay in a synthesizing approach to masters of the earlier generation, not only to Seurat but also to Gauguin, Redon, and Cézanne. Of particular importance was Gauguin's theory of Synthetism as well as the direct example of his painting.

Gauguin had been in some degree affected by the ideas of his young friend Émile Bernard (1868–1941), when the two were working seriously together in Pont-Aven in the summer of 1888. He may well have derived important elements of his Synthetism from Bernard's *cloisonnisme*, a style based on medieval enamel and stained-glass techniques, in which flat areas of color are bounded by dark, emphatic contours (fig. 66). The dominant personality, however, and the artist of genius in this relationship, was Gauguin. Despite Bernard's later angry claims, the spread of Synthetism in painting owes most to the older artist. Certainly, the arbitrary, nondescriptive color, the flat areas bounded by linear patterns, the denial of depth and sculptural modeling—all stated in such works as *Vision After the Sermon* (plate 21) and *The Yellow Christ*, as well as in most of the Tahitian paintings—were congenial to and influential for the Nabis as well as for Art Nouveau decoration. The religious, mystical, or primitive-arcadian subject matter also was appealing to those artists, who continued to seek the inner vision of the Romantics and Symbolists.

Paul Sérusier (1863–1927), one of the young artists under Gauguin's spell at Pont-Aven, experienced something of an epiphany when the older master undertook to demonstrate the Synthetist method during a painting session in a picturesque wood known as the Bois d'Amour: "How do you see these trees?" Gauguin asked. "They are yellow. Well then, put down yellow. And that shadow is rather blue. Render it with pure ultramarine. Those red leaves? Use vermilion." The picture this permitted the mesmerized Sérusier to paint, a tiny work on a cigar-box lid (plate 25), proved so daring in form, even verging on

66. ÉMILE BERNARD. *Buckwheat Harvesters, Pont-Aven.* 1888. 29¼ × 36″. Collection Josefowitz, Switzerland

67. ÉDOUARD VUILLARD. *Mother and Child*. 1899. Oil on cardboard, 19⅛ × 22¼". Glasgow Art Gallery and Museum. Presented by Sir John Richmond, 1948

pure abstraction, that the artist and his young friends thought it virtually alive with supranatural power. And so they entitled the painting *The Talisman* and dubbed themselves the "nabis," a Hebrew word meaning "prophets." These included Sérusier, Maurice Denis, Pierre Bonnard, Paul Ranson, and later Aristide Maillol, Édouard Vuillard, Félix Vallotton, K.-X. Roussel, and Armand Séguin. The Nabis were artists of varying abilities, but included three outstanding talents: Bonnard, Vuillard, and Maillol. They were important in spreading and at the same time consolidating the influence of Gauguin as well as of Redon. Aside from these artists and Cézanne, their paintings reflected in different degrees the widespread influence of Oriental painting and even, at times, of the academic Symbolist Puvis de Chavannes.

The Nabis were symptomatic of the various interests and enthusiasms of the end of the century. There were first of all the literary tendencies toward organized theory and elaborate celebrations of mystical rituals. Maurice Denis and Sérusier wrote extensively on the theory of modern painting; and Denis was responsible for the formulation of the famous phrase, "a picture—before being a war horse, a female nude, or some anecdote—is essentially a flat surface covered with colors assembled in a particular order." During the nineteenth century, artists were increasingly obsessed with the problem of the nature of a work of art. They talked and wrote about the problem of experimental art, the scientific or mystical bases of art, its large social implications. The Nabis, despite their brief existence as a group, were, in their theorizing and their issuance of dogmatic manifestos, immediate ancestors of all those groupings, manifestoes, and theories which have marked the course of twentieth-century art. They also sought a synthesis of the arts through continual activity in architectural painting, the design of glass and decorative screens, book illustration, poster design, and in stage design for the advanced theater of Henrik Ibsen, Maurice Maeterlinck, August Strindberg, and Oscar Wilde, as well as, notably, for Alfred Jarry's *Ubu Roi*.

The *Revue Blanche*, founded in 1891, became one of the chief organs of expression for Symbolist writers and painters, Nabis, and other artists of the avant-garde. Bonnard, Vuillard, Denis, Vallotton, and Toulouse-Lautrec (who was never officially a Nabi, although associated with the group) all did posters and illustrations for the *Revue Blanche* (fig. 69). The magazine was a meeting ground for like-minded artists and writers from every part of Europe, including Van de Velde, the Norwegian painter Edvard Munch, Marcel Proust, André Gide, Henrik Ibsen, August Strindberg, Oscar Wilde, Maxim Gorki, and Filippo Marinetti.

With the exception of Maillol, Bonnard, and Vuillard, who were to go on to substantial personal achievements, the importance of the Nabis is limited to their propagation of Gauguin's ideas and their dedicated support of Cézanne and Redon. Their search for a new approach to religious or specifically mystical subjects, through the means of abstract color shapes and linear patterns, affected the thinking of other experimental painters even though they themselves—with the exceptions noted—did not produce many significant paintings. The writings of Sérusier and Denis were notable documents for the genesis of abstraction and Expressionism. Without the Nabis and the Neo-Impressionists, the outburst in the arts during the first decades of the twentieth century might not have been possible.

ÉDOUARD VUILLARD (1868–1940) The Nabis did produce two painters of genius, Édouard Vuillard and Pierre Bonnard, whose long working lives can remind us how short a time actually separates us from the world of the nineteenth century, a world so different from our own that it might have existed eons ago. Vuillard, after a considerable success in the 1890s, seems to have been content to ignore the furor of new developments in the first years of the twentieth century, particularly avoiding public exhibition. Only with the retrospective exhibition at the Musée des Arts Décoratifs in 1938, two years before his death, did it become possible to evaluate his achievement. This is not to say that he

was unsuccessful during his lifetime. Both he and Bonnard sold extremely well and were much admired by connoisseurs. Their reputations, however, were for a long time private rather than public.

The world of both Vuillard and Bonnard is an intimate world, consisting of corners of the studio, the living room, the familiar view from the window, and portraits of family and close friends. Vuillard's *Self-Portrait* of 1892 (plate 26) shows him at the moment when he was closest to the theories of Gauguin and the Nabis. In their later works Vuillard and Bonnard followed their own directions, though both drew on the Impressionists or any other congenial source for the evocation of their personal environments. The painting just seen represents an unusually bold attempt at the use of vivid, even harsh, abstract color patterns of yellow, red, ocher, blue, and umber. Still, that it is a self-portrait could hardly be made more clear, since the image stands forth as that of a particular and identifiable individual, reminiscent of some of the late self-portraits of Van Gogh (fig. 65).

In his more characteristic early works Vuillard used the broken paint and small brushstroke of the Neo-Impressionists, but with a difference. In *Mother and Child* (fig. 67) he portrayed a scene that may seem oppressive today, with its end-of-the-century clutter of flowered wallpaper, figured upholstery, and patterned dresses. In his hands, however, the interior became a dazzling surface pattern for blues, reds, and yellows, comparable to a Persian painting in its harmonious richness. Space is indicated by the perspective of the chaise longue and the angled folds of the standing screen, but it is still a delimited, geometrically defined space. Characteristically, Vuillard established his color areas by the contours of figures and objects, and thus, in a sense, used color more naturalistically than a number of his contemporaries. The contours, however, are organized into a linear pattern, which helps control the color and gives to the painting an Art Nouveau feeling of rhythmic surface decoration. While clearly and affectionately evoking the real-life world of Parisian middle-class domesticity, Vuillard has done so in the Synthetic manner of Gauguin, as if he were dreaming in the presence of something simple, familiar, and loved. Thus, as the flat surface weave and jigsaw puzzle of conflicting patterns begin to generate shimmering after-images, they seem to draw from a scene of the most ordinary, albeit sweet, everyday life an ineffable sense of the strangeness and magic of life's unknown genesis and destiny. In this, Vuillard's intimist views begin to anticipate the grandly meditative, richly decorative interiors of Matisse, as well as the elusive planes and dynamic, silvery textures of Braque's and Picasso's Analytic Cubism.

This aesthetically aware, intimist rendering of the bourgeois interior, with its interlocking patterns of light and value, if not color, was shared by the young Alfred Stieglitz (1864–1946), an American in Berlin beginning his long and distinguished career in photography (fig. 68). As *Sun Rays, Berlin* would suggest, photography participated with lithography in the explosion of interest that brought new quality to the graphic arts, along with the vast multiplication of imagery produced by these media. While still in Europe, and well before he became the linchpin figure in the American avant-garde, Stieglitz was an ardent advocate of

68. ALFRED STIEGLITZ. *Sun Rays, Berlin*. 1889. Photograph. ©Alfred Stieglitz

69. PIERRE BONNARD. *La Revue Blanche*. 1894. Lithograph, 31½ × 21¼". Bibliothèque Nationale, Paris

Pictorialism in photography, a movement at one with the aestheticism of the late, Symbolist years in nineteenth-century art. The Pictorialists deplored the utilitarian banality of Realist, or "straight," photography, as well as the academic or artificial pictorialism of Rejlander and Robinson (figs. 23, 25, 26). Meanwhile, they insisted upon the artistic possibilities of camera-made imagery, but held that these could be realized only when art and science had been combined to serve both truth and beauty, thereby yielding photographs that represented less a visual document than a personal vision. For the sake of taste and feeling, of controlled "composition, chiaroscuro, truth, harmony, sentiment, and suggestion," many Pictorialists engaged in misguided attempts to emulate traditional paintings and works of graphic art. Some even felt justified in adopting whatever "ennobling processes"—deliberately blurred focus and direct hand manipulation of the print—that might achieve a heightened sense of temperament and poetry. But while such artistic license generated a plethora of "fuzzygraphics," Stieglitz, among others, maintained a strict "truth to materials" position and sought self-expression through his choice of subject, light, and atmosphere in the world about him, allowing natural fog and rain, for instance, to produce the desired effects of vagueness and mystery (fig. 535). And he joined all the Pictorialists in maintaining that their works should be presented and received with the same kind of regard accorded the fruits of other artistic media. In pursuit of this goal, progressive photographers broke away from the older camera societies, with their commercial and technological preoccupations, and, like the period's more advanced painters, sculptors, and architects, initiated a Secession movement—in Vienna, London, Paris, New York, and many other cities—designed to provide spaces for meetings and exhibitions, to stimulate enlightened critical commentary, and even to publish catalogues and periodicals devoted to the camera arts themselves. While the first major Secessionist organization may have been the Linked Ring founded in London in 1892 (renamed the Royal Photographic Society in 1894), the most distinguished and far-reaching in its impact was, as we shall see, the Photo-Secession group established by Stieglitz in New York City in 1902. With the advent of Pictorialism, aesthetically motivated photography gained sufficient respect that never again could it be dismissed without at least a debate as to why photographic images

should, merely by reason of their mechanical production, be considered works of lesser artistic import than images made entirely by hand.

PIERRE BONNARD (1867–1947) Of all the Nabis, Pierre Bonnard was the closest to Vuillard, and the two men remained friends until Vuillard's death in 1940. Like Vuillard, Bonnard lived a quiet and unobtrusive life, but whereas Vuillard stayed a bachelor, Bonnard early became attached to a young woman whom he ultimately married in 1925. It is she who appears in so many of his paintings, as a nude bathing or combing her hair, or as a shadowy but ever-present figure seated at the breakfast table, appearing at the window, or boating on the Seine. At first destined for a career in the law, Bonnard turned to painting professionally after having sold a poster to advertise champagne. He soon gained a modest success making lithographs and posters, illustrating books, and also designing occasionally for Louis Tiffany (fig. 69). He lived a comfortable life, wholly dedicated to intensive study of his circumscribed world.

Bonnard, like many of his generation, began in reaction against Impressionism, but of all the Nabis he and Vuillard were the least influenced by Gauguin. Yet he was affected by his study of Japanese prints, particularly in his adaptation of the Oriental approach to limited and tilted space in the painting. This is not so immediately apparent as it might be, since from the beginning Bonnard evinced a love of paint texture, a love that led him from the relatively subdued palette of his earlier works to the full luminosity of Impressionist color rendered in fragmented brushstrokes. His large *Screen* shows him at his most Japanese and decorative in the spirit of Art Nouveau (fig. 70). At the same time, the figures of mother and children as well as the three heavily caped nurses reveal (as was also true of Vuillard) a touch of gentle satire that well characterizes the frequently surprising penetration of observation he combined with simplicity of spirit.

In the *Interior* of 1898 (fig. 71), a work with close affinities to Vuillard's interiors of the same period, Bonnard was still painting in a relatively muted palette with, however, a sense of coloristic richness in the underpainting. In a manner reminiscent of interiors by the seventeenth-century Dutch painter Pieter de Hooch, he lit the background dining room seen through the door and placed the foreground in shad-

70. PIERRE BONNARD. *Screen*. 1899. Color lithograph on four panels, each 54 × 18¾". Collection, The Museum of Modern Art, New York. Abby Aldrich Rockefeller Fund

71. PIERRE BONNARD. *Interior.* 1898. 20½ × 13¾″. North Carolina Museum of Art, Raleigh

Matisse—who was a devoted admirer of Bonnard—and had used what he wanted of the new approaches without at any time changing his basic attitudes. Like the experimentalists, Bonnard did not paint from direct observation. A few strokes of the brush were enough to serve as notes of both color and organization. Gradually, from these notes—frequently long afterward and in a different environment—his own conception would emerge, based on the scene but changed and modified in a hundred ways, much as Picasso might have transformed a still life into a Cubist grid.

HENRI DE TOULOUSE-LAUTREC (1864–1901) Although Henri de Toulouse-Lautrec could be seen as the heir of Daumier in the field of graphic art, he also served, along with his contemporaries Gauguin and Van Gogh, as one of the principal bridges between the nineteenth-century experimental painting and many of the early twentieth-century Expressionist or plastic tendencies of Edvard Munch, Pablo Picasso, and Henri Matisse. Lautrec also looked back to Goya and the line drawings of Ingres, but first he was a passionate disciple of Degas, both in his admiration of Degas's draftsmanship and in his disengaged attitude toward the familiar subjects of the theater and of the daily routine of the bourgeoisie. Even though Lautrec, after an academic training, discovered and adapted the direct palette of the Impressionists, he remained throughout most of his career, with the exception of isolated paintings, a draftsman who used color to heighten and accent the linear rhythm of his paintings and color lithographs (fig. 72).

72. HENRI DE TOULOUSE-LAUTREC. *The Englishman at the Moulin Rouge.* 1892. Oil on cardboard, 33¾ × 26″. The Metropolitan Museum of Art, New York. Bequest of Miss Adelaide Milton de Groot

ow. The result is both an opening up of perspective space and a bringing forward of the more coloristic background to the picture plane. Like Vuillard, again, Bonnard frontalized the abruptly cut-off section of the room in a precise, flattened way—an Art Nouveau anticipation of Matisse and even of Mondrian.

Bonnard differed from Vuillard in many important respects. As he proceeded, his color became constantly brighter and gayer, until in a painting like *Dining Room on the Garden,* executed in the 1930s (plate 27), he had long since recovered the entire spectrum of luminous color, presented in large areas of clearly drawn architecture and used as counterpoint to the broken brushstrokes of the landscape. The full Impressionistic sunlight stems from the late Monet. Yet Bonnard actually belongs to the tradition of the late Manet, Renoir, and, most specifically, of Degas. Furthermore, by the time of *Dining Room on the Garden,* virtually all the great primary revolutions of twentieth-century painting had already occurred. Fauvism, with its arbitrary, expressive color, and Cubism, with its reorganization of Renaissance pictorial space, had both won their notable victories. Moreover, painting had found its way to pure abstraction and fantasy in various forms. Perfectly aware of all this, Bonnard was nonetheless content to go his own way. In the work seen here, for instance, there are evidences that he had looked closely at Fauve and Cubist paintings, particularly the works of

Origins of Modern Architecture:
NINETEENTH-CENTURY PIONEERS

It is impossible to understand the attitudes and experiments of twenti-eth-century painters without understanding the ideas of a host of nine-teenth-century forerunners: Courbet, Manet, Monet, Gauguin, Van Gogh, and Cézanne. We can hardly speak of nineteenth-century fore-runners to twentieth-century architects and sculptors in anything like the same degree, since the break between the past and the present occurred rather suddenly at the end of the nineteenth century. In archi-tecture the nineteenth century continued and expanded the pattern of stylistic revivals that had predominated in Europe since the fifteenth century and in the Americas since the sixteenth. In the year 1800, the Neoclassic revival, more specifically archeological than its Renaissance and post-Renaissance predecessor revivals, and broadened to include neo-Greek, was well established in both Europe and America as the dominant style. During the later eighteenth century, however, particu-larly in England, a Gothic revival had gained considerable momentum and continued to make headway during the first half of the nineteenth. It was accompanied by revivals of Renaissance and Baroque Classicism, movements that produced a substantial part of the monumental archi-tecture of the late nineteenth century and the early twentieth.

73. JOHN NASH. The Royal Pavilion, Brighton, England.
1815–23

Nineteenth-Century Industry and Engineering

New ideas in architecture emerged during the nineteenth century in the context of engineering, with the spread of industrialization and the utili-zation of novel building materials, notably iron, glass, and hollow ce-ramic tile. The use of iron for structural elements, although there are sporadic instances during the eighteenth century, became fairly com-mon in English industrial building only after 1800. During the first half of the nineteenth century, a concealed iron-skeleton structure was used in buildings of all types, and exposed columns and decorative ironwork appeared, particularly in nontraditional structures and notably in the Royal Pavilion at Brighton (fig. 73). Iron was also used extensively in the many new railway bridges built throughout Europe (fig. 74). Roofs of iron and glass over commercial galleries or bazaars became popular in acceptance and ambitious in design during the first half of the nine-teenth century, particularly in Paris. In greenhouses, iron was gradually substituted for wood in framing the glass panes, with a consequent en-largement of total scale. The Jardin d'Hiver in Paris, designed by Hector Horeau in 1847 and since destroyed, measured 300 by 180 feet at the base and rose to a height of 60 feet. In works such as this originated the concept of the monumental all-glass-and-metal structure, of which Sir Joseph Paxton's Crystal Palace, created for the London Exposition of 1851, was the great exemplar (fig. 75).

The sheds of the new railway stations, precisely because they were structures without tradition, provided the excuse for some of the most daring and experimental buildings in iron and glass. The Gare Saint-Lazare in Paris supplied Monet with a new experience in light, space, and movement. The use of exposed iron columns supporting iron and glass arches penetrated a few traditional structures, such as Henri La-brouste's Bibliothèque Sainte-Geneviève (fig. 76). The use of stamped cast iron for decorative details resulted in a substantial development of prefabrication before 1850. For decades thereafter, however, in large part because of the didacticism of revival-oriented theorists in architec-ture, the structural and decorative use of cast iron declined. Only at the very end of the nineteenth century, with the new nontraditional style of Art Nouveau, did metal emerge once more as the architectural element on which much of twentieth-century architecture would be based.

In architecture, as in the decorative arts, the latter half of the nine-teenth century often represented a low point in the history of taste. The Classical and Gothic revivals of the early century had been largely su-perseded by elaborate Renaissance and Baroque revivals, of which the Paris Opéra was perhaps the supreme example (fig. 77). These re-mained, far into the twentieth century, the official styles for public and monumental buildings. Residential or domestic architecture was char-acterized by a mélange of historic styles and by shoddy construction in

74. GUSTAVE EIFFEL. Truyère Bridge, Garabit, France. 1880–84

75. SIR JOSEPH PAXTON. Crystal Palace, London. 1851

76. HENRI LABROUSTE. Reading Room, Bibliothèque Ste-Geneviève, Paris. 1843–50

77. CHARLES GARNIER. L'Opéra, Paris. 1861–74

the mass tenement housing that followed the large-scale growth of cities during the Industrial Revolution.

The enormous expansion of machine production during the later eighteenth and the nineteenth centuries required the development of mass consumption for the new or more cheaply manufactured products. From this need for a mass market there arose early in the nineteenth century the credo of much modern advertising that only the most ornate, the most unoriginal, and the most vulgar products would sell. By the time of the London Exposition of 1851, the vast array of manufactured objects exhibited in Paxton's daring glass and metal Crystal Palace represented and even flaunted the degeneration of taste brought on by the emergence of a machine economy.

The exact cause, or causes, of this degeneration is not easy to determine, and probably no single explanation is entirely adequate. To a romantic nineteenth-century reformer like William Morris, friend and collaborator of the Pre-Raphaelites, the answer was simple: it was the curse of the machine, destroying the values of individual craftsmanship on which the high levels of past artistic achievement had rested. However, the machine of the nineteenth century, like the computer of today, could not exist and function independent of human control. There is no question that the manufacturer and designer of the most gruesome Victorian textiles and porcelains saw in these the same beauty as did the customer who was also attracted by the modest cost. At least, there was little qualitative difference in the home environment of the wealthy manufacturer and his humble customer. William Morris, poet, painter, designer, and social reformer, fought a rear-guard action against the rising tide of commercial vulgarization. In attempting to find the answer by turning back the clock and reviving the craft traditions of the Middle Ages, he and the Arts and Crafts movement were involved in a romantic fallacy that was actually a part of the academic, eclectic, revivalistic tradition they were attacking. Although Morris's solutions may be criti-

cized as being in themselves derivative, the question was not so much derivation as taste, discrimination, and a sense of quality.

Domestic Architecture in England and the United States

Taste, discrimination, and a sense of quality mark the style of Philip Webb, the architect whom Morris asked to design his own house at Bexley Heath, Kent, in 1869. The home commissioned by Morris, The Red House (fig. 78), in accordance with his desires, was generally Gothic in design, but Webb interpreted his mandate freely. Into a simplified, traditional, red-brick, pitched-roof Tudor Gothic manor house he introduced exterior details of classic Queen Anne windows, oculi, and a Moorish-arch entryway. The total effect of the exterior is of harmony and compact unity, despite the disparate elements. The plan is an

78. PHILIP WEBB and WILLIAM MORRIS. The Red House, Bexley Heath, Kent, England. 1859–60

79. HENRY HOBSON RICHARDSON. Stoughton-Hurlburt House, Cambridge, Massachusetts. 1883

open L-shape with commodious, well-lit rooms arranged in an easy and efficient asymmetrical pattern.

Aware of English experiments, Henry Hobson Richardson (1838–1881) nonetheless developed his own style in the United States, which fused native American traditions with those of medieval Europe. The Stoughton-Hurlburt house, Cambridge, Massachusetts (fig. 79), is one of his most familiar structures in the shingle style then rising to prominence on the Eastern Seaboard. The main outlines are reminiscent of Romanesque and Gothic traditions, but these are architecturally less significant than the spacious, screened entry and the extensive windows, which suggest his concern with the livability of the interior. The unornamented shingled exterior wraps around the main structure of the house to create a sense of simplicity and unity that takes it out of a particular time and place.

Although Stanford White (1853–1906), the most influential and talented designer for the firm of McKim, Mead and White, was in some degree responsible for the hold that academic Classicism had on American public architecture for half a century, no one can deny his abilities. In his domestic architecture White realized the quality of American Colonial building and, like Shaw and Webb, was able to select with taste the historic or geographic style that best suited the particular site or problem. The W. G. Low house of 1887 (fig. 80), a superb example of the Shingle Style, is revolutionary in contrast to the customary enormous, fashionable, and eclectic monstrosities familiar to Newport, Rhode Island. Although something like a greatly enlarged Swiss chalet, the Low house can nevertheless be compared with twentieth-century experimental architecture in its essential lack of historical association. The extensive porch and the many-windowed façade give it an effect of openness, and the all-encompassing pitched roof serves as a unifying factor.

The history of twentieth-century architecture is rooted in nineteenth-century technology, such as experiments in iron or steel, first used in the new bridges required by the expansion of rail communications, or new types of structures, on the order of railway stations, department stores, and exhibition halls, which were without tradition and lent themselves to the large-scale use of metal-framed areas of glass. However, many of the most revolutionary concepts—of utility, of commodiousness, of beauty arising from undecorated formal relations, of structures without a debt to historic styles, of forms that followed functions—were first conceived on the relatively modest scale of individual houses and small industrial buildings. The pioneer efforts of Webb in England and of Richardson and White in the United States were followed by the important experimental housing of Charles F. Voysey, Arthur H. Mackmurdo, and Charles Rennie Mackintosh in the British Isles, and in the United States by the revolutionary house designs of Frank Lloyd Wright.

Charles F. Voysey (1857–1941), through his wallpapers and textiles, had an even more immediate influence on Continental Art Nouveau than did the Arts and Crafts movement of William Morris. The furniture he designed had a rectangular, Classical form and a lightness of proportion that anticipated the better Bauhaus furniture. The principal influence on Voysey's architecture was Arthur H. Mackmurdo (1851–1942), who, in structures such as his own house and his Liverpool exhibition hall, went beyond Webb in the creation of a style that eliminated almost all reminiscences of English eighteenth-century architecture. A house by Voysey in Bedford Park, dated 1891 (fig. 81), is astonishingly original in its abstract rhythms of grouped windows and door openings against broad, white areas of unadorned walls. In his later country houses he returned, perhaps at the insistence of clients, to

80. STANFORD WHITE. W. G. Low House, Bristol, Rhode Island. 1887

suggestions of more traditional Tudor and Georgian forms. He continued to treat these, however, in a ruggedly simple manner in which plain wall masses were lightened and refined by articulated rows of windows.

Glasgow, principally in the person of Charles Rennie Mackintosh (1868–1928), was one of the most remarkable centers of British architectural experiment at the end of the nineteenth century. Mackintosh's most considerable work of architecture, created at the beginning of his career, is the Glasgow School of Art of 1898–99 and its library addition, built 1907–9 (fig. 82). The essence of this building is simplicity, clarity, monumentality, and, above all, an organization of interior space that is

81. CHARLES F. VOYSEY. The Forster House, Bedford Park, London. 1891

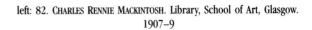

wall painting are the products of both Mackintosh and his wife, Margaret Macdonald. The stripped-down rectangular partitions and furniture, and the curvilinear figure designs on the walls, illustrate the contrasts that form the full spirit of Art Nouveau. The decorations are close to the developed paintings of Gustav Klimt and the Vienna Secession (figs. 93, 105), and in fact may have anticipated and influenced them. Mackintosh did exhibit with the Vienna Secession in 1900, and his architectural designs, furniture, glass, and enamels created a sensation.

After 1900, the architectural leadership that England had assumed, particularly through designs for houses and smaller public buildings by Webb, Voysey, and Mackintosh, declined rapidly. In the United States, Frank Lloyd Wright and a few followers carried on their spectacular experiments in detached domestic architecture. However, for many years even Wright himself was given almost no large-scale building commissions. The pioneer efforts of Louis Sullivan and the Chicago School of architects came to a dead stop in the face of the massive triumph of the Beaux-Arts tradition of academic eclecticism, which was to dominate American public building for the next thirty years.

The Chicago School and the Origins of the Skyscraper

Modern architecture may be said to have emerged in the United States Romanesque-clad in the works of H. H. Richardson. In his Marshall Field Wholesale Store (fig. 84), now destroyed, Richardson combined an effect of monumental mass achieved through the use of graduated rusticated blocks of red Missouri granite and brownstone, and the extreme openness of the fenestration. The windows, arranged in continuously diminishing arcaded rows that mirror the gradual narrowing of the masonry wall from ground to roof, are integrated with the interior space rather than being simply holes punched at intervals into the exterior wall. Although Romanesque in its feeling of mass and stability, the Marshall Field building, with its ornamental details kept to a minimum, was actually a building without a style in a traditional sense—a prototype of and a direct influence on the Chicago School of modern architecture.

The progressive influence of Richardson on American architecture was counteracted after his death as more and more young American architects studied in Paris in the academic environment of the École des Beaux-Arts. In particular, the energetic firm of McKim, Mead and White established a Classical hold on public American building that was once entirely shaken off and has now been revived. Collaborating with the Chicago firm of Burnham and Root, Charles Follen McKim designed the 1893 Chicago World's Fair as a vast and highly organized example of quasi-Roman city planning (fig. 85). The gleaming white colonnades of the World's Fair buildings affected a generation of architects and clients, and undoubtedly retarded the progress of experimental architecture in America by the same span of time.

Throughout the nineteenth century, continual expansion and improvement in the production of structural iron and steel permitted raising the height of commercial buildings, a necessity born of growing urban congestion, and, at the same time, there were sporadic experi-

83. CHARLES RENNIE MACKINTOSH. Miss Cranston's Tearoom in Ingram Street, Glasgow. 1897–98, 1907–11

not only functional but highly expressive of its function. The huge, rectangular studio windows are imbedded in the massive stone façade, creating a balance of solids and voids. The rectangular heaviness of the walls, softened only by an occasional curved masonry element, is lightened by details of fantasy, particularly in the ironwork, that show a relationship to Art Nouveau. The library addition is a large, high clerestory room with surrounding balconies. Rectangular beams and pillars are used to create a series of views that become three-dimensional, geometric abstractions.

The same intricate play with interior vistas seen in the library of the Glasgow School of Art is apparent in the Cranston Tearoom in Ingram Street (fig. 83), where most details of the interior design, furniture, and

ments in increasing the scale of windows beyond the dictates of Renaissance palace façades. Chicago in 1870 was a city without architectural style or distinction and filled with hastily built balloon-frame wood construction. A vast proportion of the building was destroyed in the great fire of 1871—an event that cleared the way for a new type of metropolis utilizing the new architectural techniques and materials developed in Europe and America over the previous hundred years.

The Home Insurance Building in Chicago (fig. 86), designed and constructed between 1883 and 1885 by the architect William Le Baron Jenney, was only ten stories high, no higher than other proto-skyscrapers already built earlier in New York. Its importance rested in the fact that it embodied true skyscraper construction in which the internal metal skeleton carried the weight of the external masonry shell. This innovation, although Jenney did not himself develop it further, together with the development of the elevator, paved the way for the indefinite extension of the height of commercial buildings and the creation of the world of the skyscraper. Burnham and Root's Reliance Building, completed in 1894, illustrated the architects' understanding of the implications of metal-frame construction through the elimination of walls and the opening up of the façades as a glass box in which solid, supporting elements were, for that time, reduced to a minimum. The concept of the twentieth-century skyscraper as a glass-encased shell framed in a metal grid was here stated for the first time.

Among the many architects attracted to Chicago from the East or from Europe by the opportunities engendered by the great fire was the Dane Dankmar Adler. He was joined in 1879 by a young Boston architect, Louis Sullivan (1856–1924), and in 1887 the firm of Adler and Sullivan hired a twenty-year-old draftsman, Frank Lloyd Wright. Adler and Sullivan entered the field of skyscraper construction in 1890 with

84. HENRY HOBSON RICHARDSON. Marshall Field Wholesale Store, Chicago (demolished 1930). 1885–87

their Wainwright Building in St. Louis. Then, in the Guaranty Trust Building (now the Prudential Building) in Buffalo, New York, Sullivan designed the first masterpiece of the early skyscrapers (fig. 87). Here, as in the Wainwright Building, the architect attacked the problem of skyscraper design by emphasizing verticality, with the result that the pilasters separating the windows are uninterrupted through most of the building's height. At the same time, he seemed already to have been aware of the peculiar design problem involved in the skyscraper, which is actually a tall building consisting of a large number of superimposed

85. D. H. BURNHAM and C. F. MCKIM. World's Fair, Chicago. 1893

86. WILLIAM LE BARON JENNEY. Home Insurance Building, Chicago
(demolished 1929). 1883–85

87. LOUIS SULLIVAN. Guaranty Trust Building (now Prudential Building),
Buffalo. 1894–95

88. CASS GILBERT. Woolworth Building, New York. 1913

horizontal layers. Thus, Sullivan accentuated the individual layers with
ornamented bands under the windows, as well as throughout the attic
story, and crowned the building with a projecting cornice that brings
the structure back to the horizontal. Meanwhile, the treatment of the
columns on the ground floor emphasizes the openness of the interior
space. Above them, the delicate pilasters between the windows soar
aloft and then join under the attic story in graceful arches that tie the
main façades together. The oval, recessed windows of the attic, being
light and open, blend into the elegant curve of the summit cornice.
Sullivan's famed ornament covers the upper part of the structure in a
light, over-all pattern, helping to unify the façade while also emphasiz-
ing the nature of the terra-cotta sheathing over the metal skeleton as a
weightless, decorative surface rather than a bearing member.

Although the Chicago School of architecture maintained its vitality
into the first decade of the twentieth century, the neo-academic styles
were gaining in strength. Not only were they to invade all public build-
ings and most domestic housing; they were also to conceal the structure
of commercial skyscrapers in trappings of Gothic or Neoclassical orna-
ment. The higher the skyscraper rose, particularly in New York, the
more it lost the clarity of form and lucid statement of function that
marked its inception in the Chicago School. By 1913 Cass Gilbert's
Woolworth Building (fig. 88) loomed 792 feet—fifty-two stories of Late
Gothic stone sheathing serving mainly to add weight, disguise the metal-
case construction frame, and create a sense of fantasy that has now
become the object of considerable Post-Modernist admiration.

Art Nouveau:
FROM EXPRESSIONISM TO FANTASY

As we saw in the discussion of Post-Impressionism, and the trend toward functional design in late nineteenth-century architecture, the *fin-de-siècle* was a period of synthesis in the arts, a time when artists sought new directions that in themselves constituted a reaction against the tide of "progress" represented by industrialization. The search of the Symbolist poets, painters, and musicians for spiritual values was part of this reaction. Gauguin used the term "synthetism" to characterize the liberating color and linear explorations that he pursued and transmitted to disciples: the synthesis of color and form into semi-abstract images. The phenomenal thing about this "synthetic" spirit—in its broader and less profound aspect—is that in the last decades of the nineteenth century and the first of the twentieth it became a great popular movement that affected the taste of every part of the population in both Europe and the United States. This was the movement called *art nouveau*, a French term meaning simply "new art." Art Nouveau was a definable style that emerged from the experiments of painters, architects, craftsmen, and designers, and, for a decade, permeated not only painting, sculpture, and architecture, but also graphic design, magazine and book illustration, furniture, textiles, glass and ceramic design, and even women's fashions. In its popular aspects it was practiced by numbers of relatively undistinguished artists and craftsmen, but few of the pioneers of twentieth-century art were uninfluenced by its forms and ideas.

Art Nouveau grew out of the English Arts and Crafts movement whose chief exponent and propagandist, as we saw earlier, was the artist-poet William Morris (1834–1896). The Arts and Crafts movement came forth as a revolt against the new age of mechanization, a Romantic effort on the part of Morris and others such as Mackmurdo to implement the philosophy of John Ruskin that true art should be both beautiful and useful (fig. 89). They saw the world of the artist-craftsman in process of destruction by industrialization, and they fought for a return to some of the standards of simplicity, beauty, and craftsmanship that they associated with earlier centuries, notably the Middle Ages. The ideas of the Arts and Crafts movement spread rapidly throughout Europe and found support in the comparable theories of French, German, Belgian, and Austrian artists and literary men. Implicit in the movement was the concept of the synthesis of the arts based on an aesthetic of dynamic linear movement. Many names were given to this phenomenon in its various manifestations, but ultimately Art Nouveau became the most generally accepted, probably through its use for the Parisian shop, Maison de l'Art Nouveau, which, with its exhibitions and extensive commissions to artists and craftsmen, was influential in propagating the style. In Germany the term *Jugendstil*, after the periodical *Jugend*, became the accepted name.

The Art Nouveau artists searched for a style and an iconography that avoided the historical styles still dominating the mass of academic painting and sculpture. In 1890, it must be remembered, the majority

89. WILLIAM MORRIS. Detail of *Pimpernel* wallpaper. 1876. Victoria and Albert Museum, London

of accepted painting, sculpture, and architecture was still that being produced in enormous quantity under the aegis of the academies. In contrast to the Arts and Crafts movement in which it had originated, Art Nouveau made use of new materials and technologies both in buildings and in decoration.

In actuality, Art Nouveau artists could not avoid the influence of past styles, but they explored those that were less well known and out of fashion with the current academicians, deriving from medieval, Oriental, or primitive art any forms or devices congenial to their search for an abstraction based on linear rhythms. Thus the linear qualities as well as the decorative synthesis of eighteenth-century Rococo, the wonderful linear interlace of Celtic or Saxon illumination and jewelry, the bold, flat patterns of Oriental and specifically of Japanese art, and the high decorative quality of Chinese and Japanese ceramics and jades all entered into the picture. The Art Nouveau artists, while seeking a kind of

left: 90. WILLIAM BLAKE. *The Great Red Dragon and the Woman Clothed with the Sun.* 1805–10. Watercolor, 16⅛ × 13⅛″. National Gallery of Art, Washington, D.C. Rosenwald Collection

right: 91. AUBREY BEARDSLEY. *Salome with the Head of John the Baptist.* 1893. India ink and watercolor, 10⅞ × 5¾″. Princeton University Library, New Jersey

abstraction, were not yet prepared for a completely nonobjective point of view. Hence most of their decoration had a source in nature, particularly in plant forms, often given a symbolic or sensuous overtone, or in microorganisms that the new explorations in botany and zoology were making familiar.

An aesthetic based on line was the natural consequence of the reaction against materialism in painting and the other arts during the later part of the nineteenth century. Impressionism had moved toward the dematerialization of objective nature by means of light and color. In the later works of Seurat and his Neo-Impressionist followers, line took on a formal, coordinating, and also an abstract-expressive function. The Synthetism of Gauguin and, after him, of those followers who called themselves the Nabis, was rooted in linear as well as color pattern. The sculptor Maillol's early paintings were in the form of decorative, outlined color areas, but when he turned to sculpture, his absorption in the new medium took him into a plastic concern for mass at variance with the Art Nouveau approach. Gauguin's sculpture was closer to this approach, particularly his reliefs, although like his woodblocks, the reliefs included a contrasting strong, primitive quality that was very much his own (fig. 63). Toulouse-Lautrec reflected (as well as influenced) the Art Nouveau spirit in his paintings and prints, particularly in his subtle use of descriptive, expressive line. Through his highly popular posters, aspects of Art Nouveau graphic design were spread throughout the Western world.

English Art Nouveau came largely from the less dynamic and more elaborately decorative and literary tradition of the Pre-Raphaelites Dante Gabriel Rossetti (fig. 40) and Edward Burne-Jones (1833–1898). The mystical visions of William Blake (fig. 90), expressed in fantastic rhythms of line and color, were an obvious ancestor, as was, in fact, the tendency of English art, from medieval times, toward the linear.

The drawings of Aubrey Beardsley (1872–1898) were immensely elaborate in their black-and-white decorative richness (fig. 91). Associated as they were with the so-termed "aesthetic" or "decadent" literature of Oscar Wilde and the *fin-de-siècle*, they probably constitute the most characteristic contribution of the English to Art Nouveau graphic

92. HENRY VAN DE VELDE. *Tropon.* c. 1899. Poster, 47⅝ × 29⅛″. Museum für Kunst und Gewerbe, Hamburg

93. GUSTAV KLIMT. *Woman with a Black Feather Hat.* 1910. 31¼ × 24¾".
Collection Viktor Fogarassy, Graz, Austria

94. GUSTAV KLIMT. Detail of Dining Room Mural, Palais Stoclet, Brussels.
c. 1905–8. Mosaic and enamel on marble

art. Beardsley, like Edgar Allan Poe and certain of the French Symbolist writers, was haunted with romantic visions of evil, of the erotic, the decadent, and the *femme fatale* discussed earlier, although his expression of these qualities was so elegantly decorative that they cannot be said to have attained much impact. In watered-down form, his style in drawing appeared all over Europe and America in popularizations of Art Nouveau illustrations.

One of the most influential figures in all the phases of Art Nouveau was the Belgian Henry van de Velde (1863–1957). Trained as a painter, he produced, as early as 1890, completely abstract compositions in typical Art Nouveau formulas of color patterns and sinuous lines (fig. 92). For a time he converted to Neo-Impressionism and read widely in the scientific theory of color and perception. He soon abandoned this direction in favor of the Symbolism of Gauguin and his school, and attempted to push his experiments in symbolic statement through abstract color expression further than had any of his contemporaries. Ultimately, Van de Velde came to believe that easel painting was a dead end and that the solution for contemporary society was to be found in the industrial arts. Thus it was finally as an architect and designer that he made his major contributions to Art Nouveau and the origins of twentieth-century art.

GUSTAV KLIMT (1862–1918) In Austria, the new ideas of Art Nouveau were given expression in the founding in 1897 of the Vienna Secession and, shortly thereafter, of its publication, *Ver Sacrum*. The major figure of the Vienna Secession was Gustav Klimt, in many ways the most complete and most talented exponent of pure international Art Nouveau style in painting (fig. 93). Klimt was well established as a successful decorative painter and fashionable portraitist, noted for the bril-

liance of his draftsmanship, when he began in the 1890s to be drawn into the stream of new European experiments. He became conscious of Dutch Symbolists such as Jan Toorop, of the Swiss Symbolist Ferdinand Hodler (fig. 112), of the English Pre-Raphaelites and of Aubrey Beardsley (plate 5; figs. 40, 91). His own style was also formed on a study of Byzantine mosaics. A passion for erotic themes led him not only to the creation of innumerable drawings, sensitive and explicit, but also to the development of a painting style that integrated sensuous nude figures with brilliantly colored decorative patterns of a richness rarely equaled in the history of modern art. He was drawn more and more to mural painting, and his murals for the University of Vienna involved elaborate and complicated symbolic statements composed of voluptuous figures floating through an amorphous, atmospheric limbo. Those he designed for Josef Hoffmann's Palais Stoclet in Brussels between 1905 and 1910 are a document of great importance in the history of modern art (figs. 94, 105, 106). Executed in glass, enamel, metal, and semiprecious stones, they combined figures conceived as flat patterns (except for modeled heads and hands) with an over-all pattern of abstract advancing spirals. Although essentially decorative in their total effect, the Stoclet murals mark the moment when modern painting was on the very edge of nonrepresentation. Through his relationship with the younger artist Egon Schiele, as well as through his own obsessive, somewhat morbid eroticism and febrile art—a glittering complex of volumetric form embedded in mosaic of jeweled and gilded, flat-pattern design (plate 28)—Klimt also occupies a special place in the story of Austrian Expressionism.

Art Nouveau Architecture and Design

In architecture it is difficult to speak of a single, unified Art Nouveau style except in the realms of surface ornament and interior decoration. There are not many buildings that can be so classified even in a peripheral sense. Yet, despite this fact, certain aspects, notably the use of the whiplash line in ornament and a generally curvilinear emphasis in decorative and, at times, even in structural elements, derive from Art Nouveau graphic art and decorative or applied arts. The Art Nouveau spirit of imaginative invention, linear and spatial flow, and of nontradi-

95. Louis Sullivan. Detail of cast-iron ornament on the Carson Pirie Scott and Company Department Store, Chicago. c. 1903–4

96. Louis Comfort Tiffany. Table Lamp. c. 1900. Bronze and favrile glass, height 27″, shade 18″ diameter. Lilian Nassau Antiques, New York

tionalism fed the inspiration of a number of architects in France, Belgium, Germany, Austria, Spain, Italy, and the United States, and enabled them to experiment more freely than they might otherwise have done with ideas opened up to them by the use of metal, glass, and reinforced-concrete construction. Since the concept of Art Nouveau involved a high degree of special design and craftsmanship, it did not lend itself to the developing field of large-scale mass construction, which probably explains why it did not result in many actual architectural monuments. However, as already noted, it did contribute substantially to the outlook that was to lead to the rise of a new and experimental architecture in the early twentieth century.

The architectural ornament of Louis Sullivan in the Guaranty Trust Building (fig. 87) or the Carson Pirie Scott store was the principal American manifestation of Art Nouveau spirit in architecture (fig. 95), and a comparable spirit permeated the early work of Sullivan's great disciple, Frank Lloyd Wright (fig. 292). The outstanding American name in Art Nouveau was that of Louis Comfort Tiffany, but his expression lay in the fields of interior design and decorative arts. In these he was not only in close touch with the European movements but himself exercised a considerable influence on them (fig. 96).

ANTONI GAUDÍ (1852–1926) In Spain, Antoni Gaudí was influenced as a student by the ideas of Milo y Fontanas, who in Rome had been attracted to the Nazarenes and to a Romantic concept of the Middle Ages as a Golden Age, which for him became a symbol for the rising nationalism of Catalonia. Also implicit in Gaudí's architecture was his early study of natural forms as a spiritual basis for architecture. He was drawn to the French medieval-revival architect, Eugène Emmanuel Viollet-le-Duc (1814–1879), not only by the latter's passion for restoring Gothic monuments, but also, and more particularly, by his strongly rational approach to Gothic structure, which he saw in the light of modern technical advances. Gaudí's early architecture belonged in the main current of Gothic revival, with the difference that it involved an imaginative use of materials, particularly in textural and coloristic arrangement, and an even more imaginative personal style in ornamental ironwork. His wrought-iron designs were arrived at independently and frequently in advance of the comparable experiments of Art Nouveau. Throughout his later career, from the late 1880s until his death in 1926, Gaudí followed his own direction, which at first was parallel to Art Nouveau and later was independent of anything that was being done in the world or would be done until the middle of the twentieth century, when his work was reassessed. Probably his greatest affinity is to the new Romantic structural experimentalists of recent years, and his greatest potential influence on the next generation of architects.

Gaudí's first major commission was to complete the Church of the Sagrada Familia in Barcelona, already designed as a neo-Gothic struc-

ture by the architect Francisco de Villar (fig. 97). Gaudí worked intermittently on this church from 1883 until his death in 1926, leaving it far from complete even then. Although he abandoned Villar's plan, there are still Gothic elements in his own design of the interior. The main parts of the completed church, particularly the four great spires of one transept, are only remotely Gothic, and although influences of Moorish, primitive African, and other exotic architectural styles may be traced, the principal effect is of a building without historic style—or rather one that expresses the imagination of the architect in the most personal and powerful sense. In the decoration of the church—still only a fragment—emerges a profusion of fantasy in biological ornament flowing into naturalistic figuration and abstract decoration. Brightly colored mosaic decorates the finials of the spires.

At the Güell Park in Barcelona, Gaudí produced a demonstration of sheer fantasy and engineering ingenuity, a Surrealist combination of landscaping and urban planning. This gigantic descendant of the Romantic, Gothic English gardens of the eighteenth century is an enormous mélange of sinuously curving walls and benches, grottoes, porticoes, arcades, all covered with brilliant mosaics of broken pottery and glass (fig. 98). In it can be observed the strongly sculptural quality of Gaudí's architecture, a quality that differentiates it from most aspects of Art Nouveau. He composed in terms not of lines but of twisted masses of sculpturally conceived masonry. Even his ironwork has a sculptural heaviness that makes it transcend the normal elegance of Art Nouveau line.

Gaudí designed the Casa Milá, a large structure freestanding around open courts, as a whole continuous movement of sculptural volumes (fig. 99). The façade, flowing around the two main elevations, is an alternation of sculptural mass and interpenetrating void. The undulating roof lines and the elaborately twisted chimney pots carry through the unified architectural-sculptural theme. Ironwork grows over the balconies like some luscious exotic vegetation. The sense of transition continues in the floor plan, where one room or corridor flows without

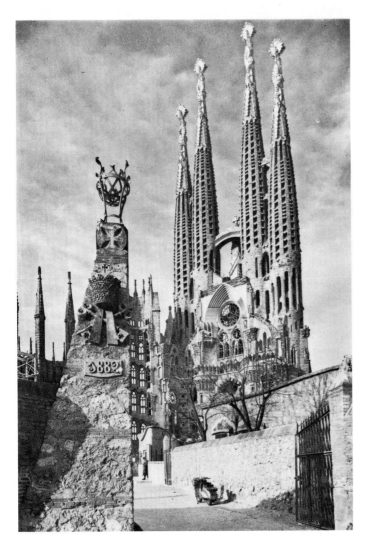

97. ANTONI GAUDÍ. Church of the Sagrada Familia, Barcelona. 1883–1926

98. ANTONI GAUDÍ. Detail of surrounding wall, Güell Park, Barcelona.
1900–14

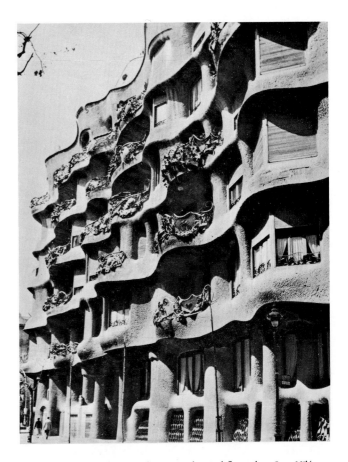

99. ANTONI GAUDÍ. Street elevation and typical floor plan, Casa Milá
Apartment House, Barcelona. 1905–7

interruption into another. Walls are curved or angled throughout, to create a feeling of everlasting change, of space without end.

In his concept of architecture as dynamic space joining the interior and external worlds and as living organism growing out of its natural environment, in his daring engineering experiments, in his imaginative use of materials—from stone that looks like a natural rock formation to the most wildly abstract color organizations of ceramic mosaic—Gaudí was a great pioneer, a prophet, one of the foundations on which architects at mid-century began to build.

VICTOR HORTA (1861–1947) If any architect might claim to have been the founder of Art Nouveau architecture, it was the Belgian Victor Horta. Trained as an academician, he was affected by Baroque and Rococo concepts of linear movement in space and inspired by his study of organic growth and of Viollet-le-Duc's structural theories. Although as a practicing architect Viollet-le-Duc had been notorious for his ruthless reconstructions of medieval architecture in France, his writings on architecture, notably his *Entretiens,* which appeared in French, English, and American editions in the 1860s and 1870s, were widely read by architects. His bold recommendations on the use of direct metal construction influenced not only Gaudí and Horta, but a host of other experimental architects at the end of the nineteenth century. Another influence on Horta was the engineer Gustave Eiffel (1832–1923), whose famous 984-foot tower, built for the Paris Exposition of 1889,

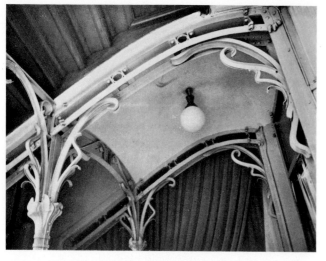

100. VICTOR HORTA. Detail of ironwork, interior, Tassel House, Brussels. 1892–93

101. VICTOR HORTA. Auditorium, Maison du Peuple, Brussels. 1897–99

103. HECTOR GUIMARD. Entrance to a Métropolitain Station, Paris. 1898–1901

104. AUGUST ENDELL. Facade, Atelier Elvira, Munich. 1897

was the most dramatic conceivable demonstration of the possibilities of exposed metal construction.

The first important commission carried out by Horta was the house of Professor Tassel in Brussels, where he substantially advanced Viollet-le-Duc's structural theories (fig. 100). The stair hall is an integrated harmony of linear rhythms, established in the balustrades of ornamental iron, the wall and floor designs, and the spiral twists of the stairsteps themselves. In contrast to Gaudí's work, all the elements are extremely elegant, attenuated, and delicate. Line triumphs completely over any concept of sculptured mass. In Horta's Maison du Peuple, built in 1897–99 for the Belgian Socialist Party and now destroyed, the façade was a curtain wall of glass supported on a minimum of metal structural frames and wrapped around the irregularly curving edge of an open *place*. The auditorium interior became an effective glass enclosure in which the angled, exposed-frame girders formed articulated supports for the double curve of the ceiling (fig. 101). Although it anticipated the glass box of twentieth-century architecture, the interior was given variety and interest by the combination of vertical glass walls, angled metal struts, and open, curving ceiling.

Many of the chief examples of Art Nouveau architecture are to be found in the designs of department stores and similar commercial

102. VICTOR HORTA. A l'Innovation Department Store, Brussels. 1901

105. JOSEF HOFFMANN. Dining Room, Palais Stoclet, Brussels. 1905–11

106. JOSEF HOFFMANN. Palais Stoclet, Brussels. 1905–11

buildings. The large-scale department store was a characteristic development of the later nineteenth century, superseding the older type of small shop and enclosing the still older form of the bazaar. Thus it was a form of building without traditions, and its functions were appropriate to an architecture that emphasized openness and spatial flow as well as ornate decorative backgrounds. Horta's department store in Brussels, À L'Innovation, made of the façade a display piece of glass and curvilinear metal supports (fig. 102). Such department stores, like Sullivan's Carson Pirie Scott store in Chicago (1899–1901, 1903–4), sprang up all over Europe and America at the beginning of the twentieth century. Their utilitarian purpose made them appropriate embodiments of the new discoveries in mass construction: exposed-metal and glass structure, and decorative tracery that could be elaborated and reduced to vulgarization with impunity. In various ways, however, they constituted vital opportunities for architectural experiment.

Many distinguished architects were associated with Art Nouveau in one context or another, but few of their works can be identified with the style to the same degree as Horta's. The stations designed by Hector Guimard (1867–1925) for the Paris Métropolitain (or Métro: subway) can be considered pure Art Nouveau, perhaps because they were less architectural structures than decorative signs or symbols (fig. 103). The same may be said of Otto Wagner's Stadtbahn stations in Vienna or the Atelier Elvira by August Endell (1871–1925) in Munich (fig. 104). However, if one were to remove the elaborate "sea horse" ornament from the façade of the Atelier Elvira, what would remain would be a relatively simple and austere structure. Details of the interior, notably the stair hall, did continue the delicate undulations of Art Nouveau *rocaille*. The Palais Stoclet in Brussels (figs. 105, 106) by the Austrian architect Josef Hoffmann (1870–1955), although the dining-room murals by Klimt (fig. 94), and the interior furnishings and decorations represent a typical Art Nouveau synthesis of decorative accessories, is nevertheless a flat-walled, rectangular structure with analogies to the later International Style and the Bauhaus. The same could be said of Otto Wagner's Postal Savings Bank in Vienna, Mackintosh's School of Art in Glasgow, and the architecture of Peter Behrens and Van de Velde (figs. 301, 303, 304). The fact that these architects were also designers of interiors and creators of decorative objects in the Art Nouveau mode tended to obscure the actual nature of their architecture.

Art Nouveau, although it drew on the expressive genius of such painters as Gauguin and Van Gogh and such architects as Gaudí, Mackintosh, and Van de Velde, remains largely a movement of the decorative arts. Architecturally, its most characteristic features have to do with interior design. Perhaps its greatest contribution lies in the fields of graphic design—posters and book illustration—and the design of lamps, textiles, furniture, ceramics, glass, and wallpaper. Much if not most of what was achieved within this framework has survived only as a curiosity or revival of a fashion. Nevertheless, Art Nouveau—short-lived as a creative period—had importance as a movement simply because it was a widespread popular revolt against the academicism of traditional historical styles. By attacking and even destroying the constant references to the classic periods of Western culture, by attempting to substitute a naturalistic or semiabstract pattern in painting and sculpture and an organic linear or spatial flow in architecture, Art Nouveau prepared the way for many of the experiments of twentieth-century art and architecture, among which Expressionism and fantasy may have been the most important.

Toward Expressionism and Fantasy in Painting

During the last years of the nineteenth century and the first years of the twentieth, France dominated the scene in painting and sculpture to the point that other national styles—German, Italian, English, or American—can be considered little more than provincial offshoots. There were, of course, a few painters and sculptors of genius produced by these and other countries: Van Gogh (Holland), Edvard Munch (Norway), James Ensor (Belgium), Medardo Rosso (Italy). In most cases, however, the emergence of these artists only pointed up the barrenness that surrounded them in their native countries. In any event, many of them, if not most, were formed in the environment of Paris.

German painting during much of the nineteenth century had been enmeshed in a morass of sentimental, naturalistic idealism. In the last years of the century the influence of the French Barbizon School was paramount. In Germany this style was given a Romantic expression that, in some degree, anticipated the first stirrings of twentieth-century German Expressionism. Such lyrical naturalism also absorbed aspects of French Impressionist color without radically changing its own essential nature. Max Liebermann, Lovis Corinth, and Max Slevogt were the prin-

107. EDVARD MUNCH. *The Sick Child*. 1885–86. 47 × 46⅝″. National Gallery, Oslo

works. But the tradition was overwhelmingly academic, rooted in French Romantic Realism of the Barbizon School and in German lyrical naturalism. Impressionism began to penetrate to Norway only in the last decade of the nineteenth century.

In 1885 Munch was first given the chance to travel abroad to Belgium and, for three weeks, to Paris. Although, like any young student, he spent much of his time saturating himself in the Old Masters of the Louvre and visiting the Salon of that year, he discovered the works of Manet and was most impressed by them. Despite academic training, he developed his own approach out of the Impressionist and Symbolist experiments he observed around him. In 1892 his reputation had grown to the point where he was invited to exhibit at the Verein Berliner Künstler (Society of Berlin Artists). His exhibition resulted in such a storm that sympathetic leaders of the liberal wing of the Society, led by Max Liebermann, resigned from the organization and formed the Berlin Secession. This recognition—and controversy—encouraged Munch to settle down in Germany, where he spent most of his time, until 1908. During this period he came to maturity as an artist and began to exercise a crucial influence on German Expressionist art as it developed.

In evaluating Munch's place in European painting it could be argued that he was formed not so much by his Norwegian origins as by his exposure first to Paris during one of the most exciting periods in the history of French painting, and then to Germany at the moment when a new and dynamic art was emerging. The singular personal quality of his paintings and prints, however, is unquestionably a result of an intensely literary and even mystical approach that was peculiarly Scandinavian,

cipal German Impressionists, and of these only Corinth seems to have made a personal statement tying Impressionism to some of the more dynamic forces of Expressionism.

At the turn of the century, German artists were ripe for new influences and movements, and thus were quick to seize on the forms and the program of Art Nouveau, which close cultural contacts with England had brought to their attention. The concept of a new ideal of Arts and Crafts or art and industry seems to have had an immediate appeal to the German temperament, and under the name *Jugendstil* this new style became popular and national (fig. 104). The subsequent development of Jugendstil in Germany toward a modern, rational architecture and a synthesis of fine and applied arts emphasizes the importance of the appearance of Art Nouveau at the moment when there was an obvious vacuum to be filled in German art. In comparison with the architectural and design experiments that grew out of the environment of Jugendstil, there is little to comment on in painting and sculpture. The Austrian Gustav Klimt probably represents the high point of German as well as Austrian Jugendstil in painting and the decorative arts.

In retrospect it is apparent that Jugendstil was important more for the new ideas it evoked than for the immediate impetus given artists of talent and ability. Edvard Munch, in many ways the father of German Expressionism, the Swiss Ferdinand Hodler, James Ensor, one of the fathers of Surrealism and twentieth-century fantasy, and Vasily Kandinsky, one of the fathers of abstraction, all grew up in the environment of Jugendstil or Art Nouveau.

EDVARD MUNCH (1863–1944) Edvard Munch, the greatest of Norwegian painters and an international pioneer of modern Expressionist painting, is that rare phenomenon, an artist of genius emerging from a national environment of no substantial original artistic tradition. Such figures are not easy to find, since experiment in the visual arts rarely seems to thrive unless there is, somewhere, a receptive public. Norway, about 1880, at the time Munch began to study painting seriously, had a number of accomplished painters and a degree of patronage for their

108. EDVARD MUNCH. *The Cry*. 1893. Oil and tempera on board, 35¾ × 29″. National Gallery, Oslo

intensified in his case by his own strange and tortured personality. Norwegian literature rose to a new level at the end of the nineteenth century with the emergence of Henrik Ibsen as a dramatist of world reputation, and many of the best analogies for Munch's paintings are to be found in the plays of Ibsen. The painter moved in literary circles in Norway as well as in Paris and Berlin, was a friend of noted writers, among them August Strindberg and the influential German art historian and critic of modern art, Julius Meier-Graefe. In 1906 Munch made stage designs for Ibsen's plays *Ghosts* and *Hedda Gabler*.

Although he lived to be eighty years old, the specters of sickness and death hovered over Munch through much of his life. His mother and sister died of tuberculosis while he was still young, and he himself suffered from serious illnesses. Sickness and death began to appear early in his painting and recurred continually. Such themes, of course, were common in the art and literature of the period, but for Munch they had a particular pertinence. *The Sick Child* was related to the illness and death of his sister (fig. 107). Other subjects that obsessed him were those of the awakening of sexual desire, and woman contrasted as innocent child and as blood-sucking vampire. Munch was emerging as a painter at the moment when Sigmund Freud was developing the theories of psychoanalysis, and the painter, in his obsessions with sex and death, at times seemed almost a classic example of the problems Freud was exploring. In painting after painting, *The Dance of Life* among them (plate 29), Munch transformed the moon and its long reflection on the water into a phallic symbol.

The anxieties that plagued the artist were frequently given more gen-

110. ERNEST J. BELLOCQ. *Untitled.* 1912. Modern print by Lee Friedlander from an original negative. Printed on paper, 7¾ × 9⅝". Collection, The Museum of Modern Art, New York. Purchase

eral and ambiguous, though no less frightening, expression. In *Evening on Karl Johan Street, Oslo* (c. 1892) the pedestrians in the early winter darkness are transformed into a ghastly concourse of walking dead. *The Cry* is an agonized shriek translated into visible vibrations that spread out like Art Nouveau sound waves (fig. 108).

Munch was enormously prolific, and throughout his life experimented with many different themes, palettes, and styles of drawing. The works of the 1890s and the early 1900s, in which the symbolic content is most explicit, are characterized by the sinuous, constantly moving, curving line of Art Nouveau, combined with color dark in hue but brilliant in intensity. Influences from Gauguin and the Nabis are present in his work of this period. His studies of nudes may represent an actual influence from Bonnard, but in any event, Munch's interpretation is entirely different, more fixated and troubling, closer to the spirit of German Expressionism, as in *Puberty* (fig. 109). This spirit—which Munch himself had helped create—manifests itself in later works, landscapes and scenes of peasants at work (for example, *Galloping Horse*), although, in these brightly painted subjects, there certainly seem to be qualities of health, power, and optimism.

At about the same time that Munch painted *Puberty*, an extraordinary but largely unknown photographer named E. J. Bellocq (1873–1949) began working in far-off New Orleans. There, in the course of photographing the denizens of the city's notorious Storyville district, Bellocq recorded the image of an adolescent prostitute (fig. 110), who, with her hands parted as if to signal the fact of an experience evidently feared by Munch's little European girl, seems no less haunting in her transcendent beauty, innocence, and fragility. With the cracked and deteriorated plate adding to the overall effect, such a picture lends powerful credence to claims that photography, albeit a mechanical process, offers as much potential for aesthetic achievement—a subject or idea made expressive by coherent form—as the other, "higher" pictorial arts. In this instance, the overtones of pedophilia simply expand the *femme fatale* syndrome to unexpected and even more disturbing dimensions. Although Bellocq may never have heard of Pictorialism (see p. 66), his *Girl on the Wicker Chaise Longue* is Pictorial photography at its best.

No simple progression can be noted in the works of Munch. He

109. EDVARD MUNCH. *Puberty.* 1894. 59 × 43¾".
National Gallery, Oslo

111. EDVARD MUNCH. *Vampire*. 1896–1902.
Woodcut. Munch-Museet, Oslo

continually turned back to and reworked earlier subjects. His obsessions with sex, violence, and death continued throughout his life. Meanwhile, Munch was a major graphic artist (fig. 111). He began making etchings and lithographs about 1894, and for a time was principally interested in using the media to restudy subjects he had painted earlier. The prints, however, were never merely reproductions of the paintings. In each case he reworked the theme in terms of the new medium, sometimes doing the same subject in drypoint, woodcut, and lithography, and varying each of these as each was modified from the painting.

FERDINAND HODLER (1853–1918) Another Northern master who anticipated modern Expressionism by making his art an early symptom of the Age of Anxiety was the Swiss Ferdinand Hodler. Hodler too knew the ravages of sickness and death, and, like Van Gogh, he had under-

gone a moral crisis in the wake of deep religious commitment. If "God is dead," as Nietzsche had declared in 1882, then Hodler, along with many other Northern artists of troubled soul and mystical spirit, would attempt to see some controlling force at work within the scheme of nature. And so he avoided the *Sturm und Drang* of earlier Romantic expressions and sought, instead, frozen stillness, spareness, and purity, the better to evoke some sense of the unity within the apparent confusion and complexity of the empirical world. This can be discerned in the famous *Night* (fig. 112), where the surfaces and volumes of nature have been described in near-obsessive detail, only to be controlled by an equally intense concern for abstract pattern, a kind of rigorously balanced, friezelike organization the artist called "parallelism." Like the wiry, sinuous contouring of every form, so at one with Art Nouveau decorativeness and so alien to the Realism it bounds, overt symmetry serves to metamorphose a naturalistically described personification of

112. FERDINAND HODLER. *Night*. 1890. 45¾ × 117¾". Kunstmuseum, Bern

Death's arrival into a timeless icon of transcendental truth. Here, as Robert Rosenblum has pointed out, goal and structure alike are fully comparable to those already seen in Munch's *Dance of Life*, completed in the same year as Hodler's *Night*.

JAMES ENSOR (1860–1949) James Ensor, whose long life almost exactly paralleled that of Munch, differed from the Norwegian in being the inheritor of one of the great traditions in European art—that of Flemish and Dutch painting. The consciousness of this heritage even compelled him to assume from time to time, though half satirically, the appearance of Rubens, and it is difficult to believe that he could have conceived his pictorial fantasies without knowledge of the works of Hieronymus Bosch (despite his denial that he was influenced by Bosch early in his career) and Pieter Brueghel the Elder. The son of an expatriate Englishman, a man of some culture and gentility, the artist was born at Ostend, on the coast of Belgium, where his Flemish mother and her relatives kept a souvenir shop filled with toys, seashells, model ships in bottles, crockery, and, above all, the grotesque masks popular at Flemish carnivals.

After spending the years 1877–80 at the Brussels Academy of Fine Arts, Ensor could produce such accomplished traditional Realist-Romantic paintings that in 1881 he was accepted in the Brussels Salon and by 1882 in the Paris Salon. His approach already was changing, however, through his discovery of French Impressionism (which was still anathema among the Paris academicians and their provincial offshoots). Even more shocking, at the time, than the Impressionist palette was Ensor's introduction of brutal or mocking subject matter, harshly authentic pictures of miserable, drunken tramps and inexplicable meetings of masked figures. It is often difficult, probably even impossible, for translated titles to convey the meanings of Ensor's fantasies. *Scandalized Masks*, for instance, shows simply his familiar setting, the corner of a room, with a masked figure sitting at a table (fig. 113). Another masked figure enters through the open door. Each is frozen at the sight of the other. The masked figures obviously derive from the Flemish carnivals of familiar tradition, but here, isolated in their grim surroundings, reacting in shock at their meeting, they cease to be merely masked mummers. The mask becomes the reality, and we feel involved in some communion of monsters. This troubling and fantastic picture reveals intensification of the artist's inner mood of disturbance. In any event, the new works did not please the judges of the Brussels Salon, and in 1884 all Ensor's entries were rejected.

Even members of the more liberal exhibiting group of Brussels, L'Essor, were somewhat uneasy about Ensor's new paintings. This led to a withdrawal of some members, to form the progressive society, Les XX. For many years the society was to support aspects of the new art in Brussels. Although it exhibited Manet, Seurat, Van Gogh, Gauguin, and Toulouse-Lautrec, and exerted an influence in the spread of Art Nouveau, hostility to Ensor's increasingly fantastic paintings grew even there. His greatest painting, *The Entry of Christ into Brussels in 1889*, was refused admission and was never publicly exhibited before 1929 (plate 30). The artist himself was saved from expulsion from the group only by his own vote.

Ensor's mature paintings still, decades later, have the capacity to shock, and so, as we study the direction of his work during the 1880s, it is not difficult to understand what a recoil it induced in even his liberal colleagues. Ensor was a true eccentric, given to passages of mad humor, but to suggest that all this was the result of severe mental derangement is too easy. He was much affected by nineteenth-century Romanticism and Symbolism, evinced in his passionate devotion to the

tales of Edgar Allan Poe and of the poems of Baudelaire. He searched the tradition of fantastic painting and graphic art for inspiration—from the tormented visions of Matthias Grünewald and Bosch to Goya. Ensor was further affected by Daumier and his social satire, by the Belgian fantasist and satirist Felicien Rops, by Gustave Doré, and by Redon.

Whatever the sources of his macabre experiments, the position Ensor won as a transitional figure in twentieth-century fantastic art is of the first importance, for he created an individual world of bizarre subjects expressed in dissonant color and palpitating line, whose "message" has more to do with our time than with the past.

During the late 1880s Ensor turned to specifically religious subjects, frequently based on the torments of Christ. They are not interpreted in a narrowly religious sense, but are rather a personal revulsion to a world of inhumanity that nauseated him. This feeling, essentially unreligious and misanthropic, was climaxed in the vast *Entry of Christ into Brussels in 1889*, a work of 1888 that depicts the passion of Christ as the center of an enormous Flemish kermess or carnival symptomatic of the indifference, stupidity, and venality of the modern world (plate 30). Here, too, the artist gave early expression to his feeling about a horrible compression of humanity that denies and destroys the space of the picture. It is indicative of Ensor's bitter humor that he dated this obscene carnival—which is also his personal Last Judgment—one year in the future.

The sense of death was strong in Ensor, manifesting itself in innumerable paintings, drawings, and prints perpetuating the walking dead of the Late Middle Ages and the *danse macabre*. Skeletons try to warm their pathetic bones at a stove clearly imprinted "*pas de feu*." Death with his scythe mows down the people of Brussels. The artist in 1888

113. JAMES ENSOR. *Scandalized Masks*. 1883. 53 × 45″. Musées Royaux des Beaux-Arts, Brussels

right: 114. JAMES ENSOR.
*Skeletons Fighting for the Body
of Hanged Man.* 1891.
23 × 29⅛". Musée Royal des
Beaux-Arts, Antwerp

below: 115. JAMES ENSOR.
*Portrait of the Artist
Surrounded by Masks.* 1899.
47 × 31½". Collection Mme. C.
Jussiant, Antwerp

portrays himself in 1960 as a relatively cheerful skeleton on the verge of complete disintegration. In *Skeletons Fighting for the Body of a Hanged Man* (fig. 114), the drama is enacted on a narrow stage reminiscent of Callot and the tradition of the Italian *commedia dell'arte*.

During the 1890s Ensor focused his talents for invective on the antagonists of his paintings, frequently with devastating results. This decade saw some of his most brilliant, morbid, gruesome, and at times obscene drawings and etchings. The masks reappeared at regular intervals, occasionally becoming particularly personal, as in *Portrait of the Artist Surrounded by Masks* (fig. 115), a painting in which he portrayed himself as Rubens—debonair mustache and beard, gay, plumed hat, and piercing glance directed at the spectator. Also, in a curious way, he is reminiscent of the Christ of Hieronymus Bosch, surrounded by his tormentors (Ensor's critics): the personification of Good, isolated by Evil but never overwhelmed.

The ancestors of twentieth-century fantasy can also be found in a trio of artists who emerged in German-speaking Europe during the Symbolist era: Böcklin, Klinger, and Kubin. The eldest of these was Arnold Böcklin (1827–1901), born in Basel, educated in Düsseldorf and Geneva, and then long resident in Italy, actually to the end of his life. Like so many others within contemporary German culture, Böcklin fell prey to the Classical dream, which prompted him to paint, with brutal, almost grotesque academic Realism, such mythical beings as Centaurs and mermaids, writhing in battle or some sexual contest between a hapless, depleted male and an exultant *femme fatale*. One of his most memorable or even haunting images, especially for painters like De Chirico and the Surrealists, came to be known as *The Island of the Dead*, a scene depicting no known reality but universally appealing to the late Romantic or Decadent imagination (fig. 116). With its uncanny stillness, its ghostly white-cowled figure, and its eerie moonlight illuminating rocks and "tombs" against the deep, mysteriously resonant

116. ARNOLD BÖCKLIN. *The Island of the Dead*. 1880. Oil on wood, 2′5″ × 4′. The Metropolitan Museum of Art, New York. Reisinger Fund

117. EUGÈNE ATGET. *St. Cloud*. 1915–19. Gold-toned printing-out paper, 7 × 9⅜″. Collection, The Museum of Modern Art, New York. Abbot-Levy Collection. Partial gift of Shirley C. Burden

118. MAX KLINGER. *The Abduction*, from the portfolio *A Glove*. 1881. Etching printed in black, 4¹¹⁄₁₆ × 10⁹⁄₁₆″. Collection, The Museum of Modern Art, New York. Purchase

blues and greens of sky, water, and tall, melancholy cypresses, the picture provided inspiration not only for subsequent painters but also for numerous poets and composers.

A kindred *fin-de-siècle* spirit—mesmerized nostalgia for a lost and decaying Classical past—inhabits the photographs of Eugène Atget (1857–1927), a self-taught master of the camera who in 1898 began recording the look of old Paris and its historic environs (fig. 117). Although employed by various official agencies to supply visual material to the Musée Carnavalet, Atget proceeded with a single-minded devotion that transformed facts into art, with the result that his unforgettable images go beyond the merely descriptive to evoke a dreamlike world that is also profoundly real. It took the Surrealists in the 1920s, however, to recognize that the special genius of Atget lay as much in fantasy as in documentation.

After studying with Böcklin, Max Klinger (1857–1920) took flight and, along with sculptures and paintings fully as academic as his master's, produced works—especially prints—evincing a sense of fantasy that many a Surrealist might envy. As the etching seen here would suggest (fig. 118), Klinger also found a kindred spirit in the dark, sinister imaginings of Goya. The sheet in question, entitled *The Abduction* and taken from a ten-unit suite known as *A Glove*, represents one more episode in the nightmare of a man fetishistically obsessed with a glove. After the Czech artist Alfred Kubin (1877–1959) saw Klinger's graphics he wrote of the effect they had on him: "I looked and quivered with delight. Here a new art was thrown open to me, which offered free play for the imaginative expression of every conceivable world of feeling. Before putting the engravings away I swore that I would dedicate my life to the creation of similar works." Actually, Kubin proved capable of phantasms well in excess of those found in the art of either Böcklin or Klinger (fig. 119). Indeed, he could be compared with Redon, except for the perversity that seems to place him among those Decadents dangerously, because naïvely, involved with diabolism—as well as far into

the future, in the Freudian world of Surrealism. In 1910 Kubin became a member of Kandinsky's Munich circle, and in 1911 he joined Der Blaue Reiter, showing with them in the Sturm exhibition of 1913. Meanwhile, in 1909, he had published a novel entitled *The Other Side (Die andere Seite)*, often regarded as a key progenitor of the hallucinatory fictions of Franz Kafka.

119. ALFRED KUBIN. *Butcher's Feast*. c. 1900. India ink wash, 9⅛ × 9″. Graphische Sammlung Albertina, Vienna

CHAPTER SIX

The Origins of Modern Sculpture

In the twentieth century, sculpture has emerged as a major art for the first time since the seventeenth. Its development in the last seventy-five years has been even more remarkable than that of painting. The painting revolution was achieved against the background of an unbroken great tradition extending back to the fourteenth century. In the nineteenth century, despite the prevalence of lesser academicians and the substantial role they played, painting was the great visual art, producing during its first seventy-five years such artists as Goya, Blake, David, Ingres, Géricault, Delacroix, Constable, Turner, Corot, Courbet, and Manet. The leading names in sculpture during this same period were Canova, Thorwaldsen, Rude, David d'Angers, Barye, Carpeaux, Dalou, Falguière, and Meunier. Of these, perhaps only Canova and Carpeaux have continuing world reputations. The sculpture of Daumier, now much admired, was a private art, little known or appreciated until its relatively recent "discovery."

The eighteenth century also was an age of painting rather than sculpture. During that century, only the sculptor Jean-Antoine Houdon may be compared with such painters as Watteau, Boucher, Fragonard, Guardi, Tiepolo, or Goya. The seventeenth century was the last great age of sculpture before the twentieth century and then principally in the person of the Baroque sculptor Bernini. In the United States, with the exception of one or two men of originality and competence, such as Augustus St. Gaudens, sculptors were secondary figures from the beginning of its history until well into the twentieth century.

When we consider the dominant place that sculpture has held in the history of art from ancient Egypt until the seventeenth century of our era, this decline appears all the more remarkable. The decline was not for want of patronage. Although the eighteenth century provided fewer large public commissions than the Renaissance or the Baroque, the nineteenth century saw mountains of sculptural monuments crowding the parks and public squares or adorning the architecture of the period. By this time, however, academic Classicism had achieved such a rigid grip on the sculptural tradition that it was literally impossible for a sculptor to gain a commission or even to survive unless he conformed. The experimental painter could usually find a small group of enlightened private patrons, but for the sculptor the very nature of his medium and the tradition of nineteenth-century sculpture as a monumental and public art made this difficult.

AUGUSTE RODIN (1840–1917) This was the situation until the third quarter of the century, when Auguste Rodin emerged on the scene in Paris. It was Rodin's achievement to have recharted the course of sculpture almost single-handedly and to have given the art an impetus that was to lead to a major renaissance. There is no one painter, not even Courbet, Manet, Monet, Cézanne, Van Gogh, or Gauguin, who occupies quite the place in modern painting that Rodin claims in modern sculpture. He began his revolution, as had Courbet in painting, with a reac-

tion against the sentimental idealism of the academicians, using as an avenue the closest return to nature. His *Man with the Broken Nose* (fig. 120) was rejected by the official Salon as being offensively realistic on the one hand and, on the other, as an unfinished fragment, a head with its rear portion broken away. His reexamination of nature was coupled with a reexamination of the art of the Middle Ages and the Renaissance—most specifically, of Donatello and Michelangelo. Although much of academic sculpture paid lip service to the High Renaissance, it was the Renaissance seen through centuries of imitative accretions that largely concealed the original works. Rodin looked at Donatello and Michelangelo as though they were masters of his own time to whom he was apprenticed, and thus he achieved the anomaly of turning their own gods against the academicians.

Rodin's achievement in the liberation of modern sculpture was one

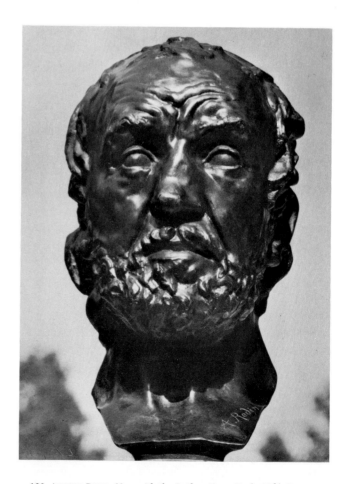

120. AUGUSTE RODIN. *Man with the Broken Nose, Mask.* 1864. Bronze, height 12¼". Hirshhorn Museum and Sculpture Garden, Smithsonian Institution, Washington, D.C.

of degree rather than of kind. It is possible to find prototypes or analogues among his contemporaries for his treatment of subject matter, space, movement, light, and material. In no other sculptor of the nineteenth century, however, are all the elements and problems of sculpture attacked with comparable energy, imagination, and invention. In no other sculptor of his time can be found such brilliant solutions.

The basic subject for sculpture from the beginning of time until the twentieth century had been the human figure. It is in terms of the figure, presented in isolation or in combination, in action or in repose, that sculptors have explored the elements of sculpture—space, mass, volume, line, texture, light, and movement. Among these elements, volume and space and their interaction have traditionally been their primary concern. There may be observed in the development of Classic, medieval, or Renaissance and Baroque sculpture similar progressions from archaic frontality to final solutions in which the figure is stated as a relatively coherent mass revolving in surrounding space, and, to some degree, interpenetrated by it. The greater sense of spatial existence in Hellenistic, Late Gothic, or Baroque sculpture inevitably involved an increase of implied movement, achieved by a twisting pose, extended gesture, or, frequently, by a broken, variegated surface texture whose light and shadow accentuated the feeling of transition or change.

The Baroque feeling for spatial existence and for movement and spontaneity was part of the nineteenth-century sculptural tradition, par-

121. AUGUSTE RODIN. *St. John the Baptist Preaching*. 1878–80. Bronze, height 6'6¾"; base 37 × 22½" (irregular). Collection, The Museum of Modern Art, New York. Mrs. Simon Guggenheim Fund

ticularly in the monumental works of Carpeaux and Dalou, and Rodin was in possession of the full range of historic sculptural forms and techniques by the time he returned from his brief visit to Italy in 1875. The *Man with the Broken Nose* of 1864, in fact, was already a mature and accomplished work suggesting the intensity of the artist's approach to subject as well as his uncanny ability to suggest simultaneously the malleable properties of the original clay and the light-saturated tensile strength of the final bronze material. It also contains the revolutionary insight into one of the most fundamental of all modernist principles, which holds that "completeness" or "finishedness" may represent an act of liberation. This is because it may also serve as a means to make the work reveal the process of its own creation—the way the artist has miraculously caused dead matter to come alive in his hands.

The Age of Bronze, Rodin's first major signed work, was accepted in the Salon of 1877, but its seeming scrupulous realism led to the suspicion that it might have been in part cast from the living model. Although Rodin had unquestionably observed the model closely from all angles and was concerned with capturing and unifying the essential quality of the living form, he was also concerned with the expression of a tragic theme, inspired perhaps by his reaction to the war of 1870, and expressed through the concept of a vanquished hero based firmly on the *Dying Slave* of Michelangelo. The influence of Michelangelo and more specifically of Donatello is evident in many of Rodin's early works. *St. John the Baptist Preaching* (fig. 121) and the related works, *The Walking Man*, clearly derive from late figures of Donatello in their intensity of spirit even more than in their adaptation of specific shapes or gestures. To Rodin, however, they were primarily exercises in movement, figures through whose aggressive, striding pose or tilted torso he studied and expressed incomparably the full and varied muscular implications of the simple act of walking. Whereas the suggestion of action, frequently violent and varied, was an essential part of the repertory of academic sculpture since the Late Renaissance, its expression in nineteenth-century sculpture normally took the form of a sort of tableau of frozen movement, as though the protagonists were performing a scene as "living sculpture." Rodin studied his models in constant motion, in changing positions and attitude, as though he were seeing the act of motion for the first time. Thus every gesture and transitory change of pose became part of his vocabulary. As he passed from this concentrated study of nature to the later Expressionist works, his most melodramatic subjects and most violently distorted poses were given credibility by their secure basis in observed nature.

In 1880 Rodin received a commission for a portal to the proposed Museum of Decorative Arts in Paris. He conceived the idea of a free interpretation of scenes from Dante's *Inferno*. By then the sculptor had already made drawings based on Dante, and liked the idea of developing the theme, partially as a means of composing in masses of small, nude figures, to demonstrate his control of his medium. Out of his ideas emerged *The Gates of Hell* (fig. 122). Although left unfinished when the artist died in 1917, it nonetheless remains one of the masterpieces of nineteenth- and twentieth-century sculpture. The portal was not cast in bronze in its unfinished state until the late 1920s. As they exist today, *The Gates* are an imperfect work of art, not only because not completed, but also, perhaps, because they could never have been completed. Rodin was unable to plan and organize *The Gates* either iconographically or as a total design. Basing his ideas loosely on individual themes from the *Divine Comedy* of Dante but utilizing ideas from the poems of Baudelaire, which he greatly admired, Rodin built, from isolated figures, groups or episodes with which he experimented at random over more than thirty years. *The Gates* suffer from their very fertility of ideas

122. AUGUSTE RODIN. *The Gates of Hell*. 1880–1917. Bronze, 18 × 12′. Rodin Museum, Philadelphia

and from the variety of the forms and scales with which they are crammed, above and across the lintel, throughout the architectural frieze and framework, and, of course, rising and falling restlessly with the plastic turbulence of the main panels. Saturated as they are with literary symbolism to the point where they almost cease to exist as any sort of sculptural totality, they nevertheless contain a vast repertory of forms and images that the sculptor developed in this context and then adapted to other uses, and sometimes vice versa. The turbulence of the subjects involved inspired him to the exploration of Expressionist violence in which the human figure was bent and twisted to the limits of endurance although with remarkably little actual naturalistic distortion. Imprisoned within the drama of their agitated and anguished state, the teeming figures—coupled, clustered, or isolated—seem a vast and melancholy meditation on the tragedy of the human condition, on the plight of souls trapped in eternal longing, and the torment of guilt and frustration.

The violent play on the human instrument seen here was a natural preamble to the Expressionist distortions of the figure developed in the twentieth century. An even more suggestive preamble is to be found in the basic concept of the subject of *The Gates*—the concept of flux or metamorphosis, in which the figures emerge from or sink into the matrix of the bronze itself, are in the process of birth from, or death and decay into, a quagmire that both liberates and threatens to engulf them. Essential to the suggestion of change in *The Gates* and in most of the

mature works of Rodin is the exploitation of light. A play of light and shadow moves over the peaks and crevasses of bronze or marble, becoming analogous to color in its creation of movement, of growth and dissolution, and thus of the essence of life itself.

Although Rodin, in the sculptural tradition that had persisted since the Renaissance, was first of all a modeler, starting with clay and then transforming the clay model into plaster and bronze, many of his most admired works are in marble (fig. 123). These also were normally based on clay and plaster originals, with much of the carving, as was customary, done by assistants. However, there is no question that Rodin himself closely supervised the work and finished the marbles with his own hand. His great feeling for the material is evident in the fact that he treated his marbles, even of the same subjects, in a manner entirely different from that which he used for bronzes. The marbles were handled with none of the expressive roughness of the bronzes (except in deliberately unfinished areas), and without deep undercutting. He paid close attention to the delicate, translucent, sensuous qualities of the marble, which in his later works he increasingly emphasized—inspired by unfinished works of Michelangelo—by contrasting highly polished flesh areas with masses of rough, unfinished stone. In this utilization of the raw material of stone for expressive ends, as in his use of the partial figure, the torso—obviously first suggested by fragments of ancient sculptures—Rodin was initiating the movement away from the human figure as the prime medium of sculptural expression. All his sculptures are rooted in the closest possible observation of the model, but the seeds of its destruction were growing in his very obsession with nature.

Many of the figures formulated for *The Gates of Hell* are at least equally famous as individual sculptures. *The Thinker* (Dante?), and also *Eve* and *The Three Shades* all emerged as separate entities, and all show Rodin most specifically under the influence of Michelangelo. The tragedy and despair of *The Gates* are perhaps best summarized in *The Crouching Woman*, which looks at first glance like an extreme of anatomical distortion (fig. 124). Actually there is little distortion involved, and the pose, which could have been ugly or ludicrous, attained in Rodin's hands a beauty that is rooted in intense suffering. The figure, a compact, twisted mass, is wonderfully realized in surrounding space. The powerful diagonals, the enveloping arms, the broken twist of the head, all serve both an expressive and a formal purpose, emphasizing the agony of the figure and carrying the eye around the mass in a series of integrated views.

In the *Iris* (fig. 125) the artist achieved an even greater violence of pose, bringing the sensuality that characterizes so many of the later figures to the point of brutality. The headless, one-armed torso, by its maimed, scarred, and truncated form, reaches a climax of vitality. This so-called "partial figure" may be no more than a sketch, but it is also a fragment that reaches an expressive completeness to which nothing could be added.

As a somewhat oblique memorial to French losses in the Franco-Prussian War of 1870, the city of Calais began formulating plans in 1884 for a public monument to be raised in memory of Eustache de Saint-Pierre, who in 1347, during the Hundred Years' War, had offered himself, along with five other prominent citizens, as hostage to the English in the hope of raising the long siege of the medieval port city. The

123. AUGUSTE RODIN. *Eve*. After 1900. Marble, 30½ × 9 × 12″.
Mr. and Mrs. James W. Alsdorf Collection, Chicago

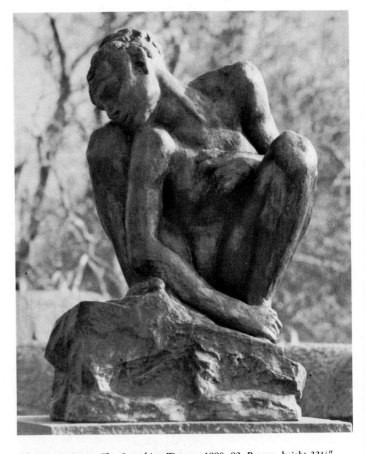

124. AUGUSTE RODIN. *The Crouching Woman*. 1880–82. Bronze, height 33¾″.
Hirshhorn Museum and Sculpture Garden, Smithsonian Institution, Washington, D.C.

commission held particular appeal for Rodin, because the ancient account of the event, in which Froissart describes the hostages as delivered barefoot and clad in sackcloth with ropes around their necks bearing the keys to the city and fortress, permitted the artist to be historically accurate and yet avoid the problem of period costumes without resorting to nudity. After winning the competition with a relatively conventional heroic design set on a tall base, Rodin soon gave way to his instinct for psychological complexity, here made up of individual responses within a group bound together by common sacrifice (fig. 126). And so he studied each figure separately and then assembled them all on a low rectangular platform, a totally nonheroic arrangement that nonetheless allows the viewer to approach the figures virtually on his own level, the better to identify with their all-too-human self-absorption and moral dilemma. It took some doing for Rodin to persuade Calais to accept the work, for rather than an image of a readily recognizable historical event, he presented six particularized variations on the theme of human courage, deeply moving in their emotional range and thus very much a private monument as well as a public one.

The debt of *The Burghers of Calais* to the fourteenth- and fifteenth-century sculptures of Claus Sluter and Claus de Werve is immediately apparent, but this influence has been combined with an assertion of the dignity of the common man analogous to the nineteenth-century sculptures of Constantin Meunier. The rough-hewn faces, powerful bodies, and the enormous hands and feet transform these burghers into laborers and peasants and at the same time enhance their power. Rodin's

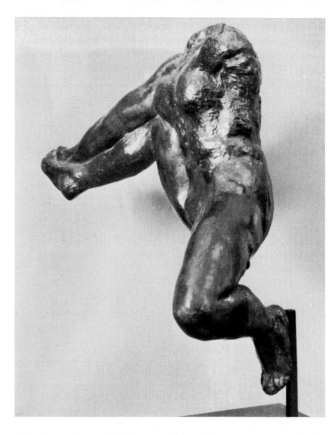

125. AUGUSTE RODIN. *Iris, Messenger of the Gods.* 1890–91. Bronze, height 32″. Hirshhorn Museum and Sculpture Garden, Smithsonian Institution, Washington, D.C.

126. AUGUSTE RODIN. *The Burghers of Calais.* 1886. Bronze, 82½ × 95 × 78″. Hirshhorn Museum and Sculpture Garden, Smithsonian Institution, Washington, D.C.

127. AUGUSTE RODIN. *Monument to Balzac*. 1897–98. Bronze (cast 1954), height 8'10"; base 48¼ × 41". Collection, The Museum of Modern Art, New York. Presented in memory of Curt Valentin by his friends

128. EDWARD STEICHEN. *Balzac (The Open Sky)*. 1909. Postgravure from *Camera Work* (no. 34–35). 1911. Plate 11. 8³⁄₁₆ × 6³⁄₁₆". Collection, The Museum of Modern Art, New York

tendency to dramatic gesture is apparent here, and the theatrical element is emphasized by the unorthodox organization, with the figures scattered about the base like a group of stragglers wandering across a stage. The informal, open arrangement of the figures is one of the most daring and original aspects of the sculpture. It is a direct attack on the Classical tradition of closed, balanced groupings for monumental sculpture. The detached placing of the masses gives the intervening spaces an importance that, for almost the first time in modern sculpture, reverses the traditional roles of solid and void, of mass and space. Space not only surrounds the figures but interpenetrates the group to create a balance anticipating some of the most revolutionary innovations of twentieth-century sculpture.

Rodin's portrait sculptures represent a chapter unto themselves in their search for personality or for symbolic statement. Even in his figure sculpture Rodin felt that what differentiated his works from those of the Greeks was his reach for the inner life of the individual human being rather than simply the logic of the human body. In the *Monument to Balzac* (fig. 127), a work commissioned in 1891 by the Writer's Association at the urging of Émile Zola, Rodin plunged so deeply into the privacy of individual psychology—his own perhaps even more than the subject's—that he failed finally to gain acceptance by the patrons. What these and the public perceived was a tall, shapeless mass crowned by a shaggy head so full of Rodin's "lumps and hollows" that it seemed more a desecrating caricature than a tribute to the great Balzac. Little were they prepared to appreciate what even the artist characterized as a

symbolism of a kind "yet unknown." Like most important works of modern art, *Balzac* grows in meaning the more the process of its invention can be discerned or discovered.

Struggling to realize a portrait that would also be a sculptural equivalent of a famously volcanic creative force, Rodin made many different studies over a period of seven years, some of an almost academic exactness, others more emblematic in nature, such as a tank-bellied, lion-headed figure standing naked with arms akimbo and legs wide apart, an image of universal fecundity that manages to look both pregnant and potent. Rather late in his research, Rodin experienced a telling proto-Freudian insight and gave effect to it in a heavily muscled contrapposto-ed nude, left headless but endowed with a pair of massive hands grasping the figure's tumescent groin, as if to seize on sex and exploit it as the most powerful of all available sources of creative energy. Although too personal a metaphor for public display, the assertion of sex as the true primitive, irrational, nonintellectual drive behind all productive activity remained in the final conception seen here, but only as a covert gesture, cloaked by the voluminous "monk's robe" the great novelist habitually wore during his long, all-night writing sessions. With its draperies gathered about as if to muster and concentrate the whole of some prodigious inspiration, all reflected like a tragic imprint on the deep-set features of the colossal head, the figure leans back dramatically but nonetheless erect, a thrusting phallic shape in which the sexual implication has ceased to be explicit and become absorbed into the whole form, now a near-abstract icon of generative power.

This symbolism of a kind "yet unknown" may have had its greatest impact in the photographs that Rodin commissioned the young Edward Steichen (1879–1973) to make of the original plaster cast of *Balzac* (fig. 128). With a typical sureness of aesthetic instinct, Rodin himself proposed that Steichen try working by moonlight. Not only did this technique avoid the flattening effect that direct sunlight would have had on the white material, but the long, long exposure it required seemed to invest the resulting pictures with a sense of timelessness totally unlike the stop-action instantaneity normally produced by the camera. Rodin detested such imagery as a treacherous distortion of reality. "It is the artist," he insisted, "who is truthful, and it is photography that lies, for in reality time does not stop, and if the artist succeeds in producing the impression of a movement which takes several moments for accomplishment, his work is certainly less conventional than the scientific image, where time is abruptly suspended." Rodin spent most of his creative life studying motion and improvising ways to express its drama and emotive effect in static sculptural form. Often he did this in drawings made from a moving model, as in a famous series based on the dancer Isadora Duncan, but always for the purpose of capturing in line the impression of a flowing, continuous process, not an arrested action (fig. 129). The transcendent sense of something greater than the facts of moment and movement also informed the late Impressionist, and even Symbolist, aesthetic cultivated by such "pictorial photographers" as Stieglitz, seen in figure 68, and now Steichen. These early masters of modernist photography formed a kind of "linked ring" with like-minded experimentalists all over the Western world, especially in London, Paris, Berlin, Vienna, and New York, to react against both the academically pretentious followers of Rejlander and Robinson and those pursuing the literal, scientific realism of a Muybridge (figs. 50, 56). Striving to exhibit their work and expand its acceptance as a genuine artistic statement, they often called themselves "photo-secessionists," thereby deliberately identifying their cause with turn-of-the-century Secession exhibitions staged by rebellious progressives in painting and sculpture.

ARISTIDE MAILLOL (1861–1944) The other French artists who may be classified as pioneers of twentieth-century sculpture—Aristide Mail-

129. AUGUSTE RODIN. *Study for Isadora Duncan.* Pencil and watercolor, 12¼ × 9" (irregular). Collection, The Museum of Modern Art, New York. Tobias Baskin Collection

lol, Antoine Bourdelle, and Charles Despiau—represent opposition to Rodin in their attempts to preserve but at the same time purify the Classical ideal. Maillol concentrated his whole attention on this restatement of Classicism, stripped of all the academic accretions of sentimental or erotic synthetic idealism, and brought down to earth in the homely actuality of his peasant models. Concentrating almost exclusively on the subject of the single female figure, standing, sitting, or reclining, and usually in repose, he stated over and over again the fundamental thesis of sculpture as integrated volume, as mass surrounded by tangible space. At the same time the nudes of Maillol always contain the breath of life, a healthy sensuousness that reflects the living model rather than any abstract Classical ideal.

Maillol began as a painter and tapestry designer, and was almost forty when, alarmed because of a dangerous eye disease, he decided to change to sculpture. Beginning with wood carvings that had a definite relation to his paintings and to the Nabis and Art Nouveau environment in which he had been working at the turn of the century, he soon moved to clay modeling and developed a mature style that changed little throughout his long and productive life. It is summarized to perfection in one of his very first sculptures, *The Mediterranean* (fig. 130), a massive, seated female nude, magnificently integrated as a set of curving

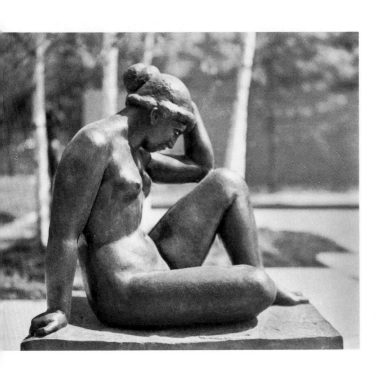

130. ARISTIDE MAILLOL. *The Mediterranean.* 1902–5. Bronze, height 41"; base 45 × 29¾". Collection, The Museum of Modern Art, New York. Gift of Stephen C. Clark

131. ARISTIDE MAILLOL. *The River*. c. 1939–43. Lead, 53¾ × 90″; base 67 × 27¾″.
Collection, The Museum of Modern Art, New York. Mrs. Simon Guggenheim Fund

132. ARISTIDE MAILLOL. *Young Cyclist*. 1907–8.
Bronze, height 38⅝″. Musée Nationale d'Art Moderne, Paris

133. ANTOINE BOURDELLE. *Hercules the Archer*. 1909. Bronze, 14¾
(without bow) × 24″. Art Institute of Chicago. A. A. Munger
Collection

134. CHARLES DESPIAU. *Mlle. Jeanne Kamienska*. 1921. Bronze, height 15″.
Hirshhorn Museum and Sculpture Garden, Smithsonian Institution,
Washington, D.C.

volumes in space and almost a textbook example of the Classical definition of sculpture. At the same time, in its quality of withdrawal, of relaxed and composed reserve, the figure approximates the spirit of Greek sculpture of the fifth century B.C., the Phidian ideal of Classical art, to a degree rarely equaled since that time. Maillol could attain to an art of movement much more particularly dynamic, as in *The River* (fig. 131), a work that may have been affected by the late paintings and the sculptures of Renoir. He could also, being an economical artist, repeat the same subject over and over again, as a complete figure or variously segmented torso with or without drapery, varying the title in accordance with the particular commission. Although he rarely attempted the subject of the male nude, his *Young Cyclist* is a work of great sensitivity and importance, in its lean and youthful realism the ancestor of the Expressionist wing of twentieth-century figurative sculpture (fig. 132).

ANTOINE BOURDELLE (1861–1929) Antoine Bourdelle, a student and assistant of Rodin, sought, like Maillol, to revitalize the Classical tradition. His approach, however, involved an eclectic, somewhat archeological return to the appearance of archaic and early fifth-century Greek sculpture, as well as of Gothic sculpture. A youthful portrait bust called *La Marquise* has a serenity that in feeling is both Classical and reminiscent of eighteenth-century portraits. *Hercules the Archer* (fig. 133) discloses Bourdelle's indebtedness to Rodin, its scarred modeling an echo of Rodin's *Thinker* translated into violent action. However, the organization of Hercules, who is braced against the rocks in a pose of fantastic effort, is essentially a profile, two-dimensional alternation of large areas of solid and void, possibly inspired by the Greco-Roman copy of the *Discobolus* by Myron. The archaistic Greek head of the *Hercules* further suggests a specific origin, although the figure is a curiously eclectic assimilation of an archaic head to a Hellenistic body.

CHARLES DESPIAU (1874–1926) The most immediate inheritor of the Maillol tradition was Charles Despiau, a limited but sensitive artist. His figures have a repose and a withdrawn elegance that transcend those of the older artist, and his portrait heads possess a reticence achieved by the utmost simplification in modeling and the elimination of all extraneous details (fig. 134). In these portraits Despiau seems to have been smoothing away naturalistic particulars beyond the demands of Classic idealism and toward the abstraction of Brancusi. But, his half-measures in reductiveness produced a generation of followers who were content with a sort of pseudo-modernism in which generalized naturalism was equated with the basic transformation that was the essence of Cubism and abstract sculpture.

One of the most conclusive symptoms of the revival of sculpture at the turn of the century was the large number of important painters who practiced sculpture—Gauguin, Degas, Renoir, and Bonnard among them. These were followed a little later by Picasso, Matisse, Modigliani, Braque, Derain, Léger, and others. Maillol and Medardo Rosso were both painters before they became sculptors.

HONORÉ DAUMIER (1810–1879) The pioneer painter-sculptor of the nineteenth century was Honoré Daumier. Most of his wonderful, sculptured caricature heads were created between 1830 and 1832, and anticipate the late Rodin in the directness of their deeply modeled surfaces (fig. 135), as does the later *Ratapoil*, a caustic caricature of Neo-Bonapartism (fig. 136). The arrogance and tawdry elegance of the pose are presented in terms of spatial existence and movement in which the fluttering, light-filled flow of clothing is a counterpoise to the bony armature of the figure itself.

135. HONORÉ DAUMIER. *Comte de Kératry (L'Obséquieux).* c. 1832. Bronze, height 4⅞″. Hirshhorn Museum and Sculpture Garden, Smithsonian Institution, Washington, D.C.

136. HONORÉ DAUMIER. *Ratapoil.* c. 1850. Bronze, height 17⅜″. Hirshhorn Museum and Sculpture Garden, Smithsonian Institution, Washington, D.C.

EDGAR DEGAS Daumier's sculpture was a prototype for the beginnings of modern sculpture but not an influence, since it was little known to the sculptors of the first modern generation. The same is true of the sculpture of Degas, most of which was never publicly exhibited during his lifetime. Unquestionably the greatest of the late nineteenth-century painter-sculptors, he was concerned primarily with the traditional formal problems of sculpture, such as the continual experiments in space and movement represented by his dancers and horses (fig. 137). The posthumous bronze casts retain the feeling of the original wax material, built up, layer by layer, to a surface in which every fragment of wax is articulated.

MEDARDO ROSSO (1858–1928) Medardo Rosso, born in Turin, Italy, in 1858, worked as a painter until 1880. After an unsuccessful term

138. MEDARDO ROSSO. *The Concierge.* 1833. Wax over plaster, height 14½″. Collection, The Museum of Modern Art, New York. Mrs. Wendell T. Bush Fund

137. EDGAR DEGAS. *Statuette: Dressed Ballerina.* c. 1922. Bronze, height 39″. The Metropolitan Museum of Art, New York. The H. O. Havemeyer Collection. Bequest of Mrs. H. O. Havemeyer, 1929

of study at the Accademia di Brera in Milan, from which he was dismissed in 1883, he lived in Paris for two years, worked in Dalou's atelier, and met Rodin. After 1889 Rosso spent most of his active career in Paris, until his death in 1928, and thus was associated more with French sculpture than with Italian. In a sense, he always remained a painter. Rodin, even in his most Impressionist works, never entirely abandoned his sense of sculptural mass and form; thus it is wrong, perhaps, even to refer to him as an Impressionist. Rosso, on the other hand, deliberately dissolved the sculptural forms until only an impression remained (fig. 138). His favorite medium, wax, allowed the most imperceptible transitions, so that it becomes difficult to tell at exactly what point a face or figure emerges from an amorphous shape and light-filled, vari-textured surface. The subjects themselves—detailed genre scenes and conversation pieces reminiscent of paintings by Édouard Vuillard—stretch the limits of traditional sculpture. Still, in his freshness of vision, his ability to catch and record the significant moment, Rosso added a new dimension to sculpture, even with works that are invariably intimist, small scale, and antiheroic, and anticipated the search for immediacy that characterizes so much of the experimental sculpture of our day.

Fauvism

Donatello au milieu des fauves! ("Donatello among the wild beasts!") was the ready quip of Louis Vauxcelles, art critic for *Gil Blas*, when he entered Gallery VII at Paris's 1905 Autumn Salon and found himself surrounded by blazingly colored, vehemently brushed canvases in the midst of which stood a small neo-Renaissance sculpture. With this witticism Vauxcelles gave the first avant-garde style to emerge in the twentieth century its sardonic name, thereby provoking one of modernism's classic "scandals." But if the paintings exhibited in the *cage aux fauves* appeared still more threatening than those of the artists' most daring predecessors, it may well have been for reasons later identified by Henri Matisse, the sober and rather professorial "King of the Wild Beasts." "This is the starting point of Fauvism," he said, "the courage to return to the purity of means." In an age dominated by middle-class nicety, academic subterfuge, and the suggestive but all-concealing graces of Art Nouveau, Matisse, André Derain, Maurice de Vlaminck, Georges Rouault, Raoul Dufy, and still other, lesser painters committed the solecism of allowing their search for immediacy and clarity to show forth with bold, almost unbearable candor. While divesting themselves of Symbolist literary aesthetics, along with *fin-de-siècle* sadness and introspection, the Fauves were content to reclaim Impressionism's direct, joyous embrace of nature and combine it with Post-Impressionism's heightened color contrasts and emotional, expressive depth. If this made their paintings seem as unresolved, as barbaric or untamed as mixed metaphors, they would nonetheless risk it for the sake of discovering a new vitality, a personal and particularly individual stimulus.

Inevitably, artists so intent on achieving personal authenticity would never form a coherent movement or issue joint theoretical manifestoes. But before drifting apart as early as 1907, the Fauves had made certain definite and unique contributions. More than ever before, they liberated color from its age-old descriptive function, even though none of them attempted complete abstraction, as did such immediate followers as Delaunay and Kandinsky. In addition, they mounted a truly youthful quest for the vital sources of creative energy, although none but Vlaminck, Rouault, and Van Dongen ever confounded life and art, as would the German Expressionists. Where their search led was to a new respect for the power of the primitive, even in the art of black Africa, and to a revisualization of Impressionism's "vacation" culture as a pagan ideal of *bonheur de vivre*. Most important of all, the Fauvist painters committed themselves to both individual and pictorial autonomy, which yielded an art delicately poised between expression derived from emotional, subjective experience and expression stimulated by an objective preoccupation with pure optical sensation. Along the way, they also revitalized the French tradition of high decorative art and enriched modern civilization with some of its bona fide and most ravishingly beautiful masterpieces—landscapes and marines, figure pieces, still lifes, and portraits serene in all but the violence of their emancipated color and handling.

HENRI MATISSE (1869–1954) Henri Matisse was born only two years after Bonnard and outlived him by seven years. These men of genius were not only exact contemporaries, but had much in common as artists. They were two of the greatest colorists of the twentieth century, and each learned something from the other. Yet Matisse, one of the pioneers of twentieth-century experiment in painting, seems to belong to a later generation, to a different world. Like Bonnard, he was destined for a career in the law, but by 1892 he had enrolled in the Académie Julian, studying with the academician A. W. Bouguereau (fig. 21). The following year he entered the École des Beaux-Arts and was fortunately able to study in the class of Gustave Moreau. Moreau, though a Symbolist, was a dedicated teacher who encouraged his students to find their own directions through constant study in the museums, as well as through individual experiment. In his class, Matisse met Georges Rouault, Albert Marquet, Henri-Charles Manguin, Charles Camoin, and Charles Guérin, all of whom were later to be associated as the Fauves.

Matisse developed slowly from the dark tonalities and the literal subjects he first explored. By 1896 he was beginning to discover Degas, Toulouse-Lautrec, Impressionism, and Japanese prints, and then Renoir and Cézanne. In 1899, in the atelier of Carrière, who was associated with Symbolism, he met André Derain. In the same year he began to experiment with figures and still lifes painted in direct, nondescriptive color. Shortly thereafter Matisse made his first attempts at sculpture and demonstrated the abilities that were to make him one of the great painter-sculptors of the twentieth century. In 1901, through Derain, he met Maurice de Vlaminck, and thus the Fauve group was almost complete.

Among the paintings that Matisse copied in the Louvre during his student days under Moreau was a still life by the seventeenth-century Dutch painter Jan Davidsz de Heem (fig. 139). Matisse's version (fig. 140) is a free copy, considerably smaller than the original. This work, of which he was to make a Cubist variation about 1916 (fig. 362), might almost be a symbol of the direction his painting was to take throughout much of his career—toward eliminating details and simplifying line and color to their elements. Even when he returned, as he did periodically, to an extreme of colorism and pattern elaboration, the enrichment phase was preliminary to yet another process of stripping off nonessentials.

At the Salon de la Société Nationale des Beaux-Arts (known as the Salon de la Nationale) of 1897, he exhibited *Dinner Table* (fig. 141), a work highly traditional on the face of it, but one of his most complicated and carefully constructed to that date. This painting, although dark in tone, revealed in its red luminosity an interest in the Impressionists, and in the abruptly tilted table that crowds and contracts the space of the picture it anticipated the move the artist would make toward a sort of architectural simplification that was the ancestor of his own version of Cubism. *Male Model* of c. 1900 (fig. 142)—the model is the same as in his sculpture *The Serf* (fig. 177)—carried this process of simplification and contraction several stages further, even to the point of some

139. JAN DAVIDSZ. DE HEEM. *The Dessert*. 1640. 58⅝ × 80″. The Louvre, Paris

140. HENRI MATISSE. Free copy of *The Dessert* by de Heem. 1893–95. 28⅞ × 39½″. Musée Cimiez-Nice, France

distortion of perspective, to achieve a sense of delimited space, in a manner suggesting influences from both Van Gogh and Cézanne. Although it was painted in an almost uniform brown and Symbolist blue tonality, with emphasis on the architectural structure, Matisse was at that time also painting out of doors and exploring the divided-color palette of the Impressionists and the abstract color patterns of the Neo-Impressionists. The *Carmelina* (fig. 143) returned to the corner of the studio in a frontalized arrangement based on Cézanne, with the model projecting sculpturally from the rectangular design of the background. With his own visage reflected in the mirror, Matisse introduced two themes—the studio interior and the artist with his model—to which he would return again and again, as if to restate the modernist's progressive abandonment of direct attachment to the outside world in favor of ever-more concentrated engrossment in the world of art itself.

During the first years of the century Matisse had continued working on his sculpture, particularly of the nude figure (fig. 178). At about the same time he also embarked on his first series of nude studies in paintings and drawings. Between 1902 and 1905 he exhibited at the gallery of Berthe Weill, then at that of Ambroise Vollard, who was rapidly becoming the principal dealer for the avant-garde artists of Paris. When the more liberal Salon d'Automne was established in 1903, Matisse showed there, along with Bonnard and Marquet. In the Salon d'Automne of 1905, a room of paintings by Matisse, Vlaminck, Derain, and Rouault, among others, is supposed to have occasioned the remark that gave the group its permanent name. According to the anecdote, the critic Louis Vauxcelles, observing a Donatellesque sculpture in the midst of the wildly coloristic paintings, exclaimed, *"Donatello au milieu des fauves!"* ("Donatello among the wild beasts!")

The word *fauves* had particular reference to the brilliant, arbitrary color, more intense than the scientific color of the Neo-Impressionists and the nondescriptive color of Gauguin and Van Gogh, and to the direct, violent brushwork with which Matisse and his friends had been experimenting for the previous year at Collioure and Saint-Tropez in the south of France. The Fauves accomplished that final liberation of color toward which, in their different ways, Cézanne, Gauguin, Van Gogh, Seurat, the Nabis, and the Neo-Impressionists had been experimenting. Using similar means, the Fauves were still intent on different ends. They wished to use violent color squeezed directly from the tube, not to describe objects in nature, not simply to set up retinal vibrations, not to

accentuate a romantic or mystical subject, but to build new pictorial values apart from all these. Thus, in a sense, they were using the color of Gauguin and Seurat, freely combined with their own linear rhythms, to reach effects similar to those which Cézanne constantly sought. It is no accident that of the artists of the previous generation, it was Cézanne whom Matisse revered the most.

Matisse had already exhibited in the Indépendants of 1905 his large Neo-Impressionist composition, *Luxe, calme et volupté* (fig. 144), a title taken from a couplet in Baudelaire's *L'Invitation au voyage*:

Là, tout n'est qu'ordre et beauté,
Luxe, calme et volupté.

In this work, which went far along the path to abstraction, he combined the mosaic landscape manner of Signac (who bought the painting) with figure organization based on versions of the *Bathers* by Cézanne (plate

141. HENRI MATISSE. *Dinner Table (La Desserte)*. 1897. 39¼ × 51½″. Collection Stavros Niarchos, Paris

142. HENRI MATISSE. *Male Model*. c. 1900. 39¾ × 28¾". Private collection

143. HENRI MATISSE. *Carmelina*. 1903. 31½ × 25¼". Museum of Fine Arts, Boston

19) and on his studies of sculpture. The painting was the first major example of a type of figure-landscape composition that was to produce several of the most important works of the next few years.

At the Salon d'Automne of 1905, Matisse also exhibited *Open Window, Collioure* and a portrait of Madame Matisse called *Woman with the Hat* (plates 31, 32). The *Open Window* is perhaps the first fully developed example of a theme that was to be favored by Matisse throughout the rest of his life. It is simply a small fragment of the wall of a room, taken up principally with a large window whose casements are thrown wide to the outside world—a balcony with flowerpots and vines, then sea, sky, and boats. Here the inside wall and the casements are composed of broad, vertical stripes of vivid greens, blues, purples, and orange, while the outside world is a gay pattern of brilliant small brushstrokes, ranging from stippled dots of green to broader strokes of pink, white, and blue in sea and sky. In this painting he has already moved far beyond Bonnard or any of the Neo-Impressionists toward a suggestion of coloristic abstraction.

In Neo-Impressionism, as in Impressionism itself, the generalized, all-over distribution of color patches and texture had produced a sense of atmospheric depth inviting optical entrance, at the same time that it also asserted the physical presence and impenetrability of the painting surface. Matisse, however, structured his architectural framework of facets and planes even broader and flatter than those of Cézanne, thereby suppressing all sense of atmosphere or internal illumination and replacing it with a taut, resistant skin of pigment that reflects light instead of generating it internally. Rather than penetration, this tough, vibrant membrane of color and pattern solicits exploration, a journey over and across but never beyond the picture plane. And even in the

"Impressionist" view through the window, the handling is so vigorously self-assertive that the scene appears to advance more than recede, as if to turn inside out the Renaissance conception of the painting as a simulacrum of a window open into the infinite depth of the real world. As

144. HENRI MATISSE. *Luxe, calme et volupté*. 1904–5. 37 × 46". Private collection, Paris

presented by Matisse, the window and its sparkling view of a holiday marina become a picture within a picture, a theme the artist would often pursue, transforming it into a metaphor of the modernist persuasion that painting must not duplicate the perceptual world but rather transcend and re-create it conceptually. Meanwhile, the stylistic discrepancy between planar and painterly facture within the same picture was typical of Fauvism in its earlier, mixed-style phase.

Matisse's *Woman with the Hat* caused even more of a furor than the *Open Window*, because of the seemingly wild abandon with which the artist had indiscriminately smeared paint over the surface, not only the background and hat but also in the face of the lady, whose features are outlined in bold strokes of green and vermilion. Paradoxically, much of the shock value sprang from the actual verisimilitude of the painted image, its closeness to a recognizable subject an obvious measure of the degree of distortion imposed upon reality by the painter. At a more developed or thoroughly abstract state, modernist art would become so independent of its sources in the phenomenal world as to seem less an attack on the precious familiar than an autonomous and thus relatively unthreatening, purely aesthetic object. In 1905, and long thereafter for lesser figures, Matisse could liberate his means mainly by choosing motifs that inspired such freedom—the luminous, relaxed, holiday world of the French Riviera, a flag-decked street, or one of the period's fantastic hats.

Something of the same aesthetic dependence upon reality governed the first photographers to take up a color process, after one was finally made commercially feasible in 1907 by Auguste and Louis Lumière (1862–1954; 1864–1948) of Lyons, France (plate 33). By coating one side of a glass plate with a mix of tiny, transparent starch particles, each dyed red, green, or blue, and the other side with a thin panchromatic emulsion, the Lumières created a light-sensitive plate that, once exposed, developed, and projected on a white ground, would reproduce a full-color image of the subject photographed. Because the process relied upon each minute deposit of starch acting as a filter for that portion of the electromagnetic spectrum transmitted by the transparent starch's own color, the Autochromes—as the Lumières called the slides made by their patented process—rendered images with the look of a fine-grained texture, an effect that simply heightened the inherent charm of the bright subject matter. This was especially true for a Fauve generation still entranced with Neo-Impressionist pointillism.

Shortly after exhibiting *Woman with the Hat*, Matisse painted another portrait of Madame Matisse that in a sense was even more audacious, precisely because more tightly drawn and structured. This is the work entitled *Green Stripe*, with a face dominated by a brilliant pea green band dividing it from hairline to chin (plate 34). At this point Matisse and his Fauve colleagues were building on the thesis put forward by Gauguin, the Symbolists, and the Nabis: that the artist is free to use his color independently of natural appearance, building a structure of abstract color shapes and lines foreign to the woman, tree, or still life that remains the basis of the structure. Perhaps Matisse's version was more immediately shocking because his subject was so simple and familiar, unlike the exotic scenes of Gauguin or the mystical fantasies of Redon, in which such arbitrary colorism seemed more acceptable.

The artist continued to experiment with arcadian figure compositions, as Cézanne and Gauguin had done, and Poussin and the Venetians before them. In the *Pastorale* of 1905, he returned to an Impressionist pattern of broken color, and then in the great *Joy of Life* he combined his various experiments in one of his finest figure-landscape paintings (fig. 145). The *Joy of Life* is filled with reminiscences, from Giovanni Bellini's *Feast of the Gods* to Persian painting, but in it the artist has

145. HENRI MATISSE. *Joy of Life (Bonheur de vivre; Joie de vivre)*. 1905–6. 68½ × 93¾". ©The Barnes Foundation, Merion, Pennsylvania

blended all these influences into a masterful arrangement of sinuous, undulating lines of figures and trees which, despite deliberate perspective diminutions, live as a pattern on the picture plane. For some sense of the sheer radiance of this all-important, truly breakthrough picture, it is better here to consider one of the sketches for it (plate 35), since the final painting is unavailable for reproduction in color. *Joy of Life* is a true pastoral, filled with a mood of sensual languor and the spirit of arcadian delights. Like Picasso's *Les Demoiselles d'Avignon* (plate 63), produced the following year, it was an ancestor of abstraction in modern painting. Its influence may even have transcended that of Picasso's great work, since the latter was not exhibited publicly until 1937, whereas the *Joy of Life* was bought immediately by Gertrude and Leo Stein, and for many years was well known in their collection. Certainly Picasso saw it either at the Indépendants, where it was exhibited in 1906, or at the Steins' apartment.

The curvilinear rhythms of the *Joy of Life* relate it to the tradition of Art Nouveau, although it transcends in quality any other painting of this tradition. Related to it also are many studies of the nude, some of which he later developed into other paintings and sculptures. In fact, Matisse's delight in drawing and painting the nude seems to have gained its first great impetus in the *Joy of Life* studies. Henceforth, however, he would treat the motif with mounting boldness. This was because Matisse had in the meantime, during the mid-part of 1906, become the first European artist to "discover" the sculpture of black Africa.

Of all the exotic and archaic influences to which European modernists subjected themselves, always in the hope of throwing off the shackles of a desiccating academic tradition and regaining a kind of primal truth and energy lost through the alienating effects of rationalist civilization, none would prove so radical or far-reaching as the art of Sub-Sahara Africa. And none would require so much effort, pain, and concentration, or so many false starts and failures, for unlike the other resources appropriated from outside contemporary European culture—Oriental, Persian, Oceanic, Egyptian, prehistoric, medieval, early or "primitive" Renaissance, folk, and children's art—tribal works were not only sculptural, as opposed to the predominantly pictorial art of Europe, but they also embodied values and conventions completely at odds with Western tradition and experience. Whereas even the most

idealized European painting remained ultimately bound up with the perceptual realities of form, space, time (narrative, movement, or the ongoing history of the art itself), and gravity, or monumentality, African figures observed no naturalistic canon of proportions, made no reference to surrounding space, contained no history (at least for Europeans), told no stories, and were both small and portable. With their relatively large, fright-mask heads, distended torsos, prominent sexual features, and squat or abbreviated limbs, what they offered were the powerful plasticity of their relationships, mostly unbound to anatomical facts, iconic rather than articulated or dynamic poses, the weightlessness of a private fetish, in contrast to the generally "public" spirit of Western high art, and, most of all, their fiercely "barbaric" look. When finally examined by such alert and independent artists as Matisse and Picasso, the figures seemed redolent of magic and mystery, the very qualities that European progressives, from Gauguin on, had been struggling to recover for new art. Here was conceptualism with a vengeance, and so expressive for that very reason that the word "hideous," when applied to tribal masks and figurines, became synonymous with "beautiful" in the vocabularies of not only Matisse and Picasso but also Derain, Vlaminck, Kirchner, Klee, Brancusi, and many others.

Thanks to his studiousness and freedom, his extraordinary balance of tradition and innovation, Matisse succeeded, earlier than anyone else, in making a successful assimilation of African influence into his art, and this occurred most remarkably in *The Blue Nude* (plate 36), which, as the subtitle would imply, came forth as a souvenir of the artist's recent visit to Biskra, a lush oasis in the North African desert. The subject of the painting—a female nude reclining in the classic Venus or "Sleeping Ariadne" pose, with one arm bent over the head and the legs flexed forward—was one that Matisse had made central to *Joy of Life*, and such was the interest it held for him that he restudied it in a clay sculpture (fig. 178), this time, however, working from the painting rather than, as was his wont, from the live model. Matisse had long made it a practice to consider the problems of plasticity by direct modeling in clay, partly as a sensuous release from painting's cerebral demands for flatness and partly as a technique for better understanding how to evoke plastic mass in the two-dimensional world of painting. Now, evidently encouraged by the example of African sculpture, he abstracted his image further, working from memory and his own sculpture, which itself was already twice removed from the original. This accounts not only for the bulbous exaggeration of breasts and buttocks, but also for the extreme contrapposto that makes torso and hips seem viewed from different angles or assembled from different bodies. The sum effect of such distortions is, as it would be in Cubism, to neutralize the sense of volume generated by the forms and thus align them within the shallow or flat depth allowed by the tilted space. Then, too, there is the scarified modeling or contouring in a brilliant, synthetic blue (perhaps a tribute to North Africa's so-called "blue people"), as well as the unmistakable masklike character of the face. But however much this may evince the impact of tribal art, it has been translated from the plastic, freestanding, iconic sculpture of Africa into a genuinely pictorial expression by means of the Cézannism that Matisse had been cultivating all along. This can be seen in the dynamic character of the whole, wherein rhyming curves and countercurves, images and after-images, and interchanges of color and texture make figure and ground merge into one another, even as the same elements serve to set them apart. Thus, as Jack Flam has pointed out, Matisse remembered the freshly watered, green, sparkling world of the Biskra oasis not in a landscape but in the symbolic, African manner of a figure abstracted to a degree never seen before in modern Western art, yet integrated with the pictorial traditions of that art in a way that could have been achieved only by one of the most independent and progressive artists of his time and place.

Responding to the charges of "ugliness" made against *The Blue Nude*, Matisse said: "If I met such a woman in the street, I should run away in terror. Above all, I do not create a woman, I make a picture." Inspired by the example of what he called the "invented planes and proportions" of African sculpture, Matisse restructured the human face and figure so imaginatively that he took painting a giant step toward liberating Western art from its age-old, abject dependence on subject matter. As always, however, he did it not in an overt manner as would Picasso, but rather in his own subtle, reflective fashion, assimilating and synthesizing his sources until they are scarcely discernible as anything other than an expression of the artist's own unique sensibility and genius.

ANDRÉ DERAIN (1880–1954) André Derain met the older Matisse at Carrière's atelier in 1899, as already noted, and was encouraged by him to proceed with his career as a painter. He already knew Maurice de Vlaminck, whom Derain in turn had led from his various careers as violinist, novelist, and bicycle racer into the field of painting. Unlike Vlaminck, who combined the physical energy of an athlete with the naïve enthusiasm of a child, Derain was a serious student of the art of the museums, a man who, despite his initial enthusiasm for the explosive color of Fauvism, was constantly haunted by a concept of painting more ordered and Classical in a traditional sense.

Although Derain's Fauve paintings embodied every kind of variation, from large-scale Pointillism to free brushwork, most characteristic, perhaps, are works like *London Bridge*, in which he took a high vantage point and laid out the large, main color areas of green, blue, red, and yellow (plate 37). The perspective is tilted; the background sky is rose-red. The buildings against the sky are silhouettes in green and blue. The meticulous reiteration of large color areas, foreground and background, and the abruptly foreshortened space, serve the purpose of delimiting the depth, almost in a textbook manner. The brilliantly synthetic color is an accomplished arrangement of harmonies and dissonances, excellently coordinated by the architecture of bridge and buildings.

Derain's Fauve paintings are among his best, but nevertheless reveal the "flaw" that was to become continually more apparent in his later works. He was essentially an academic painter who happened to become involved in a revolutionary movement, participated in it effectively, but was never completely happy in the context. In 1906 he became a friend of Picasso and was drawn into the vortex of proto-Cubism. He was one of the first to discover African art and to develop an interest in primitivism in a broader sense. His *Bathers* of 1908 is a combination of Cézanne, Picasso's proto-Cubism, and various researches into primitivism. But during the next few years, when Picasso and Braque were developing the concepts of Analytic Cubism, Derain was moving back consistently to Cézanne and to Cézanne's sources in Poussin and Chardin. His direction was always away from the experiments of the twentieth century, back through the classic innovators of the late nineteenth century, to the Renaissance.

MAURICE DE VLAMINCK (1876–1958) The career of Maurice de Vlaminck presents many parallels with Derain's, even though the artists were so different in personality and in their approach to the art of painting. Vlaminck was born in Paris in 1876 of Flemish stock, something which was of considerable importance to him personally and

146. MAURICE DE VLAMINCK. *Picnic in the Country*. 1905. 35 × 45⅝".
Private collection, Paris

147. MAURICE DE VLAMINCK. *Hamlet in the Snow*. 1943. 5⅛ × 6¼".
Whereabouts unknown

which may have contributed to the nature of his painting. From the time he met Derain and turned to painting, as previously noted, he was enraptured with color. Thus the Van Gogh exhibition at the Bernheim-Jeune Gallery in 1901 was a revelation to him. At the Salon des Indépendants in the same year, Derain introduced him to Matisse who, despite his wisdom and his qualities of leadership, was less successful in directing the exuberant Vlaminck than he was with any of the other younger Fauves. Van Gogh remained Vlaminck's great love, and in his Fauve paintings Vlaminck characteristically used the short, choppy brushstrokes of the Dutchman to attain a comparable kind of coloristic dynamism. However, as is evident in *Picnic in the Country*, he could never manage Van Gogh's complete integration of all elements (fig. 146). The two figures, modeled freely but rather literally, are isolated within the coil of swirling color patches; they are foreigners from the world of nature, picnicking in a forest of paint.

By 1908 Vlaminck too was beginning to be affected by the new view of Cézanne that resulted from the exhibitions after Cézanne's death in 1906. And although for a time he was in touch with the new explorations of Picasso and Braque leading toward Analytic Cubism and even used various forms of simplification based on their ideas, in actuality he, like Derain, was gradually retreating into the world of representation by way of Cézanne.

The effort finally became too much, and, by 1915, Vlaminck had moved toward a kind of expressive Realism that he continued to pursue for the rest of his life (fig. 147). His first great love had been Van Gogh, and to Van Gogh he finally returned. Throughout his career he remained closer to the northern or Germanic Expressionist tradition than any French painter with the possible exception of Georges Rouault. His characteristic later landscapes take us back to the world of Ruisdael, Hobbema, and seventeenth-century Dutch landscape, interpreted in heavily textured brush painting. His color becomes generally tonal; the effect is of threatening skies over a road winding through a desolate countryside. The formula ultimately arrived at by Vlaminck proved highly effective, skillfully presented, and charged with emotion. He was content simply to play variations on it throughout most of his life. Yet, with it he was able to maintain and even to increase his reputation until his death in 1958.

RAOUL DUFY (1877–1953) Raoul Dufy was shocked out of his reverence for the Impressionists and Van Gogh by his discovery of Matisse's 1905 painting *Luxe, calme et volupté*. In a sense, he remained faithful to this vision and to Fauve color throughout his life. In his *Street Decked with Flags, Le Havre*, the flags help to evoke a gay scene, but the close-up view creates a strong feeling of abstract geometric pattern (plate 38). The theme of the street with flags has been almost a symbol of the search for free, abstract color from Manet to the present, especially among the secondary artists who clung to subject matter and could be free in form only when the motif allowed. Artistic giants like Matisse, Picasso, and Braque eventually gained the strength and independence to transcend their external references and transform them into paintings that came forth as largely autonomous constructions of color and design.

Influenced by Georges Braque, his fellow painter from Le Havre,

148. J. H. LARTIGUE. *Beach at Villerville*. 1908. Photograph. Courtesy
Rapho-Guillimette, Paris

Dufy after 1908 experimented with a modified form of Cubism, but he was never really happy in this vein. Gradually he returned to his former loves—decorative color and elegant draftsmanship—and formulated a personal style based on his earlier Fauvism. This rainbow, calligraphic style he maintained with variations until the end of his life.

Dufy's privileged, Belle Époque world of regattas and racecourses was also celebrated by the French contemporary photographer Henri Lartigue (b. 1894), once the fast-action handheld camera had been introduced in 1888 and then progressively improved, enabling this affluent artist to capture not only his family and friends at their pleasures (fig. 148), but also the gradual advent of such twentieth-century phenomena as aviation. Owing to his view of photography as a pursuit carried on for private satisfaction and delight, Lartigue did not become generally known until 1963, when his work took an immediate place in the history of art as a direct ancestor of the "straight" but unmistakably distinctive vision of such photographers as Brassaï and Henri Cartier-Bresson.

GEORGES ROUAULT (1871–1958) The one Fauve who was almost exclusively concerned with a deliberately Expressionist subject matter is perhaps not to be considered a Fauve at all. This is Georges Rouault, who exhibited three works in the 1905 Salon d'Automne and thus is associated with the revolt of the Wild Beasts, although his paintings were not actually shown in the room of the Fauves. Throughout his long and productive career, Rouault remained something of a primitive, a

150. GEORGES ROUAULT. *Head of a Tragic Clown*. 1904. Watercolor and pastel, 14½ × 10½". Private collection, Switzerland

simple and naïve man who was deeply religious, deeply emotional, and profoundly moralistic. He came from a family of craftsmen, and he himself was first apprenticed to a stained-glass artisan. In the studio of Gustave Moreau he met Matisse and other future Fauves, and soon became Moreau's favorite pupil. Although Moreau had a great capacity for encouraging the varied experiments of his students, he could not help feeling a particular affection for the one who followed most closely his own style and concepts. This, of course, was Rouault.

By 1903 Rouault's art, like that of Matisse and others in the group of young rebels surrounding him, was suffering profound changes, reflecting a radical shift in his emotional and moral outlook. Under the influence of the Catholic writer and propagandist Léon Bloy, Rouault sought subjects appropriate to his sense of indignation and disgust over the evils of bourgeois complacency that, as it seemed to him, permeated society. The prostitute became his symbol of this rotting society (fig. 149). He depicted her with a fierce loathing for the corruption she represents, rather than objectively, with a touch of cynical sympathy, as in the work of Toulouse-Lautrec. In many of these studies, done in watercolor, the woman is set within a narrow space, highly atmospheric, and painted in predominantly blue hues, more murky than those used by Picasso slightly earlier. The yellow-white bodies of the prostitutes, touched with light blue shadows, are modeled sculpturally with heavy outlines. The faces are repulsive masks, and the figures exude an aura of decay and death. Rarely in the history of art has the nude been painted with such revulsion.

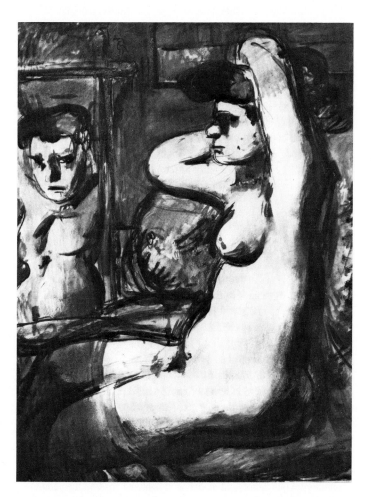

149. GEORGES ROUAULT. *Before a Mirror*. 1906. Watercolor on cardboard, 27⅝ × 20⅞". Musée Nationale d'Art Moderne, Paris

Rouault's moral indignation further manifested itself, like Daumier's, in vicious caricatures of judges and politicians, whom the artist saw as representatives of the evils inherent in the legal and political machinery. As a counterpoint to the prostitute as a symbol of corrupt society he used the figure of the circus clown, sometimes the gay nomad beating his drum, wandering free of care from city to city, but more often a tragic, lacerated victim, as in *Head of a Tragic Clown* (fig. 150). For a period, during his early career, specifically religious subjects were subordinated to the prostitutes, corrupt judges, and clowns, which Rouault infused with such powerful religious and moral overtones that they remained secular only in their identities. When the figure of Christ does appear it is as a tragic mask of the Man of Sorrows deriving directly from a crucified Christ by Grünewald or a tormented Christ by Bosch. In these subject paintings, as in landscapes up to about 1917, color was subordinated to rich but somber hues, and much of the dynamism was achieved by the fierce, uncouth power of his drawing.

Then another change becomes evident. Subjects taken directly from the Gospels became the artist's predominant interest—the Crucifixion, Christ and His Disciples, and other scenes from the life of Christ, as well as the lives of the saints, particularly his beloved Joan of Arc. Pierrots and clowns of all descriptions recurred, and so, increasingly, did landscapes with figures—usually religious in significance—and heavily painted still lifes.

The characteristics of the developed style are seen in *The Old King* (plate 39). The design has become geometrically abstract in feeling. Colors are intensified to achieve the glow of stained glass. A heavy black

151. GEORGES ROUAULT. *It is hard to live* ... Plate 12 from *Miserere.* 1922. Etching, aquatint, drypoint, and roulette over heliogravure. Plate: 18⅞ × 14³⁄₁₆″. Collection, The Museum of Modern Art, New York. Gift of the Artist

outline is used to define forms and control structure. Paint is usually applied heavily with the underpainting glowing through, in the manner of Rembrandt. Even more significant than changes in style and technique is the change in mood. Tragedy and sorrow persist in many works, particularly those dealing with the suffering of Christ. But optimism is frequent, and in all works there is a note of calm, as though in his deeply felt Christianity the artist saw hope for suffering mankind in the face of the evils still surrounding him. Although Rouault never entirely gave up the spirit of moral indignation expressed in the virulent satire that marked his early works, the sense of calm and the hope of salvation in the later paintings mark him as one of the few authentic religious painters of the modern world.

By 1917 Ambroise Vollard had become his sole dealer, and under Vollard's patronage and inspiration Rouault, for ten years, devoted himself almost exclusively to the production of graphic works, notably the series published in 1948 under the title *Miserere.* These etchings and aquatints are filled with the artist's suffering from the horrors of World War I, yet with his hope and faith in man's ultimate salvation as well. Technically, the prints are masterpieces of graphic compression. The blacks, worked over and over again with an infinite patience that, in the artist's eyes, would never stop short of perfection, have the depth and richness of his most vivid oil colors, as in *It is hard to live* ... (fig. 151).

A phenomenon of Fauvism is that a number of otherwise undistinguished painters produced the best works of their lives while directly associated with the movement. For Matisse, of course, Fauvism was only a beginning from which he went on to greater achievements. Derain and Vlaminck, however, did nothing subsequently that had the vitality of their Fauve works. It is interesting to speculate on why these young men should briefly have outdone themselves, but the single overriding explanation is probably the presence of Henri Matisse—older than the others, wiser, more mature and developed as an artist, the natural leader and teacher of the group and, simply, a genius destined to become one of the greatest masters of modern painting. But in addition to Matisse and Rouault, there was also Georges Braque who, after discovering his first brief and relatively late inspiration in Fauvism, would go on to greatness. Along the way, Braque too would restudy Cézanne, but with consequences for twentieth-century art so momentous that they must await a subsequent chapter, on Cubism.

Matisse's Later Fauvist Art

Only during 1905 and 1906, with such works as *Open Window, Collioure* (plate 31) does Matisse really seem to have pushed his riotous colors and brush textures to their limits. Even within the same period, his analytical mind and broad perception were devoted to other problems. The *Luxe, calme et volupté* of 1904–5 (fig. 144) was an exercise in Neo-Impressionism; while in the *Joy of Life* (fig. 145) the artist was already beginning to control the brush gesture and to order his color in large areas defined by sinuous curves of figures and trees. The reinterpretation of plastic form in terms of the "invented planes and proportions" of African sculpture became his preoccupation in *The Blue Nude* (plate 36). Now, in *Le Luxe II*, a work of 1907–8 (fig. 152), Matisse would bring to something of a climax his interest in restructuring pictorial space as an organization of contrasting, juxtaposed color areas. Despite the artist's abandonment of perspective, except for the arbitrary diminution of one figure, and modeling in light and shadow, the painting is not merely surface decoration. The figures, modeled only by the contour lines, have substance; they exist and move in space, with the

152. Henri Matisse. *Le Luxe II*. 1907–8. Casein on canvas, 82⅛ × 54¾".
Statens Museum for Kunst, Copenhagen. Rump Collection

illusion of depth, light, and air created solely by flat color shapes that also confirm the integrity of the picture plane. Thus at the moment when Picasso and Braque were making their first experiments in a form of proto-Cubism, or even before, Matisse had already created a new kind of pictorial space. The first version, *Le Luxe I*, was painted early in 1907.

His exploration of this space was carried still further in *Harmony in Red* (plate 40). This astonishing work was begun early in 1908 as *Harmony in Blue* and then repainted in the spring of 1909. Here Matisse returned to the formula of the *Dinner Table*, which he had painted early in 1897 (fig. 141). A comparison of the two canvases reveals dramatically the revolution that had occurred in this artist's works—and in fact in modern painting—during a ten-year period. Admittedly, the first *Dinner Table* was still an apprentice piece, a relatively conventional exploration of Impressionist light and color and contracted space, actually more traditional than paintings executed by the Impressionists twenty years earlier. Nevertheless, when submitted to the Salon de la Nationale it was severely criticized by the conservatives as being tainted with Impressionism. In *Harmony in Red* we have moved into a new world, more strange and esoteric than anything ever envisioned by the Impressionists or even by Gauguin. The space of the room interior is defined by a single unmodulated area of red, whose adherence to the picture plane is reinforced by arabesques of plant forms flowing impartially across walls and table surface. The out-of-doors is defined by

abstract tree and plant forms silhouetted against the green ground and blue sky. The red building in the extreme upper distance, which reiterates the color of the room, in some manner establishes the illusion of depth in the landscape. Although abandoning formal perspective, the artist has used a few minor perspective touches such as the frame of the window, the chair in the left foreground, the placing of the objects on the table, and the way in which arabesques on the table curve around its edges. In essence, however, he has again—and in an even greater degree than in *Le Luxe II*—created a new, tangible world of pictorial space through color and line.

The exploration of line-color-space continued in a group of figure paintings in which the figures, boldly outlined, were isolated against grounds of intense color. From the time he had discovered Cézanne, a version of whose *Bathers* he had purchased in 1899 when he could ill afford it, Matisse had been intrigued by the arcadian theme of nudes in a landscape, as noted earlier. The *Luxe, calme et volupté* and *Joy of Life* constituted early experiments carried much further in *Le Luxe II*. In two huge paintings of the first importance, *Dance* of 1909–10 (plate 41) and *Music* of 1910, both commissioned by the Russian Sergei Shchukin, Matisse reached the climax of his early explorations of form as well as of relations of form and content. The origins of *Dance* have been variously traced to Greek vase painting or peasant dances. Specifically, the motif was first used by Matisse in the background group of *Joy of Life*, although there the figures revolve in a more literally illusionistic depth. In *Dance*, the colors have been limited to an intense green for the ground, an equally intense blue for the sky, and brick-red for the figures. The figures are sealed into the foreground by the color areas of sky and ground, but they nevertheless dance easily in an airy space created by these contrasting juxtaposed hues and by their own modeled contours and sweeping movements. The depth and intensity of the colors change in different lights, at times setting up visual vibrations that make the entire surface dance. *Music* is a perfect foil for the violence of *Dance*, in the static frontalized poses of the figures arranged like notes on a stave, each isolated from the others to create a mood of trancelike withdrawal. In both paintings the arcadian worlds of earlier painters have been transformed and transported into the twentieth century, while retaining their original magic and mystery.

In *Red Studio* (plate 42) he carried the principle of the single, unifying color much further than in *Harmony in Red*. The studio interior is described by a uniform area of red, covering floor and walls. A corner is identified by a single white line, which angles inward to create the corner by joining a second line more or less parallel to the picture plane. Furnishings—table, chair, cupboard, and sculpture stands—are ghost objects outlined in white lines. The tangible accents are the paintings of the artist, hanging on or stacked against the walls—ceramics, sculptures, vase, glass, and pencils. By 1911, when this was painted, Picasso, Braque, and the other Cubists, as we shall see, had in their own ways been experimenting with the organization and contraction of pictorial space for some five years. Matisse was affected by their ideas, but he had to find his own solutions. Nevertheless, it was probably in consequence of Analytic Cubism that he simplified his organization to a rectangular frontality. Soaked in monochrome red and activated by a cunning disposition of accents, this painting marks the end of Matisse's Fauve experiment and also the beginning of his own version of Cubism, which was to engage him for the next few years. It was a form of geometric simplification in which objects were flattened and frontalized, but there was never a degree of fragmentation, of shifting and tilted planes, that in the works of the Cubists proper created the sense of constantly changing vision on the part of the spectator.

Expressionism in Germany

The development of Expressionism in early twentieth-century German painting must be placed against the background of a body of theoretical, critical, and historical writing on art produced in Germany during the late nineteenth century. The neo-Kantian philosopher Conrad Fiedler (1841–1895) explored the possibility of an objective science of art, at the same time recognizing the problems of individual creation. He opposed existing concepts of art as imitation of nature, on the one hand, and as the expression of noble literary themes or pure human emotion, on the other. To him, the form of the work of art grew out of the content, the idea, and was indistinguishable from it. He was perhaps the first critic to see the work as the product of an "inner necessity," although he did not give to this phrase the sense of compulsion or mystical emphasis it later gained in the hands of the Expressionist painters. Fiedler's principal contention was that the work of art was essentially the result of the artist's unique, visual perception, given free form by his powers of selection. His ideas were further developed in an important work by the sculptor Adolf von Hildebrand (1847–1921): *The Problem of Form in Painting and Sculpture*, published in 1873.

At the same time, the pioneer psychologist Theodor Lipps (1851–1914) was advancing and expanding the somewhat older theory of empathy, according to which the spectator's identification with the work of art is the basis for aesthetic enjoyment and appreciation. This concept, which carried with it the suggestion that colors or lines or shapes or spaces have specific emotive qualities—are joyful or sad, inspiring or depressing, forceful or weak—was widespread in writings on Neo-Impressionism, Art Nouveau, and, later, on Cubism and Expressionism as well. The most important result of Lipps's theories appeared in the crucial publication in 1908 of Wilhelm Worringer's *Abstraktion und Einfühlung (Abstraction and Empathy)*. Worringer built his thesis on a combination of the theory of empathy and theories developed by Alois Riegl (1858–1905) on the importance of the artist's intent. Whereas he recognized the significance of empathy in the creation of representational styles, he saw the crisis of the modern artist as a flight from nature, an "inner compulsion" toward the selective organization or abstraction of nature. As might be expected, Worringer became one of the chief supporters and propagandists of the Expressionists, particularly after becoming acquainted with Vasily Kandinsky in 1908.

Even before the publication of Worringer's book, related ideas had appeared in the publications associated with Art Nouveau—notably *Jugend*, the critic Julius Meier-Graefe's journal *Pan*, and the Parisian journal *La Revue Blanche*, which reflected the stylistic theories of the Nabis. Paul Signac's important work, *From Delacroix to Neo-Impressionism*, had been translated into German in 1899, the year of its original publication, and exercised a significant influence with its credo of abstract organization of color and line as the painter's primary concern. Its impact was the greater because the paintings of Seurat and the Neo-Impressionists had already been exhibited in Germany. Henry van

de Velde, in addition, had preached the doctrine of line as an abstract force before the turn of the century.

The direct line of German Romanticism and Naturalism from Caspar David Friedrich to late nineteenth-century Symbolism and then to twentieth-century Expressionism has already been suggested. After visiting Paris in 1872, Max Liebermann (1847–1935) was closely associated with the Dutch naturalistic tradition exemplified by the early work of Vincent van Gogh. He was a talented, eclectic painter whose virtuoso brushwork revealed his continuing admiration for Frans Hals. On his return home, he introduced a form of Impressionism into Germany. Then on the heels of the proto-Expressionist art of such Northern and Middle Europeans as Klimt, Munch, Hodler, Ensor, Böcklin, Klinger, and Kubin came the Fauves at the 1905 Salon d'Automne in Paris. The latter's Expressionist innovations now coincided with the first stirrings of twentieth-century German Expressionism in the works of at least two individuals not associated specifically with any of the alliances that punctuated German twentieth-century painting.

PAULA MODERSOHN-BECKER (1876–1907) Paula Modersohn-Becker painted in the artists' colony at Worpswede after 1899, and, although not associated with any group, was in touch with new developments in art and literature through her friendship with the poet Rainer Maria Rilke (who had been Rodin's secretary), as well as through a number of visits to Paris. In these she discovered successively the French Barbizon painters, the Impressionists, and then, in 1905 and 1906, the works of Gauguin and Cézanne. Her early death has left us with only a suggestion of what she might have achieved, but in works such as her *Self-Portrait with Camellia* (fig. 153) there is apparent her understanding of the broad simplification of color areas she had seen in Gauguin, assimilated to an atmospheric, romantic interpretation of personality that shows her roots in German lyrical naturalism and her link with twentieth-century German Expressionism.

EMIL NOLDE (1867–1956) The main pioneer of German Expressionism was Emil Nolde. As a youth he studied woodcarving and for a time worked as a designer of furniture and decorative arts in Berlin. His first paintings of mountains transformed into giants or hideous trolls revealed qualities of primitive Germanic fantasy that attracted the editors of the periodical *Jugend*, who reproduced two of his grotesques as postcards and used a number of his illustrations.

The sale of these cards enabled Nolde to return to school and to take up painting seriously in Munich, Dachau, and Paris. While in Paris during the years 1899–1900, he, like so many foreign students, worked his way gradually from Daumier and Delacroix to Manet and the Impressionists. Although Nolde was initially disappointed in what he had learned from the Impressionists, his color took on a new brilliance and violence as a result of his exposure. In 1906 he accepted an invitation

Colorplate 31. HENRI MATISSE. *Open Window, Collioure*. 1905.
21¾ × 18⅛″. Collection Mr. and Mrs. John Hay Whitney,
New York

Colorplate 33. LUMIÈRE BROTHERS. *Young Lady with an Umbrella*. 1906–10. Autochrome.
Fondation Nationale de la Photographie, Lyons, France. ©Société Lumière

Colorplate 32. HENRI MATISSE. *Woman with the Hat*. 1905. 32 × 23¾″.
Collection Mrs. Walter A. Haas, San Francisco

Colorplate 34. HENRI MATISSE. *Green Stripe (Madame Matisse)*. 1905. Oil and tempera
on canvas, 15⅞ × 12⅞″. Statens Museum for Kunst, Copenhagen. Rump Collection

Colorplate 35. HENRI MATISSE.
Joy of Life (Sketch). 1905.
18 × 21½". Statens Museum
for Kunst, Copenhagen

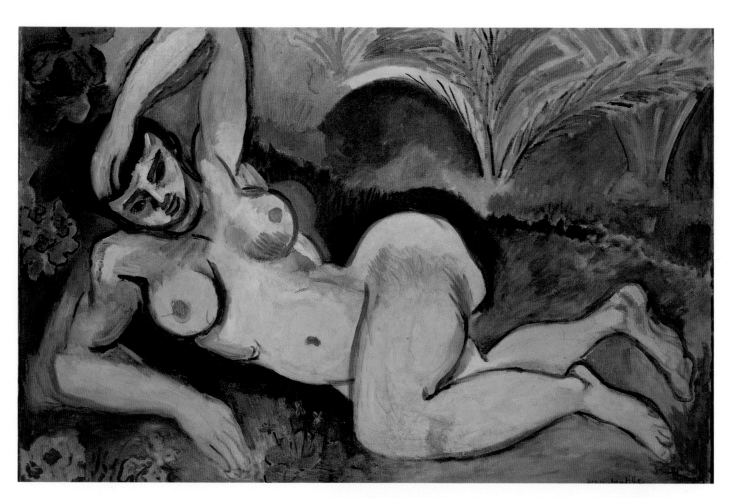

Colorplate 36. HENRI MATISSE. **The Blue Nude**. 1907. 36¼ × 55¼". The Baltimore Museum of Art. Cone Collection, formed by Dr. Claribel Cone
and Miss Etta Cone. BMA 1950.228

Colorplate 37. ANDRÉ
DERAIN. *London Bridge*.
1906. 26 × 39″.
Collection, The Museum
of Modern Art, New York.
Gift of Mr. and Mrs.
Charles Zadok

above: Colorplate 38. RAOUL DUFY. *Street Decked with Flags, Le Havre*.
1906. 31⅞ × 25⅞″. Musée National d'Art Moderne, Paris

left: Colorplate 39. GEORGES ROUAULT. *The Old King*. 1916–37.
30¼ × 21¼″. Carnegie Institute, Pittsburgh

opposite above: Colorplate 40. HENRI MATISSE. *Harmony in Red (La Chambre rouge; La Desserte—Harmonie rouge)*. 1908–9. 71¼ × 96⅞".
The Hermitage Museum, Leningrad

above: Colorplate 41. HENRI MATISSE. *The Dance*. 1910. 102½ × 154". The Hermitage Museum, Leningrad

opposite below: Colorplate 42. HENRI MATISSE. *Red Studio*. 1911. 71¼ × 86¼". Collection, The Museum of Modern Art, New York.
Mrs. Simon Guggenheim Fund

Colorplate 43. EMIL NOLDE. *The Last Supper.* 1909. 33⅞ × 42⅛". Statens Museum for Kunst, Copenhagen

Colorplate 44. EMIL NOLDE. *The Evening (Marsh Landscape).* 1916. 29 × 39⅝". Kunstmuseum, Basel

Colorplate 45. ERNST LUDWIG KIRCHNER. *Street, Dresden*. 1908; dated 1907 on painting. 59¼ × 78⅞". Collection, The Museum of Modern Art, New York. Purchase

Colorplate 46. MAX PECHSTEIN. *Indian and Woman*. 1910. 32¼ × 26¼". Collection Mr. and Mrs. Morton D. May, St. Louis

Colorplate 47. KARL SCHMIDT-ROTTLUFF. *Rising Moon*. 1912. 34½ × 37½". Collection Mr. and Mrs. Morton D. May, St. Louis

left: Colorplate 48. VASILY KANDINSKY. *Composition No. 2.* 1910.
38⅜ × 51¾". The Solomon R. Guggenheim Museum, New York

above: Colorplate 49. VASILY KANDINSKY. *Black Lines.* 1913. 51 × 51¼".
The Solomon R. Guggenheim Museum, New York

right: Colorplate 50. VASILY KANDINSKY. *Painting (Winter).* 1914. 64⅛ × 48⅜".
The Solomon R. Guggenheim Museum, New York

Colorplate 51. FRANZ MARC. *Blue Horses*. 1911. 40¾ × 70⅞″. Walker Art Center, Minneapolis

Colorplate 52. FRANZ MARC. *Stables*. 1913–14. 29⅛ × 62¼″. The Solomon R. Guggenheim Museum, New York

Colorplate 53. FRANZ MARC. *Fighting Forms*. 1914. 35⅞ × 51¾″.
Bayerische Staatgemäldesammlungen, Munich

Colorplate 54. AUGUST MACKE. *Great Zoological Garden*. 1912. 51⅛ × 90¾″. Museum am Ostwall, Dortmund, West Germany

118

Colorplate 55. ALEXEJ VON JAWLENSKY. *Helene with Red Turban*. 1910. 36½ × 31¼″. The Solomon R. Guggenheim Museum, New York

Colorplate 56. PAUL KLEE. *Hammamet with the Mosque*. 1914. 8⅛ × 7½″. The Metropolitan Museum of Art, New York. Berggruen Klee Collection, 1984

Colorplate 57. LYONEL FEININGER. *Harbor Mole*. 1913. 31¾ × 39¾″. Collection Mr. and Mrs. John Drew, Pittsburgh

left: Colorplate 58. EGON SCHIELE. *The Self Seer II (Death and the Man)*. 1911. 31⅝ × 31½". Collection Dr. Rudolf Leopold, Vienna

below: Colorplate 59. OSKAR KOKOSCHKA. *The Bride of the Wind*. 1914. 71¼ × 86⅝". Kunstmuseum, Basel

above left: 153. PAULA MODERSOHN-BECKER. *Self-Portrait with Camellia*. 1907. 24¼ × 12". Folkwang Museum, Essen, West Germany

above right: 154. EMIL NOLDE. *Christ Among the Children*. 1910. 34⅛ × 41⅞". Collection, The Museum of Modern Art, New York. Gift of the Artist

to become a member of the new artists' alliance Die Brücke. About the same time, along with many of his colleagues, he had begun to produce etchings and lithographs. Essentially a solitary, Nolde left Die Brücke after a year, and devoted himself more and more to a personal form of Expressionist religious paintings and prints.

Among the first of Nolde's visionary religious paintings was *The Last Supper* of 1909 (plate 43). One thinks back to Rembrandt's *Christ at Emmaus* or even Leonardo da Vinci's *Last Supper*, but Nolde's mood and impact are different from the quiet and restraint of both the earlier works. The figures are crammed into a practically nonexistent space, the red of their robes and the yellow-green of their faces flaring like torches out of the surrounding shadow. The faces themselves are skull-like masks that derive from the carnival processions of Ensor. Here, however, they are given intense personalities—no longer masked and inscrutable fantasies but individualized human beings passionately involved in a situation of extreme drama. The compression of the group packed within the frontal plane of the painting—again stemming from Ensor—heightens the sense of impending crisis until it becomes almost intolerable.

This painting exemplifies the qualities of Nolde's religious expression in an emotional frenzy that would be excessive were it not so convincing. In *Christ Among the Children* (fig. 154) Nolde used a similar composition of compression, but, unlike *The Last Supper*, with its rising climax of tragedy, the work is a paean of unadulterated joy. Even the colors in which he painted the children, predominantly brilliant yellows and light reds and purples, become abstract symbols of radiant happiness.

At the outbreak of war in 1914 Nolde moved into an old farmhouse at Seebüll, near his birthplace on the Baltic, where, in a long series of landscapes, he used the true colors of the region—the sharp green of meadows, the yellow of mustard fields, the deep blue of the northern lakes, rivers, and streams punctuating flatlands dominated by a vast sky filled with wandering clouds and an ever-changing spectrum of gorgeous luminary effects—to create paintings in which the German Expressionist yearning for a fusion of the self with the cosmos seems fulfilled in some "primal state" of pantheistic unity (plate 44). Whereas the Fauves would have painted this nature as serene and idyllic, Nolde stroked on broad, sweeping flows of incandescent color and transformed his world into an emotional event alive with apocalyptic import.

Nolde was an individual Expressionist in the sense that Rouault was one. And there are points of analogy between the two men in the emotional nature of their religious convictions, but there are also important differences. Both were colorists but different in their approach to color. Rouault's color seems almost subdued when placed side by side with the frequently garish brilliance of Nolde's, and the Frenchman's compositions are more controlled. Even his interpretations of the Gospels become quiet and restrained by comparison with Nolde's. The striking differences, and the points of resemblance between the two men, raise the fascinating but difficult question of national characteristics in art.

Die Brücke

In 1905 Ernst Ludwig Kirchner, together with Erich Heckel, Karl Schmidt-Rottluff, and Fritz Bleyl, formed the association known as Die Brücke (The Bridge—linking "all the revolutionary and surging elements"). These young architectural students, all of whom wanted to be painters, were drawn together by what they were against in the art that

surrounded them, rather than by any preconceived program. Imbued with the persuasive spirit of Arts and Crafts and Jugendstil, they rented an empty shop in a workers' district and began to paint, carve, and make woodcuts. The influence of the Middle Ages on them was strong, and consciously or unconsciously they sought to re-create the atmosphere of the medieval craftsmen's guilds. Although they worked in many media, probably their intensive study of the possibilities of woodcut did most to formulate their styles and to clarify their directions.

For them, Van Gogh was the clearest example of an artist driven by an "inner force" and "inner necessity," his paintings presented an ecstatic identification or empathy of the artist with the subject he was interpreting. The graphic works of Munch were widely known in Germany by 1905, and the artist himself was spending most of his time there. His obsession with symbolic subject struck a sympathetic chord in young German artists, and from his mastery of the graphic techniques they could learn much. Among historic styles, the most exciting discovery was primitive art from African jungle or Pacific island, of which notable collections existed in the Dresden Ethnographic Museum.

In 1906 Nolde was invited to join Die Brücke, and the artist, who had long felt himself isolated in his experiments, accepted with delight. In the same year, Max Pechstein joined the group. Also in 1906 Heckel, then working for an architect, persuaded a manufacturer for whom he had executed a showroom to permit the Brücke artists to exhibit there. This was the historic first Brücke exhibition, which marked the emergence of twentieth-century German Expressionism. Little information about the exhibition has survived, since no catalogue was issued, and it attracted virtually no attention. At that time, as a result of a close working relationship, the paintings and prints of the Brücke members except for those of Nolde, an older, established artist, had much in common.

Kirchner had arrived at a bold, simplified organization of large color masses deriving from his experimentation with woodcut. His 1900 lithograph *Head of a Man with a Nude* with the extreme close-up of the face partially shrouded by the minuscule figure of the nude is a strange, erotic evocation, leaning heavily on Munch. Schmidt-Rottluff was still using heavy impasto with aggressive brushstrokes, derivative from Van Gogh but moving beyond him in their undisciplined energy.

During the next few years the Brücke painters continued their program not only in exhibitions but also in publications designed by the various members and in manifestoes in which Kirchner's ideas were most evident. The human figure was studied assiduously in the way Rodin had studied the nude: not posed formally but simply existing in the environment. Despite developing differences in style, the natural consequence of the complicated personalities of the artists, a hard, Gothic angularity permeated the works of most of the group.

The Brücke painters soon became conscious of the revolution that the Fauves were creating in Paris and were affected by their use of color. However, their own paintings remained different in the degree that they maintained the Germanic sense of expressive subject matter and form characteristic of jagged, Gothic structure. By 1911 most of the Brücke group were in Berlin, where a new style appeared in their works, a style that evinced the increasing consciousness of French Cubism as well as Fauvism, given a Germanic excitement and narrative impact. By 1913 Die Brücke was dissolved as an association, and the artists proceeded individually to greater or lesser reputation.

ERNST LUDWIG KIRCHNER (1880–1938) Of the younger German artists, perhaps the most influential in the organization and direction of the energies and aspirations of his colleagues was Ernst Ludwig Kirchner. He was destined to become an artist from his high school days, and his ambition was reinforced by his discovery of the woodcuts of Dürer and this master's Late Gothic predecessors. Yet, his own first woodcuts, done before 1900, were probably influenced by Félix Vallotton and Edvard Munch. Between 1901 and 1903 Kirchner studied architecture in Dresden, and then, during 1903 and 1904, painting in Munich. Here he was influenced by Art Nouveau designs and repelled by the *retardataire* paintings he saw in the exhibition of the Munich Secession. Kirchner continued his study of Dürer and discovered the expressive economy of Rembrandt's drawings. His historical studies ranged over the art of all periods and cultures, but, like so many of the younger German artists of the time, he was particularly drawn to the German Gothic. Of modern artists, the first revelation for Kirchner was the work of Seurat. Going beyond Seurat's researches, Kirchner undertook studies of nineteenth-century color theories that led him back to Goethe's *Zur Farbenlehre (History of the Theory of Colors)*.

Kirchner's painting style about 1904 showed influences from the Pointillism of the Neo-Impressionists but a larger, more dynamic brushstroke related to that of Van Gogh, whose work he saw, along with paintings by Gauguin and Cézanne, in the exhibition of the Munich Artists' Association held that year. On his return to Dresden and architecture school in 1904 Kirchner became acquainted with Heckel, Schmidt-Rottluff, and Bleyl, and with them, as already noted, he founded the Brücke group.

The development of Kirchner's work may be suggested in a few key paintings and prints. *Girl Under a Japanese Umbrella* is a Fauve work (fig. 155), with the stunning yellows and pinks of the flesh tones accented with greens and blues. The figure, the umbrella, and the decorative background are all massed in the frontal plane of the picture to

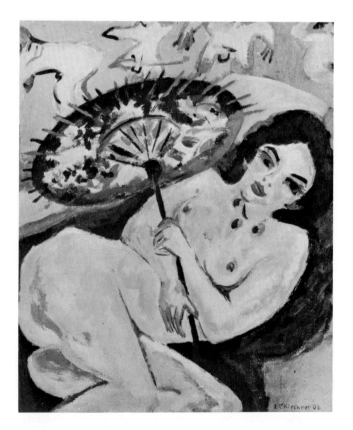

155. ERNST LUDWIG KIRCHNER. *Girl Under a Japanese Umbrella*. 1906. 36½ × 31⅝″. Kunstsammlung Nordrhein-Westfalen, Düsseldorf

156. ERNST LUDWIG KIRCHNER. *Street, Berlin.* 1913. 47½ × 35⅞". Collection, The Museum of Modern Art, New York. Purchase

157. ERNST LUDWIG KIRCHNER. *Market Place with Red Tower.* 1915. 47½ × 35⅞". Folkwang Museum, Essen, West Germany

create a pattern of abstract color splashes. *Street, Dresden* of 1908 is an assembly of curvilinear figures who undulate like wraiths without individual motive power, drifting in a world of dreams (plate 45). Another version of this work, painted in 1913 after Kirchner had moved to Berlin, suggests the forces affecting young artists during these years (fig. 156). Whereas the earlier version is derivative from the linear arabesques of Art Nouveau and the fantasy of Edvard Munch, the latter acknowledges the debt to Cubism, which was spreading from Picasso, Braque, Delaunay, and their Parisian followers. The structure is jagged and geometric, the space confined and well organized. Here, however, Cubist pattern is combined with Fauve color, and above all with a Gothic distortion and a Germanic emotional vibration that give the scene an intensity unlike anything in contemporary France. If Kirchner's *Market Place with Red Tower* (fig. 157) is compared with one of Delaunay's Eiffel Towers, from which it obviously stems, the difference between the German and the French vision becomes evident. Delaunay's *Eiffel Tower in Trees* of 1909 represents an expressive interpretation of Cubism in which the expression is achieved by the dynamism of abstract color shapes and lines (fig. 255). Whatever associations the spectator may read into the picture are his own affair. Kirchner's *Market Place with Red Tower*—like *Street, Berlin* and most other paintings by the Brücke group—is expressive in a more explicit way. Although the artist had studied the works of the Cubists, he used Cubist geometry with caution and without real understanding, combining it with defined perspective space distorted in the manner of Van Gogh for the similar end of creating a claustrophobic effect of compression. The total structure owes as much to late medieval paintings and manuscript illumination as to Cubism. The sense of the German Gothic past rarely deserted Kirchner. He was the most articulate of the original Brücke group, and

continued to work, if not to develop, as an artist, with long sieges of depression and illness ending with his suicide in 1938.

ERICH HECKEL (1883–1970) Heckel was a more restrained Expressionist whose early paintings at their best showed flashes of psychological insight or lyricism. Too frequently his emaciated figures suggest a

158. ERICH HECKEL. *Two Men at a Table.* 1912. 38⅛ × 47¼". Kunsthaus, Hamburg

159. OTTO MÜLLER. *Bathing Women*. 1912. Bildarchiv Rheinisches Museum, Cologne

160. HEINRICH KÜHN. *The Artist's Umbrella*. 1910. Hand-printed photogravure on heavy woven paper. The Metropolitan Museum of Art, New York. The Alfred Stieglitz Collection, 1949

Mannerist formula rather than any strong sense of inner conflict. In fact, after 1920 he turned more and more to the painting of colorful but essentially Romantic-Realist landscapes. A work such as *Two Men at a Table* (fig. 158), however, is a successful evocation of a dramatic inter-

161. KARL SCHMIDT-ROTTLUFF. *Self-Portrait with Monocle*. 1910. 33⅛ × 30″. Nationalgalerie, Berlin

play in which not only the figures but the contracted, tilted space of the room is charged with emotion. This painting, dedicated "To Dostoyevsky," is almost a literal illustration from the Russian novelist's *Brothers Karamazov*. The painting of the tortured Christ, the suffering face of the man at the left, the menace of the other—all refer to Ivan's story of Christ and the Grand Inquisitor.

OTTO MÜLLER (1874–1930) Müller's colors are the most delicate and muted of all the Brücke painters, his paintings the most suggestive of an Oriental elegance in their organization. His nudes are attenuated, slant-eyed, awkwardly graceful figures whose softly outlined, yellow-ocher bodies blend imperceptibly and harmoniously into the green and yellow foliage of their setting (fig. 159). With nudes in congress and in open nature, unidealized and candidly presented, Brücke artists discovered one of their favorite subjects, seeing it as a welcome release from nineteenth-century prudery and a liberating plunge into primal experience. But the relative gentleness of Müller's treatment found an echo in the contemporary photographs of the German-born photographer Heinrich Kühn (1866–1944), who, like early twentieth-century modernists in painting, sought to flatten his space and create a more two-dimensional design—a Pictorial effect, as the photographers would have said—by viewing his subject or scene from above (fig. 160).

MAX PECHSTEIN (1881–1953) Pechstein and Schmidt-Rottluff represent a bolder, more coloristic vein of Expressionism, although the two differed markedly from each other. Pechstein was the most eclectic of the Brücke group, capable of notable individual paintings that, however, go from one style to another. The early *Indian and Woman* shows him at his dramatic best in terms of the exotic subject, modeling of the figures, and Fauve-inspired color (plate 46). Pechstein's drawing is sculptural and curvilinear in contrast to that of Müller or Heckel. His

color tends to be heavy and sometimes coarse, but from these very qualities he at times achieves considerable expressive power.

KARL SCHMIDT-ROTTLUFF (1884–1976) In 1910 Karl Schmidt-Rottluff portrayed himself in a green turtleneck sweater, complete with beard and monocle, against an abstract background of a yellow opening flanked by purple curtains—the perfect picture of the arrogant young Expressionist (fig. 161). Although this was an exaggerated effect adopted for the particular painting, it does suggest qualities that characterize the artists of Die Brücke and specifically Schmidt-Rottluff himself. Aside from Nolde, he was the boldest colorist of the group, given to vivid blues and crimsons, yellows and greens, juxtaposed in jarring but effective dissonance. Although never an abstractionist, he was probably the member of Die Brücke who moved furthest and most convincingly in the direction of abstract structure (plate 47). He organized Cubist simplified interiors, Fauve landscapes, and primitive figures with an authority suggestive of the later Picasso.

Expressionist Prints

One of the principal contributions of German Expressionism was the revival of printmaking as a major form of art. During the nineteenth century a large number of the experimental painters and sculptors made prints, and toward the end of the century, in the hands of artists like Toulouse-Lautrec, Gauguin, Maillol, Redon, and Ensor, printmaking assumed an importance as an independent art form beyond anything that had existed since the Renaissance. The early twentieth-century artists outside Germany—Picasso, Munch, Matisse, Bonnard, Klee, Rouault—were all important printmakers as well as painters. In Germany, however, printmaking occupied a special place, and its revival contributed to the character of painting and sculpture. Of the Brücke group, Nolde was one of the first to realize the possibilities of woodcut. Although his *Prophet* of 1912 (fig. 162) owes something to Late Gothic German woodcuts and the woodcuts of Gauguin, as well as to the lithographs of Goya, Nolde here achieves an intensity of black-and-white contrast that transcends the works of his predecessors. Kirchner, in both black-and-white and color woodcuts, developed a more intricate, linear pattern that looked back to the woodcuts of Dürer and Schon-

above: 162. EMIL NOLDE. *Prophet*. 1912. Woodcut. Kunstmuseum der Stadt, Düsseldorf

below left: 163. ERNST LUDWIG KIRCHNER. *Head of Henry van de Velde*. 1917. Woodcut. Staatliche Graphische Sammlung, Munich

below center: 164. MAX PECHSTEIN. *Dialogue*. 1920. Color woodcut, composition, 15¹³⁄₁₆ × 12⁹⁄₁₆″. Collection, The Museum of Modern Art, New York. Gift of Paul J. Sachs

below right: 165. KARL SCHMIDT-ROTTLUFF. *Two Heads*. 1918. Woodcut. Brücke-Museum, Berlin

166. KÄTHE KOLLWITZ. *Death Seizing a Woman*. 1934. Lithograph, printed in black, composition 15¹³⁄₁₆ × 12⁹⁄₁₆". Collection, The Museum of Modern Art, New York. Purchase Fund

gauer (fig. 163). Heckel sought a sparse, abstract pattern in his simplified figures, and both Pechstein and Schmidt-Rottluff were carried away by the medium to the creation of a kind of exaggerated Mannerism, in which they used a Cubist stylization to emphasize their effects (figs. 164, 165).

KÄTHE KOLLWITZ (1867–1945) Käthe Kollwitz, as the wife of a doctor concerned with the medical problems of the poor, devoted her life and her art, both printmaking and sculpture, to a form of protest or social criticism (fig. 166). She was the first of the German Social Realists, among them Otto Dix and George Grosz (fig. 347; plate 107), who would develop out of Expressionism during and after World War I. Essentially a Realist, she stands somewhat aside from the Expressionism of Die Brücke or Kandinsky or Der Blaue Reiter, powerfully concerned with the problems and sufferings of the poor and underprivileged.

Der Blaue Reiter

VASILY KANDINSKY (1866–1944) The Brücke artists were the first manifestation of Expressionism in Germany but not necessarily the most significant. While they were active, first in Dresden and then in Berlin, a movement of more far-reaching implications was germinating in Munich around one of the great personalities of modern art, Vasily Kandinsky.

Kandinsky was born in Moscow in 1866 and studied law and eco-

nomics at the University of Moscow. Visits to Paris and an exhibition of French painting in Moscow aroused his interest to the point that, at the age of thirty, he refused a professorship of law in order to study painting. He then went to Munich, where he was soon caught up in the atmosphere of Art Nouveau then permeating the city.

Munich, since 1890, had been one of the most active centers of experimental art in all Europe. The Munich Secession of 1892 represented a first effort of younger artists to secede from the academy-dominated organization of their elders. This new association included both Realists and Impressionists such as Slevogt, Corinth, and Liebermann. Kandinsky soon was taking a leading part in the Munich art world, even while undergoing the academic discipline of the studios of Anton Azbé and Franz von Stuck. In 1901 he formed a new artists' association, Phalanx, and opened his own art school. In the same year he was exhibiting in the Berlin Secession, and by 1904 had shown works in the Paris Salon d'Automne and Exposition Nationale des Beaux-Arts. By 1909 Kandinsky was leading a revolt against the Munich Secession that resulted in the formation of the Neue Künstler Vereinigung (NKV, New Artists Association). The Phalanx and the Munich Secession, in 1904, had shown the Neo-Impressionists, as well as Cézanne, Gauguin, and Van Gogh. In addition to Kandinsky, the NKV included Jawlensky, Gabriele Münter (whom Kandinsky had met in 1902), Alfred Kubin, and, later, Franz Marc, Karl Hofer, and others. Its second exhibition, in 1910, showed the works not only of Germans but also of leading French and Parisian experimental painters: Picasso, Braque, Rouault, Derain, Vlaminck, and Van Dongen.

During this period, Kandinsky's ideas about nonobjective painting, or painting without literal subject matter, were germinating, and in 1910 he was working on his classic statement, *Concerning the Spiritual in Art*. In 1911 a split in the NKV resulted in the secession of Kandinsky, accompanied by Marc and Gabriele Münter. The immediate consequence was the formation of the association Der Blaue Reiter (The Blue Rider), a name taken from a book published by Kandinsky and Marc, which had in turn taken its name from a painting by Kandinsky. The historic exhibition held at the Thannhauser Gallery in Munich (December 1911–January 1912) included works by Kandinsky, Marc, August Macke, Heinrich Campendonck, Gabriele Münter, the composer Arnold Schönberg, the two Frenchmen Henri Rousseau and Robert Delaunay, and others. Paul Klee, already associated with the group, showed with them in a graphics exhibition in 1912. This was a much larger show. The entries were expanded to include artists of Die Brücke and additional French and Russian artists: De La Fresnaye, Malevich, and Jean (Hans) Arp, an Alsatian.

In *Concerning the Spiritual in Art*, published in 1912, Kandinsky formulated the ideas that had obsessed him since his student days in Russia. Always a serious student, he had devoted much time to the problem of the relations between art and music. The dematerialization of the object that he had first sensed in the paintings of Monet had continued to intrigue him as, through the exhibitions in Munich and his continual travels, he learned more about the revolutionary new discoveries of the Neo-Impressionists, the Symbolists, the Fauves, and the Cubists. Advances in the physical sciences had shattered his remaining faith in a world of tangible objects, and at the same time strengthened his conviction that art had to be concerned with the spiritual rather than the material. Despite his strong scientific and legal interests, Kandinsky was attracted to theosophy, spiritism, and the occult. There was always a mystical core in his thinking—something he at times attributed to his Russian roots. Whatever it was, this mysticism, this sense of an inner creative force, a product of the spirit rather than of external vi-

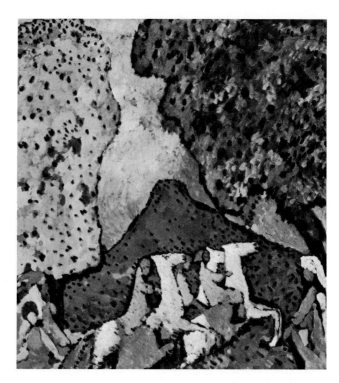

167. GABRIELE MÜNTER. *Peasant Woman of Murnau with Children.*
c. 1909–10. Painted on glass, 8½ × 7¹¹⁄₁₆″. Städtische Galerie im
Lehnbachhaus, Munich

168. VASILY KANDINSKY. *Blue Mountain, No. 84.* 1908. 41⅜ × 37⅞″.
The Solomon R. Guggenheim Museum,
New York

sion or manual skill, it enabled him to arrive at an art entirely without subject matter except insofar as colors and lines and their relationships constituted a subject. "The harmony of color and form," he wrote, "must be based solely upon the principle of the proper contact with the human soul."

The early paintings of Kandinsky went through various stages of Impressionism and Art Nouveau decoration, but all were characterized by a feeling for color and many for a fairytale quality of narrative, reminiscent of his early interest in Russian folktales and mythology. Kandinsky even pursued this line of investigation into a kind of Utopian phase, carried out in the Bavarian village of Murnau, where both he and Gabriele Münter (1877–1962) took up *Hinterglasmalerei,* a local form of folk art in which the painting is done on the underside of glass (fig. 167). The archaism of the style and its spiritual purity seem to forecast the more radical simplifications that would soon come. Impressionism was followed by exercises in Neo-Impressionist patterned color and then by excursions into the greater freedom of Fauvism. *Blue Mountain, No. 84* (fig. 168) is a romantic work of stippled color dots organized within a few large, flat, outlined shapes of mountains and trees, with silhouetted riders constituting a moving pattern on the frontal plane. Technical characteristics can be traced to the color space of Gauguin and the Pointillism of Seurat, while the decorative formula suggests Art Nouveau. It was only a short step from this painting to *Composition No. 2* (plate 48), in which the riders and other figures have become color spots or linear patterns, and the picture space a vibrant arrangement of rapidly moving color areas, with the story submerged in abstract pattern. By this time, having absorbed the implications of Fauve color organization, Kandinsky was beginning to state his intent by using titles derived from music—*Composition, Improvisation, Lyrical,* etc. Progressively, throughout the years 1910–12, using the analogies of music, Kandinsky would develop his themes of spiritual conflict re-

solved through line and color, space and movement, until in the "improvisations" of late 1913 and 1914 he had realized an abstract Expressionism free of all apparent reference to observed nature. And so, along with Kupka, Delaunay, Larianov, and Malevich, he was one of the first, if not—as traditionally thought—the very first, modern European artist to break through the representational barrier and carry painting into the strange and unexplored world of total abstraction (plate 49). But while all the other pioneers of pictorial nonobjectivity worked in a Cubist-derived geometric mode, Kandinsky alone became the father of the free, painterly, improvisatory, Expressionist, biomorphic manner that would develop through the Surrealist art of Masson, Miró, and Matta to attain its climax in the environmentally scaled, "holistic" compositions of Jackson Pollock in the years 1947–50.

Following his initial foray into radical nonrepresentation, Kandinsky did not continue unswervingly in that direction. But as he increasingly used his powerful, sincere spirit to overcome the dominant materialism of the age, the great Russian succeeded in creating masterpieces of abstract Expressionist painting, pictorial fields in which colors, shapes, and lines seem engaged in some furious cosmic battle. In a splendid series painted in 1914 and devoted to the seasons, the artist has suggested the nature of each quarterly unit within the annual cycle through a demonstration of the expressive, even descriptive powers of abstract means (plate 50).

In 1914 the war forced Kandinsky to return to Russia, and, shortly thereafter, another phase of his long and productive career began. In looking at the work of the other members of Der Blaue Reiter up to 1914, we should recall that the individuals involved were not held together by common stylistic principles but rather constituted a loose association of young artists, enthusiastic about new experiments and united in their oppositions. Aside from personal friendships, it was the inquiring, mature mind and the personality of Kandinsky that gave the

group cohesion and direction. The yearbook *Der Blaue Reiter*, edited by Kandinsky and Franz Marc, appeared in 1912 and served as a forum for the opinions of the group. The new experiments of Picasso and Matisse in Paris were discussed at length, and the aims and conflicts of the new German art associations were described. In the creation of the new culture and new approach to painting, importance was attached to the influence of all kinds of primitive and naïve art.

FRANZ MARC (1880–1916) Of the Blaue Reiter painters, Franz Marc was the closest in spirit to the traditions of German Romanticism and lyrical Naturalism. In Paris, in 1907, he sought personal solutions in the paintings of Van Gogh for his deep-rooted uncertainties and torment of soul. He also was seeking some inner harmony between himself and the world around him that he could express in paint. This harmony he found in the forms of animals, particularly horses and deer. The undulating movement of his earlier paintings of animals owed a great deal to the still important tradition of Art Nouveau. Through his friend the painter August Macke, Marc developed, about 1910, enthusiasms for color laid on in large areas, color whose richness and beauty were expressive also of the harmonies he was seeking. The great *Blue Horses* of 1911 is one of the masterpieces of Marc's earlier, curvilinear style (plate 51). The three brilliant blue beasts are modeled out sculpturally from the equally vivid reds, greens, and yellows of the landscape. The artist has here used an extreme close-up view, with the bodies of the horses filling most of the canvas. The horizon line is high, so that the curves of the red hills repeat the lines of the horses' curving flanks. Although the modeling of the animals gives them the effect of sculptured relief projecting from a uniform background, there is no real spatial differentiation between creatures and environment except that the sky is rendered more softly and less tangibly to create some illusion of distance. In fact, the artist uses the two tree trunks and the green of the foliage in front of and behind the horses to tie foreground and background together. At this time Marc's color had a specifically symbolic rather than descriptive function. He saw blue as a masculine principle, robust and spiritual; yellow as a feminine principle, gentle, serene, and sensual; red as matter, brutal and heavy. In the mixing of these colors to create greens and violets, and in their proportions one to the other on the canvas, the colors-as-abstract-shapes took on spiritual or material significance independent of the subject.

Yet Marc, even though working closely with Kandinsky and aware of his historic experiments, could never bring himself to abandon recognizable subject matter entirely. Only at intervals at the end of his brief life, in sketches that he made in the notebook he carried until he was killed in the war in 1916, was there evidence finally of a move to abstraction. Although the animal theme arose in the first instance from his love of animals, it soon became for him a symbol of that more primitive and arcadian life sought by so many of the Expressionist painters.

During the years 1911–12 Marc was absorbing the ideas and forms of the Cubists and finding them applicable to his own concepts of the mystery and poetry of color. Marc's approach to art was religious in a manner that could be described as pantheistic, although it is suggestive that in his paintings only animals are assimilated harmoniously into nature—never man. Marc, with Macke, visited Delaunay in Paris in 1912, and the same year found him impressed by the exhibition of Italian Futurists he saw in Munich. Out of these two influences, as well as the example of Kandinsky, Delaunay's abstract, coloristic art, and the Futurists' use of Cubist structures, emerged his own mature style—which, tragically, he was permitted to explore for only two or three more years.

In *Stables* the artist combined his earlier curvilinear patterns with a new rectangular geometry (plate 52). The horses, massed in the frontal plane, are dismembered and recomposed as abstract-color areas, to the point where they appear now as flat shapes on the surface of the canvas. The forms are composed parallel to the picture plane rather than tilted in limited depth. This treatment was in accordance with the experiments of Delaunay in his Window and Disk series (fig. 256; plate 77). At this stage, however, Marc's paintings were still far less abstract than Delaunay's, and their sense of nervous energy made them akin to those of the Futurists. His color now achieved a translucence beyond anything he had attempted earlier. The sense of rapid metamorphosis is due to the action of color as color, rather than to the dismembered geometric shapes. Intense but light-filled blues and reds, greens, violets, and yellows flicker over the structurally and spatially unified surface to create an impact of dazzling illusion. At times the effect is of the changing, light-drenched color of Gothic stained-glass windows, at other times of a hall of mirrors creating an infinity of fragmented color-saturated images. Marc's use of color at this stage owed much to Macke, who frequently used the theme of people reflected in shop windows as a means of distorting space and multiplying images.

During 1913 Marc returned on occasion to a type of landscape virtually literal for him, but his main direction was toward greater abstraction and depiction of a world of conflict. His work suggests an immensely dynamic, dark premonition of destruction. The jagged diagonal lines crisscross like machine-gun fire, while the trees crash as though struck by lightning, themselves destroyed and destroying the helpless deer and horses. Marc accelerated Futurist speed and increased the sense of conflict of abstract forms, even though the animal victims are depicted quite literally. Implicit here is the artist's next stage, embodied in a painting almost completely abstract, the *Fighting Forms* of 1914 (plate 53). Here Marc returned to curvilinear pattern in a violent battle of black and red color shapes, of light and darkness. In this nonfigurative painting, Marc's most complete turn toward abstract Expressionism, the forms are given such vitality that they take on the insane characteristics of forces in an ultimate encounter.

AUGUST MACKE (1887–1914) Of the major figures in Der Blaue Reiter, August Macke, despite his close association with and influence on Franz Marc, should probably not be considered an Expressionist at all. Macke, like Marc, was influenced by Kandinsky, Delaunay, and the Futurists, and perhaps more immediately by the color concepts of Gauguin and Matisse. Since he was killed in September 1914, one month after the beginning of World War I, his achievement must be gauged by the work of only four years.

After some Fauve- and Cubist-motivated exercises in semiabstraction, Macke began to paint city scenes in high-keyed color, using diluted oil paint in effects close to that of watercolor. The *Great Zoological Garden*, a triptych of 1912 (plate 54), is a loving transformation of a familiar scene into a fairyland of translucent color. Pictorial space is delimited by foliage and buildings that derive from the later watercolors of Cézanne. One can sense the eclectic atmosphere of influences from Renoir, Seurat, and Matisse. The artist moves easily from passages as abstract as the architecture to passages as literally representational as the animals and the foreground figures. The work has a unity, however, despite the disparate styles it embodies, a unity of mood that is gay, light, and charming, disarming because of the naïve joy that permeates it.

Macke occasionally experimented with abstract organization, but his principal interest during the last two years of his life continued to be his

169. AUGUST MACKE. *Landscape with Cows and Camel*. 1914. 18½ × 21¼".
Kunsthaus, Zurich

cityscapes, which were decorative colored impressions of elegant ladies and gentlemen strolling in the park or studying the wares in brightly lit shop windows. In numerous versions of such themes, he shows his fascination with the mirrorlike effects of windows as a means of transforming the perspective space of the street into the spatial effect of Cubism.

The last works, inspired by his brief trip to Tunisia with Paul Klee in the spring of 1914, reveal a spirit of Cubist structure derivative from later works of Franz Marc, as these in turn had been inspired by the color harmonies of Macke. *Landscape with Cows and Camel* is more subdued in color than most of his cityscapes or the Tunisian watercolors (fig. 169). The animals are still depicted literally but are arranged with meticulous geometry within a landscape consisting of beautifully disposed color shapes. The mood is of pastoral and romantic melancholy. Macke's exciting Tunisian watercolors verged on an abstract color exploration—which he was never to fulfill, and which Klee was to realize.

ALEXEJ VON JAWLENSKY (1864–1941) Jawlensky was well established in his career as an officer of the Russian Imperial Guard before he decided to become a painter. After studies in Moscow he enrolled in Azbé's school in Munich, where he met Kandinsky. Although not officially a member of Der Blaue Reiter, Jawlensky was sympathetic to its aims and continued for years to be close to Kandinsky. After the war he formed Die Blauen Vier (The Blue Four), along with Kandinsky, Klee, and Lyonel Feininger.

By 1905 Jawlensky was painting in a Fauve palette, and his drawings of nudes of the next few years are suggestive of Matisse. *Helene with Red Turban* (plate 55) might have been inspired by Matisse's portrait of Mme Matisse entitled *Green Stripe* (plate 34), as far as the color

170. ALEXEJ VON JAWLENSKY. *Mme. Turandot*. 1912. 23 × 20". Collection Andreas Jawlensky. Locarno, Switzerland

patterns are concerned. It embodies a different mood, however, one of reflection and melancholy indicative of the introspective, religious qualities that became manifest in Jawlensky's works. About 1910 he settled on his primary theme, the portrait head, which he explored thenceforward with mystical intensity. *Mme. Turandot* is an early example (fig. 170), painted in a manner that combines characteristics of Russian peasant painting and Russo-Byzantine icons—qualities that were to become more and more dominant. A sense of geometry became strongly evident in the heads of the 1920s, but in the 1930s the geometry gradually loosened, and the artist dissolved the linear structure in an abstraction of forceful brush gesture.

The paintings of Jawlensky constitute a curious and seemingly isolated phenomenon in German Expressionist painting. As a microcosm, they do epitomize a certain contemporary development, for he moved from colorism to Bauhaus geometry and then to a personal form almost of abstract Expressionism. However, they maintain, from beginning to end, a sense of intense inward vision, that inner spiritual force which Kandinsky felt to be the essence of the Expressionist attitude.

PAUL KLEE (1879–1940) Paul Klee was one of the most varied, complex, and brilliant talents in the twentieth century. His stylistic development is difficult to trace even after 1914, since the artist, from this moment of maturity, was continually reexamining themes and forms in his efforts to come closer to essences.

Klee was born in Switzerland, the son of a musician and, like Feininger, initially inclined toward music, but having decided on the career of painting, he went to Munich to study, in 1898. During the years 1903–6 he produced a number of etchings (fig. 171), which in their precise, hard technique suggested the German graphic tradition of the Renaissance, in their mannered linearism the atmosphere of Art Nouveau, and in their mad fantasy a personal vision reflecting the influence of the Expressionist printmaker Alfred Kubin (fig. 119). These were also among the first of Klee's works in which the title became an integral part.

Klee traveled extensively in Italy and France between 1901 and 1905 and probably saw works of Matisse. Between 1908 and 1910 he became aware of Cézanne, Van Gogh, and the beginnings of the modern movement in painting. In 1911 he had a one-man exhibition at the Thannhauser Gallery in Munich and in the same year met the Blaue Reiter painters Kandinsky, Marc, Macke, Jawlensky, and Gabriele Münter. Over the next few years he participated in the Blaue Reiter exhibitions, wrote for *Der Sturm*, and, in Paris again in 1912, met Delaunay and saw further paintings by Picasso, Braque, and Henri Rousseau. Of importance was a trip he took with Macke in 1914, to Tunis and other parts of North Africa.

He was affected, like Delacroix and other Romantics before him, by the brilliance of the sunshine and the color and clarity of the atmosphere. To catch the quality of the scene Klee, like Macke, turned to watercolor and a form of semiabstract color pattern based on Cubism (plate 56). Klee had a long and incredibly fertile career, the remainder of which will be traced in a later chapter.

LYONEL FEININGER (1871–1956) Although Lyonel Feininger was born an American of German-American parents, as a painter he belongs within the European orbit. The son of distinguished musicians, he was early destined for a musical career. But already, before he was ten, he was drawing his impressions of buildings, boats, and elevated trains of New York City. He went to Germany in 1887 to study music, but soon

171. PAUL KLEE. *Two Men Meet, Each Supposing the Other to Be of Higher Rank.* 1903. Etching. The Solomon R. Guggenheim Museum, New York

turned to painting. In Berlin between 1893 and 1905 Feininger earned his living as an illustrator and caricaturist for German and American periodicals, developing a brittle, angular style of figure drawing related to aspects of Art Nouveau, but revealing a personal sense of slightly mad satire. The years 1906–8, in Paris, brought him in touch with the early pioneers of modern French painting. And by 1912–13 the artist had arrived at his own version of Cubism, particularly the form of Cubism with which Marc was experimenting at the same moment. Feininger was invited to exhibit with Der Blaue Reiter in 1913. Thus, not surprisingly, he and Marc shared the sources of Orphism and Futurism, which particularly appealed to the romantic expressive sensibilities of both. Whereas Marc translated his beloved animals into luminous Cubist planes, Feininger continued with his favorite themes of architecture, boats, and the sea. In *Harbor Mole* of 1913 (plate 57), he recomposed the scene into a scintillating interplay of color facets, geometric in outline but given a sense of rapid color change by the transparent, delicately graded color areas. In this work Feininger stated in a most accomplished manner the approach he was to continue, with variations, throughout the rest of his long life. It was an approach of strong, straight-line structure played against sensuous and softly luminous color. The interplay between taut linear structure and romantic color, with space constantly shifting between abstraction and representation, created effects of dynamic tension to carry the paintings beyond their decorative surface into a romantic-expressive mood. Another effect peculiar to Feininger among the European Expressionists—although also to be seen in works of the American painter John Marin (fig. 531)—is a reduction of scale in which objects almost always seem diminished by distance.

In 1919 Feininger was invited to join the staff of the Bauhaus, with which he remained associated until its dissolution in 1933. His own painting continued steadily in the direction he had chosen, sometimes emerging in shattered architectural structures, sometimes in serene and light-filled structures full of poetic suggestion. Back in the United States in 1937, he was affected by the new and exciting environment, and began to recapture the brittle, broken quality of line of his first drawings and paintings.

Feininger was essentially a painter of the city, of architecture massed parallel to the picture plane—but he had a second and obsessive love for the sea and ships. These he painted all his life, first for the subject, then increasingly for the challenge of bringing a scene of empty space, of sky and water meeting on the horizon under the control of the picture plane. It was a challenge that had intrigued painters of the modern movement at least from the time of Courbet.

Expressionism in Austria

Expressionism, like Romanticism or Classicism, is a term that has been applied to tendencies recurring in the arts since antiquity. Herwarth Walden, poet, critic, musician, and the founder of the avant-garde periodical *Der Sturm*, drew the distinction between new, revolutionary tendencies and the Impressionism that formed their immediate background and frequently was thought of as their principal enemy. What he called Expressionism, however, included Cubism, Futurism, and even abstraction. In 1912, Walden opened a gallery in Berlin for avant-garde art, the Sturm Galerie, where he exhibited Kandinsky and Der Blaue Reiter, Die Brücke and the Italian Futurists, Braque, Derain, Vlaminck, Auguste Herbin, and others grouped as French Expressionists. Also shown were Ensor, Klee, and Delaunay. In 1913 came the climax of the Sturm Galerie's exhibitions, the First German Autumn Salon including

360 works. Henri Rousseau's room had twenty paintings, and almost the entire international range of experimental painting and sculpture at that moment was shown. Although during and after the war the various activities of Der Sturm lost their impetus, Berlin, between 1910 and 1914, was a rallying point for most of the new European ideas and revolutionary movements, largely through the leadership of Herwarth Walden.

Modern Expressionism in Germany, Austria, and the Scandinavian countries was an offshoot of Romanticism and, as previously noted, had its roots in late nineteenth-century Symbolism and Post-Impressionism. Its essence was the expression of inner meaning through outer form. This outer form ranged from any kind of expressive realism to the abstract Expressionism of Kandinsky. Italian Futurism was an Expressionist form of Cubism; the new objectivity *(Neue Sachlichkeit)* of Otto Dix and George Grosz toward the end of World War I developed from Expressionism; and even the new fantasy, Dadaism, and Surrealism came out of nineteenth-century Romanticism—specifically, from Symbolism—by way of Expressionism. To understand the various directions in which Expressionism moved during and after World War I, we may look at two artists who were associated in some degree with Expressionism, but who, like Klee and Feininger, had each his different interpretation: the Austrians Egon Schiele and Oskar Kokoschka.

EGON SCHIELE (1890–1918) Egon Schiele lived a short and tragic life, dying in the influenza epidemic of 1918. He was a precocious draftsman and, despite opposition from his uncle (who was his guardian after his father died insane), studied at the Vienna Academy of Art. His principal encouragement came from Gustav Klimt, aged forty-five when they met in 1907, and at his height as a painter and leader of the avant-garde in Vienna. The two artists remained close for the rest of their lives, but there were obviously strong conflicts between them. Although Schiele was briefly influenced by Klimt, much of his developed style was a specific reaction against the older man.

In the *Self-Portrait I* of 1909 (fig. 172) Schiele retains some of Klimt's Art Nouveau pattern in the drapery, but the intense portrayal, with its narrowed gaze and angular, emaciated figure, differs from even the most direct and least embellished of Klimt's portraits. Klimt's *Black Feather Hat*, painted the next year (fig. 93), clearly shows the older artist's ability to combine linear style with delicate Impressionist color. The portrayal is sharp and perceptive, but what first appeals to us is the elegant, decorative flow of line up the fur boa and gracefully posed arm to the delicate face crowned by the mass of red hair on which the blue-black feather hat is suspended. Schiele's *Self-Portrait* has little grace and elegance, although many of the elements are similar. Here one is faced with a stark and angry actuality—an inner tension and conflict.

Further comparisons of paintings by Klimt and Schiele are valuable in illustrating both the continuity and the change between nineteenth-century Symbolism and early twentieth-century Expressionism. Klimt's painting *Death and Life* (plate 28) is heavy with symbolism presented in terms of the richest and most colorful patterns. Another version, by Schiele, painted in 1911, is *The Self Seer II* (plate 58). This work is comparable in subject, but the approach could not be more different. The man (possibly a self-portrait), rigidly frontalized in the center of the painting, stares out at the spectator. His face is a horrible and bloody mask of ultimate fear. The figure of Death hovers behind, a ghostly presence folding the man in his arms in what might almost be an embrace. The paint is built up in jagged brushstrokes on figures emerging from a background of harsh and dissonant tones of ocher, red, and green.

The revealing contrasts could be extended to almost every subject the two artists essayed—since both painted portraits, landscapes, and figures, as well as symbolic compositions. In Schiele's portraiture, other than his self-portraits, there persisted the same intensity of characterization, achieved by his use of harsh, brittle line against a broken field of dissonant colors integrating figure and abstract environment (fig. 173). Klimt was a superb draftsman, particularly of female nudes drawn with a loving line that brought out every erotic implication. On the other hand, the female nudes of Schiele, drawn with even greater power, often combine erotic attraction with revulsion (fig. 174).

OSKAR KOKOSCHKA (1886–1980) Produced during a brief life of poverty and hardship and isolation in Vienna, a life interrupted by the Great War and curtailed at the age of twenty-eight, Schiele's remarkable, tortured art seems limited in comparison with that of Oskar Ko-

above left: 172. EGON SCHIELE. *Self-Portrait I*. 1909. 43½ × 14⅛". Private collection, Turin

left: 173. EGON SCHIELE. *The Painter Paris von Gütersloh*. 1918. 55½ × 43½". The Minneapolis Institute of Arts. Gift of the P. D. McMillan Land Company

above: 174. EGON SCHIELE. *Girl in Black Stockings*. 1911. Gouache and pencil, 21½ × 14½". Collection Christian M. Nebehay, Vienna

175. OSKAR KOKOSCHKA. *Portrait of Adolf Loos.*
1909. 29⅛ × 35⅞". Staatliche Museen, Berlin

koschka, also a product of Vienna but a man who soon moved out into the larger world of modern art to become one of the international figures of twentieth-century Expressionism. Between 1905 and 1908 Kokoschka was caught up in Viennese Art Nouveau, and his series of lithographs entitled *Dreaming Boys* suggests the influence of Klimt and Aubrey Beardsley. Even before going to Berlin at the invitation of Herwarth Walden in 1910, Kokoschka was already instinctively an Expressionist. Particularly in his early "black portraits," his passionate search was for the exposure of an inner sensibility—which may have belonged more to himself than to the sitter. His very first images, such as the 1909 portrait of the architect Adolph Loos, are among his masterpieces within this genre (fig. 175). Here, the figure projects from its dark background, and the tension in the contemplative face is caught up in the sensitive, nervously clasped hands. The romantic basis of his early painting appears in *The Bride of the Wind* (plate 59), an apotheosis of his love affair with Alma Mahler, in which the lovers, composed with flickering, light-saturated brushstrokes, are swept through a dream landscape of night-filled, cold blue mountains and valleys lit only by the gleam of a shadowed moon.

Seriously wounded in World War I, Kokoschka produced little for several years, but his ideas and even his style were undergoing constant change. In 1924 he abruptly set out on travels. During this interval— some seven years—he explored the problem of landscape, combining free, arbitrary, and brilliant Impressionist or Fauve color with a traditional perspective-space organization that went back to the beginnings

of Flemish landscape. The Thames landscape, which he painted on several occasions, is typical of his approach at this time in the high vantage point, the bold use of linear perspective in the bridges, the yellows, blues, and reds flickering over and unifying the picture surface and, as they describe the rushing buses and cars in the foreground, recording the dynamism of the great city. Kokoschka's Expressionism was always personal. Throughout his long life he exemplified the spirit of modern Expressionism—the power of emotion, the anguish, the joy, the deeply felt sensitiveness to the inner qualities of man and nature.

In 1933, as a result of financial difficulties, the painter returned from his long travels. He went first to Vienna and then, in 1934, to Prague, where he remained for four years. During this period his works in public collections in Germany were confiscated by the Nazis as examples of "degenerate art."

In 1938 London became his home, although whenever possible he continued his restless traveling. After 1953 he lived principally in Switzerland. At all times his work maintained its freedom, its freshness and boldness. Colors are more violent, characterizations forceful, at times to the point of caricature. The long vista of his work makes it clear, however, that consistency of approach unifies his different experiments. Although he never deserted figuration, his later paintings have a kinship to aspects of postwar Abstract Expressionism. This is only a coincidental relationship suggesting a common origin, however. Throughout his life Kokoschka remained spiritually contemporary and an Expressionist in his personal idiom.

Early Twentieth-Century Sculpture

In sculpture as in architecture, the nineteenth century produced few if any new spatial experiments. Neoclassical sculptors reverted to a concept of controlled sculptural forms within a limited space. Romantic and Realist sculptors, although they once again sought to introduce movement and open space, cannot be said to have in any way enlarged the vocabulary of the Baroque. Even Rodin, generally considered the father of modern sculpture, was usually content to organize his groups within the rotating, spiral movements of the Late Renaissance and the Baroque. Only in a few of his major works, such as *The Burghers of Calais* and *The Gates of Hell*, did he begin to explore new space concepts (figs. 122, 126).

The twentieth century has continued, in one form or another, most of the sculptural-spatial tendencies already discussed. But modern experimental sculptors have also made fundamental new departures, particularly in sculpture as construction or assemblage, in experiments with new materials, and in the exploration of sculpture as shaped space rather than as mass existing in surrounding space. In addition, partly as a result of influence from primitive and archaic art, there has been a contrasting abandonment of full spatial organization for a return to frontality and monumentality achieved through simplified masses.

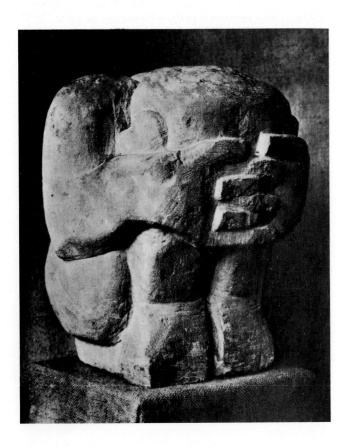

The Ongoing Figurative Tradition

Auguste Rodin, his reputation increasing until by the time of his death it had become worldwide, lived until 1917. Aristide Maillol did not die until 1944, and continued to be a productive sculptor until his death. Antoine Bourdelle lived until 1929. Charles Despiau until 1946. The figurative tradition of these masters was, as we saw in Chapter 6, reinforced by the growing recognition accorded the sculpture of Edgar Degas. Despite revolutionary new experiments being carried on by Cubist and abstract sculptors, the figurative tradition continued to dominate the scene in every part of Europe and the United States, waning for a time between the two world wars, but gaining in strength once more after the end of World War II. Among the twentieth-century painter-sculptors, Matisse depicted the human figure throughout his life, while Picasso began to desert naturalistic representation with a group of primitivist woodcarvings, dated 1907, in which the influence of Iberian or archaic Greek and black African sculpture is even more explicit than in his paintings of that year. Also in 1907, Derain carved in stone a *Crouching Man*, transformed into a single block of stone—a startling example of proto-Cubist sculpture (fig. 176).

HENRI MATISSE The late David Smith, one of the outstanding American sculptors of the twentieth century (figs. 608–610), frequently contended that modern sculpture was created by painters. Although this cannot be taken as literally true, given the achievements of Rodin, Brancusi, Duchamp-Villon, and Lipchitz, certainly major contributions to sculpture were made by such painters as Degas, Renoir, Picasso, Modigliani, and Matisse. In his approach to the problem of sculptural space, Matisse frequently adhered to the Renaissance, wherein the spatial existence of the work is established by its twisting pose. This can be seen in his very first attempt at sculpture, made under the influence of Antoine-Louis Barye, the nineteenth-century *animalier*. Here Matisse made a free copy of a Barye jaguar, with the beast organized in a writhing, twisting pose of great tension. He also studied for a time with Bourdelle (fig. 133), and was strongly influenced by Rodin, then at the height of his powers and reputation. Matisse's *The Serf* was begun in 1900, but not completed until 1903 (fig. 177). Although sculptured after a well-known male model, Bevilacqua, who had posed for Rodin, it was adapted in attitude and concept (although on a reduced scale) from Rodin's *Walking Man*. It is interesting to note that in *The Serf* Matisse carried the Expressionist modeling of the surface even further than Rodin.

Aside from the great Fauvist figure compositions seen in Chapter 7, Matisse in the years between 1905 and 1910 was studying the figure in

176. ANDRÉ DERAIN. *Crouching Man*. 1907. Stone, 13 × 11". Galerie Louise Leiris, Paris

left: 177. HENRI MATISSE. *The Serf.* 1900–1903. Bronze, height 36″. Hirshhorn Museum and Sculpture Garden, Smithsonian Institution, Washington, D.C.

above: 178. HENRI MATISSE. *Reclining Nude, I.* 1907. Bronze, 13½ × 19¾″. Collection, The Museum of Modern Art, New York. Acquired through the Lillie P. Bliss Bequest

right: 179. HENRI MATISSE. *La Serpentine.* 1909. Bronze, height 22¼″; base 11 × 7½″. Collection, The Museum of Modern Art, New York. Gift of Abby Aldrich Rockefeller

every conceivable pose and in every medium—drawing, painting, linoleum cut, and lithography, as well as sculpture. Although he would use a number of media for the same or similar pose, he revealed his awareness of their separate properties. Thus his linoleum cuts, perhaps influenced by the woodcuts of Gauguin, have a harsh, primitive quality entirely different from the grace and sophistication of the drawings and lithographs. The sculpture entitled *Reclining Nude, I* (fig. 178) is the most successful of the early attempts at a reclining figure integrated with surrounding space through its elaborate, twisting pose, a problem the artist, working under the influence of African sculpture, would resolve to dramatic effect in *The Blue Nude* (plate 36). Matisse was to experiment over the years with a number of variants of this "Venus" figure, generally more simplified and geometrized. The most delightful expression is seen in *La Serpentine* (fig. 179), where Matisse used extreme attenuation and distortion to emphasize the boneless relaxation with which the young girl drapes herself over the pillar. This is a work obviously related to the swirling figures of *The Dance* (plate 41).

A year earlier, he had tried his hand at a very different kind of sculptural arrangement, in the small *Two Negresses* (fig. 180), which consists of two figures standing side by side, one front view, and the other, back view. Although it may have some connection with Early Renaissance exercises in anatomy in which Pollaiuolo and others depicted athletic nudes in front and back veiws, there is a closer connection with some frontalized examples of primitive, specifically African sculpture.

The exploration must have intrigued Matisse since it led him to his most ambitious excursion in sculpture, the first of the four great Backs, executed c. 1909 (fig. 181). This work, more than six feet high, is a development of the theme stated in *Two Negresses*, now translated into a single figure in bas-relief, seen from the back. It is modeled in a relatively representational manner, freely expressive in the modulations of a muscular back, and it reveals the feeling Matisse had for sculptural form rendered on a monumental scale. *Back, II* is simplified in a man-

180. HENRI MATISSE. *Two Negresses.* 1908. Bronze, height 18¼″. Hirshhorn Museum and Sculpture Garden, Smithsonian Institution, Washington, D.C.

Jeannette, III, Jeannette, IV, and *Jeannette, V* (fig. 184), he worked from his imagination in an progressive process of Cubist, African-inspired transformation of the human head, first into an Expressionist study exaggerating all the features and then into a geometric organization of features in the mass of the head. Picasso had produced his Cubist *Head of a Woman* in 1909 (fig. 217), and this work may have prompted Matisse's experiments.

WILHELM LEHMBRUCK (1881–1919) With the exception of such older masters as Maillol and Despiau, the tradition of Realist or Realist-Expressionist sculpture flourished more energetically outside France than inside, after 1910. In Germany the major figure was Wilhelm Lehmbruck who, after an academic training, turned for inspiration first to the Belgian sculptor of miners and industrial workers, Constantin Meunier (1831–1905), and then to Rodin. The principal single influence on his sculpture was probably Maillol, although during the four years he spent in Paris (1910–14), he became acquainted with Matisse, Constantin Brancusi, and Alexander Archipenko. A *Standing Woman* of 1910 (fig. 185), in which the drapery is knotted above the knees in a formula derived from Greek Classical sculpture, illustrates the immediate impact of Maillol, as well as of antiquity. The details of the face are somewhat blurred, in a manner that Lehmbruck may have learned from the study of the fourth-century Greek sculpture of Praxiteles. This treatment gives the figure a peculiarly withdrawn quality, a sense of apartness and of inward contemplation, recalling not only the Praxitelean mode but also some of the mystical Madonnas of Gothic sculpture. It is eminently probable that all these elements—Classical, Gothic, and modern—went into Lehmbruck's sculpture. Another important influence was the Belgian sculptor George Minne (1866–1941), who was associated with Symbolism and Art Nouveau. The immediate ancestor of Lehmbruck's later style, seen in *Kneeling Woman* (fig. 186), was undoubtedly Minne's attenuated *Kneeling Figure*, which in 1898 the artist expanded in a group of figures for a fountain (fig. 187).

The emotional power of Lehmbruck's work comes not from his stud-

ner reflecting the artist's interest in Cubism at this time, and *Back, III* (fig. 182) is so reduced to its architectural components that it becomes almost a work of abstract sculpture. Here, as in *The Blue Nude*, Matisse would seem to have made a synthesis of African and Cézannesque elements, this time, however, in order to acknowledge, as well as resist, the formal discoveries made by the Cubists.

Matisse's other major effort in sculpture was the series of Jeannette heads. *Jeannette I* and *Jeannette II* (fig. 183) are direct portraits done from life in the freely expressive manner of late Rodin bronzes. But with

far left: 185. WILHELM LEHMBRUCK. *Standing Woman*. 1910. Bronze (cast in 1916–17, from an original plaster), height 6′3⅛″; base diameter 20½″. Collection, The Museum of Modern Art, New York. Given anonymously

center left: 186. WILHELM LEHMBRUCK. *Kneeling Woman*. 1911. Cast stone, height 69½″; base 56 × 27″. Collection, The Museum of Modern Art, New York. Abby Aldrich Rockefeller Fund

above: 187. GEORGES MINNE. *Fountain of Kneeling Figures*.1898–1906. Marble. Folkwang Museum, Essen, West Germany (transferred from Folkwang Museum, Hagen)

left: 188. GEORGE KOLBE. *Standing Nude*. 1926. Bronze, height 50½″. Walker Art Center, Minneapolis

below: 189. ERNST BARLACH. *The Avenger*. 1914. Bronze, width 23″. Hirshhorn Museum and Sculpture Garden, Smithsonian Institution, Washington, D.C.

ies of the past but from his own sensitive and melancholy personality, from the suffering that finally, in 1919, led him to suicide. Lehmbruck's surviving works are not many, but three or four of them, at least, are of the first importance. The *Kneeling Woman*, like the other mature works, is a sculpture in which the artist utilized the most extreme distortion of elongation—possibly suggested by figures in Byzantine mosaics and Romanesque sculpture, as well as by Minne's fountains. In Lehmbruck's hands it carried the sense of contemplation and withdrawal expressed in the *Standing Woman* still further. The *Kneeling Woman*, despite elongation that might be regarded as grotesque, is a figure of the most delicate, feminine grace. Her inclined head with shadowed eyes is that of a medieval saint, and her delicately posed hands have all the elegance of a figure by Watteau.

GEORG KOLBE (1877–1941) The human figure was so thoroughly entrenched as the principal vehicle of expression for sculptors after some six thousand years, that it was even more difficult for sculptors to depart from it than for painters to depart from landscape, figure, or still life rendered in the tradition of illusionistic space. It was also difficult for sculptors, while adhering to the subject of the recognizable figure, to say anything new or startlingly different from what had been said at some other point in history.

The other leading German sculptors of the early century were Georg Kolbe, Ernst Barlach, Käthe Kollwitz, and Gerhard Marcks. Kolbe began as a painter and, influenced by Rodin, changed to sculpture. In his works were combined the formal aspects of Maillol's figures with the light-reflecting surfaces of Rodin's. After some essays in highly simplified figuration, Kolbe settled into a charming formula of rhythmic nudes, appealing but essentially reiterating a Renaissance formula with a Rodinesque broken surface (fig. 188).

ERNST BARLACH (1870–1938) Barlach embodied influences from Russian peasant art with aspects of medieval German sculpture and some of the superficial forms of Cubist sculpture, all for an essentially

narrative purpose. He was capable of sculptural organizations of sweeping power and the integration of the single gesture of humor and pathos and primitive tragedy, as in *The Avenger* (fig. 189). His was still a storytelling art, however, a kind of socially conscious Expressionism that used the outer forms of contemporary experiment for a traditional narrative. Barlach was also a printmaker of some distinction, an exponent of the more explicit stream of German Expressionist graphic artists, who were given to forms of exaggerated emotion.

190. KÄTHE KOLLWITZ. *Mother and Child (Pietà)*. c. 1917, cast after 1954. Bronze, height 28½″. Hirshhorn Museum and Sculpture Garden, Smithsonian Institution, Washington, D.C.

191. KÄTHE KOLLWITZ. *Self-Portrait*. 1936. Bronze, height 15¼″. Hirshhorn Museum and Sculpture Garden, Smithsonian Institution, Washington, D.C.

KÄTHE KOLLWITZ Käthe Kollwitz—even better known for her graphics (fig. 166)—was capable of just as exaggerated expression, but with a difference. Her intense emotionalism, whether for a cause, or in memory of her son killed in World War I, arose from a profoundly felt grief that transmitted itself to her sculpture and prints. Her *Mother and Child* (fig. 190) is the passionate cry of a suffering mother, expressed in a sculpture that is a compact, massive structure of figures that melt into one another. Her *Self-Portrait* (fig. 191) is a beautiful characterization of a homely peasant face that has suffered and become beautiful through the understanding and acceptance of suffering.

CONSTANTIN BRANCUSI (1876–1957) In France, during the early years of the twentieth century, the most individual figure—and one of the greatest sculptors of the century—was Constantin Brancusi, born in Rumania, the son of peasants. In 1887 he left home and worked for a time at odd jobs. Between 1894 and 1898 he was apprenticed to a cabinetmaker and studied in the provincial city of Craiova. Between 1898 and 1902 he continued his studies at the Bucharest Academy of Fine Arts. Then in 1902 Brancusi departed for Paris by way of Germany and Switzerland, finally arriving in 1904. After further studies at the École des Beaux-Arts under the sculptor Mercié, he began exhibiting, first at the Salon de la Nationale and then at the Salon d'Automne. Rodin, impressed by his contributions to the 1907 Salon d'Automne, invited him to become an assistant. Brancusi refused with the classic remark, "Nothing grows under the shade of great trees."

The sculpture of Brancusi is in one sense isolated, in another universal. He worked with few themes, never really deserting the figure, but he touched, affected, and influenced most of the major strains of sculpture after him. From the tradition of Rodin came the figure *Sleep* (fig. 192), in which the shadowed head sinks into the matrix of the marble, after the manner of late studies by that master. The theme of the Sleeping Muse was to become an obsession with Brancusi, and he played variations on it for some twenty years. In the next version (fig. 193), and later, the head was transformed to an egg shape, with the features lightly but sharply cut from the ovoid mass. As became his custom with his basic themes, he presented this form in marble, bronze, and plaster, almost always with slight adjustments that turned each version into a unique work.

In a subsequent work, the theme was further simplified to a teardrop shape in which the features largely disappeared, with the exception of an indicated ear. To this piece he gave the name of *Prometheus* (1911). The form in turn led to *The Newborn* (fig. 194), in which the oval volume is segmented in an indication of the screaming, gaping mouth of the infant, and finally to his ultimate return to the egg in the polished shape entitled, most appropriately, *The Beginning of the World*, which he also called *Sculpture for the Blind* (fig. 195).

This tale of the egg was only one of a number of related themes that Brancusi continued to follow, with a hypnotic concentration on creation, birth, life, and death. The influence of Cycladic and archaic Greek sculpture is evident in the *Girl's Head*, done 1907–8, at about the same time when the idea of a strange, goggle-eyed head inclined from a long and sinuous neck, began to appear. This form was developed further in

left: 192. CONSTANTIN BRANCUSI. *Sleep*. 1908. Marble, height 10¼".
National Gallery, Bucharest

left middle: 193. CONSTANTIN BRANCUSI. *Sleeping Muse*. 1909–10.
Marble, height 11½". Hirshhorn Museum and Sculpture Garden,
Smithsonian Institution, Washington, D.C.

left below: 194. CONSTANTIN BRANCUSI. *The Newborn*. 1915. Marble,
height 5⅝". Philadelphia Museum of Art. Louise and Walter
Arensberg Collection

above: 195. CONSTANTIN BRANCUSI. *The Beginning of the World*.
c. 1920. Marble, height 7". Norton Simon Museum of Art,
Fullerton, California

left: 196. CONSTANTIN BRANCUSI. *Mlle. Pogany*. 1931. Marble, height 17¼". Philadelphia Museum of Art

right: 197. CONSTANTIN BRANCUSI. *Torso of a Young Man*. 1917. Polished bronze, height 18¼". Hirshhorn Museum and Sculpture Garden, Smithsonian Institution, Washington, D.C.

below left: 198. EDWARD WESTON. *Shells*. 1927. Gelatin-silver print. Photographed by Edward Weston ©1981. Arizona Board of Regents, Center for Creative Photography

below right: 199. CONSTANTIN BRANCUSI. *The Kiss*. 1912. Limestone, height 23". Philadelphia Museum of Art. Louise and Walter Arensberg Collection

a number of drawings and paintings, and then materialized in the many variations on the *Mlle. Pogany* in marble and polished bronze (fig. 196). The *Torso of a Young Man* went as far as Brancusi ever did in the direction of precise cylinders, but still remains a phallic symbol (fig. 197).

An artist who shared Brancusi's quest for the essence of things and discovered it in images of remarkable purity and cool elegance was the American photographer Edward Weston (1886–1958). Indeed, Weston's picture of a gleaming nautilus shell, set against a velvet-black ground, seems to be nature's own organic response to the formal perfection of *Mlle. Pogany* (fig. 198). Here the photographer truly achieved his goal of a subject revealed in its "deepest moment of perception." By controlling form through his selection of motif, exposure time, and use of the ground-glass focusing screen of a large-format camera, Weston could previsualize his prints and, without resorting to extraphotographic devices, eliminate the random effects of light, atmosphere, and moment. In this way he created a timeless image, left behind the Pictorialism of earlier aesthetic photography, and entered the mainstream of modern art.

The subjects of Brancusi were so elemental and his themes so basic that, although he had few direct followers, nothing that happened subsequently in sculpture seems foreign to him. *The Kiss* is the ancestor of much Cubist sculpture (fig. 199). The artist was particularly obsessed with birds and the idea of flight, which he progressively explored in the bird forms *Maiastra* (1912), *Bird* (1915), and *Bird in Space* (1919), in which the image of the bird became the abstract concept of flight (plate 60).

The art of Brancusi encompassed the nature of materials in all its manifestations. He finished his bronzes and marbles to a degree of perfection rarely seen in the history of sculpture. At the same time he placed these polished shapes on roughly carved stone pedestals, or on bases hacked out of tree trunks, in order to attain a mystical fusion of disembodied light-reflecting surfaces and solid, earthbound mass. In his wood sculptures, although he occasionally strove for the same degree of finish—as in the *Cock* (1924), where the polished, stepped shape seems to give form to the repeated cock's crow—he more normally worked for a primitive, roughed-out totem, as in the *King of Kings* (fig. 200), where the great regal shape based on the forms of a massive old wine press expressed with tremendous authority the spirit of primitive Oriental religion.

Brancusi was a man who sought absolutes but who wished to be as a child. He himself said, "All my life I have sought the essence of flight. Don't look for mysteries. I give you pure joy. Look at the sculptures until you see them. Those nearest to God have seen them."

200. CONSTANTIN BRANCUSI. *King of Kings*. Early 1930s. Wood, height 9'10".
The Solomon R. Guggenheim Museum, New York

Cubism

In 1908 a witty but dumbfounded Matisse christened the momentous phenomenon known as Cubism when, after viewing the recent, startlingly Cézannist works of Georges Braque, he grumbled to the critic Louis Vauxcelles that the last artist lured into Fauvism had begun composing pictures of nothing but *petits cubes*. And indeed, by the time Vauxcelles wrote about Braque's *bizarreries cubiques* (plate 64), the young painter had already formulated the essential syntax of Cubism, the most revolutionary new pictorial language to appear since the Renaissance. To Matisse's discomfort, this was the consequence of an intensive analysis not of Cézanne's mastery of color-form but rather of the structural armature underlying it, an analysis made by Braque working alone.

Thenceforth, however, Cubism would evolve as a genuine collaborative effort. Joining Braque in 1909 was the Spaniard Pablo Picasso, who brought to their common experiment the galvanic energy and godlike powers of invention that, more than anything else, transformed Cubism into the indispensable *lingua franca* of modern art for over half a century. Together, the two painters so reconceived pictorial space as to shatter the four-hundred-year-old conventions of Renaissance perspective, already long threatened by the friezelike compositions first adopted by David (fig. 2). Breaking up the ancient system's fixed, unitary, hierarchical focus into democratically multiple perspectives, they created a mixed or composite image, presented as if viewed from many different angles at once. And so at the same time that Cubism reflected a subtle and knowing grasp of human perception, with its reliance on more than a single glance, Braque and Picasso also introduced into the static world of painting the sense of a new, fourth dimension: time. Thrillingly contemporary as all this may sound, it had an effect infinitely more disturbing than anything produced by the Fauves. While the latter had seemed "wild" enough in their dislocating use of color, they otherwise left the human figure intact. Now, however, the Cubists began slicing it up into the same planar components used to realize every other aspect of the picture, and then reshuffling the shards into structures far more faithful to the painting's own internal laws than to the laws of external reality. With this, Braque and Picasso also set the stage for transforming Cubism into a totally objective or Constructivist form of abstraction. But just as the Fauves allowed other, still more subjective painters—mostly non-French—to extend their innovations into pure color abstraction, the pioneer Cubists found their own art to be too "drenched in humanity" to sever all links with sensuous life. Therefore, a Cubist painting by Braque or Picasso hovers between autonomy as an object, a two-dimensional surface, and allusion to the three-dimensional realm of observation. A tense and tantalizing equivocation, Cubism transcended its reputation as a rational or classical alternative to the romantic intuitiveness of Fauvism to become a language of such flexibility and force that it could express everything from the Utopian aspirations of De Stijl to the psychosexual dreams of the Surrealists.

PABLO PICASSO (1881–1973) The most remarkable phenomenon of twentieth-century art is Pablo Ruiz y Picasso, in terms of whose achievements a large part of the period's history could be written. Born in Málaga, Spain, he participated in most art movements since the end of the nineteenth century, and himself created many of them. Picasso's father was an artist and art teacher, and Picasso grew up in an environment of art and artists. He received most of his training in Barcelona, then as now the most internationally aware and intellectually stimulating city in Spain. Picasso had, like all his young colleagues, a passionate ambition to go to Paris, and in the year 1900 he made his first excursion. Even before this time he had demonstrated considerable talent and prodigious technical accomplishment as he experimented with various styles, from that of academic Realism to Toulouse-Lautrec and Art

201. PABLO PICASSO. *The End of the Road.* c. 1898. Watercolor and Conté crayon, 17⅞ × 11¾". Thannhauser Collection, New York. Courtesy Thannhauser Foundation

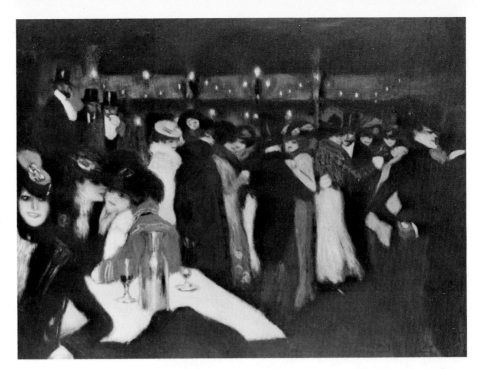

202. PABLO PICASSO. *Le Moulin de la Galette*. 1900. 35½ × 46″. Thannhauser Collection, New York. Courtesy Thannhauser Foundation

Nouveau. A small painting, *The End of the Road* (fig. 201), executed in Barcelona around 1898, suggests, in the curving areas of flat color, influences from Gauguin and Art Nouveau. The theme of suffering—here, the aged and infirm totter up the path to the gateway where the angel of death awaits—was one with which he was to be concerned for a number of years. The rather self-conscious social commentary and heavy-handed symbolism in the contrast of the wealthy in their carriages and the poverty-stricken on foot moving toward the same destination stems from the revolutionary spirit of the Barcelona of his youth.

In Paris in 1900 Picasso became conversant with the Old Masters in the Louvre, as well as with Classical and pre-Classical sculpture. He saturated himself in the work of the vanguard, the Impressionists and Post-Impressionists. *Le Moulin de la Galette* (fig. 202), his first important painting in Paris, may have been suggested by Renoir's famous version of 1876 (plate 11), where the closely packed patterns of the figures and contrasting lights and darks in the constricted space of the club seem comparable to those in Picasso's painting done a quarter of a century later. Yet nothing could be further apart in spirit than these two works. The scene by Renoir is all light and innocent gaiety, a party of the artist and his friends. Picasso, obviously fascinated by Toulouse-Lautrec's interpretations of Paris nightlife (fig. 72), translates it into a dark and glowing assemblage of the demimonde as seen through the romantic eyes of a boy only recently arrived in the big and wicked city. It is a startling production for a nineteen-year-old.

During the next two or three years Picasso experimented with various styles, assimilating the influences of the Impressionists, of Degas, Gauguin, and the Nabis. Between 1901 and 1904 he used, in many paintings, a predominantly blue palette for the portrayal of figures and themes expressing suffering—frequently hunger and cold, the hardships he experienced while attempting to establish himself. Several times he was forced to return home for lack of funds, but each time Paris drew him back. The misery of those years as well as a deep-seated sympathy for the suffering of others is superbly expressed in *Woman Ironing* (plate 61), its motif descended from a number of studies that Degas made of poor working women and presented with deep understanding of their unhappy condition. Picasso, however, carries the theme far beyond sympathy and understanding, to make of this emaciated, desperately exhausted woman a symbol of all the underprivileged

and exploited. The painting cannot, of course, be separated from its subject, but the elongated, angular figure, probably reflecting some influence from El Greco, is beautifully integrated into the surrounding space, both in terms of the drawing and of the unified, neutral colors of gray, blue, and ocher.

203. PABLO PICASSO. *La Toilette*. 1906. 59½ × 39″. The Albright-Knox Art Gallery, Buffalo

204. PABLO PICASSO. *Gertrude Stein*. 1905. 39¼ × 32″. The Metropolitan Museum of Art, New York. Bequest of Gertrude Stein, 1946

In 1904 Picasso moved into the famous (or infamous) tenement on Montmartre dubbed the Bateau-Lavoir ("laundry boat"), and here he lived until 1909 in the midst of an ever-growing circle of friends: painters, poets, actors, and critics, including the devoted Max Jacob, who was to die in a Nazi concentration camp, and Guillaume Apollinaire, who was to become the literary apostle of Cubism. Between 1905 and 1907 the melancholy of the artist lightened and took on a romantic quality in his so-termed Rose period. During 1905 his subjects were largely circus performers, following a tradition established by Seurat and Toulouse-Lautrec. For Picasso, however, the interest again lay in the performers seen off guard, without the glamour, as rather pathetic individuals. Most of these paintings are drawings of figures set before a generalized background created out of a few broad tones of rose and blue, colors from which the figures themselves are also constructed (plate 62). Thus they do not represent any remarkable innovations but simply exist as romantic paintings, executed with consummate skill and sensitivity, superbly drawn, and reflecting in a general sense the experiments that had been carried on by the previous generation of Impressionist and Symbolist painters.

An important change began to take place in the latter part of 1905, as Picasso entered his first Classical phase. In *La Toilette* of 1906 (fig. 203), the figures have taken on an aura of beauty and serenity that suggests a specific influence from Greek white-ground vases. The element of pathos has disappeared, and we have what is in the truly Classical sense a composition of two figures, draped and undraped, enclosed in a limited depth and organized in harmonious relation to each other as well as to the space they occupy. Compared with the Classical compositions of Puvis de Chavannes, at which the artist unquestionably had looked (fig. 61), this is a work of a freshness and serenity, closer to the

spirit of Athens in the fifth century B.C. than anything by Puvis or by the generations of academic Neoclassicists who had sought so assiduously to recapture a lost ideal.

The first Classical period was only a transitional moment interrupted by excursions into expressive angularity suggestive of El Greco. It was a moment of great importance, however, in the sense that the influence of Greek sculpture and vase painting must have assisted in the artist's re-evaluation of Renaissance space concepts. This generally sculptural-relief approach was accentuated by his "discovery" of pre-Roman Iberian sculpture, in terms of which he made his first essays into a kind of sculptural primitivism. The portrait of Gertrude Stein (fig. 204), with which he struggled before he left for Spain in 1906, having the subject sit for as many as ninety-two sessions, and the face of which he repainted from memory on his return, is perhaps the first document in a series that transformed the course of twentieth-century painting, and even of sculpture. Although Picasso and Matisse probably met in 1905, the younger artist was not drawn into the orbit of the Fauves and their coloristic revolt. Up to this point he had not exhibited at the Salon d'Automne or the Salon des Indépendants. In fact, he was still living as a provincial in Paris among his fellow nationals and still-unrecognized poets and critics. Thus he was able to go his own way and to introduce into modern painting elements foreign to the ideas and approaches of the artists who had grown up in the French tradition. It must never be forgotten that Picasso was born a Spaniard and always remained one. Gertrude Stein, strongly modeled and painted in dark tones with glowing underpainting, fills her corner of space like some powerful, massive work of sculpture. The repainted face is given a stylized, masklike character that anticipates the primitivism of the next few years. *Two Nudes* (fig. 205) marks the extreme point of heavy, primitive, sculptural modeling in which the figures begin to take on a certain geometric angularity and the faces a raw, plastic simplicity that not only reflects further influence from pre-Christian Iberian sculpture, but also reveals a bent toward conceptual form of the sort that Picasso would find in African sculpture. In his colors the artist had moved away from rose pink and light blue to a more austere formula of yellow ochers and brick reds, suggestive of the colors of ancient painting.

Although his paintings were not immediately influenced by it, Picasso must by this time have been affected by the Fauve exhibition in the 1905 Salon d'Automne; and there seems to be no doubt that he was strongly moved by the gallery of Cézanne's paintings shown at the same Salon, as well as by the Cézanne exhibition in 1906, the year of the old master's death, and the retrospective of 1907 at the Salon d'Automne. These exhibitions, in fact, exercised a definitive influence on a large number of the younger experimental artists who were then working in Paris. The various influences were consolidated in the spring of 1907 with the production of Picasso's first masterpiece, *Les Demoiselles d'Avignon* (plate 63). The idea for this large figure study may have been generated by the example of Matisse who, between 1905 and 1907, was engaged in his own series of figure studies. *Joy of Life*, as we saw (fig. 145), came forth as a climactic evocation of Western humanity's ancient dream of the Golden Age, a prelapsarian realm innocently hedonistic and free of guilt, which Matisse symbolically recovered for the modern world by virtue of the serene boldness with which he declared his freedom from the puritanical constraints of worn-out pictorial conventions. Moved by this example of one remarkable painter's epic, summary view of life and art, as well as by the model Matisse had found in Cézanne's *Large Bathers* (plate 19), the twenty-six-year-old Picasso marshaled his legendary energies and unleashed them upon his own heroic enterprise. They poured into a vast painting that would reach well beyond

Matisse and Cézanne to draw on sources so numerous, disparate, and shockingly alien that the artist would never, despite herculean efforts, resolve them into a unified whole. Instead, Picasso abandoned the picture in what seemed to be an unfinished state, like "a battleground of trial and experiment," as Alfred Barr would unforgettably characterize *Les Demoiselles d'Avignon*. Yet, for all its violently obvious inconsistencies of style, or indeed because of them, the painting now seems inevitable, a work so powerful that it simply created its own rules and aesthetic criteria, totally unrelated to traditional concepts of beauty and completeness. And this is as it should be, for, as recent scholarship has revealed, Picasso met the challenge of Matisse's *Joy of Life* by countering that monumentally halcyon picture with its antithesis, a volcanic and deeply personal expression of the world as a shambles, a postlapsarian place populated by guilt-ridden humanity confronting the horror of its own inevitable demise. After the sensible, reflective Braque saw the *Demoiselles*, he confessed that the picture "made [me] feel as if someone were drinking gasoline and spitting fire."

For many years, however, beginning in the 1930s, the *Demoiselles* impressed some of the most perceptive and informed critics as "a tran-

205. PABLO PICASSO. *Two Nudes*. 1906, late. 59⅝ × 36⅝". Collection, The Museum of Modern Art, New York. Gift of G. David Thompson in honor of Alfred H. Barr, Jr.

sitional picture," albeit one of watershed importance, because it was deemed to have ushered in, "cataclysmically," the development of Cubism. The seeds of this momentous style seemed to lie in, for example, the shallow, sealed space, the anatomical deformations that put profile noses on frontal heads or a full-front eye on a profile face, and the fracturing of the total field, figures and background alike, into an overall network of jagged edges and tilting planes. Meanwhile, the fevered search for reasons to consider the *Demoiselles* "the first Cubist picture" obscured the fact that the sheer savagery of both its images and its handling make the picture more an outburst of Expressionist feeling than an early manifestation of Cubism's calm, thoughtful procedures and intellectual content. Along the way, however, repeated and intensive analyses of the work did reveal the rich array of sources that Picasso drew on to create this most complex of paintings, ranging from archaic Iberian sculpture, Greek vase painting, and Egyptian art through the angular forms and harsh white highlights of El Greco to Gauguin's primitivism, the "Negro" art of Africa, and what Picasso saw as "Cézanne's anxiety." Since the critical approach was mainly formal, the all-too-evident antagonism among these various elements often seemed a "problem," left unresolved and barely held in tension by the force of Picasso's own artistic personality.

Finally, however, as the Picasso estate posthumously released a number of previously unknown sketches for the *Demoiselles*, it became apparent that the picture could be best understood in terms of its genesis in an autobiographical allegory of innocence and experience. The two scholars most actively engaged in the reassessment of the *Demoiselles* are Leo Steinberg and William Rubin, who by rediscovering much of the artist's primary impulse, along with the chronology and processes of his work, have also revealed a potent content never before fully appreciated. While the overall consequence of this may now be the removal of the *Demoiselles* from the canon of Cubist art, it also solves the problem of form or style and reconfirms the inherent splendor of the painting by disclosing the expressive rightness of its own internal conflicts.

That Picasso undertook the *Demoiselles* in a heightened state of anxiety and ambition is known from the eyewitness account of the poet André Salmon, who wrote:

> Picasso was unsettled. He turned his canvases to the wall and laid down his brushes.... During the long days and as many nights, he drew, giving concrete expression to abstract ideas and reducing the results to their fundamentals. Never was a labor more arduous, and it was without his former youthful enthusiasm that Picasso began on a great canvas that was to be the first result of his researches.

Among the first drawings the artist did in preparation for the "great canvas" is the one seen in Figure 206, executed during the early spring of 1907. It is a compositional study showing the reception room in a brothel, with a clothed sailor at the center surrounded by five variously posed nude women, the scene entered from the left by a male medical student, clothed and carrying a book, which in earlier sketches had been a skull. Here, somewhat in the righteous spirit of the artist's earlier work, would seem to be a *vanitas, memento mori*, or morality tale of one young man seeking pleasure at the risk of contracting disease, only to be promised a cure with the arrival of the second young man. As the preparatory phase continued, Picasso clearly wanted to move beyond the numbing clichés of his old narrative mode and allow his theme the dignity of embodiment in a more direct or symbolic image. The shift can be seen in the watercolor produced in figure 207, where only the nudes remain, the male at the center having been eliminated

206. PABLO PICASSO. *Study for Les Demoiselles d'Avignon*. 1907. Charcoal and pastel, 18⅞ × 25. Kunstmuseum, Basel

207. PABLO PICASSO. *Study for Les Demoiselles d'Avignon*. 1907. Watercolor, 6⅝ × 8¼″. Philadelphia Museum of Art. A. E. Gallatin Collection

altogether and the one on the left transformed into a female before conflation with the nude who originally stood next to him. It was this conception that then went onto the canvas in a flattened, geometricized version of the Iberian style seen in *Two Nudes*. And with that, Picasso concluded his first "campaign" of work on the *Demoiselles* in May or June of 1907.

Evidently dissatisfied with "the first results of his researches," which would have had all the women look like the two sloe-eyed pink seductresses now at the center of the *Demoiselles*, Picasso seems to have cast about for an expressive or plastic means capable of reinvesting the picture with some of the moral and psychological implications lost when he suppressed the sailor and medical student, thereby transforming his conception from an essentially anecdotal image into a more iconic one. It was in this state of eagerness for new solutions that the artist made his

own "discovery" of black African sculpture, an exotic kind of art he already knew about from Matisse and others, but which seems not to have meant much to him until June 1907, when he made his historic visit to Paris's old Musée du Trocadéro. There, upon beholding the tribal masks and "fetishes" in the ethnographic collection, he experienced a revelation—a genuine epiphany. "At that moment," Picasso said, "I realized what painting was all about." The "shock" of this recognition was still with him in 1937, when he declared to André Malraux:

> The masks weren't just like any other pieces of sculpture. Not at all. They were magic things.... The Negro pieces were *intercesseurs*, mediators.... They were against everything—against unknown, threatening spirits. I always looked at fetishes. I understood; I too am against everything. I too believe that everything is unknown, that everything is an enemy! Everything!... I understood what Negroes use their sculptures for. They were weapons. To help people avoid coming under the influence of spirits again, to help them become independent. They're tools. If we give spirits a form, we become independent. Spirits, the unconscious (people still weren't talking about that much), emotion—they're all the same thing. I understood why I was a painter. All alone in that awful museum, with masks, dolls, made by the redskins, dusty mannekins. *Les Demoiselles d'Avignon* must have come to me that day, but not at all because of the forms; because it was my first exorcism painting—yes absolutely.

Thus shaken and illuminated, Picasso returned to the *Demoiselles* canvas with regenerated, even ferocious, vitality for a second and final campaign of painting, designed, as Rubin has pointed out, to recapture the project's original meaning through the medium of style rather than narrative illustration, and recapture it on a more profound, if more generalized, level consistent with the "iconic" form the painting had already assumed. He would do this by introducing into the picture a range of different types of figuration, to evoke one man's darkening insights into the nature of femininity, from the allure of the fair-skinned Iberian demoiselles at the center, their arms raised in the Venus pose favored by Cézanne and Matisse (fig. 178), through the mystery of the dusky, rather Gauguinesque primitive on the left to the demonic, gash-faced African witches on the right. In this way an artist who is known to have frequented prostitutes (especially in Barcelona's Correr d'Avigno, or Avignon Street, which accounts for the title given the picture by a close associate) objectified what Steinberg has called his "trauma of sexual encounter" and what Rubin believes to have been Picasso's *femme fatale* fixation, well known from earlier art for its schizoid view of women as virgins or vampires, as the givers of life or the dealers of death. For Rubin, the "barbaric" character of Picasso's "African" faces conjures "something that transcends our sense of civilized experience, something ominous and monstrous such as Conrad's Kurtz discovered in the heart of darkness."

Thus when the deeply superstitious Picasso discovered primitive or, more specifically, African sculptures, he was also discovering his own sense of their magic, objects made by people who believed that "if we give [threatening] spirits form, we become independent" or free of them. And as exemplified by the African masks, this function could clearly occur more effectively in reductive or ideographic, rather than descriptive, modes of representation. In the "ideographic" revisions he then imposed on the *Demoiselles*, Picasso spanned the polarity from Eros to Thanatos and thus exorcized the fear of his own mortality. By doing so through a radical shift from a perceptual to a conceptual way

of working, he expelled from his art the last vestiges of nineteenth-century painting, far beyond anything attempted by the contemporary Fauves, and cleared the path for the development of Cubism, without however actually pointing out the precise direction.

Although the emotional vehemence and rude plasticity of the *Demoiselles* could scarcely be more opposite to Cubism's cerebral concerns and the planar or pictorial elisions, one of the fundamental problems posed by the painting—how to represent significant content in a more direct, or symbolic, and less literary or descriptive fashion—were among those that Cubism would solve. Meanwhile, the fear and fantasy that Picasso dredged from his subconscious and projected onto the *Demoiselles* canvas, as if in a trance, anticipated the Freudian psychology and "automatic" strategies of Surrealism, as did the nightmarelike juxtaposition within the same space of previously unassociated images. But quite apart from all this, the painting constituted the major turning point in the career of Pablo Picasso, who would go on to become the most prodigious and influential artist of the twentieth century, and if for none of the other compelling reasons, this alone would make *Les Demoiselles d'Avignon* one of the two or three most important pictorial documents of its time or ours.

Picasso continued under the spell of Africa for the remainder of 1907 and throughout most of 1908, producing a series of Negro paintings that arrived like spinoffs from the generative matrix of the *Demoiselles*. In them he seemed intent upon exploring individually the main divergent trends he had forced to cohabit, however explosively, in the great experimental canvas. The first of the paintings present surface arrangements fragmented into all-over, active patterns of flat, angular planes differentiated by Fauve color and by striations and bold contouring. Increasingly, however, the artist found himself responding to tribal sculpture as abstract plastic mass. For the moment, this took him away from the problems of space that the incipient Cézannism of the *Demoiselles* suggested he had begun to approach. Along the way Picasso discarded color and resorted to an earthen monochrome, giving effect to static, ponderous images, some of which could almost be literal representations of Congolese masks and statuettes, although he never actually copied an African work. By the end of summer in 1908, which Picasso spent with Fernande Olivier near the French village of La Rue-des-Bois, the artist had begun to gain command of his unruly, disparate sources and from them to wrest a new and independent stylistic synthesis. In *Woman with a Fan*, for instance (fig. 208), the single seated figure—as iconic as anything in the *Demoiselles*—displays not only the brutally reductive look of African carvings, but also the stiff, frontal, or hieratic stance adopted by Cézanne for the portraits of his wife.

In arriving at such archetypal simplifications, Picasso found reinforcement in the living example of Henri Rousseau, Paris's aged master of pure, naïve, invention and direct pictorial clarity. No doubt already aware of the *Douanier* (so-called for the minor job Rousseau long held in the French customs service) from his work exhibited at the "Fauve" Salon of 1905, Picasso recognized the primitive master's inimitable hand when, in the spring of 1908, he came across an enormous female portrait in the shop of a Montmartre junk dealer. After buying the picture, he then held a banquet in honor of its proud creator. The party, staged in the Bateau-Lavoir, included Apollinaire, Max Jacob, Braque, Marie Laurencin, Maurice Raynald, Leo and Gertrude Stein, Fernande Olivier, and several critics of liberated spirit. It entered history as one of the century's most legendary avant-garde events. But Picasso seems to have responded to Rousseau less in his figural work than in the landscapes he executed at La Rue-des-Bois, with their toylike houses and schematic branches and boughs (fig. 209). And the shift in subject

208. PABLO PICASSO. *Woman with a Fan*. 1908. 59 × 39⅜". The Hermitage Museum, Leningrad

209. PABLO PICASSO. *Landscape, La Rue des Bois*. 1908. 39⅝ × 32". Collection, The Museum of Modern Art, New York. Gift of David Rockefeller

matter, away from the figure, was especially important for Picasso's development toward an ever-more abstract style, for at the same time that it moderated his native tendency to think sculpturally, it also challenged him to compose in terms of the entire pictorial field. Not only does landscape, by its infinite expanse, lend itself to a generalized, all-over configuration, but, as Cézanne learned, the painter can counteract traditional perspective merely by taking a high viewing angle. This raises the horizon line and tilts the ground plane toward the picture surface, which automatically transforms a space in depth to one in height. It also yields the greater information about the contents of the space that conceptualizing artists always seek. Having introduced this rational element into the handling of nature, the artist can go further and feel much freer in landscape to rearrange its relatively anonymous forms for purely aesthetic purposes. As the *Demoiselles* and *Woman with a Fan* prove—or indeed Matisse's *Blue Nude* (plate 36)—it is difficult to distort, segment, or "analyze" the human image, with all the immediacy of identification such a subject entails, and not generate an almost Expressionist sense of tension.

With a subject that encouraged boldly reductive but dispassionate pictorialization, Picasso found a largely aesthetic outlet for the wild African energies stirred up in the course of his work on the *Demoiselles*. Now, in the Rue-des-Bois landscape seen here, hard contours and aggressive, sculptural modeling gave way to the flatter effects of shading, applied with a much-softened, domesticated version of tribal striations.

210. ALVIN LANGDON COBURN. *Octopus.* 1913. Photograph. Courtesy the International Museum of Photography at George Eastman House, Rochester, New York

This alone yields a more cohesive relationship between form and space, which is needed, since the distances to be collapsed are much greater than those in figural subjects. The problem even inspired Picasso to make a tentative revival of the *passage* technique pioneered by Cézanne. This can be seen, for instance, in the foreground tree, where the crooked branch melds into the far horizon, thereby enabling the viewer to "read" the limb simultaneously as both withdrawing into depth and pulling depth forward. Also proto-Cubist is the restricted palette—almost monochrome—which permits the artist to avoid the isolating effects of local color and to differentiate planes by some element common to them all. This is chiaroscuro, with the lights and darks juxtaposed not as if caused by a fixed source of illumination, but arbitrarily, according to the artist's sense of how to realize the picture as the counterpart of a variable surface in low relief. Only rudimentary and nascent in the Rue-des-Bois works, this realization—and the true Cubism it brought—would not become fully formed in Picasso's art until a year later, after the Spaniard had experienced the more thoroughgoing interpretation of Cézanne made in the meantime by Georges Braque.

At this early stage of the modernist evolution toward advanced abstraction, the technique of viewing from above, for the sake of a more purely formal effect, was one that appealed to the period's experimental photographers, especially those, like Heinrich Kühn, seen in figure 160, and Britain's Alvin Langdon Coburn (1882–1966), determined to work in a "straight" manner, without artificial hand manipulation of negatives and prints (fig. 210).

GEORGES BRAQUE (1882–1963) Braque's father and grandfather were amateur painters, and as a boy the artist had been encouraged to draw, first in Argenteuil near Paris, and then in Le Havre, where he attended a night class at the École des Beaux-Arts. Following his father's and grandfather's trade, Braque was apprenticed as a house painter in 1899, and, at the end of 1900, he went to Paris to continue his training. It is at least conceivable that some of the decorative and trompe-l'oeil effects that later penetrated his paintings and collages were a result of the initial experience the artist had as a house painter-decorator. After a year of military service and brief academic preparation, Braque, in the summer of 1904, met Raoul and Jean Dufy at the village of Honfleur, on the Channel, and in the fall he set up his own studio in the French capital. Like all serious young artists in turn-of-the-century Paris, he studied the Old Masters in the Louvre and found himself drawn to Egyptian and archaic sculpture. A born Classicist, Braque felt a special identification with Poussin, which meant that he also continued his earlier devotion to Corot. Meanwhile, he discovered the Impressionists, along with Gauguin and, especially, Van Gogh and Seurat. In the year 1905, perhaps through Dufy and Friesz, both fellow artists from Le Havre, he gradually became aware of Matisse and the new paintings of the Fauves. Owing, however, to his innate Classicist sensibility, Braque, the youngest of the Fauves, could never be entirely comfortable with the "wildness" of Fauve color and line. The radiant iridescence of the 1907 *Landscape at La Ciotat* was about as liberated as this artist allowed himself to become in chromatics (fig. 211). And the drawing, with its generalized distribution of chiaroscuro accents, seems less Fauvist than a blueprint for the new kind of pictorial structure that would come with Cubism. Certainly it represents the most penetrating insight into Cézannist principles then to be seen in art, other than that of Matisse.

As the earnest, striving Braque slowly and systematically pursued this line of development, he succeeded during the next few weeks in formulating the essential grammar and syntax of Cubism, and thus arrived at this revolutionary breakthrough style well before, as well as quite inde-

211. GEORGES BRAQUE. *Landscape at La Ciotat*. 1907. 28¼ × 23⅛".
Collection, The Museum of Modern Art, New York. Acquired through
Katherine S. Dreier and Adele R. Levy Bequests

212. GEORGES BRAQUE. *Landscape with Houses*. 1907. 21¼ × 18⅛". Private
collection, France

pendently, of the protean, mercurial Picasso, whom the French artist
had yet to meet. Viewing Cézanne as the "modern Poussin," rather than
the "anxious" artist cherished by Picasso, Braque gradually trans-
formed the all-over pattern of his stylized draftsmanship, like that in
Landscape at La Ciotat, into a kind of pictorial plane geometry that
would be true proto-Cubism in all but name. This can be seen in *Land-
scape with Houses*, a painting executed in October–November 1907
and published for the first time in 1977 by William Rubin (fig. 212).
Like Picasso, as well as Cézanne before him, and for the same reason,
Braque could more readily attain a conceptualized image of reality
when working from landscape or still life, both motifs free of the Ex-
pressionist, psychological subjectivity implicit in the human face and
figure. Moreover, the abstracting process came more easily once the
artist undertook to finish the picture seen here in his Paris studio, rely-
ing on memory and imagination as much as on the sketches he had
prepared the previous summer at L'Estaque on the Mediterranean
coast, where Cézanne himself had often painted. It also helped that
Braque retained the altitudinous perspective learned from Cézanne and
already adopted in *Landscape at La Ciotat*, which permitted him to
construe space in height rather than depth, so that the contents seem
ready to spill down and spread out toward the viewer. Still more impor-
tant, however, Braque had now discovered Cézannist *passage*, principle
and purpose alike, with the result that as the planes tumble forward,
they seem to slide, "bleed," or pass into one another, a consequence of
their contours having been broken or "breeched." Led on by such per-
vasive and systematic elision, the eye can now glide from plane to plane,
journeying into depth while simultaneously exploring surface. Such "si-
multaneity" of contradictory sensations and the flat or shallow, bas-
relief space it seems to evoke would prove absolutely paradigmatic or

fundamental for the new, thoroughly modernist pictorialism of high
Cubist art. With the continuity, or pictorial unity, interrupted only along
the roofline of the topmost house, Braque's all but comprehensive use
of *passage* stands in marked contrast to the tentative and inconsistent
beginnings made by Picasso in his contemporary landscapes (fig. 209).
Moreover, Braque further abstracted his image by suppressing such
details as doors and windows for the sake of purer geometry, and even
stylized the sky and foliage, as Cézanne did, in order to shape them as
analogies of the architectural forms. Reinforcing the pictorial unity this
yields is the subdued color—ochers, greens, and pale blue with an
occasional touch of rose—which leaves the image in all its aspects to
be realized primarily through light-dark relationships. Thus while all of
Picasso's contemporary pictures represent a more radical form of con-
ceptualized painting than anything produced by Braque in his proto-
Cubist work, the French artist had set out on a stylistic path that, relative
to art's destiny with Cubism, would place him well ahead of the other-
wise more venturesome Picasso for the next year and a half.

Meanwhile, Braque's new paintings attracted Daniel Henry Kahn-
weiler, the dealer most loyal to the Cubists, and through him entered
the circle of Picasso and Apollinaire. In late 1907 the artist beheld *Les
Demoiselles d'Avignon* for the first time. If Braque had been moved to
renounce Fauvism because "you can't remain forever in a state of par-
oxysm," it is little wonder that the *Demoiselles* made him feel "as if
someone were drinking gasoline and spitting fire!" But with his ratio-
nal, intelligent mind, he seems to have realized that the *Demoiselles*
was something to be reckoned with. It inspired him, in other words, to
attempt a kind of resolution that had eluded even Picasso—between
the pictorial issues raised by Cézanne and the sculptural ones taken up
by the Spaniard in his fascination with Iberian and African figures. Pi-

213. GEORGES BRAQUE. *The Bather*. 1907. 55⅛ × 39″. Collection Mme. Marie Cuttoli, Paris

Having experimented with an uncongenial subject, Braque now understood that the formal unity he sought lay in a complete radicalization of Cézannian space. This can be seen in *Houses at L'Estaque* (plate 64), the historic painting that provoked the derisive wit of Henri Matisse and thereby inspired the term Cubism. Finished at the end of the summer of 1908, a season the artist once again spent at L'Estaque, *Houses at L'Estaque* would indeed seem to be a literal response to Cézanne's celebrated injunction, published by Émile Bernard less than a year earlier, to see nature in "the cylinder, the sphere, the cone." Ironically, the Master of Aix said nothing about cubes, nor did he ever paint such pure geometries. Nevertheless, the statement would become something of a Mosaic law for the Cubists, even as their images progressively lost all resemblance to three-dimensional solids. Actually of greater significance than the famous dictum, both immediate and long term, was Cézanne's demonstrated conception of space, a conception Rubin has characterized as "bas-relief." As a way of reconciling Old Master illusionism with the physical flatness and opacity of the painter's working surface, Cézanne had found a way to depict depth but only to a limited degree, and had blocked imaged recession by painting in some kind of strong background plane. Against this, illusionistically solid volumes appear to stand forward but not free, therefore without either space or closure on the far side. Bas-relief, of course, is sculpture, but sculpture organized in a planar or pictorial manner (fig. 3); thus, once rendered in painting, it offered important possibilities for satisfying and even integrating the disparate concerns of Picasso and Braque—the problems of form and those of space. By coming to terms with both in *Houses at L'Estaque*, Braque brought Cubism out of a formative state and into its first maturity.

Braque is known to have initiated *Houses at L'Estaque* by painting *sur le motif*, but as he began to search for "something deeper and more lasting" than the mutable light and color of Provence, he returned to the studio and took the half-finished canvas with him. At this remove from reality, Braque made a decisive shift, away from Cézanne's precarious but even balance between perception and conception, and came down heavily on the side of pictorial independence. The scene, mounting straight up the canvas, terminates well above the frame and thus fills the entire visual field with a compact assortment of nothing but houses and trees. Denied a horizon line, the eye has everywhere been blocked from escape into blue, atmospheric depth. Braque further simplified the image and stripped it bare—buildings and terrain alike—of almost all but essential planes, thereby implying that an elementary family of forms underlies every variety of phenomena. Also in the spirit of unifying reductiveness, the artist now restricted his palette to an austere triad of ocher, gray, and green, systematically applied in parallel, Cézannist hatchings. This indicates that as he moved his painting toward still greater flatness, the Cubist chose to preserve the effects of relief not through Cézanne's method of contrasts in color, but rather with the less sensuous means of chiaroscuro—contrasts in light and dark. Having thus purified his art and reduced it largely to problems of structure, Braque would seem to have achieved a Classicism bordering on the Platonic. But like everything genuinely Classical, the harmony of *Houses at L'Estaque* is a dynamic one, a realm of rationality made expressive by a good measure of aesthetic license. As Braque's painted planes tilt and cluster, they do so in ways as autonomous as the color, responding to the laws of neither perspective nor directional light, but rather to the artist's own vision of his picture as a kind of articulated relief surface. Here, the points of reference, instead of falling outside the painting, as do the viewing angles and sources of light in traditional painting, are those of the canvas itself, whose flatness and rectilinearity can be

casso, as his early career has suggested, would always maintain an overriding interest in the human image, the foremost subject of sculpture and one always fraught with emotional possibilities. Braque, on the other hand, preferred the more neutral or dispassionate motifs offered by landscape and still life, both of them difficult in sculpture, yet natural to the pictorial arts. Thus, as the cofounders of Cubism approached a common style, they moved from diametrically opposite positions toward convergence. For his part, Picasso could define Cubism as "an art dealing primarily with forms." Braque, on the other hand, held that Cubism "was the materialization of a new space," the "visual space" he sensed separating "objects from each other." It was his accommodation of these polar conceptions that enabled Braque, before Picasso, to achieve the first truly Cubist picture.

Along the way, however, Braque evidently felt it necessary to become engaged with Picasso's own subject matter, the female nude, which he did on an enormous canvas that shows the primitivized image spread out like a weightless trophy skin and flattened as if against the floor (fig. 213). With its several aspects thus accounted for, Braque proceeded to synthesize them by means of *passage*—mainly in the adjacent planes of near arm, back, neck, head, and far arm—into a single composite silhouette. And if the large, curved, loosely brushed, and intersecting lozenges imply a certain bulk in the figure, they also serve to analogize it to the flatness of the similarly articulated ground, even as color and contouring tend to separate them.

sensed as a structuring framework around which the image and its planar parts interlock as though upon an all-over, trellislike scaffolding.

Although Braque, together with Picasso, would destroy the Renaissance picture as a window, by painting always more flatly and abstractly, they had no intention of restoring it as a façade. In *Houses at L'Estaque*, for instance, Braque reversed the withdrawing tendencies of perspective space and, in a manner quite different from that of Matisse in *Open Window, Collioure* (plate 31), began "advancing the picture toward myself bit by bit," painting the foremost plane last after commencing with the most distant. Consequently, through creative process as well as through composition, a Cubist picture appears not to recede but rather to move out toward the spectator. Under such pressure, planes open at their edges and elide—pass into one another—the effect of which is to dematerialize forms as dense, self-contained entities, while simultaneously collapsing and materializing the spaces that separate them.

When Braque submitted his new work to the progressive Salon d'Automne in the fall of 1908, the jury, which included Matisse, Rouault, and Marquet, rejected all his entries. It was upon this occasion that Matisse is supposed to have referred to the *petits cubes* of Braque: "*Toujours les cubes!*" Although two of his paintings were reclaimed by jurors Marquet and Guérin, Braque refused to exhibit any, and instead held a one-man show of twenty-seven paintings in November 1908, at the Kahnweiler Gallery, with a preface to the catalogue by Guillaume Apollinaire. Vauxcelles, the critic who had coined the name for the Fauves, reviewed the exhibition and, using Matisse's phrase, spoke of Braque's reducing "everything, landscape and figures and houses, to geometric patterns, to cubes." It was not long before the epithet "Cubism" had become the official name of the most important single movement in the painting of the twentieth century.

Picasso, by the sheer plastic energy of his handling, would always be able to produce more powerful and expressive pictures than those of Braque, but from the standpoint of Cubist syntax, the Spaniard's 1908 work—even the most Cézannist of the Rue-des-Bois landscapes—lagged a full year behind the advances made by the Frenchman. Indeed, it was Braque who would now lead, persuading Picasso, by the example of such works as *Houses at L'Estaque*, to repaint *Three Women* (fig. 214) and transform it from an Expressionist African work, vigorously sculptural and articulated by striations of raw color, into a painting almost as controlled, consistent, and subtly modulated throughout as anything by Braque at this time. Initiated in the spring of 1908, as a postlude to the *Demoiselles*, but reworked late in the year, the *Three Women* we now see is, in Rubin's opinion, the earliest known attempt by Picasso to utilize the Cézannian technique of *passage* in a systematic and comprehensive way. Subtle facture and smoothly gradated tones permit the step-by-step linkage of planes that, once applied to the canvas all-over, make the painting seem the pictorial equivalent—an illusion or simulacrum—of a composition in bas-relief.

Just as Braque could come to grips with Picasso's interest in form only by momentarily relinquishing the landscape for the figure, Picasso did not fully master the new pictorial space until he had returned to landscape. And when he did, at Horta de Ebro in Spain, during the summer of 1909, the pictures that emerged were the artist's first completely Cubist works. In *Houses on the Hill, Horta de Ebro* (fig. 215) Picasso so abstracted his subject that the painted image seems little more than a relief surface crystallized into an angular network of semitransparent planes, with these gridlocked and fused until space and mass are scarcely distinguishable. Abetting the sense of a reality puri-

214. PABLO PICASSO. *Three Women*. 1908. 78¾ × 90⅛″. The Hermitage Museum, Leningrad

215. PABLO PICASSO. *Houses on the Hill, Horta de Ebro*. 1909. 25⅝ × 31⅞″. Collection, The Museum of Modern Art, New York. Nelson A. Rockefeller Bequest

fied of all but its essential geometries is the monochrome gray-buff tonality made possible by the elimination of vegetable life. Another contributing factor arises from the shadows and directional lines, which violate the laws of light and perspective to produce value contrasts that imply an ambiguous, indeterminate depth while also articulating the picture plane as an overall relief pattern. With contours broken here and there, intervals and objects slide into one another, carrying the eye from point to point without abrupt transition.

216. PABLO PICASSO. *Head of a Woman*. 1909. Gouache, 24¼ × 18¾".
Art Institute of Chicago. E. E. Ayer Fund

217. PABLO PICASSO. *Head of a Woman (Fernande)*. 1909. Bronze, height
16¼". Collection, The Museum of Modern Art, New York. Purchase

Analytic Cubism

In late 1909 Braque and Picasso entered a period of collaboration so close that later the Frenchman could say: "We were like two mountain climbers roped together." Their experiment in artistic intimacy lasted until the outbreak of the Great War in 1914, when Braque entered military service. The relationship produced wonders, for the very good reason that the artists, being quite different, contributed qualities that were perfectly complementary. The German dealer Wilhelm Uhde would put it this way: "Braque's temperament was limpid, precise, and bourgeois; Picasso's somber, excessive, and revolutionary. To the spiritual marriage which they contracted, one brought a great sensibility, the other a great plastic gift." As a result, Picasso found himself working with a systematic, deliberative concentration totally uncharacteristic of him at any other time in his long career, when normally his creative energies could find sufficient outlet only through eclectic virtuosity. Meanwhile, Braque enjoyed the advantage of being engaged with one of the most powerful plastic imaginations known to Western art, a forming genius that endowed Cubism with a heroic splendor completely foreign to the reticence of Braque's native Classicism. In the course of their joint venture, the two artists became so integral to one another that in the absence of signatures—which, like dates, rarely appear on their works at this time—it is all but impossible to sort out who made which specific contribution to the rapidly evolving progress of the Cubist style. But it seems certain that even in the common form language of Cubism, Picasso would never completely forfeit his sculptural and Expressionist

touch, while Braque would remain lyrical in feeling and faithful to his French love of exquisitely manipulated *matière*.

Impelled by their doubled concentration, Braque and Picasso soon learned to apply Cézanne's lessons well beyond anything intended by Cézanne himself. The artists worked so analytically—with Picasso breaking down and reconceiving form in terms of its planar components, while Braque materialized space into a comparable array of shifting, shardlike elements—that the sophisticated, revolutionary art they now brought forth came to be known as Analytic Cubism. The takeoff for this thrust into high twentieth-century modernism can be traced to, for instance, Braque's *Violin and Palette* (plate 65), a tall still-life composition the contents of whose lower half—the arabesque shape of the musical instrument and its surrounding space—seem caught up in a process of disintegration and reintegration, a surface on the verge of becoming a continuous gem-cut scatter of fragmented form and faceted space. Then, as if to reconfirm the essential Realism of Cubist art—on the eve of its crossover into total abstraction—Braque returned, perhaps nostalgically, into the old mode of representation in the upper half of the painting. There he rendered in perfect *trompe-l'oeil* a shadow-casting nail driven into the wall and holding a palette. With this witty juxtaposition of Renaissance illusionism and Cubism's new conceptual way of evoking reality, the artist seemed to assert the ultimate artifice of all pictorial conventions, just as Picasso's assemblage of variant facial styles in *Les Demoiselles d'Avignon* demonstrated the worth of all descriptive systems, as long as they effectively serve their expressive purposes. By implication, however, Cubism may be superior by virtue of its

Colorplate 60. CONSTANTIN BRANCUSI. *Bird in Space*. 1919. Bronze (unique cast), 54″. Philadelphia Museum of Art. Louise and Walter Arensberg Collection

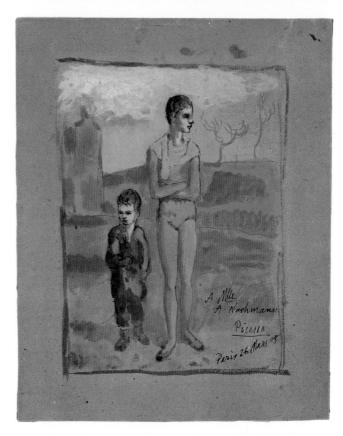

Colorplate 61. PABLO PICASSO. *Woman Ironing*. 1904.
45¾ × 28⅝″. Thannhauser Collection, New York.
Courtesy Thannhauser Foundation

Colorplate 62. PABLO PICASSO. *Young Acrobat and Child*. 1905. Watercolor
and gouache, 9¼ × 7″. Collection The Solomon R. Guggenheim Museum.
Justin K. Thannhauser Collection

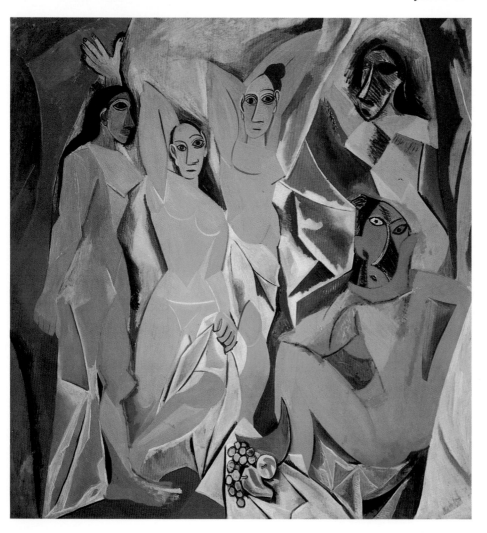

Colorplate 63. PABLO PICASSO.
Les Demoiselles d'Avignon. 1907.
96 × 92″. Collection, The Museum of
Modern Art, New York. Acquired through
the Lillie P. Bliss Bequest

Colorplate 64. GEORGES BRAQUE. *Houses at L'Estaque*. 1908. 28¾ × 23⅝″. Hermann and Margit Rupf Foundation, Kunstmuseum, Bern

Colorplate 65. GEORGES BRAQUE. *Violin and Palette*. 1909–10. 36¼ × 16⅞″. The Solomon R. Guggenheim Museum, New York

Colorplate 66. PABLO PICASSO. *Man with a Hat*. 1912, December. Charcoal, ink, and pasted paper, 24½ × 18⅝″. Collection, The Museum of Modern Art, New York. Purchase

Colorplate 67. PABLO PICASSO. *Green Still Life*. 1914, summer. 23½ × 31¼″. Collection, The Museum of Modern Art, New York. Lillie P. Bliss Collection

155

left: Colorplate 68. ALEXANDER ARCHIPENKO. *Medrano II*. 1913. Mixed media, 49⅞ × 20¼ × 12½″. The Solomon R. Guggenheim Museum, New York

above: Colorplate 69. HENRI LAURENS. *Guitar and Clarinet*. 1920. Polychromed stone, 12⅝ × 14½ × 3½″. Hirshhorn Museum and Sculpture Garden, Smithsonian Institution, Washington, D.C.

right: Colorplate 70. JUAN GRIS. *La Place Ravignan,
Still Life in Front of an Open Window.* 1915.
45⅞ × 35⅛″. Philadelphia Museum of Art. Louise
and Walter Arensberg Collection

below: Colorplate 71. JUAN GRIS. *Guitar with Sheet
of Music.* 1926. 25⅝ × 31⅞″. Collection Mr. and
Mrs. Daniel Saidenberg, New York

Colorplate 72. ALBERT GLEIZES. *Symphony in Violet*. 1930–31. 77 × 51½″. Collection Rudolf Indlekofer, Basel

Colorplate 73. ROGER DE LA FRESNAYE. *The Conquest of the Air*. 1913. 92⅞ × 77″. Collection, The Museum of Modern Art, New York. Mrs. Simon Guggenheim Fund

Colorplate 74. FERNAND LÉGER. *The City*. 1919. 7′7″ × 9′9″. Philadelphia Museum of Art. A. E. Gallatin Collection

Colorplate 75. FERNAND LÉGER. *Three Women*. 1921. 72¼ × 99". Collection, The Museum of Modern Art, New York. Mrs. Simon Guggenheim Fund

Colorplate 76. FERNAND LÉGER. *The Great Parade*. 1954. 9' × 13'1". The Solomon R. Guggenheim Museum, New York

Colorplate 77. ROBERT DELAUNAY. *Simultaneous Contrasts: Sun and Moon*. 1913. 53" diameter. Collection, The Museum of Modern Art, New York. Mrs. Simon Guggenheim Fund

218. PABLO PICASSO. *Girl with a Mandolin (Fannie Tellier)*. 1910.
39½ × 29″. Collection, The Museum of Modern Art, New York.
Nelson A. Rockefeller Bequest

219. PABLO PICASSO. *David-Henry Kahnweiler*. 1910. 39⅝ × 28⅝″.
Art Institute of Chicago. Gift of Mrs. Gilbert W. Chapman

candor, its refusal to be what no picture is, a transparent window opening onto the phenomenal world. Here fully stated are all those concepts of metamorphosis, of simultaneous and consecutive vision, in which the artist has finally liberated himself from the Renaissance world of nature observed by means of the arbitrary principle of mathematical perspective. It represents the painter's moment of liberation from a system that had held artists captive for five hundred years. Henceforth they would be free of the concept of a painting as an imitation of visual reality. They were now free to explore any desired direction of vision, experience, or intuition. Simultaneously, Braque could also have been announcing, by means of his veristic nail, that the founding Cubists, unlike many of their immediate and distant successors, would remain faithful to the tradition of Mediterranean humanism and never totally lose contact with perceptual reality in favor of entering a Platonic world of pure abstraction.

Picasso's progress into Analytic Cubism is best traced through his constant involvement with the human face and figure. By 1909 the artist had begun to push his initial investigations to their logical conclusions. In a series of portrait heads, including a number of Fernande Olivier, the young woman who shared his years of struggle, it is possible to see, almost step by step, the breaking down of the sculptural mass of the head into a series of flat planes that reestablished the sense of the picture surface (fig. 216). These experiments in painting led him to explore the same problem in reverse, in the bronze *Head of a Woman* (fig. 217). Picasso had practiced sculpture sporadically since before 1900 in works that closely paralleled his contemporaneous interests in

the field of painting and may have helped to clarify them. *Head of a Woman* subordinates characterization in an attempt to create a three-dimensional design. The work is not entirely successful as Cubist sculpture, since the geometry is worked in and out over the surface of the head. Although it is historically of the greatest significance as the first step toward an entirely new kind of sculpture—that of construction or assemblage—at this point Picasso had not yet realized the implications of Cubism for sculpture.

A transitional but already quite thoroughly analyzed image is that in the charming and evocative *Girl with a Mandolin*, executed by Picasso in early 1910 (fig. 218). Here the figure holding the mandolin is de-from the faceted ground with arms and breast modeled in a sculptural manner. Thus it does not attain the complete integration of subject and total picture space noted in Braque's *Violin and Palette* and, for that matter, in late works of Cézanne, which both artists had been studying (plate 17).

In his portrait of the dealer Kahnweiler, however, Picasso caught up with Braque and applied their analytical method so consistently that he all but dissolved the subject in a glittering shower of tiny, angled planes (fig. 219). Gently tilting to and fro, and defined as transparent by their intersecting edges, they seem to hover within the smoky atmosphere of a shallow, ambiguous space. A comparison of this work with *Les Demoiselles d'Avignon* or even *Girl with a Mandolin*, reveals not only the distance now traversed by modernist painting, but also the degree to which verisimilitude was still possible in works by an artist intent upon realizing pictorial autonomy. Under close scrutiny, the shuffled and dis-

left: 220. PABLO PICASSO. *Nude Woman*. 1910. 73¾ × 24″. National Gallery of Art, Washington, D.C. Ailsa Mellon Bruce Fund, 1972

right: 221. PABLO PICASSO. *Accordionist*. 1911. 51¼ × 35¼″. The Solomon R. Guggenheim Museum, New York

opposite: 222. GEORGES BRAQUE. *The Portuguese*. 1911. 46⅛ × 32″. Öffentliche Kunstsammlung, Basel

sociated marks cluster at crucial points and resolve into the unmistakable features of a then familiar art world figure. Elsewhere in the painting, however, connections fail and become absorbed into the overall screen of facets, which, because of *passage*, may be understood, paradoxically, as resting both behind and in front of one another. Often angles remain abstract drawing, the principal function of which is to reiterate the format's major axes and thereby structure the picture as a kind of architectural scaffolding. Picasso was famous for his dark, penetrating gaze, but despite the blaze of looking and intellectual analysis necessary to create a masterpiece like the Kahnweiler portrait, the sheer delicacy with which the artist has manipulated his deliberately limited means—a near monochromy of grays, beiges, and pinkish creams, symbolic geometry, and a small painterly touch worthy of Braque himself, the Neo-Impressionists, or even Rembrandt—guaranteed that cold formalism would not, in this most aristocratic and erudite phase of Cubism, prevail over intuitive procedures and warm, humanist feeling.

The innately bolder and more visionary Picasso soon raced beyond Braque and carried Analytic Cubism very close to its logical conclusion in total abstraction. This occurred at Cadaqués, Spain, during the summer of 1910, when Picasso generated a series of pictures similar to the one in figure 220. Here the image has been so fractured and schematically reassembled that its origin in a standing figure could be identified only if approached through the evolutionary sequence of studies that brought the resulting assemblage of arcs and angles into being. Chiaroscuro, in its soft, shimmering gradations, defines not rounded surfaces but flattened planes, which pass into one another, overlap, and

ultimately confound spatial relationships. Whatever sense of closure—of contour, volume, or silhouette—the viewer may gain must be reconstructed imaginatively from an open armature of floating, geometricized fragments that subtly counterbalance one another the full height of a tall and rather teetering composition. As Alfred Barr pointed out, Picasso's 1910 *Nude Woman* could just as well be understood as the plan, section, and elevation of one structure all combined and superimposed in the same painting.

With his portrait of Kahnweiler, Picasso ushered in the "High" or "Heroic" phase of Analytic Cubism, and with the all but undecipherable works of Cadaqués he gave the style its most "hermetic" interpretation. Almost immediately, however, both Picasso and Braque realized that the balance between visual description and pictorial architecture had shifted too far toward the latter. To confirm his realistic intentions, Braque said: "When the fragmentation of objects appeared in my painting around 1910, it was a technique for getting closer to the object." And Picasso added: "Our subjects must be a source of interest," for the whole purpose of abstraction was not to abandon subject matter, but rather to "keep the joy of discovery, the pleasure of the unexpected." The better to stay in touch with palpable reality, the artists invariably created iconography out of their own immediate and intimate world of everyday experience: portraits and figure studies of friends, lovers, agents, and admired café performers; still lifes composed of the palettes, guitars, sheet music, pipes, glasses, and bottles always present and regularly used in the studio; landscapes from summer vacation sites. In this way the Cubists filled their art with elements "already drenched in humanity," even as they strove to view and record them

with an extreme and deforming objectivity.

Following the climactic pictures painted at Cadaqués, Picasso and Braque drew back from their flirtation with nonobjectivity and aimed for a less abstruse mode of expression, but one nonetheless free of discredited techniques from the past. A representative solution came in the summer of 1911, when Picasso, while working with Braque at Céret in the French Pyrenees, painted the *Accordionist* (fig. 221). Here, at first glance, the relation of art to nature may seem no more secure than in the Cadaqués *Nude Woman*. But with patient looking, the detached slices of form and space coalesce at the center of the field and there allow an image to emerge, a half-length pyramidal mass tumbling down upon the picture's edge. Within this flotation of loose shingles, moreover, Picasso has provided a few leading signs or clues to help the viewer decipher the picture, as for instance in the volute terminals of chair arms at the lower left and right. Fringed eyelids and a double-crescent mustache locate the figure's head, while just below center the pleats of a bellows and a row of circular keys touched by tubular fingers identify the small, boxlike accordion. But even in the more arcane passages, where disembodied lines and tones seem to refer to nothing but themselves, the relationships come together in a way to suggest the rhythmic shifts and broad diagonal movements of an accordionist expanding and contracting his instrument.

In their Cubism of 1911 Picasso and Braque achieved a kind of classic art, in that it emerges, like all Classicism, from a delicately balanced compound of the objective and the subjective. Painters who could reduce nature's volumes to thin planes, shuffle the pieces, drain them of positive color, and then reassemble the whole into frontalized struc-

tures as evidently abstract as architecture seemed to many of their contemporaries to be intent upon transforming art into science. This accounts for the term "Analytic" and the frequent analogies made to geometry, both plane and solid. It also explains how Apollinaire, as early as 1913, could compare the Cubist painters' fusion of variant perspectives—its "simultaneity"—to the space-time, or four-dimensional continuum posited by Einstein in the physics of relativity. But however dissecting their investigative spirit, Picasso and Braque were intuitive, not scientific or mathematical, in their methods. Nothing could be more personal, and therefore realistic, than the first Cubists' subject matter, nor anything more exquisite than the subtle irregularities of their freehand drawing and painterly surfaces. In the *Accordionist* it was neither a straight edge nor a compass, but rather a heightened sensibility and an infinitely varied touch, that translated the human image and environment into a tremulous web of mysterious spatial relations. Only an artistic vision could so simplify on the one hand and so complicate on the other, divesting observable reality of all detail while recombining what remains in the most intricate and unimaginable ways.

This means that for pictorial purposes, Cubism's inventors were no less realistic in their treatment of subject matter than they were in their choice of it. Having selected familiar forms, they proceeded to use them mainly as points of departure for creating original works of art, aesthetic objects equal to anything in nature but utterly independent of it. Therefrom stems the "hermetic" quality of Analytic Cubism, the difficult relation to actual appearances that causes us to discern enigma and inquire: Who are these sitters posed so iconically in a Rembrandtesque half-light? Very much to the point, the question penetrates the core meaning of Cubism, an art that denies a single definition of reality and replaces it with a multiple interpretation. In the simultaneous coalescence and dissolution of its planes, shifting in and out of our visual grasp, the Analytic Cubist picture suggests the fluid process of cognition itself. This too prompted certain observers to associate Cubism with other arts and sciences, the better to comprehend the style as a form of up-to-date Realism. In it they saw reflected the new-found truths of existence, as perceived not only by Einstein but also by Freud, Bergson, and Husserl, and such stream-of-consciousness writers as Proust, Joyce, and Woolf. Standing apart from these speculations, Picasso could appreciate them for their attempt "to give [Cubism] an easier interpretation," but he also deplored the consequences, calling them "pure literature, not to say nonsense...blinding people with theories." More than many of the movements it spawned, Cubism was intended by its inventors to be a visual experience without ideological burden or doctrinaire aesthetic. "In general people see nature in conventional fashion," Picasso said in the 1940s. To challenge that, he determined, early in the century, to "give man an image of himself whose elements are collected from among the usual way of seeing things in traditional painting and then reassembled in a fashion that is unexpected and disturbing enough to make it impossible for him to escape the questions it raises." As Robert Rosenblum points out, not since the Florentine Renaissance has there been so exalted a union of art, nature, and geometry.

In 1911, the climactic year of Analytic Cubism, Picasso and Braque succeeded in merging their styles to the point where truly the hand of one painter could scarcely be distinguished from the other. Now, just as this common mode seemed transfixed in a world of magical abstractions, Braque actually surpassed Picasso in his eagerness to assert the precise, if paradoxical, relation of his art to everyday experience. In *The Portuguese* (fig. 222) he achieved one of Cubism's great masterpieces and superimposed upon its fragile network of silvery planes an element

223. PABLO PICASSO. *Architect's Table*. 1912. 28⅝ × 23½". Collection, The Museum of Modern Art, New York. Gift of William S. Paley

a painting as a *tableau-objet*, as a constructed object with its own independent existence, a universe unto itself, not mirroring the outside world but re-creating it in a completely new form. Particularly expressive of this concept is the character of the light in Cubist pictures, which seems not reflected from an outside source but generated from within the cells of a crystalline substance. And the attitude prevailed when, as the final innovation of their Analytic Cubist style, Braque and Picasso adopted an oval format and thereby solved what Braque referred to as "the problem" of the corners. Cut clear of the "fading" that occurs toward the edges in pictures like the *Accordionist* and *The Portuguese*, Picasso's *Architect's Table* presents a more centralized composition and thus a more "all-over" and self-contained image (fig. 223). This free-floating, independent quality is further enhanced by the salad mix of realities all tossed together in the same work. Here Picasso thought nothing of foreshortening two of the most abstract planes and thus transforming them into an architect's square and a calling card from "Mis [sic] Gertrude Stein." And in using typography to objectify the literal flatness of the picture surface, he simultaneously expressed the most tender and intimate sentiments toward his new love, Marcelle Humbert, whom he named *Ma Jolie* ("My Pretty One") for a then popular romantic song. Virtually endless in their contradictions and variant levels of meaning, the masterworks produced by Picasso and Braque during the Analytic Cubist period surely confirm the twentieth century's destruction of absolutes and the consequent relativity of modern values. At the same time, however, the paintings create a harmony all their own, which places them in direct line with the very tradition Cubism sought to destroy. The Renaissance, too, it should be remembered, attained greatness by realizing a tense and vital equilibrium between the world of nature and that of art.

Synthetic Cubism

In their campaign to formulate a truly pictorial way of evoking nature in art, Picasso and Braque found the analytical approach so fulfilling that they took over two years—centering upon 1910–11—to exhaust its possibilities. For artists as independent and creative as the founding Cubists, this was a considerable period to spend in investigations that required the general suppression of their individual identity and abstention from those most sensuous and realistic of means—positive color and textural variety. Thus in 1912 first Picasso and then Braque began to invent anew, not in a way to transform their Cubism into something else, but rather to develop it in directions that proved as logical as they were unexpected. So remarkable indeed were the pioneers' new technical inventions—collage and *papier collé*—that by virtue of them the two artists succeeded in clarifying not only the link that art has to external reality, but also—and paradoxically—the reality of the picture as a flat, autonomous, nonillusionistic construction. Intensive visual analysis had taught the Cubists how to reduce real objects to abstract components—lines, planes, and values—and eventually how to exploit these components as expressive and constructive elements altogether independent of one another, as well as of the cooperative role they formerly played in representational art. Now, Picasso and Braque gained similar command over color and texture, thanks to their novel techniques, which forfeited oil and brushwork in favor of real components pasted directly onto the picture. Thus equipped to work freely with the full range of pictorial means, the Cubist innovators commenced to create pictures less by breaking down forms than by building them up in ways so subjective and arbitrary as to yield an image that seems more a

of mundane reality even more blatant than that of the tromp-l'oeil nail painted into the 1909–10 *Violin and Palette*. Again drawing upon his youthful training in the techniques of decorative and commercial art, Braque not only simulated short lengths of rope but also stenciled across the picture surface numbers and letters excerpted from the kind of poster typically found in bars where a Portuguese guitarist would play. Like the eye-fooling nail, these familiar shapes with their well-known meanings helped to identify and anchor increasingly complex and vaporous configurations to material and legible reality. But they are also signs and symbols, not images, and by using them in fragmentary form, Braque seemed to imply that the equally fragmentary geometries of his picture—the newly invented vocabulary of Cubism—have no more obligation to present the illusion of perceived reality than a word does to be the very thing it speaks of. A major innovation in Western painting, this assimilation into art of a certain kind of literal but nonillusionistic reality prophesied the move that the Cubists soon would make to transform their already highly conceptualized language into a still less imitative and more purely symbolic form of expression. Meanwhile, the numerals and letters, being absolutely flat and light-absorbent, draw attention, by analogy, to the rigid, opaque, two-dimensional fact of the painting surface. By contrast, they also disconcert the spectator into taking into account just how much spatiality can still be sensed among the picture's lines, shades, and textured surfaces, even when these illusionistic devices have been so disengaged from reality as to describe little but tissuelike elements interwoven to the depth of a sliver.

By stressing what the Renaissance tradition tried so hard to deny—the material actuality of the painting surface—the stenciled signs and symbols give dramatic effect to the modernist notion of what a picture ought to be. As early as 1910 Braque and Picasso had begun to speak of

symbol than a representation of visual fact. The new approach, being constructive and therefore synthetic rather than analytic, carried Picasso and Braque into a new stylistic mode, which we know as Synthetic Cubism. It proved even more fertile than Analytic Cubism and endured all the way through the mid-1920s, bringing forth pictures immediately recognizable for their greater flatness, simplicity, and monumentality, their richer colors and textures, their varied, even relaxed, moods, and the sheer individuality of genius and invention poured into them by their creators.

The innovations of 1912 were linked to the recent past by every effort the Cubist fathers had made to affirm the realistic basis of their art. In 1909–10, as we know, Braque employed a trompe-l'oeil verism for the upper half of *Violin and Palette*, as if metaphorically to "nail" his painting to external reality, even as the abstracting style of the lower half impelled Cubism toward its most obscure and hermetic expression. Then, in 1911, at the very height of that phase, Braque stenciled a series of letters and numbers onto the canvas of *The Portuguese*, thereby introducing a kind of highly legible and literal reality that emphasizes both the picture's surface-adhering, depth-denying qualities and the illusionism lingering among its painterly, interpenetrated planes. In a further attempt to clarify the identity of objects analyzed almost beyond recognition, Braque also began to revive certain of the techniques— mainly the "combing" of paint to imitate grained wood—acquired during his days as a house painter-decorator. Simultaneously, or shortly thereafter, Picasso literalized the lines and planes of his High Analytic Cubist paintings into a series of open-work reliefs constructed of paper and cardboard, and eventually of materials even more alien to fine art. In early 1912, for instance, he fashioned an actual bas-relief, not by the traditional technique of modeling, which he had used for the monolithic *Head of a Woman* of 1909 (fig. 217), but by the revolutionary process of constructing a guitar from the industrial materials of sheet metal

and wire (fig. 224). In this way he realized a three-dimensional, open-work equivalent of the shallow space and frontalized, interpenetrating planes found in the Analytic pictures. With typical Cubist irony, Picasso put the front of the instruments's body away and built the sound hole as a cylinder, thereby making the central void the only positive and integral form in the composition. This cut and assembled work, while belonging to the history of sculpture, led the artist directly to *Still Life with Chair Caning* and therewith to one of the great turning points in twentieth-century art.

Determined to provide a clearer description of the visual world, but without recourse to the conventions of traditional picture-making, Picasso in early 1912 produced *Still Life with Chair Caning* (fig. 225), a work whose tiny size and humble materials belie the momentous revolution it perpetrated in both form and process. Instead of relying upon paint and brush to create his picture, Picasso began by pasting on the canvas a piece of oilcloth commercially printed to simulate the woven pattern of chair caning. With this stroke, he invented one of modern art's most liberating techniques—collage—so called for the French word *coller*, meaning "to glue." The significance of the image thus established became apparent once Picasso overpainted part of the surface with an Analytic Cubist rendering of a goblet, a knife, lemon slices, an oyster shell, a pipe, and the letters JOU. For just as the first syllable of JOURNAL can stand for the whole of the word and signify, without actually reproducing, the newspaper likely to be present on a café table, the caning stands for or symbolizes a chair drawn up to a table. It is a kind of pictorial synecdoche, wherein a part serves well enough to eliminate the need for illustrating the whole. With collage—the realization of a picture by means of assembling readymade fragments taken from the world outside the picture—Picasso could now make a still more searching exploration of the paradoxical nature of reality. The printed fabric, having clearly been cut from the whole cloth of a ma-

above left: 224. PABLO PICASSO. *Guitar*. 1912. Sheet metal and wire, height 30¾". Estate of the Artist

above right: 225. PABLO PICASSO. *Still Life with Chair Caning*. 1911–12. Oil and pasted paper simulating chair caning on canvas, oval 10⅝ × 13¾". Estate of the Artist

226. GEORGES BRAQUE. *Fruit Dish and Glass*. 1912. Pasted paper and charcoal on paper, 24 × 17½". Private collection

where truth or fiction may lie—in the artificial wood of the real wallpaper, or in the honest fraud of the Cubist still life. In the end, how could art and reality be more thoroughly confounded than in decorative wallpaper whose imitation of wood paneling has been forced into service as illusory furniture?

While Braque stayed seriously with the decorative qualities of his *papier collé* elements, Picasso characteristically saw expressive and, frequently, funny implications in the new medium. A delightful and celebrated instance is *Man with a Hat*, a collage of both verbal and visual puns (plate 66). To suggest volume, without recourse to illusionism, the artist juxtaposed contrasted sheets of paper, with newsprint representing the illuminated side of the face and solid blue the aspect in shadow. Meanwhile, as Robert Rosenblum has discovered, the newsprint fragment near the mouth and nose refers to teeth and nasal cavities, just as the one over the chest reports on a treatment for tuberculosis.

The paintings of 1913 and 1914, influenced by collage, also began to have larger, geometric color shapes and more positive color. Picasso's *Card Player* (fig. 227) is a key work, composed in broad, clearly differentiated areas, summarizing the experiments of Analytic Cubism and collage. The forms and the emergent sense of expressive mood or identity in the figures suggest the great Cubist compositions of the early 1920s, such as the versions of the *Three Musicians* (plate 118).

The principal trend of paintings by both Picasso and Braque after 1913, however, was toward enrichment of the plastic means—space, color, linear movement, and texture. Changes in expressive means included the reintroduction of subject, of personality in the figures, and of mood in the picture as a whole. In *Green Still Life* (plate 67) Picasso not only reintroduced positive color but opened up the space of the

chine-made product, would seem to be more real than the unabashedly fictitious Cubist still life. But by offering color and the semblance of texture in lieu of a complete form, the machine-printed oilcloth—although an eye-fooling facsimile of chair caning—seems hardly less false than the picture's painted and highly stylized images. In a further irony, even the most abstract of the analyzed objects appears naturalistically volumetric in relation to the flat pattern of the trompe-l'oeil caning. Then, as if he had not sufficiently demolished some of the most sacrosanct conceptions and practices of post-Renaissance art, Picasso surrounded his oval composition with a length of ordinary rope. Here, too, fact and fiction are challenged through confounding, for while the rope functions as a frame that by tradition must separate a pictorial illusion from the reality it imitates, the commonplaceness of the material used mocks that tradition, and even subverts it by seeming to be the decorative edge of a flat surface supporting an assemblage of still-life objects.

Inspired by Picasso's discovery of a new, constructive method of creating art, Braque in September of 1912 invented *papier collé*, a pictorial composition made with fragments of "pasted paper." In *Fruit Dish and Glass* (fig. 226), the first such work, the artist glued onto a support three pieces of wallpaper printed in the exact simulacrum of grained oak. As stripped in below, the wallpaper suggests the drawer of a table set with a bowl of fruit and a wine glass. Above, the patterned paper evokes the wall of a BAR where ALE would be served. Now Braque too has challenged both retina and reason to determine just

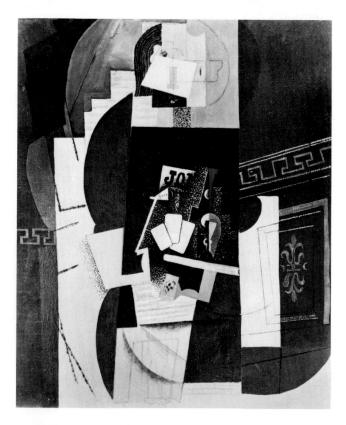

227. PABLO PICASSO. *Card Player*. 1913–14. 42½ × 35¼". Collection, The Museum of Modern Art, New York. Acquired through the Lillie P. Bliss Bequest

room and disposed the objects of the still life in a tangible manner that looked back to Cézanne, just as the stippled textural elements looked back to Neo-Impressionism. Thus the painting can be considered an eclectic work in which the artist was attempting to see the relations of his Analytic Cubist explorations to previous attempts to reexamine the illusionistic space of the Renaissance tradition. This could be considered a desertion of the structural purity of earlier Cubism in favor of a decorative or "rococo" direction. At this point, however, it was essential for both Picasso and Braque to move from an intensive to an extensive approach, to enlarge the Cubist vocabulary they had created. Also, during these years, from 1910 to 1914, Cubist painting had spread in many variations throughout Europe, and even the founders could not help being affected by the different approaches of Robert Delaunay, Albert Gleizes, Juan Gris, and Fernand Léger.

Photographers, too, being exponents of a truly modern medium, found ways to join the Cubists in their analysis of form. Picasso even remarked later that Stieglitz (figs. 68, 535, 536) and he had been working in the same avant-garde spirit. Beginning in the teens of the century, photographers like Paul Strand (1890–1976) and Florence Henri (1893–1982) photographed from still lifes designed to yield images filled with all-over, Cubist-like arrangements of transparent, reflective planes and abstract or organic shapes, the latter often suggesting Cézannesque cones, spheres, and cylinders (figs. 228, 229).

With the commencement of World War I in August 1914, the intimate collaboration of Picasso and Braque came to an end. Braque went into the French army, along with Apollinaire, Derain, Jean Cocteau, and many other leading young French artists and writers. Picasso, a Spaniard and a nonbelligerent, remained in Paris until 1917, when he went to Rome with Cocteau to join Diaghilev's Ballets Russes as a designer. Thus, in France as in Germany, England, and Italy, the four years of war marked a terminal point to the first great period of twentieth-century experiment in the arts. The war also terminated the careers of some of Europe's most talented young artists and writers, Marc and Macke in Germany, Duchamp-Villon and Apollinaire in France, and Umberto Boccioni in Italy.

Cubist Sculpture

Although the contribution made by Brancusi was unique, and although this artist seems to have been a curiously isolated figure throughout his life, he was not alone in his search for absolutes (figs. 192–197, 199–200). The revolutions of Fauvism and Cubism in painting were accompanied by comparable revolutions in sculpture, despite the vigorous persistence of the older tradition of sculptural figuration. As a result of the explorations of Picasso and Braque, Cubist painting by 1910 had dispensed with three-dimensional modeling; strong color had been subordinated to a close harmony of subdued color; and the subject (usually figure or still life) had been transposed into a linear geometry of intersecting and frequently transparent planes, a sort of grid moving within a confined depth from the frontal plane of the painting.

The corresponding problem was a search for the fundamentals of sculptural form through stripping off all the illusionistic accretions of the Renaissance tradition. Brancusi carried on such explorations, but they were less familiar to the younger experimental sculptors than the Cubist innovations of the painters. With its strict geometry of spatial analysis, Cubism seemed immediately applicable to the problem of sculpture. The first Cubist sculptors were affected not only by Cubist painting but, also like the Cubist painters, by the discovery of African

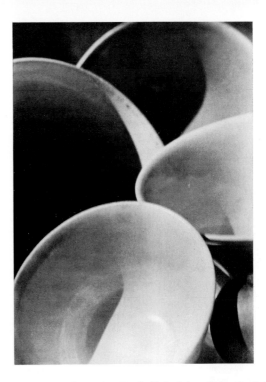

228. PAUL STRAND. *Abstraction, Bowls, Twin Lakes, Connecticut, 1916.* 1916. Photograph. Courtesy Paul Strand Archive

229. FLORENCE HENRI. *Abstract Composition.* 1929. Gelatin-silver print. Galerie Wilde, Cologne

primitive sculpture. Picasso's carved wooden figures of 1907 already suggest the background of African or archaic Greek sculpture, and his 1909 *Head of a Woman* is an attempt at a literal translation into sculpture of a painted Cubist head.

The collage *Still Life with Chair Caning* and the metal construction entitled *Guitar*, both made in 1912, are testimony, also, to his reviving interest in sculpture. In 1913 and 1914 Picasso again translated Cubist still-life paintings into constructions of wood, paper, and other materials, obviously in an investigation of the three-dimensional implications of Cubist painted space. Or, to put it another way, these works were projections of his paintings and collages into three dimensions, and, although they continued the sense of subject that persisted in Cubist painting, they were known to the Russian Constructivist Vladimir Tatlin, whose abstract construction they affected as well as those of the other Russian Constructivists (figs. 274–276, 278). During 1914 Picasso carried his sculptural interests further in a wood-and-metal assemblage of musical instruments, in which he opened up the potentials of construc-

tion for new concepts of sculptural space and abstract design (fig. 230).

Related to the decorative Cubism of the painting entitled *Green Still Life* (plate 67) is a sculpture, or "object," that Picasso also made in 1914 and had cast in bronze and painted in six variants. This is the *Glass of Absinthe* (fig. 231), in which the artist gave one of the first sculptural expressions to the passion for the "found object" that was to characterize much of his own subsequent sculpture as well as much of the other sculpture of the twentieth century—until it reached its climax in the Junk sculpture and Pop Art of the 1950s and 1960s.

ALEXANDER ARCHIPENKO (1887–1964) Alexander Archipenko has a strong claim to priority as a pioneer Cubist sculptor. Born in Kiev, Russia, he studied art in Kiev and Moscow until he went to Paris in 1908. By 1910 he was exhibiting in various German cities and had started his own school of sculpture in Paris. In his earliest works showing the impact of Cubism, such as the *Black Seated Torso* of 1909 (fig. 232), his use of a barely suggested geometric structure gives the elegantly revolving figure a firmness that prevents it from becoming purely decorative in an Art Nouveau manner. By 1912 Archipenko had realized the implications of Cubism for sculpture and had opened up voids within the mass of the figure to a point where the historic concept of a sculpture as a solid surrounded by space was reversed. In *Walking Woman*, the sculptured figure became a series of voids or spaces shaped and defined by solid outlines (fig. 233). In 1913–14 Archipenko made another contribution by adapting the new technique of collage to sculpture, and making constructions out of various materials,

such as wood, glass, and metal. Although the "Médrano" figures that he constructed during the next few years tend toward the mannered (plate 68), the technique that he devised was of importance to the emerging tradition of sculpture as a construction composed of space rather than mass.

Picasso's constructions or assemblages were more advanced than the Médrano constructions of Archipenko in their abstract constructive qualities, but the latter's Cubist figures had more immediate influence, first because they were more widely exhibited at an early date, and second for the very reason that they were applying Cubist principles to the long familiar sculptural subject of the human figure, which seemed to make the implications of mass-space reversals more easily comprehensible. Archipenko's contribution was made between the years 1910 and 1920, when the artist was in close touch with the Cubist painters. After that date, particularly after he moved to the United States in 1923, his sculpture reverted to a pleasant, graceful figuration that used the forms of Cubist art essentially as surface decoration.

RAYMOND DUCHAMP-VILLON (1876–1918) The artist of the greatest potential and, possibly, of the least fulfilled ability among the first Cubist sculptors was Raymond Duchamp-Villon, whose substantial talents were cut off by his early death in 1918. He was one of a family of six children, of whom four became artists. His brothers were the painters Marcel Duchamp and Jacques Villon, while his sister was the painter Suzanne Duchamp. Duchamp-Villon started in medicine but in 1900 abandoned it for sculpture. The following year he was exhibiting in the Salon de la Nationale. At first influenced by Rodin, like all his genera-

above: 232. ALEXANDER ARCHIPENKO. *Black Seated Torso*. 1909. Bronze, height 12″. Collection Mme. Alexander Archipenko

right: 233. ALEXANDER ARCHIPENKO. *Walking Woman*. 1912. Bronze, height 26⅜″. Collection Mme. Alexander Archipenko

tion, he moved rapidly into the orbit of the Cubists, taking the final step in the great *Horse* (fig. 234). The various preliminary versions trace the development of Duchamp-Villon's idea from flowing, curvilinear, relatively representational forms to final abstraction of all elements into a powerful statement of diagonal planes and concave and convex shapes that move, unfold, and integrate space into the mass of the sculpture. Thus Duchamp-Villon, despite the differences of his approach and solutions, sought essences as Brancusi did. By continually stripping away extraneous details, he came at last to complete sculptural experience.

JACQUES LIPCHITZ (1891–1973) No other sculptor explored the possibilities of Cubist sculpture as did Jacques Lipchitz, yet Cubism was only one chapter in his extensive career. Born in Lithuania in 1891, Lipchitz arrived in Paris in 1909 and there studied at the École des Beaux-Arts and the Académie Julian. In 1913 he met Picasso and began his association with the Cubists. He was particularly close to Juan Gris, as well as to Amedeo Modigliani and Matisse. In 1913 he introduced some geometric stylization into a series of figure sculptures, and by 1916 he was producing a wide variety of Cubist works in stone, bronze, and wood construction. In the large *Head* of 1915 the features are subordinated to the point of abstraction (fig. 235). A rectangular mass is intersected by a central diagonal ridge that rises into two curving, opposed, horizontal shelves, suggesting eyes, eyebrows, and ears. The whole, however, is essentially a structure of interpenetrating lines and masses, constituting one of the first successful Cubist sculptures.

Between 1915 and 1917, Lipchitz, in his stone carvings and wood constructions, attained his highest degree of abstract simplification. An

234. RAYMOND DUCHAMP-VILLON. *Horse*. 1914. Bronze, height 15⅜″. Collection Edgar Kaufmann, Jr., New York

 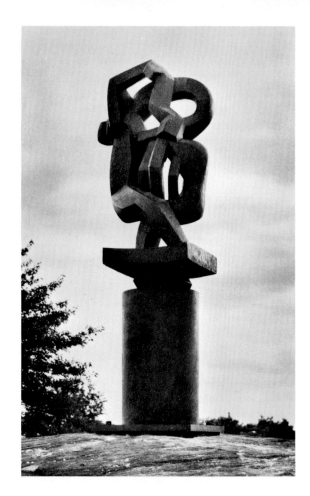

above left: 235. JACQUES LIPCHITZ. *Head*. 1915. Bronze, height 24″. Hirshhorn Museum and Sculpture Garden, Smithsonian Institution, Washington, D.C.

above center: 236. JACQUES LIPCHITZ. *Standing Personage*. 1916. Stone, height 42½″. The Solomon R. Guggenheim Museum, New York

above right: 237. JACQUES LIPCHITZ. *Joie de Vivre*. 1927–60. Bronze, height 11′. The Whitney Museum of American Art, New York

above: 238. JACQUES LIPCHITZ. *Reclining Nude with Guitar*. 1928. Bronze, height 27″. Hirshhorn Museum and Sculpture Garden, Smithsonian Institution, Washington, D.C.

right: 239. JACQUES LIPCHITZ. *Figure*. 1926–30. Bronze (cast 1937), 7′1¼″ × 38⅝″. Collection, The Museum of Modern Art, New York. Van Gogh Purchase Fund

implicit figure had always been present, but this was now reduced to a series of vertical and horizontal planes penetrating one another, with some counterpoint of curvilinear contours (fig. 236). Despite the classic repose of these sculptures, Lipchitz was not content with either their abstraction or their rectangular regularity; so, in 1917, he began to complicate the figures and at the same time to introduce a greater degree of mass. From 1917 through the early 1920s the sculptures involve a complex of qualities, both rich and monumental, and frequently take on a specific mood or personality. During the 1920s he executed some of his most monumental Cubist works, such as the *Joie de vivre* (fig. 237).

Cubism, for Lipchitz, had been a liberating factor, and between 1915 and 1925 he created many important Cubist sculptures. He early realized that Cubism had as significant a role to play in sculpture as in painting. It was a means of reexamining the nature of sculptural form in its essence and of asserting the work of sculpture as an entity all by itself rather than as an imitation of anything. The Cubist sense of form remained with Lipchitz throughout his life, even though his style departed radically from geometric Cubism.

In Lipchitz's maquettes (original clay or bronze sketches), however, there became evident by 1925 a desire for liberation from Cubist forms and for discovery of a new subject content and a new expression. This was the moment when the artist began to create his transparents (fig. 238), in which he reversed solid and void in a series of experiments that were to have an important impact on the later history of modern sculpture.

Lipchitz, like many of his generation, originally revolted against Rodin as too overpowering an influence. Now, however, he had begun to realize that Rodin was the master of them all, the father of modern sculpture. From this point forward, expressive content became paramount in his sculpture, and led to the free, baroque modeling of his later works. The monumental *Figure* is a tremendous, primitive totem of overpowering presence (fig. 239). Although primitive art was a personal passion with Lipchitz, his own inspiration came primarily from Classical and Biblical sources.

A theme that fascinated Lipchitz from the mid-1930s is Prometheus and the vulture. For the Paris World's Fair of 1937 he created a vast plaster of Prometheus strangling the vulture. To him the subject was a symbol of the victory of light over darkness, of knowledge over ignorance, and he explored it in many different versions. The definitive work was produced between 1944 and 1953. In the example seen here (fig. 240) the geometry of Cubism seems to have been replaced by a baroque, curvilinear movement of volumes. His original Cubist disciplined control, however, is still evident in the balance of solids and voids.

In May 1940, with the German invasion of France, Lipchitz left Paris and in 1941 reached the United States, where he lived until his death. His fears and uncertainties in the 1930s were now translated into optimism, which continued to manifest itself in the works of the last twenty-five years, most notably perhaps in the statue of *Notre Dame de Liesse* (fig. 241) and in related pieces on which he worked beginning in 1948. Lipchitz was deeply moved when he—as he said, "a Jew, true to the faith of his ancestors"—was asked to create a shrine for the Christian Madonna. The solution at which he finally arrived—the Madonna whose form becomes one with the heart-shaped mandorla surrounding her—drew on all the experience of his working life. The essence of the altarpiece lies in its profound statement of the concept of metamorphosis, a concept central to Lipchitz's sculpture during most of his career.

240. JACQUES LIPCHITZ. *Prometheus Strangling the Vulture*. 1944. Bronze, height 96½". Walker Art Center, Minneapolis

241. JACQUES LIPCHITZ. *Notre Dame de Liesse*. 1948. Bronze, height 33". Estate of the Artist

left: 242. HENRI LAURENS. *Petite Amphion*. 1937. Bronze, height 16″. Marlborough Gallery, New York

right: 243. OSSIP ZADKINE. *Mother and Child (Forms and Light)*. 1918. Marble, height 23¾″. Hirshhorn Museum and Sculpture Garden, Smithsonian Institution, Washington, D.C.

In the idea of change, or becoming, are involved all the artist's thoughts on birth and life and death. The Virgin of Mercy as she is transformed into a mandorla becomes a symbol of the transformation of the flesh and the spirit.

HENRI LAURENS (1885–1954) The Cubist sculptures of Henri Laurens, whether still life or figure, generally retain a defined sense of subject. Laurens was that rare phenomenon of the School of Paris, an artist who actually was born, lived, and died in Paris. He was apprenticed in a decorator's workshop, where, like Braque, he may have absorbed certain techniques of embellishment later translated into his sculptures. In fact, in 1911 he met Braque, who was in the midst of his explorations of Analytic Cubism. The two were drawn to each other and remained lifetime friends. Laurens's close relations with the painters may explain his frequent use of color in his sculptures, color beautifully and soberly integrated into low reliefs or freestanding stone blocks (plate 69). Many of the Cubist sculptors experimented with color, just as the painters sought relief effects with collage. For Laurens the use of color had a special significance. Referring to the long tradition of color in sculpture from antiquity to the Renaissance, he emphasized its function in eliminating variations of light on sculpture. As he explained, "When a statue is red, blue, or yellow, it remains red, blue, or yellow. But a statue that has not been colored is continually changing under the shifting light and shadows. My own aim, in coloring a statue, is that it should have its own light."

Laurens was a fine designer and book illustrator and, like Picasso, with whom he became friendly in 1915, he designed sets for Diaghilev's Ballets Russes. During the 1920s he relaxed the more rigid geometry of his earlier Cubist works and developed his personal form of curvilinear Cubism. At first the curvilinear elements were balanced with rectilinear forms, but by the end of the decade his interest had shifted to the creation of curving volumes, and the rounded moving rhythms of his later style. The suggestion of specific subject matter, frequently taken from Classical myth, is increased. The *Petite Amphion* of 1937 (fig. 242)

combines extremely free organic shapes, comparable to some of the Surrealist bone figures of Picasso (plate 143), with a pattern of rigidly parallel lines to evoke the magical lyre of the son of Zeus.

Despite his introduction of an element of personality in his figures and his more explicit subjects, either mythological or allegorical, Laurens remained throughout his career a sculptor interested essentially in his plastic means, expressed first in Cubist forms and later in baroque movement of volumes in space. In this he differed from Lipchitz who, after the 1920s, turned more and more to subjects in which the idea expressed, whether taken from Classical mythology, the Old or New Testament, or his personal agony or exultation, increasingly dominated and directed the plastic means.

OSSIP ZADKINE (1890–1966) Zadkine never really deserted Cubism, although from the very beginning his Cubist sculptures took on Expressionist overtones. Born in Smolensk, Russia, in 1890, he was in Paris in 1909, at the moment of the inception of Cubism. The marble *Mother and Child* of 1918 illustrates the massive, closed quality of his first works (fig. 243). Solids and voids in the figures are interchanged, and the whole is exceptionally tightly organized. Interest in formal elements, however, did not prevent an intense statement of the mother-child relationship, which makes of this work essentially a subject sculpture. After 1920 his Cubism took on elaborately decorative, curvilinear qualities that also frequently suggested his close interest in the qualities of materials—wood, bronze, and stone—which he sought to express in their essence.

For sculpture, Cubism was one of the greatest liberating forces. It opened the path to subjects other than the human figure; it led the way to complete abstraction; it defined the nature of sculpture as an art of mass, volume, and space; and it developed new possibilities in the utilization and expansion of these elements. In sculpture as in painting, Cubism has never really died. In one form or another, it continues to affect the ideas and the production of younger sculptors of all tendencies in every part of the world.

The Spread of Cubism

In 1911, while Picasso and Braque were working together so closely that it is difficult to separate their art, the Spaniard was comparatively more developed as an artist than his French colleague, on the whole a more colorful personality, and, despite his refusal to exhibit in official Salons, better known to contemporary critics. Picasso therefore generally received credit for being the leader and the more original spirit in their collaboration. Braque's significance as a full partner with some claim to primacy in the development of Cubism came in for recognition only gradually. In 1910, meanwhile, a number of other emergent Cubists had begun to formulate individual attitudes that were destined to enlarge the boundaries of the style. Of these, Albert Gleizes and Jean Metzinger were to develop also into talented critics and expositors of Cubism. In their book *On Cubism*, published in 1912, they produced one of the first important theoretical works on the movement. Gleizes and Metzinger met regularly with Robert Delaunay, Fernand Léger, and Henri Le Fauconnier (1881–1946) at the home of the Socialist writer Alexandre Mercereau, at the café Closerie des Lilas and, on Tuesday evenings, at sessions organized by the journal *Vers et Prose*. At the café, these painters met with older, Symbolist writers and younger, enthusiastic critics, such as Guillaume Apollinaire and André Salmon. At the moment when Braque joined Picasso in his avoidance of the French Salons, this second group of Cubists gained rapid notice and began to exercise a substantial influence, not only in France, but also in Germany, specifically on the artists of Der Blaue Reiter.

In the 1911 Salon des Indépendants, the group arranged to have their works hung together, and included a few other artists of sympathetic tendencies, among them Marie Laurencin. The concentrated showing of Cubist experiments created a sensation, garnering violent attacks from most critics, but also an enthusiastic champion in Apollinaire. This official emergence of Cubism was followed by an exhibition of works of many of the group as well as those of the Cubist sculptor Archipenko at the Société des Artistes Indépendants in Brussels. Although Picasso and Braque did not take part in these 1911 Salons, their innovations were widely known. Braque had shown Cubist works in the Salon of 1909, and paintings by both artists could be seen at the galleries of the dealers Kahnweiler and Wilhelm Uhde. Both Delaunay and Metzinger knew Picasso. Metzinger had written on Picasso's new work as early as 1910, particularly noting his development of multiple views and his abandonment of Renaissance perspective. Apollinaire also acted as an important link between Picasso and Braque and the others.

During 1911, Archipenko and Roger de La Fresnaye joined the Gleizes-Metzinger group, together with Francis Picabia, and Apollinaire's friend Marie Laurencin. The three brothers Jacques Villon, Marcel Duchamp, and Raymond Duchamp-Villon; the Czech František Kupka; and, most significant, the Spaniard Juan Gris were all new additions. Having lived next to Picasso since 1906 at the old tenement known as the Bateau-Lavoir, Gris was aware of the genesis of Cubism, although during much of this period he himself had given evidence only

of being a clever draftsman who lived by doing satirical drawings for journals. However, Gris must have been studying assiduously, because, when he finally submitted his *Portrait of Picasso* to the Salon des Indépendants of 1912, the work was a masterly and personal interpretation of Cubism. In that salon the Cubists were now so well represented that protests against their influence were made in the Chamber of Deputies. Meanwhile, their impact abroad was increasing steadily as Cubist art became known through exhibitions in Germany, Russia, England, Spain, and the United States. The Italian Futurists, as we shall see, had brought their Expressionist variation of Cubism back to Italy in 1911. In 1912 Kandinsky published works of Le Fauconnier and other Cubists in *Der Blaue Reiter*. Paul Klee in the same year and Franz Marc and August Macke, somewhat later, were visiting Delaunay in his Paris studio and taking ideas back to Germany.

By 1912 not only the Futurists but still other artists were beginning to push the original Cubist concepts to new limits. Delaunay was developing his art of "simultaneous contrasts of color" based on the ideas of that same color theorist, Chevreul, who had so strongly influenced Seurat, Signac, and the Neo-Impressionists. Out of this investigation grew the abstract style to which Apollinaire gave the name Orphism. In the large exhibition at the Galerie La Boétie, held in October 1912 and entitled (probably by Jacques Villon) "Section d'Or" (Golden Section), the entries by Marcel Duchamp, Picabia, and Kupka particularly were seen to be moving in new directions. The Dutch painter Mondrian had arrived in Paris in 1912 and was already beginning to use the Cubist grid as the basis of an abstract type of construction. The move to complete abstraction was simultaneously in process, between 1910 and 1914, in Russia, where Mikhail Larionov invented Rayonism in 1912 and Kasimir Malevich was working toward Suprematism, finally realized in 1915.

During 1912 and 1913 appeared not only Gleizes and Metzinger's *On Cubism*, but also Apollinaire's book *Les Peintres cubistes* and other articles or book chapters by André Salmon, Olivier Hourcade, Maurice Raynal, and other critics, who traced the origins of Cubism and attempted to define its nature and its distinctions from Renaissance perspective painting. Even today, when we are accustomed to the meteoric rise and fall of art movements and styles, it is difficult to appreciate the speed with which Cubism, beginning in 1907–8 with the isolated experiments of Braque and Picasso, had by 1912 become a worldwide movement whose history was already in process of being written and whose development was already branching off in different directions: toward abstraction, toward a new Expressionism, and even toward new concepts of reality.

JUAN GRIS (1887–1927) Gris's 1912 *Portrait of Picasso* (fig. 244) is akin to studies of heads made by Picasso in 1909 as regards the arbitrary relations of form to surrounding space (fig. 216), but it has a mathematical control quite unrelated to anything that Picasso, Braque,

244. JUAN GRIS. *Portrait of Picasso*. 1912. 36¾ × 29¼". Art Institute of Chicago. Gift of Leigh B. Block

or the other Cubists had attempted. From this monochromatic painting Gris moved to a coloristic formula that may have anticipated the later or developed Synthetic Cubist paintings of Braque and Picasso. The *La Place Ravignan, Still Life in Front of an Open Window* (plate 70) is an accomplished combination of Renaissance and Cubist space—an anomaly that was to intrigue Picasso, Braque, and other Cubists for many years to come, almost as an intellectual exercise in perception. The interior embodies all the elements of Synthetic Cubism, with large, intensely colored geometric planes interlocking and absorbing the familiar collage components: the newspaper, *Le Journal*; the wine label, *Médoc*; the decorative grillwork. However, the foreground pattern of tilted color shapes leads the eye to the window that opens out on a uniformly blue area of trees and buildings. Thus the space of the picture shifts abruptly from the ambiguity and multifaceted structure of Cubism to the cool clarity of the detail of external space seen through the traditional Renaissance window. Gris was one of the first Cubists to realize the possibilities of this double way of seeing.

Gris was largely instrumental in bringing light and color back into Cubism, at times to the point of overly decorative lyricism. At the end of his short life, however, he was beginning to explore a manner of utmost austerity, in which objects—mandolin, table, sheet music, or window and outer space—were simplified to elemental color shapes. In *Guitar with Sheet of Music*, a work of 1926 (plate 71), he reduced these familiar objects of Cubist still life to stark, simple shapes separated by intervals as tangible as solids. In his colors he eliminated the luminous iridescence from which had arisen much of the sensuous and decorative lyricism of earlier works. The paint is applied as a matte surface that reinforces the sense of architectural structure and, at the same

time, asserts its own nature as paint. The bright primary colors—the blue of the sky, the yellow of the mandolin's body, the red of the cloth—are framed by neutral tones. The table and window frame are composed of low-keyed ochers that merge imperceptibly with varying values of brown, all within the deep gray shadow of the room. Within this subdued but beautifully integrated color construction, the artist has created, through the linear geometry of his edges, a tour de force of shifting planes and ambiguous but structured space. He used the full repertoire both of the Cubist grid and of Renaissance perspective, playing innumerable tricks of illusion but always bringing us back to the picture plane—the painted surface. The left-hand window frame reverses itself before our eyes. Meanwhile, the diagonal yellow line that bounds the red cloth on the left is drawn perfectly straight, yet is made to bend, visually, by the deeper value of the cloth as it (presumably) folds over the edge of the table. The deeper value of ocher between the mandolin body and the cloth and sheet music similarly bends away at the right as the black-and-white striped neck of the mandolin recedes into a perspective infinity. The white V of the open sheet music joins with the right-hand side of the table to rise up as a piece of Constructivist sculpture (fig. 471). Gris here, in fact, integrates effects of architectural recession, sculptural projection, and flat painted surface into a tightly interlocked pictorial harmony. This is the important point—that the technical illusions are controlled as significant but subordinate elements in one of the last masterpieces of the artist's brief and brilliant career.

ALBERT GLEIZES (1881–1953) The contributions of Gleizes and Metzinger to the Cubist movement are usually overshadowed by the reputation of their theoretical writings, specifically the pioneer *On Cubism*, in which much of the pictorial vocabulary of Cubism was first elucidated. Gleizes in particular was instrumental in expanding the range of the new art, both in type of subject and of attitude toward subject, for he himself, very early in the history of Cubism, became involved with expressive as well as plastic and formal elements. His monumental 1912 painting *Harvest Threshing* (fig. 245) is a provocative opening up of the generally hermetic world of the Cubists, and in its suggestions of the dignity of labor it has social implications. Although the total palette remains within the subdued range of Picasso and Braque at the same moment—grays, greens, browns, with flashes of red and yellow— Gleizes's color achieves a richness that gives the work romantic overtones suggestive of Jules Breton or Jean-François Millet (fig. 18).

In his later works Gleizes turned to a form of lyrical abstraction based on curvilinear shapes, frequently inspired by musical motifs, as in *Symphony in Violet* (plate 72).

JEAN METZINGER (1883–1956) The early Cubist paintings of Jean Metzinger are luminous variations on Cézanne, whereas slightly later works suggest an academic approach more intellectual than visual. *The Bathers* (fig. 246) illustrates his penchant for a carefully constructed rectangular design, in which the romantic luminosity of the paint plays against the classic geometry of the linear structure. Metzinger moved with every variation of the Cubist breeze. For a time he toyed with effects derived from the Italian Futurists, later moving easily into the Synthetic Cubist realm of larger shapes and more vivid color. Then, with the return to the object that marked so much painting toward the end of World War I, he assimilated photographic images of architectural scenes to a decorative Cubist frame. His style was soon an idealized realism for which Cubist pattern was a decorative background. This formula, unfortunately, enmeshed many of the lesser Cubists and, at times, even so major a figure as Gris.

245. ALBERT GLEIZES. *Harvest Threshing*. 1912. 8'10" × 11'7". The Solomon R. Guggenheim Museum, New York

ROGER DE LA FRESNAYE (1885–1925) Roger de La Fresnaye came out of Cézanne almost more literally than did any of the other Cubists. His early landscapes were even more traditional in their mode of representation than the Cézanne landscapes on which they were based. However, De La Fresnaye soon moved on to a pattern of abstract shapes, strongly colored and contrasting with the literal rendition of the figure. The whole was rendered in thin washes of atmospheric paint suggestive of watercolor. This approach he employed on a monumental scale in his *Conquest of the Air* (plate 73), which, like Delaunay's large painting *Homage to Blériot*, provides striking evidence of the enthusiasm of the period's experimental artists for the new world of technology then paralleling their own explorations of new ways of transforming the universe. In their lyrical color and nebulous spatial transitions, the mature paintings of De La Fresnaye illustrate the degree to which Cubism was a novel way of seeing, a new perception that opened up a thousand unexplored avenues of expression.

FERNAND LÉGER (1881–1955) The impact of Cubism was tremendous. Not only did it spread rapidly; it also led at once to variations on existing styles and to the creation of new styles. In Germany and Italy it served as a base for Expressionist approaches; in Holland and Russia it was a first step toward absolute abstraction; in the United States it led to a new approach to Realism; and throughout the world it fed the new arts of fantasy, Dada, and Surrealism. One almost inevitable offshoot was an art commemorating the ever-expanding industrial machine world. The geometric basis of much Cubist painting provided analogies to machine forms and an excuse for a machine iconography. Of the French Cubists only one of the great masters devoted his life to the application of Cubist forms to machine iconography. This was Fernand Léger—ironically enough of Norman peasant stock and maintaining many of the qualities of his peasant ancestors throughout his life. Léger's painting passed from the influence of Cézanne to that of Picasso in his proto-Cubist, sculptural stage. One of his first major canvases,

246. JEAN METZINGER. *The Bathers*. 1913. 58¼ × 41⅞". Philadelphia Museum of Art. Louise and Walter Arensberg Collection

above left: 247. FERNAND LÉGER. *Nudes in the Forest*. 1909–10. 47¼ × 66⅞″. Kröller-Müller Museum, Otterlo, The Netherlands

above right: 248. FERNAND LÉGER. *Contrast of Forms*. 1913. Oil on burlap, 51 × 38″. Philadelphia Museum of Art. Louise and Walter Arensberg Collection

Nudes in the Forest (fig. 247), was possibly inspired by Picasso's 1908 *Nude in the Forest* (Hermitage, Leningrad), a work similar in style to the Rue-des-Bois landscape seen in figure 209. But in Léger's hands the theme became an unearthly habitation of machine forms and robots. Here Léger seems literally to be attempting to create a work of art out of the cylinders and cones to which Cézanne referred. The sobriety of the colors, coupled with the frenzied activity of the robots, creates an atmosphere of demonic action symbolic of a new, dehumanized world. It is an anticipation of the world that the Italian Futurists sought to create in painting, here with an emphasis on doom, however, rather than on hope and progress.

Léger soon lightened his palette and began to experiment with atmospheric effects, and from this phase he moved to an examination of machine forms freely rendered in predominantly primary colors. These color shapes were sometimes made to suggest mechanical figures. At other times the abstract structure was made explicit by such titles as *Contrast of Forms* (fig. 248). Although Léger's passion for geometric shapes rendered in bright color periodically led him to the edge of nonrepresentational art, it was the fascination of subject, normally with some machine symbolism of social significance, that always drew him back.

The City, executed in 1919, marks another major step in the artist's exploration of reality and the painted surface (plate 74). In most of the earlier canvases Léger had worked in an unabashedly sculptural manner, modeling his forms out from the surface of the canvas even to the point where they seemed to detach themselves. Now he obviously set out to control his sculptural exuberance through a rigid architecture establishing the primacy of the two-dimensional picture plane. Still, Léger used the range of advanced Synthetic Cubism to play every sort of illusionistic variation. The foreground column is modeled as a bas-relief. Tilted planes suggest the illusion of perspective depth. Literal elements of machines, buildings, robot figures mounting a staircase, stenciled letters, signs—all contribute to the kaleidoscopic glimpses of the urban industrial world.

249. MAURICE TABARD. *Nude*. 1929. Vintage silver print. New Orleans Museum of Art

250. FERNAND LÉGER. *The Baluster*. 1925. 51 × 38¼". Collection, The Museum of Modern Art, New York. Mrs. Simon Guggenheim Fund

251. FERNAND LÉGER. *The Polychrome Divers*. 1942–46. 98⅜ × 72⅞". Musée Fernand Léger, Biot, France

In his figure compositions of the 1920s and 1930s, Léger created a disciplined and somewhat frightening symbol of the brave new world of the machine in a manner that stemmed from the French Classic tradition of Poussin and David. *Three Women* (plate 75), in its depersonalization of the figures, which are machine volumes modeled out from the rigidly rectangular background and stare fixedly, uniformly, and impersonally at the spectator, takes a further step toward abstraction at the same time that it evokes an Art Deco environment of machine fantasy.

Inevitably, Cubism and the machine style also affected the more aesthetically minded photographers of the period, such as Maurice Tabard (b. 1897), who, in the work seen here (fig. 249), broke up and reassembled the figure within the same mechanized pattern of light and dark serving to structure the surface as a web of rectilinear coordinates.

Léger only rarely produced paintings that could be considered entirely abstract, and often these derived from motifs, such as those of architecture, that were themselves abstract. Like *Three Women*, *The Baluster* (fig. 250) shares its pristine qualities with the 1920s Purism of Ozenfant and Le Corbusier (figs. 253, 254), as well as with the austere elegance of Art Deco. Meanwhile, the inherent monumentality of its simple forms and iconic frontality places *The Baluster* at one with the "return to order" Classicism that emerged in the years following the aesthetic upheaval of early modernist experiments and the military violence of World War I.

During the last twenty years of his life, Léger concentrated his efforts on a few basic themes, which he explored in many different ways, from the most abstract efforts of his career to the most representational. In these he sought to sum up his experiences in the exploration of man

252. FERNAND LÉGER. *Homage to Louis David*. 1948–49. 60½ × 72¾". Musée National d'Art Moderne, Paris

and his place in the contemporary industrial world. Although it was only in part a social exploration, this element was important to him. It was also a visual exploration of his world as an artist, a final and culminating assessment of his plastic means for presenting it. In the many works of The Divers series the artist explored variations of a flowing,

interwoven composition of boldly outlined figures presented as flat or modeled color shapes moving in and out of shallow depth (fig. 251). In contrast with The Divers, where the artist's emphasis falls on the formal problem of composing figures moving in space, The Cyclists pictures turn to more easily comprehended subject matter. In one version made in 1948–49, *Homage to Louis David* (fig. 252), he shows the happy petit-bourgeois family on its Sunday outing, the women in shorts and bathing suits, the men overdressed for the occasion, and the entire family stiffly posed for the itinerant photographer. Like all Léger's late paintings, the picture has a Cubist structural frame. But it is also a realistic if stylized presentation, with suggestions of the primitive, or naïve, elements of social commentary, even of Surrealist fantasy. Moreover, all of these characteristics reflect concepts, styles, and movements that had merged, flourished, and—in some cases—declined in the first forty years of the twentieth century. Despite his dedication to his own form of machine Cubism, Léger was not untouched by those developments.

In *The Great Parade* of 1954 Léger brought to culmination a series in which figure and environment are realistically drawn in heavy black outline on a white ground, over which float free, variously shaped planes of transparent red, blue, orange, yellow, and green (plate 76). This huge work also reflects a lifelong obsession with circus themes, an obsession common to many masters of modern art.

Despite the proportionately greater interest in specific representation, illustrative subject, and social observation, these late works are remarkably consistent with Léger's earliest essays in Cubism based on machine forms. The artist was one of the few who, quite literally, never really deserted Cubism but was able to demonstrate, in every phase of his prolific output, its potential for continually fresh and varied expression.

Purism

The machine Cubism of Léger bears some relationship to the variant on Cubism called Purism, developed around 1918 by the architect-painter Charles-Édouard Jeanneret (called Le Corbusier; 1887–1965) and the painter Amédée Ozenfant (1886–1966). In their manifesto entitled *After Cubism*, published in 1918, Ozenfant and Jeanneret attacked the then current state of Cubism as having degenerated into a form of elaborate decoration. In their painting they sought an architectural simplicity of vertical-horizontal structure, and elimination of decorative ornateness as well as illustrative or fantastic subjects. To them the machine became the perfect symbol for the kind of pure, functional painting they hoped to achieve—just as, in his early, minimal architecture, Le Corbusier thought of a house first as a machine for living. Purist principles are illustrated in Ozenfant's *Still Life* and Jeanneret's *Still Life* (figs. 253, 254). In both works, executed in 1920, the still-life objects are arranged frontally, with colors subdued and shapes modeled in an illusion of projecting volumes. Symmetrical and mechanical curves move across the rectangular grid with the antiseptic purity of a well-tended, brand-new machine. Jeanneret continued to paint throughout his life, but his theories gained significant expression only in the great architecture he produced as Le Corbusier. Ozenfant had enunciated his ideas of Purism in *L'Élan*, a magazine published from 1915 to 1917, before he met Jeanneret, and in *L'Esprit Nouveau*, published with Jeanneret from 1920 to 1925. Ozenfant later turned to mural painting.

Orphism

ROBERT DELAUNAY (1885–1941) Unlike Léger, Robert Delaunay moved rapidly through his apprenticeship to Cubism and by 1912 had arrived at a formula of brilliantly colored abstractions with only the most tenuous roots in naturalistic observation. His restless and inquiring mind had ranged over the entire terrain of modern art, from the color theories of Chevreul and the space concepts of Cézanne to Braque and Picasso and Henri Rousseau. Delaunay avoided the figure, the still life, and the constricted interior, and in his first Cubist paintings took as

253. AMÉDÉE OZENFANT. *Still Life*. 1920. 31⅞ × 39¼". The Solomon R. Guggenheim Museum, New York

254. LE CORBUSIER (CHARLES-ÉDOUARD JEANNERET). *Still Life*. 1920. 31⅞ × 39¼". Collection, The Museum of Modern Art, New York. Van Gogh Purchase Fund

themes two great works of architecture, the Gothic church of Saint-Severin and the Eiffel Tower. Like a recollection of Cézanne, the 1909 *Eiffel Tower in Trees* (fig. 255) is framed behind a foreground tree, depicted in light hues of ocher and blue, with a pattern of circular cloud shapes that accentuate the tempo of the painting. The fragmentation of the tower and foliage here serves the purpose not only of suggesting the shifting vision of Cubism, but also of rapid motion, so that the tower and its environment seem carried into the dimension of outer space.

The Cubist Eiffel Tower paintings owe much to the tradition of Fauvism. Their expressive qualities of motion and struggle appealed to the German Expressionists Marc and Macke when they visited Delaunay's studio in 1912, and prompted Kandinsky to invite Delaunay to exhibit with Der Blaue Reiter.

By 1910 Delaunay was beginning to move beyond the Fauve-Cubism spirit of the Eiffel Tower paintings and into an area of geometric abstraction charted, as we shall see, by no other painter except Kupka. In *Window on the City No. 4* of 1910–11 (fig. 256) Delaunay used a checkerboard pattern of color dots, rooted in Pointillism and framed in a larger pattern of geometric shapes to create a kaleidoscopic world of fragmented images. To all intents and purposes it is a work of abstraction—one of the first in modern painting.

Delaunay was one of the first to bring a full-color palette into Analytic Cubism and thus to prepare the way for Synthetic Cubism. By 1912 he had abandoned even the overtone of subject, creating an arrangement of vividly colored circles and shapes that have no reference in observed nature (plate 77).

FRANTIŠEK KUPKA (1871–1957) At the same moment, Kupka, working in Paris, had arrived at the same point of abstraction. He probably, in fact, had arrived there somewhat earlier, but since he was then relatively unknown compared with Delaunay, his immediate influence could not have been comparable. As early as 1909, Kupka, in *The First Step*, had made an abstract pattern of color spheres suggestive of planets revolving around dead white suns, and it constitutes a document in the origins of abstraction. In 1912, with the painting he entitled the *Disks of Newton* (plate 78), he created an abstract world of vibrating, rotating color circles. During the same year, Kupka produced geometric abstractions involving curves other than the circle and, most important, his *Vertical Planes* (fig. 257), a somber study of vertical rectangles in low-keyed grays, blacks, and whites, with one accent of violet, a work that anticipated the Suprematism of Kasimir Malevich (figs. 270, 271).

Delaunay had given his circular disks the title of *Disques Simultanés* (*Simultaneous Disks*, a title derived from Chevreul), but Apollinaire named the abstract experiments of Delaunay and Kupka Orphism, a recognition that what was involved was an art in its way as divorced as music from the representation of the visual world or literal subject. Kandinsky, it will be recalled, would equate his abstract Expressionist paintings with pure musical sensation (plate 48).

From the middle of the nineteenth century, artists, in a sense, had been groping their way toward a goal achieved, within two or three years of one another, by Kupka and Delaunay in France; by Larionov and Malevich in Russia; by Wyndham Lewis and David Bomberg in England; by Arthur Dove in the United States; and by Kandinsky in Ger-

257. FRANTIŠEK KUPKA. *Vertical Planes.* 1912–13. 79⅜ × 46¾″. Estate of the Artist

rectangular, while the figures concentrate with tense energy and are characterized by an individuality that causes their fragmentation to invoke a fantastic rather than a structural presence. Even at the moment when he was learning about Cubism, Duchamp was already revolting against it, transforming it into something entirely different from the conceptions of its creators.

During the same year Duchamp painted the first version of *Nude Descending a Staircase*, a work destined to become internationally notorious as a popular symbol of the madness of modern art. In the famous second version, seen here (plate 79), the figure has been so fragmented and multiplied and the facets so sharply geometrized that the implied motion accelerates to staccato. Other Cubists objected to the work for its literary title and explicit subject, and Duchamp withdrew it from the 1912 Salon des Indépendants. The critics were right. This is not simply a Cubist painting; it is a painting in which Cubist means are used for some peculiarly personal expressive effect. The rapidly descending figure was not merely an organization of abstract lines and shapes but also a living figure set in a common enough environment, engaged in a routine but disconcertingly transformed activity. Duchamp here was deliberately attempting to reintroduce elements of subject—action, mood, personality—into Cubist painting. In so doing he was striking at the bases of Cubist thinking, and initiating a new kind of subject emphasis that was to affect Italian Futurist painting and sculpture immediately. Later, and even more directly, it was to shape the course of Dadaism, Surrealism, and other explorations into fantasy and expression. Duchamp was an instinctive Dadaist, an iconoclast in art even before the creation of Dada, so it is natural that he should have been immediately recognized by the first Dadaists and Surrealists as a great forerunner. From an attack on Cubism that involved a new ap-

many: an art of nonrepresentation in which the illusion of nature was completely eliminated, and whose end purpose was organization of the artist's means—color, line, space, and their interrelations and expressive potentials. It is thus curious that the impact of the actual achievement was not initially greater or more widespread. The quest for an abstract vocabulary continued to be carried on during the second decade of the twentieth century, particularly by a few artists in Holland, Russia, and Germany, but during the same period World War I was disrupting all creative effort everywhere. New forces, new attitudes, were beginning to make themselves felt.

MARCEL DUCHAMP (1887–1968) Among the first artists to desert Cubism in favor of a new approach to subject and expressive content was Marcel Duchamp, one of the most fascinating, controversial, and influential figures in the history of modern art. As previously noted, Duchamp was the youngest of three brothers, all of whom contributed significantly to the art of the twentieth century. Until 1910 he worked in a relatively conventional manner based on Cézanne and the Impressionists. In 1911 Duchamp painted *Portrait of Chess Players* (fig. 258), obviously after coming under the influence of Picasso's and Braque's Cubist explorations. The color is low-keyed and virtually monochromatic, the space ambiguous. The linear rhythms are cursive rather than

258. MARCEL DUCHAMP. *Portrait of Chess Players.* 1911. 39¾ × 39¾″. Philadelphia Museum of Art. Louise and Walter Arensberg Collection

proach to subject, he passed, between 1912 and 1914, to an attack on the nature of subject painting, and finally to a personal reevaluation of art and an attack on its very nature. This phase of his career is properly examined later, along with fantasic, irrational, and accidental art, as well as antiart—all slowly becoming major opposition to Cubism and abstraction.

JACQUES VILLON (1875–1963) Duchamp's elder brother Jacques, who took the name Villon, was at the other extreme from Marcel. He established a personal, highly abstract, and poetic approach to Cubism, and maintained this approach with elegance and consistency throughout his long life. In the 1913 *Soldiers on the March* (plate 80) the colors are cool and delicate, and the crystalline structure of jagged triangular shapes with precisely ruled contours becomes predominant. This is the type of structure that Villon made his own and on which he played variations throughout his life. The sense of rapid, clearly defined motion represents a personal exploration of Cubism that was to have an impact on the development of Futurism.

During the 1920s and 1930s Villon moved back and forth between abstraction and a kind of simplified Realism. The abstract work was based on Cubist forms but with no suggestion of Cubist subject. The geometric *Color Perspective*, for instance (fig. 259), is an abstraction in which Villon's sole concern was the formal relationships of the color shapes and the space they occupy and create.

FRANCIS PICABIA (1879–1953) The transition of Francis Picabia from Cubism to Dadaism parallels that of Duchamp, but Picabia cannot be considered an artist of the same magnitude. Until 1912 he was involved with the Cubist exhibitions and propaganda of Gleizes and Metzinger and exhibited with the Section d'Or, after which he went over to Orphism. In *Catch as Catch Can* (plate 81) the interplay of blacks and reds suggests the rhythmic pattern of a procession. Thus the painting demonstrates a departure from orthodox Cubism in giving stress to actual incident and attempting to retain the literal character of the event within the Cubist context. This concern with subject led Picabia, in 1913, to abandon Cubism and begin creating a world of unearthly machines (figs. 332, 333). In New York in 1915, together with Duchamp and Man Ray, he founded the American wing of what was to become international Dada. From that moment forward, Picabia was intensely involved in Dada and Surrealism.

Futurism in Italy

Cubism, although it began to affect German Expressionism only in the later paintings of Marc, Macke, and Lyonel Feininger, was implicit in Italian Futurist painting and sculpture at the very birth of the movement. Futurism was first of all a literary concept, born in the mind of the poet and propagandist Filippo Tommaso Marinetti in 1908, and propagated in a series of manifestoes in 1909, 1910, and subsequently. Essentially a Milanese movement, it began as a rebellion of young intellectuals against the cultural torpor into which Italy had sunk during the nineteenth century, and, as so frequently happens in such movements, its manifestoes were initially intent on what they had to destroy. The first manifesto demanded the destruction of the libraries, the museums, the academies, and the cities of the past that were themselves mausoleums. It extolled the beauties of revolution, of war, of the speed and dynamism of modern technology: "...a roaring motorcar, which looks as though running on shrapnel, is more beautiful than the *Victory of*

259. JACQUES VILLON. *Color Perspective*. 1921. 21⅜ × 28⅝″. The Solomon R. Guggenheim Museum, New York

Samothrace." Much of the spirit of Futurism reflected the flamboyant personality of Marinetti himself, and he in turn was an extreme case of the indignation that his generation felt over the cultural and political decline of Italy. The Futurism of Marinetti and his followers was rooted in the philosophies of Henri Bergson and Friedrich Nietzsche and in the prevalent atmosphere of anarchism. It attacked the ills of a lopsided aristocratic and bourgeois society. In the field of politics it unfortunately became a pillar of Italian Fascism.

Early in 1909 the painters Umberto Boccioni, Carlo Carrà, and Luigi Russolo joined with Marinetti. Later they were also joined by Gino Severini, who had been working in Paris since 1906, and Giacomo Balla. The group drew up its own manifesto in 1910. This again attacked the museums, the libraries, and the academies, and paid homage to the idea of simultaneity of vision, of metamorphosis, and of motion that constantly multiplied the moving object. Particular emphasis was given to the unification of the painted object and environment, so that no clear distinction could be drawn between the two. The targets of the Futurists included all forms of imitation, concepts of harmony and good taste, all art critics, all traditional subjects, tonal painting, and even the perennial staple, the painted nude.

At this point, the paintings of the Futurists had little in common and demonstrated no startling originality. Many of their ideas still came from the unified color patterns of the Impressionists and even more explicitly from the divisionist techniques of the Neo-Impressionists. But unlike Impressionism, Post-Impressionism, Fauvism, and Cubism, all of which were generated by a steady interaction of theory and practice, Futurism emerged as a full-blown theory based on and anticipated by literary theories, the illustration of which the artists then set out to realize in paintings. This was really a sort of academy of the avant-garde, and it is remarkable that so substantial a number of effective and, at times, original works should have been produced by it. The Futurists were passionately concerned with the problem of establishing an empathic identity between the spectator and the painting, "putting the spectator in the center of the picture." In this they were close to the German Expressionists, as noted previously. And although they ab-

sorbed the technical vocabulary of Cubism, their aim was not formal analysis but direct appeal to the emotions.

The art of the Futurists extolled metropolitan life and modern industry. This did not result in a machine aesthetic in the manner of Léger, since they were concerned with unrestrained expression of individual ideals, with mystical revelation achieved through an orgiastic involvement in total action. Despite the Futurists' identity of purpose, Futurist art cannot be considered a unified style like Impressionism or Cubism. Balla, the oldest of the group and the teacher of Severini and Boccioni, early in the century was painting realistic pictures with social implications. He then became a leading Italian exponent of Neo-Impressionist divisionism, and in this context most strongly influenced the younger Futurists.

Balla's 1909 painting *Street Light* (plate 82) is an early example of pure Futurism. Using V-shaped brushstrokes of complementary colors radiating from the central source of the lamp, he created an optical illusion of light rays translated into dazzling colors so intense that their vibration becomes painful to the eye.

In 1910–11 Boccioni, perhaps the most talented of the Futurists, brought forth one of his most monumental works in *The City Rises* (plate 83), a painting wherein he sought his first "great synthesis of labor, light, and movement." Dominated by the large, surging figure of the foreground horse before which the human figures fall like ninepins, it constitutes one of the Futurists' first major statements of the qualities of violent action, speed, the disintegration of solid objects by light, and their reintegration into the totality of the picture by the very same light. Such a statement represents one aspect of the Futurist credo: the dynamism of work, of labor, in modern industrial society, with sheer power symbolized by rearing, thundering horses.

The Futurist exhibition in Milan in May 1911 was the first of the efforts by the new Italian artists to make their theories concrete. Intoxicated by this initial effort, they then sought, through the agency Marinetti, to invade the great art world of Paris. In the fall of 1911 Carrà and Boccioni visited Paris in order to study the latest manifestations before attempting an exhibition there. What they learned is evident in the repainted version of Boccioni's *Farewells* (fig. 260), a 1911 work

260. UMBERTO BOCCIONI. *States of Mind: The Farewells.* 1911. 27¾ × 37⅞". Collection, The Museum of Modern Art, New York. Gift of Nelson A. Rockefeller

261. GIACOMO BALLA. *Dynamism of a Dog on a Leash (Leash in Motion).* 1912. 35 × 45½". Courtesy George F. Goodyear and the Buffalo Fine Arts Academy, New York

that is part of the triptych *States of Mind*. Within the vibrating, curving pattern the artist introduced a Cubist structure of interwoven facets that sets up a tension of forces, of linear movement. Space is constricted and controlled, giving the effect of compression rather than indefinite expansion. Boccioni even added the shock of a literal, realistic collage-like element in the scrupulously rendered numbers on the cab of the dissolving engine. It will be recalled that Braque, earlier in the year, and Picasso, toward the end of the year, introduced lettering and numbers into their Analytic Cubist works (figs. 222, 223).

The exhibition of the Futurists, held in February 1912 at the gallery of Bernheim-Jeune in Paris, was widely noticed and reviewed favorably by Apollinaire himself. It later circulated to London, Berlin, Brussels, The Hague, Amsterdam, and Munich. Within the year, from being an essentially provincial movement in Italy, Futurism suddenly became a significant part of international experimental art.

GIACOMO BALLA (1871–1958) Balla, who was older than the other four members of the group, worked in Rome rather than in Milan. He pursued his own distinctive experiments, particularly in rendering motion through simultaneous views of many aspects of objects. His *Dynamism of a Dog on a Leash* (fig. 261), with its multiplication of arms and legs, has become one of the familiar and delightful creations of Futurist simultaneity. The little terrier scurries along on short legs accelerated and multiplied to the point where they almost turn into wheels. This device for suggesting rapid motion or physical activity later became a cliché of the comic strips and animated cartoons. The transformation of figures and objects into a moving pattern of color and line is seen again in his *Flight of the Swifts* (plate 84), a bold interplay of rectilinear and curvilinear elements, both in their entirety and fragmented. The curving horizontal of the swifts' rapid flight contrasts with the zigzag organization of wings and feathers, and both gain force from the off-vertical lines that stand up like poles. The birds are literal and nonliteral, but the sense of flight is striking. Balla was a lyrical painter who achieved his effect without the noise and violence of some of his colleagues.

Also at work within the ambience of Futurist dynamism was the Italian photographer and filmmaker Antonio Giulio Bragaglia (1889–1963), who, like Marcel Duchamp in *Nude Descending a Staircase* and Balla, had been stimulated by the stop-action photographs of peo-

262. ANTONIO GIULIO BRAGAGLIA. *The Cellist*. 1913. Photograph. Courtesy Sotheby's Inc., 1986

ple and animals made not only by Muybridge and Eakins but also by the French scientist Étienne Jules Marey. Bragaglia, however, departed from all those and shot time exposures of moving forms (fig. 262), convinced that the resulting blurred image of continuous action constituted a more accurate or expressive record than the sequence of discrete, frozen moments. In 1913 Bragaglia published a number of his "photodynamic" works in a book entitled *Fotodinamismo futurista*.

GINO SEVERINI (1883–1966) Gino Severini, living in Paris, was for several years more closely associated with the growth of Cubism than the other Futurists. His approach to Futurism is summarized in *Dynamic Hieroglyphic of the Bal Tabarin* (plate 85), a gay and amusing distillation of Paris night life. The basis of the composition lies in Cubist faceting put into rapid motion within large, swinging curves. The brightly dressed chorus girls, the throaty chanteuse, the top-hatted, monocled patron, the waiters, the food, the wine, the flags, the carnival atmosphere are all presented in a spirit of delight, reminding us that the Futurists' revolt was against the deadly dullness of nineteenth-century bourgeois morality. This work is a tour de force involving almost every device of Cubist painting and collage, not only the color shapes that are contained in the Cubist grid, but also elements of sculptural modeling that create effects of advancing volumes. Additionally present were the carefully lettered words, "Valse," "Polka," "Bowling," and the sequins of the girls' costumes added as collage. The color has Impressionist freshness, its arbitrary distribution a Fauve boldness. Many areas and objects are mechanized and finely stippled in a Neo-Impressionist manner. Severini even included one or two passages of literal representation, such as the minuscule Arab horseman and the tiny but explicit nude riding a large pair of scissors.

The sense of fragmented but still dominating reality that persisted in Severini's Cubist paintings between 1912 and 1914 found its most logical expression in a series of works involving transportation, which began in 1912 with studies of the Paris Métro. With the coming of the war, the theme of the train flashing through a Cubist landscape began to intrigue him. *Red Cross Train* is a stylization of motion (fig. 263), much more deliberate in its tempo than the *Bal Tabarin*. The telescoped, but clearly recognizable train, with regular balloons of smoke billowing forth, cuts across the middle distance of large, handsome planes of strong color that intersect the train and absorb it into the total

pattern. The divisionist brushstroke is used in the color areas, and the total effect is static rather than dynamic, and surprisingly abstract in feeling. Perhaps the most significant development in Severini's painting during those two years was a movement toward total abstraction stemming from the influence of Delaunay. In *Spherical Expansion of Light* Severini organized what might be called a Futurist abstract pattern of triangles and curves, built up of divisionist brushstrokes (plate 86).

CARLO CARRÀ (1881–1966) Carlo Carrà was important in bridging the gap between Italian Futurism and what he and De Chirico would call *Pittura metafisica* (fig. 264). From 1912, however, Carrà moved steadily toward an orthodox version of Cubism that bore little relation

263. GINO SEVERINI. *Red Cross Train*. 1914. 35¼ × 45¾". The Solomon R. Guggenheim Museum, New York

264. CARLO CARRÀ. *Simultaneity, Woman on a Balcony*. 1912–13. 57⅞ × 52⅜". Collection Riccardo and Magda Jucker, Milan

to the ideals of speed and dynamism extolled in the Futurist manifestoes. He returned to the nude, a subject that led him toward a form of massive, sculptural modeling. It was only a short step from this work to the metaphysical painting of Giorgio de Chirico, which Carrà began to adopt about 1916. Meanwhile, in the *Patriotic Celebration* (plate 87) Carrà followed Marinetti's invention of "free words" meant to supersede "free verse" and, through their visual associations, to affect and stimulate the spirit and imagination directly, without the intervention of reason. Again, the Futurists anticipated tendencies that were not to become dominant until almost half a century later.

above: 265. UMBERTO BOCCIONI. *Dynamism of a Cyclist.* 1913. 27⅝ × 37⅜". Collection Gianni Mattioli, Milan

below: 266. UMBERTO BOCCIONI. *Development of a Bottle in Space.* 1912. Silvered bronze (cast 1931), 15 × 12⅞ × 23". Collection, The Museum of Modern Art, New York. Aristide Maillol Fund

right: 267. UMBERTO BOCCIONI. *Unique Forms of Continuity in Space.* 1913. Bronze (cast 1931), 43⅞ × 34⅞ × 15¾". Collection, The Museum of Modern Art, New York. Acquired through the Lillie P. Bliss Bequest

UMBERTO BOCCIONI (1882–1916) Umberto Boccioni's career, cut short in 1916, demonstrated greater consistency than that of most of his fellow Futurists. For a time he, like his colleagues, played back and forth between precise Realism and a Cubist-Futurist structure of transparent color planes. His *Dynamism of a Cyclist* (fig. 265) illustrates a move toward abstraction almost as complete as Severini's, with the difference that Boccioni faithfully maintained a suggestiveness of abstract shapes, to the point where they resemble Kandinsky's more ordered abstraction of the same moment (plate 49). But the greatest contribution of Boccioni during the last few years of his life was the creation of Futurist sculpture. Taking off from the Impressionist sculptures of Medardo Rosso (fig. 138)—perhaps the only other Italian sculptor of stature working in the early years of the twentieth century—Boccioni sought to assimilate the figure or object to the surrounding environment in the manner of his paintings. This he did first by attacking the age-old problem of how to organize three-dimensional, intangible space so that it is expressed as fully as solid mass. In his *Technical Manifesto of Futurist Sculpture* (1912), he began with the customary attack on all academic tradition. The attack became specific and virulent on the subject of the nude, which still dominated the work not only of the traditionalists but even of the leading progressive sculptors Rodin, Bourdelle, and Maillol. In Rosso's Impressionist sculpture and contemporary themes Boccioni found the most exciting innovations for sculpture. Yet he recognized that, in his concern for the transitory moment, Rosso was bound to the subject in nature in the same way as the Impressionist painters.

Boccioni, on the other hand, sought eternal values in sculpture—"the style of movement" and "sculpture as environment." "Absolute

and complete abolition of definite lines and closed sculpture. We break open the figure and enclose it in environment." He reaffirmed the sculptor's right to use any form of distortion or fragmentation of figure or object, and insisted on the use of every kind of material—"glass, wood, cardboard, iron, cement, horsehair, leather, cloth, mirrors, electric lights, etc., etc."

Boccioni's sculpture manifesto was even more important than the Futurist painting manifestoes in the degree that it prophesied the development of Constructivist sculpture, Dada and Surrealist assemblage, sculpture as literal motion, and even the environments of Pop sculptors of the 1960s. Boccioni did not mention Picasso's 1909 Cubist head or Archipenko's or Duchamp-Villon's first Cubist experiments, and he may not have been aware of these. The program he was proposing, however, went beyond anything envisaged in the Cubists' early and tentative efforts at sculpture. Boccioni's *Development of a Bottle in Space* (fig. 266), although cast in bronze, constituted an enlargement of the tradition for the analysis of sculptural space. The bottle is stripped open, unwound, and integrated with an environmental base that makes of the homely object, only fifteen inches high, the model of a vast monument of three-dimensional masses existing totally in surrounding three-dimensional space. More ambitious, though less successful as sculptural environments, were the artist's two destroyed works of 1912, *Fusion of a Head and a Window* and *Head & House & Light*, in which he attempted a literal interaction of figure and architectural elements, using every sort of material. These notable experiments, although disastrous in execution, were nevertheless prophetic prototypes of Dada and Surrealist assemblages and Pop Art environments.

Boccioni's most impressive sculpture, the *Unique Forms of Continuity in Space* (fig. 267), was also his most sculpturally traditional and the one most specifically related to his paintings. The striding figure, made up of fluttering, curving planes of bronze, moves essentially in two dimensions, like a translation of his painted figures into relief. In effect, it is comparable with the *Victory of Samothrace*, with her wings and draperies flowing out behind her, rather than like the total sculptural environment for which he pleaded in his own sculptural manifesto.

World War I wrote *finis* to the first and only significant stage of Italian Futurism, although many of the more propagandist ideas and slogans were integrated into the rising tide of Fascism and used for political and social ends. The Futurists themselves, still led by Marinetti, were drawn more and more into specific war propaganda. Carrà devised the hysterical if fascinating propaganda collage (plate 87). Using radiations of colors and lines and verbal symbols, he extolled the King and the army, and simulated visually the noises of sirens and mobs. Boccioni, in the *Cavalry Charge*, extolled his subject in jagged diagonals of lances, and Severini followed his more temperate series of Red Cross Trains with an *Armored Train* (1915), a pictorial monument to mechanized warfare.

Abstraction in Russia

The term "abstraction," understood as something abstracted from nature, has always been a matter of controversy, perhaps because of the implication that to "abstract" something is to lessen or demean it. Music and architecture have always been recognized as abstract arts whereas, in the Classical tradition from the time of Aristotle, literature and the visual arts of painting and sculpture have been conceived of as imitative arts. From at least the middle of the nineteenth century artists

were consciously or unconsciously moving toward a conception of painting as an entity unto itself and not an imitation of anything else. The difficulty with "abstract" as a term for art that does not represent nature is that it has been used indiscriminately for all art in which the subject is subordinated or distorted in order to place the emphasis on the plastic or expressive means. The term is sometimes loosely applied to certain Fauve and Cubist paintings where subject does not predominate, as well as to examples of Cubist sculpture. However, as long as there is a residue of recognizable subject, abstract is not really an unexceptionable designation. Cubism, as already seen, may be on the road to abstraction, but it is not in itself totally abstract.

Various efforts have been made to find a more satisfactory name for the waves of nonimitative paintings and sculptures that the twentieth century has produced. Theo van Doesburg proposed the term "concrete" in 1930, and "nonobjective" has been widely used for the abstractions of Mondrian and his followers. No really satisfactory substitute has been found, however, and there seems no reason why the term "abstract" should not continue to be used.

Kandinsky was long thought to have been the first abstract painter who realized the implications of the nonrepresentational, Expressionist works he created. Beyond question, however, abstract paintings existed before Kandinsky. A number of Art Nouveau paintings by Van de Velde and others have no recognizable subject matter, although they may be loosely based on plant forms. Delaunay in 1911 was creating color patterns from which the naturalistic subject had virtually disappeared, and Kupka was working in an almost completely abstract manner at the same moment, perhaps even earlier.

It is at least conceivable that the almost total absence of experiment in Russian art made certain artists, aware of developments in France and other countries, feel that the only solution was the most violent form of revolution against the dominant academic past. In any event, in sculpture as in painting, Russia passed with little transition from nineteenth-century academicism to complete abstraction. Only a few artists were involved—among the painters, Mikhail Larionov, Natalia Goncharova, Kasimir Malevich, El Lissitzky and, of course, Kandinsky; among the sculptors, Vladimir Tatlin, Alexander Rodchenko, Naum Gabo, and his brother, Anton Pevsner—but their influence was crucial for all subsequent twentieth-century art.

In the attempt to evaluate the Russian achievement in the early century, a number of points must be kept in mind. Russia, since the eighteenth century of Peter and Catherine the Great, had maintained a tradition of patronage of the arts and had close and continuous ties with the West. Russians who could afford it traveled frequently to France, Italy, and Germany. Through periodicals they were aware of new developments in art, music, and literature. Russian literature and music had attained great heights during the nineteenth century, and theater and ballet had made substantial strides. The nineteenth-century Russian proclivity for Utopian communities made itself evident in the arts, in groups such as the Wanderers, a colony of artists brought together in the 1870s by Savva Mamontov, a wealthy, nationalistic Russian connoisseur and social idealist. Mamontov was also active as a patron of the theater and opera, and helped to open up theater design to practicing artists. This wedding of painting and theater was to become characteristic of the expansion of Russian experiments in the arts.

Perhaps the most talented of the Russian pioneers who eased the transition to the twentieth century was Mikhail Vrubel (1856–1910), a man who received little recognition during his own lifetime. Through Vrubel, who was a brilliant draftsman saturated in the Russian Byzantine tradition, much of the spirit of Western Art Nouveau entered Rus-

sian art. Art Nouveau and the ideas of French Symbolists and Nabis made themselves widely felt in the late 1880s through the movement known as the World of Art (Mir Iskusstva), under the leadership of Alexander Benois, a talented entrepreneur, artist, theater designer, cosmopolitan critic, and scholar who preached and practiced the integration and the unity of the arts.

Léon Bakst, who later gained international fame as a stage designer, was one of the first professional artists associated with the World of Art. In 1890 the group was joined by Sergei Diaghilev, destined to become perhaps the greatest of all impresarios of the ballet. The *World of Art* periodical, first published in 1898, brought together the younger leaders among poets and artists and served to introduce, to a Russian audience, the French Symbolist poets, the English and Austrian Art Nouveau artists and architects, and the French Post-Impressionists. A few years later, Diaghilev was launched on his career as an impresario, arranging exhibitions, concerts, theatrical and operatic performances, and ultimately the Ballets Russes, which opened in Paris in 1909 and went from success to success. From then on, Diaghilev was to draw on many of the greatest names in European painting to create sets.

After the *World of Art* magazine came other avant-garde journals. Through them, and through journeys to Paris and Italy, young Russian artists could watch the progress of Fauvism, Cubism, Futurism, and their offshoots. Great collections of the new French art were formed by Sergei Shchukin and Ivan Morozov in Moscow. Shchukin's collection by 1914 contained over 200 works by French Impressionist, Post-Impressionist, Fauve, and Cubist painters, including more than 50 by Picasso and Matisse, as well as examples by Manet, Monet, Renoir, Cézanne, and Van Gogh. Morozov's slightly less experimental collection of 130 works included Cézanne, Renoir, and Gauguin, and many works by Matisse. Both Shchukin and Morozov were most generous in opening their collections to Russian artists, and the effect of the Western vanguard on these creative individuals was incalculable. Through modern art collections and the exhibitions of the Jack of Diamonds group founded in 1910 by Larionov, Cubist experiments were known in St. Petersburg (Leningrad) and Moscow almost as early as they were inaugurated.

269. NATALIA SERGEEVNA GONCHAROVA. *Icon Painting Motifs*. 1912. Watercolor on cardboard, 19½ × 13⅝". ©1981 George Costakis. Collection Tretiakov Gallery, Moscow. Gift of George Costakis

Marinetti, apostle of Futurism, visited Russia in 1914 (and perhaps earlier), and his ideas may have affected some of the Russian avant-garde.

RAYONISM, CUBO-FUTURISM, AND SUPREMATISM

MIKHAIL LARIONOV (1881–1964) and NATALIA GONCHAROVA (1881–1962) Early in 1911 Larionov and Goncharova were in correspondence with Kandinsky, who evinced considerable interest in their experiments. In 1912 they started a movement called Rayonism, and in the 1913 exhibition called "The Target" the first group of Rayonist works were shown. Rayonism was an offshoot of Cubism, and also related to Italian Futurism in its emphasis on dynamic, linear light rays. Through these, Larionov sought to express visually the new concepts of time and space that had taken shape in the thought of the mathematicians Arthur Cayley and Felix Klein, the philosopher-physicist Ernst Mach, the physicist Albert Einstein, and others. In Larionov's manifesto, a seeming satire on Futurist manifestoes, he extolled the everyday objects of current civilization, denied the existence of individuality, and praised the Orient as against the West.

Larionov and Goncharova left Russia in 1914 to design for Diaghilev.

268. MIKHAIL LARIONOV. *Blue Rayonnism*. 1912. 25½ × 27½". Collection Boris Tcherinsky, Paris

Neither artist produced more than a few Rayonist paintings that were significant (fig. 268), but their ideas, involving an art that was a synthesis of Cubism, Futurism, and Orphism and, in addition, "a sensation of what one may call 'the fourth dimension,' " were of the greatest significance in their influence on Malevich and the development of Suprematism.

After emigrating to the West in 1915, Larionov and Goncharova revived their folk style (fig. 269), the conceptual nature of which explains, to some degree, how an ancient heritage of icons and flat-pattern design prepared Russians to accept total abstraction more readily than Picasso and Braque, steeped as these were in the Classical, humanist Mediterranean tradition, with its love of sensuous, earth-rooted, man-centered life.

LIUBOV POPOVA (1889–1924) One of the very strongest artists to emerge within the milieu of the prerevolutionary Russian avant-garde was the tragically short-lived Liubov Popova, whose instinctively sure hand and brilliant palette are evident even in her earliest work. The daughter of a wealthy bourgeois family, Popova was able to travel extensively throughout her formative years, during which she visited Paris in 1912 and studied under the Cubists Le Fauconnier and Metzinger. Needless to say, she was also in contact with Goncharova, Larionov, and the World of Art circle. When war broke out in 1914, Popova was in Italy, whence she returned to Russia and there developed her mature Cubo-Futurist style, showing a complete assimilation of Western pictorial devices into her own personal idiom of rich, almost Oriental color and such distinctively Russian forms as the Cyrillic alphabet (plate 88). Here the Cubist-derived language of integrated, pictorialized form and space may have received its most authoritative expression outside the oeuvre of the two founding Cubists themselves. This makes Popova's work of about 1914–15 especially interesting, even though the artist, before her death in 1924, would go on to produce, in the years 1918–22, what Margit Rowell has called "the clearest and most consistent conception of Constructivism in painting to appear in the Soviet Union or elsewhere."

KASIMIR MALEVICH (1878–1935) More than any other individual, even Delaunay or Kupka, it was Kasimir Malevich who first took Cubist geometry to its logical conclusion of absolute abstraction. Malevich studied art in Moscow, where he was introduced to the new tendencies through the opportunity of visiting the collections of Shchukin and Morozov. In 1906 he met Larionov and in 1910 exhibited with him and Goncharova in the first Jack of Diamonds show. By 1911 he was painting in a Cubist manner. *Morning in the Country After Rain* (plate 89) is composed with cylindrical sculptural figures of peasants in a mechanized landscape, with houses, trees, and groundlines modeled in light, graded hues of red, white, and blue. The resemblance to Léger's somewhat later machine Cubism is startling (fig. 247; plate 74), but it is questionable whether either man saw the other's early works. For the next two years Malevich explored different aspects and devices of Cubism and Futurism, calling them "Cubo-Futurism," possibly the first instance of an artist applying this term to his own art. But he was obsessed with the anomaly of residual subject matter in his work until, as he himself stated: "... in the year 1913, in my desperate attempt to free art from the burden of the object, I took refuge in the square form and exhibited a picture which consisted of nothing more than a black square on a white field." This was a pencil drawing, the first manifestation of the style to which Malevich would give the name Suprematism (fig. 270), which, however, became a reality in painting and a move-

270. KASIMIR MALEVICH. *Basic Suprematist Element*. 1913. Drawing. Russian State Museums, Leningrad

ment only in 1915. The artist, in his volume of essays entitled *The World of Non-Objectivity*, defined Suprematism as "the supremacy of pure feeling in creative art." "To the suprematist," he went on, "the visual phenomena of the objective world are, in themselves, meaningless; the significant thing is feeling, as such, quite apart from the environment in which it is called forth."

As with Kandinsky and his first abstract paintings (plate 49), the creation of this simple square on a white ground was a moment of spiritual revelation to Malevich, who was a devout Christian mystic. For the first time in the history of painting, he felt, it had been demonstrated that a painting could exist completely independent of any reflection or imitation of the external world—whether figure, landscape, or still life. Actually, of course, he had been preceded by Delaunay and Kupka in the creation of abstract paintings, and he was certainly aware of their efforts, as well as those of Kandinsky, who would move to largely non-objective imagery in late 1913. Malevich, however, has an important claim to primacy in having carried abstraction to an ultimate geometric simplification—the black square of the drawing within the white square of the paper. It is tempting to reflect on the fact that the two dominant wings of twentieth-century abstraction—the abstract Expressionism of Kandinsky and the geometric abstraction of Malevich—should have been founded by two Russians. Each of these men had a conviction that his discoveries were spiritual visions rooted in the traditions of Old Russia. The coincidence is intriguing.

During 1913 Malevich continued with his Suprematist pencil drawings, creating first, after the initial square, an off-center circle within a square, then a horizontal rectangle crossing a vertical rectangle within the square to form a square cross. In the initial Suprematist composition, the black square within a white square was neutral in effect. In the second composition, the black circle hovering in the corner of a white square began to develop associative as well as spatial inferences. In the next composition in the series, by intensifying the dark value of the superimposed horizontal rectangle, a definite sense of the third dimen-

271. KASIMIR MALEVICH. *Suprematist Composition: White on White.*
c. 1918. 31¼ × 31¼″. Collection, The Museum of Modern Art,
New York

by his disciples, notably El Lissitzky, they influenced the design teachings of the Bauhaus and the course of the International Style of modern architecture.

EL LISSITZKY (1890–1956) Of the artists emerging from Russian Suprematism the most influential internationally was El (Eleazar) Lissitzky, who studied engineering in Germany and on his return to Russia was associated with the nonobjectivism of Rodchenko and the Constructivism of Tatlin until the hostility of the Russian revolutionary government forced him to leave again for Berlin in 1921. In Berlin he was associated with the Dutch abstractionist Theo van Doesburg and the Hungarian László Moholy-Nagy. He significantly influenced the bringing together of Russian Suprematism, nonobjectivism, and Constructivism, Dutch De Stijl, and the ideas of the German Bauhaus and, through Moholy-Nagy, the transmittal of these ideas to a generation of students in the United States and elsewhere. Lissitzky was not an original talent but a most important intermediary in the communication of the various concepts of abstraction then emerging simultaneously and independently in different parts of Europe. In his nonobjective painting-constructions, to which he gave the name "Proun" (fig. 272), he played with the elements of contemporary geometric abstraction combined with perspective illusions at an abstract level paralleling the contemporary efforts of Picasso, Gris, and other Cubists at their stage of developed Synthetic Cubism.

sion was introduced. The rectangle seems to float forward, creating the illusion of a layer of space between the horizontal and the vertical planes. From these works, Malevich developed a variation on the Suprematist square involving a new, biplanar Suprematist composition. This is simply two black rectangles staggered side by side in a vertical-horizontal-vertical effect, a modest but important anticipation of the shaped canvas of artists of the 1960s. In his attempts to define the fundamental new vocabulary he felt himself to be creating, he tried other combinations of rectangle, circle, and cross, oriented vertically and horizontally. Already within the year 1913, his passionate curiosity about the expressive relations of abstract geometric shapes had led him to desert the static rectangular structure and to move to a more dynamic organization of diagonally oriented rectangles arranged in a complex state of tension with one another.

It was the world of aviation and modern technology that he began to explore late in 1913 as he tilted his rectangles from the vertical. Thus between 1914 and 1918 he created Suprematist compositions "expressing the sensation of flight . . . the sensation of metallic sounds . . . the feeling of wireless telegraphy"; "white on white, expressing the feeling of fading away . . . magnetic attraction"; conveying the feeling of movement and resistance, the feeling of a mystic "wave" from "outer space," and even "the feeling of non-objectivity." In 1918, after the period of complication, he returned to a further simplification in the series of paintings of white on white. One example displays an acutely tilted square of white within the canvas square of a somewhat different value of white (fig. 271)—a reduction of painting to the simplest relations of geometric shapes.

Malevich understood the historic importance of architecture as, basically, an abstract visual art, and between 1915 and 1923 he experimented with three-dimensional drawings and models in which he studied the problems of form in three dimensions. These abstract three-dimensional models not only were of significance in the growth of Constructivism in Russia but, transmitted to Germany and Western Europe

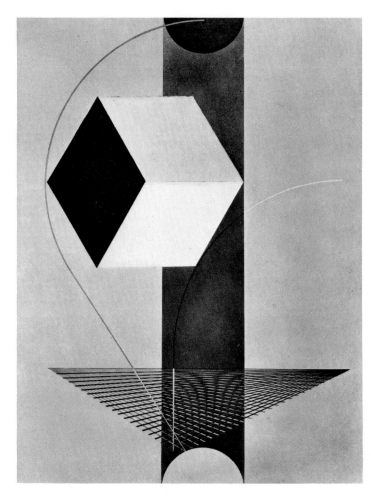

272. EL LISSITZKY. *Construction 99 (Proun 99).* 1924–25. Oil on wood,
50½ × 38¾″. Yale University Art Gallery, New Haven, Connecticut. Gift of
the Société Anonyme

273. VASILY KANDINSKY. *Several Circles, No. 323*. 1926. 55⅛ × 55⅛″. The Solomon R. Guggenheim Museum, New York

VASILY KANDINSKY A far greater figure in the transmission of Russian experiments in abstraction and construction to the West was Vasily Kandinsky. Forced by the outbreak of war to leave Germany, he went back to Russia in 1914. After the Russian Revolution, he was appointed professor at the Fine Arts Academy in Moscow in 1918, and in 1919 helped reorganize Russian museums. In 1920 he was appointed a professor at the University of Moscow, and a government-sponsored one-man exhibition of his works was held in the Soviet capital. However, when Kandinsky found his conception of art as a spiritual process coming into conflict with the Utilitarian doctrines of the ascendant Constructivists, he decided to leave Russia again, this time in 1921 and forever. Now he arrived back in Germany, where he would soon be appointed a professor and later vice president of the newly formed Bauhaus at Weimar.

Meanwhile, until 1920, Kandinsky continued to paint in the manner of free abstraction that he had first devised during the period 1910–14 (fig. 168; plates 48–50). In the year of his Moscow retrospective, he began to introduce, in certain paintings, regular shapes and straight or geometrically curving lines. During 1921, the geometric patterns took over altogether, and the artist moved into another major phase of his career. There can be no doubt that Kandinsky had been affected by the geometric abstractions of Malevich, Rodchenko, Tatlin, and the Constructivists. Despite the change from free forms to color shapes bounded by regular, hard edges, the tempo of the paintings remained rapid, and the action continued to be the conflict of abstract forms. *White Line, No. 232* is a transitional work in which the major color areas are painted in a loose, atmospheric manner (plate 90). However, they are accented by a pattern of sharp straight lines and regular-curve-bounded areas that brings to the work a briskness of geometric control. The circle as a central motif intrigued him during the mid-1920s, perhaps as a result of his ever-increasing fascination with the themes of universal space and the interaction of galaxies (fig. 273). However, Kandinsky's style of the 1920s takes the story of abstraction in painting into another chapter.

RUSSIAN CONSTRUCTIVISM

One of the significant new concepts to develop in twentieth-century sculpture was that of construction. Sculpture, from the beginning of its history, had involved a process of creating form by taking away from the amorphous mass of the raw material—the carving of wood or stone—or by building up from the mass—modeling in clay or wax. These approaches presuppose emphasis on sculpture as an art of mass rather than of space. Even in such eras as the Hellenistic or the Baroque, when attention was paid to sculpture as an art of space, the three-dimensional masses of the carved or modeled figures were still dominant. Traditional techniques persisted well into the twentieth century, even in the work of so revolutionary a figure as Brancusi. As has been pointed out, the first Cubist sculpture of Picasso, the 1909 *Head of a Woman*, involved a deep faceting of the surface that respected the central mass (fig. 217).

True constructed sculpture, in which the form is created from elements of wood or metal, glass, or plastic, was a predictable consequence of the Cubists' experiments in painting. In 1912 Picasso designed a three-dimensional Cubist construction from paper and string, and in the same year he was making drawings for other constructions. His 1912 *Guitar* and 1914 *Musical Instruments* are constructions of sheet metal and wire, or wood, Cubist in form (figs. 224, 230). Although they were crude in execution, the artist stated in them the basic problem of Constructivist sculpture—the assertion of sculptural space rather than of sculptural mass.

It is curious that after these pioneer efforts of Picasso, the subsequent development of constructed sculpture, particularly in its direction toward complete abstraction, should have taken place not in France but elsewhere. Archipenko, working in Paris, had made a contribution to space sculpture with his 1912 *Walking Woman*, but this was still a modeled figure built up from clay in the traditional manner (fig. 233). Boccioni's Futurist sculpture manifesto of 1912 recommended the use of unorthodox materials suitable to construction, but his actual constructed sculpture was tied to literal or Cubist subjects. Archipenko's constructed Médrano figures, executed between 1912 and 1914, were experiments in space-mass reversals (plate 68), but the artist never deserted the subject—figure or still life—and soon reverted to a form of Cubist sculpture modeled in clay for casting in bronze.

In France and Italy the traditional techniques of sculpture—modeling, carving, bronze casting—were probably too powerfully imbedded to be overthrown, even by the leaders of the modern revolution. Sculptors who attended art schools—Brancusi and Lipchitz for example—were trained in technical approaches unchanged since the eighteenth century. Modern sculpture in France emerged from the Renaissance tradition more gradually and imperceptibly than modern painting. Thus it is possibly a consequence of this evolutionary rather than revolutionary process that most of the pioneer experimentalists continued to utilize traditional techniques and the traditional human figure. Aside from Picasso's isolated experiments and the more developed constructions of Henri Laurens, the translation of Cubist collage into three-dimensional abstract construction was achieved in Russia first, then in Holland and Germany.

VLADIMIR TATLIN (1895–1956) The founder of Russian Constructivism was Vladimir Tatlin. In 1913 he visited Berlin and Paris. He saw the paintings in Picasso's studio in Paris and not only was affected by them, but also—and particularly—by the constructions in which Picasso was investigating the implications of collage for sculpture. The result, on Tatlin's return to Russia, was a series of reliefs constructed from

274. VLADIMIR TATLIN. Model for *Monument to the Third International.* 1919–20. Wood, iron, and glass. Russian State Museums, Leningrad

and enduring effect on the development and character of Constructivist art.

As a dedicated materialist, Tatlin rejoiced in the Russian Revolution and cultivated his natural interest in engineering and architecture, an interest that saw its most ambitious result in the artist's model for a *Monument to the Third International* (fig 274). Had the full-scale project been built, it would have been approximately thirteen hundred feet high, the biggest sculptural form ever conceived by man. Even as architecture, which in essence it was, the monument would have had no parallel, except, perhaps, Frank Lloyd Wright's concept of the Mile High Skyscraper. It was to have been a metal spiral frame tilted at an angle and encompassing a glass cylinder, cube, and cone. The various glass units, housing conferences and meetings, were to revolve, making a complete revolution once a year, once a month, and once a day. It anticipated, and in scale transcended, all subsequent developments in constructed sculpture as space, environment, and motion.

With the consolidation of the Soviet system in the 1920s, Tatlin readily adapted his nature-of-materials philosophy to the dogmas of Utilitarianism, which held that in the classless society art should be practical, easily comprehensible, and socially useful. As this point of view became dominant in the Soviet Union, along with the banalities of the mandated Social Realist style, it worked tragically against such spiritually and aesthetically motivated artists as Malevich and Kandinsky, driving the latter out of Russia altogether and into the more liberal West. Tatlin, however, went on to direct various important Soviet art schools and enthusiastically applied his immense talent to the designing of such articles as workers' clothing and household furniture.

275. ALEXANDER RODCHENKO. *Construction of Distance.* 1920. Wood. Private collection

wood, metal, and cardboard, with surfaces coated with plaster, glazes, and broken glass. They were among the first complete abstractions, constructed or modeled, in the history of sculpture—the ancestors of the Dada sculptures of Kurt Schwitters or the "junk" sculpture of the 1960s.

Tatlin's first abstract reliefs have disappeared, and the only record of them is a number of indifferently reproduced illustrations. Even these, however, show, between 1913 and 1916, an obsession with space as the primary concern of the sculptor. Detached, without a solid base, they embody the idea of flight. The so-called "counter-reliefs," begun in 1914, were suspended by wires across the corner of a room, as far removed from the earthbound tradition of past sculpture as the limited technical resources of the artist permitted.

Meanwhile, Tatlin had developed a repertoire of forms in keeping with what he believed to be the properties of his chosen materials. According to the principles of the "culture of materials," or "truth to materials," each substance, through its structural laws, dictates specific forms, such as the flat geometric plane of wood, the curved shell of glass, and the rolled cylinder or cone of metal. For a work of art to have significance, Tatlin came to believe that these principles must be considered in both the conception and the execution of the work, which would then embody the laws of life itself. The theory would have a long

ALEXANDER RODCHENKO (1891–1956) Rodchenko, who in 1914–15 had come under the influence of Malevich, worked with Tatlin in 1916 and soon began to experiment with constructions. By 1920 he, like Tatlin, was turning more and more to the so-called Utilitarian idea that the artist must serve the Revolution through a practical application of his art in engineering, architecture, and industrial design. In his *Construction of Distance* (fig. 275) he massed rectangular blocks in a horizontal-vertical grouping as abstract as a Mondrian painting and even more suggestive of the developing forms of the International Style in architecture. His *Hanging Construction* is a nest of intersecting circles which move slowly in currents of air (fig. 276). This is one of the first introductions into constructed sculpture of actual movement, in a form suggestive of the fascination with space travel that underlay many of the ideas of Russian Constructivists.

A genius, a virtuoso master of every medium, and totally committed to the Soviet experiment, Rodchenko could see nothing except in revolutionary terms, and nowhere does this capacity appear more evident than in the artist's remarkable photographs (fig. 277). Commenting on images like the one reproduced here, Rodchenko wrote in 1928: "In photography there is the old point of view, the angle of vision of a man who stands on the ground and looks straight ahead or, as I call it, makes 'bellybutton' shots. . . . The most interesting angle shots today are those 'down from above' and 'up from below,' and their diagonals." By 1928 photographers had long since discovered the value of the altitudinous perspective as a device for realizing a more abstract kind of image (fig. 210), but never before Rodchenko's *Assembling for a Demonstration* had so much human incident been assimilated into an

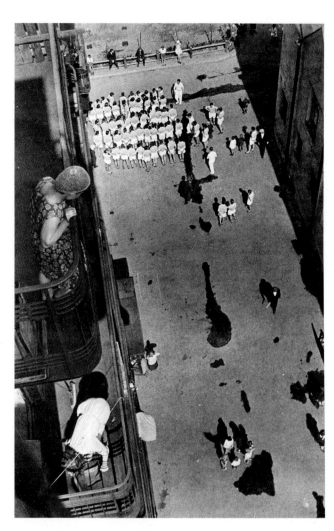

277. ALEXANDER RODCHENKO. *Assembling for a Demonstration*. 1928. Gelatin-silver print. Collection, The Museum of Modern Art, New York. Mr. and Mrs. John Spencer Fund

overall scheme or system of surface pattern. Given the time and the place in which it was made, Rodchenko's photograph seems a metaphor of gripping faith in the value of the new state-dominated, "classless" society.

OLGA ROZANOVA (1886–1918) The artists who adopted the name Constructivist in 1921 worked in three-dimensional form, but the origin of the aesthetic in Tatlin's philosophy of materials (*faktura*) made it clear that paint and the paint surface—its thickness, glossiness, technique of application—could be considered and treated as autonomous expression, as texture or fabric that generates specific forms. In this way the narrative function of figurative art would be replaced by a self-contained system. As early as 1913 Olga Rozanova had asserted that the painter should "speak solely the language of pure plastic experience." In 1917, as if to illustrate the principle, she painted the remarkable picture in plate 91, its composition made up of nothing but a wide, lavishly brushed green stripe running up, or down, the center and cutting through a creamy white field of contrasted but equally strong scumbled texture. The result seems to reach across the decades to the 1950s and Barnett Newman's more monumental but scarcely less radical "zip" paintings (plate 188). From Malevich, Rozanova had acquired a sense of planes freed in pictorial space, but by the time she did the

276. ALEXANDER RODCHENKO. *Hanging Construction*. 1920. Wood. Whereabouts unknown

278. NAUM GABO. *First Constructed Head*. 1915. Wood, height 28". Whereabouts unknown

work seen here, the artist had given up the notion of etherealizing space in favor of joining the future Constructivists in their desire to materialize and render space active and palpable.

The Constructivist experiments of Tatlin and Rodchenko came to an end in the early 1920s, as the Russian revolutionary regime began to discourage abstract experiment and to encourage practical enterprises useful to a struggling economy. Many of the artists involved in Suprematism and Constructivism—in which Russia for a short period even held a position of world leadership—left Russia after 1920. The most independent contributions of those who remained, including Tatlin and Rodchenko, were to be in theater design.

Despite the importance of the pioneer work in Constructivism in Russia, the expansion and development of this concept were to occur elsewhere. The fact that painters like Kandinsky and sculptors like Naum Gabo and Anton Pevsner left Russia and carried their ideas to Western Europe was of the first importance in the creation of a new International Style in art and architecture.

NAUM GABO (1890–1977) and ANTON PEVSNER (1886–1962) The two leading Russian figures in the spread of Constructivism were the brothers Anton Pevsner and Naum Gabo. Pevsner was first of all a painter whose history summarized that of many younger Russian artists. His exposure to nonacademic art first came about through his introduction to traditional Russian icons and folk art. He then discovered the Impressionists, Fauves, and Cubists in the Morozov and Shchukin collec-

tions. In Paris, between 1911 and 1914, he knew and was influenced by Archipenko and Modigliani. Between 1915 and 1917 he lived in Norway with his brother Naum and, on his return to Russia after the Revolution, Pevsner received a teaching appointment at the Moscow Academy, as did Malevich, Kandinsky, and Tatlin.

Naum Gabo (Naum Neemia Pevsner), who changed his name to avoid confusion with his elder brother, was sent to Munich in 1910 to study medicine, but turned to mathematics and engineering. His interest in art was awakened by the exhibitions of Der Blaue Reiter in 1911 and 1912 and the lectures of the great art historian and critic Heinrich Wölfflin. In Norway during the war, Gabo was fascinated by the vast spaces of the Norwegian landscape and the contrasts of solid and void. In the winter of 1915–16 he began to make a series of heads and whole figures of pieces of cardboard or thin sheets of metal, figurative constructions transforming the masses of the head into lines or plane edges framing geometric voids (fig. 278).

In 1917, after the Russian Revolution, Gabo returned to Russia with Pevsner. In Moscow he was drawn into the orbit of the avant-garde, meeting Kandinsky and Malevich and discovering Tatlin's constructions. Between 1917 and 1920 the hopes and enthusiasms of the Russian experimental artists were at their peak. The struggle for a new art of the twentieth century seemed to have been won. Most of the abstract artists, according to Gabo, were enthusiastic about the Revolution, because they hoped that from it would come the liberation and triumph of all progressive tendencies in art.

Colorplate 78. FRANTIŠEK KUPKA. *Disks of Newton (Study for Fugue in Two Colors)*. 1912. 39⅜ × 29″. Philadelphia Museum of Art. Louise and Walter Arensberg Collection

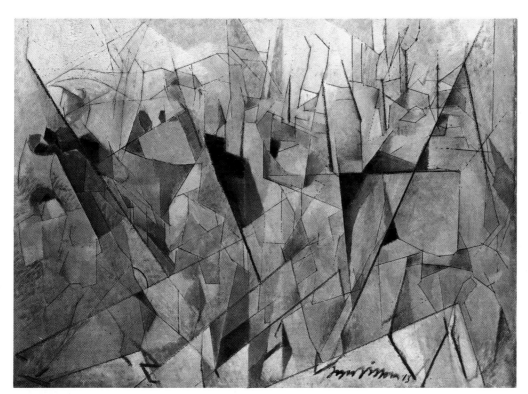

above: Colorplate 79. MARCEL DUCHAMP. *Nude Descending a Staircase, No. 2*. 1912. 58 × 35″. Philadelphia Museum of Art. Louise and Walter Arensberg Collection

left: Colorplate 80. JACQUES VILLON. *Soldiers on the March*. 1913. 25⅝ × 36¼″. Galerie Louis Carré, Paris

193

Colorplate 81. FRANCIS PICABIA. *Catch as Catch Can*. 1913. 39⅝ × 32¼".
Philadelphia Museum of Art. Louise and Walter Arensberg Collection

Colorplate 82. GIACOMO BALLA. *Street Light*. 1909. 68¾ × 45¼". Collection,
The Museum of Modern Art, New York. Hillman Periodicals Fund

above: Colorplate 83. UMBERTO BOCCIONI. *The City Rises*. 1910. 6'6½" × 9'10½". Collection, The Museum of Modern Art, New York. Mrs. Simon Guggenheim Fund

opposite below: Colorplate 84. GIACOMO BALLA. *Flight of the Swifts*. 1913. Watercolor on paper, 23 × 33". Collection Mr. and Mrs. Joseph Slifka, New York

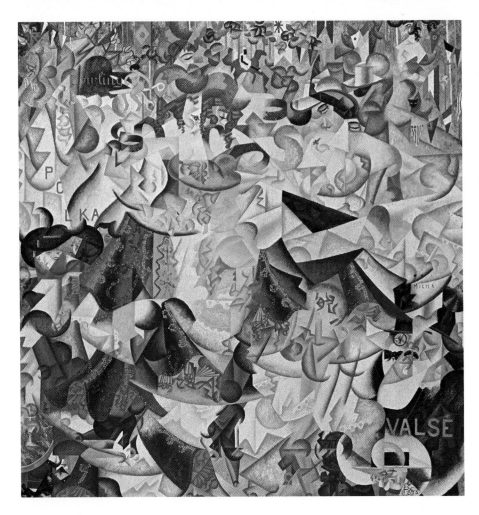

left: Colorplate 85. GINO SEVERINI. *Dynamic Hieroglyphic of the Bal Tabarin*. 1912. Oil on canvas, with sequins, 63⅝ × 61½". Collection, The Museum of Modern Art, New York. Acquired through the Lillie P. Bliss Bequest

below left: Colorplate 86. GINO SEVERINI. *Spherical Expansion of Light (Centrifugal)*. 1914. 24 × 20". Collection Riccardo and Magda Jucker, Milan

below right: Colorplate 87. CARLO CARRÀ. *Patriotic Celebration (Free Word Painting)*. 1914. Collage on cardboard, 15¼ × 11¾". Collection Gianni Mattioli, Milan

above: Colorplate 88. LIUBOV POPOVA. *Early Morning*. 1914. 28 × 35″. Collection, The Museum of Modern Art, New York. The Riklis Collection of the McCrory Corporation (fractional gift)

right: Colorplate 89. KASIMIR MALEVICH. *Morning in the Country After Rain*. 1911. 31½ × 31⅜″. The Solomon R. Guggenheim Museum, New York

Colorplate 90. VASILY KANDINSKY. *White Line, No. 232*. 1920. 38⅝ × 31½″. Collection Mme. Nina Kandinsky, Neuilly-sur-Seine, France.

Colorplate 91. OLGA ROZANOVA. *Untitled (Green Stripe)*. 1917. 28 × 20⅞″. ©1981 George Costakis Collection. Owned by Art Co. Ltd.

Colorplate 92. PIET
MONDRIAN. *The Red Tree*.
1908. 27½ × 39″.
Gemeente Museum, The
Hague, The Netherlands

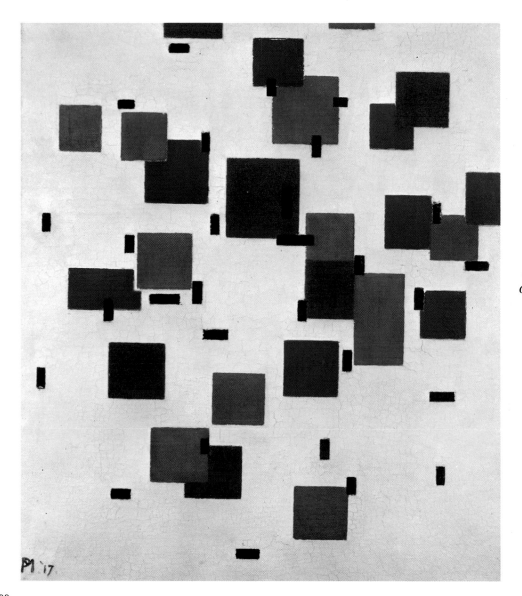

Colorplate 93. PIET MONDRIAN.
Composition in Color A. 1917.
19½ × 17⅜″. Kröller-Müller
Museum, Otterlo,
The Netherlands

By 1920, however, Tatlin and the group around him had become increasingly doctrinaire in their Utilitarianism, which insisted that art had to serve the Revolution in specific, practical ways. Artists had to abandon or subordinate pure experiment in painting and sculpture, and turn their energies to engineering, industrial, or product design. This position was opposed by Gabo and Pevsner and their followers, who fought for the survival of the independent artist and his right to follow his own path of free experiment wherever this might lead.

The first major result of this conflict of attitudes was the publication in Moscow on August 5, 1920, of the so-called *Realistic Manifesto*. It was signed by Gabo and Pevsner, but Gabo drafted it and was principally responsible for the ideas it contained. In a larger sense, however, as Gabo himself has pointed out, the manifesto was the culmination of ideas that had been fermenting in the charged atmosphere of Russian abstract art over the previous several years. One reason the term "realistic" was used for the manifesto was that the label "constructivist" had not at that time gained any general circulation (although Gabo and others were already referring to their works as constructions). More important, however, was the deliberate use of "realistic" to underline the artists' conviction that what they were doing in their abstract paintings and constructions constituted a new reality, a Platonic reality of ideas or forms more absolute than any imitation of nature.

The manifesto is a passionate plea for a new great style in art, appropriate to the "unfolding epoch of human history." The essence of the new program was a rebirth of space and time as the "only forms on which life is built and hence art must be constructed." Descriptive color, line, space, and mass were denounced; all elements were to have their own reality; and time and movement were to become basic in their works.

Although Gabo has described the manifesto as a résumé of what was then going on in his group rather than a program, it is nevertheless a document of the highest importance in the history of twentieth-century art, one that summarizes brilliantly a large portion of the issues and problems with which the emerging abstract painters and sculptors had been struggling since the origins of Cubism.

Until 1920, the experimentalists were allowed the freedom they were, first, probably, because of the continuing civil war and, second, because they filled a vacuum in the schools and academies caused by the flight of the older academicians. Anatoly Lunacharsky, the Commissar of Education, was a cultivated man sympathetic to the new trends, and Lenin, busy with more immediate problems, was content to leave the decisions on artistic matters to him. With the return of more peaceful and stable conditions, however, the old academic ideals and the new technological ideals soon assumed control. Both were now in the service of Communist philosophy: art had to be understandable to the masses and useful to industry. The result was the departure from Russia of many leading spirits of the new art—Kandinsky, Gabo, Pevsner, and Lissitzky. They emigrated when they saw there was nothing further they could do in Russia, and, as we shall see, continued to develop their ideas and spread them throughout the Western world.

De Stijl in The Netherlands

World War I marked the terminal point of the first waves of twentieth-century invention, and interrupted or ended the careers of many artists. During the war every nation was isolated, and French domination of experiment in art broke down. Rethinking of concepts of modern painting, sculpture, and architecture led to the emergence of new experiments and new ideas in which other nations began to assume a position of leadership. The Russian experiments in abstraction, Suprematism, and Constructivism might not have attained the position they did, had not war and revolution isolated Malevich, Tatlin, Kandinsky, and Gabo from the rest of Europe.

A striking instance of the effect of isolation is to be seen in the notable native development of art in The Netherlands, neutral during World War I, and thus culturally as well as politically removed from both sides. In the nineteenth century, the Low Countries had produced a number of painters of talent and one of genius—Vincent van Gogh, who had attained his moment of supreme achievement through exposure to the French Impressionists and Post-Impressionists. Dutch experimentalists at the beginning of the twentieth century, such as Van Dongen, had been drawn to Paris and assimilated into the French movements of Fauvism or Cubism.

In general, Dutch artists and architects seem to have moved rather cautiously into the twentieth century. In architecture, Berlage was the first important innovator and, as such, almost alone (fig. 302). International Art Nouveau had less impact on Holland than on Belgium, Austria, or France, except on the painters Jan Toorop and Johan Thorn Prikker and a few designers, such as J. Jurriaan Kok. The transition to revolutionary modern art during World War I may be traced in the career of Piet Mondrian, one of the century's great masters.

In 1914 Mondrian returned to The Netherlands for a visit and was caught by the outbreak of war. Soon he discovered other Dutch artists with aspirations similar to his own. These were Bart van der Leck and Theo van Doesburg. Van Doesburg, eleven years younger than Mondrian, was the leading spirit in the formation of the De Stijl group and the creation of the periodical *De Stijl*. Also to be associated with De Stijl were the Hungarian painter Vilmos Huszar, who had settled in Holland, the Belgian sculptor Georges Vantongerloo, and the architects J. J. P. Oud and Robert van 't Hoff (figs. 310–312).

During 1915 Van Doesburg was already discussing the idea for a new periodical with Mondrian, who, however, felt that the time was not ripe. Nevertheless, Van Doesburg continued to pursue his project after he was demobilized in 1916, and in 1917 the periodical *De Stijl* appeared. It was dedicated to the "absolute devaluation of tradition . . . the exposure of the whole swindle of lyricism and sentiment." The artists involved emphasized "the need for abstraction and simplification": mathematical structure opposed to Impressionism and all "baroque" forms of art. Van Doesburg, even earlier than Mondrian, had become convinced of the paramount importance of the straight line in art, and had even thought of naming his periodical *The Straight Line*. They sought "for clarity, for certainty, and for order." Almost at once their works began to display these qualities, transmitted through the straight line, the rectangle, or the cube, as well as through colors simplified to the primaries red, yellow, and blue and the neutrals black, white, and gray. It should be stressed that for the De Stijl artists these simplifications had their own symbolic significance based on Oriental philosophy and the current teachings of theosophy.

Of the greatest importance in the idea of De Stijl was the concept of the collaboration of artists, the development of the common point of view among painters, sculptors, architects, and graphic and industrial designers. This is a familiar concept, already noted in connection with several earlier movements.

The De Stijl artists were well aware of developments in modern art in France, Germany, and Italy—Fauvism, Cubism, German Expressionism, and Italian Futurism. But they recognized as masters only a few pioneers, such as Cézanne in painting and Frank Lloyd Wright, Berlage

279. PIET MONDRIAN. *Mill by the Water.* c. 1905. Oil on canvas mounted on cardboard, 11⅞ × 15″. Collection, The Museum of Modern Art, New York. Purchase

and, perhaps, Behrens and the later Van de Velde in architecture. They had little or no awareness of the Russian experiments in abstraction until the end of the war had reestablished communication.

The influential theoreticians of De Stijl were Mondrian and Van Doesburg. In 1917, Van Doesburg published a book, *The New Movement in Painting*, and Mondrian published in *De Stijl* a series of articles, including "Neo-Plasticism in Painting," which in 1920, after his return to France, he expanded into his book *Le Néo-Plasticisme*, one of the key documents of abstract art.

Mondrian, obsessed by the mystical implications of vertical-horizontal opposition, spent the rest of his life exploring them. Van der Leck reverted to representation. By 1924 Van Doesburg was seeking a new and individual variation which he named "elementarism," and in which he continued to use a composition consisting of rectangles, but tilted them at 45 degrees to achieve what he felt to be a more immediately dynamic form of expression. At this point Mondrian left De Stijl, offended by what he regarded as Van Doesburg's heresy in deserting the vertical axis.

PIET MONDRIAN (1872–1944) and NEO-PLASTICISM Mondrian, originally Pieter Mondriaan, was trained in the Amsterdam Academy and until 1904 had worked as a naturalistic painter. About 1908 he came under the influence of Toorop and began painting in a manner associated with Symbolism. Even earlier his landscapes contained anticipations of his characteristic vertical-horizontal composition, restricted but defined picture space, emphasis on linear structure, and, above all, fascinated observation of a single scene or object, whether a windmill, trees, a solitary tree, or an isolated chrysanthemum.

The early landscapes also adhered to a principle of frontality and, particularly in the windmill paintings, to cut-off, close-up presentation. The instinct to controlled, abstract organization of picture space seems to have been intense from the outset (fig. 279).

By 1908 Mondrian was becoming aware of some of the innovations

of modern art. His color blossomed in blues, yellows, reds, and greens. In forest scenes he emphasized the linear undulation of saplings, in shore and seascapes the coloristic movement of sand dunes and water. For the next few years, church façades and haystacks were presented frontally in planes of abstract arbitrary color or in patterns of red and yellow color spots deriving from the Neo-Impressionists and in even greater degree from the short, harsh, but disciplined brushstrokes of Van Gogh. In portraiture and figure painting, Mondrian since 1900 had also emphasized a frontalized, close-up view, sometimes reminiscent of Edvard Munch and often reflecting an absorption in Oriental mysticism.

In 1911 Mondrian left Holland for Paris, where he was caught in the tide of Cubism, and he sensed in it the approach toward which he had been moving intuitively. With any of his favorite subjects—the tree, the dunes and ocean, the church or windmill, all rooted in the familiar environment of the Low Countries—one can trace his progress from naturalism through Symbolism, Impressionism, Post-Impressionism, Fauvism, and Cubism, to abstraction. In *The Red Tree* (plate 92) he combined the tortured expression of Van Gogh, the nondescriptive color of the Fauves, and the linear pattern of Art Nouveau in a work that is still individual and structural in a plastic sense. Over the next few years the same subject would be treated in a mode of more linear abstraction, which by 1912 had approximated to Cubist facets. Although Mondrian, during his first years in Paris, subordinated his colors to grays, greens, and ochers under the influence of the Analytic Cubism of Picasso and Braque, his most Cubist paintings still maintained an essential frontality. He rarely attempted the tilted planes or sculptural projection that gave the works of the French Cubists their defined though limited sense of three-dimensional spatial existence. Even while absorbing the tenets of Cubism, Mondrian was already moving beyond to eliminate both subject and three-dimensional illusionistic depth.

As early as 1912 the tree had virtually disappeared into a linear maze that covered the surface of the canvas (fig. 280). The feeling for centralized composition is evident in the greater central density with the gradual loosening of the pattern toward the edges. This centralized emphasis was also articulated through use of the oval frame (inspired by the Cubists), and the contained linear structure became rectangular

280. PIET MONDRIAN. *Flowering Apple Tree.* 1912. 30¾ × 41¾″. Gemeente Museum, The Hague, The Netherlands

and abstract (fig. 281), leading inexorably toward a geometric abstraction of verticals and horizontals. By 1913 the artist was also beginning to experiment with bright colors again, asserting their identity within linear rectangles.

In Paris, as we have noted, Mondrian was first attracted by the position of the Cubists, but he gradually began to feel that Cubism "did not accept the logical consequences of its own discoveries: it was not developing abstraction toward its ultimate goal, the expression of pure reality. I felt that this could only be established by *pure plastics (plasticism)*." In this statement, made in 1942, he emphasized the two words that summarize his lifelong quest—"plastic" and "reality." To him "plastic expression" meant simply the action of forms and colors. "Reality" or "the new reality" was the reality of plastic expression, or the reality of forms and colors in the painting. Thus the new reality was the present reality of the painting itself as opposed to an illusionistic reality based on imitation of nature, or romantic or expressive associations.

Gradually, as the artist tells it, Mondrian became aware that: "(a) in plastic art reality can be expressed only through the equilibrium of *dynamic movements* of form and color; (b) pure means afford the most effective way of attaining this." These ideas led him to the organizational principle of the balance of unequal opposites achieved through the right angle, and the simplification of color to the primary hues plus black and white. It is important to recall that Mondrian did not arrive at his final position solely through theoretical speculation. As we have seen, his paintings almost from the beginning were moving inexorably

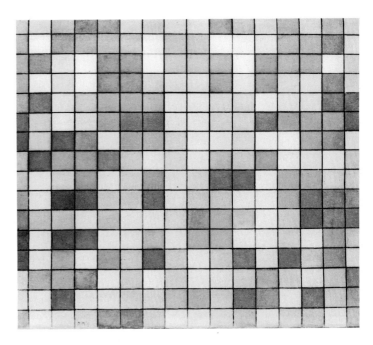

282. Piet Mondrian. *Composition (Checker Board, Bright Colors)*. 1919. 33⅞ × 41¾". Collection S. B. Slijper, Blaricum, The Netherlands

281. Piet Mondrian. *Color Planes in Oval*. c. 1914. 42⅜ × 31". Collection, The Museum of Modern Art, New York. Purchase

toward a pattern of abstract simplification based on the rectangle of the picture plane.

During 1914 Mondrian eliminated all vestiges of curved lines, so that the structure became predominantly vertical and horizontal. The paintings were still rooted in subject: a church façade or sand and ocean, but these were now simplified to a pattern of short, straight lines, like plus and minus signs, through which the artist sought to suggest the underlying structure of nature. During 1917 and later he explored another variation—rectangles of flat color without defined edges, suspended in a sometimes loose, sometimes precise rectangular arrangement (plate 93). The color rectangles sometimes touch, sometimes float independently, and sometimes overlap. They appear positively as forms in front of the white or generally light background. Their interaction creates a surprising illusion of depth, even though kept rigidly parallel to the picture surface.

Mondrian soon realized that the detached color planes created both a tangible sense of depth and a differentiation of foreground and background that interfered with the unity he was seeking. This discovery led him during 1918 and 1919 to a series of works organized on a rectangular grid, at first with heavily outlined squares or rectangles arranged on a neutral ground, then with the rectangles defined as hues of primary colors, red, yellow, and blue, against white, black, or gray (fig. 282). These checkerboard paintings still appeared to the painter as foregrounds of color forms against a ground of white or gray—and thus "impure" in color, lacking a total unity. Finally, therefore, he united the field by making the heavy lines move through the rectangles to create a linear structure in tension with the color rectangles. About 1919 Mondrian came to the fulfillment of his ideals of the expression of universals through dynamic balance of vertical and horizontal linear structure and fundamental hues of color. He would continue to refine them throughout the 1920s, '30s, and early '40s, until, as we shall see in a later chapter, he had attained something close to the ultimate in monumental purity and simplicity (plates 157, 158).

283. PAUL CÉZANNE. *The Card Players*. c. 1892. 25½ × 32″. The
Metropolitan Museum of Art, New York. Bequest of Stephen C. Clark, 1960

284. THEO VAN DOESBURG. *Card Players*. 1916–17. Tempera on canvas,
46½ × 58″. Collection Mme. Van Doesburg, Meudon, France

Always, it must be repeated, Mondrian, through his "equivalence of
opposites," was seeking the expression of a unity that in its turn would
be expressive of the higher mystical unity he sensed in man and the
universe. This was his ultimate aim, not creation of abstract structure
through elimination of recognizable subject. Nevertheless, like the oth-
er members of the De Stijl group, he recognized the implications of
their abstract principles for the new architecture and for new concepts
of pure design in all fields.

THEO VAN DOESBURG (1883–1931) As already noted, Van Doesburg
was the moving spirit in the formation and development of De Stijl.
During his two years in the army (1914–16) he studied the new experi-
mental painting and sculpture, and was particularly impressed by Kan-
dinsky's essay, *Concerning the Spiritual in Art*, which became for him
almost a Bible. In 1916 he was experimenting with free abstraction in
the manner of Kandinsky, as well as with forms of Cubism, but was still
searching for his own path. This he found in his composition of *Card
Players* (fig. 284), based on Cézanne (fig. 283), but with the figures
simplified to a complex of interacting shapes based on rectangles, the
colors flat and delimited, although not to the point of absolute primar-
ies. During 1918 and 1919, fascinated by the mathematical implications
of his new abstraction, Van Doesburg explored its possibilities in linear
structures, as in a later version of the *Card Players* (fig. 285). For a
time Mondrian was unquestionably affected by the fertility of Van Does-
burg's imagination. When artists work together as closely as the De Stijl
painters did during 1917–19, it is extremely difficult and perhaps point-
less to establish absolute priorities. Van Doesburg, Mondrian, and their
colleague Van der Leck for a time were all nourished by one another.
By 1920, however, each was again beginning to go in his own direction.

Van Doesburg, after the war, continued to be the most articulate
propagandist for the principles of De Stijl, traveling widely and lectur-
ing. He had notable influence on students and on some of the faculty of
the Weimar Bauhaus (despite antagonism from its administration), and
on artists in Berlin and elsewhere. His lively interest in Dada also mani-
fested itself in poems written under the pseudonym of I. K. Bonset.

285. THEO VAN DOESBURG. *Card Players*. 1917. 45⅝ × 41¾″. Gemeente
Museum, The Hague, The Netherlands

Moreover, he and Kurt Schwitters made a Dada cultural tour of
Holland.

The interests of Van Doesburg did not conflict with his painting, and
he followed Neo-Plastic principles until he published his *Fundamen-
tals of the New Art* in 1924. He then began to abandon the rigid verti-
cal-horizontal formula of Mondrian and De Stijl and to introduce
diagonals. This heresy led to Mondrian's resignation from De Stijl. In a
1926 manifesto in *De Stijl*, Van Doesburg named his new departure

Elementarism, and argued that the inclined plane reintroduced surprise, instability, and dynamism. In his murals at the Café L'Aubette, Strasbourg (decorated in collaboration with Arp and Sophie Taeuber-Arp), Van Doesburg made his most monumental statement of Elementarist principles (fig. 286). He tilted his boldly colored rectangles at 45-degree angles and framed them in uniform strips of color. The tilted rectangles are in part cut off by the ceiling and base. Across the center runs a long balcony with steps at one end that add a horizontal and diagonal to the design. Incomplete rectangles emerge as triangles or irregular geometric shapes. In his Elementarist paintings Van Doesburg seems deliberately to have substituted an expanding, fragmentary structure for the unified, hermetically sealed world of Mondrian.

GEORGES VANTONGERLOO (1886–1965) In sculpture the achievements of De Stijl were not comparable to those of the Russian Constructivists and were, in fact, concentrated principally in the works of the Belgian Georges Vantongerloo. Vantongerloo was not only a sculptor but also a painter, architect, and theoretician. His first abstract sculptures, executed during the years 1917 and 1918, were still conceived in the traditional and sculptural sense as masses carved out of the block rather than as constructions built up out of separate elements. They constitute notable transformations of De Stijl painting into three-dimensional design. Later, Vantongerloo turned to open construction, sometimes in an architectural form (fig. 287), and sometimes in free linear patterns. In his subsequent painting and sculpture he frequently deserted the straight line in favor of the curved, but throughout his career Vantongerloo maintained an interest in a mathematical basis for his art, to the point of deriving compositions from algebraic equations.

Early Twentieth-Century Architecture

The United States

FRANK LLOYD WRIGHT (1867–1959) Frank Lloyd Wright was dedicated by his mother to a career in architecture even before he was born. He studied engineering at the University of Wisconsin, where he read Ruskin and was particularly drawn to the rational, structural interpretation of Gothic architecture in the writings of Viollet-le-Duc. In 1887 he was employed by the Chicago firm of Adler and Sullivan (fig. 87), with whom he worked until he established his own practice in 1893. There is little doubt that many of the houses built by the Sullivan firm during the years Wright was employed there represented his ideas. For many years of his independent career Wright had few major commissions for public buildings, office buildings, or skyscrapers. The 1904 Larkin Building in Buffalo, New York (figs. 293, 294), was his only large-scale structure prior to Chicago's Midway Gardens (1914) and the Imperial Hotel in Tokyo (1915–22). All three, incidentally, have been destroyed.

Thus Wright's basic philosophy of architecture was stated primarily through the house form. His earliest houses, such as his own house in Oak Park, Illinois (1889), reflect influences from the shingle-style houses of H. H. Richardson, Bruce Price, and McKim, Mead and White (figs. 79, 80). These involved the development of the open, free-flowing plan of the English architects Philip Webb and Norman Shaw. The characteristically American feature of the veranda, open or screened, wrapping around two sides of the house, lent itself to an enhancement of the sense of outside space that penetrated to the main living rooms. Also,

the cruciform plan, with space surrounding the central core of fireplace and utility areas, had an impact on Wright that affected his approach to house design as well as to more monumental design projects.

In the 1900–02 Ward Willitts House at Highland Park, Illinois (fig. 288), Wright made one of his first individual and mature statements of the principles and ideas he had been formulating during his apprentice years. The plan, inspired largely by the Japanese exhibition hall of the 1893 Chicago Exposition, is based on a cross axis. The Japanese influence is seen in the dominant wide, low-gabled roof, and the vertical stripping on the façade. The sources, however, are less significant than the welding together of all elements of plan, interior and exterior, in a single integration of space and mass and surface. From the compact, dense center arrangement of fireplace and utility units, the space of the interior flows out in an indefinite expansion carried, without transition, to the exterior and beyond. The essence of the design in the Willitts House and in the series of houses by Wright and his followers to which the name Prairie Style has been given is a predominant horizontal accent of roof lines, beams, and walls, held in tension by contrasting verticals.

The interior of the typical Wright Prairie house is characterized by low ceilings, frequently pitched at unorthodox angles, a cavelike sense of intimacy and security, and constantly changing vistas of one space flowing into another (fig. 289). Such an interior has been contrasted with that of a Palladian villa, also cruciform in plan, but with clearly articulated rectangular rooms flanking the open, soaring dome of the central space. The Wright building is seen as an image of modern man

above: 288. FRANK LLOYD WRIGHT. Ward Willitts House, Highland Park, Illinois. 1900–1902

right: 289. FRANK LLOYD WRIGHT. Interior, Taliesin, Spring Green, Wisconsin. 1925

290. FRANK LLOYD WRIGHT. Robie House, Chicago. 1909

above: 291. FRANK LLOYD WRIGHT. Plans of ground floor and first floor,
Robie House

right: 292. FRANK LLOYD WRIGHT. Dining Room, Robie House, Chicago. 1909

seeking security in a world of constant change, the villa an image of
Renaissance man comfortably occupying the ideal center of his self-
contained, humanistic universe.

The masterpiece of Wright's Prairie Style is the 1909 Robie House in
Chicago (figs. 290, 291, 292). Centered around the fireplace, the house
is arranged on one dominant axis, with the sweep of the horizontal roof
line cantilevered out with steel beams in great unsupported projections
and anchored at the center, with the chimneys and upper gables at right
angles to the principal axis. Windows are arranged in long, symmetrical
rows and are deeply imbedded into the brick masses of the structure.
The principal horizontally oriented lines of the house are reiterated and
expanded in the terraces and walls that transform interior into exterior
space and vice versa. The elements of this house, combining the out-
ward flowing space of the interior, the linear and planar design of exte-
rior roof line and wall areas, with a fortresslike mass of chimneys and
corner piers, summarize as well other experiments which Wright had
carried on earlier in the Larkin Building of 1904 (figs. 293, 294).

The Larkin Building represented radical differences from the Prairie

house in that it was organized as rectangular masses in which the prob-
lem the architect had set himself was an articulation of mass and space
into a single, close unity. The Larkin Building was, on the exterior, a
rectangular, flat-roofed structure, whose immense corner piers protect-
ed and supported the window walls that reflected an open interior well
surrounded by balconies. Before it was torn down "in the path of prog-
ress," this was one of those early modern industrial structures that
suggested the tremendous possibilities for development of new kinds of
internal, expressive space in the new tall buildings of America. The
economics of industrial building was soon to destroy these possibilities.

above: 293. FRANK LLOYD WRIGHT. Larkin Building, Buffalo, New York. 1904 (demolished 1950)

right: 294. FRANK LLOYD WRIGHT. Interior, Larkin Building

below: 295. FRANK LLOYD WRIGHT. Imperial Hotel, Tokyo. 1915–22 (demolished 1968)

The place of Wright as a pioneer of the international modern movement is no longer a matter of controversy. Historically his experiments in architecture as organic space and as abstract design of a new kind antedate those of most of the twentieth-century European pioneers. The only question is the degree in which he influenced them directly. His designs had been published in Europe by 1910 and 1911, notably in the German editions of Ernst Wasmuth, and were studied by H. P. Berlage, Walter Gropius, and other architects. His works were known and admired by artists and architects of the Dutch De Stijl group, Robert van 't Hoff, J. J. P. Oud, Theo van Doesburg, Georges Vantongerloo, and Piet Mondrian. His design had common denominators not only with the Classical formalism of these artists but also with the shifting planes and ambiguous space relationships of Cubism. At the very moment he was becoming a world figure, however, Wright was entering upon a period of neglect and even vilification in his own country. His highly publicized personal problems, including the tragic destruction of his first home at Taliesin in Wisconsin, helped drive him from the successful Midwestern practice he had built up in the early years of the century. Even more significant than these personal factors were cultural and social changes that, by the year 1915, had alienated the patronage for experimental architecture in the Midwest. Shortly after the turn of the century the industrial architecture of Sullivan and others in Chicago had been superseded by the rising tide of academic eclecticism. In domestic architecture, following the fashions of the Eastern Seaboard, various historical styles—Italian Renaissance, Queen Anne, Colonial, and English Tudor Gothic—followed one another in rapid succession. Large-scale construction of mass housing soon led to vulgarization of these styles.

Wright himself, about 1915, began increasingly to explore exotic styles, particularly Oriental and Mayan architecture. The Imperial Hotel in Tokyo (fig. 295) occupied most of his time between 1915 and 1922 and represents his most ornately complicated decorative period, filled with suggestions of Pre-Columbian influence. In addition, it embodied his most daring and intricate structural experiments to that date, experiments that enabled the building to survive the wildly destructive Japanese earthquakes of 1923 (only to be destroyed by man in 1968). For twenty years after the Imperial Hotel, Wright's international reputation was constantly enlarging, but he frequently had difficulty earning a living. He was indomitable, however, and continued to write, lecture, and teach, secure in the consciousness of his own genius and place in history, and inventing brilliantly whenever he received commissions.

France

AUGUSTE PERRET (1874–1954) Aside from Wright, a number of his followers, and a few isolated architects of talent such as Bernard Maybeck in California, American architecture between 1915 and 1940 was largely in the hands of the academicians and the builders. In England, also, there was little experiment for many years after the turn of the century. In Continental Europe before 1914, the most significant innovations were to be found in Germany and Austria. These were fed by certain exciting new happenings, in painting and sculpture as well as in architecture, that originated in France, Holland, and Belgium. French architecture during this period was dominated by the Beaux-Arts tradition, except for the work of two architects of high ability, Auguste Perret and Tony Garnier. Both were pioneers in concrete, employed without pretense or stylistic concealment. Perret was the more important in actual achievement, while Garnier's principal fame rested on his early (1901–4), vast and visionary plans for an Industrial City. Perret, whose family construction business specialized in reinforced-concrete building, developed a mastery of this material that demonstrated for future generations of architects its immense structural flexibility and decorative possibilities.

In his 1902–3 apartment building at 25 bis Rue Franklin in Paris (fig. 296) Perret covered the thin, reinforced-concrete skeleton with glazed terra-cotta tiles decorated in the Art Nouveau foliate pattern. The structure is clearly revealed, however, and allows for an almost complete concentration of large window openings on the façade. The architect increased the possibilities for daylight illumination by folding the façade around a front wall and then arranging the principal rooms so that all had outside windows. The strength and lightness of the material also substantially increased openness and spatial flow.

Other buildings, such as the Ponthieu garage in Paris (1906) and the foyer of Paris' Théâtre des Champs-Elysées (1910–11), illustrated Perret's constantly developing ability to exploit and express the qualities of ferroconcrete, but his masterpiece in this material is probably his church of Notre Dame at Le Raincy, built near Paris in 1922–23 (fig. 297). Here he used the simplest form of the Early Christian basilica, a long rectangle with only a slightly curving apse, a broad, low-arched narthex, and side aisles just indicated by comparably low transverse arches. The miracle of this church, however, is the degree in which construction in reinforced concrete permitted the complete elimination of walls, something that Gothic architects always sought but never actually achieved, not even in the ultimate refinement of the Sainte-Chapelle in Paris. The roof rests completely on widely spaced slender columns, and the walls are simply constructed of stained glass (designed by Mau-

296. AUGUSTE PERRET. Apartment House, Paris. 1902–3

297. AUGUSTE PERRET. Church of Notre Dame, Le Raincy, France. 1922–23

rice Denis) arranged on a pierced screen of precast-concrete elements. Despite certain design flaws in the rendering of the façade tower, the church at Le Raincy remains one of the first monuments, not only in the structural use of ferroconcrete but also in the demonstration of its ultimate potential in design refinement.

Despite the great achievements in the 1920s and 1930s of Le Corbusier (to be discussed later), and despite the fact that Paris remained the world center for experimental painting and sculpture during the first half of the twentieth century, the phrase "curiously and disappointingly conventional" must be used for the preponderance of contemporaneous French architecture, as well as for British and American.

Austria and Germany

Experimental architecture in Spain, Britain, France, and the United States during the first part of the twentieth century has been traced in terms of the work of a few isolated architects of genius—Gaudí in Spain, Mackintosh in Britain, Perret and Garnier in France, and Sullivan and Wright in the United States. There also emerged men of high talent in other countries: Horta and Van de Velde in Belgium; Wagner, Loos, Hoffmann, and Olbrich in Austria; Hendrik Petrus Berlage in The Netherlands; and Peter Behrens, Richard Riemerschmid, Hans Poelzig, and others in Germany. An important difference in the development of these architects lay in the degree to which, largely as a result of enlightened governmental and industrial patronage in Germany before 1930, their experiments, instead of depending only on the genius of individual men, were coordinated and directed toward the creation of a "school" of modern architecture. In this process, the contributions of certain patrons were of the greatest importance. Such patrons included the Arch-

299. ADOLF LOOS. Steiner House, Vienna. 1910

duke Ernst Ludwig of Hesse; the A.E.G. (German General Electrical Company); the diplomat, critic, and educator Hermann Muthesius; Alfred Lichtwark, director of the Hamburg Gallery; politicians such as Friedrich Naumann; and others.

OTTO WAGNER (1841–1918) Otto Wagner was a relatively academic architect during the early part of his life. The stations for the Vienna subway (1896–97) were simple and functional buildings dressed with Baroque details. In his book on modern architecture published in 1894, however, Wagner had already evinced his ideas about a modern architecture that used modern materials. The hall of the 1905 Vienna Post Office Savings Bank is a monument to the unadorned use of metal and glass in the creation of airy, light-filled, and unobstructed space (fig. 298). There is a certain stylistic similarity here to the auditorium that Victor Horta built in his Maison du Peuple in Brussels (fig. 101), but also a considerable advance in the elimination of structural elements for the creation of a single unified and simple space.

ADOLF LOOS (1870–1933) Also active in Vienna early in the century was Adolf Loos. After studying architecture at Dresden, Loos worked in the United States for three years from 1893, taking various odd jobs while learning about the new concepts of American architecture, particularly the skyscraper designs of Sullivan and other pioneers of the Chicago School. Settling in Vienna in 1896, he followed principles enunciated by Wagner and Sullivan and wrote extensively against the Art Nouveau decorative approach of the Vienna Secession and in favor of an architecture of pure form expressive of function. His 1910 Steiner House in Vienna (fig. 299) anticipated the unadorned cubic forms of the so-termed International Style of architecture that was to develop from the concepts of J. J. P. Oud, Walter Gropius, Miës van der Rohe, and Le Corbusier in the 1920s and 1930s. The plan and façade are symmetrical; simple, large-paned windows arranged in horizontal rows are sunk into the façade without ornamental sash. Reinforced concrete was here applied to a private house for almost the first time. Although the architecture and ideas of Loos never gained the wide dissemination they deserved, he was an architect of the greatest importance, and the Steiner House is a key monument in the creation of the new style.

298. OTTO WAGNER. Post Office Savings Bank, Vienna. 1905

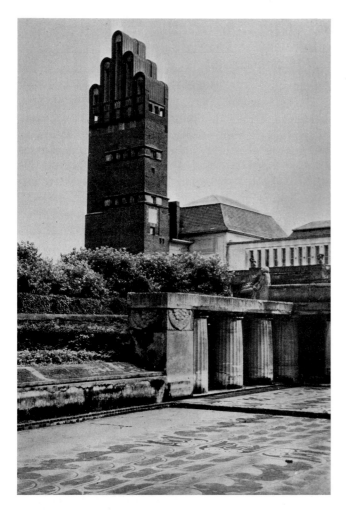

300. Josef Maria Olbrich. Hochzeitsturm (Wedding Tower), Darmstadt, West Germany. 1907

JOSEF HOFFMANN (1870–1956) Among the Art Nouveau architects attacked by Loos were Olbrich and Hoffmann, who, with the painter Gustav Klimt, were the founders of the Vienna Secession movement. Hoffmann's masterpiece is the great house he built for the Stoclet family in Brussels, the Palais Stoclet (figs. 105, 106). Although this splendid mansion is characterized by severe rectangular planning and façades, and broad, clear, white areas framed in dark, linear strips, its essence is a virtuoso display of elegant and attenuated proportions that gives the entire design a curiously insubstantial and even two-dimensional effect that relates it to the mainstream of Art Nouveau.

Hoffmann's importance as a pioneer is perhaps greater for his part in establishing the Wiener Werkstätte (Vienna Workshops) than for his achievement as a practicing architect. The Workshops, which originated around 1900, continued the craft traditions of William Morris and the English Arts and Crafts movement, with the contradictory new feature that the machine was now accepted as a basic tool of the designer. For thirty years the Workshops exercised a notable influence through the teaching of fine design not only in handicrafts but also in industrial objects. About the same time, a cabinetmaker, Karl Schmidt, had started to employ architects and artists to design furniture for his shop in Dresden. Out of this grew the Deutsche Werkstätte (German Workshops), which similarly sought to apply the principles of Morris to the larger field of industrial design. From these experiments, as well as others conducted at schools of arts and crafts in Austria and Germany, origi-

nated in 1907 the Deutscher Werkbund (German Work or Craft Alliance), which in turn was the immediate predecessor of the Bauhaus, one of the schools most influential in the development of modern architecture and industrial design.

JOSEF MARIA OLBRICH (1867–1908) Relations between Austrian and German architecture were extremely close in the early years of the century. When the Archduke Ernst Ludwig of Hesse wished to effect a revival of the arts by founding an artists' colony at Darmstadt he employed Olbrich to design most of the buildings, including the Hochzeitsturm (Wedding Tower), intended as the focal structure and symbol of the entire project (fig. 300). This tower, which still dominates Darmstadt, was intended less as a functional structure than as a monument. Although it was inspired by the American concept of the skyscraper, its visual impact owes much to the towers of German medieval churches. One innovation, however, was of significance for later skyscraper design. This is the manner in which rows of windows are grouped within a common frame and wrapped around a corner of the building.

PETER BEHRENS (1868–1940) Peter Behrens, more than any other German architect of the early twentieth century, constitutes the bridge between the past and the present, between tradition and experiment. He began his career as a painter, producing Art Nouveau graphics, and then was led from an interest in crafts to the central problems of industrial design for machine production. Perhaps as a result of his experience in the artists' collaborative at Darmstadt, he turned to architecture. In 1903 he was appointed director of the Düsseldorf School of Art, and in 1907 the AEG hired him as architect and coordinator of design in the broadest possible sense, including products and publications. This appointment by a great industrial organization of an artist and architect to supervise and improve the quality of all its products was an epoch-making event in the history of modern architecture and design.

One of his first buildings for AEG, and a landmark in the history of modern architecture, is the Turbine Factory in Berlin (fig. 301). Although the building is given a somewhat traditional appearance of monumentality by the huge corner masonry piers (which in actuality have

301. Peter Behrens. AEG Turbine Factory, Berlin. 1908–9

nothing to do with the support of the building) and the overpowering visual mass of roof (which again belies its actual structural lightness), it is essentially a glass-and-steel structure, a light frame of hinged steel beams that enable walls to be expanses of glass. Despite the carry-over of certain traditional forms, this is a building immensely important, not only in its bold structural engineering, but also in its frank statement of construction, and in the social implications of a factory built to include the maximum of air and space and light. It is functional in terms not only of the processes of manufacture but also of the working conditions of the employees—something rarely considered in earlier factories.

The hiring of Behrens by the AEG and similar appointments of consultants in design by other industries seem to have marked the emergence of some feeling of responsibility on the part of large-scale industry. Certain enlightened industrialists began to grasp the fact that well-designed products were not necessarily more expensive to produce than products that were badly designed and shoddily made. Also, in the rapidly expanding industrial scene and the changing political environment of the early twentieth century, the image presented by industry to the public at large was assuming increasing importance. After a century or more of short-sighted and senseless exploitation of natural and human resources, it was finally evident that an effort must be made to educate business and civic leaders, and the general public as well, to the importance of large-scale industry in creating an expanding economy, raising living standards, even in glorifying a national image.

Some such ideas may have influenced Behrens's attempt to transform his functional glass-and-steel Turbine Factory into a monument expressing and extolling the place and achievements of modern German industry. Meanwhile, Behrens is important not only as an architect but as a teacher of a generation that included Gropius, Le Corbusier, and Miës van der Rohe—all of whom worked with him early in their careers.

The Low Countries

HENDRIK PETRUS BERLAGE (1856–1934) In The Netherlands, Hendrik Petrus Berlage was the first of the innovators. He was not an innovator in the sense of creating startling new concepts in design, materials, or structure. Throughout his life Berlage considered himself a traditionalist. He was passionately devoted, however, to stripping off the ornamental accessories of academic architecture and expressing honest structure and function. He characteristically used brick as a building material, the brick that, in the absence of stone and other materials, has created the architectural face of the Low Countries. His best-known building, the Amsterdam Stock Exchange, is principally of brick, accented with details of light stone (fig. 302). The brick is presented, outside and in, without disguise or embellishment, as is also the steel framework that supports the glass ceiling. The general effect, with the massive corner tower and the low arcades of the interior, is obviously inspired by Romanesque architecture, in some degree seen through the eyes of the American architect H. H. Richardson, whose work he knew and admired (fig. 84).

Berlage, in his writings, insisted on the primacy of interior space. The walls defining the spaces had to express not only the nature of their materials, but their strength and bearing function undisguised by ornament as well. Above all, Berlage through systematic proportions sought a total effect of unity and repose built from diversity, and thus ultimately an enduring style analogous to but not imitated from that created by the Greeks of the fifth century B.C. He conceived of an interrelationship of architecture, painting, and sculpture, but with architecture in the dominant role.

Berlage's approach to architecture was affected by that of Frank Lloyd Wright, whose work he knew through publications and then saw

302. HENDRIK PETRUS BERLAGE. Stock Exchange, Amsterdam. 1898–1903

on a trip to the United States. He was enthusiastic about Wright and particularly about the Larkin Building with its obvious analogies to his own Amsterdam Stock Exchange. What appealed to Berlage and his followers in Wright was his rational, mechanistic aspect: Wright as the architect who sought to control and utilize the machine, to explore new materials and techniques in the creation of a new society.

HENRY VAN DE VELDE (1863–1957) The complex relationship among English Pre-Raphaelite painting, Morris and the English Arts and Crafts movement, French Impressionist, Neo-Impressionist, and Symbolist painting, Art Nouveau design, and the beginnings of modern rational architecture is summarized and pointed up in the fertile career of the Belgian Henry van de Velde, encountered earlier in the chapter on Art Nouveau (fig. 92). Not only was Van de Velde a painter, craftsman, industrial designer, and architect; he was also a critic who exercised an extensive influence on German architecture and design. Trained as a painter, first in Antwerp and then in Paris, he was in touch with the Impressionists and interested in Symbolist poetry. Back in Antwerp, painting in a manner influenced by Seurat, he exhibited with Les XX, the avant-garde Brussels group (see p. 85). Through them he discovered Gauguin, William Morris, and the English Arts and Crafts movement. As a result, he enthusiastically took up the graphic arts, particularly poster and book design, and then, in 1894, turned to the design of furniture. All the time, he was writing energetically, preaching the elimination of traditional ornament, the assertion of the nature of materials, and the development of new, rational principles in architecture and design.

In 1899 Van de Velde moved to Germany and, over the next few years, turned to architecture. In the 1914 Werkbund Theater in Cologne (figs. 303, 304) Van de Velde made contributions to the problems of theater design, particularly in the stage area. The exterior revealed the emergence of a personal style in the way in which the façades defined the volume of the interior. Following the end of World War I, the houses and other buildings on which he worked, notably the Kröller-Müller Museum at Otterlo, The Netherlands, are characterized by austerity and refinement of details and proportions—evidence, perhaps, of the reciprocal influence of younger experimental architects who had emerged from his original educational systems.

Not the least of Van de Velde's achievements by any means was the educational program he developed at the Weimar School, which he founded in 1906 under the patronage of the Duke of Saxe-Weimar. This put its emphasis on creativity, free experiment, and escape from dependence on past traditions. When Van de Velde left Weimar in 1914 he recommended as his successor for the directorship the young architect Walter Gropius. Gropius was appointed to the post in 1915 and assumed his duties after the war, in 1919, with full authority to reorganize the curriculum of the schools of fine and applied arts. He consolidated the separate schools under the new name of Das Staatliche Bauhaus, Weimar. Under the abbreviated designation of Bauhaus, this was to become, as we shall see, the most influential school in the history of architecture and design.

The 1914–18 period of World War I obviously interrupted the many experiments in architecture, as well as in painting and sculpture, that had blossomed throughout the first years of the twentieth century. During these war years there was emerging a new generation of architects—Gropius and Miës van der Rohe in Germany; Le Corbusier in France; Oud and Gerrit Thomas Rietveld in Holland; Eliel Saarinen and Alvar Aalto in Finland. Together with Frank Lloyd Wright in the United States, these men were to build on the foundations of the pioneers to create one of the great architectural revolutions of history.

Expressionist Architecture

The spirit of Expressionism manifested itself in German architecture as well as in painting and sculpture between 1910 and 1925. Although this did not result initially in any large number of important buildings, and although Expressionism in architecture was terminated by the rise of Nazism, it did establish the base for a movement that has been realized only in the 1950s and 1960s. The first evidence of the Expressionist attitude was probably that of monumentality, as was seen in Behrens's

305. HANS POELZIG. Grosses Schauspielhaus (Great Theater), Berlin. 1919

306. MAX BERG. Centenary Hall, Breslau, Poland. 1912–13

Turbine Factory and Van de Velde's Werkbund Theater. The Expressionist attitude, however, soon made itself felt in buildings as eccentric and dynamic as those of Gaudí in Barcelona (figs. 97, 99). Of these, the most impressive is the 1919 Grosses Schauspielhaus (Great Theater) in Berlin, created by the architect Hans Poelzig (1869–1936) for the theatrical impresario Max Reinhardt (fig. 305). This was actually a conversion of an old building, the Circus Schumann. Using stalactite forms over the entire ceiling and most of the walls, and filtering light through them, Poelzig created a vast arena of fantasy appropriate to Reinhardt's spectacular productions.

Comparable in its impact was the Centenary Hall designed by Max Berg (1870–1948) for Breslau (fig. 306). Although the circular exterior was relatively sedate, the huge interior presented an overpowering space defined by the great ribbed dome. This was a work that looked forward to the mid-century architecture of engineers. The layout of the centennial buildings combined Classical frontality with a monumental confusion of styles that proved, nevertheless, highly impressive.

Of the architects who emerged from German Expressionism, perhaps the most significant was Erich Mendelsohn (1887–1953). Mendelsohn began practice in 1912, but his work was interrupted by World War I. Following the war, one of his first important buildings was the Einstein Tower in Potsdam (fig. 307), the first designs of which he made as early as 1917. This is one of the principal documents of Expressionist architecture. On the exterior, Mendelsohn emphasized qualities of continuity and flow appropriate to the material of concrete. The

windows flow around the rounded corners, while the exterior stairs flow up and into the cavern of the entrance. The entire structure, designed as a monument as well as a functioning interior, has a quality essentially organic, prophetic of the later works of Le Corbusier and the younger Saarinen.

Many other architects, particularly in Germany and Holland, were affected by the spirit of Expressionism during the 1920s. The educator, philosopher, and occultist Rudolph Steiner (1861–1925), although not trained as an architect, did produce remarkable examples of Utopian architecture in his Goetheanum I and II, the latter of which became a tremendous sculptural monument of concrete that again looked back to Gaudí and forward to the *architecture brut* of today (fig. 308).

Although Expressionist architecture at this stage would seem to have been in direct opposition to the principles evolved by Gropius and others at the Bauhaus, it still had initial impact on details of International Style buildings. However, Expressionism as seen here must be regarded as an interval in the history of architecture whose implications did not begin to be realized for some thirty years, until the austerity and pristine elegance of the International Style had begun to pall.

Futurist Architecture

In the First Free Futurist Exhibition, held in Rome in 1914, a number of younger artists—Giorgio Morandi, Mario Sironi, Enrico Prampolini, and others—joined with the original five. The most interesting new recruit was the young architect Antonio Sant'Elia (1888–1966), who drew up his own *Manifesto of Futurist Architecture*, probably with the ever-present assistance of Marinetti. Like Tony Garnier in his plans for the Industrial City, Sant'Elia conceived of cities built of the newest materials, in terms of the needs of modern man, and as expressions of the dynamism of the modern spirit. His ideas, largely monumental visions, remained on the drawing board. Today they have the dated appearance of a Classical pseudo-modernism, but his *Manifesto* is perhaps his greatest achievement, for it was an important contribution to the development of modern architecture in Europe. However, in some of his daring engineering concepts (fig. 309) there is a suggestion of the magnificent achievements of Pier Luigi Nervi, the Italian master and one of the world's masters of structural engineering (figs. 849, 850).

307. ERICH MENDELSOHN. Einstein Tower, Potsdam. 1920–21 (destroyed)

308. RUDOLF STEINER. Goetheanum II, Dornach, Switzerland. 1925–28

309. ANTONIO SANT'ELIA. Project for Città Nuova. 1914

310. ROBERT VAN 'T HOFF.
Huis ter Heide. Utrecht,
The Netherlands. 1916

De Stijl Architecture

Despite the uniqueness of Mondrian, the principal impact of De Stijl on modern art came from architecture. During the war years, neutral Holland was one of the very few countries in Europe where building could continue, with the consequence that the transition from prewar to postwar architectural experiment can be followed most clearly in that country. Many of the ideas and theories fermenting everywhere in Europe before 1914 came to their first realization in The Netherlands at this time. The Dutch solutions, consequently, were studied by artists and architects everywhere the instant the war ended. The formative influences on De Stijl architects were Hendrik Petrus Berlage and Frank Lloyd Wright, both seen earlier in this chapter (figs. 288–295, 302).

Oud, Van 't Hoff, and Rietveld were also acquainted with the early modernists in Germany and Austria—Behrens, Loos, Hoffmann, and Olbrich—but their association with Mondrian and Van Doesburg had considerable influence on the forms their architecture would assume. M. H. J. Schoenmaekers, with his mystical cosmogony based on the rectangle, and his Neo-Platonic doctrine of ultimate realities, provided the philosophical base not only for Mondrian's paintings but also for the architects' thinking. From these ingredients arose an architecture of flat roofs, with plain walls arranged according to definite systems to create an interior space that was both functional and harmonious. Here was a major inception of the style to which the name International Style has been given and which was to dominate monumental building during the middle years of the twentieth century, especially the forms of the skyscraper.

In their aesthetic, the architects and artists of De Stijl were much concerned with the place of the machine and its function in the creation of a new art and a new architecture. They shared this concern with the Italian Futurists, with whom Van Doesburg corresponded (Severini was

311. J. J. P. OUD.
Workers' Housing
Estate, Hook of
Holland. 1924–27

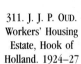

a regular corresponding member of De Stijl), but they departed from the emotional, Expressionist, Futurist exaltation of the machine in favor of a position that sought to utilize the machine in the creation of a new collective order. From this approach arose their importance for subsequent experimental architecture.

The actual buildings created by these architects before 1921 were not numerous. A house built by Robert van 't Hoff (1852–1911) in Utrecht in 1916 antedated the formation of De Stijl, and was almost entirely based on his observations of Wright in Chicago, as may be seen in the cantilevered cornices, the grouping of windows, the massing of corners, as well as the severe rectangularity of the whole (fig. 310).

The 1917 project that J. J. P. Oud (1890–1963) prepared for seaside housing on the Strand Boulevard at Scheveningen gives the future International Style formula for housing in a flat-roofed, terraced row of rather monotonously repeated individual rectangular units. A 1919 project by Oud for a small factory was a more imaginative and mature combination of cubic masses alternating effectively with vertical chimney pylons and horizontal windows in the Wright manner. Instead of the typical early Wright pitched roof, however, the De Stijl architects, almost from the beginning, opted for a flat roof, thus demonstrating a relationship to the De Stijl painters. In the best known and, in many ways, the most influential of his early buildings, the 1924–27 housing project for workers at Hook of Holland (fig. 311), Oud employed wraparound, curved corners on his façades and solidly expressed brickwork in a manner that suggested a direct line of influence from Berlage, despite the rectangularity and openness of the fenestration and the flat roofs. The workers' houses had an importance beyond their stylistic influence as an early example of enlightened planning for well-designed, low-cost housing. In the façade design of the Café de Unie in Rotterdam (fig. 312), a less serious work, Oud almost literally translated a Mondrian painting into architectural terms, at the same time illustrating the possibilities of Mondrian's style for industrial, poster, and typographic design. Oud lived until 1963 and, in his later, monumental buildings, was once more absorbed into the International Style of which he was a somewhat reluctant pioneer.

Van 't Hoff was a more adventurous spirit, at least in his theories. He was the first member of De Stijl to discover Sant'Elia (fig. 309), about whose unfulfilled architectural projects he wrote in *De Stijl*. The other two leading architects associated with De Stijl (aside from Van Doesburg himself, who not only was active as an architectural designer and a color consultant but wrote architectural criticism under various names) were Gerrit Rietveld (1888–1964) and Cor van Eesteren. Both rose to prominence after the end of World War I, so that their achievements belong to the period of the international spread of De Stijl. In his

312. J. J. P. OUD. Café de Unie, Rotterdam. 1925 (destroyed 1940)

1923–24 model for the Schröder House in Utrecht (plate 94), Rietveld used detached interlocking planes of rectangular slabs, joined by unadorned piping, to break up the structure, giving the whole the appearance of a piece of Constructivist sculpture. However, the design is not simply a De Stijl mannerism, for the large corner and row windows give ample interior light; cantilevered roofs shelter the interior from the sun; and the rooms of the house are thus light, airy, and cool. Until his death in 1964, Rietveld remained one of the masters of Dutch architecture, receiving many major commissions, of which the last was the Van Gogh Museum in Amsterdam, begun in 1967.

Cor van Eesteren (b. 1897) collaborated with Van Doesburg in a number of architectural designs during the 1920s, including a project for a house that was one of the most monumental efforts in De Stijl domestic architecture attempted to that date. This palatial edifice (fig. 313), in contrast with Rietveld's approach, emphasized the pristine rectangular masses of the building, coordinated as a series of wings spreading out from a central core defined by the strong vertical accent of the chimney pier in the Wrightian mode. In the central mass they opened up the interior space with cantilevered terraces that anticipated Wright's 1936 house in Bear Run, Pennsylvania (figs. 446, 447).

313. VAN EESTEREN and VAN DOESBURG. Project for Rosenberg House. 1923

From Fantasy to Dada and the New Objectivity

In the wake of the twentieth century's initial exploration of form, the early paintings of Paul Klee introduced aspects of a second major trend in modern art (plate 56). This was the exploration of the irrational and the fantastic in naïve painting, primitivism, Dadaism, and Surrealism. These movements are descendants of nineteenth-century Romanticism and Symbolism. Behind them stretch a thousand years or more of individuals and movements concerned with some sort of personal, eccentric, unorthodox, mystical, or supernatural expression. Christian art from the fourth to the sixteenth century is a concentrated examination of the fantastic in its supernatural aspects, as believing Christian artists tried to describe the indescribable punishments of sinners and the ecstasies of the blessed. Sporadic efforts at this kind of art continued through the eighteenth century, culminating in William Blake's mystic visions and Francisco Goya's macabre and powerful nightmares describing a world gone rotten (figs. 14, 15).

314. HENRI ROUSSEAU. *Myself: Portrait Landscape.* 1890. 57½ × 44½".
National Gallery, Prague

As Romanticism grew and spread in the nineteenth century, fantasy appeared in many forms in painting, sculpture, and architecture. In the latter part of the century, Gustave Moreau, Rodolphe Bresdin, and Odilon Redon created separate dream worlds, but only Redon emerged as a master of the first rank (plate 20). The principal transition from nineteenth-century Romanticism to twentieth-century fantasy was provided by Redon, James Ensor (plate 30), and Henri Rousseau.

HENRI ROUSSEAU (1844–1910) Until 1885, when he retired from his post of inspector at a toll station, Rousseau was an untrained Sunday painter. In 1886 the "Douanier" began to paint full time and to exhibit regularly at the Salon des Indépendants. He drew and painted throughout his life—still lifes and landscapes that remind us of work by amateur or folk artists produced in every part of Europe and the Americas. His fresh directness came primarily from the limitations of his untrained vision. It is questionable whether he can really be classified as a naïve or primitive after 1885. Once his full energies were turned to painting, Rousseau seems to have developed a native ability into a sophisticated technique and to have noted the differences between his approach and that of the Salon artists.

Rousseau was a fascinating mixture of naïveté, innocence, and wisdom, seemingly humorless. He combined a strange imagination with a way of seeing that was magical, sharp, and direct. His first painting exhibited in the Salon des Indépendants, *Carnival Evening* (plate 95), the work that marks his debut as a full-time painter, is a masterpiece. The design includes deep space with all elements treated frontally and flatly. The black silhouettes of trees and house are drawn in painstaking detail—the accretive approach used by the archaic artist. Color throughout is low-keyed, as befits a night scene, but the lighted distant mountains between the dark sky and the even darker foreground of trees create a sense of weird white moonlight. The two tiny figures in harlequin costumes in the foreground glow with an inner light. Despite the painstakingly worked surface and the naïveté of his drawing, the artist not only fills his painting with poetry but achieves a structure that, for him, is extremely sophisticated for its date of 1886. The picture plane controls the design and the organization of depth to a degree that is prophetic of a major concern of art even today.

By 1890 the Douanier had exhibited some twenty paintings at the Salon des Indépendants. Although consistently ridiculed by the public and the critics, the works increasingly excited the interest of serious artists. Redon had already recognized something unique in the art of Rousseau, and during the 1890s his admirers included Degas, Toulouse-Lautrec, and even Renoir. His self-portrait entitled *Myself: Portrait Landscape* (fig. 314) extols the great 1889 exposition in Paris and shows the Eiffel Tower, a balloon, a flag-decked ship, and an iron bridge over the Seine (Pont des Arts). In the foreground stands the majestic figure of the bearded artist, dressed in black and crowned with

315. HENRI ROUSSEAU.
The Sleeping Gypsy.
1897. 51 × 79″.
Collection, The
Museum of Modern
Art, New York. Gift of
Mrs. Simon
Guggenheim

a black beret. His brush is in his right hand, and his palette, inscribed with the names of his past and present wives, is in his left. Rousseau's image of himself as a master of modern painting is nowhere more apparent.

With painstaking care and deliberation, Rousseau continually painted and drew scenes of Paris, still lifes, portraits of his friends and neighbors, and details of plants, leaves, and animals. His romantic passion for far-off jungles filled with strange terror and beauty first appeared in developed form in 1891 in *Storm in the Jungle* and then recurred in a series of his best-known canvases. His exotic paintings of North Africa, like *The Sleeping Gypsy* (fig. 315), were part of the tradition of such scenes, long since become clichés in the hands of academicians. To the end of his life Rousseau continued his childlike admiration for the Salon painters, particularly for the technical finish of their works. *The Sleeping Gypsy* is one of the most entrancing and magical paintings in modern art. By this time he could create mood through a few elements, broadly conceived but meticulously rendered. The composition has a curiously abstract quality (the mandolin and bottle foretell Cubist studio props), but the mood is overpoweringly strange and eerie—a vast and lonely landscape framing a mysterious scene. In this work, as in others, Rousseau expressed qualities of strangeness that were unvoiced, inexpressible rather than apparent, anticipating the standard vocabulary of the Surrealists.

The last series painted by Rousseau, and the climax of his vision, also present scenes of the jungle. In these the little leaves he picked up, and the animals and plants he observed in the Paris Zoo and Botanical Garden, were transformed into scenes of tropical mystery. The setting in each is a mass of broad-leaved jungle foliage, gorgeous orchids, exotic fruits, and apprehensive, anachronistic animals peering out of the underbrush. The climax of such scenes is *The Dream* of 1910 (plate 96), Rousseau's last great work, painted in the year of his death. It is a fantasy that the Surrealists undoubtedly envied. In the midst of a wildly abundant jungle, with its peering lions, brilliant birds, shadowy bison, pale moon, and dark-skinned flute player, a luscious, if malformed,

nude rests on a splendid Victorian sofa. Rousseau's charmingly simple explanation of this improbable creation—that the lady on the couch dreamed herself transported to the midst of the jungle—explains the work at an elementary level. The conception is perfect, too engaging to need any explanation other than its existence.

During his later years, Rousseau became something of a celebrity for the new generation of artists and critics. He held regular musical soirées at his studio. Picasso, in 1908, after discovering a portrait of a woman by Rousseau at Père Soulié's junk shop, purchased it for five francs and gave a large party for him in his studio, a party that, as we saw earlier, has gone down in the history of modern painting. The party was half a joke on the innocent old Douanier, who took himself so seriously as an artist, but more an affectionate tribute to a naïve man recognized to be more genius than naïve. The apotheosis of Henri Rousseau as painter and prophet came in the last decade of his life. Rousseau, despite the early date of his birth, belongs next to Picasso, Braque, Matisse, and the other painters who constituted the first generation of twentieth-century art.

Another precursor of twentieth-century fantasy was Rousseau's near contemporary and fellow autodidact Eugène Atget, the naïve and masterful photographer whose romantically melancholy image of the old royal gardens at Saint-Cloud we saw in figure 117. After having failed at merchant seamanship and acting, the forty-year-old Atget took up photography and conceived what a friend called "the ambition to create a collection of all that which both in Paris and its surroundings was artistic and picturesque. An immense subject." Over the next thirty years until he died in 1927, Atget labored with a singleminded devotion to record the entire face of the French capital, especially those aspects of it most threatened by "progress." Among the approximately ten thousand pictures that survive—images of streets, buildings, historic monuments, architectural details, parks, peddlers, vehicles, trees, flowers, rivers, ponds, the interiors of palaces, bourgeois apartments, and ragpickers' hovels—are a series of shop fronts that, with their grinning dummies and superimposed reflections from across the street, would

fascinate the Surrealists as "found" images of dislocated time and place (fig. 316). Man Ray was so taken with the work seen here that he arranged for it to be reproduced in *La Révolution surréaliste* in 1926. The sense it evokes of a dream world, of a strange "reality," of threatened loss could only have been enhanced by equipment and techniques that were already obsolescent when Atget adopted them and all but anachronistic by the time of his death. As John Szarkowski wrote in *Looking at Pictures*:

Other photographers had been concerned with describing specific facts (documentation), or with exploiting their individual sensibilities (self-expression). Atget encompassed and transcended both approaches when he set himself the task of understanding and interpreting in visual terms a complex, ancient, and living tradition. The pictures that he made in the service of this concept are seductively and deceptively simple, wholly poised, reticent, dense with experience, mysterious, and true.

MARC CHAGALL (1889–1985) Marc Chagall was born in Vitebsk, Russia, of a large and poor Jewish family. From his background he acquired a wonderful repertoire of Russian-Jewish folktales and a deep and sentimental attachment to the Jewish religion and traditions. There was also inbred in him a fairytale sense of fantasy. Out of these elements emerged his personal and poetic painting. Chagall attended various art schools in St. Petersburg, but derived little benefit until he enrolled in an experimental school directed by the theater designer Léon Bakst, who was influenced by the new ideas emanating from France. Chagall then could not rest until he departed for Paris in 1910.

In Paris, Chagall entered the orbit of Apollinaire and the leaders of the new Cubism, as well as that of Modigliani, Soutine, and Jules Pascin. Chagall's Russian paintings had largely been intimate genre scenes, often brightened by elements of Russian or Jewish folklore. Bakst's school caused him to make bold efforts using Fauve color and constricted space. His intoxication with Paris opened a floodgate of experiments in Fauve color and Cubist space, and above all of subjects filled with lyric fantasy. Within two years of his arrival, Chagall was producing mature and weirdly poetic paintings.

Homage to Apollinaire (fig. 317), which seems something of a sport among his early efforts, already shows his utilization of Cubist space. Although the work belongs in the early Cubist tradition, specifically that of Delaunay, nothing about it is recognizably derivative. The organization of color shapes within the circular and spiral scheme is Cubist in origin but individual in presentation—shapes cut across the double figure of Adam and Eve, integrating them with the rotating ground. Adam and Eve, their two bodies emerging from one pair of legs to symbolize the union and opposition of male and female, derive from medieval representations of the Fall of Man. The numbers on the left arc of the outer circle introduce the notion of time.

The symbolism of *Homage to Apollinaire* has been variously interpreted. The theme of lovers irrevocably joined continues throughout Chagall's work and his life, but it is a mistake to interpret literally Chagall's symbolic vocabulary. His knowledge of Jewish and Christian themes was extensive, as was his knowledge of ancient mythology and his native Russian folklore, but he was not concerned with scholarly development. *Homage to Apollinaire* is probably as close as he ever came to a scholarly approach, but its poetic charm and mystery are the result of unexpected juxtapositions dredged up from the artist's unconscious memory.

316. EUGÈNE ATGET. *Avenue des Gobelins*. 1910. Aristotype print. Collection, The Museum of Modern Art, New York

During the next years in Paris, the painter continued to utilize the new forms in expressing his personal fantasy. In *Paris Through the Window* (plate 97), the double-faced Janus figure in the lower right corner (in appearance more like Apollinaire than Chagall himself), with two profiles in contrasting light and shadow, suggests a double nature for the painting—the romantic Paris of actuality and Paris transformed in the poet's dreams with trains floating upside down, pedestrians promenading parallel to the sidewalks, and an aviator supported by a triangular kite. The suggested studio interior with its carefully drawn chair and flowers, and even its Janus-faced poet, seems closer to everyday experience than to the Paris of the poet's dream. The window with its frame of red, yellow, blue, and green, and its human-headed cat acting as a domesticated Cerberus, becomes a partition between the two cities. The sky composed in large geometric areas and the animated buildings, particularly the somewhat tilted Eiffel Tower, suggest Delaunay's dynamic method imposed upon a dream of gentle nostalgia.

In 1914, Herwarth Walden, previously mentioned (p. 131), arranged an exhibition of Chagall's work in Berlin. It had a great impact on the German Expressionists, one that extended well beyond World War I. The outbreak of war caught Chagall in Russia, where he then stayed until 1922. After the Russian Revolution, like Malevich and other avant-garde artists, he served for a time as a commissar of fine arts and formed a free art academy. Perhaps his most fruitful work was for the Yiddish theater in Moscow, painting murals and designing settings and costumes. This opportunity to work on a large scale in the theater continued to fascinate him and to inspire some of his most striking paintings (plate 98).

After his reunion with his beloved Bella, whom he married in 1915, Chagall commemorated his feeling for her in a group of paintings of lovers. In *Birthday* (plate 99) he floats ecstatically through the air and, with delicious absurdity, twists his head for a kiss, as Bella pauses in her household chores.

Back in Paris in 1923, Chagall became increasingly active in the graphic arts, especially for the dealer Ambroise Vollard. Over the years he continued to move from project to project with undiminished energy and enthusiasm. In 1945 he designed sets and costumes for Stravinsky's *Firebird*. He made color lithographs, produced sculptures and ceramics, designed a ceiling for the Paris Opéra (1963) and murals for the Metropolitan Opera at Lincoln Center in New York (1966). Chagall's love of rich, translucent color, particularly the primaries blue, red, and yellow, made stained glass a medium natural for him. His most impressive windows may be those he designed for the Synagogue of the Hadassah Medical Center in Jerusalem.

The Metaphysical School

GIORGIO DE CHIRICO (1888–1978) Giorgio de Chirico links nineteenth-century Romantic fantasy with twentieth-century movements in the irrational, Dadaism, and Surrealism. Born in Greece of Italian parents, De Chirico learned drawing in Athens. After the death of his father, a railroad architect, the family moved to Munich, where the artistic leanings of the elder son Giorgio (then seventeen), and the musical leanings of the younger son Alberto, could be advanced. There De Chirico was exposed to the art of the late nineteenth-century German-Swiss Romantic Arnold Böcklin, as well as of Max Klinger, who carried the Romantic tradition into the twentieth century (fig. 116). Although he quickly outgrew Böcklin, De Chirico retained certain images throughout his "metaphysical" period, particularly Böcklin's black, shadow fig-

317. MARC CHAGALL. *Homage to Apollinaire.* 1911–12. 82¼ × 78″.
Stedelijk van
Abbe-Museum, Eindhoven, The Netherlands

ure of Odysseus with his back to the spectator in *Odysseus and Calypso.* What impressed De Chirico in the work of the older Romantic was Böcklin's ability to impart "surprise," to make real and comprehensible the improbable or fantastic, by juxtaposing it with normal everyday experience. While in Munich, De Chirico was also affected by the philosophical writings of Nietzsche and Schopenhauer. His concept of a painting as a symbolic vision was partly based on Nietzsche, even down to the particular form taken by this dream: a deserted Italian city square—perhaps Turin, where Nietzsche spent some late years—deep in an autumn afternoon when the air is unnaturally clear and the shadows long. Too, Nietzsche's insistence on the lyric significance behind the surface appearance of mundane objects led De Chirico to his metaphysical examination of still life.

Other sources for De Chirico's personal dream world may be found in ideas then fermenting in Germany. A sheet from Max Klinger's strange suite of etchings *Paraphrase on the Finding of a Glove*, illustrating fetishism and antedating the published theories of Freud, was later specifically used by De Chirico. Klinger, encountered earlier in figure 118, also influenced the Expressionist exponent of fantasy, Alfred Kubin, as we have seen, a graphic artist of considerable power (fig. 119). Kubin's drawing *Vision of Italy*, a lonely piazza dominated by a statue of winged Pegasus, may have intrigued De Chirico.

While De Chirico was in Germany, from 1905 to 1909, Art Nouveau was still a force and the German Expressionists were beginning to make themselves known. Ideal or mystical philosophies and pseudo-philosophies were everywhere gaining currency among artists and writers, and modern theosophy was an international cult. We have already seen the theosophical bases of Kandinsky's approach to abstraction, and mystical concepts of an inner reality beyond surface appearance affected artists as divergent as Mondrian and Klee.

Psychoanalysis, with its study of the subconscious, the symbolism of dreams, and the importance of instinct and emotion in human behavior, also had great importance for artists seeking new modes of expression. These artists were rarely profound students of philosophy or psychology. They assimilated, generally, a popularization of ideas in the air and, like everyone else, sometimes misunderstood or misapplied them. But many individual artists seized upon such current ideas, and though these might ultimately be proved invalid or to have been grasped only vaguely by the artist, they became the basis for works of art through the artist's peculiar and intense perception. De Chirico constantly referred to the metaphysical content of his paintings, using the term loosely or inaccurately to cover various effects of strangeness, surprise, and shock. One may ask to what extent was De Chirico's individual fantasy a direct result of the influences to which he was exposed during the Munich years. This question, of course, could be asked about any artist whose works represent a departure, and may often be pointless or unanswerable. It does have relevance, however, to De Chirico's development, since his earliest paintings, between 1910 and 1915, were so distinct from those by other artists around him and so influential in the development of fantasy, particularly the ideas of the Surrealists. It is also important to consider the personality of De Chirico himself—a notably strange and complicated one. Thus it is very likely that even if he had been exposed to quite different influences, he would still have formed some comparable expression.

De Chirico's approach to art, during his early and most important phase—up to 1920—was to examine a theme as though to wring from it its central mystery. In 1912 and 1913 the artist painted a group of works incorporating a Hellenistic sculpture of a reclining Ariadne, of which *The Soothsayer's Recompense* (fig. 318), one of the finest, pre-

right: 318. GIORGIO DE CHIRICO. *The Soothsayer's Recompense.* 1913. 53½ × 71″. Philadelphia Museum of Art. Louise and Walter Arensberg Collection

below left: 319. GIORGIO DE CHIRICO. *Grand Metaphysical Interior.* 1917. 37 × 27¾″. Collection, The Museum of Modern Art, New York. Gift of James Thrall Soby

below right: 320. GIORGIO DE CHIRICO. *The Sacred Fish.* 1919. 29½ × 24⅜″. Collection, The Museum of Modern Art, New York. Acquired through the Lillie P. Bliss Bequest

sents Classical façades parallel to the picture plane, but the large clock and the train moving along the horizon are nineteenth-century elements having an anachronistic affinity with the architecture. Such anomalies are commonplace in Italian cities: a palazzo may become a nineteenth-century railway station suggesting the melancholy of departure (a title

he used), a melancholy saturating the shadowed square in which deserted Ariadne mourns her departed Theseus. At times, the strange, sad loneliness of De Chirico's squares takes on the dimension of fear, of isolation in a vast, empty space.

The Melancholy and Mystery of a Street of 1914 is perhaps De Chi-

rico's finest example of deep perspective used for emotional effect (plate 100). On the right an arcaded building in deep browns and grays casts a shadow filling the foreground; a lower white arcade on the left sweeps back toward infinity; the sky is dark and threatening. Into the brightly lit space between the buildings emerges a shadowy little girl rolling her hoop, a wraithlike figure drawn inexorably toward a looming black shadow of a figure behind the dark building. In the shadowed foreground is again an anachronism, an empty old-fashioned freight car whose open doors add another disturbing element of the commonplace. The scene may be described matter-of-factly: an Italian city square with shadows lengthening in a late autumn afternoon; an arcade of shops closed for the day; railway tracks in the lower left corner; the shadow of a heroic nineteenth-century statue; a little girl hurrying home. But from these familiar components the artist creates a mood of frightening strangeness.

During 1914 and 1915 De Chirico began to paint constricted architectural settings in which objects have a greater place. All objects are painted with a hard insistence on their three-dimensional reality that makes us see them as object-ideas transcending our visual or tactile experience of them. De Chirico was to explore the metaphysical reality of objects over the next few years.

A related interest began in 1914 and lasted for several years, that of mannequins, suggesting the articulated wooden figures used in drawing classes, dressmakers' dummies, or Renaissance lay figures and anatomical charts. Mannequins as the protagonists in De Chirico's pictorial dramas may have been inspired by his brother's play about "a man without voice, without eyes or face," but the faceless mannequin also develops logically from the headless draped figure or the anonymous frock-coated statue in the square, its back to the spectator. Whatever the origin of De Chirico's mannequin iconography, the entire aura of the paintings in this series recalls Renaissance architectural perspectives of the fifteenth and sixteenth centuries, made dramatic by extreme foreshortenings and close-ups. When the artist refers specifically to Renaissance Classicism, however, it is to the High and Late Renaissance of Michelangelo, Raphael, and their followers.

In Ferrara, from 1915 to 1919, De Chirico summed up his explorations of the previous years in a fully developed mature style. Their haunting, dreamlike fusion of reality and unreality earned them the appellation Metaphysical, and when De Chirico met the artists Carlo Carrà and Filippo de Pisis in the army hospital in Ferrara, they formed the association known as the *Scuola Metafisica*, or Metaphysical School. *The Great Metaphysician*, *The Disquieting Muses*, and *Grand Metaphysical Interior*, the key paintings of the Ferrarese sojourn, were the climax of the artist's visions of loneliness and nostalgia, his fear of the unknown, his premonitions of the future, and the reality beyond physical reality. De Chirico saw himself as an oracle. *The Great Metaphysician* combines the architectural space of the empty city square and the developed mannequin figure (plate 101). The deep square is sealed in with low Classical buildings. The sky occupies half of the canvas, becoming light toward the horizon. The buildings to right and left are abstract silhouettes extending geometric shadows over the brown area of the square. Only the rear buildings and the foreground monument are brightly lit. This monument on a low base is a looming construction of elements from the studio and drafting table, crowned by a blank mannequin head.

The Grand Metaphysical Interior illustrates other aspects of De Chirico's Ferrarese period (fig. 319). Here he develops sharp and brilliant color and, in certain details, precisely defined textural surface. The interior is constricted by tilted gray planes. A realistic landscape paint-

321. GIORGIO DE CHIRICO. *Horses and Bathers* (*Cavalli e Bagnanti*). 1936. Tempera on paper, 12 × 9¾". Private collection

ing and a framed relief of suspended objects are both set on a construction of armatures and mathematical instruments. This is a superb example of the artist's concern for the metaphysical reality of objects, illustrated particularly in the two suspended rolls of Italian bread, but the prosaic literalness of the landscape painting is a premonition of the coming change in De Chirico's work.

The Sacred Fish, a strange and somber conception, is executed with an oily brush (fig. 320). The fish are placed in the suggestion of a cross on the trapezoidal altar; to the left is a candle decorated with a starfish; in the foreground is a puzzle box of brightly colored triangles, one of those mathematical props that haunt the paintings of this period. The space of the painting is almost uniformly in shadow, with a variety of vertical shapes dividing the space like stage flats. The painting has overtones of some obscene ritual of black magic, and this made the work appeal strongly to the Surrealists.

After 1920, just as De Chirico began to be recognized as a forerunner of new movements in many parts of Europe and the United States, he suddenly turned against the direction of his own painting. After a time of indecision, years in which he made exact copies of his Metaphysical paintings on commission, he settled on an academic Classicism that he continued to pursue (fig. 321). He did not actually repudiate his own early works, for he took pride in his reputation and became jealously possessive of his achievements. The end of World War I, however, was for him the end of a road. He was by no means alone in his abandonment of experiment or in his attempt to rejoin the mainstream of Renaissance painting. The end of the war saw many artists deserting Fauve or Cubist or abstract directions, some temporarily, others permanently. In the case of De Chirico, the withdrawal into reaction has made the artist something of a hero to certain Post-Modernists of the 1980s.

CARLO CARRÀ It seems fateful that Carrà, a Futurist and a Metaphysical painter, was sent to Ferrara for military service. Here he met De Chirico in 1917. Carrà had been replacing the coloristic fluidity of his Futurist paintings with a more disciplined style akin to Analytic Cubism. He then introduced a modeled nude in some paintings, as a gesture to his growing admiration for Giotto and Early Renaissance painters. In the first war years he applied Marinetti's concept of free words to collages with propagandistic intent (plate 87). The form proposed by Marinetti, and practiced for a time by Carrà as well as by Severini, specifically influenced poets and artists among the Dadaists and Surrealists. Its more recent influence on the Pop artists is comparable to that of Russolo's noise organ on electronic music.

The directions of Carrà's paintings and collages after 1912 indicate his search for a new content and for forms more plastic and less fragmented than those of Futurism. By 1916 he adapted ideas of Early Renaissance masters and the modern master of naïve expression, Henri Rousseau. Then De Chirico provided Carrà with an answer, and his works immediately reflected it. He painted pictures in 1917 that are almost pastiches of De Chirico's, but in *The Drunken Gentleman*, dated 1916 but certainly painted in 1917 (fig. 322), he developed an individual approach. The objects—sculptured head, bottle, glass, etc.—are modeled with clear simplicity in muted color gradations of gray and white, given strength and solidity by the heavy impasto of the paint. Out of elementary still-life props the artist created his own metaphysical reality.

In 1918 Carrà published *Pittura Metafisica*, a book enunciating its philosophy. De Chirico, feeling justifiably that he was not given adequate credit, became embittered, and ended both their friendship and the Metaphysical School as a formal movement. The Metaphysical School had never been a school, a movement, or even a style in the sense that Cubism might be so considered. In addition to De Chirico and Carrà, the artists principally associated with it were De Chirico's younger brother who was known as Alberto Savinio (he became a serious painter at a later date), Filippo de Pisis, and briefly, Mario Sironi. The only other great name was Giorgio Morandi, because for a short time he used some of its subject matter. His genius lay elsewhere.

The essence of the Metaphysical School was in the conviction of a few artists, notably De Chirico and Carrà, that the answer to the dilemma of modern art lay in the plastic reshaping of Renaissance visual reality, principally linear perspective. The Metaphysical painters retained the forms of Renaissance reality, perspective space, recognizable environment, and sculptural figures and objects, and by various juxtapositions producing surprise and shock created an atmosphere of strangeness, sometimes even of fear and horror. In their search for a new content, the Metaphysical painters took the first deliberate step for those who have since been exploring possibilities for expression in the intuitive and the irrational.

Zurich Dada: 1916–19

During World War I searches for a new fantastic subject matter and content began to come into focus. Zurich, in neutral Switzerland, was the first important center in which arose an art, a literature, and even a music of the fantastic and the absurd. On this city in 1915 converged a number of young men, almost all in their twenties, exiles from the war that was sweeping over Europe. These included the German writers Hugo Ball and Richard Huelsenbeck, the Rumanian poet Tristan Tzara, the Rumanian painter and sculptor Marcel Janco, the Alsatian painter,

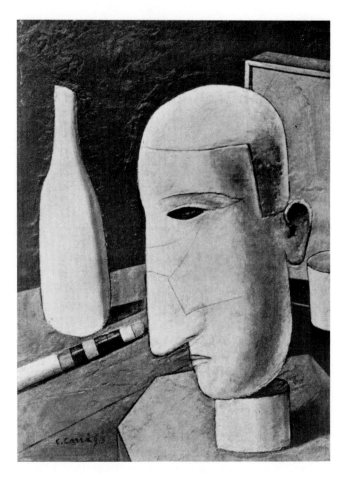

322. CARLO CARRÀ. *The Drunken Gentleman*. 1917. 23⅝ × 17½″.
Collection Carlo Frua de Angeli, Milan

sculptor, and poet Jean (Hans) Arp, and the German painter Hans Richter, who became a noted experimental filmmaker. Many other poets and artists were associated with Zurich Dada, but these were the leaders whose demonstrations, readings of poetry, noise concerts, art exhibitions, and writings attacked the traditions and preconceptions of Western art and literature. Thrown together in Zurich, these young men and women, such as the Swiss painter and designer Sophie Taeuber, later Sophie Taeuber-Arp, expressed their reactions to the spreading hysteria and madness of a world at war, in forms that were intended as only negative, anarchic, and destructive. From the very beginning, however, the Dadaists showed a seriousness of purpose and a search for new vision and content that went beyond any frivolous desire to outrage the bourgeoisie. This is not to deny that in the manifestations of Dada there was a central force of mad humor. This wildly imaginative humor is one of its lasting delights—whether manifested in free word-association poetry readings drowned in the din of noise machines, in mad theatrical or cabaret performances, in nonsense lectures, or in paintings produced by chance or intuition uncontrolled by reason. Nevertheless, it had a serious intent: the Zurich Dadaists were making a critical reexamination of the traditions, premises, rules, logical bases, even the concepts of order, coherence, and beauty that had guided the creation of the arts throughout history.

Hugo Ball, a philosopher and mystic as well as a poet, was the first actor in the Dada drama. In the spring of 1916, he founded the Cabaret Voltaire, in Zurich, as a meeting place for these free spirits and a stage from which existing values could be attacked. Interestingly enough,

across the street from the Cabaret Voltaire lived Lenin, who with other quiet, studious Russians was planning a world revolution.

The term Dada was coined in 1916 to describe the movement then emerging from the seeming chaos of the Cabaret Voltaire, but its origin is still doubtful. The popular version advanced by Huelsenbeck is that a French-German dictionary opened at random produced the word "dada," meaning a child's rocking horse or hobby horse. Richter remembers the *da, da, da da* ("yes, yes") in the Rumanian conversation of Tzara and Janco. *Dada* in French also means a hobby, event, or obsession. Other possible sources are in dialects of Italian and Kru African. Whatever its origin, the name Dada is the central, mocking symbol of this attack on established movements, whether traditional or experimental, that characterized early twentieth-century art. The Dadaists used many of the formulas of Futurism in the propagation of their ideas—the free words of Marinetti, whether spoken or written; the noise-music effects of Russolo to drown out the poets; the numerous manifestoes. But their intent was opposite to that of the Futurists, who extolled the machine world and saw in mechanization, revolution, and war the rational and logical means, however brutal, to the solution of human problems.

The Dadaists felt that reason and logic had led to the disaster of world war, and that the only way to salvation was through political anarchy, the natural emotions, the intuitive, and the irrational. Their outlook in one respect was a return to Kandinsky's inner necessity, the spiritual in art, but Dada, at least at its inception, was negative and pessimistic.

Zurich Dada was primarily a literary manifestation, whose ideological roots were in the poetry of Arthur Rimbaud, in the theater of Alfred Jarry, and in the critical ideas of Max Jacob and Guillaume Apollinaire. In painting and sculpture, until Picabia arrived, the only real innovations were the free-form reliefs and collages "arranged according to the laws of chance" by Jean Arp. With few exceptions, the paintings and sculptures of other artists associated with Zurich Dada broke little new ground. In abstract and Expressionist film—principally through the experiments of Hans Richter and Viking Eggeling—and in photography and typographic design the Zurich Dadaists did make important innovations.

Hugo Ball introduced abstract poetry with his poem *O Gadji Beri Bimba* in July 1916, and in June 1917 he presented an entire evening of abstract poetry that almost caused a full-blown riot. His thesis, that conventional language had no more place in poetry than the outworn human image in painting, produced a chant of more or less melodic syllables without meaning: "zimzim urallala zimzim zanzibar zimlalla zam...." The frenzied reactions of the audience did not prevent the experiment from affecting the subsequent course of poetry. But one cannot evaluate Zurich Dada by a tally of its concrete achievements or stylistic influences. Dada's importance was as a state of mind, not as a style or movement.

The Zurich Dadaists were violently opposed to any organized program in the arts, or any movement that might express the common stylistic denominator of a coherent group. Nevertheless, three factors shaped their creative efforts. These were *bruitisme* (noise-music, from *le bruit*—"noise"—as in *le concert bruitiste*), simultaneity, and chance. *Bruitisme* came from the Futurists, and simultaneity from the Cubists via the Futurists, although the Dadaists thought these principles to be negative, destructive forces. Chance, of course, exists to some degree in any act of artistic creation. In the past the artist normally attempted to control or to direct it, but it now became an overriding principle. All three, despite the artists' avowed negativism, soon became the basis for their positive and revolutionary approach to the creative

act, an approach still found in poetry, music, drama, and painting.

With the end of the war Zurich Dada was drawing to an end. The first enthusiasms were fading; its participants were scattering; but its worldwide impact had only begun. The Spanish painter Francis Picabia arrived in 1918, bringing contact with similar developments in New York and Barcelona. Picabia, together with Marcel Duchamp and Man Ray, had contributed to a Dada atmosphere in New York around Alfred Stieglitz's Gallery 291 and his periodical *291*. With the help of the collector Walter Arensberg, Picabia had begun to publish his own journal of protest against everything, which he called *391*. After a journey to Barcelona, where he found many like-minded expatriates, including Marie Laurencin, Picabia visited Zurich, drawn by the spreading reputation of the originators of Dada. Returning to Paris at the end of the war, he became a link between the postwar Dadaists of Germany and France.

JEAN (HANS) ARP (1887–1966) The one major artist to emerge from Zurich Dada was the Alsatian Jean or Hans Arp. Arp was born in Strasbourg, then a German city but subsequently recovered by France. He studied painting and poetry, and in Paris in 1904 he discovered modern painting, which he then pursued in studies at the Weimar School of Art and the Académie Julian in Paris. He also wrote poetry of great originality and distinction throughout his life. The disparity between his formal training and the paintings he found valid brought uncertainty, and he spent the years 1908–10 in reflection in various small villages in Switzerland. The Swiss landscape seems to have made a lasting impression on him, and the abstraction to which he eventually turned was based on nature and living organic shapes.

In Switzerland, Arp met Paul Klee, and after his return to Germany he was drawn into the orbit of Kandinsky and the Blaue Reiter painters. In 1912 he exhibited in Herwarth Walden's first Autumn Salon, and by 1914, back in Paris, he belonged to the circle of Picasso, Modigliani, Apollinaire, Max Jacob, and Delaunay.

Arp took an unusually long time finding his own direction. Since he destroyed most of his pre-1915 paintings, the path of his struggle is difficult if not impossible to trace. He experimented with geometric abstraction based on Cubism, and by 1915, in Zurich, he was producing, as fast as his fingers could work, drawings and collages whose shapes suggest leaves and insect or animal life but which were actually abstractions. With Sophie Taeuber (1889–1943), whom he met in 1915 and

323. SOPHIE TAEUBER-ARP. *Untitled*. 1920. Watercolor, 16⅛ × 11″. Private Collection

During the same period Arp devised a type of relief consisting of thin layers of wood shapes suggesting plants, exotic vegetables, crustaceans, or swarming amoebae, brightly painted, with strong implications of life, growth, and metamorphosis. A particular shape might suggest a specific object and thus give the relief its name, as in *Fleur Marteau* (plate 102). Although the origin of the shapes was initially intuitive (a line doodled on a piece of paper, a contour cut quickly through a thin piece of wood), the shape was rarely rectilinear and only occasionally loosely circular. The contour lines were organic in the sense of suggesting the irregularity of a living organism. Despite his deliberate avoidance of rational processes in drawing or cutting, Arp possessed a highly experienced hand which, even when unguided, inevitably repeated directions that formed certain recognizable shapes which could be only his. A viola shape suggested a female torso; its uninterrupted surface needed some accent; this was provided by a cut-out circle that became a navel. For a period in the 1920s any circle became for Arp a navel, whatever its context (fig. 325).

Although Arp participated less actively than some Dada colleagues in the group's performances, he contributed drawings and poems to the Dada publications between 1916 and 1919, while perfecting his own abstract organic fantasy. In his works he normally referred to the organic, whether something seen under the microscope or a human head or torso. In his later, freestanding sculptures in marble or bronze, the suggestion of head or torso became more frequent and explicit. When asked in 1956 about a 1953 piece entitled *Aquatic*—which, reclining, suggests some form of sea life, and standing on end, a particularly sen-

324. JEAN ARP. *Collage Arranged According to the Laws of Chance.* 1916–17. Torn and pasted papers, 19⅛ × 13⅝″. Collection, The Museum of Modern Art, New York. Purchase

later married, he produced textile designs (fig. 323). Assisted by her, he further clarified his ideas: "These pictures are Realities in themselves, without meaning or cerebral intention. We...allowed the elementary and spontaneous to react in full freedom. Since the disposition of planes, and the proportions and colors of these planes seemed to depend purely on chance, I declared that these works, like nature, were ordered according to the laws of chance, chance being for me merely a limited part of an unfathomable *raison d'être*, of an order inaccessible in its totality...." Also emerging at this time was the artist's conviction of the metaphysical reality of objects and of life itself—some common denominator belonging to both the lowest and the highest forms of animals and plants. It may have been his passion to express his reality in the most concrete terms possible, as an organic abstraction (or, as he preferred to say, an organic *concretion*) that led him from painting to collage and then to relief and sculpture in the round.

In 1916–17 Arp produced some collages of torn, rectangular pieces of colored papers scattered in a vaguely rectangular arrangement on a paper ground (fig. 324). The story is told of their origin that Arp had torn up a drawing that displeased him and dropped the pieces on the floor, then suddenly saw in the arrangement of the fallen scraps the solution of the problems with which he had been struggling. Regardless of the truth in this anecdote the artist experimented with collages created in this manner, just as Tzara created poems from words cut out of newspapers, shaken and scattered on a table.

325. JEAN ARP. *Torso, Navel.* 1920. Wood, 26 × 17 × 4″. Collection Mme. Arp-Hagenbach, Meudon, France

suous female torso (fig. 386)—he commented, "In one aspect or another, my sculptures are always torsos." In the same way that De Chirico is the forerunner of the wing of Surrealism that uses realistic techniques and recognizable images, Arp is the forerunner of the other wing that uses abstract organic shapes and arbitrary, nondescriptive color to create a world of fantasy beyond the visible world. The only recognizable influence on him is Brancusi, but his descendants are Joan Miró, Alexander Calder, and a subsequent generation of painters and sculptors.

New York Dada: 1915–20

New York Dada during World War I largely resulted from the accident that Marcel Duchamp and Francis Picabia both had come to New York and found a congenial environment in the avant-garde gallery of Alfred Stieglitz. Born in the United States, Stieglitz studied in Berlin, where he discovered his first enthusiasm, photography. He became a pioneer of photography as a fine art (fig. 68). With another notable photographer, Edward Steichen (fig. 128), he founded the Little Gallery of the Photo-Secession at 291 Fifth Avenue, and published a journal, *Camera Work*. Exhibitions and articles were devoted to all the arts, emphasizing the new European trends. By 1913 the gallery (later renamed 291) and the periodical had introduced the American public to such European masters as Rodin, Toulouse-Lautrec, Henri Rousseau, Matisse, and Picasso. In the next few years Stieglitz showed Braque, Brancusi, Picabia, and African sculpture.

In 1915, assisted by Duchamp and Picabia, Stieglitz founded another periodical, *291*, to present the antiart ideas of these artists. Thus, chronologically earlier than the Dada movement in Zurich, comparable ideas were fermenting independently in a small cohesive group in New York. Aside from the two Europeans, the most important figures in the group were the young American artists Man Ray and Morton Schamberg, and the collector Walter Arensberg. The artist of greatest stature and influence was Marcel Duchamp, who really created New York Dada.

MARCEL DUCHAMP Duchamp's career as a painter was almost over when he arrived in New York in 1915. In the preceding three years he had gradually withdrawn from the professional art world for reasons never satisfactorily explained. In part it was due to disillusionment with the direction that Cubism was taking toward decorative formalism, and in part with a much larger question in his mind concerning the fundamental validity of art.

Duchamp's questioning was first expressed in such paintings as *Nude Descending a Staircase No. 2* (plate 79), which used Cubist faceting and simultaneity for expressive rather than formal purposes. Here, the Paris exhibition of the Futurists in February 1912 had helped the artist to clarify his attitudes, although his intention was at the opposite extreme to theirs. Their dynamism, their "machine aesthetic," was an optimistic, humorless exaltation of the new world of the machine, of speed, flight, and efficiency, with progress measured in these terms. Duchamp, though he used some of their devices, expressed disillusionment through satirical humor. His sources, as with so much of Dada and Surrealism, were works of literature rather than art. The dedicated humorlessness of much early modern painting and sculpture may have contributed to Duchamp's rejection of it.

During 1912 Duchamp, like Picabia, turned to the painting of machines of his own devising. First came the several variants on *The King*

326. MARCEL DUCHAMP. *The King and Queen Traversed by Swift Nudes*. 1912. 45¼ × 50½". Philadelphia Museum of Art. Louise and Walter Arensberg Collection

and Queen Traversed by Swift Nudes (fig. 326). The King and Queen are totemistic, machine figures derived from chessmen. Insofar as the figures can be identified within the luminous, sculptural elements from which they are constructed, they combine royal dignity with stylized caricature appropriate to their origin in chessmen or playing cards. The "swift nudes" around them act as divisive elements that yet seem to join them together. The figures are not only mechanized but are machines in operation, pumping some form of sexual energy from one to another.

The artist pursued his fantasies of sex machines in a series of paintings and drawings on which he worked during 1912–13, including *Virgin*, *The Passage from Virgin to Bride* (plate 103), *Bride*, and the initial drawing for the great painting on glass, *The Bride Stripped Bare by Her Bachelors, Even* (plate 105). The nature of these works, which climaxed and virtually terminated Duchamp's career as a painter, is that of a machine organism, and suggests anatomical diagrams of the respiratory, circulatory, digestive, or reproductive systems of higher mammals. The *Virgin* is a relatively simple organic system, the *Bride*, more complicated and developed. The *Passage* transposes the forms of the *Virgin* to those of the *Bride*, and in it the artist most completely and successfully translates mysterious internal forces into a total pictorial harmony.

In these paintings Duchamp was seeking to reinstate human content in Cubism, to translate legendary themes into the bold forms of modern biology and engineering. Such an intent, in so subtle and ironic a mind, could only be satiric. The *Virgin* and the *Bride*, symbols of inviolable purity and sanctified consummation, are presented as elaborate systems of anatomical plumbing. Thus, it would seem, the artist restores traditional subject in order to destroy it. If this is true, however, an ambiguity exists, for the paintings, particularly the more developed *Bride* and *The Passage from Virgin to Bride*, have a mystery that takes them out of the realm of satire. The *Passage* in particular is a brilliant abstract construction, its closely keyed colors delicately graded and contrasted in light and shadow. Duchamp seems almost trapped by his own abili-

327. MARCEL DUCHAMP. *Chocolate Grinder, No. 1*. 1913. 24¾ × 25⅝".
Philadelphia Museum of Art. Louise and Walter Arensberg Collection

ties. Doubting the traditional validity of painting and sculpture as legitimate modes of contemporary expression, and determined to undermine and destroy Cubism, he nevertheless created pictures having demonstrable value, harmony, and symbolism within the existing vocabulary of art. Perhaps his recognition of this fact led him to abandon painting at the age of twenty-five. In his first sketches and diagrams for *The Bride Stripped Bare by Her Bachelors, Even,* he was already exploring the possibility of an aesthetic based on mathematical relationships.

On a short vacation trip in the fall of 1912 Duchamp, Picabia, Gabrielle Buffet, and Apollinaire discussed the state of art and the possibilities for new directions and forms in terms of every sort of paradox. As an immediate result, an exhibition was organized as a secession from the Salon d'Automne, which was dominated by a Cubism that, in the estimation of the little group, had become academic. This was the famous Salon de la Section d'Or, held on the Rue La Boétie in October 1912 (see p. 173).

In this Salon, named by Duchamp's brother Jacques Villon, were actually assembled all aspects of Cubism, with the notable exceptions of Picasso and Braque, but Cubism interpreted more freely than the jury of the Salon d'Automne permitted. Many offshoots of Cubism were also admitted, including experiments toward abstraction and fantasy. Duchamp showed *Nude Descending a Staircase* (withdrawn from the previous Salon d'Automne), *Portrait of Chess Players,* a watercolor of

328. MARCEL DUCHAMP. *Bicycle Wheel*. 1951 (third version, after lost original of 1913). Assemblage, metal wheel, 25½" diameter, mounted on painted wood stool, 23¾" high; overall 50½" high. Collection, The Museum of Modern Art, New York. The Sidney and Harriet Janis Collection

329. MARCEL DUCHAMP. *Rotative Plaques*. 1920. Glass, metal, and wood, 73 × 48 × 40". Yale University Art Gallery, New Haven, Connecticut. Gift of the Société Anonyme

The King and Queen Traversed by Swift Nudes, and still another watercolor. This was the first Paris showing of a number of his important paintings, and the last for forty years.

During this same year the so-called Armory Show was being organized in New York, and the American painters Walt Kuhn and Arthur B. Davies and the painter-critic Walter Pach were then in Paris selecting works by French artists. Four paintings by Duchamp were chosen, including *Nude Descending a Staircase* and *The King and Queen Traversed by Swift Nudes*. When the Armory Show opened in February 1913, Duchamp's paintings, and most particularly the *Nude*, became the *succès de scandale* of the exhibition. Despite the attacks in the press, all four of Duchamp's paintings were sold, and he suddenly found himself internationally notorious. Picabia, represented in the show by *I See Again in Memory My Dear Udnie* and *I Too Have Lived in America* (the title inspired perhaps by Poussin's *Et in Arcadia Ego*), visited the exhibition and returned full of enthusiasm for the vitality and hospitality of the new land.

Duchamp was meanwhile proceeding with his experiments toward a form of art or nonart based on everyday subject matter with a new significance determined by the artist, and with internal relationships proceeding from a relativistic mathematics and physics of his own devising. Although he had almost ceased to paint, Duchamp worked intermittently toward a climactic object intended to sum up the ideas and forms he had introduced in his *Virgin* and *Bride*. For this project he made, between 1913 and 1915, the drawings, designs, and mathematical calculations for *Bachelor Machine* and *Chocolate Grinder* (fig. 327), later to become the male elements accompanying the bride in *The Bride Stripped Bare by Her Bachelors, Even*.

In 1913, at a single stroke, the artist fathered two of the major innovations of twentieth-century sculpture: the mobile—sculpture that physically moves—and the readymade, or "found" object—sculpture made from or including existing objects, usually commonplace, here an old bicycle wheel mounted on an ordinary kitchen stool (fig. 328). It is always possible to argue that both concepts existed earlier, but Duchamp's introduction of them at this particular moment led to their being developed in subsequent movements—Dada, Surrealism, kinetic sculpture, "junk" sculpture, and Pop Art. Duchamp experimented briefly with mechanical motion in his *Rotative Plaques* (fig. 329) of the 1920s and his *Roto-reliefs* of the 1930s. Toward the end of World War I the Russian Constructivists introduced actual motion in sculpture, but neither they nor Duchamp followed up its immense possibilities.

In the readymades, Duchamp found forms that of their nature raised questions concerning historic values in art. He has described the various stages of his discovery, and, as quoted by Richter in *Dada*, Duchamp tells that in 1913 he mounted a bicycle wheel on the top of a kitchen stool and watched it turn; bought a cheap reproduction of a winter evening landscape, in which he inserted one red and one yellow dot at the horizon and gave it the title *Pharmacy*; bought a snow shovel in 1915 and wrote on it *"in advance of the broken arm."* About then he used the term "readymade" to designate this form of manifestation. The choice of these readymades was never dictated by aesthetic delectation, but rather it "was based on a reaction of *visual indifference* with a total absence of good or bad taste... in fact a complete anesthesia." The short sentence occasionally inscribed on the readymade was important, in that it was not intended as a title, but "to carry the mind of the spectator toward other regions, more verbal." Sometimes Duchamp added graphic details that, in order to satisfy his craving for word-play, he called *"ready-made aided."* Then, "wanting to expose the basic antinomy between art and 'ready-mades' I imagined a *reciprocal*

330. MARCEL DUCHAMP. *Fountain* and *Bottle Rack*. 1917. Installation Exhibition, Stockholm, 1963

ready-made: use a Rembrandt as an ironing board!" Because the readymade could be repeated indiscriminately, he decided to make only a small number yearly, since "for the spectator even more than for the artist, *art is a habit-forming drug* and I wanted to protect my ready-made against such *contamination*." He stressed that it was in the very nature of the readymade to lack uniqueness, and nearly every readymade existing today is not an original in the conventional sense. Then, to complete this vicious circle, he remarked: "Since the tubes of paint used by an artist are manufactured and ready-made products we must conclude that all paintings in the world are *ready-mades aided*."

One glimpses in the foregoing the complex process of Duchamp's thought—the delight in paradox, the play of visual against verbal, and the penchant for alliteration and double and triple meanings. Over the years he produced replicas of originals of replicas of readymades; documents such as *Valise* and *Green Box*, summarizing his life's work; and statements, interviews, and exhibitions that becloud the picture even further. And, despite his antiaesthetic attitude, readymades, as he warned, did finally become works of art and have taken on a perverse beauty of their own. Younger artists have continued to make readymades or found objects, and the question of whether they are works of art at all is argued to the present time. Duchamp was clear on the matter: the conception, the "discovery," was what made a work of art, not the uniqueness of the object. In New York he began serious work on his *Large Glass*. To the 1917 exhibition of the New York Society of Independent Artists he submitted a porcelain urinal entitled *Fountain* and signed *R. Mutt* (fig. 330). When this entry was rejected, he resigned from the association, and the *Fountain* became one of the most notorious of all Duchamp's readymades.

In 1918, Duchamp made *Tu m'* (plate 104) for Katherine Dreier, a daring collector and leading spirit in American avant-garde art. It includes cast shadows, drawn in pencil, of a bicycle wheel, corkscrew, and hat-rack; a pyramid of color samples; a *trompe-l'oeil* tear in the canvas "fastened" by three real safety pins; a sign-painter's hand, as well as chance shapes and geometrically derived shapes. Much of Op Art and even a certain aspect of hard-edge Minimal Art are directly traceable to this work.

The Bride Stripped Bare by Her Bachelors, Even, or *The Large*

331. MARCEL DUCHAMP. *3 Stoppages Étalon*. 1913–14. Assemblage, three threads glued to three painted canvas strips, 5¼ × 47¼″, each mounted on glass panel; three wood slats, shaped along one edge to match curves of threads; whole fitted into wood box, 11⅛ × 50⅞ × 9″. Collection, The Museum of Modern Art, New York. Katherine S. Dreier Bequest

new form to the unit of length.... Three canvases were put on long stretchers and painted prussian blue. Each thread was dropped on a canvas and varnish was dripped onto the thread to bond it to the canvas.... The canvases were later cut from the stretchers and glued down onto strips of plate glass. When the decision was taken to use these curves in the *Large Glass* itself, and a method developed to make this integration, three wooden rulers were cut from draftsmen's straight-edges to be used as templates. The box made to house the equipment (looking like the cases made for croquet sets) completed the work in 1914.

Duchamp's *3 Stoppages Étalon* is thus a remarkable document in the history of chance as a controlling factor in the creation of something that might still be considered a work of art. The lines traced by the three threads are not only rhythmic in themselves but, taken together, constitute a total harmony. A young painter recently attempted to duplicate this experiment, but the result was always a snarled and knotted mess no matter what thickness of thread or string or rope he used. A devout admirer of Duchamp, he was at first disillusioned by the suspicion that the threads had been arranged rather than dropped. Then he realized that the idea of the experiment—not the action itself—had intrigued Duchamp, and that what was commemorated in the final work of art was the idea.

332. FRANCIS PICABIA. *Ici, c'est Stieglitz*. 1915. Pen and red and black ink, 29⅞ × 20″. The Metropolitan Museum of Art, New York. The Alfred Stieglitz Collection, 1949

Glass (plate 105), was completed in 1923, as far as it could be completed. Whatever its state, the work seems the summation of the artist's dreams of a machine age, the mathematically derived love goddess, below whom swarm her bachelors, mere drones or empty malic molds being infused with the sperm gas or fluid constantly ground forth by the rollers of the chocolate machine. *Large Glass* can only be explained as a complex love machine full of sexual overtones that terminate in a curious pattern of sterility and frustration. Duchamp's machines were never intended to have a rational or logical solution, and his own exegeses add to the dimensions of the problem. After New York dust had fallen on certain sections for over a year, the artist had it photographed by Man Ray; then he cleaned everything but a section of the cones, to which he cemented the dust with a fixative. The final touch came when the *Glass* was broken while in transit and was thereby webbed with a network of cracks. Duchamp is reported to have commented with satisfaction, "Now it is complete." Since the cracks provide an unexpected transition between the Bride and her Bachelors, aesthetically he may have been right (and this he would deplore).

In 1913 Marcel Duchamp had carried out an experiment in chance that resulted in *3 Stoppages Étalon* (fig. 331) and was later applied to *The Large Glass*. According to the original description:

A straight horizontal thread one metre in length falls from a height of one metre onto a horizontal plane while twisting at will and gives a

FRANCIS PICABIA Picabia was born in Paris of wealthy Cuban and French parents, and acquired a reputation as the playboy of Dada and Surrealism. Between 1908 and 1911 he moved from Impressionism to Cubism. He joined the Section d'Or briefly and then experimented with the Orphism of Delaunay and with Futurism (plate 81). In New York in 1915 he collaborated with Marcel Duchamp in the American version of proto-Dada, and, in the spirit of Duchamp, took up machine imagery as an emblematic and ironic mode of representation. In this style Picabia achieved some of his most distinctive work, particularly a series of Machine Portraits of himself and his key associates in New York. Thus he saw Stieglitz, the distinguished photographer as well as the backer of both 291 and *291*, New York's first gallery and journal devoted to vanguard art, as a broken bellows camera, equipped with an automobile brake in working position and a gear shift in neutral, signifying the frustrations experienced by someone trying to present experimental art in philistine America (fig. 332). Both the Gothic letters and the title—*IDEAL*—confirm the conceptual or heraldic form of the portrait, while also establishing a witty contrast between the commonplace, mechanical imagery and the ancient, noble devices of traditional heraldry. Made for publication in *291*, Picabia's 1915 portraits are modest in size, materials, and ambition, but in other works the artist developed his machine aesthetic—his "functionless" machines—into quite splendidly iconic paintings, still tongue-in-cheek, however, in their commentary on the seriocomic character of human sexual drives (fig. 333).

Returning to Europe in 1916 Picabia founded his journal *391* in Barcelona, and published it intermittently in New York, Zurich, and

334. FRANCIS PICABIA. *Dispar*. c. 1924. Oil on plywood, 59¼ × 37½". Private collection

333. FRANCIS PICABIA. *Amorous Procession*. 1917. Oil on cardboard, 38¼ × 29⅛". Collection Morton G. Neumann, Chicago

Paris until 1924. After meeting the Zurich Dadaists in 1918, he was active in the Dada group in Paris. Always in revolt, he then reverted to representational art and, after the emergence of Surrealism, painted a series of Transparencies (fig. 334). In these deeply personal, enigmatic works, the artist superimposed layer upon layer of elegantly delineated silhouettes and features of serene, classically beautiful male and female images, sometimes accompanied by exotic flora and fauna. Because of their sleek, Art Deco period look and their retardataire, descriptive style, the Transparencies were long dismissed as decadently devoid of either content or formal interest. Picabia himself merely described the works as realms in which he might express for himself "the resemblance of my interior desires," or as "where all my instincts may have a free course." Recently, however, for the very reason that they are transparent in form but veiled in content, Picabia's Transparencies have assumed new importance among the acknowledged prototypes of the 1980s Neo-Expressionism or Neo-Surrealism.

With the end of World War II, Picabia resumed abstract painting. His artistic qualities tend to be obscured by his personality—exuberant and wealthy, with a concomitant magnificence of gesture, he loved controversy, wished to be in the forefront of every battle, and had a cultivated sense of the ridiculous. More than any of the Dadaists and Surrealists, except Duchamp and Arp, he introduced sheer nonsense—sometimes, as in the Transparencies, an aristocratic aloofness—into these sometimes overly serious explorations of the irrational, and enthusiasm into every kind of experiment or manifestation.

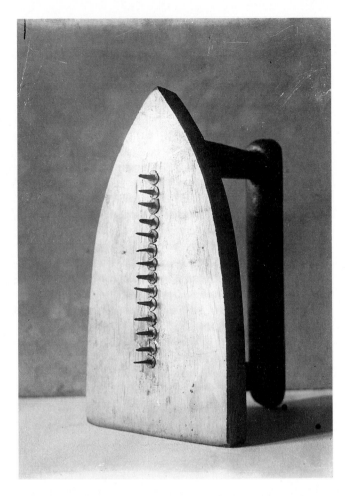

above: 335. MORTON L. SCHAMBERG. *God*. c. 1918. Miter box and plumbing trap, height 10½″. Philadelphia Museum of Art. Louise and Walter Arensberg Collection

right: 336. MAN RAY. *Gift*. Replica of lost original of 1921. Flatiron with nails, height 6½″. Collection Mr. and Mrs. Morton G. Neumann, Chicago

below left: 337. MAN RAY. *Rayograph*. 1922. Gelatin-silver print. Collection, The Museum of Modern Art, New York. Gift of James Thrall Soby

below right: 338. MAN RAY. *Fingers*. 1930. Solarized gelatin-silver print from negative print. Collection, The Museum of Modern Art, New York. Gift of James Thrall Soby

Colorplate 94. GERRIT RIETVELD.
Model of the Schröder House.
1923–24. Glass and wood,
17⅜ × 28⅜ × 19¼″ without glass
case. Stedelijk Museum, Amsterdam

Colorplate 95. HENRI ROUSSEAU.
Carnival Evening. 1886.
46 × 35¼″. Philadelphia Museum of
Art. The Louis E. Stern Collection

above: Colorplate 96. HENRI ROUSSEAU. *The Dream*. 1910. 6'8½" × 9'9½". Collection, The Museum of Modern Art, New York. Gift of Nelson A. Rockefeller

left: Colorplate 97. MARC CHAGALL. *Paris Through the Window*. 1913. 52⅜ × 54¾". The Solomon R. Guggenheim Museum, New York

right: Colorplate 98. MARC CHAGALL.
The Green Violinist. 1918.
77¾ × 42¾″. The Solomon R.
Guggenheim Museum, New York

below: Colorplate 99. MARC CHAGALL.
Birthday. 1915–23. 31⅞ × 39⅜″.
The Solomon R. Guggenheim
Museum, New York

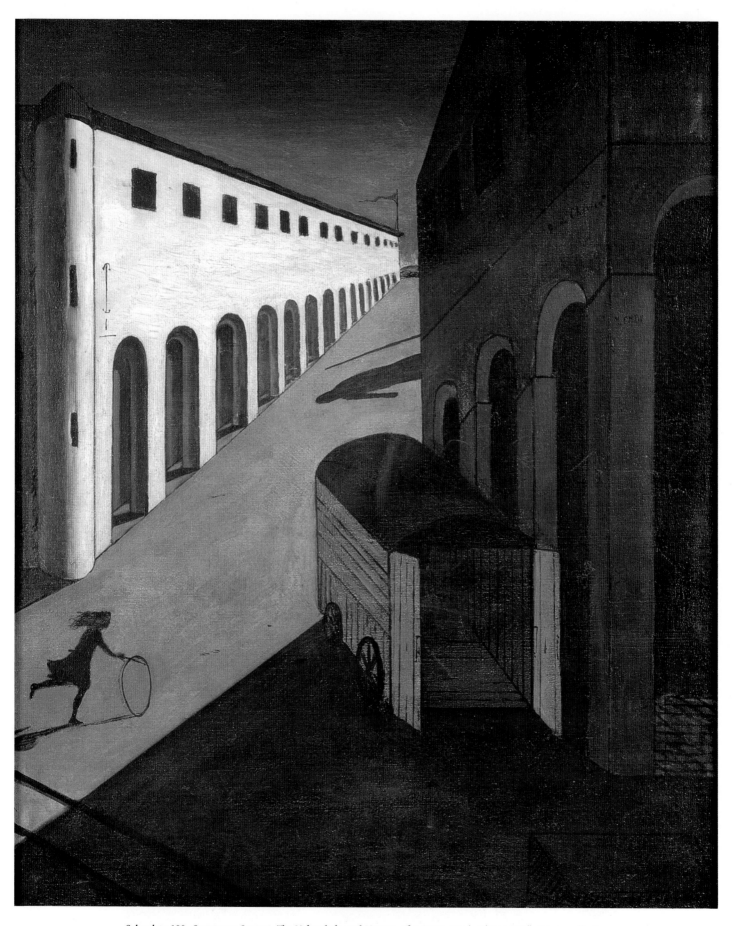

Colorplate 100. GIORGIO DE CHIRICO. *The Melancholy and Mystery of a Street*. 1914. 34¼ × 28⅛″. Private collection

Colorplate 101. GIORGIO DE CHIRICO. *The Great Metaphysician*. 1917. 41⅛ × 27½". Collection, The Museum of Modern Art, New York. The Philip L. Goodwin Collection

Colorplate 102. JEAN ARP. *Fleur Marteau*. 1916. Oil on wood, 24⅜ × 19⅝". Collection François Arp, Paris

Colorplate 103. MARCEL DUCHAMP. *The Passage from Virgin to Bride*. 1912. 23⅜ × 21¼". Collection, The Museum of Modern Art, New York. Purchase

Colorplate 104. MARCEL DUCHAMP. *Tu m'*. 1918. Oil and graphite on canvas, with brush, safety pins, nut and bolt, 27½″ × 10′2¾″. Yale University Art Gallery, New Haven, Connecticut. Bequest of Katherine S. Dreier

Colorplate 105. MARCEL DUCHAMP. *The Bride Stripped Bare by Her Bachelors, Even (The Large Glass)*. 1915–23. Oil, lead wire, foil, dust, and varnish on glass, 8′11″ × 5′7″. Philadelphia Museum of Art. Bequest of Katherine S. Dreier

Colorplate 106. MAX ERNST. *The Elephant Celebes*. 1921. 51⅛ × 43¼″.
Collection The Elephant Trust, London

Colorplate 107. GEORGE GROSZ. *Dedication to Oskar Panizza*.
1917–18. 55⅛ × 43¼″. Staatsgalerie, Stuttgart

Colorplate 108. MAX BECKMANN. *Departure*. 1932–33. Triptych, oil on canvas, side panels each 84¾ × 39¼″, center panel 84¾ × 45⅜″. Collection,
The Museum of Modern Art, New York. Given anonymously

MORTON SCHAMBERG (1881–1918) Relatively unburdened by tradition and always somewhat bumptious toward it, American artists who met Duchamp and Picabia in New York had little difficulty entering into the Dada spirit. Indeed, one of the most daring of all Dada objects was made by Philadelphia-born Morton Schamberg, who mounted a plumbing connection on a miter box and sardonically titled it *God* (fig. 335).

MAN RAY (1890–1977) No less ingenious in his ability to devise Dada objects was Man Ray (fig. 336), also from Philadelphia but an artist who, unlike the short-lived Schamberg, went on to pursue a lengthy, active career in the ambience of Surrealism. A born fantasist, Man Ray took up photography, through his association with Stieglitz, and invented what he called the Rayograph, a cameraless photographic image made by a process in which objects were placed on or near sensitized paper, which was then exposed directly to light. In the proper Duchamp or Dada manner, the technique had been discovered accidentally in the darkroom. By controlling exposure and by moving or removing objects, the artist could use this "automatic" process to create images of a strangely abstract or symbolic character (fig. 337). Man Ray succeeded in realizing similarly bizarre and evocative results in his Aerographs, actually the first spray-gun paintings, and in his Solarizations, made by another photographic process, this time one already known to commercial photographers. The peculiar dreamlike quality of a solarized print appeared when a sensitive emulsion had been developed but not fixed and then reexposed to naked light and developed once again, producing a reversal of tones along every sharp edge (fig. 338). From 1920 onward, Man Ray became an established figure in the Parisian avant-garde, gaining fame and a good living with photographs of artists and art, as well as in fashion photography (fig. 393).

339. HANNAH HÖCH. *Cut with the Kitchen Knife.* 1919. Collage of pasted papers, 44⅞ × 35½". Nationalgalerie, Staatliche Museen, Berlin

German Dada: 1918–23

In 1917 Richard Huelsenbeck had returned to Berlin from Zurich. Disillusion and criticism were rampant. The war was exhausting and endless; restrictions were severe; and the outcome was increasingly in doubt. The atmosphere was conducive to the spread of Dada. Huelsenbeck joined a small group including the brothers Wieland and Johann Herzfelde (who changed his name to John Heartfield as a pro-American gesture), the painters Raoul Hausmann, George Grosz, and, later, Johannes Baader. Huelsenbeck opened the Dada campaign early in 1918 with speeches and manifestoes attacking all phases of the artistic status quo, including Expressionism, Cubism, and Futurism. A Club Dada was formed, to which Kurt Schwitters, later the chief ornament of German Dada, was refused membership. After the war came a period of political chaos, which was not ended by the formation of the German Republic. Berlin Dada quickly took on a left-wing, Communist direction, although the political sophistication of its members was not great. The Herzfelde brothers' journal, *Neue Jugend*, and their publishing house, Malik-Verlag, utilized Dada techniques for political propaganda. George Grosz made for it many savage social and political drawings and paintings. One of the publications financed by the Herzfelde brothers was *Everyman His Own Football*. Although the work was quickly banned, its title became a rallying cry for German revolutionists.

Berlin Dada did not produce many artists or poets of the stature of George Grosz or even of Raoul Hausmann. The Zurich Dada experiments in noise-music and in abstract phonetic poetry were further explored. Hausmann, who traced the history of such efforts with German thoroughness, claimed the invention of a form of optophonetic poem,

involving "respiratory and auditive combinations, firmly tied to a unit of duration," expressed in typography by "letters of varying sizes and thicknesses which thus took on the character of musical notations."

In the visual arts a major invention or discovery was photomontage for Dada effect. This was created by cutting up and pasting together, in new and startling contexts, photographs of individuals and events, posters, book jackets, and a variety of typefaces—anything to achieve shock. Both Hausmann and Grosz, along with Hannah Höch (1889–1979), claimed to have originated Dada photomontage (fig. 339). The technique, of course, derived from Cubist collage or *papier collé*, except that, in the Dada version, subject was paramount. Even this form has antecedents in Futurist collages (plate 87). However, photomontage proved to be an ideal form for Dadaists and subsequently for Surrealists, and was expanded to heights of fantasy.

KURT SCHWITTERS (1887–1948) Somewhat apart from the Berlin Dadaists was the Hanoverian artist Kurt Schwitters. Although not admitted to Club Dada, he was the purest exponent of the Dada spirit to emerge from Germany, if not from the entire movement. Schwitters completed his formal training at the Academy in Dresden and painted portraits for a living. Denied access to Berlin Dada, Schwitters established his own variant in Hanover under the designation *Merz*, a word derived from Com*merz*bank. He was a talented poet, impressive in his readings, deadly serious about his efforts in painting, collage, and construction. These always involved a degree of deadpan humor delightful to those who knew him, but shattering to strange audiences. His collages were made of rubbish picked up from the street—cigarette wrappers, tickets, newspapers, string, boards, wire screens, whatever caught

340. KURT SCHWITTERS. *Okola*. 1926. Collage, 6¾ × 5⅛". Formerly Collection G. David Thompson

341. KURT SCHWITTERS. *Merzbild 25A*. 1920. Collage, 41 × 31⅛". Kunstsammlung Nordrhein-Westfalen, Düsseldorf

342. KURT SCHWITTERS. *Hanover Merzbau*. 1925 (destroyed)

his fancy. The works (*merzbilder*) he created were seriously studied as Cubist structures, but different in essence from Cubist, Futurist, Dada, Expressionist, or propagandist collages. Miraculously, he was able to transform the rubbish, the detritus of his surroundings, into strange and wonderful beauty (fig. 340).

Schwitters introduced himself to Raoul Hausmann in a Berlin café in 1918 by saying, "I am a painter and I nail my pictures together." This description applies to all his relief constructions (fig. 341), since he drew no hard-and-fast line between them and *papiers collés*, but most specifically to his series of great constructions that he called *Schwitters Column* or *Merzbau*. He began the first one in his house in Hanover as an abstract plaster sculpture with apertures dedicated to his Dadaist and Constructivist friends and containing objects commemorating them: Mondrian, Gabo, Arp, Lissitzky, Malevich, Richter, Miës van der Rohe, and Van Doesburg (fig. 342). The *Merzbau* grew throughout the 1920s with successive accretions of every kind of material until it filled the room. Having then no place to go but up, he continued the construction with implacable logic into the second story. When he was driven from Germany by the Nazis and his original *Merzbau* was destroyed, Schwitters started another one in Norway. The Nazi invasion forced him to England, where he began again for the third time. After his death in 1948, the third *Merzbau* was rescued and preserved in the University of Newcastle.

Early in the 1920s the De Stijl artist Van Doesburg had become friendly with Schwitters, and they collaborated on a number of publications, and even made a Dada tour of Holland. Schwitters more and more became attracted to the geometric abstractionists and Constructivists, for despite the fantasy and rubbish materials in his works, they

demonstrated relationships and proportions that are almost as subtle as Mondrian's. Schwitters's stature as an artist continues to grow with the passage of time.

MAX ERNST (1891–1976) Jean Arp moved to Cologne in 1919 and with the young German artist Max Ernst collaborated to form another wing of Dada. The two had met in Cologne in 1914, but Ernst then served in the German army. At the end of the war, he discovered Zurich Dada and the paintings of De Chirico and Klee. Ernst's own paintings, until he moved to Paris in 1921, were rooted in a Late Gothic fantasy drawn from Dürer, Grünewald, and Bosch. The artist was also fascinated by German Romanticism in the macabre forms of Max Klinger and Arnold Böcklin. This "gothic quality" (in the widest sense) remained the most consistent characteristic of Ernst's fantasies. In 1919–20 he produced collages and photomontages that demonstrated a genius for suggesting the metamorphosis or double identity of objects, a topic later central to Surrealist iconography. In *Here Everything Is Still Floating* (fig. 343) an anatomical drawing of a beetle becomes, upsidedown, a steamboat floating through the depths of the sea. This was actually a collaborative effort, with Arp providing the name. From time to time Ernst, Arp, and a young painter-poet J. T. Baargeld collaborated on collages entitled *Fatagagas*, short for *Fabrication des Tableaux garantis gazometriques*. Through their magazine, *Die Schammade*, they had contacts with the French poets and critics André Breton, Paul Éluard, and Louis Aragon.

While convalescing from an illness, Ernst discovered the possibilities of using engravings from nineteenth-century magazines as the basis for transformation in collage; he came upon another new world in biological drawings of microorganisms (fig. 344). Thus, singlehanded, he created much of the Surrealist vocabulary.

Despite the close friendship between Ernst and Arp, their approaches to painting, collage, and sculpture were different. Arp's was toward abstract, organic Surrealism in which figures or other objects may be suggested but are rarely explicit. Ernst, following the example of De Chirico and fortified by his own "gothic" imagination, became a principal founder of the wing of Surrealism that utilized Magic Realism—that is, precisely delineated, recognizable objects, distorted and transformed, but nevertheless presented with a ruthless realism that throws into shocking relief their newly acquired fantasy. *The Elephant Celebes* is a mechanized monster whose trunk-tail-pipe-line sports a cowskull-head above an immaculate white collar (plate 106). Sinister tusks protrude from the nonvisible end. A headless Classical torso beckons to the beast with an elegantly gloved hand. *The Elephant Celebes* is not intended for rational explanation even as a symbolic presentation. Its images are unrelated, some (the elephant) threatening, others (the beckoning torso) less explicable. Like the early paintings of De Chirico by which it was profoundly influenced, it suggests a nightmare. Its appeal is to the level of perception below consciousness.

343. MAX ERNST. *Here Everything Is Still Floating*. 1920. Pasted photoengraving and pencil, sheet 4⅛ × 4⅞". Collection, The Museum of Modern Art, New York. Purchase

344. MAX ERNST. *The Gramineous Bicycle Garnished with bells the dappled fire damps and the echinoderms bending the spine to look for caresses*. Cologne, 1920 or 1921. Botanical chart altered with gouache, 29¼ × 39¼". Collection, The Museum of Modern Art, New York. Purchase

Paris Dada: 1919–22

When Arp and Ernst left Cologne in 1921 and Baargeld abandoned painting, Dada was terminated in that city, at the same time that it was also ending in Berlin. Duchamp and Man Ray put a period point to New York Dada with the single issue of a periodical *New York Dada*. The original Zurich Dadaists had long since scattered. Thus Dada as an organized movement was dead, except in Paris. Duchamp had largely given up creative activity (unless his very existence might be so described) apart from occasional motion experiments, the completion of his *Large Glass*, and participation in commemorative exhibitions and publications. In Germany only Kurt Schwitters continued, a one-man Dada movement.

By 1918 writers in Paris, including Louis Aragon, André Breton, and Georges Ribemont-Dessaignes, were contributing to the Zurich periodical *Dada*, and shortly Tristan Tzara began writing for Breton and Aragon's journal *Littérature*. Picabia, after visiting the Dadaists in Zurich,

published No. IX of *391* in Paris, and in 1919 Tzara himself also arrived there. Thus by the end of the war a Dada movement was growing in the French capital, but it had primarily a literary nature. While in painting and sculpture Dada was largely an imported product, in poetry and theater it was in a tradition of the irrational and absurd that extended from Baudelaire, Rimbaud, and Mallarmé to Alfred Jarry, Raymond Roussel, Apollinaire, and Cocteau. Paris Dada in the hands of the literary men consisted of frequent manifestoes, demonstrations, periodicals, events, and happenings more violent and hysterical than ever before. The artists Arp, Ernst, and Picabia took a less active part in the demonstrations, although Picabia contributed his own manifestoes. The original impetus and enthusiasm seemed to be lacking, however, and divisive factions arose, led principally by Tzara and by Breton. The early Dadaists, like the Bolsheviks of the Russian Revolution, sought to maintain a constant state of revolution, even anarchy, but new forces led by Breton sought a more constructive revolutionary scheme based on Dada. In its original form Dada expired in the wild confusion of the Congress of Paris called in 1922 by the Dadaists. The former Dadaists, including Picabia, who followed Breton, were joined by powerful new voices, among them Cocteau and Ezra Pound. By 1924 this group was consolidated under the name Surrealism.

The "New Objectivity" in Germany

In Germany the end of World War I brought a period of chaotic struggle between the extreme left and the extreme right. The Social Democrat government could control neither the still-powerful military, nor the rampant inflation. Experimental artists and writers were generally on the left wing, hopeful that from chaos would emerge a more equable society. Immediately following the Social Democrat revolution of 1918, some of the leaders of German Expressionism formed the November Group and were soon joined by Dadaists. In 1919 the Workers' Council for Art was organized. It sought more state support, more commissions from industry, and the reorganization of art schools. These artists included many of the original Expressionists, such architects as Walter Gropius and Erich Mendelsohn, and leading poets, musicians, and critics. Many of the aims of the November Group and the Workers' Council were incorporated into the program of the Weimar Bauhaus.

In their exhibitions the November Group reestablished contact with France and other countries, and antagonisms among the various new alignments were submerged for a time in behalf of a common front. The Expressionists were exhibited, as well as representatives of Cubism, abstraction, Constructivism, and Dada, while the new architects showed projects for city planning and large-scale housing. Societies similar to the November Group sprang up in many parts of Germany, and their manifestoes read like a curious blend of Socialist idealism and revivalist religion.

The common front of Socialist idealism did not last long. The workers whom the artists extolled and to whom they appealed were even more suspicious of the new art forms than was the capitalist bourgeoisie. It was naturally from the latter that new patrons of art emerged. By 1924 German politics was shifting inevitably to the right, and the artists' Utopianism was in many cases turning into disillusionment and cynicism. There now emerged a form of Social Realism in painting to which the name the New Objectivity (*Die Neue Sachlichkeit*) was given. Meanwhile, the Bauhaus, since 1919 at Weimar, had tried to apply the ideas of the November Group and the Workers' Council toward a new relationship between artist and society, and in 1925 it was forced by the rising tide of conservative opposition to move to Dessau. Its faculty members still clung to postwar Expressionist and Socialist ideas, although by 1925 their program mostly concerned the training of artists, craftsmen, and designers for an industrial, capitalist society.

GEORGE GROSZ (1893–1959) The principal painters associated with the New Objectivity were George Grosz, Otto Dix, and Max Beckmann—three artists whose style touched briefly at certain points but who had essentially different motivations. Grosz studied from 1912 to 1914 at the Royal Arts and Crafts School in Berlin, partially supporting himself with drawings of the shady side of Berlin night life. These caustic works prepared him for his later violent statements of disgust with postwar Germany and mankind generally. In 1913 he visited Paris and, despite later disclaimers, was obviously affected by Cubism and its offshoots, particularly by Delaunay and Italian Futurism. After two years in the army (1914–16), he resumed his caricatures while convalescing in Berlin. They reveal an embittered personality, now fortified by observations of autocracy, corruption, and the horrors of a world at war. Recalled to the army in 1917, Grosz ended his military career in an asylum on whose personnel and administration he made devastating comment.

After the war Grosz was drawn into Berlin Dada and its overriding left-wing bias. He made stage designs, and collaborated on periodicals, but continued his own work of political or social satire. Only occasionally did he move into fantasy, and then with loathing for this world rather than nostalgia for a world of dreams. The *Dedication to Oskar Panizza* of 1917–18 is his most Futurist work (plate 107). Showing a funeral turned into a riot, the painting is flooded with a blood or fire red. The buildings lean crazily; an insane mob is packed around the paraded coffin on which Death sits triumphantly, swigging at a bottle; the faces are horrible masks; humanity is swept into a hell of its own making. Yet the artist controls the chaos with a geometry of the buildings and the planes into which he segments the crowd.

Rarely has an artist been motivated so completely by hatred. The drawing *Fit for Active Service* (fig. 345) shows Grosz's sense of the macabre and detestation of the bureaucracy, with a fat complacent doctor pronouncing his "O.K." of a desiccated cadaver before arrogant Prussian-type officers and stupid enlisted men. The spare economy of the draftsmanship in this work as well as a certain Cubist contraction of space are also evident in a number of paintings done by the artist in the same period. *Republican Automatons* (fig. 346) applies the style and motifs of De Chirico and the Metaphysical School to political satire, as empty-headed, blank-faced, and mutilated automatons parade loyally through the streets of a mechanistic metropolis on their way to vote as they are told. In such works as this Grosz comes closest to the spirit of the fantasy of the Dadaists and Surrealists. But he expressed his most passionate convictions in drawings and paintings that continue the Expressionist tradition in savagely denouncing a decaying Germany of brutal profiteers and obscene prostitutes, of limitless gluttony and sensuality beside abject poverty, disease, and death. Normally Grosz worked in a style of spare and brittle drawing combined with a fluid watercolor. In the mid-1920s, however, he briefly used precise realism in portraiture, close to the New Objectivity of Otto Dix (fig. 348).

Grosz was frequently in trouble with the authorities, but it was Nazism that caused him to flee. In the United States during the 1930s, his personality was quite transformed. Although he occasionally caricatured American types, these were relatively mild, even affectionate. America for him was a dream come true, and he painted the skyscrapers of New York or the dunes of Provincetown in a sentimental haze. His

pervading sensuality was expressed in warm portrayals of Rubens-like nudes.

The growth of Nazism rekindled his power of brutal commentary, and World War II caused Grosz to paint a series expressing bitter hatred and at times deep personal disillusionment. In the later works sheer repulsion replaces the passionate convictions of his earlier statements. A highly complicated person with changing and at times confused motivations despite his intense emotional and intellectual responses, Grosz lost in his promised land something that he never regained.

OTTO DIX (1891–1969) The artist whose works most clearly defined the nature of the New Objectivity was Otto Dix. Born of working-class parents, he was a proletarian by upbringing as well as by theoretical conviction. His war paintings were gruesome descriptions of indescribable horrors, rooted in the German Gothic tradition of Grünewald (figs. 8, 347). Like Grosz, Dix was exposed to influences from Cubism to Dada, but from the beginning he was concerned with uncompromising realism. This is a symptom of the postwar reaction against abstraction, a reaction most marked in Germany but also evident in most of Europe and in America. Even the pioneers of Fauvism and Cubism were in-

348. OTTO DIX. *Dr. Mayer-Hermann.* 1926.
Oil and tempera on wood, 58¾ × 39″.
Collection, The Museum of Modern Art, New
York. Gift of Philip Johnson

volved in it. However, the super-realism of Dix was not simply a return to the past. In his *Dr. Mayer-Hermann* the physician's massive figure is seated frontally, framed by the vaguely menacing machines of his profession (fig. 348). Although the painting includes nothing bizarre or extraneous, the overpowering confrontation gives a sense of the unreal. For this type of super-realism—as distinct from Surrealism—there was coined the term Magic Realism: a mode of representation that takes on an aura of the fantastic because commonplace objects are presented with unexpectedly exaggerated and detailed forthrightness. Dix remained in Germany during the Nazi regime, although forbidden to exhibit. After the war he turned to a form of mystical, religious expression.

The portraiture of artists like Dix may very well have been influenced by the contemporary photographs of August Sander (1876–1964), a great German artist who out of sheer peasant instinct became a natural and powerful exponent of the New Objectivity. Trained in fine art at the Dresden Academy, Sander set about to accomplish nothing less than a comprehensive photographic portrait of "Man in Twentieth-Century Germany." He was convinced that the camera, if honestly and straightforwardly employed, could probe beneath appearances and dissect the truth that lay within. From this visual analysis of specific individuals would emerge universal knowledge of cultural types and the environments that shaped them (fig. 349). But for all his broad reading and genuine intellectuality, Sander saw German society as an almost medi-

349. AUGUST SANDER. (Circus People). 1930. Gelatin-silver print. Collection, The Museum of Modern Art, New York. Gift of the Photographer

350. ALBERT RENGER-PATZSCH. *Irons Used in Shoemaking, Fagus Works.* c. 1925. Photograph. Galerie Wilde, Cologne

eval hierarchy—a "sociological arc"—of occupations and classes. In 1929 he published the first volume of his *magnum opus*—one of the most ambitious in the history of photography—under the title *Face of Time (Antlitz der Zeit)*, only to see it suppressed and the plates (but not the negatives) destroyed in the early 1930s by the Nazis, who inevitably found the photographer's ideas contrary to their own pathological views of race and class. For his part, Sander wrote: "It is not my intention either to criticize or to describe these people, but to create a piece of history with my pictures."

The German photographer most immediately identified with the New Objectivity was Albert Renger-Patzsch (1897–1966). Like Paul Strand in the United States (fig. 228), Renger-Patzsch avoided the double exposures and photographic manipulations of Man Ray and Moholy-Nagy (fig. 337), as well as the artificiality and soulfulness of the Pictorialists, to practice "straight" photography closely and sharply focused on objects isolated, or abstracted, from the natural and man-made worlds (fig. 350). But for all its unblinking realism, such an approach yielded details so enlarged and crisply purified of their structural or functional contexts that the lens-filling, overall pattern they produce borders on pure design. Still, Renger-Patzsch insisted upon his undeniable commitment to factuality and his "aloofness to art for art's sake."

MAX BECKMANN (1884–1950) Beckmann was the principal artist associated with the New Objectivity, but could only briefly be called a precise Realist in the sense of Dix. Born of substantial parents in Leipzig, he was steeped in the Early Renaissance painters of Germany and The Netherlands, and the great seventeenth-century Dutch painters. After studies at the Weimar academy and a brief visit to Paris, Beckmann settled in 1903 in Berlin, then a ferment of German Impressionism and Art Nouveau. Influenced by Delacroix and by the German academic tradition, he painted large religious and Classical machines, and versions of contemporary disasters such as the sinking of the *Titanic* (1912), done in the mode of Géricault's *Raft of the Medusa*. By 1913 Beckmann was a well-known academician. His service in World War I had a sobering effect, turning him toward a search for internal reality. The *Self-Portrait with Red Scarf* of 1917 shows Beckmann as haunted and anxious (fig. 351). Now the influence of Munch began to loom large. Beckmann's struggle is apparent in a big, unfinished *Resurrection*, on which he painted sporadically between 1916 and 1918. Here he attempted to join his more intense and immediate vision of the war years to his prewar academic formulas. This work, though unsuccessful, liberated him from his academic past. In two pendant paintings of 1917, *The Descent from the Cross* (fig. 352) and *Christ and the Woman Taken in Adultery*, he found a personal expression, rooted in Grünewald, Bosch, and Brueghel, although the jagged shapes and delimited space also owed much to Cubism. Out of this mating of Late Gothic, Cubism, and German Expressionism emerged Beckmann's next style.

Although he was not politically oriented, Beckmann responded to the violence and cruelty of the end of the war, painting dramas of torture and brutality, symptomatic of the lawlessness of the time and prophetic of the legalized sadism of the 1930s. Rendered in pale, emotionally repulsive colors, the figures could be twisted and distorted within a compressed space, as in late medieval representations of the tortures of the damned (in Beckmann's work, the innocent), and the horror heightened by explicit and accurate details. Such works, which impart symbolic content through harsh examination of external appearance, were close to and even anticipated the New Objectivity of Grosz and Dix. Beckmann's attitude, growing out of Expressionism but adding

351. MAX BECKMANN. *Self-Portrait with Red Scarf.* 1917. 31½ × 23⅝".
Staatsgalerie, Stuttgart

352. MAX BECKMANN. *The Descent from the Cross.* 1917. 59½ × 50¾".
Collection, The Museum of Modern Art, New York. Curt Valentin Bequest

353. MAX BECKMANN. *Blindman's Buff*. 1945. Triptych, side panels each 74½ × 42½", middle panel 80 × 90". The Minneapolis Institute of Arts. Gift of Mr. and Mrs. Donald Winston

precise though distorted reality, was defined as Magic Realism in 1923 by G. F. Hartlaub, director of the Kunsthalle in Mannheim, and documented in an exhibition at that museum in 1925.

In the later 1920s Beckmann was moving from success to success, but when the Nazis came to power in 1933 he was stripped of his position and designated a "degenerate artist." In 1937 he moved to Amsterdam. In 1947, after years of hiding from the Nazis, Beckmann accepted a teaching position at Washington University, St. Louis, Missouri, and migrated to the United States, where he spent the rest of his life.

Throughout the 1930s and 1940s Beckmann continued to develop his ideas of coloristic richness, monumentality, and complexity of subject. The enriched color came from visits to Paris and contacts with French masters, particularly Matisse and Picasso. However, his emphasis on literary subjects having heavy symbolic content reflected his Germanic personality. The first climax of his new, monumental-symbolic approach was the large 1932–33 triptych *Departure* (plate 108). Alfred Barr described it as "an allegory of the triumphal voyage of the modern spirit through and beyond the agony of the modern world." The right wing shows frustration, indecision, and man's self-torture; in the left wing, sadistic mutilation, man's torture of others. Beckmann said of this triptych in 1937: "On the right wing you can see yourself trying to find your way in the darkness, lighting the hall and staircase with a miserable lamp dragging along tied to you as part of yourself, the corpse of your memories, of your wrongs, of your failures, the murder everyone commits at some time of his life—you can never free yourself of your past, you have to carry the corpse while Life plays the drum." Also, despite his disavowal of political interests, the left-hand panel

must refer to the rise of dictatorship that was already driving liberal artists, writers, and thinkers underground.

The darkness and suffering in the wings are resolved in the brilliant sunlight colors of the central panel, where the king, the mother, and the child set forth, guided by the veiled boatman. Again, Beckmann: "The King and Queen have freed themselves of the tortures of life—they have overcome them. The Queen carries the greatest treasure—Freedom—as her child in her lap. Freedom is the one thing that matters—it is the departure, the new start."

It is important to emphasize the fact that Beckmann's allegories and symbols were not a literal iconography to be read by anyone given the key. The spectator had to participate actively; and the allusions could mean something different to each viewer. *Blindman's Buff* (fig. 353) is a complicated allegorical triptych, vivid in color, filled with Classical allusions, sexual symbolism, and contrasting attitudes of repose and gay debauchery. It may reflect the uninhibited relaxation after World War II. In the central panel perform a Classical lyre player and a flute player together with a savage beating a drum; a woman is embraced by a dinner-jacketed man with a horse-head mask (the artist?). The wings are filled with a leering, whispering, gossiping crowd of spectators, who surround the principal figures: on the left the kneeling girl in blue, and the blindfolded young man on the right—both contemplative and detached, like the donors in a late medieval triptych. Both have lighted candles, Beckmann's favorite phallic symbol. *Blindman's Buff* may be read as a victory bacchanal, a condemnation of contemporary mores, or simply as a dispassionate observation on whatever is evil or good in the world.

The School of Paris Between the Wars

In post-1918 Paris, shellshocked from four years of tragic warfare as well as from decades of ever-more "scandalous" avant-gardism, the time had come for a "call to order." Now culture trended away from precedent-shattering innovation, at least in matters of pure form, toward something like the lucidity and reasonableness of the Classical tradition, a tradition already native to France in Gothic times, when the term *École de Paris* first emerged. So profound was the longing for stability that even Dada, once it finally hit the French capital in the late teens, like a time bomb planted before the Armistice, soon fizzled and gave way, as we shall see in the next chapter, to the less nihilistic, if thoroughly antirationalist, movement known as Surrealism. In Paris the twenties roared with Jazz Age abandon, but almost always in a cool, streamlined environment of Art Deco elegance, itself a Classical, as well as Constructivist, taming of Romantic, curvilinear Art Nouveau energy.

But far from transforming Paris into a citadel of reaction, the new commonsensibility ushered in a mood of enlightened tolerance. While, on the one hand, official taste grew less aggressively hostile to modern-ism, progressive painters and sculptors, on the other hand, felt free to relax from formal experimentation, to settle for a period of consolidation and refinement of the extraordinary gains already made. This proved a siren song luring to Paris whole troupes of gifted artists in retreat from revolution in Russia, inflation in Germany, and provincialism in America. Foreign talent combined with the indigenous French masters seen earlier—virtually all of them, from Bonnard and Vuillard onward, triumphantly active and producing some of their most sublime masterpieces—to assure the continuing status of Paris as the glittering, cosmopolitan capital of world art.

In the present context, therefore, the School of Paris cannot be considered anything more than an umbrella term implying a certain high level of professionalism with a modernist bent. It has often been stretched to cover literally every kind of art practiced in Paris between the two World Wars, from Surrealism, which cared little or nothing for form, to the radical formalism of the Abstraction-Création group. For our purposes, however, these extremes have been allowed to break away and become the subject matter of later chapters. This leaves the School of Paris to embrace a wide variety of artists who intersected one another not only through their common base in France, but also in their assorted independence of all narrowly defined aesthetic categories. While distinctly modernist in their willingness to distort imagery for reasons of style or expression, they nonetheless regarded imagery as fundamental to the meaning of their work. The group could hardly have been more distinguished, including as it did the likes of Braque, Léger, Matisse, and the protean Picasso in his Neoclassical and late Cubist, if not his Surrealist, phases. But perhaps even more representative of the polyglot School of Paris than those universal geniuses may have been a rather Expressionist subgroup known as *les maudits*—Modigliani from Italy, Soutine from Russia, Pascin from Bulgaria, and the French-man Maurice Utrillo—"cursed" not only by poverty and alienation but also by the picturesque, ultimately disastrous bohemianism of their disorderly life styles. Much of this gravitated around the sidewalk cafés of Montparnasse and Saint-Germain-des-Prés, the Left Bank quarters favored by the Parisian avant-garde since the midteens, when *la bande à Picasso* abandoned Montmartre to the tourists.

AMEDEO MODIGLIANI (1884–1920) Modigliani was born of well-to-do parents in Leghorn, Italy. His training as an artist was often interrupted by illness, but he managed to get to Paris by 1906. Although he was essentially a painter, in 1909, influenced by Brancusi, he began to experiment with sculpture. His life was tragically short. For fourteen years he worked in Paris, riddled with tuberculosis, drugs, and alcohol, but drawing and painting obsessively.

Modigliani was not really an artist of the twentieth century, despite his connections with the School of Paris. He would have been at home in the Florence of Uccello or Botticelli. He utilized Post-Impressionist

354. AMEDEO MODIGLIANI. *The Cellist*. 1909. 29 × 23½″. Private collection, Paris

delimitation of picture space and Cubist restriction of color. Within these limits he was concerned with portraits, nudes, occasional studies of children, and sculptured heads or figures of Africa, archaic Greece, or the Early Middle Ages.

His career was so abbreviated that it is almost impossible to speak of a stylistic development, although one can observe a gradual transition from a Nabi formula, in which the figure is securely integrated in the space of an interior, toward a pattern of linear or sculptural detachment. *The Cellist* hung in the 1910 Salon des Indépendants and brought the artist some recognition (fig. 354). It was not a revolutionary subject or concept however. It was inspired by the Cézanne exhibition of 1907, which had been an overpowering experience for him. Despite this, Cézanne's concept of a figure balanced within its spatial environment was not congenial to Modigliani.

The experiments Modigliani carried out with sculpture over the next few years confirmed his passion for rendering the figure as sculptural relief and later as expressive contour drawing detached with beautiful lucidity from its background. The sculptural sources that appealed to Modigliani, aside from Brancusi, were archaic Greek *kouroi* and those African masks in which emphasis was on linear elongation of the features (fig. 355). Sometimes he would turn to flat-topped, horizontally designed heads derived from the early medieval art of France or Spain, or to caryatids, treated with a crude blockiness of masses and surface that suggests late antique Classical forms.

Modigliani was one of the master portraitists of twentieth-century painting. Although all of his portraits are given a family resemblance by his personal, elegant elongation or his use of forms deriving from primitive and archaic art, his friends, among whom were notable artists and critics of the early twentieth century, are characterized with a sensi-

356. AMEDEO MODIGLIANI. *Chaim Soutine.* 1917. 36⅛ × 23½″. National Gallery of Art, Washington, D.C. Chester Dale Collection

355. AMEDEO MODIGLIANI. *Head.* c. 1912. Limestone, height 25″. The Solomon R. Guggenheim Museum, New York

tive perception that accurately records their personalities, their eccentricities and foibles.

Character analysis from works of art is a dangerous game, particularly when the sitter is anonymous and we have no corroborative documentation. However, we are on safer ground when examining Modigliani's many portraits of well-known personalities. Chaim Soutine, for example, comes forth as a Russian peasant whose broad, flat nose, thick lips, and Slavic cheekbones seem to accentuate the almost cruel perception behind the half-closed eyes (fig. 356).

Aside from these well-known figures, Modigliani's portraits extend over the range of his friends and acquaintances, not only celebrities but anonymous boys, girls, and children—anyone who would pose for him without a fee. The same is true of his paintings of the nude, although he probably had sometimes to depend on professional models. His depictions of the nude or partially draped female are among the most beautiful and sensuous in the whole of art. The figure is normally set within a narrow depth of colored space. The artist was fond of contrast of draped white sheets against a deep Venetian red (plate 109). The figure is outlined with a flowing but precise line, while the full and sensuous volumes are modeled with almost imperceptible gradations of flesh tones. The torso is often extremely elongated, but there is no visual sense of grotesque distortion. We are concerned only with suave harmony in a pose of such idyllic composure that the twentieth-century nude recalls the reclining Venus of the Renaissance.

CHAIM SOUTINE (1894–1943) Soutine differed from the other *peintres maudits* within the School of Paris in that his problem of dissipation was complicated by a will to self-destruction. Born into a poor Russian-Jewish family, he somehow developed a passion for painting and drawing, managed to attend some classes in Minsk and Vilna, and, through the help of a patron, went to Paris in 1911. He studied at the École des Beaux-Arts, but it was through the artists whom he met at the old tenement known as La Ruche that he began to find his way.

Soutine constantly destroyed or reworked his paintings, so that it is almost impossible to trace his development from an early to a mature style. He had an affection for some artists, like Bonnard, who represented an offshoot of Impressionism, and he expressed admiration for Rouault. But his own paintings have an affinity (without direct influence) with German Expressionism, particularly the works of Emil Nolde (plate 43). This is a similarity of spirit, not specifically of style. Soutine belonged to the line of Van Gogh, even though he resented the implication. In one sense he was right to resent it, for although Van Gogh painted man and nature in terms of an inner torment, it was a torment disciplined by brushstrokes as precise and architectural as those of Neo-Impressionism. The essence of Soutine's Expressionism lies in the intuitive power, the seemingly uncontrolled but immensely descriptive brush gesture (plate 110). In this quality he is closer than any artist of the early twentieth century to the Abstract Expressionists of the 1950s, especially De Kooning (fig. 580). The Old Masters for whom he expressed enthusiasm—El Greco and the later Rembrandt—helped him to express in paint his peculiar way of seeing, but ultimately both the vision and the expression were his own. Like Van Gogh, Soutine was a tormented soul, given to violent excesses of temperament.

The first liberation of Soutine's expressive powers came in 1919, when, through the help of his friend and dealer, Leopold Zborowski (who had helped Modigliani), he was able to spend three years in a town in the Pyrenees called Céret. The mountain landscape inspired him to a frenzy of free, Expressionist brush paintings that transcended in violence anything produced by the Fauves or the German Expressionists (fig. 357). In these works, trees, houses, and mountains are ripped apart as though by a literally earth-shattering cataclysm. Soutine painted furiously during this period, and seems himself to have been torn apart. But the result was his first success. After his return to Paris, a large number of his canvases were bought by the American collector Albert C. Barnes.

In his portraits and figure paintings of the 1920s there was frequently an accent on a predominant color—red, blue, or white—around which the concept was built. In *Woman in Red* the sitter is posed diagonally across an armchair over which her voluminous red dress flows (plate 110). The red of the dress permeates her face and hands, is picked up in her necklace and in the red-brown tonality of the ground. Only the blue of the hat stands out against it. The hands are distorted as though from arthritis, and the face has the frozen, twisted grin of a paralytic. As in many of Soutine's portraits, the first impression is of a cruel caricature. Then, suddenly, one becomes aware of something disturbing, pathetic, sometimes frightening, something that pertains to the artist rather than to the sitter.

Soutine, like many indigent artists, had painted still lifes of fish or fowl from the beginning of his career, because the model could be painted and then eaten. However, his still lifes were different—the fowl scrawny and cadaverous, the fish repulsively goggle-eyed and gapemouthed. Before him perhaps only Courbet (whom Soutine admired) and Manet, influenced by Courbet, had painted fish so blatantly and repulsively dead. His passion for Rembrandt was commemorated in a

357. CHAIM SOUTINE. *Gnarled Trees.* c. 1921. 38 × 25". Collection Mr. and Mrs. Ralph F. Colin, New York

number of extraordinary paintings that were free adaptations of Rembrandt's. In *Side of Beef* Soutine transcended Rembrandt's *Butchered Ox*, in the Louvre, in gruesome, bloody impact (plate 111). The story of the painting is well known—the pathetic girl model daily fetching blood from the butcher's shop to refurbish the rapidly decaying carcass while nauseated neighbors screamed for the police. But it is a curious fact that, once the initial shock has passed, we can appreciate the artist's passion for the sheer loveliness of the vermilion carcass shot through with yellow against the azure blue of the ground. In this and in many paintings Soutine demonstrated how close are the extremes of ugliness and beauty—how death and dissolution can involve resurrection.

JULES PASCIN (1885–1930) In the gaiety and easy hedonism of his life, Jules Pascin seems to represent an absolute contrast to the tortured Soutine. Yet it was he who committed suicide, at the age of forty-five, on the opening day of a major exhibition of his paintings. Pascin worked first in Vienna and Berlin and early demonstrated the talent of illustrator and caricaturist by which he always earned a respectable living. He was in Paris by the end of 1905, but before 1914 his reputation was greater in Germany than in France. He made drawings for the satirical journal *Simplicissimus* and exhibited at the 1911 Berlin Secession and the Independents exhibition in Cologne in 1912. In 1913 he also exhibited twelve works in the Armory Show in New York.

Pascin was acquainted with German Expressionism, particularly Die

358. JULES PASCIN. *Nude with Green Hat.* c. 1925. 36¼ × 30¼". Cincinnati Art Museum. Virginia Helm Irwin Bequest

359. JULES PASCIN. *Back View of Venus.* 1924–25. 31⅞ × 25⅝". Musée d'Art Moderne de la Ville de Paris

Brücke, before World War I, and some of his earliest surviving paintings suggest Erich Heckel. By 1912 or 1913 he had settled on a style of figure painting in which his elegant draftsmanship was reinforced by delicate, atmospheric color tones in an effect of romantic mood that, in his mature works, could range from the nostalgia and innocence of childhood to the erotic fantasies of his studies of prostitutes (fig. 358). The artist early established a personal manner, a successful and accomplished formula with many levels of appeal, and he only occasionally saw any need to modify it. He did, from time to time, produce perceptive portraits, usually of his wife or his friends. In occasional figure studies he demonstrated a brutal power of expressive drawing indicative of abilities far beyond his pleasant, titillating norm, as in the work seen here (fig. 359). But the pleasures of leading a gay life seemed preferable until his health—and possibly also his vision of himself—deteriorated and he killed himself in 1930.

Pascin has a continuing reputation, for the erotic charm of his paintings has a never-dying appeal. He directly influenced the development of the modern movement in the United States, to which he came in 1914 and remained until 1920.

To this trio of foreign-born artists who helped make the School of Paris the epitome of cosmopolitanism must be added the photographer Brassaï (b. 1899), from that exotic part of Eastern Europe known as Transylvania. Following his days as a painting student in Budapest and Berlin, Brassaï arrived in the French capital in 1923 and promptly fell in love with its streets, bars, and brothels, its artists, poets, and writers, all of which he sought out nightly from dusk to dawn, while sleeping throughout the day. Once introduced to the small camera by his friend and fellow Hungarian André Kertész (fig. 364), the enraptured Brassaï proceeded, with all the gusto of a modern-day Balzac, to record the whole of the Parisian human comedy, doing so as faithfully and objectively as possible (fig. 360). He simply watched for the moment when character seemed most naked and most rooted in time and place. Then, without revulsion or exaggeration, he shot it by the best and most revealing light, a street lamp during the misty morn or a flashbulb in a dim café. But artist that he was, Brassaï never forgot that expression depends upon relevant form. "The sources are always exciting," he said, "but they flow formless.... How to capture them, how to retain them without form? Not being a stenographer, nor a recording machine, my course seems clear: to cast the living thing into an immutable form.... In a word, *I invent nothing, I imagine everything.*"

MAURICE UTRILLO (1885–1955) The life and art of Maurice Utrillo provide perhaps the greatest paradox among the *peintres maudits*. He was the illegitimate son of Suzanne Valadon, a famous model for Renoir, Degas, and Toulouse-Lautrec, who later became an accomplished painter herself. Utrillo began to drink as a child, was expelled from school, dismissed from a position in a bank, and by the age of eighteen was in a sanatorium for alcoholics.

Somehow, during Utrillo's chaotic adolescence—probably through his mother's influence—he became interested in painting. He was self-trained, like his mother, but his art was hardly, if at all, influenced by her. Although his painting was technically quite accomplished, and one can recognize stylistic influences from the Impressionists or their successors, he was closer to the purposely naïve type of painting then developing from the recognition of Rousseau's genius. His obsessive concentration on an extremely limited subject matter and painstaking reproduction of it—the familiar scenes of Montmartre painted almost street by street—reflects the attitudes of the naïve and the primitive. (The word "primitive," in this context, is used to signify a nonacadem-

ic, often self-taught, folk art vision, rather than non-European tribal or exotic character.)

The first paintings that still survive are of the suburb of Montmagny where he grew up, and of Montmartre after he moved there (plate 112). Painted approximately between 1903 and 1909, they tend to coarse brush texture and sober color. He then passed into an Impressionist phase reminiscent of late paintings by Pissarro. About 1910 Utrillo began to reproduce the chalky white buildings of Montmartre. On occasional trips away from Paris he painted churches and village scenes that were variations on his basic theme (fig. 361). His favorite scenes recur over and over again, his memory refreshed from postcards. After 1919 his color brightened and figures occur more frequently. From 1930 until his death in 1955, Utrillo, now decorated with the Legion of Honor, lived at Le Vésinet outside Paris, where his wife watched over him carefully, and he divided his time between painting and religious devotions. During these twenty-five years of rectitude, he did little but repeat his earlier paintings.

Utrillo's case is curious. He was able to nourish a small but consistent talent for over fifty years. The talent was exaggerated by his association with great figures and movements of modern painting. Through his mother he was even linked with the Impressionists and Post-Impressionists of the late nineteenth century. In the 1930s and 1940s the collectors and museums wishing to include the early twentieth-century School of Paris found in Utrillo an artist who seemed to have been a pioneer, yet whose paintings looked respectable among Old Masters, Impressionists, or modern academic Realists or Romantics.

above: 360. BRASSAÏ. *Dance Hall*. 1932. Gelatin-silver print. Collection, The Museum of Modern Art, New York. David H. McAlpin Fund

right: 361. MAURICE UTRILLO. *Street in Asnières*. 1913–15. 29 × 36¼″. Nelson Gallery-Atkins Museum, Kansas City, Missouri. Friends of Art Collection

362. HENRI MATISSE. *Variation on a Still Life by De Heem.* c. 1915–17.
71 × 87¾". Mrs. Florene May Schoenborn and Samuel Marx Collection,
New York

HENRI MATISSE Sophisticatedly sensitive artist that he was, as well as
a painter thoroughly immersed in the art of Cézanne, whence he de-
rived his own Fauvism, Matisse inevitably found himself responding,
even in full color, to the more structured interpretation of the Aix mas-
ter realized by Braque and Picasso. This was evident in the 1911 *Red
Studio*, already seen as possibly the culmination of Matisse's prewar
Fauvist period (plate 42). Subsequently the great colorist went on to
produce in c. 1915–17 what may have been his most orthodox Cubist
painting in *Variation on a Still Life by De Heem* (fig. 362), where he
demonstrated and clarified for himself the development that had taken
place since his first free copy executed in 1893–95 (figs. 139, 140).
Now the palette has become much lighter; the space is closed in and
frontalized; the tablecloth and the architecture of the room are geome-
trized, as are the fruits and vessels on the table. The result is a success-
ful example of a developed or Synthetic Cubism, but as far as Matisse
was concerned, it represented simply an exercise performed for his
own information. After exploring the range of endeavor of his Cubist
colleagues, he again pursued his own directions. Still, his studies of
Cubism were extremely helpful to Matisse, for they taught him how to
simplify his pictorial structures, to control his occasional tendency to
be overly decorative, and to use the rectangle as a counterpoint for the
curvilinear arabesque that came most naturally to him.

The *Piano Lesson* of 1916, unquestionably, is the artist's most suc-
cessful and characteristic excursion into Cubism (plate 113). This
work is a large, abstract arrangement of geometric color planes—love-
ly grays and greens, and a tilted plane of rose pink. The planes are
accented by decorative curving patterns based on the iron grille of the
balcony and the music stand of the piano. The environment is made
tangible by the head of the child sculpturally modeled in line, by the
seated figure in the background, and the indication of Matisse's sculp-
ture *Decorative Figure*, which appears in so many of his paintings.
Here again, his interpretation of Cubism is intensely personal, with
none of the shifting views and steep perspective that mark the main line
of Picasso, Braque, and Juan Gris. Its frontality and its dominant uni-

form planes of geometric color areas show that Matisse here is moving
close to the later nonobjective paintings of Mondrian and the abstrac-
tionists. This seems almost certain when it becomes evident that the
composition has been derived from the mathematically determined
proportions of the Golden Section (possibly an echo of the Section d'Or
exhibition in 1912), a cerebral exercise worked out in gray and subtly
balanced against passages of lyrical pastel and the sensuous curvilin-
earity of window grille, rack, and little nude sculpture. Yet even in their
rigorously flattened and ruled world, the sense of a subject and of a
living space in which personages can move and breathe is always evi-
dent, and the mood of nostalgia and contemplation is the essence of the
painting.

Always full of the future, Matisse began to sense, even at the height of
his Cubist phase and in the midst of war, the advent of a less aggressive
and challenging mood—the "return to order"—that would come with
the end of hostilities. This can be seen in *Music Lesson* (fig. 363), a
second version of the theme treated in *Piano Lesson* and also under-
taken in 1916. Here Matisse reversed his usual course of development
and worked not to simplify but rather to complicate, to allow his "sup-
pressed voluptuousness" to come to the fore and overwhelm Cubist
austerity with a lush, hedonist indulgence in arabesque grace and deco-
rative exuberance. Now, and throughout most of the 1920s, he would
supplant heroic abstraction with intimacy, charm, atmospheric illusion-
ism, and lavish, Oriental color. Yet, even within this deceptively relaxed
manner, the artist could produce images and compositions of grand,
even solemn magnificence.

With the early 1920s Matisse ushered in a new period of decorative
richness, the period of Odalisques, when the artist would carry his sen-

363. HENRI MATISSE. *Music Lesson.* 1917. 96 × 82½". ©The Barnes
Foundation, Merion, Pennsylvania

suousness and characteristic color pattern to its maximum elaboration. The *Decorative Figure Against an Ornamental Background* (plate 114) of 1927 epitomizes this most Rococo phase of Matisse's work, although again it is given a personal variation by the sculptural modeling of the nude, imbedded in and finally flattened against the plane by the background wall of insistent floral decoration. Such solidly modeled figures appear in his sculptures of this period and also in the lithographs he was then making.

During the 1920s Matisse also revived his interest in the window theme, first observed in the Fauve *Open Window, Collioure* of 1905 (plate 31) and often with a table, still life, or figure set before it. Through this subject, in fact, one may follow the progress that Matisse made from Fauve color to Cubist reductiveness and back to the Orien-

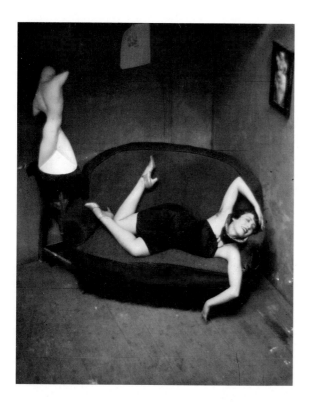

tal, coloristic, and curvilinear style of the postwar years. In *Still Life in the Studio, Nice*, a painting of 1923 (plate 115), Matisse gave full play to his brilliant palette, now so irradiated that the Cubist structure comes through as if perceived in soft focus. This rich and powerful canvas—with the artist once again portrayed in mirror reflection as in the 1903 *Carmelina* (fig. 143) but with the nude model now represented in surrogate by the luscious still life of fruit and flowers—may very well have launched Picasso on his own remarkable series of window still lifes, painted in the mid-1920s (plates 119, 120).

A photographer with something of Matisse's wit and lyrical, life-affirming *joie de vivre*, tethered to a rigorous, original sense of form, was André Kertész (1894–1985), who, like his fellow Hungarian Brassaï, helped season the School of Paris with the spice of cultural variety. Unlike Brassaï, Kertész was already a practicing photographer when he arrived in France from Budapest in 1925. It was there, however, that he became a virtuoso of the 35mm camera, the famous Leica introduced in 1925, and emerged as a pioneer of modern photojournalism. In his personal work, Kertész used the flexible new equipment not so much for analytical description, which the large-format camera did better, as for capturing the odd, fleeting moment or elliptical view when the charm of life, the beauty of the world, or the preciousness of sight are most, because unexpectedly, revealed (fig. 364).

Meanwhile, Matisse, back in 1908, had expressed his desire to create "an art of balance, of purity and serenity devoid of troubling or depressing subject matter, an art which would be for every mental worker . . . something like a good armchair in which to rest from physical fatigue." Hedonist as this may seem, Matisse was almost puritanical in his self-effacing and unsparing search for the ideal. Thus, in the wake of his 1920s luxuriance, the sixty-six-year-old artist set out once again to renew his art by reducing it to essentials. The evidence of this prolonged and systematic exercise has survived in a telling series of photographs, made during the course of the work—state by state—that Matisse carried out toward the ultimate realization of his famous *Large Reclining Nude* formerly called *Pink Nude* of 1935 (plate 116; fig. 365). Progressively ironing out, selecting, simplifying, and reducing—not only form but also color, until the latter consists of little more than rose, blue, black, and white—Matisse got his Odalisque to rest within the pure, rhythmic flow of her uninterrupted curves. While this cursive sweep evokes her feminine volumes, it also fixes, even gridlocks, them

above: 364. ANDRÉ KERTÉSZ. *Satiric Dancer, Paris*. 1926. Gelatin-silver print. Susan Harder Gallery, New York. ©Estate of André Kertész

right: 365. HENRI MATISSE. *Large Reclining Nude (Grand Nu Couché)*. Formerly called *Pink Nude*. 1935. State I of 22 states; photographs sent by the artist to Etta Cone, in letters of September 19 and November 16, 1935. Baltimore Museum of Art. Cone Archive

366. HENRI MATISSE. "Hériodiade," from *Poésies de Stéphane Mallarmé.* 1932. Etching (1/29), page size 13¹⁄₁₆ × 9¹⁵⁄₁₆". Collection, The Museum of Modern Art, New York. Louis E. Stern Collection

367. HENRI MATISSE. *The Cowboy.* Plate 14 from *Jazz.* Paris, Tériade. 1947. Pochoir, sheet 16⁵⁄₈ × 25⁵⁄₈". Collection, The Museum of Modern Art, New York. Gift of the Artist

368. HENRI MATISSE. Chapel of the Rosary of the Dominican Nuns, Vence, France. Consecrated June 25, 1951

into the squared support of the chaise longue, if not "a good arm-chair." Here is the perfect antithetical pendant to the Fauve-primitive *Blue Nude* of 1907 (plate 36), a sculpturesque image resolved on the focal plane by complicated and far less radical means than those of the *Large Reclining Nude.*

Never less than proudly decorative—like the grand French tradition that preceded him from Le Brun at Versailles through Boucher and Fragonard in the eighteenth century to Delacroix, Renoir, and Monet in the nineteenth—Matisse had ample opportunity to be overtly decorative when, in 1932, he began designing and illustrating special editions of great texts, the first of which was *Poésies de Stéphane Mallarmé,* published by Albert Skira (fig. 366). In the graphics for these volumes Matisse so extended the aesthetic economy already seen in the *Large Reclining Nude* that, even when restricted to line and black-and-white, he could endow the image with a living sense of color and volume.

When war struck Europe again, Matisse reacted as he had in 1916–18 and countered the inhumanity of the moment with an art radiant with affirmative, humanist faith. Slowly, however, he succumbed not to military aggression but rather to physical disability, which put him in bed, where, out of necessity, the elderly master proceeded to invent a new technique and through it to discover a joyous new style. Very great artists—Michelangelo, Titian, Rembrandt, Ingres, Monet, and Picasso among them—have frequently got their second wind in extreme old age and raced ahead to one final, transcendent burst of expressive freedom. Usually this takes the form of great spiritual or philosophical weight that seems all the more effective for being expressed through diminished technical or physical resources. With Matisse, however, the hand could hardly have been more secure or the conception more youthful (fig. 367; plate 117), and it says something that the artists who best understood Matisse's late work were the new Color Field painters just emerging in New York toward the end of the 1950s. What they saw was an art created by a man lying on his back, drawing with charcoal, fastened to the end of a long wand, on paper attached to the ceiling above. In this way Matisse produced vast compositions that he then executed by "cutting into color," color hand-stroked onto paper so that it assumes a translucent purity of unparalleled resonance. Once assembled into the composition—sometimes figurative, but very often unabashedly abstract-decorative like a carpet or tapestry, and almost always mural in scale—the *découpages* or paper cut-out works can be seen as the very apotheosis of the artist's initial Cézanne-inspired Fauve aesthetic, consisting of planes of pure color flattened by their interlocking, picture-puzzle relationships, but conjuring dimensionality by the fullness of their color and the monumental simplicity of their arabesque shapes. Moreover, by cutting into color, Matisse was manipulating his material in a way that translated into pictorial terms his experience in handling clay for sculpture. With this, he at last attained the synthesis he had long sought of sculpture and painting. So universal was the new artistic potential discovered by the aged Matisse—by then one of the abiding geniuses of Western civilization—that its irrepressible gaiety seems fully at one not only with *Jazz* (fig. 367), but also with the murals, chasubles, stained glass, and furniture that the artist designed for the Dominican nuns at the Rosary Chapel in the French Mediterranean village of Vence (fig. 368).

PABLO PICASSO The career of Picasso during World War I exemplifies much that was happening during those years. After the period of discovery and experiment in Analytic Cubism, collage, and the beginning of Synthetic Cubism (1908–14), there was a pause during which the artist used Cubism for decorative or fantastic-Expressionist ends

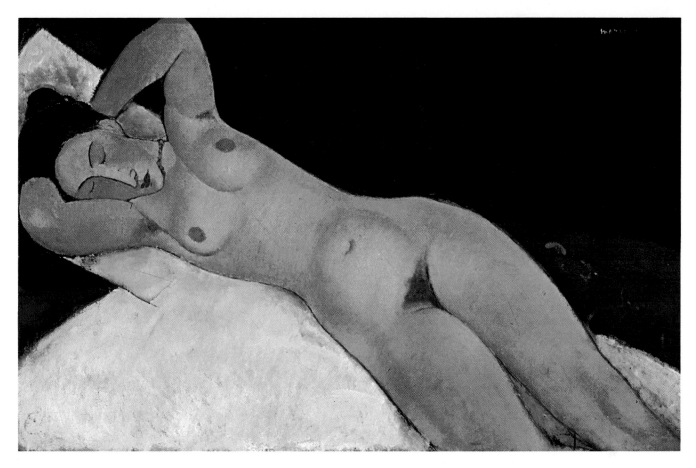

Colorplate 109. AMEDEO MODIGLIANI. *Nude*. 1917. 28¾ × 45¾″. The Solomon R. Guggenheim Museum, New York

Colorplate 110. CHAIM SOUTINE. *Woman in Red*. c. 1922. 25 × 21″.
Collection Dr. Ruth Bakwin, New York

Colorplate 111. CHAIM SOUTINE. *Side of Beef*. c. 1925. 55¼ × 42⅜″.
The Albright-Knox Art Gallery, Buffalo, New York

Colorplate 112. MAURICE UTRILLO. *Rooftops of Montmagny*. 1906–7. 65 × 54″. Musée National d'Art Moderne, Paris

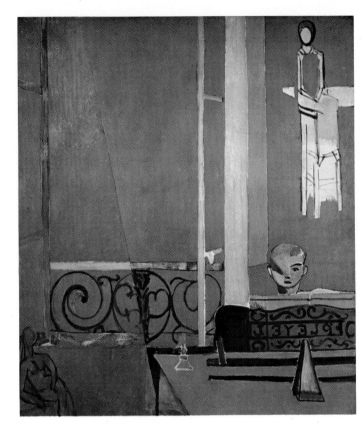

Colorplate 113. HENRI MATISSE. *Piano Lesson*. 1916. 96½ × 83¾″. Collection, The Museum of Modern Art, New York. Mrs. Simon Guggenheim Fund

Colorplate 114. HENRI MATISSE. *Decorative Figure Against an Ornamental Background*. 1927. 51⅛ × 38½″. Musée National d'Art Moderne, Paris

Colorplate 115. HENRI MATISSE. *Still Life in the Studio, Nice*. 1923. 39¾ × 32″. Collection Mrs. Albert D. Lasker, New York

Colorplate 116. HENRI MATISSE. *Large Reclining Nude (Grand Nu Couché)*, formerly called *Pink Nude*. 1935. 26 × 36½″. The Baltimore Museum of Art. Cone Collection, formed by Dr. Claribel Cone and Miss Etta Cone of Baltimore

Colorplate 117. HENRI MATISSE. *Ivy in Flower*. 1953. Collage: colored paper and pencil, 112 × 112″. Dallas Museum of Art, Foundation for the Arts Collection. Gift of the Albert and Mary Lasker Foundation

Colorplate 118. PABLO PICASSO. *Three Musicians*. 1921. 79 × 87¾″. Collection, The Museum of Modern Art, New York. Mrs. Simon Guggenheim Fund

Colorplate 119. PABLO PICASSO. *Mandolin and Guitar*. 1924. Oil and sand on canvas, 56⅛ × 79¾″. The Solomon R. Guggenheim Museum, New York

Colorplate 120. PABLO PICASSO. *The Studio*. 1925. 38⅝ × 51⅝″. Collection James Johnson Sweeney

left: Colorplate 121. GEORGES BRAQUE. *Café-Bar*. 1919. 63¼ × 31⅞″. Kunstmuseum, Basel

below: Colorplate 122. GEORGES BRAQUE. *Vase, Palette, and Skull*. 1939. Oil and sand on canvas, 36 × 36″. Collection Mr. and Mrs. David Lloyd Kreeger, Washington, D.C.

Colorplate 123. RAOUL DUFY.
*Indian Model in the Studio
at L'Impasse Guelma.*
1928. 31⅞ × 39⅜″. Collection
A. D. Mouradian, Paris

Colorplate 124. MAX ERNST. *Two Children Are Threatened by a Nightingale*. 1924. Oil on wood with wood construction, 27½ × 22½ × 4½". Collection, The Museum of Modern Art, New York. Purchase

Colorplate 125. MAX ERNST. *Europe After the Rain*. 1940–42. 21½ × 58⅛". Wadsworth Atheneum, Hartford, Connecticut. The Ella Gallup Sumner and Mary Catlin Sumner Collection

Colorplate 126. JOAN MIRÓ. *The Harlequin's Carnival*. 1924–25. 26 × 36⅝".
The Albright-Knox Art Gallery, Buffalo, New York

Colorplate 127. JOAN MIRÓ. *Dog Barking at the Moon*. 1926. 28¾ × 36¼".
Philadelphia Museum of Art. A. E. Gallatin Collection

Colorplate 128. JOAN MIRÓ. *Dutch Interior II*. 1928. 36¼ × 28⅜". Collection Peggy Guggenheim, Venice

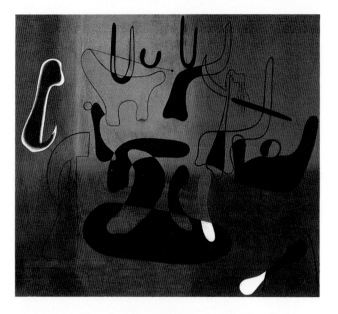

left: Colorplate 129. JOAN MIRÓ.
Painting. 1933. 68⅛ × 78¼″.
Collection, The Museum of Modern
Art, New York. Gift of the Advisory
Committee (by exchange)

below: Colorplate 130. JOAN MIRÓ.
Nursery Decoration. 1938.
2′7½″ × 10′6″. Collection Mr. and
Mrs. Richard K. Weil, St. Louis

bottom: Colorplate 131. JOAN MIRÓ.
Blue II. 1961. 8′10¼″ × 11′7¾″.
Pierre Matisse Gallery, New York

369. PABLO PICASSO. *Ambroise Vollard*. 1915. Pencil on paper, 18⅜ × 12⁹⁄₁₆″. The Metropolitan Museum of Art, New York. Elisha Whittelsey Collection, 1947

370. PABLO PICASSO. *The American Manager*. 1919. Statkewicz as the American Manager in first performance of ballet *Parade*; costume designed by Picasso. Cardboard, paper, wood, leather, and metal, 134½ × 96 × 44½″. Collection, The Museum of Modern Art, New York

(plate 67; fig. 231). Then, suddenly, in 1914–15 he began a series of realistic portrait drawings in a sensitive, even exquisite linear technique that recalls his longtime admiration for the drawings of Ingres (fig. 369). The war years and the early 1920s saw a return to forms of Realism on the part of other French painters—Derain, Vlaminck, Dufy—originally associated with Fauvism or Cubism.

The return to nature is understandable as a reaction against new styles and movements that had been pursued assiduously for five to ten years. This pattern has repeated itself at intervals during the twentieth century, and is observable at all periods in the history of art. In Picasso's case, however, the Realistic drawings and, subsequently, Realistic paintings, constituted not a reaction against Cubism, but a sort of catharsis enabling him to reexamine its nature. In any event, he pursued Cubist experiments side by side with Realistic and Classical drawings and paintings in the early 1920s.

In 1917 Picasso agreed, somewhat reluctantly because of his hatred for travel or disruption of his routine, to go to Rome with Jean Cocteau to design curtains, sets, and costumes for a new ballet, *Parade*, being prepared for Diaghilev's Russian Ballet Company. This brought the artist back into the world of the theater which, with the circus, had been an early love and had provided him with subject matter for his Blue and Pink periods. *Parade* was a notable example of Diaghilev's genius for bringing together the greatest experimental talents of the day. Aside from Cocteau, who wrote the book, and Picasso, the music was composed by Erik Satie and the choreography by Léonide Massine. The ballet was a satire on the world of the theater, with a theme of symbolic conflict between the delicate humanity and harmony of the music and the dancers, on the one hand, and the overpowering force of the

371. PABLO PICASSO. *Portrait of Igor Stravinsky*. 1920. Pencil, 24¼ × 18¾″. Private collection, U.S.A.

mechanist-Cubist managers (fig. 370) and the deafening noise of the sound effects, on the other. Its mixture of reality and fantasy led Apollinaire in his program notes to refer to its *sur-réalisme*, one of the first recorded uses of this term to describe an art form. *Parade* involved elements of shock that the Dadaists were then exploiting in Zurich, and the contrasts of the commonplace and fantastic such as De Chirico had introduced into his paintings.

Picasso's early love of the characters from the Italian comedy and its descendant, the French circus, was renewed. Pierrots, Harlequins, and musicians again became a central theme. The world of the theater and music took on for him a fresh aspect that resulted in a number of brilliant portraits (fig. 371) and figure drawings, particularly compositions of nudes done in delicately economical outlines.

During the early postwar period Picasso experimented with different attitudes toward Cubism and representation. In the latter, the most purely Classical or Neoclassical style was manifested before 1923 in drawings that have the quality of white-ground Greek vase paintings of the fifth century B.C. Already by 1920 such drawings embodied a specifically Greek or Roman subject matter which he continued to explore thereafter. During the same year he also began to produce paintings, frequently on a large scale, in which his concept of the Classical is in a different and monumental vein (fig. 372). He pursued this manner for the next three or four years in painting and continued it in sculpture in the early 1930s. It is as though the years of working with flat, tilted Cubist planes had built up a need to go to the extreme of sculptural mass. The faces are simplified in the heavy, coarse manner of Roman rather than Greek sculpture, and when Picasso placed the figures before a landscape, he simplified the background to frontalized accents that tend to close rather than open the space. Thus the effect of high sculptural relief is maintained throughout. Normally the figures exhibit

373. PABLO PICASSO. *The Race.* 1922. Tempera on wood, 12⅞ × 16¼".
Estate of the Artist

Classic repose, but occasionally Picasso puts them into violent if lumbering activity that lends a quality of fantasy, as in *The Race* (fig. 373). The colors of these paintings, in accordance with their Classical origins, are light and bright—light blues and reds, with raw pink flesh tones. We should recall that crude, massive figure compositions were not new in Picasso's career, for during his period of archaic and proto-Cubist works (1906–8), he produced a number of comparable massive and primitively powerful paintings (fig. 205).

372. PABLO PICASSO. *Three Women at the Spring.* 1921. 6'8¼" × 68½".
Collection, The Museum of Modern Art, New York. Gift of Mr. and Mrs.
Allan D. Emil

374. PABLO PICASSO. *The Pipes of Pan.* 1923. 80½ × 68½". Estate of the
Artist

375. PABLO PICASSO. *Nessus and Dejanira*. 1920. Pencil, 8¼ × 10¼".
Collection, The Museum of Modern Art, New York. Acquired through the
Lillie P. Bliss Bequest

376. PABLO PICASSO. *By the Sea*. 1920. Oil on wood, 31⅞ × 39⅜".
Collection George Friedland, Philadelphia

By 1923 the Greco-Roman phase was over. Picasso continued to paint for two or three more years in a classical vein, but now with a lyrical Classicism close to the spirit of Athens in the fifth century B.C. One of the outstanding works of this phase is *The Pipes of Pan* (fig. 374). The two youths are presented as massive yet graceful athletes, absorbed in their own remote and magical world under the spell of primitive music. In other works of the same period an even more delicate and lyrical quality is evident, taking us back to Picasso's first Classical, Rose period.

By 1925 this second Classical phase was over in the figure paintings, to recur in the next decades from time to time. Classical motifs continued to appear in still lifes, and the type of Classical line drawing he had developed during the war (again it should be emphasized, the revival of a drawing style of his Rose period) would continue in his work in one form or another. The specific Classical subject taken from Greek or Roman mythology also continued without interruption in the drawings and prints. Belonging to this second Classical phase is the *Nessus and Dejanira*, a portrayal of the rape of Dejanira, wife of Herakles, by the centaur, Nessus (fig. 375). The subject so intrigued the artist that he made versions in pencil, silverpoint, watercolor, and etching. The representational line drawings also revived his interest in the graphic arts, particularly etching and lithography. He produced prints at the beginning of his career, and some during the earlier Cubist phase and the war years. From the early 1920s printmaking became a major phase of his production, to the point where Picasso must be regarded as one of the great printmakers of the century.

In the early 1920s Picasso also produced a few strange and almost inexplicable figure pieces of which the most curious is *By the Sea* (fig. 376). The subject and the light, simple colors are of the Classical type—three nudes, reclining or gamboling at the seashore. Here, however, the artist has used grotesque distortions, particularly of the running and standing figures, that predict the next, or Surrealist, stage of his work.

The incredible aspect of Picasso's art during this ten-year period (1915–25) is that he was also producing major Cubist paintings. After the decorative enrichment of the Cubist paintings around 1914–15, including Pointillist color and elaborate, applied textures (plate 67), the artist moved back, in his Cubist paintings of 1916–18, to a greater austerity of more simplified flat patterns, frequently based on the figure (fig. 377). Simultaneously, he made realistic versions of this subject, a favorite with him. From compositions involving figures, there gradually

377. PABLO PICASSO. *Harlequin with Violin*. 1918. 56 × 39½". Private
collection, New York

evolved the two versions of the *Three Musicians*, both masterworks of the Cubist tradition created in 1921 (plate 118). The three figures are seated in a row, frontal against an enclosing back wall, and fixed by the restricted foreground. There are many differences in the two versions, that at Philadelphia being generally more intricate and varied in forms and colors, that in New York simple and more somber. They are a superb summation of the Cubist tradition up to this point, but they also embody something new. The three masked, mysterious figures are not merely organizations of flat-color shapes arranged to create a bold but harmonious unity; they are also presences, suggestive not so much of gay musicians from the *commedia dell'arte*, as of some menacing tribunal whose role as musicians is a deception and a mockery. Probably the figures could read in other ways, but the significant point is their emergence as definite personalities. At this point Cubism takes on an Expressionist or fantastic quality, one that adds to it a new dimension and changes its nature.

The other direction in which Picasso took Cubism involved sacrifice of the purity of its Analytic phase, for the sake of new exploration of pictorial space. The result was, between 1924 and 1926, a series of the most colorful and spatially intricate still lifes in the history of Cubism. The *Mandolin and Guitar* illustrates the artist's superb control over the entire repertory of Cubist and perspective space (plate 119). The center of the painting is occupied by the characteristic Cubist still life—the mandolin and guitar twisting and turning on the table, encompassed in mandorlas of abstract color-shapes: vivid reds, blues, purples, yellows, and ochers against more subdued but still-rich earth colors. The tablecloth is vari-colored and patterned, while the corner of the room with the open window is a complex of tilted wall planes and receding perspective lines creating a considerable illusion of depth, which, however, seems constantly to be turning back upon itself, shifting and changing into flat planes of color. By violating every canon of earlier, Analytic Cubism, Picasso has accelerated the process of spatial metamorphosis to the point where the commanding element is the dynamism of the total space of the painting. Space here, in a most tangible manner, but a manner entirely different from that of the Surrealists, becomes literally expressive.

It is interesting to recall the extent to which the subject of the open window, often with a table, still life, or figure before it, had also been a favorite of Matisse (plate 115). Because of certain points of relationship between Matisse's works, such as *Still Life in the Studio, Nice*, and Picasso's contemporary paintings of similar subjects, it is possible to believe that Picasso may have been looking at the French master. Yet his approach was entirely different, based as it was on Cubism.

Picasso, in some Cubist still lifes of the mid-1920s, introduced Classical busts as motifs suggesting the artist's simultaneous exploration of Classic monumentality and idealism. Sometimes, as in *The Studio* of 1925 (plate 120), the bust implies a different form of expression, a quality of mystery analogous to De Chirico's use of Classical motifs (fig. 318). At this moment the Surrealists were emerging as an organized group, and Picasso himself was soon to begin exploring the realm of fantasy.

GEORGES BRAQUE Braque and Picasso parted company in 1914, never to regain the intimacy of the formative years of Cubism. After his war service and the slow recovery from a serious wound, Braque returned to Paris in the fall of 1917. The scene had changed during his years of absence. Picasso was in Italy, and other pioneers of Cubism or Fauvism were widely scattered. However, Juan Gris was still in Paris, painting in a manner that impressed Braque and inspired him in his

efforts to find his own way once more. By 1918–19 a new and personal approach to Synthetic Cubism began to be apparent in a series of paintings, of which *Café-Bar* is a document for Braque's style for the next twenty years (plate 121). As such it deserves close examination. The painting is tall and relatively narrow, a shape which Braque had liked during his first essays in Cubism (plate 65) and which he now began to utilize on a more monumental scale. The subject is a still life of guitar, pipe, journal, and miscellaneous objects piled vertically on a small, marble-topped pedestal table of the type whose French name is *guéridon*. This table was used many times in subsequent paintings, to which its name has been attached. It is placed as it might be on the sidewalk before a Paris café, with the diamond-shaped tiles of the pavement indicated at the base and the words *Café-Bar* at the top, presumably painted on the window of the café. The variously suggested elements of the environment are held together by a pattern of horizontal green rectangles patterned with orange-yellow dots, placed like an architectural framework parallel to the picture plane. Compared with his prewar Cubist paintings, this has more sense of illusionist depth and actual environment, although closed in comparison with Picasso's window paintings of the same year. Also, although the colors are rich, and Braque's feeling for texture is more than ever apparent, the total effect recalls, more than Picasso's, the subdued tonality that both artists worked with during their early collaboration (fig. 222). This is perhaps the key to the difference between their maturities. Whereas the approach of Picasso was experimental and varied, that of Braque was conservative and intensive, continuing the first lessons of Cubism. Even when he made his most radical departures into his own form of Classical figure painting during the 1920s, the color remained predominantly the grays, greens, browns, and ochers of Analytic Cubism. From time to time, throughout his subsequent career, he tried his hand at high-keyed and positive color, but when he did, one sensed a certain graying of the reds and yellows that softened their impact and integrated them into a tonal harmony. The principal characteristic of Braque's style emerging about 1919 was that of a textural sensuousness in which the angular geometry of earlier Cubism began to diffuse into an overall fluid pattern of organic shapes.

This style manifested itself in the early 1920s in figure paintings in which the artist seems to have deserted Cubism as completely as Picasso did in his Classical figure paintings. The difference again lay in the painterliness of Braque's oils and drawings, as compared with Picasso's Ingres-like contour drawings and the sculptural massiveness of his Classical paintings. In *Nude Woman with Basket of Fruit* the figure flows through the limited space of the picture in a sheer delight of sensual femininity (fig. 378). The composition is a close blend of half-tones defined by the loose, flowing contours of the figure. In these paintings and figure drawings of the 1920s the artist effected his personal escape from the rigidity of his earlier Cubism and prepared the way for his enriched approach to Cubist design of the later 1920s and 1930s.

The most dramatic variation on his steady, introspective progress occurred in the early 1930s when, under the influence of Greek vase painting, Braque created a series of line drawings and engravings with continuous contours. This flat, linear style also penetrated to his newly austere paintings of the period: scenes of artist and model or simply figures in the studio (fig. 379). These works exhibit some of the most varied effects of Braque's entire career. The colors are subdued but rich and sensuous. Still lifes and the shadowed interiors occupied by somber figures are shot through with passages of luscious color, and filled with a mystery of loneliness (plate 122). In his late maturity,

above left: 378. GEORGES BRAQUE. *Nude Woman with Basket of Fruit.* 1926. 63¾ × 29¼". National Gallery of Art, Washington, D.C. Chester Dale Collection

above right: 379. GEORGES BRAQUE. *Woman with Mandolin.* 1917. 36¼ × 25⅝". Collection Jean Masurel, Roubaix, France

Braque, without sacrificing any of the restraint or control that had marked his career, added an element of romantic enrichment to culminate and enlarge upon his lifetime of intensive contemplation.

RAOUL DUFY Unlike Braque, Dufy joined Matisse in remaining true to the principles of Fauve color but, in the years following the "Wild Beast" episode (plate 38), refined them into a signature style of astonishing clarity and sumptuousness. Even more than Matisse, he was a proud decorator with a connoisseur's taste for the hedonist joys of the good life. During the 1920s and 1930s Dufy achieved such popularity, not only in paintings, watercolors, and drawings, but also in ceramics, textiles, illustrated books, and stage design, that his art, with its rainbow palette and stylish, insouciant drawing, seems to embody the very hallmark look of the period. *Indian Model in the Studio at L'Impasse Guelma* (plate 123), a painting in which Dufy evidently wanted to outdo Matisse in the introduction of Oriental pattern into the studio setting, shows many of the characteristics of the artist's developed painting manner. The oil color is laid on in thin washes suggestive of watercol-

or—a medium in which Dufy worked extensively. The broad, clear area of very light blue that covers the studio wall forms a background to the intricate pattern of rugs and paintings whose exotic focus is the delightful Indian model herself. The importance of descriptive line is such that the painting—and this is true of many if not most of Dufy's works—seems a delicately colored ink drawing.

Dufy combined influences from Matisse, Rococo art of the eighteenth century, Persian and Indian painting, and occasionally modern primitives such as Henri Rousseau, transforming all these, however, into a delightful, intimate world of his own. The artist could take a panoramic view and suggest, in minuscule touches of color and nervous arabesques of line, the movement and excitement of crowds of holiday seekers. Horse races at Deauville or Ascot, regattas at Henley, Cowes, or Deauville, boats in sun-filled harbors, the circus, the concert hall—all these made up the world of Raoul Dufy. Conscious of the revolutions surrounding him on all sides, he flirted occasionally with abstraction, only to turn it into elegant decoration. His talent was charming, if eclectic; his aims were never sufficiently ambitious to make

380. GEORGE HOYNINGEN-HUENE. *Untitled, (Fashion Izod)*. 1930. Photograph. Courtesy *Vogue*. ©1930 (renewed 1958) by The Condé Nast Publications, Inc.

381. MARIE LAURENCIN. *Nymph and Hind*. 1925. 28 × 20½". Philadelphia Museum of Art. Given by Mr. and Mrs. Robert Cameron Morris

the most of his natural abilities. Yet his reputation throughout his life and since his death has remained remarkably high. His early association with the Fauves and the continuing appeal of his later works have established him popularly as a leader of modern art, even in the 1970s and 1980s, when he has become one of the heroes of the Pattern and Decoration movement.

As Dufy's career would suggest, the two decades between the wars were a remarkably modish period, even as the 1930s brought the Great Depression and the growing threat of renewed military conflict. One explanation for this phenomenon emerges from the technical advances made in photography and photoengraving processes, which in turn gave rise to handsomely illustrated, yet popularly priced fashion journals, among them *Vogue* and *Harper's Bazaar*. One of the fashion photographers whose work for Paris *Vogue* transcends the ephemerality of its initial purpose to find a sure place in the realm of art—a trail already blazed by the great Steichen (fig. 576)—was the Russian-born George Hoyningen-Huene (1900–1968). Thanks to his innate Classicism, Hoyningen-Heune managed in 1930 to translate Art Deco taste into images as lean and formal as they are original and seductive (fig.

380), all the while imbued with a tinge of the Surreal, just then emerging as a dominant force throughout the arts.

MARIE LAURENCIN (1885–1956) Another popular figure in the School of Paris was Marie Laurencin, the attractive Frenchwoman who captured the heart of Guillaume Apollinaire, the poet-champion of the first Cubists, and then went on to earn herself a firm footing in the history of modern art. Like Chagall, Laurencin knew the most advanced modernism from the inside—even Dada—but chose to cultivate a personal, or naïve, mythology projected in a self-taught, slightly primitive Rococo manner. With its fey spirit, lyrical simplicity, and roseate colorism, Laurencin's art possesses undeniable charm and decorative appeal (fig. 381). Moreover, it continues to show remarkable signs of genuine staying power. Laurencin herself may have given the clue when she said: "My pictures are the love stories I tell to myself and which I want to tell others." In addition to painting, Laurencin designed sets for Poulenc's *Les Biches*, staged in 1924 by the Ballets Russes, and illustrated some thirty books, among them *Alice's Adventures in Wonderland*.

Surrealism

In 1917 Apollinaire referred to his own drama *Les Mamelles de Tiré-sias*, and also to the ballet *Parade* produced by Diaghilev, as Surrealist. The term was commonly used thereafter by André Breton, Paul Éluard, and other contributors to the Paris journal *Littérature*. The concept of a literary and art movement to be formally designated Surrealism, however, did not emerge until Dada had breathed its last in Paris.

During the first years after World War I, French writers had been trying to formulate an aesthetic of the nonrational stemming from Arthur Rimbaud, the self-styled Comte de Lautréamont, Alfred Jarry, and Apollinaire, and they sought their answer in the Dadaists, then converging on Paris. Breton joined Tzara, Picabia, and Duchamp in publishing the February 1919 edition of *Bulletin Dada* and other Dada journals and manifestations from 1920 to 1922. During the same period there were exhibitions of Picabia and Max Ernst, the latter with an introduction by André Breton. By 1922 Breton was growing disillusioned with Dada on the curious but perhaps legitimate ground that it was becoming institutionalized and academic. He opposed the large Dada Exhibition held at the Galerie Montaigne, and led the revolt that broke up the Dada Congress of Paris. But together with Philippe Soupault, he explored the possibilities of automatic writing in his 1922 Surrealist texts called *The Magnetic Fields* (some automatic writing had already been done about three years earlier).

After 1922 Breton assumed the principal editorship of *Littérature*, and gradually augmented his original band of writers with artists whose work and attitudes were closest to his own: Picabia, who contributed poems, aphorisms, and cover designs; Man Ray, who was experimenting with abstract photographs that he called "rayograms"; and Max Ernst. Artists and writers continued to explore automatic writing, the poetry of the magical, and the world of dreams and the Freudian subconscious. The group met Breton regularly at his or Paul Éluard's home, or at some favorite café, where they discussed the meaning for the contemporary artist of Lautréamont, Rimbaud, or Jarry, or the significance of the marvelous, the irrational, and the accidental in painting and poetry. From these meetings emerged Breton's *Manifesto of Surrealism* in 1924, containing this definition:

SURREALISM, *noun, masc., pure psychic automatism by which it is intended to express, either verbally or in writing, the true function of thought. Thought dictated in the absence of all control exerted by reason, and outside all aesthetic or moral preoccupations.*

ENCYCL. Philos. *Surrealism is based on the belief in the superior reality of certain forms of association heretofore neglected, in the omnipotence of the dream, and in the disinterested play of thought. It leads to the permanent destruction of all other psychic mechanisms and to its substitution for them in the solution of the principal problems of life.*

This definition emphasizes words rather than plastic images, literature rather than painting or sculpture. The movement was dominated by poets and literary critics who felt themselves the heirs of Rimbaud, Lautréamont, and Jarry. Breton, in addition, was a serious student and disciple of Freud, from whose teachings he derived the Surrealist position concerning the central significance, to poet and artist, of dreams and the subconscious. He conceived of the Surreal condition as a moment of revelation in which are resolved the contradictions and oppositions of dreams and realities. In the second manifesto of Surrealism, issued in 1930, he said: "There is a certain point for the mind from which life and death, the real and the imaginary, the past and the future, the communicable and the incommunicable, the high and the low cease being perceived as contradictions."

The element of chance, of randomness and coincidence in the formation of a work of art, or more important, of an artist, had for years been explored by the Dadaists. Now it was made the basis for intensive study. Implicit in the Surrealist program was the need for revolt—revolt against institutions and philosophies, against the older statesmen, philosophers, poets, and artists who had led the younger generation into the dreadful carnage of World War I. The Surrealists and Dadaists were all in their twenties, and, to understand the ferocity of their antagonisms, their recent experience of four years of total war must be kept in mind. This experience made the Surrealists attach much importance to the poet's isolation, his alienation from society and even from nature.

Two nineteenth-century poets were major symbols and prophets for the Surrealists. Isidore Ducasse (1846–1880), who assumed the name Comte de Lautréamont, and Arthur Rimbaud (1854–1891) were violent and outspoken critics of established nineteenth-century poets and of forms and concepts of nineteenth-century poetry. Unknown to each other, both lived almost in isolation, wandered from place to place, and both died young; yet they wrote great poetry while still adolescents, tearing at the foundations of Romantic verse. They had irresistible appeal to the Surrealists.

Lautréamont's poem *Les Chants de Maldoror* presents the archetypal hero of the Surrealists: man, dual in nature, drawn equally by the spiritual force of God and the animal ferocity of beasts of prey. Like Baudelaire's *Dandy*, he possesses superior intelligence and sensitivity that he controls by coldness—the hero who lives apart from the world while living in it. Lautréamont parallels Baudelaire's image of the poet who is also priest and warrior—who creates through knowing and through killing. The work of art must be a work of destruction as well as of creation. The idea of revolt permeates Lautréamont's poetry: revolt against tradition, against the family, against society, and against God himself.

The ideas of Rimbaud at seventeen years of age seemed, even more than those of Lautréamont, to define for the Surrealists the nature of the

poet and poetry. Rimbaud's intensive reading in Oriental and Greek mystical religions had fixed the poet, in his mind, as one possessed of divine madness, like Prometheus, the thief of the sacred flame. The poet, like the Christian mystic, must attain the visionary state through rigid discipline—but here a discipline of alienation, monstrosities of love, suffering, and madness. Like the Surrealists later, Rimbaud was concerned with the implications of dreams, the subconscious (then still undefined), automatism, and chance. Words took on a magical significance, not as description or communication, but as mysterious invocations. Poetry was a voyage into the unknown.

The ideas advanced in Breton's manifestoes had belonged to the art and literature of revolt for some fifty years, but now they were codified explicitly. A dogma of Surrealist principles was formulated, and, almost at once, schisms and heresies appeared. Fortunately for the vitality of Surrealist painting and sculpture, few of its exponents practiced the word according to Breton with scrupulous literalness. In fact, the major Surrealist painters have little stylistic similarity, aside from seeking new subject matter or a new departure from traditional content. Since individualism and isolation were at the core of the movement, the artists sought, above all, to be individuals. Many established artists—like Picasso or De Chirico, for instance—who were assimilated by the Surrealists (officially or otherwise) had, of course, been individuals long before the 1924 *Manifesto of Surrealism.*

The first group exhibition of Surrealist artists was in 1925 at the Galerie Pierre. It included Arp, De Chirico, Ernst, Klee, Man Ray, Masson, Miró, Picasso, and Pierre Roy. In that year Yves Tanguy joined the group. A Surrealist gallery was opened in 1927 with an exhibition of these artists joined by Marcel Duchamp and Picabia. Except for René Magritte, who joined later that year, and Salvador Dali, who did not visit Paris until 1928, this was the roster of the first Surrealist generation.

In the mid-1920s, De Chirico had abandoned his early Metaphysical paintings (except for making copies of them) in favor of an academic Classicism. Paul Klee, at the Bauhaus, was producing his most magical fantasies. Picasso, after balancing Classicism against Synthetic Cubism for several years, was experimenting with fantasy by the evocation of monsters. Marcel Duchamp, back in Paris after leaving the *Large Glass* unfinished (plate 105)—or perhaps finished through the shattering of the glass in transit—had ceased to produce art but not to participate in its eccentric manifestations. He continued to explore motion in his *Rotative Plaques* (fig. 329). Man Ray, in Paris since 1921, still painted but was turning to photography and cinema, media in which he was a pioneer experimentalist. Duchamp made in 1924 what may be called a Surrealist film, *Anemic Cinema* (a typical Duchamp anagram), in Man Ray's studio, and Man Ray produced *Starfish*, with a script by Robert Desnos in 1928. The influence of Surrealism on the cinema can here only be suggested. The film had already been used by George Méliès to explore the fantastic in his *Hydrothérapie fantastique* in 1900. The first great example was Robert Wiene's *Cabinet of Doctor Caligari* (1919). René Clair experimented with the Surrealist film in *Entr'acte* (1924), while *Un Chien Andalou* (1929) by Salvador Dali and Luis Buñuel and *Blood of a Poet* (1931) by Jean Cocteau have become classics of the Surrealist film.

JEAN (HANS) ARP Jean Arp, one of the original Zurich Dadaists (plate 102), was active in Paris Dada during its brief life, showing in the International Dada Exhibition of 1922, at the Galerie Montaigne, and contributing poems and drawings to Dada periodicals. When official Surrealism emerged in 1924 Arp was an active participant. At the same time, he remained in close contact with German and Dutch abstraction-

382. JEAN ARP. *Rising Navel and Two Heads*. 1927–28. Mural, oil on plaster. Café L'Aubette, Strasbourg (destroyed 1940)

ists and Constructivists. He also contributed to Theo van Doesburg's *De Stijl*, and with El Lissitzky edited *The Isms of Art*. After 1925 he and Sophie Taeuber-Arp made their home in Meudon outside of Paris.

During the 1920s Arp's favorite material was wood, which the artist made into painted reliefs. He also produced paintings, some on cardboard with cut-out designs making a sort of reverse collage. As we saw in Chapter 13, he had experimented with geometric abstractions between 1915 and 1920, occasionally collaborating with Sophie Taeuber. These abstractions were close to the contemporaneous works by Mondrian and Van Doesburg, although Arp has said that he knew nothing of their abstract paintings before 1919, and that he learned about constructed paintings principally from Sophie Taeuber-Arp, a fine painter who pioneered in Geometric Abstraction (fig. 323). Arp, however, abandoned geometric shapes by 1920 and already held the fixed conviction that "art is a fruit that grows in man, like a fruit on a plant, or a child in its mother's womb." Yet he never questioned the right of other artists to follow the path of geometry, and, in fact, remained a close friend of Van Doesburg and a fervent propagandist for the paintings of Sophie Taeuber-Arp.

With the collaboration of these two artists, Arp decorated ten rooms of the Café L'Aubette in his native city, Strasbourg. His murals for the café (now destroyed) were the boldest, freest, and most simplified examples of his organic abstraction. They utilized his favorite motifs: the navel and mushroom-shaped heads, sometimes sporting a mustache and round-dot eyes (fig. 382). Despite the connotations of the titles, such as *Rising Navel and Two Heads* and *Navel-Sun*, these murals were among the most important abstractions of the organic or biomorphic type by any artist up to this time. *Rising Navel and Two Heads* was simply three flat, horizontal, scalloped bands of color, with two color shapes suggesting flat mushrooms floating across the center band. *Navel-Sun* was a loosely circular white shape with a dark center, floating on a large dark rectangle whose edge, undulating slightly, separates it from a narrow band above. There are no parallels for these paintings until the so-termed Color Field painters of the 1950s and 1960s.

Of particular interest among Arp's reliefs and collages during the 1920s were those entitled or subtitled *Arranged According to the Laws of Chance* (fig. 383). These continued the 1916–17 experiment in

383. JEAN ARP. *Objects Arranged According to the Laws of Chance, or Navels.* 1930. Varnished wood relief, 10⅜ × 11⅛". Collection, The Museum of Modern Art, New York

384. JEAN ARP. *Head with Three Annoying Objects.* 1930. Bronze, 14⅛ × 10¼ × 7½". Estate of Jean Arp

Squares Arranged According to the Laws of Chance (fig. 324), although, now, most of the forms were organic rather than geometric. In the same vein, he produced string reliefs—loops of string dropped accidentally on a piece of paper and seemingly fixed there. It should be emphasized that the casually placed relief elements and the dropped loops of string have magically assumed form unique to the artist's personal style. Arp, it would appear may have given the laws of chance some assistance, and for this he had a precedent in Duchamp's *3 Stoppages Étalon*, the result of a 1913 experiment in chance (fig. 331).

However, the creation of a work of art lies in the motivation of the artist, for the important element is the choice of chance, not chance itself. This principle was recently formulated by the composer Morton Feldman, when pressed on the place of choice or chance in his compositions. His answer was, succinctly: "Choice, of course. I choose chance."

Arp's great step forward in sculpture occurred at the beginning of the 1930s when he began to work completely in the round, to model clay and plaster for transference into bronze or marble. From the first his freestanding sculptures offered a unique imagery and concept of sculpture, and influenced major sculptors of the next generation— among them Alexander Calder, Henry Moore, and Barbara Hepworth. Arp shared Brancusi's devotion to mass rather than space as the fundamental element of sculpture (fig. 196). He thus stands at the opposite pole from the Constructivists Gabo and Pevsner (figs. 471, 493). In developing the ideas of his painted reliefs, he had introduced seemingly haphazard detached forms that hovered around the matrix like satellites. Thus *Head with Three Annoying Objects* includes a large biomorphic mass on which rest the three objects variously identified as a mustache, a mandolin, and a fly (fig. 384). It had been Arp's custom for the previous ten years to name the objects in his reliefs and collages after the fact, in accordance with the suggested association. This habit of applying titles to completed works was intended to inspire associations or to baffle and infuriate the spectator. It had been introduced by the Dadaists and was then developed by the Surrealists. Also, Arp's

385. JEAN ARP. *To Be Lost in the Woods.* 1932. Bronze. Benjamin Dunkelman Collection, Toronto

sculptural creations, consisting of several elements that could be displaced and adjusted by the spectator, not only influenced Moore and Hepworth, but also continue to influence younger sculptors today.

To Be Lost in the Woods, a work of 1932 and one of Arp's earliest as well as most complex bronzes, includes a base that becomes part of the total design (fig. 385). The base is a pedestal form, an upper and a lower square block joined by two loosely cylindrical and conical shapes. On the upper block rest three organic forms, the two smaller nesting within the larger. This small structure, less than thirty inches in height, embodies forms and ideas that Arp was to explore over the rest

386. JEAN ARP. *Aquatic*. 1953. Marble, height 13″. Walker Art Center, Minneapolis

387. JEAN ARP. *Composition*. 1937. Collage of torn paper, india ink wash, and pencil, 11¾ × 9″. Philadelphia Museum of Art. A. E. Gallatin Collection

of his career. The idea of the base as an integral part of the sculpture came from Brancusi, although the latter normally shaped bases in archaic forms of rough-hewn wood in order to heighten their contrast with the polished finish of marble or bronze (fig. 197). In Arp's sculpture both base and surmounting organic shapes are of bronze, so that the whole is one vari-shaped but unitary structure. The cylindrical or vase shapes of the base recur as late as 1947, and the concept of free forms resting on a receptacle shape reappears then as well as throughout the intervening years.

The most interesting part of *To Be Lost in the Woods* is the cluster of three interlocked organic shapes at the top. The artist here introduces sculptural forms in the round that, although abstract, nevertheless are reminiscent of identifiable portions of human anatomy. In the hands of Arp's followers, the biomorphic sculptural form developed into a major tradition in twentieth-century art. The forms were derived from those in *Head with Three Annoying Objects*, but are now generalized into humanoid abstractions.

To these shapes Arp applied the name "human concretion," a title that had a double significance for him. In 1930 Theo van Doesburg had proposed the name "concrete art" as a more accurate description for abstract art. He contended that the term "abstract" implied a taking away from, a diminution of, natural forms and therefore a degree of denigration. What could be more real, he asked, more concrete than the fundamental forms and colors of nonrepresentational or nonobjective art? Although Van Doesburg's term did not gain universal recognition, Arp used it faithfully, and as human concretions, it has gained a specific, descriptive connotation for his sculptures in the round. He himself said: "Concretion signifies the natural process of condensation, hardening, coagulating, thickening, growing together. Concretion designates the solidification of a mass. Concretion designates curdling, the curdling of the earth and the heavenly bodies. Concretion designates solidification, the mass of the stone, the plant, the animal, the man. Concretion is something that has grown."

This statement could be interpreted as a manifesto in opposition to the Constructivist assertion of the primacy of space in sculpture. More pertinent, however, is its emphasis on sculpture as a process of growth, making tangible the life processes of the universe, from the microscopic to the macrocosmic. Thus a human concretion was not only an abstraction based on human forms but also a distillation in sculpture of life itself.

The art of Jean Arp took many different forms between 1930 and 1966, the year of the artist's death. Abstract (or concrete) forms suggesting gnomes, sirens, snakes, chimeras, clouds, leaves, owls, crystals, shells, buds that were clustered breasts, a cobra-centaur, starfish, seeds and fruit, wineskins, and flowers emerged continually, spaced with forms suggesting such notions as growth, metamorphosis, dreams, and silence. *Aquatic*, a work of 1953 (fig. 386), represents his most explicit figurative sculpture. Here the suggestion of metamorphosis is particularly striking. The artist tells us it may be displayed horizontally or vertically: vertically it is a female nude, horizontally, a finny monster.

While developing his freestanding sculpture, Arp continued to make reliefs and collages. And besides painted reliefs, he experimented with natural woods, stone, and bronze, in regular, loosely geometric, or free forms. His collages of the 1930s were a catharsis from the immaculateness of the sculptures (fig. 387). The change in his approach to collages was described by Arp:

The search for an unattainable perfection, the delusions that a work could be completely finished, became a torment. I cut the papers for

above left: 388. MAX ERNST. *Two Ambiguous Figures.* 1919. Collage with gouache and pencil, 9½ × 6½″. Succession Arp

above right: 389. MAX ERNST. *The Horde.* 1927. 44⅞ × 57½″. Stedelijk Museum, Amsterdam

my collages with extreme precision and smoothed them down with a special sandpaper.... The tiniest crack in a bit of paper often led me to destroy a whole collage.... The word "perfection" means not only the fullness of life but also its end, its completion, its finish; the word "accident" implies not only chance, fortuitous combination, but also what happens to us, what befalls us.... I began to tear my papers instead of cutting them neatly with scissors. I tore up drawings and carelessly smeared paste over and under them. If the ink dissolved and ran, I was delighted.... I had accepted the transience, the dribbling away, the brevity, the impermanence, the fading, the withering, the spookishness of our existence.... These torn pictures, these *papiers déchirés* brought me closer to a faith other than earthly....

Many of these torn-paper collages found their way to the United States and offered a link between organic Surrealism and postwar American Abstract Expressionism.

MAX ERNST The career of Max Ernst as a painter and sculptor, interrupted by four years in the German army, may be said really to have begun when he moved to Paris in 1922. *The Elephant Celebes* was the chief painting of his pre-Paris period (plate 106), although Ernst had produced other works of considerable interest, including paintings and drawings of machine monsters such as *Two Ambiguous Figures* (fig. 388), inspired by Picabia (fig. 333). Aside from these, his Dada collages were of first importance (fig. 343).

The manner of *The Elephant Celebes*, derived principally from De Chirico's early style, continues in *Two Children Are Threatened by a Nightingale*, a 1924 dream landscape with small figures, executed in unbelievably garish color (plate 124). The fantasy is given peculiar emphasis by the elements in actual relief—the house on the right and the open gate on the left. Even the heavy, traditional frame introduces an oppressive note. Contrary to Ernst's usual sequence, the title of this

painting came first. In his biographical summary, speaking in the third person, the artist noted: "...He never imposes a title on a painting. He waits until a title imposes itself. Here, however, the title existed *before* the picture was painted. A few days before, he had written a prose poem which began: *à la tombée de la nuit, à la lisière de la ville, deux enfants sont menacés par un rossignol....* He did not attempt to illustrate this poem, but that is the way it happened."

In 1925 Ernst began to make drawings that he termed *frottage*, or "rubbing," in which he used the child's technique of placing a piece of paper on a textured surface and rubbing over it with a pencil. The resulting image was largely a consequence of the laws of chance. The transposed textures were then reorganized in new contexts, and new and unforeseen associations were aroused. Not only did frottage provide the technical basis for a series of unorthodox drawings; it also intensified Ernst's perception of the textures in his environment— wood, cloth, leaves, plaster, and wallpaper. This perception caused his paintings of the late 1920s and the 1930s to take on an Expressionist appearance (fig. 389; plate 125), one that recalls his devotion to Late Gothic art and to the lush fantasies of nineteenth-century Romantics such as Moreau or Böcklin (figs. 60, 116). This was to be Ernst's most consistent direction for some twenty years, although concurrently he also explored a dozen other avenues that ranged from dissolving, curvilinear figure groups reminiscent of Picasso to isolated, precisely modeled birds in the manner of Magritte. His passion for birds, docile or menacing, was stated in particularly gruesome symbolism in the 1942 *Surrealism and Painting* (fig. 390), showing a monstrous beast made of smoothly rounded sections of human anatomy, serpents, and birds' heads. The monster is daintily making an abstract drawing, perhaps "automatically" and obviously in the all-over manner developed by the postwar Abstract Expressionists (plate 180). Possibly the work reflects something of the continuing warfare between Surrealism and abstraction. The interest in geometry, which Ernst satirized in this and other

above: 390. MAX ERNST. *Surrealism and Painting*. 1942. 76¾ × 91¾″. Private collection, New York

left: 391. MAX ERNST. *Mundus Est Fabula*. 1959. 51¼ × 64″. Collection, The Museum of Modern Art, New York. Gift of the Artist

above left: 392. HENRI CARTIER-BRESSON. *Cordoba, Spain*. 1933. Photograph. ©Henri Cartier-Bresson

above right: 393. MAN RAY. *Untitled*. 1936. Halftone reproduction. Published in *Harper's Bazaar*, November 1936. Courtesy *Harper's Bazaar*

paintings, would nevertheless reappear in his work of the 1950s and 1960s. He explored minute crystalline structures and vast constellations in space to create a universe simultaneously visible in microscope and telescope (fig. 391).

Though Max Ernst had unquestionable significance in the general course of twentieth-century painting since World War I, and despite his undeniably great talents, he remained an eclectic. His brilliant adaptations were haunted by reminiscences of the art he had admired and artists he had worked with. These include not only Late Gothic artists and nineteenth-century Romantics but also De Chirico, Picasso, Picabia, Klee, Magritte, Tanguy, Dali, and the younger Surrealist Matta Echaurren. Certain of Ernst's late assemblages suggested an elegant assimilation of his earliest collages to current Pop Art. Some of these influences were reciprocal in the close-knit world of the Surrealists. And it must be noted that no one encompassed so completely the whole of Surrealism—with the exception of the abstract-organic wing of Arp and Miró. Within Ernst's considerable achievement as a painter, it is the early collages and photomontages that today seem most fresh and individual. Since the early 1930s, Ernst had increasingly turned to sculpture, which will be discussed elsewhere (figs. 441–443).

Photography, with its power to record, heighten, or distort reality, a power vastly increased with the invention of the small, hand-held 35mm Leica, proved a natural, even fertile medium for artists moved by the Surrealist spirit. One of the most remarkable of these was France's Henri Cartier-Bresson (b. 1908), who, after studying painting with the Cubist master André Lhote, took up photography and worked as a photojournalist covering such epochal events as the Spanish Civil War (1936–39). Citing Man Ray, Eugène Atget, and André Kertész as his chief influences, Cartier-Bresson composed, as the Surrealists would say, "automatically"—that is, by allowing his viewfinder to "discover" a composition within the world moving about him. Once this had been seized upon, the photographer printed the whole uncropped negative, an image in which "by chance" the subject is captured in a "decisive moment," a split second when the unreality of reality was revealed in its most significant aspect and most evocative form (fig. 392). Here in a witty juxtaposition of art and life, somewhat like that in Ernst's collages, a substantial lady clasps a hand to her bosom while standing, evidently unaware, before a life-size poster of a model lacing a corset across her chest. Whether photojournalism or high art, Cartier-Bresson's pictures have been universally admired for the timeless beauty of their momentary equipoise among form, expression, and content.

The photographer most consistently liberated by Surrealism was the one-time New York Dadaist Man Ray (figs. 336–338), who after 1921 lived in Paris, there becoming a force within the circle around André Breton. This was true even though in the course of his long and active career Man Ray worked not only in photography but also in painting, sculpture, collage, constructed objects, and film. Moreover, he valued his painting more than his peerless photography, asserting that "I paint what cannot be photographed. I photograph what I do not wish to paint." Regarding one of his most famous paintings, *Observatory Time—The Lovers* executed in 1930–32, Man Ray wrote:

One of these enlargements of a pair of lips haunted me like a dream remembered: I decided to paint the subject on a scale of superhuman proportions. If there had been a color process enabling me to make a photograph of such dimensions and showing the lips floating over a landscape, I would certainly have preferred to do it that way.

To support himself while carrying out such ambitious painting projects, Man Ray did fashion photography and photographic portraits of his celebrated friends in art, literature, and society. For *Harper's Bazaar* in 1936 he posed a model wearing a couturier beach robe against the backdrop of *Observatory Time—The Lovers* (fig. 393), thereby endowing luxury, libido, painting, and photography with the kind of levity, surprise, and Freudian association so revered by the Surrealists.

JOAN MIRÓ (1893–1983) A Catalan born at Montroig near Barcelona, Joan Miró was one of the greatest talents of Surrealism and a master of twentieth-century painting. Although active for many years in Paris, he constantly returned to his native country. In art schools in Barcelona he was introduced to French Romantic and Realist art and then to the Impressionists and Post-Impressionists. His first independent paintings, executed in 1916–18, show that Cézanne and Van Gogh affected him most. But the artist was also beginning to admire contemporary masters, especially Matisse and a fellow Spaniard, Pablo Picasso.

394. JOAN MIRÓ. *Nude with Mirror*. 1919. 44 × 40″. Collection Mr. and Mrs. Pierre Matisse, New York

395. JOAN MIRÓ. *Still Life with Old Shoe*. Paris, 1937. 32 × 46″. Collection, The Museum of Modern Art, New York. James Thrall Soby Bequest

From Matisse he learned how large areas of color and pattern could flatten and control his picture plane. *Nude with Mirror* (fig. 394) combines Cubist faceting, flat-color areas, and geometric pattern with a sculptural figure, the result of which is both serious and ludicrous. It is a combination that pervades Miró's art—scenes of wild humor and fantasy presented in a deadpan manner as seemingly humorless and attentively detailed as Henri Rousseau's.

Miró had become acquainted with the works of the leading avant-garde artists of Paris through reproductions and exhibitions in Barcelona. On his first visit to Paris in 1919, he was warmly received by Picasso, met the leaders of French art and, perhaps through Picasso, became utterly fascinated with Rousseau's painting. Spending winters in Paris and summers in Montroig, the artist continued until 1924 to paint in a vein of geometric, primitive Realism.

In a group of paintings of 1923–24, Miró moved into the realm of fantasy, formulating his vocabulary of the marvelous—almost a new language of twentieth-century art. He had admired Picabia's machine fantasies in Barcelona in 1917. Then during his first Paris years he had naturally been drawn to the Dadaists. Miró found enchantment in Klee's work, and he was particularly friendly with Breton and the other poets who soon launched the Surrealist revolution. Although these factors of environment may explain Miró's desire to enter the world of fantasy and delight, and although a natural inclination to fantasy was evident in his earlier works, these do not yet explain his authoritative creation of this unique world. *Harlequin's Carnival*, one of the first Surrealist pictures (plate 126), takes place within the suggested confines of a room. The perspective of the window opening on the night gives an odd inversion of space. A wild party rages inside, where only the human being is lugubrious, an elegantly mustached man with a long-stemmed pipe, staring sadly at the spectator. Surrounding him is every sort of animal, beastie, or organism, all having a fine time. There is no specific symbolism, simply a brilliant, fantastic imagination that has been given full rein. Certain favorite motifs recur in a number of paintings—the ladder with the ubiquitous ear, the eye, the man with the pipe, the arrow-bird—but the salient points of Miró's art are not iconographical or structural. One element is fantastic humor, of which he, Klee, Arp, and, slightly later, Alexander Calder are the modern masters. The other salient point is the vividness of Miró's unreal world. His organisms and animals, even his inanimate objects, all rendered as flatly abstract, biomorphic shapes, have an eager vitality that makes them more real to us than the crowds we pass daily.

The career of Joan Miró was so prolific, so consistent yet so diversified, that it is difficult to trace in a general account. In the mid-1920s he explored different aspects of his new world, from the complexity of *Harlequin's Carnival* to the magic simplicity of *Dog Barking at the Moon* (plate 127).

In 1928 Miró visited Holland. Inspired by the Dutch little masters, he produced a series entitled Dutch Interiors that exemplifies the metamorphosis from reality to fantasy. Starting from Jan Steen's (1626–1679) painting *The Cat's Dancing Lesson*, Miró transformed it into *Dutch Interior II*, a vivid phantasmagoria of amorphous shapes floating in ambiguous space (plate 128). Most of Steen's original figures and objects have been retained, and it is fascinating to see how they have been interpreted. The figure peering in the window has become a sort of ghostly emanation. The enclosure of Miró's group within the roughly oval ribbons of color, which end in an arrowhead and a little monster, seems to have been inspired by Steen's tightly knit figure composition.

In the late 1920s and early 1930s Miró began to experiment with collage and assemblage, and to create the monster figures that he continued for another decade. Most impressive was the group of large

paintings of 1933, his most abstract up to then. A number were based on collage elements, realistic details torn from newspapers and pasted on cardboard. The motifs—tools, furniture, dishes, and glassware—suggested to him abstract-organic shapes, sometimes with implied faces or figures. The predominantly abstract intent of these paintings is indicated by their neutral titles. *Painting* is almost completely nonfigurative, and most impressive in its shadowed color, soft greens, blues, and graded tones of brown (plate 129). On this background of atmospheric color float abstract-organic shapes, predominantly black. One is outlined in white, two have white areas, one a vivid red, others are merely black outlines. In contrast with Miró's paintings of the 1920s, this work has serenity and mystery, and its color shapes are perhaps closest to those of Arp.

After this quiet and abstract interval, Miró continued his savage paintings. *Nursery Decoration* is the largest (plate 130). Although violent—black and red monsters on a ground predominantly brilliant blue—the beasts are not particularly alarming. One feels the artist's affection for even the fiercest creatures of his imagination. More disturbing is *Still Life with Old Shoe*, displaying the deep reaction of this nonpolitical artist against the Fascists in the Spanish Civil War (fig. 395). Picasso painted his great denunciation *Guernica* for the Spanish Pavilion at the Paris exposition that year (fig. 424). The imagery of *Still Life with Old Shoe* is explicit—the old shoe, the gin bottle, the fork plunged into the apple, the loaf of bread whose cut end becomes a skull—all disposed in an indeterminate space, with revolting color and black and sinister shapes. Again, this is not specific symbolism. The work simply reflects Miró's revulsion against events in his beloved Spain, and he expresses it in objects, colors, and shapes that convey decay, disease, and death. From this time comes Miró's self-portrait, a drawing in which his staring eyes and pursed lips reflect his obsession with the macabre (fig. 396). The harsh draftsmanship and hypnotic frontality mark a reversion to his early style.

With the outbreak of World War II, Miró settled permanently in Palma de Mallorca. The isolation of the war years and the need for contemplation and reevaluation led him to read mystical literature and to listen to the music of Mozart and Bach. Until 1942 he worked on the small gouaches entitled Constellations, which are among his most intricate and lyrical compositions. These works recapture the delicate beauty and gaiety of his paintings of the 1920s, but the artist was now concerned with ideas of flight and transformation as he contemplated the migration of birds, the seasonal renewal of butterfly hordes, the flow of constellations and galaxies (fig. 397). In 1945 the Constellations were shown at New York's Pierre Matisse Gallery, where they affected the emerging American Abstract Expressionist painters. Miró had been shown in New York regularly from 1930, and was better known there than almost any contemporary European master except Picasso and Matisse, and possibly Mondrian and Kandinsky. As the leader of the organic-abstract wing of Surrealism, he had an incalculable impact on younger American painters, then seeking their way out of the morass of Social Realism and Regionalism (plates 177, 180).

By the end of World War II, Miró was working on a large scale, with bold shapes, patterns, and colors. On varied grounds the artist constructed objects, signs, and figures with rough, heavy brushstrokes and intense color. This was his style when he began to work with the ceramist José Artigas, creating pottery, ceramic sculpture, and finally ceramic-tile murals of great strength, including two ceramic murals for UNESCO Headquarters (fig. 398). The scale of the walls and the rough surface of the ceramic tiles inspired deep colors and simple, monumental shapes. Miró and Artigas organized the design on the walls with scrupulous care in relation to the architecture of the buildings. Miró

396. JOAN MIRÓ. *Self-Portrait*. 1937–38. Pencil, crayon, and oil on canvas, 57½ × 38¼". Estate of James Thrall Soby, New Canaan, Connecticut

397. JOAN MIRÓ. *The Poetess*. 1940. Gouache on paper, 15 × 18". Collection Mr. and Mrs. Ralph F. Colin, New York

398. Joan Miró and José Artigas. *Wall of the Sun (Day)*. 1955–58. Ceramic mural, 9′10″ × 49′. UNESCO, Paris

said, "I sought a brutal expression in the large wall, a more poetic one in the smaller. Within each composition I sought at the same time a contrast by opposing to the black, ferocious and dynamic drawing, calm colored forms, flat or in squares." The artists looked back to the prehistoric paintings at Altamira in Spain, to the stone walls of Spanish Romanesque churches, Spanish Romanesque paintings, and to details of Gaudí's Park Güell in Barcelona (fig. 98).

In Miró's work of the 1960s the freshness was in no way diminished, often showing his interest in the American Abstract Expressionists who earlier had been influenced by him. The mural-sized painting *Blue II* of 1961 is an almost pure example of Color Field painting—a great blue ground with a row of brightly colored oval shapes creeping across microorganisms in an emulsion (plate 131).

Surrealism in the 1930s

From its inception, Surrealism in painting took two directions. The first, represented by Miró, André Masson, and, later, Matta, is sometimes called organic Surrealism, or emblematic, biomorphic, or even absolute Surrealism. In this tendency, automatism—"dictation of thought without control of the mind"—is predominant, and the results are generally close to abstraction, although some degree of imagery is normally present. The origins of this wing were in the experiments in chance and automatism carried on by the Dadaists and, earlier, by certain Futurists. The effects, particularly those sought by Masson, were close to and influenced by the automatic writing of Surrealist poets.

The other direction in Surrealist painting is associated with Pierre Roy, Salvador Dali, Yves Tanguy, René Magritte, and Paul Delvaux. It presents, in meticulous detail, recognizable scenes and objects that are taken out of natural context, distorted and combined in fantastic ways as they might be in dreams. Its sources are in the art of Henri Rousseau, Chagall, Ensor, De Chirico, and nineteenth-century Romantics. This wing, called Super-Realism or naturalistic Surrealism, attempts to use

the images of the subconscious, defined by Freud as uncontrolled by conscious reason (although Dali, in his "paranoiac-critical methods," claimed to have control over his subconscious). Freud's theories of the

399. Pablo Picasso. *Minotaure*. 1933. Collage of pencil on paper, corrugated cardboard, silver foil, ribbon wallpaper painted with gold paint and gouache, paper doily, burnt linen leaves, tacks, and charcoal on wood, 19⅛ × 16⅛″. Collection, The Museum of Modern Art, New York. Gift of Mr. and Mrs. Alexandre P. Rosenberg

Colorplate 132. ANDRÉ MASSON. *Pasiphaë.* 1943. Oil and tempera on canvas, 39¾ × 50″. Private collection, Glencoe, Illinois

Colorplate 133. YVES TANGUY. *Mama, Papa Is Wounded!* 1927. 36¼ × 28¾″.
Collection, The Museum of Modern Art, New York

Colorplate 134. YVES TANGUY. *Multiplication of the Arcs*. 1954. 40 × 60″. Collection, The Museum of Modern Art, New York. Mrs. Simon Guggenheim Fund

Colorplate 135. MATTA. *Disasters of Mysticism*. 1942. 38¼ × 51¾″. Estate of James Thrall Soby, New Canaan, Connecticut

Colorplate 136. SALVADOR DALI.
Accommodations of Desire.
1929. Oil on panel, 8⅝ × 13¾".
Collection Mr. and Mrs. Julien
Levy, Bridgewater, Connecticut

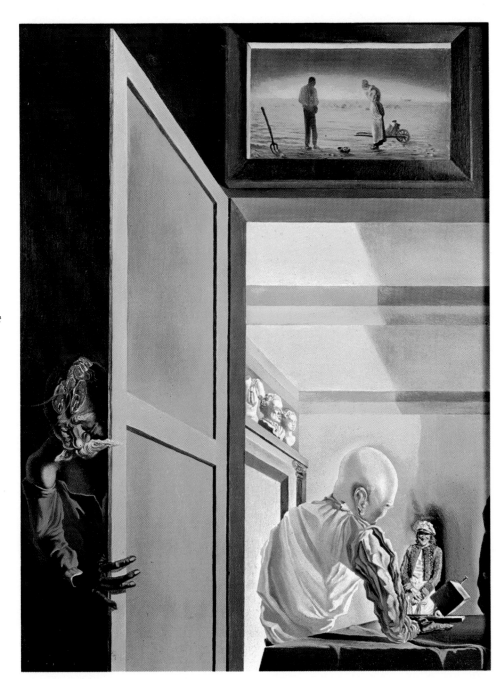

Colorplate 137. SALVADOR DALI.
*Gala and the Angelus of Millet
Immediately Preceding the
Arrival of the Conic
Anamorphoses*. 1933.
9⅜ × 7⅜". Collection Henry
P. McIlhenny, Philadelphia

left: Colorplate 138. RENÉ MAGRITTE. *The False Mirror*. 1928. 21¼ × 31⅞″. Collection, The Museum of Modern Art, New York. Purchase

below: Colorplate 139. RENÉ MAGRITTE. *The Promenades of Euclid*. 1955. 63½ × 51½″. The Minneapolis Institute of Arts

Colorplate 140. PAVEL TCHELITCHEW. *Hide-and-Seek (Cache-cache)*. 1940–42. 78½ × 84¾″. Collection,
The Museum of Modern Art, New York. Mrs. Simon Guggenheim Fund

Colorplate 141. PAUL DELVAUX. *Entrance to the City*. 1940. 63 × 70⅞″.
Collection Mme. Robert Giron, Brussels

Colorplate 142. PABLO PICASSO. *Three Dancers (The Dance)*. 1925. 84⅝ × 56¼″. The Tate Gallery, London

Colorplate 143. PABLO PICASSO. *Seated Bather*. 1930. 64¼ × 51″. Collection, The Museum of Modern Art, New York. Mrs. Simon Guggenheim Fund

Colorplate 145. PABLO PICASSO. *Girl Before a Mirror*. 1932, March 14. 64 × 51¼″. Collection, The Museum of Modern Art, New York. Gift of Mrs. Simon Guggenheim

Colorplate 144. PABLO PICASSO. *Painter and Model*. 1928. 51⅛ × 64¼″. The Sidney and Harriet Janis Collection. Gift to The Museum of Modern Art, New York

287

Colorplate 146. PABLO PICASSO. *Crucifixion*. 1930. Oil on wood, 20⅛ × 26″. Estate of the Artist

Colorplate 147. PABLO PICASSO. *La Joie de vivre*. 1946. 47¼ × 98½″. Musée Grimaldi, Antibes, France

subconscious and of the significance of dreams were, of course, fundamental to all aspects of Surrealism.

No hard-and-fast line can be drawn between the two wings. Artists such as Max Ernst, Kurt Seligmann, and Victor Brauner attempted all variations of Surrealist experiment at different times. Even Masson turned to a naturalistic form of Surrealism in the late 1930s. Picasso, as might be expected, created a Surrealist style of his own. The division between the two wings is apparent, but no precise classification is necessary for such artists as Picasso, Miró, and Arp.

Out of the organic Surrealism of Miró and Masson, and the concepts of automatism and intuitive painting, have emerged many creative directions of Abstract Expressionism and other abstract styles in the later twentieth century. Out of the naturalistic Surrealism, aside from variations on the same theme in the styles of a number of younger exponents, have come certain forms of Magic (or Precise) Realism, on the one hand, and romantic fantasy, on the other. But to the popular imagination it was the naturalistic Surrealism associated with Dali, Tanguy, Roy, and others of that group that signified Surrealism, even though it has had less influence historically than the organic Surrealism of Miró, Masson, and Matta.

It should be remembered that Surrealism was a revolutionary movement not only in literature and art but also in politics. The periodical founded by Breton in 1925 as the voice of Surrealism was named *La Révolution surréaliste*, and it maintained a steady Communist line during the 1920s. The Dadaists at the end of the war were anarchists, and many future Surrealists joined them. Feeling that government systems guided by tradition and reason had led mankind into the bloodiest holocaust in history, they insisted that nongovernment was better, that the irrational was preferable to the rational in art, and in all of life and civilization. The Russian Revolution and the spread of Communism provided a channel for Surrealist protests during the 1920s. Louis Aragon and, later, Paul Éluard joined the Communist Party, while Breton, after exposure to the reactionary bias of Soviet Communism or Stalinism in art and literature, took a position closer to Trotskyism in the late 1930s. Writers were more active than painters in revolutionary propaganda, although Picasso in the 1930s became a Communist in bitter protest against the Fascism of Franco, and continued to maintain that position. Although schisms were occurring among the original Surrealists by 1930, new artists and poets were joining, and Surrealism was spreading throughout the world. Salvador Dali joined in 1929, the sculptor Alberto Giacometti in 1931, Victor Brauner in 1932, Wolfgang Paalen in 1935. Other artists included Paul Delvaux, Henry Moore, Hans Bellmer, Oscar Dominguez, Kurt Seligmann, Roland Penrose, and Matta Echaurren. The list of writers was considerably longer. Surrealist groups and exhibitions were organized in England, Czechoslovakia, Belgium, Egypt, Denmark, Japan, Holland, Rumania, and Hungary. Despite this substantial expansion, internecine warfare resulted in continual resignations, dismissals, and reconciliations. Also, artists such as Picasso were adopted by the Surrealists without joining officially.

During the 1930s the major publication of the Surrealists was the lavish journal *Minotaure*, founded in 1933 by Albert Skira and E. Tériade. Although emphasizing the role of the Surrealists, the editors drew into their orbit any of the established masters of modern art and letters who they felt had made contributions. These included artists as diverse as Matisse, Kandinsky, Laurens, and Derain. Picasso made the cover design for the first issue, a collage having in its center a Classical drawing of the minotaur holding a short sword (fig. 399). His association with the journal may have fostered his interest in the beast.

ANDRÉ MASSON (b. 1896) Among the first Surrealist artists, André Masson was the most passionate revolutionary, a man of violent convictions who had been deeply scarred, spiritually even more than physically, by his war experiences. Wounded almost to the point of death, he was long hospitalized. After partially recovering, he continued to rage against the insanity of man and society until this led to his confinement for a while in a mental hospital. Masson was by nature an anarchist, his convictions fortified by his experience. His belief that the rational must be dominated by the irrational did not come by any rational process.

The paintings done by Masson in the early 1920s reveal the artist's debt to Cubism, particularly that of Juan Gris, and he kept the structure and space of Cubism in his early experiments with automatism and Expressionist fantasies, as in *Wreath*, a work of 1925. In that year Masson was regularly contributing automatic drawings to *La Révolution surréaliste*, works that directly express his emotions and contain various images having to do with the sadism of man and the brutality of all living things, down to fishes and insects. Scenes of massacres abound, as in *Battle of Fishes* (fig. 400). Accompanying this bitter pessimism is a passionate hope, through painting, to be able to find and express the

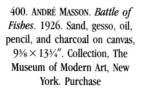

400. ANDRÉ MASSON. *Battle of Fishes*. 1926. Sand, gesso, oil, pencil, and charcoal on canvas, 9⅜ × 13¾". Collection, The Museum of Modern Art, New York. Purchase

401. YVES TANGUY. *The Storm*. 1926. 32 × 25¾". Philadelphia Museum of Art. Louise and Walter Arensberg Collection

402. YVES TANGUY. *The Furniture of Time*. 1939. 46 × 35¼". Collection, The Museum of Modern Art, New York. James Thrall Soby Bequest

mysterious unity of the universe hinted at in primitive myths and religions.

In the late 1930s, after living principally in Spain for two years, Masson temporarily turned to the other, naturalistic, wing of Surrealism. He painted monstrous, recognizable figures in a manner influenced by Picasso and possibly Dali. With the coming of World War II, he moved to the United States and exhibited regularly in New York, exercising influence on some of the younger American painters. In New York he reverted to a somewhat automatist, Expressionist approach in works such as *Pasiphaë* (plate 132). Masson, after his return to France in 1945, sought tranquillity in a new approach to Expressionism. In the 1960s he turned to an abstract Surrealism or Expressionism that suggests a reverse influence from Abstract Expressionism.

Despite the violence and integrity of his emotional response and his historical significance in linking European Surrealism and American Abstract Expressionism, Masson must be considered a talented eclectic whose major personal contribution was made in the 1920s.

YVES TANGUY (1900–1955) Tanguy had literary interests and close associations with the Surrealist writers Jacques Prévert and Marcel Duhamel in Paris after 1922, but he was instinctively drawn to painting as his personal means of expression. With his friend Prévert he discovered the writings of Lautréamont and other prophets of Surrealism. At the same time, despite a complete lack of training, Tanguy was making sketches for his own amusement, and in 1923, inspired by a De Chirico painting in the window of the dealer Paul Guillaume, he began to paint

in earnest. Until 1926 he painted assiduously in a naïve manner, and then just as assiduously destroyed the canvases. After meeting André Breton, Tanguy began contributing to *La Révolution surréaliste* and was adopted into the Surrealist movement. Suddenly, in *The Storm* of 1926, a personal manner emerged, having the mystery of ocean depths, a luminescent darkness in which float manifestations of primordial life (fig. 401). Tanguy's subsequent progress was incredible, in both technique and fantastic imagination. *Mama, Papa Is Wounded!* was the masterpiece of this first stage and exhibited all the obsessions that were to haunt him for the rest of his career (plate 133). The first of these was an infinite perspective depth, rendered simply by graded color and a sharp horizon line—a space that combines vast emptiness and intimate enclosure, where ambiguous little organic shapes are floating, isolated but at home. The fantasy of this untrained artist so perfectly expressed the Surrealist credo that Tanguy himself almost seems a product of Breton's imagination.

The submarine, or subterranean, atmosphere of these first Surrealist paintings continued until 1930, in works filled with a romantic atmosphere of the hidden worlds of the microscope. After making a visit to Africa in 1930 and 1931, where he saw brilliant light and color, Tanguy began to define his forms precisely and expose them to a cruel sunlight. The space in his paintings during the 1930s became vast; earth merges imperceptibly with sky at an indefinable distance. *The Furniture of Time* offers no points of reference for measuring the space in which the curious objects drift aimlessly and uneasily (fig. 402). The objects are hard, mineral, or bonelike, yet they seem animated by some vestigial

life from a destroyed universe. It is as though the artist had some premonition of the fears that would later haunt the world in the first and perhaps the last age of the atomic bomb.

Having arrived at his particular vision, Tanguy's art changed only in degree, not in kind. After moving to the United States in 1939 and settling in Woodbury, Connecticut, with his wife, the American Surrealist painter Kay Sage, he continued to evoke his barren, destroyed universe. In his last painting, *Multiplication of the Arcs* (plate 134), the objects fill the ground area back to a newly established horizon line, to create an enigmatic, foreboding scene that James Thrall Soby called "a sort of boneyard of the world." Some form of life—animal? vegetable? mineral?—seems to have reconquered the devastated cosmos.

There is a hypnotic pattern about Tanguy's paintings. Once the artist had established his image in 1926, he varied it only after careful deliberation. He had only one real image: a desolate universe in which some primitive life struggles to survive. This limitation produced one of the most pertinent and prophetic concepts in modern art.

MATTA (b. 1912) When he migrated to the United States in 1939, Chilean-born Matta (Sebastian Antonio Matta Echaurren) was relatively little known despite his association with the Surrealists in Paris. His one-man show at the Julien Levy Gallery in 1940 was so completely outside the experience of most American experimental artists that its impact was momentous. Although Matta, the last painter, along with Arshile Gorky, claimed for Surrealism by André Breton, was much younger than most of his expatriate European colleagues and less well known, his paintings marked a step of liberation, beyond even the most advanced of the European Surrealists, and represented the step forward that American artists were seeking. Over the next few years, together with the American painter Robert Motherwell, Matta helped to bridge the gap between European Surrealism and the American movement to be called Abstract Expressionism. Matta's painting at that point is exemplified in the 1942 *Disasters of Mysticism* (plate 135). Although this has some roots in Masson and Tanguy, it is a lyrical excursion into fantasy, different from either. In its ambiguous, "automatist" flow, from brilliant flame-light into deepest shadow, it suggests the ever-changing universe of outer space. The concern with a kind of space fantasy obsessed Matta more and more in his later work, where paintings became machines dedicated to some incomprehensible battle of planets or robots. Although in the later paintings fantastic subject became more explicit, those executed between 1940 and 1944 were influential because of their expression of violent but indefinable conflicts through abstract means.

SALVADOR DALI (b. 1904) The artist who above all others symbolizes Surrealism in the mind of the general public is the Spaniard Salvador Dali. Not only his paintings, but his writings, his utterances, his actions, his appearance, his mustache, his genius for publicity—with all of these he has made the word Surrealism a common noun in all languages, denoting an art that is irrational, erotic, insane—and fashionable. Dali's life itself has been so completely Surrealist that his integrity and his pictorial accomplishment have been questioned, most bitterly by other Surrealists. The primary evidence must be the paintings themselves, and no one can deny the immense talent, the power of imagination, or the intense conviction that they display.

Dali was born at Figueras, near Barcelona. Like Picasso, Miró, and, before them, Gaudí, he is a product of the Catalan environment. A substantial part of the iconography of Dali, real or imagined, is obviously taken from scenes of his childhood and adolescence. The landscape of

these early years is constantly in his paintings, which are marked by the violence of his temperament—ecstatic, filled with fantasy, terror, and megalomania. Barcelona at the end of World War I was influenced by Italian and French art, and Dali encountered, successively, Impressionism, Neo-Impressionism, and Futurism before he went to Madrid's Academy of Fine Arts in 1921. He followed the normal academic training, developing a highly significant passion for nineteenth-century academicians and Romantics such as Jean-François Millet, Arnold Böcklin, and particularly the meticulous narrative painter Ernest Meissonier. His discoveries in modern painting during the early 1920s were De Chirico, Carrà, and the Italian Metaphysical School, whose works were reproduced in the periodical *Valori Plastici*. More important for his development was the discovery of Freud, whose writings on dreams and the subconscious seemed to answer the torments and erotic fantasies he had suffered since childhood. His friendship with the Spanish poet Federico García Lorca, who frequently expressed his dreams and fantasies through drawings of exquisite, romantic sensibility, may have led Dali to the opposite extreme of attempting to create, through precise *trompe-l'oeil* technique, a dream world more tangibly real than observed nature. Between 1925 and 1927 he explored several styles: the Cubism of Picasso and Juan Gris, the Neoclassicism of Picasso, and a precise Realism derived from Vermeer.

In 1928 Dali visited Paris and met the Surrealists. In 1929 he moved there, to become an official member of the group, and in that year he married Gala Éluard, formerly the wife of the Surrealist writer Paul Éluard. He had by now formulated the theoretical basis of his painting, described as "paranoiac-critical": the creation of a visionary reality from elements of visions, dreams, memories, and psychological or pathological distortions.

Out of his academic training and his admiration for such masters as Vermeer and Meissonier, Dali developed an incredibly precise miniature technique, accompanying with a particularly disagreeable, discordant, but luminous color derived from the Romantic Realists and tinted photographs (he has referred to his paintings as "hand-painted dream photographs"). He frequently used familiar objects as a point of departure—Millet's sentimental painting *The Angelus*, watches, insects, pianos, telephones, old prints or photographs—many having fetishist significance. He declared his primary images to be blood, decay, and excrement. From the commonplace object Dali set up a chain of metamorphoses gradually or suddenly dissolving and transforming the object into a nightmare image, given conviction by the hard Realistic technique. In collaboration with Luis Buñuel, Dali turned to the cinema and produced two documents in the history of film fantasy, *Un Chien Andalou* (1929) and *L'Âge d'or* (1930). The cinema medium had infinite possibilities for the Surrealists, in the creation of dissolves, metamorphoses, and double and quadruple images, and Dali made brilliant use of these.

In his first fantastic paintings Dali discarded all the influences of Cubism, Classicism, or Impressionism and introduced the microscopic Realism of his developed style. Matured with amazing rapidity, he produced *Illumined Pleasures* and *Accommodations of Desire* in 1929 (fig. 403; plate 136). By then he had joined the Paris Surrealists and had been exposed to ideas of Ernst, Miró, and Tanguy. With its repeated variations of the snarling lion's head in process of continuous transformation, *Accommodations of Desire* exemplifies the artist's determination to create a super-reality by ruthless objectification of the dream, and to paint like a madman—not in an occasional state of receptive somnambulism, but in a continuous frenzy of induced paranoia. In his book, *La Femme visible* (1930), Dali wrote: "I believe the moment is

at hand when, by a paranoiac and active advance of the mind, it will be possible (simultaneously with automatism and other passive states) to systematize confusion and thus to help discredit completely the world of reality." By 1930 Dali had left De Chirico's generalized dream world for his own world of violence, blood, and decay. He sought to create in his art a specific documentation of Freudian theories applied to his own inner world. He started a painting with the first image that came into his mind and went on from one association to the next, multiplying images of persecution or megalomania like a true paranoiac. He defined his paranoiac-critical method as a "spontaneous method of irrational knowledge based upon the interpretative-critical association of deliri-ous phenomena."

Dali shared the Surrealist antagonism to formalist art, from Neo-Impressionism to Cubism and abstraction. *The Persistence of Memory* of 1931 is a denial of every twentieth-century experiment in abstract organization (fig. 404). Its miniature technique goes back to the Flem-ish art of the fifteenth century, and its sour greens and yellows recall nineteenth-century chromo-lithographs. The space is as infinite as Tan-guy's, but rendered with hard objectivity. The picture's fame comes largely from the presentation of recognizable objects in an unusual con-text, with unnatural attributes. The limp watches, in fact, have become a popular visual synonym for Surrealist fantasy.

Dali's painting during the 1930s vacillated between an outrageous fantasy and a strange atmosphere of quiet achieved less obviously. *Gala*

403. SALVADOR DALI. *Illumined Pleasures*. 1929. Oil and collage on composition board, 9⅜ × 13¾". The Sidney and Harriet Janis Collection. Gift to The Museum of Modern Art, New York

404. SALVADOR DALI. *The Persistence of Memory*. 1931. 9½ × 13". Collection, The Museum of Modern Art, New York. Given anonymously

and the Angelus of Millet Immediately Preceding the Arrival of the Conic Anamorphoses exemplifies the first aspect (plate 137). In the back of a brilliantly lighted room is Gala, grinning broadly, as though snapped by an amateur photographer; in the front sits an enigmatic male. Over the open doorway is a print of Millet's *Angelus*, a sexual fetish for Dali. Around the open door a monstrous comic figure emerges from the shadow, wearing a lobster on his head. There is no rational explanation for the juxtaposition of familiar and phantasmagoric, but the nightmare is undeniable.

In another portrait of Gala nothing is distorted or overly fantastic, yet the impact is greater (fig. 405). Gala sits in the immediate foreground with her back to the spectator, a somewhat matronly figure in a figured jacket. She also sits, a mirror image, facing herself, against the opposite wall. Behind her head is another version of Millet's *Angelus*. The two Galas sit on different seats, and there is no mirror. Dali has produced this strangely moving painting by very simple means. The mirror image as an instrument of fantasy has intrigued other artists. It occurs, for example, in Van Eyck's portrait of Arnolfini and his wife in the fifteenth century, in Italian Mannerist portraits by Parmigianino in the sixteenth, and in works by Vermeer and Velázquez (*Las Meninas*) in the seventeenth. Baroque and Rococo stage designers were also fascinated by the visual implications of mirror images, and in the twentieth century Picasso used the theme in his Surrealist works of the 1920s, producing a masterpiece in 1932 with *Girl Before a Mirror* (plate 145). Dali's version probably owes most to those of his idol, Vermeer—either *The Artist in His Studio* or, even closer, *The Letter*.

In 1941 came a transition in the career of Salvador Dali, who announced his determination to "become Classic," to return to the High

405. SALVADOR DALI. *Portrait of Gala*. 1935. Oil on wood, 12¾ × 10½". Collection, The Museum of Modern Art, New York. Gift of Abby Aldrich Rockefeller

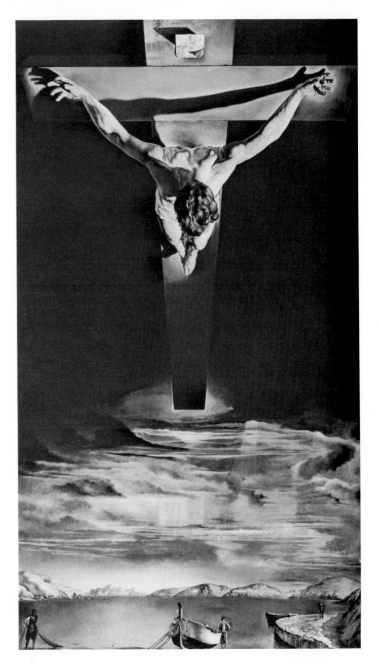

406. SALVADOR DALI. *The Crucifixion*. 1951. 80⅝ × 45⅝". Glasgow Art Gallery and Museum

Renaissance of Raphael. When he had met Sigmund Freud in London in 1938, shortly before the psychoanalyst's death, Freud commented: "What interests me in your art is not the unconscious but the conscious." Whether this remark was satiric or serious, it is pertinent in evaluating Dali's induced paranoia. In the late 1930s the artist was moving away from Surrealism toward both a Renaissance ideal Classicism and the developing Neo-Romanticism of Christian Bérard, Eugène Berman, and Pavel Tchelitchew (figs. 415–417). Dali had already been expelled from the Surrealist party in 1934 by André Breton (who spent much time expelling heretics and welcoming new converts).

In 1940 Dali moved to the United States. His notoriety and fashionable acceptance reached their height with designs for the theater, smart shops, periodicals, jewelry, and objets d'art. Since 1950 his principal works have been devoted to Christian religious art exalting the mystery of Christ and the Mass. Large examples now hang in the Glasgow Art Gallery and Museum (fig. 406), the National Gallery of Art, Washington, D.C., and New York's Metropolitan Museum of Art.

RENÉ MAGRITTE (1898–1967) In contrast to Dali, René Magritte has been called the invisible man among the Surrealists. George Melly, in the script for a BBC film on Magritte, wrote: "He is a secret agent; his object is to bring into disrepute the whole apparatus of bourgeois reality. Like all saboteurs, he avoids detection by dressing and behaving like everybody else." Thanks perhaps to the artist's anonymity, the works of Magritte have had gradual but overwhelming impact, like a glacial flow.

After years of sporadic study at the Brussels Academy of Fine Arts, Magritte, like Tanguy, was shocked into realizing his destiny when in 1922 he saw a reproduction of De Chirico's 1914 painting *The Song of Love*. In 1926 he emerged as an individual artist with a style based on that of De Chirico. In that year Magritte, with *The Menaced Assassin* (fig. 407), summarized the elements he was to use in a lifetime of paintings, their shock based equally on the strange, the erotic, and the ordinary. The barren perspective space is derived from De Chirico and from the flimsy unreal stage sets of early cinema melodramas. The action partakes of these scenes. Its horror is clearly synthetic and, in a strange reversal, so becomes more horrible. The murdered girl is a department-store mannequin whose nude body yields real blood. The assassin, listening soulfully to the gramophone, is a clothes model whose painted wax face is identical with those of the watchers at the back window and the detectives lurking in front. And Magritte himself is, simultaneously, the anonymous, unseen man in the bowler hat, the assassin, the saboteur, the watcher, the secret agent.

During that same year Magritte joined other Belgian writers, musicians, and artists in an informal group comparable to the Paris Surrealists. He then moved to a Paris suburb and participated for the next three years in Surrealist affairs. Wearying of the frenetic, polemical atmosphere of Paris, he returned to Brussels in 1930 and lived there quietly for the rest of his life. Because of this withdrawal from the art centers of the world, Magritte's paintings did not receive the attention they deserve. With important exhibitions in Europe and the United States since World War II, climaxed by the retrospective at New York's Museum of Modern Art in 1965, the artist's unique contribution to Surrealism and the history of fantasy is now recognized.

After 1926 Magritte changed his style of precise, Magic Realism very little, except for temporary excursions into other manners, and because he frequently returned to earlier subjects, it is difficult to establish the chronology of his undated works. *Man with Newspaper* (fig. 408) shows four identical views of the window corner in a modest café—identical, that is, except that the man appears only in the first; in the other three he has vanished. That is all; yet the sense of melodrama is acute. Again one is reminded of the silent motion picture of the early 1920s, the four views suggesting four frames of the film. The setting has the insubstantial, barren look of early cinemas, and the next event in the drama might be the disappearance of the room itself. Magritte was fascinated by the unreality of early efforts in film realism, and as a boy, he had delighted in "Fantomas," penny thriller mysteries. Drawing on these sources, he extracted their essence in his fantasies of the commonplace. To this offshoot of Surrealism the name Magic Realism is given. Magic Realism, which flourished in Europe and America in the 1930s and 1940s, is the precise, realistic presentation of an ordinary scene with no strange or monstrous distortion. The magic arises from the fantastic juxtaposition of elements or events that do not normally belong together. De Chirico's paintings might be better described as Magic Realist than Surrealist. Other Surrealists have used devices of Magic Realism, but Magritte (with Pierre Roy) is the major master of the approach.

The perfect symbol (except that Magritte disliked attributions of specific symbolism) for his approach is the painting entitled *The Treachery*

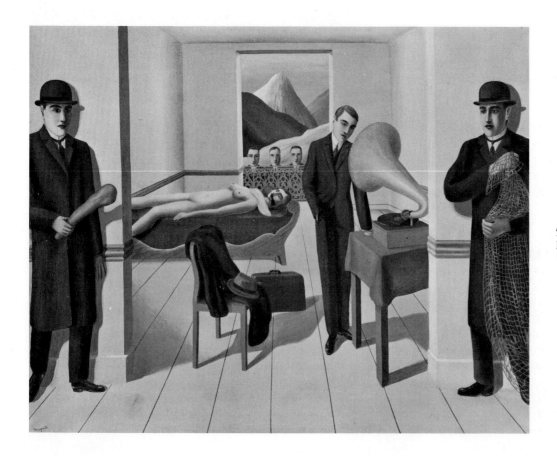

407. RENÉ MAGRITTE. *The Menaced Assassin.* 1926. 59¼ × 76⅞". Collection, The Museum of Modern Art, New York. Kay Sage Tanguy Fund

(or Perfidy) of Images (fig. 409). It portrays a briar pipe so meticulously that it might serve as a tobacconist's trademark. Beneath, rendered with comparable precision, is the legend *Ceci n'est pas une pipe* ("This is not a pipe"). This delightful work confounds pictorial reality. A similar idea is embodied in *The False Mirror* (plate 138): the eye as a false mirror when it views the white clouds and blue sky of nature. This might be another statement of the artist's faith, for *The False Mirror* introduces the illusionistic theme of the landscape that is a painting, not nature. The problem of real space versus spatial illusion is as old as painting itself, but here it is imaginatively treated. Magritte's studies include many variations of the theme, the simplest of which shows an easel with a painted canvas in front of a window. Through the window is a landscape, and the scene on the painted canvas exactly replaces that segment which it reproduces, carrying the problem of nature-illusion-painting into a fourth dimension (plate 139). *The Promenades of Euclid*, the work seen here, depicts a cityscape with a great avenue in abrupt perspective. The avenue becomes, visually, a triangle that reiterates the conical shape of the adjacent tower. Thus the promenade becomes Euclidean. The Gothic tower recalls Magritte's Flemish antecedents in painting, Van Eyck and Rogier van der Weyden, who also painted views through a window. But here it is the illusion and the illusion of a semblance—the painted picture as part of a painted picture—that is so fascinating.

Magritte has explored aspects of the gruesome that sometimes verge on the revolting. The succinctly titled *Portrait* (fig. 410) is a still life of a succulent slice of ham accompanied by wine bottle, glass, knife, and

left: 411. RENÉ MAGRITTE. *Perspective: Madame Récamier of David*. 1951. 24½ × 32⅛". Private collection

below: 412. HANS BELLMER. *Doll*. 1937. Wood, metal, and papier-mâché. Private collection

fork, all drawn with the utmost precision. The table on which they rest is a vertical rectangle of dark gray. Out of the center of the slice of ham stares a human eye. It is difficult to explain why this rather obvious juxtaposition should be so shocking. One is reminded of the little man in an early film who, served with a plate containing two fried eggs, screamed: "Take them away! They're staring at me!"

Much of Magritte's iconography was established early in the 1930s, but his variations have been infinitely ingenious. The Classical tradition continued, for example, in macabre but somehow amusing variants on David's *Madame Récamier* and Manet's *Balcony*, with elegant coffins substituted for the figures (fig. 411).

In certain pictures of the 1950s, Magritte calcified all the parts—figures, interiors, landscapes, objects—into a single rock texture. The basic forms and themes, however, continued the fantasy of the commonplace through the 1960s. A midnight street scene is surmounted with the blue sky and floating clouds of noon; jockeys race over cars and through rooms; or an elegant horsewoman passing through a forest is segmented by the trees. But Magritte's world always contains the unobtrusive, invisible man in bowler hat and black topcoat, singly and in groups, as in *Golconda* (1953), where a swarm descends over the city.

Second-Wave Surrealists

In 1923 Polish-born Hans Bellmer (1902–1975), a graphic artist trained at the Berlin Technical School, began assembling strange constructions called "dolls," adolescent female mannequins whose articulated and ball-jointed parts—heads, arms, trunks, legs, wigs, glass eyes—could be dismembered and reassembled in every manner of erotic or masochistic posture (fig. 412). The artist then photographed the fetishistic objects, whose hallucinatory and near pornographic arrangements appealed to the Surrealists. This led to publication in a 1934 issue of *Minotaure*, under the title *Poupée* ("Doll"), a career for the artist in the Surrealist milieu of Paris, and a place for his camera-made images in the history of photography. Bellmer also vented his rather Gothic imagination in a number of splendid, if sometimes unpublishable, drawings. Oscar Dominguez (1906–1957), a Spaniard noted for his assemblage of found objects, also contributed to the Surrealists the technique known as decalcomania: inks or watercolor paints transferred from one sheet of paper to another under pressure

(fig. 413). The process appealed to the Surrealists—particularly Max Ernst—for its startling automatic effects. Meret Oppenheim (b. 1913) attained fame with her *Object*, a cup, plate, and spoon covered with fur (fig. 414). The "fur-lined tea cup" has become a synonym for all the vagaries of Surrealism.

Neo-Romanticism

Neo-Romanticism and Magic Realism are two of the most clearly definable reactions related to Surrealism in the 1930s. It is not quite correct to call these tendencies offsprings of Surrealism, since they paralleled its development. In a larger sense they were part of the manifold reaction against Cubism and abstraction. It is difficult, however, to conceive of their ultimate concentration on effects of mystery and fantasy without the climate of Surrealism.

413. OSCAR DOMINGUEZ. *Untitled*. 1936. Gouache (decalcomania),
14⅛ × 11½". Collection, The Museum of Modern Art, New York. Purchase

414. MERET OPPENHEIM. *Object*. 1936. Fur-covered cup, 4⅜" diameter;
saucer, 9⅜" diameter; spoon 8" long. Collection, The Museum of Modern
Art, New York. Purchase

Neo-Romanticism involved four key figures: Christian Bérard
(1902–1949); the brothers Eugène Berman (1899–1972) and Léonid
Berman (b. 1896), who painted under the name of Léonid; and Pavel
Tchelitchew (1898–1957). The Bermans and Tchelitchew were Rus-
sian by birth and lived for a period in the United States during and after
World War II. Bérard and Eugène Berman achieved distinction as the-
ater designers, particularly for the Ballets Russes de Monte Carlo. Ber-
man and the other Neo-Romantics, in reaction both to abstraction and
Surrealism, sought lyrical qualities and the return to man, his emotions,
and his immediate environment. Berman, in particular, had been fasci-
nated continually by a romantic image of Italy and its past (fig. 415).
Léonid early was attracted to seascapes, particularly shore scenes when
the tide was out. These became vast areas of sand and sky rendered in
precise draftsmanship and neutral colors. Bérard's double self-portrait,
On the Beach (fig. 416), using these same empty spaces of sea and sky

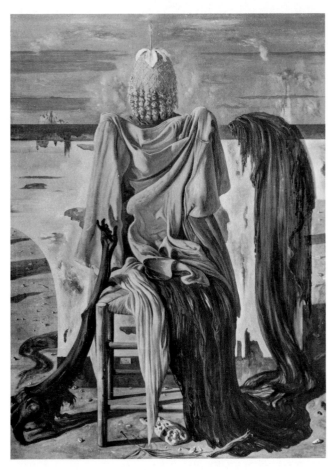

415. EUGENE BERMAN. *Muse of the Western World*. 1942. 50⅞ × 37¾". The
Metropolitan Museum of Art, New York. George A. Hearn Fund, 1943

416. CHRISTIAN BERARD. *On the Beach (Double Self-Portrait)*. 1933.
31⅞ × 46". Collection, The Museum of Modern Art, New York. Gift of
James Thrall Soby

417. PAVEL TCHELITCHEW. *Still Life Clown*. 1930. 39½ × 25⅝″. Art Institute of Chicago

418. PIERRE ROY. *Danger on the Stairs*. 1927 or 1928. 36 × 23⅝″. Collection, The Museum of Modern Art, New York. Gift of Abby Aldrich Rockefeller

for a background to a photographic self-portrait, is turned into fantasy by the second head peering across its own arm. No distortions or fantastic images are used; yet this work becomes Surrealist through the inexplicable second self. Tchelitchew in the same way translated reality into fantasy, so that familiar objects create an unfamiliar illusion (fig. 417). In his monumental painting *Hide-and-Seek* he deserted Romantic Realism in a weird dissection of inner anatomies (plate 140).

Magic Realism

The line between Surrealism and what is variously called Magic Realism, Precise Realism, or Sharp-Focus Realism is even more difficult to draw than that between Surrealism and Neo-Romanticism. In general, the Magic Realists, deriving directly from De Chirico, created mystery and the marvelous through juxtapositions that are disturbing even when it is difficult to see exactly why. The Magic Realists, even though they may not indulge in Freudian dream images, were interested in translating everyday experience into strangeness (see also p. 246 and, for another type of Magic Realism, pp. 294–95).

PIERRE ROY (1880–1950) Pierre Roy, one of the original Surrealists, later disowned by them, may be considered an immediate father of Magic Realism. His *Danger on the Stairs* is an overt example of fantastic dissociation, but nonetheless effective for that (fig. 418). It is melodramatically obvious, but the precise rendering, the elimination of all extraneous elements, and the inexplicability of the event make it frightening.

PAUL DELVAUX (b. 1897) Paul Delvaux, like Magritte a long-time resident of Brussels, came to Surrealism slowly. Beginning in 1935, he painted his dream of fair women, usually nude but occasionally clothed in chaste, Victorian dress. They are like sleepwalkers in a dream world of Classical temples, Renaissance perspective, or Victorian architecture. Occasionally lovers appear, but normally the males are shabbily dressed scholars, intent on personal problems and strangely oblivious of the women. *Entrance to the City* gives the basic formula (plate 141): a spacious landscape; nude girls wandering about, each lost in her own dreams; clothed male figures, with here a partly disrobed young man studying a large plan; here also a pair of embracing female lovers and a bowler-hatted gentleman (reminiscent of Magritte) read-

ing his newspaper while walking. The chief source seems to be fifteenth-century perspective painting, and even the feeling of withdrawal in the figures suggests the influence of Piero della Francesca (fig. 4) translated into Delvaux's peculiar personal fantasy.

Though not a major original master of fantasy, Delvaux created a dream world that is nevertheless compelling, meticulously rendered, richly and sensitively colored, and filled with a nostalgic sadness that transforms even his erotic nudes into something elusive and unreal.

Pablo Picasso and Surrealism

In 1920 Picasso transformed a Classical figure study, *By the Sea*, into a fantasy by grotesquely distorting the figures (fig. 376). This was one of the few such experiments among his Classical works, but the developed Synthetic Cubist *Three Musicians* of 1921 and the curvilinear Cubist paintings of 1923–25 show that the artist was exploring aspects of fantasy in other ways (plates 118–120). By then Picasso was well aware of the Paris Dadaists, knew Breton, and had been adopted by the Surrealists. He contributed some abstract drawings to the second number of *La Révolution surréaliste* (January 15, 1925), and in the fourth number (July 15, 1925) André Breton, the editor, included an account of *Les Demoiselles d'Avignon*, reproduced collages by Picasso and his new painting, *Three Dancers* or *The Dance* (plate 142). From 1923 to 1925 come some of the artist's most classically lyrical drawings of dancers (fig. 419), but the new painting was a startling departure from these. In a room that combines Cubist space with a suggestion of perspective depth like Picasso's other great Cubist paintings of this period, three weird figures perform an ecstatic dance. The figures to the right are jagged and angular, while the figure to the left is curvilinear and abandoned. Picasso used every device in the Cubist figure vocabulary—simultaneous views, full face and profile, hidden or shadow profiles,

faceting, interpenetration—to create a fantastic image. This painting is almost as important a milestone in Picasso's development as the *Demoiselles d'Avignon* of 1907.

In the late 1920s and the 1930s Picasso followed *Three Dancers* with an outburst of fantasy in painting and sculpture so rich that it cannot be tabulated, much less classified. The sculpturesque Classical paintings (figs. 372–375) were transformed into a series of metamorphic organisms derived from his various Bathers on the Beach. These organisms led him to return to sculpture, which he had neglected since 1914. In 1928 he made sketches for sculptural monuments that were assemblages of bonelike figures. These "bone figures" continued into the 1930s and recurred at intervals for the rest of his life. An early masterpiece is *Seated Bather* (plate 143), which is part skeleton, part petrified woman, and all monster, taking her ease in the Mediterranean sun. Pencil drawings published in 1933 in *Minotaure*, the lavish Surrealist journal of the 1930s, illustrate the artist's fertile imagination in creating figure sculptures that are partly living organisms and partly machines. *Girls with a Toy Boat* combines sculptural structure with curvilinear, pneumatic effects (fig. 420). There is a curious humanity about all these monsters. *Seated Bather* has the nonchalance of a bathing beauty, and these two girls concentrate on their boat like children (although they do not appear particularly childlike). The head that peers over the distant horizon is less menacing than interested in their play.

The kind of elastic distortion achieved by Picasso through sheer force of imagination opened a rich vein of possibilities for photography, equipped as this medium was with every sort of optical device. Within the same period that the Spanish master painted *Girls with Toy Boat*, André Kertész, already seen in figure 364, was creating similar funhouse effects by photographing a nude model reflected in a special mirror (fig. 421). Even after World War II, England's Bill Brandt (1906–1983) rediscovered his early days in Surrealist Paris, where he

left: 419. PABLO PICASSO. *Four Dancers*. 1925. Pen and ink, 13⅞ × 10″. Collection, The Museum of Modern Art, New York. Gift of Abby Aldrich Rockefeller

below: 420. PABLO PICASSO. *Girls with a Toy Boat*. 1937. Oil, pastel, and crayon on canvas, 50½ × 76¾″. Peggy Guggenheim Foundation, Venice

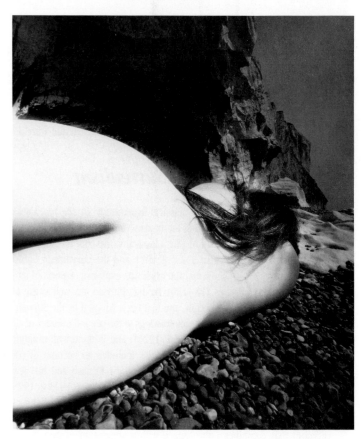

421. ANDRÉ KERTESZ. *Distortion No. 4.* 1933. Gelatin-silver print. ©Estate Kertesz

422. BILL BRANDT. *Nude, East Essex Coast.* 1953. Gelatin-silver print. ©Bill Brandt

had studied under Man Ray, and gave up documentation, a type of photography for which he was famous, in favor of reexploring the "poetry" of optical distortion, or what the artist called "something beyond reality" (fig. 422). Once again the subject was the female nude, this time however transformed into a Surreal dream landscape by means of an extremely wide-angle lens and a tiny aperture.

Picasso's accomplishment since 1925 can perhaps best be summarized by particular themes. One is the artist in his studio, a favorite subject with the Cubists because it permitted familiar, easily accessible scenes and objects to be examined. Picasso returned to the theme in the 1920s, not to reconstitute plastic reality but rather to reexamine the nature of reality itself. His interest may have been aroused by a commission from Ambroise Vollard to provide drawings for an edition of Balzac's *Le Chef-d'oeuvre inconnu (The Unknown Masterpiece)*, published in 1931 (fig. 423). This story concerns a deranged painter who spent ten years painting the portrait of a woman and ended with a mass of incomprehensible scribbles. Picasso's interpretation may show his disbelief in absolute abstraction, although he also included a number of line-and-dot drawings (1926) that are more abstract than anything he did before or since. In a richly coloristic work of 1928 he introduced a note of fantasy (plate 144). Here reality and illusion are reversed, and painter and model become Surrealist ciphers, but the portrait on the artist's canvas is a Classical profile. Picasso would return to the theme time after time.

In *Girl Before a Mirror*, a key painting of the 1930s (plate 145), Picasso played a further variation on this theme. It has brilliant color and assimilates Classical repose with fantasy and Cubist space, through which the early 1930s became one of the great periods of Picasso's

career. Such moments of summation alternate with cycles of fertile and varied experiment. The magical *Girl Before a Mirror* brings together Picasso's total experience of curvilinear Cubism and Classical idealism. The painting is powerful in color patterns and linear rhythms, but above all it is a work of poetry. The maiden, rapt in contemplation of her mirror image, sees not merely a reversed reflection but a mystery and a

423. PABLO PICASSO. *Painter with a Model Knitting,* from *Le Chef-d'oeuvre inconnu,* by Honoré de Balzac. Paris, 1927. Published Paris, Ambroise Vollard, 1931. Etching, printed in black, plate 7⁹⁄₁₆ × 10⅞". Collection, The Museum of Modern Art, New York. The Louis E. Stern Collection

424. PABLO PICASSO. *Guernica*. 1937. 11′6″ × 25′8″. The Prado, Madrid

prophecy. This lyrical work revives the poetry of the Blue and Rose periods and of his period of Classical idealism. It also adds a dimension of strangeness to the exotic Odalisques that Matisse painted, and anticipates Braque's haunting studio scenes.

Picasso's major painting of the 1930s and one of the masterworks of the twentieth century is *Guernica* (fig. 424). Executed in 1937, the painting was inspired by the Spanish Civil War—specifically, the destruction of the Basque town of Guernica by German bombers in the service of Spanish Fascists. Picasso was deeply involved in the conflict from the beginning, and in a sense had been unconsciously preparing for this statement since the end of the 1920s. Some of its forms first appear in the *Three Dancers* of 1925. Around 1930 he made a number

of studies for scenes of the Passion of Christ. The small, brilliant *Crucifixion* was the most resolved (plate 146) and has a tortured agony that looks back to the Isenheim Altarpiece (fig. 8) and forward to the *Guernica*. In a 1933 series of etchings of The Sculptor's Studio (later combined in the Vollard suite) the figure of the Minotaur, the bull-man monster of ancient Crete, first appeared. In later plates the Minotaur became the main protagonist. During 1933 and 1934 Picasso also painted bullfights of particular savagery. These works reflected conflicts in the artist's personal life, and produced the climax of graphic work, the *Minotauromachia* of 1935 (fig. 425). It presents a number of figures reminiscent of Picasso's life and his Spanish past, particularly his recollections of Goya: the women in the window, the Christ-like figure

425. PABLO PICASSO. *Minotauromachia*. 1935. Etching, printed in black, plate 19½ × 27⁷⁄₁₆″. Collection, The Museum of Modern Art, New York. Purchase fund

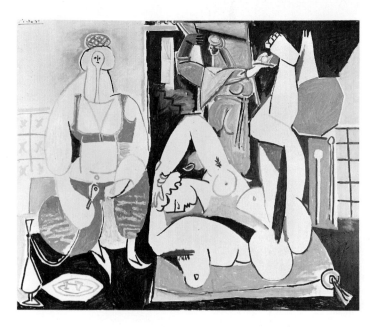

426. PABLO PICASSO. *Women of Algiers*. 1955. 44⅞ × 57½". Collection Mr. and Mrs. Victor W. Ganz, New York

pipe and frisky goats gambol around the dancing nymph who trips over her feet, while her abundant hair and lavish breasts flap in the breeze. This is, in fact, a superb satire of the tradition of pastoral painting, to which Picasso was so devoted.

In his work following the end of the war Picasso gave no evidence of any decline in his amazing energy, in the form of a stream of paintings, sculptures, ceramics, and prints. The adaptation he made of works by the Old Masters illustrates a mood of reflection on himself and his relation to the art of the past. During the 1950s and 1960s Picasso produced many free variants of works by Poussin, Lucas Cranach, Velázquez, Delacroix (fig. 426)—all brilliant in color, organization, and conception. Finally, in one last, spectacular burst of energy, the venerable Spanish master broke free into a rampantly erotic Expressionism that, far from representing a weakening of powers, actually leaped forward in spirit and form alike to anticipate the Neo-Expressionism of the 1980s (fig. 1017).

Fantasy in Sculpture and Assemblage

A strain of fantasy is present in twentieth-century sculpture from its beginnings. This was almost assured by the mere fact that sculptors, except for the abstract Constructivists, continued to use the human head and figure as their basic subjects. Thus an element of human semblance remained in some degree present, no matter how much the heads and figures were transformed by every sort of simplification, distortion, stylization, or Cubist manipulation. Picasso was capable of introducing human fantasy, even into nonfigurative sculpture, such as the famous *Glass of Absinthe* (fig. 231). Seen from one side, the glass opens up in a huge mouth with protruding tongue reaching for the lump of sugar on the spoon above. This is a direct ancestor of all the "object sculptures" with which the Dadaists began to play and which have reached their apotheosis in contemporary Pop Art (fig. 701).

Fantasy became explicit in modern sculpture with Boccioni (fig. 267). The next step, even more significant, was Marcel Duchamp's invention of the readymade (fig. 328). Probably not even Duchamp could envisage the impact his readymades were to have on definitions and traditions.

Among the Zurich Dadaists in 1916–19, the only contributions to a sculpture of fantasy were certain reliefs by Arp (plate 102). Later, he developed his organic-figurative fantasies into freestanding works (fig. 385). Sophie Taeuber-Arp made a wooden *Dada Head* (fig. 427) in 1920, perhaps inspired by Raoul Hausmann's *Mechanical Head* (fig. 428), in which a variety of miscellaneous objects—a metal collapsing cup, a tape measure, labels, a pocketbook—are attached to a mannequin's head. The masterpieces of Dada sculpture or assemblage are Kurt Schwitters's three environmental *Merzbauten* (fig. 342). The *Merzbau*, involving different sets and secret grottoes that the artist manipulated for his friends, were also ancestors of the Happenings of today.

Although the Paris Surrealists during the 1920s experimented with forms of collage and assemblage, Arp made their only major contribution to fantasy in sculpture before the revival of Picasso's interest in sculpture and the emergence of Julio González and Alberto Giacometti. Of the Cubist sculptors, only Jacques Lipchitz seems to have been affected by the Surrealist environment (if not the doctrine), but the exception is important. Lipchitz had steadily explored the possibilities of Cubism from 1914 into the 1920s, passing from abstract forms to figures and

on the ladder, the little girl holding flowers and candle, the screaming horse carrying the dead woman with bared breasts, the Minotaur groping his way blindly. The place of the Minotaur in Picasso's iconography is ambiguous. He may be a symbol of insensate, brute force, or a symbol of Spain, or sometimes his role is that of the artist himself. Not even in so representational a work as this, however, and even less in the *Guernica*, can we look for specific, literary symbolism. Picasso is transmitting feelings of terror and pity in a generalized sense, not a literal documentation of these emotions.

Picasso was active on the side of the Loyalists in the Spanish Civil War. In January 1937 he created an etching composed of a number of episodes accompanied by a poem, *The Dream and Lie of Franco*. Franco is shown as a turnip-headed monster, and the bull the symbol of resurgent Spain. In May and June 1937 Picasso painted his great canvas *Guernica* for the Spanish Pavilion of the Paris World's Fair. It is a huge painting in black, white, and gray, a scene of terror and devastation. To express this the artist drew on the experience of his entire life. Although he used motifs such as the screaming horse or agonized figures derived from his Surrealist distortions of the 1920s, the structure is based on the Cubist grid. It is the most powerfully Expressionist application of Cubism ever created.

Probably a hundred sketches and related drawings or paintings surround the *Guernica*. Its impact on the artist himself may be seen in innumerable works during the next decades. Even in the brief period of relaxation before the outbreak of World War II, many of Picasso's paintings have a quality of deep disturbance. Although the artist was not molested by the Germans during the occupation of France, his paintings and sculptures reveal his bitterness. The theme of the skull is frequent; colors are dark and dissonant, distortions extreme and obsessive. Only in paintings of his family do his humor and sentiment sporadically revive.

The liberation of Paris brought paintings of untrammeled gaiety. *La Joie de vivre* (plate 147), for example, takes us back to Matisse's composition of 1905–6 (fig. 145). Picasso too conceived in flat-color planes and curving outlines, for a painting in which serious centaurs

reliefs of increasing complexity, and then in the early 1920s to monu-
mental Cubist figures (figs. 235, 236). In the same period he produced
straightforward portraits again and, in 1926, played variations on Cub-
ist forms in little openwork sculptures modeled in wax for casting in
bronze (fig. 238). These are of interest intrinsically and historically in
that, although cast rather than worked in direct metal, they anticipate
the openwork figure constructions of both Picasso and González. Also,
during the mid-1920s, along with some of his climactic Cubist sculp-
tures (fig. 237), Lipchitz played variations in figures whose individual
personalities asserted themselves over the Cubist forms. He also made
sketches that were to be formulated in the great *Figure* of 1926–30 (fig.
239), a primitive totem whose hypnotic, staring presence marks the
transition of Lipchitz to a new phase of Expressionist subject. It was no
accident that this should have happened exactly at the moment when
Surrealist fantasy was reaching its first peak.

PABLO PICASSO About 1928 Picasso's Surrealist bone paintings re-
vived his interest in sculpture, which, except for a few sporadic assem-
blages, he had abandoned since 1914. Then, about 1930, with the
technical help of his old friend Julio González, a skilled metalworker,
he produced welded iron constructions that, together with similar con-
structions produced at the same time by González himself, marked the
emergence of direct-metal sculpture as a major, modern medium. Pi-
casso's *Woman in the Garden* (fig. 429), a large and free construction
involving plant forms and an exuberant figure made up of curving lines
and organic-shaped planes, is one of the most intricate, charming—

left: 427. SOPHIE TAEUBER-ARP.
Dada Head. 1920. Painted wood,
height 13⅜". Succession Arp

below left: 428. RAOUL HAUSMANN.
Mechanical Head. 1919–20.
Wood, leather, aluminum, brass,
and cardboard, 12⅝ × 9".
Collection the Artist

below right: 429. PABLO PICASSO.
Woman in the Garden.
1929–30. Bronze after welded
iron, height 82¾". Estate of the
Artist

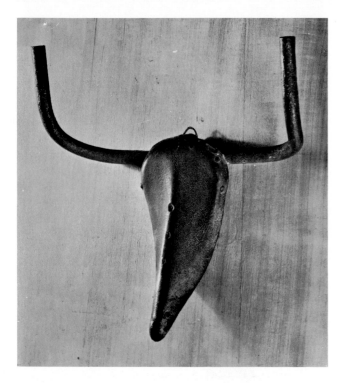

430. PABLO PICASSO. *Bull's Head*. 1943. Bronze, height 16⅛". Galerie Louise Leiris, Paris

left: 431. PABLO PICASSO. *The Shepherd*. 1944. Bronze, height 87". Galerie Louise Leiris, Paris

above right: 432. PABLO PICASSO. *Baboon and Young*. 1951. Bronze (cast 1949), after found objects, height 21"; base 13¼ × 6⅞". Collection, The Museum of Modern Art, New York. Mrs. Simon Guggenheim Fund

right: 433. PABLO PICASSO. *The Bathers*. 1956–57. Bronze, height of tallest figure 8'8½". Galerie Louise Leiris, Paris

and monumental—works of direct-metal sculpture produced to that date. The artist also made wood carvings of elongated figures, later cast in bronze, that have a certain affinity to the later, characteristic figures of Giacometti. Other metal constructions made by Picasso during 1931 revive the artist's old passion for African art.

Carried away by enthusiasm, Picasso modeled in clay or plaster until by 1933 his studio at Boisgeloup was filled: massive heads of women, reflecting his contemporaneous curvilinear style in painting and looking back in some degree to his Greco-Roman style; torsos transformed into anthropomorphic monsters; surprisingly representational animals—a cock and a heifer; figures assembled from found objects organized with humor and delight. Of the found-object sculptures perhaps the most renowned is the *Bull's Head* of 1943 (fig. 430), which consists of an old bicycle seat and handlebars—a wonderful confirmation of Duchamp's assertion that for the artist it is only the idea that matters. During the war Picasso created, in plaster for bronze, a shepherd holding a lamb, one of his most moving conceptions (fig. 431). Picasso was obviously thinking of the Early Christian figure of the Good Shepherd, Christ the protector of the oppressed, a figure that may be traced back to Classical pagan religions as well as to the Old Testament.

As we have seen in painting, Picasso lightened his spirit with the end of the war. His tempo of production in painting, sculpture, and graphic art accelerated, and he found a new interest, this time in ceramics. His delight in the portrayal of animals continued with the *Baboon and Young,* also in bronze (fig. 432). The baboon's head is a toy automobile, and the whole figure was derived from this chance resemblance. During the later 1950s and the 1960s Picasso concentrated his sculptural activities in cut-out works made from sheet metal or in flat stick figures assembled from wooden planks, then cast them in bronze (fig. 433). The figures recall some small paintings of about 1928, in which flat, cut-out bathers gambol on a beach.

The sculpture of Picasso after the 1920s has had a special pertinence to contemporary sculpture, not only in its exploration of the techniques of direct metal and the use of the found object, but also, and particularly, in the expanding application of fantastic subject.

JULIO GONZÁLEZ (1876–1942) González, another son of Barcelona, had been trained in metalwork by his father, a goldsmith, but for many years he practiced as a painter. In Paris by 1900, he came to know Picasso, Brancusi, and Despiau, but after the death of his brother Jean in 1908, he dropped out of the art world for about twenty years. Then, at the end of the 1920s, Picasso asked him for technical help in constructed sculpture, his new interest. González had for some years been experimenting with relief sculpture, cut or incised from flat sheets of metal, and had made Cubist figures and masks in the spirit of Analytic Cubism (fig. 434). The openwork construction of the latter had no precedents in figure sculpture except the transparencies on which Lipchitz had been working for three or four years. It may be said that González began a new age of iron for sculpture. By 1931 he was working in direct, welded iron, with a completely open, linear construction in which the solids were merely contours defining the voids. The difference between these constructions and the earlier ones of Gabo and the Russian Constructivists lies not only in the technique—which was to have such far-reaching effects on younger sculptors—but also in the fact that González was always involved in the figure. Shining through the fantasy of the elegant forms of the first two is a delicate sense of humanity. *Cactus Man,* as the name implies (fig. 435), is a bristly and aggressive individual, suggesting a new authority in the artist's work, which death cut short at this point.

434. JULIO GONZÁLEZ. *Mask of Roberta in the Sun.* 1927. Iron, height 7⅛". Collection Roberta Gonzalez, Paris

435. JULIO GONZÁLEZ. *Cactus Man I.* 1939–40. Bronze, height 26". Collection Hans Hartung, Paris

436. JULIO GONZÁLEZ. *Montserrat.* 1936–37. Wrought and welded iron,
65 × 18½". Stedelijk Museum, Amsterdam

At the end of the 1920s Giacometti was drawn into the orbit of the
Paris Surrealists. For the next few years he made works that reflected
their ideas, and until 1935 he exhibited with Miró and Arp at the Galerie
Pierre. The sculptures he produced during these years, considered as
expressions of fantasy, are among the masterpieces of Surrealist sculp-
ture. *Woman with Her Throat Cut* (fig. 438), a bronze construction of
a dismembered female corpse, bears a family resemblance to Picasso's
1930 *Seated Bather* (plate 143).

Of greatest significance in terms of the artist's subsequent directions
are certain experiments in open-space construction, a series of works
that climaxed in *The Palace at 4 A.M.* of 1932–33, a structure of wood-
en rods defining the outlines of a house (fig. 439). At the left a woman
in an old-fashioned long dress stands before three tall rectangular pan-
els. She seems to look toward a raised panel on which is fixed a long,
oval spoon shape with a ball on it. To the right, within a rectangular
cage, is suspended a spinal column, and in the center of the edifice
hangs a narrow panel of glass. Above, floating in a rectangle that might
be a window, is a sort of pterodactyl—"the skeleton birds that flutter
with cries of joy at four o'clock." This strange edifice was the product
of a period in the artist's life that haunted him and about which he has
written movingly: "...when for six whole months hour after hour was
passed in the company of a woman who, concentrating all life in her-
self, magically transformed my every moment." *The Palace at 4 A.M.*,
whatever the associations and reminiscences involved, was primarily
significant for its wonderful, haunting quality of mystery arising from
the artist's sense of the loneliness of modern man. It was this perhaps
that he saw with such frightening clarity whenever he tried to draw a
figure or paint a portrait, and it was this sense of loneliness that he felt
so incapable of rendering. Yet he rendered it with incomparable con-
viction. This despite the fact that he always denied any desire to com-
ment on the condition of man, to evoke the feeling of alienation.

Ever since he returned to the study of the figure in 1935, his interest
was, as it had been when Giacometti was a student, to render the object
and the space that contained it as exactly as his eye saw them. Since an
object seen close became for him a meaningless confusion of details,
he increased the distance between himself and the object until it began
to come into focus and he could perceive it as a totality within its own
definable space. This establishment of the correct visual distance was
only a first step. There were still details to be stripped away in the
sculptures and the isolated figures of his paintings. The effect, whether
he sought it or not, is an overpowering sense of aloneness, although
one may also read in the figures a quality of integrity rather than of
alienation, something that enables them to survive like characters in a
play of Samuel Beckett, even in a void, in an ultimate situation. In ap-
proaching Giacometti's later figure sculpture, the viewer should re-
member *The Palace at 4 A.M.*

The need to attempt what he felt to be impossible, "to render what
the eye really sees," led Giacometti to abandon his Surrealist sculpture
and to begin the most intensive possible examination of a limited sub-
ject—the figure and portrait head—first with a professional model
and later with his brother Diego or his wife, Annette, as models. A
transitional work is the 1934–35 *Invisible Objects,* an elongated fig-
ure, half sitting on a chair structure that provides an environment (fig.
440). The mask face and the very concept—"hands holding the
void"—mark this as a fantasy figure with Surrealist overtones. That the
concept should be in the form of a single, vertical, attenuated figure is
significant for Giacometti's later work, which in style, time, and mood
belongs to a later chapter.

Side by side with these openwork, direct-metal constructions, Gon-
zález continued to produce naturalistic heads and figures, for instance,
the large wrought-iron and welded *Montserrat* (fig. 436), a heroic fig-
ure of a Spanish peasant woman, symbol of the resistance of the Span-
ish people against Fascism.

ALBERTO GIACOMETTI (1901–1966) If González was the pioneer of
the new iron age, Alberto Giacometti was the creator of a new image of
man. Son of a Swiss Impressionist painter, he was drawing by the age of
nine, painting by twelve, and made his first bust of his brother Diego
when he was thirteen. After studies in Geneva and a long stay with his
father in Italy, where he saturated himself in Italo-Byzantine art and the
paintings of Cimabue and Giotto, and became acquainted with the Fu-
turists, he moved to Paris in 1922. Here he studied with Bourdelle for
three years and then set up a studio with Diego, an accomplished tech-
nician who continued to be his assistant and model to the end of his
life.

The first independent sculptures reflected awareness of the Cubist
sculptures of Lipchitz and Laurens and, more important, of primitive
and prehistoric art. Giacometti's *Spoon Woman* of 1926–27 is a fron-
talized, Surrealist-primitive totem, with a spiritual if not a stylistic affin-
ity to the work of Brancusi (fig. 437). It is the first attempt of a young
sculptor to create form that is completely abstract yet has the presence
of a figure.

left: 437. ALBERTO GIACOMETTI. *Spoon Woman (Femme cuiller)*. 1926–27. Bronze, height 57″. The Solomon R. Guggenheim Museum, New York

below: 438. ALBERTO GIACOMETTI. *Woman with Her Throat Cut*. 1932. Bronze (cast 1949), 8 × 34½ × 25″. Collection, The Museum of Modern Art, New York. Purchase

above: 439. ALBERTO GIACOMETTI. *The Palace at 4 A.M.* 1932–33. Wood, glass, wire, and string, 25 × 28¼ × 15¾″. Collection, The Museum of Modern Art, New York. Purchase

right: 440. ALBERTO GIACOMETTI. *Invisible Objects (Hands Holding the Void)*. 1934–35. Plaster, height 61½″. Yale University Art Gallery, New Haven, Connecticut

left: 441. MAX ERNST. *Oedipus II*. 1934. Bronze, height 24⅜". Private collection, New York

right: 442. MAX ERNST. *Les Asperges de la lune*. 1935. Plaster, height 65¼". Collection, The Museum of Modern Art, New York. Purchase

below: 443. MAX ERNST. *The King Playing with the Queen*. 1944. Bronze (cast 1954, from original plaster), height 38½". Collection, The Museum of Modern Art, New York. Gift of Dominique and John de Menil

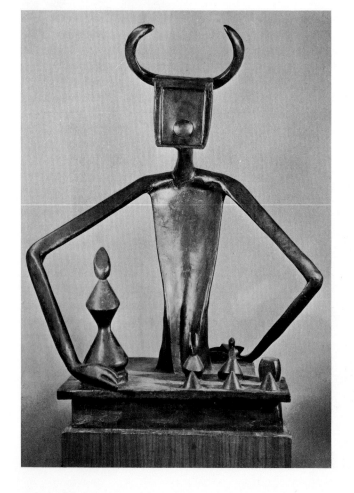

MAX ERNST Ernst was drawn to sculpture in 1934 through his friendship with Giacometti, at the moment when the latter was leaving Surrealism for his own new vision of reality. Thereafter Ernst increasingly concerned himself with sculpture, and his productivity in this medium almost matched that in painting and collage. His first works were modified, egg-shaped boulders whose surfaces he carved with abstract patterns in the manner of Arp. From this the artist went on to several sculptures worked in plaster for casting in bronze. *Oedipus II* is a military-looking figure with phallic overtones (fig. 441). Based on casts of wooden pails assembled in precarious balance, it recalls the artist's 1920 collage *The Hat Makes the Man*, but the big-nosed visage certainly owes something to Picasso's sculpture of the early 1930s. Other sculptures resulting from this first enthusiasm in 1934–35 were a *Bird Head* reminiscent of a type of Gabon reliquary, metal-covered figures, and *Les Asperges de la lune,* two enormously elongated-plant figures who maintain a certain shy personal interrelationship (fig. 442). In 1944, in the United States, Ernst created a series of frontalized figures reminiscent of African sculpture, Picasso, and even, at times, Duchamp (fig. 443).

The International Style in Architecture:
THE FIRST WAVE

During the 1920s, the architectural pioneers of the first modern generation—Wright in the United States, Perret in France, Loos in Austria, and Behrens in Germany—continued to consolidate their positions, although not at the same rate of progress or recognition.

FRANK LLOYD WRIGHT Between 1915 and 1922, Wright, as previously noted, was occupied principally with the Imperial Hotel in Tokyo—now, regrettably, destroyed (fig. 295). At the same time he was building houses in California—notably the Millard house of 1923 (fig. 444)—with a new, massive, rectangular outline resulting from his experimentation with poured concrete. In the Millard house he used precast patterned concrete blocks. Built on an inclined plot, this house was organized as a compact vertical cube. Its sharp contrast with the horizontality of the earlier Prairie houses demonstrates Wright's unfailing ability to adapt his design to new situations and materials.

In the next decade Wright had no important commissions. His prog-

444. FRANK LLOYD WRIGHT. Millard House, Pasadena, California. 1923

left: 445. FRANK LLOYD WRIGHT. Price Tower, Bartlesville, Oklahoma. 1953

bottom: 446. FRANK LLOYD WRIGHT. Kaufmann House, Bear Run, Pennsylvania. 1936

below: 447. FRANK LLOYD WRIGHT. Interior, Kaufmann House. 1936

ress must be charted through such projects as his 1929 design for an unbuilt skyscraper, St. Mark's Tower in New York. The Tower, finally built in 1953 as the Price Tower in Bartlesville, Oklahoma (fig. 445), was, for its time, a daring concept: a cruciform "airplane propeller" structural unit sheathed in a glass shell and supporting cantilevered floors. Boldly protruding terraces and soaring utility pylons gave the skyscraper the stylistic signature of its author.

During the 1930s, despite the Great Depression, Wright began to secure important commissions and also to make a contribution in the field of low-cost individual housing (the Usonian houses), as well as in city planning. During the period c. 1931–35, when commissions were few, he developed his plan for Broadacre City, an integrated and self-sufficient community of detached housing with built-in industries. Like most such schemes, Broadacre City was never realized, but it did enable Wright to clarify his ideas on city planning, further developing the idea of the garden town, with detached houses within ample natural surroundings.

His most important realized structures of the 1930s were the Kaufmann House, "Falling Water," at Bear Run, Pennsylvania, and the Administration Building of the S. C. Johnson and Son Company, Racine, Wisconsin. The Kaufmann House, built in 1936 over a waterfall, is one of Wright's most stunning conceptions (figs. 446, 447). In the use of ferroconcrete for the cantilevered terraces, it has an affinity to the International Style. It is a basic Wright conception, however, combining features of the original Prairie houses and the California houses built of pre-cast concrete blocks. The adaptation to a specific and dramatic site exemplifies one of Wright's greatest abilities: to use all the implications of a site, no matter how difficult it might seem. In the Kaufmann House we still have a central, vertical mass of utilities and chimneys anchoring the suspended horizontals. The central mass consists of rough, local stone courses contrasting with the beige-colored concrete. The building is particularly effective in its contrast of solid and voids, and the interior is literally the welcoming cave in the middle of the woods. The plan combines openness, efficient flow, and containment of individual areas, with the integration of exterior and interior.

The Johnson Administration Building, started in the same year as the Kaufmann House, inaugurated a new phase in Wright's style (figs. 448, 449). In this building, which resembles a gigantic and beautiful machine, Wright began to use dominant curvilinear elements. The building is brick, with no windows except the translucent but not transparent bands of window wrapped around the tower. Natural lighting is achieved in other areas through skylights and tubular glass strips. Thus the effect of the building is one of self-containment, a turning inward upon itself. The interior is a forest of slender columns tapering to the base like those at the Palace of Minos in Crete. The columns terminate at the top in broad, shallow capitals which repeat the circular motif throughout. Encouraged by a sympathetic patron, Wright was able to design all details including desks and office chairs.

The Johnson Building may have been a gesture of defiance toward the rectangularity of the spreading International Style. In any event, it illustrated once again Wright's inexhaustible fertility, and led to many buildings embodying the principle of the circle.

In France, Perret completed his concrete-and-glass masterpiece, the church at Le Raincy, between 1922 and 1923 (fig. 297), after which there came a long *détente* of solid industrial building, experimental in its use of ferroconcrete but conventional in design. Loos, in Vienna, lived only to 1933, and most of his completed architectural works during the 1920s continued to be houses of relatively modest proportions. His career as an architect was rather strange for a man now recognized

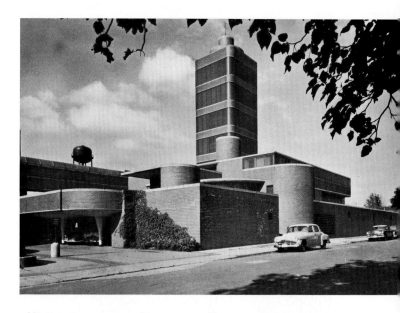

448. FRANK LLOYD WRIGHT. Administration Building, S. C. Johnson and Son Company, Racine, Wisconsin. 1936–39, 1950

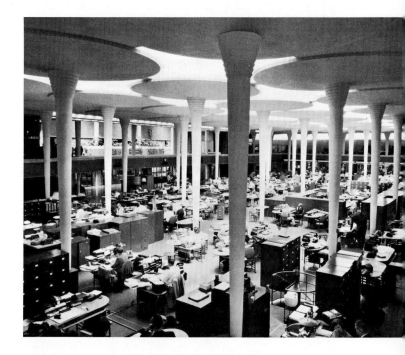

449. FRANK LLOYD WRIGHT. Interior, Administration Building, S. C. Johnson and Son Company. 1936–39, 1950

as a major pioneer of modern building. A large percentage of his works consisted of interior design—the reconstruction and decoration of the interiors and façades of existing shops or restaurants, or the redecoration of apartments. The spare rectangularity of the garden façade of his Steiner house (fig. 299) anticipated De Stijl and International Style architecture. In the early 1920s Behrens moved into an Expressionist phase in his Höchst Dye Works (1920–25). His influence pervaded the architecture of the postwar era, for among those who had worked with him as students or assistants were Walter Gropius (1907–10), Le Corbusier (1910–11), and Miës van der Rohe (1908–11).

The International Style

The term International Style for the wave of new experiment in architecture that gained momentum during the 1920s was given prominence by an exhibition of advanced tendencies held at The Museum of Modern Art, New York, in 1932. Communication among architects had been reestablished so rapidly after World War I and stylistic diffusion had spread so wide that it had become difficult to speak of national styles. Rather, there were now centers of experimentation upon which architects and artists converged from everywhere. The catalogue by Henry-Russell Hitchcock and Philip Johnson accompanying the exhibition attempted to define the characteristics of the style. The authors emphasized the importance of structural steel and ferroconcrete, whose characteristic properties led to novel forms and thus to the first style based on a new structural system since the Romanesque and Gothic architecture of the twelfth and thirteenth centuries. Function was asserted to be of fundamental stylistic importance (although sharp issue was taken with those who contended that function was all).

The first principle of the new architecture of steel or ferroconcrete was elimination of the bearing wall. The outside wall became a skin of glass, metal, or masonry constituting an enclosure rather than a support. Thus, one could speak of an architecture of volume rather than of mass. Window and door openings could be enlarged indefinitely and distributed freely to serve both function—activity, access, or light—and design of exterior or interior. The regular distribution of structural supports led to rectangular regularity of design but not to the balanced axial symmetry of Classical architecture.

The next principle was avoidance of applied decoration: the creation of style through the proportioning and distribution of solid and void. The elimination of strong contrasts of color on both interiors and exteriors was presented as a characteristic, although the influence of Mondrian and Van Doesburg on certain Dutch architects was noted. The International Style resulted in new concepts of spatial organization, particularly a free flow of interior space, as opposed to the stringing together of static symmetrical boxes that had been previously necessitated by interior bearing walls. Finally, the International Style lent itself admirably to urban planning, low-cost mass housing, and garden cities—to any form of large-scale building involving inexpensive, standardized units of construction.

Unquestionably the experiments of the pioneers of modern architecture in the use of new materials and in the stripping away of accretions of Classical, Gothic, or Renaissance tradition resulted in various common denominators that may be classified as a common style. However, the individual stamp of the pioneers is recognizable even in their most comparable architecture. Wright, it must be stressed, influenced but never considered himself a participant in the International Style. In fact, he was in violent opposition to many of its ideas and exponents.

WALTER GROPIUS (1883–1969) Among the architects who assumed positions of leadership in Europe after World War I, Gropius, as director of the Bauhaus, exercised the greatest direct influence on the younger generation. After spending two years in the office of Behrens, he joined forces with Adolf Meyer (1881–1929) to build, in 1911, a factory for the Fagus Shoe Company at Alfeld-an-der-Leine (fig. 450). Deriving from Behrens's turbine shop (fig. 301), and not really involving any radically new structural system, the Fagus building still represents a sensational innovation in its utilization of complete glass sheathing even at the corners. In effect, Gropius here had invented the curtain wall that would create so much of the form of subsequent large-scale twentieth-

450. WALTER GROPIUS and ADOLF MEYER. Fagus Shoe Factory, Alfeld-an-der-Leine, West Germany. 1911–16

451. WALTER GROPIUS and ADOLF MEYER. Model Factory at the Werkbund Exhibition, Cologne. 1914

left: 452. WALTER GROPIUS and ADOLF MEYER. Design for the Chicago Tribune Tower. 1922

right: 453. RAYMOND HOOD. Chicago Tribune Tower. 1922

century architecture. As a result of the success of this building, Gropius and Meyer were commissioned to build a model factory and office building for the 1914 Werkbund exhibition in Cologne (fig. 451). What is interesting about this structure is the manner in which the architects harmonized a variety of materials and structural forms. They combined massive brickwork with open glass sheathing, the latter most effectively used to define the exterior spiral staircases at the corners. Broadly horizontal overhanging roofs recall Frank Lloyd Wright, and the entire building reveals the range of architectural forms of which the new style was capable at its inception.

In 1919, after the interruption of the war years, Gropius took up his duties as director of the Weimar Schools of Arts and Crafts, a position he had inherited from Henry van de Velde in 1915 but had been unable to assume because of the war. These schools he combined under the name of the Bauhaus. During the years that he was director of the Bauhaus, Gropius continued his own architectural practice in collaboration with Meyer until Meyer's death. One of the projects, unfulfilled, was the design for the Chicago Tribune Tower in 1922 (fig. 452). The competition for this tower, entered by architects from every part of the world, was a turning point in the warfare between the traditional and modern approaches to architecture. Although the traditionalists won the battle with the Gothic cathedral designed by the American architect Raymond Hood (fig. 453), the wide publicity dramatized the conflict. The design of Gropius and Meyer, in the spare rectangularity of its forms, its emphasis on skeletal structure, and its wide tripartite windows, was actual-

ly building on the original skyscraper designs of Sullivan and the Chicago School (figs. 86, 87), and at the same time looking forward to the skyscraper of the mid-twentieth century.

The most important architectural achievement of Walter Gropius while he was at the Bauhaus (1919–28) was the design for the new Bauhaus buildings at Dessau, where the school moved in 1925 (fig. 454). These buildings, finished in 1926, may be said to define for large-scale building the nature and characteristics of the International Style. They involved a complex of classrooms, studios, workshops, library, and living quarters for faculty and students. The workshops consisted of a glass box rising four stories and presenting the curtain wall, the glass sheath or skin, freely suspended on the structural-steel elements. The form of the workshop wing suggests the uninterrupted spaces of its interior. On the other hand, in the dormitory wing, the balconies and smaller window units contrasting with clear expanses of wall surface imply the broken-up interiors of individual apartments.

The plan of the Bauhaus is roughly cruciform (or, ironically in view of the Bauhaus's fate, a truncated swastika) with administrative offices concentrated in the broad, uninterrupted ferroconcrete span of the bridge linking workshops with classrooms and library. In every way the architect sought for the most efficient organization of interior space. At the same time he was sensitive to the abstract organization of the rectangular exterior—the relation of windows to walls, concrete to glass, verticals to horizontals, lights to darks. The Bauhaus combined functional organization and structure with a Mondrian design in three di-

left: 454. WALTER GROPIUS.
Workshop Wing, Bauhaus,
Dessau, East Germany. 1925–26

below left: 455. ELIEL SAARINEN.
Design for the Chicago Tribune
Tower. 1922

below right: 456. ELIEL SAARINEN
and EERO SAARINEN. Interior,
Tabernacle Church of Christ,
Columbus, Indiana. 1941–42

mensions. Not only were the Bauhaus buildings revolutionary in the efficient planning for a complex series of activities, in the application of abstract principles of design on the basis of the interaction of verticals and horizontals; they also, as Siegfried Giedion has stressed, embodied a new concept of architectural space. The flat roof of the Bauhaus and the long, uninterrupted planes of white walls and continuous window voids create a lightness that opens up the space of the structure. Seen from above, the buildings seem to float. The glass areas integrate the interior and exterior worlds in a simultaneous and continuously shifting vision that Giedion relates to Analytic Cubism, and sees as the reflection of an attitude toward architectural space involving also the element of time.

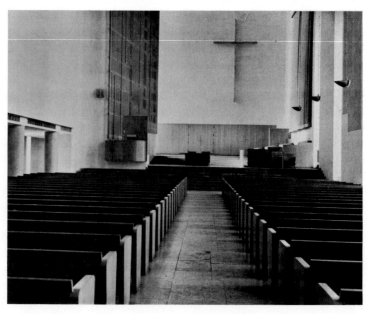

Gropius left the Bauhaus in 1928 to devote his full time to architectural practice. Until he was forced by the Nazis' rise to power to leave Germany in 1934—first for England and then, in 1937, for the United States—most of his building was in the realm of low-cost or middle-cost housing. This area always remained close to Gropius's heart, since the architect was deeply interested in the social as well as the aesthetic implications of housing and city planning. He was a pioneer in the development of tall-slab apartment houses widely spaced among garden areas to give maximum light and air as well as garden surroundings. He already demonstrated in the 1927–28 Dammerstock housing project near Karlsruhe and in the Siemensstadt project of 1929–30 that such planned communities could have the amenities of suburban living while providing quarters for a large urban population. Such designs have since been the basis for a large part of planned-housing developments everywhere.

ELIEL SAARINEN (1873–1950) The historic and prophetic nature of the Chicago Tribune Tower competition was largely overlooked, even by the critics of Hood's design, for whom the most effective solution was that of the second-prize winner, Eliel Saarinen (fig. 455). The leading Finnish architect of the early twentieth century, Saarinen belonged chronologically with the first generation of architectural pioneers. His design for the Tribune Tower is as rooted in the Middle Ages as that of Howells and Hood, but conveys a general impression of being modern. At a moment when American builders were turning away from outright revival styles but were not yet prepared to accept radical solutions, Saarinen's qualified modernism had great appeal and influence. He moved permanently to the United States in 1923, and his American fame for the next twenty years rivaled and frequently surpassed that of Frank Lloyd Wright. His latest works, after 1937, were done in collaboration with his son Eero, who was to become one of the most creative American architects of the mid-century. These revealed acceptance of the International Style, unquestionably as a result of the son's influence. One of the most successful results of this partnership was the small but beautifully realized Tabernacle Church of Christ in Columbus, Indiana (fig. 456). Although the sense of tradition remains, and a sense of craftsmanship in the brickwork as well, the church, in its sensitive and expressive lighting, well-proportioned walls, and clearly ordered interior space, draws on the ideas of younger European architects.

LE CORBUSIER (1887–1965) Among the second generation of architectural pioneers who rose to prominence during the 1920s, the name Le Corbusier, the architectural pseudonym of the Swiss Charles-Édouard Jeanneret, belongs at the highest level. Le Corbusier was a searching and intense spirit, a passionate but frustrated painter, a brilliant critic, and an effective propagandist for his own architectural ideas. He learned the properties of ferroconcrete with Perret in Paris, worked for a period with Behrens in Berlin, studied the tradition of the Vienna Workshops, and traveled widely. Although he never became a painter of the first rank, his interest in and knowledge of Cubism and its offshoots affected his attitude toward architectural space and structure. Le Corbusier's principal exploration throughout much of his career was the problem of the house—first the problem of minimal housing, to which he applied his famous phrase, "a machine for living." His aims were to create structures using to the limit the properties of ferroconcrete, its lightness and strength, structures in which the plan would achieve the utmost in freedom and flexibility, in the interpenetration of inner and outer space. A drawing of 1914 states the problem and his solution (fig. 457). This is simply a perspective drawing of a structure

457. LE CORBUSIER. Perspective drawing for Domino Housing Project. 1914

consisting of six slender pillars standing on a broad, flat base and supporting two other floors or areas that may be interpreted as an upper floor and a flat roof. The stories are connected by a free-standing, minimal staircase. The ground floor is raised on six blocks, suggestive of his later use of stilts or piers.

This drawing is of importance in establishing at this early date Le Corbusier's philosophy of building. With these few elements he could do anything he wanted. Outer walls, windows, or complete glass sheaths can simply be hung on this frame. Inner partitions can be distributed and shaped in any manner the architect desires. The entire structure can be repeated indefinitely either vertically or horizontally, with any number of variations. Le Corbusier did not, of course, invent the system of ferroconcrete screen-wall construction. (As previously mentioned, Behrens and Gropius had already constructed buildings involving the principle.) What he did was to state in the most elementary terms the principle on which a great part of twentieth-century architecture was to be based. Here in effect was the equation of the International Style. Le Corbusier's five points for contemporary construction were: (1) the pillar, to be left free to rise through the open space of the house; (2) the functional independence of skeleton and wall, not only of outer walls but also of inner partitions; (3) the free plan—composing interior space with nonbearing interior walls to create free flow of space and also interpenetration of inner and outer space; (4) the free façade—the completely flexible and variable wall, which is merely a nonsupporting skin or sheath; (5) the roof garden—the development of the flat roof as an additional living area.

Le Corbusier's principles, both structural and aesthetic, first became evident in his projects for houses built in 1919–22. On the one hand, the feeling for the rectangular outline of the house—the box whose interior he would carve out at will—was essentially an aesthetic bias, related to De Stijl abstract painting and his own Purist painting (fig. 254). On the other hand, Le Corbusier was perhaps the most fanatical of the early modern masters of architecture in his insistence that a house was a machine for living, just as an airplane was a machine for flying, and that its technical requirements must be studied in exactly the same way.

The masterpiece among Le Corbusier's early houses was the Villa

right: 458. LE CORBUSIER. Villa Savoye, Poissy, France. 1928–30

below: 459. LE CORBUSIER. Interior, Villa Savoye, Poissy, France. 1928–30

Savoye at Poissy, near Paris, built between 1928 and 1930 (figs. 458, 459). The house is almost a square in plan, with the upper living area supported on delicate piers. The enclosed ground level has a curved-glass end wall containing garage and service functions, set well under the suspended second story. In the main living area on the second level the architect has demonstrated brilliantly his aim of integrating inside and outside space. The rooms open on a terrace, which is protected by half walls or windbreaks above horizontal openings that continue the line of the strip windows. The appearance of the house, with the suspended rectangular block accented by the cylindrical staircase towers, does have the quality of a beautiful ship or machine of the future. In section the horizontal elements are tied together by the ramps, which move in and out of doors. The integration of verticals and horizontals and of inner and outer space is so complete and so complex that it is almost impossible to realize the effect in a single photograph or even a series of photographs.

Le Corbusier, like Wright, had few major commissions during the 1920s, but he continually advanced his ideas and his reputation through his writings and through his visionary urban-planning projects. In 1922 he drew up a plan for a contemporary city of three million inhabitants, involving rows of isolated skyscrapers connected by vast highways and set in the midst of parks. This was still a theoretical con-

cept, inspired by the Utopian cities of Sant'Elia (fig. 309) and Garnier but entailing practical solutions to urban planning that anticipated the slab housing of Gropius and subsequent city planners. His realization of the variety of problems involved in the modern city went far beyond that of his models, and he made his suggested solutions even more specific in his so-termed Voisin plans for Paris (1922, 1925). In these the emphasis was always on the control of indefinite outward expansion of the city through the concentration of residential areas in isolated skyscrapers, set within parks but made easily accessible to one another by various classified systems of transportation.

The competition for the League of Nations buildings in 1927 had particular significance for the history of modern architecture. Despite the fact that the final award was made to a pseudomodern, essentially academic design, the entry of Le Corbusier and Pierre Jeanneret (his cousin, with whom he was in partnership) was so obviously superior that the project led to major commissions during the early 1930s.

Le Corbusier's writings, also, have been tremendously influential in modern world architecture. His trenchant book *Vers une architecture* (1923) was immediately translated into English and other languages, and has since become a standard treatise. In it he announced firmly that engineers, not architects, were carrying on basic traditions, and that an American grain elevator whose massive simplicity was a direct consequence of its function was architecture in the finest sense. He extolled the beauty of the ocean liner, the airplane, the automobile, the turbine engine, bridge construction and dock machinery, all products of the engineer, whose designs had to reflect functions and could not be embellished with nonessential decoration. While there was nothing radically new in these ideas (Louis Sullivan had insisted much earlier that "form follows function"), Le Corbusier dramatized the problems of modern architecture through brilliant comparisons and biting criticisms and, in effect, spread the word to a new generation.

MIËS VAN DER ROHE (1886–1969) Miës van der Rohe's contribution lies in the refinement of the basic forms of the International Style, rather than in the development of its formal and engineering possibilities. He gave architectural expression to the concepts of De Stijl and particularly of Mondrian.

The earliest major influences on Miës were his father, a master mason from whom he initially gained his respect for craftsmanship; then Peter Behrens, in whose atelier he worked for three years; and Frank Lloyd Wright, the 1910 exhibition of whose works in Berlin was a dis-

turbing but exhilarating experience. From Wright Miës gained his appreciation for the open, flowing plan and for the predominant horizontality of his earlier buildings. He was affected not only by Behrens's famous turbine factory, but even more by Gropius's 1911 Fagus factory, with its complete statement of the glass curtain wall. Gropius had been in Behrens's office between 1907 and 1910, and the association between Gropius and Miës that began there continued.

Miës's style remained almost conventionally Neoclassical until after World War I. Then, following the long wartime interruption, he plunged into the varied and hectic experimentation that characterized the Berlin School. After 1919 most of the new ideas fermenting in the arts during the war began to converge on Berlin, which became one of the world capitals for art and architecture. These ideas included the German tradition of Expressionism, Russian Suprematism and Constructivism, Dutch De Stijl, and international Dadaism. Contact was reestablished with French Cubists and Italian Futurists. The Bauhaus school created by Gropius at Weimar in 1919 was in continuous and close contact with Berlin.

In 1919 and 1921 Miës completed two designs for skyscrapers, which, although never built, established the basis of his reputation. One was triangular in plan, the second a free-form plan of undulating curves. In these he proposed the boldest use yet envisaged of an all-glass sheathing suspended on a central core including elevators and other utilities (fig. 460). No such daring design for a skyscraper or, for that matter, for any other monumental building, was to be erected for thirty or forty years. The emphasis in these was on the formal and expressive qualities of the glass sheath, particularly its property of reflection. There was no real indication of either the structural system or the disposition of interior space. The projects still belonged in the realm of visionary architecture, but they were prophetic of a solution of the skyscraper that made even Gropius's advanced design for the Tribune Tower seem somewhat dated. Wright's design for St. Mark's Tower in 1929 was actually more completely realized.

Miës's other unrealized projects of the early 1920s included a concrete office building with continuous ribbon windows set back from concrete-strip parapets, and two designs for country houses, the first (1923) in brick and the second (1924) in concrete. The brick country-house design brought together Wright's open plan with long walls integrating inside and outside space, and a Classical arrangement of rectangular brick wall masses and window voids exemplifying the principles of De Stijl architecture. The plan of this house, as drawn with the utmost economy and elegance, is, in Mondrian's sense, a pure plastic abstraction (figs. 461, 462).

460. MIËS VAN DER ROHE. Model of the Glass Skyscraper. 1919–21

461, 462. MIËS VAN DER ROHE. Elevation and Plan for Brick Country House. 1923

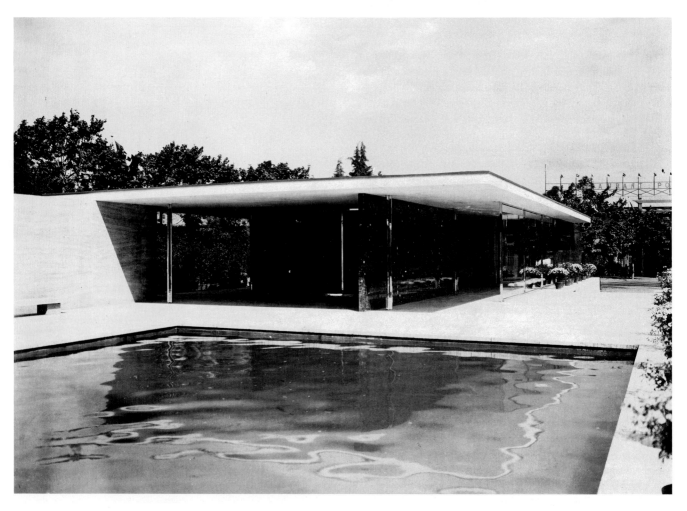

463. MIËS VAN DER ROHE. German Pavilion, International Exposition, Barcelona. 1929 (destroyed)

The last two works executed by Miës in Europe, before the rise of Nazism limited his activity and then forced his migration to the United States, were the German pavilion for the Barcelona Exposition in 1929 and the Tugendhat house at Brno, Czechoslovakia, in 1930. The Barcelona pavilion, destroyed at the end of the exposition, has become one of the classics of Miës's career and of the International Style (fig. 463). Here was the most complete statement to this date of all the qualities of refinement, simplification, and elegance of scale and proportion that Miës above all others has brought to modern architecture. It exemplified his famous phrase "less is more." In this building he contrasted the richness of highly polished marble wall slabs with the chrome-sheathed slender columns supporting the broad, overhanging flat roof. The marble and glass interior walls stood free, serving simply to define space. In contrast to the earlier brick country house, the architect put limits on the space of pavilion and court by enclosing them in end walls. This definition of free-flowing interior space within a total rectangle was to become a signature for Miës in his later career. The pavilion was furnished with chairs, stools, and glass tables designed only by Miës, which themselves have become classics. In the Barcelona pavilion Miës demonstrated that the International Style had come of age, had come to a maturity that permitted comparison with the great styles of the past.

Miës became director of the Bauhaus in 1930 but had little opportunity to advance its program. After moving from Dessau to Berlin in that year, the school suffered increasing pressure from the Nazis until it was finally closed in 1933. In 1937, with less and less opportunity to practice, Miës left for the United States, where in the last decades of his life he was able to fulfill, in a number of great projects, the genius already apparent in the relatively few buildings he actually built in Europe.

The Bauhaus: 1919–33

As has already been suggested, one of the most remarkable phenomena of the 1920s was the school Das Staatliche Bauhaus, formed by Walter Gropius in 1919 from the two ducal schools of arts and crafts in Weimar. As was the case with the English Arts and Crafts and the Deutsche Werkbund traditions, Gropius was convinced of the need for unity of architect, artist, and craftsman. The program of Gropius was a new departure in its insistence not that the architect, the painter, or the sculptor should work with the craftsman, but that they should first of all be craftsmen. The idea of learning by doing, of developing an aesthetic on the basis of sound craftsmanship, was revolutionary.

The core of Bauhaus teaching was a foundation course designed to liberate the student from his past experiences and prejudices. This course, initially developed by the Swiss painter Johannes Itten, introduced the student to materials and techniques through elementary but fundamental practical experiments. A substantial part of the attack was on the Classical traditions which still dominated the academies. It included practical experience but also investigation of non-Western philosophies and mystical religions. The approach to materials itself frequently became a sort of mystique. During the first years of the Bauhaus there was very little emphasis on the machine or on art in its relation to industrial society. However, the important aspect of the curriculum was that it was never static, that it remained in a continual state of change and development. As Miës van der Rohe said at a dinner for Gropius in 1953: "The Bauhaus was not an institution with a clear program—it was an idea, and Gropius formulated this idea with great precision.... that it was an idea I think is the cause of this enormous

influence the Bauhaus had on every progressive school around the globe. You cannot do that with organization, you cannot do that with propaganda. Only an idea spreads so far...."

Around the idea was formed one of the most remarkable art faculties in history. Vasily Kandinsky, Paul Klee, Lyonel Feininger, Georg Muche, Oskar Schlemmer were among those who taught painting, graphic arts, and stage design. Pottery was taught by Gerhard Marcks, who was also a sculptor and graphic artist. When Johannes Itten left in 1923, the foundation course was given by László Moholy-Nagy, painter, photographer, theater and graphic designer and, through his writings and teaching, the most influential figure after Gropius in developing and spreading the Bauhaus idea. When the Bauhaus moved from Weimar to Dessau, several former students joined the faculty—the architects and designers Marcel Breuer and Herbert Bayer, and the painter and designer Josef Albers, who reorganized the foundation course.

Of the artist-teachers, Kandinsky, Klee, and Feininger were to become recognized as masters of twentieth-century painting. Gerhard Marcks, after living in obscurity during the Nazi years, emerged after World War II as a leading German figurative sculptor. Moholy-Nagy, through his books *The New Vision* and *Vision in Motion* and his directorship of the New Bauhaus, founded in Chicago in 1937 (now the Institute of Design of the Illinois Institute of Technology), greatly influenced the teaching of design in this country. Josef Albers, a teacher at Black Mountain College in North Carolina (1933–50) and subsequently at Yale University, had a comparable influence (plate 148). Marcel Breuer, principally active at the Bauhaus as a furniture designer, ultimately joined Gropius in 1937 on the faculty of Harvard University and practiced architecture with him. After Breuer left this partnership in 1941, his reputation steadily grew to a position of world renown (figs. 844, 879, 887).

The Bauhaus during the 1920s spread its ideas through the publication of remarkable documents by staff members and by other pioneers of Cubism and abstraction. Thus it became the center during the 1920s for the propagation and development of new international experiments, especially the International School of architecture, and geometric abstraction in painting and sculpture. For a time, some currents of Dadaism touched the Bauhaus, but its influence was never strong there, nor was that of German Expressionism in painting, or German or Dutch Expressionism in architecture. The first proclamation of the Bauhaus declared: "Architects, painters, and sculptors must recognize anew the composite character of a building as an entity. . . . Art is not a 'profession.' There is no essential difference between the artist and the craftsman. The artist is an exalted craftsman. . . . Together let us conceive and create the new building of the future, which will embrace architecture and sculpture and painting in one unity and which will rise one day toward heaven from the hands of a million workers like the crystal symbol of a new faith."

This initial statement reflected some of the Socialism then current in Germany and throughout much of Europe. Suspicion of this political attitude caused antagonism toward the school among the more conservative elements in Weimar, an antagonism that finally in 1925 drove the Bauhaus from that city to its new home in Dessau.

The Bauhaus in its first few years was necessarily tentative and experimental in applying the "idea" of Walter Gropius. By 1923, however, this idea had been clarified and tested into a more specific program. Gropius reiterated the principle of "a universal unity in which all opposing forces exist in a state of absolute balance." The emphasis on form as the embodiment of ideas, or of the inner self or inner compulsion, shows the influence of Kandinsky and "the spiritual in art." Gropi-

us stipulated "a thorough practical, manual training in workshops actively engaged in production, coupled with sound theoretical instruction in the laws of design." This statement accordingly put more emphasis on the training of industrial designers than had the initial proclamation—an obvious result of the intervening experience of the Bauhaus teachers.

The underlying theory was established in terms that reflected Klee's ideas as well as those of Kandinsky. Theosophical and Neo-Platonic ideas may be noted, and awareness of the new mathematics and physics. It thus combined attitudes that had been in the air for years, not too logically integrated, perhaps, but nevertheless profoundly felt and destined to have worldwide influence.

The Bauhaus curriculum was divided into two broad areas: crafts and form problems. Each course had a "form" teacher and a "craft" teacher. This division was necessary because a faculty could not be found during the first four years who were capable of integrating the theory and practice of painting, sculpture, architecture, design, and crafts—although Klee taught textile design and Marcks pottery. With the move to Dessau, however, and the addition of Bauhaus-trained staff members, the various parts of the program were brought into closer proximity. The integration of arts and crafts became realized, particularly by Moholy-Nagy and Albers, and subsequently continued by their activities in the United States.

The emphasis of the 1923 curriculum was on training designers for industry. In Dessau the accent on architecture—which Gropius always considered the mother of the arts—was substantially increased, although the architecture students were expected to complete their training in engineering schools. He said: "We want to create a clear, organic architecture, whose inner logic will be radiant and naked, unencumbered by lying façades and trickeries; we want an architecture adapted to our world of machines, radios and fast motor cars, an architecture whose function is clearly recognizable in the relation of its form."

Despite the high talents of the painting faculty, few painters of distinction emerged. Since the history of the Bauhaus has been written principally by architects, areas of discontent among the painters and sculptors were perhaps glossed over. The greatest practical achievements were probably in interior, product, and graphic design. During his years at the Bauhaus, Marcel Breuer created many furniture designs that have become classics, including the first tubular steel chair. In ceramic and metal design a new vocabulary of simple, functional shapes was established. The courses in display and typographic design under Bayer, Moholy-Nagy, Tschichold, and others revolutionized these fields. Bauhaus designs have passed so completely into the visual language of the twentieth century that many have become clichés, and it is now difficult to realize how revolutionary they were on first appearance. Certain designs, such as Breuer's tubular chair and his basic table and cabinet designs, Gropius's designs for standard unit furniture, and designs by other faculty members or students for stacking chairs, stools, dinnerware, lighting fixtures, textiles, display and typography, were so basic that they still continue in use.

Moholy-Nagy's experiments in abstract film and photography inaugurated a new era in these media, just as his light modulators—constructions involving space, light, and movement (fig. 473)—were pioneer efforts whose potentials are being realized only now.

Gropius had early been interested in theater architecture, although only his 1923 City Theater at Jena was actually built. However, his designs for Erwin Piscator for the Total Theater (1929), entirely flexible in the combination of the proscenium and arena stage, still influence theater design.

464. RICHARD NEUTRA. Dr. Lovell's "Health" House, Los Angeles. 1927–29

American Architecture in the Wake of Wright and the Bauhaus

In the 1930s a number of events and individuals pointed the way to a new modern era in American design. The Museum of Modern Art in New York began a series of important exhibitions, the first of which, organized in 1932 by Henry-Russell Hitchcock and Philip Johnson, gave the International Style its name. There followed exhibitions of the Chicago School (1935), Le Corbusier (1935), Aalto (1938), and the Bauhaus (1938). In this decade, also, a number of new skyscrapers were built that broke the eclecticism of the skyscraper form, and introduced aspects of the Chicago School, or principles of the Bauhaus and the International Style.

During the first half of the twentieth century, most experiments in

465. REINHARD and HOFMEISTER, MORRIS, CORBETT, HARRISON, HARMON and MACMURRAY, HOOD and FOUILHOUX. Rockefeller Center, New York. 1931–37

modern architecture were carried out in individual houses. This is understandable, since the cost of building a skyscraper or a great industrial complex is so exorbitant that it took a half-century before patrons dared to gamble on modern buildings. As noted, the architecture of Frank Lloyd Wright during most of his life consisted of individual houses. The first European architects to come to America in the 1920s, William Lescaze (1896–1969), Richard Neutra (1892–1970), and Rudolph Schindler (1887–1953), devoted much of their careers to house architecture. Both Schindler and Neutra worked for Wright, and each built a house in California for Dr. Richard Lovell, combining aspects of Wright's house design with that of the International Style. The Neutra house in particular (fig. 464)—placed spectacularly on a mountainside and, through its open terraced construction, taking every advantage of the amenities of landscape and climate—created a distinct style of Southern California architecture. It may even have had some influence on Wright's Kaufmann House (fig. 446).

The most comprehensive complex of skyscrapers is Rockefeller Center in New York, begun in 1931 and finished in 1973. Although the original buildings have elements of Gothic detail, these are simplified to a relatively unobtrusive point, and have been eliminated in the newer buildings of the 1950s and 1960s (fig. 465). Rockefeller Center is of significance not only in marking a step toward a rational skyscraper design, but even more in its planning concept. Introduced here are

467. RAYMOND HOOD and J. ANDRÉ FOUILHOUX. McGraw-Hill Building, New York. 1931

large open areas for pedestrians between the office buildings; many recreational facilities; an elaborate cinema (Radio City Music Hall); radio and television studios; a theater, skating rink, and restaurants. Few, if any, office complexes in twentieth-century American architecture have improved on the total concept of Rockefeller Center. Its design is notable as an early example of the tendency to bring together large teams of architects and engineers to work cooperatively on a huge and complicated commission. The architects were Reinhard and Hofmeister, with Morris, Corbett, Harrison, Harmon and MacMurray, Hood and Fouilhoux. Although the introduction of this great mass of buildings into central Manhattan aggravated the problem of urban traffic congestion, Rockefeller Center did introduce an attitude of concern for the individual and his environment.

One of the architects collaborating on this scheme, Raymond Hood (1881–1934), almost singlehandedly charted the evolution of the skyscraper between 1920 and the early 1930s. His was the winning entry for the Chicago Tribune Tower, an extreme, although functionally effective, example of neo-Gothic design (fig. 453). With John Mead Howells, Hood designed the 1930 Daily News Building and, with J. André Fouilhoux, the McGraw-Hill Building in New York (figs. 466, 467). In both, the revivalist accretions of previous skyscrapers were stripped off. An interesting point of these two buildings is that the architects, realizing the peculiar design problem of the skyscraper—a tall building consisting of horizontal layers—designed the Daily News with an accent on the vertical and the McGraw-Hill Building with an accent on the horizontal.

A more revolutionary interpretation of the skyscraper than any of those noted is the Philadelphia Savings Fund Society (PSFS) Building, by

466. RAYMOND HOOD and JOHN MEAD HOWELLS. Daily News Building, New York. 1930

468. GEORGE HOWE and WILLIAM LESCAZE.
Philadelphia Savings Fund Society
Building, Philadelphia. 1931–32

George Howe (1886–1955) and William Lescaze (1896–1969) (fig. 468). The PSFS is the first fully realized application of the International Style to skyscraper design. Hood and Howells's Daily News Building still used heavy masonry sheathing, into which the vertical window strips were set deeply. PSFS, using a much greater expanse of glass, ties vertical and horizontal accents together with a light but strong statement of the steel skeleton. The plan of individual floors is a T-shape and embodies a sound understanding of skyscraper planning in its effective segregation of service from office spaces.

Compared with this structure, the Chrysler Building, completed 1929, and the Empire State Building of 1930–32, familiar landmarks of the New York skyline, represent retrogression, both in their forms and functional design. This, unfortunately, is true of most skyscrapers erected in the United States between the 1930s and the 1960s. Although the New York skyline, particularly by night, has a magical and exciting appearance, individual buildings are best examined at a distance. In New York, particularly, because of builders' desire to utilize every permissible inch of available space, there developed a peculiar kind of structure, with stories stepped back to conform (though barely) to the building codes. This "ziggurat" was perhaps the most characteristic design of the New York tall office building for twenty years after 1930. Only in the 1950s did architects and their patrons begin to realize the importance of open space for pedestrians and, as well, the public-relations value of a well-designed structure that could become a landmark. For reasons already noted—and especially the influence of International Style and specifically Bauhaus-trained architects—there occurred a major renaissance and flowering of skyscraper design after the mid-century in the United States and, indeed, throughout the world.

International Abstraction Between the Wars

Even though pluralism is currently thought to be a phenomenon distinctively characteristic of art in the eclectic 1970s and 1980s, art has never been other than pluralistic, a fact clearly evinced by our chapters on the interwar years. Certainly, it prevailed among the Surrealists, each of whom strove to create only in response to the dictates of his own unique subconscious. Thus, while some of Breton's followers could produce photographically exact dreamscapes, others—Arp, Miró, Masson—visualized in various forms of biomorphic abstraction. And to the degree that nondescriptive art could play a significant role on the main stage of world art, it was thanks to the relative popularity of the abstract Surrealists. Also present in Paris, however, and richly resourceful, if largely invisible to the public, was the more meditative and formally more radical art of the geometric abstractionists, such as the Constructivist sculptor Anton Pevsner and the De Stijl painter Piet Mondrian. But amidst the seductive hedonism of School of Paris painting and the sensationalism of the Surrealists, Mondrian, for instance, could survive only by secretly painting and selling flower pictures.

As this would infer, abstraction of a more uncompromising sort—especially geometric abstraction, that puritan offspring of Cubism and Futurism—led a vagrant, even refugee existence between the two World Wars. After 1921, when the Utilitarian or Productivist faction came to the fore in Soviet art, the mystical Kandinsky and many of the Utopian-minded Constructivists fled to the West. And when the original ideals of Russian Constructivism, along with those of Dutch De Stijl, finally found a home, it was at the Bauhaus, a provincial German outpost despite its universalist aspirations and subsequent international influence (see pp. 318–319). In 1933, however, after migrating from Weimar to Dessau and finally to Berlin, the Bauhaus closed as the Nazis, like the Soviets beginning in the 1920s, proceeded to suppress every kind of advanced art and architecture. Thus, when Kandinsky moved to Paris, at the end of his teaching career at the Bauhaus, and Naum Gabo took Constructivism to London in 1936, Utopianism seemed once again to have proved futile. Faced with Depression, the Moscow trials, the Spanish Civil War, and the rise of Nazism, geometric and machine-style abstractionists, for the most part, abandoned their earlier visions of art in the service of a new order and replaced them with purely aesthetic interests. But even when nonobjectivity became as pluralistic as Surrealism and the School of Paris, allowing its purity to be inflected by sensuous, romantic, decorative, or even fantastic elements—or opened to an interface in London between the Constructivism of Ben Nicholson and the Arp-like biomorphism of Henry Moore and Barbara Hepworth—autonomous abstraction did not fulfill its promise of universal expressssiveness until it had made one further move. This time, at the outbreak of World War II, it traveled all the way across the Atlantic to the most pluralistic of all societies. During the twenties and thirties, meanwhile, the master abstractionists of the Old World—Gabo, Pevsner, Kandinsky, and the intermittently abstract Klee—worked quietly but productively apart from the vociferous hijinks of the Breton crowd. Grown tough on adversity and indifference, they endowed civilization with some of its sovereign, ultimately most fertile achievements.

Constructivism

NAUM GABO Following his departure from Russia in 1922, where the totally abstract art he had helped to evolve proved incompatible with the Utilitarian policies of the Soviet regime (fig. 278), Naum Gabo lived in Germany until 1932, perfecting his Constructivist sculpture and contributing importantly though indirectly to Moholy-Nagy's ideas on light, space, and movement at the Bauhaus. In 1920 Gabo had designed a motor-propelled kinetic construction consisting of a single vibrating rod (fig. 469), one of the boldest of the artist's conceptions and a key prototype of the whole modern tradition of kinetic sculpture. He pursued experiments in motion, but for some reason did not take them to their logical conclusions. However, he intensively explored the possibilities of new materials, particularly of plastics, for the creation of monumental designs, searching for a form of architectural expression through constructed sculpture. About the *Column* of 1923 (fig. 470), he said: "My works of this time, up to 1924...are all in the search for

below: 469. NAUM GABO. *Kinetic Construction*. 1920. Metal rod vibrating by means of a motor, height 18″ without base. The Tate Gallery, London

below right: 470. NAUM GABO. *Column*. 1923. Plastic, wood, and metal, height 41″. The Solomon R. Guggenheim Museum, New York

left: 471. NAUM GABO. *Linear Construction, Variation.* 1942–43. Plastic and nylon thread, 24½ × 24½". The Phillips Collection, Washington, D.C.

right: 472. NAUM GABO. Construction for the Bijenkorf department store, Rotterdam. 1954–57. Steel, bronze wire, freestone substructure, height 85'

an image which would fuse the sculptural element with the architectural element into one unit. I consider this Column the culmination of that search." Gabo was too far ahead of his time. However, his vision of the inevitable marriage of International Style in architecture with open, constructed sculpture has been fulfilled by a generation of followers.

During the 1920s Gabo was advancing construction in plastics in new directions and dimensions: a stage set for Diaghilev's 1926 ballet *La Chatte*; designs for the projected Palace of the Soviets (1931)—a daring, winged structure of reinforced concrete. The artist occasionally returned to carving in stone—works that are essentially mass, to counterpoint, refresh, and clarify his thoughts on sculpture as limitless and illimitable space. In 1932 Gabo left Germany for Paris where he was active in the Abstraction-Création group organized to combat Surrealism. His next move was to England, where in the years 1936–46 he was active in the circle of abstractionists centering on Herbert Read, Ben Nicholson, Barbara Hepworth, and Henry Moore. Thereafter Gabo lived in the United States until his death in 1977.

Gabo's principal innovation of the 1940s was a construction using webs of taut plastic strings on frames of interlocking plastic sheets (fig. 471). In these he attained transparent delicacy and weightlessness unprecedented in sculpture. But he had only one major architectural-sculptural commission, a monument for the Bijenkorf department store in Rotterdam (fig. 472). Although Gabo completed few other architectural constructions of any scale, he continued to make Constructivist designs for both formal and expressive architecture.

Gabo's constructions affected abstract sculpture in Germany during the 1920s, and also contributed to experimental stage design, to architecture, and to the pedagogical systems at the Bauhaus, particularly of Moholy-Nagy.

LÁSZLÓ MOHOLY-NAGY (1895–1946) Moholy-Nagy was an important educator and propagandist for abstract art, Constructivism, func-

tional design, and architecture. A Hungarian trained in law, he was wounded on the Russian front and became interested in painting during the long convalescence. In 1921 in Düsseldorf he met the Russian abstractionist El Lissitzky and through him was immediately attracted to abstract art.

Moholy-Nagy then met Walter Gropius in 1922 at the Russian Constructivist exhibition in Berlin and proved so impressive that Gropius made him a professor in the Weimar Bauhaus. Until 1928 Moholy-Nagy was a principal theoretician in applying the Bauhaus concept of art to industry and architecture. He then left the Bauhaus, eventually to reside in Amsterdam and London, painting, writing, and experimenting in all media. In 1937 he founded the New Bauhaus in Chicago, which became the Institute of Design and is now a part of the Illinois Institute of Technology. His two principal books, *The New Vision* and *Vision in Motion*, are major documents of the Bauhaus method. His stylistic autobiography, *Abstract of an Artist* (English edition of *The New Vision*), is one of the clearest statements of the modern artist's search for a place in technology and industry. Moholy-Nagy was first a relatively representational painter, then discovered meaning in drawings by Rembrandt and Van Gogh that for him transcended surface appearance. Through the Symbolists and Expressionists, he became aware of intuition as a forceful plastic means. Experimentation followed, and Moholy-Nagy went through the entire course of modern achievement. By 1921 his interests began to focus on elements that dominated his creative expression for the rest of his life—light, space, and motion. He explored transparent and malleable materials, the possibilities of abstract photography, and the cinema.

Moholy-Nagy pioneered in the creation of light-and-motion machines built from reflecting metals and transparent plastics, constructions that he named "light modulators" (fig. 473). During the 1920s he was one of the chief progenitors of the mechanized kinetic sculpture that has proliferated since 1950. Moholy-Nagy also worked with ab-

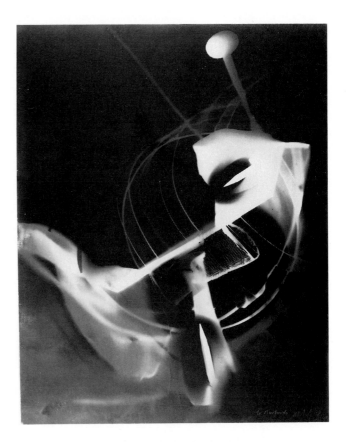

473. LÁSZLÓ MOHOLY-NAGY. *Light-Space Modulator*. 1922–30. Metal and plastic, height 59½″. Busch-Reisinger Museum, Harvard University, Cambridge, Massachusetts

474. LÁSZLÓ MOHOLY-NAGY. *Untitled (Photogram)*. Not dated. Art Institute of Chicago. Gift of George and Ruth Barford

475. LÁSZLÓ MOHOLY-NAGY. *Untitled (View looking down from the Berlin Radio Tower)*. Not dated. Art Institute of Chicago. Julien Levy Collection

stract modeled or constructed sculpture, light paintings, and graphic and product design. His own achievements were so many and so varied that they are not adequately appreciated even today. But his teaching of the implications of abstract painting and sculpture for industrial design, graphic design, architecture, and the total environment of man have affected an entire generation of artists, architects, designers, and consumers everywhere.

Always alert to ways of exploring the potential of light for plastic expression, Moholy-Nagy also became an adventurous photographer, on his own inventing, about the same time as Man Ray (fig. 337), cameraless images, which the Hungarian and his photographer wife, Lucia Moholy, called *photograms* (fig. 474). However, unlike Man Ray, with his interest in the sur-reality of images discovered by "automatic" means, Moholy-Nagy remained true to his Constructivist aesthetic and used the objects placed on sensitive paper as "light modulators," materials for exercises in light and form capable of yielding architectonic compositions. When he took up the camera, Moholy-Nagy regarded it as an instrument for extending vision and discovering forms otherwise unavailable to the naked eye. In the "new vision" of the world presented in his 1925 Bauhaus book entitled *Painting Photography Film (Malerei Fotografie Film)* the artist included not only his own photographic works but also scientific, news, and aerial photographs, all of them presented as works of art. About his 1928 aerial view taken from Berlin's radio tower (fig. 475), Moholy-Nagy wrote: "The receding and advancing values of the black and white, grays and textures, are here reminiscent of the photogram." To him, the camera was a graphic tool equal to any as a means of rendering reality and disclosing its underly-

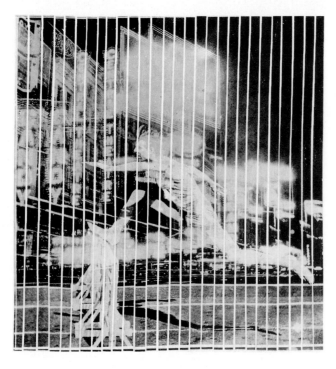

476. EL LISSITZKY. *Photomontage (Striated)*. 1930. Spliced and mounted gelatin-silver print. Private collection, New York

477. PAUL CITROËN. *Metropolis*. 1923. Collage, 30 × 23″. Printroom of the University of Leiden, The Netherlands

ing purity of form. And so he wrote in a frequently quoted statement: "…the illiterate of the future will be ignorant of camera and pen alike."

The Constructivists found photomontage as fertile a process as did the Dadaists, but while they often produced similar effects, their purposes in juxtaposing images altogether various in context, subject, scale, proportion, and tonal value were quite different, usually related to education or formal problems, rather than personal fantasy or Freudian revelation. El Lissitzky, first seen here as a founding Constructivist in postrevolutionary Russia (fig. 272), used photomontage on book jackets and in posters, combining images with words as a form of "documentary truth" designed to alert Soviet citizenry to the meaning of the new socioeconomic order. During his years in Germany (1922–

28), however, when he made contact with Walter Gropius and Moholy-Nagy and through them and the Bauhaus transmitted the ideas of Russian Constructivism to the entire world, Lissitzky seemed less involved with aggressive propaganda than with pure aesthetic experiment, as in the photomontage reproduced here, a composition created, unlike most photomontages, by multiple exposure rather than by cutting and pasting (fig. 476).

Cutting and pasting were precisely how the Bauhaus photographer Paul Citroën (b. 1896) composed the famous 1920 photomontage entitled *Metropolis* (fig. 477). Within the enormous thirty-by-forty inch format, Citroën crushed together such a towering mass of urban imagery that Moholy-Nagy called it "a gigantic sea of masonry," stabilized, however, by Constructivism's controlling principle of abstract design.

478. JOSEF ALBERS. *City*. 1928. Colored glass, 11 × 21⅝″. Kunsthaus, Zurich

JOSEF ALBERS (1888–1976) After Johannes Itten left the Bauhaus, the foundation course was given by Josef Albers and Moholy-Nagy, each teaching in accordance with his own ideas. Albers, after studying widely in Germany, entered the Bauhaus as a student and, in addition to his work in the foundation course, taught furniture design, drawing, and calligraphy. He remained with the Bauhaus until the Nazis closed it in 1933 and then migrated to the United States. Through his work, teaching, and lecturing at Black Mountain College in North Carolina, Harvard, Yale, and many other colleges, art schools, and museums, Albers was the first to bring Bauhaus ideas to the United States, and from the time of his arrival in 1933 he became a major influence in the training of American artists, architects, and designers.

It is possible that the early apprenticeship Albers received in a stained-glass workshop inspired his lifelong interest in problems of light and color within geometric frames. In his glass paintings of the 1920s (fig. 478) one can observe the transition from free-form compositions of glass fragments to a rigid rectangular pattern in which the relations of each color strip to all the others are meticulously calculated. The transparency of glass also led him to the investigation of perspective illusions in which geometric shapes reverse themselves. The approach can be summarized in terms of a painting, first created as a glass work in 1931 and then re-created in tempera about 1935. It is a painting on a black ground, of straight, white lines enclosing areas of white, and light and dark gray (fig. 479). In the book *Despite Straight Lines* Albers describes precisely the many mutations of surface, vertical, and in-depth visual movement stimulated by these figures.

This and subsequent exercises in optics and perception were rooted in Cubist concepts of simultaneity and fragmentation of vision, as well as the explorations of Van Doesburg, Mondrian, Malevich, and others into the questions of nonperspective pictorial space. Specifically influential were the Proun paintings of Lissitzky, in which the artist attempted the reintegration of perspective spatial illusion with the approaches of the Cubists and abstractionists (fig. 272).

During the 1950s and 1960s Albers settled on the formula that he entitled *Homage to the Square*, where he explored endlessly the relationships of color-squares confined within squares (plate 148). The calculated interaction of color and of straight lines, and their intimate relationships, became the central pursuit of the artist. By confining himself to these elements for some forty years, Albers made notable contributions to the study of perception, both in how we see and in how to understand what we see. His scientific theories and his rational approach manifested in his teaching and his writing obscured the fact that, in the process of his studies, he created a body of works of art important for their influence on geometric abstractionists and Optical painters, and in themselves works of beauty and value.

The importance of Albers's experiments, however, lay in the statement, in the clearest and simplest terms, of the problem "how do we see the third dimension when created as an illusion by the artist in terms of lines, flat shapes and colors on a two-dimensional surface?" Albers followed this approach to painting, perception, illusion, and the interaction of pictorial elements during his entire career.

Germany's Machine Style

In the early 1920s there arose in Germany a school of machine painters and sculptors whose art both extolled the machine as a hope for the future and pointed out the danger that men might be turned into robots in a soulless machine society.

479. JOSEF ALBERS. *Steps After Glass Painting of 1931*. c. 1935. Tempera. Whereabouts unknown

OSKAR SCHLEMMER (1888–1943) The paintings of Oskar Schlemmer, who taught theater design, sculpture, and mural painting at the Bauhaus from 1920 to 1929, were related to the Classical proto-Surrealism of De Chirico, Carrà, and the Metaphysical School, Léger's machine Cubism, the Purism of Ozenfant and Jeanneret, and the machinism of Belling. He synthesized from these sources a personal

480. OSKAR SCHLEMMER. *Figures Resting in Space (Room of Rest)*. 1925. 43¼ × 33⅜". Marlborough Fine Art Ltd., London

481. OSKAR SCHLEMMER. *Abstract Figure*. 1962 (after plaster original, 1921). Bronze, 42⅛ × 26⅜". Collection Frau Tut Schlemmer, Stuttgart

482. RUDOLF BELLING. *Sculpture*. 1923. Bronze, partly silvered, 18⅞ × 7¾ × 8½". Collection, The Museum of Modern Art, New York. A. Conger Goodyear Fund

483. WILLI BAUMEISTER. *Stone Garden I*. 1939. 39⅜ × 31⅞". Collection Felicitas-Karg Baumeister, Stuttgart

and strangely moving world of architectural, perspective space, populated by mannequin figures isolated in a state of permanent hypnosis. Schlemmer also had affinity with the great Italian muralists of the fifteenth century, particularly with Piero della Francesca and his impersonal, sculpturally simplified figures and mathematically precise perspective space (fig. 4). In *Figures Resting in Space (Room of Rest)* of 1925 (fig. 480) he used the checkerboard floor of Early Renaissance perspective paintings diminishing to a white, rectangular opening at the back of the room. Two figures rest in the middle distance. Out of the foreground looms the back of a stiff, robot figure extending from floor to above the visible ceiling line. His legs are cut off by the mass of a head that is just entering the picture. The mechanical figures seen from the back in extreme close-up, the empty rectangle of the room in shadow but opening into the white emptiness of the space beyond, lend a sense of mystery that suggests the playing out of some disquieting drama. Schlemmer's turning back to the Classicism of the Renaissance was not a personal reaction against abstraction since the artist was always a figurative painter. In his sculpture, principally the reliefs that project his paintings into the third dimension, he moved closer to abstraction, but with a figure always evident or implied. His sculpture belonged in the decorative, mechanistic tradition of Archipenko (plate 68), and only rarely, as in *Abstract Figure* (fig. 481), achieved distinction of its own.

RUDOLF BELLING (1886–1972) A principal exponent of the "machine" doctrine was the sculptor Rudolf Belling, one of the founders of Germany's November Group. He was influenced by Archipenko, who

lived in Germany in the early 1920s, but after attempting Cubist sculptures, he created works in which the head or figure was translated into machine forms. The mechanistic approach, in his hands, took on an expressive as much as an abstract quality, pointing to a world in which man had become a machine (fig. 482).

WILLI BAUMEISTER (1889–1955) Baumeister, like Schlemmer, was a pupil of Adolf Hoelzel at the Stuttgart Academy and a friend of the Swiss painter Otto Meyer-Amden, whose mystical ideas on mathematical symbols influenced both younger artists. Baumeister was one of the few German painters of any significance before World War II to explore the possibilities of free abstraction. He was first affected by Cubism and Purism, although he added a textural element by building up his surfaces sculpturally with sand and plaster. Gradually, free forms appeared among his machine forms, and by the early 1930s the forms, suggestive of figures, had taken on organic shape, influenced by the Surrealist paintings of Joan Miró and at times of Paul Klee in a work like *Stone Garden I* (fig. 483). During the Nazi regime he continued to paint in secret, advancing his own ideas toward freer abstraction—ideograms with elusive suggestions of figures. These signs came from the artist's imagination, but were based on the art of primitive peoples.

Unlike Schlemmer, whose misfortune it was to remain in Germany during the Nazi dictatorship and to die in obscurity in 1943, and unlike Belling, who migrated to Turkey in 1933 and sank into academic oblivion, Baumeister became one of the heroes of the postwar generation of German artists. Although his works belong in the world of abstract, organic Surrealism, he was able to maintain an individual, magical expression even while painting under the greatest difficulties.

Non-Surreal Abstract Fantasy

PAUL KLEE First seen here in the context of Der Blaue Reiter (fig. 171), Klee immediately thereafter served in the German army. In 1920 Gropius invited him to join the staff of the Bauhaus at Weimar, and he remained affiliated with the school from 1921 to 1931. Becoming a teacher forced him to examine the tenets of his own painting, something that he did in publications of the greatest significance for modern art and particularly for those aspects concerned with expression of personal fantasy. He sought to clarify the process of creation as an intuitive act arising from the peculiar spirit of the artist but affected by all his experiences, remembered consciously or not, including the images, materials, and forms with which he had worked. The art of Klee, as differentiated from that of Mondrian or even of Kandinsky in his later phase, was always rooted in nature. He observed and drew from nature every waking moment. His great storehouse of naturalistic observations, however, was only the raw material on which his vision could draw at the moment of revelation. He was like Mondrian and Kandinsky in his mystical sense of an inner content beneath surface nature.

Also like Mondrian and Kandinsky, Klee was concerned in his teachings and his painting with the geometric elements of the work of art—the point, the line, the plane, the solid. To him, however, these elements had a primary basis in nature and growth. It was the process of change from one to the other that fascinated him. To Klee the painting continually grew and changed in time as well as in space. In the same way color was not simply relationships, harmonious or otherwise, nor even a means of establishing space in the picture. Color was energy. It was emotion that established the mood of the painting within which the line established the action.

484. PAUL KLEE. *Around the Fish*. 1926. 18⅜ × 25⅛″. Collection, The Museum of Modern Art, New York. Abby Aldrich Rockefeller Fund

Klee was only rarely a pure abstractionist (plate 149), and then principally in his Bauhaus years, when he was close to Kandinsky and the traditions of Russian Suprematism and Constructivism and Dutch De Stijl. His paintings have a pulsating energy that seems organic rather than geometric. But they were never based on immediately observed nature except in his early works and sketchbook notations. He began to draw like a child, letting the pencil or brush lead him until the image began to emerge. As it did, of course, his conscious experience and skills came back into play in order to carry the first intuitive image to a satisfactory conclusion. At that conclusion some other association, recollection, or immediate inspiration would result in the title which then became part of the total work.

Klee thus was a Romantic, a mystic. He saw the painting, or rather the creative act, as a magical experience in which the artist was enabled in moments of illumination to combine an inner vision with an outer experience of the world, in the visible rendering of a truth that was not "truth to man or nature" but was itself parallel to and capable of illuminating the essence of man or nature. The "microcosm" of his art, paralleling the "macrocosm" of nature, derives from Oriental ideas. Klee's art obviously grew out of the traditions of Romanticism and specifically of Symbolism, but he departed from both these traditions in that his inner truth, his inner vision, was revealed not only in the subject, the color, and the shapes as defined entities, but even more in the process of creation that the spectator inevitably had to retrace step-by-step on the canvas. Klee was a "primitive of a new sensibility," as Cézanne before him had described himself as a primitive of a new vision.

Teaching gave Klee much of his iconography. As he used arrows to indicate lines of force for his students, these arrows began to creep into his works (fig. 484). Color charts, perspective renderings, graphs, rapidly rendered heads, plant forms, linear patterns, Pointillist patterns, checkerboards, scattered or combined elements of all descriptions, used to prove a point, became part of that reservoir of subconscious visual experience which the artist then would transform into a magical idea.

In the paintings between 1914 and 1918, one can observe experiments with Cubist structure and an occasional excursion into a literary

fantasy (plate 149). In 1918 personal fantasy took over in forms that seem to have roots in the art of children, primitives, or madmen. His formal and expressive concepts were largely established before 1920. *Dance, Monster, to My Soft Song!* of 1922 shows a vast, mad-eyed, purple-nosed head on an infinitesimal body, a child's drawing integrated with the most sophisticated gradations of yellow ocher and umber (fig. 485). This is the essence of one aspect of Klee's work—the childlike image that is in fact a subtle blending of the primitive line mask with the delicate color atmosphere of the ground. Childlike figure- and object-drawings are scattered or floating in an ambiguous space composed of delicate and subtle harmonies of color and light that add mystery and strangeness to the concept. The combination of naïve and sophisticated rendition creates a shock effect of incompatible elements that yet are a single and total visual experience.

In Klee's work as differentiated from that of more formally organized fantasists—Dadaists and Surrealists—the effects were visual or pictorial forms, not intellectual or literary concepts imposed on pictorial means. Although these seemingly elementary exercises of his *Pedagogical Sketchbook* reveal Klee to have been a master of picture construction and thoughtful planning, even in his works that are most abstract, most concerned with the relationships of lines and color planes and picture space, the final result can rarely be thought of as a geometric abstraction in the sense of Mondrian or Van Doesburg. The designations of "abstract" or "representational" cease to have any application. Klee's world is so personal and individual, so completely a part of—yet so completely divorced from—either normal human experience or existing ideas of abstract picture structure, whether geometric or abstract Expressionist, that it exists independently of these, yet still encompasses them.

In *Red Balloon* the colors are confined within the linear contours but still blend imperceptibly with the drifting, changing color of the

485. PAUL KLEE. *Dance, Monster, to My Soft Song!* 1922. Mixed media on gauze mounted on paper, 17¾ × 12⅞". The Solomon R. Guggenheim Museum, New York

above: 486. PAUL KLEE. *Ad Parnassum.* 1932. Casein and oil on canvas, 39⅜ × 49⅝". Kunstmuseum, Bern

right: 487. PAUL KLEE. *Revolution of the Viaduct.* 1937. Oil on panel, 23⅝ × 19⅝". Kunsthalle, Hamburg

whole (plate 150). The red shapes at the upper left and right are confined by lines only toward the center. Toward the edges of the painting the reds change and flow into the delicate, grayed washes of the ground. The rest of the geometric structure, the total or partial squares and rectangles of yellow and green and umber, float in an indefinable space, impossible to fix or locate exactly. Even the blue-green shape at the bottom, defined at the right by an angled line that suggests a momentary recession into depth, only helps to complicate the spatial ambiguity. The central red circle alone—the "red balloon"—seems to hold as a mysterious focus about which everything else slowly gravitates in a perpetual state of change.

This, then, is an abstraction that is not an abstraction. It is a work of fantasy created out of abstract elements. Klee experimented with his personal forms of geometric abstraction most frequently during his Bauhaus years in the 1920s, an obvious reflection of the Constructivist atmosphere with which he was surrounded. *In the Current Six Thresholds* (plate 149) is a nonobjective arrangement of vertical-horizontal rectangles, in which gradations of deep color are contained within precisely ruled lines. Yet the total effect—as is usual with Klee—is organic rather than geometric. The forms seem produced by growth, and the sense of change is present throughout. Most of Klee's paintings were in combinations of ink and watercolor, media appropriate to the effects of fluidity that he sought, but this particular work is in a combination of oil and tempera, media he used to obtain effects of particular richness or density.

During the 1920s Klee produced a series of black pictures in which he used the oil medium, sometimes combined with watercolor. Some of these were dark underwater scenes where fish swam through the depths of the ocean surrounded by exotic plants, abstract shapes, and sometimes strange little human figures. This theme, embodying an arrangement of irrelevant objects, some mathematical, some organic, is presented as a sort of Surrealist still life in *Around the Fish* (fig. 484). Here the precisely delineated fish on the oval purple platter is surrounded by objects, some machine forms, some organic, some emblematic. A schematic head on the upper left grows on a long stem from a container that might be a machine and is startled to be met head-on by a red arrow attached to the fish by a thin line. A full and a crescent moon, a red dot, a green cross, and an exclamation point are scattered throughout the black sky—or ocean depth—in which all these disparate signs and objects float. In this and related works Klee came closest to the efforts of the Surrealists, who claimed him as a pioneer.

The range of Klee's experiments was so varied that it touched at one moment or another on almost every aspect of twentieth-century painting. During the early 1930s he explored a form of Pointillism (taking it from Picasso's Synthetic Cubism [plate 67], rather than from Seurat). In the relatively monumental *Ad Parnassum* all-over patterns of brightly colored dots, sometimes loosely formed into different colored triangles and controlled by a few strong lines, create an architectural image (fig. 486). After Klee left the Bauhaus and despite the long illness that led to his death in 1940, his genius spread out in continually richer and more varied forms.

Figures, faces (sometimes only great peering eyes), fantastic landscapes, architectural structures—sometimes menacing—continued to appear in his art during the 1930s (fig. 487). Perhaps the principal characteristic of the last works was an expression, monumental for Klee, in which he used bold and free black linear patterns against his colored field. In some of the late works, consisting only of a few brushed lines suggesting a figure or a snake, he drew close to some of the organic-Surrealist paintings of Joan Miró (plate 151). However, as

488. VASILY KANDINSKY. *Accented Corners, No. 247*. 1923. Oil on burlap, 51¼ × 51¼". The Solomon R. Guggenheim Museum, New York

always when one detects a relationship that may be an influence between Klee and another artist, it is difficult to tell who influenced whom.

The art of Paul Klee introduces into the study of modern painting and sculpture, and even of architecture, the range of tendencies having to do with the exploration of the fantastic. Although possessed of a unique genius, Klee was not in any sense working in isolation, for a large number of artists, both as individuals and as organized groups—Dadaists, Metaphysical painters, and Surrealists—were concerned with themes of fantasy, rooted in new theories of the subconscious, in revolt against the insanity of war or, sometimes, simply in revolt against the predominance of abstract, formal elements in the experimental art of the twentieth century.

VASILY KANDINSKY Kandinsky returned to Germany from Russia in 1921, and in 1922 joined the faculty of the Bauhaus. In the previous years, under the influence of Russian Suprematism and Constructivism, his painting had turned gradually from free abstraction to a form of geometric abstraction. This change has already been seen in *White Line, No. 232*, a work of 1920 (plate 90), which shows some regular shapes, straight lines, and curving shapes with sharply defined edges. By 1923, in *Accented Corners, No. 247*, regular, hard-edged shapes have taken over (fig. 488).

This is not to say that Kandinsky after 1921 deserted the Expressionist basis of his earlier style. His mystical-Theosophical ideas persisted. Even during his most rigidly geometric period his paintings were dynamic in structure, with triangles, circles, and lines flashing in and out of one another in unstable diagonals. He continued to use variegated color areas as contrasts with the geometry of the line. At times the mood becomes quiet, as in *Several Circles, No. 323*, where the transparent color circles float serenely across one another in a gray-black space (plate 152).

In correspondence with his biographer, Will Grohmann, during this period, Kandinsky emphasized his passion for the expressive power of abstract motifs, but he still thought of his painting as Romantic: "The purpose, the content of art is Romanticism, and it is our fault if we understand the concept exclusively in terms of its temporary manifestations. . . . the circle which I have been using to such a large extent in my recent work can often be described only as a Romantic circle. And the coming Romanticism is a piece of ice in which a flame burns."

Kandinsky was a most influential member of the Bauhaus faculty, and not only because of his greatness as an artist, a pioneer of modern abstraction, and a talented teacher bringing firsthand knowledge of the Russian revolution in abstract art. He was also capable of formulating his visual and theoretical concepts with precision and clarity. In 1926 he published, as a Bauhaus Book, *Point and Line to Plane*, his textbook for a course in composition. As compared with Paul Klee's *Pedagogical Sketchbook* of the previous year, Kandinsky's attempts a more absolute definition of the elements of a work of art and their relations one to another and to the whole. Here the artist affirmed the spiritual or Romantic basis of his art, and his correspondence of the time reveals his combination of the pragmatic and the mystical.

Kandinsky continued his association with the Bauhaus until the school was closed in 1933. He painted prolifically, creating works filled with subject implications and form conflicts, but always staying within the abstract means. Toward the end of the Bauhaus years the lyrical, coloristic aspect of Kandinsky's painting began to reemerge and to supersede the architectonic approach. In *Between the Light, No. 559* the shapes are still geometric, stratified in an even more vertical and horizontal manner than before (plate 153). The color is soft and muted, however, while precise shapes are surrounded by a diffused nimbus of light and color, so that the total effect is quiet and Romantic. Some shapes suggest Egyptian or American Indian hieroglyphs, conveying a feeling of the exotic. Kandinsky was now aware of the Surrealist activities of the 1920s, and one senses in this, as well as in works created after he moved to France in 1933, qualities akin to abstract Surrealism. The color shapes take on their own life and play or do battle like microorganisms or space monsters.

By late 1933 Kandinsky was in Paris, his home until his death. He was soon involved in the Abstraction-Création group of artists, and became friendly with Miró, Arp, and Pevsner. This last period was for him extraordinarily rich both in quantity of work and in the enlargement of his ideas and his forms. In general Kandinsky continued toward freer, more biomorphic shapes and colors, and at times he created textures more brilliant and varied than any since his abstract Expressionist works. The edges of his shapes remained sharp, but the shapes seem to have emerged from microscopic fantasy. In *Composition IX, No. 626* he established a mathematical color base by sectioning the two ends with identical triangles, one inverted and the other upright (plate 154). The parallelogram shape between the two triangles is subdivided into four smaller identical parallelograms. On this rigidly defined but vividly coloristic ground the artist scattered a wild assortment of dancing little shapes: circles, checkerboard squares, long, narrow rectangles, and amoebalike figures. The device of playing small free forms against a large geometric pattern intrigued him during these years. Sometimes the ground was an alternation of a few large identical vertical rectangles, sometimes a black-and-white checkerboard, but the contrast of freedom and control came from his lifelong concentration on the relations between intuitive expression and calculated abstract form.

This personal abstract fantasy was the principal departure made by Kandinsky in his later years. At times he scattered his tiny free forms haphazardly over a unified color ground. At other times he returned to a design of the fewest possible elements, as if to purify his means. Kandinsky's last paintings represent the flowering of one of the most remarkable and influential talents in modern art.

Abstraction in Paris During the 1930s

Paris during the twentieth century has drawn artists from every part of the world. Hence, the School of Paris, as we have seen, is international rather than specifically French, and during the 1920s in France, abstract painting and sculpture were largely imported products, forced to struggle for survival against the influences of the older masters of modern art as well as the sensation created by the Surrealists. Although Picasso, Braque, and even Matisse had come close to abstraction before and during World War I, they did not take the final steps, and in the next decades they pursued their individual paths. Of the Cubists, Delaunay, one of the pioneers of abstraction, during the 1920s was principally interested in Cubist figuration, although after 1930 he returned to abstraction in painting and sculpture. Léger painted a number of quite abstract designs during the 1920s (fig. 250). The Purism of Ozenfant and Jeanneret during its short life continued to cling to the object. The influence of Dutch De Stijl and Russian Constructivism and Suprematism was more apparent in Germany than in France during the 1920s, partly because of the Bauhaus and partly because France has been less receptive to imported influences in modern art. When the De Stijl artists held an exhibition in 1923 at the gallery of Léonce Rosenberg, it aroused little general interest. Mondrian, then living in Paris, could sell nothing, and secretly painted flower pictures to earn a living.

In 1925 a large exhibition of contemporary art was organized in Paris by a Polish painter, Poznanski, at the hall of the Antique Dealers Syndicate. Among those included were Arp, Baumeister, Brancusi, the pioneer American abstractionist Patrick Henry Bruce, Robert and Sonia Delaunay, Van Doesburg, César Domela, Goncharova, Gris, Klee, Larionov, Léger, Louis Marcoussis, Miró, Moholy-Nagy, Mondrian, Ben Nicholson, Ozenfant, Enrico Prampolini, Victor Servranckx, Vantongerloo, Jacques Villon, and Friedrich Vordemberge-Gildewart. The purpose of the exhibition was stated as "not to show examples of every tendency in contemporary painting, but to take stock, as completely as circumstances permit, of what is going on in *non-imitative plastic art*, the possibility of which was first conceived by the Cubist movement." There are obvious omissions, such as the Czech Kupka, one of the first abstract painters in Paris (plate 78); still, it was a surprisingly comprehensive showing of abstract tendencies. In the face of the rising tides of representation and Surrealism, however, it did not attract wide attention.

The next major event in the history of abstraction in Paris did not come until 1930, when the artist-critic Michel Seuphor and the Uruguayan painter Joaquín Torres-García founded the group and periodical entitled *Cercle et Carré* (Circle and Square). The first exhibition, held in April 1930, on the ground floor of the building in which Picasso lived, included Arp (always *persona grata* with both Surrealists and abstractionists), Baumeister, Jean Gorin (a new French disciple of Mondrian), Kandinsky, Le Corbusier, Léger, Mondrian, Ozenfant, Pevsner, Prampolini, Russolo, Schwitters, the American Futurist Joseph Stella, Sophie Taeuber-Arp, Torres-García, Vordemberge-Gildewart, and Vantongerloo. Also shown, according to Seuphor, but not in the catalogue, were Otto Freundlich from Germany, Jean Xceron from the United States, Moholy-Nagy, Hans Richter, and Raoul Hausmann.

The periodical and the exhibition, although short-lived, had a considerable impact. Their impetus and their mailing lists were taken over by Vantongerloo and Auguste Herbin, upon the formation in 1931 of a comparable group, Abstraction-Création, with a periodical of the same name. Herbin had pursued a long, slow path toward abstraction from about 1906 to the end of the 1920s. During the early 1920s he returned to representation, but by 1927 he had again become completely abstract. Abstraction-Création, both in its exhibitions and its publications, was a force for abstract art until 1936. After World War II it was succeeded by the Salon des Réalités Nouvelles, which carried on the battle for abstract art, in particular for the tradition of Mondrian and Constructivism.

In the early 1930s the rise of Nazism in Germany brought more of the older masters of abstraction to Paris. Gabo moved there from Berlin in 1932, rejoining his brother Pevsner, who had lived in Paris during the 1920s. Kandinsky came in 1933, followed by many younger abstractionists.

The mixture of artists from Russia, Holland, Germany, and France itself, as well as from other countries, resulted in a gradual breaking down of distinctions. By the mid-1930s, despite the general coolness of the French to geometric abstraction, Abstraction-Création on occasion had as many as four hundred members—from Suprematism, Constructivism, De Stijl, and their many offshoots. With the exception of Mondrian, who adhered rigidly to his basic principles, most abstractionists took from each source whatever they needed. Even Van Doesburg's Elementarism, with its departure from the vertical-horizontal axis in favor of the diagonal (fig. 286), owed much to Suprematism, as did a large proportion of Kandinsky's paintings of the 1920s and 1930s.

AUGUSTE HERBIN (1882–1960) Auguste Herbin, Jean Gorin, and Jean Hélion were the three French painters to emerge from the abstract environment during the 1930s. Herbin, as noted, had grown up in the atmosphere of early Cubism, but from the beginning was interested in pursuing his own researches on color and its interrelationships, based on the color theory of Goethe. By the end of World War I his abstract paintings were startling in the impact of their colors and geometric shapes. In the 1920s Herbin turned briefly to representation, applying his ideas about color and abstract shapes to landscape and figure. About 1927 he went back to abstraction and remained there, in a manner that seems to have particular pertinence for younger Hard-Edge painters, Pop artists, or sculptors. Although the 1939 *Composition* (plate 155) owes something to Delaunay's paintings of the 1930s, the dynamics of his color shapes are entirely his own. In *Rain* (fig. 489), a typical postwar painting, the forms assume a hypnotic presence, through the flat, intense color and the frankly mathematical shapes. When they are studied, the color relations form optical illusions. In fact, Herbin is an important pioneer in what would become retinal or Optical painting. He has written effectively of his theories of color, its relations, and its psychological impact.

Neither of the other two French members of the abstract community in Paris ever arrived at so individual a form of expression, but both were artists of distinction.

PIET MONDRIAN Mondrian lived in Paris between 1919 and 1938, and although he did not take the initiative in the organization of Cercle et Carré or Abstraction-Création, his presence and participation were of the greatest significance for the growth and spread of abstraction. As already noted, he had resigned from De Stijl in 1925 after Van Doesburg introduced the diagonal as part of its vocabulary. Painting and

489. AUGUSTE HERBIN. *Rain*. 1953. 45⅝ × 35″. Galerie Denise René, Paris

writing on his theories, he fully formulated his ideas during the 1920s.

In 1919 Mondrian had found his solution to the problem with which he had been struggling for several years—how to express universals through a dynamic balance of vertical and horizontal structure, with primary hues of color disposed in rectangular areas. He was disturbed by the fact that up to this point, in most of his severely geometric paintings—including the floating color-plane compositions and the so-termed grid or checkerboard paintings—the shapes of red, blue, or yellow seemed visually to function as foreground forms against a white and gray background, and thus to interfere with total unity (plate 93). The solution, he found, lay in making the structure independent of color, with heavy lines (which he never thought of as lines in the sense of edges) moving through the rectangles of color. By this device he was able to gain a mastery over color and space that he did not exhaust in the next twenty years.

The perfected formula is seen in the 1921–25 *Tableau II* (plate 156). Here is the familiar palette of red, blue, yellow, black, and two shades of gray. The total structure is emphatic, not simply containing the color rectangles but functioning as a counterpoint to them. Both red and gray areas are divided into larger and smaller rectangles. The black rectangles, since they are transpositions of lines to planes, act as further unifying elements between line and color. Mondrian is careful to leave the edges of the painting open. Along the top and in the lower left corner he does not bring the verticals quite to the edge, with the consequence that the grays at these points surround the end of the lines. Only in the lower right does the black come to the edge, and this is actually a black area through which the line moves slightly to the left of the edge. In all other parts a color, principally gray, but red and yellow at the

490. PIET MONDRIAN. *Composition in White, Black, and Red.* 1936.
40¼ × 41″. Collection, The Museum of Modern Art, New York. Gift of the
Advisory Committee

almost totally a structure of vertical and horizontal black lines on a white ground, with a small black rectangle in the upper left corner and a long red strip at the bottom (fig. 490). The lines, however, represent intricate proportions, both in the rectangles they define and in their own thickness and distribution. In the right lower corner horizontal lines, varied subtly in width, create a grid in which the white spaces seem to expand and contract in a visual ambiguity.

In further variations the artist turned from canvases of square or almost square shape to the diamond shape—the square turned on edge. This shape inspired some of his most austere designs, in which his desire to violate the frame, to express a sense of incompleteness, was given tangible expression. *Composition with Yellow Lines* is prophetic in its use of primary yellow lines rather than black (fig. 491), and represents an ultimate simplification in its design of four lines, delicately adjusted in width and cutting across the angles of the diamond. Mondrian's fascination with the incomplete within the complete, the tension of lines cut off by the edge of the canvas that seek to continue on to an invisible point of juncture outside the canvas, is nowhere better expressed than here. The desire of the lines to rejoin and complete themselves, to recover the square, is almost painful. The fascination of the painting also lies in another direction—the abandonment of black.

In 1938, with the approach of war, Mondrian left Paris for London. After two years he moved to New York, where he spent his final four years. Manhattan became the last great love of his life, perhaps because of the Neo-Plastic effect created by skyscrapers rising from the narrow canyons of the streets and the rigid grid of its plan. The major new stimulus to the artist was that of lights at night, when the skyscrapers were transformed into a brilliant pattern of light and shadow, blinking and changing. Mondrian also loved the tempo, the dynamism, of the city—the dance halls, the jazz bands, the excitement of movement and change. He felt driven to translate it into his seemingly austere patterns of rectangular linear structures and color shapes. When we look at his impressions of New York, we must recall that he was originally and temperamentally a landscapist (fig. 279). He had spent twenty-three years—1888–1911—studying the Dutch landscape or still lifes associated with that landscape. For the next five years his developing abstractions were still rooted in landscape. He was extremely sensitive to his surroundings, and the experience of New York, which held a romantic attraction, proved to be overwhelming.

The impact of the city is most evident in *Broadway Boogie-Woogie*, painted in 1942–43 (plate 158). Here the artist returned to the square canvas but departed radically from the formula which had occupied him for over twenty years. There is still the rectangular grid, but the black, linear structure balanced against color areas is gone. In fact, the process is reversed: the grid itself is the color, with the lines consisting of little squares or rectangles of red, yellow, and blue. The ground is a single plane of off-white, and against it vibrate the varicolored lines and scattered areas of red, yellow, and blue. One can "read" the night façades of office buildings with blinking window lights.

In evaluating the course of geometric abstraction from its beginnings, about 1911, to the present time, an understanding of the part played by Piet Mondrian is of paramount importance. He was the principal figure in the founding of geometric abstraction during World War I, for the ideas of De Stijl and their logical development were primarily his achievement. Mondrian's influence extended not only to abstract painting and sculpture but also to the forms of the International Style in architecture as well. Through the teachings of the Bauhaus in Germany and its offshoots in the United States, his theories were spread throughout the Western world. During the 1920s and 1930s in Paris it was

upper left, forms the outer boundary. The result that Mondrian sought—an absolute but dynamic balance of vertical and horizontal structure, using primary hues and black and white—is thus achieved. Everything in the painting holds its place visually. By some curious visual phenomenon, caused by the structure and the subtle disposition of color areas, the grays are as assertive as the reds or yellows; they advance as well as recede. The painting is not in any sense of the word flat. Everything is held firmly in place, but under great tension.

The open composition with emphasis on large white or light-gray areas predominated in Mondrian's production during the 1920s, and in fact for the rest of his life. At the end of the 1920s he did reverse the process in a number of paintings in which the structure of the lines is comparably simple, but the dominating color areas are one or another of the primaries at maximum intensity. *Composition with Red, Blue, and Yellow* is a square canvas with a large color square of red, upper right, joined point to point by intersecting black lines with a small square of comparably intense blue, lower left (plate 157). Surrounding them, equally defined by heavy black lines, are rectangles of off-white. In the lower right corner is one small rectangle of yellow. The curious fact about this painting is again that the white areas, combined with the subordinate blue and yellow, effectively control and balance the great red square. It is as though Mondrian, in command of all the elements of abstract painting, now feels confident that he can keep even the most assertive colors under absolute control.

Once having satisfied himself of this fact, Mondrian returned to an intensive examination of the open composition in which color was subordinated to a subtle variation on vertical-horizontal linear patterns on a neutral white or off-white ground, with minimal accents of positive color. This approach he followed during the 1930s in a refinement of his elements and relations. *Composition in White, Black, and Red* is

491. PIET MONDRIAN. *Composition with Yellow Lines*. 1933. 52⅜" (on the diagonal). Gemeente Museum, The Hague, The Netherlands

probably the presence and inspiration of Mondrian more than that of any other single person that enabled abstraction to survive and gradually to gain strength—in the face of the revolution of Surrealism and the counterrevolution of representation, economic depression, threats of dictatorship, and war.

In the United States Mondrian was a legendary figure inspiring not only the geometric abstractionists, who had been carrying on a minority battle against Social Realism and Regionalism, but also a number of younger artists who were to create a major revolution in American art. The emerging Abstract Expressionists of the early 1940s almost without exception had the greatest respect and actual reverence for Mondrian, even though their painting took directions that would seem diametrically opposed to everything he believed in. And, finally, when one examines more recent tendencies in American abstract painting—Hard-Edge abstraction, Op Art, or Color Field painting—in almost every case a line may be traced to Mondrian. His impact on the course of twentieth-century art may even have transcended that of Picasso, Braque, or Matisse.

ANTON PEVSNER Pevsner left Russia in 1923, after his brother Naum Gabo had moved to Berlin, and in 1924 he settled in Paris. About 1925

he began to work seriously in abstract constructed sculpture, apparently with the advice and encouragement of Gabo. There is some confusion about the part played by Pevsner in the founding of Russian Constructivism. (It is sometimes difficult to trace the origins of art movements or the development of individual artists, partly because artists become art-history-minded and concern themselves with questions of chronological priority. For the documentation of the rise of abstract art in Russia during World War I and the Russian Revolution, there are further complications owing to the isolation, general confusion, and lack of adequate contemporary publications.)

Considering Pevsner's late start (he was forty years old in 1925), his subsequent development into one of the major Constructivists is all the more remarkable. Since the *Portrait of Marcel Duchamp* was commissioned by the Société Anonyme in 1926, we may accept the work—an open plastic construction based on Gabo (figs. 278, 492)—as a starting point for the artist's sculpture. By the end of the 1920s Pevsner had abandoned construction in plastics (with a few exceptions) in favor of direct-metal abstractions in bronze or copper. He established his own identity as a sculptor not only in his choice of different materials but, more important, in the individual style of construction that he formulated over the next twenty years. *Construction in Space* is a crisp, dynam-

492. ANTON PEVSNER. *Portrait of Marcel Duchamp*. 1926. Celluloid on copper. 37 × 25¾″. Yale University Art Gallery, New Haven, Connecticut. Société Anonyme Collection

ic machine form, engineered in the most accomplished fashion (fig. 493). Despite this precision, Pevsner categorically denied, quite correctly, any mathematical basis in the organization of his mature works.

In such a piece as the 1938–39 *Projection into Space* he perfected his technique and his sculptural conceptions (fig. 494). The work is polished bronze, not cast but hammered out to machine precision. Faithful to the *Realistic Manifesto* (see p. 201), he took space as his primary means of expression, complete three-dimensional space articulated as tangibly as Bernini in the seventeenth century articulated his figures to express the space that surrounded them. Gabo was drawn to transparent plastic materials by his desire to make of space the paramount sculptural medium defined only in a minimal sense by lines or imperceptible planes. Pevsner was attracted by the relations between tangible space and tangible planes and lines, in materials sufficiently dense to define both the enclosed and the surrounding space. In this sense he was a more traditional sculptor, carrying on the concepts of space definition first fully stated in Hellenistic sculpture and then in that of the Baroque. However, there are differences. *Projection into Space* is a group of abstract, spiraling shapes whose rotating effect is accentuated by the radiating lines on the curving planes. It is a work whose structure carries the eye of the spectator around the perimeter and almost forces him to walk around it and view it from different points of view. As against a Hellenistic or Baroque sculpture it is a series of curving planes that not only define surrounding space but, more important, enclose space as the walls of a building enclose architectural space. The other important feature here and in much of Pevsner's subsequent

493. ANTON PEVSNER. *Construction in Space*. 1929. Burnt sheet brass and glass, height 27⅛″. Kunstmuseum, Basel. E. Hoffmann Collection

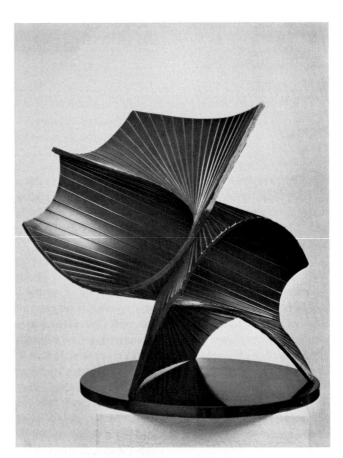

494. ANTON PEVSNER. *Projection into Space*. 1938–39. Bronze and oxidized copper, 21½ × 15¾ × 19¾″. Collection Frau M. Sacher-Stehlin, Pratteln, Switzerland

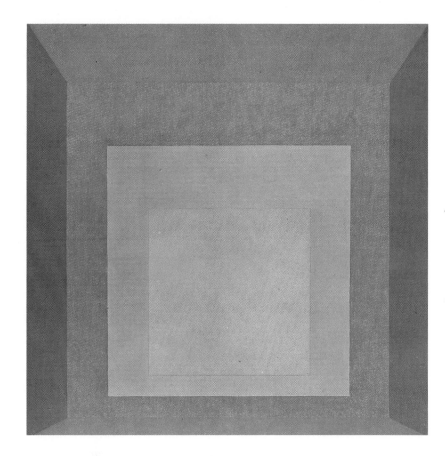

left: Colorplate 148. JOSEF ALBERS. *Homage to the Square: Apparition.* 1959. Oil on board, 47½ × 47½". The Solomon R. Guggenheim Museum, New York

below: Colorplate 149. PAUL KLEE. *In the Current Six Thresholds.* 1929. Tempera and oil on canvas, 17 × 17". The Solomon R. Guggenheim Museum, New York

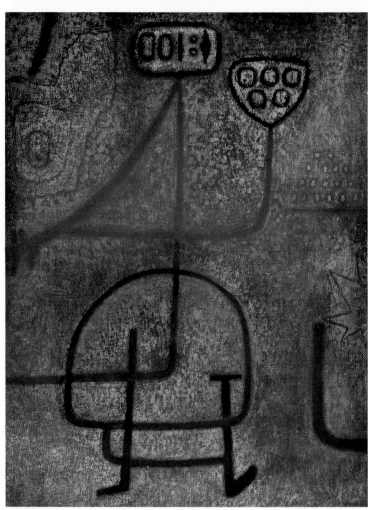

above left: Colorplate 150. PAUL KLEE. *Red Balloon*. 1922. Oil on chalk-primed muslin, mounted on board, 11½ × 12¼". The Solomon R. Guggenheim Museum, New York

above right: Colorplate 151. PAUL KLEE. *La Belle Jardinière*. 1939. Tempera and oil on canvas, 37⅜ × 27⅝". Paul Klee Collection, Kunstmuseum, Bern

right: Colorplate 152. VASILY KANDINSKY. *Several Circles, No. 323*. 1926. Oil on canvas, 55⅛ × 55⅛". The Solomon R. Guggenheim Museum, New York

left: Colorplate 153.
VASILY KANDINSKY.
Between the Light, No. 559. 1931. Oil on cardboard, 27⅝ × 31½″. Private collection, Italy

below: Colorplate 154.
VASILY KANDINSKY.
Composition IX, No. 626. 1936. 47⅞ × 76¾″. Musée National d'Art Moderne, Paris

Colorplate 155. AUGUSTE HERBIN. *Composition.* 1939. 18½ × 43¼″. Collection Pierre Peissi, Paris

Colorplate 156. PIET MONDRIAN. *Tableau II.* 1921–25. 29½ × 25⅝″. Collection Max Bill, Zurich

Colorplate 157. PIET MONDRIAN. *Composition with Red, Blue, and Yellow.* 1930.
20 × 20″. Collection Mr. and Mrs. Armand P. Bartos, New York

Colorplate 158. PIET MONDRIAN. *Broadway Boogie-Woogie.* 1942–43. 50 × 50″. Collection,
The Museum of Modern Art, New York. Given anonymously

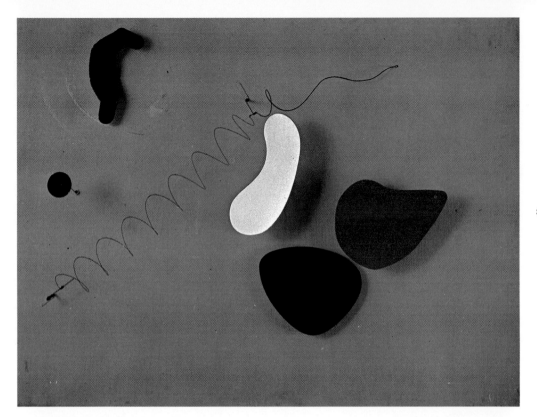

Colorplate 159. ALEXANDER CALDER. *The Orange Panel.* 1943. Mobile, oil on wood, sheet metal, wire, and motor, 36 × 48″. Collection Mrs. H. Gates Lloyd, Haverford, Pennsylvania

Colorplate 160. BEN NICHOLSON. *Saronikos.* 1966. Carved pavatex relief, 29⅛ × 50⅜″. Marlborough Gallery, New York

Colorplate 161. Barbara Hepworth. *Landscape Sculpture.* 1944. Bronze, length 26″. Number four of edition of seven. Marlborough Gallery, New York

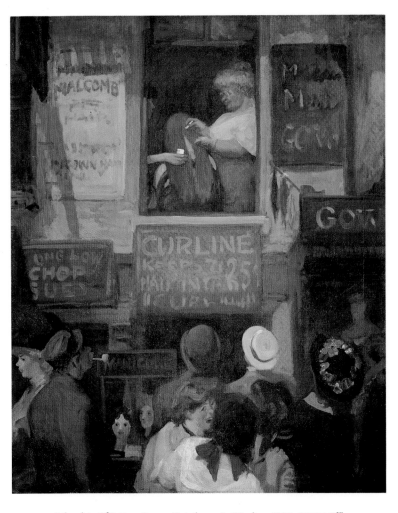

Colorplate 162. JOHN SLOAN. *Hairdresser's Window.* 1907. 31⅞ × 26″.
Wadsworth Atheneum, Hartford. The Ella Gallup Sumner and Mary Catlin
Sumner Collection

Colorplate 164. MARSDEN HARTLEY. *Portrait of a German Officer.* 1914.
68¼ × 41⅜″. The Metropolitan Museum of Art, New York. The Alfred
Stieglitz Collection, 1949

Colorplate 163. MAURICE
PRENDERGAST. *The Idlers.*
1916–18. 21 × 23″. Ran-
dolph-Macon Woman's Col-
lege, Lynchburg, Virginia

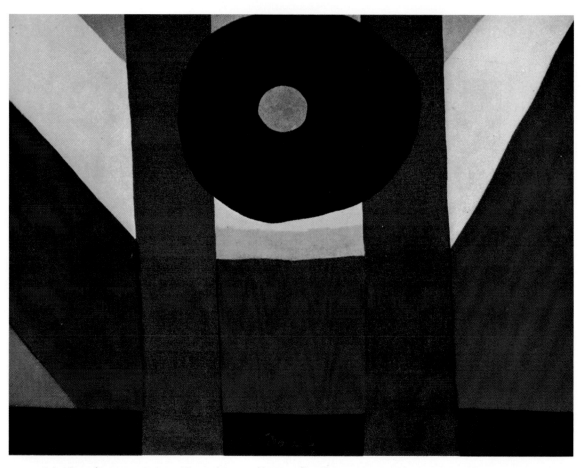

Colorplate 165. ARTHUR G. DOVE. *That Red One*. 1944. 27 × 36″. William H. Lane Foundation, Leominster, Massachusetts

Colorplate 166. GEORGIA O'KEEFFE. *Yellow Cactus Flower*. 1929. 29¾ × 41½″. Fort Worth Art Center, Texas. Gift of the William E. Scott Foundation

Colorplate 167. STANTON MACDONALD-WRIGHT. *Abstraction on Spectrum (Organization, 5)*. 1914. 30 × 24″. © Des Moines Art Center, Iowa. Nathan Emory Coffin Memorial Collection

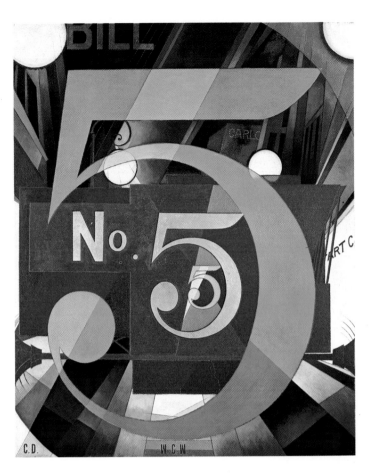

Colorplate 168. CHARLES DEMUTH. *I Saw the Figure 5 in Gold*. 1928. Oil on composition board, 36 × 29¾″. The Metropolitan Museum of Art, New York. The Alfred Stieglitz Collection, 1949

Colorplate 169. EDWARD HOPPER. *Early Sunday Morning*. 1930. 35 × 60″. The Whitney Museum of American Art, New York

above: Colorplate 170. PETER
BLUME. *The Eternal City.* 1937.
Oil on composition board,
34 × 47⅞". Collection, The
Museum of Modern Art,
New York. Mrs. Simon
Guggenheim Fund

left: Colorplate 171. STUART
DAVIS. *Rapt at Rappaport's.*
1952. 52⅜ × 40⅜". Hirshhorn
Museum and Sculpture Garden,
Smithsonian Institution,
Washington, D.C.

above: Colorplate 172. STUART DAVIS. *Colonial Cubism.* 1954. 45 × 60″. Walker Art Center, Minneapolis

left: Colorplate 173. BURGOYNE DILLER. *Second Themes.* 1937–38. 30 × 30″. The Metropolitan Museum of Art, New York. George A. Hearn Fund, 1963

Colorplate 174. MILTON AVERY. *Swimmers and Sunbathers.* 1945. 28 × 48⅛″. The Metropolitan Museum of Art, New York. Gift of Mr. and Mrs. Roy R. Neuberger, 1951

Colorplate 175. AUGUSTUS VINCENT TACK. *Storm.* Before 1928. 37 × 48″. The Phillips Collection, Washington, D.C.

right: 495. ANTON PEVSNER. *Dynamic Projection in the 30th Degree*. 1950–51. Bronze, height over 96″. Aula Magna, University City, Caracas, Venezuela (Carlos Raúl Villanueva, architect)

below: 496. ANTON PEVSNER. *Oval Fresco*. 1945. Bronze and oxidized tin, 31½ × 18¼″. Stedelijk Museum, Amsterdam

sculpture is the dynamism of the spiraling planes, the illusion of movement in a static design. This quality probably derives from such Futurist sculptures as Boccioni's *Development of a Bottle in Space* (fig. 266), but here is given increased dynamism by the elimination of the subject, the bottle. We are left with the spiraling movement as an abstract but concrete fact.

In subsequent works the artist massed his linear ridges so closely that the entire structure seems to be composed of a tight mass of thin reeds spinning in space (fig. 495). For some reason, the tight, linear construction seems to accelerate the tempo of the spiraling motion, an illusion perhaps accentuated by the horizontal elements flying out at right angles from the compressed waist of the hourglass construction. By the mid-1940s, Pevsner was sufficiently in control of his bronze structures to revert to a frontalized, totemistic form with perspective recessions moving back from an invisible picture plane in a tour de force of reality imitating illusion (fig. 496).

Pevsner's bronze constructions, in which he wrapped planes of metal in rhythmic spirals around definable depth, lent themselves to monumental scale, and he was able to carry out several large architectural commissions. The most dramatic was at the University of Caracas, Venezuela, the *Dynamic Projection in the 30th Degree*, which is over eight feet high (fig. 495). This is a sweeping diagonal form that combines solidity of shape with the freedom of a vast pennant held rigid by the force of a tornado wind. Until his death in 1962, Pevsner was the major exponent of abstract constructed sculpture working in Paris. Although he seemed isolated during these years, just as Brancusi also seemed isolated in Paris, his influence was slowly spreading through the world.

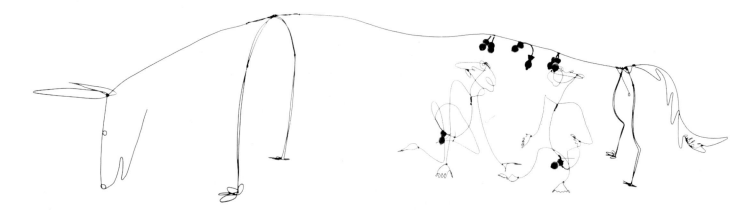

497. ALEXANDER CALDER. *Romulus and Remus*. 1928. Wire sculpture, 2'7" × 9'4". The Solomon R. Guggenheim Museum, New York

ALEXANDER CALDER (1898–1976) Born in Philadelphia, Calder was the son and grandson of sculptors. After studying engineering he was gradually drawn into the field of art, principally as an illustrator. In 1926 he went to Paris, where he first attracted the attention of avant-garde artists and writers with his *Circus*, a full-fledged, activated environment, and his portraits and caricatures constructed from wire. There followed his 1929 wire sculpture *Fishbowl with Crank*, which has been described as a hand-operated mobile, and early drawings and wire constructions of marked technical ingenuity and playful humor, such as *Romulus and Remus* of 1928 (fig. 497).

In 1930 Calder came under the influence of Mondrian and of the Constructivists—specifically Gabo. He began to experiment with abstract painting and, more significant, abstract wire constructions that illustrated an immediate mastery of constructed space sculpture (fig. 498). These early abstract sculptures had a predominantly austere, geometric form, although the suggestion of subject—constellations, universes—was rarely absent.

Calder's first group of hand and motor "mobiles" was exhibited in 1932 at the Galerie Vignon, where they were so christened by Marcel Duchamp. When Arp heard the name "mobile," he asked, "What were those things you did last year—stabiles?" Thus was born the word which technically might apply to any sculpture that does not move but which has become specifically associated with Calder. During the 1930s the artist created motorized mobiles, both as reliefs, with the moving parts on a plane of wooden boards or within a rectangular frame, and freestanding, with elements moving in three-dimensional space. Of the first type, one of the earliest on a large scale is *The White Frame* of 1934 (fig. 499). In this, a few elements are set against a plain, flat background: a large, suspended disk at the right, a spiral wire at the left, and between them, suspended on wires, a white ring and two small balls, one red and one black. Put into motion, the large disk swings back and forth as a pendulum, the spiral rotates rapidly to create a multiple spiral effect, and the ring and balls spin. Whereas *The White Frame* still (with the exception of the spiral) reflects Mondrian and

below left: 498. ALEXANDER CALDER. *Universe*. 1931. Wire and wood, height 36". Estate of the Artist

below right: 499. ALEXANDER CALDER. *The White Frame*. 1934. Mobile, wood, wires, ropes, sheet, and motor, 7½ × 9'. Moderna Museet, Stockholm

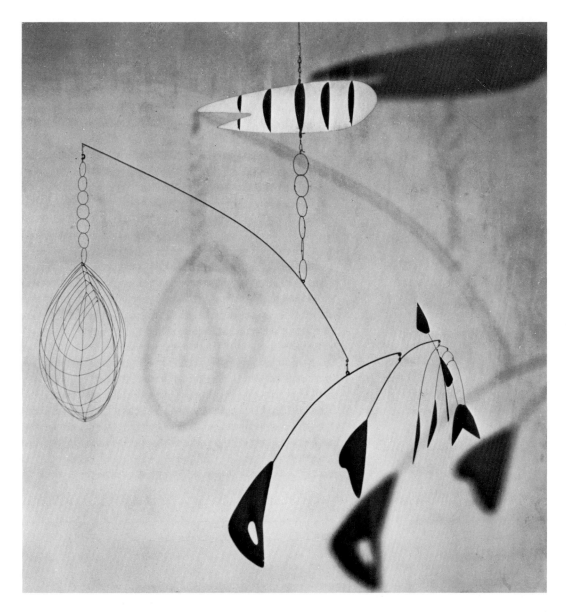

500. ALEXANDER CALDER. *Lobster Trap and Fish Tail*. 1939. Mobile, painted steel wire, and sheet aluminum, approximately 8'6" × 9'6". Collection, The Museum of Modern Art, New York. Commissioned by the Advisory Committee for stairwell of Museum

geometric abstraction, *The Orange Panel* of 1943 reveals a major change of the late 1930s (plate 159). Calder now used free forms and scattered them loosely over intensely colored ground, reflecting both Miró and Arp, his good friends. From this point onward, Calder's production moved easily between geometric or Neo-Plastic forms and those associated with organic Surrealism.

The characteristic works of the 1930s and 1940s—those on which the image of the artist has been created—are the wind mobiles, either standing or hanging, made of plates of metal or other materials suspended on strings or wires, in a state of delicate balance. The earliest wind mobiles were relatively simple structures in which a variety of objects, pieces of glass, wood, or free-form metal moved slowly in the breeze. A far greater variety of motion was possible than in the mechanically driven mobiles. For one thing, the element of chance played an important role. Motion varied from slow, stately rotation to a rapid staccato beat. In the more complex examples, shapes rotated, soared, changed tempo, and, in certain instances, emitted alarming sounds. By the end of the 1930s Calder's wind mobiles had become extremely sophisticated and could be made to loop and swirl up and down as well as around or back and forth. One of the largest hanging mobiles of the 1930s is *Lobster Trap and Fish Tail* (fig. 500). Although it is quite

abstract in its forms, the subject association is strong. The torpedo-shaped element at top could be a lobster cautiously approaching the trap, represented by a delicate wire cage balancing at one end of a bent rod. Dangling from the other end is a cluster of fan-shaped metal plates suggestive of a school of fish. The delicacy of the elements somewhat disguises the actual size, some nine-and-a-half feet in diameter.

After World War II, as we shall discover in a later chapter, Calder would realize one of the most international of careers, expanding the abstract art already formulated in the 1930s to an architectural scale of unprecedented grandeur.

The Emergence of Abstraction in Great Britain

At this point we must retrace our steps briefly, to bring the development of modern art in Great Britain to somewhere near its present position of importance in the world. British art, like art in the United States, had followed an essentially traditional course at the end of the 1800s and during the first decades of the 1900s. It was insular and had no interna-

501. WALTER SICKERT. *Ennui*. 1913–14. 60 × 44¼″. The Tate Gallery, London. Presented by C.A.S.I.

Manet, and the Nabis than to developed Impressionism (fig. 501). He became a leader among the young British painters, and his studio in Camden Town became the gathering place for progressive artists and critics who included Percy Wyndham Lewis, Lucien Pissarro, son of Camille Pissarro, and the critic Frank Rutter. In 1913 they merged into the London Group, which continued for many years as a forum for experiment and discussion.

Individual artists such as Whistler, Sickert, and Steer continued to be in touch with Paris, but their impact on the general directions of British painting and sculpture seemed imperceptible until after World War I. Nevertheless, a number of talented younger artists and critics in England were mounting campaigns against the strongly entrenched Royal Academy and its offshoots. By the turn of the century, the New English Art Club, founded in 1885, had become almost as academic as the Academy. Artists and critics such as Frank Rutter attempted to emulate the Salon des Indépendants in the nonjury exhibitions of the Allied Artists Association. These not only offered an opportunity for younger British artists to show their works, but introduced a number of the new European painters and sculptors to the British public.

Of crucial importance in the emergence of a new art in England were the exhibitions organized by the critic Roger Fry (1866–1934) at the Grafton Galleries in London. In the first, which ran from November 1910 to January 1911, Fry presented Manet and the Post-Impressionists, including Cézanne, Gauguin, Van Gogh, and the French Symbolists. The term Post-Impressionism was in fact the creation of Roger Fry, designed to distinguish the works of Cézanne, Van Gogh, Gauguin, and

tional impact—in the sense of influencing modern art in general—until the years immediately following World War II. Just as refugee modernists were to affect British art and architecture in the 1930s and 1940s (many proceeding to the United States where they effected the same influence), so foreigners had, in the late nineteenth century, disturbed the course of British art.

Despite the French admiration for Constable and Turner, and despite the fact that Monet, Pissarro, Sisley, Manet, and Toulouse-Lautrec visited or lived for periods in London, the influence of Impressionism and Post-Impressionism on British painting was belated and watered-down. Modern art in Britain during the early twentieth century, like that in the United States, followed the developments and vicissitudes of the comparable French movements at some remove. Despite the geographic proximity of England to France, crosscurrents were painfully slow. The greatest single influence for new experiment was Whistler, who lived in London after 1859 (fig. 43). He carried on a continual battle for the recognition in England of progressive French painting, and it was a result of his insistence that the late Impressionist paintings of Monet, as well as works of Cézanne, were first exhibited by official art organizations. He also inspired young English artists like Walter Richard Sickert (1860–1942) to go to Paris and study the Impressionists at first hand.

When we examine the works of the English pioneers, little genuine innovation can be found, although there are many individual works of quality. Philip Wilson Steer (1860–1942) was the most dedicated Impressionist. Sickert, himself, after experimenting with Impressionism, returned to a form of tonal, Expressionist painting, closer to Courbet,

502. MATTHEW SMITH. *Fitzroy Street Nude No. 2*. 1916. 40 × 30″. Collection British Council, London

their generation from those of the Impressionists. The second exhibition of Post-Impressionists, mounted October–December 1912, included Matisse, Picasso, and other Fauves and Cubists. Fry himself, through his writings and personal prestige, remained a powerful voice for a new English art all his life, although he continued to prefer Cézanne and Matisse rather than the Cubists and their followers.

Despite public hostility to the Grafton exhibitions, their impact on younger British artists, such as Harold Gilman and Frederick Spencer Gore, was considerable. With Walter Sickert, Duncan Grant, and others they formed the Camden Town group in 1911 (renamed the London Group in 1913, when it was joined by Jacob Epstein, C. R. W. Nevinson, and others who represented aspects of Expressionism and Futurism). A section for English artists, principally from the Camden Town group, was included in Fry's second exhibition of 1912.

Of his generation, the painter closest to European modernism and particularly to Fauvism and Expressionism was Matthew Smith (1879–1959), who studied with Matisse and spent much time in France over some thirty years. The 1916 *Fitzroy Street Nude No. 2* (fig. 502) is reminiscent of Van Gogh and Matisse in the spatial contraction and arbitrary color, with other relationships which are probably direct influences. Yet it is a work of individuality, closer to European modernism than most contemporary British works.

The most successful English painter of the period from approximately 1910 to World War I was probably Augustus John (1878–1961), a highly talented artist who dabbled in every style, but settled on none. Although attracted to the formalism of Pierre Puvis de Chavannes and various stages of Expressionistic naturalism, John was always revolting against the Academy. He was, however, essentially concerned with creating a new Academy and his long career was, if anything, a hindrance to the development of a native English modern movement.

VORTICISM The final chapter in the story of modern English art before World War I was the emergence of the group who called themselves Vorticists (from "vortex"), led by the talented painter, writer, and polemicist Percy Wyndham Lewis (1882–1957). In the catalogue of the only exhibition of Vorticism, at the Doré Galleries in 1915, Lewis described the movement: "By vorticism we mean (a) Activity as opposed to the tasteful Passivity of Picasso; (b) Significance as opposed to the dull and anecdotal character to which the Naturalist is condemned; (c) Essential Movement and Activity (such as the energy of a mind) as opposed to the imitative cinematography, the fuss and hysterics of the Futurists." Characteristically, Lewis was a literary man, and much of his contribution lay in the field of criticism rather than creation. He was influenced by Cubism and, despite his polemics against it, by Futurism (fig. 503). Primarily he was attempting, by every means in his power, to attack and break down the academic complacency that surrounded him in England. In the vortex he was looking for a central point of Classical clarity, an art of "activity, significance, and essential movement, and a modernism that should be clean, hard, and plastic."

Lewis passed through many phases during his mercurial career. Few of his early, Vorticist paintings survive, and his achievement must be judged largely by works dating from the 1920s and 1930s. *Revolution* of c. 1917 is a curious work, a sort of abstract city of the future in the process of disruption by rebellious computers (fig. 504). Later the artist experimented with stylized, totemistic figures, and in the same period did portraits of Edith Sitwell, Ezra Pound, and other literary figures, giving them, through a suggestion of Cubist structure, an appearance of modernism. The personification of the subjects is, nevertheless, precise and arresting.

503. PERCY WYNDHAM LEWIS. *Composition*. 1913. Watercolor drawing on paper, 13½ × 10½". The Tate Gallery, London

504. PERCY WYNDHAM LEWIS. *Revolution*. c. 1917. 78 × 60". The Tate Gallery, London

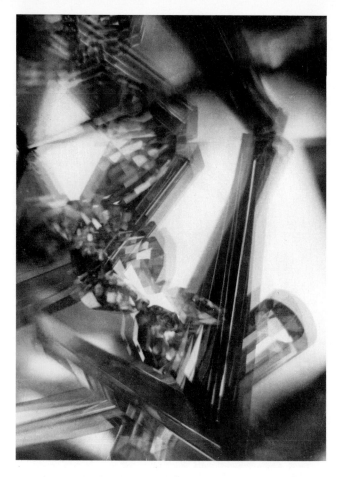

505. ALVIN LANGDON COBURN. *Vortograph No. 1*. 1917. Gelatin-silver print. Collection, The Museum of Modern Art, New York. Gift of the photographer

506. STANLEY SPENCER. *Resurrection*. 1928–29. 21′ × 17′6″. Sandham Memorial Chapel, Burghclere, England. Property of the National Trust

Other artists associated with Vorticism and Lewis were C. R. W. Nevinson, who painted war pictures combining elements of Cubism and Futurism; William Roberts, who passed from a narrative form of Cubism to a later style of expressive, frequently brutal power; David Bomberg; Edward Wadsworth; and the sculptor Henri Gaudier-Brzeska. Of particular significance for Vorticism was the association of the poet Ezra Pound, who gave the movement its name and, with Lewis, founded the periodical *Blast*, whose subtitle read *Review of the Great English Vortex*. With World War I, Vorticism, not in itself a highly original artistic movement, was ended as an organized force. It produced few artists of ability or originality. For modern art in England, nevertheless, it was of great importance in marking the moment of complete involvement in the new experimental art of Europe.

Also involved with Vorticism was the English photographer Alvin Langdon Coburn, already a committed modernist when three years earlier he photographed downward to produce the abstract pattern seen in figure 210. For what Lewis and Pound called Vortographs, Coburn now photographed through a kind of kaleidoscope—actually three mirrors clamped together as a hollow triangle—to record the refracted image of crystal and wood pieces arranged on a glass tabletop (fig. 505). The results are among the most thoroughly abstract photographs ever made.

STANLEY SPENCER (1891–1959) The two English painters of greatest stature between the wars represent extremes of contrast. One, Stanley Spencer, went through life seemingly oblivious to everything in twentieth-century painting except for some aspects of Surrealism or sharp-focus Realism. In his earlier paintings with Christian themes he developed a curious, personal style in his drawing reminiscent of early Italian or Flemish paintings, which enhanced his visionary effects. In the late 1920s Spencer received a large mural commission for the Oratory of All Souls, in Burghclere, Berkshire. For this he painted a series based on his war experiences, climaxed by the huge *Resurrection* (fig. 506), an endless panorama of the dead soldiers struggling from their graves amidst a forest of overturned crosses. While Spencer maintained his religious convictions throughout his life, in his later works he also turned to strange presentations of scenes with erotic overtones, sometimes suggestive of paintings by Balthus. Even these usually have religious implications in the sense of a modern morality play.

BEN NICHOLSON (1894–1982) The other outstanding English painter to emerge between the wars was Ben Nicholson, who was also a distinguished sculptor. Whereas Spencer might be considered narrowly English, Nicholson was the most internationally minded artist of his generation in Great Britain. He spent much of 1911–13 in France and Italy, where he encountered the new art. Acquaintance with Wyndham Lewis and the Vorticists led him to experiment with forms of semiabstraction as early as World War I. During the 1920s he practiced variants on the Cubism of Braque and Picasso, with a general accent on balanced frontality comparable to paintings of the Purists Ozenfant and Jeanneret. His association with the Abstraction-Création group in 1933 and his meeting with Mondrian about that time led him to complete geometric abstraction in the Mondrian tradition. This tradition, interpreted in a personal manner, charted his subsequent career in both his paintings and his reliefs, but he also continued to explore aspects of Cubism, of Purism, and even combinations of abstraction with literal details of landscape.

The art formulated by Nicholson seems to stand apart from that of the Continental masters (figs. 507, 508), and his Cubist works could

507. BEN NICHOLSON. *Painted Relief.* 1939. Synthetic board mounted on plywood, painted, 32⅞ × 45″. Collection, The Museum of Modern Art, New York. Gift of H. S. Ede and the Artist (by exchange)

never be confused with those of any of the French Cubists. Moreover, his abstract painting and reliefs, while stemming from those of Mondrian, do not reveal their source in the sense that those of other followers, French, Dutch, or American, inevitably do. The difference is difficult to define; it may have something to do with Nicholson's continuing feeling for objective nature, his particular feeling for line, or perhaps some intangible in the English tradition.

Early works still in the Purist phase reveal most of the characteristics of Nicholson's mature style. The color is subdued, matte, and delicately harmonious: a limited range of gray whites to grayed ochers, with a few accents of black and muted red, and rubbed pencil passages of dark gray. The surfaces look as though the finished oil painting had been gone over with an abrasive. All the elements of still life, table, bottle, and bowls, are frontalized and flattened. The effect is predominantly linear. The shapes are outlined with ruler and compass in fine and precise contour. Despite the undistorted definition of the objects, the impact is abstract.

In the 1930s Nicholson turned to a form of rigid, vertical-horizontal abstraction and, perhaps inspired by his wife, Barbara Hepworth (fig. 516), began to experiment with relief sculpture. As Nicholson may have turned to relief sculpture as a result of his wife's activities, so Hepworth may have been inspired to the use of regular, mathematical shapes and even the linear stretched string motifs as a result of Nicholson's abstractions.

The 1939 *Painted Relief* is a meticulous adjustment of squares and rectangles in low but varying relief projections (fig. 507). The larger shapes are a uniform muted, sand color. Played against these are a square of dull ocher, a rectangle of red-brown and, top and bottom at the left, strips of pure white. The only lines are two finely etched circles, placed slightly off-center in the major squares. The edges of the relief shapes also act as a precise, rectangular linear structure. In his white reliefs, produced principally during the 1930s and 1940s, all color and drawn line are eliminated. The total effect is achieved through the interaction of overlapping, interacting rectangles, with an occasional circle in sunken relief (fig. 508). In these, the concepts of Mondrian would

seem to be carried to a point of pure abstraction even beyond Mondrian himself. The control Nicholson had over his medium and all elements of composition constitutes an outstanding characteristic of his art.

In the same period Nicholson also produced paintings involving the same principles of strict rectangularity, using the primary colors with black, white, and grays, sometimes varying the values and intensities, and combining light, delicate blues with intense yellows. The artist habitually drew and painted from nature—landscapes, figures, and still lifes. The drawings have an Ingres-like delicacy and precision, and, as might be expected, architectural themes appealed particularly to Nicholson. Occasionally in the landscape paintings he indulged in a form of

508. BEN NICHOLSON. *White Relief.* 1936. Oil on carved board, 8 × 9¼″. Collection Naum Gabo, Middlebury, Connecticut

509. JACOB EPSTEIN. *The Rock Drill*. 1913. Sculpted bronze,
27¾ × 23 × 17½″. The Tate Gallery, London

510. JACOB EPSTEIN. *The Visitation*. 1926, cast 1955. Bronze, height 66″.
Hirshhorn Museum and Sculpture Garden, Smithsonian Institution,
Washington, D.C.

personal fantasy in which one of his abstract structures is superimposed on a quite literal landscape. However, a late work like the 1966 *Saronikos* shows Nicholson's abiding dedication to pure abstraction (plate 160).

511. HENRI GAUDIER-BRZESKA. *Crouching Figure*. 1914. Marble,
height 8¾″. Walker Art Center, Minneapolis

JACOB EPSTEIN (1880–1959) Epstein, an American, settled in London in 1905 and became a highly controversial figure both for his portraits and for his architectural sculptures, regularly rousing the English public to fury. He was in touch with Picasso, Brancusi, and Modigliani before World War I and through them was introduced to primitive art, a powerful influence on his early work. One of his first mature sculptures, *The Rock Drill* of 1913, is also one of his most individual and impressive (fig. 509). Recalling the forms of Cubist sculpture (although antedating most), it is essentially an Expressionist work, a mechanistic monster that anticipated some aspects of machine Expressionism or Surrealist sculpture.

Epstein's sculpture in general divided itself into two phases, the monumental carved figures, massive and brutal in their statement of the weight of the materials, and the Expressionist works, principally portraits but also the late religious pieces, modeled in clay for bronze, with surfaces so exaggeratedly broken as to become mannered (fig. 510). The influence of Epstein on Moore is to be seen primarily in the carved figures Moore produced at the beginning of his career.

HENRI GAUDIER-BRZESKA (1891–1915) Gaudier-Brzeska was born in France and trained in France, Germany, and England. Between 1911 and 1915, when he was killed in World War I, he lived in London, like Epstein active in the Vorticist circle around Wyndham Lewis. He had, thus, only about four years of mature sculptural expression. He was a friend of Ezra Pound and other literary figures who have created a legend concerning him which obscures the true picture. The relatively few works Gaudier left do indicate a great natural talent and an awareness of new experiment in sculpture, unparalleled in England at the time

(fig. 511). From 1912 to 1914 he was already exploring the possibilities of primitivism and Cubism for sculpture in a variety of works already as developed as those of Duchamp-Villon and Lipchitz.

HENRY MOORE (b. 1898) Of English artists whose works had international implications for the modern movement before World War II, the most important is the sculptor Henry Moore. Even he did not begin to assume a genuinely international stature, in the sense of influencing as well as being influenced, before 1945. He was, however, a mature artist by the early 1930s, in touch with the main lines of Surrealism and abstraction on the Continent, as well as all the new developments in sculpture, from Rodin through Brancusi to Picasso and Giacometti. More significant, by 1935 he had already made original statements and had arrived at many of the sculptural figurative concepts that he was to build on for the rest of his career.

Son of a coal miner, Moore studied at the Royal College of Art until 1925, receiving a sound, academic training. The greatest immediate influence on him were the works of art he studied in English and European museums, particularly the Classical, pre-Classical, and non-Western art—African or Pre-Columbian—he saw in the British Museum. He was also attracted to English medieval church sculpture and to those masters of the Renaissance tradition—Masaccio, Michelangelo, Rodin, Maillol—who had a particular feeling for the monumental. In English sculpture of the immediate past there was little on which he could draw, with the exception of the two highly disparate figures, Epstein and Gaudier-Brzeska. Moore was certainly aware of Gaudier in the early 1920s, and several figures seem to relate to those of the earlier sculptor.

Between 1926 and 1930 the dominant influence on Moore was Pre-Columbian art. The 1929 *Reclining Figure* (fig. 512) is one of the artist's first masterpieces in sculpture, a work that may owe its original inspiration to the Toltec sculpture of Chac-Mool, the Mexican Rain Spirit (with overtones of Maillol), but of a massive blockiness that stems from a passionate devotion to the principle of truth to materials. In this and other reclining figures, torsos, and mother-and-child groups of the late 1920s, Moore established basic themes on which he was to play variations for the rest of his life.

In the early 1930s the influence of Surrealist sculpture, particularly that of Picasso, became evident. Moore began to explore other materials, particularly bronze, and his figures took on a fluidity and sense of

512. HENRY MOORE. *Reclining Figure*. 1929. Hornton stone, height 22½″. Leeds City Art Galleries, England

transparent surface appropriate to the (to him) new material. Similar effects were achieved in carved wood in which he followed the wood grain meticulously (fig. 513). A characteristic of the figures of the 1930s is the opening up of voids, frequently to the point where the solids function as frames for the voids, but Moore put his personal stamp on the formula in his maintenance of Classical humanity in his figures.

In the early 1930s, as well, Moore turned to abstract forms, and by opening up the masses and creating dispersed groups he studied various kinds of space relationships. This began a continuing concern with a sculpture of tensions between void and solid. These experiments were then translated back into the figures. The interest in spatial problems led Moore during the 1940s and 1950s to an ever greater use of bronze and other metals in which he could enlarge the voids of the figures. *Interior-Exterior Reclining Figure* of 1951 (fig. 660) is one of a series of intricate and subtle arrangements of interpenetrating solids and voids, themes so fertile in both form and content that they must be pursued in a later chapter.

513. HENRY MOORE. *Reclining Figure*. 1939. Elm wood, 37″ × 6′7″ × 30″. © 1985 Founders Society, The Detroit Institute of Arts. Gift of the Dexter M. Ferry, Jr., Trustee Corporation

left: 514. BARBARA HEPWORTH. *Two Segments and Sphere*. 1935–36. Marble, height 12″. L. H. Florsheim Foundation for Fine Arts, Chicago

right: 515. BARBARA HEPWORTH. *Single Form*. 1937. White marble, height 22½″. Estate of the Artist

BARBARA HEPWORTH (1903–1975) Barbara Hepworth, the other English sculptor of international stature before World War II, for a long time did not receive her merited recognition because of identification with Henry Moore. Like him, she worked abstractly during the 1930s, frequently placing separate shapes in tension or subtle relationships with one another (fig. 514). At that time she also explored the use of strings stretched across voids and, on occasion, lines, abstract or describing profile faces, etched into the stone (plate 161). Hepworth and Moore remained in close touch, each affected by experiments the other initiated. Both were reacting to the modern sculpture they discovered in Paris during the 1920s, but Moore was drawn more to the Surrealist-figurative sculpture of Picasso, and Hepworth more to the abstract-or-ganic sculpture of Brancusi or Jean Arp, and to the Constructivism of Gabo.

In 1931 Hepworth married Ben Nicholson, and with him became a leader of the English abstract movement during the 1930s. In 1933 they were invited to become members of the Abstraction-Création group in Paris, and were active in the Unit One group which was attempting to establish a common front for modern art in England. After its dissolution they, together with Gabo, published *Circle* in 1937, as a program for abstract painting, Constructivism, and modern architecture and design. This work introduced many of the ideas of the Bauhaus to Britain.

Nicholson and Hepworth were also close to Herbert Read, the critic, then emerging as the leading advocate of modern art in England. When, during the 1930s, Gabo, Mondrian, Gropius, Moholy-Nagy, Breuer, and other European artists and architects moved to England, Hepworth and Nicholson were able to strengthen old friendships and form new ones among these pioneers of modernism.

The later 1930s produced some of Hepworth's most severely simplified sculptures, a number of them consisting of a single marble column, gently rounded or delicately indented to emphasize their organic, figurative source (fig. 515). Perfection of finish, making the marble glow with an inner life, is a fundamental quality of Hepworth's sculptures. Her wood sculptures of the 1940s are marked by the same loving finish; the woods are beautiful and frequently exotic—mahogany, scented guarea, lagowood, or rosewood—worked to bring out their essential nature. Easier to work than stone, wood inspired her to an increasingly open type of composition, with voids penetrating the mass of the material. She also began at this time to use color, generally whites and blues in interior areas, to contrast with the natural wood of the exterior, and stretched strings to accent and define the space across the voids (fig. 516). For a period after World War II, as we shall see in a subsequent chapter, the sense of a naturalistic subject reemerged, sometimes in the interior void, sometimes in massive abstract figures, as Hepworth continued to move from strength to strength throughout her long and distinguished career.

516. BARBARA HEPWORTH. *Wave*. 1943–44. Plane wood with color and strings, length 18½″. Collection Mr. and Mrs. Ashley Havinden, England

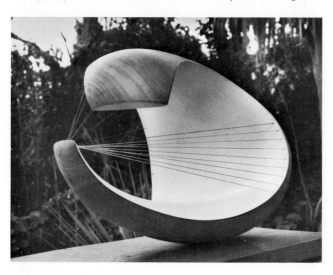

American Art Between the Wars

At the opening of the twentieth century, American painting and sculpture, like their counterparts in Great Britain, lagged considerably behind the most progressive developments in Continental Europe. And this was true despite the fact that, from the beginning, American culture had sporadically generated major figures, such as West and Copley in Colonial times and the late nineteenth-century expatriates Whistler, Cassatt, and Sargent, capable of holding their own in the European capitals of world art (plates 8, 13; fig. 519). In one respect, the general backwardness of painting and sculpture in the United States was curious, for after the Civil War Americans had proved vigorously original in architecture and through this medium, as we have seen, had made a decisive contribution to the visual arts. But what brought that promising start to a halt was the same academic bias that had held so many painters and sculptors in thrall to outmoded aesthetics inherited from the Classical and Romantic past. Such could be said for the whole of Western civilization, but while the more self-assured among the innately gifted Europeans grew strong through resistance to the tyrannical Academy,

518. WILLIAM HARNETT. *After the Hunt*. 1885. 71 × 48″. The Fine Arts Museums of San Francisco. Mildred Anna Williams Collection

517. RAPHAELLE PEALE. *After the Bath*. 1823. 29 × 24″. Nelson Gallery-Atkins Museum, Kansas City, Missouri

Americans suffered the insecurity typical of provincials and generally felt the need to master tradition rather than innovate against it. However, being politically revolutionary and ruggedly independent in spirit, they also instinctively knew that to realize any significant degree of progress in art, it would be necessary to achieve their own artistic identity, probably by assimilating influences from the generative centers in Europe until those had been transformed by authentic native sensibility into something free and distinctive.

With their national character and history polarized between the material and the mystical, Americans had most consistently expressed their artistic personality in some form of Realism, but a Realism so obsessive

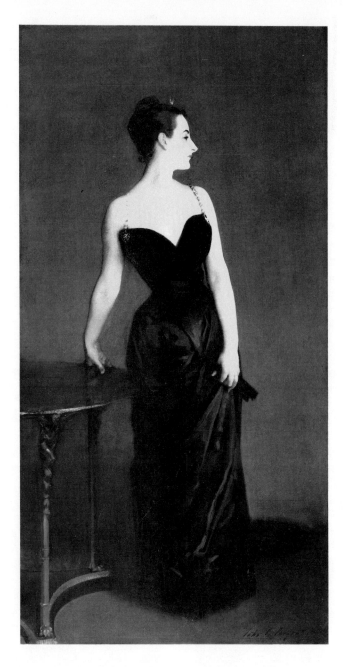

left: 519. JOHN SINGER SARGENT. *Madame X (Mme. Gautreau)*. 1884. 82⅛ × 43¼". The Metropolitan Museum of Art, New York. Arthur H. Hearn Fund, 1916

opposite: 520. GERTRUDE KÄSEBIER. *Blessed Art Thou Among Women*. c. 1900. Platinum print on Japanese tissue, 9⅜ × 5½". Collection, The Museum of Modern Art, New York. Gift of Mrs. Hermine M. Turner

in its concern for the integrity of palpable things that reality, once scientifically measured, delineated, or actually dissolved, entered the realm of the ideal, thereupon becoming a vehicle of feeling, intuition, or metaphysical meaning. Barbara Novak, in her wide-ranging studies of American painting, has found this interface of percept and concept to be as much true for the archaic seventeenth-century limners as for the pantheistic Hudson River landscapists in the nineteenth century, or even for the Abstract Expressionists during the 1940s and 1950s. And it can be found in almost every American painter strong enough to rise above the pervasive banality of artistic production in the United States before 1900. Certainly it is evident in the rivetingly precise portraiture of John Singleton Copley (1741–1827) and in the almost magical illusionism of the genre works painted by Raphaelle Peale (1774–1825; fig. 517). And it emerges dramatically in the *trompe-l'oeil* painters of the latter nineteenth century, most notably among them William Michael Harnett (1848–1892; fig. 518). The urge to see not only the actual but also the essential lodged within it explains the long infatuation Americans had with the suavities of retardataire, academic styles. Finally, it explains the ease and alacrity with which Americans first took the

plunge into total abstraction during the second decade of the twentieth century and the subsequent thirty-year struggle they had in realizing the fullness of its possibilities.

However retrograde the painting and sculpture back home, no artist had sensed the coming of the new more presciently than the glamorous expatriates already discussed. After beginning within the Realist ambience of Courbet and Manet, even to the point of having his subjects sit for as many hours of close looking as those of Copley a century earlier, Whistler then proceeded to synthesize his image from memory, until he had created, not a duplicate of nature, but rather what he called "an arrangement of line, form, and colour first" (fig. 43). With his "arrangements," "harmonies," or "symphonies" of formal elements, corresponding as much to conceptual as to perceptual reality, Whistler anticipated by a decade or more the "art for art's sake" attitude of the late Pre-Raphaelites in London and the Post-Impressionists in France, those inescapable fathers of twentieth-century modernism. Mary Cassatt, too, simply by aligning her art with that of Degas, the most linear and conceptual of the Impressionists, held on to material reality with a stubborn tenacity that made the artist "exclusively of her people," as

521. CLARENCE H. WHITE. *Ring Toss*. 1899. Platinum print. Library of Congress, Washington, D.C.

one French critic put it (plate 13). By refusing to allow light and color to disintegrate solid form, Cassatt had to reconcile volume with plane in ways that placed her ahead of the Impressionists and somewhat over the threshold into the aesthetic, if not the spiritual, world of Cézanne, Seurat, Gauguin, and Van Gogh. While the elite social status enjoyed by Cassatt denied her the possibility of influencing the Bohemia-bound painting of the modernist innovators, it also permitted her to play the all-important role of tastemaker to American millionaires, whose acquisitions of Impressionist masterpieces began the process of elevating standards of art appreciation in the United States, as well as establishing the foundations of the great collections of modern art now accessible in American museums. And even John Singer Sargent (1856–1925), whose flashing, liquid stroke and flattering touch in portraiture made him one of the most famous and wealthy artists of his time, proved incapable of dissolving structure when he attempted to emulate the Impressionists' molecular technique. Moreover, in a major work like *Madame X* (fig. 519) Sargent revealed himself almost mesmerized, like a latter-day Ingres, by the abstract qualities of pure line and flat silhouette, at the same time that he so caught the explicit qualities of surface and inner character that the painting, when publicly shown, created a scandal, prompting the artist to leave Paris and establish his practice in London. In his most painterly works, meanwhile, Sargent carried gestural virtuosity, inspired by Hals and Velázquez and often condemned as

overly facile, to levels of pictorial autonomy not exceeded before the advent of the far more profoundly motivated Abstract Expressionists after World War II.

If Whistler, Cassatt, and Sargent failed to reach the artistic summits attained by their most accomplished European allies, Americans choosing photography as their medium of expression not only stood out in the international Salons organized for exhibiting the new camera-made art, but often won the major prizes and set the criteria for both technical mastery and aesthetic vision. This has already been seen in the images of Bellocq, Man Ray, Steichen, Stieglitz, Strand, and Weston, reproduced in earlier chapters as examples of the best work of its kind and thus strong enough to appear alongside the European painting and sculpture being discussed. Meanwhile, Whistler, Cassatt, and Sargent had also had their American peers in photography, principally Gertrude Käsebier (1852–1934) and Clarence H. White (1871–1925), both of whom worked in the Impressionist manner favored by many of the so-called "pictorial" photographers during the later nineteenth century (figs. 520, 521). Like Cassatt, Käsebier specialized in the mother-and-child theme, while White aligned himself with the elite social content of Sargent's portraiture and the Orientalizing aestheticism of Whistler's "musical" arrangements. If Americans ranked relatively higher in the world of photography than in that of painting and sculpture, it could be because they had a mechanical device to help solve whatever their technical limitations may have been in the more traditional means of image-making. Moreover, the camera offered an unparalleled capacity to render the reality so beloved by Americans, at the same time that it also could easily transform visual facts, as Käsebier and White did with their soft focus, and thus endow them with the special meaning characteristically sought by American artists.

WINSLOW HOMER (1836–1910) More exclusively rooted in American experience than Whistler, Cassatt, and Sargent, and thus more representative of the point of departure for American art in the twentieth century, were Winslow Homer, Thomas Eakins, and Albert Pinkham Ryder. After participating fully in the spontaneous generation of *plein-air* painting that occurred almost worldwide during the 1860s, Homer went on to concentrate his art on close-up, snapshot views of high seas or the rock-bound Maine shoreline at full, pounding tide (fig. 522). In these extracts from nature, the artist so fixated on discrete moments of time and place that oceanic turbulence yields its transience to a near-iconic image of eternity.

THOMAS EAKINS (1844–1916) In his determination to fuse art and science for the sake of an uncompromising Realism in painting, Thomas Eakins all but revived the Renaissance tenets of Leonardo da Vinci. Not only did Eakins dissect right along with medical students and join Eadweard Muybridge in his experiments with stop-action photography, especially those devoted to human movement (fig. 56), but he even had an assistant pose on a cross in full sunlight as the model for a Crucifixion scene. He also introduced his female students to the anatomical facts of the male nude, a step that forced his resignation from the august Philadelphia Academy of Fine Arts. But at the same time that in his portraits he described the surfaces of flesh and fabric in near-photographic detail, Eakins almost invariably depicted his subjects with eyes averted and expressions of pensive withdrawal into an inner realm of mind and spirit (fig. 523). Matching this abstraction from the specifics of the outside world is the flattening effect of the blank, planar, anonymous space in which the substantial human volumes have been suspended. Here, as Barbara Novak has written, "the reality of fact is replaced by the reality of dream. It is the other side of the American coin, not as frequently upturned, but ever present."

ALBERT PINKHAM RYDER (1847–1917) In the art of Albert Pinkham Ryder the reality of dream is utterly dominant, even in paintings so

d Goodrich has
was the product
nd reworking a
that "the artist
ve to express his
oud accurate in
n Ryder wanted
for whose sub-
mporaries, har-
nd piled on his
by applying wet
is pictures to go
cayed, ironically
he never-ending
tize the extraor-
its detail refined
broad, simple,
often evokes the
ix as well as the
ttle wonder that
k most admired

h century, it was
to innumerable
out unfortunately
r Paris. Augustus
ng in New York,
nout his life (fig.
lities of personal
ive or allegorical
nineteenth-cen-
t-Gaudens seems
Renaissance, no-

524. ALBERT PINKHAM RYDER. *Moonlight Marine*. 1890–1910. Oil on wood, 11⅜ × 12″. The Metropolitan Museum of Art, New York. Samuel D. Lee Fund, 1934

525. AUGUSTUS SAINT-GAUDENS. *Adams Memorial*. 1886–91. Bronze, height 70″. Rock Creek Cemetery, Washington, D.C.

The Eight

Despite the individual qualities of Eakins, Homer, Ryder, Saint-Gaudens, and a few others, these artists introduced no lasting innovations in American painting or sculpture as had Matisse, Monet, Cézanne, Van Gogh, or Rodin in European art during their lifetimes. In the year 1900, aside from a small number of individuals who had spent much of their lives in Europe, there were few Americans even aware of what was going on in European painting and sculpture. Despite the expatriates; despite the introduction of French Impressionism to the United States; and despite the fact that many American artists at the end of the last century studied in Italy, Germany, or France, the first modern American revolution in painting was not away from, but toward, Realism—not toward experiment with form, only toward new pictorial subject matter. This anomaly is explained in part by the fact that the academic spirit had become anathema to young painters around 1900. Thus the move toward Realism was, as it had been in Paris about 1850, a reaction against a sterile, eclectic tradition and was embodied in a small group of painters, several from Philadelphia, most of whom depicted the New York scene with a literalness that shocked their public accustomed to the bland generalizations of the Academy.

526. ROBERT HENRI. *Laughing Child*. 1907. 24 × 20". The Whitney Museum of American Art, New York

the five Philadelphia artists, joined by Ernest Lawson, an American Impressionist, Arthur B. Davies, whose painting is perhaps closest to European Symbolism, and Maurice Prendergast (1854–1924), who developed a style based on Neo-Impressionism (plate 163), mounted the independent show of their paintings at the Macbeth Gallery in New York City. This was the exhibition of The Eight or the Ash Can School, a milestone in the history of modern American painting. Again it must be emphasized that these painters were not joined by any common style or philosophy. They represented various points of view and were united only by their mutual hostility to the entrenched art of the academicians and by the conviction that the artist had the right to paint any subject he wanted. In fact, the show was mostly criticized for its "inappropriate" recording of the uglier aspects of the New York scene (plate 162). There was little in American painting at this point, besides an occasional secondhand Impressionism, that derived from the European experiments in modernism of the previous fifty years, and yet none of The Eight could be described as a Social Realist.

The 1908 exhibition of The Eight is probably most significant as an isolated event in the history of modern American art rather than in terms of any widespread influence it may have had at the time. However, a number of artists and students who in different ways continued the exploration of new ideas in American painting did gather at the independent art school established by Henri. These included Stanton Mac-Donald-Wright, Patrick Henry Bruce, and Stuart Davis, who would become leading American abstractionists, as well as George Bellows,

At this moment, about 1908, survival by an artist was largely contingent on membership in the National Academy of Design, the American equivalent of the French Academy of Arts. In February 1908 eight painters participated in an historic exhibition at the Macbeth Gallery in New York City. The intellectual leader of this loosely constituted group was Robert Henri (1865–1929), who had studied with Thomas Anshutz, a pupil of Thomas Eakins. Henri had visited Paris in 1888 and been impressed by the works of Manet, especially those in a Spanish mode. Throughout his life he continued to be a bravura brush painter, closer to Frans Hals or Velázquez than to the Impressionists or Post-Impressionists (fig. 526). However, he was a dedicated teacher and a leader who instinctively rebelled against the clichés of the American academic tradition. The National Academy of Design in the United States at the turn of the twentieth century, while perpetuating the traditions of the French Academy of the latter nineteenth century, had nothing of the French Academy's organization in teaching or its accumulated experience. It did, however, exercise a comparable influence on developing artists. The young painters whom Henri gathered around him in Philadelphia were essentially newspaper illustrators providing on-the-spot pictorial sketches, a form not yet replaced by the new art of photography. As a result of this vocation, John Sloan (1871–1951) and the others came to painting first as draftsmen, and thus in most cases their art emphasized drawing rather than color, while their subject matter portrayed the momentary and the transient aspects of American life (plate 162). It was only gradually that some of them, notably William Glackens (1870–1938) and Everett Shinn, began to feel the influence of the color of Renoir and the Impressionists (fig. 527).

After another trip to Paris in 1898 Henri moved to New York and was soon joined there by Glackens, Shinn, Sloan, and George Luks. In 1908, reacting against refusal to the National Academy 1907 spring exhibition,

527. WILLIAM GLACKENS. *Chez Mouquin*. 1905. 48¼ × 36¼". Art Institute of Chicago. Friends of American Art Collection

Edward Hopper, Yasuo Kuniyoshi, and Walt Kuhn, who subsequently explored various forms of Realism or Romanticism.

The social criticism inherent in Ash Can subject matter, such as the scenes of urban grime and disadvantage painted by Sloan and Luks, became even more explicit in the photographic work of Jacob August Riis (1849–1914), a Danish immigrant who took his camera into alleys and tenements on New York's Lower East Side for the express purpose of crusading against the wretched conditions he found there (fig. 528). Although a "straight" photographer in the purest sense of the word, saying of his camera that "I had use for it, and beyond that I never went," Riis produced as reportage some of the most moving documents ever to come from the photographic medium.

Riis's counterpart in the industrial hinterland was Lewis W. Hine (1874–1940), one of the first and certainly one of the greatest photographers ever to use the camera as an instrument of social reform. After an initial series devoted to immigrants on Ellis Island, Hine spent the years 1908–16 visiting factories to photograph and expose child-labor abuses (fig. 529). So powerful were his images that they helped win passage of laws protecting children against industrial exploitation. In another, almost equally famous series Hine took hundreds of pictures of men at work on the Empire State Building during its construction in 1930–31. As managed by this master, documentary photography became, as one writer put it, "a timeless humanist art."

The Stieglitz Circle: 291

Meanwhile, in 1905, at a gallery at 291 Fifth Avenue, the photographer Alfred Stieglitz, together with another brilliant photographer, Edward Steichen, began to hold exhibitions of photography and shortly thereafter of modern European paintings and sculpture, as well as African primitive art. Stieglitz's revolution and the artists whose work he exhibited were much more cosmopolitan than the Henri group, in much closer touch with actual current events and artists in Europe, and less militant about any chauvinistic program of Americanism in art. Also, Stieglitz and Steichen in the field of photography were first-class artists (figs. 68, 128), capable of recognizing comparable quality in painting and sculpture. They were in touch with avant-garde leaders in Paris, not only with artists but also with writers and collectors such as Gertrude Stein and her brothers Michael and Leo, the first collectors of Matisse and Picasso. Stieglitz's Gallery 291 would serve as a rallying place for the American pioneers of international modernism—painters like John Marin, Marsden Hartley, Max Weber, Alfred Maurer, Arthur Dove, Georgia O'Keeffe, and Stanton Macdonald-Wright. Between 1908 and 1917 Gallery 291 held exhibitions of works by Rodin, Matisse, Rousseau, Charles Sheeler, Charles Demuth, Toulouse-Lautrec, Brancusi, and Elie Nadelman.

right: 530. MAX WEBER. *Chinese Restaurant*.
1915. 40 × 48″. The Whitney Museum of
American Art, New York. Purchase

below left: 531. JOHN MARIN. *Lower Manhattan
(Composition Derived from Top of the
Woolworth Building)*. 1922. Watercolor and
charcoal with paper cutout attached with thread,
21⅝ × 26⅞″. Collection, The Museum of Modern
Art, New York. Acquired through the Lillie P.
Bliss Bequest

below right: 532. ARTHUR G. DOVE. *Abstraction
No. 1*. 1910. 9 × 10½″. Private collection

MAX WEBER (1881–1961) Max Weber absorbed the lessons of the
Fauves and Cubists almost from the beginning of his career and then, as
with a number of American pioneers of modernism, turned to a form of
Romantic expression. The 1915 *Chinese Restaurant* was his most am-
bitious excursion into Cubism (fig. 530), but the optical insistence on
the checkerboard pattern relates it as well to the American tradition of
trompe-l'oeil. Toward the end of World War I the artist abandoned
Cubism for a form of linear expression related to Chagall and Soutine.

MARSDEN HARTLEY (1877–1943) Marsden Hartley discovered Der
Blaue Reiter in Berlin in 1912. The German flag series, painted about

1914, was his most effective abstractions, deriving from Cubism or the
Orphist abstractions of Delaunay but different in impact (plate 164). It
is not correct to refer to these as abstractions, since Hartley used the
colors and images of the German flag literally, though broken up and
reorganized, to symbolize the aggressive war spirit he found in Germany
in 1914. His flag series would influence experimental American paint-
ers from Stuart Davis to Jasper Johns.

JOHN MARIN (1870–1953) The other artists whom Stieglitz contin-
ued to exhibit and promote—John Marin, Arthur Dove, and Georgia
O'Keeffe—were all very different from Hartley, Maurer, Weber, and

one another. Taken together, these six painters personify the different ways in which modern art was first brought to the United States, and its advances and retreats during the first forty years of the century.

John Marin, one of the chief American masters of watercolor painting, was in Europe between 1905 and 1911. Perhaps his greatest single source was the late watercolors of Cézanne, but Cubist structure remained the controlling force throughout Marin's life, particularly the dynamic Cubism of Delaunay and the Futurists. Early paintings by Marin of New York commemorate the tempo of the city, just as Delaunay's Eiffel Tower paintings reflected that of Paris. In summer, the artist painted the Maine coast. During the 1920s and 1930s he carried his interpretations of New York closer to a form of Expressionist abstraction, although again the subject is always clearly there. In *Lower Manhattan*, a work of 1922 (fig. 531), we have an explosion of buildings whose destructive agent seems to be the black sun with its yellow star center.

ARTHUR G. DOVE (1880–1946) Dove abandoned a career as an illustrator to go to Paris in 1907 and become a painter. His paintings of 1910, to which he gave the name Abstractions (fig. 532), have some residue of subject matter—suggestions of buildings or landscapes—but they are nevertheless even closer to a nonobjective image than the paintings of the same time by Kandinsky, whose work Dove knew (plate 48). In his two years of study, Dove seems to have absorbed remarkably the entire course of modern European art.

Dove soon felt the need to return to a greater degree of representation, but throughout his life he was concerned with the spiritual forces of nature rather than its external forms. Like many American artists, he was affected by the emergence of European Surrealism during the 1920s, but his fantasy belonged more with the American Romanticism of Albert P. Ryder or the Symbolism of Odilon Redon. During the 1930s his sense of fantasy was at its height, with landscapes transformed into monsters, or his favorite image, the sun or moon, transformed into a great Cyclops's eye.

Dove made little change in his work until the 1940s, when he experimented with geometric abstraction. Even in his most abstract works, such as *That Red One* of 1944 (plate 165), the sense of organic nature and of his personal fantasy remains, with the geometric shapes transforming themselves into a black, dead sun in a cosmic spacescape.

An aspect of Dove's achievement now in process of reevaluation is his collages, produced principally during the 1920s. The artist was aware of the evolution of Cubist collage, but his own efforts have more in common with nineteenth-century American folk art and *trompe-l'oeil* paintings, and the collages and assemblages of the Dadaists. Dove knew of the activities of the New York Dadaists Marcel Duchamp, Man Ray, and Picabia during World War I. His own collages range from landscapes made up literally of their natural ingredients—sand, shells, twigs, and leaves—in a folk art assemblage, to satiric *papiers-collés*. *Goin' Fishin'*, an assemblage of fragmented fishing poles and denim shirt sleeves (fig. 533), is a work that seems more in an American tradition extending from the nineteenth century, but it should also be seen in relation to the fascinating constructions, much later, of Joseph Cornell, and the giant shirts and soft constructions of Claes Oldenburg (figs. 722, 723).

GEORGIA O'KEEFFE (1887–1986) The phenomenal Georgia O'Keeffe differed from most of the other American pioneers of modernism in that her training was entirely native, and it is difficult to describe any specific, direct influence from European modernism. Thus she seemed

533. ARTHUR G. DOVE. *Goin' Fishin'*. 1925. Collage, 19½ × 24″. The Phillips Collection, Washington, D.C.

all the more precocious in the exercises in open, free, biomorphic Kandinsky-like abstraction that she carried out during the teens of the century (fig. 534). From the beginning, her imagery, whether the subject was New York skyscrapers, enormously enlarged details of flowers,

534. GEORGIA O'KEEFFE. *Drawing No. 13*. 1915. Charcoal, 24⅜ × 18½″. The Metropolitan Museum of Art, New York. The Alfred Stieglitz Collection, 1949

left: 535. ALFRED STIEGLITZ. *The Street, Fifth Avenue*. 1896. Gravure, 12 × 9″. The Albright-Knox Art Gallery, Buffalo. General Purchase Funds, 1911

below: 536. ALFRED STIEGLITZ. *Equivalent*. 1930. Chloride print. Art Institute of Chicago. The Alfred Stieglitz Collection

537. IMOGEN CUNNINGHAM. *Two Callas*. Photograph. ©Imogen Cunningham Trust, 1970

bleached cow skulls or pelvises, Western barns or adobe churches, involved a precision of linear presentation that somehow turned the work into an abstraction (plate 166). Such sharp-focus, close-up details may also reveal the influence of the expanding art of photography as practiced by Stieglitz. Still vigorously productive in the 1980s, O'Keeffe never failed to sense the new and respond to it in her own inimitable, even magnificent fashion.

In his own art, meanwhile, Stieglitz had moved quite sharply away from the pictorialism of his early work toward ever-more "straight" photography—that is, toward photographs that look like photographs, free of lens or darkroom manipulations designed to make them resemble paintings. To achieve the blurring so prized by the pictorialists, Stieglitz simply waited until atmospheric conditions allowed it to be recorded and developed with normal equipment and procedures (fig. 535). In his most daring series, he photographed cloud formations, seeking in them what he called "equivalents"—formal relationships—that expressed for the artist his "most profound experience of life" (fig. 536). Utterly realistic, the Equivalents—Stieglitz's *Songs of the Sky*—are also abstract images of a Romantic, sublime nature that anticipated something of both the form and the content of postwar Abstract Expressionist painting.

From her origins in soft-focus pictorialism, the West Coast photographer Imogen Cunningham (1883–1976) also shifted to straight photography, producing a series of plant studies (fig. 537) in which blown-up details and immaculate lighting yield an image analogous to the near-abstract flower paintings of Georgia O'Keeffe.

JOSEPH STELLA (1877–1945) A painter closely associated with the Stieglitz circle but independent of it was Joseph Stella, perhaps the most

talented of the artists who brought specific aspects of European modernism to the United States. Born in Italy, Stella came to America in 1902, but between 1909 and 1912 he was in France and Italy. In Italian Futurism Stella found his specific inspiration and for a number of years produced works that, in their linear dynamism and coloristic brilliance, compare favorably with those of Boccioni or Severini. To the Italian Futurists the United States of the early twentieth century was a romantic ideal—a world of exploding energy, new frontiers, expanding industry, and unlimited opportunity. Stella brought this romantic enthusiasm to his interpretations of New York. His masterpieces are his several versions of the Brooklyn Bridge, that beautiful construction that had become a symbol of New York. The earliest version, dated 1917–18 (fig. 538), is the most explicitly Futurist in the dynamism of its geometric linear pattern, the luminosity of its color, its kaleidoscopic mingling of shifting views. The effect may also reflect the influence of the cinema, then reaching its first maturity.

The impact of Stieglitz and his exhibitions at Gallery 291 is difficult to evaluate, but there can be no question that the miscellaneous group of Americans shown by him constituted the core of experimental art in the United States from 1910 to 1940 and was the single most important factor, aside from the Armory Show, in the birth of the modern spirit.

The Armory Show: 1913

The most spectacular event in the history of American art during the early part of the century was unquestionably the International Exhibition of Modern Art held in New York at the 69th Regiment Armory on Lexington Avenue at 25th Street between February 17 and March 15, 1913. Organized by a group known as the Association of American Painters and Sculptors, the exhibition was generally intended as a large show of European and American artists, to compete with the regular exhibitions of the National Academy of Design. Arthur B. Davies, a member of The Eight respected by both the Academy and the independents and highly knowledgeable in the international art field, was chosen as chairman, and Walt Kuhn, assisted in Europe by the painter and critic Walter Pach, did much of the selection. Kuhn and Pach visited Cologne, The Hague, Munich, Berlin, and Paris, as well as London, where the second show of modern art at the Grafton Galleries was being held. Once assembled and hung, the Armory Show proved to be a monumental though uneven exhibition of nineteenth- and early twentieth-century painting and sculpture of Europe, ranging from some representation of Ingres and Delacroix through Daumier, Courbet, Manet, the Impressionists, Van Gogh, Gauguin, Cézanne, Seurat and his followers, and others. Matisse and the Fauves were well represented, as were Picasso, Braque, and the Cubists, the Nabis, and Odilon Redon. German Expressionists were slighted, while the Orphic Cubists and the Italian Futurists withdrew. Among sculptors, the Europeans Rodin, Maillol, Brancusi, Nadelman, and Lehmbruck as well as the American Lachaise were included, although sculpture generally received far less representation than painting. American painting of all varieties and quality dominated the show in sheer numbers, but failed in its impact relative to that of the exotic imports from Europe.

The Armory Show created a sensation, and while the lay press covered it extensively (at first with praise), the affair was savagely attacked by critics and American artists. Matisse was singled out for abuse, as were the Cubists, while Duchamp's *Nude Descending a Staircase* enjoyed a *succès de scandale*, identified as "an explosion in a shingle factory."

538. JOSEPH STELLA. *Brooklyn Bridge*. 1917–18. 84 × 76″.
Yale University Art Gallery, New Haven, Connecticut.
Gift of the Société Anonyme

As a result of the controversy, an estimated 75,000 people attended the exhibition. In Chicago, where the European section and approximately half the American section were shown at the Art Institute, nearly 200,000 visitors crowded the galleries. Here the students of the Art Institute's school, egged on by their faculty, burned Matisse and Brancusi in effigy. In Boston, where some 250 examples of the European section were displayed at Copley Hall, the reaction was more tepid.

By any standard the Armory Show must be considered a remarkable achievement, but the full impact was not absorbed for another thirty years. Almost immediately, however, there were evidences of change in American art and collecting. New galleries dealing in modern painting and sculpture began to appear. Although communications were soon to be interrupted by World War I, more American artists than ever were inspired to go to Europe for study. American museums began to buy and to show modern French masters. Some popular education in the tenets of modern art was accomplished, and a small but influential new class of collectors, which included John Quinn, Arthur Jerome Eddy, Walter Arensberg, A. E. Gallatin, Lillie P. Bliss, and Katherine Dreier among others, was born. From their holdings would come the nuclei of the great public collections of modern art that Americans know today.

Synchromism

Within the native contingent showing at the 69th Regiment Armory appeared the paintings of two Paris-based Americans who were making their local debuts as bona fide European modernists: Morgan Russell

(1886–1953) and Patrick Henry Bruce. So totally had these artists, along with the all-important Stanton Macdonald-Wright (1890–1973), immersed themselves in the modernist spirit that they earned the honor of becoming the only American artists ever to formulate a common aesthetic program and even to issue a manifesto, which appeared in 1913. Calling themselves Synchromists, Russell and Macdonald-Wright, both of whom were in France by 1907, took their principles from the color theories of the Neo-Impressionists and their formal vocabulary from the similarly inspired Orphic Cubists. The abstract paintings, or Synchromies, that resulted were close to the works of Delaunay and Kupka and probably were inspired by them, despite intense rivalry and vehement assertions of originality on the part of the Americans. For a few years, Synchromism did produce a number of individual abstractions in which the properties and relations of pure color were explored. Macdonald-Wright's *Abstraction on Spectrum* (plate 167) may owe much to Delaunay's disks, but it has a freshness, even an aggressive expressiveness, that adds separate dimensions. Russell's most monumental work, *Synchromy in Orange: To Form* (fig. 539), illustrates his denser, less lyrical handling of color, but the same concern with structure built on planes of color. The Synchromists had exhibited in Munich and at the Galerie Bernheim-Jeune in Paris during 1913, and they would again show in New York in 1914.

Like Russell, Patrick Henry Bruce (1880–1937) had worked with Matisse as well as with Delaunay. Bruce was obsessed with creating works that "by reason of their structural qualities, could be looked at from four sides." During the 1920s and 1930s the sculptural or architectural concept became quite explicit in his paintings as he placed three-dimensional geometric shapes within a limited though clearly stated extension into space (fig. 540). The three-dimensional geometric

objects, created out of flat, hard-edge area combinations, are designed as shapes to emphasize multiple views. Other American painters, among them Morton Schamberg, Andrew Dasburg, and Thomas Hart Benton, tried their hands at forms of Synchromist painting, but by the end of World War I the movement had largely ceased to exist and most of the artists involved, with the exception of Bruce and Russell, were returning to figuration.

The Precisionists

The most significant manifestation of a new spirit in American art during the 1920s was the movement to which the name Precisionism has been given. It has also been labeled Cubist-Realism or Cubo-Realism, and the Precisionists are sometimes unhappily known as Immaculates. All these labels refer to an art that is descriptive at base, but controlled in one way or another by geometric simplification that stems from Cubism. The approach of the Precisionists has already been suggested in the discussion of Georgia O'Keeffe, who, with Charles Sheeler, was the central figure in its formulation. Precisionism, as seen in the works of these artists, and of Charles Demuth, Ralston Crawford, and Niles Spencer, is basically a precise and frequently photographically Realistic art stripped of detail to the point that it becomes abstract in its impact.

The painting of O'Keeffe until the late 1920s was largely concerned with organic subjects: flowers or plant forms in extreme close-up. She also produced occasional and sometimes romantic interpretations of architectural themes. Sheeler and Demuth favored architectural landscape; Sheeler, machine forms as well. Machine forms, given Dada or Surrealist overtones, were also favorite subjects of Morton Schamberg (fig. 335), who was probably the closest to the circle of Marcel Duchamp. Some of the Precisionists met regularly with members of New York Dada at the collector Walter Arensberg's apartment for all-night discussions on the state of art and the world.

CHARLES SHEELER (1883–1965) In its severity and elimination of details, Sheeler's *Church Street "El,"* a work of 1922 (fig. 541) is closer to geometric abstraction than to Cubist painting. There is no shifting or multiple views as in Cubism, and the peculiar distortion of the forms—the extreme paralax foreshortening—arose from the artist's probable use of a photograph as his model. To support himself while in art school, the Philadelphia-born and -trained Sheeler had taken up pho-

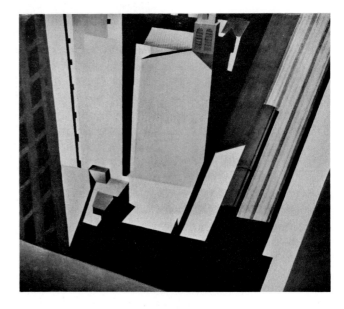

541. CHARLES SHEELER. *Church Street "El"*. 1922. 16 × 18½". Collection Mrs. Earle Horter, Philadelphia

tography in 1912, making records of new houses and buildings for architectural firms. By 1919 he was a professional photographer active in New York, where he soon entered the circle of Stieglitz, Steichen, and Strand, while also making contact with the more advanced painters. Now he regularly photographed skyscrapers, double exposing, tilting his camera, and then transferring these special effects and the patterns they produced to his paintings. In 1921 Sheeler and Paul Strand collaborated on a six-minute film entitled *Manahatta* (or *New York the Magnificent*), using a kaleidoscopic technique to celebrate the dizzying effect of life surrounded by a dense forest of tall buildings. Even though Sheeler gave up professional photography in 1930 to concentrate on painting, the relationship between his camera work and his canvases seems to have been virtually symbiotic, as can be seen in a comparison of the photograph entitled *Drive Wheels* and the painting known as *Rolling Power* (figs. 542, 543). The latter comes across as an almost literal transcription of the former, except for the suppression of such details as the grease on the engine's piston box, all in keeping with

below left: 542. CHARLES SHEELER. *Drive Wheels*. 1939. Photograph. Smith College Museum of Art, Northampton, Massachusetts. Gift of Dorothy C. Miller '25 (Mrs. Holger Cahill)

below right: 543. CHARLES SHEELER. *Rolling Power*. 1939. 15 × 30". Smith College Museum of Art, Northampton, Massachusetts. Purchased, 1940

Precisionism's love of Cubist simplicity, immaculate surfaces and edges, and purified machine imagery. Unlike the camera, Sheeler the painter could be highly selective in his record of the details provided by reality, and thus create arbitrary patterns of light and shadow and flat color that transform themselves into abstract relationships. The artist employed this manner in paintings of factory scenes or machine close-ups—admiring symbols of the expanding world of industry—and the identical attitude is found in studies of his own living room.

CHARLES DEMUTH (1883–1935) Charles Demuth, a Pennsylvanian, was the third major figure of the first generation Precisionists, and, in his most developed paintings, the closest to the French Cubists. His first mature works were illustrations for books, as well as imaginative studies of dancers, acrobats, and flower or plant forms, free and organic in treatment, seemingly at the other extreme from a Precisionist style. In a number of landscapes executed in watercolor in Bermuda in 1917, using interpenetrating and shifting planes and suggestions of multiple views (fig. 544), Demuth began his experiments with abstract lines of force, comparable to those used by Italian Futurists or by Lyonel Feininger (plate 57). In his late works Demuth expanded his exploration of the abstract or symbolic implications of the American scene in ways that have influenced younger artists since. He became interested in the advertising signs on buildings and along highways, not as blemishes on the American landscape but as images with a certain abstract beauty of their own (fig. 545).

In this period Demuth also produced a series of poster portraits made up of images and words and lettering associated with friends. *I Saw the Figure 5 in Gold* (plate 168) is a tribute to the poet William Carlos Williams; in fact, it is based on Williams's poem *The Great Figure*, to which the painter may also have contributed:

Among the rain
and lights
I saw the figure 5
in gold
on a red
fire truck
moving
tense
unheeded
to gong clangs
siren howls
and wheels rumbling
through the dark city.

The numerous references to Williams in the painting are explicit. The golden 5s radiate from the center in a Futurist dynamic; buildings tilt in space; and rays of color-light sweep across the middle distance and foreground, tying together perspective recession and picture plane. Demuth, despite his short career, may have been the most talented and comprehensive in approach of the painters associated with Precisionism, and he anticipated and influenced still another generation of Magic Realists and Pop artists. Stuart Davis, the major American artist to emerge during the 1920s, has admitted with gratitude his debt to Demuth. Today, Robert Indiana and Jasper Johns have painted their variants on the theme of 5 as tributes to him (fig. 715).

American Scene Painting

The 1930s in the United States was a decade of Depression, reaction, and isolation in politics and art. The Realists—the original revolution-

above: 544. CHARLES DEMUTH. *Bermuda No. 2—The Schooner*. 1917. Watercolor, 10 × 13⅞″. The Metropolitan Museum of Art, New York. The Alfred Stieglitz Collection, 1949

right: 545. CHARLES DEMUTH. *Buildings, Lancaster*. 1930. Oil on composition board, 24 × 20″. The Whitney Museum of American Art, New York. Anonymous Gift

546. THOMAS HART BENTON. *Arts of the West.* 1932. Tempera, 94 × 161″. New Britain Museum of American Art, Connecticut

aries—had now replaced the Academy as the guardians of conservatism and were fighting a rearguard battle against modernism. The second wave of Realists put greater emphasis on the Americanism of their works, whether these were bitter attacks on the American political and economic system that had produced the sufferings of the Great Depression, or chauvinistic praise of the virtues of an actually declining agrarian America. Art reflected the spirit of isolationism that dominated so much of American thought and action after World War I. It became socially conscious, nationalist, and regionalist.

From the point of view of the art produced, the 1930s may seem a bleak and reactionary time in the United States. But the crucial event of this decade—indeed, a catalyst transcending even the Armory Show—was the establishment, by the United States government, of a Federal Art Project, a subdivision of the WPA (Works Progress Administration). Just as the WPA provided jobs for the unemployed, the Art Project enabled many of the major American painters to survive, and a large percentage of the younger artists who created a new art in America after World War II might never have had a chance to emerge had it not been for the government-sponsored program of mural and easel painting.

The decade, however, marked a *détente* in modern art in America. Although there were many artists of talent, and many interesting directions in American art, some of them remarkably advanced, those who claimed the most attention throughout the era were the painters of the so-called American Scene, an umbrella term covering a wide range of Realist activity, from the generally left-wing Social Realists through what might be called Romantic and Magic Realists to the more reactionary and nationalistic Regionalists. Divergent as their sociopolitical concerns may have been, the several factions merged in their common preference for retardataire, illustrational styles and their contempt for "highbrow" European formalism, an aesthetic stance they shared during the period with both the dogmatic Social Realists of the Soviet Union and the internationally respected, but no less propagandistic, mural masters of Mexico.

THOMAS HART BENTON (1889–1975) Dominant among the American Scene artists were the Regionalists Thomas Hart Benton, John Steuart Curry, and Grant Wood, and of these the most ambitious, vocal, and ultimately influential was Benton. A born-again Realist, Benton attacked modernism, especially that espoused by Stieglitz and his circle, with the fury of one who knew its diabolical lures only too well, having experienced them in depth during an early period with the Synchromists in Paris. "I wallowed," he once said, "in every cockeyed ism that came along, and it took me ten years to get all that modernist dirt out of my system." Rabidly xenophobic, the Missouri-born Benton railed against the great cities as "nothing but coffins for living and thinking," and declared that "only by our own participation in the reality of American life could . . . [Curry, Wood, and I] come to forms in which Americans would find an opportunity for genuine spectator participation." For the sake of preserving "true" American values, Benton conceived a grandiose program of public mural art that would provide a complete pictorial history of the United States in sixty-four panels, sixteen of which the artist actually completed. As reflected in the work reproduced here (fig. 546), Benton turned back to sixteenth-century Mannerism for stylistic conventions that permitted him to orchestrate vast operatic scenes, often with heaving skies and landscapes crammed with balletic figures as muscle-bound and overwrought as any by Michelangelo, all clamped into place and held to the wall by, ironically, a totally abstract conception of compositional order. Benton also enters the history of art as the one-time teacher, at New York's Art Students League, of Jackson Pollock, who would transform the older master's rugged individualism, energy, and mural scale into the very highest form of the modernism Benton so detested.

GRANT WOOD (1892–1942) Following a stint at the Académie Julian in Paris during the early 1920s, where he caught up with, at least, the Impressionists, Iowa-born Grant Wood repented his modernist sins and converted to a more literal form of old-time Realism when, in 1928, he discovered the art of the fifteenth-century Flemish and German primitives in the course of a brief visit to Munich. Adapting this stylistic prototype to the Regionalist concerns he shared with Benton, Wood produced *American Gothic* in 1930, probably the painting most celebrated by the artist's fellow citizens throughout the Depression years

(fig. 547). And this is understandable, for not only is the picture highly legible and its subjects an instantly recognizable set of types, but the marriage of a miniaturist, antique style with contemporary, homespun, Puritan content yields a caricatural charm and a sense of "presence" transcending the arrière-garde populism of its original inspiration.

CHARLES BURCHFIELD (1893–1967) A more Romantic approach to Regionalism was taken by the Ohio artist Charles Burchfield. Following an early psychological crisis, Burchfield tended to project chronic fears and obsessions into his paintings of rural and small-town America (fig. 548), until these assumed a spooky animism and a curvilinear fantasy somewhat reminiscent of the pantheistic landscapes of the early nineteenth-century English Romantic painter Samuel Palmer.

EDWARD HOPPER (1882–1967) The greatest artist associated with American Scene painting was undoubtedly Edward Hopper, a mainly urban, New York counterpart of the Midwestern Regionalists. Although he had made several long visits to France between 1906 and 1910, at the exact moment of the Fauve explosion and the beginnings of Cubism, Hopper, seemingly unaffected by either of them, early began to state his basic Romantic-Realist themes of isolated houses and lonely individuals in "one night cheap hotels." Hopper's subject, his attitude to it, and his style were established in the 1920s and varied little thereafter. One of his finest works was *Early Sunday Morning*, painted in 1930 (plate 169). The row of buildings, with their shops below and dreary apartments above, fill the canvas from end to end, reiterating and closing in the surface, except for the narrow rectangle of blue sky and the foreground of deserted street. It is, thus, organized in a purely plastic, vertical-horizontal manner. The form and the appearance are, nevertheless, only attributes of a mood as lonely as a De Chirico Italian piazza transformed into an American provincial town.

 Much of the effect of Hopper's paintings is derived from his sensitivity to light—the light of early morning or of twilight; the dreary light filtered into the hotel room or office; or the garish light of the lunch counter isolated within the surrounding darkness. Calling the United States a "chaos of ugliness," Hopper revealed some of the secret of the enchantment present in his own art when he declared an admiration for

above: 547. GRANT WOOD. *American Gothic*. 1930. Oil on beaverboard, 29⅞ × 24⅞". Art Institute of Chicago. Friends of American Art Collection

right: 548. CHARLES BURCHFIELD. *November Evening*. 1934. 32⅛ × 52". The Metropolitan Museum of Art, New York. George A. Hearn Fund, 1934

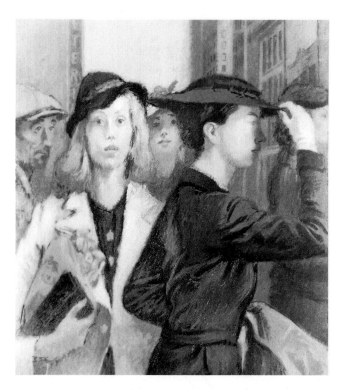

549. RAPHAEL SOYER. *Office Girls*. 1936. 26 × 24". The Whitney Museum of American Art, New York. Purchase

550. ISABEL BISHOP. *Waiting*. 1938. Oil and tempera on gesso panel, 29 × 22½". Collection Newark Museum, New Jersey. Purchase 1944, Arthur F. Agner Memorial Committee

551. BEN SHAHN. *The Passion of Sacco and Vanzetti*. 1931–32. Tempera on canvas, 84½ × 48". The Whitney Museum of American Art, New York. Gift of Edith and Milton Lowenthal

Burchfield's ability to discover a "hideous beauty" in the vulgar, eclectic jumble of the American Scene, with its "fantastic roofs, pseudo-Gothic, French Mansard, Colonial, mongrel or what not."

Also active in the American Scene were such confirmed urban Realists as Reginald Marsh, the brothers Moses and Raphael Soyer, Yasuo Kuniyoshi, and Isabel Bishop, all of whom employed a conscientious, hard-earned Renaissance or Baroque manner to portray and dignify the gritty look of Depression-wracked New York and its unemployed or overworked and underpaid masses. Raphael Soyer (b. 1899) proved particularly astute at capturing the fragility and stoic forbearance of tired office girls preserving their selfhood within the anonymous crowd pressing along the city streets (fig. 549). Isabel Bishop (b. 1902) often turned to a more mature type, no less trapped or courageous but confronted with a different, more complex set of problems (fig. 550), rendered in infinite delicacy with the ancient media of oil and tempera.

BEN SHAHN (1898–1969) While the nostalgia-ridden Regionalists responded to the stricken times by urging their compatriots to "paint American," and turn isolationist, a more pragmatic group cried "paint proletarian." These artists—the Social Realists—were concerned not only with domestic issues but also with the rise of Fascism abroad. Like many members of the 1930s intelligentsia, they tended to place their faith in Marxist principles, until this was shaken by the Moscow Trials of 1936–37 and the Hitler-Stalin Nonaggression Pact of 1939. Foremost among the Social Realists was Ben Shahn, whose work has its roots in Expressionism, naïve art, and the Cubist dislocation of planes. Shahn gained recognition in the early 1930s through his paintings on the notorious case of Sacco and Vanzetti. These were bitter denunciations of the American legal system which had condemned the two anarchists to death (fig. 551).

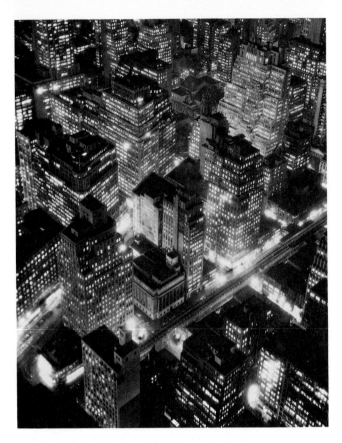

552. BERENICE ABBOTT. *New York at Night*. 1933. Gelatin-silver print. Collection, The Museum of Modern Art, New York. Purchase

553. DOROTHEA LANGE. *Migrant Mother*. 1936. Photograph. Library of Congress, Washington, D.C. Farm Security Administration Collection

PETER BLUME (b. 1906) The Russian-born Social Realist Peter Blume looked abroad and excoriated the evils of Italian Fascism in a caricatural manner that, with its Magic Realist detail (plate 170), invites comparison with the "hand-painted dream photographs" of Salvador Dali (fig. 404). But although the Spanish master, like most Surrealists, concerned himself with archetypal imagery generated by the subconscious, Blume worked from the intellect and dealt with problems of the outside world. There, the bilious green head of a jack-in-the-box Mussolini looms over the ruins of Classical civilization, while the Man of Sorrows continues his eternal mourning on the right.

AMERICAN DOCUMENTARY PHOTOGRAPHY IN THE 1930s If the banks and crops failed, as the economy stalled and the Midwest farm belt turned into the Dust Bowl, Americans at least reaped a rich harvest of the most splendid documentary photography ever produced, much of it sponsored by various federal agencies set up to help a distressed nation cope with the crisis of the times. Not only was Lewis W. Hine still active, photographing construction laborers swarming over the steel skeleton of the nascent Empire State Building, but Berenice Abbott (b. 1898) returned to New York in 1929 from Paris, where she had learned photography as an assistant to Man Ray. One of the first to appreciate the genius of Atget (figs. 117, 316), and the only photographer ever to make portrait studies of the aged French master, Abbott fell in love with Manhattan upon her rediscovery of it, much as Atget had with Paris. First working alone and then for the WPA, she set herself the task of capturing the inner spirit and driving force of the metropolis as well as its outward aspect. Though utterly straight in her methods, Abbott, owing to her years among the Parisian avant-garde, inevitably saw her fabulous subject in modernist, abstract terms (fig. 552).

554. WALKER EVANS. *Garage, Atlanta, Georgia*. 1936. Gelatin-silver print. Library of Congress, Washington, D.C. Farm Security Administration Collection

Dorothea Lange (1895–1965), following studies at Columbia University under Clarence H. White, opened a photographic studio in San Francisco, where she found her most vital themes in the life of the streets. This prepared her for the horrors of the Depression, when she joined what

555. JAMES VAN DER ZEE. *Couple in Raccoon Coats*. 1932. Gelatin-silver print. ©1969 James Van Der Zee. All rights reserved

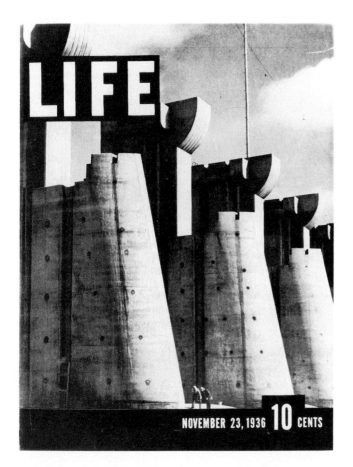

556. MARGARET BOURKE-WHITE. *Fort Peck Dam, Montana*. Photograph (first cover of *Life* magazine). Margaret Bourke-White, *Life* magazine ©1936, 1964 Time, Inc.

became the United States Farm Security Administration as a photographer charged with recording the condition of destitute agrarian folk all over the country, especially those fleeing the Dust Bowl for the supposed El Dorado of California. There, with empathy and respect toward her subjects for exactly what they were, Lange photographed a tired, anxious, but stalwart mother surrounded by her ragamuffin children in a migrant worker camp (fig. 553). This unforgettable and often reproduced image has been called "The Madonna of the Depression." Like Abbott, Walker Evans (1903–1975) studied in Paris, albeit in literature rather than art, and like Lange, he went to work photographing for the FSA. The straightest of straight photographers, Evans brought such passion to his work that in his images the simple, direct statement ends up being almost infinitely complex as metaphor, irony, and compelling form (fig. 554). Evans liked to invoke Flaubert in asserting that the artist should be invisible yet all-powerful.

While Abbott was scanning the skyscraper world of 1930s New York and Lange as well as Evans the contemporary small-town and rural scene, James Van Der Zee (1886–1983) was preparing a comprehensive portrait of Harlem (fig. 555). With his background in art and music, this photographer had no qualms about tempering documentary purpose with a conscious effort to show both his subjects and his work at their aesthetic best, even to the point of executing his own backdrops and painting directly on prints. Such idealism kept Van Der Zee going for fifty years, compiling a tremendous and flattering archive of imagery showing how Harlem—not only the "beautiful people" seen here but also events, such as weddings, funerals, anniversaries, and graduations—appeared to one tireless, devoted, and gifted observer.

The most famous photographer of the period was unquestionably Margaret Bourke-White (1904–1971), another student of Clarence H. White and a hard-driving professional who, as Alfred Eisenstaedt wrote, "would get up at daybreak to photograph a bread crumb." Really a photojournalist, Bourke-White was the first staff photographer recruited for Henry Luce's *Fortune* magazine, and when the same publisher launched *Life* in 1936, Bourke-White's photo of Fort Peck Dam appeared on the first issue (fig. 556). As this image indicates, Bourke-White favored the monumental realized not only through boldly simplified compositions but also through a concentration on colossal structures, mainly industrial. While emphasizing the positive in this aspect of her work—evidence of society's power to act in a time of faltering confidence—the photographer also focused her camera on human suffering, in the American South during the Depression and in the war zones and prison camps of the early 1940s.

The Mexicans

DIEGO RIVERA (1886–1957) Particularly influential to American painters of the 1930s (although not necessarily in the direction of modernism) were the Mexican muralists Rivera and Orozco. Rivera had studied and lived in Europe between 1909 and 1921, and been associated with Cubism. During the 1920s he received important commissions for monumental frescoes from the Mexican government. This was the period when Rivera turned against the modern movement in an attempt to create a national Mexican style reflecting both the history of Mexico and the Socialist spirit of the Mexican revolution (fig. 557). One of the most acclaimed artists of his time, especially in the United States, Rivera deliberately worked against his own artistic sophistication in order to act on firmly held Marxist ideals and found a people's art suited to the perceived needs of postrevolutionary Mexico. The decorative, expository, and folkloric character of the mural art he forged, consisting of simple, monumental forms and bold areas of color, made him a true hero of Mexican culture. Rivera also carried out several major

commissions in the United States, foremost among them a series of frescoed murals for the Detroit Institute of Arts, depicting industrial scenes, automobile manufacture, medical research, and transportation, all executed in the artist's familiar Social Realist style. Something of a scandal occurred in New York when Rivera included a portrait of Lenin in a mural he was painting at Rockefeller Center, provoking the sponsors to have the work-in-progress destroyed.

JOSÉ CLEMENTE OROZCO (1883–1949) Orozco, who received his training in Mexico City, and who was perhaps even more strongly influenced than Rivera by Mexican Indian traditions, also had important fresco commissions in the United States during the 1930s, notably at Dartmouth College in Hanover, New Hampshire. Here, in the Baker Library, between 1932 and 1934, he created a panorama of the history of the Americas, beginning with the story of Quetzalcoatl, continuing with the coming of the Spaniards, the Catholic Church, and concluding with the self-destruction of the machine age climaxed in a great Byzantine figure of a flayed Christ in process of destroying his own cross (fig. 558).

DAVID ALFARO SIQUEIROS (1896–1974) The third member of the Mexican triumvirate of muralists, David Siqueiros, was less immediately influential on United States mural painters, since he was less well known. The 1937 *Echo of a Scream* illustrates his vigorous pictorial attack (fig. 559). In the 1960s Siqueiros emerged from prison, where he was sent for political activities, to embark on the most ambitious fresco project of his life in Mexico City.

The Mexican muralists struck a common chord with American artists, partially because they represented a living tradition of fresco painting and partially because theirs was an art of social protest with an obvious appeal to the left wing, a dominant factor of American cultural life throughout the Depression decade.

Closely associated with the artist-reformers of Mexico was the Italian-born photographer Tina Modotti (1896–1942), who, with her longtime companion Edward Weston, arrived in Mexico in the early 1920s and worked there until her expulsion in 1930 for political activism. With a sure eye for the telling image and a keen sense of the light-dark contrasts of the Hispanic world, Modotti built a remarkable, if now rather scattered, corpus of photographs, works that seem all the more dramatic for being absolutely straight (fig. 560).

Toward Abstract Art

During the 1930s modernism, particularly Cubism and abstraction, seemed to have been driven underground, although the Federal Art Project did support many of the more experimental artists. Thus the seeds were sown that resulted, after the war, in a transformation of the United States from the position of a provincial follower to that of a full partner in the creation of new art and architecture.

When American artists under the Project began to receive commissions for murals they generally had little experience in the techniques and few immediate guidelines. Some turned back to the Renaissance for inspiration. A few, such as Arshile Gorky, Willem de Kooning, Philip Guston, and James Brooks, used the opportunity to explore aspects of Cubism or abstraction on a large scale. The significant wall paintings produced by the Project were, with the exception of those by Stuart Davis, from the hands of artists still relatively unknown: Gorky, Guston, Brooks, and Burgoyne Diller.

During the 1930s, in sculpture as in painting, despite the predominance of the academicians and the isolation of the progressive artists, a number of sculptors were emerging, some of whom were destined to change the face of American sculpture at the end of World War II. Alexander Calder, as we have seen (fig. 500), was an established artist-sculptor during the 1930s, but in a European rather than an American context. Internationally he was the best-known American sculptor before the war, and remained so thereafter. His influence grew continuously, although it has been most apparent in American Constructivist sculpture since 1945.

Other sculptors who emerged during the 1930s but whose principal achievements have taken place since 1945 were Reuben Nakian, Joseph Cornell, Seymour Lipton, Raoul Hague, David Smith, and Theodore Roszak. These, together with certain others, were the sculptors who created the new American sculpture of the 1950s. Within this achievement, the work of David Smith today exercises an influence that is worldwide.

A number of other events and developments of the 1920s and 1930s also suggested the path to the future. In 1920 Katherine Dreier, painter and collector, advised by Marcel Duchamp, had organized the Société Anonyme for the purpose of buying and exhibiting examples of the most advanced European and American art. The Société not only held exhibitions but arranged lectures and symposiums. A. E. Gallatin, another painter-collector, in 1927 put his personal collection of modern art on display at New York University under the name of The Gallery of Living Art. It remained on exhibition for fifteen years. (This collection, now at the Philadelphia Museum together with the even more important one of Walter C. Arensberg, includes examples by Brancusi, Braque, Cézanne, Kandinsky, Klee, Léger, Matisse, Miró, Mondrian, and many others.) The Gallery of Living Art became, in effect, the first museum with a permanent collection of exclusively modern art to be established in New York City, or perhaps anywhere in the world. It was followed by the creation of The Museum of Modern Art in 1929, which climaxed its initial series of exhibitions by modern masters with the historic shows entitled "Cubism and Abstract Art" and "Fantastic Art, Dada, Surrealism," both in 1936. In 1935 the Whitney Museum held its first exhibition of American abstract art, and in 1936 the American Abstract Artists (AAA) group was organized.

During the 1930s a few progressive European artists began to visit or migrate to the United States. Léger made three visits before settling at the outbreak of World War II. Not only Duchamp, but Jean Hélion, Ozenfant, Moholy-Nagy, Josef Albers, and Hans Hofmann were all living in the United States before 1940. The last four were particularly influential as teachers. The group as a whole represented the first influx of the European artists who spent the war years in the United States and who helped to transform the face of American art. Conversely, younger American painters continued to visit and study in Paris during the 1930s. Throughout the late 1930s and 1940s the AAA held annual exhibitions dedicated to the promotion of every form of abstraction, but with particular emphasis on Constructivist and Neo-Plasticist abstraction related to those then being propagated in Paris by the Cercle et Carré and Abstraction-Création groups. With the exception of Stuart Davis, most of the artists of the group came to maturity after World War II. Their emergence during the 1930s and the gradual reestablishment of close contacts with the European modernists were of great importance for the subsequent course of modern American art.

STUART DAVIS (1894–1964) Stuart Davis was the most significant American painter to emerge between the two world wars. His profes-

563. STUART DAVIS. *House and Street*. 1931. 26 × 42¼″. The Whitney Museum of American Art, New York

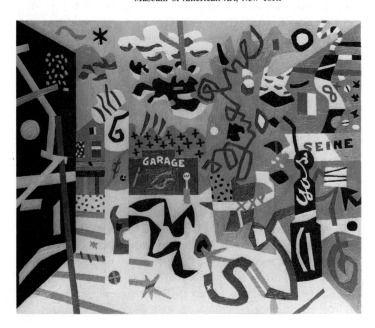

sional career encompassed virtually the entire span of modern art in the United States. While still a student, he exhibited five watercolors in the 1913 Armory Show and was overwhelmed by the experience of the European modernism on display. His collages and paintings of the early 1920s are explorations of the everyday scene, executed in a manner that became his own but that still is a transition between nineteenth-century American *trompe-l'oeil* and Pop Art of the 1960s (fig. 561).

In his Eggbeater series of 1927–28, the first genuine abstractions to be initiated by an American artist in ten years, Davis attempted to rid himself of the last illusionistic vestiges of nature, painting an eggbeater, an electric fan, and a rubber glove again and again until they had ceased to exist in his eyes and mind except as color, line, and shape relations (fig. 562). These abstract works were followed by a series of relatively literal cityscapes, a product of his visit to Paris in 1928–29. The dialogue between reality and abstraction continued throughout the 1930s with works such as *House and Street* (fig. 563), one of the earliest examples of a divided composition in which the shift of point of view between right and left side suggests the frames of motion picture film, with a consequent linking of simultaneous and consecutive vision. Davis continued the interplay of clearly defined, if fragmented, objects with geometric abstract organization. His color became more brilliant, and he intensified the tempo, the sense of movement, the gaiety, and

564. STUART DAVIS. *Report from Rockport*. 1940. 24 × 30″. Milton and Edith A. Lowenthal Collection

rhythmic beat of his works through an increasing complication of smaller, more irregular, and more contrasted color shapes.

The climax of these experiments may be seen in a 1940 work like *Report from Rockport* (fig. 564). Although more abstract than most paintings of the 1930s, *Report from Rockport* includes recognizable bits such as buildings and gas pumps. There is a strong suggestion of depth, achieved by linear perspective as well as by color, but major color areas reaffirm the picture surface. This surface twists and vibrates with jagged, abstract color shapes and lines, elements that put the scene into violent and fantastic movement translating the jazz tempo of America into abstract color harmonies and dissonances.

In the 1952 painting *Rapt at Rappaport's*, the alliterative and slangy title once more invades the actual painting, the staccato letters flashing across the lower part like a news bulletin (plate 171). Large color shapes of red, blue, and black are suspended against a unified ground color, in this case, green. The larger shapes are flatly arranged, and the whole painting tends toward the overall pattern that Davis explored in a number of works during the 1950s. The surface is livened with a series of characteristic invented shapes, the torn S or 8 ribbon, the floating white circles or rectangles, the X and star fragment, that act as directional thrusts. The cross, rectangle, and square, established in a precise geometrical relation to one another, reaffirm the total picture rectangle as well as the degree in which depth is here achieved by relations of flat, overlapping color planes.

There are few if any modern artists who have used titles of paintings in as imaginative and yet as structural a manner as did Stuart Davis. He added another dimension to abstract paintings in his use of letters, words, phrases, and the mood or tempo of the painting.

Colonial Cubism is one of the largest, simplest, and most powerful organizations ever achieved by Davis (plate 172). The colors are limited, while the architectural structure of interlocking planes which pull and push against one another results in enormous tension. Aside from a few irregular circular shapes and the brittle calligraphy of the signature, all areas have a sharp, rectilinear regularity. With the exception of the artist's signature, all lettering, words, or phrases have been eliminated. It is a work in which Davis was obviously rethinking some of the tenets of Cubism. But a comparison of this painting with any Cubist work of Picasso, Léger, or any other European Cubist, will reveal how completely Davis created his own world from Cubist elements.

Stuart Davis is almost the only American painter of the twentieth century whose works have transcended every change in style, movement, or fashion. Even during the 1950s he continued to have the respect and admiration of the most experimental new artists. With the emergence of Pop Art and other attempts at a reexploration of the subject, his paintings have taken on a new significance in the history of modern American art.

BURGOYNE DILLER (1906–1965) One of the most accomplished and productive artists who adopted a Constructivist mode and exhibited with the AAA was Burgoyne Diller, born and educated in the Middle West but matured in New York. Once enrolled at the Art Students League in 1929, Diller very rapidly assimilated influences from Cubism, German Expressionism, Kandinsky, and Suprematism, much of which he knew only through reproductions in such imported journals as *Cahiers d'art*. Finally, toward the end of 1933, he had his first direct experience of a painting by Mondrian, whose Neo-Plasticist principles became the main source of the formal interests Diller would henceforth pursue, without his being particularly affected by the Dutch artist's Utopian philosophy. But far from servile in his dependence on Neo-

565. IRENE RICE PEREIRA. *Abstraction*. 1940. 30 × 38″. Honolulu Academy of Arts. Gift of Philip E. Spalding, 1949

Plasticism, Diller went his own way by integrating color and line, so that lines became color planes (plate 173), all the while that Mondrian continued to maintain color planes and black lines as separate and discrete entities. Moreover, by allowing the color line-planes of his paintings and reliefs to overlap, Diller created a more complex and dynamic sense of space than the implacable flatness and stasis required by Mondrian. In hindsight, these differences assume significance as forecasts of the special kind of space and imagery that would emerge in the radical abstraction developed by the New York School following World War II.

IRENE RICE PEREIRA (1907–1971) Another pioneer American abstractionist to appear in the 1930s was Irene Rice Pereira. Taking her inspiration primarily from the Bauhaus, Pereira sought to fuse art and science, or technology, in a new kind of visionary image grounded in abstract geometry, but aspiring, like the Supremiatist art of Malevich, toward an even more rarefied realm of experience. Boston-born and professionally active in New York, Pereira developed a seasoned style compounded of sharply rectilinear hard-edged and crystalline planes, often rendered as if floated or suspended one in front of the other, with transparent tissues giving visual access to textured, opaque surfaces lying below (fig. 565). The resulting effect is that of a complex, many-layered field of color and light. Endowed with a vigorous intellect, Pereira published several volumes of her essays and drawings, among them *The Nature of Space* (1957) and *The Transcendental Formal Logic of the Infinite* (1966).

GERALD MURPHY (1888–1964) One of the most secure manifestations of European formalism to be achieved by an American between the wars was the small but impressive and highly individual oeuvre of Gerald Murphy, a wealthy expatriate long resident in France on whom Scott Fitzgerald modeled the hero of *Tender Is the Night*. An untrained but innately sophisticated talent, Murphy worked with painstaking slowness, produced only one painting a year, and no more, probably, than

566. GERALD MURPHY. *Razor*. 1924. 32⅝ × 36½″. Dallas Museum of Art, Foundation for the Arts Collection. Gift of the Artist

from Matisse but involving an altogether personal poetry. In his later years he turned more to landscape which, though always recognizable, became more and more abstract in organization (plate 174). Avery was not only a distinguished painter but also a major link between the color paintings and collages of Matisse and the American Color Field painters of the 1950s and 1960s, such as Mark Rothko, Adolph Gottlieb, and Helen Frankenthaler.

HORACE PIPPIN (1888–1946) Like France's Henri Rousseau at the turn of the century, Horace Pippin, the black artist from West Chester, Pennsylvania, worked in isolation and neglect until discovered by eyes acculturated to the formal rigors of modern painting. As a genuine *naïf*, probably the most gifted ever to emerge in American art, the autodidact Pippin understood by instinct what classically educated painters had to learn through painful trial and error: that in modern pictorial reality, idea counts for more than eye. As Pippin himself put it:

> The pictures which I have already painted come to me in my mind, and if to me it is a worth while picture, I paint it. I go over that picture in my mind several times and when I am ready to paint it I have all the details that I need. I take my time and examine every coat of paint carefully and to be sure that the exact color which I have in mind is satisfactory to me My opinion of art is that a man should have love for it, because my idea is that he paints from his heart and mind. To me it seems impossible for another to teach one of Art.

And so in a work like *Domino Players* (fig. 567) flat pattern and design perform the miracle always sought in art, thereby transforming inert materials and imagery into something marvelous and moving. So sure was Pippin in his command of simple, interlocking positive and negative shapes that the painting seen here takes its place quite comfortably alongside the works of Stuart Davis, or even Avery and Matisse, with whom Pippin has often been compared.

LOREN MacIVER (b. 1909) The fantasy of Loren MacIver belongs in a lyrical vein. MacIver lived and painted in New York City all her life. In a work like the 1940 *Hopscotch* (fig. 568) she observed a small detail of cracked and broken sidewalk with the chalked numbers of the game at the right, but transformed this detail into a free abstraction, lyrical in color and large in feeling. Using prosaic elements, she created a world of poetic fantasy with definite affinities to the lyrical wing of Abstract Expressionism.

sixteen in all, a mere six of which are known to survive (fig. 566). Still, he had absorbed the principles of Synthetic Cubism and, somewhat in the manner of Stuart Davis, had succeeded in turning them to his own purposes, which were to transform American popular imagery into a high art of simple, emblematic force, flat picture-puzzle design, and grand scale. All this, plus the Art Deco elegance of the handling, places Murphy in a special realm entirely his own, but one that looked clairvoyantly forward to the Pop Art of the 1950s and 1960s. On this development, however, he had no influence whatever, owing to his isolation abroad and the extremely late discovery of his rare and long-obscured art.

MILTON AVERY (1893–1965) A less uncompromising but nonetheless bold modernist was the almost equally isolated Milton Avery, who characteristically worked in broad, simplified planes of color deriving

567. HORACE PIPPIN. *Domino Players*. 1943. Oil on composition panel, 12¾ × 22″. The Phillips Collection, Washington, D.C.

568. LOREN MACIVER. *Hopscotch*. 1940. 27 × 35⅞". Collection, The Museum of Modern Art, New York. Purchase

569. MORRIS GRAVES. *Blind Bird*. 1940. Gouache, 30⅛ × 27". Collection, The Museum of Modern Art, New York. Purchase

MORRIS GRAVES (b. 1910) The West Coast artist Morris Graves gained distinction for his mysterious and delicately drawn little paintings of birds, images that have a spiritual affinity to the works of Paul Klee. Graves came under the influence of Oriental religion and philosophy, particularly Zen Buddhism, and saturated himself in the mythology of the Northwest Indians. His *Blind Bird* is a strange and seemingly pathetic little creature, but hypnotic in its effect (fig. 569). Graves said, "I paint to rest from the phenomenon of the external world . . . and to make notations of its essences with which to verify the inner eye." In his own way, he carried on that search for the inner reality, the inner spirit, to which Kandinsky and Klee devoted their lives.

AUGUSTUS VINCENT TACK (1870–1949) The most maverick and removed of all the progressive American painters between the wars may have been Augustus Vincent Tack. He alone managed to integrate modernism's nonobjective and figural modes into organic, sublimely evocative, wall-size abstractions that formed a unique bridge between an older pantheistic tradition of landscape painting, last seen in the work of Ryder, and its new, brilliant flowering in the heroic abstractions of the postwar New York School. Duncan Phillips, Tack's faithful patron throughout the 1920s and 1930s, foresaw it all when, in commenting on *Storm* (plate 175), a vast, Wagnerian sky or craggy mountainscape shredded into meandering fragments of celestial blue, transcendental gold, and earthly brown, he declared: "We behold the majesty of omnipotent purpose emerging in awe-inspiring symmetry out of thundering chaos. . . . It is a symbol of a new world in the making, of turbulence stilled after tempest by a universal God." Here is American Romanticism in the most advanced form it would take during the period, a view of the material world examined so intensely that it dissolved—was "stilled"—into pure emblem or icon, an aesthetic surrogate for the divine, ordering presence sensed within the magnificent, overwhelming disorder of raw nature. A Roman Catholic who became a religious cosmopolitan through his study of Oriental mysticism and perhaps even Theosophy, Tack was, as Robert Rosenblum has pointed out, a spiritual and artistic heir to that great legacy of feeling-drenched, quasi-abstract landscape painting which began with Friedrich and Turner and continued in the Expressionist works of Van Gogh, Hodler, and Kandinsky. Even so—or perhaps for that very reason—his art remained, until the

early 1970s, almost as unknown to the world at large as that of Gerald Murphy.

A photographer with a comparable sense of the sublime was Ansel Adams (1902–1984), who could have been a concert pianist but for his overwhelming love of nature at its grandest, a passion discovered at the age of fourteen during a visit to California's Yosemite Valley (fig. 570). After helping found Group *f*/64 in 1932, an organization of West Coast professionals devoted to "straight" photography as an art form,

570. ANSEL ADAMS. *Frozen Lakes and Cliffs, The Sierra Nevada, Sequoia National Park, California*. 1932. Courtesy the Trustees of the Ansel Adams Publishing Rights Trust. All rights reserved

Adams met and engaged the support of Alfred Stieglitz, then already well into his straight yet Romantic series of Equivalents. A masterful technician, Adams revealed himself to be an authentic disciple of Stieglitz when he wrote: "A great photograph is a full expression in the deepest sense, and is, thereby, a true expression of what one feels about life in its entirety. And the expression of what one feels should be set forth in terms of simple devotion to the medium—a statement of the utmost clarity and perfection possible under the conditions of creation and production." After helping establish the Department of Photography at New York's Museum of Modern Art in 1940, Adams performed a similar service for what is now the San Francisco Art Institute.

American Sculpture Between the Wars

American sculpture during the first forty years of the twentieth century lagged far behind painting in quantity, quality, and originality. Throughout this period the academicians predominated, and such modernist developments in sculpture as Cubism or Constructivism were hardly visible. Archipenko, who had lived in the United States since 1923 and who had taught at various universities, finally opened his own school in

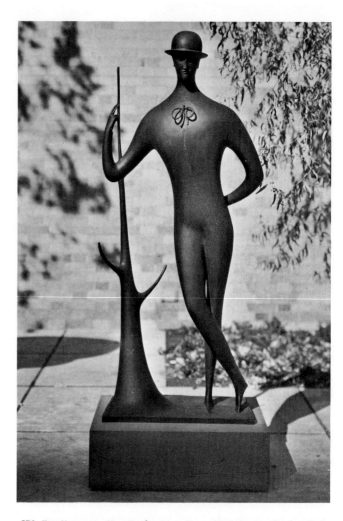

572. ELIE NADELMAN. *Man in the Open Air*. c. 1915. Bronze, height 54½"; base 11¾ × 21½". Collection, The Museum of Modern Art, New York. Gift of William S. Paley (by exchange)

New York City in 1939. Meanwhile, Alexander Calder, Theodore Roszak, Isamu Noguchi, and Herbert Ferber were at work, but as late as 1948 there was little that could be considered new or experimental.

GASTON LACHAISE (1882–1935) Among the first generation of modern American sculptors, two of the most interesting were Europeans, trained in Europe, who migrated to the United States early in their careers. These were Gaston Lachaise and Elie Nadelman. Lachaise was born in Paris and trained at the École des Beaux-Arts. By 1910 he had begun to experiment with the image that was to obsess him during the rest of his career, that of a female nude with enormous breasts and thighs and delicately tapering arms and legs. This form derives from Maillol, but in Lachaise's versions it received a range of expression from pneumatic elegance to a gross power which transcends that of the prehistoric female fertility figures (fig. 571).

ELIE NADELMAN (1882–1946) Elie Nadelman received his European academic training at the Academy in Warsaw. Around 1909 in Paris he was making serious studies of the problems of reducing the human figure to almost abstract curvilinear patterns. After his move to the United States in 1914, Nadelman progressively developed a style that might be described as a form of sophisticated primitivism, marked by simplified surfaces and linear outlines placed in the service of a witty and amusing commentary on contemporary life (fig. 572).

571. GASTON LACHAISE. *Standing Woman (Elevation)*. 1912–27. Bronze, height 70". The Albright-Knox Art Gallery, Buffalo

573. JOHN STORRS. *Forms in Space #1*. 1926. Combination of metals, height 21″. The Downtown Gallery, New York

575. ISAMU NOGUCHI. *Death*. 1934. Monel metal, 36 × 33 × 18″. Collection the Artist

JOHN STORRS (1885–1956) An American sculptor working in an original Art Deco-related Cubist, or "skyscraper," style during the 1920s and 1930s was John Storrs. Owing to the artist's long expatriation to France's Loire Valley, Storrs's achievement, like that of Gerald Murphy, was not recognized, and remained largely forgotten until its recent rediscovery (fig. 573).

574. JOHN FLANNAGAN. *New One*. 1935. Granite, height 6½ × 11½″. The Minneapolis Institute of Arts. The Ethel Morrison Van Derlip Fund

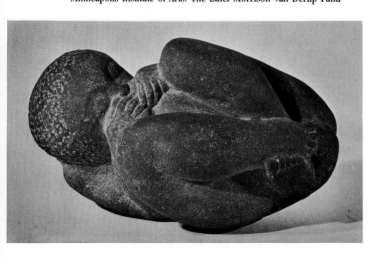

JOHN FLANAGAN (1895–1942) The American sculptural tradition during the first forty years of the century was primarily a tradition of carving, including a number of talented artists, such as Chaim Gross and Hugo Robus, who also worked extensively in bronze. John Flanagan was a unique native talent. Despite an expressed antipathy to the new sculpture in Europe, he nevertheless followed that sculpture closely. Flanagan worked best on a small scale, and his most successful evocations were small animals and newborn children (fig. 574).

ISAMU NOGUCHI (b. 1904) Isamu Noguchi belongs with Alexander Calder as an international rather than a specifically American figure in the history of modern sculpture. He was born in Los Angeles of a Japanese father and an American mother, and then lived in Japan from the age of two to fourteen before returning to the United States. When Noguchi decided to become a sculptor he was apprenticed for a period with the American academic-Realist sculptor Gutzon Borglum and received his earliest art training in an academic tradition. After having become acquainted with Brancusi's sculpture, Noguchi sought the Romanian artist out in Paris in 1927 and served as his assistant for two years. From Brancusi, Noguchi learned the nature of sculptural materials, and during the Paris sojourn he also became acquainted with and

576. EDWARD STEICHEN. *Black*. Photograph. Courtesy *Vogue*. ©1935
(renewed 1963) The Condé Nast Publications, Inc.

was influenced by the work of Picasso and the Constructivists, as well as Calder and Giacometti. Back in New York in 1929, Noguchi earned his living by doing portraits while continuing his exploration of abstraction. On visits to China and Japan during the 1930s, he studied Chinese brush painting and learned the principles of Japanese ceramic and garden design. An experimental play mountain designed for the New York City Parks Department in 1933—although unfortunately never accepted—was one of the earliest examples of his many garden or landscape designs involving space and sculptural principles that anticipated current experiments in Earth sculpture. In that same year Noguchi made a rare excursion into social protest for *Death (Lynch Figure)*, in which, however, the artist resisted Social Realist stylistics in favor of the Constructivist principles and Giacometti-like Surrealism he had acquired in Paris (fig. 575). With its hideously contorted figure swung from a real rope within an open cage, the sculpture makes a searing comment on the troubled world of the 1930s. From that era Noguchi would go on, as we shall see in later chapters, to build one of the truly major careers in the art of the postwar decades.

The Brancusi-like sleekness of form, so at one with the Art Deco

ambience of the 1920s and 1930s, reached something of a culmination in the period's fashion photography, the flip side of the cultural coin in an age that brought the miseries of Depression and Fascism, along with the racism denounced by Noguchi in his tragic, but no less sleekly handled, image in *Death (Lynch Figure)*. Of all the photographers active in fashion, surely the greatest was Edward Steichen (fig. 576), the artist encountered many chapters ago in his haunting moonlit time exposure of Rodin's *Balzac* (fig. 128). After World War I, during which he worked as an aerial photographer, the artist abandoned his soft-focus pictorialism and joined with Stieglitz, a long-time associate in New York's Photo-Secession, 291, and *Camera Work* magazine, to practice and promote straight, unmanipulated photography. Thanks to his innate as well as cultivated sophistication, Steichen became chief photographer for *Vogue* and *Vanity Fair*, publications in which his celebrity portraits and fashion photos appeared regularly from 1923 to 1938. During World War II he once again served the nation, this time as director of the U.S. Navy Photographic Institute. Finally, in 1947, Steichen was appointed director of the Department of Photography at The Museum of Modern Art, a position he held until his retirement in 1962.

Abstract Expressionism and the New American Sculpture

Virtually all the important masters of painting and sculpture during the prewar era were active into the 1950s and 1960s. Questions have been raised over their influence on the postwar generation, but, as will be seen, certain prewar masters were crucial to subsequent developments. The influence of Picasso on a number of artists who were to become leaders in Abstract Expressionism and other types of free abstraction was particularly important during the 1940s. The influence of Matisse was most significant for painters of the 1950s and 1960s concerned with color organization. Even more influential on the experimental wing of painting after mid-century were Mondrian, Kandinsky, Arp, Miró, Duchamp, Klee, and Schwitters. The influence of the sculptural pioneers is evident to the degree that the new sculpture has involved Constructivism, the utilization of the found object, and figurative fantasy. Even the principles of light and motion in sculpture were laid down in the 1920s and 1930s by Gabo, Duchamp, Moholy-Nagy, Calder, and others.

A major characteristic of painting and sculpture after mid-century is internationalism. From the beginning, modern experimental art had cut across boundaries, but identifiable national statements persisted until World War II. Paris, of course, was a center where artists gathered from every part of Europe and the Americas. Despite the internationalism of Paris, the modern movement, as we have seen, in Germany and Austria took the particular form of Expressionism, in Italy of Futurism, in Russia and Holland of Constructivism. After 1945, it is difficult to draw even such broad distinctions as these. Until 1960, the predominant tendencies everywhere—in Europe, North and South America, and even Japan—were abstract, whether geometric abstraction or some form of Abstract Expressionism. Influences were transmitted so rapidly from country to country that it has become impossible to pin down the origin of new developments. Artists are not only immediately aware of everything going on in the world through exhibitions and art publications, but they also travel on a scale never equaled in previous history.

The essential achievement of painters and sculptors after mid-century may be summarized as the consolidation and expansion of ideas formulated by the pioneers. The one major breakthrough into new territory has been Abstract Expressionism. Cubism, Fauvism, and Dada were departures as radical and significant as perspective painting five hundred years before. Like perspective painting, the implications of which were so extensive that the eras of the High Renaissance and the Baroque were spent in working them out, the experimental art of the early twentieth century did not begin to exhaust the potentials of its new vocabularies. The young artists of the postwar world have enlarged these vocabularies enormously, rethought their implications, and applied them to new contexts.

As we saw in Chapter 18, experimental American painting during the 1930s had been chiefly associated with geometric abstraction. Most of the European painters and sculptors who came to the United States in the 1930s and 1940s were, as mentioned earlier, leaders of Cubism or geometric abstraction. Mondrian, unquestionably the most important figure among the refugee artists, was already a symbol and an ideal for all those artists associated with the American Abstract Artists group. He immediately found many disciples.

Despite the appearance, in the flesh, of this prophet of geometric abstraction, the consummation of the first major wave of American abstraction was, paradoxically, the revolution of Abstract Expressionism—a movement or style largely divorced from the traditions of geometry. Other European artists previously discussed, who came to New York as a result of the war, included Surrealists representing the European avant-garde during the 1920s and 1930s.

The relations of the new movement—to be known as Abstract Expressionism—to Surrealism, and particularly to the organic, abstract, automatist Surrealism of Miró, Masson, and Matta, are obvious. In tracing its origins, however, one must also look to Kandinsky, Soutine, and the later style of Picasso. American pioneers, like Marin, Weber, Dove, Tobey, and Gorky, anticipated where they did not influence directly. From its origins in 1942 until its official recognition in The Museum of Modern Art 1951 exhibition "Abstract Painting and Sculpture in America," Abstract Expressionism developed into the most powerful original movement in the history of American art. During this period, the artists involved were conscious of their participation in exciting, if loosely defined, phenomena. A few critics, notably Clement Greenberg, championed the new movement, while a few dealers, such as Betty Parsons, Charles Egan, and Samuel Kootz, began to present the artists. Recognition by major museums and by art journals—heavily committed even after the war to Social Realism, art-as-documentation, Latin American art, and finally, reestablishment of contact with European art—came more slowly.

Abstract Expressionism was not so much a style as an idea (the Abstract Expressionists were diverse individuals who had little in common except what they were against). As already suggested, its roots are to be found in the efforts of a few individuals working in relative isolation during the 1930s and 1940s. The essence of Abstract Expressionism is the spontaneous assertion of the individual. It is impossible, therefore, to make comprehensive generalizations about the movement as a style. Any conclusion which can be drawn must be the cumulative effect of a study of individual artists who were engaged in the New York ferment during the 1940s and 1950s.

Despite a vast amount of informed, even passionate, writing about Abstract Expressionism in the United States and in the world, there remain elements of obscurity and controversy concerning its origins. These encompass the whole expressive wing of modern art from Van Gogh and Gauguin through the Fauves, German Expressionists, Dadaists, Futurists, and Surrealists. Impressionism, as well, played an important part. Also involved is the history of the acceptance of modern

577. HANS HOFMANN. *Spring.* 1940. Oil on wood, 11⅜ × 14⅜". Collection Peter A. Rübel, Connecticut

Expressionist and abstract art in the United States. In 1942, immediately after America's entry into World War II, the dominant styles of painting were still Social Realism and Regionalism. The war created a ferment that brought on the victory of abstract and Expressionistic art and the creation of the first major original direction in the history of American painting.

The term Abstract Expressionism was first used in 1919 to describe certain paintings of Kandinsky, and used in the same context by Alfred Barr in 1929. The critic Robert Coates applied it to a number of younger American painters in 1946, particularly to De Kooning, Jackson Pollock, and their followers. Harold Rosenberg coined the phrase Action Painting. Other terms, including the more neutral New York School, have been used for the extraordinary flowering that came in American painting throughout the 1940s and 1950s. None of these labels, with the possible exception of the last, which is nondescriptive, is particularly satisfactory, because of the individualistic approach of the artists concerned.

After its large 1951 exhibition entitled "Abstract Painting and Sculpture in America," The Museum of Modern Art mounted another exhibition, this one called "The New American Painting," and sent it on tour to eight European countries during 1958–59. The first show represented the introduction and official recognition of Abstract Expressionism by a major museum; the second might be considered an international apotheosis.

Although American Abstract Expressionism, or the New York School, is as diverse as the artists involved, in a very broad sense two main tendencies may be noted. The first is that of the Action painters, concerned in different ways with the gesture of the brush and the texture of the paint. It included such major artists as Pollock, De Kooning, and Kline. The other group consisted of the Color Field painters, concerned with the statement of an abstract sign or image in terms of a large, unified color shape or area. Here must be included Rothko, Newman, and Reinhardt, as well as, to a degree, Gottlieb, Motherwell, and Still. This two-part division is arbitrary, since other categories—Abstract

Impressionism, Lyrical Abstraction—could be formulated to embrace Guston, Brooks, and Marca-Relli. In the early part of the 1950s, however, attention was focused mainly on the Action painters, and most of the second generation were drawn to De Kooning or Pollock.

Action or Gesture Painting

HANS HOFMANN (1880–1966) Of the European painters who strongly affected American avant-garde art in mid-century, one of the most remarkable was Hans Hofmann, a phenomenon in that his career literally encompassed two worlds and two generations. Born in Bavaria, Hofmann lived and studied in Paris between 1903 and 1914, during this time experiencing the range of new movements from Neo-Impressionism to Fauvism and Cubism. He was particularly close to Delaunay, whose ideas on color structure influenced him (as they did Kandinsky, Klee, and Marc) even more than did Picasso's and Braque's Cubism. In 1915 Hofmann opened his first school in Munich and from this point, until the mid-1950s, his reputation was primarily that of a great teacher. In 1932 he moved to the United States to teach, first at the Art Students League, then at his own Hans Hofmann School of Fine Arts in New York and Provincetown, Massachusetts. Most of Hofmann's European paintings were destroyed in a studio fire, and thus it is almost as though he first emerged as a full-fledged painter about 1940, at the age of sixty. Hofmann's greatest concern as a painter, as teacher, and as theoretician lay in his concepts of pictorial structure on architectonic principles rooted in early Cubism. This did not prevent him from attempting the freest kinds of automatic painting. A number of such Abstract Expressionist works executed around 1940, although on a small scale, anticipated the Action Painting of Pollock (fig. 577).

During the last twenty-six years of his life, Hofmann painted with amazing fertility and variety, ranging in expression from a lyrical Romanticism to precise geometry (plate 176). Although his range was enormous, it was always, in his later years, within the abstract means. His influence on a generation of younger artists is incalculable.

ARSHILE GORKY (1904–1948) Armenian-born Arshile Gorky illustrates most specifically the line between Picasso, European Surrealism, and American Abstract Expressionism. Gorky arrived in the United States in 1920, a refugee from the Turkish campaign of genocide against the Armenian people, and almost from the beginning of his career as a painter he was deeply influenced by European artists, particularly Cézanne and Picasso. Gorky was also a friend of Stuart Davis, Willem de Kooning, and Frederick Kiesler. In his last decade or so, he did paintings and drawings that were freely Expressionist in an abstract sense. One of his climactic works is *The Liver Is the Cock's Comb* of 1944 (plate 177), a huge composition with characteristics of a wild and vast landscape, or of a microscopic detail of internal anatomy. At this point there seems to be no doubt that Gorky had moved from Picasso to the early free abstractions of Kandinsky, the "original" Abstract Expressionist. The Surrealist sense of organic fantasy is, however, greater than in Kandinsky, which became particularly apparent in the drawings, where fantastic shapes are more explicit. At this point, then, the artist was bringing together aspects of Kandinsky's free abstraction, Miró's and Masson's organic Surrealism, and residues of Picasso (fig. 578). Although the sense of subject is much stronger than will be the case in the Abstract Expressionist works of De Kooning and Pollock during the late 1940s and 1950s, the sources and the vocabulary have been clearly stated.

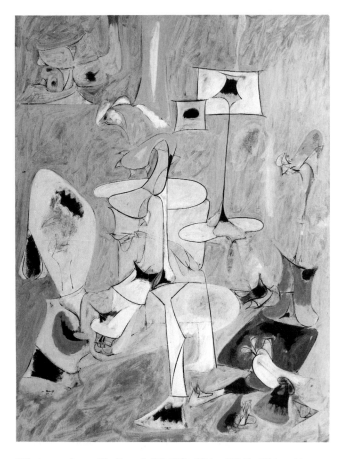

578. ARSHILE GORKY. *The Betrothal II*. 1947. 50¾ × 38″. The Whitney Museum of American Art, New York

579. WILLEM DE KOONING. *Night Square*. 1950–51. Oil on masonite, 30 × 40″. Formerly collection Mrs. Martha Jackson, New York

ations ranging from the threatening, to simple caricature, to the gently erotic. During the late 1950s, De Kooning returned for long periods to abstraction, given in his hands an extraordinary dynamic force (plate 178). These abstractions, while losing nothing of their expressive violence of brushstroke, later tend to larger gestures and an architectural

WILLEM DE KOONING (b. 1904) A central figure in the story of Abstract Expressionism is Willem de Kooning, even though he was not one of the first to emerge in the public eye during the 1940s. De Kooning, born in Rotterdam, Holland, came to the United States in 1926, after which he soon became a close friend of Gorky and a number of the artists who were to be associated with Abstract Expressionism. Although he did not exhibit until 1948, De Kooning was an underground force about whom the younger experimental painters were talking.

De Kooning was a figure painter and portraitist until 1940, one whose studies of individuals in an environment had an affinity to the paintings of Giacometti. When he began painting abstractions, the shapes were first suggestive of Picasso seen through Gorky. In the early 1940s, however, these curvilinear shapes—still with organic or biomorphic suggestions—were presented with a counterpoint of jagged, brittle lines that heightened the energy of the canvas. Some of the most successful are a group of black paintings with white drawing executed around 1950 (fig. 579). By 1950 the artist had also developed his personal aspect of Abstract Expressionism, distinct from Kandinsky, Gorky, Picasso, or anyone who had preceded him, and he emerged as one of the prophets of a new style, a new intensive mode of expression. At the same moment his nostalgia for the figure impelled him to begin his famous series of Woman paintings, overpowering, at times repellent, but hypnotic evocations of woman as sex symbol, fertility goddess— and in the tradition of Edvard Munch—blood-sucking vampire. His exploration of the Woman theme still continues (fig. 580), with vari-

580. WILLEM DE KOONING. *Woman VI*. 1953. 68½ × 58½″. Museum of Art, Carnegie Institute, Pittsburgh, Pennsylvania

Abstract Expressionism and the New American Sculpture • 389

581. WILLEM DE KOONING. *Reclining Figure in Marsh Landscape.* 1967. Oil on paper, 18¼ × 23″. Collection Mr. and Mrs. Jay R. Braus, Larchmont, New York

582. JACKSON POLLOCK. *Night Ceremony.* 1944. 72 × 43″. Collection Mr. and Mrs. Bernard J. Reis, New York

structure somewhat related to the paintings of Franz Kline. From these, in the early 1960s, De Kooning turned back with an almost rhythmic alternation to a form of figure painting, but executed with a delicacy transcending any he had done before (fig. 581).

De Kooning continues to paint brilliantly into the 1980s, and although a large number of the recent works are abstract, the suggestion of a figure lurks in the background (plate 179). Here, in his characteristic light, delicate palette of rose, yellow, green, blue, and white, De Kooning has decelerated his violent brushstroke into a grandly fluid, almost Rubensian flow of graceful color shapes. This is a great painter's old-age style in its full glory, comparable to that of Rubens, Rembrandt, Michelangelo, Titian, or Picasso and Matisse.

JACKSON POLLOCK (1912–1956) Jackson Pollock has become a worldwide symbol of the new American painting after World War II. Pollock came from Cody, Wyoming, by way of Arizona and California, to study in New York at the Art Students League with Thomas Hart Benton, and a relation can be seen between his abstract arabesques and Benton's figurative patterns (fig. 546). The paintings done by Pollock in the mid-1940s, usually involving some degree of actual or implied figuration, were coarse and heavy (fig. 582), suggestive of Picasso, Max Ernst, and, at times, Miró or Masson, but filled with a nervous, brutal energy all their own. By 1947—even earlier in drawings—the artist had begun to experiment with all-over painting, a labyrinthine network of lines, splatters, and paint drips from which emerged the great "poured" paintings of the next few years (plate 180). These paintings, generally executed on a large canvas laid out on the floor, are the works most popularly associated with so-called Action Painting.

It was never the intention of the critic Harold Rosenberg, in coining this term, to imply that Action Painting was a kind of athletic exercise. Nor is it true that the furious and seemingly haphazard scattering of the paint involved a completely uncontrolled, intuitive act. There is no question that, in the paintings of Pollock and many of the other Abstract

583. Jackson Pollock at work in his Long Island studio, 1950

Expressionists, the element of intuition or the accidental plays a large and deliberate part, and this was indeed one of the principal contributions of Abstract Expressionism, which had found its own inspiration in Surrealism's "psychic automatism." However, nothing that an experienced and accomplished artist does can be completely accidental. There is always involved the control of many years' practice and reflection. It is no accident that the drip paintings of Pollock executed between 1947 and 1951 have a common identity and personal presence (fig. 583).

Aside from their intrinsic quality, Pollock's spun-out skeins of poured pigment contributed other elements that changed the course of modern painting. There was, first, the concept of the all-over painting, the painting seemingly without beginning or end, extending to the very limits of the canvas and implying an extension even beyond. This "holism," together with the large scale of the works, introduced another concept—that of wall painting different from the tradition of easel painting, even as it existed in Cubism and geometric abstraction. This was the final break from the Renaissance idea of painting detached from spectator, to be looked at as a self-contained unit. The painting became "holistic," an environment, an ensemble which encompassed the spectator, surrounding him on all sides. The feeling of absorption or participation is heightened by the ambiguity of the picture space. The colors and lines, although never puncturing deep perspective holes in the surface, still create an illusion of continuous movement, a billowing, a surging back and forth, within a limited depth. In these ways, Pollock departed from the tradition of Renaissance and modern painting before him, and although he had no direct stylistic followers, he affected the course of experimental painting after him.

The last few years of Pollock's life were marked by doubts and indecisions. He explored problems of the figure in several drawings and paintings, using black predominantly, and between 1953 and 1956 returned to traditional brush painting, heavy in impasto, and involving images reminiscent of paintings of the early 1940s (plate 181). Although these later works have suffered in critical opinion when compared to the great drip paintings, some of the black-and-white canvases particularly suggest a new phase of signal importance, unfortunately terminated by the artist's death in an automobile accident in 1956.

FRANZ KLINE (1910–1962) Until 1950 Kline was a figurative painter or a painter of figures and urban scenes tinged with Social Realism. Even after he began to paint abstractly, Kline remained as fascinated with the details and tempo of contemporary America as Stuart Davis. At the same time he was also deeply immersed in the tradition of Western painting, from Rembrandt to Goya. A passion for drawing manifested itself during the 1940s, particularly in his habit of making little black-and-white sketches, fragments in which he studied single motifs or space relations. One day in 1949, looking at some of these sketches enlarged through an opaque projector, he saw their implications as large-scale, free abstract images. This was a revelation that from one moment to the next changed him from a representational painter (who as early as 1947 attempted occasional small exercises in abstraction) to a full-fledged Abstract Expressionist (figs. 584, 585). Using cheap, commercial paints and housepainter brushes, Kline attacked large pieces of canvas attached to the walls of his studio.

Although Kline in 1950 was well aware of the experiments of the pioneer Abstract Expressionists already mentioned, the impetus for his style seems to have come primarily from his own earlier sketches, suddenly seen in a new, magnified context. More significant, the works he began to produce about 1949–50 represented a form of expression

584. FRANZ KLINE. *Nijinsky (Petrushka)*.
1949. 33½ × 28″. Collection Mr. and Mrs. I. David Orr, Cedarhurst, New York

585. FRANZ KLINE. *Nijinsky (Petrushka)*. c. 1950. 46 × 35¼″. Collection Muriel Newman, Chicago

Abstract Expressionism and the New American Sculpture • 391

right: 586. FRANZ KLINE. *Mahoning.*
1956. 6'8" × 8'4". The Whitney
Museum of American Art, New York

below: 587. BRADLEY WALKER TOMLIN.
Tension by Moonlight. 1948.
32 × 44". Betty Parsons Gallery, New
York

entirely individual, one of the major contributions to Abstract Expressionism. Kline's first large-scale black-and-white abstractions are dated 1950. Among their unique qualities are the big, rugged, but controlled brushstroke; the powerful, architectural structure; and in the paint texture as well as in the shaping of forms, an insistence on the equivalence of the whites that prevents the work from becoming simply a blown-up black drawing on a white ground. The titles of most of his works are the chance associations with something encountered in daily life.

Kline was a phenomenon in the rapidity with which he achieved a mastery of his new Abstract Expressionist vocabulary. Even the first works have nothing tentative about them. By 1955 he was producing a series of masterpieces, monumental in scale and conception. *Mahoning* (fig. 586) continues the architectural frame with a great Gothic structure of broken beams tied together in a seemingly crazy arrange-

ment, suggestive of change and decay, that yet has something of the permanent and the immutable, as in the architecture of Gaudí. The balance of blacks and whites is such that concentrated study transforms the painting into a structure of white solids on black voids. It is no accident that the painted structures of Franz Kline had their impact on Constructivist sculptors of the 1960s. His introduction of color in the late 1950s is still a matter of controversy. Unfortunately, the artist did not live long enough to demonstrate that color could add a new dimension to his work.

BRADLEY WALKER TOMLIN (1899–1953) Until the last five years of his life, Tomlin was one of the most sensitive and accomplished American Cubists in a tradition stemming from Braque or Gris. Then, about 1948, he began to experiment with a form of free calligraphy, principally in black and white, deriving from his interest in Zen Buddhism and its manifestation in Japanese brush painting (fig. 587). From this moment of liberation, he returned during the last three or four years of his life to abstract geometry rooted in Cubism, in its shifting, ambiguous space, but close to Mondrian in its delicate and rhythmic arrangement of rectangular patterns. As was the case with most of his experimenting contemporaries, Tomlin did not fit neatly into any specific category. He may be described simply as an artist who was working out a new and personal direction, based on some of the pioneers of European modernism.

WILLIAM BAZIOTES (1912–1963) Baziotes was even more closely associated with the origins of American Abstract Expressionism than was Tomlin, but is equally difficult to categorize as an Expressionist. His origins were specifically in the abstract Surrealism of Miró or Masson, seen at times through Gorky or, considerably earlier, through Odilon Redon. A friend of Motherwell and Matta since the early 1940s, Baziotes explored with them aspects of Surrealist automatism, and was at the center of the new postwar developments in American art. His own painting remained remarkably consistent and personal from the begin-

ning to the end of his career. It was characterized by shifting, fluid, luminous color into which were worked biomorphic shapes drawn with great sensitivity and always suggestive of some form of microcosmic or marine life (plate 182).

MARK TOBEY (1890–1976) Tobey was the pioneer American modernist whose influence on Abstract Expressionism is seemingly most explicit but actually most ambiguous. About 1918 he was converted to the Bahai faith, which preaches the oneness of mankind, an indivisible reality that does not admit of multiplicity. In 1923 Tobey began studying Chinese brush painting, and in 1934 he studied Zen Buddhism in China and Japan. Inevitably he was drawn, by a profound inner compulsion, to a personal kind of abstract expression with strongly religious overtones.

In Chicago and New York Tobey was entranced by the impact of the great city—the lights, the motion, the noise. This impact Tobey sought to express in a pattern of all-over line played against fields of varied color (fig. 588). At this stage he was still using a form of Renaissance perspective recession, although the line pattern tended to flatten this out.

Although Tobey had gradually become aware of the implications of Cubism and of abstraction and fantasy, particularly as seen in Kandinsky, Mondrian, Klee, and Picasso, he had to work out his own abstract expression in terms of his religious convictions. These had to do not only with the Bahai doctrines and the Oriental concepts of union of spirit (theoretically comparable to the ideas of Mondrian and Kandinsky), but also with a passionate conviction concerning the significance of space, of the void, not as something empty like a vacuum, but as something filled or charged with energy, with forces invisible to the eye but infinitely important. His paintings were abstractions of nature, if this may be taken to imply cosmic as well as terrestrial natural forces. Tobey abandoned Renaissance perspective and Classical modeling in favor of a multiple vision analogous to, but different from, that of the Cubists. As realized in his best-known pictures (fig. 589), this took the form of a highly refined "white writing," a kind of nonreferential callig-

raphy that in its intricate, jazzy rhythms seems a small-scale, wrist-painted version of the broader, arm-gestured, all-over surfaces poured and stroked by Pollock, De Kooning, and Kline in their more abstract works. Certainly there is a superficial resemblance between Tobey's all-over paintings and Pollock's. Tobey composed paintings from linear

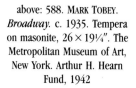

above: 588. MARK TOBEY. *Broadway.* c. 1935. Tempera on masonite, 26 × 19¼". The Metropolitan Museum of Art, New York. Arthur H. Hearn Fund, 1942

right: 589. MARK TOBEY. *Universal Field.* 1949. Pastel and tempera on cardboard. 28 × 44". The Whitney Museum of American Art, New York. Purchase

590. PHILIP GUSTON. *Zone*. 1954. 46 × 48⅛″. Edward L. Broida Trust, Los Angeles

591. PHILIP GUSTON. *The Desert*. 1974. 6′½″ × 9′7″. David McKee Gallery, New York

arabesques and fluid color before Pollock's drip paintings. Both artists were interested in space as a void charged with particles of energy, but the forms and the effects of both are different. It is probable that Pollock saw Tobey's white-line paintings during the 1940s, but if he was influenced by them he made of them something uniquely his own.

PHILIP GUSTON (1913–1980) Another wing of Abstract Expressionism is represented by Philip Guston, who has been variously referred to as an Abstract Impressionist or Romantic Expressionist. Guston was a successful figurative painter in the 1940s, with an individual form of fantasy related to Surrealism and Magic Realism but independent of them. In 1947–48 he began to experiment with an abstract statement with reminiscences of buildings and urban landscapes. After many painful intervals of doubt and hesitation, there emerged in 1950 an abstract style which, over the next three or four years, manifested itself as a freely textural, vertical-horizontal composition loosely based on his admiration for Mondrian (fig. 590).

Guston's development, in contrast with that of Kline and some of the other painters associated with the New York School, was a gradual but consistent progression from lyrical figuration to expressive geometry to free and brilliant coloration in the mid-1950s. The paintings of 1954–55 combine mass in the color shapes with atmospheric depth. At the same time, the tendency to concentrate centralized color masses within a light and fluid environment gave these masses a new subject implication. From this point forward the artist was thinking of color shapes—reds, blues, and greens intertwined with blacks—as personalities engaged in conflicts within the total space of the painting (plate 183). Darkness, or at least a gray-black tonality, increasingly dominated the works of the 1960s. The abstract color shapes, with their curious interchanges and conflicts, took on naturalistic, if undefinable associations.

Owing to his powerful sense of subject, of figuration, Guston could create the impact of a living personage with merely a large black color shape in the scumbled tonality of the painting. In the 1970s the subject became explicit once more, as Guston reintroduced figures and even

narrative in some ways reminiscent of his representational paintings of the 1940s. The content was now set forth with a new brutality and implication of specific narrative. Using a primitive comic strip technique and a harsh and even discordant coloration, which however still reflected his great powers as a colorist, Guston presented scenes of Ku Klux Klan members riding complacently about their wretched business or strange scenes in which piled up shoes suggest remnants of massacred victims (fig. 591). As is evident in his paintings of the mid-1950s, Guston was one of the most brilliant lyrical colorists among the Abstract Expressionists. During the 1960s and the early 1970s it was almost as though he had deliberately set out to deny his own qualities of appealing, sensuous color in favor of a powerful, disturbing, harsh image stated in discord, with a new awareness of the American scene involving a ruthless sadism (plate 184). In the work seen here Guston made a fascinating return to the brilliant reds and rich impasto of the 1950s in a series of paintings where, almost symbolically, the sinister "bosses" and Ku Klux Klan members begin to be swallowed up in an ocean of color. With their deliberately "bad painting" and revived figuration, the late canvases of Philip Guston provided inspiration for the Post-Minimalist or New Image and Neo-Expressionist paintings of the early 1970s and 1980s.

JAMES BROOKS (b. 1906) It was in Cubism, perhaps inspired by his long friendship with Bradley Walker Tomlin, that Brooks arrived at his first abstractions. This was, however, a curvilinear, free version of Cubism frequently composed within the tondo form (fig. 592). After producing a number of works suggestive of the current drip paintings by Pollock, Brooks went on to a phase of free but tense color structures in which the curvilinear Cubist forms and a lyrical pattern are implicit. He exemplifies a group of artists associated, perhaps erroneously, with Abstract Expressionism (Esteban Vicente, Adja Yunkers, Cameron Booth, Giorgio Cavallon, and others) who combined a delight in brilliant color with structure of the highest order achieved in deceptively immediate and direct painting.

left: 592. JAMES BROOKS. *Tondo.* 1951. Diameter 82″. Collection Rockefeller Institute

below: 593. CONRAD MARCA-RELLI. *L-2-66.* 1966. Oil and canvas collage, 72 × 60″. Marlborough Gallery, New York

CONRAD MARCA-RELLI (b. 1913) There is no more anomalous inclusion among Abstract Expressionists than Marca-Relli, a member of the New York School from the early 1950s whose painting was more figurative than abstract, more Classical than Expressionist. There is definite expressive content in his works, but it is inextricably involved with integrated formal structure. Marca-Relli created figure studies freely composed of oil paint and canvas collage, owing something to the traditions of Metaphysical painting, of Gorky, and De Kooning. His principal concern in the 1950s remained, nevertheless, the control of the total picture space, which he sought to achieve through large-scale, almost explosive figure organizations rather than through architectural themes. Finally, at the end of the 1950s figuration was interrupted by abstract constructions. This led to the paintings and relief sculptures of the mid-1960s, the most restrained and simplified of the artist's career (plate 185). Meanwhile, the interlocked shapes in a series of large black-and-white canvas collages yield an Oriental quality, a sense of Japanese calligraphy seen in detail but greatly enlarged (fig. 593).

Color Field Painting

MARK ROTHKO (1903–1970) Rothko began painting in 1925 and exhibiting in 1929. By 1947 he had commenced to formulate his mature style consisting of large, floating color shapes with loose, undefined edges that gave them both a sense of movement and tangible

depth (fig. 594). Over the next few years these shapes were refined and simplified to the point where they consisted of generally large color rectangles floating on a color ground. The oil paint is thinly washed on with considerable tonal variation, which adds to the effect of a constant cloudlike, visual shifting. In *Green, Red on Orange* of 1950 (plate 186) the dominant earth colors, red-browns of varying densities combined with a central strip of yellow ocher, are suspended on a ground of light but intense blue, apparent around the edges and in a horizontal strip that seems to penetrate the surface below the central yellow. Now Rothko was painting on a huge scale, something that contributed to the effect of enclosing, encompassing color. This is a kind of painting that by the sheer sensuousness of its color areas, by the dimensions, and by the sense of indefinite outward expansion without any central focus, is designed to absorb and engulf the spectator, to assimilate him into a total color experience.

During the 1950s Rothko maintained his basic image of large, loose color rectangles stacked or juxtaposed and floating in space, but played color and shape variations on them. Sometimes he changed the formula to a hollow rectangle or U-shape, and, increasingly, at the end of the 1950s he began to move away from bright, sensuous color toward color that was deep and somber, even, by implication, tragic (plate 187). In the 1960s he pursued this more heroic vein both in individual wall paintings and in murals for Harvard University and a chapel at St. Thomas University in Houston, Texas. The latter series consists of a group of huge panels, almost uniform in their deep red-brown color, filling the entire space of available walls. These are designed to be completely homogeneous with the architecture and the changing light of the

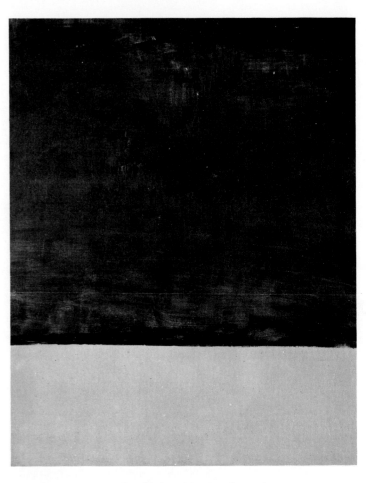

595. MARK ROTHKO. *Untitled (Black and Gray)*. 1969. Acrylic on canvas, 93 × 76″. Collection Mr. and Mrs. Harry W. Anderson, Atherton, California

594. MARK ROTHKO. *No. 18*. 1948. 67¼ × 55⅞″. Vassar College Art Gallery, Poughkeepsie, New York. Gift of Mrs. John D. Rockefeller III

chapel interior, and thus represent a total architectural-pictorial experience in a sense analogous to that attempted by the religious muralists of the Baroque seventeenth century.

Immediately before his tragic death in 1970, Rothko was experimenting with a form of geometry in which his luminous color panels were set within rigidly vertical horizontal frames (fig. 595).

BARNETT NEWMAN (1905–1970) A principal characteristic of the Color Field painters and their many followers is concentration on and continual reworking of a specific theme. Perhaps the most extreme examples of this tendency are to be found in the mature works of Barnett Newman and Ad Reinhardt. Newman in the mid-1940s was working in a pattern of loose vertical-horizontal geometry with a predominance of vertical lines or color areas, broken at the edges and alternating with circular or spheroid shapes. By the end of the decade he had simplified his formula to a unified color field interrupted by a vertical line—a "zip" as the artist called it—or, rather, a narrow, vertical contrasting color space (plate 188). Newman's paintings, with their rigid verticality, have inevitably been related to Mondrian. They are, however, very different in their impact—not only because of their much larger format, but because of the nature of the vertical line whose deliberately fragmented edges create the impression of an opening in the picture plane rather than a line on the surface. It is as though the predominant color field has been torn apart and we are given a glimpse into some

left: Colorplate 176. HANS HOFMANN. *The Gate.* 1960. 74⅝ × 48¼″. The Solomon R. Guggenheim Museum, New York

below: Colorplate 177. ARSHILE GORKY. *The Liver Is the Cock's Comb.* 1944. 72 × 98″. The Albright-Knox Art Gallery, Buffalo, New York. Gift of Seymour H. Knox

Colorplate 178. WILLEM
DE KOONING. *Composition.* 1955.
79⅛ × 69⅛″. The Solomon R.
Guggenheim Museum, New York

Colorplate 179. WILLEM
DE KOONING. *Pirate (Untitled II)*.
1981. 7′4″ × 6′4¾″.
Collection, The Museum of
Modern Art, New York. Sidney
and Harriet Janis Collection
Fund

Colorplate 180. JACKSON POLLOCK. *Lavender Mist.* 1950. Oil, enamel, and aluminum paint on canvas, 7'4" × 9'11". Collection Alfonso Ossorio, East Hampton, New York

Colorplate 181. JACKSON POLLOCK. *Ocean Greyness.* 1953. 57¾ × 90⅛". The Solomon R. Guggenheim Museum, New York

Colorplate 182. WILLIAM BAZIOTES. *Dusk.* 1958. 60⅜ × 48¼″. The Solomon R. Guggenheim Museum, New York

Colorplate 183. PHILIP GUSTON. *Dial.* 1956. 72 × 76″. The Whitney Museum of American Art, New York. Purchase

Colorplate 184. PHILIP GUSTON. *Blue Light.* 1975. 73 × 80½″. David McKee Gallery, New York

Colorplate 185. CONRAD MARCA-RELLI. *The Blackboard.* 1961. Oil and canvas collage, 7 × 10′. Seattle Art Museum. Eugene Fuller Memorial Collection

Colorplate 186. MARK ROTHKO. *Green, Red, and Orange.* 1950. 93 × 59″. Mr. and Mrs. Andrew Saul, New York

Colorplate 187. MARK ROTHKO. *White and Greens in Blue.* 1957. 8′4″ × 6′10″. Private collection, New York

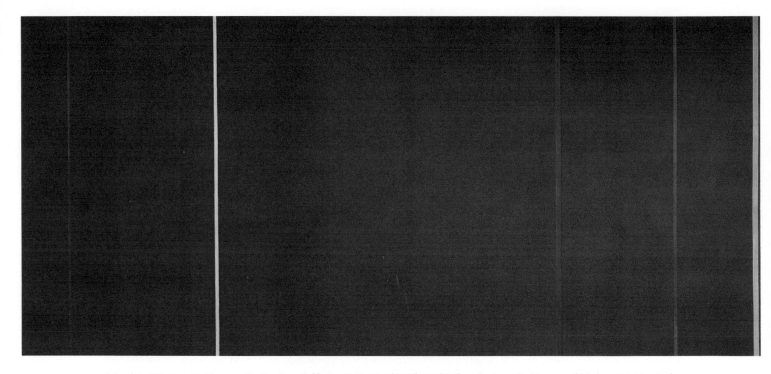

Colorplate 188. BARNETT NEWMAN. *Vir Heroicus Sublimis.* 1950–51. 7'11⅜" × 17'9¼". Collection, The Museum of Modern Art, New York. Gift of Mr. and Mrs. Ben Heller

Colorplate 189. AD REINHARDT. *Abstract Painting, Blue.* 1952. 75 × 28". Museum of Art, Carnegie Institute, Pittsburgh. Museum purchase: Gift of Women's Committee of the Museum of Art, 65.26

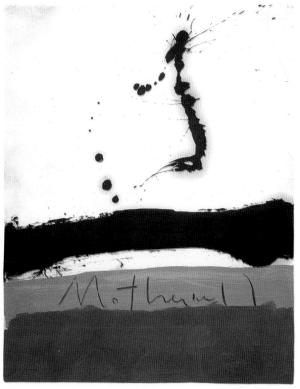

above: Colorplate 190. ROBERT MOTHERWELL. *Elegy to the Spanish Republic No. 34.* 1953–54. 80 × 100". The Albright-Knox Art Gallery, Buffalo, New York. Gift of Seymour H. Knox, 1957

left: Colorplate 191. ROBERT MOTHERWELL. *Beside the Sea No. 2.* 1962. 29 × 22¾". Collection the Artist

Colorplate 192. ROBERT MOTHERWELL. *Summer Open with Mediterranean Blue.* 1974. 48 × 108″. Collection the Artist

Colorplate 193. CLYFFORD STILL. *Number 2.* 1949. 92 × 67″.
Collection Mr. and Mrs. Ben Heller, New York

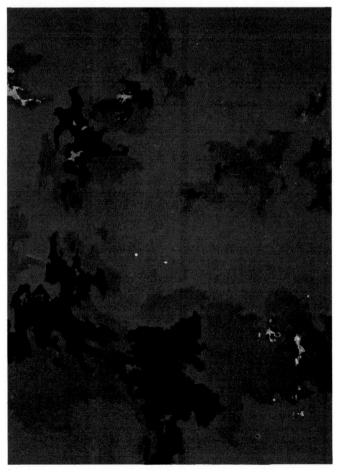

sort of subsurface. There is thus established a tangible tension between the color surface and the "zip," which seems to be a structural or spatial opening and closing (fig. 596). In the 1970s Newman was one of the principal forces in shaping the direction of younger abstract painters such as Brice Marden, Robert Ryman, Jo Baer, and others who attempted to carry Newman's Minimalism to its ultimate conclusion.

AD REINHARDT (1913–1967) Ad Reinhardt, one of the pioneer American abstractionists, was already painting in a geometric, rectangular style in the late 1930s. He was one of the most brilliant and individual minds among postwar avant-garde American painters, a superb caricaturist and a student of Oriental art. After abstract experiments in the 1940s, with Mondrian geometry alternating with more freely composed allover patterns, in the early 1950s, Reinhardt began to simplify his palette to a single color. The first group of such paintings was in red, the next in blue, and the final group, on which he worked for the rest of his life, in black (plate 189). One first observes these later paintings simply as a unitary field of red, blue, or black. With time, however, there begins to emerge a second, inner image—a smaller rectangle, square, or central cross consisting of a slightly different value or tone of the color. His stated purpose was always elimination of all associations, all extraneous elements, the refinement of paintings to a single dominant experience. There is no question that these later works were powerful visual, Expressionist images, hypnotic in their effect. During the 1970s Reinhardt's work continued to have a significant influence on the

597. ADOLPH GOTTLIEB. *Voyager's Return.* 1946. 37⅞ × 29⅞". Collection, The Museum of Modern Art, New York. Gift of Mr. and Mrs. Roy R. Neuberger

596. BARNETT NEWMAN. *Stations of the Cross: Twelfth Station.* 1965. Acrylic polymer on canvas, 78 × 60". Estate of the Artist

new Post-Minimal painters and sculptors, while the artist himself became something of a cult figure among the Conceptualists, partly as a result of his writings and his extreme positions on the nature and function of the artist.

Combined Field and Gesture Painting

ADOLPH GOTTLIEB (1903–1974) Foremost among the Abstract Expressionists who combined elements of both Gesture and Field painting to achieve distinctive styles entirely their own was Adolph Gottlieb. Born in New York City, Gottlieb studied at the Art Students League with John Sloan and, through a visit to Europe in 1921–22, became aware of new European experiments in Cubism and Abstraction. A stay in Arizona during 1937 resulted in a number of curious Magic-Realist paintings of objects picked up from the desert arranged within rectangular compartments. These anticipated the Pictographs that represent the artist's most serious explorations during the next fifteen years: a grid arrangement filled with two-dimensional ideograms (fig. 597). These latter were unquestionably influenced by Torres-García as well as Paul Klee, although gradually Gottlieb increased the scale and variety to a degree of monumentality beyond anything attempted by his predecessors.

During the 1950s Gottlieb began to play variations on a theme that he entitled Imaginary Landscapes, consisting of a foreground of heavily

598. ADOLPH GOTTLIEB. *The Frozen Sounds, Number 1*. 1951. 36 × 48″. The Whitney Museum of American Art, New York. Gift of Mr. and Mrs. Samuel M. Kootz

599. ADOLPH GOTTLIEB. *Orb*. 1964. 90 × 60″. Dallas Museum of Art

textured paint with a sharply accented horizon line above which a group of astral presences—spheres, ovals, or rectangles—float in an empty sky (fig. 598). The other principal development of the late 1950s and 1960s was the series commonly called Bursts, a sort of cosmic landscape consisting generally of an upper circular or ovoid element suggestive of a burning sun, below which is a broken, exploding element, open and dynamic in contrast with the sun above (fig. 599). The artist played infinite variations on these forms, and in late works combined aspects of the Bursts with the Imaginary Landscapes.

ROBERT MOTHERWELL (b. 1915) Robert Motherwell, the youngest of the artists originally associated with Abstract Expressionism, also bridges both its Gestural and Field tendencies. His early training was in art history, criticism, and philosophy. As a painter, he was largely self-trained with the exception of some formal study with the Surrealist Kurt Seligmann. In 1941 Motherwell made the acquaintance of European artists then in New York, particularly the Surrealists Max Ernst, Tanguy, Masson, and Matta. The aspects of Surrealism that most intrigued him were automatism, the concept of the intuitive, the irrational, and the accidental in the creation of a work of art. His first paintings represented an initial attempt to resolve the seeming contradictions between Mondrian (whom he had also met in New York) and the abstract Surrealists.

Despite its seeming variety, there is a remarkable consistency in Motherwell's work that embodies a range from Classical austerity to Romantic expression but above all illustrates the continual enlargement and enrichment of certain basic forms and themes. In 1943 the artist began to experiment with collage, and one of the important creations of this period is *Pancho Villa, Dead and Alive* (fig. 600) in which are introduced qualities of rough automatist expression as well as forms and images that were to become a signature, such as the ovoid shapes held in tension between vertical, architectural elements.

In 1949 Motherwell painted *At Five in the Afternoon* after a poem by Lorca (fig. 601). This was the first in the great series of paintings entitled *Elegy to the Spanish Republic*, a title inspired by the artist's profound reaction to the Spanish Civil War. Since then Motherwell has painted more than one hundred and fifty variants of the Elegy theme. These works, composed of stark and predominantly black-and-white images, are in contrast with the brilliantly coloristic collages and paintings also created by the artist during the 1950s, 1960s, and 1970s. Although the Elegies constitute only one, but most important, aspect of Motherwell's oeuvre, they tell us much about his attitude to the art of painting. As noted, they consist for the most part of a few large, simple forms, vertical rectangles holding somewhat ovoid shapes in suspension. In the Elegies, Motherwell liberated himself from the tradition of easel painting and formulated his mature concept of the painting as a mural, preserving the integrity of the picture plane and capable of an indefinite lateral expansion (plate 190).

Paintings of the mid-1950s, such as the *Je t'aime* series, revealed the artist's ability to compose in terms of brush and calligraphic color, but, in general, color remained the province of the collages until the early 1960s, when it began to emerge triumphantly in the many paintings celebrating the artist's passion for the sea, especially in his series of small-scale uniformly sized works in oil or acrylic on paper entitled *Beside the Sea* (plate 191).

From the 1950s until the present Motherwell has continued to make collages, in many of which he uses postcards, posters, wine labels, or musical scores that constitute a visual day-by-day biography of the artist (fig. 602). During the 1970s the collages became ever more monumen-

600. ROBERT MOTHERWELL. *Pancho Villa, Dead and Alive*. 1943. Gouache, oil, with collage on cardboard, 28 × 35⅞″. Collection, The Museum of Modern Art, New York. Purchase

601. ROBERT MOTHERWELL. *At Five in the Afternoon*. 1949. Casein on composition board, 15 × 20″. Collection the Artist

tal and range in form from the most violently expressive to the most Classically austere.

While there was never any abandonment of the Elegy theme for an extended period, the late 1960s saw the discovery of the second great theme of the artist's career, the Open series, the "wall and window" paintings (plate 192). In these the exploration is primarily that of color conceived on a large scale, filled with all the sensitivity and beauty of which the artist is capable. The Opens range from relatively uniform, although never flat, areas of color to large-scale exercises in rhythmic, variegated brushwork. There is always movement and light within the ground, and the so-termed window motif common to these paintings as well as the *dado* that appears from time to time creates curious illusions that take the paintings out of the realm of color patterns. Although the Opens represent the most extreme contrast to the Elegies in their sensuous color and in their architectural organization, they have the common denominator of being images filled with associations rather than arrangements of formal elements.

CLYFFORD STILL (1904–1980) A member of the Abstract Expressionist group who transcended all categories to become a class unto himself was Clyfford Still, one of the first postwar instances of the American university artist-teacher. Between 1946 and 1950, Still taught at the California School of Fine Arts in San Francisco, then (under its director Douglas MacAgy) one of the most progressive art schools in the world.

Still's exhibitions at the Betty Parsons Gallery—1947, 1950, and 1951—were of great influence in the establishment of the Color Field wing of Abstract Expressionism. Since the late 1930s he had painted in a freely abstract manner involving large, flowing images executed in a heavy, even coarse, paint texture of all-over color, shifting and changing, opening and closing space, with no beginning or no end. By 1947 he was working on a huge scale, sometimes eight-by-ten feet, with immense color areas predominantly black or red or yellow in a constant state of fluid though turgid movement (plate 193). Over the next twenty years Still persisted in his basic image, a predominant color varying in value and shot through with brilliant or somber accents breaking out

from the ground. Although in his late years Still lived in relative seclusion and did not exhibit frequently, he remained a most important influence on works of younger painters such as Jules Olitski and Larry Poons.

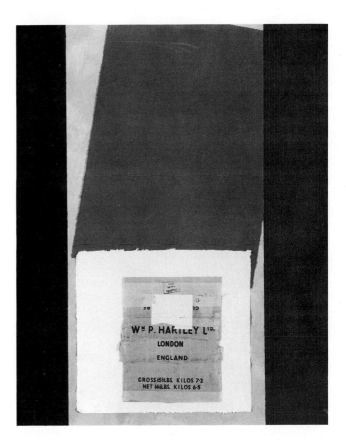

602. ROBERT MOTHERWELL. *Hartley in London*. 1975. Collage on canvas, 48 × 24″. Collection the Artist

TOWARD AN ABSTRACT EXPRESSIONIST PHOTOGRAPHY Depression, political upheaval, and war had shaped the vision of photographers just as much as that of painters. Meanwhile, photography—now ubiquitous not only in news coverage and advertising but also in professional journals, book publications, and special exhibitions—had exerted an unavoidably powerful effect on the vision of everyone, painters perhaps most of all. Even the field pictures made by the Hungarian-American photographer Robert Capa (1913–1954), during first the Spanish Civil War and then World War II (fig. 603), seemed to anticipate both Action Painting's fluid, all-over organization and its conception of the picture as an expression of personal, tragic experience universalized through abstract gesture. But at the same time that photojournalism, scientific aerial photography, and microphotography helped prepare the human eye for the pictorial formulations of Abstract Expressionism (fig. 604), the grandeur and metaphor of Abstract Expressionist painting encour-

605. MINOR WHITE. *Sun in Rock, Devil's Slide, 1947.* October 12, 1947. Gelatin-silver print. Collection, The Museum of Modern Art, New York. Gift of Shirley Burden. Courtesy the Minor White Archive, Princeton University. ©1982 Trustees of Princeton University

603. ROBERT CAPA. *Normandy Invasion, June 6, 1944.* Gelatin-silver print. ©Robert Capa

606. AARON SISKIND. *Chicago 1949.* Gelatin-silver print. ©Aarón Siskind

604. UNKNOWN PHOTOGRAPHER. *Mt. Vesuvius, 1944, After the Eruption of 1944.* Gelatin-silver print. The Imperial War Museum, London

aged photographers to reinvestigate the potential of both straight and manipulated procedures for creating new and meaningful abstract imagery. This was especially true once the cessation of hostilities in 1945 and the growing affluence of the United States reduced the need for the kind of documentary reportage presented by the economic and military events of the 1930s and 1940s.

Foremost among the photographers who, thanks to the influence of Stieglitz and his Equivalents series (fig. 536), used perfectly straight photography—sharp lens and large-format camera—to discover imagery capable of yielding abstract forms potent with mystical feeling was Minor White (1908–1976). In works like the one seen here (fig. 605), White seemed also to be clearly aware of stylistic developments in the contemporary art of Abstract Expressionism's gestural painters. As a teacher, writer, and founder, as well as a long-time editor, of *Aperture*

magazine, White had a vast and enduring influence on a whole generation of younger photographers. Aaron Siskind (b. 1903) too lost interest in subject matter as a source of emotive content and turned instead toward flat, richly textured patterns discovered on such surfaces as those of old weathered walls, segments of advertising signs, graffiti, and peeling posters (fig. 606). In his preoccupation with the expressive qualities of two-dimensional design, Siskind found himself in sympathetic company among painters like Franz Klein and Willem de Kooning. Another photographer whose work looks at home with New York gestural paintings was Eliot Porter (b. 1901), a practitioner capable of producing images of nature with as much value for science as for art (plate 194). In his *Red Osier* the generalized mesh of precisely defined yet indivisible lines, the delicate color orchestration, and the lyrical mood all seem comparable, in purely photographic terms, to the great ramified networks of poured pigment realized by Jackson Pollock in the years 1947–50. To attain such quality, Porter, unlike most color photographers, made his own color separation negatives and dye transfers.

If these photographers seem aligned aesthetically with the Action painters, others appeared to identify spiritually and formally with the quietist Color Field branch of Abstract Expressionism. Here the leading master was Harry Callahan (b. 1912), whose principal influence came from Ansel Adams and the former Bauhaus faculty at the Institute of Design in Chicago, where he taught for a while beginning in 1946. Working continuously with three deeply felt personal themes—his wife, Eleanor, the cheerless urban scene, and the joys of simple, unspoiled nature (fig. 607)—Callahan has generated a body of utterly realistic work of such uncompromising spareness and subtlety that it borders on abstraction almost as reduced and iconic as that of Ad Reinhardt. An exceptionally gifted colorist with an eye for the evocative detail was Syl Labrot (1929–1983), whose untitled work reproduced in plate 195 manages to lose none of its distinctly photographic quality by being compared with the paintings of Mark Rothko and Adolph Gottlieb.

Postwar American Sculpture

DAVID SMITH (1906–1965) Constructed sculpture—as contrasted with sculpture cast in bronze or modeled in stone—and particularly direct-metal constructed sculpture, constituted a major direction taken by American artists after World War II. Of his generation David Smith was the most original talent whose influence has become worldwide.

607. HARRY CALLAHAN. *Weed Against the Sky, Detroit*. 1948. Gelatin-silver print.
©Harry Callahan

Smith was born in Decatur, Illinois, and between 1927 and 1932 he studied painting at the Art Students League in New York. About 1930, intrigued by reproductions of Picasso's welded-steel sculptures of 1928–29, Smith began to experiment with constructed sculpture.

During the 1930s and 1940s Smith endowed his sculpture with a Surrealist quality, derived from Picasso and González (although this was alternated with geometric construction). With the 1948 *Royal Bird*, a viciously aggressive skeleton of some great airborne creature of prey (fig. 608), Smith attained a climax of figurative expression at the mo-

608. DAVID SMITH. *The Royal Bird*. 1948. Stainless steel, 21¾ × 59 × 9″. Walker Art Center, Minneapolis. T. B. Walker Foundation Acquisition, 1952

ment he was beginning to move away from Surrealism. The early 1950s were marked in his works by linearism, a drawing of space in steel. This was Constructivist sculpture in the original sense of Gabo's Realistic Manifesto, in which the voids constituted the forms defined by the steel lines. Even when the sculptures were composed two-dimensionally, the natural setting, seen through the open spaces, introduced ever-changing suggestions of depth, color, and movement (fig. 609).

Smith worked long and painfully in the perfection of his sculptural concepts. He was never trained formally as a sculptor and thus was able to avoid the academic intervals from which most American sculptors of the 1930s and 1940s suffered. He first learned to weld in an automobile plant in the summer of 1925, and in World War II he worked in a locomotive factory. Here the artist not only advanced his technical experience in handling metals, but the sheer scale of locomotives also suggested possibilities for the monumental development of his direct-metal sculpture. After the war his studio, on an upstate New York farm, was a complete machine shop, and during the 1950s and 1960s he populated the fields with his sculptures, ever more monumental in scale and conception.

During much of his career Smith, like Picasso in painting, worked on series of related sculptures in unrelated styles. The different sequences were worked on concurrently or overlapping chronologically. In the 1950s the Agricola constructions (with obvious agrarian overtones) continued the open, linear approach, while the Sentinels were usually monolithic, figurative sculptures, at times employing elements from farm machinery. This tendency to use found objects was accelerated as the decade advanced. In contrast with most of the Junk sculptors who used found objects, Smith—after using them early in his career—integrated such objects in the total structure so that their original function was subordinated in the totality of the new design, as in the Tank Totems and the Sentinels (fig. 610).

In the last great series, with the generic name of Cubi, Smith was employing the cube and the cylinder, now worked in polished, then

609. DAVID SMITH. *Star Cage*. 1950. Steel, height 44¾". John Rood Sculpture Collection, University Gallery, University of Minnesota, Minneapolis

abraded, stainless steel, in the creation of great, architectural structures, as illustrated in figure 611. His relation to the subsequent development of Primary Structures or Minimal Art is most important. In one respect he differs from most of his sculptural descendants who, in a deliberate insistence on anonymity, design their structures and then generally have them manufactured and painted by others—professional technicians. Smith, however, made his own works, only rarely employing shop assistants. Even in the mechanistic Cubi series he constructed and finished the works himself. In these the artist exercised particular care in the polishing of the surfaces to create effects of brilliant, all-over calligraphy out of the highly reflecting, light-saturated surfaces.

REUBEN NAKIAN (b. 1897) One of the most impressive American sculptors after World War II was Reuben Nakian. It is something of a paradox to refer to him as a Constructivist, since by passionate inclination he was a modeler whose favorite materials were terra cotta or plaster prepared as a base for bronze. Nakian, in contrast to David Smith, went through an academic training. During the 1930s he was engaged in portrait sculpture. At the same time he was beginning to become acquainted with experimental artists—Davis, Gorky, and De Kooning. Gorky in particular was influential in introducing Nakian to the tradition of modern European art. In the late 1940s the artist started to work in terra cotta, creating free, Expressionist interpretations of themes from Classical mythology. Nakian worked on a small scale since, even by the 1950s, he could not afford large-scale efforts in either terra cotta or bronze. In 1954 he began using a technique of thin coats of plaster spread over cloth and attached to elaborate but delicate metal armatures, a technique closer in effect to construction than to traditional bronze casting, and which is difficult to cast. It was nevertheless a technique that Nakian perfected over the next few years, and through which he made an individual contribution to sculpture. His first major success came in 1958—when he was sixty-one—with the creation of a number of steel-plate constructions, the largest and most impressive of which was the *Rape of Lucrece*, the product of a five-year endeavor (fig. 612). In these constructions he used large diagonal and curving plates mounted on a complex arrangement of metal pipes, to create a violent interplay of abstract shapes.

In the early 1970s Nakian achieved what is perhaps his greatest, most monumental sculpture, the *Descent from the Cross* (fig. 613). This work is composed in plaster and intended to be cast in bronze. The plaster blocks are conceived like enormous rock forms, dolmens tilted and leaning precariously against one another. Although it is an abstract work, the subject underlies the entire structure. One is immediately reminded of a great Deposition by Tintoretto or Rubens in which the figure of Christ is lifted gently down from the Cross.

THEODORE ROSZAK (1907–1981) The other American sculptors identified with abstraction or construction in the postwar years are as varied as the potentialities of their media. Theodore Roszak, who was first a painter, became a geometric Constructivist in the 1930s. A decade later he developed his free-form constructions of steel, brazed with bronze, brass, or nickel. These are Romantic statements, frequently rooted in literary ideas, abstractions with naturalistic forms implicit—bone structures, birds, sea life, or plant forms. Although Roszak could achieve great power in certain works, his sculptures are usually characterized by a bold elegance in which spiky, aggressive shapes have been combined with shapes of extreme delicacy. His surfaces are characterized by coloristic variety ranging from polished steel elements to areas that are burned and tortured into fantastic effects (fig. 614). There is

above left: 610. DAVID SMITH. *Sentinel IV*. 1957. Steel, painted black, height 81¾". Private collection, Connecticut

above right: 611. DAVID SMITH. Left: *Cubi XVIII*. 1964. Stainless steel, height 9′8″. Museum of Fine Arts, Boston. Anonymous donation. Center: *Cubi XVII*. 1963. Stainless steel, height 9′. Dallas Museum of Art. Right: *Cubi XIX*. 1964. Stainless steel, height 9′5″. The Tate Gallery, London

below left: 612. REUBEN NAKIAN. *Rape of Lucrece*. 1953–58. Direct steel, height 12′. Egan Gallery, New York

below right: 613. REUBEN NAKIAN. *Descent from the Cross*. 1972. Plaster to be cast in bronze, height 10′. Whereabouts unknown

always a strong sense of symbolic subject in Roszak's sculpture. The most persistent image involves the struggle between the forces that created life and those that might destroy it.

SEYMOUR LIPTON (1903–1981) Lipton hammered sheets of Monel metal, nickel-silver, or bronze into large spatial volumes, suggestive at times of plant forms, at others of an architecture of fantasy (fig. 615). His works combine monumentality and repose with a sense of poetry and mystery. Spatially they offer an interplay of exterior and interior forms that emphasize the nature of the material.

HERBERT FERBER (b. 1906) The sculptors just seen represent only two of the many directions taken by Americans working in Constructiv-

above left: 614. THEODORE ROSZAK. *Rodeo*. 1967. Steel, height 20″. Collection the Artist

above right: 615. SEYMOUR LIPTON. *Cosmos*. 1973. Nickel silver on Monel metal, 70 × 73 × 36″. Marlborough Gallery, New York

right: 616. HERBERT FERBER. *Environmental Sculpture*. 1967. Fiberglass and polyester resin. Voorhees Hall, Rutgers University, New Brunswick, New Jersey

ist or direct-metal sculpture. The list and the directions could be expanded indefinitely. Herbert Ferber has made significant explorations of sculpture as environment, even creating in 1960 an entire sculptural room into which the spectator enters (fig. 616). This trend to sculpture-as-architecture would increase dramatically during the 1960s among younger sculptors or sculptors more recently on the scene.

IBRAM LASSAW (b. 1913) As the works already seen would suggest, many American sculptors shared the dynamic, open-form aesthetics espoused by the Abstract Expressionists. Ibram Lassaw even managed to three-dimensionalize Pollock's all-over webs of flowing lines, doing so in reliefs and freestanding constructions formed as intricate, welded cages (fig. 617). However, rather than Pollock's daring equilibrium of colliding opposites—freedom and control—Lassaw seemed more at one with the mystical harmony of Mark Tobey. And indeed he was a student of the German mystics, among them Meister Eckhardt, and he also knew Zen philosophy. Thus prepared, Lassaw proceeded somewhat like an alchemist, fusing the oil and water principles of Constructivism and Surrealism.

ISAMU NOGUCHI Noguchi, whose rare work of Expressionist social protest we encountered in figure 575, had by the end of the war returned to pure abstraction and the beautifully polished stone work he originally learned from Brancusi in Paris (fig. 618). But even here a figure is evoked, somewhat Surrealist in character, not only by the Greek title *Kouros*, but also by the Miró-like biomorphism of the eye-holed and armed-crossed forms, all interlocked and arranged in the vertical manner of a standing statue. The title also reminds us of the essential Classicism of Noguchi's work, as balanced and lucid, fragile yet stable, varied yet ordered as the French tradition in which the artist began. Noguchi continues, as we shall see, to serve that tradition and his own remarkable gifts with unabating energy and imagination.

619. JOSEPH CORNELL. *Medici Slot Machine*. 1942. Construction,
13½ × 12 × 4¼". Collection Mr. and Mrs. Bernard J. Reis, New York

620. JOSEPH CORNELL. *Pharmacy*. 1943. Construction, 15¼ × 12 × 3⅛".
Collection Mrs. Marcel Duchamp, New York

JOSEPH CORNELL (1903–1972) A highly cultivated American who continued and brought great distinction to the tradition of assemblage that Picasso began early in the century was Joseph Cornell, whose interests, as indicated in his box constructions, ranged over much of the art and literature of the Western world. In the early 1930s Cornell became acquainted with the Julien Levy Gallery, a center for the display of European Surrealism. Here he met many of the exiled Surrealists. His first experiments with collage were inspired by works of Max Ernst, and soon Julien Levy was exhibiting his small constructions along with the works of the Surrealists. By the mid-1930s Cornell had settled on his formula of a simple box, glass-fronted usually, in which he arranged objects, photographs, maps. With these he created a personal dream world related to Surrealist assemblage, but also to Renaissance perspective paintings and to nineteenth-century American *trompe-l'oeil* paintings—in the last case translated back into the three-dimensional objects that first inspired them.

Cornell's boxes are filled with associations—of home, family, childhood, of all the literature he had read and the art he had seen. The only proper analogy to them is Marcel Proust. His entire life seems to have been devoted to the remembrance of things past, a nostalgia for a lost childhood or a lost world. The *Medici Slot Machine* of 1942, one of the

early masterpieces, centered on a *Young Prince of the Este Family* by Giovanni Battista Moroni (c. 1525–1578), employs aspects of Cubism, geometric abstraction, multiple images taken from the early cinema, as well as symbols suggesting relations between past and present (fig. 619). There is not in this or subsequent works an organized iconography capable of precise analysis. Everything is allusion or romantic reminiscence gathered together, as one idea or image suggested another, to create one of the most intimate and magical worlds in all modern art.

During the 1940s and 1950s Cornell played many variations on his world, sometimes with an unquestioned influence from Mondrian, creating three-dimensional Neo-Plastic constructions. At other times, using mirror backgrounds, he anticipated the formulas of the Optical artists of the 1960s (fig. 620). For thirty years or more Cornell was the most closely guarded yet public secret among American artists. It is indicative of his universal appeal that everyone who knows his work claims to have discovered him—this despite the fact that his exhibitions have received enthusiastic reviews in the press since the 1930s. Yet, like Magritte, Cornell remained the invisible man until the 1960s, when his influence seemed to become universal, the invisible man who was everywhere.

Postwar European Painting and Sculpture

The School of Paris

In the years immediately following World War II, various forms of free abstraction dominated the painting of Europe as well as of the United States, although, as in the development of Giacometti, Dubuffet, and Bacon, fantastic and Expressionist figuration received a new impetus. The School of Paris was enriched by the continuing activity of the old masters and the return from the United States of Léger, Chagall, Ernst, Masson, Picabia, Hélion, and others, including Duchamp who, after 1945, commuted between Paris and New York.

The first group of painters to gain notice in terms of a program were those who called themselves "Young Painters in the French Tradition," under which name they had exhibited together in 1941, during the German occupation. These were Jean Bazaine, Alfred Manessier, the Belgian Gustave Singier, Jean Le Moal, and Charles Lapicque. Most of these had studied with Roger Bissière (1888–1964), who was influenced by Klee and had worked and taught quietly for many years, influencing a generation of younger artists, but not himself gaining recognition until the end of his life. Bissière employed an all-over, generally rectangular linear pattern through which he played spots of Impressionist color in the creation of a flickering, luminous surface (fig. 621). Despite their abstract appearance, his paintings emerged, in the traditional manner of French modernism, from a sensitive reduction of a natural subject or scene. In the case of Bissière, this translation of reality into art produced scintillating fretwork of interacting colors expressive of the original, but now submerged, theme. Owing to the underlying naturalism of his art, Bissière always refused to be called an "abstract" painter.

The disciples of Bissière practiced a variety of styles, but shared common traits of lyrical color and free but controlled structure with affinities to Fauve landscapes. Jean Bazaine (1904–1975) used directional lines of force, rooted in Analytical Cubism, combined with tonal grounds shot through with rich but subdued color (fig. 622). Alfred Manessier (b. 1911), on the other hand, employed a free geometry,

above: 621. ROGER BISSIÈRE. *Composition (331)*. 1957. 18 × 21½". Collection Otto Henkell, Wiesbaden, Germany

left: 622. JEAN BAZAINE. *Marée basse.* 1955. 55¼ × 76¾". Galerie Maeght, Paris

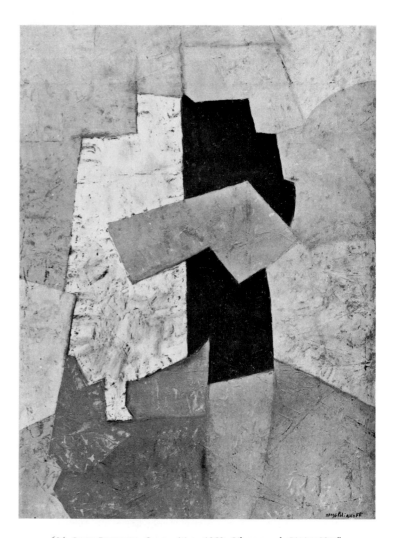

623. ALFRED MANESSIER. *Crown of Thorns*. 1950. 64¼ × 38⅝″. Musée d'Art Moderne, Paris

624. SERGE POLIAKOFF. *Composition*. 1950. Oil on wood, 51⅜ × 38¼″. The Solomon R. Guggenheim Museum, New York

625. BRAM VAN VELDE. *Peinture*. 51 × 77″. Stedelijk Museum, Amsterdam

with irregular, flowing shapes, organized in a clear pattern of flat color areas (fig. 623). The group as a whole does suggest the French tradition from Impressionism through Fauvism and Cubism, and has even been categorized as Abstract Impressionist. They and a number of other artists associated with them, such as the Russians André Lanskoy, Serge Poliakoff, and Nicolas de Staël, constituted the dominant new direction in School of Paris painting after 1945.

Serge Poliakoff (1906–1969) worked in large, bold, but not intense colors, roughly textured and matte in surface, to create effects of crude, primitive force (fig. 624).

Nicolas de Staël (1914–1955) was born an aristocrat in Old Russia and grew up in Belgium, where he attended the Royal Academy of Fine Arts. In the 1940s he was painting abstractly, but as his work developed he became more and more concerned with the problem of nature versus abstraction. De Staël seems increasingly to have been dissatisfied with the nonobjective aspect of his own works and desirous of finding solutions that would assert the subject while maintaining the abstract forms (plate 196). He experimented with many styles in landscape, still life, and figure, some atmospherical and mystical, some simplified to large planes of flat color accented by a few contrasting color spots. In the last year of his life he began painting quite literal scenes of boats and birds and ocean, in thin, pale colors reminiscent of the later landscapes of Marquet. In 1955 De Staël died by suicide, having reached an impasse, it seems (as in the case of Jackson Pollock), from which there was no exit.

Bram van Velde (1895–1981) was one of the most isolated and powerful of L'Art Informel painters. The sense of subject, usually in the form of large heads with great staring eyes, continued in his work until the 1960s. This, however, was less significant than his use of free abstract color-shapes accentuated with patterns of dripping paint (fig. 625). Van Velde was the European artist closest perhaps to aspects of American Action Painting, particularly that of his fellow Hollander, De Kooning. He provided an unconscious link between the Americans and the CoBrA group (figs. 683–686).

Jean Fautrier (1898–1964), one of the older artists who emerged after World War II, painted representationally through the 1930s, frequently figure studies reminiscent of early Rouault or of Pascin. During World War II he produced a series of small, strange paintings that he called Hostages. Built-up masses of paint centralized on a neutral ground, they resembled decayed human heads served on platters. The Hostage paintings, exhibited in 1945, *were* decapitated heads transformed into paint objects. These were followed by a series of Nudes, or Naked Torsos, whose hacked and mutilated shapes suddenly emerge as such from the heavy paste of clay, paint, glue, and other materials which are built up in a half-relief (plate 197). The artist's insistence on the painting as an object in itself with a tangible, physical existence, would particularly impress a generation of younger artists, not only the so-called "matter" and Tachist painters, but experimentalists of all shades.

L'Art Informel and Tachisme

Despite the prevalence of the Lyrical or Abstract Impressionist wing of free abstraction in Paris during the 1940s and 1950s, other artists were emerging dedicated to expressive brush gesture. These included Hans Hartung, Gérard Schneider, Pierre Soulages, and Georges Mathieu, constituting a group who, in their accent on the direct, the intuitive, and the spontaneous, produced a movement parallel with the American Abstract Expressionists. To these as well as to others such as Wols, Alechinsky, Van Velde, or Asger Jorn, who pursued free abstraction in quite different manners, the terms *L'Art Informel* and/or *Tachisme* have been applied.

L'Art Informel is a term devised by the French critic Michel Tapié. As used in European painting and as it has spread throughout the world, it is an extremely broad label roughly equivalent to American Abstract Expressionism and, specifically, to Action Painting. It represents the departure from the tradition of Cubism and geometric abstraction in the creation of a new form of expression. The emergence of this art from the generally decorative patterns of postwar French abstraction exactly coincided in time, if not in forms, with the origins of Abstract Expressionism in the United States. To European painters, far more than to the Americans, the problem was escape from the overpowering tradition of Cubism. L'Art Informel refers to intuitive, spontaneous, undisciplined art (but is not to be thought of as informal, in the sense of opposite to formal). In this art, for which Tapié coined another term, *un art autre*—"another art," or way-out art—the essence is creation with no desire for, nor preconceptions of, control, geometric or otherwise. It is painting that begins with the brush and a blank canvas, may go anywhere, and thus generated various other verbal categories: *Tachisme* (from the French word *tache*), meaning the use of the "blot," the "stain," the "spot," or the "drip"; lyrical abstraction in its freely decorative phase; gesture painting, or the insistence on the statement of the brushstroke; abstract calligraphy; matter painting, indicating the assertion of the material of paint, fortified with sand, clay, or other materials. All these are different manifestations of L'Art Informel. The term, like Abstract Expressionism, is so broad and all-inclusive as to be almost meaningless, but its usefulness is the emphasis it places on opposition to all phases of disciplined, geometric, or concrete art.

HANS HARTUNG (b. 1904) German by birth and training, Hartung did not settle in Paris until 1935. His individual, brittle, linear style may owe something to the earlier abstract Expressionism of Kandinsky, whom he met in 1925. Hartung experimented with free abstract drawings and watercolors as early as 1922, a fact that has added to the controversy: who originated Abstract Expressionism? During the 1930s Hartung explored personal variants on Cubism and on abstract Surrealism related to that of Miró and Masson. He also produced constructed sculpture in the tradition of González, and Surrealist collages or assemblages. His principal interest remained that of sensitive, generally brisk linear structures played against delicate, luminous washes of color. In the late 1940s Hartung developed his mature style of free linearism over total color fields. In the 1960s he moved to a more total form of Field painting in which light and shadow are played over one another in chiaroscuro effects that might almost be abstractions from late Rembrandts (plate 198). Hartung's seventieth birthday was celebrated in 1974 with major retrospective exhibitions in France and New York's Metropolitan Museum.

PIERRE SOULAGES (b. 1919) Soulages first came to Paris in 1938 but did not settle there until 1946. Almost immediately he began painting abstractions, structures based on studies of tree forms. The architectural sense and the closely keyed color range that characterize his abstract style (plate 199)—this sense of physical, massive structure in which the blacks stand forth like powerful presences—may have been inspired originally by the prehistoric dolmens of his native Auvergne, as it certainly was by the Romanesque sculpture of the area. Soulages has consistently followed the principle of the subdued palette, feeling that

626. WOLS. *Oil.* 1949. Alexander Iolas Gallery

"the more limited the means, the stronger the expression." Within this limited means—the great sweeping lines or color areas, usually black or dark color, heavy in impasto, applied with the palette knife or large, housepainter's brushes—Soulages achieved an art of power and elegance, particularly notable not only in the forms but in the penetrating, encompassing light that unifies the painting.

WOLS (1913–1951) The Berlin-born Wols (A. O. Wolfgang Schulze), who lived principally in France after 1932, developed an abstract style following World War II with some analogies to that of Fautrier. He also built up his paint in a heavy central mass varying from the monochromatic ground more in value than in hue, but shot through with flashes of intense colors that create the impact of magnified biological specimens or half-healed wounds (fig. 626).

Wols had begun his life in the visual arts as a photographer and became totally involved in drawing and painting largely as a consequence of his wartime exile in the south of France. With the peace of 1945, another German photographer who found inspiration in Paris— albeit only periodically—was Otto Steinert (1915–1983), subsequently an influential curator of photography at the Folkwang Museum in Essen. And Steinert too insisted that his modernist conception of the two-dimensional picture plane contain analogies to the observable world (fig. 627). In the picture seen here he achieved a perfect abstract design much as the Post-Impressionists had done, taking a vantage point from a window above the street, which automatically transformed the practical facts of sidewalk and gutter into a normally unobserved decorative pattern of concentric circles, interlocking verticals and horizontals, and

mosaic frieze of cobblestone tesserae. On this occasion, by means of a time exposure, Steinert also transformed a passing pedestrian into a Tachist gesture comparable to those of Hartung and Wols.

GEORGES MATHIEU (b. 1921) Mathieu has been described as the Salvador Dali of L'Art Informel. After World War II he moved toward a calligraphic style that owes something to Hartung. His calligraphy, however, consists of sweeping patterns of lines squeezed directly from the tube in slashing impulsive gestures (plate 200). To him, speed of execution is essential for intuitive spontaneity, which, in turn, will lead to universality. Typically Mathieu turned to elaborate titles taken from battles or other events of French history, reflecting his insistence that he is a traditional history painter working in an abstract means. In love with spectacle and performance, he has at times painted, dressed in armor, before an audience, attacking the canvas as though it were the Saracen and he were Roland. His critics have frequently raised the question as to who won the battle. It must be recognized, nevertheless, that Mathieu, like Dali, despite exhibitionism and paradox, became an artist of substantial abilities, one of the leading European exponents of brush, gesture, or Action Painting.

MARIA ELENA VIEIRA DA SILVA (b. 1908) A Parisian artist difficult to classify but one of great sensitivity is Lisbon-born Vieira da Silva. Since the 1940s she has been obsessed with the interaction of perspective and nonperspective space in paintings that are literally based on architectural themes of the city. *The Invisible Stroller* is related to Picasso's Synthetic Cubist paintings of the 1920s in its fluctuations of Renaissance perspective and the Cubist grid (fig. 628). From this point forward she gradually flattened the perspective while retaining the rigid, rectangular, architectural structure. The view of the city, seen from eye level, eventually became the view from an airplane where, as one rises higher and higher, details begin to be blurred and colors melt into general tonalities.

JEAN-PAUL RIOPELLE (b. 1923) Riopelle has lived in Paris since the late 1940s and is married to the American Abstract Expressionist Joan Mitchell (fig. 761). Although deriving originally from Jackson Pollock, his painting is essentially a kind of controlled chance, an intricate mosaic of small, regular strokes of jewellike color, held together by directional lines of force (fig. 629).

627. OTTO STEINERT. *A Pedestrian, 1950.* Photograph. Folkwang Museum, Essen, West Germany

628. MARIA ELENA VIEIRA DA SILVA. *The Invisible Stroller.* 1951. 52 × 66″. San Francisco Museum of Art. Gift of Mr. and Mrs. Wellington S. Henderson

left: 629. JEAN-PAUL RIOPELLE. *Blue Night.* 1953. 44⅞ × 76¾″. The Solomon R. Guggenheim Museum, New York

below: 630. AFRO BASALDELLA. *For an Anniversary.* 1955. 59 × 78⅝″. The Solomon R. Guggenheim Museum, New York. Gift of Mr. and Mrs. Joseph Pulitzer, Jr., 1958

AFRO BASADELLA (b. 1912) In Italy, L'Art Informel found an early advocate in Afro, as Afro Basadella is generally known. Really a Lyrical Abstractionist, Afro created during the 1950s an atmospheric world of light and shadows, with subdued, harmonious colors and shapes that are in a constant state of metamorphosis (fig. 630). In later works of the 1960s the color and shapes are sharply defined and jagged, in the spirit of American Action Painting.

ALBERTO BURRI (b. 1915) Burri was a doctor by profession and began painting while he was a prisoner of war in the United States. Presumably because of the lack of adequate materials, he used old sacks roughly sewn together and heavily splashed with paint. The results were often reminiscent of bloodstained bandages, torn and scarred—devastating commentaries on war's death and destruction (plate 201). They have been related to Schwitters's collages, but their impact is much more brutal and even horrifying than anything Schwitters produced. For a period in the mid-1950s Burri burned designs on

thin wood panels like those used in orange crates. In them, as in the earlier works, there is a strange conflict between, on the one hand, the ephemeral material (which sometimes disintegrates visibly when moved from place to place), the sense of destruction and disintegration, and, on the other hand, the elegance and control with which the artist arranges his elements. Burri has also worked in metal and plastics, melting and re-forming these with a blow torch to achieve results of vivid coloristic beauty combined with effects of disease and decay. His influence has been widespread, particularly on those younger artists who raise questions concerning the nature and the transience of a work of art.

ANTONI TÀPIES (b. 1923) L'Art Informel and Abstract Expressionism spread in one form or another to every part of the world. In Spain, Tàpies was one of the leading exponents of matter painting, building up large surfaces with combinations of somber paint, varnishes, sand, and powdered marble to create an effect of solid relief. His colors are generally subdued but rich, with surfaces worked in many ways—punctured, incised, modeled in relief. During the 1960s he characteristically turned to a coloristic pattern, still involving large-scale areas modulated in tone (plate 202). Later, in combinations that suggested the paintings of Barnett Newman and some of the Pop artists, he combined contrasting stripes against color fields as well as specific objects. In the 1970s Tàpies in many works returned to his earlier medium of sand on canvas, now combined with very free linear patterns to create rough-textured organic works.

Europe's New Abstract Expressionist Sculpture

The nonfigurative Expressionist mode of Europe's L'Art Informel and Tachist painting had what could be called a three-dimensional counterpart in the art of several sculptors. The eldest of these, Zoltan Kemeny (1907–1965), had been born in Rumania and trained in Hungary before he took up residence in Zurich in 1942. One of the most individual and fascinating of sculptors, Kemeny created reliefs of a free, abstract, strong pictorial character through a form of assemblage involving scraps of every kind of metal, copper, iron, zinc, aluminum (plate 203). Cutting these scraps into different shapes—small squares, cylinders, or long strips—he welded them together, principally in relief, to create magical images, sometimes growing plants, sometimes strange cellular structures. Within the limitations of his technique Kemeny achieved an amazing range of effects. Color, created through selection of materials and through changes wrought by the intense flame of the welding torch, is of particular importance in the final result.

A younger master of similar spirit is the talented Spanish sculptor Eduardo Chillida (b. 1924). Working with iron—originally forged in open, linear shapes, but more recently in massive, monumental bars—he has created some of the most impressive pure abstractions of the mid-century, often rather like Pollock's lines or Kline's massive strokes released from the picture plane and set free to float in deep space (fig. 631). Earlier works suggest the old tools from which they were forged, but later pieces have a pure and powerful architectural abstraction with extremely subtle relations of the massive, tilted rectangular shapes (fig. 632).

The brothers Pomodoro—Arnaldo (b. 1926) and Gio (b. 1930)—work principally in bronze. Although they have individual styles, they

left: 631. EDUARDO CHILLIDA. *Dream Anvil No. 10*. 1962. Iron on wooden base, 17⅛ × 20½ × 15⅛". Kunstmuseum, Basel. Emanuel Hoffmann Foundation

below: 632. EDUARDO CHILLIDA. *Space Modulation IV*. 1966. Iron, height 22¾". Collection Aimé Maeght, Paris

Colorplate 194. ELIOT PORTER. *Red Osier, near Great Barrington, Massachusetts.* 1957. Dye transfer print, 30 × 40″. © Eliot Porter

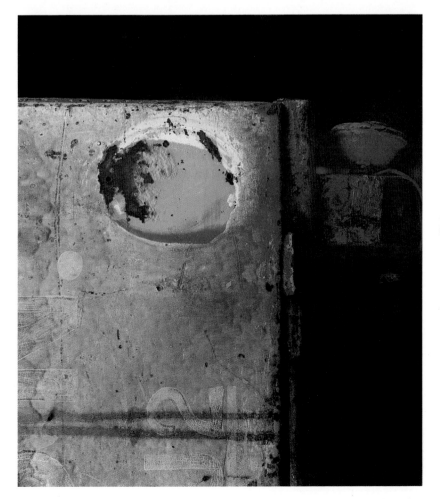

Colorplate 195. SYL LABROT. *Untitled.* 1960. Dye transfer print. Visual Studies Workshop Collection, Rochester, New York. © Barbara Wilson Labrot

left: Colorplate 196. Nicolas de Staël. *Untitled.* 1951. 63 × 29″. Collection Mr. and Mrs. Lee A. Ault, New York

opposite above: Colorplate 197. Jean Fautrier. *Nude.* 1960. 35 × 57½″. Collection de Montaigu, Paris

below left: Colorplate 198. Hans Hartung. *Untitled.* 1963. 39⅜ × 31⅞″. Private collection

above: Colorplate 199. Pierre Soulages. *Painting.* 1952. 77⅜ × 51¼″. The Solomon R. Guggenheim Museum, New York

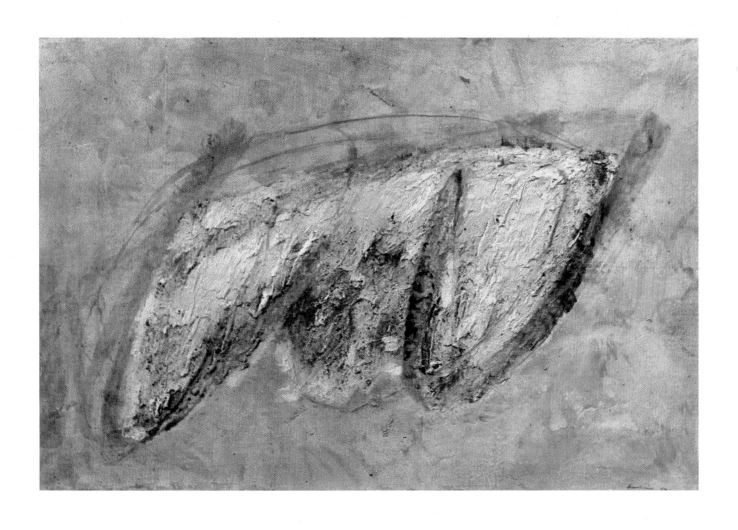

Colorplate 200. GEORGES MATHIEU. *Painting.* 1953. 6′6″ × 9′10″. The Solomon R. Guggenheim Museum, New York

Colorplate 201. ALBERTO BURRI. *Composition.* 1953. Oil, gold, and glue on canvas and burlap, 34 × 39⅜″. The Solomon R. Guggenheim Museum, New York

Colorplate 203. ZOLTAN KEMENY. *Zephyr.* 1964. Brass and colored polyester relief, 53 × 42½″. Collection Mme. Madeline Kemeny, Paris

Colorplate 202. ANTONI TÀPIES. *Painting Collage.* 1964. Collage on canvas, 14 × 22″. Martha Jackson Gallery, New York

right and opposite: Colorplate 204. ALBERTO GIACOMETTI. *Man Pointing* (and detail). 1947. Bronze, height 6′10½″, base 12 × 13½″. Collection, The Museum of Modern Art, New York. Gift of Mrs. John D. Rockefeller, III

Colorplate 205. JEAN DUBUFFET. *View of Paris: The Life of Pleasure.* 1944. 35 × 45¾".
Collection Mr. and Mrs. David M. Solinger, New York

Colorplate 206. JEAN DUBUFFET. *The Gypsy.* 1954.
36¼ × 29". Alex Hillman Family Collection

Colorplate 207. JEAN DUBUFFET. *Virtual Virtue.* 1963. 37¾ × 50⅞". Saidenberg Gallery, New York

Colorplate 208. FRANCIS BACON. *Head Surrounded by Sides of Beef (Study After Velázquez)*. 1954. 50⅞ × 48″. Art Institute of Chicago. Harriott A. Fox Fund

Colorplate 209. HUNDERTWASSER. *Maison née à Stockholm, morte à Paris und die Beweinung meiner selbst (House born in Stockholm)*. 1965. 32 × 23⅔″. Collection J. J. Aberbach, New York

Colorplate 210. KAREL APPEL. *Angry Landscape*. 1967. 51¼ × 76¾″. Collection Jimmy J. Younger, Houston

Colorplate 211. ASGER JORN. *Hors d'âge.* 1972. 51½ × 64″. Estate of John Lefebre, New York

complement each other in curious ways, even to their separate use of male and female sex imagery. Arnaldo employs a few simple, basic forms, tall columns, large spheres, and rectangular forms, either as reliefs or freestanding. Modeled in plaster and cast in bronze, the forms are as smooth and highly polished as Brancusi's pristine volumes, but fractured in strategic places to reveal crevices and faults that are eaten away in textural configurations suggestive of the Expressionist calligraphy of contemporary painting (fig. 633). It is as though beautifully finished, intricate machines had been shattered by an explosion, revealing the complicated workings within. The distinctive style created by Gio Pomodoro is related to his brother's in the emphasis on precision of technique, explainable in part by the fact that both brothers began as goldsmiths and decorators. Whereas Arnaldo's approach is essentially mechanistic—even his columns and spheres are phallic only in a remotely symbolic sense—Gio's sculptures are intensely sensual. The sexuality derives not only from the overtly vaginal symbolism, but also and predominantly from the undulating, organic, light-reflecting surfaces of large sheets of bronze (fig. 634). The concept of sculptural frontality evident in Gio's works owes a great deal to American Abstract Expressionist and Color Field painters such as Pollock, Kline, and Newman.

633. ARNALDO POMODORO. Exhibition at the Venice Biennale, 1964: Left: *Estate of J. F. Kennedy.* 1963–64. Bronze. Center: *Sfera.* 1964. Bronze. Right: *3 Travellers Columns.* 1961–64. Bronze. Marlborough Gallery, New York

Postwar European Figuration and Fantasy

Beginning in the early 1950s, despite the dominance of Abstract Expressionism in both the United States and Europe, there were recurring waves of insistence on a return to the figure, to a new naturalism or naturalistic fantasy. De Kooning and Pollock, as we have seen, experimented with figuration at the beginning of the 1950s, and De Kooning continued thereafter. The term "figuration" is ambiguous, since it can refer not only to the human (or animal) figure, rendered in some degree explicitly, but also to the implication of figures in abstract works. There was, however, in the late 1940s and the 1950s a deliberate and concerted attempt to reintroduce subject-matter figures, most frequently in a macabre effect. One may trace this tendency back to the Dadaists, the Surrealists, and specifically to Picasso in the 1920s and 1930s. Crucial to the new figuration were Alberto Giacometti and Jean Dubuffet.

ALBERTO GIACOMETTI Some of the most powerful new art to appear in the postwar years came from the hands of Alberto Giacometti, who, as we know, had given the Surrealists their most important sculptor (figs. 437–440). In 1935, however, Giacometti broke with Surrealism, doing so rather dramatically, for he had become convinced that his imaginary, semiabstract Surrealist constructions were carrying him too far from the world of actuality. He then returned to a study of the figure, with the intent of rendering the object and the space that contained it exactly as his eye saw them. Almost at once the artist began to realize the magnitude of the quest he was undertaking. From 1935 to 1940 he worked all day from a model but, as he said, "nothing was as I had imagined." He then decided to make a new start:

I began to work from memory.... But wanting to create from memory what I had seen, to my terror the sculptures became smaller and smaller, they had a likeness only when they were small, yet their dimensions revolted me, and tirelessly I began again, only to end

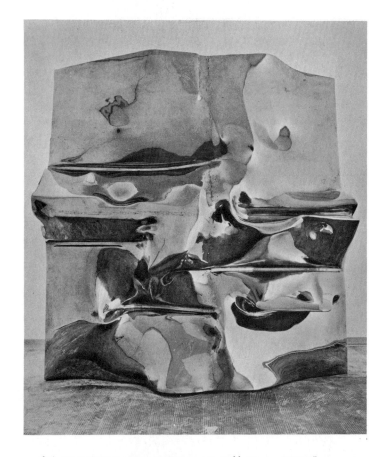

634. GIO POMODORO. *Borromini Square II.* 1966. Bronze, 78 × 78". Marlborough Gallery, New York

several months later at the same point. A large figure seemed to me false and a small one equally unbearable, and then often they became so tiny that with one touch of my knife they disappeared into dust. But head and figures seemed to me to have a bit of truth only when small. All this changed a little in 1945 through drawing. This led me to want to make larger figures, but then to my surprise, they achieved a likeness only when tall and slender....

635. ALBERTO GIACOMETTI. *Head of a Man on a Rod.* 1947. Bronze, height 21¾". Collection William N. Eisendrath, Jr., St. Louis, Missouri

636. ALBERTO GIACOMETTI. *Monumental Head.* 1960. Bronze, height 37½". Hirshhorn Museum and Sculpture Garden, Smithsonian Institution, Washington, D.C.

637. ALBERTO GIACOMETTI. *Chariot.* 1950. Bronze, height 57". Collection, The Museum of Modern Art, New York

638. ALBERTO GIACOMETTI. *Composition with Seven Figures and One Head.* 1950. Bronze, height 22". The Reader's Digest Collection

639. ALBERTO GIACOMETTI. *Dog.* 1951, cast 1957. Bronze, height 17¼". Hirshhorn Museum and Sculpture Garden, Smithsonian Institution, Washington, D.C.

When Giacometti returned to Paris from Switzerland after the war, his ten-year struggle, during which he finished few works, had been resolved. Although every painting and sculpture was an agony of working and reworking, Giacometti was able, in the last twenty years of his life, to produce a body of sculptures and paintings that mark him as one of the masters of twentieth-century art.

The 1947 *Head of a Man on a Rod* (fig. 635), of which he did several versions, is really two profiles pressed together, scarred and pitted in effects that are both a horrible laceration of the flesh and the translation of the face into a rugged, rocky landscape. Giacometti had early developed (perhaps from his studies of ancient sculpture) a passion for color in sculpture, and one of the most striking aspects of the latter works is the patinas he has used in the bronze (plate 204).

Giacometti's favorite models continued to be his brother Diego, his mother, and his wife, Annette. Diego is the subject of dozens of sculptures and paintings, ranging from relatively representational works to grotesque, attenuated, and pitted masks, but always alive and clearly recognizable (fig. 636). The single spindly figure appeared in a hundred variants on the artist's basic theme: standing rigid; walking like an Egyptian deity; mounted on a chariot suggesting an Etruscan bronze (fig. 637); in groups, and in environments evoking the isolation of the individual (fig. 638). In the 1950s Giacometti occasionally varied his theme, as in the wonderful study of the starving dog, in whom he saw himself (fig. 639). "It's me," he said. "One day I saw myself in the street just like that. I was the dog."

From the 1940s Giacometti also drew and painted with furious though consistently frustrated energy. He sought to pin down the space, the environment occupied by the figure, that could only be suggested in the sculptures. In their subordination of color and emphasis on the action of line, the paintings have the appearance of drawings or even engravings. The impact in the paintings (although related) comes largely from Giacometti's technique of elimination or erasure. In *The Artist's Mother* (fig. 640) the figure is almost completely assimilated into the network of linear details of the bourgeois living room. These details are nowhere explicit, but still they obtrude in an atmosphere that becomes oppressive, while the old woman sits isolated in their midst.

The German-born French photographer Gisèle Freund (b. 1912), who before the war had accomplished the extraordinary feat of having a doctoral thesis on nineteenth-century photography accepted at the hidebound Sorbonne, concentrated on the human countenance, in the form of portraiture, with almost as much determination as Giacometti. Freund, however, followed a self-defined program of capturing the images of Europe's great surviving humanist writers, intellectuals, and artists (fig. 641). In this she was like a one-woman crusader determined to recapture for humanity whatever exemplars remained of European civilization following the decimations it had suffered, first at the hands of totalitarian regimes—Nazi, Fascist, Communist—and then at those of the warmongers who took control in 1939.

BALTHUS (b. 1908) A painter closely allied to Giacometti since the early 1930s and who, like the Swiss master, came into his greatest fame after the war, is Balthasar Klossowski, the self-styled and reclusive Comte de Rolla. From a background that included an art historian father, a painter mother, and the poet Rainer Maria Rilke, Balthus emerged at a very young age within the Surrealist ambience. But Surrealism could not hold an artist so literal-minded as Balthus in his obsession with the erotic qualities of dreaming, semiaware pubescent girls, whom he painted in situations of riveting enigma (fig. 642). Often the atmosphere of these lavishly brushed paintings—their surfaces

640. ALBERTO GIACOMETTI. *The Artist's Mother.* 1950. 35⅜ × 24″. Collection, The Museum of Modern Art, New York. Acquired through the Lillie P. Bliss Bequest

641. GISÈLE FREUND. *Richard Wright.* Photograph. ©Giselle Freund/Photo Researchers Inc.

642. BALTHUS. *The Golden Days (Les Beaux Jours)*. 1944–46.
58¼ × 78⅜″. Hirshhorn Museum and Sculpture Garden,
Smithsonian Institution, Washington, D.C.

built up, albeit in smooth layers, almost as materially as those of the Tachists—seems all the more charged for being contained within an architectonic structure as Classically calm and balanced as those of Piero della Francesca and Poussin. The result is an eerie sense of the anxiety and decadence that haunted the renascent Europe of the postwar years.

JEAN DUBUFFET (1901–1985) The greatest French artist to emerge after World War II, Dubuffet was forty-three years old when, in 1944, he had his first one-man exhibition, at the Galerie René Drouin in Paris. After brief study at the Académie Julian in 1918, which he found uncongenial, Dubuffet retired from the art world for some twenty-five years. He continued to draw and paint privately, but much of his time was taken up with music, the study of languages, experimental theater and puppetry. Of importance to the artist in finally discovering what it was he wanted to do was Hans Prinzhorn's book, *Bildnerei der Geisteskranken*, on the art of the insane. Here Dubuffet found a brutal power of expression that seemed to him much more valid than the art of the museums or even the most experimental new art. The art of the insane and the art of children became the models on which he built his approach. The artist whose works attracted Dubuffet most was Paul Klee, who had also used children's and psychopathic art as sources.

After 1944 Dubuffet became one of the most prolific painters in history, and concurrently carried on an awe-inspiring program of writing on, cataloguing, and publishing his own development and his own works. The first of the new paintings were panoramic views of Paris and Parisians, the buses, the metro, the shops, the back streets (plate 205). The colors are bright and gay, the people drawn in a childlike manner, and the space composed as in primitive or archaic painting, with depth indicated symbolically by stratification—the lowest stratum closest to the spectator. It is at this stage that Dubuffet's paintings are closest in spirit to those of Klee.

Successively Dubuffet explored the variations of graffiti—images and messages, frequently obscene, scratched on walls—and the textural effects of Paris walls with their generations of superimposed post-

ers. The scratched, mutilated surface, built up in combinations of paint, paper, and sand particularly appealed to him. *Festival de terre* (fig. 643), with its three figures who combine aspects of the psychopathic and the fetus floating insanely in a placenta-landscape, illustrates the most brutal aspect of his art.

Dubuffet's characteristic technique, used for some fifteen years after the artist had arrived at it about 1945, was based on a thick ground made of sand, earth, fixatives, and other mysterious elements into which the pigment was mixed. Figures were incised into this ground, and the whole scratched, scarred, worked in every way to give it a tangible, powerful reality. This reality of the painting as a physical object is of major importance in the attainment of the mysterious, primordial effect Dubuffet was seeking. Out of ground or paste emerge monstrous figures that combine qualities of madness with the power of prehistoric fertility images (fig. 644).

Dubuffet's landscapes are those of the moon or of a world in birth or in death, like close-up views of geologic formations, barren of any vegetation, incapable of supporting any life (fig. 645). Works through the 1950s are predominantly in close-keyed browns, dull ochers, and blacks, normally verging toward monochrome. All is darkness, but there is in them, however, magical light that glows within the paste or pigment.

Independent of the American Abstract Expressionists, and anticipating many of them, Dubuffet worked in a largely intuitive manner, using every accident that might occur in his working of the heavy ground. With modified techniques and materials his figures became more wildly mad, with sharply broken contours and smeared, bloody surfaces (plate 206).

It was always Dubuffet's habit to work on a single theme or a few related themes for a period of a year or more. Thus the landscapes of the early 1950s were followed by a series of landscape-tables. The figures of the mid-1950s were accompanied by sculptured figures made of coal clinkers fixed with cement, or combinations of slag and tree roots, forming strange little figures, close in spirit to the painted figures of the period.

In Vence in 1955 Dubuffet created a series of landscapes with figures in an India ink medium of imprint assemblage. The stay produced a variety of subjects, inspired by the local scene—gardens, carts, assemblages of butterfly wings, rough surfaces of old roads, studies of grasses and plants. In all of these Dubuffet was constantly experimenting with new techniques, frequently at first in India ink or watercolor, later to be developed in oil. The works are some of the most profound and poetic fantasies of the imagination to be produced by a twentieth-century artist. One of the main sources of his inspiration was the great collection he began in 1945 of *art brut*: art that is rough, raw, or even unadulterated. Numbering thousands of works in all media, the collection contained the art of the insane, the primitive, and the naïve. To Dubuffet these works had an authenticity, an originality, a passion, even a frenzy, that was utterly lacking in the works of professional artists. It is this divine madness that he continually searched for in his own works.

About 1957 Dubuffet made a number of paintings of doors (fig. 646). These developed out of assemblages based on walls with stains, and graffiti made up of oil painting fragments, cut up and pasted together in new relationships. He used novel and highly individual techniques to give "the impression of teeming matter, alive and sparkling... which could also evoke all kinds of indeterminate textures, and even galaxies and nebulae."

Between 1962 and 1966 Dubuffet was occupied with what he referred to as the "Twenty-Third Period of My Works," to which he gave

643. JEAN DUBUFFET. *Festival de terre*. 1951. 35¾ × 48¼". Private collection, New York

645. JEAN DUBUFFET. *The Geologist*. 1950. 38 × 51". Private collection, New York

644. JEAN DUBUFFET. *Triumph and Glory (Corps de Dame)*. 1950. 51 × 38½". The Solomon R. Guggenheim Museum, New York

646. JEAN DUBUFFET. *Door with Couch-Grass*. 1957. Oil on canvas with assemblage, 74⅜ × 57½". The Solomon R. Guggenheim Museum, New York

the coined name L'Hourloupe. These works represent one of the most radical departures in the artist's stylistic development and chronologically one of the most sustained. Some doodling with a red ballpoint pen while telephoning, in July 1962, inspired him to create a small book of drawings with text. The drawings were in red and blue lines on a black

ground, the lettering in white on black. Semiautomatic and self-contained, the drawings were free-form, abstract shapes, flowing and changing like amoebae, filled with suggestions of living organisms even at times of human figures.

From this modest beginning the artist developed a vast repertoire of

647. JEAN DUBUFFET. *Nunc Stans*. 1965. Vinyl on canvas, 5'4" × 27'. The Solomon R. Guggenheim Museum, New York

all-over, color-shape paintings, some on a scale transcending anything he had ever done previously. In *Virtual Virtue* (plate 207) dozens of little figures are engaged in frenzied physical embrace. They are drawn in undulating lines of red and blue with black and purple, while the figures are white-bodied with blue tints. The total effect is that of a wild maze in which the figures are trapped and which is at the same time made up of the figures. Many variants on the linear-landscape-figure-object maze appeared during 1962 and 1963, with sporadic recurrence of individual *personnages*.

Objects and utensils began to appear in the series regularly, from January 1964. These included typewriters, lamps, scales, fishing boats, wheelbarrows, and beds. At the end of 1964 objects ceased and people in landscapes recurred. Then, in February 1965, the themes became the tap, the washbasin, the open book, and the clock. The climax of the entire series is the 1965 *Nunc Stans* (fig. 647), a gigantic color jigsaw puzzle of interlocked figures, faces, and objects. Despite the insistence on ordinary household utensils, these are invariably anthropomorphized, made into human organisms involved in fantastic and frenetic

left: 648. JEAN DUBUFFET. *Group of Four Trees*. 1972. Epoxy paint on polyurethane over metal structure, 38 × 40 × 34'. Collection The Chase Manhattan Bank/The Museum of Modern Art, New York

649. ROBERT DOISNEAU. Scene from sequence *The Skier and His Cello*. 1958. Photograph. ©Robert Doisneau

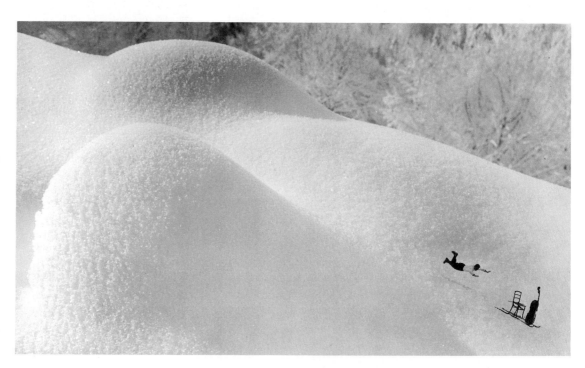

434

dances and embraces. During the 1970s Dubuffet continued his production of fantastic figuration in the mode of *Virtual Virtue* and *Nunc Stans*, but the figures are generally larger and more specifically evident. At the same time he began to make the obvious translation of the figures in sculpture, sometimes on a heroic, even environmental scale (fig. 648).

Something of Dubuffet's serious whimsy was shared in the postwar years by the French photographer Robert Doisneau (b. 1912), who, like the great Brassaï roamed the streets of Paris seeking and finding what he called "the unimaginable image" within "the marvels of daily life" (fig. 649). Having discovered that nothing is more bizarre than the banal, Doisneau managed to brighten a depressed, existential age with his witty, but never snide, photographic commentary of the foibles and misadventures of the human race at full cry.

FRANCIS BACON (b. 1910) The only other figurative Expressionists powerful enough in postwar Europe to be compared with Giacometti and Dubuffet were British. Chief among these was the Irish-born Francis Bacon, one of the artistic giants of his time. About 1945 Bacon made a series of studies on the theme of the Crucifixion, the climax of which was a *Magdalene*, a massively modeled figure inspired by Giotto, set within a room suggestive of an art gallery (fig. 650). The space of the room is defined by some perspective lines, but the color is a unified yellow-orange. The figure, partially draped, solid as a marble altar, is bent double. Over her head is a blue umbrella from which hangs a semitransparent veil, and below this, partially obscured, is her head, like that of some weird animal, extended on a long neck, mouth wide open in a great wail or scream of grief. This work established many of the themes Bacon would develop over the years. His devotion to the monstrous, the deformed, or the diseased has been variously interpreted as a reaction to the plight of the world and humanity. The *Magdalene* also reveals his superb qualities as a pure painter and his obsessive sense of tradition, in this case extending from Giotto in the fourteenth century to the sixteenth-century High Renaissance.

Bacon uses paintings of the past as the basis of his works, but he transforms these in terms of his own inward vision or torment. In the early 1950s he made a series of studies of a Pope, after Velázquez's *Portrait of Pope Innocent X* in the Doria Gallery in Rome. The subject is usually shown seated in a large, unified surrounding space, the figure blurred as though seen through a veil, while the perspective lines suggest a glass box within which the figure is trapped. The mouth is usually open in a shout or a scream. In *Head Surrounded by Sides of Beef*, two great, bloody sides of beef are placed heraldically above, on either side of the ecclesiastical presence (plate 208). This motif, deriving ultimately from Rembrandt seen through Soutine (plate 111)—with whom Bacon has many traits in common—first appeared in 1946. The exact meaning of the Pope series is deliberately obscured by the artist, but there can be no question of the disturbing, sometimes horrifying, impact. Nor can there be any question of the beauty of the painting and the grandness of the conception. In fact, the dignity, the spaciousness, the traditionalism of the concept and its execution throw into relief the disturbing qualities.

Also, understandably, fascinated by Vincent van Gogh, Bacon made many variations on Van Gogh's *The Artist on the Road to Tarascon* (now destroyed), and has done a great number of portraits that are extensions of Van Gogh's last self-portraits (fig. 651). Here, using whirling brushstrokes, he twists the face as it might be seen in an excessively distorted mirror, while still maintaining an element of the recognizable. The effect is one of madness.

650. FRANCIS BACON. *The Magdalene*. 1945–46. 57¼ × 50¾". Bagshaw Art Gallery, Batley, England

651. FRANCIS BACON. *Head of a Man–Study of a Drawing by Van Gogh*. 1959. 26⅛ × 24⅛". Collection Mr. and Mrs. Harry C. Cooper, Los Angeles

above: 652, 653, and 654. FRANCIS BACON. *Three Studies for a Crucifixion*. 1962. Each panel 78 × 57″. The Solomon R. Guggenheim Museum, New York

below: 655. GRAHAM SUTHERLAND. *Crucifixion*. 1946. Oil on hardboard, 96 × 90″. Church of St. Matthew, Northampton, England

A climactic work of the early 1960s is the triptych *Three Studies for a Crucifixion* (figs. 652–654). In it the artist summarized motifs and forms developed during the preceding decade: the figures in large space, the sides of beef, the nude on a bed in a room with curving walls and drawn shades. The figure is, however, a broken, bloodied cadaver that might have been beaten to death in a concentration camp.

GRAHAM SUTHERLAND (1903–1980) Scarcely less given to agonized imagery and expression was Graham Sutherland. Beginning with meticulously representational paintings and etchings during the 1920s,

Sutherland during the 1930s explored forms of symbolic landscape with reminiscences of Gauguin. In the 1940s these landscapes—trees and rock forms—were transformed into monstrous figures that suggest some of Picasso's Expressionist-Surrealist work of the 1930s. The war years led to a certain reversion in the representation of devastated, bombed-out buildings, and industrial scenes. By the end of World War II Sutherland had arrived at his characteristic jagged, thistlelike totems, frequently based quite literally on plant forms but transformed into menacing beasts or chimeras. A commission for the painting of a Crucifixion in St. Matthew's Church, Northampton, led him back to Grünewald's Isenheim Altarpiece (fig. 8). In Grünewald's torn, lacerated figures he found a natural affinity (fig. 655). In the 1950s and 1960s Sutherland continued to play variations on his individual totems, sometimes in his handling of space and atmosphere coming close to contemporaneous works by Francis Bacon. Along with his Expressionist works, he carried on a successful career as a portraitist, painting many of the great figures of his time in literal but penetrating interpretations.

HENRY MOORE In sculpture, too, the British surged ahead in postwar Europe, thanks to the ever-expanding genius of Henry Moore and Barbara Hepworth, two artists who, like Giacometti, had defined their artistic personalities in the 1930s (figs. 512, 513) and then, with far greater consistency, carried them toward something like an apotheosis after 1945. Stylistically and temperamentally, however, they contemplated the human condition in calmer, more pondered, philosophical—though hardly less moving—terms than such contemporary peers in quality as Bacon, Sutherland, Giacometti, and Dubuffet. But while faithful to their origins in abstraction, both Moore and Hepworth continued to work in a biomorphic mode always, even at its most reductive, on the brink of evoking the human presence, quite explicitly in the case of Moore with his recumbent forms, and more distinctly than before the war in the case of Hepworth, who in her later work often favored standing dolmen- or totemlike images called "Figures." Meanwhile, tragedies of war and personal loss seemed to endow the innate composure of these artists—their balance of Classical clarity

and pantheistic feeling—with a new emotional depth bordering on Expressionism. Within these broad confines, however, Moore and Hepworth, being major artists, went their own gloriously independent ways.

During World War II Moore made thousands of drawings of the underground air-raid shelters in London (fig. 656). These inspired some of his most tender family groups and Christian religious works, as well as some of his most Classical—in a literal Greek mode—restrained, and monumental draped figures (fig. 657). The early 1950s brought forth new experiments in attenuated, angular bone figures. The figures

in *King and Queen* (fig. 658), with masks for faces and flattened-out, leaflike bodies, maintain a sense of personality, of regal dignity. *Falling Warrior* constitutes a macabre and tragic symbol of a world bent on destroying itself (fig. 659). Throughout this time Moore continued to explore and develop his theme of recumbent figures composed as an intricate arrangement of interpenetrating solids and voids (fig. 660).

After mid-century Moore, the acknowledged dean of English sculptors and a figure of world reputation, received many commissions for architectural sculpture. Museums and commercial or industrial firms

above left: 656. HENRY MOORE. *Tube Shelter Perspective*. 1941. Chalk, pen, and watercolor, 8½ × 6½″. Collection Mrs. Henry Moore, England

above right: 657. HENRY MOORE. *Madonna and Child*. 1943–44. Hornton stone, height 59″. Church of St. Matthew, Northampton, England

left: 658. HENRY MOORE. *King and Queen*. 1952–53. Bronze, height 63½″. Hirshhorn Museum and Sculpture Garden, Smithsonian Institution, Washington, D.C. ·

are happy to acquire one of his later, monumental reclining figures, which seem to adapt to and enhance any architectural setting (fig. 661). Generally, these latest works involve three directions, all in some degree based on earlier concepts of reclining or standing figures. The most impressive of them are probably the reclining rock, or mountain figures, vast in scale, craggy in effect, frequently broken in two or three parts so that the spectator can walk into them. At the other extreme is a type of reclining figure, smoothly contoured and reminiscent of the inside-outside figures of the 1930s. Third is a form of shattered bone figure, usually standing, that develops ideas of the earlier bone figures and warriors. Here the sense of death and destruction is strong (fig. 662). Most of the recent work is in bronze, now the artist's favorite material. The earlier insistence on truth to materials has ceased to be a dominant factor, and bronze is given a range of effect, from the most jagged and rocky to the most finished and biomorphic. Moore has explored the full possibilities of sculptural forms and materials, but has always brought his explorations back to the problems of humanity.

659. HENRY MOORE. *Falling Warrior*. 1956–57. Bronze, length 57¾″. Hirshhorn Museum and Sculpture Garden, Smithsonian Institution, Washington, D.C.

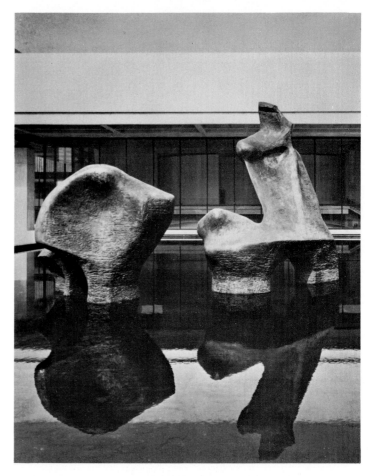

661. HENRY MOORE. *Lincoln Center Reclining Figure*. 1963–65. Bronze, height 16′. Lincoln Center for the Performing Arts, Inc., New York

660. HENRY MOORE. *Interior-Exterior Reclining Figure (Working Model for Reclining Figure: Internal and External Forms)*. 1951. Bronze, height 14″. Hirshhorn Museum and Sculpture Garden, Smithsonian Institution, Washington, D.C.

662. HENRY MOORE. *Nuclear Energy*. 1964–66. Bronze, height 12′. University of Chicago, Illinois

BARBARA HEPWORTH During the 1950s Hepworth, already seen in her early work (figs. 514–516), discovered a promising new direction through a series of Groups in white marble, small in scale, magical in their impact, and related to her early group compositions and also to Giacometti's groups of walking figures (fig. 663). In these, external lighting effects become an important aspect of their total effect. Subsequently the artist shifted to a series of flat, thin forms intertwined in curving loops. These are usually modeled in metalized plaster and cast in metal. The bronze, biomorphic *Porthmeor: Sea Form*, roughly textured and massive despite its openness of form, suggests some deep-sea crustacean or coral growth (fig. 664). After 1960 Hepworth received a number of commissions that permitted her to compose on a monumental scale. One of the most effective is *Meridian* for State House, Holborn, London (fig. 665)—a great, openwork structure, a varied, expanding, and continuous ribbon, reminiscent of some vast plant form, combining monumentality with qualities of delicacy and grace. Between 1970 and 1975 Hepworth, while continuing with her elegant smaller stone carvings and bronze castings, created some of her most monumental totem figures (fig. 666). Each work is individual but the whole is conceived as an outdoor environment.

above left: 663. BARBARA HEPWORTH. *Group III (Evocation)*. 1952. Serravezza marble, height 9″. Collection Margaret Gardner, England

left: 664. BARBARA HEPWORTH. *Porthmeor: Sea Form*. 1958. Bronze, height 30½″. The Joseph H. Hirshhorn Collection

below left: 665. BARBARA HEPWORTH. *Meridian*. 1958–59. Sculpture for State House, Holburn, London. Bronze, height 15′

below: 666. BARBARA HEPWORTH. *Ancestor II: Nine Figures on a Hill*. 1970. Bronze, height 8′11″. Edition of four. Estate of Barbara Hepworth. Courtesy Marlborough Fine Art Ltd., London

left: 667. GERMAINE RICHIER. *The Hurricane*. 1948–49. Bronze, height 70⅛". Collection Dr. W. A. Bechtler, Zollikon, Switzerland

right: 668. GERMAINE RICHIER. *The Horse with Six Heads*. 1953. Bronze, height 13⅜". Richier Estate, courtesy Galerie Creuzevault, Paris

later works of Rodin and Bourdelle, and is continued in other French or School of Paris sculptors, notably César and Ipousteguy.

CÉSAR BALDACCINI (b. 1921) Whereas Richier stretched the possible limits of bronze casting, César created comparable effects from the assemblage of old iron scraps and machine fragments. In this he anticipated the so-called Junk sculptors who, using the detritus of machine civilization, would make telling comments on that civilization. In his

left: 669. CÉSAR. *Nude*. 1958. Bronze, height 24⅞". Hirshhorn Museum and Sculpture Garden, Smithsonian Institution, Washington, D.C.

GERMAINE RICHIER (1904–1959) Richier was a student and assistant of Bourdelle in the late 1920s. Since Bourdelle had been an assistant to Rodin, Richier thus inherited the main line of modern figurative sculpture. The earliest surviving sculptures of the late 1930s and early 1940s are sensitive portrait heads in the Rodin tradition. The macabre quality of later works is fully formulated in the devastating female figure known as *The Hurricane* (fig. 667). This is a monster, powerful as a gorilla, with pitted, torn, and lacerated flesh, that in a curious way is both threatening and pitiful, characteristics typical of Richier's race of brutish beings.

Richier experimented with the bronze technique, using paper-thin plaster models, into the surface of which she pressed every sort of organic object. These experiments were first carried on in small works—fanciful chessmen or trees or plants. Sometimes she placed her figures in front of a frame, the background of which is either worked in relief or, in some larger works, painted by a painter friend. Richier's passion for experiment as well as fantasy is carried to extremes in works like *The Horse with Six Heads* (fig. 668). The shell is a miracle of bronze casting, thin to the point of transparency, with the shredded surface everywhere torn open, like rotted flesh that has been picked over by vultures. In later works the violence of expression becomes excessive, close to the extreme forms of German Expressionism. There are relations not only to Giacometti, but even more to Dubuffet's figures. In fact, the vehemence of her imagination may be traced to some of the

assemblages of automobile bodies crushed under great pressure into massive blocks of varicolored materials, as they are in auto junkyards when the metal is processed for reuse (fig. 670).

JEAN-ROBERT IPOUSTEGUY (b. 1920) Ipousteguy left painting for sculpture about 1954. Since that time he has become one of the most impressive figurative Expressionists. From initially abstract experiments using a variety of materials, he moved to a form of figure sculpture and to themes principally executed in bronze that, while intensely personal in their formulation, embody a strong sense of tradition. The 1959 *David* is a massive, totemistic figure whose head is a threatening helmet (fig. 671). The technique, which Ipousteguy has made his own, employs extremely heavy bronze, carefully finished in a black or very dark patina, a smooth mass that is then shattered at many points. It is as though the impregnable material has been torn apart by some cosmic explosion. *Alexander Before Ecbatana*, a work of 1965 (fig. 672), illustrates the increasing complexity of spatial organization as well as the artist's deliberate use of the grand, academic, historical theme. The conqueror, Alexander, before the walls of Ecbatana, capital of the kingdom of the Medes, is an immense symbol of insatiable power. His triple face is enclosed in and emerges from a huge helmet structure that seems to have been literally ripped open. The city is presented symboli-

670. CÉSAR. *The Yellow Buick.* 1961. Compressed automobile, 59½ × 30¾ × 24⅞". Collection, The Museum of Modern Art, New York. Gift of Mr. and Mrs. John Rewald

constructions, César, over long periods of time, has worked abstractly, but he returns continually to the figure, and the figure is implicit in many of the abstract works. His 1958 *Nude* is a pair of legs with lower torso, eroded and made more horrible by the sense of life that remains (fig. 669). During the late 1950s and the 1960s the artist made many

above: 671. JEAN IPOUSTEGUY. *David.* 1959. Bronze, height 47". Hirshhorn Museum and Sculpture Garden, Smithsonian Institution, Washington, D.C.

left: 672. JEAN IPOUSTEGUY. *Alexander Before Ecbatana.* 1965. Bronze, 5'8" × 13'2" × 4'. Galerie Claude Bernard, Paris

673. MARINO MARINI. *Horse and Rider.* 1949. Bronze, height 71″. Walker
Art Center, Minneapolis

674. MARINO MARINI. *Horse and Rider.* 1952–53. Bronze, height 82″.
Hirshhorn Museum and Sculpture Garden, Smithsonian Institution,
Washington, D.C.

675. MARINO MARINI. *Ideal Stone Composition.* 1971. Stone, 44⅞ × 89″.
Estate of the Artist

cally by a landscape sculpture that is already completely subordinated
to the conqueror. This is an effective and powerful work in organization
and conception, but also of great interest in its revival of the grandiose
history theme. Such a subject was a favorite with the official academic

painters during the nineteenth-century, and it was even used frequently
by so original a talent as Delacroix. In returning to the clichés of the
academy it is as though Ipousteguy were attempting to prove that even
the most tired themes could be given new significance, could serve as
the basis for a new kind of expression in the later twentieth century.

MARINO MARINI (1901–1980) The main Italian contribution in
postwar figuration came in sculpture, in the work of at least two men of
talent, Marino Marini and Giacomo Manzù, and numerous others of
ability and originality. Marini was a mature artist in the 1930s, already
experimenting with his favorite subjects, including the Horse-and-Rider
theme, which during the war became for him a symbol for suffering and
homeless humanity. The versions of the earlier 1940s are plump, se-
date, and somewhat reminiscent of Chinese carvings of peasants riding
oxen (fig. 673). As he continued with the subject the action becomes
more dramatic, the horse and rider more angular and attenuated. The
horse, with elongated, widely stretched legs and upthrust head, screams
in agony, in a manner that recalls Picasso's *Guernica* (fig. 424). The
rider, with outflung stumps of arms, falls back in a violent gesture of
absolute despair (fig. 674). The next stage saw the rider almost com-
pletely overthrown, and later the horse and rider were transformed into
an abstract arrangement of parts. Subsequently the horse was further
translated—like Henry Moore's reclining human figure—into a mas-
sive, mountainous form roughly hewn from the rock (fig. 675).

GIACOMO MANZÙ (b. 1908) Manzù was influenced by Medardo Rosso (fig. 138), but his real loves were Donatello, Jacopo della Quercia, and the Italian Renaissance. *Young Girl on a Chair* is a completely traditional work that has, nevertheless, a lightness and vitality that make it contemporary (fig. 676). This work also, particularly with the introduction of the prosaic chair, illustrates the close study of nature in which the artist's works are rooted, and also the poetry that he is able to instill into the subject. The chair has recurred in a number of independent versions cast in bronze or, in one small version, in gold, with still-life elements of drapery, branches, or a lobster. This literal statement of commonplace objects simply as objects, without any mystical or symbolic overtones, brought Manzù close to some of the younger artists in Europe and America who preferred to call themselves object-makers.

The Cardinal series takes a conventional subject and creates from it a mood of withdrawal and mystery, at the same time utilizing the heavy robes for a simple and monumental sculptural volume (fig. 677). Manzù is one of the few living artists with a genuine feeling for Christian subject matter. He was close to Pope John XXIII, and has carried out a number of great religious commissions, notably the bronze door panels for St. Peter's Basilica (fig. 678), and for the Salzburg Cathedral. Manzù as a sculptor is an anomaly: a Renaissance artist who has made his place in the contemporary world, a traditional sculptor who is never academic.

676. GIACOMO MANZÙ. *Young Girl on a Chair.* 1955. Bronze, height 44″. Hirshhorn Museum and Sculpture Garden, Smithsonian Institution, Washington, D.C.

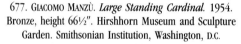

677. GIACOMO MANZÙ. *Large Standing Cardinal.* 1954. Bronze, height 66½″. Hirshhorn Museum and Sculpture Garden. Smithsonian Institution, Washington, D.C.

678. GIACOMO MANZÙ. *Death by Violence I.* 1962. Bronze door panel, 39¾ × 28¼″. St. Peter's, Rome

REG BUTLER (1917–1981) Despite the impressive achievements of Bacon and Sutherland, the British figurative tradition in the postwar era had been carried on more in sculpture than in painting until the emergence of British Pop Art. Reg Butler's sculpture developed from an abstract construction derived from González to an expressive figure style that has more in common with Marini and the Italians than it has with Moore (fig. 679). In 1968 he began an entirely new phase with the creation of a group of female nudes made of bronze but painted in a precise although somewhat corpselike simulation of real flesh and hair (fig. 680). In these sculptures Butler seems to observe the Super-Realism of sculptors like Duane Hanson and John De Andrea (figs. 974, 975). For these artists, however, precise naturalism is the desired end, whereas the works of Butler involve a peculiar form of self-expression that takes the figures beyond the stage of simple representation.

FRITZ WOTRUBA (1907–1975) Among noteworthy European sculptors utilizing the figure who emerged in the postwar era was the Austrian Fritz Wotruba. Beginning in a Classical vein, he gradually evolved a personal form of primitive image, with its roots in Cubism or more specifically in abstraction. His monumental figures, roughly carved from a single block of stone, are literally made up of cubes or cylinder shapes seemingly assembled to suggest the main masses of a standing, seated, or reclining figure (fig. 681).

HUNDERTWASSER (b. 1928) The Viennese Hundertwasser (Friedrich Stowasser) continued the Austrian Art Nouveau Expressionist tradition of Klimt and Schiele with the addition of strong overtones from Paul Klee. In the self-portrait seen here he created a brilliant pastiche of Art Nouveau decoration surrounded by touches of Expressionism and fantasy (plate 209).

The introspection of Hundertwasser's self-portrait in the painting

left: 679. REG BUTLER. *Girl*. 1954–56. Bronze, height 88¼". Hirshhorn Museum and Sculpture Garden, Smithsonian Institution, Washington, D.C.

below: 680. REG BUTLER. *Girl on Back*. 1968–72. Painted bronze, 33 × 34 × 51½". Pierre Matisse Gallery, New York

left: 681. FRITZ WOTRUBA. *Figure with Raised Arms.* 1956–57. Bronze, height 75¼". Hirshhorn Museum and Sculpture Garden, Smithsonian Institution, Washington, D.C.

above: 682. JOSEF SUDEK. *The Window of My Studio.* 1954. Photograph. ©Josef Sudek

just seen, with the image posed as if observed through a window, took a somewhat less morbid turn in the art of another Eastern European, the Czech photographer Josef Sudek (1896–1976). During the years 1944–53 Sudek devoted most of his creative effort to focusing his camera on whatever caught his eye through the window of his studio, which looked directly out on a street in Prague (fig. 682). Here, the Renaissance conception of the picture as a window opening onto a world of solid forms in deep space has been subverted to a modernist notion, which tends to construe the picture as a plane covered with elements that reveal nothing so much as the flatness of the surface and the configuration they form thereon. But however two-dimensional his image, Sudek filled it with his own special poetry, which the photographer explained thus: "I believe that photography loves banal objects. I am sure you know the fairy tales of Andersen: when the children go to bed, the objects come to life, toys, for example. I like to tell stories about the life of inanimate objects, to relate something mysterious: the seventh side of a dice."

683. KAREL APPEL. *Portrait of Willem Sandberg*. 1956. 51¼ × 31⅞".
Museum of Fine Arts, Boston. Tompkins Collection

CoBrA

In The Netherlands the postwar urge toward an Expressionist liberation from the rationalist constraints of geometric or Constructivist abstraction proved particularly urgent, arriving as it did in the very home of Mondrian and De Stijl. There in 1948 Karel Appel, Cornelis Corneille, and George Constant established the Experimental Group, seeking new forms of elemental expression, as much opposed to Mondrian and De Stijl as to the academy. Through contacts with similar groups in Copenhagen and Brussels, this evolved into the international Expressionist group CoBrA (Copenhagen, Brussels, and Amsterdam), of which the Danish painter Asger Jorn and the Belgian Pierre Alechinsky were other notable members. Most of the painters associated with the CoBrA group employed some sort of subject or figuration, usually derived from folk art, children's art, prehistoric or primitive art. The most important unifying principle among these divergent artists was their doctrine of complete freedom of abstract expressive forms, with accent on brush

gesture. In this they were allied to Dubuffet and Fautrier in France, for both of whom the artists of CoBrA had great respect, although the directions their free expression took were different, generally more violent, colorful, dynamic, and seemingly chaotic. The CoBrA artists, as noted, also differed widely among themselves, Asger Jorn and Karel Appel the more violent in their wild synthesis of forms and brilliant color, Pierre Alechinsky and Corneille in some degree more apparently controlled.

Karel Appel (b. 1921) has consistently painted figures and portraits with linear and coloristic enthusiasm (fig. 683; plate 210). Although his painting did not change radically during the 1970s, the figure seemed to emerge more specifically and with a wonderful quality of childlike madness (fig. 684).

Of all the CoBrA painters, with the exception perhaps of Appel, Asger Jorn (1914–1973) represents the most extreme reaction against concrete art's principles of order and harmony. Whereas Appel established a certain control through his representation of an explicit face or figure, Jorn produced paintings that at first glance have the impact of Ruskin's epithet concerning Whistler—a pot of paint flung in the face of the public. Using largely undiluted primary colors with blacks, whites, and greens, Jorn smeared, slashed, and dripped the paint in a seemingly uncontrolled frenzy (fig. 685). Yet the control, established in large, swinging, linear movements, and asymmetrically balanced color shapes remained sufficient to bring a degree of order out of chaos while not diminishing the explosive fury of the abstract expression (plate 211).

Pierre Alechinsky (b. 1924), by comparison, particularly in his earlier works of the 1950s, used an all-over structure of tightly interwoven elements with a sense of order deriving from microcosmic organisms (fig. 686).

684. KAREL APPEL. *Two Times*. 1974. 50 × 40". Collection Samuel and Ethel Roth

685. ASGER JORN. *Green Ballet.* 1960. 57 × 78¾″. The Solomon R. Guggenheim Museum, New York

686. PIERRE ALECHINSKY. *Ant Hill.* 1954. 59½ × 93⅞″. The Solomon R. Guggenheim Museum, New York

Pop Art, Assemblage, and Europe's New Realism

At this point the related developments of Pop Art, Happenings, environments, assemblage, and so-called *nouveau réalisme* must be discussed. The lines of demarcation between them are not sharp (sometimes they are not even meaningful), but in common these tendencies are concerned with the visible, tangible world—a world of objects and everyday events—as the basic material of their creative activities. Thus they are a powerful reaction to all forms of abstraction—even though often heavily dependent on the accomplishments of abstract art.

Two important exhibitions were held in New York late in 1961 and late in 1962. The earlier in date was The Museum of Modern Art's "The Art of Assemblage," while the other was the Sidney Janis Gallery's "New Realists." The MoMA show, organized by William C. Seitz, surveyed that aspect of modern art involving the accumulation of objects, from two-dimensional Cubist *papiers collés* and photographic montages, through every sort of Dada and Surrealist object, to Junk sculpture, and on to complete room environments. Seitz defined the assemblages thus: (1) "They are predominantly *asembled* rather than painted, drawn, modeled, or carved. (2) Entirely or in part, their constituent elements are pre-formed natural or manufactured materials, objects, or fragments not intended as art materials."

The New Realists' exhibition, mounted the following year, included a number of the recognized British and American Pop artists and also representatives of the French Nouveau Réalisme, and artists from Italy and Sweden working in related directions. Although the American Pop artists had been emerging for several years, Janis's show was an official recognition of their arrival. At the moment the term Pop Art was not generally applied to them, and their relations to European Nouveau Réalisme remained unclear. This exhibition made it apparent that these artists, all of whom were concerned with subject—in contradistinction to Abstract Expressionist or L'Art Informel artists—nevertheless were exploring it in strikingly individual ways. The Europeans seemed closer to the tradition of Dada and Surrealism, the British and Americans more involved in contemporary popular culture and representational, commercial images. For a number of years in the 1960s, different labels—Neo-Dadaists, Factualists, Popular Realists, New Realists, and Pop artists—were applied indiscriminately. Pop Art won the field, obviously because it provided a catchy, slangy title that was immediately picked up by newspapers, periodicals, and television. As we have noted, even in the United States it continues to be used loosely, so that with the possible exceptions of Rauschenberg, Johns, Warhol, Rosenquist, Wesselmann, Lichtenstein, and Oldenburg, most artists associated with the movement must be examined individually to determine their exact involvement. Included would be a few British and American artists such as Richard Hamilton, Peter Blake, Peter Phillips, David Hockney, and R. B. Kitaj in England, and Wayne Thiebaud and Mel Ramos in California.

The movement known as *le nouveau réalisme* was founded in 1960 by the critic Pierre Restany and the artist Yves Klein. A manifesto was issued in Milan, and exhibitions of the group were held at Restany's Gallery J. in Paris during late 1960 and in May 1961. The latter was labeled "40 Degrees Above Dada," indicating a kinship with the earlier movement. Restany's statement that "the new realism registers the sociological reality without any controversial intention" indicates a desire for impersonal presentation of subject without Expressionist or Social-Realist overtones. This aim was comparable to that of Pop Art, but the results proved as different as the artists involved. These included Klein, Martial Raysse, Arman Fernandez, César Baldaccini, Jean Tinguely, Daniel Spoerri, Raymond Hains, Jacques de la Villeglé, and François Dufrêne. All of these, with the exception of Klein, were included in the assemblage exhibition, and most were naturally in the New York New Realists show. The catalogue of the latter show quoted some excerpts from Pierre Restany:

In Europe, as well as in the United States, we are finding new directions in nature, for contemporary nature is mechanical, industrial and flooded with advertisements. . . . The reality of everyday life has now become the factory and the city. Born under the twin signs of standardization and efficiency, extroversion is the rule of the new world. . . .

Pop Art in Great Britain

Although Pop Art has often been regarded as an American phenomenon, it actually originated in England in the mid-1950s. The term was presumably coined by the English critic Lawrence Alloway but for a somewhat different context than its subsequent use. As Alloway himself pointed out, late in 1952 a group of young painters, sculptors, architects, and critics were meeting in London at the Institute of Contemporary Art. Called the Independent Group, those involved, aside from Alloway, were the architects Alison and Peter Smithson, the sculptor Eduardo Paolozzi, the architectural historian Reyner Banham, the artist Richard Hamilton, and others. The discussions focused around popular culture and its implications—such things as Western movies, space fiction, billboards, machines. In short they dwelled on aspects of the contemporary scene considered to be antiaesthetic. Out of these meetings emerged the term the New Brutalism (see p. 539) and, in the

left: 687. RICHARD HAMILTON. *Just What Is It That Makes Today's Homes So Different, So Appealing?* 1956. Collage, 10¼ × 9¾". Collection Edwin Janss, Jr., California

below: 688. PETER BLAKE. *On the Balcony*. 1955–57. 47¾ × 35¾". The Tate Gallery, London

works of Richard Hamilton, Paolozzi, and others, certain works that established much of the vocabulary and attitude of subsequent Pop Art.

RICHARD HAMILTON (b. 1922) One of the most fascinating of the pioneer Pop works is a small collage made in 1956 by Richard Hamilton and entitled *Just What Is It That Makes Today's Homes So Different, So Appealing?* (fig. 687). A photomural of this was used as a theme in an exhibition held at the Whitechapel Art Gallery in 1956 entitled "This is Tomorrow." Hamilton was a disciple of Marcel Duchamp, and it should be noted that Duchamp's philosophy of art or antiart has been perhaps the major influence on Pop artists. The other outstanding influence was, understandably, Kurt Schwitters. Hamilton's collage shows a "modern" apartment decorated with a haughty female nude and her mate, a muscle-man in a typical you-too-can-be-strong pose. The apartment is furnished with products of mass culture: television, tape recorder, an enlarged cover from a comic book, a Ford emblem, and an advertisement for a vacuum cleaner. Through the window can be seen a movie marquee featuring Al Jolson in *The Jazz Singer*.

The important point about Hamilton's, and subsequent Pop artists', approach to popular culture or mass media is that their purpose was not satirical or in any way antagonistic. They were not Expressionists such as George Grosz and the Social Realists of the 1930s who were attacking the ugliness and inequities of urban civilization. In simple terms, they were looking at the world in which they lived, the great city, and examining the objects and images that surrounded them with an intensity and penetration which frequently made one conscious of that reality for the first time.

PETER BLAKE (b. 1932) Of the other English Pop artists, one of the best known was Peter Blake, who took objects of popular idolatry, such as Elvis Presley, the Beatles, or pin-up girls, and presented them with a

seriousness and literalness that endowed the subjects with qualities of sympathetic sadness or humor (fig. 688).

PETER PHILLIPS (b. 1931) Like Blake and many of the younger experimenting English artists, Phillips was a product of the Royal College of Art, which had recently become one of the most progressive art schools in the world. His paintings, brilliant in color and aggressive in their organization of precisely represented machine objects, came close in feeling to some of the contemporary American Pop artists such as James Rosenquist or Tom Wesselmann (plate 212).

ALLEN JONES (b. 1936) During the 1960s Jones was concerned with an erotic imagery—partial figures of girls with gartered stockings revealing long areas of thigh. The imagery became more explicit in the 1970s with full-length stripteases, complete with the accolade of the male audience (fig. 689).

R. B. KITAJ (b. 1932) An ambiguous but crucial figure in the development of English Pop is the American R. B. Kitaj, who studied in the Royal College under the G.I. Bill and has since lived mainly in England. Kitaj painted and continues to paint everyday scenes or modern historical events and personalities in simple, broad, flat color areas combined with strong linear emphasis (fig. 690). His works are fragmented images involving every kind of association and a sense of incompleteness

that in itself has an impact of fantasy and grotesquerie. Although it is difficult to define his work narrowly within the tradition of Pop Art, despite the comic-strip look of the work, his images had a great influence on the English Pop artists and the latter influenced him. Unique to Kitaj, however, was an emphatic disinterest in popular culture, counterbalanced by a serious, wide-ranging commitment to ideas and literature of the highest order, often mixed in his paintings as an evocative combination of words and images derived from sources too complex to yield a clear or specific message. Characteristic is the work seen here, offering a Parisian café scene in which the German-born critic Walter Benjamin can be identified, juxtaposed to a man wielding a red pick, as if to announce the calamities of 1940 that would scatter such bright company and drive Benjamin to suicide as the German army began occupying the French capital.

DAVID HOCKNEY (b. 1937) A fellow student of Kitaj's at the Royal College was the precocious David Hockney, so gifted and productive that he had already gained international fame by the time of his graduation. Emerging within the same period as the Beatles, Hockney—with his peroxide hair, granny glasses, gold lamé jacket, and easy charm—became something of a media event in his own right, a genial exponent of the go-go, hedonistic style of the 1960s. Symptomatically, he celebrated his adventures during a 1961 visit to New York by creating a series of etchings entitled *A Rake's Progress*. But in his Pop-like attempt

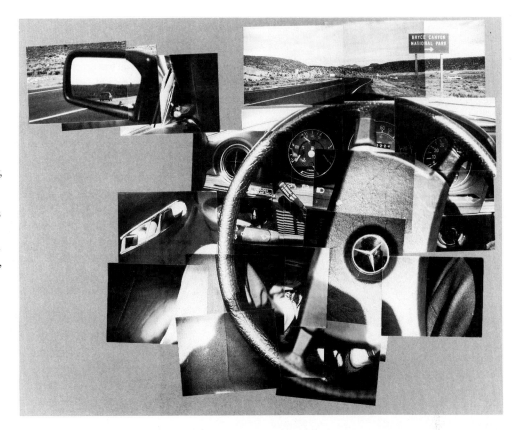

right: 691. DAVID HOCKNEY. *Steering Wheel*. Utah, October, 1982. Photographic collage, 30 × 36″. ©David Hockney. Published by Petersburg Press

below: 692. TONY RAY-JONES. *Glyndebourne*. 1967. Gelatin-silver print. ©Anna Ray-Jones, New York

to close the gap between art and life, Hockney drew neither imagery nor style from the comics and the ads; instead he used his own life and the lives of his friends and lovers—their faces and figures, houses and interiors—and rendered them with the slyest, most knowing means in modern art, sometimes inspired by Picasso and Matisse, but often, in a delicate *faux naif* manner, by children, or, again, by the rich Rubensian sweep of an admired older contemporary such as Francis Bacon (plate 208). Hockney loves to go out in the midday sun, especially in Southern California where he has long maintained a residence. There the swimming pool became a central image of his art, complete with its cool, synthetic hues and, often, handsome human flesh. This, however, has already disappeared below the surface in *A Bigger Splash* (plate 213), a painting that combines Hockney's signature equilibrium of elegant Matissean flat-pattern design and luxurious mood with something of Bacon's painterly virtuosity for the splash itself. As wittily deadpan as he is poetic, Hockney has commented on his bemusement over the brevity of the water's leap into the air, contrasted to the extended time it took him to paint the frozen effect. The sense of suspended animation prompted one critic to describe the distinctive character of Hockney's art as the "epitome of expectant stillness." This, along with the peculiar high-noon brightness—like an Ektachrome slide—was made possible by the artist's habit of working from photographs. Infatuated with the Polaroid, Hockney has recently been using it to reexplore the riches of the space-time equation investigated by Braque and Picasso in Analytic Cubism (fig. 691). Hockney so loves the camera that he once starred in his own movie—entitled, no less, *The Bigger Splash*—and favored his viewers with the sight of him playing a scene in the nude.

Another exceedingly English artist within the ambience of 1960s Pop, and one imbued with a measure of Hockney's warmth, charm, and wit, was Tony Ray-Jones (1941–1972), who used his camera to indulge an abiding love for the oddities and eccentricities of English daily life.

In his all-too-brief career, the peripatetic Ray-Jones prowled whatever precincts—beach resorts, festivals, dog shows, trade conventions, beauty contests—attracted people in sufficient numbers for his fellow countrymen to reveal themselves at their most characteristic and thus peculiar (fig. 692). But having studied design at Yale and photography under Alexey Brodovitch and Richard Avedon at the Design Laboratory in New York, Ray-Jones was also a master of his craft and therefore all but equal to Hockney in his awareness of tonal and compositional values. In 1968 the photographer made this comment about his work: "My aim is to communicate something of the spirit and the mentality of the English, their habits and their way of life, the ironies that exist in the way they do things, partly through tradition and partly through the nature of their environment and mentality."

693. EDUARDO PAOLOZZI. *Medea.* 1964. Welded aluminum. 81 × 72 × 45".
Robert Fraser Gallery, London

EDUARDO PAOLOZZI (b. 1924) One sculptor was of particular importance in the development of British Pop Art during the 1950s. This is Eduardo Paolozzi. Originally influenced by Giacometti, Paolozzi, after 1954, became obsessed with the relations of technology to art and emerged as a serious spokesman for Pop culture. His sculptures, although cast in bronze, were essentially assemblages of machine parts translated into persuasively human or animal monsters. In the mid-1960s Paolozzi pursued many studies and experiments in the area of industrial society that climaxed in a series of his most effective works to that time. These were constructed principally of polished aluminum and vary from austere, simplified forms to elaborate machine constructions that take on a life of their own (fig. 693). In fact, among the sculptors who were increasingly drawn to machine forms, Paolozzi may have been the most explicit in his suggestion that the machine could actually operate.

Pop Art in the United States

Pop Art in all its manifestations was given its greatest impetus in the United States during the 1960s. This was an art that had a natural appeal to American artists, living in the midst of the most blatant and pervasive industrial and commercial environment. Many of the images used by the British Pop artists during the later 1950s derived from American motion pictures, popular idols, comic strips, or signboards. In the case of the English artists these were viewed at some remove, thus frequently being instilled with romantic, sentimental overtones. For

the American Pop artists, once they realized the tremendous possibilities of their everyday environment in the creation of new subject matter, the result was generally more bold, aggressive, even overpowering, than in the case of their European counterparts.

American Pop Art was first of all a major reaction against the Abstract Expressionism that had dominated painting in the United States during the late 1940s and the 1950s. Toward the end of the latter decade, as we have already noted, there were many indications that American painting would return to a new kind of figuration, a new humanism. A number of talented artists emerged using as a theme the figure in a Renaissance environment. This, however, would only be a looking back, and something more positive was needed in the search for a new subject. American art had a long tradition of interest in immediate environment that extended to the *trompe-l'oeil* paintings of the nineteenth century and was kept alive by many of the Precisionist painters during the early twentieth century, most particularly by Stuart Davis. Marcel Duchamp's long residence in the United States and his antiart program had a gradually increasing influence on younger artists during the 1950s. This was also true of Léger's machine Cubism. Léger, during his American sojourn of the 1940s, became involved in an almost literal exaltation of the industrial scene. Duchamp, of course, led younger painters back to Dada and most specifically to Kurt Schwitters, who has been perhaps the greatest influence on Pop artists aside from Duchamp. In the latter 1950s, artists were becoming concerned with Pop Art and pop culture not only in England but also in France, where the movement known as *le nouveau réalisme* was gaining strength.

RICHARD LINDNER (1901–1978) There were many artists other than those mentioned who could be considered examples of proto-Pop. Richard Lindner came to the United States from his native Germany in 1941 and gained a gradually increasing reputation during the 1950s and 1960s. His work is related to the machine Cubism of Léger as well as that of Schlemmer. He created a curious and personal dream world of tightly corseted mannequins who at times seem to be caricatures of erotic themes, with bright, flat, even harsh colors and every kind of dissociated image (plate 214). These images, which are strange and filled with personal and literary associations, recapitulate the artist's past. Lindner provided a specific link between certain aspects of early Surrealism, machine Cubism, and the mechanistic wing of American Pop Art.

LARRY RIVERS (b. 1923) Rivers is a talented, brilliant eclectic whose paintings represent almost a history of American styles at mid-century. His literal, explicit studies of nudes painted in 1954–55 were one of the first major attacks on Abstract Expressionism (fig. 694). In the same period Rivers was experimenting with figure sculpture in the tradition of Rodin and Medardo Rosso. Since the mid-1950s, he has developed a characteristic image rooted in Cubist (specifically early Duchamp) fragmentation and simultaneity. The reexamination of American history and of Old Master paintings seen in reproduction has particularly intrigued him (fig. 695). Rivers cannot be described exactly as a Pop artist, but he shares the concern for the everyday image while differing in the degree of Expressionist commentary.

ROBERT RAUSCHENBERG (b. 1925) The most important painter in the establishment of American Pop's vocabulary is Robert Rauschenberg, who studied at the Académie Julian in Paris and in the late 1940s at Black Mountain College, North Carolina, with Josef Albers. Jasper Johns, another important pioneer of Pop, was there at the same time.

From Albers, Rauschenberg learned not so much a style as an attitude. Although he considers Albers the most important teacher he ever had, even more important in his development was the presence at Black Mountain of the composer John Cage, perhaps the greatest single influence in the development of Pop Art as well as offshoots such as Happenings, environments, and innumerable experiments in music, theater, dance, and so-called "mixed media" productions.

In January 1955, in an exhibition at the Egan Gallery, Rauschenberg introduced what he called "combine" paintings, in which he bodily incorporated objects into the structure of the canvas. These at first were relatively modest collage elements—photographs, prints, or newspaper clippings such as might have been accumulated on the walls of his studio. There was one outstanding exception, *The Bed* (fig. 696), which included a pillow and quilt over which paint was splashed in an Abstract Expressionist manner. Rauschenberg came out of Abstract Expressionism and has never entirely departed from it. His most spectacular combine painting, the 1959 *Monogram* (fig. 697), with a stuffed ram encompassed in an automobile tire, includes a painted and collage base in which free brush painting acts as a unifying element.

The combine paintings of Rauschenberg had their obvious origin in the collages and constructions of Schwitters and some of the other Dadaists. The American artist's motivation and approach, however, were different not only in the great spatial expansion, but also in the use of the topical, the specific association with which the artist at the same moment was concerned. It was this attempt to create a unity out of impermanent materials, topical events, and an expressive brushstroke that gave his paintings their particular qualities and raised numerous questions concerning the nature of subject and abstraction in the later twentieth century.

During the 1960s Rauschenberg, like many other artists, increasing-

above left: 696. ROBERT RAUSCHENBERG. *The Bed.* 1955. Construction, 74 × 31″. Collection Mr. and Mrs. Leo Castelli, New York

above right: 697. ROBERT RAUSCHENBERG. *Monogram.* 1959. Construction, 48 × 72 × 72″. Leo Castelli Gallery, New York

below: 698. ROBERT RAUSCHENBERG. *Lake Placid Glori-Fried Yarns from New England.* 1971. Cardboard, plywood, rope, and wood pole, 9′6¾″ × 13′5″ × 8″ (width variable). Leo Castelli Gallery, New York

above: 699. JASPER JOHNS. *Flag*. 1954. Encaustic and collage on canvas,
42 × 60″. Collection Philip Johnson, New York

right: 700. JASPER JOHNS. *Target with Plaster Casts*. 1955. Encaustic collage
on canvas with wood construction and plaster casts, 51 × 44 × 3½″.
Collection Mr. and Mrs. Leo Castelli, New York

ly used silkscreen transfers to create a kaleidoscope of images deriving from the daily press and motion pictures even more than from the example of the Dadaists (plate 215). Frequently his ideas and images have been taken over by younger Pop artists, but his overriding concern with the creation of a total harmony out of the most disparate elements and his actual concern for the subject make him, rather than a Pop artist, a painter not only in the tradition of Abstract Expressionism but of Expressionism in its broader subject sense.

In the late 1960s and in the 1970s Rauschenberg, like many of the original Pop artists, was involved in a wide variety of activities, including dance and performance. In the specific areas of painting and sculptural constructions, some of his most interesting concepts are the large-scale cardboard constructs created for specific spaces and the silkscreen transfers on textile materials (fig. 698; plate 216). Rauschenberg remains one of the most inventive and impressive of the American artists to emerge from Abstract Expressionism. With a career extending from that movement through Pop Art to forms of Conceptualism, he cannot be classified narrowly. Rauschenberg quite simply continues to be a major force in contemporary art.

JASPER JOHNS (b. 1930) Johns appeared on the New York scene in 1955 at the same moment as Rauschenberg, with personal images entirely different but equally revolutionary. These were, at first, paintings of targets and American flags executed in encaustic with the paint built up almost in relief (fig. 699). The paintings were executed with such precision and neutrality as to become objects in themselves rather than reproductions of familiar objects. Johns's early paintings were of great importance in shaping contemporary art attitudes. In addition to targets and flags, he took the most familiar items—numerals and number charts, color charts, maps of the United States—and then painted them, particularly in his earlier works, with an absolute objectivity, an objectivity nevertheless sullied by the occasional intrusion of mysterious, romantic elements such as the plaster-cast body parts in *Target with Plaster Casts* (fig. 700). In this work he would seem to have

asserted an utter impartiality toward two equally valid forms of representation: illusionistic or illustrational and emblematic or abstract. The enigmatic result, paradoxically, is that Johns's object—flag, target, number chart—ceases to be a reproduction of anything and takes on an identity of its own. This element of impersonality—the creation of a work of art which, even if it includes a recognizable subject, has no existence other than as an object in itself—became central to many of the painters and sculptors of the 1960s.

Johns also produced a number of sculptures that have stated the Pop Art problem of the everyday object which, in Duchamp's phrase, becomes a work of art because the artist says it is. By taking a coffee can filled with paintbrushes, or two beer cans, and casting them in bronze,

701. JASPER JOHNS. *Painted Bronze (Beer Cans)*. 1960. Painted bronze,
5½ × 8 × 4¾″. Private collection

702. JASPER JOHNS. *Weeping Women*. 1975. Encaustic on canvas, 4′2″ × 8′6¼″. Collection Mildred and Herbert Lee, Belmont, Massachusetts

he immortalized the commonplace (fig. 701). Again, the motivation of Johns was somewhat different from other Pop artists' in that he continually seemed to be concerned with the creation of a work of art, no matter what the subject may be.

From the end of the 1950s, Johns's paintings became more free in the use of Expressionist brushstrokes and in the interpolation of objects. As such, they seemed to draw closer to the combine paintings of Rauschenberg (plate 217).

In the 1970s Johns did paintings that suggest a continuing dialogue between his passions for painterliness and for precision. In the triptych *Voices Two* (plate 218), while using his familiar number and letter symbols, he assimilated them into a powerfully integrated and broadly brushed gray field. On the other hand, subsequent works combined relief structures with precise painted patterns. In an exhibition at the beginning of 1976 the trend to precision was evident in a group of new paintings in which Johns explored a form of tight linear, crosshatch, or "tweed" pattern in a number of variations. Of this group, *Weeping Women* maintains the painterly and atmospheric approach, despite the inclusion of the carefully delineated irons (fig. 702). In this work there is as well a curious reminiscence of Futurist figuration, and perhaps of Duchamp's *Nude Descending a Staircase*.

In his more recent paintings, such as *Ventriloquist* (plate 219), Johns has projected a pessimistic mood, not only in lugubriously exquisite colors—including a double flag chromatically reversed into "negative" hues—but also in the imagery. Within the latter can be detected, for instance, an outline of that Melvillean nemesis Moby Dick submerged in the abstract, "straightened" hatching on the left and a rendering of a sheet from Barnett Newman's lithograph series called *Stations of the Cross*. The view is that from Johns's bath, and the title of the work, meaning a voice from another place, suggests that the images represent random thoughts or reveries of the intimate, personal sort which float up from the Surrealist subconscious in moments of relax-

ation, as when soaking in a tub. But they also summarize much of Johns's career, as do the encaustic medium and the concatenation of styles, from the Peto-like *trompe-l'oeil* technique used for the hinges joining the two halves of the "diptych," the Braque-like nail, the sexually evocative faucet, and the pottery made by a friend, through Newman's Abstract Expressionist manner, where Johns began, to the Minimalist mode of the overall field, whether "combed" on the left or merely scumbled on the right. Using a Pop vocabulary of mixed-media effects and lucid legibility, Johns has begun to lead beyond the paradoxes of art-making through the "perilous night" of life itself, to evoke the title of another work in the artist's latest and most complex series of works.

THE SNAPSHOT AESTHETIC IN AMERICAN PHOTOGRAPHY As the vernacular resources and the mixed media of Pop artists would suggest, photography had become an even-more dominant presence in Western culture. While this made the camera a virtually indispensable tool in every kind of artistic endeavor, the familiarity and growing facility of light-sensitized imagery tended to deheroicize the mystical pretensions and technical perfection sought by, for instance, Stieglitz, Weston, and White. In the place of such elevated straight photography came the "snapshot aesthetic," its subject matter derived from the everyday "social landscape" and its procedures as deceptively haphazard as such fare would require. The Pop-like distance and irony of the new photography first emerged, appropriately enough, in the work of an artist from abroad, the Swiss-American Robert Frank (b. 1924). Aided by a Guggenheim grant, Frank in 1955 set upon a journey of discovery throughout the United States, using his 35mm camera to take a fresh, detached, but ultimately critical, if not absolutely damning, look at American society soaked in consumerism, superciliousness, and waste (fig. 703). In the image seen here, what better visual metaphor could there be for the inanity and ballyhoo that plague the legitimacy of the national political process? If Frank, as he says, states his opinions out of love, native-born

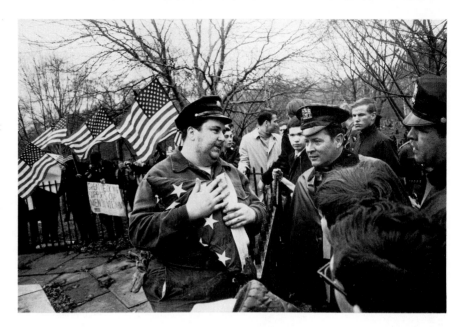

below: 703. ROBERT FRANK. *Political Rally, Chicago, 1956*. Gelatin-silver print. ©Robert Frank, from *The Americans*, 1958

right: 704. GARRY WINOGRAND. *Peace Demonstration, Central Park, New York*. 1970. Gelatin-silver print

below right: 705. JIM DINE. *Child's Rainbow Closet*. 1962. Oil on canvas with wood, metal, comb, and brush, 72 × 48″. Whereabouts unknown

Garry Winogrand (1928–1984) felt no compunctions about making blunt humor the primary impetus of his approach to the American scene (fig. 704). Along the way he has also forgotten nothing of the aesthetic principles learned while a painting student at Columbia University, for however informal *Peace Demonstration* may appear, as in the tipping of the camera, the resulting image is a marvel of conflicting patterns contained and somehow controlled with the rigor of a Gustav Klimt (plate 28). So much could be said for the whole of Pop Art, for

underlying its surface vulgarity rests a solid substructure of high art tradition. Herein, moreover, lies a significant source of the irony felt, if not seen, to be pervading most Pop works.

JIM DINE (b. 1936) Dine, like Rauschenberg and, later, Johns, had roots in Abstract Expressionism, although he seemed to treat it with a certain irony, combining brush-gesture painting with objects out of Duchamp (figs. 705, 706). These are not only physically present but fre-

706. JIM DINE. *Hatchet with Two Palettes, State #2*. 1963. Oil on canvas with wood and metal, 72 × 54″. The Harry N. Abrams Family Collection, New York

quently are also reiterated in painted images or shadows, and then reiterated again through lettered titles, as though the artist were giving an elementary lesson with ironic overtones in the various dimensions of reality.

ROY LICHTENSTEIN (b. 1923) Lichtenstein may have defined the basic premises of Pop Art (if anyone could) more precisely than any other American painter. He took as his primary subject the most banal comic strips or advertisements and enlarged them faithfully in oil or acrylic paint, using limited, flat colors and hard, precise drawing (fig. 707). The result is a hard-edge subject painting that documents while it gently parodies the familiar hero images of modern America. It should be noted that Lichtenstein deliberately selected the old-fashioned comic strip, of violent action and sentimental romance, rather than the new sophisticated strip. Using the comic-strip technique, down to the Ben Day printing dots, he has also made free adaptations of reproductions of paintings by Picasso and Mondrian. In the 1960s he created landscapes and whiplash, Abstract Expressionist works with his quasi-mechanical means (fig. 708). Thereafter, Lichtenstein has concentrated more and more on large-scale abstract variations on famous paintings by the masters of modern art, all translated into the artist's characteristic dot-and-line technique (plate. 220).

These adaptations of the works of painters of the past constitute a fascinating chapter in the history of postwar painting, both in Europe and in America. There is nothing new about such a tendency. Artists of all periods in history have copied or adapted works by past masters as a studio exercise to understand better the approach of the older artist or as a deliberate translation into a new image. We are reminded of Van Gogh's free copies of Millet or Picasso's adaptations of Velázquez or Delacroix (fig. 426).

The paintings of Lichtenstein, as well as those of Wesselmann, Rosenquist, and Warhol, share not only an attachment to the everyday, commonplace, or vulgar image of modern industrial America, but also the treatment of this image in an impersonal, neutral manner. They do not comment on the scene or attack it like Social Realists, nor do they exalt it like ad men. They seem to be saying simply that this is the world we live in, this is the urban landscape, these are the symbols, the interiors, the still lifes that make up our own lives. As opposed to the Junk sculptors, the assemblage artists who have created their works from the rubbish, the garbage, the refuse of modern industrial society, the Pop artists deal principally with the new, the "store-bought,"

707. ROY LICHTENSTEIN. *Whaam*. 1963. Magna on two canvas panels, 5′8″ × 13′4″. The Tate Gallery, London

the idealized vulgarity of advertising, of the supermarket, and of television commercials.

JAMES ROSENQUIST (b. 1933) Rosenquist for a period was a billboard painter, working high over New York's Times Square. The experience of painting glamour girls with faces thirty feet in diameter gave him an extreme close-up vision of commercial art, which he then translated into huge paintings of fragmented reality put together under the control of Cubism. As compared with Lichtenstein, Rosenquist was de-voted to the organization of the total picture surface and, on occasion, to pictorial effects that can only be described as Expressionist. An extremely ambitious painting of 1965 is *F-111*, ten feet high and eighty-six feet long, capable of being organized into a complete room, to surround the spectator (fig. 709). This work, named after an American fighter-bomber, comprises a series of images of destruction combined with prosaic details of happy, everyday American life in the 1960s—an impressive if somewhat confusing indictment of mechanized, or any other kind of, warfare.

710. TOM WESSELMANN. *Interior No. 2.* 1964. Mixed media, including fan, clock, light, 60 × 48 × 60″. Private collection

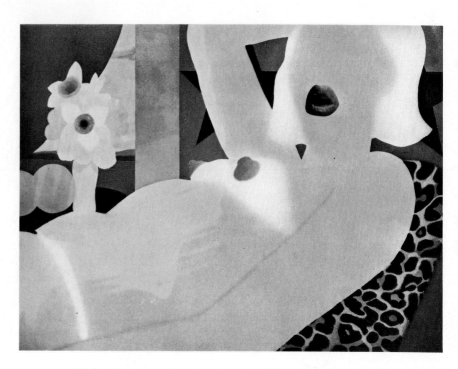

711. TOM WESSELMANN. *Great American Nude #57.* 1964. Collage, 48 × 60″.
Private collection

TOM WESSELMANN (b. 1931) Wesselmann came forward as the artist of the television commercial and of movie-magazine sex. Using assemblage elements—real clocks, television sets, air conditioners, with photomontage effects for window views, plus sound effects—he created an urban environment in which the aggressive reality of actual objects or photographic images gave them a sense of unreality as compared with the painted passages (fig. 710). For a number of years he played variations on the theme of the Great American Nude, a faceless American sex symbol, pristine and pneumatic, but no more sensual than his supermarket groceries are edible (fig. 711). However, in

712. ANDY WARHOL. *Marilyn Monroe.* 1962. Oil, acrylic, and silkscreen enamel on canvas, 20 × 16″. Collection Jasper Johns, New York

713. ANDY WARHOL. *Electric Chair.* 1965. Acrylic and silkscreen enamel on canvas, 22 × 28″. Leo Castelli Gallery, New York

Colorplate 212. PETER PHILLIPS. *Custom Painting No. 3.* 1964–65. Oil on canvas, 84 × 69″. Collection Watson Powell, Des Moines, Iowa

Colorplate 214. RICHARD LINDNER. *Hello.* 1966. 70 × 60″. Private collection, New York

Colorplate 213. DAVID HOCKNEY. *A Bigger Splash.* 1967. Acrylic on canvas, 96⅛ × 96⅛″. The Pantechnicon, London

Colorplate 215. ROBERT RAUSCHENBERG. *Estate*. 1963. 96 × 70″.
Philadelphia Museum of Art

Colorplate 216. ROBERT RAUSCHENBERG. *Blue Urchin* (Hoarfrost Series).
1974. Collage and solvent transfer on cloth, 76 × 49″. Sonnabend Gallery,
New York

Colorplate 217. JASPER JOHNS. *Field Painting*. 1964. Oil and canvas on wood with objects, 72 × 36¾". Collection the Artist

Colorplate 219. JASPER JOHNS. *Ventriloquist*. 1983. Encaustic on canvas, 75 × 50". Museum of Fine Arts, Houston. Museum purchase with funds provided by Agnes Cullen Arnold Endowment Fund

Colorplate 218. JASPER JOHNS. *Voices Two*. 1971. Oil and collage on canvas, triptych, each panel 72 × 50". Kunstmuseum, Basel

left: Colorplate 220. ROY LICHTENSTEIN. *Artist's Studio: The Dance*. 1974. Oil and magna on canvas, 8′ × 10′8″. Mr. and Mrs. S.I. Newhouse, Jr., New York

below left: Colorplate 221. TOM WESSELMANN. *Smoker #17*. 1975. 8′ × 10′11″. Sidney Janis Gallery, New York

right: Colorplate 222. ANDY WARHOL. *Green Coca-Cola Bottles*. 1962. 6′10″ × 8′9″. Private collection, New York

above right: Colorplate 223. WAYNE THIEBAUD. *Pie Counter*. 1963. 30 × 36″ The Whitney Museum of American Art, New York

opposite: Colorplate 224. CLAES OLDENBURG. *Standing Mitt with Ball*. 1973. Steel, height 12′ Collection Mr. and Mrs. Albrecht Saalfield

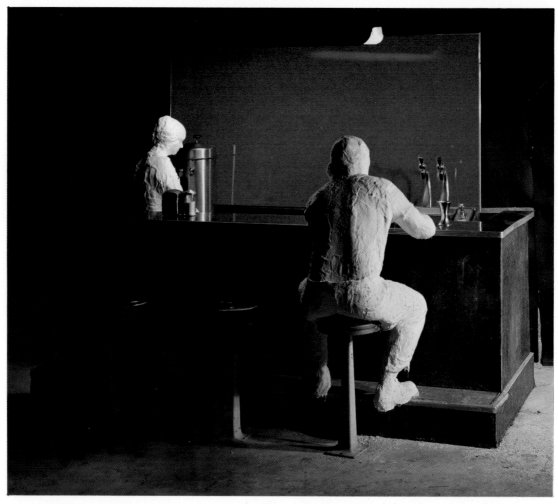

Colorplate 225. GEORGE SEGAL. *The Diner*. 1964–66. Plaster, wood, chrome, masonite, and formica, 8′6″ × 9′ × 7′3″.
Walker Art Center, Minneapolis

Colorplate 227. LOUISE NEVELSON. Left: *An American Tribute to the British People*. 1960–65. Wood painted gold, 10′2″ × 14′3″. The Tate Gallery, London.
Right: *Sun Garden, No. 1*. 1964. Wood painted gold, 72 × 41″. Collection Mr. and Mrs. Charles M. Diker

Colorplate 226. MARISOL. *The Family*. 1962. Painted wood and other materials in three sections, 82⅝″ × 65½″. Collection, The Museum of Modern Art, New York

Colorplate 228. LOUISE BOURGEOIS. *The Destruction of the Father*. 1974. Latex and stone, length 7′. Collection the Artist

Colorplate 229. YVES KLEIN. *Fire Painting*. 1961–62. Flame burned into asbestos with pigment, 43 × 30″. Alexandre Iolas Gallery, New York

Colorplate 230. YVES KLEIN. *Blue Monochrome*. 1961. Oil on cotton cloth over plywood, 6'4⅞" × 55⅛". Collection, The Museum of Modern Art, New York. Sidney and Harriet Janis Collection (fractional gift)

714. DUANE MICHALS.
Paradise Regained. 1968.
Series of gelatin-silver
prints. ©Duane Michals,
Courtesy Sidney Janis
Gallery, New York

Smoker #17 (plate 221), which is simply a forthright depiction of the cigarette smoker's hand and mouth encased in a haze of smoke, Wesselmann achieved an image that is almost alarmingly erotic. This painting, measuring eight feet by ten feet eleven inches, was symptomatic of the general trend toward the monumental in painting and sculpture that marked the period. Although James Rosenquist was among the very first to realize the possibilities of the extreme close-up, none of the many other painters who used this approach did so to better effect than Wesselmann.

ANDY WARHOL (b. 1930) The artist who more than any other stands for Pop in the public imagination, through his paintings, objects, underground movies, and personal life, is Andy Warhol. Like several of the other Pop masters, Warhol was first a successful commercial artist. Initially, as a Pop figure, he drew attention through his concentration on standard brands and supermarket products—Coca-Cola bottles, Campbell's soup cans, and Brillo cartons (plate 222). His most characteristic manner was repetition—endless rows of Coca-Cola bottles, literally presented, and arranged as they might be on supermarket shelves or as they might pass in review on a television commercial. From this he turned to the examination of the contemporary American folk hero—Elvis Presley, the love goddesses Elizabeth Taylor and Marilyn Monroe (fig. 712). Using silkscreen processes for mechanical repetition, Warhol further emphasized his desire to eliminate the personal signature of the artist, to depict the life and the images of our time without comment.

For a period in the mid-1960s, Warhol utilized scenes of destruction or disaster taken from press photographs and presented them with the same impersonality, suggesting that these also are aspects of the current scene to which familiarity breeds indifference. In such gruesome pictures of automobile wrecks the nature of the subject makes the attain-

ment of a neutral attitude more difficult. *Electric Chair* (fig. 713), taken from an old photograph, shows the grim, barren death chamber with the empty seat in the center and the sign SILENCE on the wall. Presented by the artist either singly or in monotonous repetition, the scene becomes a chilling image, as much through the abstract austerity of its organization as through its associations.

In the later 1960s Warhol turned more and more to the making of films, so-termed "underground movies." Using his principle of monotonous repetition, which gradually becomes hypnotic in its effect, he documented the world in which he lived. Although these films and even the process of making them contained strong elements of parody of the commercial film world, they were a serious and sometimes important venture on the part of the artist. The story line, particularly as it dealt with erotic themes, gradually became stronger, at the same time that some of the films yielded (for experimental movies) substantial financial rewards. Warhol's turning to the films was also symptomatic of the synthesis of media—the "mixed media"—that entered into the work of Pop artists.

During the 1970s, Warhol increasingly made the subject of his art his own image and that of his entourage, and he has been remarkably imaginative and successful in the promotion of these subjects. He appears regularly in the society columns, and according to one tradition, he even did a lecture tour by proxy, sending along one of his followers as a Warhol replacement. His published autobiography reinforces the impression of him as a highly intelligent and witty commentator on the contemporary scene. Meanwhile, the scene itself is reported monthly in Warhol's newsprint magazine *Interview*.

The serial arrangements, the narrative content, and even the narcissism found in Warhol's art appeared in the personal photography of Duane Michals (b. 1932), who acquired such proclivities from the same source as Warhol—Madison Avenue, where Michals works regu-

715. ROBERT INDIANA.
The Demuth Five. 1963. 68 × 68″ (on the diagonal). Private collection

716. ROBERT INDIANA. *LOVE*. 1972. Polychrome aluminum, 72 × 72 × 36″.
Galerie Denise René, Paris

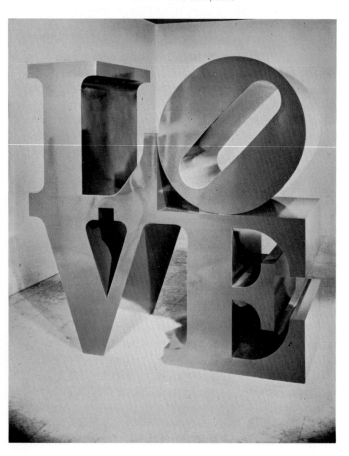

larly as a commercial photographer. Convinced that a single image offers little more than the record of a split second cut from the ongoing flow of time, Michals constructs "photostories," or playlets, to expose or symbolize the reality behind our perceptions of it (fig. 714). "I use photography," the artist says, "to help me explain my experience to myself. . . . I believe in the imagination. What I cannot see is infinitely more important than what I can see." In the sequence reproduced here, Michals and his sister subject seem to be stepping back in time until, as the clothes gradually vanish and the vegetation expands, they have rediscovered themselves in the primal state of Adam and Eve in the Garden of Eden.

ROBERT INDIANA (b. 1938) Robert Indiana (Robert Clark of Indiana), Allan D'Arcangelo, and Ed Ruscha are descendants of the American Precisionists. Indiana even painted a figure 5 in homage to Demuth (fig. 715; plate 168). Like Stuart Davis, he has been obsessed with word images, in his case attaining a stark simplicity that suggests the flashing words of neon signs (with distinctions)—EAT, LOVE, DIE. These are rendered in clashing colors and precise, hard-edge color shapes that relate him both to the Op and Color Field painters of the 1960s. Unlike most of Pop Art, which manifests little or no overt comment on society, Indiana's word-images are often bitter indictments, in code, of modern life, and sometimes even a devastating indictment of brutality, as in his Southern States series. However, it was with his rendering of LOVE that Indiana assured a place for himself in the history of the times (fig. 716). He continued to produce, among other new images, many LOVE variations on an ever-increasing scale, as in the large sculpture seen here.

ALLAN D'ARCANGELO (b. 1930) D'Arcangelo took as his theme the highway, usually the super-highway with road signs appearing and disappearing as drivers move across the nation (fig. 717).

717. ALLAN D'ARCANGELO. *Full Moon*. 1963. Acrylic on canvas, four panels
61 × 64″. Collection Kimiko and John G. Powers, New York

ED RUSCHA (b. 1937) Ruscha too used filling stations to symbolize the monotonous conformity of the American scene (fig. 718), a process he would continue in photographic "documentation" during a later Conceptual phase (figs. 905, 906).

WAYNE THIEBAUD (b. 1920) and MEL RAMOS (b. 1935) Two California painters more directly in the stream of Pop Art are Wayne Thiebaud and Mel Ramos, both of Sacramento. Their palettes are similar in their bright, commercial vulgarity. Thiebaud has specialized in still lifes of carefully arranged, meticulously depicted, lusciously brushed and colored, singularly perfect but unappetizing bakery goods (plate 223). Ramos developed as his image the playmate or calendar nude of contemporary folklore. Displaying her ample charms and smiling a fetching, synthetic smile, she is gracefully posed on an oversized hamburger or piece of cheese as in *Val Veeta* (fig. 719). Ramos apotheosizes the original commercial art versions. His satire of both girlie magazines and aspects of American advertising can only be described as deadpan.

ERNEST TROVA (b. 1927) Trova has invented a disconcerting symbol of humanity in modern times. Anonymous, human yet machined, with machine appendages, this robot-man tumbles, stands at eternal attention, strides, or reclines. Whatever his stance, he seems to be in the process of turning into yet another machine of his own invention. The total effect of Trova's figures is to provide a glimpse into a frightening science-fiction future into which humanity has stumbled (fig. 720).

Happenings and Environments

The concept of mixing the various media and, more importantly, the arts with life, was an integral aspect of the Pop revolution. The leading spokesman for this attitude remains Allan Kaprow, the creator of Happenings and environments. The first of these, entitled *18 Happenings in 6 Parts*, was held at the Reuben Gallery in 1959. The Reuben Gallery, in existence only during 1959 and 1960, became one of a group of struggling art galleries in downtown New York, important as experimental centers in which many of the leading younger artists of the 1960s first appeared. Among those who showed at the Reuben Gallery, aside from Kaprow, were Jim Dine, Claes Oldenburg, George Segal, and

720. ERNEST TROVA. *Study for Falling Man.* 1966. Polished silicone, bronze, and enamel, 20 × 72 × 28". Private collection

Lucas Samaras. Another indication of the internationalization of modern art must also be seen in this connection. The Japanese have made some claim to priority in Happenings, since the so-called Gutai Group, of Osaka, staged Happening-like performances as early as 1955, and from 1957 onward such performances were held in Tokyo as well as Osaka.

Happenings may have had their ultimate origins in the Dada manifestations held during World War I. They might even be traced to the improvisations of the *commedia dell'arte* of the eighteenth century. In the 1940s the composer John Cage was experimenting with musical forms that involved unplanned audience participation. Happenings have also been considered a development into action out of the principles of collage (fig. 721). Kaprow has defined a Happening as

> ... an assemblage of events performed or perceived in more than one time and place. Its material environments may be constructed, taken over directly from what is available, or altered slightly; just as its activities may be invented or commonplace. A Happening, unlike a stage play, may occur at a supermarket, driving along a highway, under a pile of rags, and in a friend's kitchen, either at once or sequentially. If sequentially, time may extend to more than a year. The Happening is performed according to plan but without rehearsal, audience, or repetition. It is art but seems closer to life.

He also defined an environment as "literally a surrounding to be entered into...." Whatever its history and its exact characteristics (which must obviously vary extremely in each instance) the idea of the Happening and the word itself in a few years have become part of American folk culture. Many of the terms, images, and ideas of Pop Art found instant popular acceptance, if not always complete comprehension, on the part of the mass media, including television, films, newspapers, and magazines. Even television and newspaper advertisements, women's fashions, and product design were affected, resulting in a fascinating cycle in which forms and images taken from popular culture and translated into works of art were then retranslated into other objects of popular culture.

CLAES OLDENBURG (b. 1929) One of the most talented and intelligent of all contemporary artists, Oldenburg created his version of Happenings in his Ray Gun "Spex," described as a museum for Pop events, which later developed into his Ray Gun theater. Then in 1961 he opened an actual store on 2nd Street in New York, an environment filled with objects made of painted plaster and attractively priced for such amounts as $198.99. Many of these objects represented food— ice cream sundaes, sandwiches, or pieces of cake roughly modeled and garishly painted in serious parody of cheap restaurant staples. Later, with his wife doing much of the sewing, he began creating these delicacies in vinyl and canvas, stuffed with kapok, but now on a gigantic scale as they might appear in a Surrealist nightmare (fig. 722). Through his interest in paradox, Oldenburg is closer to the original Dadaists or Surrealists than most of the other Pop artists.

The use of these materials led him ultimately to translation of hard or rigid objects, bathroom or kitchen fixtures, into soft and collapsing versions (fig. 723). These familiar, prosaic washstands, typewriters, engines, or radiators, carefully rendered but collapsing in violation of their essential nature, became disturbing commentaries on the values of contemporary life. Oldenburg has also made many proposals for monuments: a colossal peeled banana for Times Square, a gigantic ironing board for the lower East Side of New York, a mammoth Teddy Bear for Central Park. Meanwhile, Oldenburg has been kept busy turning out versions in fiberglass and/or bronze of such works as his *Alphabet/Good Humor* (fig. 724) and his twelve-foot-high *Standing Mitt with Ball* (plate 224). Most popular perhaps has been his *Geometric Mouse, Scale A* of steel and aluminum, ranging in scale from twelve to twenty feet high (fig. 725). This work, first conceived in 1969, now adorns outdoor plazas and museum sculpture gardens from Washington, D.C., to Minneapolis, Houston, and beyond. The *Geometric Mouse*, despite the hostile reception accorded it by various city fathers—those in Houston insist that it is actually a rat—is a handsome work of abstract sculpture, consisting of a few heavy, interlocked metal planes, but still bearing an eerie resemblance to its namesake. Oldenburg remains one of the most brilliantly inventive of all those artists who emerged from the movement of Pop Art (fig. 949).

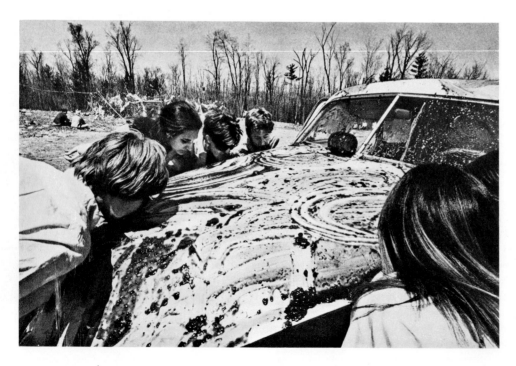

721. ALLAN KAPROW. From *Household,* a Happening commissioned by Cornell University. 1964

722. CLAES OLDENBURG. *"Floor Cake" (Giant Piece of Cake)*, installation view, Sidney Janis Gallery, New York. 1962. Painted canvas filled with foam rubber, 5 × 9 × 4′. Collection, The Museum of Modern Art, New York

723. CLAES OLDENBURG. *Soft Toilet*. 1966. Vinyl, Plexiglas, and kapok, 55 × 28 × 33″. Collection Mr. and Mrs. Victor W. Ganz, New York

left: 724. CLAES OLDENBURG. *Alphabet/Good Humor*. 1975. Painted fiberglass and bronze, 11′10″ × 5′8″ × 2′4″. Collection Michael Crichton, Los Angeles

below: 725. CLAES OLDENBURG. *Geometric Mouse, Scale A*. 1969. Steel and aluminum, height 12′. Intended gift to Walker Art Center by Miles Q. Fiterman, Minneapolis

GEORGE SEGAL (b. 1924) Among the sculptors associated with Pop Art, one of the most impressive is George Segal. It should be noted again that distinctions of painting or sculpture ceased to exist in Pop. Most of the artists identified as painters have created sculpture, and those identified as sculptors, such as Oldenburg, protest the designation, preferring to be called object-makers. Segal began as a painter, a student of Hans Hofmann, and gradually turned to sculpture only in 1958. He was for a number of years closely associated with the pioneer Happener Allan Kaprow, a fact that may have developed his interest in sculpture as a total environment. His forms are almost invariably cast in plaster from the human figure. The figure is then set in an actual environment—an elevator, a lunch counter, a movie ticket booth, or the interior of a bus, with the props of the environment purchased from junkyards (plate 225). But though modeled from life, the figures are left rough and unfinished, ghostly wraiths of human beings existing in a tangible world. The result is an effect of loneliness and mystery, comparable at times to the paintings of Edward Hopper. Inevitably, Segal turned to the nude and, on occasion, to erotic images, but even in his treatment of sensual subjects his peculiar qualities of melancholy and apartness still persist (fig. 726).

EDWARD KIENHOLZ (b. 1927) Kienholz has in common with Segal the creation of elaborate tableaux that are perhaps closer to assemblages than to Pop Art. Sometimes, as in his famous bar (fig. 727), he simply reproduces a familiar environment, but with fantastic accuracy of selective detail. Frequently, however, he has embodied a mordant, even gruesome criticism of American life. *The State Hospital* is a construction of a cell with a mental patient and his self-image, modeled with revolting realism—the living dead (fig. 728). Strapped to their bunks, the two effigies of the same creature—one with goldfish swimming in his glass bowl head—make one of the most horrifying concepts created by any modern artist. Kienholz, who works in Los Angeles, should in fact be considered an Expressionist sculptor concerned with the stupidity or the misery that is hidden just behind the façade of modern, commercial civilization.

above: 726. GEORGE SEGAL. *Girl Putting on Scarab Necklace*. 1975. Plaster, wood, metal, and glass, 84 × 45 × 45″. Sidney Janis Gallery, New York

below: 727. EDWARD KIENHOLZ. *The Beanery*. 1965. Mixed media, 7 × 22 × 6′. Formerly Dwan Gallery, New York

728. EDWARD KIENHOLZ. *The State Hospital*. 1964–66. Mixed media, 8 × 12 × 10'. Moderna Museet, Stockholm

729. MARISOL. *Veil*. 1975. Plaster, rope, and hair, 20½ × 11 × 5". Sidney Janis Gallery, New York

730. RED GROOMS and the Ruckus Construction Company. *Ruckus Manhattan* (detail: World Trade Center, West Side Highway). 1975–76. Mixed media. Installation view, Marlborough Gallery, New York, 1976

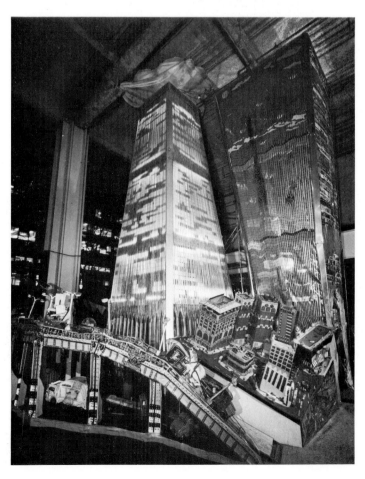

MARISOL (b. 1930) Marisol Escobar, the Paris-born Venezuelan artist active in New York, has created a world of her own from wood, plaster, paint, and unpredictable objects. The artist's own face and parts of her body are everywhere, but she does not ignore the "personalities" of our day, or the more humble folk (plate 226). Her environmental works may perhaps be described also as Pop or assemblages, for she uses every technique of art to transform rough or "store-bought" materials into grimly satiric presences. Marisol's ever-present, striking features appear in a medallion relief that is perhaps the most startling of all her self-portraits, both in its immediate impact and its implications (fig. 729). This is a life cast of the artist's face, the eyes closed and blurred, like those of a corpse, a suggestion made explicit by the strands of hair falling in a veil over the artist's face. One is reminded of the shrunken heads produced by South American Indians, and it would seem logical that Marisol is here presenting a reminiscence from her own Venezuelan background. The plaque surrounding the hair is roughly inscribed with an autobiographical statement that has many fascinating implications.

RED GROOMS (b. 1937) The element of caricature on an environmental scale is best exemplified in the satirical work of Red Grooms, who peoples entire rooms with cutout figures and objects painted in brilliant and clashing colors. He has continually enlarged his scope to embrace constructions such as *A Vision of the City of Chicago* and the famous *Ruckus Manhattan*, interpreted in a spirit of wild fantasy and broad slapstick humor (fig. 730).

LUCAS SAMARAS (b. 1936) Samaras uses boxes and other receptacles in a manner derivative perhaps of Joseph Cornell, but with an entirely different emphasis. In his containers, plaques, books, and table

731. LUCAS SAMARAS. *Box No. 3*. 1962–63. Mixed media. Collection Howard Lipman Foundation

733. LUCAS SAMARAS. *Room No. 2*. 1966. Wood and mirrors, 8 × 10 × 8′. The Albright-Knox Art Gallery, Buffalo

below: 732. LUCAS SAMARAS. *Chairs*. 1965. Yarn and pins on wood chairs, 35½ × 61 × 20″. Walker Art Center, Minneapolis. Art Acquisition Fund, 1966

specific sense. Samaras sees in everyday objects a combination of menace and erotic love, and it is this sexual horror, yet attraction, that manifests itself in his work. Two chairs, one covered with pins and leaning back, the other painted and leaning forward, create the effect of a horrible sexual dance of the inanimate and commonplace (fig. 732). To touch one of his objects is to be mutilated. Yet the impulse to touch it, the tactile attraction, can be powerful.

The quality of elegance apparent in these objects became quite pronounced after 1965 in works of crystalline precision. This led him to a form of construction in which mirrors multiply to infinity the image of a single chair (fig. 733). Recently, his experiments in optical illusion have led him to a series of what he calls "photo-transformations" in which his own image, placed within his familiar environment, is translated into monstrous forms (plate 263).

Assemblage and Junk Sculpture

In a sense, much of this book has been tracing the history of assemblage, for among its precursors must be included Cubist collage, Picasso's early still-life constructions, the Futurists (notably Boccioni's constructions), the Dadaists, the Surrealists, and their descendants. Kurt Schwitters was the founder of the tradition of Junk sculpture, which assumed an important place in sculptural experiment after World War II. Man Ray was closer to Pop Art and the New Realists in his transformation of existing, manufactured objects, although his aim was always the paradox of Surrealism (fig. 336). The great name and the

settings, prosaic elements are given qualities of menace by the inclusion of knives, razor blades, and thousands of ordinary but outward-pointing pins (fig. 731). The objects are meticulously made, with a perverse beauty embodied in the threat that is involved. They cannot be classified as Dada or Pop Art in the traditional sense; rather, they are highly Expressionist, even Surrealist works that are actually disturbing in a most

great influence for Pop artists and the New Realists was, of course, Marcel Duchamp. Even the word "assemblage," as well as many others, such as "readymade," or "mobile," that have particular pertinence today, belong to him. His last oil painting, *Tu m'* (plate 104), is almost a dictionary of postwar tendencies in art, from Pop, to Op, to Color Field painting, to programmed or structured painting or sculpture. Another influential figure was the American Joseph Cornell, seen in Chapter 19 (figs. 619, 620).

FREDERICK KIESLER Another trailblazer who made contributions of an entirely different kind to the art of environment was Frederick Kiesler, a great visionary architect (fig. 870). In an exhibition organized at the end of his life, he combined sculptural forms with colored panels and objects suggestive of church furniture to create a somber and somehow menacing chapel dedicated to some sinister religion (fig. 734). Bone forms cast in bronze were placed before painted, lighted niches like relics to be worshiped. On a table altar stood another such relic, and hovering over this was a suspended table form whose downward-pointing legs posed a tangible threat. This group was appropriately named *The Last Judgment*. Although the exhibition or environment had to be placed in a gallery and the relationships between the parts established by dramatic lighting, ideally its setting should have been an architectural space designed by Kiesler himself. Although later dispersed, the work has few modern parallels in its combination of Surrealist-Expressionist atmosphere with Constructivist forms.

LOUISE NEVELSON (b. 1900) More properly in the tradition of assemblage is Louise Nevelson, whose characteristic works of the 1960s were large wooden walls made of dozens of individual boxes filled with hundreds of carefully arranged found objects—usually sawed-up fragments of furniture or woodwork rescued from old, destroyed houses

735. LOUISE NEVELSON. *Transparent Sculpture VI*. 1967–68. Lucite, 19 × 20 × 8″. The Whitney Museum of American Art, New York

(plate 227). These were then painted a uniform black or, in her later work, white or gold, and despite their composition from junk, they achieve qualities of decayed elegance, reminiscent of the graceful old houses from which the elements were mined. Subsequently Nevelson turned to new materials—aluminum, epoxy, or clear Lucite, often on a smaller scale and produced in multiple editions (fig. 735). She thus joined the ranks of those artists concerned with optical and light effects. Despite the new immaculate precision, these works still have the altar-like quality of the wooden walls.

left: 736. LOUISE NEVELSON. *Dawn Shadows*. 1982. Steel painted black, approximately 30′ high. Madison Plaza, Chicago

below: 737. LOUISE NEVELSON. *Chapel of the Good Shepherd* (North Wall, St. Peter's Church, New York). 1977

In later years the prolific Nevelson has executed many commissions for large-scale outdoor works, experimenting with new materials—aluminum, steel, Cor-ten steel (fig. 736). She has also created in her traditional wood ensembles a number of complete room environments of great beauty in which she has incorporated some of the simplifications of her transparent Lucite sculpture (fig. 737).

LOUISE BOURGEOIS (b. 1911) A sculptor almost impossible to classify in terms of contemporary trends, but nevertheless one of the most individual and imaginative on the American scene, is French-born Louise Bourgeois. Beginning as a painter-engraver in the milieu of Surrealism, Bourgeois turned to carved sculpture in the later 1940s, creating isolated, elongated forms whose closest analogue is perhaps the sculp-

left: 738. LOUISE BOURGEOIS. *The Blind Leading the Blind*. 1948. Wood, 7′ × 7′4″. Xavier Fourcade, Inc., New York

below: 739. LOUISE BOURGEOIS. *Black March*. 1970. Marble, 44 × 44 × 47″. Courtesy the Artist

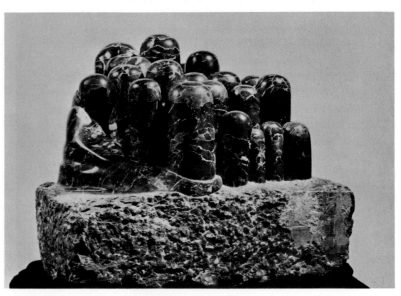

tures of Giacometti, although there are few if any stylistic relationships. These alternated with clustered groups, often wood assemblages in which the abstract, totemic shapes painted black-and-white take on a strangely human, communal quality (fig. 738). More recently Bourgeois has turned to stone carving in which she arranges her clusters of rounded, vertical, highly colored and polished forms with somewhat phallic implications on roughly hewn bases, with a strange, almost magical effect (fig. 739). Working on an unprecedented scale with latex and stone, she created during the 1970s a series of sculptures unique in their fantasy. *The Destruction of the Father* can best be described as a cavelike environment with weird stalactite forms combined with massive boulder shapes (plate 228). Louise Bourgeois is obsessed with globular shapes that bubble forth as though in the process of being born from a rough matrix.

The development described as Junk sculpture was widespread in Europe and the United States during the 1950s. Junk sculpture—a designation that most of the artists involved do not particularly care for— is that branch of assemblage that deliberately seeks out the junk, the cast-offs of urban civilization, and transforms it into a work of art either by selection, reorganization, or presentation without comment. Schwitters was the first great exemplar of this attitude, although the ultimate origin was in Cubist collage and construction. Picking up every sort of rubbish from the streets, the German Dadaist would then lovingly transform these into collages or reliefs and, on a monumental scale, into his Merzbau (fig. 342). The use of found objects permeated Dada and Surrealism and revived in the so-called "combine" paintings of Rauschenberg. Dubuffet's sculptures made from coke clinkers and Burri's torn and bleeding burlap paintings are aspects of Junk culture (plate 201), as are the curious reliefs by the Englishman John Latham made of old, mutilated books. In France, César has been the principal exponent, first with his rusty figurative sculptures made of machine parts, and then with his huge junked automobiles compressed into cubes under titanic pressure (fig. 670). In England, Paolozzi produced Junk machine-parts figures, but has since turned to an art of shiny, new, machine precision, more properly associated with Pop Art. In the United States, Junk artists abound, perhaps because there is more junk. Automobile graveyards are a familiar part of the American scene, as are huge, smoking garbage dumps.

RICHARD STANKIEWICZ (b. 1922) Stankiewicz was one of the first and most important of the postwar Junk sculptors, working both at the level of Surrealist figuration and also at that of abstract construction. The piece seen in figure 740, although made up of old, rusty pieces of machinery, is a pure abstract arrangement of parts, as precisely organized as a construction by Gabo. The junk has here been transformed by the artist's hand into a work of beauty in which even the corroded surfaces begin to take on new textural significance.

JOHN CHAMBERLAIN (b. 1927) Chamberlain has used parts of junked automobile bodies, with their highly enameled, colored surfaces, to create abstract assemblages of considerable beauty (fig. 741). Later Chamberlain turned to sculptures in soft synthetics such as urethane, to create abstract counterparts of Oldenburg's soft constructions. He has, however, continued with his basic enameled metal assemblages, many of which have become progressively more precisely composed.

LEE BONTECOU (b. 1931) For a number of years Bontecou worked with an obsessive image of face-vagina, frequently with frightening zipper teeth, made up of old pieces of welded steel and canvas (fig. 742).

740. RICHARD STANKIEWICZ. *Untitled*. 1962. Iron and steel, height 40½″. The Solomon R. Guggenheim Museum, New York. Gift of Elinor L. Arnason

741. JOHN CHAMBERLAIN. *Char-Willie*. 1974. Chrome and painted auto parts, 4′5″ × 9′3″ × 1′10″. Locksley-Shea, Rome

742. LEE BONTECOU. *Untitled*. 1964. Welded steel with canvas, 72 × 80 × 18″. Leo Castelli Gallery, New York

743. MARY BAUERMEISTER. *All Broken Up*. 1965–67. Mixed media, 5′7″ × 9′2″. Private collection, New York

MARY BAUERMEISTER (b. 1934) Bauermeister, one of the youngest and, in terms of her use of materials, most attractive of the assemblage artists, combined glass and colored marble balls with painted plaster grounds, sometimes worked with graffiti, to create works that are overwhelmingly decorative in their appeal. The piece reproduced in figure 743 recalls the bibelot shelves of Victorian England or even the *cabinets des amateurs* of the French eighteenth century.

Europe's New Realism

YVES KLEIN (1928–1962) A seminal figure of Pierre Restany's *le nouveau réalisme* was Yves Klein, one of the brilliant talents of the postwar period, whose early death arrested a career still full of promise. Klein was a remarkable pioneer not only in the creation of environments but also in Light Art, in Minimal painting, and in Body Art. Many of his experiments can best be categorized as Conceptual Art. He was a restless and imaginative innovator with a genuine, original fantasy that lent authenticity to his most outrageous displays. He and his followers have been described as "attitude artists," a term that suggests their concern with the dramatization of ideas beyond the creation of individual works of art. In 1956 Klein held an exhibition of floating blue globes, thus anticipating Warhol's floating plastic pillows by some ten years. In 1958 he attracted thousands of people to an exhibition of nothingness—*le vide*—bare walls that were offered to the patrons to be paid for in pure gold. His blue Anthropometrics of 1960 were nude models, covered with blue paint, who were rolled on canvases to create shadow-prints of their bodies (fig. 744). These were followed by his Cosmogonies, in which he experimented with the effects of rain on canvas covered with wet blue paint. Then came the fire paintings, actual flame burned into asbestos with red, blue, and yellow pigment (plate 229), and the planetary reliefs of Mars, Venus, and the Earth. His blue sponges may be described as found objects or, since they are painted his favorite blue—an eye-dazzling ultramarine the artist patented as IKB ("International Klein Blue")—and attached to bases or to a wall, perhaps Duchamp's term "readymade aided" is preferable. His mon-

ochrome paintings, in which he finally settled on the characteristic ultramarine, were extensions of his concept of the painting of nothingness into what in the late 1960s would be called Minimalism (plate 230). In this blue he saw the supreme "representation of the immaterial, the sovereign liberation of the spirit." With his passion for a spiritual content comparable to that preached by Kandinsky, Mondrian, and Malevich, Klein was moving against the trend of his time, with its insistence on impersonality; on the painting or sculpture as an object; and on the object as an end in itself.

ARMAN (b. 1928) The other artists associated with the New Realism are all distinct individuals with interests that range from assemblage to Neo-Dada, to motion sculpture, to forms of Pop. Arman (Armand Fernandez) was a friend and in some degree a competitor of Klein's. It was perhaps his desire to oppose a concept of fullness or completeness (*le plein*) to Klein's nothingness (*le vide*) that led him to his accumulations of reiterated objects—old sabres, eyeglasses and glass eyes, the broken little hands of cast-off dolls (fig. 745). Originally Arman was concerned with the tragic, Expressionist quality of these sad, broken fragments, scattered haphazardly in a wooden box. Then he began to imbed them in plastic, as here, and, later, to create clear plastic figures to act as containers for the objects. Thus the transparent nude torso in figure 746 contains a cluster of inverted paint tubes that pour brilliantly colored streamers of paint down into her belly and groin. The figure is romantically entitled *La Couleur de mon amour*.

CHRISTO (b. 1935) Bulgarian-born Christo (Christo Javachef) has a passion for packaging objects, anything from a bicycle to a woman, to a skyscraper. His *empaquetages* are again an art of attitude (deriving perhaps from some comparable efforts by Man Ray). These, and his later storefronts concealed by curtains, represent another commentary on contemporary industrial or product civilization, a return of objects and institutions to a form of nothingness. During the 1970s Christo expanded his concept to a colossal scale and began wrapping museums and palaces in both Europe and America (fig. 747). With this, however, he had only begun, as we shall see in a later chapter.

744. YVES KLEIN. *Shroud Anthropometry 20,* "*Vampire.*" 1960. Pigment on canvas, 43 × 30″. Galerie Flinker, Paris

745. ARMAN. *Argusmyope.* 1963. Accumulation of old spectacles in polyester, 28⅛ × 13¾″. Private collection, Brussels

746. ARMAN. *La Couleur de mon amour.* 1966. Polyester with embedded objects, 35 × 12″. Collection Philippe Durand-Ruel, Paris

747. CHRISTO. *Packed, Kunsthalle.* 1968. 27,000 square feet of synthetic fabric and 10,000 feet of rope. ©Christo 1968

748. MARTIAL RAYSSE. *Tableau dans le style français.* 1965. Assemblage on canvas, 85⅞ × 54⅜″. Collection Runquist

MARTIAL RAYSSE (b. 1936) Raysse came the closest of all the New Realists to Pop Art, although he gave to his version a certain elegance and snobbism suggesting the beach at Nice rather than the one at Coney Island. Using life-sized cutouts of bathing beauties set in an actual environment of sand and sun umbrellas, he achieved startling simulations of elaborate advertisements for expensive watering places (fig. 748). Something of the same feeling emerges from his own versions of Old Master paintings.

right: 749. LUCIEN CLERGUE. *Nude of the Sea.*
1962. Gelatin-silver print. Worcester Art
Museum, Massachusetts

below: 750. MIMMO ROTELLA. *Untitled.* 1963.
Décollage. Galerie J, Paris

This French artist had a soul mate in the French photographer Lucien Clergue (b. 1924), who, beginning in 1956, did a long series of images devoted to the nude posed on the beaches of Mediterranean France (fig. 749). Both in the serialism of the treatment and the banality of the subject, Clergue declared his identity with the Pop generation, reinforcing this with a covert luxuriance in such purely formal considerations as light, texture, and pictorial structure.

MIMMO ROTELLA (b. 1918) Rotella was an early practitioner of the New Realist technique know as *décollage* (fig. 750). This, presumably the antithesis of collage, is the art of tearing or destroying posters to create new juxtapositions. It offered nothing actually new, except, perhaps, a particular application. Anyone living in a large city is familiar with the layers upon layers of half-torn posters—modern urban palimpsests—that decorate billboards and walls when these have not been renewed. It is possible that the idea of collage originated with the torn and mutilated posters on Paris walls. The new aspect of décollage lay in its use of the slick images of modern advertising, for films or soapsuds, not in its pristine Pop Art guise, but torn and tattered with one superimposed image intruding on another. This became a sort of symbolic revolt against the commercial vulgarization typical of the urbanscape.

HERVÉ TÉLÉMAQUE (b. 1937) The Haitian-born Télémaque was close to American Pop Art, and more specifically to Kitaj's Anglo-American version, in his use of fragmented images from contemporary journals and advertising (fig. 751). He isolated his often violently dramatized images of the contemporary scene with large areas of black canvas. The drama of violence is heightened by the use of every form of unrelated image, suggesting both the early cinema and aspects of Surrealism.

JUAN GENOVÉS (b. 1930) Although it was characteristic of much art—whether Pop, New Realism, or the sculpture variously labeled Primary, Minimal, ABC, etc.—to avoid comment, to insist on its absolute objectivity in the early 1960s, the tendency to comment increased during the second half of the decade. This was the natural consequence of the tensions emerging from Vietnam, from struggles for equal rights or self-determination, and from the worldwide student revolts. Robert Indiana's blunt word-images have been mentioned, and James Rosenquist's huge *F-111* was, as noted, a denunciation of war rather than a documentation of Pop culture. The young Spanish artist Juan Genovés

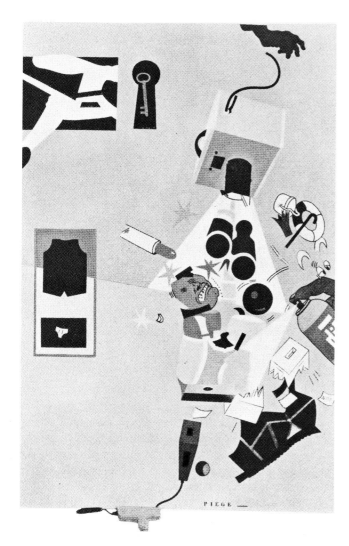

751. HERVÉ TÉLÉMAQUE. *Piège*. 1964. 76¾ × 51⅛". Galerie Mathias Fels, Paris

752. JUAN GENOVÉS. *Sobre la Represión Politica*. 1973. Acrylic on canvas, 57⅛ × 63". Marlborough Gallery, New York

753. FERNANDO BOTERO. *Portrait of a Family*. 1974. 93½ × 77". Collection Toni and Martin Sosnoff

turned the photograph image of the Pop artists or the New Realists into a frightening portrayal of war and mass destruction. In photographic flashes seen through the bombsight of a war plane or through the rifle-sight of an executioner, vast crowds flee hopelessly from inevitable mass murder. Victims, suddenly caught in a searchlight from which they cannot escape, are simply obliterated or led away, handcuffed, to be lined up against a wall and shot (fig. 752).

FERNANDO BOTERO (b. 1932) Like many strong artists, the Colombian painter Botero creates an artistic world quite his own, identifiable with the Latin American bourgeoisie (or subjects in earlier "high" art), but transformed into a fantasy realm of pneumatically obese figures, elaborate South American costumes, and feigned naïve or peasant manner, all held together by a subversive, devilish wit (fig. 753). Chronologically, however, Botero belongs with the New Realist generation, and both the hard-edge readability and the irony of his art, like the frequent cosmopolitan contacts with Paris and Madrid, make him seem reasonably at home among Europe's New Realists. In Spain, where he attended Madrid's San Fernando Academy, Botero found his great mentors in Goya and Velázquez, gaining an ironic view of the human comedy from the one and from the other a respect for solid, meticulously rendered form. But the love of lucid space and monumental quietude

comes from Piero della Francesca, whose wall paintings and fresco technique Botero studied in and around Florence. Having absorbed all these influences, the artist then integrated them into something unique to himself, a beguiling, warmly droll enigma that could have come from no one but Botero.

Sixties Abstraction:

RENASCENT CONSTRUCTIVISM, POST-PAINTERLY ABSTRACTION, OP ART, KINETIC SCULPTURE, MINIMALISM

As postwar Europe and America increasingly relaxed from the stern necessities of the thirties and forties, the rare synthesis of mystical aspiration and physical gesture realized by the Abstract Expressionist generation began to break apart, releasing its constituent elements to follow their own separate, if not altogether unrelated, lines of development. While some of these, like the Pop and New Realist trends seen in the last chapter, led to Neo-Dada attempts to make art ever more inclusive of the most ordinary reality, others manifested themeves in systematic campaigns of excluding from art all but its own most essential properties. Common to the sixties generally, however, was a cool, usually deadpan reaction against what was perceived to be the Action and Tachist painters' overheated subjectivity, along with the sublime confusion this now seemed to have produced in both form and content.

Something of the dual response to fifties art—to its creators' "elitist" sense of themselves as existential heroes and of their works as sacred objects—has already been seen in the career of Yves Klein, who, on the one hand, effected sculpture in the Duchampian "readymade-aided" fashion, by mounting blue-sprayed sponges on pedestals, and, on the other hand, "organized" an exhibition that consisted merely of nothingness (*le vide*). And when Klein made paintings by exposing a colored support to such external, nonart elements as fire and rainwater or by emptying the canvas of all but its irreducible condition of flat, monochrome, rectangular shape, he briefly merged and anticipated the sixties drive toward extremes of both materiality and immateriality (plates 229, 230). Either way, the tendency involved simplifications so progressive that by the end of the decade the abstraction they produced would be known by such terms as Minimalism, ABC Art, or Primary Structures. While all of this may have come about as a necessary "correction" of fifties heroics, the new abstractionists would evince still greater "heroism," not only in the sheer size of their works but also in their ambition to create more and more significant art from less and less. As Robert Rauschenberg said, the authenticity of his generation lay not in *angst* but rather in irony.

Pop Art, thanks to its ability to entertain a newly affluent, status-conscious mass audience, may have earned its title by becoming the most popular development ever to have occurred in the higher reaches of culture. During the sixties, however, before the underlying complexity of Pop had been fully appreciated, it was abstraction that dominated within the world of art itself, mainly because its essential sobriety and internal processes of self-purification engaged the attention of the most serious critics and thinkers. And little wonder, since those processes, first initiated in the subjective, Expressionist colorism of Gauguin, Van Gogh, the Fauves, and their German followers as well as in the more objective, analytical art of Cézanne and the Cubists, carried twentieth-century abstraction to what so far has been its culminating phase. In Europe the new nonobjective artists went forward by looking back to the Constructivism of the 1930s Abstraction-Création group, or beyond that to the Bauhaus, De Stijl, and the Russian avant-garde. In contrast to the Europeans, however, who tended to "construct" as their chosen antecedents had, by adding together or accumulating basic formal, interrelated elements, the Americans, for the most part, pursued ever greater reductiveness by translating into geometric form the allover painterly holism or nonrelatedness of the Abstract Expressionists' field-like structure, already a drastic and revitalizing mutation of Cubist-based abstraction achieved through the liberating techniques of Surrealist automatism.

Concrete Art

In 1930, as we saw, Theo van Doesburg coined the word "concrete" as a substitute for "nonobjective" in its specific application to the geometric abstractions of De Stijl. This was followed in 1931 by the Abstraction-Création group which, during the 1930s, sought to advance the principles of pure abstraction and of Mondrian's Neo-Plasticism. The concept of Concrete Art was revived in 1947 in the Salon des Réalités Nouvelles, while the gallery of Denise René, opened in Paris in 1944, became an international center for the propagation of Concrete Art. Among the leaders outside of France was Josef Albers, who had gone to the United States in 1933 and whose influence there on the spread of geometric abstraction has been discussed (fig. 479; plate 148). He exhibited regularly with the American Abstract Artists group as well as with Abstraction-Création in Paris.

MAX BILL (b. 1908) Equally important for the spread of Concrete Art in Europe have been the Swiss, with Max Bill a leader in the perpetuation and specific definition of Concrete Art, a term he began applying to his own work in 1936. The term has the advantage over the word "abstract," in that it referred to a particular phase of abstract art, the radically reductive, Constructivist, geometric tradition of Mondrian and Van Doesburg. It also serves as a rallying cry in its emphasis on the painting as an entity in itself, as something *concrete* rather than as something abstracted from (with the implication of derivation from) nature. Bill defined Concrete Art as follows: "Concrete painting eliminates all naturalistic representation; it avails itself exclusively of the fundamental elements of painting, the color and form of the surface. Its essence is, then, the complete emancipation of every natural model; pure creation." This definition does not depart much from the original definitions of Mondrian and Van Doesburg, and postwar Concrete Art is essentially a continuation of their ideas and forms, as well as those of Arp, Gabo, and Pevsner. Its importance as an international movement lies in its expansion of the possibilities and forms. Many aspects of postwar Constructivism, Color Field painting, Systemic painting, and Op Art stem from the tradition of De Stijl and Concrete Art.

Max Bill studied at the Dessau Bauhaus between 1927 and 1929 when Josef Albers was teaching there. Subsequently he developed into

one of the most talented and varied exponents of Bauhaus ideas, as a painter, sculptor, architect, graphic and industrial designer, and writer. He was associated with Abstraction-Création in Paris and organized exhibitions of Concrete Art in Switzerland. Unlike Pevsner, Bill was always fascinated by the relations of mathematics and art. He insisted that painting and sculpture have always had mathematical bases, whether arrived at consciously or unconsciously. By mathematics he was not referring to plane geometry or simple arithmetic, but to the relativistic mathematics of Einstein and nuclear physics. He also insisted on the philosophical and even—in the spirit of Kandinsky and Malevich—the spiritual or ethical roots of modern art. He was referring primarily, of course, to Concrete Art in whose forms he found simplicity, clarity, and harmony, qualities symbolic of universal ideas (fig. 754).

In his paintings, Bill, like Albers, was constantly experimenting with color relationships, particularly the interaction of colors upon one another. Thus his works bear titles like *Four Color Pairs Around a White Center, Condensation from Violet to Yellow, Four Complementary Color Groups in a Blue Field.* In sculpture Bill frequently used geometric shapes, as in *Endless Ribbon from a Ring I* seen here. The form that has intrigued him the most and on which he played many variations is the endless helix or spiral that turns back upon itself with no beginning and no end.

RICHARD PAUL LOHSE (b. 1902) Like Max Bill, Lohse made mathematics the basis of his painting. He sought the simplest possible unit such as a small color square and then, using not more than five color hues but a great range of color values, built his units into larger and larger complexes through mathematically precise distribution of hues and values in exact and intellectually predetermined relationships (fig. 755). This resulted in a composition or color structure that spreads laterally and uniformly, with no single focus, to the edges of the canvas, and the implication and the potential of spreading to infinity beyond the edges. Despite the rigidity of Lohse's system, the subtlety and richness of his colors, the shimmering quality deriving from their infinitely varied relationships, give to his works a lyrical, poetic feeling. His art is of importance as an immediate prototype for recent tendencies in Systemic painting and Optical Art.

ALBERTO MAGNELLI (1888–1978) At the opposite pole from Bill but still within the definition of Concrete Art was the older painter Alberto

top: 754. MAX BILL. *Endless Ribbon from a Ring I.* 1947–49, executed 1960. Gilded copper on crystalline base, 14½ × 27 × 7½". Hirshhorn Museum and Sculpture Garden, Smithsonian Institution, Washington, D.C.

above: 755. RICHARD PAUL LOHSE. *Pure Elements Concentrated in Rhythmic Groups.* 1949–56. Private collection

left: 756. ALBERTO MAGNELLI. *Sonorous Border.* 1938. 38¼ × 57½". Galerie de France, Paris

Magnelli. Though he produced abstractions as early as 1915, Magnelli painted figuratively during the 1920s and early 1930s. He did not enter upon his later abstract (or Concrete) style until after 1935, and gained little recognition for it until after World War II. Magnelli's works normally involve a dynamic interplay, tension, or even conflict of shapes (fig. 756). These are mainly geometric, but the artist did not hesitate to depart from absolutely regular forms if necessary. His colors are flat, matte, unmodulated, without luminosity, and unrelated to colors in na-

ture, thus strengthening the feeling of complete abstraction. There is, nevertheless, such sharp tension between the various forms and colors that they take on a kind of abstract personality, even at times an abstract Surrealist quality.

JEAN DEWASNE (b. 1912) Among the Paris postwar leaders in Concrete Art was Jean Dewasne, a former Cubist who strove for Mondrian's purity in the elimination of association, but with greater intensification of color and variety of abstract shapes. In the 1960s he used enamel paints on porcelain surfaces to create effects of mechanical reductiveness and power, deriving from Léger but going beyond him in machine depersonalization (fig. 757). The forms of his painting inevitably led Dewasne to experiment with machine sculpture. In these works he achieved an impact and a monumentality beyond anything in his previous career.

LUCIO FONTANA (1899–1968) The only European painter who, in his famous slit and perforated Spatialist canvases of the 1950s and 1960s (fig. 758), came close in form and spirit to the Post-Painterly and Minimalist abstractions of contemporary American art was Italy's Argentine-born Lucio Fontana. By that time, however, the protean and prodigious Fontana had worked through many bold phases in his long career, producing, in 1930, the first nonfigurative sculpture seen in Italy, joining the Paris-based Abstraction-Création group in 1935, and in 1937 signing the *First Manifesto of Italian Abstract Artists.* While in Buenos Aires during World War II Fontana published the *White Manifesto,* outlining his idea of a new art for a new age made with such modern materials as neon light and television, media whose potential would not be tapped for art until the 1960s and 1970s. The *White Manifesto* also anticipated the theory of what would be known as Spatialism, a concept that rejected the illusionistic or "virtual" space of traditional easel painting in favor of the free development of color and form in real space. The purpose here was to create an art that would "transcend the area of the canvas, or the volume of the statue, to assume further dimensions and become...an integral part of architecture, transmitted into the surrounding space and using discoveries in science and technology." The Spatialist program was designed to eman-

cipate art from past preconceptions, to "abandon the acceptance of known forms in art and begin the development of an art based on the unity of time and space." Thus prepared, Fontana proved especially effective in his challenge to the dominance of L'Art Informel and Tachism in postwar Europe. At first, beginning in 1949, he simply perforated or slit the canvas, thereby in effect destroying the actual picture plane that had been the point of departure throughout essentially the entire history of painting. During the 1950s he experimented with matter, as did his fellow countrymen Afro and Alberto Burri (fig. 630; plate 201), building up his penetrated surfaces with heavy paint, paste, canvas fragments, or ceramic shards. It was in 1958–59 that, feeling he was complicating and embellishing the works too much, Fontana slashed a spoiled canvas and realized that in this simple act he could achieve the integration of surface with depth that he had been seeking. With this gesture, he could be said even to have anticipated Performance Art.

Fontana also became a pioneer of environments when in 1949 he used free forms and black light to create vast Spatialist surrounds, experiments followed in the 1950s by large-scale architectural-spatial designs, worked out in collaboration with the architect Luciano Baldessari. In his desire to break down categories of painting, sculpture, and even architecture, Fontana described his works as *Concetti Spaziale* (CS), or "Spatial Concepts," thus announcing the Conceptualism that would not actually take hold in Western art until the 1970s. In later years he multiplied his investigations, using sheet-metal burned with blow torches, ceramics, and lacquered wood combined with canvas. In these last, the detached, cutout elements floating over the ground give a new and mysterious ambiguity to his Spatial Concepts (plate 231).

Post-Painterly Color Field Abstraction

A number of exhibitions held in the 1960s drew attention to certain changes that were occurring in American painting. During 1959 and 1960, French and Company, a gallery of traditional art in New York City, established a brief-lived program for contemporary art. The critic Clement Greenberg, acting as consultant, organized a series of one-man exhibitions including Barnett Newman, David Smith, Morris Louis, Kenneth Noland, Jules Olitski, and Friedel Dzubas—artists who were to be recognized as major forces in the Color Field painting and Primary Structures of the 1960s.

In 1961 New York's Guggenheim Museum held an exhibition entitled "American Abstract Expressionists and Imagists," intended as a survey of the contemporary New York School. Since its inception in the 1940s the New York School had clearly been more than a group of Action painters, but included artists of many different directions. The exhibition pointed up the fact that, aside from the gestural or brush painters Pollock, De Kooning, Hofmann, Brooks, and others, there had always been another strain, to which the name Abstract Imagists was applied for convenience. Through their extreme simplification of the canvas, these were painters concerned with creating a dominant, all-encompassing presence. This presence could be described as an image in the sense of an abstract symbol rather than a reflection or imitation of anything in nature. The paintings of Rothko, Newman, Gottlieb, Reinhardt, and frequently Motherwell and Still, all very different, had in common this sense of symbolic content achieved through large, flatly painted color areas and dramatic statement of isolated and simplified elements. A comparable effect was achieved in the endless hypnotic

squares of Josef Albers and, among younger artists, in the floating, free color-shapes of Raymond Parker, or the precisely delineated shape-tensions of Ellsworth Kelly and Leon Polk Smith.

These exhibitions illustrated the fact that many young artists were attempting to break away from what they felt to be the tyranny of the Action branch of Abstract Expressionism, particularly in its emphasis on the individual brush gesture. Some of these were seeking new directions within the formal control of geometry or what would be called Hard-Edge painting, while others turned to Expressionist figuration, or the re-exploration of Dada or Surrealism, to Pop Art, Op Art, or light and motion. Most suggestive was the apparent expansion of that direction then called Abstract Imagism, to which many other names have been applied, including Post-Painterly Abstraction (by Clement Greenberg), and, most permanent of all, Color Field painting, sometimes simplified to Field painting. Still other names have been applied to various aspects of this direction during the 1960s—Systemic painting (by Lawrence Alloway) or the more tenacious Minimal painting.

These labels do not necessarily encompass all the same artists or all the directions involved—which range from forms of all-over painting to almost blank canvases. The emphasis throughout, however, is on pure, abstract *painting*, in distinction to figuration, optical illusion, object-making, fantasy, light, motion, or any of the other tendencies away from the act of painting itself.

In the 1961 exhibition at the Guggenheim, the list of artists associated with these new forms included Nassos Daphnis, Friedel Dzubas, Helen Frankenthaler, Al Held, Ralph Humphrey, Alfred Jensen, Morris Louis, Kenneth Noland, Ludwig Sander, Leon Polk Smith, Theodoros Stamos, Frank Stella, and Jack Youngerman. These and the others represented a wide variety of points of view. Some were then categorized as Hard-Edge painters, working in broad, flat, unmodulated color areas bounded by precisely delineated edges.

Among all the painters working against the current of gestural Abstract Expressionism in the late 1950s there was a general move (as Greenberg has pointed out) to openness of design and image—frequently the use of staining and raw canvas—and toward a clarity and freshness that differentiated them from the compression and brush expression of the Action painters. Aside from the Hard-Edge painters, others such as Frankenthaler, Louis, Dzubas, and Stamos were working more freely, although with an increasing subordination of brush gesture and paint texture. The directions and qualities suggested in the work of these artists—some already established masters, some just beginning to appear on the scene—were to be the dominant directions and qualities in abstract painting during the 1960s.

In 1963 the Jewish Museum in New York presented an exhibition entitled "Toward a New Abstraction." Kenneth Noland was a featured painter at the United States pavilion of the Venice Biennale in 1964, and was given a one-man exhibition at the Jewish Museum in 1965. The Jewish Museum also defined the sculpture of Primary Structures in a large exhibition held in the spring of 1966. In 1964, Clement Greenberg organized an exhibition for the Los Angeles County Museum, which then traveled to the Walker Art Center, Minneapolis, and the Art Gallery, Toronto. This he entitled "Post-Painterly Abstraction," using "painterly" in the sense of the German word *malerisch*, as used by the Swiss art historian Heinrich Wölfflin. In Greenberg's words, "Painterly (which Wölfflin applied to Baroque art to separate it from Classical, High Renaissance art) means, among other things, the blurred, broken, loose definition of color and contour. The opposite of painterly is clear, unbroken, and sharp definition, which Wölfflin called 'linear'." Greenberg applied the term "painterly" to the Abstract Expressionism of Pollock,

Hofmann, De Kooning, Kline, and their immediate followers who employed the apparent brush gesture—"the stroke left by the loaded brush or knife that frays out, when the stroke is long enough, into streaks, ripples, and specks of paint." Greenberg further pointed out:

> By contrast with the interweaving of light and dark gradations in the typical Abstract Expressionist picture, all the artists in this show move towards a physical openness of design, or towards linear clarity, or towards both. They continue, in this respect, a tendency that began well inside Painterly Abstraction itself, in the works of artists like Still, Newman, Rothko, Motherwell, Mathieu, the 1950–54 Kline, and even Pollock. A good part of the reaction against Abstract Expressionism is, as I've already suggested, a continuation of it. There is no question, in any case, of repudiating its best achievements.

Among the qualities that Greenberg notes in the artists exhibited are (in some cases) the hard edge; in most cases, "the high keying, as well as lucidity, of their color...contrasts of pure hue rather than contrasts of light and dark...relatively anonymous execution."

The thirty-one artists in the exhibition included, among others, Gene Davis, Friedel Dzubas, Paul Feeley, John Ferren, Sam Francis, Helen Frankenthaler, Al Held, Alfred Jensen, Ellsworth Kelly, Alexander Liberman, Morris Louis, Kenneth Noland, Jules Olitski, Raymond Parker, Ludwig Sander, and Frank Stella. Canadian artists included Jack Bush and Kenneth Lochhead.

The next exhibition to document aspects of the new abstraction came in 1966 and was entitled "Systemic Painting" by Lawrence Alloway, who organized the show for the Guggenheim Museum. This was a somewhat more specialized affair than the other two exhibitions, but it did overlap with both of them and suggest significant new directions in American abstract painting. It must always be kept in mind that these events (at least the latter two) occurred while Pop Art was dominating the American scene, closely followed in many areas by Optical painting and by light and motion.

The exhibition of Systemic painting included, among others, Paul Feeley, Ellsworth Kelly, Kenneth Noland, Neil Williams, Larry Zox, Frank Stella, Larry Poons, Al Held, Leon Polk Smith, Jack Youngerman, and Nicholas Krushenick. Alloway drew attention to what he called "One Image art" in the works of many of these artists—the contemporary tendency to play continuous variations on a single theme. Noland, for instance, painted circles, then chevrons; Feeley did quatrefoils; and Reinhardt evoked crosses.

Alloway saw in One Image art the application of serial systems, and thus proposed the term Systemic:

> The application of the term systemic to One Image painting is obvious, but, in fact, it is applied more widely here. It refers to paintings which consist of a single field of color, or to groups of such paintings. Paintings based on modules are included, with the grid either contained in a rectangle or expanding to take in parts of the surrounding space (Gourfain and Insley respectively). It refers to paint-

ers who work in a much freer manner, but who end up with either a wholistic area or a reduced number of colors (Held and Youngerman respectively). The field and the module (with its serial potential as an extendible grid) have in common a level of organization that precludes breaking the system. This organization does not function as the invisible servicing of the work of art, but is the visible skin. It is not, that is to say, an underlying composition, but a factual display. In all these works, the end-state of the painting is known prior to completion (unlike the theory of Abstract Expressionism). This does not exclude empirical modifications of work in progress, but it does focus them within a system. A system is an organized whole, the parts of which demonstrate some regularities. A system is not antithetical to the values suggested by such artwork word-clusters as humanist, organic, and process. On the contrary, while the artist is engaged with it, a system is a process; trial and error, instead of being incorporated into the painting, occur off the canvas. The predictive power of the artist, minimized by the prestige of gestural painting, is strongly operative, from ideas and early sketches to the ordering of exactly scaled and shaped stretchers and help by assistants.

Without citing all such labels, among them "cool art" (by Irving Sandler), enough have been noted to suggest the range of American abstract painting in the 1960s. Although certain common denominators are apparent, probably no single, encompassing term can be found to describe this painting any more satisfactorily than Abstract Expressionism in the 1950s. For the purposes of discussion we will use the broad term Color Field painting in our analysis of a number of individual artists who will illustrate the range of expression involved.

SAM FRANCIS (b. 1923) Greenberg's inclusion of Sam Francis among his Post-Painterly abstractionists may seem somewhat surprising, since Francis during the 1950s was associated with American Abstract Expressionism and L'Art Informel in Paris, where he lived until 1961. In other words, he would be considered a "painterly" artist. His inclusion, nevertheless, is not illogical, since the direction of his painting had been toward that openness and clarity of which Greenberg spoke. In fact, despite his continuing use of the brush gesture, the drip and spatter, his relations to the Color Field painters were greater than his differences, and he even anticipated some of them in his use of extreme openness of organization. The 1954 *Red and Black* is rich and dense in its structure (fig. 759), while *Shining Back*, a work of 1958, is far more open, although the drips and spatters are even more apparent (fig. 760). In later works, despite lingering vestiges of spatters, the essential organization is that of a few free but controlled color-shapes, red, yellow, and blue, defining the limits of a dominant white space. Francis's paintings of the early 1970s increasingly emphasized the edge to the point where his paint spatters at times surround a clear or almost clear center area of canvas (plate 232). There continues to be a great range in his painting within the general formula of Lyrical Abstraction. At times he uses a precise linear structure as a control for his free patterns of stains and spatters. Although Francis has been associated with the Color Field painters, it is always important to remember that he antedated the classification and should be thought of essentially as a

highly talented contemporary pure painter, who has gone his own way and developed logically and impressively without concern for fashions or categories.

JOAN MITCHELL (b. 1926) An artist also sometimes included within the category of Color Field painters is Joan Mitchell, one of the younger artists associated with Abstract Expressionism during the 1950s, along with Francis, Norman Bluhm, Ray Parker, and others. Married to Jean-Paul Riopelle (fig. 629), Mitchell has lived in Paris since 1959, there pursuing her own directions in painting. These have maintained many of the painterly qualities of the De Kooning or Kline tradition, increasingly organized within a large simplified structural frame (fig. 761).

HELEN FRANKENTHALER (b. 1928) Another transitional figure between Abstract Expressionism and Color Field painting is the remarkable and ever-fresh Helen Frankenthaler, who became the first American painter after Jackson Pollock to see the implications of the color-staining of raw canvas to create an integration of color and ground in which foreground and background ceased to exist. This concept was taken up by Morris Louis in 1954, and out of it emerged important aspects of Color Field painting. Frankenthaler employs an open composition, frequently building around a free-abstract central image and also stressing the picture edge (plate 233). The paint is applied in uniformly thin washes. There is no sense of paint texture—a general characteristic of Color Field painting—although there is some gradation of tone around the edges of color-shapes, giving these a sense of detachment from the canvas. The irregular central motifs float within a rectangle, which, in turn, is surrounded by irregular light and dark frames. These latter create a feeling that the center of the painting is opening up in a limited but defined depth. Since then Frankenthaler, without changing her basic approach or image, has continued to develop strongly. Her paintings have not only expanded in scale but demonstrate an ease, openness, and variety that mark her as one of the

761. JOAN MITCHELL. *Lucky Seven*. 1962. 79 × 74 × ⅜". Hirshhorn Museum and Sculpture Garden, Smithsonian Institution, Washington, D.C.

762. HELEN FRANKENTHALER. *Lunar Avenue*. 1975. Acrylic on canvas, 12'8" × 7'9½". Private collection

MORRIS LOUIS (1912–1962) Louis was one of the most talented new American painters to emerge in the 1950s. Living in Washington, D.C., somewhat apart from the New York scene and working almost in isolation, he and a group of artists that included Kenneth Noland were central to the development of Color Field painting. The basic point about Louis's work and that of other Color Field painters, in contrast to most of the other new approaches of the 1960s—Pop Art, Op Art, light, motion, and so on—is that they continued a tradition of pure painting, particularly that of Pollock, Newman, Still, Motherwell, or Reinhardt. They were concerned with the classic problems of pictorial space and the statement of the picture plane. Louis characteristically applied extremely liquid paint to an unstretched canvas, allowing it to flow over the inclined surface in effects sometimes suggestive of translucent color veils. There is no brush gesture, although the flat, thin pigment is at times modulated in billowing tonal waves (plate 235). His "veil" paintings consist of bands of brilliant, curving color-shapes submerged in translucent tones through which they shine principally at the edges. Although subdued, the resulting color is immensely rich. In another formula the artist used long, parallel strips of pure color arranged side by side in rainbow effects. Although the separate colors here are clearly distinguished, the edges are soft and slightly interpenetrating (plate 236).

JULES OLITSKI (b. 1932) Olitski seems to be a man of romantic sensibility reacting to the pure sensuousness of his large, assertive color

foremost lyrical colorists of this generation. Some of her works are extremely sparse and economical in their balance of limited color areas against large areas of blank canvas (fig. 762). In others, without abandoning the transparency of her staining technique, she achieves the total density of a forest landscape (plate 234).

If Frankenthaler's great lyrical abstractions seem heir to the Romantic nineteenth-century Nocturnes of Whistler (fig. 43), so do the equally abstract photographic images of Paul Caponigro (b. 1932), perhaps for the very good reason that he began his artistic life in music (fig. 763). A student of Minor White, Caponigro also revealed himself to be a disciple of Stieglitz when he wrote: "The world, the unity of force and movement, could be seen in nature—in a face, a stone, or a patch of sunlight. The subtle suggestions generated by configurations of cloud and stone, of shape and tone, made of the photograph a meeting place, from which to continue on an ever more adventurous journey through a landscape of reflection, of introspection." To express his sense of the individual's oneness with the world of nature, Caponigro seeks out such natural phenomena as rock structures, eroded surfaces, tangled branches, or water environments and photographs them close up with a large-format camera, always on the alert for an arresting, flat-pattern design with symbolic potential.

763. PAUL CAPONIGRO. *Schoodic Point, Maine, 1960*. Gelatin-silver print. ©1960 Paul Caponigro

areas. In earlier works he, like so many of his contemporaries, explored circle forms, but his were generally irregular, off-center, interrupted by the frame of the picture to create vaguely organic effects reminiscent of Arp. Moving away from these forms, Olitski began, about 1963, to saturate his canvas with liquid paint, over which he rolled additional and varying colors. In later works, he sprayed on successive layers of color in an essentially commercial process that yet admitted of a considerable degree of accident in surface drips and spatters (plate 237). The dazzling, varied areas of paint are defined by edges or corners and perhaps internal spots of roughly modeled paint that control the seemingly limitless surfaces. Sometimes apparently crude and coloristically disturbing, Olitski's flamboyant works are nevertheless hypnotic in their impact.

Much has been made of the color painters' emphasis on the canvas edge in contrast to the traditional pattern of centralization. This move to the framing edge of the canvas in painting has perhaps some analogies to the accent on horizontality in contemporary abstract sculpture, which similarly may be considered a reaction against the long tradition of centralized focus in sculpture.

LARRY POONS (b. 1937) Poons, who in the 1960s created an intriguing form of Systemic painting with optical illusionistic implications (plate 238), subsequently moved in the direction of matter painting (fig. 764). His heavily textured canvases frequently have long, vertical dragged brushstrokes, densely arranged in rich color patterns. Both Olitski and Poons, who perhaps should not be coupled, indicated a tendency on the part of certain artists associated with the more objective wing of Color Field painting to move in the direction of pure, sensuous, highly textured surfaces. Needless to say, both of them were working on the mural scale that proved normal in so-called "late-modern" painting.

JACK BUSH (b. 1909) Within the broad, vague category of Field painting, the Canadian Jack Bush formulated a sort of abstract landscape, frequently superimposing bold floating color shapes on a delicately textured ground to create an illusion of abstract figuration within a representational field (plate 239).

GENE DAVIS (b. 1920) An artist equally at home among the Color Field painters or with the Hard-Edge masters, or even the Op artists yet to be encountered, was Gene Davis, another of that remarkable group of painters, including Morris Louis, Kenneth Noland, Howard Mehring, and Thomas Downing, who emerged from Washington, D.C. Davis might also be associated with the so-termed Minimal artists because of his concentration on a single repeated image and principles of balanced frontality (plate 240). Davis's sixties image was the vertical color stripe, rigidly defined through the use of masking tape and presented in different paintings in a range of widths from narrow lines to color strips inches wide. He normally used uniform widths for the verticals in a given painting. Selecting highly saturated and varied colors, Davis arrived at effects of great color density, different from the openness of the Color Field painters, and as retinally exciting as works by genuine Op artists.

As the trend toward progressively more radical abstraction intensified throughout the sixties, urged on by doctrinaire critical support, commercial hype, and media exposure, only exceptionally strong artists could maintain their aesthetic independence of the dominant mode. Fortunately, the period was blessed with a number of such masters, artists who could remain free in their use of abstract pictorial language,

764. LARRY POONS. *Cutting Water*. 1970. Acrylic on canvas, 7' × 5'4".
Whereabouts unknown

yet speak for their age in terms that were nonetheless authentic and universal. Several of the most interesting figures among the mavericks enjoyed the advantage—for purposes of their individuality—of regular residence remote from the competitive, egocentric, hothouse world of the New York art scene.

RICHARD DIEBENKORN (b. 1922) In the course of his long career, which began in the 1940s, California artist Richard Diebenkorn has evolved his art through three distinct phases. During the first he worked in an Abstract Expressionist vein, guided by the living examples of Clyfford Still and Mark Rothko during their tenure at the California School of Fine Arts (now the San Francisco Art Institute). While the outward forms of his style would change, the artist early on discovered his most fundamental concern, which was traditional in the Cézannesque sense of wanting not to work from pure ideas, imagination, or feelings, but rather to abstract from his perception of things seen, the purpose in his case being to realize painterly, atmospheric distillations of the Western American landscape. From the outset, he learned to achieve this in a personal, idiomatic manner, which was to translate his sensuous, visual experience into broad fields of colored light structured in relation to the flatness and rectilinearity of the picture plane by a framework of firm but painterly geometry. Already, even as an Abstract Expressionist, Diebenkorn was, like most of his generation, a cool formalist, and in the context of his art, he eschewed private, autobiographic associations in favor of meanings more generally evocative of the interaction between inner and outer worlds. This can be seen to particular advantage in *Man and Woman in a Large Room* (fig. 765), executed after the

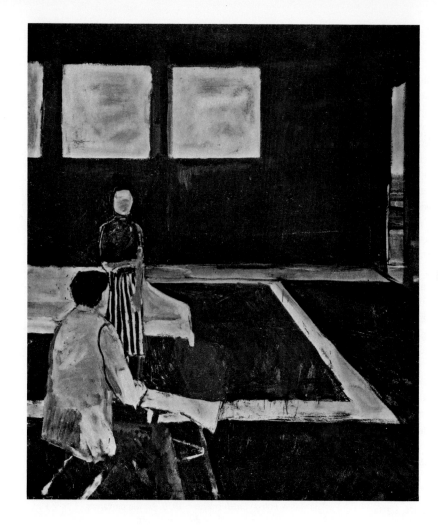

765. RICHARD DIEBENKORN. *Man and Woman in Large Room*. 1957. 71 × 62½". Hirshhorn Museum and Sculpture Garden, Smithsonian Institution, Washington, D.C.

artist shifted from abstraction to figuration, a change that occurred in 1954 while he was in close contact with two other California painters: David Park and Elmer Bischoff. The picture functions all the better as a visual metaphor because the figures, despite the Expressionist potential of their juxtaposition and handling, participate in the overall structure of the total image, while also enriching its sober, contemplative mood with an undercurrent of emotional pressure. In the early 1960s Diebenkorn moved on from this second or figurative phase, and in 1967, following his relocation to Santa Monica, he began what has become his third and continuing mode, devoted to a series of majestic nonfigurative abstractions known as the Ocean Park paintings. Now in variation after variation, and with Matisse as a primary source, in addition to Mondrian, Monet, and of course Abstract Expressionism, Diebenkorn purified and monumentalized his personal scheme of mist- and light-filled color planes emanating from but rigorously contained within a softly drawn architectural scaffolding (plate 241). Pentimenti and odd, oblique angles in the structural borders or beams and the expansiveness and close harmony of the slightly off colors work alone, without benefit of human images, to generate a sense of tension within the pervasive calm, a sense of presence within figuratively empty fields. Reconciling hard and soft, the perceived and the felt, an outer framework of geometry and an inner realm of diaphanous, suffused color, Diebenkorn endows his pictures with the complex reality of his own experience, of things known in the exterior world of nature and then translated into the enclosed, poetic world of art. With this grand, Classical equipoise, Diebenkorn continues in his own serene, analytical manner the heroic balance between gestural and field painting, passion and intellect, intimacy and alienation originally struck by more emotionally driven artists, among them Adolph Gottlieb, Robert Motherwell, and Clyfford Still.

CY TWOMBLY (b. 1928) After World War II the slightly younger Cy Twombly established a more or less permanent base in Rome, where he too succeeded in calmly pivoting his art on the convergence point of freedom and control, lucidity and opacity. A poet as well as a painter, Twombly found his characteristic image in a slate-gray ground covered over with white graffiti drawing intermingled with words and numbers, like chalk lessons half-erased on the blackboard at the end of a busy school day (fig. 766). Sometimes snatches of personal verse, often brief quotations from a Classical source, always legible at first sight, though never complete or coherent on close examination, Twombly's scribbles and scrawls activate the surface with gestures as decisive as Pollock's, but, unlike true Action painting, remain short-winded and indeterminate. While logic may be denied, however, the evocation is lyric and romantically personal, like a well-kept diary that is as beautiful and intriguing to read as it is enigmatic and ambiguous in meaning.

ALFRED JENSEN (1903–1981) Still more abstruse, even explicitly so, are the utterly nonfigurative paintings of Alfred Jensen, who never gained much public attention, but in the late sixties began to have significant influence within the art world itself. A mystic motivated by an idiosyncratic preoccupation with whatever hermetic ideas and theories might explain the dualities of the universe—equations and axioms, Tantric diagrams, Goethe's theory of color, Egyptian and Aztec calendars, cabalistic and alchemical signs—Jensen formulated a no less obsessive methodology for giving expression to such content in purely pictorial terms. And so striking is the result—brilliant, intricately plotted plaids and patterns dabbed on in layers as thick as cake frosting—that, with its marriage of messy human handling and arcane content, the art attracts and holds the eye like a magnetic field of color, form,

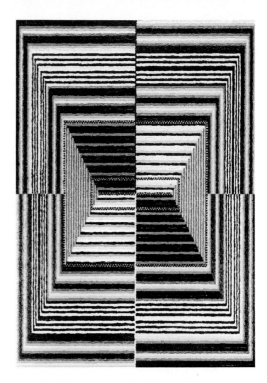

766. CY TWOMBLY. *Untitled.* 1969. Crayon and oil on canvas, 6'6" × 8'7". The Whitney
Museum of American Art, New York. Gift of Mr. and Mrs. Rudolf B. Schulhof

767. ALFRED JENSEN. *The Acroatic Triangle Per 12.* 1967.
71½ × 50¾". Cordier and Ekstrom, Inc., New York

and materialized feeling (fig. 767; plate 242). The viewer need not read
the *I Ching* or the Rosetta Stone in order to be seduced by the dazzling
visual effects such rarefied sources inspired Jensen to produce.

768. ELLSWORTH KELLY. *Orange and Green.* 1966. 88 × 65". Sidney Janis
Gallery, New York

Hard-Edge Painting

The term "hard-edge" was first used by the California critic Jules
Langsner in 1959, and then given its current definition by Lawrence
Alloway in 1959–60. According to Alloway, Hard-Edge was defined in
opposition to geometric art, in the following way: "The 'cone, cylinder,
and sphere' of Cézanne-fame have persisted in much 20th-century
painting. Even where these forms are not purely represented, abstract
artists have tended toward a compilation of separable elements. Form
has been treated as discrete entities," whereas "forms are few in hard-
edge and the surface immaculate.... The whole picture becomes the
unit; forms extend the length of the painting or are restricted to two or
three tones. The result of this sparseness is that the spatial effect of
figures on a field is avoided." The important distinction drawn here
between Hard-Edge and the older geometric tradition is the search for a
total unity in which there is generally no foreground or background, no
"figures on a field." During the 1950s Ellsworth Kelly, Ad Reinhardt,
Leon Polk Smith, Alexander Liberman, Sidney Wolfson, and Agnes Mar-
tin (most of them exhibiting at the Betty Parsons Gallery in New York)
were the principal pioneers. Barnett Newman (also showing at Par-
sons) was a force in related but not identical space and color
explorations.

ELLSWORTH KELLY (b. 1923) Kelly, who may also be considered a
leading Primary structuralist, was a leader of the Hard-Edge faction
within Color Field painting. His preference at that time was for large,
bright, slightly irregular, ovoid shapes contrasted with rectangular
planes of color. The influence of Arp was evident at times. In the 1960s
his shapes became more absolutely symmetrical, whether rectangular
or in terms of flattened ovals (fig. 768), and he worked increasingly

769. ELLSWORTH KELLY. *Untitled*. 1974. Painted aluminum, 5'3¾" × 16'10". Leo Castelli Gallery, New York

with regular alternations of color rectangles arranged like a color chart, a concept pioneered by Duchamp in *Tu m'* (plate 104), but with the added dimension of subtle and startling color relationships and contrasts (plate 243). Kelly, like many Hard-Edge and Minimal paint-

770. JACK YOUNGERMAN. *Roundabout*. 1970. Acrylic on canvas, diameter 96". The Albright-Knox Art Gallery, Buffalo. Gift of Seymour H. Knox

ers, has moved into the field of the shaped canvas or of construction. He does not differentiate between his paintings and his sculptures, and some of his works are difficult to classify. Thus *Untitled* of 1974 (fig. 769), a neutral painting on aluminum, gains much of its effect from its relief projection. Kelly also creates freestanding sculptures, works in which the image of each component is not radically different from that of his painting, although projected on an environmental scale and constructed industrially of Cor-ten steel.

JACK YOUNGERMAN (b. 1926) Like Kelly, Jack Youngerman matured artistically in Paris, during the postwar years, courtesy of the GI Bill, before returning to join the New York School in the 1950s. He then became known for bringing a special Matisse-like rhythm and grace to the Constructivist tradition by rendering leaf, flower, or butterfly forms with the brilliantly colored flatness and clarity of Hard-Edge painting (fig. 770). In this, he looked back not only to Arp and Matisse, but also to the rhapsodic, nature-focused art of such earlier Americans as Dove, O'Keeffe, and Gorky. For a while, he so designed his undulant silhouettes that figure and ground, somewhat in the manner of contemporary Op Art, appear to reverse, negative-positive fashion.

KENNETH NOLAND (b. 1924) Although Noland, as noted, was close to Louis during the 1950s and, like him, sought a Color Field painting essentially departing from the brush-gesture mode of De Kooning or Kline, his personal solutions were quite different from those of his fellow Washingtonian. Using the same thin pigment to stain unsized canvas, Noland made his first completely individual statement when, as he said, he discovered the center of the canvas. From this point, between the mid-1950s and 1962, his principal image was the circle or series of concentric circles exactly centered on a square canvas (plate 244). Since this relation of circle to square was necessarily ambiguous, about

1963 Noland began to experiment with different forms, first ovoid shapes placed above center, and then meticulously symmetrical chevrons starting in the upper corners and coming to a point in the exact center of the bottom edge (fig. 771). These chevrons, by their placing as well as their shape, gave a new significance to the shape of the canvas and created a total, unified harmony in which color and structure, canvas plane and edges are integrated.

After 1964, working within personally defined limits of color and shape relationships, Noland systematically expanded his vocabulary. The symmetrical chevrons were followed by asymmetrical examples. Long, narrow paintings with chevrons only sightly bent led to a series in which systems of horizontal strata were explored, sometimes with color variations on identical strata, sometimes with graded horizontals, as in *Graded Exposure* (plate 245). In the next few years the artist moved from the solution of *Graded Exposure* to a formula of vertical or horizontal canvases in which the "plaid" pattern allowed a dominant emphasis to fall on the framing edge. In the mid-1970s he changed his approach dramatically to a structure of diagonal color areas, in some of which he utilized an over-all stipple texture. The most intriguing visual effect of these extremely large canvases was the introduction of a dramatic perspective illusion achieved by a shaped canvas in which one edge is a diagonal rather than a vertical (fig. 772). In this and other shaped canvases, Noland seemed to be reexamining in a highly personal manner the perennial question of Renaissance perspective.

AL HELD (b. 1928) Both for his own qualities and to illustrate the range of this new abstraction, Al Held must be mentioned in relation to Color Field as well as Hard-Edge painting. He remains one of the strongest of the sixties abstractionists both in his forms and in his use of color, but, unlike most of the other Color Field painters who eliminated brushstrokes and paint texture, Held built up his paint to a massive over-all texture that added to the total sense of weight and rugged power. He worked over his paint surfaces, sometimes layering them to a thickness of an inch, although since 1963 he has sanded down the surface to a machine precision. The powerful impact of the heavy pigment remains, however, central to the artist's intent. For a period in the 1960s, Held based paintings on letters of the alphabet (fig. 773). In

771. KENNETH NOLAND. *Golden Day*. 1964. Acrylic on canvas, 72 × 72".
Private collection

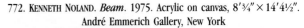

772. KENNETH NOLAND. *Beam*. 1975. Acrylic on canvas, 8'¾" × 14'4½".
André Emmerich Gallery, New York

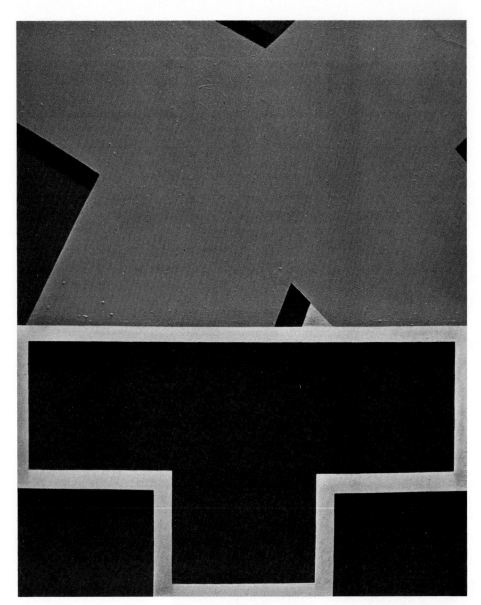

left: 773. AL HELD. *Ivan the Terrible*. 1961.
Acrylic on canvas, 12′ × 9′6″. André
Emmerich Gallery, New York

opposite left: 774. AL HELD. *Flemish IX*.
1974. Acrylic on canvas, 72 × 60″. Sable-
Castelli Gallery, Toronto

opposite right: 775. AL HELD. *Mercury Zone
II*. 1975. Acrylic on canvas, 72 × 60″. André
Emmerich Gallery, New York

these, again, the open portions of the letters were subordinated to a minimum, to hold the edges of the canvas and establish the sense of great scale.

If the flat, unmodulated or the thinly stained paint surface must be considered a criterion of Color Field painting, Held should not really be associated with this direction. He is concerned with scale as a basic expressive end—not vast scale that simply crushes the spectator, but scale that may awe him, yet at the same time enlarges the human scale. The scale he seeks is not that of Rothko, who wanted to achieve a sense of intimacy in his large canvases by absorbing the spectator into them. Held's massive paint surface is like a wall that makes of the painting something akin to an architectural wall or a great relief sculpture. It is in this emphasis on the painting as an object, a reality in itself rather than an illusion of anything else, that Held considers himself a Realist. The search for this kind of reality has, of course, been the quest of every serious abstract (or concrete) artist in the history of modern art. In his attempt to achieve this total reality by emphasizing the physical reality of the paint itself, the medium from which the painting is made, Held in a sense has been returning to the very beginnings of modern art, to Gustave Courbet, who also insisted on the reality of the painting as an object, the reality of its surface, and the reality of the paint (fig. 39).

The insistent exploration of a form of rigid geometric abstraction almost inevitably led Held to the refinement of his means to a black-and-white structure. In a group of paintings of 1974 and early 1975 he presented an architecture of boxlike structures outlined in white against a uniform black ground. This was a painting of linear perspective illusion carried to the point where it might almost be an exercise in Euclidean geometry (fig. 774). The power and compression of Held's structures make the painting transcend any mere mathematical diagram. The title "Flemish" in the series suggests that Held, like many of his contemporaries in the 1970s, had been looking at Old Master paintings, in this instance conceivably the works of Jan van Eyck or Rogier van der Weyden.

The black paintings with white linear structures also have been accompanied by their counterparts, which consist of black lines on a flat white ground. In earlier examples the perspective structures were heavily outlined. In a number of the white paintings, however, the lines became much more delicate, mixed with the weightier ones. Transparent, curvilinear elements became increasingly dominant as the total spatial interplay. In *Mercury Zone II* (fig. 775) both the title and the spatial movement suggest a contemporary interest in interplanetary exploration. At a moment when man had not only landed on the moon but

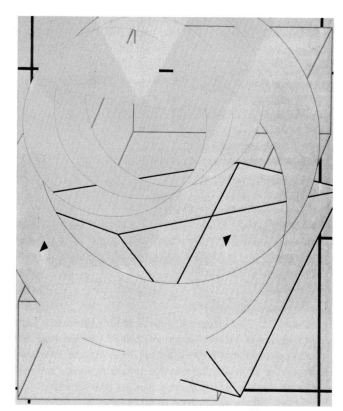

was actively exploring the other planets of the solar system and inter-planetary space, it seemed natural that artists should become intrigued with some of the astronomical images associated with the exploration of outer space.

Held's work, impressive in its own right, also proved indicative of a continuing trend among a number of painters in Europe and America to a re-examination of Renaissance linear perspective. This trend might be considered as another aspect of the retreat from modernism, back to the Classical tradition of Western art, which is apparent in many differ-ent ways in the last quarter of the twentieth century. The question that must be asked is whether such a re-examination of past traditions is indicative of the rise of a new academy. And the question must be con-tinually kept in mind as we attempt to evaluate the tendencies and di-rections of painting, sculpture, and architecture toward the new *fin de siècle*. Without prejudging the case, we should meanwhile recall that the arts of every period have been built on the arts of the past, even when artists were most emphatically rebelling against tradition. The is-sue is not the use of the past but how the past is used: whether it is slavish imitation or the enlargement of a vocabulary.

When Held reintroduced color, he did so with a vengeance, adopting a high-keyed intensity that combines with expanding scale to give his newer paintings an almost overwhelming impact (plate 246). And color too, by its clarity and precise, anonymous handling, joins with line, value, and perspective to compound the conflict of works in which lu-cidity of representation arouses expectations of Renaissance formal and spatial coherence only for this to be frustrated by Surreal, Piranesi-like ambiguity. Held's color, for instance, is consistent only in its steady defiance of the perspective drawing, so that identical intensities of hue remain the same and thus flatten forms whose shapes imply recession or advance. Throughout these powerful and challenging pictures, im-ages constantly fail to conform to what experience and tradition have

prepared eyes to anticipate in logical-seeming spatial structures. And so, as in the *perpetuum mobile* of Pollock's calligraphic complexity, the eye gives up trying to sort out the irresolutions and accepts the special unity or indivisibility—the holism—of the total configuration, whose consistency, for Held, lies in its unyielding contradiction. Now, instead of movement through space, the viewer experiences a sense of timeless present. True to their modernist aesthetic, the pictures deny meaning outside themselves, communicate nothing beyond their own literal presence, and thus encourage the viewer to discover his own internal unity, even while surrounded by an empirical world riven with doubt and dissension.

The Shaped Canvas

The search for new forms and expressive means led painters of the 1960s into a number of experiments, some of which were only bypaths, while some would prove enduringly significant. We have referred fre-quently to the tendency toward synthesis of the arts that marked much of sixties painting and sculpture. Happenings, developed by artists, were actually a form of theater, at times involving dance and music as well as characteristics derived from painting or sculpture. And they sur-vive, as we shall see, in Performance Art. Sculptured tableaux, such as those of George Segal, are also closely related to theater. Kinetic and Op Art as well as Minimal Art often broke down or blurred the distinctions between painting and sculpture.

Another new form of the 1960s, the so-termed "shaped canvas," would also seem at first exposure to represent a synthesis of painting and sculpture. Yet, this is not actually the case. Although the traditional format of a painting throughout history has been a flat rectangle, other configurations such as the square, diamond, tondo, or cross have also

776. FRANK STELLA. *Quathlamba*. 1964. Metallic powder in polymer emulsion on canvas, 6′5″ × 13′7″. Private collection

been used. The Gothic frames of medieval or Early Renaissance altarpieces resulted in irregular shapes with pointed tops and wings that could be placed at right angles to the wall. Other irregular forms such as the oval or the quatrefoil emerged in Baroque or Rococo, and even Cubist, paintings. In modern painting there has been surprisingly little experiment with the actual shape of the painting until recent times. Jackson Pollock painted some extremely long, narrow, horizontal works, and in the early 1950s Barnett Newman made several tall vertical paintings only a few inches wide, as though he were detaching and isolating his stripe as a separate presence.

Still, the shaped canvas made it seem as if painting and sculpture were drawing ever closer together. An increasing number of painters used the shaped canvas for specific effects that emphasized the painted forms within the canvas surface. Thus Wesselmann, in some works from his Smoker series, cut the edges of the canvas in curvilinear shapes that reiterate the shapes of the hand and mouth and smoke within the painting (plate 221). These works do not involve projection or recession in the canvas but simply an organically shaped contour. Ellsworth Kelly, using extremely subtle relief projections or freestanding structures whose implications are still two-dimensional, breaks the bounds between painting and sculpture. Kenneth Noland, in one series of works, also explored possibilities of departure from the traditional rectangular frame of the canvas. England's Richard Smith (b. 1931) used violent, jagged edges on his canvases which lend them a particular expressive effect (plate 247).

In all these artists, variations in the shape of the canvas were essentially on the two-dimensional plane. The pictures do not project substantially forward in the third dimension. Charles Hinman (b. 1932) provided an exception in that he shaped his works in strong projection, using cubes or curving, cylindrical forms, and large areas of color in the shaping of powerful relief sculptural effects (plate 248).

FRANK STELLA (b. 1936) Frank Stella too would develop his shaped canvases toward relief constructions, dramatic ones, with aggressive thrusts away from the wall. But this came only in the logical order of a serial evolving from a primary investigation of flatness in its most radical form. One of the youngest and most talented of the artists associated with the new American painting, Stella first gained wide recognition in 1960 with a number of works exhibited by New York's Museum of Modern Art, during one of its periodic group shows of American artists, on this occasion entitled "Sixteen Americans." The so-called "stripe"

paintings shown there were principally large, vertical rectangles, with an absolutely symmetrical pattern of light lines forming regular, spaced rectangles radiating inward from the canvas edge to the cruciform center (fig. 776). These paintings, in their balanced symmetry and repetition of identical motifs, were related to experiments by Minimal or Primary Structure sculptors (plate 249). They had, however, a magical and compelling power of their own. Over the next few years, using copper or aluminum paint, the artist explored different shapes for the canvas, which were suggested by his rectilinear pattern. The first element in such a repeated pattern became a notch in the canvas. This developed into U-shaped or L-shaped canvases in which the support became a sort of frame around the blank wall. In these, Stella used deep framing edges which gave a particular sense of object solidity to the painting. After some explorations of more coloristic rectangular stripe patterns with at times optical effects, Stella, about 1967, turned to brilliantly chromatic shapes, interrelating protractor-drawn semicircles with rectangular or diamond effects. These "protractor" works sometimes suggest abstract triptychs, with their circular tops recalling later Renaissance altarpieces (plate 250).

Stella in the 1970s moved increasingly toward a form of three-dimensional painted relief, bold in color and dynamic in structure (fig. 777). Soon it became difficult to tell if the works were paintings or sculptures, for by now the artist was using lacquer and oil colors on aluminum bases (plate 251). These impressive and powerful works illustrate the trend of the 1970s to destroy the traditional boundaries between the individual art forms. It is interesting to compare the piece just seen with Anthony Caro's natural and painted steel sculpture *Monsoon Drift* (fig. 812).

In the years since, Stella has become virtually peerless in his sustained productivity, in the brilliance and daring of his invention, with the result that he continues, almost inexorably, to push his art in directions that could hardly be more unpredictable—or more self-evidently logical once accomplished. And the unique genius of this young "Old Master" has not gone unremarked, for in 1983, in his forty-seventh year, Stella received the honor of being named Harvard's Charles Eliot Norton Professor of Poetry, an annual appointment previously held by such creative notables as T. S. Eliot, Igor Stravinsky, Ben Shahn, and R. Buckminster Fuller. So great was the demand for tickets to the six public lectures required of the chair holder that, for the first time, the series had to be transferred to a much larger auditorium, which throughout remained uncharacteristically filled to the rafters by an in-

telligentsia that in many instances had traveled great distances to attend. What they heard was a passionate defense of abstraction, and a cunningly formulated argument for a process through which abstraction may yet fulfill its promise as the twentieth century's preeminent contribution to the pictorial arts. Along the way, however, it must, according to the artist, recover the vigor, the sense of theater, and the spatial complexity it possessed in the art of the Abstract Expressionists. By way of example, Stella evoked his recent experience in Italy, where he saw how Caravaggio and Rubens had breathed new Baroque life into the Classical tradition, following its enervation by later sixteenth-century Mannerism, and thus recovered in their own art the vitality, warmth, and grandeur radiating the monumental achievements of the High Renaissance (figs. 7, 9). In order to rekindle abstraction from the chill purity of late modernism—a Minimalist phase likened by Stella to pre-Caravaggio Mannerism—abstract painting must abandon the spiritualized cerebrations the Pollock–Rothko generation inherited from such northern Europeans as Kandinsky, Malevich, and Mondrian and re-embrace "the tough, stubborn materialism of Cézanne, Monet, and Picasso," all earth-rooted, humanist southern Europeans more involved with pictorial values than ideas.

As daring in action as in word, Stella has shown the way in series after series, especially in his spectacular Shards, huge, flamboyant wall reliefs for which the artist relinquished his original practice of preparing each work with such care that it required no design changes during execution (plate 252). Instead, he simply extemporized from scraps left over at the factory where his previous sequence had been executed from various industrial materials. Thus, in process itself, Stella demonstrated the dynamic freedom, quickness, and energy that he demands be materially and visually present in the final static image. In *Shards V*, seen here, with its billowing projection, its dramatically angled planes and snaking curves, its garish hues and high-velocity graffiti drawing, all rigorously controlled by the square format and emphatic, wall-affirming frontality, the artist would indeed appear to have made the Baroque spirit reincarnate in full-bodied modernist form.

above: 777. FRANK STELLA. Exhibition, 1971. Lawrence Rubin Gallery, New York

right: 778. FRANK STELLA. *Guifa e la berretta rossa*. 1984. Oil, urethane enamel, fluorescent alkyd, acrylic and printing ink on canvas, etched magnesium, aluminum, and fiberglass, 9'8½″ × 16'2″ × 1'11″. Collection, The Museum of Modern Art, New York. Purchase

In a subsequent series entitled Cones and Pillars, Stella has further thickened his plot by introducing into the turbulent Baroque energies, "glitzy" Pop colors, and scrawling, Abstract Expressionist calligraphy of the Shards reliefs forms whose Classical overtones and sleek stereometric facture would seem to be hopelessly at odds with the Romantic excess and irregularity of their immediate pictorial environment (fig. 778). If such Dada-like multiplicity wars with the very notion of unity, the problem could only have been compounded when the artist chose to work with media ranging from oil, urethane, and enamel to fluorescent alkyd, acrylic, and printing ink, applied to supports that include canvas, etched magnesium, aluminum, and fiberglass. Still, even as the cones and pillars do bizarre, anticlassical things, such as unfurling into fans and rolling out like lengths of carpet, they remind us of that ancient, warm-blooded Mediterranean tradition and its resurgence in the Classical-Romantic Cézanne, who said to seek in nature "the cylinder, sphere, and cone." And it was, of course, Cézanne who, by struggling heroically to resolve the conflict between his "sensations" of the perceptual world and his conception of the separate, special world of painting, fathered the very kind of modern abstraction, based on "tough, stubborn materialism," that Stella has resoundingly reaffirmed in the cohabitation now forced upon his old and new, notably uncompanionable and combative elements. And if they do this in something less than Classical calm, at least they fight one another to a draw, thereby attaining Classicism's Baroque equivalent, a precarious but powerful and dynamic counterpoise that makes perfect, if improbable and unprecedented, sense.

Optical Painting (Op Art)

More or less related tendencies in the painting of the 1960s may be grouped under the heading of Optical (or Retinal) painting. These involve a wide range of experiments, best defined in examination of the individual works. As has frequently been pointed out, the labels attached to modern monuments in art are rarely satisfactory, and are used for want of anything better. What is called Op Art overlaps at one end with light sculpture or construction (in its concern with illusion, perception, and the physical and psychological impact of color), and with light experiments on the spectator. At the other end, it impinges on some, though not by any means all, aspects of Color Field painting in its use of brilliant unmodulated color in retinally stimulating combinations, especially in the art of Larry Poons.

Optical illusion, in one form or another, has intrigued painters from the beginnings of art in the cave paintings of Altamira. Pompeian painting and Roman mosaics employed linear perspective rather for decorative, illusionistic effects than for the establishment of three-dimensional pictorial space. With the discovery, or rediscovery, of linear and atmospheric perspective in the fifteenth century, painters from Uccello to Crivelli delighted in the illusions of depth or shifting viewpoints permitted by the new technique. As we have noted at the beginning of this book, these experiments in perspective illusion attained fabulous dimensions in paintings of the Baroque and Rococo (figs. 10, 11).

Theories of color and perception may be traced to the philosophers George Berkeley and David Hume in the eighteenth century, as well as to Goethe. In the nineteenth century, Delacroix was a pioneer in the exploration of color theory, while the Impressionists and Neo-Impressionists carried experimentation in the perception of color to new limits. The influence of Chevreul, Von Helmholtz, and Rood, along with other writers on color and optics, on Seurat and the Neo-Impressionists, as well as later artists, has been discussed.

There were elements of optical illusion in the paintings of Mondrian, Van Doesburg, and other painters of De Stijl, although this was not a central factor except in Mondrian's late paintings (plate 158). Moholy-Nagy and Albers introduced optical experiments into the curriculum of the Bauhaus, both in terms of color and perspective. Albers, with his series Homage to the Square, made some of the most impressive twentieth-century contributions to the study of color relationships, as in his black-and-white drawings and engravings he had advanced the entire field of perspective illusion (plate 148; fig. 479). During the 1960s a new generation of painters and sculptors throughout the world turned to forms of art involving optical illusion or some other specific aspect of perception, several examples of which have already been seen in this chapter.

VICTOR VASARELY (b. 1908) The Hungarian-French painter Victor Vasarely was the most influential master in the realm of Op Art. Although his earlier paintings belonged in the general tradition of Concrete Art, Vasarely in the 1940s devoted himself to Optical Art and theories of perception. He began with a serious study of the works and ideas of Mondrian and Kandinsky, as well as the entire history of color theory, perception, and illusion. Since a large proportion of contemporary statements in Optical Art are observable in his works, they may be used to illustrate these statements generally. Vasarely's art theories, first

779. VICTOR VASARELY. *Sorata-T*. 1953. Triptych, engraved glass slabs, 6′6″ × 15′. Private collection

Colorplate 231. LUCIO FONTANA. *Green Oval Concept*. 1963.
70 × 48½″. Galleria dell'Ariete, Milan

Colorplate 232. SAM FRANCIS. *Untitled, No. 11*. 1973. Acrylic on canvas, 8 × 10′. André Emmerich Gallery, New York

Colorplate 233. HELEN FRANKENTHALER. *Interior Landscape*. 1964.
Acrylic on canvas, 8′8¾″ × 7′8¾″. San Francisco Museum of Art.
Gift of the Women's Board

Colorplate 234. HELEN FRANKENTHALER. *Elberta*. 1975. Acrylic on canvas, 6′7″ × 8′1″.
Private collection

Colorplate 235. MORRIS LOUIS. *Kaf.* 1959–60. Acrylic on canvas, 8′4″ × 12′. Collection Kimiko and John G. Powers, New York

Colorplate 236. MORRIS LOUIS. *Moving In.* 1961. Acrylic on canvas, 87½ × 41½″. André Emmerich Gallery, New York

Colorplate 237. JULES OLITSKI. *High a Yellow.* 1967. Acrylic on canvas, 7′8½″ × 12′6″. The Whitney Museum of American Art, New York

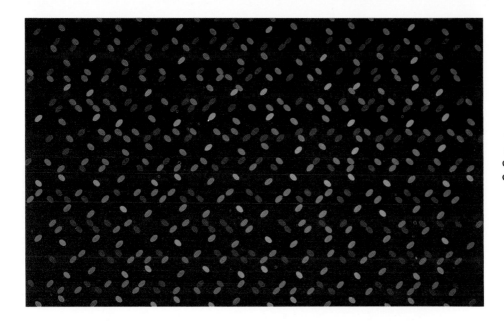

Colorplate 238. LARRY POONS. *Nixes Mate*. 1964. Acrylic on canvas, 5′10″ × 9′4″. Formerly collection Robert C. Scull, New York

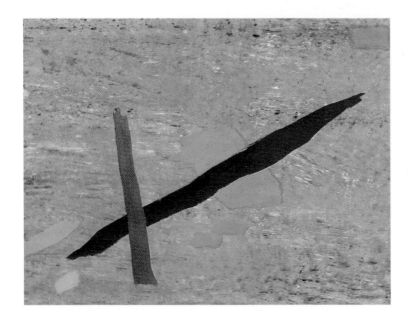

Colorplate 239. JACK BUSH. *Red Pink Cross*. 1973. 66¼ × 89″. Private collection, Boston

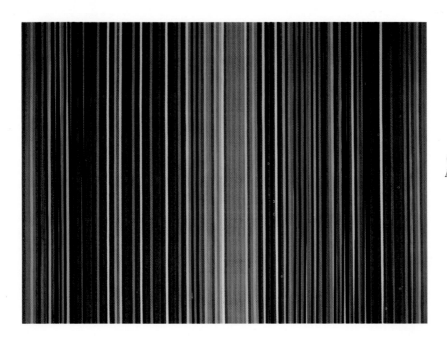

Colorplate 240. GENE DAVIS. *Moon Dog*. 1966. 10 × 16′. Private collection

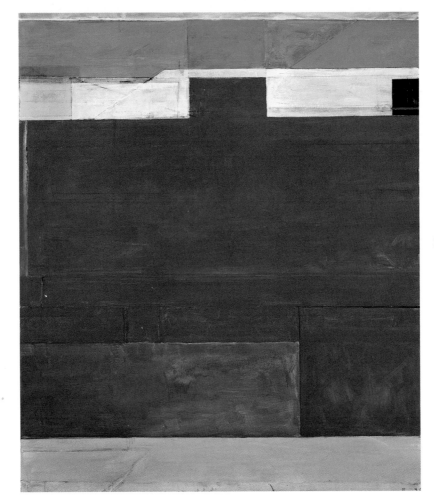

Colorplate 241. RICHARD DIEBENKORN. *Ocean Park No. 128*. 1984. 93 × 81″. Private collection, New York

Colorplate 242. ALFRED JENSEN. *The Ten Thousand Things*. 1972. Two panels, each 63½ × 69″. Private collection

Colorplate 243. ELLSWORTH KELLY. *Blue, Green, Yellow, Orange, Red*. 1966. Acrylic on canvas, five panels, each 60 × 48″. The Solomon R. Guggenheim Museum, New York

Colorplate 244. KENNETH NOLAND. *A Warm Sound in a Gray Field*. 1961.
82½ × 81″. Private collection, New York

Colorplate 245. KENNETH NOLAND. *Graded Exposure*. 1967. Acrylic on canvas, 7′4¾″ × 19′1″. Collection Mrs. Samuel G. Rautbord, Chicago

Colorplate 246. AL HELD. *Mantegna's Edge*. 1983. Mural, length 55'. Southland Center, Dallas

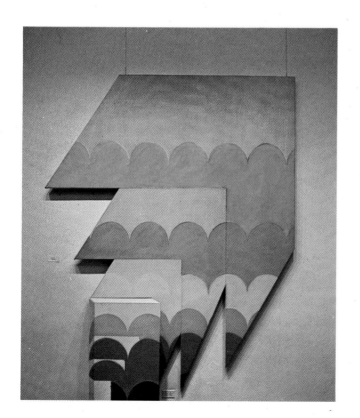

left: Colorplate 247. RICHARD SMITH. *Slices*. 1964. 10'5" × 8'4". Private collection, New York

below: Colorplate 248. CHARLES HINMAN. *Lode Star*. 1962. Construction, canvas-wood frame, 60 × 86½ × 14". Private collection, New York

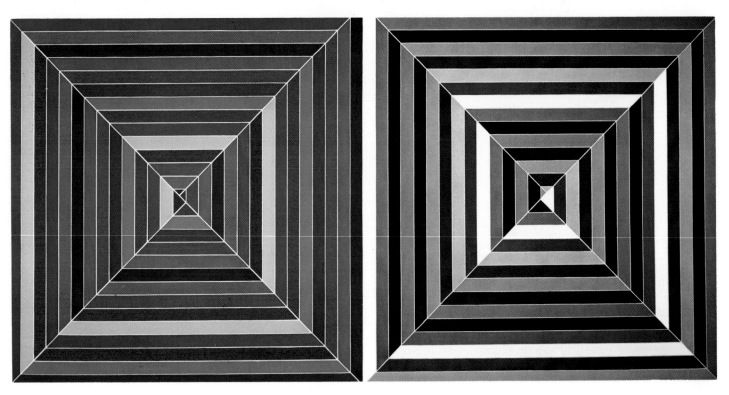

Colorplate 249. FRANK STELLA. *Jasper's Dilemma*. 1962–63. Alkyd on canvas, 6'5" × 12'10". Collection Alan Power, London

Colorplate 250. FRANK STELLA. *Agbatana III*. 1968. Fluorescent acrylic on canvas, 9'11⅞" × 14'11⅞". Allen Memorial Art Gallery, Oberlin College. Ruth C. Roush Fund for Contemporary Art and National Foundation of the Arts and Humanities Grant

Colorplate 251. FRANK STELLA. *Montenegro I*. 1975. Lacquer and oil on aluminum, 7′6″ × 9′9″. Knoedler Contemporary Art, New York

Colorplate 252. FRANK STELLA. *Shards V*. 1983. Mixed media on aluminum, 39¾ × 45⅜ × 10″. Private collection

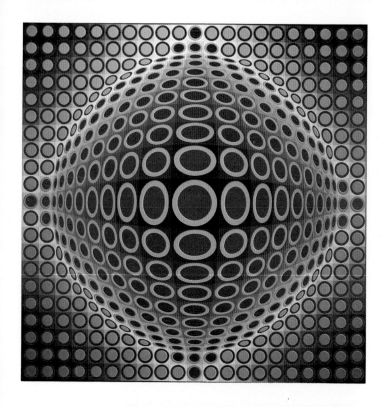

left: Colorplate 253. VICTOR VASARELY. *Vega Per*. 1969.
63 × 63″. Honolulu Academy of Arts. Gift of the Honorable
Clare Boothe Luce

below left: Colorplate 254. CHRYSSA. *Ampersand III*. 1966.
Neon lights in Plexiglas, height 30¼″. Robert E. Abrams
Family Collection

bottom: Colorplate 255. DAN FLAVIN. *Untitled (In Memory
of My Father D. Nicholas Flavin)*. 1974. Daylight
fluorescent light; 8 × 48′. Leo Castelli Gallery, New York

below: Colorplate 256. LARRY BELL. *Memories of Mike*.
1967. Vacuum-plated glass, 24¼″ cube. Private collection

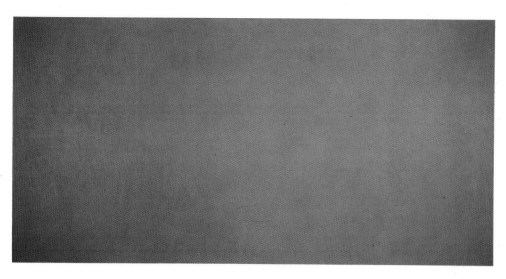

Colorplate 257. AGNES MARTIN. *Night Sea*. 1963. Oil and gold leaf on canvas, 6 × 6′. Charles Saatchi Collection, London

Colorplate 258. BRICE MARDEN. *The Dylan Painting*. 1966. Oil and wax on canvas, 5 × 10′. Collection Helen Portugal, New York

Colorplate 259. ALEXANDER CALDER. *Four Elements*. 1962. Standing mobile, sheet metal and motor, height 30′. Moderna Museet, Stockholm

Colorplate 260. ALEXANDER CALDER. *La Grande Vitesse*. 1969.
Painted steel plate, height 55′. Calder Plaza, Vandenberg Center,
Grand Rapids, Michigan

left: Colorplate 261. ANTHONY CARO.
Midday. 1960. Painted steel,
7′10″ × 12′6″ × 3′2″. Collection
Timothy and Paul Caro, London

below: Colorplate 262.
FRANK LLOYD WRIGHT. Taliesin West,
Phoenix, Arizona. Begun 1938

presented in his 1955 *Yellow Manifesto*, involved the replacement of traditional easel painting by what he called "kinetic plastics." To him, "painting and sculpture become anachronistic terms: it is more exact to speak of a bi-, tri-, and multidimensional plastic art. We no longer have distinct manifestations of a creative sensibility, but the development of a single plastic sensibility in different spaces." Vasarely sought the abandonment of painting as the individual gesture, the signature of the isolated artist. Art to him in a modern, technical society had to have a social context. The work of art was seen as the artist's original idea rather than the object consisting of paint on canvas. This idea, realized in terms of flat, geometric-abstract shapes mathematically organized, with standardized colors, flatly applied, could then be capable of projection, re-creation, or multiplication into different forms—murals, books, tapestries, glass, mosaic, slides, films, or television. For the traditional concept of the work of art as a unique object produced by an isolated artist, Vasarely substituted the concept of social art, produced by the artist in full command of modern industrial communications techniques, for a mass audience.

Implicit in the painting of Vasarely is the utilization of various devices to create illusions of movement and metamorphosis within the abstract organization. The artist was a pioneer in the development of almost every form of optical device for the creation of a new art of visual illusion. He divided his works into systematic categories in which he explored different aspects of art and illusion. His *photo-graphisms* are black-and-white line drawings or paintings. Some of these were made specifically for reproduction, and in them Vasarely frequently covered the drawing with a transparent plastic sheet. The plastic sheet has the same design as the drawing but in a reverse, negative-positive relationship. When the two drawings—on paper and on plastic—are synchronized, the result is simply a denser version. As the plastic is drawn up and down over the paper, the design changes tangibly before our eyes. Here, literal movement creates the illusion. This and many further devices developed by Vasarely and other Op artists produced refinements of processes long familiar in games of illusion or halls of mirrors.

In his Deep Kinetic Works, Vasarely translated the principle of the plastic drawings into large-scale glass constructions, such as the 1953 *Sorata-T*, a standing triptych, six-and-one-half by fifteen feet in dimension (fig. 779). The three transparent glass screens may be placed at various angles to create different combinations of the linear patterns. Such art lends itself to monumental statements that Vasarely was able to realize in murals, ceramic walls, and large-scale glass constructions. What he called his Refractions involve glass or mirror effects with constantly changing images.

Since Vasarely was aware of the range of optical effects possible in black-and-white, a large proportion of his works is limited to these colors, referred to by the artist simply as B N (*blanche noir:* "white black"). As the Cubists and then the De Stijl painters limited their palettes in order to clarify their structural principles, so Vasarely and Optical painters after him realized the importance of a comparable and even more arbitrary color limitation in order to establish the vocabulary of illusion.

It was, nevertheless, in color that the full range of possibilities for Optical painting could be realized, and Vasarely was well aware of this. In the 1960s his color burst out with a variety and brilliance unparalleled in his career. Using small, standard color shapes—squares, triangles, diamonds, rectangles, circles, sometimes frontalized, sometimes tilted, in flat, brilliant colors against equally strong contrasting color-grounds—he set up retinal vibrations that dazzle the eye and bewilder perception (plate 253).

780. BRIDGET RILEY. *Drift 2*. 1966. Emulsion on canvas, 91½ × 89½". The Albright-Knox Art Gallery, Buffalo

BRIDGET RILEY (b. 1931) Of Op artists in the precise sense of being concerned with visual illusion, the British painter Bridget Riley must be counted among the most effective. Employing largely black, white, and different values of gray, with repeated, serial units frontalized and tilted at various angles, she makes her picture plane weave and billow before our eyes. She also employs variations in tone (which Vasarely rejected) to accentuate the illusion (fig. 780).

RICHARD ANUSZKIEWICZ (b. 1930) A student of Josef Albers, the American artist Richard Anuszkiewicz normally uses straight lines and

781. RICHARD ANUSZKIEWICZ. *Inflexion*. 1967. Liquitex on canvas, 60 × 60". Collection the Artist

perspective devices to create startling emphases and inversions of illusionistic depth. In *Inflexion* (fig. 781) he skillfully reversed the direction of the radiating lines on each side of the square, thus making what at a quick glance looks like a traditional perspective box suddenly begin to turn itself inside out.

YAACOV AGAM (b. 1928) Israeli-born Agam (Jacob Gipstein) is identified with a form of Optical painting, or rather painted relief, in which the illusion is created by the movement of the spectator. *Double Metamorphosis II* (fig. 782), one of the largest of these, is a grid with regular geometric color shapes painted over the projections. Seen straight on, the color shapes are frontalized (fig. 783), but as one walks from one end to another, they shift into tilted, perspective shapes. The device used here is actually the reverse of that employed by some Renaissance painters intrigued by the illusionistic possibilities of linear perspective. (Hans Holbein the Younger in his 1533 painting *The Ambassadors* introduced in the foreground an exceedingly foreshortened skull—a *memento mori*. If one stands at the side of the picture and looks across it, the skull resumes its normal shape.) The interesting fact about Agam's relief paintings, beyond their technical virtuosity, is that each successive view composes effectively.

Op Art has also inspired a movement toward all-over painting in which a network or a mosaic of color strokes or dots covers the canvas and seems to expand beyond its limits. As we saw in plate 238, Larry Poons, during the 1960s, created a seemingly haphazard but actually meticulously programmed mosaic of small oval shapes that vibrate intensely over grounds of strong color. The organization of Poons's color-shapes, worked out mathematically on graph paper, was another indication of the tendency to systems or to what, in the 1960s, was called Systemic painting.

Motion and Light

Two directions explored sporadically since early in the twentieth century were given a great new impetus in the 1960s. These are motion and light used literally, rather than as painted or sculptured illusions. Duchamp's and Gabo's pioneer experiments in motion, and Moholy-Nagy's in motion and light, have already been noted. Before World War II (and since, as we shall see), Calder was the one artist who made a major art form of motion. Except for further explorations carried on by Moholy-Nagy and his students during the 1930s and 1940s, the use of light as a medium was limited to variations on "color organs," in which programmed devices of one kind or another produced shifting patterns of colored lights. These originated in experiments carried on in 1922 at the Bauhaus by Ludwig Hirschfeld-Mack and by the American Thomas Wilfred (1889–1968), inventor of the color organ and a brilliant, creative talent. The last years of the 1960s saw a tremendous revival in the use of light as an art form, and in the so-called "mixed media," where the senses are assaulted by live action, sound, light, and motion pictures at the same time.

Gabo revived his interest in mechanical motion in the early 1940s, and about 1950 Nicolas Schöffer began using electric motors to activate his constructions. During the 1950s and 1960s the interest in light and motion suddenly snowballed through a series of exhibitions and the organization of a number of experimental groups. Although this has become a worldwide movement, the first great impetus came from Europe, particularly from France, Germany, and Italy. Beginning in 1955 a center for the presentation of kinetic and light art was the Denise René Gallery in Paris, formerly the stronghold for the promotion of Concrete Art. In that year a large exhibition held there included kinetic works by Duchamp, Calder, Vasarely, Pol Bury, Jean Tinguely, Yaacov Agam, and

Jesus Rafaël Soto. The first phase of the new movement climaxed in the great exhibition held sequentially at the Stedelijk Museum in Amsterdam, the Louisiana Museum in Denmark, and the Moderna Museet in Stockholm. This was a vast and somewhat chaotic assembly of every aspect of the history of light and motion, actual or illusionistic, back to the origins of the automobile and to Eadweard Muybridge's nineteenth-century photographic studies of the human and animal figures in motion. Although the exhibition did not draw any conclusions, it did illustrate dramatically that the previous few years had seen a tremendous acceleration of interest in these problems. The popular curiosity about this art is evinced by the fact that the exhibitions were seen by well over one hundred thousand persons.

During the 1960s exhibitions of light and motion proliferated throughout the world, and the number of artists involved in different aspects increased spectacularly. A few outstanding examples will illustrate the range of possibilities already achieved.

NICOLAS SCHÖFFER (b. 1912) It is interesting to note that Nicolas Schöffer, the principal inheritor of the space-motion-light tradition of Moholy-Nagy, should also be a Hungarian. After various explorations of Expressionism and Surrealism, Schöffer, in 1950, turned to abstract-geometric construction in metal, in the tradition of Mondrian and Neo-Plasticism. He was soon drawn to cybernetics, the theory of systems and communications in their application to computers, and presently he turned to motion and light. Even the terminology he used—spatiodynamics, luminodynamism, et cetera—suggested the desire for an integration of art with science and engineering, typical of the kinetic and light sculptors (fig. 784). Schöffer, while retaining the rectilinear forms of his structures, has explored every aspect of motion and light, frequently on a monumental scale. He has created light and motion settings for ballets and large-scale spectacles, and has even projected an entire cybernetic university city for thirty thousand students.

JEAN TINGUELY (b. 1925) In the art of motion Switzerland's Jean Tinguely represents the opposite extreme to Schöffer. For Tinguely,

mechanized motion is the medium for the creation of sheer fantasy. He is Kurt Schwitters translated into movement. After preliminary efforts and the formulation of metamechanic reliefs and what he called "metamatics," which permitted the use of chance in motion machines, he introduced painting machines in 1955. These he perfected in his 1959 metamatic painting machines, the most impressive of which was the *metamatic-automobile-odorante-et-sonore* for the first biennial of Paris. It produced some forty thousand Abstract Expressionist paintings. His 1960 *Homage to New York*, created in the garden of New York's Museum of Modern Art, was a machine designed to destroy itself—which it finally did with the aid of the New York Fire Department. In Tinguely's machines (fig. 785), which are pure Dada, one is inevitably reminded of the wonderful machines created for the comic strips by the cartoonist Rube Goldberg. Tinguely is a great master of the ludicrous, but he is also a poet and a serious theoretician. Two of his most suggestive statements are: "the only stable thing is movement" and "the machine allows me, above anything, to reach poetry."

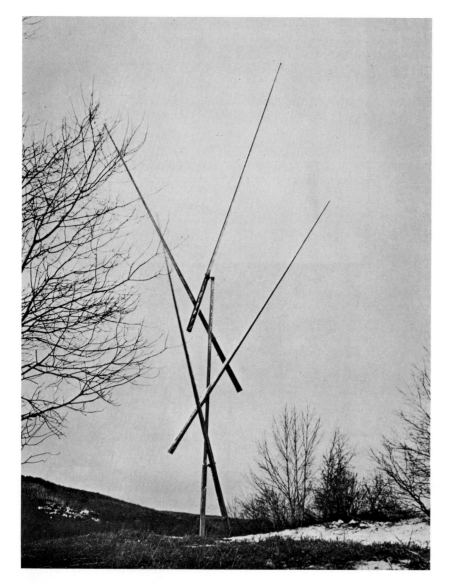

above left: 786. POL BURY. Portion of *The Staircase*. 1965. Wood with motor. The Solomon R. Guggenheim Museum, New York

above right: 787. LEN LYE. *Fountain II*. 1963. Steel rods and base, height 89½". Howard Wise Gallery, New York

left: 788. GEORGE RICKEY. *Four Lines Up*. 1967. Stainless steel, height 16'. Collection Mr. and Mrs. Robert H. Levi, Lutherville, Maryland

below: 789. JESUS RAFAËL SOTO. *Petite Double Face*. 1967. Wood and metal, 23⅝ × 15". Marlborough Gallery, New York

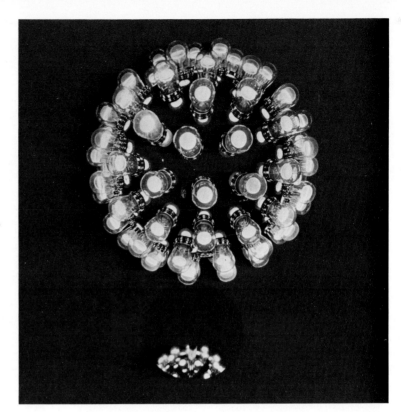

790. OTTO PIENE. *Electric Flower*. 1967. Light bulbs, diameter 16". Howard Wise Gallery, New York

POL BURY (b. 1922) Pol Bury is one of the most varied, prolific, and subtle of the kinetic sculptors. Using highly finished materials of wood and metal, he makes motorized constructions in which rolling wooden balls, vibrating metal strips, and crawling steel cubes move at so imperceptible a pace that the movement seems illusionary (fig. 786).

LEN LYE (1901–1980) Lye, a New Zealander, was a pioneer experimental filmmaker as well as kinetic artist. His works, at the opposite extreme to those of Bury, are characterized by tremendous acceleration of movement, in vibrating rods or whirling metal strips with concomitant effects of screaming noise. (Noise is frequently an important accessory of kinetic sculpture. Tinguely has at times programmed groups of old radios in complete disharmony. Calder occasionally introduced gongs into his wind mobiles.) But Lye also created delicately balanced, nonmechanized mobiles, tall groups of rods that vibrate gently of their own accord (fig. 787).

GEORGE RICKEY (b. 1907) Among the mobilists, one of the most interesting to emerge in the United States since World War II is George Rickey. Rickey composes long, tapering strips or leaf clusters of stainless steel in a state of balance so delicate that the slightest breeze or touch of the hand sets them into a slow, stately motion or a quivering vibration (fig. 788). During the 1970s Rickey enlarged his vocabulary with the introduction of large-scale rectangular, circular, and triangular forms in aluminum, so precisely balanced that they maintain the quality of imperceptible and increasingly intricate patterns in movement. His is an art of motion entirely different from but, in its own way, as unique as that of Calder.

JESUS RAFAËL SOTO (b. 1923) Soto is not literally a motion artist except insofar as his constructions, consisting of exquisitely arranged metal rods are sensitive to the point that even a change in atmosphere will start an oscillation (fig. 789). A Venezuelan resident in Paris, Soto began as an illusionistic painter and then moved to a form of linear construction during the 1960s. He has developed a personal image of great elegance, sometimes translated into a form of large-scale architecture involving spectator participation. In exhibitions at the Solomon R. Guggenheim Museum in New York and the Hirshhorn Museum and Sculpture Garden in Washington, D.C., he created out of his typical plastic strings entire room environments into which the spectator could enter.

The arts of light and motion proliferated a number of new artists' organizations and manifestoes during the late 1950s and 1960s. In 1955, in connection with the exhibition "Movement" at the Denise René Gallery in Paris, Victor Vasarely, the pioneer of French Op Art, issued his *Yellow Manifesto*, outlining his theories of perception and color. Bruno Munari (b. 1907), who was producing kinetic works in Italy as early as 1933, was also an important theoretician. Very active in Spain, Equipo 57 (founded in 1957) represented a group of artists who worked as an anonymous team in the exploration of motion and vision. This anonymity, deriving from concepts of the social implications of art and also, perhaps, from the examples of scientific or industrial research teams, was evident at the outset in the Group T in Milan, founded in 1959; Group N in Padua, founded in 1960; and Group 0 (Zero) in Dusseldorf, Germany. In most cases the theoretical passion for anonymity soon dimmed, and the artists began to emerge as separate individuals.

OTTO PIENE (b. 1928) Group 0 (the 0 derives from the moment of blast-off in a space rocket countdown) was initiated in 1957 by Otto Piene and Heinz Mack (b. 1931). Piene, now resident in the United States, was one of the most fertile talents exploring the possibilities of light (fig. 790). In 1961 he created an entire light ballet that toured European museums. In 1964–65 he carried out a commission to design the lighting for the new City Opera House in Bonn. This consisted of an elaborate and intricate system of chandeliers for the foyer and "milky ways"—complexes of thousands of individual bulbs—programmed to change, or alter their intensity, in coordination with the stage lighting.

791. JULIO LE PARC. *Continuel Lumière Formes en Contorsion*. 1966. Motorized aluminum and wood, 80 × 48½ × 8″. Howard Wise Gallery, New York

792. RICHARD LIPPOLD. *Variation Within a Sphere, No. 10: the Sun*. 1953–56. Gold-filled wire, c. 11 × 22 × 5½′. The Metropolitan Museum of Art, New York. Fletcher Fund, 1956

793. DAN FLAVIN. Installation view of *Pink and Gold*. 1968. Light columns. Formerly Dwan Gallery, New York

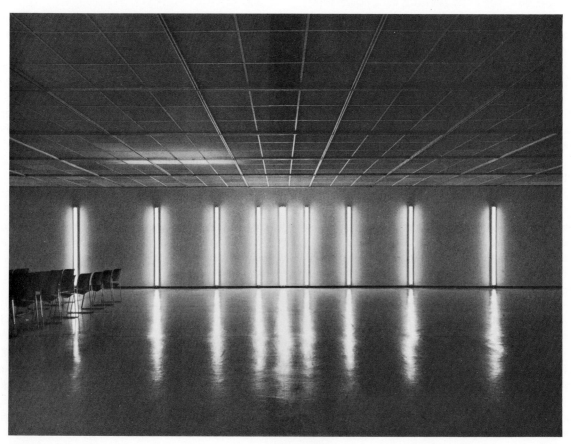

This provided a brilliant illustration of new possibilities for theater or institutional lighting, not only beautiful in its effects but also, apparently, highly efficient in its function.

JULIO LE PARC (b. 1928) Of the light experimentalists, the Argentinian Julio Le Parc has been one of the most imaginative, varied, and visually—even aesthetically—successful in his employment of every conceivable device of light, movement, and illusion (fig. 791). The award to him of the painting prize at the 1966 Venice Biennale was not only a recognition of his talents but also an official recognition of the new arts. Since 1958 Le Parc has lived in Paris where, in 1960, he was a founder of the Groupe de Recherche d'Art Visuel. With its home base at the Denise René Gallery, this group carried on research in light, perception, movement, and illusion. Le Parc became a major bridge between various overlapping but normally separate tendencies in the art of the 1960s, not only light and movement, but also different forms of optical, illusionistic painting and programmed art.

RICHARD LIPPOLD (b. 1915) In the United States, interest in light sculpture accelerated during the 1960s in many different forms. A pioneer, although he did not actually use artificial illumination in his constructions, was Richard Lippold. Also a talented industrial designer, Lippold has produced a series of impressive architectural-sculptural structures since the 1940s. They are intricately composed of intensely polished gold wires and plaques whose brilliant surfaces shine with an iridescent luminescence, particularly when lighted artificially (fig. 792).

CHRYSSA (b. 1933) The Greek artist Chryssa bridged the gap between Pop Art and light sculpture. She first explored emblematic or serial relief forms composed of identical, rhythmically arranged elements of projection circles or rectangles. Then in the early 1960s she made lead reliefs derived from newspaper printing forms. From this Chryssa passed to a kind of found-object sculpture in which she used fragments of neon signs. The love of industrial or commercial lettering, whether from newspapers or signs, became a persistent aspect of her works. In this she was recording the American scene in a manner analogous to the Pop artists or to the earlier tradition of Stuart Davis and Charles Demuth. Soon the fascination with the possibilities of light, mainly neon tube light, took over completely, in the construction of elaborate light machines which, in some curious manner, maintain their qualities of contemporary American industrial objects (plate 254).

EAT Perhaps the most significant group effort was EAT—Experiments in Art and Technology—which developed from a series of performances involving Robert Rauschenberg, the engineer Billy Kluver, and the composer John Cage. "9 Evenings: Theater and Engineering," presented in 1966, involved dance, electronic music, and video projection. In turn, these presentations may be traced back to experiments carried on by Cage since the 1940s as well as a collaborative exhibition held at the Denise René Gallery in Paris in 1955. Experiments by the Groupe de Recherche d'Art Visuel (GRAV), sponsored by the René Gallery in Paris during the 1950s and 1960s, also anticipated the EAT group in the utilization of sophisticated technology and effects of light and movement. EAT perhaps extended the collaborative effort furthest in its attraction of large-scale financial support, particularly for its Pepsi-Cola Pavilion at the Osaka World's Fair of 1970.

DAN FLAVIN (b. 1933) While in general light art may have declined during the 1970s, certain artists continue to transcend the narrow limitations of the medium. Perhaps the most impressive of these is Dan Flavin, for whom light was never a gimmick or an eye-appealing contrivance but an accent that defines certain spatial voids (fig. 793). If anything, Flavin's light art has grown in authority and in architectural magnitude. With a few fluorescent lights judiciously placed he is able to create a magical space into which the spectator enters and participates (plate 255).

LARRY BELL (b. 1939) At the opposite extreme to these aggressive light interpretations of contemporary industrial America are the infinitely subtle glass boxes of Larry Bell (plate 256). The glass cubes, resting on transparent glass bases, are coated on the inner surface, creating the most delicate effects of transparent light and color that seem to shift continually. Bell's is an art both romantically coloristic and classically austere, with affinities both to Primary or Minimal structures and Optical or retinal painting.

ROBERT IRWIN (b. 1928) It is difficult to decide whether Robert Irwin should be classified as a light artist or as a Minimalist shaping the void. Taking architectural spaces of galleries or museums and using tightly stretched semitransparent textile scrims which are lighted from behind, he creates an eerie, isolated space with an effect that can only be described as hypnotic (fig. 794). The spectator is drawn toward the void which he cannot enter but which, upon contemplation, increasingly surrounds him. This is only one instance of a wide variety of images and effects that Irwin has been able to create with his minimal means of scrim and light. His obsession with the void may have its roots in the empty gallery of Yves Klein, but Irwin has immensely enlarged upon the earlier concept. His is an art of total illusion seemingly created out of nothingness, and it leads us to Minimalism.

794. ROBERT IRWIN. *No Title.* 1971. Scrim environment. Walker Art Center, Minneapolis. Gift of the Artist

Minimal Art and Primary Structures

In the 1960s Constructivism gained a new impetus in the so-called Primary Structure and Minimal or ABC Art. Many of the painters and sculptors involved have objected to the term Minimal for much the same reason that abstract painters objected to "abstract," with its implication of some lessening or even denigration. In any event, Minimalism represented a significant attitude of the 1960s, even more in the United States than in England, but also in Japan, Germany, Australia, Canada, and other countries. It related closely to a number of significant tendencies of the decade: the sculpture that creates an architectural space or environment; the paintings involving the shaped canvas (here it is often difficult to draw the line); and the paintings with mathematical systems as the bases of their organization. It also had relations to certain aspects of Color Field painting that, in turn, overlapped with Systemic painting. In almost all these different sculptural and pictorial experiments there was usually a strong geometric base, the use of intense, unmodulated industrial colors, and elemental shapes.

AGNES MARTIN (b. 1912) Among the Minimalists, the senior painter remains Agnes Martin, who refined her art over many years, during which she progressed from rather traditional still lifes to Gorky-like biomorphic abstractions, before arriving in the early 1960s at her mature, mandarin distillations of pure form. This occurred in New York City, where the artist had moved from New Mexico, taking with her a haunting memory of the desert's powdery air and light. This she evoked by the improbable process of honing and purifying her means until they consisted of nothing but large square canvases gridded all over with lines so delicately defined and subtly spaced as to suggest not austere, cerebral geometry but trembling, spiritual vibrations, what Lawrence Alloway characterized as "a veil, a shadow, a bloom" (fig. 795; plate 257). Declaring their physical realities and limitations yet mysteriously intangible, intellectually derived but romantic in feeling and effect, the paintings of Agnes Martin are the product of a mind and a sensibility steeped not only in the meditative, holistic forms of Reinhardt, Rothko, and Newman, but also the paintings of Paul Klee and the landscapes, as well as the poetry, of Old China. While using hard-edged structure in a visually self-dissolving or -contradicting manner, Martin had no interest whatever in the retinal games played by the Op masters. Nor has she ever aspired to the heroics of the Abstract Expressionists. Rather, she proceeds with exquisite economy, nuance, and reserve to so use mathematical rigor that it transforms stability into an evanescent image of luminous atmosphere, making visible the artist's sense of life's essence as a timeless, shadowy emanation. "When I cover the square with rectangles," she said, "it lightens the weight of the square, destroys its power."

ROBERT RYMAN (b. 1930) By way of elucidating his great "silent" all-white paintings (fig. 796), Ryman has said in a frequently quoted statement: "It's not a question of what to paint but how to paint." With these words he declared his commitment to pure painting, painting so self-reflexively involved, with its own most essential properties, processes, and qualities as an object, that the artist's systematic exploration of these factors becomes a "story" in itself, even though the resulting picture portrays or represents nothing in the traditional way of narrative art. "To make" has often figured in Ryman's conversation, for he considers "making" a matter of knowing the language of his materials—canvas, steel, cardboard, paper, wood, fiberglass, mylar interacting with oil, tempera, acrylic, epoxy, enamel—and of exploiting its syntax so that paintings come alive with their own story—how a dumb object among other objects became a thing of rare aesthetic coherence. Thus, in Ryman's art, monochromatic reductiveness has resulted in a subtle recomplication, paradoxically arising from the artist's sensibility to means and his consequent inability to take painting's support for granted. He romances the latter endlessly, covering it with white so nuanced that monochromy seems almost to break up into a rainbow array of chromatics, and then determining the support in relation to a whole network of physical factors, among them the size of the wall and the height at which the painting is to be hung. By such rigorous reconsideration and elevation of material detail and issues of optical perception, as well as by the magical beauty of his painting touch, Ryman invests his pictures with a lyrical presence, all the while that he has pursued a stern Minimalist program of deconstruction and purification. In the work seen here, Ryman applied white polymer paint in an even film to twelve squares of handmade Classico paper precisely assembled to form a larger square gridded by shadows between smaller units. With these positioned slightly off center on a white ground, three types of squares in different scales and relationships echo and interact with one another, thus re-elaborating the literal while seducing the eye by testing its visual acuity. With less having indeed become more, here is Systemic, Minimal painting at its most advanced.

ROBERT MANGOLD (b. 1937) In his reaction against the perceived excess of Abstract Expressionism, Robert Mangold stressed the factuality, rather than the ineffability, of art by creating surfaces so perdurably hard, so industrially finished, and so eccentrically shaped that the object quality of the work could not be denied. Yet like all the major Minimalists, as well as their great mentor Ad Reinhardt, Mangold succeeded in translating purism into poetry, mainly by the sheer caprice and sensuous refinement with which he honored his commitment to anonymity, literalism, and precise measure. This became delightfully clear in paintings executed in the late sixties and early seventies, when the neutrality of monotone grounds was aroused by aerated, decorative color, while the dominance of overall shape was subverted from within by an "error" in the overcalculated, "mechanical" drawing (fig. 797) Destabilized by elusive color and the imperfection of internal pattern, stringent, self-referring formalism gave way to spreading openness and unpredictability reminiscent of the outside world of nature and humanity. And so Mangold too struck a balance between impersonality and individualism, thereby bringing a welcome warmth to the pervasive cool of Minimalist aesthetics.

BRICE MARDEN (b. 1938) The precocious Brice Marden had hardly graduated from the Yale School of Art when he found his signature scheme of rectangular panels combined in often symbolic order and painted with dense monochrome fields of beeswax mixed with oil (plate 258). Since that time Marden has become a virtuoso in his ability to balance color, surface, and shape throughout a continuously developed and extended series of variations, progressing always toward ever-more quintessential possibilities within a set of purposeful restrictions. Programmatic and intellectualized as such art may be, it also gains in feeling from the artist's intuitive ability to invent original, nameless colors that frustrated critics cite by such terms as putty, orange-plum, and elephant's breath. And just as idiosyncratic hues defy the abstraction of their geometric fields and matte surfaces to become evocative, the dynamic symmetry and proportion of the panels' interrelationships—fre-

795. AGNES MARTIN. *Flowers in the Wind*. 1963. 75 × 75″. Robert E. Abrams Family Collection

796. ROBERT RYMAN. *Classico III*. 1968. Polymer on paper, 93 × 89″. Stedelijk Museum, Amsterdam

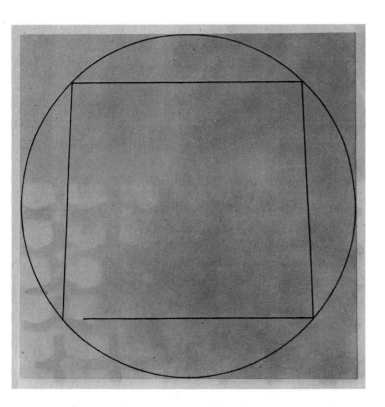

above: 797. ROBERT MANGOLD. *Untitled*. 1973. Acrylic and pencil on masonite, 24 × 24″. John Weber Gallery, New York

right: 798. BRICE MARDEN. *Elements III*. 1983–84. 84 × 36″. Collection Douglas Cramer, Los Angeles

quently post-and-lintel-like altars or temples and governed by the Golden Section—assume a universal, mystical significance (fig. 798). Here again, then, we find the Minimalist paradox of extreme simplicity capable of rewarding sustained contemplation with revelations of unsuspected spiritual complexity or sheer hedonist delectation.

799. DOROTHEA ROCKBURNE. *Neighborhood*. 1973. Wall drawing, pencil and colored pencil with vellum, 13′4″ × 8′4″. Collection, The Museum of Modern Art, New York. Gift of J. Frederick Byers III

DOROTHEA ROCKBURNE (b. 1934) Drawing directly on the wall or attaching thereto a flattened, geometric shape created merely by folding brown wrapping paper, Dorothea Rockburne would seem to have so reduced her means as to take Minimalism over the line into Arte Povera (fig. 799). However, the direction proved quite different, fixed by the artist's preoccupation with the mathematics of set theory as an intellectually pure strategy for creating an intricate interplay of simple geometric forms and real space (fig. 800). So dependent was this art on process itself that Rockburne created it directly on the gallery wall, thereby condemning her pieces to a poignant, even romantic life of fragility and impermanence. Subsequently, she found it possible to work in more durable materials and installations, as well as with richer elements, such as color and texture. Still, Rockburne remains loyal to her fundamental principle of "making parts that form units that go together to make larger units." And the logical yet unexpected way the scientifically derived but imaginative folding produces flat prismatic shapes—built up, subdivided, creased, and integrated through drawing into the adjacent space—ends by seducing the eye while engaging the mind. It also reveals why the challenge of working within Minimalism's puritanically self-denying regimen appealed to some of the most gifted artists to emerge in the 1960s, offering them variables as elementary as the themes of Beethoven and no less subject to an infinity of permutations and combinations.

The serialism, the interest in process as a key source of content, and the search for the complex within the simple, unified image—all fundamental to the Minimalist aesthetic—could be found in the fieldlike collages created by the photographer Ray K. Metzker (b. 1931), a former student of the influential Harry Callahan at the Institute of Design in Chicago (fig. 801). But like most straight photographers, Metzker begins with a subject in the phenomenal world. Having photographed this not as a single, fixed image but rather as a series of related moments, he then combines, repeats, juxtaposes, and superimposes them until he has achieved a composite, gridlike organization reminiscent of Minima-

800. DOROTHEA ROCKBURNE. *Egyptian Painting, Seti*. 1980. Conté crayon, oil on gesso linen, glue, 95 × 51¼″. Xavier Fourcade, Inc., New York

801. RAY K. METZKER. *Untitled*. 1966. Gelatin-silver print. Collection, The Museum of Modern Art, New York

802. ALEXANDER CALDER. *Mobile*. 1959. Sheet metal, width 42′. International Arrivals Building, Kennedy Airport, New York

list painting, a single visual entity in which the whole is different and more rewarding than its parts. Metzker says of his work: "Where photography has been primarily a process of selection and extraction, I wish to investigate the possibilities of synthesis."

If Minimalist painting came as an extreme reaction to the gestural sublimities of Action painting, Primary Structures emerged in obvious revolt against the Romantic-fantastic figuration, the Expressionist direct-metal abstraction, and even the Classical geometry of 1950s sculpture. The immediate reaction presented by Primary Structures was against the personal expression of the earlier Abstract Expressionist painters or the direct-metal and Junk sculptors. Thus their outstanding quality became an industrial impersonality deriving from the fact that they were normally fabricated industrially, from plans made by the artist. Even more, it involved a questioning of the tradition of sculpture as an isolated object, on a pedestal, made of traditional materials of marble or bronze. The urge to impersonality, to the creation of a thing rather than a painting or a sculpture in the classic sense, originated in painting. Mondrian, of course, was a source, but one can trace a line to the 1960s Minimalists direct from previous Constructivists such as

Mathias Goeritz, Max Bill, or Vantongerloo. The leading direct influences on the new sculptors and painters, however, were probably Ad Reinhardt and Barnett Newman. Among the sculptors it was unquestionably David Smith who affected the new generation, even though Smith handcrafted his own sculptures.

ALEXANDER CALDER In his later monumental stabiles and mobiles, Calder, whose prewar career we reviewed in Chapter 17, set the example for the utilization of skilled industrial workers in the manufacture of the final work on the basis of the artist's design. From the late 1940s he had developed a growing interest in monumental forms, and in the transformation of the mobile to a great architectural-sculptural wind machine whose powerful but precisely balanced metal rods, tipped with large, flat, organically shaped disks, encompass and define large areas of architectural space. In 1957 Calder executed a giant mobile commissioned for Idlewild (now Kennedy) Airport in New York (fig. 802). The completed structure, with its very large leaf blades painted red and black and its orange accents, now hangs in the enormous hall of the International Arrivals Building. This combination of mobile and archi-

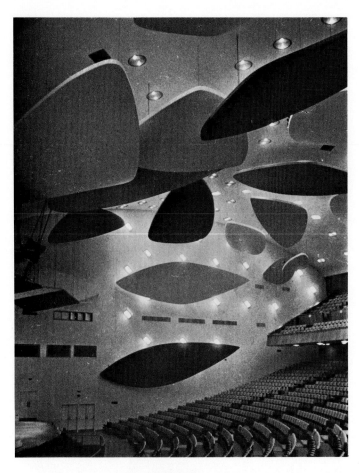

803. ALEXANDER CALDER. *Acoustical Ceiling*. 1952. Aula Magna, University City, Caracas, Venezuela

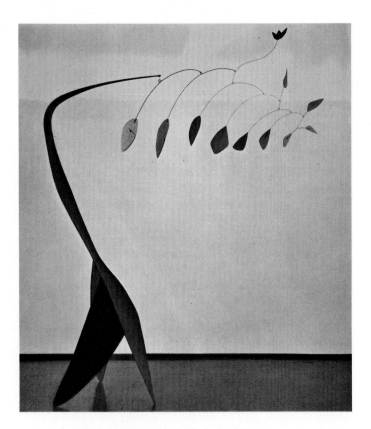

804. ALEXANDER CALDER. *Red Petals*. 1942. Standing mobile, painted iron, height 9′2″. Collection Arts Club of Chicago

tecture demonstrated the possibilities of the mobile form, conceived and carried on this scale, for really grand expression. In a still larger commission Calder created a hanging construction (although not a mobile) as the acoustical ceiling for an auditorium in University City, Caracas, Venezuela (fig. 803). There, the entire ceiling is broken up with gigantic, brightly colored free shapes which seem to float in mid-air, and which define and enhance the architectural space of the interior. Also, astonishingly, the shapes function as far as the acoustical properties of the hall are concerned.

Since the mobile, powered by currents of air, could function better outdoors than indoors, Calder began early to explore the possibilities for outdoor mobiles. These could best be resolved in terms of some form of standing structure, and, intrigued by the possibility of developing such structures, the artist undertook new experiments. One of the earliest was the 1942 *Red Petals* (fig. 804), a graceful, naturalistic form, in every detail suggestive of some exotic plant or tree. The base is a tripod of triangular leaf forms that grow into a tall, curving stem, nine feet high, from whose tip extend the delicate tendrils of wires balancing leaf or flower shapes. The importance of this work lies not only in its large scale and its biomorphic beauty, but in its statement of the standing mobile as an organic whole, interrelating stabile and mobile forms. Calder, in the late 1950s and 1960s, created many large, standing mobile units that rotate in limited but impressive movement over a generally pyramidal base, essentially neutral in form (fig. 805).

Calder's most impressive achievement of the 1960s, however, occurred in his great "stabiles"—a term really belonging to Calder—but even in his work it has particular application only to his large-scale metal-plate constructions, normally painted black. Calder had begun his career as a sculptor of carved wooden animals or wire structures (fig. 497). In the 1940s he made a number of Constellations inspired by the painted Constellations of Miró: fantastic, free-form, highly finished wooden shapes joined by webs of wire (plate 159). Although nothing actually moves, these bizarre stabiles of witty and monstrous animal or plant life sometimes suggest violent activity.

A second form of the early large-scale stabile was very different in its somewhat geometric character, though also intended to be some strange monster. *Black Beast* is four large cutout plates intersecting at extreme angles, shaped to create an open structure (fig. 806). With voids below as well as above, the structure is joined only at a narrow waist. There are suggestions of heads and legs attached to torsos. Viewed from different angles, the animal changes to a group of animals or to animals and human figures. Despite such connotations, the whole has a strongly architectural effect. This suggestion of sculpture becoming an architectural environment is what makes *Black Beast* an important prototype for another major group of the later stabiles.

The thirty-foot-high construction now in front of the Modern Museum in Stockholm was made after a model for an unrealized commission to make a motorized mobile for the New York World's Fair of 1938 (plate 259). As the title *Four Elements* indicates, the piece is quadripartite, consisting of a great black bastion with a pointed tabletop that rocks back and forth on its base; an orange-and-black figure motif with outflung, curved arms, that whirls round and round; a tall, black-and-white pole with an orange disk at the end of a slowly revolving arm set at right angles; and a column of diminishing half-circles, painted orange and yellow. All four units have separate motors, making the shapes leap and lunge and spin in interactions often reminiscent of a Dada manifestation.

Calder moved into the Minimalist sixties with undiminished energy and invention, deriving as these did from a power base of personal

805. ALEXANDER CALDER. *The Spiral*. 1958. Standing mobile, sheet metal and metal rods, height 30′. UNESCO, Paris

genius, formal mastery, and progressive, accumulated achievement. During the final decade of his life, Calder, like a great eagle spreading its wings, easily enlarged his vision to match and even pace the new Minimalist conception of vast, environmental scale, radically reductive industrial form and process, and tantalizing, contradictory effects of elegance and lightness. One of the most impressive metal sculptures of any period is *La Grande Vitesse* in Grand Rapids, Michigan, a triumphantly expansive stabile with which Calder filled an otherwise deadly public space with Miró-like charm and radiant splendor (plate 260). While suggesting a great exotic flower in its prime or a Graham dancer in full arabesque, the assemblage of red biomorphic planes boldly displays its rivets and struts and thus declares its architectural character, sheltering potential, and humanist content, the latter a distinguishing principle of Calder's art from the very beginning.

The British sculptor Lynn Chadwick (b. 1914) also began his artistic life in architecture and mobiles, but inevitably came under the influence of the great Henry Moore. Thus, some sense of the figure lingers in his work, even as the artist in the 1960s moved toward a more geometrically abstract image. The 1963 *Winged Figures*, however, display much of the simplicity and monumentality of the new, Minimal sculpture (fig.

806. ALEXANDER CALDER. *Black Beast*. 1940. Stabile, sheet steel, height 8′9″. Collection Mr. and Mrs. Eliot Noyes, New Canaan, Connecticut

807. LYNN CHADWICK. *Winged Figures*. 1963. Painted iron, length 18'. Collection the Artist

808. KENNETH ARMITAGE. *The Bed*. 1965. Fiberglass and polyester resin, 48 × 35½ × 68½". Collection the Artist

807). His fellow countryman Kenneth Armitage (b. 1916), although essentially a figurative sculptor, also gave way to the Minimalist urge and developed a more abstract image, with elements of figurative fantasy locked into a Constructivist matrix (fig. 808). William Turnbull (b. 1922), a Scot, became one of the most talented of the younger British sculptors, with roots in Brancusi but playing his own variations on his source. In the late 1960s Turnbull began to work on a form of Primary Structure—vertical slabs of painted steel imbedded in steel bases (fig. 809). Although the elements here were machine-fabricated to the artist's specifications, the monumental impact is comparable to his earlier stone and bronze works. Victor Pasmore (b. 1908) is the leading English Constructivist in the tradition of Mondrian (fig. 810). Pasmore was a painter, first Impressionist and then Neo-Plastic until 1951, when he came under the influence of Charles Biederman, a Neo-Plastic Constructivist and theoretician of Constructivism living in Red Wing, Minnesota. Biederman's book *Art as the Evolution of Visual Knowledge* advances his version of Constructivism, named Structuralism, and has had a remarkable impact on younger Constructivists in England and in Canada.

ANTHONY CARO (b. 1924) Among the younger artists associated with Constructivism and Minimal Art, Anthony Caro is one of the most remarkable talents to emerge in England since World War II (plate 261). Like so many of the new English painters and sculptors, Caro developed in the enlightened atmosphere of the Royal College schools. With his large, powerful constructions, frequently assembled from industrial steel girders and painted bright colors, Caro has emerged as a singularly gifted Constructivist since the death of David Smith. Although he would not deny his debt to Smith, Caro exists very much in his own right as a creative personality. His work, transcending most of the definitions of Minimal sculpture, ranges from the extremely elegant to the massive and brutal (figs. 811, 812). He has learned that sculpture is not necessarily a centralized monument but may range over an open structure, a large wall, or may be a horizontally defined assemblage.

Philip King (b. 1934) and William Tucker (b. 1935) are other British exponents of the direction in sculpture known variously as Primary Structures or Minimal sculpture. In *Brake* (fig. 813) King used fiber-

809. WILLIAM TURNBULL. *3X1, Second Version*. 1966. Polychromed steel, 84½ × 31 × 93". Collection the Artist

810. VICTOR PASMORE. *Projective Construction in White, Black, Silver, and Mahogany*. 1965. Wood, plastic and aluminum, 48 × 48 × 14". Marlborough Fine Art Ltd., London

left: 811. ANTHONY CARO. *Riviera*. 1971–74. Rusted steel, 10′7″ × 27′ × 10′ Collection Mr. and Mrs. Bagley Wright, Seattle

below: 812. ANTHONY CARO. *Monsoon Drift*. 1975. Steel, 10′1″ × 17′3″ × 5′8″. André Emmerich Gallery, New York

glass and plastic in the creation of an austere and elegant structure consisting simply of five meticulously spaced slabs. This was fabricated by an industrial firm, in an edition of three, from the artist's full-scale model. In the same manner, Tucker's *Four Part Sculpture No. 1* (fig. 814), made of fiberglass, was manufactured industrially to the artist's specifications and then painted by the artist. This consists merely of four large, immaculate cylinders placed horizontally side by side.

MATHIAS GOERITZ (b. 1915) The leading Constructivist sculptor of Mexico is German-born Mathias Goeritz. Since 1949 Goeritz has created in Mexico an impressive body of architectural-environmental abstract sculpture. This includes his experimental museum called The Echo, entire rooms filled with massive, tilted, geometric structures through which the spectator walks (fig. 815). Even more monumental are the *Five Towers*, designed as the approach for a satellite city—

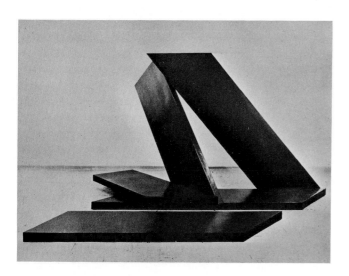

813. PHILIP KING. *Brake*. 1966. Fiberglass and plastic, 7 × 12 × 9′. Rowan Gallery, London

814. WILLIAM TUCKER. *Four Part Sculpture No. 1*. 1966. Fiberglass, 18 × 72 × 90″. Collection the Artist

vertical, triangular forms soaring to heights that range from one hundred and twenty to one hundred and eighty-five feet (fig. 816). Goeritz's stark, powerful sculptures have undoubtedly influenced American as well as European sculptors in their approach to problems of large-scale environmental sculpture or Primary Structures.

Also German-born is the Swiss-trained United States resident Evelyn Hofer, a photographer who, along with her distinguished career as a fashion photographer for *Harper's Bazaar* and *Vogue*, discovered an outlet for her quite exalted sense of abstract form in old, classicizing architecture (fig. 817). In the image seen here, she recorded a nineteenth-century cast-iron façade in New York's SoHo district, a corroded commercial neighborhood where so many sixties artists found the cheap loft space that made possible the immense scale on which they cast their paintings and sculptures. Moreover, Hofer matched the Minimalists in their love of clarity, nuance, and monumental simplicity derived from a systematic, gridded repetition of like or related units.

Primary Structures spread even more widely in the United States than in England and elsewhere during the 1960s. American Primary Structures, particularly, owe something to David Smith's forms. Still closer as prototype or in concept was the work of Barnett Newman, particularly the few sculptures he produced, consisting of tall, vertical slabs of steel, and the late, black paintings of Ad Reinhardt, with their insistence on impersonality and elimination of all extraneous elements (fig. 818).

above left: 815. MATHIAS GOERITZ. Steel structure, height 14′9″, in patio of The Echo, Experimental Museum, Mexico City. 1952–53

left: 816. MATHIAS GOERITZ, LUIS BARRAGAN, and MARIO PANI. *The Square of the Five Towers*, 1957–58. Painted concrete, Satellite City, Mexico City

below: 817. EVELYN HOFER. *Cast-Iron Building, Broadway and Broome.* c. 1965. Gelatin-silver print. ©Evelyn Hofer

above left: 818. BARNETT NEWMAN. *Here*. 1959. Bronze, height 8'. Collection Mrs. Barnett Newman, New York

above right: 819. TONY SMITH. *Cigarette*. 1961–66. Plywood to be made in steel, 15 × 26 × 18'. Fischbach Gallery, New York

below: 820. DONALD JUDD. *Untitled*. 1965. Galvanized iron, seven boxes, each 9 × 40 × 31" (9" between each box). Gordon Locksley Gallery, Minneapolis

TONY SMITH (b. 1912) The constructions of Tony Smith are perhaps too Expressionist to fit the Primary Structure category, although the artist is now associated with it. His huge, heavy structures, preferably arched forms, either triangular or square, frequently turn back upon themselves to create dynamic tensions (fig. 819).

DONALD JUDD (b. 1928) Donald Judd carried the objective attitude to a point of mathematical precision. He repeated identical units, normally quadrangular, at identical intervals (fig. 820). These are made of galvanized iron or aluminum, occasionally with Plexiglas. Although Judd sometimes painted the aluminum in strong colors, he at first used the galvanized iron in its original unpainted form, something that seemed to emphasize its neutrality.

Judd is himself a critic and became an articulate spokesman for the new sculpture. He vehemently insisted that Primary Structures or Minimal sculpture—most specifically his own—constitute a direction essentially different from earlier Constructivism or rectilinear abstract painting. The difference, as he saw it, lay in his search for an absolute unity or wholeness through repetition of identical units in absolute symmetry. Even Mondrian "composed" a picture by asymmetrical balance of differing color areas. Judd also insisted on the nonenvironmental character of this sculpture. Despite its frequently monumental scale, it remains detached from the spectator, who is not, unlike those involved with the emotional works of, for instance, Calder or Dubuffet, intended to enter into it and become a part of it. Although the principles of

right: 821. DONALD JUDD. *Untitled*. 1968. Stainless steel, eight boxes, each $48 \times 48 \times 48''$ (12'' between each box). Private collection

below: 822. RONALD BLADEN. *The X*. 1967. Painted wood to be made in metal, $22'8'' \times 24'6'' \times 12'6''$. Fischbach Gallery, New York

nature of space, and the nature of sculptural form. Can an absolutely mechanical arrangement of identical solids at identical intervals constitute a work of art? Since Judd's works of the 1960s grew continually in subtlety of proportion, even though arranged according to specific mathematical systems, and since they have grown in coloristic richness and variety of elemental forms, the answer would seem to be yes.

Progressively Judd's works, like most of those of Minimal sculptors, expanded in scale and impressiveness. Although his eight boxes in the 1968 *Untitled* (fig. 821) are each merely four feet square, with twelve-inch intervals between them, they add up to an imposing total image, due in part to the use of highly reflective stainless steel.

RONALD BLADEN (b. 1918) Bladen, a Canadian, used monumental, architectural forms, frequently painted black, that loom up like great barriers in the space they occupy (fig. 822). Like Tony Smith, with

823. ROBERT MORRIS. *Untitled*. 1967. Nine steel units, each $36 \times 36 \times 36''$. The Solomon R. Guggenheim Museum, New York

balanced symmetry and repetition could be seen in many new sculptures and paintings, so narrow a definition would exclude many of the sculptors such as David Smith and Anthony Caro, who certainly influenced the direction, as well as many younger artists after mid-century, who sought their own identity in the face of the enormous weight of earlier modern art. Their question frequently seemed to be, "What can be done that has not been done before?"

Judd's works do, nevertheless, state the thesis of Primary Structures, for they raise fundamental questions concerning the nature and even the validity of the work of art, the nature of the aesthetic experience, the

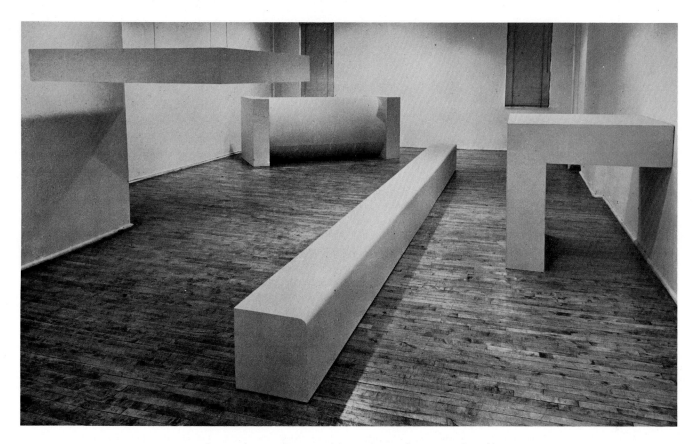

above: 824. ROBERT MORRIS. Exhibition, Green Gallery, New York, 1964

below: 825. SOL LEWITT. *Sculpture Series "A"*. 1967. Installation view, Dwan Gallery, Los Angeles

whom he has a certain affinity, Bladen made his mock-ups in painted wood since the cost of executing these vast structures in metal would be exorbitant. The Primary structuralists, with only a few exceptions, must await patrons for the final realization of their projects.

ROBERT MORRIS (b. 1931) Morris, who during the 1960s was associated with Minimal sculpture, since that time has, of course, become a leader in a wide variety of sculptural, environmental, Conceptual, and Post-Minimal forms. He was a pioneer in the organization of entire rooms into a unity of sculptural mass and space. The 1967 *Untitled* (fig. 823), each unit of which is large enough to be occupied by several persons, combines efficiency with environmental-space design, since the thin metal H-elements can be stacked together in a space little greater than a single one of them.

The monumental size of much Minimal sculpture led inevitably during the 1960s and 1970s to the concept of sculpture designed for a specific space or place. This in turn resulted in ideas such as the use of the gallery space itself as an element in an architectural-sculptural organization. A pioneer experiment in this direction was Robert Morris's 1964 exhibition at the Green Gallery in New York where large, geometric sculptural modules were integrated within the room, whose space became an element of the total sculpture (fig. 824). The idea, of course, had been anticipated by such varied sculptural environments as Schwitters's *Merzbau* of 1925 and Yves Klein's *Le Vide* exhibition of the late 1950s in which the spectators provided the sculptural accents for the empty, white-walled gallery. The implications of sculpture in place have been explored and expanded enormously during the 1970s and extended to environments based on painting, Conceptualism, and Earthworks.

SOL LeWITT (b. 1928) LeWitt is identified with a kind of serial Minimalism consisting of open, identical cubes composed to form proportionately larger units. These cubes increase in scale until they dominate the architectural space that contains them (fig. 825). In such works, the physical essence is only the outline of the cubes, while the cubes themselves are empty space. LeWitt was an early pioneer of Conceptualism with his 1968 *Box in the Hole*. This work, created in The Netherlands, consisted of a metal cube that the artist buried, covered over, and preserved in a series of process photographs.

826. SOL LEWITT. *All Combinations of Arcs from Four Corners, Arcs from Four Sides, Straight Lines, Not-Straight Lines and Broken Lines* (detail: White lines on a black wall). 1976. Installation view, John Weber Gallery, New York

827. CARL ANDRE. *64 Pieces of Magnesium.* 1969. Magnesium, 64 × 64". John Weber Gallery, New York

During the early 1970s LeWitt exploited gallery space in another way—by drawing directly on the walls. These drawings—frequently destroyed at the close of each exhibition—were generally accumulations of rectangles, drawn with a ruler and pencil, toned to various degrees of gray, accompanied by written specifications. The internal

828. RICHARD SERRA. *Two Square Corners.* 1983. Steel, two plates: 60 × 60 × 2½"; 48 × 48 × 2½"; total height 8'10". Courtesy Larry Gagosian Gallery, Los Angeles, New York/Blum Helman Gallery, New York

lines of each rectangle, creating the tones, might be diagonal as well as vertical or horizontal and the result was frequently a geometric abstraction of considerable beauty (fig. 826).

CARL ANDRE (b. 1935) Influenced early by the ideas of his friend Frank Stella and the sculptor Brancusi, Carl Andre combined timbers extended horizontally, bricks, and styrofoam units or identical metal squares assembled on the floor into works intended to be walked on (fig. 827). The accent on the horizontal and the interchangeable parts strikes at the traditional concept of a sculpture as a vertical, unified form.

RICHARD SERRA (b. 1939) In contrast, Serra, after experimenting with different materials such as sheets of vulcanized rubber, created sculptures consisting of enormously heavy sheets of steel or lead that balanced against or on top of one another (fig. 828). Like Andre, he has also been interested in a form of "scatter sculpture," in which series of torn lead sheets are scattered on the floor or molten lead is splashed along the base of a wall. Throughout the 1970s and 1980s Serra has progressively enlarged the scale of his sculptures, taken them out-of-doors, and combined his sheets of steel with a landscape environment, thus effecting the inevitable transition from sculpture placed in an interior environment to sculpture that becomes part of a landscape (figs. 951, 952).

During the late 1960s, most of the experiments in so-called Minimal sculpture involved plywood mock-ups, the only material in which sculptors were able to suggest their ideas for a new monumentalism. Since that time, as a result of the expanding art market and the increasing realization of architects and city planners that large-scale sculptural constructions provide an appropriate adornment to new urban architectural schemes, sculptors have had an opportunity comparable to that of the nineteenth-century academicians. Living Old-Masters like Alexander Calder and Isamu Noguchi were increasingly called upon for works to provide a focus for new urban plazas or gardens (figs. 951, 952). During his later years, Picasso permitted the enlargement of many of his Constructivist sculptures. One of the most impressive of these, as well as one of the most locally controversial, now adorns Chicago's Civic Center.

The International Style in Architecture:
THE SECOND WAVE

The early achievements of modern architecture—really a series of isolated experiments in the first third of the century—have too often been transformed into academic clichés. This is particularly true of the International Style, with its ferroconcrete or its glass or metal sheathing suspended on a steel framework. Everywhere in the world one now sees buildings, large or small, which are practically indistinguishable from one another—large-scale imitations of surface appearance. In architecture, even more than in painting and sculpture, the creation of new ideas has become difficult partly because of the fertility of the pioneers, and partly because of the pattern of patronage. Whereas there has been a great expansion in governmental, industrial, and domestic building since 1945, there has not been a comparable expansion in urban planning, housing projects, or other areas with problems different from those explored earlier. The younger architect of the late twentieth century has had unparalleled opportunities to work in a contemporary mode but, paradoxically, few opportunities to present solutions for the most pressing architectural problems of his era—town and city planning, large-scale low-cost housing, slum clearance, urban congestion, and transportation. Notwithstanding these limitations, an astounding number of talented architects came to maturity after the 1930s. Meanwhile, the great innovators lived on, with increasing activity and recognition, far into the century.

In architecture as in all the other arts and sciences the United States benefited from the fact that Nazi repression drove many of the artists, architects, and scientists out of Germany. Walter Gropius left Germany in 1934 for England, staying there for three years and collaborating with Maxwell Fry in the design of Impington College in Cambridgeshire. In 1937 he left for the United States, to become Professor and then Chairman of the Department of Architecture at Harvard University. Marcel Breuer also had arrived in America in 1937, to join Gropius at Harvard. They remained in partnership until 1941, when Breuer entered practice on his own.

Moholy-Nagy had been invited to Chicago, also in 1937, to form a New Bauhaus. In the same year, Josef Albers arrived in America to teach design and painting, first at Black Mountain College and then at Yale University. In 1938, Miës van der Rohe, who had arrived in the United States the year before, was invited to the Illinois Institute of Technology (then the Armour Institute). José Luis Sert (b. 1902) migrated to the United States in 1939 and in 1958 became Dean of the Harvard Graduate School of Design.

At that time, American schools of architecture in general were still following the academic Beaux-Arts tradition. It was largely as a result of Gropius's and Miës's efforts, as well as those of a few other distinguished immigrants, that architectural schools were transformed over the next twenty years and American architecture entered into a new age of modern architectural experiment. In the same way, Moholy-Nagy,

Albers, and others affected the industrial, product, and graphic design of the United States.

By 1930 many of the ideas of twentieth-century architecture had been stated in one form or another, with the exception of new concepts still developing in the field of engineering. The 1930s saw a degree of retrogression, particularly in Communist or Fascist countries such as Russia and Germany. In those countries and, to a lesser degree, in Italy, an overblown academic style took the place of modern innovation. Such a style was also used for Italian governmental buildings (but free experiment, particularly in engineering, was not entirely discouraged). Even in France, despite the achievements of Le Corbusier, official buildings such as the 1937 Museum of Modern Art in Paris, frequently reverted to a form of Neoclassicism. In contrast, during this period and since, Finland and the Scandinavian countries—Sweden, Norway, and Denmark—made notable contributions to modern design in architecture, furniture, crafts, and industrial products.

Later Styles of the Pioneers

FRANK LLOYD WRIGHT Despite the circular theme developed in the 1936–39 Johnson Building (fig. 448), Wright did not desert the rectangle or the triangle. Taliesin West, the home that he began to build for himself in 1938 near Phoenix, Arizona, and which, characteristically, was still in the process of building and rebuilding until his death in 1959, is in plan and elevation a series of interlocked triangles. The architect's most dramatic assimilation of a building into a natural environment, it becomes an outgrowth of the desert and mountain landscape (plate 262). Other Wright buildings involving the triangle or pyramid are the Unitarian Church in Madison, Wisconsin (1947), and Beth Sholom Synagogue in Elkins Park, Pennsylvania (1959), the latter reminiscent of a Sumerian ziggurat.

Wright completed a number of buildings involving the circle, and the climax of these experiments was the Solomon R. Guggenheim Museum in New York City (figs. 829, 830). First conceived in 1943, it was not actually completed until 1959, after Wright's death. The Guggenheim Museum has been more discussed than any other twentieth-century building. It is the only building the leading American architect was ever commissioned to do in the nation's largest city, and it was many years before he could obtain the necessary building permits for so revolutionary a structure. It consists of two parts: the main exhibition hall and a small administration building, both circular in shape. The gallery proper is a continuous spiral ramp around an open, central well. The building radiates outward toward the top, each ramp becoming deeper than the one below, all of them suspended on huge pylons. A skylight dome on ribs provides natural, general lighting, while continuous strip-light-

Pantheon. As a museum it involves easy and efficient circulation, in contrast to the traditional museum with its galleries consisting of a series of interconnected boxlike rooms. The architect also introduced two new aspects of viewing. The division of the ramps into bays, in which not more than three or four paintings are hung, allows the spectator, stepping into the bay, an intimacy that focuses his attention on each individual work. Then, when he turns around and looks across the open central area, he is given a panorama that suggests interesting and frequently exciting comparisons.

WALTER GROPIUS In America, Gropius soon put into effect his principles of collaboration and his ideas concerning the social responsibilities of the architect. In 1945, with some of his students, he formed The Architects' Collaborative (TAC) to design buildings in the United States and elsewhere. At Harvard he continued his design of school structures with the Harvard Graduate Center of 1949–50. Here he had the problem of placing a modern building within a traditional environment that extended from the eighteenth to the twentieth centuries. He made no compromises to tradition but used stone and other materials to enrich and give warmth and variety to his modern structure. He also commissioned artists such as Miró, Arp, and Albers to design murals, thus introducing to Harvard the Bauhaus concept of the integration of the arts. In his later years, with The Architects' Collaborative, Gropius moved again into full-scale architectural production. Perhaps the most ambitious of the later designs was the 1953 Boston Back Bay Center, unhappily never constructed (fig. 831). This was a large-scale project involving office buildings, a convention hall, a shopping center, underground parking lot, and a motor hotel. It involved two slab structures set in a T-form, raised on stilts above the intricate, landscaped pedestrian walks and driveways. The façades were to have been richly textured, and the entire complex represented a superior example of recent American experiments in the creation of total, industrial, mercantile, or cultural centers—social and environmental experiments with which Gropius himself had been concerned in Germany during the 1920s.

ing around the ramps provides additional light. Permanent projecting fins divide the ramps into equal bays. The interior of the Guggenheim Museum is one of the great architectural spaces of the twentieth century, inviting comparison with the interior of St. Peter's or the Roman

right: 831. WALTER GROPIUS. Project for City Center for Boston Back Bay. 1953

bottom: 832. MIËS VAN DER ROHE. Block plan for Illinois Institute of Technology, Chicago. 1940

below right: 833. MIËS VAN DER ROHE. New National Gallery, Berlin, 1968. Sculpture is by Alexander Calder

MIËS VAN DER ROHE Miës van der Rohe, having completed relatively few buildings before leaving Germany in 1937, was finally able to put his ideas into practice in the United States. In the skyscrapers he created, as well as in the new campus for the Illinois Institute of Technology, his solutions were so superb and the impact of the buildings so impressive that his influence on younger American architects has been incalculable. The plan of the Institute, as drawn by Miës in 1940, is characteristically a beautiful abstraction (fig. 832). Located in a deteriorating area on the south side of Chicago, the school complex became a model of efficient organization and urban planning. In fact, it provided the inspiration for large-scale slum clearance in the area. The buildings, of steel construction, are organized on a modular principle. Each in itself and all in their relations to one another exemplify Miës's sensitivity to every aspect of proportion and detail of construction.

After having envisioned (but not built) two of the most advanced skyscraper designs, in 1919 and 1919–21, Miës was finally enabled to carry out some of his ideas in the 1951 apartments on Lake Shore Drive in Chicago (fig. 861), and in New York's 1956–57 Seagram Building, on which Philip C. Johnson collaborated (fig. 863). The Seagram Building and Miës's Federal Center in Chicago (1964) represent the climax of a development in the United States that began with Sullivan and the Chicago School, was diverted during the age of eclecticism, and gradu-

ally came back to original principles. This development will be traced below.

In his later works such as the National Gallery in Berlin (fig. 833), Miës not only refined his modular system to a point of utmost simplicity, but, using a suspended frame structure, he was able to realize his ideals of a complete and uninterrupted interior space to be divided or subdivided at will.

834. LE CORBUSIER. Unité d'Habitation, Marseilles, France. 1947–52

LE CORBUSIER The characteristics of Le Corbusier's later style were the exploration of free, organic forms and the statement of materials, principally his favorite ferroconcrete, in its raw original state as it emerged from the molds. The 1947–52 apartment building in Marseilles known as the Unité d'Habitation (fig. 834), on the one hand carries out the architect's town-planning ideas and, on the other hand, expresses the rough-surfaced concrete details as massive sculpture. The building is composed of small duplex apartments with a two-story living room, developing his earlier housing schemes. It includes shops, restaurants, and recreation areas, to constitute a self-contained community. Here Le Corbusier abandoned the original concept of concrete as a precisely surfaced machine material and presented it in its rough, primitive state. In doing so, he inaugurated a new style, almost a new

age, in modern architecture, to which a name, the New Brutalism, was later given. Possibly related to the French word *brut* (uncut, rough, raw), but first associated with the Smithson family (fig. 842), the term has taken many forms, but involves fundamentally the idea of truth to materials and the blunt statement of their essence. Frank Lloyd Wright had preached this doctrine from the beginning of his career, and Miës van der Rohe in his own way was as ruthlessly dedicated to the statement of glass and steel as Le Corbusier was to the statement of concrete. New Brutalism, however, most characteristically manifests itself in concrete not only because of its texture but even more because of its innate sculptural properties.

The pilgrimage Chapel of Notre Dame du Haut at Ronchamp in France, built in 1950–54 high on a hill, is the first climax of Le Cor-

above: 835. LE CORBUSIER. Notre Dame du Haut, Ronchamp, France. 1950–54

right: 836. LE CORBUSIER. Interior, Notre Dame du Haut. 1950–54

busier's new sculptural style (figs. 835, 836). It is molded of white concrete topped by the dark, floating mass of the roof and accented by the towers (inspired by Hadrian's villa), which serve as a geometric counterpoint to the main mass. The interior is lit by windows of varying sizes and shapes that open up from small apertures to create focused tunnels of light. This is one of the great religious structures of the twentieth century, in external forms and the mystery of its interior going back beyond Christianity to the prehistoric grave forms of megalithic times.

In the 1950s Le Corbusier was finally given the opportunity to put into effect his lifelong ideas on total city planning in the design and construction of Chandigarh, a new capital for the Punjab in India, on which he worked into the 1960s. The city of Chandigarh is situated on a plain at the edge of hills, and the capital buildings, comprising the Secretariat, the Assembly, and the High Court, rise to the north in the foothills, with the three buildings arranged in an arc around a central area and accompanied by terraces, gardens, and pools. Access roads to the city are largely concealed, while changing vistas are achieved through ingeniously placed manmade mounds. The Assembly building (fig. 837) is the most impressive of the three, with its ceremonial entrance portico and upward-curving roof set on pylons, the whole reflected in the pool and approached by a causeway. The interior, designed for monumental effect, is another great modern architectural space. Le Corbusier's achievement is embodied not only in the individual buildings, but in their subtle visual relationships to one another. The total complex constitutes a fitting climax to Le Corbusier's career.

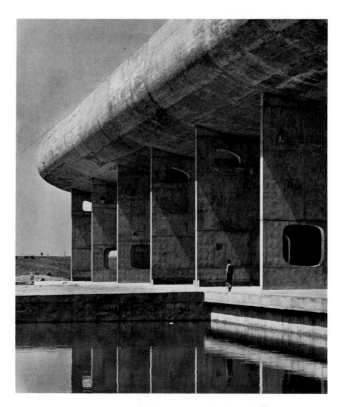

837. LE CORBUSIER. Assembly Building, Chandigarh, India. 1959–62

Finland

ALVAR AALTO (1898–1976) Notable for his contribution to the modern tradition is Alvar Aalto, until his death the leading architect of Northern Europe. Aalto created architecture that is characterized by a warmth and humanity in his use of materials, individualizing particular buildings, and harmonizing with the human scale. Compared to that of Le Corbusier or Wright, it is almost self-effacing. The structure seems to grow out of the site and out of particular, individual problems, whether

those of factory, house, school, or town plan. Also a leading designer of furniture, Aalto was particularly effective in his development of bentwood chairs and tables. One of his most successful houses is that built for the art dealer and collector Louis Carré, the house appropriately known as the Maison Carré constructed between 1956 and 1958 at Bazoches, not far from Paris (figs. 838, 839). The house is placed on a rise of ground, and the diagonal of the roof reiterates the landscape. The exterior is an integrated alternation of diagonals and planes, constructed of concrete with accents of stone and wood. Inside the archi-

above: 838. ALVAR AALTO. Maison Carré, Bazoches-sur-Guyonne, France. 1956–58

right: 839. ALVAR AALTO. Interior, Maison Carré. 1956–58

840. ALVAR AALTO. Town Hall, Säynätsalo, Finland. c. 1950–53

tect used light woods on curving ceilings and walls to create an effect of moving and integrated space. The house is completely furnished with Aalto furniture.

As the leading architect of Finland and Scandinavia, Alvar Aalto had opportunities to experiment with public buildings, churches, and town planning, and he achieved one of his most personal expressions in the Town Hall at Säynätsalo (fig. 840). This is a center for a small town including a council room, library, offices, shops, and homes. The brick structure with broken, tilted roof lines merges with the natural environment. Heavy timbers, beautifully detailed, are used for ceilings, to contrast with the brick walls inside and out. Although somewhat romantic in concept, this center illustrates the combination of effective planning and respect for the natural environment characteristic of Aalto and the best North-European architecture.

Great Britain

After the important pioneer work of the late nineteenth century by Morris, Webb, Voysey, and Mackintosh, there was, as has been noted, little experimental architecture in Great Britain during the first decades of the twentieth century. In the 1930s a new impetus was given by the arrival in Britain of the German architects Walter Gropius, Marcel Breuer, Erich Mendelsohn, and the Russian Serge Chermayeff. The impetus was interrupted by the devastation of World War II, and, after the war, budgetary limitations prevented large-scale architectural development. Although few great individual buildings have been erected in England in the twentieth century, progress has been made in two areas, town and country planning, and the design of schools and colleges.

841. HUBERT BENNETT and others. Alton Estate, Roehampton, London. 1952–59

842. ALISON and PETER SMITHSON. Robin Hood Gardens Estate, London. 1972

843. JAMES STIRLING. History Faculty, Cambridge University, England. 1968

The wide-scale destruction occurring during World War II resulted in intensive research on the problems of town planning, although much of this was not subsequently put into practice, and Great Britain, like most of Europe and America, suffered after the war from the disease of hastily built mass housing. Nevertheless, in planned communities such as the Alton Estate at Roehampton, Hubert Bennett, collaborating with other architects, succeeded in establishing prototypes (fig. 841). Developed under the London County Council, Roehampton is an outstanding example of low-cost housing, accommodating some ninety-five hundred persons. Tower apartments, rectangular slab blocks, and row houses are widely spaced amid extensive, landscaped surroundings. The influence of Le Corbusier is evident in the design and distribution of the buildings.

ALISON SMITHSON (b. 1928) AND PETER SMITHSON (b. 1923) Two of the most influential of the younger British architects are Alison and Peter Smithson. The Smithsons were probably responsible for the phrase New Brutalism, which originated in 1954 and which became almost a cliché for the definition of new tendencies in architecture. The term refers not only to the brutal statement of materials as practiced by Le Corbusier and a host of followers, but also to the uncompromising, if meticulous, assertion of structure practiced by Miës van der Rohe. It is in effect a return to basic principles of modern architecture, frequently lost sight of in the embellishments of the mid-century. In its origin it might be equated to the revolutions of Jackson Pollock and the American Abstract Expressionists, to Dubuffet and *l'art brut*, or to electronic noise-music. It is interesting that Brutalist architecture, constituting an Expressionist application of International Style functionalism, should have been named in England. However, it was in England, as we have seen, that the term Pop Art was coined about 1955 or 1956.

In the Smithson's Robin Hood Gardens Estate for London (fig. 842) the texture of the façade breaks down the mass and both holds together and diversifies the vertical and horizontal elements. The treatment of the exterior is somewhat related to that of Le Corbusier's Unité d'Habitation in Marseilles.

JAMES STIRLING (b. 1926) James Stirling, one of the most imagina-

tive and influential architects of the present generation, was also associated with Brutalism and the tradition of Le Corbusier. Stirling has a masterful ability to combine all materials—glass, masonry, and metal—in exciting new contexts. Like Louis Kahn's (fig. 880), his early buildings are not so much functional, in the original International Style sense, as expressive and personal. With James Gowan he designed the low-cost housing scheme of Ham Common in 1956 when he was studying the later ideas of Le Corbusier and exploring the possibilities for use of readymade industrial products in new architectural contexts. For the Leicester Engineering Laboratories, Stirling and Gowan developed a system of drawing in perspective that was actually a method of spatial designing that led to new visual concepts with the building itself. In the Cambridge University History Faculty he used the same approach even more dynamically to achieve a dense and complex spatial integration (fig. 843). Although Stirling, an important teacher and thinker in his field, has often been pessimistic about the present state of architecture, his own work continually reveals its possibilities, especially, as we shall see, in his new Post-Modern work (plate 319; figs. 1101, 1102).

France

With the exception of the titanic figure of Le Corbusier and earlier works by Auguste Perret, French architecture of the twentieth century has had few moments of inspiration. This is in part the result of the continuing academic system of training for architects, and the persisting influence of a bureaucratic old guard. Some progress has been made in housing, and some of the best buildings have been churches. Perret's reconstruction of Le Havre after World War II, begun in 1947, proved to be an uninspired example of modern Classicism. Le Corbusier (born a Swiss) produced a number of masterpieces, but his influence was greater outside of France than in it.

The most ambitious postwar structure erected in Paris was the UNESCO building (United Nations Educational Scientific and Cultural Organization) in the Place de Fontenoy. The architects were Marcel Breuer and Bernard Zehrfuss and the engineer Pier Luigi Nervi. The eight-story Secretariat building is Y-shaped, adjoined to a fine conference hall, designed principally by Nervi. Although the total complex is

above: 844. MARCEL BREUER. IBM-France Research Center, La Gaude Var, France. 1960–62

right: 845. RENZO PIANO and RICHARD ROGERS. Centre National d'Art et de Culture Georges Pompidou, Paris. 1971–78

excellently adapted to a difficult site, and although it is adorned by a large number of sculptures, paintings, and murals by leading artists such as Miró (fig. 398), Calder, Picasso, Noguchi, and Henry Moore, the total effect of the UNESCO building, with the exception of the Conference Hall, tends to be disappointing. Breuer developed the ideas and plan of the UNESCO building into his work on a research center for IBM-France at La Gaude Var (fig. 844). This is a huge structure of a comparable, double Y-plan, with windows set within deep, heavy, concrete frames, the whole on concrete supports. The effect is of openness and airiness combined with massive, rugged detail. The enlargement of the elements results in greater sculptural cohesion than in the UNESCO building.

The most sensational and hotly debated building to be designed in the 1960s and erected in Paris during the early 1970s was a high-tech extravaganza officially known as Le Centre National d'Art et de Culture Georges Pompidou, but invariably referred to simply as Beaubourg, for the name of the old market district whose site the new museum now occupies. One of the few constructed buildings conceived by England's Archigram group, Beaubourg would seem to have taken Bauhaus pragmatism and technology as its point of departure, only to transform them into a Surreal dream of pipes and trusses, marine funnels and vents, most of which festoon the exoskeleton with all the logic of a Rube Goldberg "machine" (fig. 845). One commentator called the building "a child's tinkertoy fantasy realized on an elephantine scale." However, despite a gargantuan appetite for fuel and unmanageable, barnlike galleries, Beaubourg is in fact a great popular success, largely because of a five-story outside escalator, whose transparent plastic tubes offer riders a moving, spectacular view of Paris, and an immense, completely open plaza. The latter has become a forum—like the parvis of a medieval cathedral—for the whole human carnival, from artists displaying their works to jugglers, chamber music ensembles, fire-eaters, and, of course, ordinary tourists and even Parisians going about their daily business.

Germany

As we have seen, Germany until 1930 was probably the world leader in the development of a new architecture. During the Nazi regime German architecture declined from its position of world leadership to academic mediocrity. The destruction during World War II left the way open for a major rebuilding program. Unfortunately, a tradition of experiment and of progressive teaching and sympathetic patronage had also been destroyed by the Nazis. Thus much of the new building was mediocre, and, even in those structures where a conscious effort was made, inspiration and dedicated talent were lacking. Germany lost a generation of progressive architects and patrons.

HANS SCHAROUN (1893–1972) Among the best buildings in postwar Germany are the new churches, theaters, and concert halls. Of the concert halls, the most ambitious is Hans Scharoun's Philharmonic Hall in Berlin of 1956–63 (fig. 846). Scharoun was one of the pioneer German modern architects who produced a number of experimental houses and housing projects during the 1920s and 1930s and was active in urban planning projects. He remained in Germany during the Nazi regime and the war, but was permitted to do little building. In the postwar period Scharoun provided an important link between the past and the present, responsible for the extensive Charlottenburg-Nord housing development in Berlin (1955–61) and other housing projects, as well as the Berlin Philharmonic Hall. The Philharmonic stems from Walter

846. HANS SCHAROUN. Interior, Philharmonic Hall, Berlin. 1956–63

Gropius's concept of the Total Theater in which the audience surrounds the stage—in this case the orchestra. The ideal, here attempted on a vast scale, is that of achieving intimacy between the audience and the players. This partook of the worldwide trend toward audience participation in theater, music, and Happenings.

Italy

Modern architecture made a somewhat belated arrival in Italy, perhaps because the sense of the past was so strong. No wonder that new or foreign experiments should have had difficulty in penetrating. The one outstanding architect produced by Futurism was killed in World War I at the age of twenty-eight. This was Antonio Sant'Elia, whose visionary designs have been discussed (fig. 309). Had he lived, Sant'Elia might have accelerated the progress of modern architecture in Italy. As it was, his ideas faded along with Futurism, and his influence was felt principally, through publications, on pioneers outside of Italy, importantly on Le Corbusier, and on the architects of De Stijl and the Bauhaus.

Although progressive architecture was not formally suppressed by Italian Fascism as it was in Germany under the Nazis, the climate did not favor growth. The official governmental style looked back to showy monumentalism, of which the nineteenth-century monument to Victor Emmanuel II in Rome is the most distressing example. The Group of 7, younger architects, banded together in 1933 for a functional or rational architecture with a specifically Mediterranean accent. A few outstanding, though isolated, buildings resulted from Italian rationalism between the wars, notably Giuseppe Terragni's 1932–36 House of the People at Como (fig. 847).

After World War II Italy expanded its experiment in progressive architecture, moving into a position of European and even world leadership in many aspects of industry, product, and fashion design. One of the first outstanding postwar structures is the Main (Termini) Railroad Station in Rome (fig. 848). A good example of Italian engineering, its cantilevered roof of unusual design permits the use of continuous glass walls between the supporting columns, and uninterrupted interior space. The architects Calini and Montuori incorporated the ruins of the fourth-century B.C. Servian wall into the total design, as a dramatic con-

847. GIUSEPPE TERRAGNI. Casa del Popolo, Como, Italy. 1932–36

trast to the modern building. As this would suggest, Italian postwar architecture was characterized generally by qualities of drama and excitement as well as by sound planning.

PIER LUIGI NERVI (1891–1979) The most influential of Italy's prewar form-givers was the engineer-architect Pier Luigi Nervi. Nervi was one of the great builders of all time, with a resounding ability to translate engineering structure into architectural forms of beauty. Chronologically he belongs with the pioneers of modern architecture, and his fundamental theses were stated in a number of important buildings executed during the 1930s. His preferred material was reinforced concrete, and his main contribution the realization of its potentials in the creation of new shapes and dimensions of space. One of the most important commissions in his career was the design of an aircraft hangar in 1935, the first of a number of variants he built for the military from 1936 to 1941. These hangars, which involved uninterrupted roof spans, led him to a study of different ways to create such spans. He learned how to lighten and strengthen his materials, and to play aesthetic and structural variations in his designs.

After 1945 Nervi had unparalleled opportunities of putting his theories into practice. Because the immense exhibition building in Turin had to be constructed rapidly in 1948–49, the architect developed a formula for small, prefabricated units that could be assembled easily on location.

Two of the dramatic applications of his experiments with ferroconcrete are the small and large sports palaces built originally for the 1960 Olympic Games in Rome (figs. 849, 850). The smaller one seen here, meant to hold four to five thousand spectators, was built in 1956–57, in collaboration with the architect Annibale Vitellozzi. The building is essentially a circular roof structure in which the enclosed shell roof, 197 feet in diameter, rests lightly on thirty-six Y-shaped concrete supports. The edge of the roof is scalloped, both to accentuate the points of support and to increase the feeling of lightness. A continuous window band between this scalloped edge and the outside wall provides uniform day-

848. CALINI and MONTUORI. Interior, Termini Station, Rome. 1948–50

light and adds to the floating quality of the ceiling. On the interior, the ceiling, a honeycomb of radiating, interlaced curves, floats without apparent support.

GIO PONTI (1891–1979) Nervi, during the 1950s and 1960s, collaborated with architects all over the world, including Italy's own Gio Ponti. The distinguished Ponti was the chief architect of the Pirelli Tower in Milan (fig. 851). He developed slowly but consistently from Neoclassical beginnings toward an elaborate modernism. The Pirelli Tower, for which Nervi was the structural engineer, remains Ponti's masterpiece, and one of the most lucid and individual interpretations of the skyscraper yet achieved. Since, in contrast to most American skyscrapers built before the 1950s, it is a separate building surrounded by lower structures, designed to be seen from all sides, the architect was concerned with making it a total, harmonious unit. A boat-shaped plan, rather than the customary rectangle slab, was used. It is unusual and impressive, departing from tradition in that the entire building is carried on tapering piers. These result in enlargement of the spaces as the piers become lighter toward the top. The entire building, with the diagonal areas at the ends enclosed and framing the side walls of glass, has a sculptural quality, a sense of solidity and mass unusual in contemporary skyscraper design.

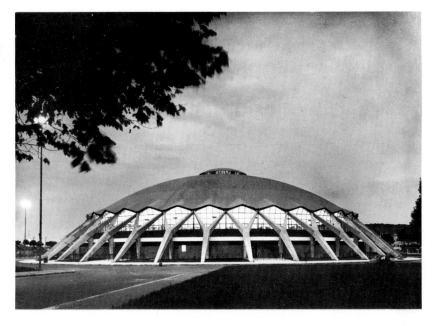

left: 849. PIER LUIGI NERVI and ANNIBALE VITELLOZZI. Sports Palace, Rome. 1956–57

below left: 850. PIER LUIGI NERVI and ANNIBALE VITELLOZZI. Interior, Sports Palace. 1956–57

below: 851. GIO PONTI, PIER LUIGI NERVI, and others. Pirelli Tower, Milan, Italy. 1956–59

Latin America

OSCAR NIEMEYER (b. 1907) The most spectacular example of the spread of the International Style occurred in Latin America after 1940. Le Corbusier's participation in the design of the Ministry of Education and Health in Rio de Janeiro between 1937 and 1943 provided the spark that ignited the younger Latin American architects, notably Oscar Niemeyer in Brazil. Le Corbusier's influence is apparent in most of the subsequent development of Brazilian architecture, but Niemeyer and the others added Expressionist and Baroque elements involving curving shapes, in plans and façades, together with lavish use of color that reflected the Latin American tradition.

Niemeyer's greatest commission, and one of the most dramatic commissions in the history of architecture, was the design of an entire city at Brasilia, the new capital of Brazil (fig. 852). The general plan of the city was laid out by Lúcio Costa, the dean of modern Brazilian architecture, but Niemeyer was entrusted with the principal public buildings. Brasilia is a Utopian project possibly doomed to failure. The idea of building an entire city in the middle of a vast country, far removed from any of the principal centers of commerce and industry, represents the ultimate excursion into fantasy. At a time in the history of architecture, however, when only lip service was being given, and very little actual attention paid, to total concepts of urban planning, such a project must be seen as important, even in its deficiencies and failures.

852. OSCAR NIEMEYER. Palace of the Dawn, Brasilia, Brazil. 1959

Canada and Australia

In Canada and Australia, vast and lightly populated countries, modern architecture in the 1950s and 1960s has accelerated at a pace unparalleled in their history. New buildings of all descriptions—skyscrapers, factories, housing projects, educational institutions, shopping centers, cultural centers, air terminals, and government buildings—have created a new architectural face for both of these countries. Although a subject of controversy, the City Hall in Toronto, designed by Viljo Rewell and built in 1965, is an original and exciting symbol of the new spirit in

above: 853. VILJO REWELL. City Hall, Toronto. 1965

right: 854. JOHN ANDREWS. Science and Humanities Wings, Scarborough College, Toronto. 1966

Canada (fig. 853). Scarborough College in Ontario, designed by the Australian-born architect John Andrews, is a dramatic new educational complex in Canada (fig. 854). Created in the tradition of Le Corbusier—massive structures of undressed concrete, monumental proportions, and noble vistas—this is a concept that would be notable in the modern architecture of any country.

In Australia, there has been a comparable development of new architectural forms, from the slab skyscraper to the integrated educational institution and advanced experiments in housing and urban planning. The most spectacular modern structure is the Sydney Opera House on Bennelong Point, Sydney Harbor (fig. 855). Architects Hall, Todd, and Littleton succeeded the Danish Jørn Utzon, who made the original design. This cultural center includes an opera hall, a theater, an exhibition area, a cinema, and a chamber music hall.

Japan

KENZO TANGE (b. 1913) An independent style in modern Japanese architecture has been apparent only since the 1960s. Before, there was principally derivative commercial modern building, particularly in Tokyo, but little of any distinction or originality. The leader of the new Japanese architecture is Kenzo Tange. Like most of the younger Japanese architects, he is a disciple of Le Corbusier and particularly of Le Corbusier's later, Brutalist style. Tokyo City Hall, a work of 1952–57, is a rather thin and overly elegant version of Le Corbusier's Unité d'Habitation, but with his Kagawa Prefecture Office at Takamatsu (1955–58), Tange gained more authority in a combination of massive, direct concrete treatment with horizontally accentuated shapes reminiscent of traditional Japanese architecture. His Kurashiki City Hall, built in 1958–60, is an even closer approximation, in its general effect, to Le Corbusier's La Tourette monastery, with Japanese architectural reminiscences. Perhaps his most striking achievement is the pair of gymnasia

855. JØRN UTZON and HALL, TODD and LITTLETON. Sydney Opera House, Bennelong Point, Sydney Harbor, Australia. 1972

he designed for the Olympic Games held in Tokyo in 1964 (fig. 856). Both roofs are suspended from immense cables, and their structure is at once daring and graceful. Somewhat resembling seashells, the larger roof is hung from two concrete masts, while the smaller is ingeniously hung from a cable spiraling down from a single mast. The Brutalism of the buildings themselves, with their rough surface textures, bold, sweeping curves, and frank structure, gives the complex—set as it is on a huge platform of undressed stone blocks—a sense of enduring drama. Tange's Yamanishi Press Center in Kofu (fig. 857) is a fantastically monumental structure in which great pylons provide elevator and other services and act visually as tower supports for the horizontal office areas. The total impact is like that of a vast Romanesque fortified castle—an agglomeration of elements which, however, breaks down to the two basic units of the towers and the intervening rectangles.

Other Japanese architects who followed the late Le Corbusier line are Takeo Sato, whose City Hall in Iwakuni is an almost literal transposition of a Japanese pagoda (fig. 858). Sachio Otani's International Confer-

856. KENZO TANGE. Aerial view, The National Gymnasiums, Tokyo. 1964

857. KENZO TANGE. Yamanashi Press Center, Kofu, Japan. 1967

858. TAKEO SATO. City Hall, Iwakuni, Japan. 1959

ence Building in Kyoto (fig. 859) is a massive building to house meeting and exhibition rooms, restaurants, administrative offices, shops, and recreation areas. Employing old trapezoidal and triangular design elements, it represents one of the most spectacular attempts yet made to combine motifs and concepts of ancient Japanese building with modern structure on a vast scale.

Modern architecture in Japan, despite a long history of sporadic examples extending back to Frank Lloyd Wright's Imperial Hotel (fig. 295), is actually only at its inception. Assimilating the overpowering Le Corbusier influence, the tradition of Japanese architecture—which for centuries embodied so many elements that today are called modern—is helping to turn this influence into something indigenous.

859. SACHIO OTANI. International Conference Building, Kyoto, Japan

The United States

Architects in the second half of the twentieth century have been able to develop new concepts of space, either through new structural systems, or through older systems such as ferroconcrete, used in new ways. Some of the areas in which architects have worked on an unprecedented scale, aside from the skyscraper and other urban office buildings, are industrial plants and research centers; university campuses; religious structures; cultural centers including museums, theaters, and concert halls; and airports. Thus in the section immediately following, architecture in the United States is divided by category (skyscrapers, houses, industrial complexes, et cetera), and some of the major creative talents and avant-garde spirits are placed within a running text under these headings.

SKYSCRAPERS The first monument of the postwar renaissance in American architecture was the United Nations Building (1947–50), designed by an international team of architects under the general direction of Wallace K. Harrison (fig. 860). The Secretariat Building introduced to the United States a concept of the skyscraper as a tall, rectangular slab, in this case with the sides sheathed in glass, and the ends in marble. Le Corbusier was principally responsible for the main forms of the Secretariat, but its simplified, purified structure embodies the Bauhaus tradition of Gropius and Miës van der Rohe as well.

The next and, in terms of its subsequent influence, even more important skyscraper was the twin apartment building in Chicago, designed by Miës van der Rohe in 1951 (fig. 861). Miës had been in Chicago since 1937, principally occupied with the new campus of the Illinois Institute

of Technology. The skyscraper tradition of Louis Sullivan and the Chicago School inevitably had a fascination for him and drew him to a study of the skyscraper form. The basic problems involved—of steel structure, its expression, and its sheathing—were of particular interest. He had already explored these problems in his dramatic, though unbuilt, skyscraper designs in 1919 and 1919–21. The twin apartment buildings consist of two interrelated vertical blocks with the steel structure accenting the verticals. As is customary with Miës, the structures are built on a module.

The inspiration of Miës and of the United Nations Building led immediately to the first great office building of the 1950s, Lever House (fig. 862), designed by Skidmore, Owings and Merrill, and an outstanding example from this large industrial architectural firm. Lever House, intended—as was increasingly the case with the new skyscrapers—as a monument-symbol for a worldwide corporation, is a tall, rectangular slab, occupying only a small part of a New York block. It is raised on pylons which support the first enclosed level—the principal public areas, which cover a large part of the plot—thus giving the total structure a vertical L-shape. The building is one of the first instances of the all-glass structure, with horizontal ribbon windows tinted a light green to reduce glare, alternating with opaque, dark green strips. Lever House remains one of the spectacular and satisfactory buildings in New York.

Across Park Avenue from Lever House is one of the masterpieces of skyscraper architecture, Miës van der Rohe's 1958 Seagram Building (fig. 863). In it Miës and Philip Johnson were given an unparalleled opportunity to create a monument to modern industry, comparable to the Gothic cathedrals that had been monuments to medieval religious belief. The building is a statement of the slab principle, isolated with absolute symmetry within a broad plaza lightened by balanced details of

860. WALLACE K. HARRISON and others. United Nations Headquarters, New York. 1947–50

861. MIËS VAN DER ROHE. Lake Shore Drive Apartments, Chicago. 1951

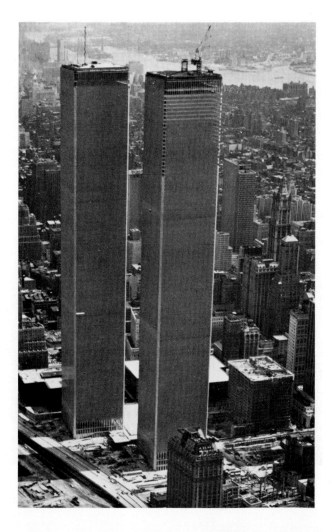

above left: 862. SKIDMORE, OWINGS and MERRILL. Lever House, New York. 1951–52

above right: 863. MIËS VAN DER ROHE and PHILIP JOHNSON. Seagram Building, New York. 1958

below left: 864. MINORU YAMASAKI. World Trade Center, New York. 1964–72

fountains. The larger skeleton structure is clearly apparent within the more delicate framing of window elements that sheath the building. The materials, metal bronze and amber glass, lend the exterior an opaque solidity that does not interfere with the total impression of light that fills the interior. The building is perhaps the consummate expression of Miës's emphasis on "the organic principle of order as a means of achieving the successful relationship of the parts to each other and to the whole." No other building of modern times has had such influence on subsequent skyscraper design.

The Miësian credo has been given its most monumental statement in the design of the World Trade Center, built for the New York Port Authority (fig. 864). Designed by Minoru Yamasaki (1912–1986) and Emery Roth & Sons, the building of 110 stories is the second-tallest in the world. There are architects, however, who escape the tradition of Miës. Among them was Eero Saarinen (1910–1961), whose CBS Building in New York reintroduced an uncompromising contrast of massive vertical piers alternating with the recessed voids of the windows (fig. 865).

In the late 1960s and 1970s skyscrapers—still essentially tall, stratified, commercial buildings—were constructed in increasing numbers

throughout the world, but with remarkably little imagination either in terms of the organization of interior space or the appearance of the exterior. It is difficult, although by no means impossible, to create new and dramatic forms for the skyscraper and at the same time to satisfy the patrons who demand the maximum of space utilization in order to recoup their enormous investments.

That it is still possible to create elegant and dramatic new skyscrapers is evidenced by the John Hancock Mutual Life Insurance Building in Boston, finished in 1975 by I. M. Pei and Partners, and the Pennzoil building in Houston, Texas, by Johnson and Burgee (fig. 866). As of 1986 the world's tallest building is the Sears Roebuck Tower in Chicago, designed by Skidmore, Owings and Merrill (fig. 867). Conceived as a bundle of "tubes" lashed together for mutual bracing, the Sears Tower would seem to return to the original pragmatism of Bauhaus aesthetics, in that each of the independent but clustered tubes has its own height and setback, dictated by the internal needs of corporate activity, as well as by the promised efficiency of decreased elevator service for the reduced space and population at the top. Also functional is the blank anodized aluminum skin, which resists weathering and soot better than other materials, while symbolizing the sobriety of the retailing enterprise headquartered within the structure.

above right: 865. EERO SAARINEN. CBS Building, New York. 1962–64

below left: 866. PHILIP JOHNSON and JOHN BURGEE. Pennzoil Place, Houston. 1972–76

below right: 867. SKIDMORE, OWINGS and MERRILL. Sears Roebuck Tower, Chicago. 1966–69

868. MARCEL BREUER. House II, New Canaan, Connecticut. 1951

HOUSES Much of the early American architecture of Gropius and Breuer consisted of houses following Bauhaus principles. Breuer's own second house at New Canaan, Connecticut, built in 1951, illustrates his adaptability in the use of materials that blend with the local scene. In this case it is principally concrete and field stone with weathered wood beams used for the ceilings (fig. 868).

Miës van der Rohe built no houses in the United States with the exception of the Farnsworth House in Illinois, but his tradition was carried on, notably by Philip Johnson, whose own home in New Canaan, Connecticut, is a classic extension of the Miësian principles (fig. 869). The main house is a glass box which provides protection but destroys the boundaries between nature and enclosed space, while the guest house is at the other extreme—a totally enclosed structure.

Of great potential significance were the visionary house designs which belong to a new stage of imaginary architecture in the larger sense. Outstanding is the Endless House designed by Frederick Kiesler (fig. 870). As early as 1925 Kiesler had conceived of a city in space built on a bridge structure, and an Endless Theater. From these, in 1934, he developed a space house and, after years of experiment, the so-termed Endless House. In this he abandoned the rectangle and returned to egg shapes, freely modeled from plastic materials and involving a continuously flowing interior space.

869. PHILIP JOHNSON. Glass House, New Canaan, Connecticut. 1949

left: 870. FREDERICK KIESLER.
Plan of Endless House.
1958–59

below: 871. PAOLO SOLERI.
Arcosanti, Scottsdale, Arizona.
Begun 1970

bottom: 872. PAOLO SOLERI.
Plan for Novanoah I, from
Arcology. 1969

Such experiments represented an attempt not only to find new forms based on natural, organic principles but also to utilize new technical and industrial developments with the potential of cutting building costs. Among them is Paolo Soleri's 1961 house and studio in Scottsdale, Arizona, literally a cave, the forerunner of which was the house in Cave Creek, Arizona (1950). Soleri's Arcosanti near Scottsdale (figs. 871, 872) has for some thirty years been an experiment with complexes described as Arcologies (from architectural-ecologies) involving a whole new concept of urban environment that would, among other things, eliminate the automobile from within the city and develop solar systems of energy. It is, in effect, an attempt to present a new solution to the ecological, economic, spatial, and energy problems of cities. Soleri has also developed plans for vast floating ocean cities, as has Jacques Rougerie. The creation of a whole new urban environment on the pe-

873. CHARLES EAMES. Eames Residence, Santa Monica, California. 1949

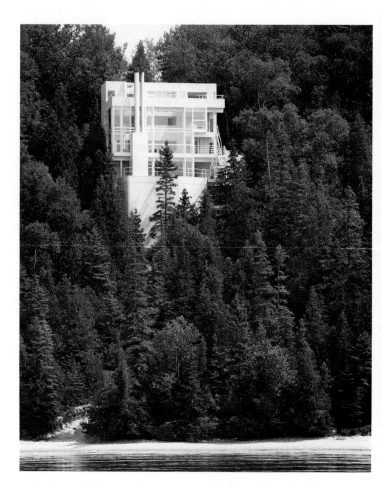

874. RICHARD MEIER. Douglas House, Harbor Springs, Michigan. 1971–73

riphery of the sea or on the actual sea itself is one of the more recent Utopian concepts of urban planning.

Prefabrication—in which individual units are mass-manufactured and then assembled—has been an unrealized dream of the twentieth century. There have been instances of successful, large-scale prefabrication such as Nervi's 1948–49 Turin Exhibition Hall, and some manufacturers in the United States offer partially prefabricated small houses. The architect-designer Charles Eames, in a number of California houses, including his own in Santa Monica (1949), has developed practical forms of partial prefabrication, using structural modules consisting of light steel-skeleton cores covered with fitted plastic, stucco, or glass panels, as well as stock doors, windows, and accessories (fig. 873).

Another straw in the wind, signaling the advent of a new antimodernist development, can be seen in the work of the self-styled New York School (not to be confused with the so-called New York School of painting that began with the Pollock–De Kooning–Rothko generation in the mid-1940s), consisting of Peter Eisenman, John Hejduk, Michael Graves, Charles Gwathmey, and Richard Meier. The most heavily commissioned of these is Richard Meier (b. 1934), whose glistening, white, Cubist temples—supersophisticated exploitations of the modernist vocabulary—have proved irresistible to status-seeking corporations, cultural institutions, and wealthy private clients (fig. 874). Here is Purist or De Stijl classicism so wittily elaborated as to become a new Mannerism, reversing simple closed forms and ribbon windows into intricate, open-work abstractions with double- and triple-height interiors and vast expanses of glass.

INDUSTRIAL COMPLEXES One of the principal postwar trends was the movement of industry away from the congestion of large cities, to the open spaces of the suburbs or smaller towns. This trend remains a natural consequence of the enormous expansion of industrial building after World War II, the exorbitant costs of land and construction in cities, as well as the realization on the part of many companies, such as insurance firms and research centers, that it is not essential to have immediate contact with clients, since virtually all their business is carried on by correspondence or telephone. There was also an increase of attention to the welfare of employees, a realization of the importance of an attractive natural environment, and awareness that employees can be housed more easily, cheaply, and comfortably in smaller communities. One of the first large-scale postwar industrial complexes to be built was the 1951–57 Technical Center for General Motors in Warren, Michigan (fig. 875). The principal architect was Eero Saarinen, a spectacular talent among younger American architects. The Center, begun in collaboration with Eero's father but essentially the work of the younger man, is a large-scale, self-sufficient complex of buildings arranged within an attractive landscape around an artificial lake. Although the Research Center in its final form was much like Miës van der Rohe's plan for the Illinois Institute of Technology, and the design of the buildings follows the International Style, its importance rests in the total planning concept and in the development of prefabricated units such as the sealed, enameled surface panels. The architect attempted to avoid a mechanical appearance of the buildings through the use of bright enamel color and the introduction of certain fanciful details such as the water tower, the dome of the Styling Auditorium, and the circular stair-

right: 875. EERO SAARINEN. General Motors Technical Center, Warren, Michigan. 1951–57

below left: 876. JOSÉ LUIS SERT. Married Student Housing, Harvard University, Cambridge, Massachusetts. 1964

below right: 877. LE CORBUSIER. Carpenter Center for the Visual Arts, Harvard University, Cambridge, Massachusetts. 1963

cases. The fountains in the lake include the *Water Ballet* of Alexander Calder.

COLLEGE CAMPUSES AND RELIGIOUS STRUCTURES After 1945 college and university enrollments expanded dramatically, with consequent building programs ranging from the addition of a classroom or dormitory to the creation of whole new campuses. Often this expansion followed traditional college architecture, with some slight gestures to modernism. In a number of instances, however, enlightened administrations called on the talents of the most advanced architects. Thus Harvard University, a campus of red-brick Georgian and Victorian structures, employed Gropius to build a new Graduate Center, and José

Luis Sert, Dean of Architecture until 1969, to design the new apartments for married graduate students (fig. 876), as well as other structures. Harvard also had the distinction of commissioning the only building by Le Corbusier in the United States (if we except his part in the design of the United Nations Buildings). This is the Carpenter Center for the Visual Arts (fig. 877), an outstanding example of Le Corbusier's late style, with its monumental shapes and rough concrete masses. It is not only a powerful instance of the architect's Brutalism, but also an unusually efficient building—a fact in itself remarkable since it was erected without a clear understanding on the part of the university as to its actual purpose. Only one fact was really known: that it was primarily a building for exhibitions, studio activities in painting, sculpture, and design.

above: 878. SKIDMORE, OWINGS and MERRILL. Air Force Academy, Colorado Springs, Colorado. 1956–62

left: 879. MARCEL BREUER and HAMILTON SMITH. St. John's Abbey and University, Collegeville, Minnesota. 1953–63

above: 880. LOUIS I. KAHN, Richards Medical Research Building, University of Pennsylvania, Philadelphia. 1957–61

left: 881. PAUL RUDOLPH. Art and Architecture Building, Yale University, New Haven, Connecticut. 1963

882. Lincoln Center, New York. From left: New York State Theater, by PHILIP JOHNSON, 1964; Metropolitan Opera House, by WALLACE K. HARRISON, 1966; Philharmonic Hall, by MAX ABRAMOWITZ, 1962

Le Corbusier, with this meager program, designed the interiors, with excellent natural light, as large, handsome, uninterrupted spaces capable of subdivision. This, as it turned out, was all that was necessary.

The educational expansion, particularly of state universities, has provided the opportunity to create entire campuses as a unit. In terms of site, one of the most spectacular of these is the Air Force Academy designed by Skidmore, Owings and Merrill between 1956 and 1962 (fig. 878). The Air Force Academy, built on a gigantic paved platform, is an interlocked series of rectangular courtyard buildings, appropriately accompanied by a huge stadium. The focal point, however, seems to be the chapel, a structure of mechanized modern Gothic modular elements.

In the planning of total campuses, university trustees and administrators have predictably turned to the architects who were sure to produce the most pleasing and spectacular effects. Frank Lloyd Wright was given an opportunity to design the campus of Florida Southern College at Lakeland (1940–59), because both the college and the architect were insolvent and willing to take a chance. Elsewhere the tendency to take a chance was less apparent in the total campus planning. In individual buildings, however, college campuses saw some remarkable experiments. In 1953–63 Marcel Breuer was given one of his first major American opportunities in the Abbey Church of St. John's, for the Benedictine College in Collegeville, Minnesota (fig. 879). The Abbey Church features a detached bell tower, a great concrete slab set up on piers. This monumental gateway to the church is itself a splendid work of abstract sculpture. The interior of the building, influenced by Le Corbusier as well as by Nervi, but evincing an individual interpretation, is one of the most compelling religious structures in the United States.

Perhaps the most influential American architect of the mid-century was Louis I. Kahn (1901–1974), although he actually built relatively few buildings. Born in Estonia and brought to Philadelphia in 1905, Kahn received an architectural training in the Beaux-Arts tradition, at the University of Pennsylvania. There followed a year in Europe, where he was impressed both by the monuments of Classical antiquity and by his discovery of Le Corbusier. For a number of years Kahn taught at Yale University, where he designed the Yale Art Gallery, the university's first modern building and one of the first contemporary approaches to the problem of the art museum. After returning to the University of Pennsyl-

vania in 1957 to teach, he designed for the university the Richards Medical Research Building, a structure comprising a series of interconnected enclosed squares—the laboratories—accented by groups of brick pylons that provide ducts for continual air circulation as well as for stair and elevator services and storage (fig. 880). Despite some functional limitations, the building is one of the most imaginative, impressive, and fresh in vision of any designed in the mid-twentieth century. Almost immediately, its effect began to be seen in imitations and adaptations in both the United States and Europe. It is difficult to describe the impact of this building and of the rest of Kahn's architecture. It combines a simplicity and clarity of form that avoids all contemporary clichés, looks to the future, and yet is as traditional as the Parthenon or the walls of Babylon.

Kahn was not only a designer concerned with mechanical and visual relationships of extraordinary subtlety and aesthetic quality, but he was also a planner, both practical and visionary, on the scale of an individual building or of an entire city. It may be that his greatest influence, however, will be through his teachings and writings.

Of other campus buildings, among the most notable are those of Paul Rudolph (b. 1918) at Yale University. Rudolph's architecture is symptomatic of the talented adaptation of the work of the pioneers, now the practice of leading architects of the younger generation. The Art and Architecture Building for Yale University is an impressive and dramatic structure, illustrative of a new eclecticism (fig. 881), with exterior masses reminiscent of early works by Frank Lloyd Wright, such as the Larkin Building (fig. 293).

CULTURAL CENTERS, THEATERS, AND MUSEUMS Another manifestation of the changing American scene after the mid-century was the proliferation of cultural centers. The idea of the cultural center, usually a complex of buildings involving one or more theaters or concert halls, frequently combined with a museum or an exhibition hall for painting and sculpture, is an outgrowth of the community art centers that emerged during the 1930s under the Federal Art Project of the WPA.

The most elaborate cultural center in the United States is Lincoln Center for the Performing Arts in New York City, which opened in 1962 with a concert in Max Abramowitz's Philharmonic Hall (fig. 882). The principal structures surround a monumental plaza, the focus of which

883. KEVIN ROCHE. Interior Courtyard, Ford Foundation Building, New York. 1967

884. I. M. PEI. Interior, Everson Museum of Art, Syracuse, New York. 1965–68

is a tall fountain designed by Philip Johnson. They comprise, in addition to Philharmonic Hall (now Avery Fisher Hall), Philip Johnson's New York State Theater (1964), Eero Saarinen's Vivian Beaumont Theater (1965), Skidmore, Owings and Merrill's Library-Museum of the Performing Arts (1965), and Wallace K. Harrison's Metropolitan Opera House (1966). A large subterranean garage underlies this group. Adjunct structures include a midtown branch of Fordham University and a new home for the Juilliard School, completed in 1969 by architects Belluschi, Catalano, and Westermann.

above: 885. I. M. PEI. Elevation of Everson Museum of Art. 1965–68

left: 886. I. M. PEI and PARTNERS. Project for the interior, East Building, National Gallery of Art, Washington, D.C.

887. MARCEL BREUER. The Whitney Museum of American Art, New York. 1966

The buildings created by this grandiose assemblage of talent exemplify—Saarinen's flexible theater excepted—the new monumental Classicism characteristic of public and official architecture in the 1960s. The project is unquestionably impressive, although many practical criticisms have been leveled against individual structures. The main difficulty, aside from problems of acoustics and sightlines, seems to lie in the impact of Lincoln Center's somewhat barren monumentality—its colossal scale lacking in ornamental detail to establish a human reference. Rockefeller Center, that huge but less pretentious combination of commerce and recreation, appears rather intimate and comfortable by comparison (fig. 465).

A building that is not in itself literally a center of cultural activities but might be considered their parent is the new home of the Ford Foundation in New York City (fig. 883). Designed by Kevin Roche and completed in 1967, this building deserves comment as a revival of an original concept seen in Wright's Larkin Building. It is a tall building conceived as balconies around an open central space. The basic L-plan is brought to a square by a landscaped courtyard, which provides a much-needed area of vegetation in Manhattan, for both working staff and passing spectators.

An art museum is actually a complicated design problem, involving basic questions of efficient circulation, adequate light—natural, artificial, or both—sufficient work and storage space and, in most cases, rooms for other events such as concerts, theatrical performances, and receptions. The 1965 design of I. M. Pei (b. 1917) for the Everson Museum of Art in Syracuse, New York, is a relatively small building with a flexible solution created in impressive masses that may owe something to the inspiration of Kahn (figs. 884, 885). I. M. Pei and Partners also designed the addition to the National Gallery in Washington, D.C. (fig. 886).

In New York, the two most impressive art museum buildings are by two older masters: Frank Lloyd Wright's Guggenheim Museum and the more recent Whitney Museum of American Art designed by Breuer (fig.

887). Breuer's building, illustrative of his later Brutalism, is a development of the forms he used earlier for St. John's Monastery Church and for the auditorium of New York University. It is a stark and impressive building, in which heavy dark granite and concrete are used inside and out. The main galleries are simply huge, uninterrupted halls capable of being divided in any way, by movable yet solid partitions. It represents the utmost flexibility in installation space and artificial lighting. Natural daylight has been sacrificed, with the exception of shaped windows that are relief accents. Although in the original design of the Whitney the architect was forced to sacrifice work and storage space, provision is made for its expansion in future construction, which, as we shall see, promises to take a very curious turn.

One of the last great buildings completed by Louis Kahn before his death and one of the most dramatic as well as functionally effective art museums in the world is the Kimbell Art Museum at Fort Worth, Texas, completed in 1972 (figs. 888, 889). Its exterior is beautifully integrated with the environment. In the monumental and yet light-filled interior, the architect combined artificial and natural light with the closest and most intelligent attention to the problems of lighting and displaying works of art.

888. LOUIS I. KAHN. Kimbell Art Museum, Fort Worth, Texas. 1972

889. LOUIS I. KAHN. Interior, Kimbell Art Museum. 1972

890. Independence Mall, Philadelphia, before reconstruction (1950)

891. Independence Mall, Philadelphia, after reconstruction (1967)

URBAN PLANNING AND AIRPORTS One of the unfulfilled dreams of modern architecture is the planning of cities. This, in fact, has been a dream of architects since antiquity, occasionally given partial fulfillment as in the new Hellenistic cities built after the conquest of Alexander the Great, the Roman forums, the Renaissance and Baroque piazzas, the

892. EERO SAARINEN. Interior, TWA Terminal, Kennedy Airport, New York. 1962

Imperial Forbidden City of Peking, and Baron Haussmann's rebuilding of Paris in the nineteenth century. Le Corbusier, as indicated, was one of the visionaries of European planning in his designs for a new Paris. It was only at Chandigarh in India that he was able to realize some of his ideas. Brasilia is perhaps the most complete realization of a new city plan in the twentieth century.

Most American efforts at urban planning or slum reconstruction have been brave but partial attempts, continually frustrated by antiquated codes and political or economic opposition. One of the most successful efforts at rebuilding the center of an American city is that of Philadelphia, begun in the 1940s. This has involved the opening up of new highways and the coordinated design of public and commercial buildings, as well as slum clearance and, most important in a city like Philadelphia, the preservation of historic monuments. Although progress has been slow, and beset with many difficulties, the achievement of Philadelphia has been remarkable (figs. 890, 891). Other comparable rehabilitation programs are being carried out, but the dream of the ideal city is still far from realization. Great metropolises like New York or Chicago continue to fight day-to-day battles of human welfare, traffic congestion, and air pollution.

Many of the best opportunities for a kind of urban planning, with new structures, have been offered by the airports proliferating in the 1950s and 1960s. Unfortunately, very few of these opportunities have been adequately realized. The architecture proved routine and the solutions of problems such as circulation are inadequate. New York's John F. Kennedy Airport is a vast hodge-podge of miscellaneous architectural styles illustrating every cliché of modern architecture. A rare few individual buildings rise above the norm. One is Eero Saarinen's TWA terminal at JFK, with its striking airplane-wing profile and interior spaces (fig. 892). In 1961–62 Saarinen had a better opportunity to design a complete terminal at the Dulles Airport for Washington, D. C. (fig. 893). It is an exciting and unified design concept in the main building with its upturned floating roof, and in the adjoining related traffic

893. EERO SAARINEN. Dulles Airport, Chantilly, Virginia. 1961–62

tower. Saarinen here also resolved practical problems such as transporting passengers directly to the plane through mobile lounges.

ARCHITECTURE AND ENGINEERING To many students of modern architecture and particularly of urban design, the solutions for the future seemed to lie less in the hands of the architects than of the engineers. Architects themselves were closely following new engineering experiments, particularly such new principles of construction as those advanced by Buckminster Fuller (1895–1983). Fuller was the universal man of modern engineering. As early as 1929 he designed a Dymaxion House (fig. 894), literally a machine for living that made Le Corbusier's concept seem metaphorical. In the early 1930s, he built a practical three-wheeled automobile which has been recognized as one of the few

rational steps to the solution of city traffic congestion—and has never been put into production. These and many other inventions led ultimately to his geodesic dome structures, which are equilibrium figures based on tetrahedrons, octahedrons, or icosahedrons. These domes, which can be created in almost any material and built to any dimensions, have been used for greenhouses, covers for industrial shops, and mobile, easily assembled living units by the American army. Although Fuller's genius had long been widely recognized, it is only in the second half of this century that he received an opportunity to demonstrate the tremendous flexibility, low cost, and ease of construction of his domes. The American Pavilion at EXPO 67 (fig. 895) was a triumphant vindication of this engineer-architect whose ideas of construction and design threatened to make most modern architecture obsolete.

above: 894. BUCKMINSTER FULLER. Dymaxion House. 1929

right: 895. BUCKMINSTER FULLER. American Pavilion, EXPO 67, Montreal. 1967

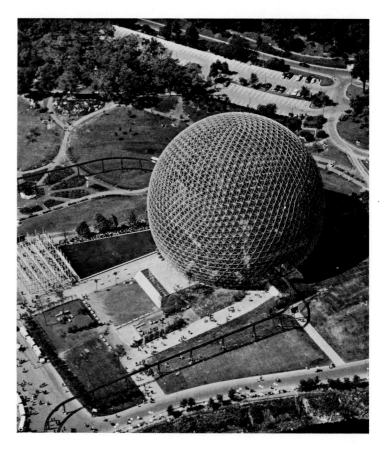

The International Style in Architecture: The Second Wave • 559

The Post-Minimal Seventies:

FROM CONCEPTUAL ART TO PUBLIC MONUMENTS

Presented with a world riven by mounting conflict, the younger artists who emerged during the late 1960s and early 1970s found little to satisfy their expressive needs in the Olympian, machinelike purity and logic of Minimal Art. It was a time desperately polarized between hawks and doves on either side of the Vietnam War, between a white, male-dominated society and the demands of disenfranchised blacks and women, between the morality of the old nuclear family and the Me Generation's drive for individual choice. Through it all, however, Minimalism reigned supreme, high above the fray. Powered by its undeniable beauty and the lucidity of its apologists, this extreme form of serenely confident modernism had come to seem the dominant mode during much of the previous decade, almost as a defiant antidote to universal malaise (fig. 896). Concurrently, of course, Pop Art had continued along its own exuberantly ironic path, gathering as it went an ever-larger constituency of admirers. But while Pop shared the same dispassionate mood as Minimalism, the very inclusiveness of its strategies and the conscious vulgarity of its sources made it appear less central to, as well as a less elevated expression of, the ongoing modernist movement than Minimalism's cerebral and self-refining exclusivity.

In retrospect, the mainstream development of the Western visual arts during the preceding century could be viewed as a continuum of historical evolution, a sequence in which any and all variations had been undertaken either in positive reference or in negative reaction to the fundamental modernist credo, which held that the aesthetic object possessed meaning only insofar as it asserted its independence of all but its own inherent nature and process of creation. Persuaded by the Miësian dictum that "less is more," as well as by the evident power of ever-more efficient technology and scientific procedure, modernism had been optimistic and even Utopian, promising not only an endless succession of stylistic advances but also progress in its effect on the gradual betterment of humankind. As this would imply, therefore, even the most self-referential and Platonically pristine art is not without its context in social circumstance and visual history, which the artist absorbs and combines in the act of making his own creative decisions. And so inevitably, as the peace marchers converged on Washington, as a vast Bauhaus-inspired housing development in St. Louis had to be dynamited, its rational plan having failed to inspire rational behavior in vandalizing inhabitants, and as the natural environment turned toxic from years of pollution by industrial waste, a new generation of artists came to regard Minimalism as not only the ultimate, logical outcome of the modern, formalist principle, but also the last gasp of what had been a glorious, albeit now depleted and discredited, tradition. In an impure world, afflicted by Watergate, inflation, drop-outs, and depression, purity of form could no longer suffice. It began to seem as if large-scale abstraction were less a symbol of the heroic and the sublime than a neurotic escape from life. In the 1970s, the New York critic John Perreault would put it this way: "Presently we need more than silent cubes, blank canvases, and gleaming white walls. We are sick to death of cold plazas, and monotonous 'curtain wall' skyscrapers.... [as well as] interiors that are more like empty meat lockers than rooms to live in."

With this, art entered what has come to be known as its "Post-Minimal" or "Post-Modern" phase, a time, like so many others throughout history, when Classical balance—in the case of Minimalism, composed of the most literal, material kind of form and the most rarefied intellectual or even spiritual content—yielded to the opposite extremes of its own internal components and produced, first, severity and, then, over-elaboration. Initially, it was the emphatic object qualities of Minimalist art that could not be tolerated, along with the commercialism that had overtaken the art scene, for by insisting on the objectivity of their non-objective art, the modernists had managed to burden an already cluttered world with more objects, thereby catering to the media-stimulated

896. TONY SMITH. *Die.* 1962. Steel, 6 × 6 × 6'. Private collection

appetite of an uncritical consumer society avid for the latest artistic sensation, however "difficult" or elitist. To avoid the stigma of commercialism and to recover something of the moral distance traditionally maintained by the avant-garde in its relations with society at large, certain anti-Minimalists ceased to make objects altogether, except as containers of information, metaphors, symbols, and meaningful images. This ushered in Conceptualism, which considered a "piece" finished as soon as the artist had conceived the idea for it and had expressed this, not in material, objective form, but rather in linguistics, documentation, and proposals. Along with Conceptualism came Process Art, which undermined Minimalist forms by subjecting them to the eroding forces of nature, such as atmospheric conditions and gravity (fig. 897). Related to Process Art were Scatter Works, consisting of raw materials dispersed over the gallery floor, a situation that opposed formalism with formlessness, and Earthworks, for which artists abandoned the studio and gallery world totally and operated in open nature, to create art by imposing form on natural formations within a given site. But while some artists turned outward to untrammeled nature, others turned inward, to their own bodies, which, on a more intimate scale, served as the "site" for formal procedures comparable to those worked upon the environment. The artist in his own person became central to Performance Art, wherein the information and ideas conveyed in Conceptualism's documents would now be communicated in theaterlike pieces, made up of songs, recitations, and dance, often accompanied by instrumental or electronic music, light displays, and video. Clearly, art had become "post-studio," with its "post-objects" frequently presented in such nonprofit "alternative spaces" as store fronts, abandoned schools, empty industrial lofts, and the public byways of cities almost anywhere in the world. And whatever form or nonform it took, the new art was not "collectible" in the usual sense, although for artists to survive, they had to be financed, sometimes, curiously, by the very persons and institutions whose commercial or bureaucratic power the artists had tried to escape or sabotage.

Simultaneously, as some artists fled studio and gallery, others returned to those precincts with a vengeance and revived oil-and-brush (or airbrush) easel painting so sharp-focused that it was immediately dubbed Photorealism. And with good reason, for this anachronistic mimesis derived not from the direct observation of the phenomenal world but rather from photographs, the very kind of documentation most favored by the iconoclastic Conceptualists. Moreover, the sense of utter, and contradictory, flatness evoked by the *trompe-l'oeil* Photorealist picture made such art seem all the more Post-Modern, an illusionism that had indeed passed through and been ironed out by formalism's reductive power.

Now, from the modernist point of view, it would appear as if someone had opened Pandora's box and released all the demons that modernity had exorcized, not only illustration but also pattern, decoration, and even narrative. Younger artists would find themselves enticed and seduced by every manner of fruit once forbidden by puritanical formalism. At the moment no terms are more current than Neo-Expressionism and Neo-Surrealism, which should indicate not only the continuing antiformalist stance of the 1980s but also the one element that virtually all the new artistic manifestations of this rampantly eclectic period have in common: their preoccupation with themes of a deeply personal nature, but often with broad political or social implications, and almost invariably at the expense of the self-purging stylistics pursued throughout modernism's long hegemony. So open, however, is this "pluralistic" and essentially trendless time that even the formalists have their place, offering a Neo-Abstraction largely under the influence of the ever-bur-

897. HANS HAACKE. *Condensation Cube*. 1963–65. Acrylic plastic, water, climatological conditions of the environment, 11¾ × 11¾ × 11⅝″. Collection the Artist

geoning inventiveness of Frank Stella, that is as impressive as any art now before the public.

Ironically, as narrow formalism reached the outer limits of its present possibilities, it also attained, in a scandal-seeking, media-saturated world, a broad public recognition and acceptability that spelled the end of its role as an avant-garde expression. By 1970 modernity had become ubiquitous, in glass-box International Style museum buildings, apartment houses, office blocks, and religious structures, all filled or adorned with the latest monumental works of Kenneth Noland, Henry Moore, and Donald Judd. Moreover, the market value of the latter could not be doubted, given the fact that record-breaking auction prices made regular headlines in both newspapers and television. And when the vacuum left by unitary, monolithic, self-eradicating modernism was filled by its opposite, the alacrity with which the public revealed itself prepared to endorse almost anything in the name of art—from Earthworks and Performances to wall hangings and costumes made of discarded gingham and glitter—meant that the very possibility of an avant-garde had perished along with the style it had promoted for a full century, to the point, finally, of fatal success. As Irving Sandler has written: "Elitists may question the motives of the mass audience for art and the quality of its esthetic experiences—but not its sympathy."

Without a dominant mode to use as its instrument of measure, criticism became either more problematic or easier, depending on the readiness or ability of the critic to determine quality at a time when each new work tended to create its own standards. But however difficult the situation for professional observers of new art, the rebellion has lent force to an accelerating revisionism in art history, a movement intent upon reconsidering the entire spectrum of modern art within a context considerably expanded, beyond the interests of autonomous style, to include every aspect of socioeconomic reality. At the same time that this process has allowed once rejected and reviled works—such as those of the academic contemporaries of Courbet, Manet, and the Impressionists—to be seen as accomplished products, albeit different in character, of the same culture that produced "mainstream" modernism, it also disclosed that modern art has always been, to one degree or

898. JOSEPH KOSUTH. *One and Three Chairs*. 1965. Wooden folding chair, height 32⅜″; photograph of chair, 36 × 24⅛″; and photographic enlargement of dictionary definition of chair, 24⅛ × 24½″. Collection, The Museum of Modern Art, New York

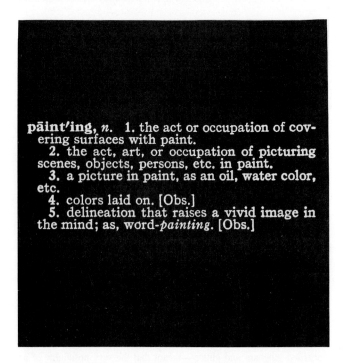

899. JOSEPH KOSUTH. *Art As Idea As Idea*. 1966. Mounted photostat, 4 × 4′. Collection Roy and Dorothy Lichtenstein

another, pluralistic, even in the oeuvre of a single protean master like Picasso, capable of working simultaneously in Classical, Expressionist, Cubist, Surrealist, and decorative styles. Thus, as art historians amass evidence enabling them to revise old simplistic interpretations of the past, younger artists are busy reviving it, so that now each new movement comes forth usually identified as an "ism" with the prefix "Neo-" attached to it. There is even Neo-Abstract Expressionism, and rightly so, since formalism at its most radical and uncompromising always contained within its mathematical purity the potential for significant content, an analogue, that is, of sublime Platonic ideas. Robert Morris, once an extreme Minimalist, now paints Turneresque scenes of holocaust, maintaining, however, that throughout his art, whatever its stylistic digressions, he has always been preoccupied with the same theme: the journey of death that is life.

So liberating has the rebellion against late modernism been that the present art scene fairly pulsates with a new energy unlike any felt since the early 1960s. And it is in no small measure thanks to feminist artists and critics, who perhaps more than any other faction perceived that an art so narrow and aloof that it had become self-eliminating could scarcely function as the expressive vehicle for a good portion of society historically excluded from the privileges of pure aesthetic deliberation. Not only have feminists brought new materials to high art—fabric, sewing, china painting, ceramics—but a new emotive content as well, mined from women's experience as nurturers and designed not to exclude and reject but rather to reach out, include, embrace, and *move*. Such an urge could only reinforce the conviction that the best art for the pluralistic present is that which exploits any idea or image by any style or medium likely to transform personal knowledge, dream, or fantasy into an effective expression of the cultural and social myths of our time.

Conceptual Art

Although a gradual and progressive "dematerialization of the art object," as the critic Lucy Lippard called the antiformalist movement, had been gathering force for some time, it became a dominant issue only in 1970, when The Museum of Modern Art in New York mounted an exhibition called simply "Information." As the title suggests, the show acknowledged that ideas had once again come to the fore in art and, for many new, as well as older, artists, had taken precedence over the traditional aesthetic object. But already in 1969 the artist Joseph Kosuth, a co-curator of "Information," could declare, with resonating conviction, that "all art . . . is conceptual in nature because art only exists conceptually." Moreover, the California artist Edward Kienholz (figs. 727, 728) had coined the term Conceptual Art as early as 1963, after which the Minimalist sculptor Sol LeWitt defined his own grid and cube works as Conceptualist (figs. 825, 826), while reinforcing his position with a theoretical exegesis that had vast influence among artists of kindred spirit. "In Conceptual Art," LeWitt wrote in 1967, "the idea or concept is the most important aspect of the work . . . all planning and decision are made beforehand and the execution is a perfunctory affair. The idea becomes the machine that makes the art. . . ."

JOSEPH KOSUTH (b. 1945) But even though Minimalism took a preconceived, intellectual approach, creating art from such "readymades" as mathematical systems, geometric form, raw industrial materials, and factory production, and pushed reductive formalism just short of total self-elimination, it required an artist like Joseph Kosuth, antiformalist but steeped in modernism's obsession with progress, to see that the next logical move lay in breaking the optical barrier and in taking art beyond the object into the realm of language, knowledge, science, and worldly data, used in and of themselves as the sum and substance of art. As if to offer a textbook demonstration of how this could be accomplished, Kosuth made *One and Three Chairs* (fig. 898), which consists of a real chair accompanied by a full-scale photograph of it and a dictionary definition of "chair," together providing a progression from the real to the ideal and thereby compassing all the essential possibilities of "chairness." Clearly the artist was concerned with exposing the mechanics of meaning, which in regard to objects involves linking a visual percept with a mental concept. Given the nature of the piece and the artist's interests, it is not inappropriate here to adopt the terminology of semiotics (the general science of signs) and say that the signifier (per-

900. Daniel Buren. *Untitled, Paris.* April 1968 (now destroyed). Photo/souvenir

901. Daniel Buren. *Untitled* (Green and White Stripes, Bleecker Street). 1973 (now destroyed). Photo/souvenir

cept) and the signified (concept) combine to produce the sign "chair." But by exhibiting, along with the percept-signifier (a common folding chair), a surrogate for the visual percept (the photograph) and a surrogate for the mental concept (the dictionary definition), Kosuth transformed his analysis into art and thus created a new, higher, more transcendent sign, or metasign, which in turn invites further similar analysis. With a speed typical of the age, he would soon omit the first two steps of his analytical process and go straight for the metasign, in a sequence of photostat blowups of dictionary definitions of art-related words (fig. 899), which, once mounted and exhibited, assume not only the character of visual art but also an objectlike aesthetic quality comparable to that of Minimalism's crisp, elegant beauty, as well as something of its serial repetitiveness.

The irony that modernist art would so rid itself of subject matter that it gave rise to an art stripped of almost everything but subject matter, only for this to lose interest, as soon as the central idea has been grasped, even as the trivial form survives, reminds us that the ultimate ancestor of the Conceptual artist was that arch-ironist Marcel Duchamp. As we saw in Chapter 13, Duchamp had undermined traditional aesthetics forever when he introduced his readymades, the most shocking of which was a urinal the artist had salvaged from a demolition site in New York and submitted for exhibition as a piece of sculpture, signed "R. Mutt" and entitled *Fountain* (fig. 330). Here, with one stroke, Duchamp reduced the creative act to the startlingly rudimentary level of simply designating this or that object or activity as "art." By implying, additionally, that art had more to do with the artist's intentions than with craftsmanship or style, Duchamp also seemed to challenge the whole scheme of critical criteria and patronage that had emerged since the late eighteenth century, when the advent of secular society resulted in a modern world progressively fraught with competing and opportunistic interests. If the artist could decide what should or should not be art, he automatically became critic and creator alike, thereby eliminating the professional tastemakers in charge of galleries, museums, and the media. And if art consisted in the artist's conception, rather than in plastic form, then it no longer constituted an object capable of being declared aesthetically significant and therefore commer-

cially valuable to the tastemakers' clientele, the moneyed status-seekers. In the end, of course, the latter won out, for as a disgusted Duchamp would eventually write: "I threw the *urinoir* into their faces, and now they come and admire it for its beauty."

While the possibilities raised by Duchamp remained little more than that—albeit carried forward by such logical successors as the Dadaists, the Futurists, the Surrealists, and the various neo-Dadaists of the 1950s and 1960s—they became central to the Conceptualists, who believed, almost fanatically, that, in the aftermath of formalism's exhaustion, art could survive only with its rehabilitation as idea. Far from giving up on art, Kosuth saw Duchamp's readymades as "the beginning of 'modern art' and the beginning of Conceptual Art." Never mind that the *Bicycle Wheel* and *Fountain* had become objets d'art (figs. 328, 330), it was the artist's intention and activity that counted as works of art. Regarding the pieces displayed in museums, they were "little more than curiosities," for as the box forms of Judd, Morris, LeWitt, Tony Smith, and Bell proved, "an object is only art when placed in the context of art."

DANIEL BUREN (b. 1938) Having determined, as Donald Judd did, that "if someone says it's art, it's art," Conceptualism soon spawned a vast and unruly variety of Post-Minimal and "post-studio" or "post-object" works ranging from Performance Art to Process and Land Art, all united, however, by a common and unprecedented emphasis upon ideas and their expression through some medium other than a unique, yet permanent and portable (hence endlessly marketable) prestige commodity: the art object. In illustration of the principle that the "ideal Conceptual work," as Mel Bochner characterized it, could be described and experienced in its description and that it be infinitely repeatable, thus devoid of "aura" and uniqueness, the French artist Daniel Buren reduced his painting to a uniform neutral and internal system of commercially printed vertical stripes, a structure that readily lent itself to infinite replication and exhibition in any environment without this changing the initial concept (figs. 900, 901). Variety came not in the form itself but rather in the context; however, the very sameness of the stripes robbed them of their intended neutrality or anonymity and conferred an individuality as irrefutable as a signature.

902. LAWRENCE WEINER. *A 36 × 36" Removal to the Lathing or Support of Plaster or Wallboard from a Wall.* 1967. Collection Seth Siegelaub, New York

LAWRENCE WEINER (b. 1940) Of all the many forms of "documentation" the Conceptualists found for their ideas, none served their purposes so perfectly as verbal language itself. "Without language, there is no art," declared Lawrence Weiner, who maintained that he cared little whether his "statements," a series of tersely phrased proposals, such as *Removal to the Lathing or Support of Plaster or Wallboard from a Wall* (fig. 902), were ever executed, by himself or anyone else. Fundamentally, he left the decision to implement the idea to the "receiver" of the work. "Once you know about a work of mine," he wrote, "you own it. There's no way I can climb into somebody's head and remove it."

DOUGLAS HUEBLER (b. 1924) Meanwhile, Douglas Huebler made the Conceptualist's attitude toward form stunningly clear in a famous pronouncement published in 1968: "The world is full of objects, more or less interesting; I do not wish to add any more. I prefer, simply, to state the existence of things in terms of time or of space." In *Location Piece #14* (fig. 903) Huebler proposed that photographs be taken from a plane window over each of the states between New York and Los Angeles. The piece would then be constituted of the twenty-four photographs, a map of the world, and the artist's statement, which, however, concluded: "The owner of the work will assume the responsibility for fulfilling every aspect of its physical execution." But even if executed, the photographs would have been indistinguishable from one another, leaving the work to be experienced only in the viewer's mind.

ROBERT BARRY (b. 1936) Yet more ephemeral, but touched with the charm of whimsy, were such proposals as the following by Robert Barry, offered as serious artistic commentary:

All the things I know
But of which I am not
At the moment thinking—
1:36 PM, June 1969.

ART = LANGUAGE Of all the artists functioning in the purified medium of words alone, the most radical and uncompromising may have been those associated with an Anglo-American group known as Art = Language. Members included Joseph Kosuth, Terry Atkinson, David Bainbridge, Michael Baldwin, Ian Burn, Charles Harrison, Harold Hurrell, Phillip Pilkington, Mel Ramsden, and David Rushton, who together began publishing a journal devoted to investigating the "language of art," but soon had their utterances recorded on tape, microfilm, and posters. After raiding the entire spectrum of intellectual disciplines in search of tools of thought, the Art = Language Conceptualists typically "collaged" their findings together in impenetrable treatises that struck some as humorous and others as infuriatingly narcissistic and futile.

JOHN BALDESSARI (b. 1931) However puritanical, and sometimes sanctimonious, the Conceptualists may have been in their denial of the myriad sensory delights offered by traditional painting and sculpture, they discovered a rain forest of new possibilities even within the relatively restricted field of language and linguistically analogous systems.

Location Piece #14
Global
Proposal*

During a given 24 hour period 24 photographs will be made of an imagined point in space that is directly over each of 24 geographic locations that exist as a series of points 15 longitudinal degrees apart along the 45° Parallel North of the Equator.

The first photograph will be made at 12:00 Noon at 0° Longitude near Contras, France. The next, and each succeeding photograph, will be made at 12:00 Noon as the series continues on to 15° Longitude East of Greenwich (near Senj, Yugoslavia) on to 30°, 45°, 60°, etc., until completed at 15° Longitude West of Greenwich. "Time" is defined in relationship to the rotation of the Earth around its axis and as that rotation takes 24 hours to be completed each "change" of time occurs at each 15° of longitude (Meridian); the *same* virtual space will exist at "Noon" over each location described by the series set for this piece. The 24 photographs will document the same natural phenomenon but the points from which they will be made graphically described 8,800 miles of linear distance and "fix" 24 hours of sequential time at one instant in real time.

The 24 photographs, a map of the world and this statement will join altogether to constitute the form of this piece.

*The owner of this work will assume the responsibility for fulfilling every aspect of its physical execution.

July, 1969 Douglas Huebler

903. DOUGLAS HUEBLER. *Location Piece #14. 1969.* 1969. Photograph and text

ART HISTORY

A young artist had just finished art school. He asked his instructor what he should do next. "Go to New York," the instructor replied, "and take slides of your work around to all the galleries and ask them if they will exhibit your work." Which the artist did.

He went to gallery after gallery with his slides. Each director picked up his slides one by one, held each up to the light the better to see it, and squinted his eyes as he looked. "You're too provincial an artist," they all said. "You are not in the mainstream." "We're looking for Art History."

He tried. He moved to New York. He painted tirelessly, seldom sleeping. He went to museum and gallery openings, studio parties, and artists' bars. He talked to every person having anything to do with art; travelled and thought and read constantly about art. He collapsed.

He took his slides around to galleries a second time. "Ah," the gallery directors said this time, "finally you are historical."

Moral: Historical mispronounced sounds like hysterical.

904. JOHN BALDESSARI. "Art History" from *Ingres and Other Parables*. 1972. Photograph and text. © *Studio International*, London

Books, newspapers, and magazines, catalogues, advertising, postal and telegraphic messages, charts, and maps were all seized upon and exploited as vehicles for the information and opinions about art and almost everything else of world interest in the early 1970s. Also susceptible to Conceptualist exploitation was photography, inherent in any modern print medium and now readily available, for the first time, in the kinetic forms of film and video. Soon the non-unique visual image would seem almost as ubiquitous in Conceptual Art as words. John Baldessari became a practitioner of Story Art, composing brief but trenchant tales about art itself, usually accompanied by a reproduction of some "key monument" from the art-historical canon (fig. 904).

ED RUSCHA For a movement obsessed with words and opposed (theoretically, at least) to galleries, traditional patronage, and all other patterns of bourgeois culture, it was inevitable that books and catalogues would provide important substitutes for paintings, sculptures, and exhibitions. As such, a catalogue like that for The Museum of Modern Art's "Information" show has become a collector's item, virtually as rare, precious, and sought after as an original, unique work of art. An artist specializing in books was the Pop master Ed Ruscha (fig. 718), who viewed his Conceptual pieces as pure documentation. After an initial fascination with words and typography, Ruscha eventually began concentrating on images and excluding all but the visual evidence he could obtain with his own hand-held camera, as in *Every Building on the Sunset Strip* (figs. 905, 906). "I have eliminated all text from my books," he told one interviewer, "I want absolutely neutral material. My pictures are not that interesting, nor the subject matter. They are simply a collection of 'facts'; my book is more like a collection of Ready-

905, 906. EDWARD RUSCHA. Title page (below left) and opening pages (below right) of *Every Building on the Sunset Strip*. 1966. Artist's book. © Edward Ruscha, Los Angeles

EVERY BUILDING
ON THE
SUNSET
STRIP

EDWARD RUSCHA

1 9 6 6

mades." Books and catalogues helped resolve a dilemma peculiar to Conceptualism, a dilemma the dealer-curator Seth Siegelart probably deliberated more thoroughly than anybody. Once "there developed an 'art,' " he wrote, "which didn't need to be hung, an art where the problem of presentation paralleled one of the problems previously involved in the making and exhibiting of painting: i.e., *to make someone else aware that an artist had done anything at all.* Because the work was not visual in nature, it did not require the traditional means of exhibition but a means that would present the intrinsic ideas of the art." The exhibition might simply be the catalogue or might occupy a gallery space, but, whatever the circumstance, every effort must be made to avoid any "outside verbal information like catalogue introductions, thematic titles, etc...."

ON KAWARA (b. 1931) Books, like verbal communication, offer a sequential, cumulative experience, as opposed to the spatial or plastic arts of traditional painting and sculpture, which, being static, have the potential for providing a total, all-at-once experience within the very instant of perception. Freed from the tedium of material restraints, the Conceptualists could now explore the fourth dimension of time more naturally than artists trapped within the two- and three-dimensional confines of concrete form. On Kawara, a Japanese artist resident in New York, made the passage of time itself the all-important subject by each day starting a small black painting that simply set forth the current date in white block letters (fig. 907). With every panel an equal component in the series, the work could reveal its full meaning only in the whole.

HANNE DARBOVEN (b. 1941) The German artist Hanne Darboven marked the evolution of time and her experience of it by filling page after page with a kind of abstract calligraphy and mysterious permutating numeration, derived in part from the days, weeks, and months of the calendar. As the artist's digits add up, multiply, and interweave, they eventually cover whole walls of gallery space (fig. 908), finally becoming a complete environment given over to a trancelike involvement with time's steady, inexorable advance.

Performance Art

Some artists even found the material limitations of written words too confining and broke free of all static forms, however ephemeral, into the utter temporality of Performance Art, creating pieces variously designated as Narrative or Story Art (involving oral or physical activity, unlike Baldessari's *Art History*), Street Works, Body, and even Process Art. In the 1970s so many artists embraced Performance that it has been called the art form most characteristic of the period. By way of explaining this phenomenon, Jack Burnham took a historical perspective and saw that "the erosion in the plastic arts toward theater was in progress early in the beginning of this century, though never so evident as when critics began to describe in detail the activities of Pollock and De Kooning in front of or over a canvas.... For a century the artist has chosen to be not only his best subject matter, but in many cases his only legitimate subject." To a generation more eager than ever to disavow the past, Performance meant venturing into an arena—theater—where artists, owing to their sheer lack of experience, felt encouraged to proceed as if totally unfettered by rules or traditions. Not only did Performance liberate artists from the art object; it also freed them to adopt whatever subject matter, medium, or material seemed promising for their purposes. Moreover, it enabled them to offer their work at any time, for any duration, at any kind of site, and in direct contact with their audience. This gave artists a more instant access to receivers of their work, without the intervention of critics and curators/dealers— and thus permitted them a new control over the display and destination of their work. For all these reasons, Performance appeared to offer the maximum possibility for converting art from a luxury item into visual communication: a vehicle for ideas and action. Lucy Lippard even declared Performance to be "the most immediate art form ... for it means getting down to the bare bones of aesthetic communication—art/self confronting audience/society."

907. ON KAWARA. *The Today Series of Date Paintings.* 1966. Photograph. Courtesy Sperone Westwater Gallery, New York

908. HANNE DARBOVEN. *24 Songs: B Form.* 1974. Installation view, Sonnabend Gallery, New York. Ink on paper

JOSEPH BEUYS (1921–1986) No artist active in the 1970s realized the heroic potential of Performance more movingly than the charismatic and controversial German sculptor Joseph Beuys. Shot down during World War II and given up for dead in the blizzard-swept Crimea, Beuys returned to peacetime existence determined to rehumanize both art and life by drastically narrowing the gap between the two. To achieve this, he would employ whatever means or materials seemed potent

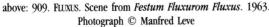

above: 909. FLUXUS. Scene from *Festum Fluxurom Fluxus*. 1963.
Photograph © Manfred Leve

right: 910. JOSEPH BEUYS. *How to Explain Pictures to a Dead Hare*. 1965.
Performance at the Galerie Schmela, Düsseldorf. Photograph © 1986,
Walter Vogel

enough to make form an agent of meaning. Thus, he began piling un-symmetrical clumps of animal grease in empty rooms and then wrapping himself in fat and felt, an act that ritualized the materials and techniques the nomadic Crimean Tatars had used to heal the artist's shattered and frozen body. Viewing his works "as stimulants for the transformation of the idea of sculpture or of art in general," Beuys intended them to provoke thoughts about what art can be and how the concept of art-making can be "extended to the invisible materials used by everyone." He wrote about "Thinking Forms," concerned with "how we mold our thoughts," about "Spoken Forms," addressed to the question of "how we shape our thoughts into words," and finally about "Social Sculpture," meaning "how we mold and shape the world in which we live: *Sculpture as an evolutionary process; everyone is an artist.*" "That is why," he continued, "the nature of my sculpture is not fixed and finished. Processes continue in most of them: chemical reactions, fermentations, color changes, decay, drying up. Everything is in a *state of change.*" So keen was his sense of process and change as the realities with which to confront and convert reality—like the homeopathic method of "healing like with like"—that Beuys in 1962 joined Fluxus, a loosely knit, nonconformist, international group noted for their Happenings, actions, publications, concerts, and mailing activities (fig. 909). By the end of 1965, however, he had severed relations with Fluxus, because "they held a mirror up to people without indicating how to change anything."

In a characteristic action Beuys took chalk and scrawled across a blackboard: "The silence of Marcel Duchamp is overrated." While Duchamp may have destroyed the language of art, Beuys, it seemed, would create a new one, based, like most newborn languages of art, on raw feelings, on pain and pleasure, used as reasoning devices and the mind as an instrument of feeling. And so in a Düsseldorf gallery the artist created *How to Explain Pictures to a Dead Hare* (fig. 910), for which he sat in a bare room surrounded by his familiar media of felt, fat, wire, and wood, his face covered with gold leaf, and a dead hare cradled in his arms. Urgently murmuring to the small moribund creature, Beuys

appeared to break the Duchampian silence and imply that to recover his voice, the artist had only to return to that ever-fresh fountainhead of all truth and honesty: personal experience, however wounded. To help explain the piece, Beuys said that in his oeuvre "the figures of the horse, the stag, the swan, and the hare constantly come and go: figures which pass freely from one level of existence to another, which represent the incarnation of the soul or the earthly form of spiritual beings with access to other regions." As for the gold mask, it made Beuys seem all the more a shaman, a healer who through magical incantation would work the miracle of bringing warmth to a world frozen in its vicious circle of greed and violence. While Beuys was referred to as "a cultural stormtrooper," others considered him a clown, and indeed the artist was not without a Chaplinesque strain, most evident in the trilby hat, ammunition jacket, waistcoat, jeans, and hunter's boots without which he virtually never appeared in public, even at state dinners.

NAM JUNE PAIK (b. 1932) A more overtly comic Performance artist once associated with Fluxus in Germany is Nam June Paik, who switched from straight electronic-music composition to the visual arts when he discovered the expressive possibilities of video. Like a vaudevillian in love with the dramatic one-liner, Paik proclaimed that "as collage technique replaced oil paint the cathode ray tube will replace the canvas." What appealed to him was the idea of subverting a technology designed to make passive consumers of its mass audience and of transforming it into a medium subject to his own artistic will, or the will of anyone interested in activating his or her relationship to the video screen. Perhaps the best demonstration of how this could occur came in the United States, where Paik took a tape of a Johnny Carson routine, one in which the star did a series of double-takes at the "wacky" avant-garde, and then, by the simple device of laying a live wire across a reel of tape, erased tiny segments of the recorded material at ever-more frequent intervals as the replayed tape unwound toward the core. In this way the artist gave evidence of his power to reach into the cultural environment and, by marking his presence there, force recognition of

cello while wearing a bra made of two miniature TV sets, which thus took on the humanity of their association with one of the most intimate of personal garments (fig. 911). When Paik and Moorman performed *Opera Sextronique* in New York in 1967 the cellist removed all her clothing and promptly provoked arrest for, as the guilty verdict read, "an art which openly outrage[d] public decency." According to Moorman, however, the case tested "the limits of artistic censorship" and resulted "in the changing of that law." The piece survives in its documentation: photographs of the performance and arrest and the judge's ten-thousand-word decision. In that statement the court took account of "those 'happeners' whose belief is that art is 'supposed to change life' as we know it," and cited a London Sunday *Times* editorial which referred to the contemporary visual arts as "a kind of brothel of the intellect."

VITO ACCONCI (b. 1940) Once Performance became Body Art it often induced a forced intimacy between the performer and his audience, with results that could be amusing, shocking, or discomfiting, but never neutral. In *Seedbed* (fig. 912) Vito Acconci spent hours during each performance day engaged in autoerotic activity beneath a gallery-wide ramp, while overhead visitors heard via a loudspeaker the auditory effects of his fantasizing. Here was the artist reintroducing into his work the element of extreme risk that seemed to have disappeared with Minimalism's machine aesthetics and industrial procedures, the risk lying not only in self-induced sexual exhaustion but also in the audience alienation such drastic strategies could produce.

LUCAS SAMARAS Something similar happened in the "Autopolaroids" of Lucas Samaras, an artist first encountered here in Chapter 21 (figs. 731–733). But while Samaras "performed" in the privacy of his own house, he documented the activities with a graphic candor that the mere words employed by a poet Acconci could scarcely match. By means of an incredibly long series of images—all presented on the tiny stage of the two-by-three-inch Polaroid format—Samaras turned view-

the fact that he had in some way altered that reality. Witty, charming, and therefore especially successful in collaboration, Paik has achieved a certain notoriety for several of the pieces he created for the classical cellist Charlotte Moorman. One of these had the instrumentalist play the

above: 911. NAM JUNE PAIK. *Bra for Living Sculpture* (worn by Charlotte Moorman), 1969. Television sets and cello. Photograph © 1969 Peter Moore. Collection Charlotte Moorman

right: 912. VITO ACCONCI. *Seedbed.* 1972. Performance at the Sonnabend Gallery, New York

913. LUCAS SAMARAS. *Autopolaroid* from *Samaras Album*. c. 1971. Polaroid. Courtesy Pace Editions, New York

bodies smeared with the blood and entrails of eviscerated animals. The dubious value of such shock therapy became tragically apparent when Schwarzkogler, in the name of art, died following a series of self-inflicted mutilations. The spiritual ancestry of such orgiastic performances would have to include not only the Marquis de Sade but also the "The-

914. BRUCE NAUMAN. *Self-Portrait as a Fountain*. 1966–70. Color photograph. Edition of eight. Courtesy Leo Castelli Gallery, New York

915. CHRIS BURDEN. *Doorway to Heaven*. November 15, 1973. "At 6 P.M. I stood in the doorway of my studio facing the Venice boardwalk. A few spectators watched as I pushed two live electric wires into my chest. The wires crossed and exploded, burning me, but saving me from electrocution."

ers into voyeurs as he acted out fantasies of transforming himself into various females, such as Degas's nude bathers (figs. 51, 913), of being castrated by glittering arsenals of kitchen cutlery, or of becoming the kind of phantasmagoric monster subsequently realized on the giant screen by Steven Spielberg (plate 263). Like Nam June Paik, Samaras intervened in a scientific process and thus demonstrated the power of the artist to effect change, in this instance either by painting or drawing on the finished photographic print or by reworking the actual color chemistry within the surface emulsion.

At the same time that Bruce Nauman (b. 1941) had the wit to make himself into a living pun on Duchamp's *Fountain* (fig. 914), other Body artists risked going beyond the avant-garde's desired cutting edge into the realm of sadomasochistic exhibitionism. Chris Burden (b. 1946), for instance, achieved international fame in 1971 with a performance in Los Angeles that consisted of his having a friend shoot him in the arm. As usual in Conceptual Art, the performance was rendered permanent in documentation, the straightforward factuality of which makes the attempt to prove the artist's ability to endure seem all the more harrowing (fig. 915). But whereas Burden so prepared and controlled most of his pieces that he posed slight danger to himself or anyone else, a group of Viennese artists "exiled" in Germany—Hermann Nitsch, Rudolph Schwarzkogler, Günter Brus, and Otto Mühl—made violence quite literally both their subject and their means. Eventually the "material actions" they staged became brutal, obscene ceremonies in which participants suffered the horror of having their naked

ater of Cruelty" introduced by the French avant-garde writer and director Antonin Artaud during the Surreal 1930s. But as Sol LeWitt has written, "Conceptual art is only good when the idea is good."

GILBERT (b. 1943) AND GEORGE (b. 1942) A considerably more constructive idea appeared when a pair of London-based artists known simply as Gilbert and George transformed themselves into "living sculpture" and brought to art and the world of the late 1960s a much-needed grace note of stylish good humor. Indeed, they would probably have been quite successful performing in an old-fashioned English music hall, which, like all the rest of their material, Gilbert and George simultaneously sent up and milked. For their best-known performance, *The Singing Sculpture* of 1971 (fig. 916), they covered their faces and hands with metallic paint, adopted the most outrageously proper English clothing and hair styles, placed themselves on a table top, and proceeded to move and mouth as if they were wound-up marionettes rendering the recorded words and music of the prewar song that gave the piece its title. Declaring "We shall never cease to pose for you, Art," they have made their whole lives into art, thereby parodying the English art scene over which they preside as salient, if sardonic, members.

In their more recent work Gilbert and George still perform, in that they continue to feature themselves in their art, but now present only the documentation in the form of grandly scaled wall compositions

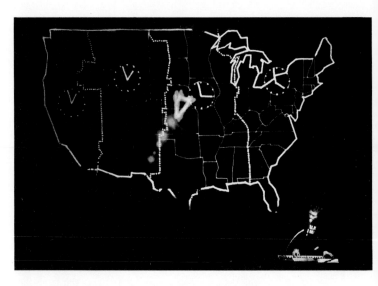

917. LAURIE ANDERSON. *United States Part II. Segment "Let X = X".* October 1980. Performance at the Orpheum Theater, New York, presented by the Kitchen. Photograph © 1980 Paula Court

made of photographs and photograms, hand-dyed, mounted, and framed. But just as they perversely designate everything they do or make "sculpture," the irrepressible pair explicity favor homoerotic content, often expressed emblematically through voluptuous flower and vegetable imagery, while presenting it within a religio-aesthetic structure of stained-glass colors, windowlike mullions, and iconic cruciform patterns (plate 264). Although there is truth and no little sadness in this self-revelation, it has, paradoxically, been treated with the most disarming kind of mannered beauty and artifice. As the critic Peter Plagens recently wrote:

> Gilbert & George knew...that letting go was an inescapable condition of modern, urban, civilized life. They knew that letting go completely was a sin, and they knew that they, being religious persons, must do penance. Being artists, they realized that sincere penance was at best homely and at worst uninteresting. They also realized that insincere penance was a staple of English life; it was what made the village vicar, who cared more about the temperature of the brandy and the fatness of the pigs than saving any soul, the most acceptable, albeit the least credible, form of priest.

LAURIE ANDERSON (b. 1947) A Performance artist who actually does appear in music halls, as well as on big-time commercial records, while successfully preserving her place in the tight little underground world of advanced art, is the multitalented Laurie Anderson. Being a second-generation Conceptualist and a child of the media age, Anderson can take for granted the intellectual rigor of her predecessors and, with infinitely greater command of far more spectacular means, transform the older artists' erudite, but rather amateurish, demonstrations into virtuoso performances that verge on professional entertainment. So totally is Anderson at one with the technology of modern communications that in a recent performance she wore a T-shirt overprinted with the words "Talk Normal," all the while that she spoke through electronic modifiers that converted her voice into the eerie sounds of computerized speech. For *United States*, a four-part epic composed and first presented over the years 1978–82, Anderson marshals the full array of

916. GILBERT AND GEORGE. *The Singing Sculpture.* 1971. Performance at the Sonnabend Gallery, New York

above: 918. LAURIE ANDERSON. During performance of *United States Part II*, at the Orpheum Theater, New York, 1980.

her accomplishments—drawing, sculpture, singing, composing, violin playing, electronic effects—to deal in half-hour segments with the themes of transportation, politics, sociopsychology, and money (figs. 917, 918). Juxtaposing images and text, sound and technological inventions, she sweeps her audience through a series of ironical "talking songs," the journey turned into a joy ride by such original devices as custom-made instruments, a slide show that magically comes and goes with the stroke of a neon violin bow, and red lips that suddenly float in the dark. With humor, language, timing, style, and undeniable stage presence, Anderson has brought the high seriousness of Conceptual Art to audiences of a size and breadth totally beyond the reach of, for instance, the gallery-bound, muscularly onanistic marathons once staged by Vito Acconci. Rejecting the literalism of such endurance tests for their lack of metaphoric power, Anderson dedicated to Chris Burden a piece that includes the refrain "It's not the bullet that kills you, it's the hole" (fig. 919). Meanwhile, works like *United States* resonate with a depth of meaning alien to popular entertainment, in part because of Anderson's modern, avant-garde preoccupation with semiotics. Having embraced this austere science, the artist proceeds to humanize it with simple, folkloric wisdom, as in "O Superman," a song whose dedication to Jules Massenet, the nineteenth-century French operatic composer, couples the piece to the aria *O Souverain....* And just as that work appeals for help, so does "O Superman," this time, however, to a generation controlled and spiritually depleted by its own media culture.

Process Art

Like Performance, Process Art countered the timelessness and structural stability of Minimal Art with impermanence and variability. But while Performance people operated in real time by making their bodies their material and personal action their means, artists interested in so-called "process" took perishability as an all-important criterion in their choice of materials and allowed the deteriorating effect of time to become their principal means. The Process artist's action concludes once he has selected the substance—ice, grass, soil, felt, snow, sawdust, even cornflakes—of his piece and has "sited" it, usually in some ran-

dom, structureless way, such as scattering, piling, draping, or smearing. The rest is left to natural forces, time in tandem with gravity, temperature, atmosphere, etc., which suggests that now, in an art where creation and structure are an integral part of the same process, "means" have, in the truest sense of the words, become "ends." Thus, literal as Process Art may be, it also constitutes, as Laurie Anderson might say, a powerful metaphor for the love-death affair that is life itself.

ROBERT MORRIS Like the eminent Process artist Joseph Beuys, who, as we have seen, worked with fat and felt—precisely because "process continues...in them: chemical reactions, fermentations, color changes, decay, drying up"—another artist fascinated with felt in the late 1960s was the prolific and protean Robert Morris (figs. 823, 824), who subverted his own Primary Structures by reinterpreting their Minimalist aesthetic in a heavy, charcoal-gray fabric that immediately collapses into shapelessness, however precisely or geometrically it may be cut (fig. 920). Soon Morris would be working with such insubstantial and transient materials as steam (fig. 921). He also opposed the absolute, concrete clarity and order of his Minimal works with "scatter pieces," actually installations of what appear to be scraps left over from the industrial manufacture of metal and felt Primary forms (fig. 922). The order within this apparent disorder consisted in a "continuity of details," like that in Pollock's all-over field painting, an art unified by

below: 919. LAURIE ANDERSON. *It's not the Bullet.* 1977. Photograph and graphite on paper, 30 × 22¼". Collection Holly and Horace Solomon, New York

920. ROBERT MORRIS. *Untitled.* 1967–68. Installation view, 1968, Leo Castelli Gallery, New York. Felt, size variable. Private collection, New York

the generalized, "holistic" continuum of its endlessly repeated drips and dribbles.

EVA HESSE (1936–1970) One of the most original and influential artists to move from Primary Structures into Process Art was the German-born Eva Hesse, who died at the tragically young age of thirty-four. Hesse saw Process, especially as found in such organic, malleable, feminine techniques as sewing, lacing, or bandaging, as a way of subjecting Minimal codes—serial order, modular repetition, anonymity—to a broader, less exclusive range of human values than those available in cerebral, male-prescribed grandeur and monumentality. Taking memory, sexuality, self-awareness, intuition, and humor as her inspira-

tion, she allowed forms to emerge from the interaction of the process inherent in her materials—latex, rubber, fiberglass, rope, cloth—with such natural forces as gravitational pull (fig. 923). Thus, her pieces stretch from ceiling to floor, suspend from pole to pole, sag and nod toward the floor, or tilt against the wall. The works seem like dream objects, materializations of things remembered from the remote past, even to the cobwebs that festoon old possessions long shut away in attics and basements. Eager to open up a situation that had closed down, Hesse said: "There isn't a rule. I don't want to keep any rules. That's why my art might be so good, because I have no fear. I could take risks." But by trying to penetrate to "what is yet not known, thought, seen, touched," she created works so steeped in process that they have proved all too susceptible to the disintegrating impact of time.

LYNDA BENGLIS (b. 1941) Finding Minimalism generally inadequate to their expressive needs, women artists have been especially venturesome in their use of Process, with its built-in fluidity, as a route not only to new form but also to new content. In the early 1970s Lynda Benglis became fascinated by the interrelationships of painting and sculpture and, to explore the issue, began pouring liquid substances onto the floor, just as a sculptor might pour molten bronze (plate 265). But instead of shaping it with a mold, she allowed the material to seek its own form, aided, however, by the artist, who mixed and puddled into the flow a startling array of fluorescent oranges, chartreuses, Day-Glo pinks, greens, and blues. In this way, she found a sculptural equivalent of the color-stain painting process developed by Morris Louis (plates 235, 236), complete with all its sensuous beauty but enhanced by a provocative element unique to Benglis. In more recent works, the artist has continued to pursue pictorial effects in wall reliefs of strong plastic, sculptural qualities, often with fan or bow-knotted shapes and invariably finished in some sumptuously decorative manner, such as gold leaf or a patina of rich verdigris (fig. 924).

SAM GILLIAM (b. 1933) With interests similar to those of Benglis, the Washington-based artist Sam Gilliam fused the two forms by flinging highly liquefied color onto stretched canvas, somewhat in the random fashion of Jackson Pollock, and then suspended the support, minus its

921. ROBERT MORRIS. *Untitled.* 1967–73. Four steam outlets placed at corners of square, 25 × 25′. Collection Western Washington University, Bellingham

922. ROBERT MORRIS. *Untitled.* 1968–69. Installation View, Leo Castelli Gallery, New York. Felt, rubber, zinc, aluminum, nickel, Cor-ten and stainless steel, size indeterminate. Courtesy Leo Castelli Gallery, New York

923. EVA HESSE. *Aught.* 1968. Double sheet latex, polyethylene inside, four units, 78 × 40″ each. University Art Museum, University of California, Berkeley. Gift of Mrs. Helen Charash

924. LYNDA BENGLIS. *Ramabai.* 1981. Brass screen, hydrocal, gesso, gold leaf, 34 × 35½ × 13″. Stefan T. Edliss Collection

925. SAM GILLIAM. *Horizontal Extension.* 1969. Installation view, Corcoran Gallery of Art, Washington, D.C. Suspended painting, acrylic on canvas with powdered aluminum, 10 × 75′. Collection the Artist

stretchers, from the ceiling (plate 266; fig. 925). Thus draped and swagged, the material ceased to do what would traditionally be expected of painted canvas and became a free-form, plastic evocation of some highly variable landscape.

JANNIS KOUNELLIS (b. 1936) In his most famous piece Jannis Kounellis, a Greek artist active in Italy and deeply influenced by the Process-related works of Alberto Burri and Luciano Fontana (plate 201; fig. 758), stabled horses in a Roman art gallery as a way of dramatizing the contrast, and necessary relationship, between the organic world of nature and the man-created, artificial world of art. The same ideas inform *Cotoniera* (fig. 926), a piece in which the soft, white, perishable fluffiness of cotton has been combined with the dark, indestructible rigidity of steel to create an ongoing dialectic of nature and structure.

HANS HAACKE (b. 1936) In the German-American artist Hans Haacke the antiform movement found its most successful exponent of Process as a means of making art play a much broader cultural role than that permitted by modernism's "art for art's sake" aesthetic. As sensitive to language as all the Conceptualists, Haacke prefers the term "system" to "process" and characterizes his works as "real time systems." These are pieces into which he introduces the forms, words, and styles of various environments outside art, his purpose being to disclose, by virtue of a strange new context, ideas, implications, and interdependencies hidden and unsuspected within ordinary, everyday events, whether natural, social, or political. In the 1960s Haacke found himself captivated mainly by the systems of nature and began making "weather boxes" (fig. 897), Plexiglas containers through whose transparent walls the viewer could observe the effects of atmospheric change within, as water condensed or evaporated according to the air, light, and temperature of the display space. Here, timeless Primary form had not been so much rejected as subjected to the workings of time.

In the 1970s Haacke switched to sociopolitical systems and their

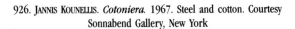

926. JANNIS KOUNELLIS. *Cotoniera.* 1967. Steel and cotton. Courtesy Sonnabend Gallery, New York

927. HANS HAACKE. *Shapolsky et al., Manhattan Real Estate Holdings, a Real-Time Social System, as of May 1, 1971.* 1971. 142 photographs, 2 maps, 6 charts. Edition of two. Collection the Artist

connections with the art system. An unforgettable example came in 1974 when the artist, at the invitation of the Wallraf-Richartz Museum in Cologne, prepared his *Manet Project*, a work that would have consisted of displaying Manet's *Bunch of Asparagus* on an easel and of surrounding the display with wall panels identifying the social and economic status of everyone who had ever owned the picture, from the time of its first purchase in 1880 until the moment of its acquisition by the museum with funds from the Friends of the Museum. Although admired by the curator of modern art, the proposal proved unacceptable to the committee organizing the exhibition, a group that feared retaliation from the chairman of the Friends, whose network of corporate connections were to be listed on one of the panels. When Daniel Buren, in a concurrent group show at the Wallraf-Richartz, tried to circumvent the rejection by pasting small versions of *Manet Project* onto his famous stripe paintings, only to have the reproductions themselves pasted over by the museum, other artists began to withdraw their submissions in protest. The attendant publicity simply served to make Haacke's controversial piece all the more significant, once it was installed in one of

Cologne's commercial galleries, and thus all the more potent as a force for social change.

Something similar happened in New York City when, upon being invited to exhibit at the Solomon R. Guggenheim Museum, Haacke created *Shapolsky et al., Manhattan Real Estate Holdings, a Real-Time Social System, as of May 1, 1971* (fig. 927). In this "Real Estate" work the artist captioned photographs of tenements, among other kinds of property, with business information about ownership, acquisition, and money values. Right away, the Real Estate pieces threatened to become so inflammatory that the Guggenheim canceled the show. While this may have preserved the political "neutrality" essential to a tax-free educational institution, it also, once again, guaranteed the very kind of public interest that could only serve Haacke's overriding purpose, which is to make art socially relevant by using its context to expose the reality and interdependence of systems so ubiquitous as to go unremarked and therefore unquestioned.

Earth and Site Works

At the same time that certain Process artists were integrating the systems of nature into their work, the better to make the inner truths of both art and life more accessible, other Conceptualists acted on the idea of taking art out of both gallery and society and fixing it within far-off, uninhabited nature as huge, immobile, if not eternal, Land- or Earthworks. Insofar as pieces of this environmental character and scale were available to the general public, it was largely through documentation, which made such informational artifacts as photographs, maps, and drawings all the more important. Ironically, the documents often assumed a somewhat disconcerting fine art, pictorial quality, especially when presented in a conventional gallery setting, for once artists re-

commenced making monumental forms, they tended to fall back on age-old principles of orderly design. Then, too, while Land artists may have escaped the precious-object marketing system of traditional art, they became heavily dependent on engineers, construction crews, earth-moving equipment, and even aerial-survey planes, the field equivalent of the factory-bound industrial procedures used by Minimalists, with all the high finance that entailed. Still, the possibility of taking art into the wilderness held great meaning at the time, for just as Performance appeared to reintroduce an element of sacred ritual and mystery into a highly secularized modern society, Earth Art seemed to formalize the revived interest in salvaging not only the environment but also what remained of such spiritually rich, archeological wonders as Stonehenge, Angkor Wat, and pre-Columbian burial mounds.

The antecedents of Land Art can be traced back through the entire history of landscape painting and sculpture, as well as to the great nineteenth-century urban and national parks and to such vast environmental projects as Brancusi's war-memorial complex in Tirgu-Jiu, Romania (fig. 928). In its most recent manifestation, however, the back-to-the-soil impulse may have first appeared in the post-studio works of Carl André, Robert Morris, and Richard Serra, who began to democratize sculpture by adopting the most commonplace materials—firebricks, logs, metal squares, styrofoam, rusted nails—and by merely scattering them over or assembling them on the floor (figs. 827, 922). Here, selection and process gave primacy to site over materials; they also shifted the perspective from that imposed by standing, vertical postures, with their anthropomorphic echoes of the human figure, to the bird's-eye overview allowed by arrangements that hug the ground like carpets.

WALTER DE MARIA (b. 1935) When the American artist Walter de Maria felt the telluric pull he initially responded by transporting earth directly into a Munich gallery (fig. 929). Once installed, *Munich Earth*

left: 928. CONSTANTINE BRANCUSI. *Endless Column.* 1938. Cast iron, height 98′. Tirgu-Jiu, Romania

right: 929. WALTER DE MARIA. *Munich Earth Room.* 1968. Installation view, Heiner Friedrich Gmbh., Munich. Earth, 50 cubic meters (1,600 cubic feet)

Room consisted of 1,766 cubic feet of rich, aromatic topsoil spread some two-feet deep throughout the display chambers. At the same time that this moist, brown-black rug kept patrons at a certain, definite distance and gave them nothing but secondary documents to acquire, it also, paradoxically, provided a light-dark, textural contrast with the gleaming white architecture and filled the air with a fresh, country fragrance, both purely sensuous or aesthetic experiences. Eventually, De Maria would expand his site to embrace vast tracts of fallow land and the entire sky above (figs. 939, 940).

ROBERT SMITHSON (1938–1973) In the same year, 1968, Robert Smithson relocated shards of sandstone from his native New Jersey to a New York City gallery and there piled them in a mirror-lined corner (fig. 930). With this he created a synthetic "nonsite" from an organic particular site and endowed a real, amorphous mass with the appearance of a shaped conical form. And just as the transferral from nature to gallery would seem to have arrested the natural process of continuous erosion and excerpted a tiny portion from an immense, universal whole, the mirrored gallery setting expands the portion illusionistically, while also affirming its actual, and therefore infinite potential for, change in character and context. Fully aware of the multiple and contrary effects of his piece—of the dialectic it set up between site and nonsite—Smithson commented on the work's power as a metaphor of flux: "One's mind and the earth are in a constant state of erosion... ideas decompose into stones of unknowing." As we shall see, Smithson would soon abandon gallery spaces altogether and wring poetry from injured, reclaimed, but ever-decaying nature itself (plate 267).

MICHAEL HEIZER (b. 1944) One of the first to make the momentous move from gallery to wilderness was the California-born artist Michael Heizer, who, with the backing of art dealer Virginia Dwan and the aid of bulldozers, excavated a Nevada site to create the Earthwork *Double Negative* (fig. 931). Quite apart from the fact that he was a Westerner and thus doubly sensitive to the immensity of the American landscape, Heizer believed, like so many Conceptualists, that "the position of art as malleable barter-exchange item falters as the cumulative economic structure gluts. The museums and collections are stuffed, the floors are sagging, but the real space exists." In the Nevada desert he found what he called "that kind of unraped, peaceful religious space artists have always tried to put in their work." For *Double Negative* Heizer and his construction team sliced into the surface of Mormon Mesa and made two cuts to a depth of fifty feet, the cuts facing one another across a deep indention to make a total piece fifteen hundred feet long and forty-two feet wide. But at the heart of this work resides a void, with the result that while providing an experience of great vastness, *Double Negative* does not so much displace space, as the ordinary sculptural mass does, as enclose it, in the way of architecture or landscape design. Here the viewer finds himself inside and surrounded by the piece, instead of outside and in confrontation with it. Meanwhile, the ramplike form of the cuts gives *Double Negative* an archeological character, evoking nothing so much as the cliff tombs in Egypt's Valley of the Kings, especially the mortuary temple of Queen Hatshepsut, where natural and manmade architecture coexist in spectacularly symbiotic relationship (fig. 932).

Smithson too moved from "nonsite" back to site and discovered a

930. ROBERT SMITHSON. *Red Sandstone Corner Piece*. 1968. Mirrors and red sandstone from Sandy Hook Quarry, New Jersey, mirrors 4′ square each. Estate of Robert Smithson

931. MICHAEL HEIZER. *Double Negative*. 1969–70. 240,000-ton displacement in rhyolite and sandstone, 1,500 × 50 × 30′. Mormon Mesa, Overton, Nevada. The Museum of Contemporary Art, Los Angeles. Gift of Virginia Dwan

932. Funerary Temple of
Hatsheput, Deir el-Bahari.
18th Dynasty, c. 1480 B.C.
Egypt

major inspiration in Utah's Great Salt Lake, which the artist saw as "an impassive faint violet sheet held captive in a stony matrix, upon which the sun poured down its crushing light." As this lyric phrase would suggest, the artist was a gifted, and even prolific writer, whose essays about his great Salt Lake creation have made *Spiral Jetty* the most famous and romantic of all the Earthworks (plate 267; fig. 933). With its graceful curl and extraordinary coloration—pink, blue, and brown-black—the piece rewards the viewer with endless aesthetic delight, but the form, for all its purity, arose from Smithson's deeply pondered

reading of the site, reinforced by his fascination with entropy—the rate at which all matter decays—and the possibilities of reclamation. At this particular point on the shore of the Great Salt Lake, Smithson found not only industrial ruin, in wreckage left behind by oil prospectors, but also a landscape wasted and corroded by its own inner dynamism:

Irregular beds of limestone dip gently eastward, massive deposits of black basalt are broken over the peninsula, giving the region a shattered appearance. It is one of the few places on the lake where the

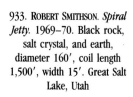

933. ROBERT SMITHSON. *Spiral Jetty.* 1969–70. Black rock, salt crystal, and earth, diameter 160′, coil length 1,500′, width 15′. Great Salt Lake, Utah

water comes right up to the mainland. Under shallow pinkish water is a network of mud cracks supporting the jig-saw puzzle that composes the salt flats. As I looked at the site, it reverberated out to the horizons only to suggest an immobile cyclone while flickering light made the entire landscape appear to quake. A dormant earthquake spread into the fluttering stillness, into a spinning sensation without movement. This site was a rotary that enclosed itself in an immense roundness. From that gyrating space emerged the possibility of the Spiral Jetty.

But the precise configuration had additional analogues in the shape of the crystals formed on the lakeside rocks and in a whirlpool that, according to legend, welled up at the center of the water from an underground tunnel connected to the Pacific Ocean. Thus, through its cursive line *Spiral Jetty* gained emblematic significance ramified into mythology as well as into the realms of macroscopic and microscopic realities. But like the exquisite pink tonality, the product of a microorganic infestation, the coil arises from a poetic grasp of the self-destroying, as well as self-regenerating, processes of nature. As Smithson wrote, the gyre does not expand into a widening circle but winds inward; it is "matter collapsing into the lake mirrored in the shape of a spiral." Prophetic words, for the piece now lies submerged under several feet of water, like some relic of the prehistoric past. Tragically, Smithson too is lost, having died in a plane crash in the course of an aerial inspection of a site in Texas.

RICHARD LONG (b. 1945) In England, with its long history of nature worship in painting, poetry, and landscape gardening, a number of artists contemporary with Heizer and Smithson also looked to landscape as a means of creating art instead of a marketable commodity. But confronted with limited funds and a much more intimate landscape—densely populated, heavily industrialized, rigorously organized and protected—they chose by taste and necessity to treat nature with a feather-light touch and, in contrast to the Americans, to work on a decidedly antiheroic scale. Like Wordsworth in his ramblings through the Lake District, Richard Long intervened in the countryside mainly by walking through it, and indeed he has made walking his principal, highly economical means of transforming land into art. Along the way he expresses his ideas about time, movement, and place by making marks on the earth, by plucking blossoms from a field of daisies, or by rearranging stones, sticks, seaweed, or other such things found in place (fig. 934). With these he effects simple basic shapes favored by humanity's forming hand through all ages and cultures: straight lines, circles, spirals, zigzags, crosses, and squares. In a typical enterprise, Long paced off four concentric squares in a Wiltshire field, carefully noting the time—from October 12 to October 15—and drawing the configuration on a map. Here the map provided the documentation, while the activity constituted the piece, rather in the ritualistic manner of a Performance work. On other occasions, however, the artist has also made photographs, which, when exhibited, take on a somewhat retrogressive pictorial character, owing principally to the banal, even if expressly universal, quality of the design they disclose. By now Long has expanded well beyond the insular space of England to wildernesses all over the world, from Bolivia and Peru to Africa and the Himalayas. "A walk is just one more layer," Long asserts, "a mark laid upon the thousands of other layers of human and geographic history on the surface of the land."

JAN DIBBETS (b. 1944) With a landscape even more restricted than that of England, The Netherlands has produced an equally distinguished

934. RICHARD LONG. *A Line in Scotland.* 1981. Framed work, photography, and text, 34½ × 49″. Private collection, London

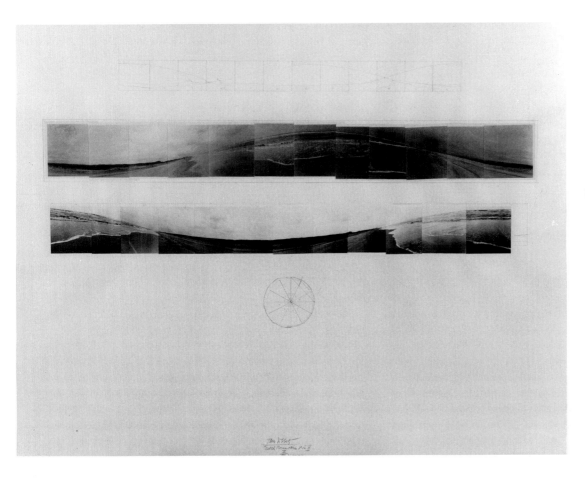

tradition of landscape painting, and in keeping with that heritage, the Dutch artist Jan Dibbets is a Realist concerned with the facts of the natural world as well as with the no less compelling facts of perception. But instead of paints, brushes, and *trompe-l'oeil* illusionism, he works with the camera, using it to explore the relationship between sight, the eye of the camera, and nature. Surrounded by the world's most platitudinous environment, Dibbets has "corrected" this "problem" by taking a sequence of twelve photographs of the native polder, with a camera rotated on its tripod thirty degrees for each shot, and by slightly and progressively tilting the camera off both horizontal and vertical axes. When mounted side by side as a composite image, the sequence describes a complete panorama, but not, thanks to the two-axial tilting, as a flat horizon. Rather, it presents a slowly rising and falling line (fig. 935). In this way, Dibbets reshaped the flatlands of Holland and created mountains, at least conceptually, without moving an ounce of soil.

DENNIS OPPENHEIM (b. 1938) Also active in The Netherlands as a Land artist was Dennis Oppenheim, who, like other Americans creating Earthworks, proved considerably more interventionist in his technique than such Europeans as Long and Dibbets. This can be seen in *Canceled Crop* (fig. 936), a work created in 1969 at Finesterwolde by plowing an "X" with 825-foot arms into a 422 by 709 foot wheatfield. As if to comment on the binding artist-gallery-art cycle, Oppenheim said of his Dutch piece: "Planting and cultivating my own material is like mining one's own pigment.... I can direct the later stages of development at will. In this case the material is planted and cultivated for the sole purpose of withholding it from a product-oriented system." In a work like this, Oppenheim could emphasize the overriding significance of time and experience in all Conceptual Art.

937. CHARLES SIMONDS. *Dwelling P.S.1.* 1975 (no longer exists). Clay and bricks, 1½" long each

938. CHARLES SIMONDS. *Stone Sprout.* 1981. Unfired clay, 10 × 30 × 30". Courtesy Leo Castelli Gallery, New York

CHARLES SIMONDS (b. 1945) An American at one with the Europeans' economy of means and abiding pantheism is Charles Simonds, who in 1971 gave ritual birth to himself and his almost mystical belief in the earth as the giver of all life when he had his person filmed emerging naked from the primordial ooze. Since that time Simonds has wandered over the world, like some ancient bard, creating an epic of his "Little People," an imaginary civilization of miniature folk who live, unseen but keenly felt, in a sacred and sexual relationship with the soil out of which the artist constructs their pueblolike dwellings and villages, tiny brick by tiny brick (fig. 937). To demonstrate the fantasy and intellect of his richly humanistic art, Simonds once again lay down naked in the mud, and, making himself into a landscape, built on the cliffside of his hip a minute archeological settlement, thereby analogizing his body, the earth, and architecture as various forms of habitation. Normally, how-

above: 939. WALTER DE MARIA. *Lightning Field.* 1971–77. A permanent earth sculpture; 400 stainless steel poles, with solid stainless steel pointed tips, arranged in a rectangular grid array (16 poles wide by 25 poles long) spaced 220' (67.05 meters) apart; pole tips form an even plane, average pole height 20'7" (6.27 meters); work must be seen over a 24-hour period. New Mexico. © 1980 DIA Art Foundation

right: 940. WALTER DE MARIA. *Lightning Field* (detail). © 1980 DIA Art Foundation

ever, Simonds works on the ledges and in the corners of abandoned buildings and lots in such urban environments as New York's Lower East Side, burnt out and decaying but alive with the soul of human aspiration left by wave after wave of immigrants. He also carries the odyssey of his own special race of Lilliputians into galleries and museums, sometimes as permanent installations clustered in the enlarged cracks and crevices of walls. Moreover, the legend continues in portable pieces where temples, tombs, and tenements climb in labyrinthine order over an irregular topography whose swelling contours often seem anthropomorphic in their associations with human breasts and genitalia (fig. 938). Inevitably such sculpture invites comparison between a small technologically innocent culture spiritually as well as sensuously integrated with its physical environment and our own technologically sophisticated society intent upon erecting an urban environment hostile to both nature and human nature. Such is the poetry of his inspiration that Simonds has become not only the creator but also the chronicler of his "Little People," recording their story and its moral implications in an eloquent account called *Three Peoples*, the title referring to the linear, circular, and spiral patterns in which the tiny colonies organize their lives.

In *Lightning Field* (figs. 939, 940) Walter de Maria, whose *Munich Earth Room* we saw in figure 929, combined the pictoriality and ephemeral character of European Land Art with the sublimity of scale and conception typical of American Earthworks. Here the principal material is lightning, drawn by four hundred stainless-steel rods standing over twenty-feet tall and arranged as a one-mile-by-one-kilometer grid set in a flat, New Mexican basin ringed about by distant mountains. Chosen not only for its magnificent, almost limitless vistas and exceptionally sparse human population, but also for its frequent incidence of atmospheric electricity, the site offered the artist a prime opportunity to create a work that would involve both earth and sky, yet intrude upon neither, by articulating their trackless expanse with deliberately induced discharges of lightning. Few have ever been eyewitnesses to *Lightning Field* in full performance, but the photographic documentation leaves little doubt about the sublime, albeit unpredictable, unrepeatable, and totally fugitive effects that can be produced by a work designed to celebrate the power and visual splendor of an awesome natural phenomenon.

NANCY HOLT (b. 1938) Although Nancy Holt came to Land Art through her husband, the late Robert Smithson, she creates formally distinct, quite architectural sculptures that are, however, "site specific"—that is, absolutely integral with their surroundings. This occurred mainly as a result of her own involvement with photography, an art in which sighting through a lens brings the alien viewer into almost voyeuristic intimacy with a specific bit of outside, even distant, reality. The experience in camera optics led Holt to make monumental forms that are literally seeing devices, fixed points for tracking the positions of the earth, the sun, and the stars. One of her most important works to date is *Stone Enclosure: Rock Rings* (plate 268), designed for and built as a permanent outdoor installation on the campus of Western Washington University at Bellingham, Washington. It consists of two concentric rings formed of stone walls two-feet thick and ten-feet high. The inner wall defines a tubular space at the center and the outer one an annular space in the corridor running between the two rings, the smaller of which measures twenty feet in diameter and the larger forty feet. Piercing the walls are eight-foot arches and twelve circular holes three feet four inches in diameter (fig. 941). Together these apertures give the spectator both physical and visual access into and even through a structure whose primitive circular presence and carefully calculated perspectives evoke Stonehenge, a prehistoric, exceedingly site-specific monument apparently constructed, at least in part, as a device for decoding terrestrial and astronomical mysteries. And so was *Stone Enclosure*, which Holt has said relates to a point in the universe, a dead center, a true north, while the twelve eye-level "portholes" establish NEW, NE, SE, SW, and NW sight lines or axes that cut diagonally across the masonry walls. Such a work provides both visual and kinetic experiences, for while it first invites the viewer to move from a broad environmental context toward the central enclosure, there to become the structure's focal point and psychological center, it then reverses this orientation and directs both sight and self-exploration toward the expanding horizon, as well as to the open sky above. Enriched by a further paradox, *Stone Enclosure* looks as if it had always been there, an impression encouraged by the ancient astronomical form and the stone material, a 230-million-year-old indigenous schist. Yet it also speaks quite poetically of the ephemeral, not only in the instability of the many circular shapes but also in the light and shadow that constantly change

941. NANCY HOLT. *Stone Enclosure: Rock Rings* (detail). 1977–78. Hand-quarried schist, outer ring 40′ diameter, inner ring 20′ diameter, height of ring walls 10′. Western Washington University, Bellingham

942. MARY MISS. *Field Rotation.* 1981. Steel, wood, and gravel, central structure 56' square, depth 7', sited on 4½ acres. Governors State University, Park Forest South, Illinois

as the earth rotates. Through its structure and the intricate internal workings this provides, Holt's site sculpture correlates form to environmental context, but in a way that reveals both only in fragments of time and space, with the whole left to be disclosed with the passage of time. Thus, *Stone Enclosure* becomes a brilliant symbol of the fact that time perceived, from finite moment to finite moment, leads to a realization of the infinitely continuous, therefore unified, nature of time.

MARY MISS (b. 1944) In contrast to Nancy Holt, who constructs permanent sites for viewing transient phenomena, Mary Miss builds deliberately fragile architectural sculptures as a means of stressing the ephemerality of experience. Common to both artists, however, is a preoccupation with time as it affects the perception of space through both movement and the moment, as well as a determination to create a viable public art by making the viewer more than a neutral perceptor of the art work and its processes. In the publicly funded *Field Rotation* (fig. 942), permanently sited at Governors State University in Park Forest South, Illinois, Miss took her primary inspiration from the terrain, an immense, flat field with a gently curved mound at the center. To explore this space and discover its potential for yielding a rich content of personal, yet shared, cultural experience, Miss used lines of posts to pattern the field as a kind of giant pinwheel. Its spokes or arms radiate outward from, while also converging toward, a "garden" sunk within the central hub or mound, the pit shaped like a fortress and built up inside as a reticulated, cross-timbered lookout rising above a "secret" well filled with water. At the same time that the posts and their fanlike movement articulate the vast openness of the American landscape, stirring the collective memory of fences and corrals, possibly even the American Indian medicine wheel, the sunken garden which these paths lead both toward and away from provides sanctuary and retreat from the surrounding barrenness, like an oasis or Persian garden, an enclosed, watered, sensuous paradise in the midst of a harsh, arid wasteland. By insisting on the importance of content in her work, Miss means the bodily experiences induced by her structures, such as the orchestrated sensations of enclosure and openness, and the associations the pieces evoke, recollections of buildings, gardens, bridges, of legend, lore, fiction, film, and theater. The artist often speaks of "layering," her search, that is, for forms whose countless references have been pro-

gressively milled, distilled, and transformed to disclose their inherent power to dramatize space and mine the archeology of human memory.

ALICE AYCOCK (b. 1946) Alice Aycock too is less interested in building perdurable monuments than in siting and structuring her sculptures to induce the viewer to move and thus intensify his experience of the environment, the work, and himself. But in a manner all her own, Aycock is concerned with the psychological implications of the architectural sites she creates for the sake of reembracing nature. Early in her career, for instance, she built *Maze* (1972), a twelve-sided wood structure of five concentric rings six-feet high and some thirty-two feet in diameter. Inspired by the reproduction in an encyclopedia of an Egyptian plan for a mazelike prison, the work was intended to force the viewer to engage in eye and body movement without his being able to comprehend the whole—thus "to create a moment of absolute panic." In 1975, on a site she chose in Far Hills, New Jersey, Aycock built *A Simple Network of Underground Wells and Tunnels,* a structure, as the title would suggest, hardly visible at eye level, but potent with experience for the spectator courageous enough to enter the piece (fig. 943). To realize it, Aycock began by marking off a twenty-eight-by-fifty-foot site with straight rows of cement blocks. Within this precinct she then excavated a twenty-by-fifty-foot area and installed two sets of three seven-foot-deep wells connected by tunnels. After capping three of the shafts, the artist lowered ladders into two of the uncapped ones, thereby inviting the observer to descend and explore an underground labyrinth of dark, dank passages. Aycock uses Minimalism's cool, structuralist vocabulary but in distinctively novel, even Surreal ways, the better to evoke such historical precedents as caves, catacombs, dungeons, or beehive tombs and to make them the expressive agents of her own childhood traumas. Elsewhere she had hammered together sheds, towers, cities, and fantastic machines, all, as Michael McDonough has written, "rendered in the simple technology of wood construction … [and all] full of images suggested, invitations denied, processions violated, and stage sets without plays. In architecture a wall is structure and materials; to Aycock it is charged with psychological and mythological possibilities. Haunted, mysterious, threatening, it is as full of tales as it is of nails."

943. ALICE AYCOCK. *A Simple Network of Underground Wells and Tunnels.* 1975. Concrete-block wells and tunnels underground, demarcated by a wall, 28 × 50', area 20 × 40'. Marriewold West, Far Hills, New Jersey

944. CHRISTO. *Running Fence, Sonoma and Marin Counties, California.* 1972–76. Woven and synthetic fabric, height 18′, length 24½ miles. Photograph by Wolfgang Volz. © Christo and Running Fence Corporation

CHRISTO Easily the most celebrated of all site sculptors is Christo, the Bulgarian-American master of *empaquetage* who has moved from his early smaller-scale works (fig. 747) to vast environmental projects that have involved wrapping not only whole buildings but even significant portions of open nature. Indeed, fame could be said to function as an essential ingredient of this artist's activity, since to carry out his epic proposals, he must engage the sympathetic attention of countless public and private interests, in whose domain he has chosen to operate. Christo may in fact be as great an artist in public relations as he is in plastic forms. If the results of his endeavors are spectacular, so have been the preparations, courtroom maneuvers, practical logistics, and financing. In the instance of *Running Fence* (fig. 944), a 1972–76 work executed in the California coastal counties of Marin and Sonoma, these entailed raising $3.2 million, through the sale of the artist's preparatory drawings as well as project-related photographs, books, and films; transforming the resistant private owners of the site into friends and supporters; a three-year legal battle to overcome the obstructionism of a notoriously pettyfogging bureaucracy, egged on by anxious environmentalists; and an unabating personal campaign to reverse the general hostility of local opinion. Once the money had been generated and all the necessary permissions gained, Christo and his faithful partner-wife had to recruit and manage sixty-five skilled workers who spent months anchoring twenty-four miles of infrastructure, and then 350 students who worked three furious days to stretch sixty-five thousand yards of nylon fabric eighteen feet high on steel cables set sixty-two feet apart. When finally in place, *Running Fence* undulated like a graceful line drawing, or the Great Wall of China, through fields, hills, and valleys, all the way to and finally into the Pacific Ocean, interrupting its progress here and there to allow for the passage of cattle tracks, a freeway, and a variety of secondary roads (plate 269). Even the most skeptical observers seemed ready to concede that the work was as dazzling in its beauty as it was fascinating in its mysteriousness, for, owing not only to a meandering, up-and-down length but also to environmental concerns that restricted public access to paved roads, the piece

could be seen never as a whole but only in tantalizing segments. It stood for two weeks and then was dismantled, leaving no ecological damage to either flora or fauna, but having generated some $9 million of economic benefits to suppliers, workers, professionals—contractors, pilots, photographers—and those who did business with them. In *Running Fence,* as in all his wrappings, Christo made the familiar visible in a new way. While creating a strange and exhilarating art work that commented on a consumer society chronically susceptible to the "enhancements" of packaging, it also revealed the beauty of a world threatened by clutter from just such lures, a beauty fully equal to the splendid enhancement brought by an unthreatening and transient art. Moreover, despite its industrial magnitude, *Running Fence* became an uplifting human experience, not only in the liberating wonder that it brought to an untold number of habit-bound minds, but also, as Pierre Restany wrote at the site, in "Christo's remarkable faith in man; a faith that elsewhere moves mountains and here runs, up hill and down dale, from the prairie to the sea."

For a more recent project, Christo moved to the eastern coast of the United States and in Miami's Biscayne Bay surrounded eleven small islands with six million square feet of glistening, flamingo-pink polypropylene fabric (plate 270). Once again he spent over $3 million and marshaled the forces of a formidable army, consisting of two attorneys, one marine biologist, two ornithologists, a marine mammal expert, a marine engineer, four other engineers, a building contractor, and over four hundred untitled workers, including a Cuban woman who normally labors in a factory sewing cargo slips and pool covers. To assuage the fears of environmentalists, Christo tested his wrapping material by stretching it over a basin holding several of the manatees that constitute the islands' principal inhabitants, only to find that the new synthetic environment affected the creatures largely by activating their amatory instincts. Furthermore, the artist proposed to wrap only the manmade land forms in the bay. When completed, *Surrounded Islands* resembled enormous waterlilies floating under a cloudless sky, as if Monet had returned to repaint his Giverny series on an epic scale. As for the

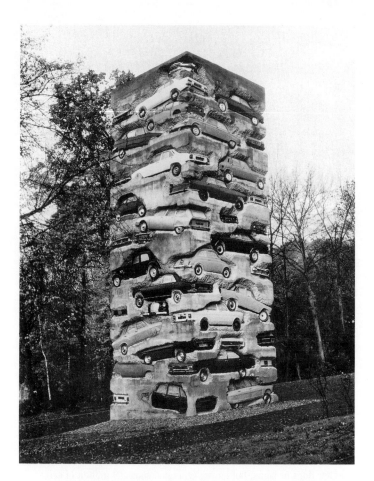

945. ARMAN. *Long-Term Parking.* 1982. 60 automobiles embedded in cement, 60 × 20 × 20′. Marisa del Re Gallery, New York

value of investing so many resources in an artistic experience of such brief duration, it would seem to have been captured by one of the Cuban seamstresses when she said: "This project refreshes the heart."

ARMAN Another European artist who has become an old master of avant-gardism by making art from nonart materials is Arman, also known for "packaging" the contents of his works, this time, however, not in fabrics but in clear plastic (figs. 745, 746). To stress the environmental character of his assemblages, Arman calls them *poubelles* ("trash cans"), a term that comments, just as Christo's wrappings do, on the prodigal waste inherent in contemporary consumerism, while also alluding to the poetry that such artists as Schwitters and Rauschenberg have been able to create by recycling discards into art. Subsequently, in his more familiar *accumulations* Arman trapped masses of human artifacts—frequently violins, paint tubes, or other objects with connotations of high culture—in transparent, quick-setting polyester, like time capsules of modern life ready to be discovered and judged by some future civilization. The *plein* or "plenty" of these 1960s works seemed to offer an alternative to the *vide* or "emptiness" of the radically dematerialized pieces brought forth by the fellow French artist Yves Klein (plate 230). Then, in 1982, Arman realized "plenty" on a grand scale—possibly the grandest in all sculpture—when he built *Long-Term Parking* (fig. 945), a sixty-foot concrete tower with some sixty complete automobiles embedded in it. The bosky, parklike setting outside Paris simply affirms the artist's contention that, far from expressing the antiart bias present in Duchamp's original use of found objects, *Long-Term Parking* reflects a desire to restructure used or damaged

materials into new, purely aesthetic forms as a metaphor of the hope that modern life may yet prove salvageable, despite the threat of total destruction posed by that most lethal of all industrial productions, the thermonuclear explosive.

Public Monuments

The environmental impulse struck a deep, resonant chord in the consciousness of artists and patrons alike, and it continues to reverberate even as the trend develops away from interventionist procedures toward sculptural or architectural forms made independently of, but in relation to, the chosen site. If such "sited sculptures" represent a return to variants of the very objects that Conceptualism set out to eliminate from art, the objects now produced by environmental-minded artists remain relatively free of the old purist egocentricity, at the same time that they retain something of the ecological spirit fostered by Land Art. Like De Maria's *Lightning Field*, they may celebrate the beauty and magnificence of natural phenomena or, in keeping with Charles Simonds's miniature pueblos, honor the earth for its power to nurture the living and receive the dead. To a considerable extent, they reflect the philosophy of Robert Smithson, who argued most eloquently for an art designed to help redeem a landscape brutalized by human disruption of its natural order. In a period of burgeoning pluralism, the new monuments, even more than the works of Simonds, would often reflect fantasy, acute sensory awareness, and a tense contest between bodily self-perception and external reality. Occasionally this has produced conflicts, especially since much of the new environmental art has been created under public commission or within the public domain, a situation that seems automatically to require that art strike some tenable balance between its own need for internal coherence and the needs of the immediate surroundings. A degree of accommodation must also be made between the essentially private, enigmatic character of modern art and the expectation that art placed in the public arena be accessible—that is, expressive and meaningful—to the public at large.

ISAMU NOGUCHI A sculptor long sensitive to and active in the environment is Isamu Noguchi, the great Japanese-American who continues to lavish his genius not only on self-sufficient works like those seen in figures 575 and 618, but also on an ever-expanding series of parks, playgrounds, and public plazas. No one has been more effective in demonstrating the wisdom of having artists involved whenever aesthetic decisions are made regarding land use, urban planning, and reclamation. The project that so far has permitted the energetic Noguchi to give his talents fullest reign is Hart Plaza in Detroit (fig. 946). Initially the commission merely called for a fountain to be built as the centerpiece of a new public space, bounded on one side by the Detroit River and on the other by every manner of urban renewal development, including the famous Renaissance Center (fig. 947). It ended finally with the implementation of a whole range of suggestions made by the sculptor for designing the entire eight-acre site in relation to his sculpture-fountain. All about this remarkable work, in a fanlike arrangement that succeeds in expressing intimacy and human scale as well as spaciousness and grandeur, are an amphitheater (which becomes a skating rink in the winter), open green and paved areas set above subterranean restaurant and performance facilities, and, at the entrance to the plaza, a torsioned pylon made of gleaming aluminum. All serve to set off the fountain, a sculptural and technological marvel worthy of Versailles itself (fig. 948). Ring-shaped like a doughnut or a fat halo, it rises twenty-four feet

947. JOHN PORTMAN. Renaissance Center, Detroit, 1975 (opened)

above a circular granite basin on two angled legs set daringly off center in a 120-degree relationship to one another. Thanks to computerization, the fountain plays through an infinite variety of aquatic routines, from a fine romantic mist to a thundering, columnlike rush of water. The polished stainless-steel and aluminum material join with the computer programming to endow Hart Plaza with a technological, or even space-age, metaphor, which seems all the more appropriate in a city whose industry has given twentieth-century America its dominant character. Here, as Noguchi himself observed, "a machine becomes a poem."

946. ISAMU NOGUCHI. Hart Plaza (aerial view), Detroit

948. ISAMU NOGUCHI. Hart Plaza (Dodge Fountain), Detroit, 1975

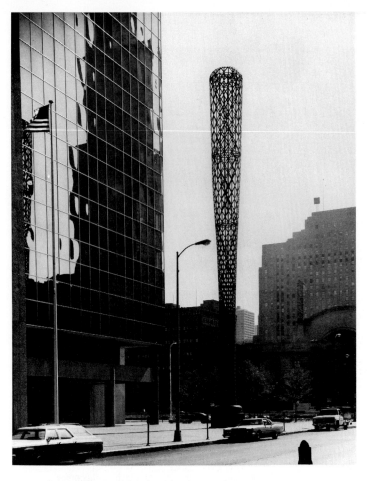

949. CLAES OLDENBURG. *Batcolumn.* 1977. Welded steel bars painted gray, height 100'. Collection United States Social Security Administration, Chicago

950. CLAES OLDENBURG. *Colossal Monument to Park Avenue: Good Humor Bar.* 1965. Crayon and watercolor, 23¼ × 18″. Collection Carroll Janis, New York

CLAES OLDENBURG If monumental sculptures have sprouted more like weeds than poems across the American urbanscape, it is largely owing to the United States General Services Administration's Art-in-Architecture program, which allows one-half of one percent of the cost of constructing a new federal building to be allocated for the installation of art works designed to enhance the new structure and its site. Since 1972 the GSA program has commissioned more than two hundred paintings, sculptures, tapestries, and fiber pieces, for locations all over the nation, by artists ranging from those of local repute to such international figures as Louise Bourgeois, Alexander Calder, Mark di Suvero, Richard Hunt, Louise Nevelson, Isamu Noguchi, George Rickey, George Segal, Tony Smith, and Frank Stella. One of the most successful of the federally sponsored public monuments would seem to be Claes Oldenburg's *Batcolumn* (fig. 949), a hundred-foot-tall open-work, diamond-grid steel shaft erected in 1977 directly in front of the new Social Security Building in a former slum near the west end of Chicago's Loop. By recasting such a banal form on a monumental, truly environmental scale, the Pop master brought to realization something of his earlier visionary "proposals" for revitalizing the urban world with fantastically immense baked potatoes, teddy bears, lipsticks, bananas, and Good Humor bars (fig. 950). The baseball bat, however, was new to his repertoire of popular iconography, and Oldenburg settled on it as perfect for Chicago, an image capable of evoking the many heroic columns in the city's older Beaux-Arts architecture, the soaring towers of the skyscraper architecture Chicago invented, the countless smokestacks celebrated by Carl Sandburg, the game played and cheered with such passion in Wrigley Field, and the city's vaunted masculinity and aggressive prowess. And as usual in a work by Oldenburg, *Batcolumn* makes a wry comment on art, this time with references to Brancusi's *Endless Column* and Gabo's 1950s construction for the Bijenkorf Department Store in Rotterdam (figs. 928, 472), doing so with such triumphant wit that the piece becomes a tribute to everything it mocks, including its own cliché-ridden prototype.

RICHARD SERRA The GSA program has also commissioned a much more controversial work, Richard Serra's *Tilted Arc* (figs. 951, 952), a 120-foot-long, 12-foot-tall, 72-ton slab of unadorned curved and tilted steel for the federal building complex (Federal Plaza) in New York City's Foley Square, installed there in 1981, and now scheduled for removal. This action is to be carried out in response to the demand of local civil servants, who found the work objectionable as a "hideous hulk of rusty scrap metal," an "iron curtain" barrier not only to passage across the plaza but also to every other activity that once took place there, such as jazz concerts, rallies, and simple lunchtime socializing. But the removal is to occur in the face of the near-universal opposition to it mounted by the professional art community, which has supported the artist in his contention that to relocate a piece he deems utterly "site specific" would be to destroy it (the very survival of the sculpture depends on the willingness of Serra to have it relocated elsewhere), and that such action would constitute a breach of the moral, as well as legal, agreement the government made to maintain the work permanently as the artist conceived it.

Meanwhile, the debate continues, although with its emphasis shifted from the specifics of the Foley Square incident to a more general consideration of how to strike some enlightened balance between the government's commitment to artistic license and the right of the public to participate in the shaping of their own environment, especially when it comes to publicly sited art paid for with tax-generated funds. And the GSA has never been indifferent to the delicate dilemma of its Art-in-

right: 951. RICHARD SERRA. *Tilted Arc*. 1981. Hot-rolled steel, length 120'. Federal Plaza, New York

left: 952. RICHARD SERRA. *Tilted Arc*. 1985. © Edward Hausner/ NYT Pictures

Architecture scheme, a fact acknowledged in early 1985 when the program received one of the first Presidential Awards for Design Excellence, part of which stated: "Artists have been given aesthetic freedom and support, even when their works have been controversial. But when new works have sometimes met with puzzlement or hostility, they have usually come to be increasingly appreciated by their 'using' public." *Tilted Arc*, however, like many major art works, was meant to be challenging and provocative, for Serra, by his own admission, built the piece specifically to "alter and dislocate the decorative effect of the plaza." Feeling themselves not only challenged but actually bullied, the work's "using" public came to believe that after three years of cohabitation with *Tilted Arc*—a relatively brief period in aesthetic matters—they were likely to grow rather more hostile than appreciative in their attitudes toward the piece. But if no other benefit is to be gained from the *Tilted Arc* experience, at least the selection process has been modified to include measures for taking public opinion into account and, more important from the artist's point of view, for informing that opinion in a persuasive and respectful manner.

Lest Americans fear that the experience with *Tilted Arc* will usher in a new Dark Age of barbarism, encouraging regional officials to dismantle any federally sponsored art work they may have failed to understand or embrace, they should consider another, much more promising and ambitious project of public art. Once again the scene is New York City, but this time with the commissions made by Battery Park City Authority, working in close cooperation with all manner of local interests, especially those involved in a vast new complex of skyscrapers and walking paths spread along a spectacular 1.5-mile esplanade bordering the Hudson River as it flows into New York Harbor (fig. 953). Mindful of the problems with *Tilted Arc*, the Authority's Fine Arts Committee took great care in forming artistic guidelines and in choosing artists for what are exceptionally choice sites. In the words of the committee chairman, "it was a tough and narrow path.... We hope the critics will think it's great, and we also want the people to like it. We think that's doable. That was the major challenge." What the committee most wanted to avoid were "plunk-down" sculptures of the sort so often found standing awkwardly in skyscraper plazas. Instead, each of the three celebrated

sculptors chosen has worked to make his or her independently conceived piece an integral part of the landscape as well as a work with recognizably social forms that invite public use of the plaza.

Moving north to south, visitors first encounter Ned Smyth's (b. 1948) rather exotic "ruin," a sort of unroofed Egyptian temple serving as a raised, colonnaded court surfaced with bluestone and congenially

953. Battery Park Site Plan (detail). 1985. Courtesy The Battery Park City Authority, New York

954. NED SMYTH. Model for Albany Street Park, Battery Park Project. 1985. Courtesy The Battery Park City Authority, New York

955. RICHARD ARTSCHWAGER. Model for West Thames Street Park, Battery Park Project. 1985. Courtesy The Battery Park City Authority, New York

956. MARY MISS. Model for South Cove Waterfront: view looking south, Battery Park Project. Collaborative design by Mary Miss, artist; Cooper, Eckstut Associates, architects; Susan Child, Child Associates, landscape architect. Courtesy The Battery Park City Authority, New York

accoutred with a gazebo and a low stone table inlaid with six chessboards (fig. 954). For the next block south, on a triangular plot of land, Richard Artschwager (b. 1924), an artist of "chameleon-like reticence," has prepared a simple but fanciful "living room" or "waiting area," furnished with two ten-foot-high granite chairs, two oversized redwood lawn chairs, and a pair of tables made from the circular gratings used to protect large tree roots (fig. 955). In the final work, Mary Miss proves that a true site artist can, however delicate the balance, survive and triumph in an urban situation. In her *South Cove*, Miss has collaborated with Stanton Eckstut, of the architectural firm responsible for the master plan of the entire development, and landscape architect Susan Child to take the bold step of integrating water and land by means of rock-lined paths, a spiral lookout ramp, a footbridge, a semicircular pier, and a cutout "island" that bobs with the tides while laden with shrubbery (fig. 956). Here, where pilings will be swallowed up or exposed by the rise and fall of the Hudson, art civilizes the shoreline and simultaneously heralds the world beyond. With this example before them, site artists may find it possible, in the aftermath of the *Tilted Arc* experience, to resist the temptation to give up on commissions for public works and return to the lone-wolf activity of working in remote, primeval nature, where the first Conceptualist Land Artists began, far from the clamor and claims of society at large.

The Pluralistic Seventies:
FROM THE NEW ILLUSIONISM TO PATTERN, DECORATION, AND NEW IMAGE ART

The New Illusionism

Almost simultaneously as Conceptualists were abandoning studios and object-making, in favor of performances, process, Earthworks, and Duchampian wordplay, others rebelled against Minimalist exclusivity by returning to the studio and reembracing the very kind of handwrought *trompe-l'oeil* or illusionistic painting and sculpture that mainstream modernism had largely rejected as irrelevant to art's higher purposes: self-purifying formalism. To the art-critical community, this constituted a counterrevolutionary development with far more shocking implications than any of the iconoclastic strategies undertaken by the Conceptualists. Thus, the new super- or hyper-Realist art triumphed principally as a dealer-collector affair, with broad popular appeal, that had to make do, unlike any other significant movement in the postwar period, outside the pale of enlightened critical support. But make do it did—and quite handsomely too—for photographically veristic easel paintings and hallucinatingly lifelike sculptures offered welcome refreshment to a world starved for collectible art, an art whose mimetic character offered the thrill of not only recognition but also verifiable rendering skills the likes of which had not been noted in more than a generation (fig. 957).

At the same time, however, the new representational work was more closely related to high modernism than many realized in the late 1960s and early 1970s, when disbelieving eyes long accustomed to ever-more radical abstraction and fantastic neo-Dada invention beheld a kind of one-for-one replication of the visible world so exact that the dealer Sidney Janis dubbed it "Sharp-Focus Realism," while his commercial peer Louis K. Meisel called it "Photorealism," the term that has stuck. First of all, recrudescent illusionism had been sanctioned by that father of minimalizing procedures as well as of Pop's readymades and fantasy, Marcel Duchamp. This came about in 1969 with the posthumous discovery of *Étant Donnés* (fig. 958), which revealed the old antiartist to have been secretly occupied during the years 1946–66, at the height of abstraction's hegemony, in creating a voyeuristic, dupe-the-eye tableau, complete with pigskin nude and motorized tinfoil waterfall (none of which is permitted to be reproduced, other than the peephole door seen here). Moreover, once art had become as literal as primary forms, found objects, in-the-flesh performances, and natural processes, it did not, after all, take such a great leap of the imagination to see that at least one next logical step lay in a return to illustrational art. By causing an extreme situation to pass into its opposite, Photorealism allowed painting and sculpture to do what they had often done before when confronted with an aesthetic deadend—return to perceptual experience, away from the dominance of concepts, and treat it as descriptively as the culture of the time would dictate. What the culture of the 1960s

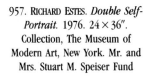

957. RICHARD ESTES. *Double Self-Portrait.* 1976. 24 × 36″. Collection, The Museum of Modern Art, New York. Mr. and Mrs. Stuart M. Speiser Fund

958. MARCEL DUCHAMP. *Étant Donnés (Given: 1. The Waterfall, 2. The Illuminating Gas)*. 1944–66. Mixed media, height 95½″. Philadelphia Museum of Art. Gift of the Cassandra Foundation

and 1970s required, however, was not a straw-hatted, besmocked plein-airist with his easel set up before a haystack, but rather a child of the media age more at home with reality as encountered in a photograph than through immediate contact with the world at large.

Photography, as we have seen, had come into being virtually at the dawn of modernism, and developed alongside modernist painting as the mechanical counterpart of art's handmade process of resolving onto a flat surface visual evidence derived from the three-dimensional world. And no element in society felt the impact of photography more acutely than painters, who immediately saw that the new technology constituted a dangerous rival to their own validity as imagists. However, they also viewed it as an almost magical aid to imitating the real world more factually, or seeing that world in totally novel ways, or, indeed, as a justification for breaking free of all need to illustrate anything other than the artist's own fantasy or ideal sense of pure form, leaving imitation to the greater accuracy of the camera. Only with Photorealism, however, did representational painters set out to make pictures that resembled less the phenomenal world than a photograph of it, complete with all the abstract qualities of monocular vision, spatial distortion, uniform focus throughout the visual field, smooth, filmic surfaces, and glittering luminosity. But having thus disciplined themselves to duplicate a preestablished two-dimensional duplicate of perceptual reality, the Photorealists joined their modernist colleagues and made process and flatness, even in an image candidly pretending to depth illusion, the determining conventions of their art.

Modernism—in its daring and highly intellectualized candor and simplicity, forever seeking to strip art of all but its most irreducibly essential elements—seemed to be continually challenging viewers to make an act of faith that they were not being taken for fools. Illusionistic Realism, on the other hand, is pure artifice or counterfeit, and as such it exists specifically to fool the viewer into believing that the painting or sculpture is what art can never totally be—life. Photorealist painting, moreover, involves the viewer in a double deception, for while it may seem to look more lifelike than anything ever seen in the world of art, it is in fact a simulacrum not of life but rather of a blown-up photographic image of life. If modernism demanded that we surrender our naïveté, realism would seem rather to call for its return. In the era of compounding irony and paradox, the comedy of errors may actually be the most potent, valid, and intoxicating of all the possibilities available to art.

Realism, of course, has always been a fundamental mode of expression in Western art, and if modernist abstraction eventually gained primacy in the 1950s and 1960s, it was, to a considerable degree, by virtue of strength won through stubborn resistance to a tradition entrenched since Classical times and absolutely dominant from the Renaissance until, at least, the very end of the nineteenth century. So versatile and resilient is the language of Realism that almost every age has been able to find therein the means to articulate its own special sense of what reality may be, ranging from the pantheism of fifteenth-century Flanders to the social activism of the 1930s, which produced the last great flowering, prior to Photorealism, of explicitly representational painting and sculpture (figs. 547, 550). Even Pop Art was originally called the "New Realism," but while emphasizing the priority of familiar and readily identifiable subject matter, Pop artists tended to isolate or stylize popular icons so as to glorify and/or mock them, rather than provide objective simulations of the everyday environment. However, Realism of a sort that Jan Vermeer or Edward Hopper could have identified with survived as a vigorous underground movement throughout the years of abstraction's unrelenting war against it. This was easier in Europe, where such dominant modernists as Matisse and Picasso stopped short of totally severing their ties with the Classical, humanist past, and thus always retained some vestige of figuration even in their most advanced and reductive works.

An important European heir to the tradition of truth to visual facts is the Berlin-born British artist Lucien Freud (b. 1922), the grandson of

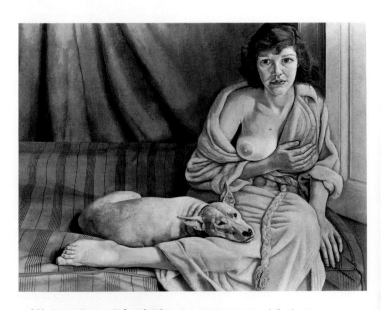

959. LUCIEN FREUD. *Girl with White Dog*. 1950–51. 30 × 40″. The Tate Gallery, London

above: 960. AVIGDOR ARIKHA. *Self-Portrait Standing Behind Canvas*. 1978. 45¼ × 29⅝". Private collection

above right: 961. ANTONIO LÓPEZ-GARCIA. *Madrid from Vallecas*. 1962–63. Oil on board, 40 × 51". Private collection

right: 962. CLAUDIO BRAVO. *Blue Package*. 1968. 38¾ × 57¾". Private collection

the great pioneer psychoanalyst. So resolute is Freud in his uncompromising devotion to what he sees that the resulting image, realized with a near obsessive command of line and texture, can seem the product of a clinically cold and analytical mind (fig. 959). Still, in their very "nakedness," nude models whom the artist has revealed in almost embarrassing close-up detail confront the viewer with an unmistakable presence and identity, even when they remain nameless. An artist positively steeped in knowledge of the Old Masters is the Paris-trained Israeli painter Avigdor Arikha (b. 1929), whose work nonetheless remains contemporary in the immediacy of the technique used, as well as in the evident conviction that behind appearances lies an all-too-real world of irrationality and danger (fig. 960). Arikha completes each painting in a single daylong burst of inspiration, ignited by a spark issuing from the artist's total absorption of centuries-old traditions of color and composition. An equally cultured Realist, but one who works with almost monastic dedication and care for craft, is the Spaniard Antonio López-Garcia (b. 1936; fig. 961). Uncannily, the element of time—its power to fulfill and to erode—seems to have been built into López-Garcia's pictures, the fruit, conceivably, of not only their slow, meticulous execution but also their geometric lucidity and pure, luminous tones. A

still-life painter who seems to have arrested time at some point before the Fall, when the world remained dust-free and flawless, is Claudio Bravo (b. 1936), the Chilean master long resident in Tangiers (fig. 962). If Christo's packages represent a gesture toward salvaging the environment from the consumerism that threatens it (fig. 747), the pristine parcels rendered by Bravo seem to suggest that reality is being delivered newborn and unspoiled to a humanity still innocent and miraculously clear of eye.

In the United States also, where, according to Claes Oldenburg, the national schizoid psyche reels "from one extreme to another, from puritanism to abandon, from solicitude to aggression," a pragmatic preoccupation with material reality was too deeply ingrained to die out, even as Abstract Expressionism and its Minimal aftermath made American painting and sculpture more rigorously abstract than anything ever seen in the history of art. Throughout this very period, in fact, the most "collectible" of all living American painters was probably that master of impeccably observed, nostalgia-drenched, native-scene painting, Andrew Wyeth (b. 1917; fig. 963). Another American artist who never lost the Realist faith was Alice Neel (1900–1984). After many years of subsisting on the fringes of mainstream art, Neel came into late, but

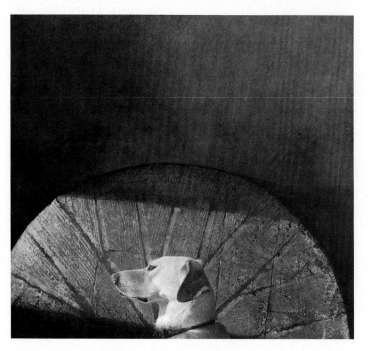

963. ANDREW WYETH. *Equinox.* 1977. Egg tempera, 34½ × 32″. Private collection

965. FAIRFIELD PORTER. *The Garden Road.* 1962. 5′2″ × 4′. Whitney Museum of American Art, New York. Gift of the Greylock Foundation

considerable, fame as a portraitist of such searching, psychologically penetrating power that she seemed to be "stealing" the very souls of her sitters (fig. 964). Within the same generation as the Expressionist Neel was the rather Post-Impressionist Fairfield Porter (1907–1975), who painted radiant, grandly composed intimist pictures that, albeit thoroughly American (plate 271; fig. 965), seem aesthetically and spiritually at one with the calm, coloristic art of Vuillard and Bonnard. Commenting on his luminous environments, Porter said: "I was never one to paint *space.* I paint air." Such was the extraordinary freedom and fluency of this artist that, although committed to figuration in his own painting, he regularly wrote criticism that early and unflaggingly supported the American Abstract Expressionists. This posed no conflict for Porter, since, as he stated, "the important thing for critics to remember is the 'subject matter' in abstract painting and the abstraction in representational work." Happy to work in the traditional genres of still life, landscape, and interior, as well as portraiture, Porter was convinced that the uncommon could be found in the commonplace, that "the extraordinary is everywhere."

CHUCK CLOSE (b. 1940) By comparison with the stop-action stillness and sharp-focus immediacy and detail of Photorealist painting, the works of the relatively traditional Realists just seen are impressionistic, the products of as many looks, long and short, as it would take to render the directly perceived subject in an optically persuasive manner by a skilled master of drawing and color. In this way, the older Realism has built within it a sense of ongoing time or duration—as we pointed out especially in the López-Garcia work—that is utterly at variance with the snapshot instantaneity of the typical Photorealist picture, which, un-

964. ALICE NEEL. *Andy Warhol.* 1970. 60 × 40″. The Whitney Museum of American Art, New York. Gift of Timothy Collins

Colorplate 263. LUCAS SAMARAS. *Photo-Transformation*. 1973–74. SX-70 Polaroid, 3 × 3″. Private collection

Colorplate 265. LYNDA BENGLIS. *Bounce*. 1969. Poured colored latex, size variable. Private collection

Colorplate 264. GILBERT AND GEORGE. *Cabbage Worship*. 1982. 30 panels, 9′10¾″ × 9′10½″ overall. North Carolina Museum of Art, Raleigh. Purchased with funds from the Madeleine Johnson Heidrick Bequest

Colorplate 266. SAM GILLIAM. *Carousel Form II.* 1969. Installation view, Corcoran Gallery of Art, Washington, D.C. Acrylic on canvas, 10 × 75′. Collection the Artist

opposite above: Colorplate 269. CHRISTO. *Running Fence, Sonoma and Marin Counties, California.* 1972–76. Woven synthetic fabric, height 18′, length 24½ miles. © Christo and Running Fence Corporation

opposite below: Colorplate 270. CHRISTO. *Surrounded Islands, Biscayne Bay, Greater Miami, Florida.* 1980–83. Photograph by Wolfgang Volz. © 1980–83 Christo/C. V. J. Corporation

Colorplate 267. ROBERT SMITHSON. *Spiral Jetty.* 1969–70. Black rock, salt crystal, and earth, diameter 160′, coil length 1,500′, width 15′. Great Salt Lake, Utah

Colorplate 268. NANCY HOLT. *Stone Enclosure: Rock Rings.* 1977–78. Hand-quarri schist, outer ring 40′ diameter, inner ring 20′ diameter, height of ring walls 10′ Western Washington University

Colorplate 271. FAIRFIELD PORTER. *Katie on Sofa.* 1959. 25¼ × 25¼". Courtesy
Hirschl and Adler Modern, New York

Colorplate 272. RICHARD ESTES. *Bus Reflections (Ansonia).* 1972. 40 × 52". Private collection

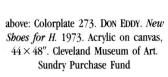

above: Colorplate 273. DON EDDY. *New Shoes for H.* 1973. Acrylic on canvas, 44 × 48″. Cleveland Museum of Art. Sundry Purchase Fund

right: Colorplate 274. DUANE HANSON. *Tourists.* 1970. Fiberglass and polyester polychromed, 64 × 65 × 47″. National Galleries of Scotland, Edinburgh

Colorplate 275. ALEX KATZ. *The Red Band.* 1978. 6 × 12′. Private collection

Colorplate 276. JANET FISH. *Stack of Plates.* 1980. 48 × 70″. Stephen S. Alpert Family Trust

Colorplate 277. NEIL WELLIVER. *Breached Beaver Dam.* 1976. 95⅞ × 96⅛″. North Carolina Museum of Art, Raleigh. Gift of Lee and Dona Bronson in honor of Edwin Gill

Colorplate 278. MIRIAM SCHAPIRO. *I'm Dancing as Fast as I Can.* 1985. Acrylic and fabric on canvas, 7′6″ × 12′. Collection Bernice Steinbaum, New York

Colorplate 279. ROBERT ZAKANITCH. *Black Mint.*
1983. Acrylic on canvas, 90 × 85″. Collection
Martin Margulies

Colorplate 280. KIM MACCONNEL. *Le Tour.*
1979. Acrylic silkscreen on fabric,
86½ × 87½″. Collection
Anita Grossman

Colorplate 281. ROBERT KUSHNER. *Blue Flounce* from *Persian Line*. 1974. Acrylic on cotton with miscellaneous fabrics and fringe, 86 × 75″. Courtesy Holly Solomon Gallery, New York

Colorplate 282. VALERIE JAUDON. *Tallahatchee*. 1984. Oil and gold leaf on canvas, 80 × 96″. Courtesy Sidney Janis Gallery, New York

Colorplate 283. JOYCE KOZLOFF. *Mural for Harvard Square Subway Station: New England Decorative Arts.* 1984. Tiles, 8 × 83′ overall

Colorplate 284. RODNEY RIPPS. *Space Man.* 1981. Oil, wax cloth, canvas, wood, copper tubing, and aluminum, approximately 10 × 10′. Collection The Rothchild Bank A. G., Zurich. On loan to the La Jolla Museum of Contemporary Art, California

Colorplate 285. SUSAN ROTHENBERG. *Bucket of Water.* 1983–84. 84″ × 91″. Private collection

Colorplate 286. JOE ZUCKER. *Merlyn's Lab*. 1977. Acrylic, rhoplex, and cotton on canvas, 8 × 8′. The Whitney Museum of American Art, New York

Colorplate 287. DONALD SULTAN. *FOUR LEMONS, February 1, 1985*. 1985. Oil, spackle, and tar on vinyl tile, 97 × 97″. Collection the Artist

603

Colorplate 288. NEIL JENNEY. *Meltdown Morning.* 1975. Oil on panel, 2′1⅜″ × 9′4½″. Philadelphia Museum of Art. Purchased: Samuel S. White, 3rd., and Vera White Collection (by exchange) and funds contributed by the Daniel W. Dietrich Foundation in honor of Mrs. H. Gates Lloyd

Colorplate 289. JENNIFER BARTLETT. *Rhapsody* (detail). 1975–76. Enamel and baked enamel silkscreen grid on steel plates; 988 plates, 12 × 12″ each, 7′6″ × 153′9″ overall. Collection Sidney Singer, New York

Colorplate 290. WILLIAM WEGMAN. *Blue Period.* 1981. Color Polaroid photograph. Private collection

966. CHUCK CLOSE. *Linda*. 1975–76. Acrylic on linen, 9 × 7′. Private collection

like the *fa presto* pictures of Arikha, may in fact require weeks or even months to execute. A case in point is the Photorealist painting of Chuck Close, who began his career as a late Abstract Expressionist, only to find himself, as did so many artists of his generation, at a creative impasse, and in need of finding what he called "new ways to make marks which make art." Like the Minimalists, Close sought to gain control of his work by subjecting it to a system, a system however derived not from some mathematically reductive or organic process but rather from photography and the techniques of photomechanical printing. While the camera-made image changed him from an abstractionist to a Realist, it also imposed the discipline of a fixed model that told precisely what the painting should look like even before it had been started (fig. 966). Furthermore, Close banished all color and worked exclusively from black-and-white images, gave up thick, luxurious paint, and permitted himself only a few tablespoons of pigment for a huge, mural-size canvas. And the latter was possible once he threw out his bristle brushes and adopted the airbrush, the better to eliminate all response to medium and surface and thus achieve an even facture resembling the

smooth, impersonal surface of a photographic print or slide. At the same time that Close used a photograph as his point of departure, in lieu of the drawings, studies, or time-consuming observation employed by traditional Realists, he committed himself to the long, arduous labor of transferring the image and all its information onto the canvas by means of a grid, a uniformly squared pattern comparable to the screen that makes tonal variations possible in photomechanical printing. The grid has served painters for literally centuries as a device for transferring compositions from one surface to another, usually while also changing their scale, but only with Photorealism did the squares become so small that they could assure the most minute facts, as well as overall form, or so insistent as to become a dominant characteristic of the art. After graphing both the photo and the canvas in exact proportion to one another—so that, for instance, a ratio of one to ten would transform a quarter-inch square on the canvas—the artist could enlarge his photographic print by means of an opaque projector and, square by square, proceed to reproduce the image on the adjacent canvas, using the airbrush or whatever marking instrument he may pre-

967. CHUCK CLOSE. *Robert/Square Fingerprint II.* 1978.
Pencil and stamp-pad ink on paper, 29½ × 22½".
Collection Mr. and Mrs. Julius E. Davis

fer. So mechanically reliable is this method—to the point of registering variations in focus caused by limited depth of field—that if, as Louis K. Meisel has written:

> . . . an 8-by-10-inch color photo were to be gridded into 10,000 tiny squares, each the size of a pencil point, and a canvas of equal size were gridded the same way, then theoretically the first 10,000 people on line waiting to buy tickets to the Super Bowl could be enlisted to create a Photorealist work of art. Each one, presented with the photo, the canvas, and a set of colored pencils, could select the pencil corresponding to the dominant color in his or her assigned square on the photo and mark the corresponding square on the canvas. (On both the photo and the canvas, all but the assigned squares would be masked from view.) The result would be an exact and impersonal visual duplication of the photo.

But as though to counterbalance the mechanical impersonality of this process, Close decided to paint only the faces of himself and his friends, only their heads full front and close up, and usually on a vast, even billboard scale. Trapped in a shallow, almost airless space and pitilessly exposed in all their porous, hirsute imperfections, the friends especially reveal their self-sacrificing intimacy with the artist—which the months required to execute some of the portraits could only have intensified—at the same time that they also appear as much heroicized as exploited. If the "new way" Close found to "make marks" seems dehumanized and simplistic, it has nonetheless permitted him to "make art" that is ripe with human complexity, as iconic as early American portraiture, as defiant as a police mug shot, and as exalted as a colossal sculpture head of the Emperor Constantine, yet endowed with the touching vulnerability of all those types. Andy Warhol, too, does photographically produced

"mug shot" portraits (fig. 712), but usually of media personalities and in a manner to guarantee a sensationalized, tabloid effect, and never with the intimacy of either extensive handcraftsmanship or personal involvement.

Eventually Close progressed toward color, at first by reproducing, one on top of the other, the cyan, magenta, and yellow separations used in photomechanical color printing of the same image. Now he tends to select the one color most suited to each grid cell, choosing from a thousand different pastels. The more Close experiments, however, the more he seems to move away from Realism as such toward greater involvement with process, which has inevitably carried his art back toward the abstraction where it began. Such a development is especially evident in the "Fingerprint" drawings, for which the artist filled each unit of the ubiquitous grid with an impression of his own fingerprint inked on a stamp pad (fig. 967). While this heightened the desired tension between the mechanical and manual aspects of the technique, as well as the fluid and fixed elements of the image, it so tipped the balance between image and system that the former seems all but devoured by the now dominant and voracious grid, where the artist has asserted less the identity of his sitter than his own controlling, fingerprinted presence. In this instance, at least, it would appear that, as always in high modernism, art and its techniques have prevailed over subject to become the "subject" in the overriding interests of form.

RALPH GOINGS (b. 1928) Although scarcely less dependent on system than Chuck Close, the California artist Ralph Goings employs a different process for blowing up and transferring the information contained in his photographic sources. And relative to Close, he would appear to be clearly more concerned with emphasizing subject matter, given the fact that his handling is so seamlessly perfect as to become virtually transparent (fig. 968). The mechanical or semimechanical means preferred by Goings happens to be the one most consistently adopted among the Photorealists, which is simply to project a slide or transparency onto the canvas and there paint over the projected image. Unlike Close, Goings uses bristle brushes rather than the airbrush, but with such sovereign technique that the smooth, glossy surface it produces seems as impersonal and devoid of touch as that of an actual

968. RALPH GOINGS. *Airstream.* 1970. 5′ × 7′1″. Museum of Modern Art, Vienna. On loan from the Neue Galerie-Sammlung Ludwig, Aachen, West Germany

969. RICHARD ESTES. *Hotel Paramount.* 1974. Gouache, 14¼ × 19½".
Private collection

photograph. At first glance, nothing could be more neutral or dispassionate than this brilliant reduplication of what is itself a duplicate of reality, but once the conscious artificiality of the painting blends with the synthetic character of the scene it describes—the highway culture of pickup trucks, house trailers, and fast-food stands—there emerges a near unbearable sense of anonymity and alienation. Pop Art dealt with similar subject matter but never without alteration, if only by context, or the saving grace of humor, but in Goings's work an ersatz, rootless world appears all the more deadly for having been presented with such photographic exactness, made possible by the incongruous sublimity of the artist's solid, painstaking craftsmanship.

RICHARD ESTES (b. 1936) If there is an art with the quintessential Photorealist look, it may well be that of Richard Estes, possibly because this painter is the least systematic and the freest of all those attempting to imitate photographic images (plate 272). Estes, for instance, does not work from a single photo but rather from two or more, combining them in various ways until his own painting has the "feel" he wants, something more complex and thus more convincing than what could be mechanically recorded by camera. And not only does he paint with bristle brushes; he also wields them with swift assurance and a firm, structuring stroke almost worthy of Manet or Cézanne. Such painterliness may account for the glittering contrasts that bring the whole of his image alive, making it seem still more like a luminous transparency than the works of Photorealists who, striving for smooth transitions, abolish every symptom of personal "handwriting." In addition, Estes is a masterful, if covert, composer, for much of the heightened sense of reality—of superreality—generated by his pictures derives from subtle refinements of order and organization, such as the diptychlike division seen in figure 969, which the camera can rarely find in the randomness of the natural or manmade world. All these qualities combine to make Estes seem the Vermeer or Canaletto of the grotesquely urbanized Post-Minimal age. But he also belongs very much to modernism, for not only do his pictures have all the flat, planar qualities of their broad sheets of reflective glass, but those very surfaces, albeit transparent, reveal less what is in the depicted depth than what is forward of the painting surface, an inside-out world reflected from the viewer's own space (fig.

957). Reinforcing the sense of utter flatness is the uniformly sharp focus with which the artist, thanks to his photographic model, has been able to resolve upon the painting's two-dimensional surface every bit of a vast quantity of visual information, however far or near. The richness of such an image reveals the importance of the camera to this new variety of realism, for never would a painter, however virtuosic his skills, be able to render all that Estes has in a single work, or with such clarity and precision, merely by studying the subject directly. In the time required to complete the picture, everything would change—the light, the reflections, the weather, the season, the presence or absence of people and traffic, and certainly the commercial displays. The methods of traditional Realism could not possibly freeze a modern urban jumble to one split second of time. As for that scene, Estes is free enough to call it "hideous," adding: "I don't enjoy looking at the things I paint, so why should you enjoy it?" Still, for all their nuanced, breathtaking artistry and immense optical complexity, the pictures remain an icily beautiful vacuum, empty of overtly moralizing content. And none is needed, for having been so lucidly presented, the evidence is self-indicting.

AUDREY FLACK (b. 1931) The first artist to paint a genuine Photorealist picture was Audrey Flack, who not only returned to illusionism, from her early career as an Abstract Expressionist, but also revived certain thematic concerns guaranteeing an emotional and psychological content remote from the cool detachment characteristic of Photorealist art. In one unforgettable series Flack created her own contemporary versions of the seventeenth-century *vanitas* picture (fig. 970). These are still-life compositions positively heaped with the jewels, cosmetics, and mirrors associated with feminine vanity, mixed, as in Old Master works, with skulls, calendars, and burning candles, those ancient *memento mori* designed to remind human beings of their mortality and thus the futility of all greed and narcissism. Flack also composes in a traditional way, assembling the picture's motifs and arranging them to suit her purposes. Only then does she take up the camera, make a slide,

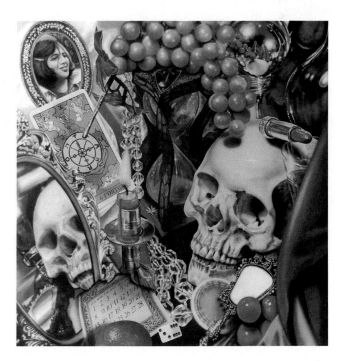

970. AUDREY FLACK. *Wheel of Fortune.* 1977–78. Oil and acrylic on canvas,
8 × 8'. Collection Louis, Susan, and Ari Meisel

above: 973. DON EDDY. *Bumper Section XXI: Isla Vista.* 1970. Acrylic on canvas, 34 × 48". Collection Arthur Levitt, New York

right: 974. DUANE HANSON. *Football Player.* 1981. Polyvinyl, polychromed in oil with accessories, lifesize. Lowe Art Museum, University of Miami. Museum purchase with funds from Friends of Art and public subscription

project it onto the canvas, and paint over the image with an airbrush. Although jammed and cropped like Mannerist still lifes, Flack's pictures possess a lushness of color, a spatial complexity, and a vastness of scale that speak clearly for the time and place in which they were executed.

MALCOLM MORLEY (b. 1931) Malcolm Morley, a British artist resident in New York since 1958, also had an early engagement with Photorealism, but given his disinterest in simulating the peculiar, glossy look of photographic images, he should be regarded as only tangentially related to the style. This, however, does not in any way diminish his importance as an artist, for Morley is in fact a master whose unrelenting search for the nature of meaning, in paint and in life, has led him in a variety of fascinating but label-defying directions. In 1969–70 one of these found the artist using photographic material as his essential study or "drawing" for a painting. This, however, was not a projected image but rather a color illustration from a magazine or a travel brochure (fig. 971). After dividing up the model into numbered squares, Morley would enlarge and transfer them, one by one, to the canvas, often painting the image upside down as an added means of maintaining the superiority of abstract process. In this instance, process offered the dual advantage of delivering the artist from involvement with the standard tricks of *trompe-l'oeil* painting, while also ensuring that the abstractly rendered image would evince something of the reality reflected in its source. But to acknowledge the artificiality of that source, Morley even retained the white border that normally surrounds a color reproduction or photographic print. Although he has denied overt political content, his choice of subject matter—Americans at some sort of simpleminded play at a time of grave social unrest—could not but place under devastating scrutiny such once-unchallenged values as the commercialized drive for affluence and power. In the Photorealist art of Malcolm Morley, subject and system would seem to combine to make a sardonic declaration that the New Realism was in fact a "New Artificialism."

ROBERT COTTINGHAM (b. 1935) Another Photorealist with a British connection is Brooklyn-born Robert Cottingham, who spent the years 1972–77 in London, all the while continuing to work from slides taken in America, largely of pre-World War II electric advertising signs, such as those on movie theater marquees, even with their bulbs removed and replaced by neon tubing (fig. 972). The foreign residence would seem to have reinforced the nostalgia already present in the subject matter, especially when the latter has been deliberately cropped to create "now" words remote from the original whole or its meaning, but close to the word play so beloved by the Conceptualists. Cottingham confesses to the element of humor and sentiment in his work, as well as to the fascination he feels for letters and for the tension produced by hard edges, brilliant, posterlike colors, and oblique angles, all to some degree the products of his earlier career in advertising and illustration.

DON EDDY (b. 1944) The youngest of the Photorealist painters is Don Eddy, a native of California whose automobile culture provided most of the imagery in the artist's earlier works. Here, however, Eddy often turned literalism inside out, by practicing synecdoche—that is, by making the part serve for the whole (fig. 973). But so abstract is the frontalized part that it scarcely refers to the whole or to the world at large, which, paradoxically, is very much accounted for, in the weird, violently distorted way of a reflection in a chromium-plated bumper section. At the same time that this segment of reality harks back to such 1920s abstractions as Fernand Léger's *Baluster* (fig. 250), other pictures by Eddy seem remarkably contemporary with the 1970s emerging

Pattern and Decoration movement. This may be due in part to the artist's habit of working from black-and-white photographs and of coloring for effects that are more synthetic than factual. This is especially evident in *New Shoes for H* (plate 273), a tour de force wherein Eddy has used an eye for excerpted detail to conflate the three spatial worlds in which the painter always operates—the picture plane, here presented by the sheet of transparent glass; the realm in depth beyond that surface, a surface verists always treat as transparent; and the point that establishes the perspective, the artist's own space, a reflection on the plate glass—all brought together, despite their obvious disparity, with a logic that only photography could capture. In the end, *New Shoes for H* becomes a metaphor for painting as Western art had then known it from Renaissance illusionism through modernism's abstract flatness and Surrealist juxtaposition, like that in Atget's shop-front photographs (fig. 316), to the new artificialism, complete with strong surface pattern and decorative color.

DUANE HANSON (b. 1925) Nowhere do the ambiguity and tension between the realness of artificiality and the artificiality of reality yield more bizarre effects than in the work of Duane Hanson, whose lifesize, freestanding sculptures would seem, at first glance, to close the famous gap between art and life with a rude, decisive bang (plate 274; fig. 974). To achieve such verisimilitude—in which artifice truly assumes the artlessness of literal reality—Hanson uses direct casting from live human beings the way super-Realist painters use photography, as a means of shortcutting the preparatory work so that the artist can devote the whole of his time and energy to virtually duplicating the look of the model. So successful is the resulting counterfeit that the delight its recognition can produce in viewers may suddenly turn to horror, when what appears to be breathing flesh and blood fails to breathe, remaining as stiff and static as death, like victims of catalepsy or simple stroke. Having cast the figure in fiberglass-reinforced polyester resin, Hanson adds to the textured reality of pores, wrinkles, and bulges the coloration of skin, veins, and even boils and bruises. Such waxworks literalism stands in fascinating contrast to the figural sculptures of George Segal (plate 225), who also casts from live models, but avoids confusion between reality and make-believe by using the colorless, or all-white, mold as the final form, whereas Hanson takes the next step and casts the negative but lifelike shape within. Furthermore, Segal restricts his use of actual objects to environmental props, while Hanson adds them to the figure itself as clothing and accessories. Curiously enough, Segal's figures have an unmistakable presence that becomes an uncanny absence in those of Hanson, possibly because of their failure to deliver what they appear to promise—warm, sentient, *speaking* life. Even though Segal's pieces display the spooky whiteness of their plaster material, it is Hanson's figures that seem like ghosts, decayed and discarded bodies whose spirits reside elsewhere. This may be in some distant past when careless overindulgence still afforded instant gratification, and had yet to produce the physical bloating and intellectual starvation observed by Hanson among the retirees living in Florida, where the artist has been active, off and on, since 1962.

JOHN DE ANDREA (b. 1944) Another hyper-Realist sculptor whose cool, scientifically objective reportage combines with a special subject matter to become simmering social commentary is John De Andrea. But by selecting perfect specimens from the springtime or high summer of life, rather than from its late autumn and winter seasons, De Andrea creates male and female figures that seem modern, biologically accurate reincarnations of the Classical ideal of dynamic beauty in graceful,

975. JOHN DE ANDREA. *Woman Sitting on Stool.* 1976. Polyester, resin, and fiberglass, lifesize. University of Virginia Art Museum, Charlottesville

harmonious repose (fig. 975). De Andrea, too, casts from molds made on the living figure, but by adding only hair to the nude form and coloring its surfaces with the greatest delicacy, until they have all the translucency of the untarnished human epidermis, he comes forth as a Classicist who, by contrast, makes Duane Hanson assume the mantel of Expressionism. But if Hanson's images look as if they had died, De Andrea's could be said never to have lived, so closely do they resemble store-window mannequins. It is as if the disheveled alienation of Hanson's senior citizens had begun in milk-fed vacuousness. As for the artist's own attitude toward the sculptures, De Andrea has said: "I always work toward some idea of beauty, and I thought that if nothing else comes of this at least I'm going to make a beautiful figure.... I set up my own world, and it is a very peaceful world—at least my sculptures are."

PHILIP PEARLSTEIN (b. 1924) The illusionist revival that produced Photorealism in painting and super-Realism in sculpture also regenerated naturalistic painting based on the traditional method of direct and prolonged examination of the model or motif. But even there, much of the new art evinced a distinctly photographic look, which hardly seems surprising, given the dominance of camera-made imagery in an age increasingly saturated by the media. One of the preeminent masters of directly perceived, sharp-eyed Realism is Philip Pearlstein, a painter who belongs to the Pop, Minimalist, and Conceptual generation and even shares its preoccupation with banal subject matter, two-dimensionality, cool, hard-edge handling, and system. Meanwhile, however, Pearlstein reached his artistic maturity about 1970, and did so with an art devoted to the nude figure represented as solid form in simulated depth (fig. 976). This, of course, made him, along with John De Andrea, an heir to Renaissance *trompe-l'oeil* Classicism, which Pearlstein, with all the strength and independence that are uniquely his, set about to integrate with modernism's flatness and cropping, characteristics initially fostered by the nineteenth-century invention of photography. Thus, at the same time that he reproduces his figures in all their sexual explicitness, he also robs them of their potential for Expressionist content by a process of depersonalization, which entails a system— somewhat like Close's, although unrelated to photography—of rendering only one part of the anatomy at a time, never in the Cézannesque manner of the whole all at once. The image simply grows outward toward the edges of the canvas and discovers them where it will, which results in the loss of extremities, a further depersonalization that becomes especially acute when it involves the head. Still, this helps flatten the heavily plastic forms, just as the tilted perspective does, while unifying and structuring the picture in a rhythmic arrangement that links human part to human part throughout the visual field. The painter calls his pictorial manipulation of the figure "a sort of still-action choreography," which he composes and recomposes with seemingly boundless invention. In a now-famous statement, Pearlstein, a highly educated and articulate man, declared:

> I have made a contribution to humanism in 20th-century painting— I rescued the human figure from its tormented, agonized condition given it by the expressionistic artists, and the cubist dissectors and distorters of the figure, and at the other extreme I have rescued it from the pornographers, and their easy exploitation of the figure for its sexual implications. I have presented the figure for itself, allowed it its own dignity as a form among other forms in nature.

Consistent in his methodology, Pearlstein leaves the studio and works *plein air* on those few but important occasions when he turns to landscape (fig. 977). But just as with the figure, the subject interests him less for its own sake than as a source of shapes capable of humanizing a paramount concern with formal issues. As Pearlstein himself explained: "I'm interested in abstraction—subject matter never interests me in any work except Dickens." This can be seen here in the tense equilibrium the artist has struck between linear precision and generalized, or undifferentiated, texture, a view into infinite depth and a vast surface-adhering, recession-blocking wall, the cubic geometry of the foreground manmade structures and the overall organic configuration of the weather-scarred rock face.

ALEX KATZ (b. 1927) Alex Katz made an early choice of figuration and stuck with it throughout abstraction's interregnum, whose sources of inspiration, such as Henri Matisse and Milton Avery (plates 34, 174), he turned to his own purposes. Foremost among these are broad fields of flat, clean color, elegantly brushed surfaces, radically simplified drawing, and epic scale (fig. 978). Selecting his subjects from among his family, friends, and art-world personalities, Katz monumentalizes them not only by the sheer size of the painted image but also by the technique of representing the sitters only from the shoulders up, as if they were antique emperors or empresses presented to the public in the

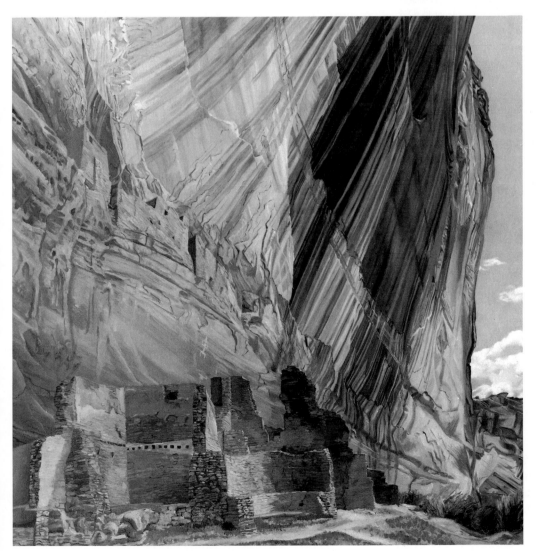

above left: 976. PHILIP PEARLSTEIN. *Two Female Models with Regency Sofa.* 1974. 60 × 70". Allan Frumkin Gallery, New York

left: 977. PHILIP PEARLSTEIN. *White House Ruin, Canyon de Chelly—Morning.* 1975. 5 × 5'. Collection Mr. and Mrs. James R. Patton, Jr.

above: 978. ALEX KATZ. *Good Morning #2.* 1974. 8 × 6'. Marlborough Gallery, New York

form of portrait busts (plate 275). But since the rendering has been done with a reductiveness reminiscent of movie billboards, the association would seem to be more with the royalty of Hollywood than with that of monarchical Europe. Katz has declared: "I like to make an image that is so simple you can't avoid it, and so complicated you can't figure it out." By this he means the tension that remains in a painting as a result of its having translated reality into purely pictorial language. To illustrate, Katz has used the painting seen in plate 275: "The original background was green grass," he said. "But when I painted green, it just didn't have enough light in it. It didn't show the light that I was seeing. So I turned it to yellow, switched to violet, and then to orange. Finally, that was a plausible light, the light I was really seeing, instead of just a bunch of pretty colors. It was a glowing summer light." For just such complexity within simplicity, Katz has become something of an alter ego to a number of figurative, even Expressionist artists, such as Eric Fischl, David Salle, and Francesco Clemente.

JANET FISH (b. 1938) Even as figurative artists succeeded in overturning the dominance of Minimalist abstraction, they betrayed their roots in that rejected aesthetic by translating its stillness and silence into a kind of frozen, stop-action image that only the camera could produce. And this was true, as we have seen, even in the work of painters, such as Pearlstein, who adamantly excluded photography from their creative process. Given its markedly static character, almost all of the New Realism could be seen as a variety of still life, whatever its subject matter. Inevitably, therefore, genuine still-life motifs made a stunning reappearance in painting, long after their early career in modernism, when artists favored inanimate, anonymous subjects as more conducive to cool, formalist manipulation or distortion than, for instance, the human image, with all its complicated moral and psychological associations. A true master of still-life genre is Janet Fish, who reaches back to the seventeenth century, that supreme age of still-life painting, in her use of profound craftsmanship for the purpose of revealing the radiant beauty present in the most commonplace objects. But far from making herself a captive of the past, Fish exploits old precedents as a means of expanding the possibilities of her modernist experience, which began in Abstract Expressionism. That experience also includes a taste for Pop subject matter, usually glassware on the

980. WILLIAM BAILEY. *Monte Migiana Still Life.* 1979. 54$\frac{3}{16}$ × 60$\frac{3}{16}$″. Pennsylvania Academy of the Fine Arts, Philadelphia. Purchased with funds from the National Endowment for the Arts (Contemporary Arts Purchase) and Bernice McIlhenny Wintersteen, The Women's Committee of the PAFA, Marion B. Stroud, Mrs. H. Gates Lloyd, and Theodore T. Newbold

order of fruit jars, gin bottles, dishes, tumblers, and goblets (fig. 979). These she assembles in sufficient numbers to suggest the serial repetitiveness so meaningful to sensibilities nurtured during the 1960s, yet with a freedom and invention, as well as an all-over distribution of accents, more akin to gestural Field painting than to Andy Warhol's serried rows of Coca-Cola bottles, with their implied commentary on mass-produced overabundance (plate 222). Far from ambivalent toward the material world, Fish seems to be in love with it (plate 276), or at least with those of its artifacts usable as vehicles for her interest in creating a dazzling array of chromatic and luminary effects, reflected from sparkling, prismatic forms and trapped within jeweled overlays of transparent glass and liquid, their glinting brilliance set forth against the near, plain background of a shallow, modernist space.

WILLIAM BAILEY (b. 1930) In contrast to the scintillating light and color of Janet Fish, William Bailey paints a tabletop still-life world of opaque crockery softly bathed in a low, suffused, even romantic light (fig. 980). The sheer serenity of the effect must emanate as much from the artist's practice of re-creating his "memory" of the motifs as from his preference for harmoniously balanced compositions of smooth, sensuous shapes and volumes juxtaposed in a limited space against the starkest of flat grounds. Acknowledging influences from the quietest still-life art of Giorgio Morandi, the color theories of his Yale teacher Josef Albers, and the rigorous geometries of Piet Mondrian, Bailey transcends them all to realize an intensely personal vision compounded of objective imagery refined to its essence and an abstract framework of ideal, Classical simplicity.

NEIL WELLIVER (b. 1929) Landscape too served early modernism well, as an image sufficiently neutral and generalized to permit, just as still life did, an objective analysis of form and space without generating

979. JANET FISH. *Three Pickle Jars.* 1972. 30 × 42″. Private collection

an unwanted Expressionist content. Conversely, an age-old pantheism made landscape the ideal agent for those more subjective modernists compelled to distort or synthesize reality for the sake of expressing inner, emotional states or some intuition of a universal sublime. Now, Neil Welliver would seem to draw on both traditions in his use of landscape as a way out of abstraction's exclusivity, and into a more inclusive, feeling-filled art, while also preserving the same sort of modernist structure that landscape originally encouraged. In the forests and swamps of Maine, where he has painted for many years, Welliver senses himself at one with Thomas Cole, the early nineteenth-century American master of the Romantic landscape, in wanting to capture the myth and spirit of primeval nature. Meanwhile, he studied under Josef Albers at Yale and has declared it his aim "to make a natural painting as fluid as a De Kooning." Indeed, his command of technique and his devotion to subject are such that, in epically scaled views like the one seen in plate 277, he succeeds in presenting a wealth of precise data by means of lines and colors whose ramified patterns yield a pictorial effect almost as decoratively flat, yet airy and open, as the paintings of the 1950s abstractionists. At the same time, Welliver's landscapes, with their crystalline light illuminating a limpidly pure, preindustrial world, have their own special poetry (fig. 981), which the critic Bill Sullivan has described as "not a Turneresque desire [on the part of the artist] to experience the extremes of nature at its most awesome and frightening, but rather a desire to be at peace with his world at all times and seasons."

ALFRED LESLIE (b. 1927) So far, the painters seen in our examination of resurgent illusionism abjured Minimalist values mainly by readmitting into art a kind of perceptual imagery that the purists among the moderns considered anathema. When it came to structuring their pic-

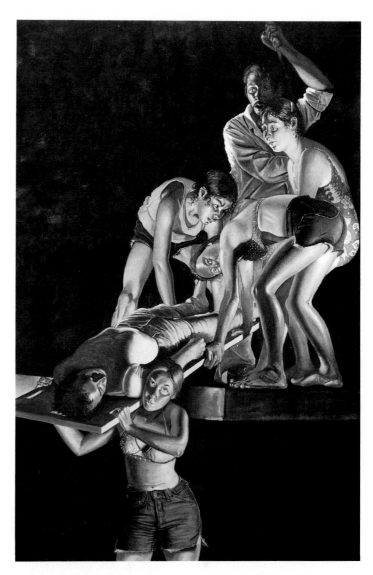

982. ALFRED LESLIE. *The 'Killing' Cycle (#5): Loading Pier.* 1974–75. 9 × 6'. Photograph © Alfred Leslie. Collection The Orchard Corporation

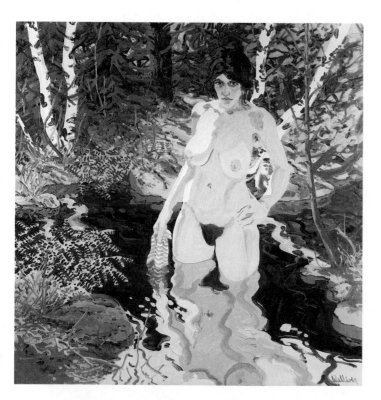

981. NEIL WELLIVER. *Girl with Striped Washcloth.* 1971. 5 × 5'. The Whitney Museum of American Art, New York. Purchased with funds from Charles Simon

tures, however, they generally found it either impossible or unnecessary to break free of the hard-won but now deeply ingrained principles of modernist form and process. Indeed, Neil Welliver does not hesitate to say of contemporary Realism that "its vitality comes from its immediate predecessors." Clearly, the impulse among the new factualists was not so much to destroy the tradition that had nourished them as to open it up and make it more generous and accepting, perhaps even democratic, than the elitist self-reference of modernism's late Minimalist phase would tolerate. But whereas the Neo-Realists seen here generally made certain that, in the relationship between form and subject, the very commonplaceness of the latter would ensure its subordination to, or at least equilibrium with, the former, other painters newly converted to Realism have shifted the weight quite heavily in favor of an all-important subject matter illusionistically rendered, mainly for its power to influence the mind and heart by deceiving the eye. Far from wishing to extend the premises of modernism, these artists pretend to have turned altogether against them, which they denounce as unmistakable symptoms of the essential soullessness and inhumanity of industrial, technological society. Alfred Leslie, for instance, had achieved considerable success in the 1950s as a second-generation New York abstractionist, only to reverse his direction during the following decade and opt for

both an aggressive realism *and* a renewal of the traditional genres or subject types, with all their narrative, symbolic, and didactic content. In his often announced desire to persuade and reform the world, Leslie became a much more determined and public moralist than Audrey Flack (fig. 970), although he too looks to the seventeenth century for his iconographic models, as well as for his dramatic, even tenebrous, Realism. An exceptionally striking work is the fifth in a series of seven enormous paintings entitled The Killing Cycle (fig. 982), a decade-long project undertaken as a memorial to Frank O'Hara, a poet-critic friendly to Leslie's generation of American artists. O'Hara had been felled by a beach taxi while standing on the sandy shore of Fire Island late one night in the summer of 1966. To give the picture genuine specificity of time and place, Leslie spent months researching the circumstances of the accident; then, to endow it with universal significance, he based the composition and its powerful chiaroscuro effects on Caravaggio's great *Entombment of Christ* in the Vatican collections (fig. 9). Thus detailed and enlarged, the picture transcends its initial inspiration to become an indictment of the mindless waste in modern life. Simultaneously, the image of the moribund O'Hara reverentially borne to his final rest by anonymous strangers assumes the quality of a Christian appeal for the unity of all humankind.

JACK BEAL (b. 1931) Alfred Leslie, perhaps despite himself, has often disclosed his modernist origins by frontalizing his figures within a shallow bas-relief space. Jack Beal, on the other hand, attempts to "divest" his painting of all such formalist conventions, since for art to become a moral force, which Beal believes to be its ultimate raison d'être, it must serve as the medium of a didactic message, conveyed through a faithful representation of the human face and figure. Surely one of the most rhetorical paintings done in recent times—by a Western artist, at least—is Beal's *Harvest* (fig. 983), which the critic Donald Kuspit has interpreted as a vast compendium of mythological archetypes presented in a modern-dress reenactment of some ancient paean to Nature for her autumn bounty. Thus, the trellis overarching the blue-jeaned young woman transforms the figure into a goddess of fertility and abundance, an identity reinforced by the harvest pattern on her blouse and the giant, burstingly ripe tomatoes she places on the wheelbarrow. Further adding to the aura of transcendental meaning is the male figure, kneeling humbly as if he were Joseph acknowledging the divine role for which his Mary has been chosen. But even here, in this revisionist world of Christian and pagan iconography, a modern or Freudian, but altogether relevant, note can be detected in the phallic shovel stem held erect near the womblike wheelbarrow. Confirming the artist's intent to sanctify the present by saturating its empirically observed phenomena with age-old emblematic import are the utter solemnity of the mood and the ambitious eight-foot-square format. In *Harvest*, illusionism joins with mythic content and modern imagery to become a Puritan sermon on the urgent need of humanity to rediscover its original harmony with the natural environment, and thus escape the brutal destructiveness of late twentieth-century existence.

983. JACK BEAL. *Harvest.* 1978–80. 8 × 8′. Courtesy Galerie Claude Bernard, Paris

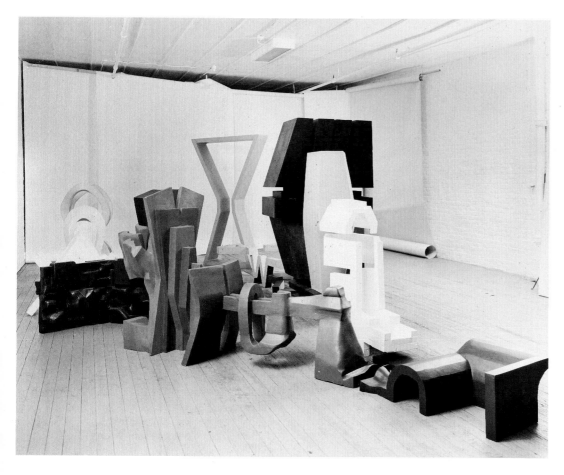

984. GEORGE SUGARMAN. *Two-in-One.*
1966. Polychromed wood,
7′ × 11′6″. Courtesy Robert Miller
Gallery, New York

Pattern and Decoration

Where convinced modernists saw Minimalism's aloof stillness, silence, and simplicity as potent with rarefied meaning, others could comprehend only a void, vast as the monumental scale preferred throughout late modern art and begging to be filled with a richly varied, even noisy abundance of pattern, decoration, *and* content. Here indeed was rebellion, for in the formalist's vocabulary of terms, the words "pattern" and "decoration" were fraught, still more than "illusionism," with pejorative connotations. And the taboo prevailed even though pattern—a systematic repetition of a motif or motifs used to cover a surface in a decoratively uniform manner—has an effect fully as flattening as any of the devices employed by the Minimalists. However, such a configuration suffered the defect of traditionally having been done by anonymous artisans, not individuals of known genius, and usually for the purpose of endowing mundane or utilitarian objects with an element of sensuous pleasure and delight, qualities thought to be secondary to the more intellectual values sought by those called to create the purely aesthetic, or nonpractical, works of high art. Thus, despite Duchamp, whose readymades proved that context can make the art, skeptical purists wondered how objects formed from designs, materials, and techniques associated with the crafts, folk art, and "women's work" could be transformed into vehicles of significant content. After all, even the Photorealists claimed little more than an indifferent attitude toward their everyday subjects.

The answer, of course, lay readily at hand, in the sources of inspiration for the new "Pattern and Decoration" movement, often abbreviated to P&D and sometimes called "The New Decorativeness," which began to stir in the early 1970s and coalesced as a major development in the second half of the decade. First of all, there was Matisse, a proud "decorator" in the grand French tradition, whose late brilliantly colored and patterned paper cut-outs had lent new joy to religion at the Vence Chapel (fig. 368), at the same time that they provided radiant models for 1960s Color Field painting (plate 117). Then, there were the arabesques and fretwork of Islam's intensely metaphysical art, the pantheistic interlaces of the medieval Celts, and the symbol-drenched geometries of Native American art, all recently brought into stunning prominence by important exhibitions or installations. Finally, but perhaps most important of all, came the so-called "craft" works—carpets, quilts, embroidery, needlepoint, mosaic, wallpaper—suddenly elevated in the artistic hierarchy along with the emerging power of women and the Third World. Apart from its irrefutable beauty, such patterned, decorative, and pragmatic "folk" art gained esteem for its content, its value, that is, as witness to the courageous determination of long-disenfranchised segments of humanity to satisfy innate aesthetic needs, despite unremitting exclusion from the mainstream of cultural experience. Pattern painting, albeit based on the same grid as that underlying formalist structures of Minimal Art, elected not to be trapped by its own system in self-serving exclusivity, but rather to embrace everything, from the gorgeously decorative painting of Gustav Klimt and Paul Gauguin to Frank Stella's exotic Protractor and Indian Bird series, Lucas Samaras's rainbow-spectrum yarns and glitz, and the rhythmically patterned sprawl of George Sugarman's polychrome sculpture (figs. 731–733, 984)—even to Japanese kimonos and Yves Saint-Laurent's sumptuous "peasant style." Writing in 1978, the critic Carey Rickey succinctly caught the rigor as well as the richness of this paradoxical and polyvalent art:

This is an art defiant in its dialectic and diversity. Pattern can be, at the same time, an assertion of a system and an intimation of chaos.

985. MIRIAM SCHAPIRO. *Big Ox No. 2.* 1968. Acrylic on canvas, 7'6" × 9'. Collection La Jolla Museum of Contemporary Art, California. Gift of Harry Kahn, New York

Patterning could be seen as an opulent response to the austerity and sterility of minimal and reductive art, as an extension of the "all-over" sensibility that characterizes both Abstract Expressionism and environmental art, or as geometric abstraction with exponential variables. It could be read as a positive brand of cultural imperialism that heralds rather than anonymously appropriates the designs of other (mostly Third World) cultures, and it could audaciously suggest that a utilitarian object is as worthy of contemplation as the customarily non-utilitarian art work. These are just a fraction of the statements pattern painting seems capable of making. Patterning's energy source is its refusal to eliminate any possibilities. Since it's never a domain of either/or decision making, pattern painting always seems to be saying, "but/and...." This is its strength.

In another review of P&D, the critic John Perreault declared:

Naked surfaces are being filled in; lifeless redundancy is being replaced by lively fields that engage the eye as well as the mind. The grids of Minimal-type painting are being transformed into nets or lattices for the drawing out of patterns that are sensuous and that have content that goes beyond self-reference and the immediate art context, although including both. As a structure and a process, patterning allows a greater complexity of visual experience than most non-realist, advanced painting in the recent past.

As these excerpted comments would indicate, Pattern and Decoration enjoyed broader and more enthusiastic critical support than the contemporaneous events in Photorealism. Formalists, of course, had little but scorn for the P&D artists, but the latter could find enlightened advocacy not only in the writings of Carey Rickey, the poet John Perreault, and Jeff Perrone, but also in the ideas of the late Amy Goldin, a critic deeply moved by the aesthetics and philosophical import of Islam-

ic and Oriental art. Indeed, Goldin became a catalytic force in P&D when she spent the 1970–71 academic year teaching at the University of California in San Diego, with whose art department Miriam Schapiro, Robert Zakanitch, Kim MacConnel, and Robert Kushner would all make contact before emerging into the full flower of their new decorative styles.

MIRIAM SCHAPIRO (b. 1923) Initially, one of the strongest and most seasoned talents to redeem her undervalued decorative materials into ambitious, original art was Miriam Schapiro, energized by passionate feminism as well as by a love of ornamental work, however low or high its origin. Like so many artists of her generation, Schapiro had begun painting in an Abstract Expressionist style, but later turned to Hard-Edge abstract illusionism, using computers in the design process (fig. 985). In the late 1960s she joined the women's movement, which led her to become, with artist Judy Chicago, codirector of the Feminist Art Program, which in 1970 sponsored Womanhouse at the California Institute of the Arts in Los Angeles. For this undertaking students rehabilitated an old abandoned dwelling into an exclusively female environment, alive with art works and performances based on women's dreams and fantasies. Since then Schapiro has drawn her imagery and materials from the history of women's "covert" art: buttons, threads, rickrack, sequins, and yarn, silk, taffeta, cotton, burlap, and wool, all sewn, embroidered, pieced, and appliquéd into useful but decorative objects. Reassembling them into dynamic, baroque, almost exploding compositions, the artist creates what she calls "femmages," a contraction of "female" and "image" that connotes something of the collage, découpage, and photomontage techniques used to make these grandly scaled projects. And the scale is important for Schapiro, since it reflects not only her modernist sensibility but also her desire to monumentalize "women's work" and thus repair the damage done by its long-degraded status. A major femmage of 1976 is *Cabinet for all Seasons,* composed

right: 986. MIRIAM SCHAPIRO. *Black Bolero.* 1980. Fabric, glitter, synthetic polymer paint on canvas, 6 × 12′. The Art Gallery of New South Wales, Australia

below: 987. ROBERT ZAKANITCH. *Double Shirt.* 1981. Acrylic on canvas, 6 × 5′. Private collection, Sweden

of four seventy-by-forty-inch panels, each of which has the shape of a roundheaded door and displays a rectangular *trompe-l'oeil* window, while the whole of the field is colored to express the artist's sense of the season, or her female intuition of the cyclical nature of life, and overlaid with a gridwork of embroidered handkerchiefs from every corner of the earth. In piece after piece, Schapiro formulated her new style, a synthesis of abstraction, feminist images, such as eggs, hearts, and kimonos, architectural framework, and decorative patterns in the form of floral bouquets, lacy borders, and floating flowers. In a recent series she chose the fan shape seen here—itself a decorative image—for wall-size canvases collaged with a carnival wealth of patterned materials, ranging from upholstery to cheap cotton and luxurious Oriental fabrics, and all combined to simulate the spreading folds of a real fan. A potpourri of art and craft, structure and decoration, abstraction and illusion, public politics and personal iconography, thought and sentiment, *Black Bolero* (fig. 986) and the recent *I'm Dancing As Fast As I Can* (plate 278) summarize an entire life and career, while also embodying Schapiro's desire to reunite humanity and make it whole again.

ROBERT ZAKANITCH (b. 1935) In 1975 Robert Zakanitch met Miriam Schapiro during a term of guest teaching at the University of California in San Diego, and early the following year in New York the two painters jointly organized the Pattern and Decoration Artists. The group held their first meeting in a SoHo loft space, thereupon revealing not only to the art world at large but even to the participating artists that more painting was being done than Conceptualism had allowed anyone to believe. This led to the "Ten Approaches to the Decorative" show in September 1976, sponsored by the Pattern and Decoration Artists themselves, and to a kind of collector interest that turned the recently opened Holly Solomon Gallery into a home for such P&D converts as Robert Kushner, Kim MacConnel, Valerie Jaudon, Ned Smyth, and Robert Zakanitch. When Zakanitch took up decorative imagery, he had

been working as a Color Field abstractionist faithful to the Minimalist grid as the structural system of his painting. Once into decoration, he retained both his color sophistication and his respect for structure, but translated the latter into a free, often organic lattice pattern and the former into floral motifs rendered with a painterly "lavender-and-plum" palette of almost unbearable lushness (plate 279; fig. 987). Together, the painterliness, the opulent hues, the blooms, and the latticework invite obvious comparison with wallpaper designs, which in fact hold a preeminent place among the artist's acknowledged sources.

Countering the formalists' critical disdain, Zakanitch made a lucid response: "In a sense all the arts are decorative but the differentiating element of all arts, attitudes, and cultures is Style, and it is style or stylization that I am more concerned with." In his huge trellis paintings, like those seen here, Zakanitch has transformed a wall of voluptuous, exotically colored flowers, their profusion barely contained within the diamond cells of the underlying lattice, into a grandiose painting statement. With their environmental scale and rhythmic, gestural handling, such works could be seen as a decorative artist's attempt to match the aspiration and achievement of the Abstract Expressionists, the reigning masters of the New York School when Zakanitch first entered it.

KIM MacCONNEL (b. 1946) Oklahoma-born Kim MacConnel was the senior of two students who found their artistic future through an encounter with the critic Amy Goldin and the artist Miriam Schapiro at the University of California in San Diego. Captivated by Goldin's insight into the spiritual and intellectual meaning of Oriental patterns, MacConnel broke free of the inhibiting strictures of his rigidly geometric, abstract painting and opened his art to all manner of signs and symbols, from primitive hieroglyphics and suave arabesques to American Indian and oriental rug design. He also made lavish use of cheap machine-printed textiles, combining their garish colors and figural, floral, or geometric patterns with the more subtle images from older cultures (plate 280). As further enrichment of this improbable mixture, MacConnel began adding his own painterly representations of birds, beasts, fruits, and vegetables to create a new egalitarian art of surprising beauty and repose. The sense of luxurious equipoise amidst visual riot emerges no

doubt from the democracy with which all elements have been treated alike, in a nonhierarchical arrangement of vertical strips or panels roughly sewn together and hung loose like a tapestry. In this complementary assemblage of disjunctive parts, repeating patterns lead the eye vertically, while color and formal analogies direct it laterally, for an active exploration of surface that satisfies spatial needs without the benefit of illusionistic depth. MacConnel explains it this way: "Good decoration plays off what is around it. In the sense much good art can in fact be bad decoration. It doesn't relate to anything around it. It is self-contained, self-referential. Further, I think bad decoration can be good art in that even though it may be bad art it can somehow transform an environment into something interesting." More recently, MacConnel has retained his paneled format but abandoned the collage technique in favor of hand painting the various colors, patterns, and motifs. Often the latter are now objects of contemporary nightmare, such as bombs and missiles, which the artist defuses by the simple device of assimilating them into the aesthetic equanimity of his all-embracing décor.

While absorbing the environment into his art, MacConnel also invests the outside world with his own sumptuous touch, mainly by appropriating the tackiest of 1950s junk-shop furniture and spreading his colors and patterns over every surface, from leather seats and backs to chrome or wooden arms and legs (fig. 988). It is as if he wanted to realize Matisse's famous fantasy: "What I dream of is an art of balance, of purity and serenity, devoid of troubling or depressing subject matter . . . a soothing, calming influence on the mind, something like a good armchair which provides relaxation from physical fatigue."

988. KIM MacCONNEL. *Paintings and Occasional Chairs.* 1984. Installation view, Holly Solomon Gallery, New York

below: 989. ROBERT KUSHNER. *Gold,* 1978, from *Sentimental Fables* performance. 1980. Photograph Courtesy Holly Solomon Gallery, New York

left: 990. ROBERT KUSHNER. *Sail Away.* 1983. Mixed fabric and acrylic 7'3" × 17'2". Courtesy Holly Solomon Gallery, New York

ROBERT KUSHNER (b. 1949) As the son of a well-known West Coast artist, the young Robert Kushner, MacConnel's fellow student at San Diego, brought considerable painting culture to his fateful meeting with Amy Goldin in 1970. Perhaps for that very reason, Kushner immediately saw the importance of Goldin's ideas for his own art, and in 1974 he joined the critic on an extended journey to Iran and Afghanistan. The experience became something of an epiphany for Kushner, who admitted: "On this trip, seeing those incredible works of genius, really master works which exist in almost any city, I really became aware of how intelligent and uplifting decoration can be." Although many of the master works happen to have been architectural, Kushner chose to express his love of arabesque fluency and grace not in mosaic or stone, but rather in loose, free-falling fabrics, decorated by their own "found" printed or woven patterns and Kushner's overpainting of leaf, vine, seed pod, floral, or, eventually, beast and human imagery. Like MacConnel, he disclosed a certain preference for a horizontal alignment of vertical panels, but instead of a generally evenhanded sameness of length, he assembled his materials in whatever manner would produce a costume-like work meant to be worn before being hung, unstretched, on the wall (plate 281). When donned, these richly patterned and colored pieces, often in original atonal harmonies, yielded an effect of barbaric splendor unknown since the imperial era in Oriental civilization or perhaps the heyday of the Ballets Russes. And indeed Kushner dressed up in his creations (fig. 989), as many as fifty in a sequence, for performances in Holly Solomon's New York gallery that resembled burlesque and strip tease—or mock fashion shows—much more than the visually destitute performances then being staged by the Conceptualists (fig. 912).

In his purely wall pieces (fig. 990), also structured from fabrics and airily billowing against the plane, Kushner makes an unabashed avowal

of his devotion to Matisse (plate 114), that pioneer seeker after *luxe, calme et volupté* in the ornamental opulence of the Near and Far East, where no distinction exists between fine and decorative art. Like the great Frenchman, Kushner counterbalances his passion for Oriental embellishment with a Western humanist interest in the Classical nude, flattened and all but lost in a crazy quilt of competing but subtly coordinated patterns, only to be slowly revealed, sometimes in mirror image reversals, by the patterns themselves as well as by the artist's own magisterial drawing. Of his figuration, Kushner has said:

> It's contour and weight. Those are the things I think about. If I'm drawing a figure, I really want the figure to feel like it has weight to it, which I think was Matisse's great contribution to modernist draftsmanship—simplifying it to the ultimate, but always maintaining volume, even if it was only a line.... I start by drawing in a background pattern... almost like drawing a still life. It's the figure and pattern, so I reproduce what I see and what I have set up, which is very similar to what happens in the Matisse interiors with nudes.

But given his taste for the collage process and for flat wallpaper-like patterns, obtained from a giddy mix of gorgeously embroidered kimono silk and basic gingham and glitter from the close-out stores along New York's Canal and Fourteenth Streets, Kushner would seem to find an artistic ancestry as much in the Synthetic Cubism of Picasso and Braque as in Matisse's monumental decorations. This is borne out by his willingness to section and obscure the human image for the sake of an all-determining concern with such purely aesthetic issues as line, edge, color, balance, and harmonious composition. Kushner has even said, despite his expansive, antielitist stance: "I really think of myself in a lot of ways as a very old-fashioned modernist who is using a different vocabulary of materials."

VALERIE JAUDON (b. 1945) Valerie Jaudon, a Mississippi-born artist with a cosmopolitan background, began in Color Field painting and, by grasping the decorative aspect of that style, has continued to be a steadfast abstractionist throughout her work in Pattern and Decoration. And to the degree that she is a purely nonobjective artist, Jaudon has remained closer to her Islamic sources, mingled with the interlaces of ancient Celtic Europe, than any of the practitioners seen thus far in the P&D movement (fig. 991). However, her patterns are not copied but freshly reinvented, ribbonlike paths traced over and under one another along arcs and angles reminiscent of Frank Stella's Protractor series (plate 250), but more like his Stripe paintings in their monochromatic copper, silver, or gold coloration (fig. 776). With their symmetrical order and complex weave of clean lines, which invite the eye but immediately lose it in the indivisibility of the total configuration, Jaudon's earlier maze patterns also become something of a hard-edge counterpart of the all-over, "holistic," or "nonrelational" compositions realized by Jackson Pollock in his mazes of freely poured pigment (plate 180). In more recent work, Jaudon has decelerated the *perpetuum mobile* of her interlaces by stabilizing them within a solidly grounded architectural image, capped by round domes, pointed steeples, and ogival arches (plate 282). Adding to the sense of gravity and depth are the impastoed surfaces and the brilliant, strongly contrasted colors that distinguish one band or strap from another as well as from the background. Illusionism is denied, however, thanks to the emphatic linearity of the interlocking geometries and their resolutely flattened "folds" and "knots." With an echo of strong feminism, Jaudon has said of her intricate art: "As far back as I can remember, everyone called my work decorative, and they were trying to put me down by saying it. Attitudes

991. VALERIE JAUDON. *Stateline.* 1978. Oil and metallic pigment on canvas, 6 × 6′. Collection Richard Levine

are changing now, but this is just the beginning. If we can only get over the strict modernist doctrines about purity of form, line, and color, then everything will open up."

JOYCE KOZLOFF (b. 1942) Feminism has also encouraged Joyce Kozloff in her decision to work in a decorative style, which she sees as a "third category" lying halfway between abstraction and representation. "It could incorporate elements from the other two categories," she has said, "but wasn't bound by their rules, and it had its own history." By sharing something of abstraction's intellectuality and the populism of illustrational art, decoration permits Kozloff to strive for what she considers a genuine public art, rigorous enough in form and content to be sustaining to anyone who must see it day after day, yet sufficiently open in its appeal to the collective conscious to avoid the pitfalls of works such as Richard Serra's *Tilted Arc* (figs. 951, 952). In her eagerness to dissolve arbitrary distinctions—between high and low art, between sophisticated and primitive cultures—Kozloff has taken a self-effacing attitude toward her sources and copied them more faithfully than most of her peers in the P&D movement, depending on her "recontextualization" of the motifs for the transformation necessary to create new art. At first, she sought her patterns in the Churrigueresque architecture of Mexico, but soon turned directly to its origins in Morocco and other parts of Islam. She then relocated them in independent picture or wall panels, composed of the most intricate, run-on, and totally abstract patterns, and executed in gouache on paper or canvas or silkscreen on fabric (fig. 992). The architectural sources of her inspiration eventually drew the artist into large-scale environmental works, not for exterior display, however, but rather for interiors, as large, complex installations that distributed patterns made of tile, fabric, and glass, among other materials, over every surface, ceilings and floors as well as walls.

More recently, Kozloff has gone truly monumental and designed comprehensive tile decorations for public transport stations in San Francisco, Buffalo, Wilmington, and Cambridge, Massachusetts. The lat-

ter project is virtually panoramic in its scope, stretching along eighty-three feet of wall space adjacent to a heavily trafficked ramp in the Harvard Square subway station and iconographically surveying the economic, social, cultural, and ecological life of early industrial New England (plate 283). The imagery ranges from purely abstract quilt and wall-stencil patterns to representations of clipper ships, milltowns, farm animals, tombstones, and the flowers and trees of open nature, all stylized, in the *naif* manner of the old Yankee limners and decorators, to fit within the star-shape of prefabricated tiles. As a counterbalance to the rigidity of the tesselation, the mood flows freely across the interlocking pattern of ceramic pieces, from the somberness of the tombstones to the humor of the parading cows and pigs. Still freer are the colors and handling, which modulate through a rhythmically controlled sequence, a sequence varied enough to encompass the bright linearity of the samplers and the warm, almost atmospheric painterliness used for the landscape passage. In his enthusiasm for the station works, the critic Jeff Perrone has written:

Kozloff's decorations are site-specific in their articulation of immediate, architectural space. But she has expanded this concept to embrace the period styles to be found in the place where her work finds

its home. The "site" for her is not only a spatial complex, but also an historical and geographical context.... If there was ever a reason for art criticism to take its form from its content, then it is here: the communal aspects of Kozloff's endeavor—the preference for interiors, mass transportation, indigenous material—imply a social interaction: not an interview, but a conversation, a dialogue.

NED SMYTH (b. 1948) No less committed to a reintegration of human experience, past and present, is Ned Smyth, an American artist who grew up in Italy surrounded by dedicated art historians. Smyth also likes to work on an architectural scale, even to create total, Eden-like settings comparable to the one already seen in figure 954. The very size and complexity of that piece allowed the artist to invest it with the kind of symbol-soaked decorative and structural features that have always endowed great public spaces with a flavorful and mysterious sense of place. In *Roman Gothic Arcade* (fig. 993), for instance, Smyth assembled a freestanding range of seven individually cast columns capped with flattened Egyptian papyrus capitals that linked up to form a sequence of roundheaded Roman arches above and a line of ogival or pointed arches below. Taken altogether, the arcade seemed to suggest civilization's evolution in the course of four thousand years of history,

992. JOYCE KOZLOFF. *Department of Cultural Affairs Installation.* 1981. Three pilasters: clay, grout, and plywood, height 9′. Collection Caroline Schneeback. *Tut's Wallpaper.* 1979. Two silkscreens on silk, 9′ × 3′9″. *Right silkscreen:* collection the artist. *Left silkscreen:* Roth Collection

from Egypt through the Roman Empire to the dawn of the modern era in the revival that came with Gothic. When stood before a raised fontlike basin backed by a flat fortress wall, the entire ensemble expanded to express, in purely nonfigurative terms, the tense equilibrium of opposites—church and state, openness and closure, the contemplative and the active—that coexist in society and provide both its foundation and its source of energy. True to his architectural sources, Smyth has made concrete his preferred material, which the artist continued to use when he shifted from abstract columns to figural ones in the form of wall reliefs, molded and colored, while still moist, and shaped by hand as paired caryatids. Medieval or even primitive looking, the dusky, Expressionist images represent nemeses of one another, struggling to share the same narrow vertical space as emblems of such Biblical concepts as sibling rivalry, twinship, power and submission, and the likeness of father to son. Having turned figurative, Smyth finally took up that oldest of media used to lend architectural forms a decorative or narrative element—mosaic—fashioned from the natural colors of marble and stone or from the more intense, jewellike tonalities of glass. But as the surfaces and imagery grew richer, the supporting forms tended to become even more condensed, from the environmental ensembles of the early work to pictorial wall slabs or merely a pair of columns. In *The Tree of Life*, for example (fig. 994), the themes of earthly paradise and the reverent garden have been vastly elaborated to present an archetypal drama of human ascendancy. Embedded within the tesselated pattern covering the artist's familiar tree-columns, a nude man, crouching above the dead, buried world of fossilized creatures, drinks from a life-giving spring, while a woman, still higher up on the adjacent column, watches him as if in a state of awakening consciousness. Here, in a world sheltered by lush, broad-leaved palms and brightened by the sun and moon, Smyth would seem to be weighing in the balance not only man and beast but also order and chaos, alienation and human interaction, the known past and the undiscovered future.

RODNEY RIPPS (b. 1950) In his search among decorative sources for the means of realizing a fresher, more expressive art than the asperities of Minimalism would permit, Rodney Ripps looked to fashion, costume design, and the gaudiness of kitsch. There he found the fake leaves, circus colors, and gold foil for which he is now well known, materials that help him to create a kind of dynamic, three-dimensional painting which, far from remaining aloof in its own self-centered world of art, reaches out to the viewer the way stage performers—clowns especially—reach out to their audience. In one notable series, Ripps attached the cloth leaves with gridlike regularity to a plywood panel and then painted this tufted surface with a thick mixture of heavily pigmented oil and wax (fig. 995). While the leaves projected from the plane and structured it as a shaggy relief, their own inherent flatness seemed to evoke the two-dimensionality of a support covered with impastoed brushstrokes in the manner of older gestural painting. Moreover, the underlying grid transformed the surface into a continuous, all-over, modernist field, visually inflected mainly by chromatic shifts, like a P&D version of Monet's late waterlily pictures (fig. 53). If the paintings also resembled floral blankets placed over coffins at funerals, Ripps would probably accept this as part of his sense of life and art as a collage of the comic and the tragic. The conception has become even more manifest in a later figural series inspired as much by Picasso's fantastic Cubist costumes for the Cocteau-Satie-Diaghilev ballet *Parade* (fig. 370) as by Frank Stella's later exotic works (plate 251), in both instances art whose strong colors and bold plasticity push aggressively toward the spectator. Ripps's *Space Man* (plate 284) proclaims its divided nature in a stylistic rupture between the leaf-covered legs and the flat, horizontal striations of the torso, the two parts shafted together by a "rocket" spine that shoots up from groin to neck, throwing off "flames" shaped and colored like giant red hots. But even as this clownish figure pirouettes into the air, the cap has been shoved down full over the face, as if to hide from a world in which fantasy often provides the sole means of survival.

995. RODNEY RIPPS. *Red Love.* 1979. Oil, wax medium, linen, and wood, 50 × 50″. Collection Bruno Bischofberger, Zurich

New Image Art

In December 1978 the Whitney Museum of American Art in New York mounted an exhibition entitled "New Image Painting," which, though less than a critical triumph, provided a label for a number of strong emerging artists whose works had little in common other than their recognizable but distinctly idiosyncratic imagery presented, for the most part, in untraditional, nonillusionistic contexts. Moreover, while honoring Minimalism's formal simplicity, love of system, and emotional restraint, they also tended to betray their roots in Conceptual Art, by continuing to be involved with elements of Process and Performance, narrative, Dada-like wit, and social-psychological issues, sometimes even in verbal modes of expression. And while all the latter may, quite correctly, imply a Post-Modern sensibility, the New Imagists have almost invariably produced works that tend to favor form in its somewhat wavering balance with content, which generally leaves content, as almost always in modern art, more evocative than obvious or specific in meaning.

The great progenitor of the New Imagists was Philip Guston, who in 1970 let it be known that he had abandoned his famous Abstract Expressionist style, its delicate shimmer reminiscent of Monet's late waterlily paintings (plate 183), for a rather raucous form of figuration that seemed to ape not only the primitive, heavy-handed manner of 1930s strip cartoons but also their narrative order and broad, goofy humor—the latter, in Guston's art, often masking profound personal

996. PHILIP GUSTON. *The Studio.* 1969. 48 × 42″. Estate of Philip Guston

and political nightmares (figs. 591, 996; plate 184). By way of explaining his "scandalous" fall into Pop territory from high-minded formalism, Guston said simply: "I got sick and tired of that purity, wanted to tell stories." After an exhibition of the "underground" art by one of mainstream modernism's giants, the critic Hilton Kramer called Guston "a mandarin pretending to be a stumblebum." However, Peter Schjeldahl, originally offended but eventually persuaded by Guston's new "bad painting" (a term spawned in another 1978 show of recent figurative art, this one presented by New York's New Museum), finally wrote:

> The clunkiness of the composition jars the images loose and dumps them into the viewer's lap. The apparent crudity of the drawing authenticates each image as literally *drawn*—extruded by imagination from the shambling contingency of the painting process. Painting's loss, thus, is imagination's gain.... One is not to bother with how the work was done and only in a casual way with how it looks or even what it is. One is to witness the emergence—the emergency!—of images that have demanded to be made visible.

In the aftermath of what seemed to be modernist burn-out, the fundamental question raised for sincere painters like Guston transcended the abstraction-vs-figuration issue to become the far more pressing one of *why*, rather than *how*, to paint. Desperate for an answer, the committed artist seized upon whatever obsession—public or private—might appear compelling enough to yield meaningful content, and thus justify engaging in the great obsession of painting itself.

As a leading member of the Abstract Expressionist generation, Philip Guston could not but paint as impulse, emotion, and the subconscious would dictate. To whatever extent his art reflected its historical precedents, this occurred as a consequence of their absorption, assimilation, and finally reification through the artist's own internal sense of necessity, a necessity fueled by an urgent desire to give personal feelings independent yet universally valid form. The tremendous integrity of Guston's art, like that of all Abstract Expressionists, rested to a large extent upon the near *tabula rasa* of pre-1940 American art. It had been on a provincial canvas relatively innocent of modernism's sophisticated touch that Pollock, De Kooning, Rothko, Newman, Still, Motherwell, and Guston, among others, had painted what would become the first genuinely original, internationally significant modernist art ever to appear in North America. By the time the New Imagists matured in the 1970s—painters like Nicholas Africano, Jennifer Bartlett, Jonathan Borofsky, Susan Rothenberg, Donald Sultan, Robert Moskowitz, and Joe Zucker, or the sculptors Joel Shapiro and Barry Flanagan—the artistic legacy they fell heir to was a heavy one indeed, consisting as it did of not only Abstract Expressionism, but also the whole incredibly dense and varied sequence of reactions and counteractions that had come tumbling thereafter. To assimilate such cultural wealth and yet move beyond posed an awesome challenge, but the artists eager to accept it proved to be a hardy, clever, immensely well-educated lot—many of them graduates of Yale's School of Art in the time of such directors as Josef Albers and Jack Tworkov—and could never have approached the problem of *how* or *why* in the comparatively free, unself-conscious way of the first generation New York School. But however complex and contradictory the situation, the younger artists who entered it arrived armor-plated with ambition, reinforced by all the competitiveness that came with an art market exploding from the effects of media hype and a surging appetite for collectible objects and imagery, after their near demise under the etherealizing or disintegrating impact of first Minimalism and then Conceptualism.

In the wake of these movements, and in the light of such concurrent ones as Photorealism and P&D, the artists to be considered here sought to single themselves out from the crowd—a crowd virtually promiscuous in its pursuit of the new—by opting for figuration revitalized through highly individualized procedures of selection, isolation, simplification, combination, or presentation. The striking originality of this art lay not in style, which varied widely from practitioner to practitioner, but rather in the particular techniques and ideas mixed and matched—"appropriated"—from the recent past, to the end that something familiar or banal would become unexpectedly fresh and strange, possibly even magical, thereby engendering a whole new sense of possibilities. As Richard Marshall wrote in the catalogue to the "New Image Painting" exhibition, the artist "felt free to manipulate the image on canvas so that it can be experienced as a physical object, an abstract configuration, a psychological associative, a receptacle for applied paint, an analytically systematized exercise, an ambiguous quasi-narrative, a specifically non-specific experience, a vehicle for formalist explorations or combinations of any." What resulted was an art rich in nourishment for both eye and mind.

SUSAN ROTHENBERG (b. 1945) In conjuring the kind of eroded or fragmentary figuration last seen in the art of Giacometti or, more robustly, De Kooning, Susan Rothenberg further defied the *vide* of Minimalism's immaculate, abstract surface by filling it *plein* with a dense, painterly, silver-gray facture reminiscent of Philip Guston's probing Abstract Expressionist brushwork and sooty palette. Together,

997. SUSAN ROTHENBERG. *Pontiac.* 1979. Acrylic and flashe on canvas, 88 × 61″. Private collection

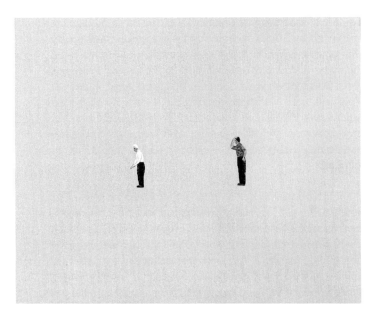

998. NICHOLAS AFRICANO. *An Argument.* 1977. Oil, acrylic, and beeswax on canvas, 5'6" × 7'. The Whitney Museum of American Art, New York

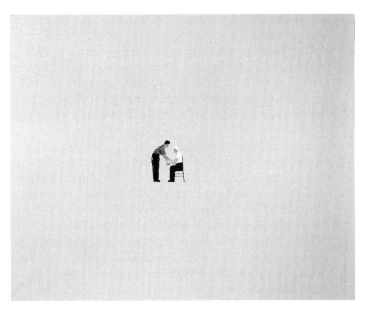

999. NICHOLAS AFRICANO. *Insulin.* 1977. Oil, beeswax, and acrylic on canvas, 66 × 84". Courtesy Holly Solomon Gallery, New York

imagery and handling have made Rothenberg seem more an Expressionist than her origins in the formalist sixties would ever have allowed. Indeed, the artist who most holds her interest seems to be Mondrian, his discipline and love of pure form, even though, as Rothenberg admits, "it's really about the attraction of opposites." Early on, for instance, she discovered she could not work with an abstract vocabulary, and needed instead imagery "physically relating to this world." Yet, Rothenberg searches not in the world and its eternal *angst* for her themes but rather within, allowing her own poetic spirit to reveal a figure as she engages in a vigorous, physical process of applying paint to canvas. The motif with which she realized her first major success was the horse (fig. 997), a massive form steeped in myth yet intimately involved with human history, obedient and faithful but also potent and wild, and often a surrogate in Romantic painting for human feeling. At a time in the Post-Minimal period when the more advanced among younger artists could not quite deal with the human face and figure, "the horse was a way of not doing people," Rothenberg has said, "yet it was a symbol of people, a self-portrait, really." Fundamentally, however, her concerns, like Giacometti's, were formal rather than thematic. In the case of Rothenberg, these centered, as in Minimal painting, on how to acknowledge and activate the flatness and objectivity of the painting surface, while also representing thereon a solid recognizable presence. First, she so distilled the figure that it consisted of little more than a dark contour line, which she spread out and absorbed into the surrounding field by drawing it with the same scrubby, reiterating brushwork employed throughout the painting. Over the hollow silhouette she then imposed vertical and/or diagonal bars whose two-dimensionality affirmed that of the surface on which they were painted, and whose loose, brushy handling also flattened the image by echoing the color and painterliness of its outline. Being substantively arbitrary, they also added to the sense of mystery in a painting where an identifiable, albeit uncertain, subject combines with a tentative but sensuously energized surface to invest the entire canvas with emotional immediacy, an immediacy nonetheless coolly resistant to Expressionist excess. In her more recent work Rothenberg has become still more private and poetically spectral in her figuration (plate 285), qualities that she manages

to universalize by radiating her painterly surfaces with a new Rembrandtesque luminosity and even a filtering of positive color, all of it validated by the artist's innate intelligence and reserve, her unfailing and unifying sensitivity to subject, structure, medium, and personal impulse.

NICHOLAS AFRICANO (b. 1948) Calling it "ground zero," Nicholas Africano rebelled against Minimalism because, as he said, "I wanted to express my own humanity with art that came from my own experience." And along with figuration as his expressive mode, Africano also opted for narrative, an understandable choice in view of his initial ambition to become a writer. Not only does the artist transform his paintings into stages where tiny characters act out their tragicomic roles against vast expanses of ominously neutral, monochrome tints (figs. 998, 999), but occasionally he even paints in words and phrases, such as: "I get hurt." Moreover, the plots unfold in series, bearing such loaded titles as Daddy's Old, Battered Women, Dr. Jekyll and Mr. Hyde, The Girl from the Golden West, Petrouchka, and Evelina, revealing Africano's keen sense of identification with the whole realm of narrative art, opera, and ballet as well as the novel. From canvas to canvas, crime and punishment take their inexorable turns, as Africano attempts to confront us with the old, but never understood, morality tale of how human relations decay from fruitful intimacy into desiccating estrangement. Here the process occurs slowly and incrementally, in brief seriocomic moments of foolishness and vulnerability, rather than in the bravura strokes and high Rubensian drama of, for instance, a Francis Bacon (figs. 652–654). To draw our attention to his Lilliputians, Africano models them in colored relief, using a rather lumpy *faux naïf* manner to stress their poignant humanity and with this the universality of their dilemmas. Meanwhile, the great empty surround or void of indifferent color spreads to become virtually continuous with our own space, leaving no doubt about the isolation in which the minifolk play out their destiny and distress. In *An Argument,* the scene immediately preceding *Insulin,* both reproduced here from the 1977 series Daddy's Old, an elderly man has turned his back to a visibly frustrated and aggrieved son, the distance between them making palpable the bitter silence that follows a quarrel. In *Insulin* we see the

son injecting his father, a gesture that in context seems an attempt to renew contact and to heal mutually inflicted wounds. Stage-managing his scenes of right and wrong, hope and despair, pain and salvation, Africano treads a tightrope, but holds his precarious balance, between soap opera and the very real calamity of the human condition. In the end, he has created what one informed observer has called "an ethical art for a time in which ethics are often viewed as impediments to success."

JOE ZUCKER (b. 1941) When he moved from abstraction to figuration, Joe Zucker, like so many of the New Imagists, allowed his imagery to be both generated and dissolved by the process of its making, a process which then became the painting's own most "absorbing" subject and narrative content. In a famous series, executed in the 1970s (plate 286), Zucker took account of modernism's fixated interest in the objective qualities of the painting support, and worked with the raw material of the support on which most painting is done—cotton—using balls of color-saturated material to construct, piece by piece and simultaneously, both the field of the painting and the image itself. So dominant was process in this art that Zucker chose his themes not for reasons of content but rather for their capacity to make technique and medium expressive. Thus, as long as he was fashioning pictures with cotton balls, it seemed logical enough that the paintings depict plantations and plantation life, with the history of the substance pursued from its origins to its translation into pictures where the story, or image, was not so much *on* the canvas as *in* the surface. Materially at least, this resolved the conflict between figure and ground, however much line and hue may set them apart. Abstraction could be further served in the all-over consistency of the texture of a surface built as a mosaic or masonry of hand-mortared molecules of cotton. Inevitably, therefore, imagery assumed the character of a metaphor of process itself, expandable to imply, as here in *Merlyn's Lab,* the alchemy whereby a painter transforms inert material into a vehicle for human wit, feeling, and ideas. From series to series, Zucker has frequently varied his methods, tools, and media, each time recasting his characters—knights and serfs, pirates and Kung Fu combatants (fig. 1000)—who almost always, however, perform the role of surrogate artist, signaling elaborate puns, visual or ritual, on the operations of the mind on matter that make art.

ROBERT MOSKOWITZ (b. 1935) Robert Moskowitz has said that "by adding an image to the painting, I was trying to focus on a more central form, something that would pull you in to such an extent that it would almost turn back into an abstraction." His method is to isolate an image of universal, even iconic familiarity—natural or cultural shrines like Rodin's *Thinker,* New York's Flatiron Building, or Yosemite National Park's Seventh Sister—and then strip the form bare of all but its own purified shape, when it then becomes virtually integral with an abstract pictorial structure as taut as any by Barnett Newman or Clyfford Still (fig. 1001). "In all good work there is a kind of ambiguity, and I am trying to get the image just over that line." By allowing it to travel no farther, however, the artist makes certain that, with the help of a clarifying title, the viewer feels sufficiently attracted, like a homing pigeon, to puzzle out and then rediscover the marvel of the monument long since rendered banal by overexposure. Aiding the cause of regenerated grandeur and refreshed vision is the epic scale on which Moskowitz casts his imagery, and his tendency to cut images free of the ground, so that they seem truly out of this world, soaring and mythic. This occurs in an

above: 1000. JOE ZUCKER. *Kung Fu (Tiger vs. Crane).* 1984. Acrylic and aluminum foil on canvas, 2 panels, 8 × 8′ overall. Courtesy Holly Solomon Gallery, New York

right: 1001. ROBERT MOSKOWITZ. *Seventh Sister.* 1981. 9′ × 3′3″. Collection The Art Institute of Chicago

environment made magical by polar extremes, often a Heaven-and-Hell division of the picture into an almost black-on-black fantasy cut through by a laser beam of sizzling light, like a Newman "zip" reduced to a trickle of molten gold. Finally, there is the enchanted realm of the artist's surface, a gorgeous display of painterly craft, alternately burnished, flickering, or luminous, glorifying the flatness of the plane and seducing the eye to explore the image declared thereon.

DONALD SULTAN (b. 1951) In his break with Minimalism, Donald Sultan, like most of his New Image peers, did not want so much to reject the past as to make his art include more of it. That art would have absorbed not only Old Master painting and drawing, Pollock, and Pop, but even Minimalism's reductiveness, and yet come out transformed into an independent, contemporary kind of aesthetic reality. In his pursuit of an image Sultan recalled a statement by Frank Stella, who said that in his own work "only what can be seen there *is* there." And so Sultan wanted figuration with the monumental simplicity and directness of abstract art, and for this reason an image that would clearly metamorphose out of the materials and mechanisms of its own creation. While teaching himself to draw—a skill seldom imparted in the figure-averse academies of the 1960s and early 1970s—and working as a handyman at the Denise René Gallery in New York, Sultan found himself retiling his employer's floor with vinyl. He immediately felt an affinity for the material's weight and thickness, as well as for the "found" colors and mottled patterns the tiles came in. Further, there was the unexpectedly sensuous way in which the cold, brittle substance became soft and pliant when warmed by cutting with a blowtorch, a process that, along with the medium and its special colors, would suggest a variety of new subject matter. Sultan also fell in love with the tar—called butyl butter—he used for fixing the tiles to their Masonite support, and began drawing and painting with it on the vinyl surface. This led to covering the plane with a thick layer of tar, which the artist would then paint on or carve into, in the latter instance achieving his image by revealing the vinyl color that lay below. When this was a flecked blue, it evoked a white-capped sea or a sky filled with scudding clouds, which the pitch-like surround inspired the artist to work into the visual pun of a factory scene, its smokestacks belching fire realized by brushing on swirls of yellow latex, altered to a lurid glow with a bath of turpentine (fig. 1002). Process had indeed now served as a means of putting more and more elements back into the art of painting. And it again served when Sultan hit upon what, so far, has been his most memorable motif, a colossal yellow lemon (plate 287)—a luscious, monumental orb with nippled protrusions—whose color seems all the more dazzling for being embedded in tar, traces of which make the fruit's flat silhouette appear to swell into full, voluptuous volume. To create such unlikely grandeur, Sultan carved the shape out of the layered tar, filled it with plaster, overpainted in yellow, and finally washed the whole surface down with solvent. By basing his image on a small painting by Manet, the artist satisfied his need to make new art that would be enriched through involvement with its own historical antecedents. And by building up, relieving, and then filling in his surface, he managed to produce pictures that seem spatially deep while remaining unequivocally flat, gridded by the underlying pattern of joined tiles, and free of old-fashioned Renaissance illusionism. But the sense of weight and substance also has a basis in objective reality, for the tar and plaster surface stands away from the wall on a massive architectural framework, comprised of the Masonite support glued to heavy plywood backing, which has been attached by steel rods to rectangular stretcher bars. What it projects is what Sultan would call "clear painting," painting in which the artist's overriding concern is with creating an image at one with the

1002. DONALD SULTAN. *PLANT May 29, 1985.* 1985. Latex and tar on vinyl tile over masonite, 96¾ × 96¾". The Hirshhorn Museum and Sculpture Garden, Smithsonian Institution, Washington, D.C.

means and tradition that produced it. While some might read messages about environmental or sexual politics in paintings of fired-up factories and giant, succulent fruit, Sultan appears to insist that "only what can be seen there *is* there." Responding to Sultan's Lemon series, the critic Calvin Tomkins wrote:

> [Donald Sultan] has achieved such a degree of control over his materials that there is no distance between the intention and the finished work. The materials may be crude, but the paintings are not. Crudeness and refinement do not cancel each other out in his work. They exist in tension—a different kind of tension in each painting. . . .

NEIL JENNEY (b. 1945) A key figure among the New Imagists was Neil Jenney, who has not so much abandoned the strategies he first learned in Minimal, Pop, and Process Art as integrate them with beautifully illusionistic subject matter to achieve paintings of galvanic visual impact and chilling moral, even admonitory force. Articulate and politically minded, Jenney has spoken of art as "a social science," and as a language through which to convey "allegorical truths." Given these views and the particular reactions of his generation, it seems altogether logical that he would declare: "I think that the most profound art in American history is Pop Art." Such ideas and sympathies are fully evident in the first, quite brilliant series of paintings that Jenney launched in 1969–70, following what now seem false starts in the formalist and then the countercultural movements of the sixties. In *Saw and Sawed,* for instance (fig. 1003), we rediscover the liquid Action Painting stroke and cartoonlike drawing favored by the Pop masters, along with the visual-cum-verbal punning so beloved by both Pop and Conceptual artists, all set forth within a monochrome Color Field organization and a heavy, title-bearing frame that together betray a Minimalist conscious-

ness of the painting as a literal object. In tension with this literalness is the witty ambiguity of the meaning implied by the juxtaposition of words and images. Like an exercise in semiotics, comparable to that already seen in Joseph Kosuth's Conceptual piece *One and Three Chairs* (fig. 898), the painting and its frame so combine percept-signifiers (images) and concept-signifiers (words) that the total work becomes a grand metasign for the process of seeing and knowing what we have seen. Thus, a saw and a log function as subject and predicate and the dressed, cut-up timber as a past-tense verb, the result of *sawing* that has acted upon what the eye *saw*. Gradually, as the visual and verbal jokes interact to beguile the mind, and the painterly deliquescence seduces the eye, attentive viewers find themselves drawn, through a chain of unexpected relationships, into a consideration of the consequences of human deeds, consequences of a serious environmental import, at least for an artist still imbued with the ethical concerns of his Conceptual past.

In his second and ongoing series of paintings, Jenney has reversed the relationship between his imagery and its enclosing frames, until the latter—massive, dark, and funereal—allows a mere slit of an opening through which to glimpse a tantalizingly lyrical and illuminated nature (plate 288). Along with the monumentalization of the coffinlike frame has come a vast enlargement of the label. And when this spells out a title like *Meltdown Morning,* the image so segmentally revealed assumes the character of longing for a paradise already lost beyond recovery, as well as mourning for the old world as it may appear—like a rare fragment presented in a museum showcase—following the nuclear winter. Here, then, is political art par excellence, and all the more so for the remarkable ease and limpid virtuosity with which the artist has rehearsed the whole civilized history of Western painting, from the *trompe-l'oeil* illusionism of his forms to the flat, bleakly abstract sky that lies behind them—all symbolic of "the day after." As in the earlier *Saw and Sawed,* Jenney has also shown his overriding preoccupation with how two or more discrepant orders of things—a physically real frame, a conceptually real title, an illusionistically or perceptually real image—become contingent upon one another for their identity and

1003. NEIL JENNEY. *Saw and Sawed.* 1969. Acrylic on canvas, 58½ × 70⅜″. The Whitney Museum of American Art, New York. Gift of Philip Johnson, 1977

significance. By simply presenting the evidence, with all the objectivity of a late modernist, the artist provokes the viewer into supplying the absent linkage between the various and alien entities or conditions, thereby implicating him in the mix of culpability and nostalgia for a once whole but now riven and inharmonious world.

JONATHAN BOROFSKY (b. 1942) By his own admission, Jonathan Borofsky has also placed politics firmly at the center of his riotously pluralistic art, saying: "It's all about the politics of the inner self, how your mind works, as well as the politics of the exterior world." To express what has become an untidy multiplicity of concerns, Borofsky is at his most characteristic not in individual works but rather in whole gallery-wide installations (fig. 1004), where he can spread over ceilings and windows, around corners and all about the floor the entire contents of his mind, his studio, and even the history of his own art, beginning at the age of eight with a still life of fruit on a table. The first time he mounted such a display, at Paula Cooper's SoHo gallery in New York in 1975, the show, Borofsky said, "seemed to give people a feeling of being inside my mind." Mostly that mind is filled with dreams or with the free associations so cherished by the Surrealists, all of which Borofsky has attempted to illustrate with an appropriate image or object. When assembled, or strewn about, the *Gesamtkunstwerk* they produce far exceeds in its all-embracing randomness, variety, and dynamism the environmental scatter works of the Conceptualists (fig. 922). A representative installation would contain a giddy mélange of drawing, painting, sculpture, audio work, and written words, all noisily and messily driving home certain persistent themes. The drawings typically begin with automatist doodles in which the artist discovers and then develops images, such as a dog with pointed ears, blown up by an opaque projector to spill over and be painted onto walls and ceilings, as if one of the beasts guarding the gates of Dante's Hell were hovering above and threatening the whole affair. But close by on the ceiling, in a recent exhibition, appeared the cut-out of a ruby, a dream image that for the artist meant a countervailing good in a world beset by evil. To symbolize his sense of the conflicts and dichotomies of life, all paradoxically bound together by a spiritual oneness, Borofsky installed a ping-pong table and advised viewers that they should "feel free to play." In the course of their game, however, they found the table painted in camouflage pattern with the defense budget of the United States stenciled on one side and that of the Soviet Union on the other. Reiterating the circular shape of the ping-pong ball, as well as the notion of connectedness within disconnectedness, were Borofsky's "Molecule Men," huge freestanding, two-dimensional figures made of plastic bubble wrap and riddled with "Swiss cheese" holes (fig. 1005). While one of these appeared to be running away, with a briefcase in hand, the other flew overhead. Truly activated presences were five giant "Hammering Men," the motorized up-and-down motion of their arms inspired by the artist's father, on whose lap young Borofsky sat while listening to "giant stories." Another character took the artist into the realm of sexual politics, where he expressed his mind in the images of an androgynous clown, half Emmett Kelly and half ballerina, dancing to the tune of "My Way." As a kind of interstitial tissue serving to link these disparate images, Borofsky littered the floor with crumpled fliers, which were in fact copies of an actual letter recounting the difficulties of an ordinary life, a "found" work picked up by the artist from a sidewalk in California. Further unity derived from the single origin of all the dissimilar images and artifacts in the dream world or associative powers of Borofsky's own mind. Moreover, the artist had imposed the continuity of his obsessive counting, a rational process of ordering, unlike the instinctual, random one seen elsewhere in his work, that he began in the late 1960s

right: 1004. JONATHAN BOROFSKY. 1984–85. Installation view, The Whitney Museum of American Art, New York

below: 1005. JONATHAN BOROFSKY. *Molecule Men at 2,845,318.* 1982–83. Painted aluminum, 10′×9′1¼″×¼″. The Edward R. Broida Trust

below right: 1006. JONATHAN BOROFSKY. *Self-Portrait.* 1980. Photograph. Edition of six. Courtesy Paula Cooper Gallery, New York

and has now taken beyond the three-million mark, along the way applying a number to each of his pieces and thus joining their separateness in one continuous, ongoing sequence (fig. 1006). The record of this monotonous activity is also displayed, in graph paper filled with numerals, stacked waist high, and enshrined in Plexiglas.

Behind so much of this—the interest in fusing art and politics, the concern for making art free of the marketplace, the use of temporary installations and impermanent wall drawings, the rejection of "fine art," the emphasis on process and rendering the intangible tangible, the value placed on ideas over objects—lies a profound debt to Conceptualism, a Conceptualism carried forward, however, into a whole new ethos by the artist's unruly compulsion to generate mixed-media imagery of a fresh and richly inventive sort. Also behind the madcap circus, its atmosphere whipped up by chattering, chimes, mantralike chants, and blue neon hoops flickering in sequence overhead, is the artist's awareness of Pollock's all-over approach to painting a canvas, extrapolated to embrace whole environments (fig. 583). "My work," Borofsky says, "is concerned with the three-dimensional interior structure, and I try to make people aware of the space they're in, in a holistic way." When accused of being simplistic in his artistic and social ideas, he has responded: "They're simple, but you have to say it over and over again,

like 'Stop the war' was repeated over and over. The simple part is the old biblical truth. We have to be fair to one another."

JENNIFER BARTLETT (b. 1941) Another New Image artist with a voracious appetite for exhibition space and the creative energy to fill it with a stunning array of unified complexity is Jennifer Bartlett, whose vast 987-unit painting entitled *Rhapsody* (fig. 1007; plate 289) became, upon its presentation in 1976, one of the most sensational works of the 1970s. Bartlett had evolved from painterly Abstract Expressionism to Process and Conceptual Art, and felt the need to do a painting that embraced it all, that would in fact have "everything in it." Coincidentally, the artist had always been an omnivorous reader and was already some thousand manuscript pages into an all-inclusive autobiographical novel, self-mockingly entitled *The History of the Universe*. In her painting, meanwhile, she had simplified her process, eliminating wooden stretchers, canvas, and the paraphernalia of oil, until it rested upon little more than the basic module of a one-foot-square steel plate, a flat, uniform surface commercially prepared with a coat of baked-on white enamel and an overprinted silkscreen grid of light-gray lines. Now she could concentrate on the labor-intensive act of painting with Testors enamel, a hobbystore medium available in twenty-five colors, which Bartlett reduced to a basic set of six—yellow, red, blue, green, black, and white. Initially she applied the colors only in the form of grid dots, in strictly planned combinations and permutations that ranged from extremely simple to quite extraordinarily elaborate. Minimalizing and Conceptual as all this may seem, Bartlett regarded her mathematical system much as she did her materials, important only insofar as it provided a direct and fuss-free means of getting into and concentrating on the act of painting itself. When finally assembled on a large loft-size wall, scores and hundreds of the enameled steel plates yielded multipart compositions filled with color-dot paintings in an eye-dazzling display of brilliantly decorative abstract patterns.

1009. PAT STEIR. *Red Tree, Blue Sky, Blue Water.* 1984. 3 panels, 5 × 5′ each. Private collection, Holland

For *Rhapsody* Bartlett expanded her repertoire of colors, not only by adding more but also by mixing and superimposing, and in a further attempt to include "everything," she decided to have figurative as well as nonfigurative images. For the former she chose the most "essential," emblematic forms of a house, a tree, a mountain, and the ocean, and for the latter a square, a circle, and a triangle—Cézanne's "cylinder, sphere, and cone" two-dimensionalized. She would also admit sections devoted purely to color, others to lines (horizontal, vertical, diagonal, curved), and some to different techniques of drawing (freehand, dotted, ruled). Finally, Bartlett determined that she would make up her mind about accepting or rejecting a specific plate within one day of finishing it, since the idea was for "the piece to have a kind of growth that was actual rather than aesthetic." Indeed, the painting would be symphonic or perhaps novelistic in character, organized and orchestrated so as to evoke the experience of a conversation, with voices rising and falling, introducing, abandoning, and then readmitting themes in an ongoing, variable weave of human sound and thought. When finished, the painting progressed section by section, moving from an introduction of all the motifs through a sequence in which each motif received its own independent, if sometimes overlapping, exposition. This continued until all the images, lines, colors, and several types of drawing and painting appeared and then blended into the cumulative development, which finally climaxed in a 126-plate ocean sequence incorporating 54 different shades of blue. Characteristically, Bartlett titled the work from a suggestion of a friend, for *Rhapsody,* she said, "was so awful I liked it. The word implied something bombastic and overambitious, which seemed accurate enough." When installed in the Paula Cooper Gallery, the great painting filled the entire space with near mathematical exactness. And it simply overwhelmed the first viewers, who immediately saw the work's narrative quality—unlike anything contemporary eyes had witnessed in years of new art—and became completely absorbed in the harmonic flow of the gathering, ever-more inclusive "conversation." When the *New York Times* critic John Russell hailed *Rhapsody* as "the most ambitious single work of art that has come my way since I started to live in New York," Bartlett's painting had become what the art world likes to call an "event." More important, as Russell went on to say, it "enlarged our notions of time, and of memory, and of change, and of painting itself."

Since *Rhapsody* Bartlett has become one of the most productive and respected of late-twentieth-century artists, largely because of her unabating readiness to risk the challenge of new problems in drawing and painting, of expanding her basic themes to new dimensions, even to accommodate sculpture and large public or private commissions (fig. 1008). As systematic yet free as ever, Bartlett has actually retaught herself the techniques of oil painting, as she worked through series that found her sequentially exploring the styles of Impressionism, Expressionism, Realism, Rayonism, Matisse, Mondrian, and Pollock, often in pairs, quartets, or quintets of contrasting canvases. And so, not only did Bartlett lead the narrative revival in painting; she also anticipated the current obsession with "appropriations."

PAT STEIR (b. 1940) Perhaps more than any other contemporary artist, Pat Steir is conscious of the reality that art always comes from older art, giving culture a vernacular of current forms, which each painter or sculptor reinvests with subtly or sharply different meanings. In this way the artist becomes grafted onto the living tissue of the past, legitimately claiming continuity. Steir explains it thus:

I feel there's really very little difference between the stylistic modes of art-historical periods. Hints of all are evident in all, and it's all the same thing—painting. The "alphabet" is the same—red, yellow, blue, black, white—but not the "handwriting." The difference is in the scale, in the use of space. Small black and white strokes that make up detail—that's Rembrandt. Expand them and it's Kline. Scale up Van Gogh's color and mark, and it's De Kooning. All art-making is research, selection, a combination of thinking and intuition, a connection between history and humanity.

A clear demonstration of the principle can be found in *Red Tree, Blue Sky, Blue Water* (fig. 1009), a triptych where the "quotation" from Van Gogh on the left progresses across the three panels in a cinematic sequence, from distant shot to medium one and finally closeup. As they move in graduated stages from resolution to dissolution, the panels also illustrate Steir's conviction that realism and abstraction are the same thing. Adding to the complexity—a complexity nourished by seventies Conceptualism—is the echo of Van Gogh's own quoted source: a Hiroshige woodcut. Furthermore, the bold red on blue coloration and the swirling, almost Art Nouveau configuration of the image in the right

1010. JOEL SHAPIRO. *Untitled.* 1973–74. Cast iron, 3 × 27¼ × 2⅝";
chipboard base, 14¾ × 29¾ × 5". Collection Paula Cooper

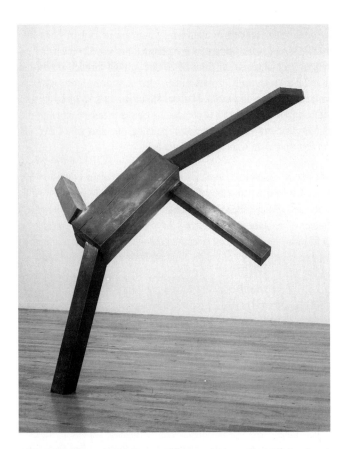

1011. JOEL SHAPIRO. *Untitled.* 1983–84. Bronze, 80¾ × 80 × 52". Number 1
of edition of three. Collection Mr. and Mrs. Barney A. Ebsworth. On loan to
the Saint Louis Art Museum

panel—a blowup of a blossom—would seem to betray a side glance at
Mondrian's 1908 *Red Tree* (plate 92). The articulate Steir, who is also
a poet, has said: "The subject of my work is point of view, our way of
seeing. I try to see through the eyes of many others." But however
absorbed she may be in historical painting, Steir is also absorbed in the

act of painting, which she evinces in an extraordinary lavishness of
stroke, medium, and color.

JOEL SHAPIRO (b. 1941) With the human figure the age-old, Classi-
cal subject of sculpture, sculptor Joel Shapiro conceivably had less diffi-
culty than painters in reembracing such an image when he determined
to warm the chill perfection of Minimalism's cubic forms with some
sense of an activated human presence. Even so, Shapiro found it neces-
sary to proceed only gradually, moving toward the figure through the
more abstract objectivity of its habitations, in an early 1970s series
devoted to the house (fig. 1010). Right away, however, Minimalism had
lost its monumentality as Shapiro miniaturized the image to somewhere
near the "little people" scale of Charles Simonds's archeological sites
(fig. 937), or Jennifer Bartlett's rudimentary dwellings, meanwhile
pruning the form of all but its own most Primary or archetypal masses.
But as dollhouse cuteness and connotations of security begin to release
open and varied responses, the susceptible viewer finds himself locked
out of a shelter not only too shrunken to enter but also denied the
windows and doors through which access—psychological or phys-
ical—might occur. Perched precariously on a chipboard shelf, cast in
iron or lead, and often fronted by a metal path that seems less a wel-
come mat than a plank to be walked toward execution at sea, Shapiro's
house scarcely represents the family home of fond memory, a memory,
however, upon whose potency the image depends for its contradictory
and subversive effect.

As for the humanity excluded from these modest abodes, Shapiro has
so formed and inflected them that, on a somewhat enhanced though
still small, knee-high scale, they share both the houses' clean lines and
conflicted condition (fig. 1011). Built of square-cut posts and cast in
iron or beautiful reddish-gold bronze—wood grain, knot holes, and
all—these stick figures display the reductive economy of a Sol LeWitt
sculpture, only to break free of the box and pivot, writhe, dance, col-
lapse, and crawl, as if to reenact in antiheroic, Constructivist terms the
whole gamut of tormented pose and gesture invented a century earlier
by Auguste Rodin (figs. 124, 125). Some of the assembled beams are
even headless and otherwise dismembered in the manner of the French
master's emotionally fraught personnages. Shapiro, however, has been
true to his age by expanding the repertoire of expression to include the
bittersweetness of clownish pratfalls and slapstick. But even here, to
modern eyes, the images seem all the more poignant for having their
rational, abstract simplicity placed at the service of an unexpected psy-
cho-physical complexity. In the figural art of Joel Shapiro, less has truly
become more, to the degree that formal analysis, with its tendency to-
ward fragmentation and distillation, becomes a symbol of violence and
the melancholy of spiritual or emotional incompleteness.

BARRY FLANAGAN (b. 1941) The British sculptor Barry Flanagan ar-
rived at his more recent imagist art by way of painting, dance, and
various Conceptual installations produced with organic materials and
processes. And throughout a highly varied oeuvre the consistent factors
have been those of poetic association, inventiveness, and good humor.
Inevitably, therefore, Flanagan favors manipulable substances, such as
hessian, rope, felt, steel, stone, ceramic, or bronze, likely to "unveil"
the image within during the course of handling and shaping. This was
the reaction of a younger artist to the formalist stance of the faculty,
including Anthony Caro (plate 261), at London's St. Martin's School of
Art, where Flanagan studied. In his most frequently quoted statement,
the artist said: "Within the sculpture there are carried its own solutions;
we invest it with problems, ideas and excitements. One merely causes
the things to reveal themselves to the sculptural awareness. It is the

1012. BARRY FLANAGAN. *Carving No. 6A.* 1982. Travertino romano chiaro marble, 51¼" long. Collection the Artist

1013. BARRY FLANAGAN. *Hare on Bell with Granite Piers.* 1983. Bronze and granite, 7′11½″ × 8′6″ × 6′3″. Number one of edition of five. Collection The Equitable Life Assurance Society of the United States

awareness that develops, not the agents of the sculptural phenomena." Following a series of rolled fabric works composed by clustering, clumping, and folding, insouciantly titled *aiing j gni aa, Heap, Pile, Stack,* and *Bundle,* Flanagan turned to clay, squeezed a lump of it in his hand, and had the moist, plastic shape translated into the unlikely material of stone, with this cut on a scale large enough to suggest that some Gulliver with hands of steel had grasped the adamantine substance (fig. 1012). Although made of a quite natural material, the naturalness it presented seemed incongruous with that of its gestural shape and texture. In the early 1980s, while squeezing and rolling clay, Flanagan found a hare "unveiling" itself in the material, and the image proved to have all the fecundity in art that the creature displays in life (fig. 1013). Leaping, strutting, dancing, balancing, or boxing, the slender, free-formed but graceful bronze hare seems an emblem of Flanagan's own spontaneity, openness, and good humor. While resonant with history and myth, and distinctly Post-Modern, the humanoid image and its folkloric form sag, teeter, and vault in light-hearted but purposeful ways that viewers cannot but feel kinesthetically within themselves.

WILLIAM WEGMAN (b. 1942) The photographer-artist William Wegman did not have to search for what may have been his most successful image; it simply came bounding into camera range in the form of a Weimaraner puppy, who grew up so stagestruck and histrionically gifted that nothing could keep him either from the lights or from performing once they were turned on (fig. 1014). Naming his dog Man Ray, for the Paris-based American Surrealist photographer, the artist punned himself—Dada fashion—into reversing roles with the dog and thus becoming his—Man's—best friend. For some ten years, until the canine celebrity died, Wegman found the photogenic Man Ray to be a gallant and sensitive actor in an ongoing comedy of still photographs, made first with a Polaroid and then with a large-format camera (plate 290). One by one they show Man costumed and fully rehearsed to play through the whole range of ordinary and supposedly rational situations in contemporary society, all rendered farcical and pretentious—often hilariously so—by ironic contrast with the manifest dignity and intelligence of the noble Weimaraner.

ROBERT MAPPLETHORPE (b. 1946) If the Conceptual mock-seriousness and genial, improvised air of Wegman and his Weimaraner could be said to represent the sunny side of the seventies, the radical chic of photographer Robert Mapplethorpe would have to signify the dark underface of the same period, a certain aspect of which felt free to explore

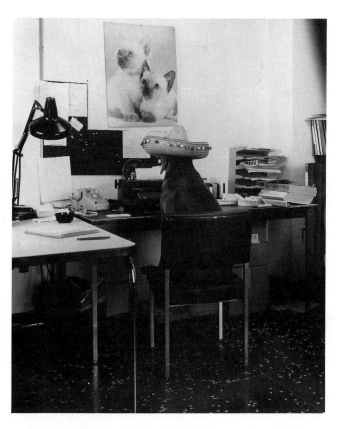

1014. WILLIAM WEGMAN. *Secretary.* 1982. Color Polaroid photograph. © William Wegman. Private collection

literally anything as long as it was done with style. Mapplethorpe's style is pure Classicism—formal, serene, and timeless. And it prevails with unwavering equanimity even though the subject is usually the mammon of high fashion, money, power, or the fast-track netherworld of drugs and sexuality. Mapplethorpe approaches it all with unflinching candor, his pictures of flowers as coolly exquisite yet overtly sexual as the black male anatomies that are his admitted personal obsession (figs. 1015, 1016). Bathed in silken light and printed in platinum, these elegant, heroic images make human flesh look as if it had been cast in bronze and then burnished to a dark, lustrous finish. With his uncanny ability to fuse fire and ice without extinguishing the one or melting the other, Mapplethorpe has become something of a cult figure as well as one of the most collected photographers of his generation. Interestingly enough, the notoriety emerges from a process whereby purely aesthetic effects—the results of precise analysis, framing, and lighting—appear all the more controlled or otherwise remarkable for having been imposed upon content to which many, or most, viewers are certain to bring a whole array of heavily loaded, even if unsuspected, responses. And in this respect Mapplethorpe could be seen as a quintessential New Imagist.

above: 1015. ROBERT MAPPLETHORPE. *Calla Lilly.* 1984. Platinum print. © Robert Mapplethorpe

right: 1016. ROBERT MAPPLETHORPE. *Ajitto (Back).* 1981. Gelatin-silver print. © Robert Mapplethorpe

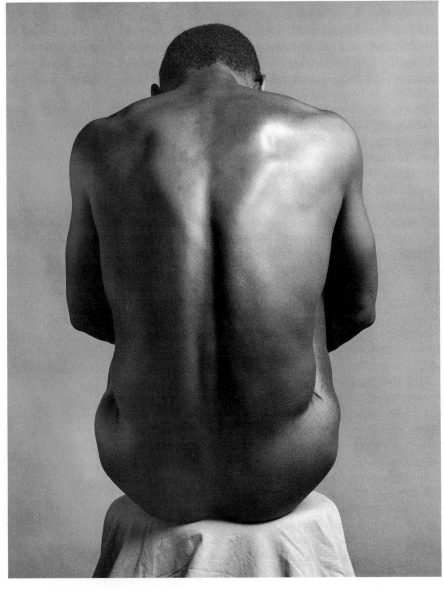

The Appropriating Eighties:

FROM NEO-EXPRESSIONISM TO NEO-ABSTRACTION

With the turn of the 1980s, the steamrolling reaction against Minimalism assumed a new intensity, kindled mostly by young painters and so powered by a youthful love of bold gesture, heroic scale, mythic content, and rebellious figuration that critics immediately dubbed it Neo-Expressionism. But the development could just as well have been called Neo-Surrealism, for while a number of the new artists did indeed defy Minimalist restraint and revive agitated, feeling-laden brushwork, almost all generated content by appropriating and often layering imagery so tabooed, archaic, or vulgar—the latter well beyond anything seen in Pop—that descriptive Realism seemed to flip over into the dislocated, floating irreality of dream, reverie, or nightmare. Yet even as the accessibility promised by identifiable subject matter served mainly to compound the Mandarin elusiveness symptomatic of virtually all modern art, collectors and museums, the media and a good segment of critical opinion rejoiced that here, at long last, were big, vigorously worked, color-filled, *meaningful* canvases. In an art world hungry as much for excitement as for imagery, this was an event, made all the more newsworthy by the fact it had been spearheaded in Europe, where German and Italian artists were working with a self-confident strength and independence not seen since the original Expressionists on the one hand or the Futurists and Metaphysical artists on the other. Now, for the first time in the postwar era, Continental artists could reclaim a full share of international attention and world leadership in new art.

The excitement, however, derived from younger American and European painters alike, in that all the so-called Neo-Expressionists evinced an aggressive, daring embrace of every possibility—metaphor, allegory, or narrative, surfaces energized by and packed with photographic processes, broken crockery, or even *oil* paint—that made the New Image art of the 1970s seem still relatively in thrall to modernist dogmas of emotional and formal reserve. Paradoxically, however—and paradox seems never far from post-Pop or post-Conceptual art—while the old avant-garde strained always toward the future by shucking the past, the Neo-Expressionists have sought to liberate themselves from modernist restrictions by rediscovering those very elements within tradition most condemned by progressive, mainstream trends, Renaissance or modern. And so Italy's Francesco Clemente has often looked not to the Caravaggio so admired by Frank Stella, but rather to the "effete" sixteenth-century Mannerists against whom Caravaggio initiated a full-blooded Baroque reform (see p. 16). Instead of the Picabia of the innovative Machine pictures, Germany's Sigmar Polke and New York's David Salle, along with Clemente, have found inspiration in the "decadent" Picabia of the Surrealizing Transparents (fig. 334; plate 294). For the Italians, especially, De Chirico offered a model—the long-dismissed, "classicizing" De Chirico of the Fascist years, that is (fig. 321), not the De Chirico of the great Metaphysical works. Anselm Kiefer and Markus Lüpertz have even had the audacity to resurrect symbols of Germany's discredited chauvinist past and the Nazi era, not only

1017. PABLO PICASSO. *Man, Guitar, and Bird-Woman.* 1970. 63¾ × 51⅛".
Estate of the Artist

military insignia but also the meglomaniac architecture of Albert Speer, the better to bring them out of the dark and neutralize their dreaded power to poison the present. And while the late modernists had tended to turn art into a religion, the New York artist Julian Schnabel rediscovered the ancient symbols of myth and faith, mined from *The Golden Bough* as well as the Old and New Testaments, and presented them with a bold sobriety of statement not essayed since the seventeenth-century Counter-Reformation. The Americans, particularly, favor the late Expressionist Picasso—the Picasso certain modernists had thought unimportant—instead of the cerebral, discriminating artist of the heroic Analytic Cubist era. They flocked to the Guggenheim Museum's 1983 exhibition devoted to the Spanish master's final decade (1963–73), drinking in not only the liberated drawing and color, but also the untrammeled, autobiographical sexuality expressed by a still-vital octogenarian (fig. 1017).

Moreover, sexuality looms large—often blatantly—throughout Neo-Expressionist or Neo-Surrealist art, which could hardly be other-

wise, given its pervasive exploitation by the media and the dominance of the media in every aspect of modern life. Whereas the Pop artists had mocked and glorified the icons of advertising and everyday consumer society, many Neo-Expressionists pluck their imagery directly from the sleazy world of sex manuals, pulp romances, and television soap operas, as well as from the more elevated sphere of high art, history, and politics. The irony here lies less in the subject matter or its pluralistic range than in the fact that, at this image craving moment, the images are so very often not created afresh. Rather, they are "appropriated" from some preestablished source and then "recontextualized" by the artist in his own painting, frequently through the semimechanical means long known from the practices of the Photorealists. Once again, necessity reigns, for at the same time that the Minimalist generation starved their art of imagery, they also deprived their students of instruction in drawing, the most fundamental skill traditionally used by artists to render figures, whether perceived in the world or conceived in the imagination.

Appropriation, however, by extracting images from their original contexts and mixing them with other images from different contexts, inevitably deprives iconography of its original import, while also endowing it with a new and unsettling impact. In the critical language of the day, this makes Neo-Expressionist art "deconstructive," a process that, ideally, liberates humanity from enslavement to empty, albeit heavily coded, clichés—such as sexist stereotypes or Minimalist aesthetics—into a freer, more constructive, or at least less preordained atmosphere. Deconstructionism, in showing the culturally dictated character of myths, whether old and hallowed or current and popular, also reveals them to be as necessary as they are potentially dangerous. And by opting for imagery and choosing to appropriate it, the Neo-Expressionists have brought art into the media-governed, image-saturated, eighties and, simultaneously, the eighties into art. It is as if the new artists had determined to retaliate against the media for having coopted art, along with every other product of civilization, by coopting the media's own obsession with imagery and their filmic processes of overlayering, juxtaposing, or sequencing all manner of disassociated visual data. Like television, furthermore, a number of the artists display the ambivalence of being caught between love and fear of both their subjects and their techniques. What remains certain is that by working with secondhand and often obscure imagery, or by combining images in mix-match relationships that resist interpretation, the Neo-Expressionists, like the modernists before them, have left the success—and the undeniable magnetism—of their work dependent upon their own performance in handling their appropriations, not only images but styles as well. This makes the artists' achievement all the more remarkable, since pure "handling" would never again embody, for example, the old Expressionist force of conviction after Robert Rauschenberg demonstrated that he could copy one of his own Abstract Expressionist paintings splash for splash, and Roy Lichtenstein reduced the spontaneous, loaded brushstroke to his own comic-strip and Ben Day formula (fig. 708).

Apart from these very broad, and highly provisional, generalities, the Neo-Expressionists—a title almost none of them reveres—have little in common, since, instead of forming a movement, they simply emerged more or less voluntarily from their respective cultural and stylistic outposts. While Schnabel tends to paint his passion plays on velvet or on surfaces encrusted with china shards, Cindy Sherman paints not at all, but rather shoots one-frame B-movies with scenarios, sets, and performance all by Sherman herself. Although both Eric Fischl and Sue Coe command a rich, painterly technique, the one employs a light, seaside

palette to explore the psychodramas of white, affluent, suburban America, while the other makes herself a contemporary heir to the dark, brooding, socially aroused art of Goya, Daumier, and Kollwitz. At the same time that A. R. Penck strips the human image to a schematic stick figure to symbolize the incompleteness felt by Germans in their painfully divided nation, Sandro Chia fattens his Neoclassical figures, even beyond the bloated ones of the late De Chirico, and sends them off in mock-heroic excursions through the Italian past. If there is even a subgroup cohesiveness to be found among the Neo-Expressionists, it would probably lie in Germany, whose new painters enjoy the special benefit of having been confronted with a kind of terrible adversity that seems always to allow strong artists to dig into themselves and come forth with their own irreducible truth and greatness. For the Germans seen here, the life-and-death challenge was how to come to terms with their country's troubled and tremendous history, and yet move on with dignity, fully aware of a problematic heritage but unbroken and resolved to make art that makes a difference.

GEORG BASELITZ (b. 1938) Among the new German painters, the senior artist is Georg Baselitz, whose paintings are also the most distinctive, mainly for the topsy-turvy state of their imagery—usually upside down—yet also for their full, ripe color and powerful, juicy, liberated brushwork (plate 291). But effective though the Dada-like disorientation may be as a metaphor for a Germany, or a world, crazily divided against itself, Baselitz's single, double, even multiple portraits, as well as his no less gravity-free still lifes and landscapes, possess a grand, almost Renaissance or Mannerist dignity and presence. Moreover, this is hardly surprising given the fact that they have been painted in an ancient castle known as Schloss Derneburg, located on wooded heights near the historic medieval town of Hildesheim, south of Hamburg. Originally a Cistercian abbey and then the home of the Princes of Münster, the great feudal residence, complete with tower, cloister, library, and banquet hall, had been so vandalized by its postwar occupants, the British army, that even an impecunious painter could afford to acquire it. Quite apart from yielding the kind of vast space needed by modern artists, Schloss Derneburg provides an exalted setting consistent with Baselitz's conviction that the serious artist in today's Germany must assert his ego, not as a narcissistic grab for personal fame or power, but rather as a necessary means of declaring his value within the social system. Through lifestyle as well as through painting style, Baselitz and his like-minded compatriots consider it essential that they be strong and independent enough to confront, assimilate, and transform from within the authoritarian structures—whether reactionary traditionalism, mindless philistinism, Nazism, or modernist abstraction—that seem to have made it impossible for German artists to serve society by challenging conventions as only a free and critically active avant-garde can. Deliberately surrounding himself with the symbols and sources of German culture and modern art—Mannerist prints and the kind of African sculpture once collected by the primitivising Brücke artists—Baselitz does not avoid or suppress the past, however uncomfortable some of it may be for present-day Germans, but actually embraces tradition, both old and recent. To him, radicalism lies not in conformity with some line of evermore self-reflexive development predetermined in New York, Paris, or London, but rather in the freedom to open up, look back, recover what has been missed, lost, or abused, or proved abusive, and rehabilitate tradition by making a fresh interpretation of it.

In a characteristic gesture, Baselitz (born Georg Kern) renamed himself for his natal village, Deutschbaselitz in Saxony, as a keepsake

above: 1018. GEORG BASELITZ. *The Brücke Choir (Der Brückenchor)*. 1983. 9′2½″ × 14′11″. Collection Emily and Jerry Spiegel, New York

right: 1019. GEORG BASELITZ. *Untitled*. 1984. Oil on linden wood, 99 × 28 × 18″. Courtesy Mary Boone Gallery, New York

after he had moved out of Russian-occupied East Germany and into West Berlin. There, furthermore, he soon became convinced that the prevailing mode of abstract painting, however much it might seem morally superior for having been banned by the Nazis, did not lie within the grasp of German genius, and decided to go against the trend by launching a one-man campaign to revive the kind of narrative and symbolic, emotive and rhapsodic art in which Germans had traditionally achieved greatness (figs. 8, 154). In 1960–63 the controversial artist published a series of manifestoes and painted his Pandemonium series portraying such isolated and marginal figures as Artaud and Lautréamont, then

famous for their influence on the Existential sensibility of Paris in the 1950s. During the years 1964–66, when international art was dominated by American Color Field painting and Pop, Baselitz developed an iconography of heroic men, huge figures towering over a devastated landscape. All of the paintings raised political and aesthetic hackles, and one, entitled *Die Grossen Freunde*, suffered the ignominy, or unintentional compliment, of being seized by the public prosecutor on the ground that it might "arouse sexual desire among certain kinds of viewers." Finally, in a resolution of the problem of how to reintroduce recognizable imagery in a novel, personally determined, and evocative manner, Baselitz settled upon his familiar form of a figure or figures left more or less intact but abstracted from perceptual reality by the upside-down posture and the disintegrating effects of brilliantly synthetic color and aggressive painterliness (fig. 1018). Working conceptually and with a kind of "divine madness" not unlike the intuitive automatism of the Abstract Surrealists and Expressionists, Baselitz uses his restless, heavily loaded brush to negate the figure in the very act of rendering it, rather like Michelangelo obsessively carving away his last *Pietàs* and thereby endowing them with haunting expressivity. In a further restoration of art to full-stream continuity of its referents and antecedents, Baselitz began to paint not heroes but his own friends—talking, eating, drinking, or doing nothing in particular—but heroicized them in scale and through the Mannerist, "anamorphic" distortions of small heads and bizarre proportions. Now the once rejected artist gained universal access, offering a grandiose, moving symbol of a ravaged society creatively attempting to come to terms with its self-destructive past and the stubborn, painful dichotomy of its present.

Baselitz also makes sculpture, hacking it out of wood until the figure almost disappears (fig. 1019). While this may be a tribute to the elderly Michelangelo, it also commemorates the first German Expressionists,

1020. MARKUS LÜPERTZ. *March Hare (Märzhase)* from the *Alice in Wonderland* series. 1981. 39⅜ × 31⅞″. Courtesy Mary Boone Gallery/Michael Werner Gallery, New York

1021. MARKUS LÜPERTZ. *Helm 1*. 1970. 92½ × 75". Courtesy Mary Boone Gallery, New York

1022. A. R. PENCK. *Crossing Over (Der Übergang)*. 1963. 37 × 47¼". Collection Dr. Becker, Neue Galerie-Sammlung Ludwig, Aachen, West Germany

who excelled in woodcut and wood carving yet suffered the stigma of "degenerate" pronounced by the Nazis (figs. 162–165).

MARKUS LÜPERTZ (b. 1941) In his rebellion against all authoritarian "norms," most particularly that perceived in the monolithic consistency and coolness of 1960s American abstraction, Markus Lüpertz made intensity the driving force behind his search for artistic independence, variability the character of his style, energetic and even wildly imaginative appropriation his process, and politics the content of his art (fig. 1020). Although he rejected art sources and materials even while accepting them, Lüpertz saw Picabia as a precursor of his own stylistic restlessness (plate 81; figs. 332–334) and Picasso as a model of the obsessive quoter of established art. No less important, however, was Pollock, who for Lüpertz seemed a "Dionysiac" painter "dithyrambically" discovering the mysteries of his own personality projected into art as an overall unifying principle. Attuned to reality yet free of it, Lüpertz uses abstracting means to invent objects that, while simulating the look of real things, remain totally fictitious, or what might be called "pseudo-objects." In the early 1970s, nonetheless, the artist executed a "motif" series in which he introduced such recognizable but taboo emblems as German military helmets, uniforms, and insignia, and combined them with palettes and other attributes of the painting profession, thereby signifying the need to confront and integrate opposites (fig. 1021). For his recent forty-eight-painting suite and its eight related mixed-media sculptures on themes from *Alice in Wonderland* (fig. 1020), Lüpertz created an illusionistic but nonillustrational imagery of such surpassing eccentricity that, like Baselitz's upside-down figures, it serves as a transcendent expression of the absurdity and bizarreness of a bifurcated postwar Germany.

A. R. PENCK (b. 1939) Having only recently crossed from East to West, A. R. Penck still struggles in his art not only with the cleft in German society but also with the need to redefine himself as an exile. The form this autodidactic artist has found most effective for his purposes consists of a stick figure—Everyman reduced to a cipher—set in multiples or singly in an all-over tapestry or batiklike pattern against a field of solid color, with figures and ground so counterbalanced as to lock together in a dynamic positive-negative relationship (plate 292). Mixing stick figures with a whole vocabulary of hieroglyphs, cybernetic symbols, graffiti signs, anthropological or folkloric images, Penck expresses such deep personal and public concerns as the urgent need for individual self-assertion in a collective society, the better to avoid the fear and violence that result from blocked communication. As a "crossover" himself, Penck has often painted poignant versions of the lone stick man—the standardized product of a machine system—walking a tightrope or a burning footbridge suspended above an abyss separating two islands of barrenness (fig. 1022).

JÖRG IMMENDORFF (b. 1945) Like a counterpart to Penck's radically depersonalized, and thus all the more private, imagery, Jörg Immendorff paints in a detailed, if highly conceptualized, Realist style, but is no less anguished than Penck over the individual entrapped by the self-contradictoriness of modern German life. In the Café Deutschland series, the central image is the artist himself, often seated at center between a pair of allegorical columns symbolizing the two halves of a polarized world (plate 293). Together, the relatively public, accessible style, the autobiographical subject, and the lurid disco scene, complete with heavy, forward-pitching perspective, express, as Donald Kuspit has written, the ambivalence of "an egalitarian Maoist oriented towards the lost cause of a democratic China, and a successful bourgeois artist appropriated by the market." Nowhere is the Surreal character of this dilemma more pronounced than in Immendorff's totemically figured chair-sculptures, carved from linden wood and polychromed (fig. 1023).

SIGMAR POLKE (b. 1941) Sigmar Polke could be said to epitomize the German artists of his generation, in that he appears to have been fully as interested in making a direct, ironic response to American aesthetic hegemony as in conceptualizing a new kind of art, an art uniquely sensitive to the peculiar complexities of life in contemporary Germany. In the 1960s, Polke adopted the Ben Day process of mechanical reproduction long before appropriated for painting by Roy Lichtenstein (figs. 707, 708). But whereas the American artist aestheticized the dot system, not only by treating it as a kind of developed Pointillism but also, later, by forcing its screen to render established icons of high art, the German simply hand-copied—"naïvely"—a blown-up media image, complete with off-register imperfections and cheap tabloid subject matter (fig. 1024). Subsequently, he depicted a rectangular section of Dutch wall tiles and in the canvas titled the work *Carl André in Delft*, the label lettered out as if by typewriter. Image and label joined together in mocking and thereby demystifying both modular Minimalism and Conceptual documentation. Polke still works on an all-over grid or otherwise mechanically patterned ground, but simply incorporates it concretely in the form of a painted fabric, which leaves painting free, so to speak, for something other than the tired strategies of formalism and Conceptualism. Rauschenberg, of course, had already incorporated ordinary textiles into his combine paintings, as part of a Cubist technique of fragmentation and collage, but also as a Neo-Dada, as well as Cubist, device for generating the shock effect once possible in the unorthodox juxtaposition of the readymade and the painterly (fig. 696). Polke, however, would develop the latter "naturally" out of the former and thus integrate the two realities holistically. Then, in a further assimilation of the mechanical with the gestural, the artist made photography the source of the imagery worked up from the underlying pattern of regularly repeating abstract motifs (plate 294). Limned as contour drawings

and layered in a manner inspired by Picabia's Transparents (fig. 334), the images seem paradoxically to dematerialize at the same time that they emerge from the material upon which the artist has painted them, thus creating a pictorial world that appears deep even as it floats free of all perspective systems. Moreover, the figuration phases in and out of focus, as if it were the product of photographic or darkroom manipulations, perhaps even of an accident with one of the toxic substances Polke is known to use in creating his curiously synthetic and characteristic colors. No less poisonous are the neo-Nazi sources of some of the imagery, which Polke would seem to offer as a warning to the wary. He also demonstrates how such unwelcome mementoes of a discredited past can be neutralized through a democratic, nonhierarchical process of layering, dematerialization, and reabsorption within a random blizzard of other images, no more logically sequenced or aligned than those experienced every day in a media-drenched world. With their appropriated patterns and figures, their artificial colors and transparent forms, their fortuitous intimacy of the absurd and the sublime, the paintings of Sigmar Polke offer a fresh visual experience that by its very exhilaration bodies forth at least one all-important theme: that painting

left: 1023. JÖRG IMMENDORFF. *Position*. 1979. Oil on linden wood, 33½ × 25⅝ × 19⅝". Courtesy Mary Boone Gallery/Michael Werner Gallery, New York

above: 1024. SIGMAR POLKE. *Bunnies*. 1966. 59 × 39½". Saatchi Collection, London

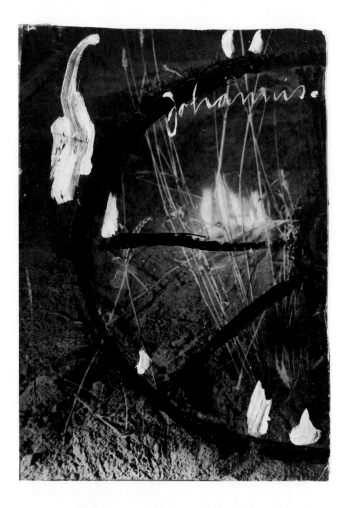

1025. ANSELM KIEFER. Title page of *Johannisnacht*. 1980. Paint on photograph, book size 23¼ × 16¾ × 7½"; page size 23¼ × 16¾ × ½". Courtesy Marian Goodman Gallery, New York

can, or should, do no more than reflect the reality of the time in which it has been fashioned, but meanwhile render that reality more tolerable by making it seem a hallucination.

ANSELM KIEFER (b. 1945) In the great black, apocalyptic paintings of Anselm Kiefer, a poet in paint born in the ashes of the Third Reich, the bardic spirit of the new German art has soared, phoenixlike, to heights of splendor that are as redemptive for painting itself as for the culture the artist both mourns and glorifies. In keeping with his mission to revisualize the mythic North in imaginative terms that truthful humanity can live with, Kiefer makes his home deep in the Odenwald, a wooded upland east of the Rhine and not far from the epochal Nibelungenstrasse. Even as a youth, the artist pondered the conflicted legacy to which Germans had fallen heir. At first he would assemble every conceivable memento of the near and distant past—images of horrors and heroes alike, nursery songs and the poems of Hölderlin—and then bind them together in volumes as thick and heavy as medieval Bibles (fig. 1025). Once he had worked the contents over with shellac, bitumen, and oil paint, the present or the painfully recent acquired the weight and look of legend, while the legendary seemed born again in modern guise.

In painting, too, Kiefer exercised the modernist's freedom to appropriate and mix whatever media—straw and sand, overprocessed photographs, lacquer, and fire—might serve the expressive purpose of

simulating ancient fields scorched and furrowed from centuries of battle and stretching into infinity as if the bitter, mindless strife had gone on forever (fig. 1026). But while the scenes have haunting presence and power, very much like the high-horizon, eagle's-eye views invented by Altdorfer in the famous sixteenth-century *Battle of Issus,* they transcend actuality to become conceptual places, realms of the mind, whose abstracting turn becomes evident in the labels the artist has written on or stapled to the canvas. At the same time that these further flatten a deep, panoramic view already as ironed out as any in modern field painting, they also identify a melancholy inventory of real, historical places: the forest where Hermann, during the "first German victory," slaughtered the Roman legions of Valerius in A.D. 9, or the much bloodied Mark Brandenburg, or the site of some desperate operation carried out by the Wermacht during World War II. They may also, as here, name or enumerate mythical or historical persons, some exemplary, others less so, such as, among both kinds, Brünnhilde and Siegfried, the Meistersinger of Nüremberg, or a fair young woman called Margarethe and her dusky Jewish counterpart, Sulamith. The latter pair—inspired by Paul Celan's *Death Fugue,* a great and moving poem of the Holocaust with a two-line refrain: "your golden hair Margarethe/ your ashen hair Sulamith"—are archetypes drawn, respectively, from Goethe's *Faust* and the Song of Solomon, and employed by Kiefer to allegorize a once integrated society now irrevocably rent by history and sorrow. Working conceptually or abstractly, as usual, the artist has represented the blue-eyed Margarethe in an extended series of pictures displaying long ropes of straw plaits dangled against an azure ground (plate 295). In a parallel series, ashy encrustations become the metaphor for Sulamith, and in one unforgettable memorial to this symbol of Jewish womanhood, Kiefer appropriated Wilhelm Kreis's mausoleum for Nazi war heroes, its wall torches blackened and its central vault now arching high above a distant altar lit with the seven flames of the Biblical menorah (fig. 1026).

This elegiac theme continues in the later *Departure from Egypt* (fig. 1027), one of Kiefer's most grandiose landscapes, rolling away majestically, yet held to the plane by the hook of Aaron's rod. Even though

1026. ANSELM KIEFER. *Sulamith.* 1983. Oil, emulsion, woodcut, shellac, acrylic, and straw on canvas, 9'6¼" × 12'1¾". Saatchi Collection, London

looking as if it had been swept by a firestorm, or mulched in blood and dung, tar and salt, the field rewards close inspection with an almost French delectation of touch and texture. From a certain distance, however, exquisite painterly effects reassemble in a larger, tougher aesthetic, yielding an image that acknowledges experience without evasion, yet with an artistry that, while giving no comfort to the amnesiac, brings hope to the thoughtful. This makes Kiefer a genuine history painter, one of the most accomplished since Delacroix, for by proving that art can

deal honestly with the century's worst calamities, he also suggests that art can cope with any subject matter. Thus, Kiefer simultaneously becomes the quintessential Post-Modernist, showing, as Peter Schjeldahl has written, that modernism is over by the very fact that he remembers it. If inconvenient truths can be recalled and turned to civilizing ends through paintings like those seen here, it is thanks to a stringent formal mastery that Kiefer inherited from his modernist forebears. Combining this with certain of humanity's other more noble attainments and in-

1029. HELMUT MIDDENDORF. *Man with Fire.*
1985. Acrylic on canvas, 6' × 8'5". Courtesy
Annina Nosei Gallery, New York

stincts, a strange and solitary exemplar of European genius has brought
forth a deeply meditated, ultimately hopeful vision of the world re-
deemed by self-knowledge and compassion.

Younger than any of the new German artists just seen, the Berlin
painters Rainer Fetting (b. 1949) and Helmut Middendorf (b. 1953)
typify their generation in that they seem less driven by the divisiveness of
postwar politics than by the pent-up feelings such pressures cause, es-
pecially in the city of Berlin (plate 296; fig. 1029). Both release them in
erotic imagery of almost hallucinating intensity and in brushwork of
daredevil freedom, as if to suggest that hot-wired spontaneity is the only
way to express the life force in oneself and one's world when both are
continuously threatened with annihilation. Here is the original Expres-
sionism of Kirchner—sexuality and fluid painterliness alike (fig.
155)—appropriated and pushed to new excesses of risk, yielding re-
sults that may seem as artificial as the cut-off situation of Berlin itself.

FRANCESCO CLEMENTE (b. 1952) The Neopolitan-born Francesco
Clemente, a self-taught painter, likes to think of himself as a dilettante,
independent of all system or prescribed logic and thus free "to main-
tain the integrity of [his] inquiry," wherever this may lead through mo-
bile chameleonlike shifts in subject and medium, style, format, and
scale. Among the "three Cs" of Italy's *transavanguardia*—a group
completed by Enzo Cucchi and Sandro Chia—who first came to inter-
national notice at the 1980 Venice Biennale, Clemente is the most flu-

ently prolific and fertile in his kaleidoscopic imagination and range of
recondite analogies. Transcending it all, however, his interests tend to
focus on psychodramatic—often explicitly or even bizarrely erotic—
self-exploration, usually in fluid tandem with myriad enigmatic cross-
references to metaphysics (Christianity, alchemy, astrology, mythology,
the Tarot) and historical art (Egyptian, Greek, Roman, Renaissance,
Surrealist, Hindu, Expressionist). But for all his Classical and cosmo-
politan erudition, Clemente betrays his inescapable modernity in an
ever-present touch of mordant, ironic humor. Nor should it surprise,
given his poetic fantasy, his openness to every possibility, his love of the
arcane, his liquid, mutating, layering approach to every medium, form,
image, or symbol, that the young Clemente found himself drawn to the
art and activities of the German Joseph Beuys, the Arte Povera master
Alighiero Boetti, and the American Cy Twombly, the either/or philos-
ophy of Duchamp and Kierkegaard, and the writings of Barthes, Borges,
and William Blake. As if flux and dislocation were the very medium of
his existence, Clemente maintains studio-residences on three conti-
nents, in Rome, Madras, and New York, and every year with his family
migrates to each for an extended period of work. While he absorbs and
exploits the imagery, ideas, and techniques native to whatever environ-
ment may claim his presence, the artist also allows his disparate influ-
ences to overlap and cross-fertilize. This becomes especially apparent
in works like the twenty-four miniatures of *Francesco Clemente
Pinxit*, executed in India and in the classical Hindu manner, using nat-
ural pigments on paper (fig. 1030). For *Two Painters* (plate 297) Cle-
mente wittily turned to primitive, popular, even kitsch sources, in both
East and West, to portray the transmigration of cultures, with the fig-
ures' reciprocal gestures toward the "orifices" signifying, in occult
terms, the liberation that one consciousness seeks in gaining access to
the other and the vulnerability this implies in both.

In New York, Clemente taught himself oil painting, a Northern, rather
than Italian, medium developed by Lowlanders, who as Dutchmen were
the first Europeans to pioneer and settle along the Hudson River. There,
like Barnett Newman, a pioneer father of the New York School, Cle-
mente created a series of pictorial works entitled The Fourteen Stations,
interpreting the theme not with the traditional iconography of Christ's
agonized journey to the Cross, but rather through a dreamlike intermin-
gling of personal psychology, cultural history, and religious symbolism
(fig. 1031). Clearly, Clemente treats religion and art alike, less as
monolithic, closed systems than as flexible, organic agencies for ex-
pressing the anxious individual's responses to everyday reality.
Throughout the Stations the artist's own naked person is ubiquitous, the
head (in actuality quite classically handsome) caricatured as a kind of
gargoyle with close-cropped hair, staring almond eyes, and a wide, rav-
enous, thick-lipped mouth. In Station No. III the image contorts into a
huge grimacing "orifice" filled with skulls instead of teeth. In Station
No. IV the figure has become what appears to be a Roman-collared
priest, screaming like Bacon's Bishops (plate 208) and lifting his white
surplice to reveal a dark, egg-shaped void just above an intact scrotum
(fig. 1031). A more poignant, if no less eccentric, persona appears in
Station No. VIII, where the nude artist lies helpless, his body strewn
with women's shoes while rats scurry among rubbish. Androgyny, of
course, is consistent with the idea contained in the fixation on orifices,
the symbolic means of escape from the bound-in, limited self and the

1030. FRANCESCO CLEMENTE. *Francesco Clemente Pinxit* (detail). 1981.
Natural pigment on paper, 24 miniatures, approximately 8¾ × 6" each.
Virginia Museum of Fine Arts, Richmond. Gift of Sydney and Frances Lewis

beginning of metamorphosis into something more generous and complete. In contrast to the serenity of the Indian works, the turbulent Fourteen Stations, fluctuating in style from the refined to the crude, no doubt reflect the contradictory and stridently competitive environment of New York City.

In Rome, appropriately enough, Clemente has created frescoes, enriched by his extensive reading in Silver Age Latin, particularly *The Golden Ass* of Apuleius and Petronius's *Satyricon*, both collections of exotic stories steeped in a heteroclite brew of mythology, Christianity, and witchcraft, and full of people and beasts transfigured into one another. Clemente also knows and has evidently been influenced by Italy's sixteenth-century esoteric tradition of *impressa*, an emblem composed of an image and a motto, which together state some philosophical principle. The most famous of all such devices originated with the Emperor Titus and eventually served as the colophon of Renaissance Venice's Aldine Press. Along with the motto *Festina Lente,* meaning "make haste slowly," it shows a dolphin, signifying speed, wrapped about an anchor, serving to brake the impetuous sea mammal. For his own *Festina Lente,* Clemente, like a latter-day Duchamp, appropriated an abandoned bicycle wheel and then partially frescoed it with the image of a jet plane. The bicycle wheel has subsequently appeared in other works, none of them more poetic, mysterious, yet wonderfully lucid than an untitled canvas painted in Rome in 1984 (plate 298). Here, the artist depicted a limpid underwater surface covered with rocks and pebbles, the arrangement as beautiful as any to be found in a clear stream—or an abstract painting. A pale-blue light tiptoes across the scene, lump by lump, insinuating the slow process of time as well as a glimpse of azure sky. Concocted of pumice and pigment, the evanescent color serves images and substance alike, while also evoking the age-old fresco art of Rome. Oddly enough, among so much quiet formalism, the last features to reveal themselves are the brightest in the painting—a scatter of five small but brilliant orange wheels, spoked and broken like discards from a child's vehicle, and so tiny they could be mistaken for citrus slices, debris from some beachside cocktail party. Thus, just as the picture seems ready to cross the line into the rationality of either full-blown naturalism or pure abstraction, it is jerked back into the world of fantasy, ultimately unfathomable even if illuminated by the antecedent of *Festina Lente.* But the irony in that painting, where the image of a

high-speed jet arrests the action of a real wheel, may be present in the later work as well, for the images of five underscaled propellers, even though dysfunctional, halt our acceleration toward conclusions remote from the sort envisioned by the artist. With this, *trompe-l'oeil* painting assumes a whole new dimension of meaning. Clemente himself likens it to the ideogram, a concept that partakes of both language and painting:

I have an idea of a kind of circuit of what I want to do. It seems that the ideogram—when the Chinese have to say "chair," they don't say chair. The ideogram doesn't depict a chair, but depicts a . . . maybe the bamboo. I mean the bamboo in the morning is taken to become the chair somehow. What they look for is the situation of what they want to depict. And they find out a kind of analogical train of things which is going on, and they depict one of those things. Nobody really knows why they choose that one and not another one. . . .

SANDRO CHIA (b. 1946) In his "deconstructive" reaction to modernist conventions, Sandro Chia, a Florentine now resident in New York,

above: 1031. FRANCESCO CLEMENTE. *The Fourteen Stations, No. IV.* 1981–82. Oil and encaustic on canvas, 78 × 88½". Saatchi Collection, London

left: 1032. SANDRO CHIA. *Three Boys on a Raft.* 1983. 8′1″ × 9′3″. Collection PaineWebber Group, Inc.

right: 1033. SANDRO CHIA. *Figure with a Tear.* 1982. Bronze, 65 × 26 × 26"; base 15 × 20 × 8". Number four of edition of four. Lannan Foundation

has relied on innate Italian exuberance and a personal knowledge of the ersatz Neoclassicism practiced during the Fascist 1920s and 1930s by such artists as Giorgio de Chirico and Ottone Rosai, themselves reactionaries against Futurism, Italy's first modernist style (fig. 321). Adopting the older masters' kitsch—their absurdly muscle-bound nudes and self-consciously mythic situations—but inflating the figures to balloon proportions while reducing the overblown narratives to the scale of fairytales, Chia parodies his sources at the same time that he thumbs his nose at the authentic Neoclassical rigor that survived in Minimalism (fig. 1032). Just as appealing as the comic amplitude of these harmless giants is the Mediterranean warmth of Chia's color and the nervous energy of his painterly surfaces, qualities of scale, palette, and touch that the artist also manages to translate into his heroic bronzes (fig. 1033). To some, Chia seems like a sixteenth-century Mannerist reborn with the spirit of Chagall.

1034. ENZO CUCCHI. *Paessagio Barbaro*. 1983. 9'9" × 13". Neue Staatsgalerie Stuttgart

1035. ENZO CUCCHI. *Vitebsk-Harar*. 1984. Oil and polyurethane on canvas, 11'9¾" × 15' × 7¾". Courtesy Sperone-Westwater Gallery, New York

ENZO CUCCHI (b. 1950) Unlike the world-traveling Clemente and Chia, Enzo Cucchi remains solidly rooted in the soil of his native region near Ancona, a seaport on Italy's Adriatic coast. There, from time immemorial, the Cucchi family has worked the land, a land whose circular compounds of farm buildings, vertical take-off roosters, and catastrophic landslides have often figured in the artist's paintings (fig. 1034). Because of his doomsday vision and his love of richly material surfaces, troweled on with what often seems a waxy mixture of rusted graphite and coal dust, Cucchi has sometimes been compared with Germany's Anselm Kiefer. What sets him unmistakably apart, however, is the special Italian or operatic spin he gives his dramas, full-throttle affairs that evoke the tenebrous, declamatory world of the proto-Baroque Caravaggio (fig. 9). Occasionally, however, a deadly, but no less dramatic, "day-after" calm settles over the scene, the field empty of all but a congealed flood of pigment, in which floats some bony ghost, a fleet of skulls, or the horrific head of a dead animal (fig. 1035).

JULIAN SCHNABEL (b. 1951) The artist most often credited with reigniting the art scene—or, more specifically, the market for new painting—has been Brooklyn-born, Texas-educated Julian Schnabel. Shortly after his graduation from the University of Houston, Schnabel was back in New York working as a cook in a SoHo restaurant, supporting himself while he steadfastly pursued his ambition to become a full-time, professional artist. In January 1982, at the age of thirty, and barely two years after he had come to public notice, Julian Schnabel received the seal of international success in the form of a retrospective exhibition at the Stedelijk in Amsterdam, one of the world's premier museums devoted to modern art. But this was only the latest event in a six-year career that included some sixteen solo shows, plus numerous group exhibitions, and a bibliography of over a hundred articles written about the artist and his work. In an age obsessed with instant fame, this was the real thing—the art-world equivalent of rock-star glamour and excitement. The skillful, high-pressure publicity campaign waged by the artist's first dealer, Mary Boone, and the rhetoric adopted by Schnabel in his public pronouncements placed a heavy burden of proof on the art itself. For viewers starved by a progressively more anorexic visual diet of Minimalism and Conceptualism, Schnabel's epically scaled, aggressively, even richly textured, and flagrantly literary or thematic pictures—reviving the whole panoply of religious and cultural archetypes once the glory of traditional high art—came as mannah from Heaven. Never mind that the materials were often vulgar, the handling slapdash, and the images long since rejected as empty of their original symbolic import—the total impact on those avid for a sense of pictorial fullness and generosity was electrifying. To this, probably more than anything else, must be attributed the skyrocketing favor Schnabel very quickly found among collectors and curators, even in the face of almost unprecedented critical hostility.

The focus of the latter fell with particular force on the so-called "velvet paintings" (plate 299), works whose surface is the kind of plushy, silken material always associated with royalty, but also, on the opposite extreme, with the tawdry world of nightclubs and the kitsch of souvenir pictures sold at cheap boardwalk galleries. For Schnabel, of course, it offers a connection with Pop media, as well as a color field of unusually sonorous purples, pinks, blacks, and ochers, the luxurious texture both absorbing and reflecting light to generate a magical sense of indeterminate space, surface-declaring and yet uncannily infinite. Velvet also provides drag and tooth for the artist's painterly touch, its bravura range of clotted and whizzing strokes reminiscent of Action painting. Sometimes the fabric soaks up the oil medium, making the

image look as if it hovered mysteriously in shallow, atmospheric depth just behind a translucent plane. No less spectacular is the battery of compositional devices, all brought on line to control and counterbalance a dismaying plurality of images gleaned from civilization's hoarded trove of emblems both high and low, frequently in contexts as evocative or personal and unspecific as ever in modern art. Moreover, the context of a work by Schnabel may range in stylistic or thematic reference throughout the history of world culture, from Classical or Christian antiquity to Caravaggio, Joseph Beuys, and the combine paintings of Robert Rauschenberg, from Baudelaire to Artaud and Burrows. When dramatized by the ramified reach of such found and attached objects as antlers, tree branches, or huge pieces of driftwood, the total effect transcends the self-conscious striving for identification with the canonic masters to achieve a genuine theatrical or operatic effect unique to Schnabel.

Far more innovative and emotional, nonetheless, are the violently three-dimensional surfaces that Schnabel realizes by embedding broken crockery in plaster spread over a reinforced wood support (fig. 1036). The idea for this startling process came to the artist during a visit to Barcelona, where he saw Antoni Gaudí's tiled mosaic benches in the Güell Park (fig. 98). However, rather than flat and smooth as Gaudí's inlays had to be on furniture, Schnabel's shards project from the plane, in an irregular, disjunctive arrangement that texturally seems to heave like miasma, but visually functions, edge to edge, as a field of enlarged Pointillist dots. At the same time that the china pieces serve to define shapes and even model form, they also break up the image and absorb it into the overall surface flicker, like a primitive, encrusted version of the Art Nouveau figure-in-pattern effects of Gustav Klimt, Gaudí's Austrian contemporary (plate 28). By painting over, around, or even under the protruding ceramic, Schnabel has been able to create every manner of pictorial drama, from the almost folkloric wit and charm of a Mexican pot piece (fig. 1036) to the mythic ritual enacted in a tour-de-force entitled *King of the Wood* (fig. 1037). Gert Schiff, writing in a catalogue essay on Schnabel's work, has traced the iconographic source of this monumental tripartite composition to a passage in James George Frazer's *Golden Bough*:

> In antiquity this sylvan landscape (i.e. the woodland around the Lake of Nemi) was the scene of a strange and recurrent tragedy. On the northern shore of the lake...stood the sacred grove and sanctuary of Diana Nemorensis, or Diana of the Wood...In this sacred grove there grew a certain tree round which at any time of the day, and probably far into the night, a grim figure might be seen to prowl. In his hand he carried a drawn sword, and he kept peering warily about him as if at any instant he expected to be set upon by an enemy. He was a priest and a murderer; and the man for whom he looked was sooner or later to murder him and hold the priesthood in his stead. Such was the rule of the sanctuary. A candidate for the priesthood could only succeed to office by slaying the priest, and having slain him, he retained office till he was himself slain by a stronger and craftier.... We picture to ourselves the scene as it may have been witnessed by a belated wayfarer on one of those wild autumn nights...the background of forest showing black and jagged against a lowering and stormy sky, the sighing of the wind in the branches, the rustle of the withered leaves under foot, the lapping of the cold water on the shore, and in the foreground, pacing to and fro, now in twilight and now in gloom, a dark figure with a glitter of steel at the shoulder whenever the pale moon, riding clear of the cloud rack, peers down at him through the matted bows.

1036. JULIAN SCHNABEL. *The Sea*. 1981. Oil and crockery on wood, 9 × 13'. Saatchi Collection, London

1037. JULIAN SCHNABEL. *King of the Wood*. 1984. Oil, bondo, plates, and spruce roots on wood, 10 × 19'6". Courtesy The Pace Gallery, New York

As Schiff has shown, Schnabel's "plate painting" follows Frazer's narrative point by point, from the "dark and jagged" forest on the left to the barbaric splendor of the priest-murderer at the center, struck by a "pale moon" through "matted boughs," here represented on the right by an actual spruce-root combine element, its spidery reach extending beyond the format. In a work like this, so perfectly resolved in its relationship between pictorial means and representational ends, so self-evident and expressive in its use of shards to excavate and archeologically, so to speak, re-create an ancient myth, Schnabel seems truly to stand tall in the blaze of publicity cast upon him by shifting tastes within the ongoing dynamics of cultural change. But given these accelerating quicksands, Schnabel may indeed be justified in his metaphysical turn of mind, which often prompts him, despite his youth and acclaim, to speak of death:

> ...My painting is more about what I think the world is like than what I think I'm like. I'm aiming at an emotional state, a state that people can literally walk into and let themselves be engulfed by. ...Maybe I make paintings larger than I am so that I can step into

them and they can massage me into a state of unspeakableness. The paintings in my last show are the view from the bridge, the bridge between life and death. I think about death all the time....

In the light of such confessions, one can easily see the painting just examined as a personal metaphor for the young artist suddenly arrived and fearfully determined to hold his place as the new "King of the Wood." But if Schnabel's mythopoetic allegory of power and death succeeds in stirring viewers—and this cannot be doubted—the emotive effect arises less from the image, which is not immediately decipherable, than from an audacious stylistic performance, or process, that simultaneously structures and shatters both surface and figure, thereby evoking the conflicted drama of delusionary omnipotence or grandeur undermined by self-protective ambivalence.

DAVID SALLE (b. 1952) Among the American Neo-Expressionists, one of the most controversial yet undeniably important artists may be David Salle (pronounced Sally), who maddens his critics by working almost exclusively with appropriations, but delights supporters by compounding this vertiginous mix of disassociated elements into a new signature style of thrilling bravado, equipoise, and independence (plate 300). The borrowings begin with Minimalism's stained color fields and diptych formats, continue with Jasper Johns's particular way of juxtaposing odd and jarring images, and, most startlingly, embrace the images themselves, plucked from art history, from popular illustrations, and from random encounters with such visual flotsam as comic books and how-to sex manuals. With characteristic daring, the artist casts his mélange of blatancy and elusiveness on a near-megalomaniac scale, mainly by projecting the images onto the colored ground and then tracing them as loosely brushed contour drawings, layered and floated in a collided intimacy somewhat like that in dreams or in one of Picabia's Surrealist Transparents (fig. 334). Or he may apply images to the surface in the form of a nonart material such as felt, a readymade, or some specially fashioned three-dimensional object. And abstract or figurative, the imagery could be handled sketchily or tightly resolved, or even in some complimentary imitation of an admired near or distant contemporary—Jackson Pollock, Andy Warhol, Jean-Paul Riopelle, Sigmar Polke.

In the painting called *Tennyson,* just seen in plate 300, the artist has disclosed his Conceptual background by lettering out the title in italic capitals, across a field dominated on the left by a nude woman with her back to the viewer and, on the right, by a found wooden relief of an ear. The name of a proper Victorian poet, a piece of erotica, and a severed ear—how could elements so ripped from their original contexts be sufficiently recontextualized within the same painting to endow that work with the kind of fresh revelation expected of significant art? At first, the images may seem to cancel one another and blank out all meaning, until it can be remembered that in 1958 Jasper Johns reproduced Tennyson's name across the bottom of an abstract canvas painted in sober gray on gray, as if it were a tribute to the artistic integrity and lyrical, high-minded spirit of England's "good grey poet." And this lead proves valid when supplemented with the additional clue of the disembodied ear, which could evoke the poet's "ear for words," or Van Gogh, but also, and more tellingly, Jasper Johns once again. The latter, we should recall, affixed a three-dimensional ear, among other anatomical parts, to *Target with Plaster Casts* (fig. 700), thereby setting up a powerful interplay between two types of reality, the opacity of their relationship suggesting the ultimate enigma that lies within either. Such correspondences generate others, as in the different colors of the letters, also a technique of Johns's, but when picked up by surrounding geometric color areas, they seem to evoke Josef Albers. Now, Victorian morality, Johnsian quality, and Bauhaus purity all combine as if in commentary on the naked woman and the kind of sexism such imagery represents. Because of his quotations from problematic sources like porno magazines, Salle has received a good measure of criticism, without the critics' taking into account, however, that an artist concerned to discover relatedness even within the extreme incongruity of modern life, and working in the sophisticated, oblique manner of Johns, would find salutary thematic use for the most alienating of all images. "The connections between things are not random," Salle said recently. "There are connections that exist between things in the world, and then there are connections that exist between the images in my pictures. Those connections are not the same. Not to perceive the difference I think could be very frustrating."

For a mammoth diptych entitled *Miner* (fig. 1038) Salle found the frontalized image of a laborer—in an old movie about class strug-

gle?—sitting with stooped shoulders and a tired, rather baleful expression on his face. In front of him at arm level float two immense diamond rings, conceivably the product of his labor and apparently objects forever beyond his reach. On either side of the subject's head are a pair of appliqués, cheap café tables with their tops smashed. Positioned and projected as they are and burst open, they could be the relics of a pub brawl, or three-dimensionalized emblems of the miner's headlights for working at some dark, stygian depth, or the glittering stone "headlights" set in the rings. And they too hover outside the miner's reach, as do the intact tables and the elegant blue lady suspended as disembodied outlines in the adjacent panel. Evidence of violence, remoteness, and despair set off vibrations unifying the disjunctive images, spaces, colors, textures, and styles in a mood of sadness and loss, forcefully redeemed for contemplation by the artist's virtuoso management of it all, including the *coup de théâtre* of the shattered tabletops. By appropriating and assembling images as disconnected as these, yet feeling their certain, if tenuous, connectedness, Salle seems to assert that if, in this age of media overkill, life is little more than a conflicted bundle of borrowed, culturally loaded ideas and images, then almost anything in it is best understood in terms of other equally loaded, borrowed ideas and images. Thus liberated from the absolutes and narrow logic of traditional modernism, and handed a slate wiped clean by modernism's final binge of self-purification, artists like Salle could use rampant imagination and inherited pictorial sophistication to express a sour, schizoid *fin-de-siècle* moment with stunning clarity and brilliance.

ERIC FISCHL (b. 1948) Despite the general sense that Post-Modernism means revived figuration, New Image and Neo-Expressionist painters, for the most part, treat the human figure as incidental to some overriding interest in problems of form, process, expression, or didactic theme. Few address their art totally to the figure in all its naked physical and psychological fullness, especially as this can be revealed in ambiguous but recognizably banal relationships among two or more images. Foremost among such painters is Eric Fischl, whose immense fleshscapes have an unusually high-voltage effect on viewers (fig. 1039), and not so much because of the nudity or the suggestions of alcoholism, voyeurism, onanism, homosexuality, bestiality, and incest.

They disturb, rather, because the obviously white middle-class suburban status of the subjects, combined with the gigantic scale of the pictures, the compositional vantage point, and the direct Manet-like naturalism of the artist's painting style make it impossible for most viewers to escape implication in whatever psychodrama Fischl has chosen to stage. In *Bad Boy,* for instance, the observer finds himself in a bedroom, awash with light filtering through slatted blinds, and immediately behind a young adolescent boy, who watches his mother and simultaneously pilfers from her purse as she lies nude napping on the bed, her legs spread wide to him—and to us. In *Sleepwalker,* from the perspective of a parent or a neighbor upstairs, we gaze down upon a moonlit backyard, where a boy in a blue plastic wading pool, bent-kneed and head lowered, grasps his sex with both hands—to masturbate, urinate, or protect himself while sleepwalking through a nightmare? And who may be guilty? The child oblivious to the world and vulnerable to discovery, whatever the nature of his act, or the viewer, safely removed and free to peer at will? That such pictures should be unsettling has been made clear by Fischl himself:

> I would like to say that central to my work is the feeling of awkwardness and self-consciousness that one experiences in the face of profound emotional events in one's life. These experiences, such as death, or loss or sexuality cannot be supported by a lifestyle that has sought so arduously to deny their meaningfulness, and a culture whose fabric is so worn out that its attendant symbols do not make for adequate clothing. One truly does not know how to act! Each new event fills us with much the same anxiety we feel when, in a dream, we discover ourselves naked in public.

But as the paintings already mentioned imply, Fischl is concerned not only with the experience of the individual's own physical and psychic nakedness but also with the prurient fascination that most have with the nakedness of others. This can be seen in painting after painting set in the gardens, on the beaches, in the well-appointed rooms, on the yachts of affluent America, all populated by flabby men, women, and children scattered about or clustered in scenes of boredom and isolation, awkward and half-embarrassed, self-absorbed and yet furtively, even intently looking or side-glancing at one another's exposure. In paintings like

1039. ERIC FISCHL. *Noon Watch.* 1983. 5′5″ × 8′4″. Collection Mathias Brunner, Zurich

1040. ROBERT LONGO. *Untitled (Men in the Cities Series)*. 1981. Charcoal and graphite on paper, 8 × 5′. Metro Pictures, New York

1041. ROBERT LONGO. *Untitled (White Riot Series)*. 1982. Charcoal, graphite, and ink on paper, 8 × 10′. The Eli and Edythe L. Broad Collection, Los Angeles

Noon Watch (fig. 1039) or *The Old Man's Boat and the Old Man's Dog* (plate 301) the typical viewer may find himself inescapably drawn into whipsaw crosscurrents of attraction and avoidance, the trap set by a humanist image and painting style, but then used not to evoke traditional idealism but rather to press modernism's critical agenda. Near or all about the self-satisfied but ungraceful, uneasy loungers in *Noon Watch* and *The Old Man's Boat* surges the enigmatic and unstable presence of water, a metaphor, like the snarling Dalmatian in the second painting, of mystery and dread, of the instability at the heart of solid-seeming bourgeois secular society, set adrift from the mythic past and now fallen prey to the contradictory impulses of modern life.

ROBERT LONGO (b. 1953) Ambitious and prodigiously multitalented is the young and successful Robert Longo, who has said: "I think my art is going to change the world. And I want as many people as possible to see it." The art with which he intends to alter the world has been described as "apocalyptic Pop," huge "salon machines" made of over-lifesize imagery appropriated from or inspired by film, television, comic books, and advertisements, a secondhand world of kitsch and high culture mixed and matched to provoke voyeuristic responses to such elementary, interrelated themes as love, death, and violence (plate 302). No less dramatic is the serendipitous variety of media that Longo and his Renaissance-like atelier of collaborators (usually named) have combined, with sleek professional expertise, to give the orchestrated assemblages their near-Wagnerian sonority: sculpture (wood carving, stone intaglio, bronze casting), painting (acrylic, spray paint, and gold leaf), drawing, silkscreen, and photography. Not only do all these disparate iconographic and material elements cohabit in Longo's work, along with an inevitable assortment of styles, ranging from "black" Reinhardt-like abstraction to magazine illustration, but, thanks to compositional skills of cold cunning, they also cohere with something like the inexorable logic of Frank Stella's more elaborate reliefs (fig. 778). If such taut, powerful icons seem curiously chill pressure chambers of contradiction—caught "somewhere between movies and monuments"—it is because Longo knows from his own heterogeneous background in Performance Art, video, film, rock music, and even the management of a famous "alternative space" (Hallwalls at the State University of New York at Buffalo) that contemporary life is all but choked on the plurality of its good and bad possibilities. Out of his own miscellaneous experience, Longo gained initial recognition with a number of large black-and-white charcoal drawings, such as the extended 1979–82 series called Men in the Cities. For these impressive works the artist photographed single figures clad in sober business clothes and seized in the contorted throes of what could be either agony or ecstasy, dying or dancing (fig. 1040). But while any such condition should create a sense of heat, the figures are like frozen energy, and perhaps all the more haunting for the tension their ambiguity produces. Indeed the technique by which they were made was a distancing one. It involved projecting the image on a large scale, combining features—head, legs, hands—from several such photographs to make more an archetype than a portrait, and then rendering the composite in charcoal and graphite on paper, an activity carried out by Longo in consort with an assistant. As the resident of a loft district near New York's Wall Street, Longo has been a regular witness to "the pressures of modern life," in which upscaling men and women, like those in glossy ads, engage in never-ending "corporate wars." The artist has made their *Totentanz*—the energy, aggression, and hostility that seethe behind bland, buttoned-down exteriors—still more explicit in the White Riot series, where middle-class types, dressed in nine-to-five wear, join in an orgy of pushing

and pulling, not unlike that seen every day on the floor of the New York Stock Exchange (fig. 1041).

Far more complex is *Ornamental Love* (plate 302), a triptych in which spray-painted crimson lovers kissing passionately in a field of black are flanked, on one side, by a Photorealist acrylic-on-aluminum painting of a collapsed bridge and, on the other, by an absurdly gorgeous cluster of gilded plaster flowers. Does the cheap sentimentality of the relief comment on the shallow exploitation of the make-believe movie love, and thus imply a consequent undermining of something more substantial—the bridge to reality? Hard to tell, since images, color, texture, and form—the whole visual variety and abundance—have been cut and joined with the omniscient, undifferentiating hand of a film director. One commentator has suggested that the key to Longo's art lies, as with so many contemporary works, in his process, whereby the artist creates a fascinating and melancholy spectacle of old modes, media, and images, and then collides them with new ones in order to reveal and recover the original Utopian hope—the spiritual élan—that lies latent even in something as debased as kitsch. Longo himself would seem to have confirmed this when he said:

> I'm trying to use the visual vocabulary of our culture to talk about how the history we know and the time we live in bear on the future. If there's a message here, it's hope. I compete with things basically oppressive, like advertising. I'm like the revenge of the media. My art has accessibility, so that the average person can like it.

CINDY SHERMAN (b. 1954) Another *auteur* in the cinematic sense is Cindy Sherman, a student with Longo at the State University of New York in Buffalo, and a no less astute appropriator of popular imagery, again for the purpose of suggesting that, among other things, the modern world's media-induced loss of firsthand experience has not occurred without compensating benefits. Along with it comes, for instance, the technology and the role models for assuming no end of variable identities, in the hope that one, or some combination, of them may fit. Beginning in 1978, Sherman has allied the arts of Performance and photography to star and simultaneously sublimate herself in an ongoing, inexhaustibly inventive series of still photographs sometimes characterized as "one-frame-movie-making" (fig. 1042). Complete with props, lighting, makeup, wigs, costume, and script, most of the pictures both milk and send up stereotypical roles played by women in films, television shows, and commercials of the 1950s and 1960s, ranging from a bored suburban housewife or a *Playboy* centerfold to a heroine reminiscent of Sissy Spacek in *Coal Miner's Daughter*. Virtually all have had an enthusiastic international reception, thanks to the artist's consummate gifts not only as a photographer but also as an actress, director, jack-of-all-theatrical-trades, and Conceptualist. In her series called Untitled Film Stills, Sherman made eight-by-ten black-and-white photos representing a whole cast of New Wave personae, presented in impeccably styled backgrounds and in evocative but enigmatic situations, such as a Monica Vitti look-alike lounging on rumpled sheets with a worn paperback romance at her side, or a woman drinking and smoking in a dim light who could be a chic night owl or a young alcoholic. Although carefully worked out, details remain unobtrusive and the attitude objective, even open, allowing viewers to complete the "stories" according to whatever memory or role consciousness they themselves may bring to the encounter. To help, Sherman counsels: "These are pictures of emotions personified, entirely of themselves with their own presence. . . . I'm trying to make other people recognize something of themselves rather than me."

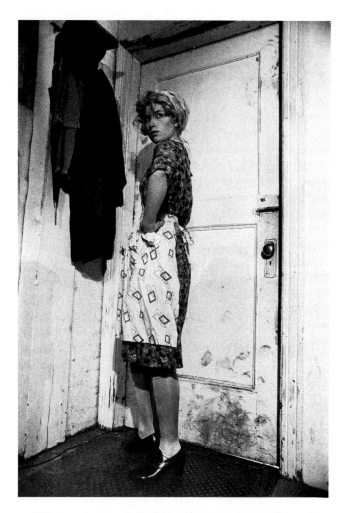

1042. CINDY SHERMAN. *Untitled Film Still*. 1979. Photograph, 10 × 8″.
Courtesy Metro Pictures, New York

1043. CINDY SHERMAN. *Untitled (#150)*. 1985. Color photograph,
49½ × 66¾″. Courtesy Metro Pictures, New York

In a 1980–82 series Sherman began working in color and on near-lifesize dimensions. But as the pictures grew larger, the situations became more concentrated, focusing on specific emotional moments rather than implying the fuller scenarios seen earlier. Setting, back-

ground (supplied by a projector system), clothes, wig, makeup, and lighting combined with the performance itself to create a unified mood: anxiety, ennui, flirtatiousness, or confidence. Often there is a disturbing detail, as in a piece of torn newspaper clutched by a plaid-skirted teenager sprawled on a linoleum kitchen floor (plate 303). Here, like a Hitchcock heroine, the subject seems vulnerable to something outside the photographic frame, thereby implicating the viewer, beyond the passive state of voyeur, into the more active condition of blackmailer, two-timer, or, eerily, a lover killed in action overseas. Sherman also took on androgyny, a pervasive theme throughout the period, and with unsettling success impersonated a string of pretty "boys." For a sumptuous 1983 series she dressed in high style and mimicked the kind of glossy fashion photography once favored by *Vogue* and *Harper's Bazaar.*

More recently Sherman accepted an assignment to illustrate children's fairytales, a project that led into dark fantasies evoking a primitive past (fig. 1043). Six feet tall and full of magical, studio-simulated moonlight, firelight, and twilight, the new "stills" found the artist venturing well away from the allure and vulnerability of her earlier stereotypes, along with their sources in popular culture, and into a fabulous, threatening world of Teutonic myth, Oriental legend, and Jungian archetype—all viewed, as Andy Grundberg has suggested, from a post-Disney perspective. Now she expanded her repertoire of disguises to include a pig's snout, a witch's warty chin, an immense tongue, and exaggerated plastic breasts and bottom. While this removal from the contemporary scene may make Sherman seem less a "deconstructionist"—an artist engaged in parodying or otherwise demystifying the hollow conventions of modern art and life—it also takes her closer to the Post-Modernism of a Neo-Expressionist like Julian Schnabel, who fearlessly makes his appropriations from the mythic past. But however near or distant the quoted source, Cindy Sherman and her fellow "image-scavengers" express a collective longing for continuity with more innocent times, times with a less problematic sense of the future.

LEON GOLUB (b. 1922) In a period of early and easy success, the Chicago-born Leon Golub stands in stark contrast, a moralist in the

1044. LEON GOLUB. *White Squad IV. El Salvador.* 1983. Acrylic on canvas, 10′ × 12′6″. Saatchi Collection, London

1045. SUE COE. *Malcolm X and the Slaughter House.* 1985. Oil on paper, collage, 59⅞ × 49¼″. Collection Don Hanson

tradition of Daumier, Gauguin, and Beckmann who for some forty years stuck quite literally by his guns, all the while "famous for being ignored," until at last, in the early 1980s, the world's unhappy concerns had so evolved as to become dead-on coincident with his own. These are the politics of power and the insidious, all-corrupting effects—violence and victimization—of power without accountability. The sixty-year-old Golub had spent the long years of his exile—out of fashion and out of the country—steadily gathering his artistic and intellectual forces, so that by the time the first pictures in the Mercenaries series came before an astounded public in 1982, they presented, as did the later White Squad pictures, a hard-won but fixating, frozen unity of raw form and brutal content (fig. 1044). Golub has said that "to figure out aspects of power, you have to look at power at the peripheries," and it was at the peripheries that this artist witnessed the rise of American formalism, seeing within its monumental and domineering abstraction a covert content of power, corrupting in that monolithic, intolerant Abstract Expressionism and Minimalism tyrannized all stylistic rivals.

Golub had begun as a leading light of Chicago's postwar figurative Expressionist movement before relocating to Europe for the years 1956–64, where he cultivated his own special, physical sense of form through a close study of Primitive, Greek, Roman, and Assyrian art. Thereafter, with his wife, the artist Nancy Spero, Golub settled in Manhattan and, under the pressures of events in Vietnam, began the slow, insistent process of coupling American stylistic potency to his own deeply felt political interests. Success, however, did not come immediately, for like many political painters, Golub rendered his protest art futile by investing it with a nonspecific iconography of massacre and atrocity, as anonymous as what could be seen every day on the evening news and all the more generalized for being projected on a gigantic

scale. By the time of the Mercenaries, however, he had arrived at his "peripheries" principle and had begun to focus on the margins of organized society—the putative jungles of South America or Africa—where the emissaries of power tend to be not anonymous armies or aloof public figures but "mercs," down-to-earth individual agents-for-hire. To ring home the evil of torture and terrorism, Golub hit upon the stunningly original and sophisticated idea of making his political criminals all too human, fascinating and specific in their cowboy swagger, sexiness, and guilty satisfaction, while at the same time reducing the intimidated victim to a dehumanized, undifferentiated state almost beneath empathy. The better to authenticate his images of unfettered police authority, Golub pieced them together from photos of political atrocities, complete with the ungainliness of men exuberantly, sensually caught up in their daily work. Furthermore, he made the petty tyrants ten feet tall, pressed them forward with a Pompeiian oxide-red ground, itself a primary emblem of imperial, political power, and cropped the antiheroes' legs off to spill the scene forward, as if into the viewer's own space. Pinned down by direct, relentless eye contact with the smirking torturers, the spectator finds himself visually involved in the seedy, almost erotic intimacy and interdependence between violator and victim. If he feels flayed by this confrontation—by his own ambiguous "sympathy for the devil"—the sensation could only be reinforced by Golub's surface, tacked unstretched to the wall like a hide, the pigments soaked into the canvas and then laboriously scraped back with the cutting edge of a meat cleaver, to effect a look as parched and crude as the subject matter. Far too committed and subtle to preach or sloganeer, Golub simply uses his long-seasoned pictorial means—a perfect congruence of image, form, process, and psychology—to induce feelings of complicity in a system that manipulates some individuals to destroy human life and others to ignore the fact that it is happening.

SUE COE (b. 1951) As politically and socially committed as Golub, but overtly outraged rather than subtle in her approach, the British-born artist Sue Coe left English reticence far behind when she moved to New York in 1972, and there began aiming her powerful agitprop collage-paintings at such targets as the CIA, male chauvinism, nuclear brinksmanship, apartheid in South Africa, and, ultimately, President "Raygun" (fig. 1045). Too, while Golub may look to the high mural or even fresco art of ancient and Renaissance-Baroque Italy for his chalky colors and pictorial rhetoric, Coe takes her inspiration from the stark black-and-white contrasts and righteous indignation of Brueghel, Goya, Daumier, and Orozco. Coe is a true Expressionist, using art to indict an unjust world with the same passion that fired such earlier twentieth-century heroes of moral protest as Käthe Kollwitz, George Grosz, Otto Dix, and Max Beckmann. Fierce in pictorial argument, Coe has appropriated a whole battery of provocative techniques—a hellishly dark palette of graphite and gore, razor-sharp drawing, jammed, irrational spaces, collaged tabloid headlines—and wields them with a seemingly unshakable faith in the rightness of her perceptions. But however extreme or fanatical these may seem to viewers of different persuasion, one can nonetheless be moved by the grim poetry at work in a midnight world of evil-doers metamorphosed into snakes and their hapless victims into angels, or in a painting overprinted with a banner like: "If animals believed in God, then the devil would look like a human being." As one critic recently wrote: "Sue Coe paints horror beautifully, ugliness elegantly, and monstrosity with precise sanity."

TOM OTTERNESS (b. 1952) A Post-Modernist par excellence, Kansas-born Otterness looks back not only over the receding mountain of modernism but also to the far-off dawn of civilization, a primordial, if not-so-innocent, time when, in Otterness's conception, humanity had the undifferentiated, universal look of "Pillsbury's dough boys," as well as an obsessive interest in cavorting with such primary forms as Cézanne's cones, cylinders, and spheres, when not otherwise engaged in every manner of primal sex. To contain the energies of his somewhat perverse little brutes, the artist tends to corral them into architectural friezes, another archaic form that assumes the character of an archeological fragment when sold by the foot (fig. 1046). Offered segmentally, the friezes also begin to look like three-dimensional comic strips and the actors like those in, for instance, "Alley Oop." The sex and symbolic geometry, the pagan Ur-folk rehearsing the primitive hilarities of contemporary Pop culture, the Classical forms issued like yard goods—all are part of Otterness's desire to make his art a universally accessible language through which to comment on the human condition. Seeing parody and irreverence as more persuasive than heavy rhetoric, the artist has had his rotund ciphers—resembling soap-carved cousins of Charles Simmonds's invisible "little people"—romp through mythopoetic sagas of labor, mass uprisings, Edenic pleasures, and group bestiality. One by one, they lampoon such grave issues as aggression, sexism, and alienation in the technological age.

In 1978, to get his message across, Otterness set up a table at Artist's Space, a SoHo outlet for the unaffiliated artist, and sold a long series of small white cast sculptures at $4.99 each, somewhat like the work of

1046. TOM OTTERNESS. Frieze installation at Brooke Alexander. 1983. Cast plaster. Collection Brooke Alexander, New York

1047. TOM OTTERNESS. *Wrestlers II*. 1979–82. Cast hydrocal with natural finish on marble base, 12 × 3½ × 3½". Edition of 250. Courtesy Brooke Alexander, New York

1048. TOM OTTERNESS. *Head*. 1984. Cast bronze, 35½ × 27½ × 23½". Number one of edition of three. Private collection

1049. JOHN AHEARN. *Homage to the People of the Bronx: Double Dutch at Kelly Street I: Freida, Jevette, Towana, Stacey*. 1981–82. Oil on fiberglass, figures lifesize. Kelly Street, South Bronx, New York

more exclusive issue seen here (fig. 1047). He also wooed his would-be public through CoLab (Collaborative Projects, Inc.), an organization founded in 1977 by some thirty artists locked out of the commerical gallery system. With Otterness as one of the chief activists, CoLab took over a former "massage" parlor and cosponsored, with Fashion Moda in the South Bronx, the now-famous "Times Square Show," a 1980 event that introduced a number of undiscovered talents, among them the Graffiti artists soon to be encountered.

Otterness is so Post-Modern that he actually goes to museums and, like generations of pre-twentieth-century academics, draws from the Old Masters. He is also an old-fashioned craftsman, modeling his forms in clay and casting them in plaster from rubber molds. A master of anatomy, Otterness has had no difficulty in suddenly evolving his ancestor figures into their contemporary progeny, something like beautifully articulated Japanese robots. Cast in gorgeous bronze and designed to play, with characteristic Otterness ribaldry, the roles of such archetypes as Adam and Eve and Jack and Jill (plate 304), they reinvent Primary Forms and truth-to-materials with a wink in the eye. Jack and Jill, moreover, have wind-up keys in their backs and lidded heads that open to disclose the vacuum inside. As unbuttoned Jack shuffles along looking too dumb, or too exhausted, to eat the banana he grasps in his right hand, the naked Jill stands tall and triumphant, with a sunflower stuck in her hair and Jack's pants held like a trophy from her left hand. Together, the pair carry their pail, whose contents—a globe—suggest that while seeking water, they also found worldly knowledge. Consistent with the enigma of the globe, however, are the grins on the faces of these fairytale automatons, grins that on close inspection seem to become grimaces, as if to remind secular society, eroticized by all the competing interests of modern life, that, in simple truth, pain and pleasure, like Jack and Jill, rarely go other than hand in hand. The depth and sophistication of Otterness's art become less covert in the *Head* of 1984, a monumental bust taken from the earlier "dough" men (fig. 1048). Here the image could be that of either a villain or a visionary, a haunting possibility that implies—optimistically?—the universal and ambiguous continuity which may yet underlie the fragmentation of contemporary existence.

JOHN AHEARN (b. 1951) Another alumnus of CoLab is John Ahearn, an Upstate New York Anglo artist who, with his associate Rigoberto Torres, has chosen to live in the destitute South Bronx and there portray its underclass citizens in an ongoing series of relief sculptures that prompted the critic Peter Schjeldahl to declare: "These are less representations than amplified human presences that, for me, deserve perhaps the finest and rarest compliment in art criticism's vocabulary: *Rembrandtian*" (plate 305). For his appropriations, Ahearn, like George Segal, Duane Hanson, and John De Andrea before him, has gone straight to humanity and made life casts. What yields the Neo-Expressionist difference is the content of indomitable subjectivity radiating from Ahearn's dusky but luminous faces, their intense gazes eloquent with soul and a ferocious dignity. The magic arises in part from the fact that while concentrating so candidly on the particular, Ahearn has nonetheless attained a transcendentally moving, expressive image. The artist explains it thus: "The basic foundation for the work is art that has a popular basis, not just in appeal, but in its origin and meaning.... It can mean something here, and also in a museum." Certainly the reliefs communicate a great deal in gallery settings, but by "here," Ahearn means the exterior walls above the very streets in which his subjects live and work (fig. 1049). So life-enhancing are these open-air installations that the artist's neighbors compete to sit for twenty minutes with their heads covered by a fast-setting dental plastic. From the molds this creates, Ahearn then casts the form in fiberglass. But what brings it to life is his immense gift for color, which allows Ahearn to evoke the ambient lights and heats of black or Hispanic skin in richly synthetic tonal mixtures—ranging from orange-yellow and whitened olive green to reddish mahogany and bluish ebony—that uncannily seem truer than life itself.

Graffitists and Cartoonists

As Neo-Expressionism opened art to all the many possibilities once banned by Minimalist purism, a number of young artists even younger than those already discussed found themselves drawn into the "energy" and "authenticity" of one of the most "impure" of all graphic modes. This was graffiti, that combination of "logos" (initials or nicknames) and scrawled "tags" (messages) their teenage perpetrators call "writing" and regularly, since about 1960, felt-tip and spray-paint or "bomb," with a folk-heroic defiance of law, all over New York City's MTA (Metropolitan Transportation Authority) trains. For most subway riders, this appropriation of public walls by an indigenous, compulsive graphism simply constitutes a charmless, criminal act of vandalism, but as the paintings of Jackson Pollock, Jean Dubuffet, Cy Twombly, and Frank Stella indicate, graffiti has long been known to and used by major artists (figs. 582, 643, 766; plate 252). Not until the 1980s, however, did the underground world of self-taught graffiti writers, mainly from the Bronx and Brooklyn, come into direct, interactive contact with the above-ground, Manhattan-based realm of so-called "mainstream" artists or art-school students. The interface occurred primarily in the small experimental nightspots of New York's East Village, such as Club 57, a church basement converted by its parishioners into an outreach space for the neighborhood's young people. In 1980 the modest, subterranean quarters were more or less taken over by students from the School of Visual Arts (SVA) who had gravitated toward the quarter's low-cost housing. At Club 57, they could relive their not-so-distant childhoods, listening to a jukebox loaded with New Wave rock, staging performances in the manner of old TV variety shows and mounted one-night exhibitions of their art, often inspired by the current semiotic interest in popular signs and symbols or old Hanna-Barbera animated cartoons. In this "funky-retro" atmosphere, the SVA crowd also began to hatch anti-Minimalist, anti-Conceptualist ideas, ideas that took on real substance when the graffiti writers showed up, attracted not only by the New Wave records but also by the opportunity to meet the art students.

The taggers' and bombers' interest in the East Village scene had been stimulated at other popular nightspots in SoHo, where art students and street artists first came together. Furthering this crossover was Fashion Moda, a South Bronx storefront gallery that, with NEA (National Endowment for the Arts) sponsorship, had been encouraging and exhibiting works on canvas by ex-graffiti writers. Soon SVA students Keith Haring and Kenny Scharf were making their way north from Club 57, by underground transit, to admire the vernacular masterpieces executed with aerosol cans of Krylon, Rustoleum, or Red Devil by writers with pseudonyms like Futura 2000, Crash, Zephyr, and Toxic. Apart from the effect on the styles of the individual artists and writers, the immediate consequence of this uptown-downtown encounter was the 1980 "Times Square Show," put on jointly by Fashion Moda and CoLab (already noted in the discussion of both Tom Otterness and John Ahearn). Here, in an old Midtown building formerly occupied by a massage parlor, art and graffiti met, probably for the first time, in a major public exhibition, a thoroughly raffish affair designed to provide not only a showcase for

ungalleried artists but also an opportunity for two sides of the cultural coin to fuse in a mutually beneficial cross-current flow. The process worked well enough that additional integrated exhibitions soon followed at other "alternative spaces." Meanwhile, Patti Astor, the former underground movie actress, and Bill Stelling, opened the Fun Gallery in the East Village for the express purpose of showing and promoting graffiti-derived art. Finally, in 1983, the upwardly mobile graffitists received something like a high-art imprimatur when, first, Rotterdam's Boymans-van Beuningen Museum put on the first museum exhibition of graffiti art and, then, the art dealer Sidney Janis offered his "Post-Graffiti" show. In this event one of the world's premier dealers in modern art displayed the scribbled canvases of Daze, Crash, Futura 2000, Toxic, A-One, Lady Pink, and the less exotically named Lee Quinones, among others, in the very galleries where for years New Yorkers had been viewing such blue-chip masters as Mondrian and Marisol.

Now, several years later, the artists who have profited the most from the once random but subsequently deliberate encounter of uptown-downtown art are those who brought to the experience the support of an art-school education. This, it would seem, equipped them with a basic pictorial language that needed only to be charged by the graffitists' ethnic rage to communicate, as well as by the example of the MTA artists' powerful calligraphic thrust, in order to expand their own Pop-cartoon-TV vocabulary into something like a new broadly expressive language. Thus, Haring and Scharf have soared to international stardom, taking with them Jean-Michel Basquiat—a genuine street, not

1050. KEITH HARING. *New York City Subway Drawing*. 1983. White chalk on black advertising space

subway, artist but one self-taught from the models of Picasso and African art—as the Graffitists with a capital "G." Meanwhile, the one-time MTA bombers continue to operate above ground, albeit with considerably less impact than the official Graffitists and, now, Rodney Alan Greenblat, a younger East Village Cartoonist never involved with clandestine graffiti.

KEITH HARING (b. 1958) The dean of the Graffitists is Keith Haring, who through his School of Visual Arts preparation and love of working in public spaces served as the all-important link between the subway world of the real autodidact graffiti "writers" and the younger "mainstream" artists responsive to an omnipresent, abrasive form of popular expression. Simultaneously as he made his presence felt in all the graffiti-and-cartoon forums, Haring was also traveling throughout New York City's subway system and leaving his artistic calling card on virtually every train platform. The ubiquitous format for his voluntary exhibitions was the black panel on which a previous advertising poster had been "canceled," providing a surface somewhat like that of a schoolroom blackboard (fig. 1050). Since 1980, Haring has made thousands of chalk drawings "in transit," always quick, simple, strong, and direct, for the activity carries with it the risk of arrest for "defacement" of public property. The artist in fact likes this element of danger, believing that it adds an essential ingredient to the content of art done in an environment fraught with sinister possibilities. Although Haring never makes a mark on a train, the main attraction for actual graffiti writers, but only on the temporary poster blanks, he professes a debt of gratitude to the Red Devil masters for helping him translate his interest in signs and symbols—semiotics—into an ideographic language with the potential for mass communication. From this came his well-known vocabulary of cartoon figures—radiant child, barking dog, flying saucer, praying man—intermingled with such universally readable signs as the cross, the halo, the pyramid, the heart, and the dollar, all rendered with such cheerfulness and generosity that their statements could neither be dismissed nor mistaken. And so, New York's straphangers have often been entertained by the dog yapping at the flying saucer as it zaps a praying man, or the flying saucer zapping a pyramid while men run off with "pulsating" bars of energy, the latter reminding those who know that Haring grew up in Kutztown, Pennsylvania, some fifty miles from Three Mile Island.

Very soon Haring's drive to communicate his Pop vision of the apocalypse made the artist just as renowned and considerably less anonymous in the above-ground world of museums and commercial galleries, where he has elaborated his black-and-white doodling into an often richly coloristic, all-over, "New Wave Aztec" manner that recalls both Jackson Pollock and A. R. Penck (fig. 1051). And while in his commercial work Haring seems to prefer drawing with black sumi ink or Magic Marker on paper, oak tag, fiberglass, or vinyl tarpaulin, he remains ready to unleash his prodigious capacity for graphic invention on almost any kind of surface, including those provided by pottery vases or plaster casts of such cliché monuments as Botticelli's Venus. On these, as well as on vast outdoor walls, he has sometimes collaborated with genuine graffiti writers, most of whom otherwise prefer the moving, subrosa environment of the MTA trains.

JEAN-MICHEL BASQUIAT (b. 1960) A key figure with whom Haring made contact at Club 57 is the Brooklyn-born, Haitian-Hispanic artist Jean-Michel Basquiat, a school dropout at seventeen and now, even though self-educated, probably the most meteoric star among all the talents associated with graffiti. And like the other arrived Graffitists, Basquiat never actually "bombed" trains. Rather, while more or less living

on the streets in Lower Manhattan, he formed a partnership with a friend named Al Diaz and began Magic Marking poetic messages, illustrated with odd symbols, all over the city, signing their work SAMO©. In the summer of 1980 SAMO© exhibited at the "Times Square Show" and attracted favorable critical attention. Shortly thereafter, Basquiat struck out on his own, and soon his drawing revealed something more than graphic street smarts—actually what appeared to be a devotion to the Picasso of *Guernica*. Basquiat's color-drenched art is characteristically peopled by schematic figures with large, flattened, African-mask faces set against fields vigorously activated by such graffiti elements as words and phrases, arrows and grids, crowns, rockets, and skyscrapers (fig. 1052). As with the deconstructionist art of Polke and Salle, unity resides not in any logical relationship among the various images, signs, and symbols but rather, if at all, in the generalized vibrations set off by so many disjunctive elements, as well as in the pervasive toughness of it all. Quite apart from his sure way with drawing, color, and composition, Basquiat may find his greatest gift in a certain innate, unteachable sense of how to balance the contradictory forces of his primitivism and sophistication, immediacy and control, wit and savagery.

KENNY SCHARF (b. 1958) Another former playmate of Haring's at Club 57, as well as a one-time classmate at the SVA, is Kenny Scharf. But while Scharf too worked briefly with graffiti writers, he actually takes his primary inspiration from the space-age fantasy world of children's

animated TV cartoons, such as *The Flintstones* and *The Jetsons*, both series generated virtually next door to where Scharf grew up in Los Angeles. At first, the artist developed his signature style three-dimensionally, as he "customized" all the electronic gear in the building used for the "Times Square Show," and then a series of Closets, complete rooms, like the one seen here, created for the 1985 Biennial at New York's Whitney Museum (fig. 1053). To customize radios, TVs, telephones, furniture, and whole environments, Scharf applies all manner of "salvage"—kitsch items on the order of plastic dinosaurs, toy robots, fake furs, ropes of tinsel, old hood ornaments, a deer head—and then proceeds to spray-paint and unify the mishmash forms and spaces alike in a continuous, blacklit, Day-Glo phantasmagoria writhing with spirals, nebula, sci-fi molecule models, snaky vegetation, and bug-eyed, gelatinous trolls.

Meanwhile, Scharf was also painting on canvas, developing his taste for Juicy Fruit colors, along with his mastery of pop-out, intergalactic

1055. RODNEY ALAN GREENBLAT. *Guardian*. 1984. Acrylic on wood with mixed media, 26 × 20 × 9″. Courtesy Gracie Mansion Gallery, New York

1056. RODNEY ALAN GREENBLAT. *The Secret*. 1985. Pastel on paper, 57¼ × 43½″. Courtesy Gracie Mansion Gallery, New York

illusionism, often in subject matter evocative of the rainforest world of Brazil, where the artist and his family spend part of every year (plate 306). For one vast salon machine, entitled *When the Worlds Collide* and measuring some ten by seventeen feet (fig. 1054), he fused, "in a kind of fun-house big bang," what critic Gerald Marzorati called "the Saturday-morning innocence, the phone-doodle psychedelia, the magpie delirium, the electric chromatic dazzle...." Here—against a spaced-out background, divided into maplike fields of empyrean blue, soft-focus jellybeans, star-studded black holes, loopy stretch springs— a huge, shiny, sharp-focus red mountain metamorphoses into a jolly monster with a waterfall tumbling over one shoulder and a moonscape visible in the depths of his broad grin. All about this goofy, improbable creature float whirling cannonballs, cotton-candy clouds, disembodied eyes and mouths, wriggling amoeboids, and an orange-colored, saber-toothed, cross-eyed pixie who seems to be parodying one of Basquiat's African masks. In *When the Worlds Collide* Tanguy-like illusionistic Surrealism or the doomsday world of Hieronymus Bosch has been reconceived by a California cartoonist, an artist certain that "you definitely cannot have too much fun" and equipped to go about it with the compositional and *trompe-l'oeil* skills of a Tiepolo.

RODNEY ALAN GREENBLAT (b. 1960) Another child of the TV age is Rodney Alan Greenblat, who has confessed an early addiction not only to the Saturday morning Hanna-Barbera comics but also to the weekly evening sitcoms. And like Kenny Scharf, Greenblat grew up in Southern California and then entered the SVA in New York. But unlike Scharf, Greenblat bypassed Club 57 and immediately began exhibiting in the gallery scene just emerging in the East Village, itself a response to the gusher of new talent pouring out of such formal and informal acade-

mies as the SVA and Club 57. Owing perhaps to his later arrival, Greenblat has not been directly involved in street or subway art; thus, while he takes a graffitist's manic approach to surfaces, filling them with a dense, horror vacuui pattern of signs, symbols, calligraphic scrawls, and images, Greenblat applies them not to appropriated walls or "salvage" but rather to carpentered objects of his own crafting (fig. 1055). He calls the process "Rodneyizing," a near, perhaps more polite, cousin of Scharf's "customizing," and a New Wave heir to Claes Oldenburg's and Red Grooms's respective ways of bringing the Pop spirit into art. In *The Guardian* seen here—a candy-colored, angel-winged totemic figure tatooed with Eskimo-like animal drawings, a speared fish in one hand, and a gilt-framed TV screen set into his chest and tuned to a sci-fi comic—a sentinel seems to have been mounted for the purpose of ensuring or proclaiming the continuity between the instinctual life of primitive humanity and that of Pop culture. Raising his all-seeing, therefore all-knowing, right hand, Greenblat's Guardian would appear to give the lie to all those rumors about the alienating effects of excessive exposure to the electronic media.

In his playful "cartooniverse" of Merrie Melodies sculpture, Loony Tunes furniture, and Disneyworld castles and arks, Greenblat also allows time and space for paintings, works often narrating the sitcom adventures of Milo and Robot. In *The Secret* (fig. 1056), which could be a doodle-dandy descendant of Chagall's *Birthday* (plate 99), a Wicked Witch of the West seems to be advising the spook-eyed protagonists to flee the menacing elements in the background—here not a Kansas tornado but something like Washington State's volcanic Mount St. Helen's—and find refuge in a many-towered, Oz-like citadel pointed out on the far horizon. "I like the idea of making happy decorative art," Greenblat says. "I like opening art to a kind of craziness, an upbeat

feeling. As for the element of fantasy, it's important to our life. If we took everything seriously, without humor, we wouldn't be able to function. The world is so full of trouble, we have to laugh in order to live."

The New Abstraction

Sometimes, perhaps in a quest for symmetry with the concurrent Neo-Expressionist or Neo-Surrealist developments just seen, the new, strongly independent nonrepresentational art that became resurgent toward the mid-1980s has been called "Neo-Abstraction." However, given the present context of retrospective or appropriative thinking, "Neo-Abstraction" implies an almost fashion-conscious, sentimental, opportunistic, recycling process utterly at variance with the slow, solitary, out-of-the-limelight circumstance in which most of the abstract artists about to be reviewed found their artistic identity. But find it they have, and with a power and an expressiveness that painters and sculptors of any persuasion might well envy. Certainly the sheer integrity of the new abstraction—an integrity born of the privileges or necessity imposed by involuntary exile—has brought a resurgence of enthusiasm for a kind of autonomous pictorial language once thought, in the aftermath of exhausted Minimalism, the least promising of all those available in plastic form. Modern art, as we have often observed in these pages, seems never to come so vigorously into its own as when confronted with the adversity of indifference. And the principle has evidently been active once again in the case of the new generation of abstractionists. Moreover, the artists appear to be very much aware of the advantages they enjoyed during the decade and a half it took for the pendulum of taste to swing full away from their aesthetic position and now begin to return. David Reed, a leading member of the group, recently put it this way:

> The hiatus in attention was extremely healthy for abstract painting on the whole. When you're out of public view, it gives you time to learn how you want to proceed. The situation was worse when abstraction—but only abstract art about process and surface—was prominent. There was a pressure to conform. Now the situation seems open again. A lot of reexamination has been going on in abstract painting. People don't know what abstraction should be, and so it can be any number of things.

Among the artists to be seen here, abstraction may indeed be anything but aloof, self-starving Minimalism—except as a style to deconstruct, and thereby perhaps rehabilitate with a totally different sensibility, like that of Sherrie Levine in her subversive yet appealing quotations of high Constructivist masterpieces. The Minimalist principle can also survive in free, experimental art like that of Sean Scully, who however has returned it to the Expressionist sources where Constructivism and subsequently Minimalism originated in Northern Europe outside the French tradition. By hand-stroking his stripes—as uncompromisingly abstract as those of the early Frank Stella—with all the intensity and passion of a gestural painter, Scully hopes to provide the viewer with something "to grab onto," something comparable to the handle offered by the images in representational art. "I think I've done it," the artist says, "by giving my paintings a kind of physical urgency." While abjuring sixties purism as too removed from "the notion of the painting being an expression of life," Scully may very well have spoken for his generation of abstractionists when he declared: "I'm interested in art that addresses itself to our highest aspirations. That's why I can't do figurative paintings—I think figurative painting's ultimately trivial

now. It's humanism and no form." Thus, like virtually every artist to be encountered here, Scully endeavors to expand abstraction and overcome its tendency toward narrowness so that, without losing its inherent sincerity, the art becomes as diverse and engaging as the best subject-matter painting.

A catalytic figure in the surge to make abstraction more accessible and expressive is, of course, Frank Stella, who, as we saw earlier, believes that abstraction can become the art of the age only by recovering the kind of robust drama and complexity found in the proto-Baroque paintings of Italy's early-seventeenth-century master Caravaggio (fig. 9). One of the new abstractionists particularly struck by Stella's ideas and example is Elizabeth Murray. With all the independence typical of the major eighties artists, Murray creates her own version of the shaped canvas, composing it of panels as shattered and shuffled as an Analytic Cubist painting and as objectlike as a relief. But Murray, like many of the artists we are to meet here, is less doctrinaire than Stella about the abstractness of her art. In order "to make tough, clear, subjective painting," she relies on her classical training and introduces imagery, wherever it may well up in the process of carrying out a fundamentally abstract scheme. The artist feels comfortable with this dialectic of the real and the ideal—a witty interplay between cartoonish drawing (itself a form of abstraction) and the soberest considerations of overall form—because, as she has stressed, "my heritage says that art is about more, not less."

In this the new abstractionists are one with their contemporaries, the Neo-Expressionists, but for a nonrepresentational art to convey more rather than less at a pluralistic moment when no commonly accepted mode of expression prevails, as Minimalism once did, the artist must, in the view of Howard Hodgkin, find the plastic equivalent of a voice authentically and movingly his own. "To be an artist now," Hodgkin declares, "you have to make your own language, and for me that has taken a very long time. Gradually, as you make your own language, the more you learn to do, the more you can do and the more you can include." Time—the asset bestowed by an adverse and prolonged shift in taste—has been crucial not only for Hodgkin but also for all the younger artists intent upon working in a language of essences rather than appearances. It permitted them the luxury of quiet, unpublicized trial-and-error experiment, until they could explore their inner resources—ideas or feelings—and translate them into a vocabulary of subjective forms that nonetheless bears within it the potential for a universally expressive syntax.

Significant art created from the inside out can be extremely rich in content, even though unsupported by recognizable figures or obvious narratives plucked from the exterior world. In its primary state, this wealth of meaning flows from the contradiction fundamental to aesthetic objects offering material analogues for immaterial experience. But as resolutions of opposites, abstract paintings and sculptures become metaphors for the body-soul complexities of life itself. Complexity, of course, means diversity, and the particular content of the works to be seen here varies along a wide spectrum of attitudes brought by artists who have matured largely in isolation from one another. Further expanding the range of substance, and the language in which it is articulated, has been the vast reinternationalization of art, an ongoing and salutary phenomenon of the 1980s already seen at work among the Neo-Expressionists. Elizabeth Murray began her professional life in the American Midwest but has become a key fixture in the New York art scene, as has Sean Scully, an Irishman who grew up in London. Howard Hodgkin has long had important links with New York, but remains firmly attached to his native England. Inevitably, each inflects the language of modernism with his or her own particular accent, though all would

1057. ROBERT MORRIS. *Untitled*. 1984. Painted cast hydrocal, pastel on paper, 90½ × 95 × 11″. Collection Suzanne and Howard Feldman, New York

probably agree with the Massachusetts-born Nancy Graves that the point to be communicated is "something beyond the given." While Graves does this by basing her sculpture and painting on abstract shapes discovered in concrete reality, Gerhard Richter seeks to express conflict or duality—that of an East German refugee in West Germany—in separate Abstract Expressionist paintings executed in different moods on the same canvas, their layered relationship evoking a complex depth altogether at odds with the almost filmic flatness of each. The painting surface or picture plane so central to the issues of modernism retains its full integrity in the art of Ron Janowich, who transforms it into an icon of sublime feeling. Bill Jensen, meanwhile, uses the support as a planting ground for an illusionistic garden alive with strange biomorphic growths, their obsessive poetry reminiscent of the penumbral imaginings of the late nineteenth-century Symbolists. Even more Surrealist is the abstract illusionism of Gary Stephan and Peter Schuyff, while Will Mentor mixes and matches appropriations made freely from the abstract dreamscape world of Yves Tanguy and René Magritte. Rather than punch holes in the focal plane, Susan Laufer so loads it with fresco that the tall, spectral figurations it yields seem to advance like long-buried mummies come to reunite a technological age with its primal past. Finally, the Anglo-American artist Judy Pfaff has literally exploded the rigid, rectangular plane and scattered its two-dimensional parts throughout whole gallery installations, which become sense-refreshing Abstract Expressionist paintings recast on a truly environmental scale.

While classical measure hovers over the work of Hodgkin, Richter, Scully, Reed, Janowich, and Schuyff, for instance, or the sculptors Scott Burton and Jackie Winsor, the Expressionism seen earlier in this chapter plays a dominant role not only in Pfaff's manic installations, but elsewhere as well in the new abstraction. That Abstract Expressionism's time had come again could not be doubted when, in the 1980s, Willem de Kooning broke free into an old-age manner of extraordinary radi-

ance and depth of feeling (plate 179). With this, a founding member of the New York School joined the exclusive ranks of such masters as Titian, Michelangelo, Rembrandt, and Matisse, whose late art bloomed as never before. In 1983 the mood of the moment was also confirmed by Robert Morris, the arch Minimalist, Conceptualist, and perennial seismographer of every aesthetic tremor, who now completed the first of his Firestorm paintings (fig. 1057). With their massive sculptural frames—as heavy and emphatic as Neil Jenney's—embedded with the debris of human mortality and their central panels pastel-painted like abstract, Turneresque visions of the Apocalypse, these powerful and shockingly unexpected works ring home, to resounding effect, a theme the artist maintains has always been at the core of his work, whatever its numerous and extreme stylistic shifts: the journey of death that is life. As if to unify his new Expressionist pictorial work with his old antiform Conceptual mode, Morris, also like Jenney, may provide an inscription to accompany the visual statement. For the work seen here, it refers to the tragic postarmistice fire-bombing of Dresden at the end of World War II:

In Dresden, it was said afterwards that temperatures in the Altstadt [the "Old City"] reached 3,000 degrees. They spoke of 250,000 dead. Wild animals from the destroyed zoo were seen walking among those leaving the ruined city.

Although few seemed to notice at the time, the grandly stoic, monumental geometry of Morris's Minimal work could be seen as symbolic cenotaphs, coffins, or memorials and his scatter pieces as matter undergoing its inevitable decay (figs. 824, 922). Driven by the fear of nuclear holocaust, Morris has abandoned his once arcane ways and joined the younger abstractionists in their determination to endow nonmimetic art with the "kind of physical urgency" described by Sean Scully.

1058. ELIZABETH MURRAY. *Beginner*. 1976. 9′5″ × 9′6″. Saatchi Collection, London

1059. ELIZABETH MURRAY. *Art Part*. 1981. Twenty-two canvases, 9′7″ × 10′4″ overall. Private collection

In the view of one of those younger abstractionists, this is as it should be, for, according to Ron Janowich:

Each generation has its time to take a chance and reinvent the language of painting. The second-generation abstractionists built on the work of their predecessors, but they weren't willing to make the leap of faith into another realm. The challenge is to extend abstraction even to the point where a sense of figurative space and abstract forms meet—including Expressionism, Minimalism, Neo-Expressionism or whatever is necessary to make this vocabulary. Now we are going ahead.

ELIZABETH MURRAY (b. 1940) When Elizabeth Murray arrived in New York in 1967—by way of Illinois and California, where she had graduated from both the Art Institute in Chicago and Mills College—an art community then moving through Minimalism toward Conceptualism greeted the newcomer with the news that painting was dead. To which Murray responded: "Oh really?... Well, to hell with *that*. I'm painting!" And paint she has, with a dedication and an industry and a deeply rooted commitment to modernism's sources, in Cézanne and Picasso, Kandinsky and Miró. Toward the latter is a deeply pondered understanding of the tradition: "It's not enough," she says, "that you learn how to paint—anybody can do that—but you learn how to be *expressive* with paint." With this as her overriding priority, Murray has consistently investigated new and challenging ideas, even those of Minimalism and Conceptualism, but especially the abstract illusionism of Al Held and the shaped reliefs of Frank Stella. At the same time, however, she has also held firmly to an early, hard-earned insight that for her the best approach was, as she declared, "painting with all my heart and my soul. I realized that, for better or worse, that was my strategy." While such a tactic meant an enduring struggle and a relatively late arrival, it offered Murray "the thrill" experienced long before by early modernists—of "always being able to reinvent your structure—to never accept your old structure." Constantly probing her own inner life for the existential

means to rediscover her art with each new work, Murray has confronted a good many contradictions, not the least of which is her realization that she is a fantasist whose love for Walt Disney is barely second to her formalist love for the earthy, sensuous painting of Cézanne. "All my work," Murray admits, "is involved with conflict—trying to make something disparate whole." A mid-seventies example of how she reconciled warring alternatives is *Beginner* (fig. 1058), a typically large painting in which a swelling, "bloopy," Arp-like form, heavily impastoed in royal purple, balances against three sides of a rectangular field loosely brushed in gray on cocoa-brown. Tying the various large and simple elements together—colors, shapes, textures, and their respective moods—is the "mediating" pink of the small, relatively complicated "umbilical cord," coiled up like a pretzel in the dark fetal biomorph and projecting one straight end over into the lighter adjacent ground. A signature touch is the slight awkwardness of the drawing and handling, a Cézannesque quality cherished by the artist as authentic evidence of her engaged, trial-and-error attempt to endow an abstract image with thought and feeling. In the art of Elizabeth Murray, an obviously labored shape, edge, relationship, or surface may be even more expressive of an unmediated flow of inspiration than the painterly bravura of many an Abstract Expressionist.

In 1979–80 Murray realized a major breakthrough in her art, a success intimately bound up with personal crises undergone and overcome. Now she raised the ante and tested the outer limits of her resolving power, by breaking up not the image but rather the canvas, "shattering" it into separate shards or fragments (fig. 1059). Further compounding the conflict was the wall, revealed through the cracks as one more participant in the battle for the viewer's eye. To make such disintegration whole again, Murray dipped into her academic background, reintroduced figuration, and imposed upon the entire archipelago of island canvases an image simple enough—brushes, palettes, cups, the painter's own hand—to be detected as a unifying factor. But this could be experienced only by observers sufficiently attentive to "read" across the relief map of fractures and fields, visually and con-

ceptually piecing the whole together like a puzzle. Murray says: "I want the panels to look as if they had been thrown against the wall, and that's how they stuck there."

In the creative act, however, Murray works much more deliberately. She begins by making full-scale drawings of imaginary shapes on huge sheets of paper tacked to the wall. The drawings then become templates for plywood supports, set on four-inch moldings, over which the canvas is stretched across the plane and down around the deep edge to make a three-dimensional painting surface. From this point on, the artist proceeds *alla prima* and by free association, allowing the shaped canvas to pull from within her the images that go into the picture. In recent work, Murray has drawn the shards closer together and even overlapped them, as if she were reinterpreting Analytic Cubism literally, but with a new lucidity of subject comparable to what emerged with Synthetic Cubism. In *More Than You Know* (plate 307), with its hectically shuffled planes and centrifugally thrusting shafts reminiscent of Frank Stella's later reliefs, the disparate becomes whole again through color, which encodes a yellow-walled room furnished with a pair of red chairs drawn up to a greenish-purple table. With a touch of Disney magic, the table metamorphoses into a robotic body for a Borofsky-like face, which seems to offer a message on a bit of stationery stamped with an abstract kiss. Like her engaging awkwardness, a certain lack of finish has increasingly appeared in Murray's work, especially evident here in the raw canvas left at the extreme edges by a feathering out of the brushwork. "I want to make a *possibility* with a painting," the artist has stated, passionately resisting all attempts to clarify her work as either abstract or representational. "A painting is still a thing on a wall. I want this openness and indeterminacy, and yet the picture is very determined—once it's there you can't change it. My work is mute in a certain way. I think that's the beautiful thing about it—that it's so vulnerable. Something is exploded out of its ordinary context into a new state."

HOWARD HODGKIN (b. 1932) In 1984, after viewing a large exhibition of paintings by the English artist Howard Hodgkin at the Venice Biennale, the art critic Robert Hughes wrote: "Not since Robert Rauschenberg's appearance at the Biennale twenty years ago has a show by a single painter so hogged the attention of visitors or looked so effortlessly superior to everything else on view by living artists." And little wonder, for Hodgkin had spent long, but richly productive, years learning to integrate an exceedingly private English sensibility with a genuinely cosmopolitan experience, and out of it to forge a new pictorial language of generous, seductive power (plate 308). As for his English background, it could hardly have been more distinguished, emerging as the artist did from an old Quaker family replete with historians, antiquarians, a scientist after whom Hodgkin's disease was named, and Roger Fry, one of the founding members of the Bloomsbury circle and the great advocate of Post-Impressionism in the English-speaking world. An evidently hereditary "sickness" rampant throughout the clan was a near uncontrollable passion for collecting, and Hodgkin confesses to having a severe case of it, contracted as a schoolboy when he fell in love with Rajput and Mogul miniatures. During World War II, his view of the world, beyond English insularity, opened still wider, thanks to an American Quaker family that resident on Long Island, New York, took in young Hodgkin as one of the many British children sent across the Atlantic to escape the German bombardments. In 1947 the seventeen-year-old artist made a return visit to his American family and rediscovered The Museum of Modern Art in New York, especially its collection of Bonnards, Vuillards, and Matisses, modern masterpieces of an order not yet on view in England. In the intimist branch of School of Paris

painting, Hodgkin found his artistic identity. Simultaneously, while trying to recover the past in the course of a sentimental journey, he also came upon his own Proustian subject: heightened moments involving specific people, often the artist himself, in particular settings, usually enclosed, remembered and made articulate through semiabstract pictorial equivalents. Hodgkin has said: "I am a representational painter, but not a painter of appearances. I paint representational pictures of emotional situations."

An apt student of his historical role models, Hodgkin acquired a classical art-school education, but understood from the start that he would have to devise an idiom his own, even if it required decades of reflection and experiment. Along the way he taught, while also steadily producing an ever more subtle and compact series of interiors filled with accumulated impressions of intimates—painters, critics, dealers, collectors—all rendered in the fine-tuned complexity of their personal relationships. An important midcareer painting was the 1975 *Grantchester Road* (fig. 1060), a characteristic work not only in its modest scale but also in its Cubist, stage-box space, flattened finally by the painted-in frame as well as by the Nabi-like polka-dot pattern and black Matissean planes echoed or rhymed throughout the picture. But the emphasis on flatness simply makes the depicted recession, slight though it may be in converging orthogonals and peephole views into blue infinity, all the more dramatic, for, as Hodgkin has said, "unless you first tell the spectator that he's looking at a flat thing, you can't otherwise make a hole in it." For all its tautness and control, however, *Grantchester Road* belies an almost Mogul sense of pageantry, in the steep, balconied vastness of the domestic interior, in the opulence of its orange, mauve, and green palette, in its parentheses of sensuously undulant planes, in the pulsating energy of the Neo-Impressionist spotting. Subversive relative to all the symmetry, rigor, and objectivity, the source of the barely suppressed luxury may be found in the figure partially visible behind a dark post in the right foreground, a portrait of the artist as a voyeur semiconcealed within the lives and spaces of his subjects.

In the 1980s Hodgkin came into full command of his language, a vocabulary of swaths, swirls, blobs, arrows, stripes, waves, and zigzags,

1060. HOWARD HODGKIN. *Grantchester Road*. 1975. Oil on wood, 49 × 57".
Private collection

all made magically coherent through a collagelike syntax of pure color-forms free-floating in buoyant yet stable counterpoise (plate 308). Thus far, his most astonishing breakthrough may have occurred in the "Neapolitan" series, pictures evoking memories of a brief, evidently romantic, sojourn in Naples. Like David Hockney in California (plate 213), Hodgkin seems to have allowed his northern being to become absolutely ravished by the caressing warmth of a southerly, watered environment. In the work seen here, the jeweled gorgeousness of the Mediterranean Sea and sky divides along no horizon line, but the reality of that voluptuous world receives full, even refulgent expression in one broad aquamarine plane, a suave, buttery stroke slowly rising along a wavecurve of pure rapture. Always hostile to line, because of its inescapable power to make form and space explicit, Hodgkin now applies his increasingly passionate colors in soft-edged, lavalike flows, creamy glissades, vaporous plumes, and bubbling clusters of shaggy spots. As this wealth of visual effects tumbles in and out of the painted frame, its multiple swatches of juxtaposed colors layer and overlap to conjure an almost erotic depth of space, while simultaneously decorating and thereby stressing the obdurate palpability of the painting surface. And just as the interleaving of color planes serves as a visual counterpart of accumulated memories, the wood support—its type, shape, and size chosen by the artist according to his feelings about the subject—brings with it a character already laden with associations, like the human consciousness alive with souvenirs ready to enrich every new experience. Dissolved and emblematic as his representations have become, Hodgkin acknowledges a pair of English presences in the mossy green cluster suspended from the upper edge of the frame, their heads emerging from the cellular mass like large smoky orbs. While the friends look upon the azure beauty of Naples's fabled bay, through a picture window like that of Italian Renaissance painting, stars and fireworks stream away in wide, staccatoed ribbons of strawberry red and glittering white lights.

Quite apart from the emancipating effect of modernism and Post-Modernism, Hodgkin credits the example of Indian miniatures—which he has collected since he was a young schoolboy—with helping him arrive at his new-found painterly and emotional freedom. "They can," he has said, "use anything in the same picture...modeling and flat pattern; expression, in terms of using emotive brushstrokes; fragments of pattern; flesh which is simply described as flat areas of pink and can turn into the most elaborated three-dimensional modeling, still in the same figure." But to bring so many layers of form and sensation into a single work, always seeking to deliver "the maximum emotional intensity, with the minimum of definition," the artist has had to proceed at a glacial pace, allowing his inner life to unfold and gradually dictate a new picture unlike any that ever preceded it. As the double dates of *In the Bay of Naples* imply, a painting by Hodgkin can take years to complete. Ideally, it is finished "when the subject comes back," complete with the original emotion in all its strength and spontaneity, as an aesthetically coherent physical object, a purely visual distillation of the mixed reveries associated with the quite specific title. With their elegant evocation of complex levels of feeling, intellect, and optical impact, the modestly scaled, blazing pictures of Howard Hodgkin—made, as the artist says, "for just one person at a time. They're from me to you"—become sumptuous, poetic symbols of the composite, multifoliate reality of human perception.

NANCY GRAVES (b. 1940) Nancy Graves has been called a "verb," to suggest the unabating speed and energy with which, Picasso-like, she finds inspiration in the most unlikely places and deftly transforms it into aesthetic objects of breathtaking wit and originality. Among her contemporaries, this artist is a genuine polymath, mining the domains of science for her forms and subjects, industry for her materials and techniques, and Post-Modernism for the exploratory freedom to convert her nonart appropriations into decorative works. These, moreover, consist of both paintings and sculptures, in addition to prints, films, and stage design, all—however scientifically derived—conveying a profound sense of the recalcitrant mysteries of life and its permutating processes. Such protean, even Renaissance range comes to Graves by virtual birthright, for as the daughter of an official at the Berkshire Museum in Pittsfield, Massachusetts, she virtually grew up in an institution that specialized in exhibiting art, history, and science side-by-side. While watching the curators classify minerals, shells, furniture, and paintings, Graves developed a respect for natural and human creation alike. Observing technicians as they made dioramas and models of animals, she

1061. NANCY GRAVES. *Camels VI, VII, and VIII.* 1968–69. Wood, steel, burlap, polyurethane animal skin, wax, and oil paint, *Camel VI* 7½ × 12 × 4'; *Camel VII* 8 × 9 × 4'; *Camel VIII* 7½ × 10 × 4'. National Gallery of Canada. Gift of Mr. Allan Bronfman

conceived a lifelong appreciation of craft. This, coupled with the museum's atmosphere of open inquiry, fed a child's desire to excel in some special way. In time, therefore, Graves acknowledged her native inclination and chose art, at first cultivating a talent for drawing and painting of scientific—or Van Eyckian—exactness.

After graduating from Yale's School of Art and Architecture, Graves moved to Europe and spent the year 1966 in Florence, assimilating historical art while struggling to break clear of it in her own work. As if by a reflex from childhood, she sought relief in the natural history museum and there had a fortuitous encounter with the wax images of Clemente Susini, an eighteenth-century anatomist who mixed art and science to Surreal effect in life-size models of human bodies, as well as human and animal organs and systems. With their chests cut open, his female figures, for instance, lay on pink satin with the natural hair on their heads held by pink ribbons. In these curiously romantic effigies Graves saw the possibility of a new kind of sculpture and through it a way out of her painting block. Like a taxidermist, but with a different purpose, she began making small stuffed animals and assembling them with found objects. In this menagerie she discovered a now-famous breakthrough image—the Bactrian, or double-humped, camel—a form that, because specific, left the artist "free to investigate the boundaries of art making" (fig. 1061). From the start Graves seems to have seen the camel pieces as pivotal, as the first step in a long unfolding line of development. Thematically, they took her into fresh territory, ancient, mythical, and fascinating, yet uncoopted by previous Western art. Formally, this made their marvelous, seriocomic lines and volumes open to an unfettered consideration of such problems as how to deal with mass and scale, how to cope with armatures, with structure and its articulation, with strange materials and new techniques. Thus absorbed, Graves made several series of full-scale camels, at first fabricating them of table legs, market baskets, polyurethane, plaster, and painted skins. Gradually, however, she progressed toward engineered, portable forms built of steel beams and covered with fur, finally producing the only camels the artist has allowed to survive for museum exhibition. Although uncannily naturalistic, the Bactrians were not exercises in taxidermy but original creations, made without reference to actual models and brought to life by the artist's own handwork and her meticulous regard for detail, texture, and proportion. By startling a public already certain it had seen everything in Oldenburg's soft sculptures, the camel pieces brought a fresh sense of wonder to Western eyes, causing observers to reflect on just how wide, after all, the possibilities of art might be. More important for Graves, the beast sculptures signified a major step toward the discovery that she could resolve the conflict between abstraction and representation by basing her art on nature.

The Bactrians also taught Graves that she had to learn or understand whatever she intended to permute or synthesize. And so while investigating the camel from the inside out, she discovered all manner of parts—fossils, skeletons, bones—that proved interesting in their own right as organically abstract forms, eminently subject to aesthetic reordering, for variety or serial repetition, for single units evoking wholes or otherwise laden with primal, symbolic import. Using science as a tool with which to probe beyond the known for what may lie beyond it, Graves has subsequently ventured into botany, meteorology, anthropology, and ethnology. In 1971, fascinated by the abstract shapes she discovered in the concrete realities revealed by maps of Mars, the moon, the ocean floor, by aerial photographs of Antarctica, the artist recommenced painting, doing so with a dynamic Pointillist touch designed to simulate the pulsations of air and water currents.

In 1976 a commission for a bronze version of one of the bone sculp-

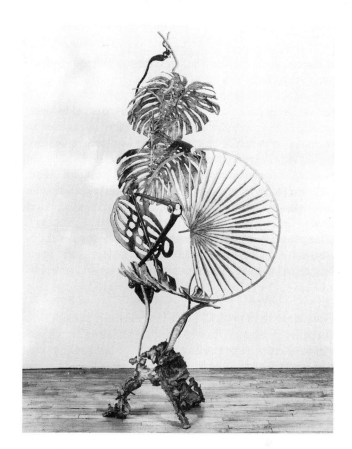

1062. NANCY GRAVES. *Zag.* 1983. Bronze with polychrome patina, 80 × 37 × 27¼". Private collection

tures brought Graves together with the Tallix Foundry in Peekskill, New York. Inevitably, a new technology launched the artist into a new phase of aesthetic experiment, this time on a tidal wave of fantasy and invention. Now her creative energies poured into exuberantly open-form, polychrome, freestanding constructions, their giddy combinations of natural and industrial shapes, their look of filigreed lightness, their pirouetting rhythms and asymmetrical balances, their exotic colors all made possible by the sophisticated Tallix casting and patinating processes (fig. 1062). And these one-of-a-kind pieces become more virtuosic all the time, as Graves regularly arrives at the foundry with shopping bags filled with fern fiddleheads, squid and crayfish, palmetto and monstera leaves, lotus pods and warty gourds, Chinese scissors, pleated lampshades, Styrofoam packing pellets, and potato chips. At Tallix she may expand the repertoire of forms to include pieces of broken equipment, old drainage pipes and plumbing fixtures, or even spillages of molten metal. Once cast by the direct method and thus frozen in minute surface detail, this motley collection becomes a stockpile from which the artist takes the building blocks of her incredibly fertile and ongoing series of constructed sculptures. Without preparatory drawings or models, Graves proceeds spontaneously, like Picasso, González, and David Smith before her, or Frank Stella today, selecting the elements and improvising their assemblage, with each decision quickly welded in place, this operation carried out by a technician standing at the ready. The object that emerges is a genuine Post-Modern hybrid—Graves's long-sought integration of the real and the ideal—for although fully present in shape and texture, the natural and man-made forms have also been abstracted and aestheticized, not only by appropriation, casting, and recontextualization, but also by a camouflage of brilliant, synthetic color. This arrives as a final stage, after the construction has been assembled, when Graves applies pigments either

by patination or by hand painting, the brushwork as freewheeling and extemporized as the structure it embellishes.

As the sculptures become more chromatic and painterly, Graves's canvases break down many of the same barriers shattered by the assemblages, but from a different angle (plate 309). The pictures, for instance, reiterate the new imagery made available through bronze casting, not only in grandly meandering contour drawing, its tendrilled, filamented shapes often profusely layered against broad, flat fields of extravagant color, but also in light-weight aluminum or fiberglass combine elements attached to the support. The latter, formed like a fragment or quotation from one of the assemblages, elaborate the spatiality of the painting by introducing a real bit of three-dimensional sculpture, along with the mysterious shadow it casts upon the plane—that "something beyond the given" Graves has always sought to incorporate in her art.

GERHARD RICHTER (b. 1932) Like his compatriot A. R. Penck, Dresden-born and -educated Gerhard Richter found himself at such odds with the social/aesthetic conditions of East Germany that he crossed over into the West. And thereby he too created within himself a schism that has become the central issue of his painting, an enigmatic, Janus-faced art recently called "the most consistently exciting and problematic work to come out of Europe in the last twenty years." At Dresden's Kunstakademie, Richter had received a rigorous training in the Social Realist version of traditional *trompe-l'oeil* painting, with all forms of modernism proscribed other than that of a few official Communists such as Picasso. When the latter proved sufficiently tempting that Richter began to experiment, the notoriety this generated persuaded the artist that he had to flee and recommence in a more open environment. After arriving in West Berlin in 1961, just two months before the construction of the Berlin Wall, Richter managed to gain scholarship admission to the Staatliche Kunstakademie in Düsseldorf, where the modernist wing of the school was then dominated by Tachist abstraction. In this style the immigrant Easterner struggled to find a new identity but failed, thus once again placing himself in the position of an outsider going against the general grain.

In 1962–63, however, authoritarian reductiveness gave way, when Pop Art first appeared in Germany, where its Neo-Dada assault on puritanical formalism received vigorous reinforcement from Joseph Beuys and the Fluxus performance group. With life rapidly becoming reintegrated into art, Richter saw reproductions of Roy Lichtenstein's Ben Day cartoon paintings in an art magazine, and realized for the first time that unconventional methods and images were not only possible but even necessary in art, particularly for a cross-over German eager to express the conflicts and dualities of his artistic as well as personal and political being. Catalyzed by the iconoclasm of Fluxus, Richter declared: "I'll paint a photo!" And so he did, realizing that by this means he could simultaneously reconcile his desire for antiart radicality and newness with his no less compelling desire for classical beauty, a beauty of handling and subject embedded in Richter from his preexile conservative training in Dresden. Since 1962 the artist has created scores of "photo-paintings" (fig. 1063), all of them more distinctly "photographic" than Rauschenberg's transfers, and yet far more like real painting than Warhol's appropriations of media imagery. By hand-painting camera-made portraits, interiors, landscapes, and Stieglitz-like skies, Richter, in his own way, resolves the rivalry between painting and photography, between abstraction and figuration, and, finally, between the divergent forces within his own split loyalties. In paintings like the one reproduced here, the artist realized, and found a metaphor of, his emancipation from enslavement to both modernist formalism and old-fashioned

1063. GERHARD RICHTER. *Scheune/Barn No. 549/1*. 1983. 27½ × 39½". Art Gallery of Ontario, Toronto

illusionism. Untethered to either one or the other, he was now free to cross back and forth, while exploring the stylistic no-man's land in between. The classical beauty so cherished by Richter emerges in the Old Master quality of his painterly touch, while classical methods survive in the artist's way of squaring the photographic images for transfer to larger canvases, a process as old as Early Renaissance wall frescoes. In his later photo/paintings, like the one already seen, Richter has felt free to depart from the original, often a snapshot made by the artist himself, as long as he preserves something of a genuine photographic look, complete with such flaws as out-of-focus blurring, graininess, or exaggerated contrasts, all of which seem to mediate between painting and photography. In their subject matter, Richter has characteristically preferred the banal or the sentimental as a foil to the classicism of his processes, rather than the tabloid themes favored by, for example, Warhol. The calm, bucolic scenes of Richter's recent work show the Central European landscape immersed in a soft, romantic atmosphere, a filter that reveals as much about how painting and photography alike distort our vision of reality as much as it does about the world depicted. Indeed, the combination of unedited photographic objectivity and poetic delicacy of handling make the landscapes seem exercises in nostalgia for a kind of Cézannesque art and nature now gone forever.

Complex and completely absorbed in the need for continual self-rediscovery, Richter never ceases to challenge his art in a dialectic of alternatives even as he pursues each new possibility to its logical conclusion. And so in the late 1960s, he began reacting against the photo/paintings with a return to pure abstraction, first in a series of heavily impastoed monochrome works called *Gray Pictures (Graue Bilder)*. In despair over the Vietnam War, he compared these canvases to John Cage's remark: "I have nothing to say, and I am saying it." "Then," he observed, "you realize after you've painted three of them that one's better than the others, and you ask yourself why that is. When I see the eight pictures together I no longer feel that they're sad, or, if so, then they're sad in a pleasant way." By the beginning of the 1980s, after investigating many different styles, Richter came to concentrate on full-color, vigorously worked Expressionist abstractions, painted as a series complementary to the cooler, more objective "classicism" of the photo/landscapes. In an earlier phase, the *Abstrakte Bilder* were also tied to photography, in that from 1976 to 1980 the artist based them on photographic blowups of small preparatory color sketches, meticulously reproducing every splash and spill. Now Richter paints his abstrac-

tions directly, without the intervention of photography, yet evokes photographic depth by investing the paintings with still more layers of involvement and contradictory feeling (plate 310). Although chromatically and gesturally similar to abstractions painted by De Kooning in the 1950s, Richter's nonrepresentational works issue from a different critical process and present a planar space less holistically or inextricably "woven" than "layered" in strata of relatively distinct elements, a structural conception already seen as symptomatic of much Post-Modern art. Unlike De Kooning, furthermore, Richter reserves figuration for a separate, complementary series—the photo/paintings—and allows not a trace of it to invade his abstractions. Inevitably his works embody meanings quite independent of those at the heart of American Abstract Expressionism. The artist begins by trying to make a finished picture, which, for him, seems to die of an excess of the very beauty he had sought. As a saving antidote, he then paints over the original image and adds a new stage of pictorial incident flowing from an opposite mood. Now an inaccessibly aloof perfection has been offset or counterbalanced by, for instance, more visceral, sometimes even kitschy or flamboyant, color and stroke. The paint/repaint or advance/reverse process may go on indefinitely, but only so far as to achieve what the artist considers a rich yet lucid harmony of dissonant relationships. Along the way Richter draws upon a vast repertoire of painterly effects—troweled, scraped, flung, scumbled, or merely brushed with a slow, Manet-like lavishness—that seem fully equal to the technical wizardry of Hans Hofmann (plate 176). And when a firestorm of yellow and green has been unleashed upon the chilly netherworld of blue and red under-

painting, Die Brücke can seem piled on top of Der Blaue Reiter as if to embody the whole schismatic history of German modernism.

JUDY PFAFF (b. 1946) Two or three generations after the original movement, London-born, American-trained Judy Pfaff is an authentic Abstract Expressionist, but working in three dimensions and on a much vaster scale than anything imagined by Jackson Pollock. Pfaff began as a painter of immense canvases, entirely abstract but dense with surface incident, created by powdered pigment and other matter crushed into layers of heavily impastoed medium. Like her predecessors from the fifties in the gestural school, she attempted to evoke specific emotional or psychological states through generalized organic imagery inspired by memories of landscape. In 1973, however, when the fixed, rectangular plane became too confining for her energy and ambition, Pfaff began to reconsider her art from ground zero, starting with small fragile objects made of wire, sticks, foil, and other simple materials. Progressively, she studied such elementary but rejuvenating problems as form, balance, light, optics, perspective, and construction, always in efforts that were experimental, impermanent, and three-dimensional, all three characteristics constant in her work ever since. Although Pfaff has become an accomplished maker of portable, durable collages and constructed reliefs, she is best known for her gallery-wide installations (fig. 1064), pieces related not only to those of Jonathan Borofsky and the "scatter-work" Conceptualists, but also to the abstract illusionism of her teacher at Yale, Al Held. And walking into a Pfaff installation, viewers often sense that they have entered a giant, truly all-over Held or Abstract Expressionist painting—one realized, that is, as a lush, fluid underwater environment providing total immersion among all manner of strange, tropical flora and fauna, brilliantly colored and suspended in free-floating relationships above, below, and on every side.

To produce her spectacular effects, Pfaff begins by assembling a huge, democratically magpie collection of nonart materials—plaster, barbed wire, neon, contact papers, woods, meshes—from junkyards and discount outlets, hardware, lumber, and paint stores. Having transported this "mixed media" to the gallery, along with whatever few artifacts she may have prefabricated in her studio, Pfaff then sets to work on site and improvisationally, first by setting up visual oppositions among painted and sculptural elements. With precariously counterbalanced rivalries as her guiding principle, she works straight through the space, adding and adjusting, establishing and upsetting formal relationships, all in a continuous flow of inspiration, editing, and fine-tuning. The process—really a performance—may require days or even weeks, during which Pfaff labors virtually nonstop, until satisfied that what she has achieved constitutes a grand, Baroque orchestration of multitudinous dissonances and harmonies, the whole operatic ensemble vibrant with the high-pitched energy that went into its creation.

In this apparent chaos, thrillingly because imperceptibly controlled by a firm underpinning of structure, extravagant objects or constructions project, or visually leap, off the walls, floor, and ceiling, all of which have been painted in intense Day-Glo colors. Together, flat painted areas and three-dimensional forms challenge, echo, and reify one another's shapes and movements, sometimes around the corner and into a further, unfolding space. As the mad, dispersed array actually and illusionistically catapults or cantilevers toward the spectator from every direction, the effect is awesomely dynamic, exuberant, and sensual. Defying the principles of mass, gravity, and balance sacred to modernism, Pfaff's pluralistic art also refutes desiccated values of rationality, unity, and purity. As a result, it engages the emotions with an intensity once thought impossible in the wake of an old, rejected order of Expressionism, while reaffirming the validity of painterly abstraction and such con-

1064. JUDY PFAFF. *Deepwater.* Installation view, 1980, Holly Solomon Gallery, New York

1065. SEAN SCULLY. *East Coast Light 2*. 1973. Acrylic on cotton duck, 85 × 95". Courtesy Juda Rowan Gallery

temporary Conceptual concerns as perception, cognition, and, always, spatial issues.

SEAN SCULLY (b. 1945) Dublin-born and art-educated in London, Sean Scully moved to New York in 1973, because, as he recently said, "I'm really pushing myself as far as I can, turning myself inside out, giving myself away." Like Frank Stella, Scully considers abstraction "the art of our age...."

It's a breaking down of certain structures, an opening up. It allows you to think about making oppressively specific references, so that the viewer is free to identify with the work. Abstract art has the possi-

bility of being incredibly generous, really out there for everybody. It's a nondenominational religious art. I think it's the spiritual art of our time.... It's very interesting to me now that abstract painting's fighting for its existence. I think that's a wonderful state for it to be in, because you can really do something. I've enjoyed the last few years very much. I like to be in a slightly uncomfortable position. I think that's good for an artist.

Scully has rarely known comfort; indeed, he grew up in extreme hardship. Salvation came through an apprenticeship in commercial printing, which led to graphic design, evening art classes, and college as well as university fellowships. From the start, however, this silver-tongued Irishman understood that he was born to be an artist. "It's . . . the feeling that you have in you. What's in you has to come out." And while Scully loves figuration and formerly took great delight in drawing from the nude, he seems always to have had an overriding interest in pure, repeated shapes, like Rothko's rectangular veils, but most consistently stripes and grids, which the artist sees as "something compelling and evolving out of the basic movements in the world." Along with these elementary forms comes a passion for color, a passion so all-consuming that Scully's palette, like Matisse's, includes not only blooming Fauve-like yellows, reds, lavenders, blues, and greens but also lavish portions of creamy whites and, most of all, a rich, lustrous black.

Initially, the artist appropriated stripes in large, densely woven "super-grids" painted in acrylic (fig. 1065), a development inspired by such hermetic abstractionists as Mondrian, the English Vorticist David Bomberg, Agnes Martin, Brice Marden, and Sol LeWitt. Far more complex, however, than the interlocking coordinates of those artists, Scully's grids—or diagrids congruent with chevron-shaped canvases—yielded intricate lattices of light bands strung over darker ones, with the intervals between layers filled with Analytic Cubist *sfumato* shading. The soft "smokiness" of this effect comes to seem almost expansive or numinous by contrast with the tape-sharp edges and explicitness of the banding. Even at eye level, the impact of the super-grid is that of an overhead fretwork, shimmering with light reflected from below. Still further dynamism takes fire, despite the gridlock system, as the diagonal alignments send the taut ribbons visually racing into the distance, while the pockets of enclosed, coffered space seem to pulsate in a push-pull contest between surface and depth.

1066. SEAN SCULLY. *Backs and Fronts*. 1981. 8 × 20′. Collection the Artist

However optically arresting the super-grids, Scully has worked ever since to make his stripes the vehicles of an emotional or spiritual substance much greater than anything obtainable from pure retinal sensation. Shortly after his arrival in New York, he began purging his art of all—even color—but the basic structural element derived from the reiterated stripe. This led to gray and then black series with subtle "whispering" shifts in tone reminiscent of Rothko and an overall dark monochromy akin to Frank Stella's early "pinstripe" works. In the course of producing the black paintings, Scully discovered that what he wanted was a physical directness—something "for the viewer to grab onto"—comparable to that provided by the figure in representational art. One technique for achieving this was to enrich the painting surface with a build-up of black from successive coats of red, blue, green, and brown, with a bit of each seeping through the deeply rutted edges left after tape had been stripped away. At the same time, Scully also scaled the pictures to human proportions, albeit heroic ones measuring seven feet tall and "shoulder wide." By the early 1980s, the color components of the glowing black began to reassert their individuality in separate bands of brown, siena, Indian red, and grayed blue, muted into an autumnal palette by a heavy admixture of the old black striping. Next came an "active" vertical stripe, reenergizing the "passivity" of the uniform horizontality of the gray and black series, the two right-angle axes joined as the paired parts of a diptych. Beginning with the diptychs, Scully has progressively elaborated his simple vocabulary of striped panels into a language of such breadth and subtlety that each painting now emerges like "a physical event, a physical personality, just like people." Now color came flooding back, the hues ranging from brilliant, clashing primaries to tawny mustards and creamy ochers, all warmed by long, sensuous strokes freely wavering over traces of contrasting oilstick color, the latter set down between stripes by unruled, tapeless drawing (plate 311). Soon diptychs became immense eight-by-ten-foot polyptychs, often assembled from panels so various in their dimensions and depths, in their colors, widths, and directions of their banding that they seemed like assemblages of human presences, interactive social beings abstracted into iconic versions of processional figures in a Classical relief (figs. 1066, 3). Occasionally there could be an inset, a small independent panel applied to or recessed within a larger one, like a conversation piece for the whole cluster of panel-personalities, or perhaps an abstract equivalent of a Matissean mirror or window evoking deep space without violating the commitment to flatness. Sometimes the "image" appears to partake of a larger scheme, especially where the colors and horizontal orientation assume the scale and atmosphere of landscape.

BILL JENSEN (b. 1945) Jensen could very well have spoken for most of his contemporaries seen here when he declared: "My paintings are not really abstract." Furthermore, he says: "I never heard of Pollock or De Kooning talking about their paintings as being purely abstract, completely devoid of any glimpses, of signs, of things they imagined they saw, things they really saw, things they felt." Thus, in his small, intimate, richly chiaroscuro paintings—a mysterious, twilit, Redon-like world of strangely metamorphic forms (fig. 1067)—Jensen reconnects not only with the original, content-seeking Abstract Expressionists, at least in their preheroic works, but also with Pollock's ancestry in such pioneer, Symbolist-inspired American modernists as Marsden Hartley, Arthur Dove, and Georgia O'Keeffe, or even their own immediate precursor, Albert Pinkham Ryder. Fully as subjective and "difficult" as the latter, Jensen nonetheless has created an engaging, communicative art, not by working on a huge, all-embracing, environmental scale, but rather by so compressing his curiously hybrid, personal image as to draw the

viewer in, generously sharing a private, inner realm of fantasy and imagination. There the eye and the mind find themselves mesmerized by a shadowy dreamscape, whose coiling and uncoiling biomorphs appear to be in the process of both revealing and concealing their secrets—really the enigma of their own creation. No less obsessive and captivating is the artist's facture, a dense, meditative painterliness, giving effect to a muted cream, bronze, and blue or green palette. Heavily cross-hatched in light-dark contrasts, the color itself reinforces the metaphor of conflict already evoked in the imploding-exploding shapes. Visionary as this art may be—a dark, Surreal, deeply spatial yet enclosed garden of horns, cones, seedpods, and giant, hairy stamens—it reaches out to nature and takes possession of the spirit. Like Baudelaire in his *correspondences,* discovering evocative correlations for all manner of visual, auditory, and olfactory sensations, Jensen seeks pictorial equivalents for the life-nurturing significance he finds throughout material and immaterial existence.

DAVID REED (b. 1946) A pyrotechnical handler of paint, David Reed seems capable of making the oil medium yield whatever effect he may desire, from the splashy gestural flourishes of De Kooning to the translucent films of Rothko to the hard-edged bolts of a Kenneth Noland, all counterbalanced with the virtuosity and poise of a Baroque composer (plate 312). And since Reed is a radical and uncompromising abstractionist, he could seem somewhat old-fashioned in the expansive, Post-Modern eighties. That is, until the viewer realizes that what tantalizes the mind, even as the eye is dazzled, comes from the mysterious ab-

1067. BILL JENSEN. *The Tempest.* 1980–81. Oil on linen, 30 × 22". Private collection

sence of texture to declare the hand of the pictorial wizard responsible for such marvels of facture and design. While sight may alert the tactile sense to expect a richly varied surface where, on the left in *Solomon's Justice,* the painting seen here, the artist has given a spectacular display of almost erotically excited brushwork, or to feel the ridged lines piled up along the edges of the tape used to paint the thin, cream-colored rod spanning the center field, actual touch discloses that, throughout, the plane is of a uniform, almost filmic smoothness. But even before approaching close enough to make physical contact with the picture, the viewer may note that the various parts of the incident-packed painting have been unified not only by compositional expertise but also by a strange bath of strobe light. In other words, what one seems to be looking at is not so much an oil painting on canvas as a photograph of one, with every element of its palpable reality resolved upon the same utterly flat, impersonal plane, just as in photography. But the complexities do not end there, for *Solomon's Justice* has in fact been hand-painted by Reed, who however used special emulsions that allow a surreally even dispersal of paint. Thus, impastoed though a passage may *look,* the strokes actually sit *in* the surface rather than *on* it. By appropriating the materials, if not the process, of a rival medium, Reed has denied his handling the clichéd immediacy of emotive self-reference

and, through unexpected anomaly, generated a mystery altogether at variance with the picture's overall lucidity of form. Right away, this implies a content more substantial than might have been assumed, related in part to a superficially concealed reality that the painting, far from its apparent instantaneity, required considerable time and thought to create. Reed has said: "I want there to be a sense of story in my paintings: that something has happened and is about to happen, that a crucial action is taking place." The story, of course, is how the painting came into being over time, and how, over time, the viewer comes to perceive the self-contradictory, and thus life-reflecting, nature of the creative process. Lying in the background and enriching the content of *Solomon's Justice* is Reed's devotion to the art of Caravaggio (fig. 9), a world of light and dark—where a crucial action is taking place, after something has happened and is about to happen—unified in a single, counterpoised moment of dramatic conflict.

RON JANOWICH (b. 1948) Among eighties abstractionists, one of the most original appropriators is Ron Janowich, who in the black oil technique of Flemish and Dutch Old Masters, from Jan van Eyck in the fifteenth century to Rubens and Rembrandt in the seventeenth, found a lucent means of endowing Constructivist form with a spatial and spiritual fullness rarely encountered in modern secular times. Along with his medium, Janowich has also adopted from ancient traditions a set of forms and formats that resonate with mystical associations, all the while that they also remain as blockily palpable and objectlike as anything in Minimalism. Although a true "painter's painter," with an expansive technical and conceptual range, Janowich tends to develop his art within the context of two complementary series, one as hard-edged, angular, cerebral, and direct as a Byzantine icon and the other round-headed, painterly, elusive, and Rembrandtesque (plate 313; fig. 1068). With color providing their active principle, however, the two series converge toward a unified, if ineffable, meaning, as jeweled intensity ignites geometrical coolness on the one hand, while, on the other, dusky ochers and lambent saffrons bank the fires of a richly sensuous facture. Either way, this is powerful color, suspended in glaze layered upon glaze of clear, crystalline substance that, like a prism, traps and refracts light until the hue it emits glows with a mysterious radiance as full-bodied as it is immaterial. Reinforcing the magical effect is the artist's masterly brushwork, which seems capable of applications as smooth and enameled as Robert Mangold's, as dynamically curvilinear as a Delacroix drawing, or slablike and loosely hatched in the manner of High Analytic Cubism. But whatever the stroke, Janowich so employs it as to reify the flatness and rectilinear axes of the plane, while evoking a sonorous, light-filled volume, a volume that can be as unspecific as an emblem or as chambered as a late Turner interior. Consistent with the artist's command of light, color, space, and surface is his sense of scale, a faculty comparable in painting to the poet's "true ear." It can be seen in the two paintings here, both monumental in impact, even though one stands seven and a half feet tall and the other measures only thirteen inches high. Such are the dualities and resolutions of this lavishly nuanced art that while savoring one of the most delectable painterly cuisines to be served up since Matisse, the viewer risks being rewarded less with a hedonist *frisson* than with a moving, poetic exposition of the strange, unifying presence felt to inhabit a world torn between dross, delicious matter and an elevated, transcendental vision.

SUSAN LAUFER (b. 1950) In her search for meaningful content beyond that offered by modernist rationality, Susan Laufer has traveled to Afghanistan and Iran, looked at primitive cultures, Surrealism, and Jungian archetypes, and freshly created a kind of encrusted, scored,

1068. RON JANOWICH. *Untitled.* 1985. Black oil on linen, 90 × 54″. Private collection

right: Colorplate 291. GEORG BASELITZ. *Orangeater.* 1981. 57½ × 45″. Collection Phoebe Chason

below: Colorplate 292. A. R. PENCK. *The Red Airplane.* 1985. 47 × 82½″. Collection Marianne and Harvey Bernstein, Old Westbury, New York

above: Colorplate 293. JÖRG IMMENDORFF.
Café Deutschland I. 1977–78. Acrylic on
canvas, 9'2" × 10'10". Neue Galerie-
Sammlung Ludwig, Aachen, West Germany

left: Colorplate 294. SIGMAR POLKE.
Hochstand. 1984. Acrylic, lacquer, and
cotton, 10'8" × 7'4". Private collection,
New York

above: Colorplate 295. ANSELM KIEFER.
Margarethe. 1981. Oil and straw on canvas,
9'2″ × 12'6″. Saatchi Collection, London

right: Colorplate 296. RAINER FETTING. *Vincent*.
1984. Oil and wood on canvas, 99⅝ × 74¾″.
Collection the Artist

Colorplate 297. FRANCESCO CLEMENTE. *Two Painters*. 1980. Gouache on nine sheets of handmade paper with cloth backing, 68 × 94⅛″. Collection Francesco Pellizzi, New York

Colorplate 298. FRANCESCO CLEMENTE. *Untitled*. 9′ × 15′8″. Collection Thomas Ammann, Zurich

above left: Colorplate 299. JULIAN SCHNABEL. *Geography Lesson*. 1980. Oil on velvet, 8 × 7′. Collection Bruno Bischofberger, Zurich. (One of four paintings from *Huge Wall Symbolizing the Fate's Inaccessibility*)

below: Colorplate 300. DAVID SALLE. *Tennyson*. 1983. Oil and acrylic on canvas, 6′6″ × 9′9″. Private collection, New York

above right: Colorplate 301. ERIC FISCHL. *The Old Man's Boat and the Old Man's Dog*. 1982. 84 × 84″. Saatchi Collection, London

above: Colorplate 302. ROBERT LONGO. *Ornamental Love*. 1983. Mixed
media, 8′5½″ × 16′10″. Private collection

below: Colorplate 303. CINDY SHERMAN. *Untitled*. 1981. Color photograph,
2 × 4′. © Cindy Sherman

below: Colorplate 304. TOM OTTERNESS. *Jack and Jill*. 1985. Cast bronze,
27 × 39 × 19″. Number one of edition of three. Private collection

right: Colorplate 305. JOHN AHEARN. *Louis and Virginia Arrojo*. 1980.
Painted plaster cast, 24 × 24½ × 7″. Courtesy Brooke Alexander, New York

right: Colorplate 306. KENNY SCHARF. *Juicy Jungle*. 1983–84. 7′3″ × 8′5″. Collection Mr. and Mrs. Kenny Scharf, New York

below: Colorplate 307. ELIZABETH MURRAY. *More Than You Know*. 1983. Oil on ten canvases, 9′3″ × 9′ × 8″ overall. The Edward R. Broida Trust, Los Angeles

right: Colorplate 308. HOWARD HODGKIN. *In the Bay of Naples*. 1980–82. Oil on wood, 4′6″ × 5′. Private collection

Colorplate 309. NANCY GRAVES. *Footscray* from the Australian series. 1985. Oil, acrylic, and glitter on canvas with painted aluminum sculpture, 6'4½" × 14'5" × 12½". Courtesy M. Knoedler and Co., New York

Colorplate 310. GERHARD RICHTER. *Vase.* 1984. 88½ × 78¾". Juliana Cheney Edward Collection. Courtesy Museum of Fine Arts, Boston

top: Colorplate 311. SEAN SCULLY. *To Want*. 1985. 8′⅛″ × 9′5⅜″ × 9⅜″. The Walker Art Center, Minneapolis. Justin Smith Purchase Fund

above: Colorplate 312. DAVID REED. *Solomon's Justice, #200*. 1981–83. 3 × 9′. Collection The Chase Manhattan Bank, North America

left: Colorplate 313. RON JANOWICH. *St. Augustine*. 1984. Black oil on linen, 13 × 9″. Collection Marilyn and Herman Schwartzman, New York

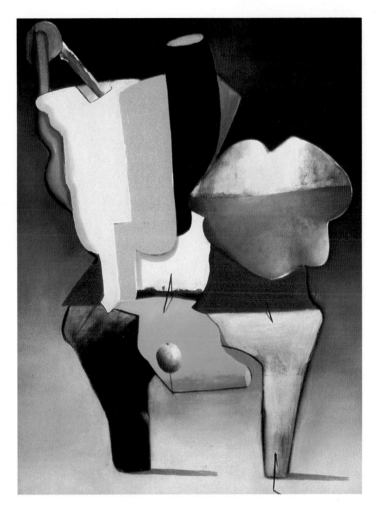

Colorplate 314. WILL MENTOR. *Blame Juan Carlos*.
1985. Oil on board, $3' \times 2'5''$. Collection Ruth
Kaufmann, New York

Colorplate 315. SHERRIE LEVINE. *Broad Stripe No. 12*.
1985. Casein and wax on mahogany, $2' \times 1'8''$.
Collection Lois and Richard Plehn, New York

Colorplate 316. CHARLES MOORE with U.I.G. and PEREZ ASSOCIATES, INC. Piazza d'Italia, New Orleans. 1975–80

Colorplate 317. ROBERT STERN. Pool House, Llewelyn, New Jersey. 1981–82

right: Colorplate 318. MICHAEL GRAVES. Portland Public Services
Building, Oregon. 1980–82

below: Colorplate 319. JAMES STIRLING. Neue Staatsgalerie, Stuttgart.
1977–83

left: 1069. SUSAN LAUFER. *First and Last/ Bandamir*. 1985. Acrylic and mixed media on masonite and wood panels, 7′4″ × 9′11″ overall. Collection Aron and Phyllis Katz

below: 1070. GARY STEPHAN. *The Rules of Appearance*. 1983. Acrylic on linen, with wood and styrofoam, 86 × 31½″. Collection James and Lorrainne Cooper, New Jersey

and patinated art that appears as old and mysterious as cave painting (fig. 1069). Yet, by allowing her forms and effects to evolve, as in process-oriented modernism, from medium and the act of working with it, Laufer has also succeeded in producing an art ripe with a sense of now—a certain complex, technological now, that is, longing for renewed contact with primal instinct. The artist begins with strong masonite or wood panels over which she applies thick layers of plaster and acrylic, building and texturing the surface until it resembles rough fresco but glows with an oily luminosity. Additional color surges up as Laufer scratches and excavates the surface to reveal substrata of vibrant crimson, black, deep blue, oxidized copper green, or ocher. Into this graffiti-enriched density she sinks small reliefs, constructed from wood and found objects, and then covers them with paint and plaster until they seem to be emerging from within the painting's grainy substance. Ambiguous and haunting, the strange, half-buried forms could be fragments of architecture or Giacometti-like sculpture, perhaps a mummy or some votive figurine. Meanwhile, the shape of the field—sometimes cruciform or partially so—and its diptych division connote altarpieces and the sacred rituals they serve. Imprecise and ultimately inaccessible as Laufer's highly personal blend of the primitive and the modern may seem, the work nonetheless succeeds for that very reason. By matching autonomous form to feeling, the artist tantalizes the mind with possibilities beyond the reach of mundane logical analysis.

GARY STEPHAN (b. 1942) With a visual imagination too vigorous to be bound by the inhibiting rules of Minimalism, Gary Stephan abandoned his initial commitment to that dominant sixties style in favor of developing a personal idiom derived in part from his training in industrial design at New York's Pratt Institute. Pragmatic and essentially materialist in his approach to painting, Stephan has said: "Paintings do something. Like cars, they do something, and the 'doing' is perceptual and neural. Paintings operate. Something happens. That is why painting is a radical activity." On another occasion he provided a clue to the particular radicality of his own pictorial activity: "The artist wants to make something that is evocative, and he doesn't care how. Something to tease your brain toward recognizability and potential." *Potential*—

1071. PETER SCHUYFF. *Untitled*. 1984. Acrylic on linen, 90 × 66". Collection Herman and Bette Ziegler, New York

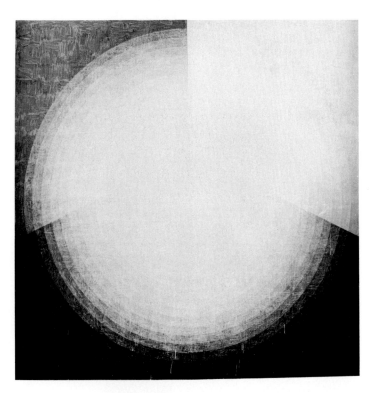

1072. PETER SCHUYFF. *Mastertone*. 1985. Acrylic on linen, 10 × 10'. Collection Jerry and Emily Spiegel, New York

possibility beyond the immediately perceived—would seem to be the operative word here, for a constant in Stephan's work since 1973 has been the age-old conflict between figure and ground—between illusionistic volume and literal flatness—but now explored in purely abstract terms (fig. 1070). Of course, similar concerns engaged the Op artists, but with his overriding interest in the ambiguities of potential, rather than instantaneous, retinal sensation, Stephan would seem to have greater affinity with an Abstract Surrealist like Yves Tanguy. And with his vocabulary of simplified geometries, especially the plane and the cone, and his painterly refinement and synthetic color, he finds a natural ancestry among the Cubists, not only the Braque of the eye-fooling nail but Léger too in *Contrast of Forms* (plate 65; fig. 248). Also providing an antecedent is Jasper Johns, another lover of visual ironies and confounded realities, and one for whom Stephan once worked as a studio assistant. Representative of Stephan's eighties work is the aptly titled *Rules of Appearances* seen here, a construction-painting composed of an exceedingly tall, thin set of stretcher bars flanked by a pair of canvases painted with a *trompe-l'oeil* cone. Bridging across from one canvas to the other, the cone appears to embrace the stretchers and the negative space they frame even as these real elements give the impression of penetrating the make-believe one. About such paintings, Carter Ratcliff has written: "... Stephan confronts the actual with the fictive, then renders portions of the fictive actual, which is to leave all such labels in a vexed state—what is one to call a carefully finished piece of wood after it has locked in with Stephan's passages of painted geometry?"

PETER SCHUYFF (b. 1956) Dutch-born, Vancouver-educated Peter Schuyff has been active in New York's East Village since 1980. Although a thoroughgoing modernist in his commitment to Cubism's planar conception of pictorial space, Schuyff first gained attention for a virtuosic series of abstract Surrealist "hand-painted dreamscapes" (fig. 1071). In these modestly scaled works, strange striped and backlit amoeboid "lattices"—rather like yeasty pretzels or abstract versions of Kenny Scharf's goofy creatures—hung in suspension and in relief against a flat field, usually plain and of a contrasting color. No less bizarre and engrossing was the figure-ground relationship, which seemed to flip back and forth between negative and positive with each new viewing. Simultaneously, Schuyff also developed an ongoing series characterized by an all-over field gridded as a checkerboard of two contrasting colors, with the hues and shapes manipulated to generate optical effects fully as hallucinatory as the biomorphic screens or lattices. In one scheme the plaid would seem to expand and contract as if laminated to a crisply articulated relief surface, its curvilinear pattern and dazzling illusionism rendered irrational by constant negative/positive reversals.

In a more fruitful idea, color and value have been so modified as to make the grid appear illuminated here and there by spotlights. While these paintings grew ever grander in both scale and concept, they also evolved into a new and concurrent series, far more monumental in structure, if not in actual size. In *Mastertone* (fig. 1072), for instance, the artist refocused his multiple spots as one huge light, radiating in concentric bands from a brilliant center. It simply floods a field no longer gridded but merely sectioned into three equilateral compartments, defined, like the circular bands, by graduated value contrasts. Always sensitive in his painterly, translucent stroke, Schuyff has further lightened his handling, while also simplifying his palette, from a sometime preference for rather acidic green, red, and cerulean combinations to a pure and classically balanced chiaroscuro. Here, the hand-painted dreamscape has ceased to be the playground for an antic or Dionysiac imagination and become host to an Apollonian intelligence,

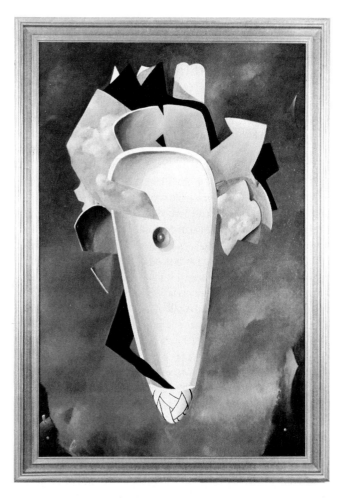

1073. WILL MENTOR. *One of the Eight Spheres of Yoga: "The Sphere of Posture."* 1985. 81 × 57". Private collection

still preoccupied with light and figure/ground issues but now basking in a moment of limpid serenity.

WILL MENTOR (b. 1958) In what appear to be Neo-Surreal portraits of freestanding assemblages drawn, or appropriated, from a gifted young painter's favorite models, Will Mentor has elaborated *trompe-l'oeil* abstraction well beyond anything seen here and thus given effect to the eerily deep dream spaces of Carrà, De Chirico, Ernst, Magritte, and Tanguy, perhaps even Georgia O'Keeffe. But this usually occurs only piecemeal, for in his serendipitous appetite for quotation, the artist loads so many morsels onto his pictorial plate that the combined image becomes a continuous sequence of interruptions (fig. 1073), as one fragment of a famous manner intersects or overlaps another. Shuffled in with perfectly flat Cubist planes, and treated in a similarly autonomous fashion, may be found segments of a bandaged De Chirico mannequin, a Tanguy bone or tooth, sometimes sliced open and left empty like the white shell of a sugar-coated almond, and passages from a Magritte cloud-flecked blue sky, the latter a negative/positive element that functions at once as a hole punched in the background and a piece coopted from a picture puzzle. The striking originality of this art arises not only from the particular selection and still-life or sculptural arrangement of new and borrowed ideas, but also from the sheer beauty of the Old Master style painting, a quality not to be dismissed, coming as it does scarcely more than a decade after painting was thought to have died.

Occasionally, Mentor directs his attention to a single source and pays it the tribute of reinterpretation, as here in plate 314, where Ernst's *The Elephant Celebes* (plate 106) seems to have become totally abstract, although now standing free in an illusionistic envelope of caressing light and air. It has also lost its rebellious irony and sexual menace, but gained a sense of innocent wonder absorbed from a young American artist enchanted with his discovery of the European masters.

SHERRIE LEVINE (b. 1947) The quintessential Post-Modernist among abstract painters may be Sherrie Levine, for not only has she appropriated her art quite literally from art history; she has done it, moreover, with a heart-stopping audacity so original that it subverts the artist's own deconstructivist case against the modernist myth of originality. In addition, she quotes the masterpieces of modernism with such sensitive craft that the results betray an authentic and poignant eighties nostalgia for ideals of form and meaning no longer available to a less credulous and coherent time. In 1981 Levine first startled the art world with an exhibition of her own unmanipulated photographs of well-known, text-book examples of photographs by such master cameramen as Edward Weston, Walker Evans, and Andreas Feininger. Here, self-eradication had been carried to a point so extreme that it seemed to guarantee some welcome degree of creative self-reassertion in whatever might follow. Not surprisingly, therefore, Levine was soon *hand-painting* watercolors and gouaches "after" art-book reproductions, complete with printing flaws, of paintings by Léger, Mondrian, Lissitzky, and Stuart Davis (fig. 1074). Now ideas and jokes were compounded almost into infinity, without anyone being sure who the butts or beneficiaries might be. True enough, the modern masters had once again been ripped off, but in a way to make them seem fresh and alive, because accessible on

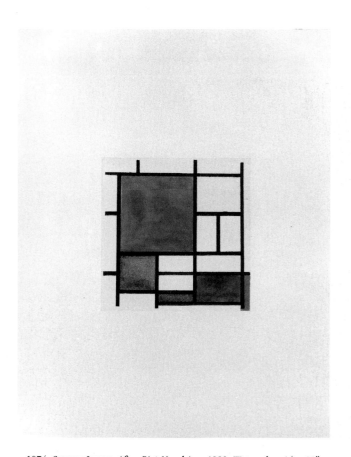

1074. SHERRIE LEVINE. *After Piet Mondrian.* 1983. Watercolor, 14 × 11". Collection Eugene and Barbara Schwartz, New York

an intimate scale as never before. The peculiar punch carried by such paintings lay in the shock of delayed recognition that while looking at fake Constructivist works, viewers were also looking at original Levines.

More recently, Levine has betrayed still more of her own personality in what are now less pure appropriations than "generic paintings," as the artist calls them. A Hard-Edge series consists of small casein and wax panels offering two-color variations on a single theme of one narrow and three wide stripes (plate 315). Here the model became a composite of all the great modernist stripe painters, ranging from Barnett Newman through Ellsworth Kelly, Brice Marden, and Frank Stella to Daniel Buren. This time Levine has been iconoclastic as much in relation to her own original radicality as in relation to the aura of sanctity that formerly enveloped the great monuments of a once radical formalism. While the new works present the overall look or "trope" of Minimal painting, they copy no one masterpiece or specific style. Nonetheless, the kind of modernism honored by parody happens to be the very sort that most unsparingly attempted to eliminate all traces of the creator's signature touch. But in the stripe paintings, Levine is very much present, not only in her small, painterly—perhaps even affectionate—stroke, but also in her almost floral sense of color, producing such radiant combinations as orange and violet. But even as her art moves toward self-declaring sensuousness, it follows a line of development first plotted out by the Conceptual, anti-Minimalist thinking first introduced in the late sixties and early seventies. So, once again, Levine could be seen as the ultimate Post-Modernist, an artist whose work crystallizes the radical positions of both Conceptualism and deconstructivism by revealing their logical but finally absurd outcome. In this way

she joins, despite herself, the ranks of the truly original, for by exploding a closed-down situation she also opens it up, showing that in Post-Modernism we may be more at the beginning of something than at the end, just as the Post-Impressionists were in that fabulous *fin-de-siècle* a century ago.

JACKIE WINSOR (b. 1941) Following a precedent long set in Western civilization, from Plato through Cézanne to the Minimalists, Canadian-born Jackie Winsor visualizes perfection in what the 1960s learned to call Primary forms—simple squares, cubes, cylinders, spheres, and grids. She is also at one with the Minimalists in making certain that, once finished, the forms evince the process of their own making. The process, however, is decidedly Post-Modern, involving as it does prolonged, ritualistically repetitive activity and materials chosen for their power to endow ideal geometry with a mysteriously contradictory sense of latent, primitive energy. It has been said of Winsor's sculpture that it "is as stable and as silent as the pyramids; yet it conveys not the awesome silence of death, but rather a living quietude in which multiple opposing forces are held in equilibrium." In a 1972 work entitled *Bound Square* the tension arose from the contrast between a boldly simple form, made of four giant logs, and the slow, meditatively complex technique employed to lash the beams together at the corners. This entailed unraveling massive old ropes, returning them to their primary state as twine, and wrapping the crinkled, hairy strands round and round, throughout several days a week for months on end, as if to join hands with and sanctify the laborers who had originally harvested the material, twisted the rope, and finally tied it into rigging. For a meticu-

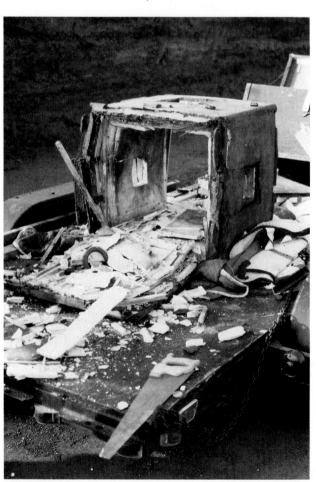

1075. JACKIE WINSOR. *Exploded Piece* (in progress). 1980–82. Wood, reinforced concrete, plaster, gold leaf, and explosive residue, 34½ × 34½ × 34½". Private collection. On loan to the Museum of Fine Arts, Boston

1076. JACKIE WINSOR. *Exploded Piece*. 1980–82. Wood, reinforced concrete, plaster, gold leaf, and explosive residue, 34½ × 34½ × 34½". Private collection. On loan to the Museum of Fine Arts, Boston

1077. DONALD LIPSKI. *Building Steam #317.* 1985. Telephone, intercom, and crystal ball, 9½ × 6 × 5″. Courtesy Germans Van Eck Gallery, New York

ing—or scavenging—the parts and discovering a kind of Surreal logic in some relationship among them (fig. 1077). In a consumer society virtually choking on its excess of obsolete and discarded things, Lipski sees neither excess nor obsolescence. To him, nothing appears so ordinary or outmoded that he cannot reendow it with a fresh sense of necessity, merely by mating the reject in an impeccably crafted but unlikely marriage with another artifact utterly alien in all but its comparable banality and irrelevance. The artist's strategy is to raid junkyards, dust bins, dumpsters, and dime stores and then combine his gleanings in assemblages that astonish and delight both eye and mind with the perfect union of their incompatible parts. Thanks to his ingeniously associative mind, Lipski can quickly grasp how the shape and clarity of a crystal ball renders it ideal for nesting in the cradle of an old telephone, or how the bottoms of transparent plastic high-heeled shoes were meant to be filled with a set of shiny ball bearings. Still more inventively, he perceived the possibilities of a sunburst made from a belt of machine-gun cartridges, its rays formed by glass pipettes stuck into the bullets' noses. Wrenched from their usual context and reordered in brilliantly dysfunctional ways, such commonplace items as rusty tongs, weathered books, pickaxes, and buckets become strange and wonderful objects of contemplation. While Lipski's work may recall Marcel Duchamp and his readymades, its lack of antiart, psychosexual, or obvious political bias and its lyrical obsessiveness give the sculptures a more certain kinship with the gentle reveries of Joseph Cornell.

MARTIN PURYEAR (b. 1941) While abjuring the reformatory spirit of Minimalism, Martin Puryear has accepted the style's simplicity and gravity but gone on to invest them with a human scale and primitive,

1078. MARTIN PURYEAR. *Self.* 1978. Polychromed red cedar and mahogany, 69 × 48 × 25″. The Joslyn Art Museum, Omaha, Nebraska. In memory of Elinor Ashton

lously calculated cube entitled *Fifty-Fifty,* Winsor used fifty pounds of nails to hammer together fifty pounds of one-by-one-inch sticks in a three-dimensional grid designed to create an equal distribution of mass and space. When the sculpture had been completed, however, the space contained within seemed far more compressed than its actual volume, since only a glimmer of light could penetrate through the dense structure. Thus interior space, by the conundrum of its apparent scarcity, became all important—really the work's deposit of content, for as Winsor has said: "The center of the piece which is in a way nothing (air and light and space) is everything." To symbolize the energy lying dormant within forms made significant by thought and feeling, the artist often inserts small windows in the sides of her cubes, openings that invite the viewer to come closer. In 1980–82 she set about activating this energy in a startlingly dramatic manner. First she built a multilayered interior of plaster, goldleaf, and fluorescent pigment contained within a cube made of hand-buffed, black concrete reinforced with welded steel. After finishing the piece to the requisite degree of perfection, Winsor added a further element—dynamite—and exploded the cube (fig. 1075). Later she gathered up the fragments, reinforced the interior, and restructured the outer layer (fig. 1076). In its final state *Exploded Cube* seems quiescent and contained, even though it bears the scars of the various stages—both the carefully measured and the immeasurably volatile—through which it passed in the course of its creation, destruction, and reconstruction. What physically happened to the form and its material constitutes the content of *Exploded Cube.* "The fact of the sculpture's destruction was catastrophic," says Winsor. "So was the metaphor. My art reflects my life and my life reflects my art. I wanted to put the unknown into the known, to make a marriage or union. I got what I asked for, but it wasn't what I thought it was going to be."

DONALD LIPSKI (b. 1947) For his sculpture, Donald Lipski takes parts and makes wholes, but he imagines the whole only after find-

animistic quality, generated by craftsmanly process and the organic forms this yields (fig. 1078). Puryear began as a *trompe-l'oeil* Realist, classically trained in painting at Catholic University in Washington, D.C., and the Royal Academy in Stockholm. He then went through the "painful" experience of discovering "a level beyond that," his search aided by graduate study at Yale and, more important, by time spent with the Peace Corps in Sierra Leone. Africa reinforced his desire for "independence from technology" and gave him an appreciation of the "magic"—the special meaning or content—that seems to emanate from hand-honed abstractions. What resulted is an art in which modernist cerebration and tribal atavism, the traditions of Western high art and those of preindustrial craft, painterly illusionism and sculptural abstraction do not so much fuse as counterbalance one another in a dialectical standoff. Frequently forms look heavy, like polished black marble, only to reveal themselves as made of relatively weightless red cedar. And as the hump visually bears down on the floor, it also appears to be pushing up through it, like the nose of a whale. Puryear's sculptures, given the distilled character of their monolithic shapes, could be seen as Minimalism's boxes and containers so filled with feeling that straight-edged geometry forcibly expands into organic mass, its inner spirit ready to break free of matter. Typically, silhouettes arch over, relax, and then go firm, closed forms threaten to open, mounds swell or slowly level off, circular lines float, quiver, or pull taut. And, as here, a form can give the impression of being two things at once—a phallic emblem, for instance, or perhaps a dunce-capped head. Finally, there is the lustrous, seamless hand-finishing, reflecting an evident conviction that through the artist's touch the power of the earth travels to and enters the fashioned artifact.

CHRISTOPHER WILMARTH (b. 1943) Although a child of Minimalism and a great admirer of both Tony Smith and Mark di Suvero, Christopher Wilmarth discovered early on that he would want to engage in processes more intuitive and Expressionist than the mathematical or industrial ones favored by his immediate predecessors. In this way he hoped to create a strongly formalist, abstract art imbued with something of the deep, warm humanity sensed in the works of Matisse and Brancusi. And so Wilmarth adopted the glass and steel, or bronze, frequently found in sixties Primary forms, but cast them on a human scale

1079. CHRISTOPHER WILMARTH. *Insert Myself Within Your Story* from the Breath series. 1979–80. Glass and steel, $12 \times 11 \times 9''$. Private collection, New York. © 1980 by Christopher Wilmarth

and layered, bent, and blew the materials until the resulting constructions look as if their eloquent interplays of light and shadow had evolved of themselves, like persons—or poems (fig. 1079). Throughout the 1970s the artist rang many variations on the thematic duality of his media—opacity contrasted with translucency, materiality with evident ethereality—but beginning in 1979 he encountered what probably has been his greatest inspiration thus far: the verse of Stéphane Mallarmé as recently translated by the American poet Frederick Morgan. After poring over the dense, inscrutable texts for weeks on end, Wilmarth eventually discovered "that the poems had a common denominator, Mallarmé's own separateness....His imagination and reverie meant more to him than anything that was actually of this world. His work is about the anguish and longing of experience not fully realized, and I found something of myself in it." For the erotic poem entitled "Insert myself within your story," Wilmarth, working with the craftsman Marvin Lipofsky, blew an ovoid shape in glass—rather like a free-form organic Brancusi egg or head—and then acid-etched the substance to make it seem alive with delicately suffused light and color. With the vitreous mass mounted on a steel support folded like a book and cut into by the outer "cover," the sculpture seems an aesthetic equivalence of a spirit impaled on the brute matter it longs both to escape and embrace.

MICHAEL SINGER (b. 1945) When he moved beyond Minimalism, Singer took with him the style's reliance on materials to dictate abstract

1080. MICHAEL SINGER. *Ritual Series/Syntax 1985* (to the memory of C'heng Man-ching). 1985. Granite and fieldstones, $12'1'' \times 8'6'' \times 4'8''$. Collection the Artist

forms and its tendency to eschew pedestals in favor of balancing, propping, stacking, or aligning pieces on the floor. Meanwhile, however, he left behind the extreme rationality, reductiveness, and stability so fundamental to the Minimalist phase of late modernism. Singer also avoided the purely gestural approaches taken by the Conceptualists, as well as the architectonics of other contemporaries, such as Alice Aycock and Mary Miss. Instead, he took courage from Allan Kaprow, his professor at Cornell University, and began experimenting on his own, not with Happenings but rather with forms derived from the artist's involvement in the variables of chance and time, in addition to those of materials and processes. Although by the 1980s the resulting art had grown in complexity and poetic content, it contained the essential qualities that Singer achieved almost from the start: rough stones and beams of diverse shapes assembled on the ground or floor in self-contained, though visibly accessible, structures held in serene balance, a balance so delicate and precarious that it seems redolent of mystery, like that emanating from altars and ritual gates (fig. 1080). In tandem with so many sculptors during the early 1970s, Singer first worked in natural environments and with the materials and shifting conditions they offered. This took him to the beaver bogs near Marlboro, Vermont, and then to the saltwater marshes of Long Island. Here, instead of imposing an a priori idea on the site, in the manner of the Earth artists, he allowed nature and its laws to act on him and his work. Eventually, however, he made outdoor sculpture that was interdependent with the exigencies of place. Then, having gained a mastery of light and shadow, density, mass, and volume, line, texture, and color while contending with the mutable circumstances of an open, untamed environment,

Singer in the mid-1970s returned to the studio and began making indoor pieces, confident that he could now maintain his aesthetic distance from such domineering trends as Minimalism and Conceptualism. Once inside, he might also consider aiming for more permanent effects, which meant converting from bamboo and marsh reeds, for instance, to milled wood and dressed stone, with all their mythic and symbolic import enhanced by reference to the artist's pantheistic relationship with natural sites. In their sheer stateliness, the most recent works, made of granite, fieldstone, and slate, sometimes combined with pine or ash, do not escape their primeval origins but rather pay tribute to the majesty of nature and the ritualistic existence it imposes on those who work with its elemental and eternal forces. Bathed in clear light, the unpredictable yet measured and balanced sequences of these arresting, evocative works radiate an aura reminiscent of sacred Druidic enclosures or Shinto shrines.

BRYAN HUNT (b. 1947) With a background in the space-age environment of Cape Canaveral as well as in the Classical world of endless drawing from the nude, Bryan Hunt brings to sculpture a duality of experience making it almost inevitable that he break free of the constraints imposed by Minimalism. Thus, he projects his art into the future by looking to the past for the expressive power of traditional means—drawing, wood carving, modeling, bronze casting—and by using them both to humanize and to ennoble the ambiguous universality of abstract shapes chosen from concrete reality. In his openness to all manner of inspiration, Hunt has made sculptures from such disparate and unpromising themes as streamlined airships, the Great Wall of Chi-

1081. BRYAN HUNT. *Small Twist*. 1978. Bronze/black patina, 68 × 18 × 22″. Courtesy Blum Helman Gallery, New York

1082. BRYAN HUNT. *Prodigal Son*. 1985. Cast bronze on limestone, 54¾ × 25½ × 25½″ (with base). Courtesy Blum Helman Gallery, New York

na, the Empire State Building, and Hoover Dam, as well as the kind of lake or body of water such a barrier would contain—a solid form with a flat top and a deep, irregular bottom. So far, however, his most famous image is that of a freestanding, bronze waterfall, its tall, slender, serpentine shape a coruscating synthesis of nature, a sensuous female figure, and pure design (fig. 1081). Sensitive to the metaphoric qualities of both image and process, Hunt chose to make his waterfalls of plaster and bronze because both materials pour, just as he gave form to the Wall of China because it appeared to symbolize an ability "to overcome everything." In recent work Hunt has overcome everything to mix forms and media—now expanded to include welded metal—in open-form constructions that seem to translate waterfalls into Classical, white-clad caryatids and dark metal armatures into drawing in space (fig. 1082). Even though these complex works will eventually be cast in monolithic bronze, they are also to be patinated in the colors of their original plaster, wood, and steel materials, making them seem a compendium of the processes traditional to sculpture prior to the advent of the depersonalizing methods of Minimalism and the antiformalist backlash of the early 1970s.

SCOTT BURTON (b. 1939) In his austerely simple sculptures, bordering on Primary forms, that also happen to be usable furniture—tables, chairs, chaises longues (fig. 1083)—Scott Burton returns Minimalism to its sources in the pragmatic, Utopian ideals of early modernism, such as De Stijl. Burton would remind us, in fact, that Gerrit Rietveld, one of De Stijl's founders (plate 94), was an architect with the kind of "sensibility [which] combines the most abstruse modernist researches with the most social-minded intentions." In one of his favorite pieces the American artist so handled a chunk of crude lava that from the back it looks like a boulder, a perfectly normal even if impressive part of the natural environment, while from the front it displays the smooth-cut shapes and proportions of a functional, actually inviting chair. A more complex creation, however, is the *Six-Part Settee* seen here, fashioned entirely of dressed and polished gray granite and composed of six interlocking parts that slide together to form a piece of two-seated furniture with back and armrests. Finished to shimmering perfection, the work invests formalist design with comfort and social content, thereby eliding the infamous gap between art and life. The ultimate proof of this comes when a Burton chair is placed among conventional chairs, where it immediately betrays its identity as art, or when one stands in a gallery where visitors feel compelled to break the usual formality of that situation and try the seat for size.

SIAH ARMAJANI (b. 1930) An artist often encountered with Scott Burton in whatever sphere—public, private, or gallery—may allow the fine and applied arts to blend is Siah Armajani, a self-described "architect/sculptor" born in Teheran but long since resettled in Minnesota. There Armajani attended Macalester College and transformed himself into an old-fashioned "populist" devoted to the moral and aesthetic values—the egalitarianism—once indigenous to the American Middle West. Meanwhile, he also remains an Iranian at heart, and the dialectic between the extreme polarities of his native and adopted cultures—one ancient and complex, the other relatively young and simple—runs through his art, filling it with no end of fascinating incongruities, all treated with wit, sophistication, Duchampian ambiguity, and serious humanitarian purpose. To begin with, Armajani makes sculptures using the vocabulary of architecture, but the pieces have little or none of the functionality seen in Burton's *Six-Part Settee*. As *Closet Under Stairs* demonstrates (fig. 1084), the space defined by the work cannot be penetrated even though the door is open, nor can the

structure's second level be physically attained, since the stairs are tilted and the elevator "rostrum" has the scale of a toy. Consequently, the construction, like a painting or a relief sculpture, offers visual but not literal entrance and conceptual or metaphorical rather than kinetic experience. At the same time, it exhibits nothing of the formal coherence expected of art, but instead a kind of intricacy reminiscent of Persian design bizarrely combined with a studied, plain-spoken awkwardness alluding to American vernacular building. And while such sculptures may nostalgically extol, indeed recommend, the democratic virtues of a pioneer society whose homely architectural language—a rural idiom of carpentered frame houses, barns, and covered bridges—Armajani speaks with such an engagingly exotic accent, the works ultimately remain private, contradictory, and inscrutable.

To help elucidate the open/closed nature of his art, Armajani has said: "There is a difference between making a work of art available and making it accessible," leaving no doubt that, in his opinion, availability should suffice in a world where the inalienable right to learn carries with it a responsibility to concentrate the mind. Armajani calls pieces like *Closet Under Stairs* entries in a *Dictionary for Building*, a general "reference source" that progressively compiles nomenclature for a modern manmade environment as commonsensical as that of nineteenth-century America. Thus, what is spelled out in Armajani's lexicon is a humanist ethic, an ethic following, to some extent, the ideas of the German philosopher Martin Heidegger (1889–1976), who insisted that in order for the West to overcome the crisis of its "mass forgetfulness of being," those who structure spaces and objects for human use must do so with an eye toward function. To drive home the message, Armajani frequently resorts to a conceptual device and letters his work with the dicta of classical American writers, such as John Dewey's warning that "as long as art is the beauty parlor of civilization, neither art nor civilization is secure." While such neotraditionalism makes the sculptor distinctly Post-Modern, as well as a great admirer of the architect Robert Venturi, Post-Modernism's "father" whom we are to meet in the next chapter, the eclectic historicizing practiced by the new architects has prompted Armajani to declare: "Antiques lack ideology." What possesses ideology, for this artist, is the pullied rostrum hung within the

1083. SCOTT BURTON. *Six-Part Settee*. 1983–85. Sienite balma granite (gray and black), 34 × 57 × 36½". Number two of an edition of three. Private collection, Minneapolis

1084. SIAH ARMAJANI. *Closet Under Stairs*. 1985. Painted wood, stain, and rope, 9'1½" × 3'4" × 7'1½". The Hirshhorn Museum and Sculpture Garden, Smithsonian Institution, Washington, D.C. Acquired through the Joseph H. Hirshhorn Purchase Fund 1986

closet here, a reconstruction of a design by the Russian Conceptualist G. G. Klucis (1895–1944), who, like Burton's Rietveld, held a Utopian vision of art's role in making a better world. With its elegantly economical form determined by a revolutionary regime's need to mount the pulpit and preach the word from every corner, the lightweight, portable rostrum, no less than Shaker furniture and the widow's walks of New England fishing villages, bears witness to a culture in which gifted persons could feel fulfilled when engaged in a process directly concerned with the well-being of the human community. Thus, through his interface with architecture, a crossover Iranian-American sculptor takes his art out of the exclusive realm of modernist self-referral and across the border into a world of broader issues. Along the way, he also gives vent to an invincible quirkiness, as if to remind us that public spaces, where architecture functions, are always inhabited by a crowd of individuals.

TONY CRAGG (b. 1949) No discussion of contemporary sculpture would be complete without reference to Great Britain, where, beginning with Moore and Hepworth and continuing with Caro, the art has consistently drawn talents of the highest order, giving British sculpture a unique importance both at home and abroad. As the work of Richard Long and Barry Flanagan would suggest (figs. 934, 1013), English sculptors maturing in the seventies and eighties have rejected the Constructivism of the Caro school, finding it a line of development now grown too academic to offer significant new possibilities. Thus, they avoid formalism for its own sake and allow their work to hover ambigu-

1085. TONY CRAGG. 1986. Installation view, Marian Goodman Gallery, New York. Mixed media

1086. BILL WOODROW. *Car Door, Armchair, and Incident.* 1981. Installation view, The Barbara Gladstone Gallery, New York. Mixed media, lifesize. Courtesy The Barbara Gladstone Gallery, New York

ously between figuration and abstraction, with the tilt generally toward the latter. Even more than Long and Flanagan, these younger artists tend to seek inspiration in base or rejected materials, usually with strong human associations and the power of metaphor. Avoiding heroics, they frequently court the fragility and impermanence of performance art. Among the English sculptors of abstract tendency to come into their own during recent years, the one with the widest international reputation is Tony Cragg, who creates scatter works composed of small plastic discards evenly distributed, like airy mosaics, across the floor or wall in abstract patterns of color and shape (fig. 1085). Scavenging and assembling bright fragments from the beaches and dustbins of England, Cragg makes a wry comment on Minimalism and its grand, holistic aspirations. As aware of consumerist humanity's relation to the natural world as Long, Cragg does not, however, withdraw from the spoiled urbanscape into romantic, virgin nature. Rather he recycles into art and thereby makes newly relevant the once-useful but now broken, dysfunctional, environmentally disfiguring products of industry. In a land echoing with idle factories, where the Industrial Revolution first exploded, it seems less worthwhile to condemn mass production than to mark or memorialize the plenitude it once provided, jobs and goods as well as polluting excess.

BILL WOODROW (b. 1948) Instead of appropriating technology as sixties artists did, Woodrow too treats the industrial age as a past civilization, as something to excavate and reconsider from the distance of a present, and quite different, reality (fig. 1086). In 1980 he began making replicas of such machines or instruments as a bicycle, a guitar, or a machine gun by cutting them out of the white-enameled metal surface of old washing machines, but leaving the male-associated forms joined to the "mother" by an umbilical cord in the form of a metal strip. In a more elaborate, even narrative, piece, Woodrow cut from a detached automobile door hung on the wall a sawed-off shotgun, with this posed on an adjacent armchair, one corner of which appears to have been blown off by the weapon and spattered over the wall behind. Here too the spatter and the chair have been connected by an umbilical cord. For

another work, the artist cannibalized an obsolete twin washer hung on the wall to make a satellite floating suspended from the ceiling. Now Woodrow would seem to have acknowledged not only the passing of the machine age but also the arrival of the information era to which it gave birth.

RICHARD DEACON (b. 1949) In 1978–79 Richard Deacon read Rainer Maria Rilke's *Sonnets to Orpheus* and conceived a profound admiration for the manner in which "the objects that appear in Rilke's poetry, whilst taking on connotations, retain the quality of actuality." And so at the same time that the many implications of ears, horns, and mouths found in Deacon's sculptures derive ultimately, if obliquely, from Rilke's central metaphor of Orpheus's head, the forms remain too ambiguous and too emphatically objects or things to become clear, precise images. This dual sense of familiarity and strangeness can be seen in *Tall Tree in the Ear* (fig. 1087), where a large blue contour "drawing" in space seems to describe a very large dry bean, held upright by the silvery armature of what could be a pear. Together, the two- and three-dimensional forms conjure the shape and volume of the ear cited in the title, while the size of them evokes the immensity of the sound issuing from a tree, possibly one with branches full of noisy starlings or with leaves rustled by a strong wind. Mystery and poetry inform this art from beginning to end, for although calling himself a "fabricator," Deacon employs simple methods, like riveting, and unaesthetic materials, such as steel and linoleum, prepares no preliminary drawings or models, and permits initial idea, material, and process to interact to produce sculptures that insist on their presence even as they imply absence.

1087. RICHARD DEACON. *Tall Tree in the Ear.* 1983–84. Galvanized steel, laminated wood, and blue canvas, 12'3⅝" × 8'2½" × 11'11". Saatchi Collection, London

CHAPTER TWENTY-SEVEN

Post-Modernism in Architecture

Post-Modernism, a term so often invoked throughout these last several chapters, seems to have originated not in the worlds of painting and sculpture, but rather in that of architecture. There, the International Style, during the years of massive building and rebuilding after World War II, had grown so dominant that nothing short of disaster could undermine its virtually totalitarian power over architects and clients alike. But disaster finally struck, prompting Charles Jencks, probably the most articulate of Post-Modernism's apologists, to cite the date and hour of its occurrence—July 15, 1972, at 3:32 P.M.—as the actual moment when architectural modernism died. "Death" came with the destruction of St. Louis's Pruitt-Igoe public-housing project, dynamited after all other measures had failed to save this monument to rational, Utopian, Bauhaus planning from the social and economic horror it had become. Built scarcely twenty years earlier, the sleek modernist complex had won the American Institute of Architects' award for its designer, Minoru Yamasaki. Complete with "streets in the air," safe from automobile traffic, and access to "sky, space, and greenery," which Le Corbusier had deemed the "three essential joys of urbanism," Pruitt-Igoe offered all, including purist styling, that enlightened, idealistic specialists had assumed would inspire, by example, a sense of virtue in the inhabitants. By the end of the 1960s, however, the clinically smart, multimillion-dollar fourteen-story slab blocks had become so vandalized, crime-ridden, squalid, and dysfunctional that only their demolition could solve the manifold problems. The best of modernist thought, owing to its aloof indifference to the small-scale, personal requirements of privacy, individuality, context, and sense of place, could do nothing to make Pruitt-Igoe Housing a workable home for the economically disadvantaged persons whose living conditions it was meant to improve.

The calamity in St. Louis, however, merely provided the "smoking gun" for critics who, since the mid-sixties, had been attempting to indict Bauhaus modernism on the grounds of its alleged bankruptcy in both form and principle. To the disenchanted, the followers of Miës, Gropius, and Le Corbusier had created a movement far too narrowly ideological, collectivist, hard-edged, and impersonal—certainly too self-referential in its insistence upon formalism dictated purely by function and technology—to give satisfaction in a society whose diversity could only become more pronounced with the arrival of the "Me Generation." Already in 1964 Lewis Mumford had written:

> Miës van der Rohe used the facilities offered by steel and glass to create some elegant monuments of nothingness. They had the dry style of machine forms without the contents. His own chaste taste gave these hollow glass shells a crystalline purity of form; but they existed alone in the Platonic world of his imagination and had no relation to site, climate, insulation, function, or internal activity; indeed, they completely turned their backs upon these realities just as the rigidly arranged chairs of his living rooms openly disregarded the necessary intimacies and informalities of conversation.

And so, in opposition to the univalence of Bauhaus aesthetics, with its wholesale dependence on right-angle geometry and industrial systems, their claims not only of rational functionality but also of universality, Post-Modernism has a voracious appetite for an irrational, eclectic mix of history, vernacular expression, decoration, and metaphor. Moreover, Post-Modernists seek to build in relation to everything, the site and its established environment, the client's specific needs, including those of wit and adventure in living, historical precedent relevant to current circumstance, and communicable symbols for the whole enterprise. Instead of Le Corbusier and Miës van der Rohe, the gods of the Post-Modernists are Antoni Gaudí and Sir Edwin Lutyens, both moderns who escaped the monolithic imperatives of modernist dogma (figs. 97–99). Among the first to appreciate them anew and to voice, as well as practice, the revisionism this represented was the Philadelphia architect and theorist Robert Venturi.

ROBERT VENTURI (b. 1925) The father of Post-Modernism is unquestionably Robert Venturi, the Philadelphia master who went to Princeton and studied under the distinguished Beaux-Arts professor Jean Labatu, rather than to Harvard, whose School of Design, as noted earlier, had been transformed by Walter Gropius into a powerful Bauhaus-like force for modernism. Right off, therefore, Venturi gained the historical background that now forms the principal point of reference for most of the new antimodern architecture. Moreover, it prepared him to see in Rome, while there during 1954 as a *Prix de Rome* winner, not a collection of great monuments but, instead, an urban environment characterized by human scale, sociable piazzas, and an intricate weave of the grand and the common. When abetted by a period in the office of Louis Kahn, another admirer of the Roman model and a leading architect then moving away from the International Style toward more rugged, Expressionist or symbolic buildings, Venturi's Roman experience served as the basis of the new philosophy that would culminate in a seminal, and now famous, book entitled *Complexity and Contradiction in Architecture* (1966). Here, with wit as well as scholarship, Venturi worked back through architectural history, to Italian Mannerist as well as Baroque prototypes, and argued that the great architecture of the past was not Classically simple, but often ambiguous and complex. He held, moreover, that modern "establishment" architects' insistence upon a single style of unrelenting reductivism had proved utterly out of phase with the irony and diversity of modern times. To Miës van der Rohe's celebrated dictum, "less is more," Venturi retorted: "Less is a bore."

Complexity and Contradiction presented nothing less than a broadside critique of mainstream modernism, at least as it had evolved in the brutally overscaled, stripped-down, steel-and-glass boxes that rose with machinelike regularity throughout the postwar world. Even now, many critics consider the book the first and most significant written statement made against the International Style. "Architects can no

1088. VENTURI, RAUCH and SCOTT BROWN. Best Products Company, Oxford Valley, Pennsylvania. 1977

longer afford to be intimidated by the puritanically moral language of orthodox modern architecture," said Venturi.

I like elements which are hybrid rather than "clear," distorted rather than "straightforward," ambiguous rather than "articulated," ...boring as well as "interesting," conventional rather than "designed," accommodating rather than excluding...inconsistent and equivocal rather than direct and clear. I am for messy vitality over obvious unity. I include the non sequitur and proclaim the duality. I am for richness of meaning rather than clarity of meaning.

Venturi believed with total conviction that the modern movement had grown stale, that the successors to the great innovative modern architects had turned the latter's splendid revolution into a new Establishment, just as authoritarian and unresponsive to contemporary needs as the old one had been in its own time and way. Confronted with the pervasive giantism, unaccommodating aloofness, sameness, banality, and opportunism—the chance to give less and charge more in the name of Utopian ideals—of the buildings designed by Bauhaus-inspired architects, Venturi decided that "Main Street is almost all right."

1089. ROBERT VENTURI. Chestnut Hill House, Philadelphia. 1962

With his wife, Denise Scott Brown, a specialist in popular culture and urban planning and a partner in the firm of Venturi, Rauch and Scott Brown, Venturi wrote a second, even more inflammatory book, this one published in 1972 and entitled *Learning from Las Vegas.* Now Venturi declared that a careful study of contemporary "vernacular architecture," like that along the automobile-dominated commercial "strip" roadways of Las Vegas, may be "as important to architects and urbanists today as were the studies of medieval Europe and ancient Rome and Greece to earlier generations." Venturi and Scott Brown had sought to learn from such a landscape because for them it constituted "a new type of urban form, radically different from that which we have known, one which we have been ill-equipped to deal with and which, from ignorance, we define today as urban sprawl. Our aim [was] ...to understand this new form and to begin to evolve techniques for its handling." Since urban sprawl has come to stay, the Venturis are persuaded that architects should learn to love it, or at least discover how "to do the strip and urban sprawl well." In the opinion of Venturi, "the seemingly chaotic juxtaposition of honky-tonk elements expresses an intriguing kind of vitality and validity."

While such Pop taste and maverick views made Venturi the leading theoretician among younger architects, they also earned him the near-universal disdain of the modernist school, who, like the critic Ada Louise Huxtable, dubbed the quietly civilized Venturi with such epithets as "guru of chaos." The Venturis' bold ideas also proved too much for the culturally ambitious but insecure dispensers of major commissions. Thus, until 1986, when Venturi, Rauch and Scott Brown won the coveted contract for the design of the extension to London's National Gallery on Trafalgar Square, the firm had to content itself with relatively small projects. Still, the partners made the most of every opportunity, even while insisting that they deliberately designed "dumb" buildings or "decorated sheds." The decorated shed concept may have received its most salient expression in the highway store the firm designed for the venturesome Best Products Company (fig. 1088), its long, low façade rising above the inevitable parking lot like a false front on Main Street in a Western frontier town, *but* displaying huge, gaily colored flowers reminiscent of those made famous in the sixties by Andy Warhol. So far, however, the prototypical Venturi house is surely the one the architect built in 1962 for his widowed mother in Chestnut Hill, Pennsylvania (fig. 1089), a work whose apparent ordinariness is just enough "off" to clue the alert viewer that something more than the ordinary has been at work—really a mind of quite exceptional humor, sophistication, and

irony. Here Venturi accepted the conventions of the "ugly and ordinary" American suburban crackerbox—its stucco veneer, wood frame, pitched roof, front porch, central chimney, etc.—and parodied them so completely as to make the commonplace seem remarkable. The process of transformation began with the scale of the façade, which the architect expanded until it rose several feet above the roof, thereby creating another false front. He then pulled it apart at the center to reveal the conceit and widened the cleft at the bottom to create a recessed porch. Visually holding the two halves together, yet oddly emphasizing their division, are the broken arch and the stretched lintel above the entrance, both paper thin like everything else about the façade, or like the crackerbox tradition itself, or even most modern curtain-wall construction. Meanwhile, the split in the front wall echoes the much older and more substantial stone architecture of the Baroque era, which in turn joins with the expanded height of the façade to endow the humble and teased crackerbox with a certain illusionistic grandeur. Such complexity and contradiction extend deep into the structure, to the chimney wall, for instance, which spreads wide like a great central mass, only to project above it the real and rather narrow chimney. But unity too has been honored among all the intricate ambiguities, as in the same size and number (five) of the asymmetrically disposed window panels on each side of the binary façade.

Hidden behind the deceptively simple exterior of the Chestnut Hill house is a complicated interior, its rooms as irregularly shaped and small in scale as the façade is grand, in the Pop manner of Oldenburg's giant hamburgers. Yet the plan is tight and rational, not whimsical, because while the crooked stairway, for instance, may be broad at the base and narrow at the top, it reflects, in Venturi's view, the difference in scale between the "public" spaces downstairs and the "intimate" ones upstairs. By its very irregularity, the interior accommodates the books, family mementos, and overstuffed furniture long owned by the client and expresses her patterns of living. It does not, like Le Corbusier's "machines for living" or Frank Lloyd Wright's Usonian houses, suggest or impose a pattern for living. Herein lies the essence of the Venturi concept, for while the Chestnut Hill house makes no attempt to be a ship, an airplane, or some organic device to commune with nature, but instead proclaims its houseness, the building does so with historically relevant allusions and yet without becoming an overt symbol, or what the Venturis call a "duck." Rather than fashion a poultry store in the form of a duck, like the one the Venturis saw on Long Island, these architects prefer to design "decorated sheds." "We don't think people want 'total design' as it is given to them by most modern architects," Scott Brown once said. "They want shelter with symbolism applied to it."

Convinced that "we need less of a prima-donna-on-the-landscape approach," Venturi undertook a commission from the Society of Friends and designed a block of ninety-one apartments for the elderly residents of an old section of Philadelphia (fig. 1090). True to Scott Brown's phrase, he offered them "shelter with symbolism applied to it," the latter in the form of a large Pop sign or marquee spelling out "Guild House" above the entrance. Since this is housing, not a house, Venturi did not hesitate to give it the cheap, utilitarian, dark-brick look of so many urban renewal projects, a look that in this case blended well with the commercial character of the inner-city neighborhood. But Guild House, while adhering to its own material and iconographical conventions, also evinces some of the nobility of a princely residence or a Baroque church. This can be seen in the bilateral symmetry stepped forward and up toward a central massing, a crescendo effect further dramatized by the white-glazed recessed entrance above which rises a series of balconies crowned by a Neo-Palladian lunette. Then, like a bit

1090. ROBERT VENTURI. Guild House, Philadelphia. 1960–63

of contemporary, proletarian heraldry, the main vertical axis breaks free above the roof line in a gold anodized television antenna—a fake one, moreover, the better to perform the role of what the quotable Venturi called "a symbol of the aged, who spend so much time looking at TV."

Guild House provided a beacon for younger architects seeking a new architecture of "inclusion"—an architecture at home in the existing environment, combining features of the average, everyday building and historical styles. Such architecture would stand opposed to the established modernist process of "exclusion," which, in view of its critics, seeks, or sought, to impose heroic, abstractly conceived forms on the social and natural landscape. In Guild House, Venturi deliberately mixed the ordinary with the sophisticated, so that he and the cognoscenti might "have their tricks," at the same time that "the people's wishes, not the architects', ultimately dominate." Here the "people's plastic flowers don't look silly in the windows."

CHARLES MOORE (b. 1925) Another student of Louis Kahn at the University of Pennsylvania and a close ally, if not an actual partner, of the Venturis is Charles Moore, who looks not so much to Las Vegas for inspiration as to Disneyland, praising it as an outstanding public space as well as an embodiment of the American Dream. Concerned with the commercial or industrial sameness of the postwar world, with the lost "sense of place" that leaves Cleveland looking like Los Angeles, Moore has become even more overtly historicist than Venturi and fully committed to "the making of places." In this, he seems more often than not to favor the "presence of the past" found in a Roman-Mediterranean kind of environment, and so far, the most remarkable example of how imaginatively he can develop the theme is the Piazza d'Italia in New Orleans (plate 316; figs. 1091, 1092). Here Moore designed a public space to provide a small Italian-American community with an architectural focus of ethnic identity, a place exuberant enough to serve as the setting of the annual St. Joseph's festival, with its vibrant street life animated by temporary concessions selling salami, cheese, pasta, *zeppoli*, etc. Working in close collaboration with architects well versed in the local culture, Moore took into account not only the taste and life patterns of the inhabitants, but also the mixed physical context into which the new piazza would have to fit. Thus, while the design incorporated the black-and-white lines of an adjacent modernist skyscraper in a graduated series of concentric rings, the circular form itself—essentially Italian Baroque in character—reaches into the community outside even as it draws that

world in. Moore found the prototypes for his circular piazza in, for example, Paris's Place des Victoires, the Maritime Theater at Hadrian's villa near Tivoli, and, most of all, the famed Trevi Fountain in Rome, an open-air scenographic extravaganza combining a Classical façade, allegorical earth sculpture, and water. For his earth sculpture, Moore went not to mythology but rather to the real map of Italy. With Sicily, the ultimate origin of New Orleans's Italians, set at the center, like the sun in a solar system, the circular configuration radiates stepwise from depth to height, so that as water cascades into the basin fountain, the black-and-white rings expand and rise like waves, all the way to the high "Alps." Also climbing toward the Alps and clustering at staggered intervals on either side of the Alpine cascade are various column screens representing the five Classical orders, the outermost and richest one, Corinthian, crowned by polished stainless-steel capitals supporting an entablature emblazoned with dedicatory Latin inscriptions. Over the Alpine waterfall stands a triumphal arch, polychromed in Pompeiian hues and outlined in neon tubing. With its eclectic mixture of historical reference and pure fantasy, such as water coursing down pilasters to suggest fluting, water spouts serving as Corinthian leaves, or stainless-steel Ionic volutes above neon necking, Charles Moore's Piazza d'Italia combines archeology, modernism, commerce, and theater to provide something for everyone—mainly a sense of place unlikely ever to be confused with Cleveland, Los Angeles, Sicily, or even the French Quarter in New Orleans itself.

HANS HOLLEIN (b. 1934) About the same time as the Venturis, Austria's Hans Hollein was out in the American West learning from Las Vegas, and doing so in rebellion against the "Prussian dogma of modernism" at the Illinois Institute of Technology, where he had enrolled in 1958. Seeing all those open spaces and the expressive freedom they seemed to generate provoked an epiphany in Hollein, who has since learned to design with a pluralistic abandon worthy of his gaudy American models, but also with an exquisitely crafted, decorative elegance

reflecting a subtle appreciation of Vienna's own Secessionist tradition (figs. 94, 298–300). Even more than the Americans, European Post-Modernists like Hollein have found few opportunities to work on a large scale, and, with one exception, the Austrian architect has had to contain his drive to invent and surprise within small jewel-box spaces, often old, refurbished interiors like that of the Austrian Travel Bureau in Vienna (fig. 1093). For this project, Hollein adopted topographical themes and scenographic methods similar to those of Charles Moore in the Piazza d'Italia—and in the same metaphorical spirit—to make a preexisting hall suggest all the many places to which the Travel Bureau

1093. HANS HOLLEIN. Austrian Travel Bureau, Vienna. 1978

1094. Hans Hollein. Städtisches Museum Abteiberg, Mönchengladbach, West Germany. 1976–82

could send its clients. Thus, the assemblage of allusive forms and images found here includes a grove of brass palm trees clearly based on those in John Nash's kitchen for the early nineteenth-century Brighton Pavilion, a broken "Grecian" column, pyramids, and a model of the Wright brothers' biplane, plus rivers, mountains, and a ship's railing. Lined up along the central axis, like a miniature Las Vegas strip, are such temptations as an Oriental pavilion, a chessboard seating area, and a sales booth for theater tickets, the latter backed by a woodcut of Serlio's *Comic Scene* and furnished with a cash window in the form of a Rolls-Royce radiator grille. All about, meanwhile, the hall itself—a place designed to encourage free *spending*—has been styled to resemble a reconstruction of Otto Wagner's 1904–6 Post Office Savings Bank (fig. 298).

Recently, the small West German town of Mönchengladbach gave Hollein his one big commission, for a museum set on a hillside (fig. 1094). Declaring that he "was never afraid to use materials in new contexts—plaster or aluminum or marble, and all this together," Hollein designed his museum like a tiny town within a town, an agglomeration of distinct but compatible structures set on a stone *Platz*. With its undulating red-brick terraces snuggled against the slope, its relaxed and vaguely mock-ancient but nonabrasive Disneyland replicas, its odd and delightfully particular cutout corner or voluptuous semicircular marble stairs, the Mönchengladbach Museum struck critic Kurt Andersen as having "the virtuoso exuberance of a big, ambitious first novel, brimming with every story fragment and shimmering turn of phrase the author can muster."

ROBERT A. M. STERN (b. 1939) Another American architect profoundly influenced by Robert Venturi, as well as by Charles Moore, under whom he studied at Yale, is Robert A. M. Stern. Like his mentors, Stern not only carries on an increasingly active practice in Post-Modern

architecture but also teaches (at Columbia University), writes, and edits. In 1986 he hosted an Educational Television series entitled *Pride of Place: Building the American Dream.* Although fully as witty and sophisticated as Venturi and Moore, Stern is also more literal and fastidious in his use of historical precedents, and considerably more given to patrician sumptuousness. Indeed, he has developed into something of a one-man McKim, Mead and White, in that he seems never quite so truly himself as when designing the sort of grand shingle-style country house or holiday retreat that the turn-of-the-century New York firm once produced with such gloriously understated, aristocratic bravura. Thus, while reveling in the decorative revival quite as joyously as Venturi and Moore, Stern does so less in the Pop spirit animating the Piazza d'Italia and Venturi's Best Products façade than in the fanciful manner of the Brighton Pavilion already appropriated by Hans Hollein. This can be seen to splendid effect in the Pool House that the architect built for a great mansion in Llewelyn, New Jersey (plate 317), where stainless-steel "palm columns" evoke the famous supports in John Nash's kitchen built for the Prince Regent. But if the glistening material of these uprights produces a "wet" effect appropriate to the setting, so do the polychrome wall tiles derived from a kind of décor favored by the Secessionist Viennese (fig. 94). Further enhancing the bathhouse theme are the Art Deco figural quoins and the thick Tuscan columns, the latter reminiscent of Roman *terme.*

MICHAEL GRAVES (b. 1934) Among American Post-Modernists, the most thoroughgoing, yet original Classicist may be Michael Graves, whose Public Services Building in Portland, Oregon (plate 318; fig. 1095), in the opinion of Charles Jencks, constitutes "the first major monument of Post-Modernism, just as the Bauhaus was of Modernism, because with all its faults it still is the first to show that one can build with art, ornament, and symbolism on a grand scale and in a language

1095. MICHAEL GRAVES. Portland Public Services Building, Oregon. 1980–82

the inhabitants understand." The latter contention was borne out when Graves twice won the commission over pure modernists, and then again when his sculpture known as *Portlandia*, a female personification of civic virtue over the main entrance, had to be restored by popular demand after purists had managed to get the piece removed. Graves has said that he designs as if he were a child, and indeed "The Portland" rather resembles a child's construction, made with toylike blocks, a few radically simplified Classical forms, and a wildly unfettered sense of

scale. Set on a three-storied stepped base, the mass of the building rises twelve stories high to form a near-cube, its shape and scale fixed and inflated by a grid of small windows. The drama of Mannerist exaggeration continues in the immense mirror-glass window on the front, so utterly at variance with the scale of the checkerboard apertures. Surrounding the colossal window on the cream-colored façade is a no less monumental, maroon-colored reformulation of the Classical vocabulary: twin, giant pilasters with bracket capitals, or impost blocks, surmounted by a cyclopian keystone, a normally massive form whose obvious two-dimensionality here betrays the building's illusory blockiness as a typically modern paper-thin shell. This interplay of surface and depth continues along the sides, where immense green festoons or stylized garlands billow in relief (originally they were to have projected in buoyant Baroque flourishes) above a trabeated row of giant pilasters and tall ribbon windows. For such scalar distortion and free invention within the Classical mode, one would have to look back to the Napoleonic era, whose Ledoux and, certainly, Boullée had even more difficulty getting their designs built than the Post-Modernists. But following numerous challenges, delays, and modifications, The Portland has become a reality in every sense of the word, a truly civic building imbued with all the dignity of the human past made whole with a boldly asserted, living present.

JOHNSON AND BURGEE Graves's Portland Public Services Building may be "the first major monument of Post-Modernism," but the largest and certainly the most notorious such structure is the New York headquarters of AT&T designed by Philip Johnson in collaboration with his partner John Burgee (figs. 1096–1098). Adding to the shock factor of

1096. PHILIP JOHNSON and JOHN BURGEE. AT&T Headquarters, New York. 1978–83

1097. PHILIP JOHNSON and JOHN BURGEE. AT&T Headquarters, New York. 1978–83

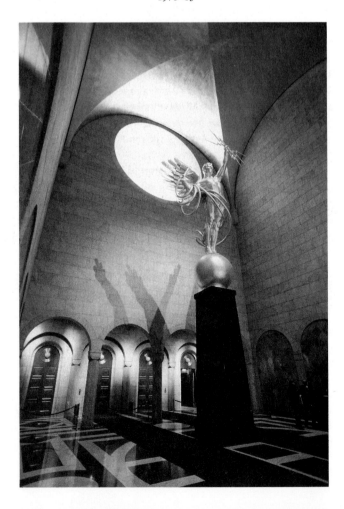

this famously revisionist, or antimodern, tower is the fact that Johnson, with Henry Russell Hitchcock, had written the book which, beginning in 1932, brought the International Style to the English-speaking world and thus made it a true architectural *lingua franca* (fig. 869). But when Johnson early on called Robert Venturi "certainly the leading theoretician of the younger architects of this country, if not the world," it was as though he felt it particularly incumbent upon him, as one of the key apologists for Bauhaus modernism, to speak out when that concept had clearly exhausted all potential for realizing its own goals. By this time, of course, Johnson was the virtual dean of American architects, and the immense prestige his accomplishments brought him enabled the droll and articulate master not only to swing the jury toward Graves in the Portland competition, but also to persuade stolid AT&T to invest over $200 million in a Post-Modern design of almost perverse irony and elegance.

From hindsight, it seems that only Johnson, his witty mind ever turning through a vast, erudite range of aesthetic reference, could have perceived in the skyscraper soaring above an open lobby an analogy of the highboy, with the building's floors likened to a colossal stack of drawers set in a chest supported by tall legs and ending in a scroll top. With this, Johnson brought history back into modern highrise architecture, a history evoking the grandeur of the Baroque period but rendered suitable to the commercial, Pop world of now by reference not to palace or ecclesiastical forms, but rather to furniture, a domain in which eighteenth-century Americans excelled long before they had the means to build monumentally. While the forest of "legs" below provides a capacious open loggia, some five or six stories high, for the public on crowded Madison Avenue, the broken pediment above gives AT&T a corporate logo unmistakable in its profile and visible for miles about. In between, the shaft rises 647 granite-clad feet to provide "drawers" or stories like none other built in our time, since, owing to their double height, there are only thirty-six of them in what would normally be a sixty-story tower! Meanwhile, in the street-level, immensely tall lobby, the historicism assumes a dizzy complexity. While the façade of central oculus-over-arch flanked by trabeated loggias recalls Brunelleschi's fifteenth-century Pazzi Chapel in Florence, the interior abandons the Renaissance for a groin-vaulted Romanesque space, housing, like a pagan cult chamber, the colossally garish *Golden Boy,* a nude personification of Telecommunications salvaged from the topmost spire of the old AT&T Building in Lower Manhattan. And herein may lie the essence of Post-Modernism, which longs for the monumentality and symbolism of old but, lacking the faith originally embodied in those forms, must inevitably undermine them with ingenious puns and brilliant self-mockery.

RICARDO BOFILL (b. 1939) In Europe the Post-Modernist who has succeeded in building on the most spectacular scale and with the most daring appropriations from the historical past may be Ricardo Bofill, a Spaniard with an extensive practice in France and generally known by the name of his firm, Taller Bofill or Taller de Arquitectura. "Daily life should not be banalized, but exalted to become rich and meaningful," says Bofill in explanation of such overwhelming projects as the housing complex he has built, under commission from local authorities, for a new commuter town in the Marne Valley outside Paris (figs. 1099, 1100). To bring drama to humdrum life in the exurbs, Bofill fitted 584 apartments into a vast, nine-story Roman Theater, a nineteen-story Pal-

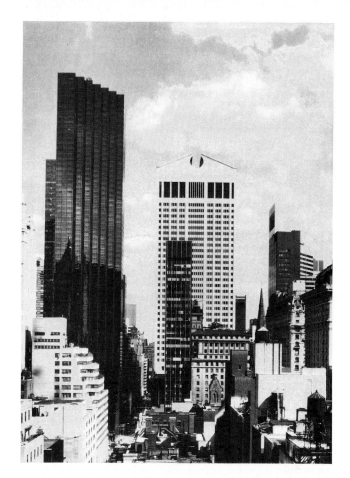

1098. PHILIP JOHNSON and JOHN BURGEE. AT&T Headquarters, New York. 1978–83

1099, 1100. RICARDO BOFILL and TALLER DE ARQUITECTURA. The Spaces of Abraxas, Marne-la-Vallée, France. 1978–82

1101. JAMES STIRLING. Neue Staatsgalerie, Stuttgart. 1977–83

1102. JAMES STIRLING. Model, Neue Staatsgalerie

ace, and a ten-story Triumphal Arch positioned between the two. The Spaces of Abraxas—as the complex is called for the Mesopotamian symbol of both good and bad—would seem to combine the gargantuan scale and density of a Piranesi "prison" with the freedom and fancy of a garden folly. Although composed of three awkwardly disparate forms—a U in plan, an inverted U in elevation, and a semicircle—they have been unified by the architect's overriding conception of the Theater as an audience, the Triumphal Arch as the stage set, and the Palace as a backdrop. Another unifying feature is the slitlike "urban window" cut into the Theater in line with the main axis running through the Arch to the center of the Palace. Then, too, there is the vocabulary, which everywhere is Classical, but realized with the economy and materials of modernism's precast concrete, glass, and steel and reused in ways never imagined in antiquity or the Renaissance. This is particularly evident in the giant columns, some of which are stair towers, some glass-fronted bays for stacks of living rooms, and others mere channels left to be filled by tall cypresses. For the upper stories of the Theater, meanwhile, capitals have been transformed into balconies. Peter Hodgkinson, once of Britain's Archigram but now a Bofill associate, has called The Spaces of Abraxas "the Cape Canaveral of the Classical space age, the return of a people's ritual, a group of buildings that communicate space, telling the fable of an ancient epic rediscovered to serve man anew."

JAMES STIRLING Already one of Britain's most important architects in the 1960s, when he worked in a somewhat Brutalist vein (fig. 843), Stirling seems to have been liberated by Post-Modernism into full possession of his own expansive genius, best exemplified in the exciting new addition to the Neue Staatsgalerie, or Museum, in Stuttgart (plate

319; figs. 1101, 1102). Here, assisted by Michael Wilford, he took advantage of the freedom allowed by revisionist aesthetics to solve manifold problems presented by a difficult hillside site, hemmed in below by an eight-lane highway, above by a terraced street, and on one side by the original Renaissance Revival museum. With so many practical considerations to satisfy, Stirling decided to deal with them in "a collage of old and new elements . . . to evoke an association with museum." And so while the three main exhibition wings repeat the U-shaped plan of the nineteenth-century structure next door, the external impression is that of a powerful Egyptian massing, ramped from level to level like the funerary temple of Queen Hatshepsut at Deir el-Bahari, but faced with sandstone and travertine strips more suggestive of medieval Italy. Visually the ramps and the masonry unify what is a jumble of disparate forms clustered within the courtyard framed by the embracing U. Among these are an open rotunda surrounding a sculpture court, the glazed, undulating walls of an entrance shaped rather like a three-dimensional grand piano, and a blue-columned, red-linteled, and glass-roofed High-Tech taxi stand. Despite so many historical references and such diverse configurations, a sense of unity and distinctive place becomes quite real, even moving, as the ramps convey the pedestrian along a zigzag path leading from the lower highway into and steeply halfway round the inner circumference of the rotunda, and finally through a tunnel in the cleft walls to the upper terraced street behind the museum. Adding to this heady mix of sophisticated, urbanistic pluralism is the keenly British sensibility of Stirling himself, who could not but feel the grace and allure of the Royal Crescent at eighteenth-century Bath as he designed his circuit through the heart of art history at Stuttgart's Neue Staatsgalerie.

Since this is a general book, not intended for the specialist, it was not deemed necessary to list all sources or background material. Books, periodical literature, and museum or gallery catalogues have been pruned to a manageable list. It should be emphasized that as we approach our own day, periodical articles on contemporary artists and current movements become increasingly important.

The bibliography is organized as follows:

I. *General.* This is an informal rather than comprehensive list of books on literature, aesthetics, philosophy, and cultural history—essays and interviews—as well as surveys of modern art which have been found useful as background material.
II. *Dictionaries and Encyclopedias*
III. *Architecture, Engineering, and Design*
 A. From the Origins of Modernism to the 1970s
 B. Post-Modernism in Architecture
IV. *Photography*
V. *Painting and Sculpture*
 A. Movements
 B. Countries
VI. *Artists, Architects, and Photographers*

ABBREVIATIONS

E.C. Exhibition Catalogue
MMA. Metropolitan Museum of Art, New York
MOMA. Museum of Modern Art, New York
SRGM. Solomon R. Guggenheim Museum, New York
WMAA. Whitney Museum of American Art, New York
Works cited here are in English, except for selected important sources, catalogues, and documents.

I. GENERAL

ARNHEIM, R. *Art and Visual Perception.* Rev. ed. Berkeley and Los Angeles, 1974.
ASHTON, D. *The Unknown Shore.* New York, 1962.
BALAKIAN, A. *The Symbolist Movement.* New York, 1967.
BARNES, A. *The Art in Painting.* 3d ed. New York, 1937.
BARNES, H. E. *An Intellectual and Cultural History of the Western World.* 3 vols. New York, 1965.
BARR, JR., A. H. *Defining Modern Art: Selected Writings of Alfred H. Barr.* Edited by I. Sandler and A. Newman. New York, 1986. Introduction I. Sandler.
BATTCOCK, G. *Why Art: Casual Notes on the Aesthetics of the Immediate Past.* New York, 1977.
BAUDELAIRE, C. *The Mirror of Art.* London, 1955.
————. *Painter of Modern Life and Other Writings on Art.* London, 1964.
————. *Art in Paris, 1845–1862.* London, 1965.
BERGER, J. *About Looking.* New York, 1980.
BESSET, M. *Art of the Twentieth Century.* New York, 1976.
BLANSHARD, F. B. *Retreat from Likeness in the Theory of Painting.* 2d ed. New York, 1949.
BOIME, A. *The Academy and French Painting in the Nineteenth Century.* London and New York, 1971.
BOWNESS, A. *Modern European Art.* New York, 1972.
BUTLER, R. *Western Sculpture: Definitions of Man.* New York, 1975.
CAWS, M. A. *The Eye in the Text: Essays on Perception, Mannerist to Modern.* Princeton, 1981.
CLARK, K. *Ruskin Today.* Harmondsworth, 1964.
COLLINGWOOD, R. G. *The Principles of Art.* New York, 1958.

————. *Essays in the Philosophy of Art.* Bloomington, Ind., 1964.
CONE, M. *The Roots & Routes of Art in the 20th Century.* New York, 1975.
COPLESTON, F. *A History of Philosophy.* 7 vols. New York, 1946–63.
————. *Contemporary Philosophy.* New York, 1963.
DANTO, A. *The Transfiguration of the Commonplace: A Philosophy of Art.* Cambridge, Mass., 1981.
DEGEORGE, R. T. and F. M., eds. *The Structuralists: From Marx to Lévi-Strauss.* Garden City, N.Y., 1972.
DUFRENNE, M., ed. *Main Trends in Aesthetics and the Science of Art.* New York, 1979.
ELLMANN, R., and FEIDELSON, C., eds. *The Modern Tradition: Backgrounds of Modern Literature.* New York, 1965.
EVANS, M., ed. *The Painter's Object.* London, 1937.
FIEDLER, C. *On Judging Works of Visual Art.* Berkeley and Los Angeles, 1949.
FLETCHER, V. J. *Dreams and Nightmares: Utopian Visions in Modern Art.* Washington, D.C., Hirshhorn Museum and Sculpture Garden, 1983. E.C.
FOCILLON, H. *The Life of Forms in Art.* New York, 1958.
FRASCINA, F., and HARRISON, C., eds. *Modern Art and Modernism: A Critical Anthology.* New York, 1982.
FRY, R. *Vision and Design.* Harmondsworth, 1961.
————. *Last Lectures.* Boston, 1962.
GABLIK, S. *Progress in Art.* New York, 1977.
GILSON, E. *Painting and Reality.* New York, 1957.
GOETHE, J. W. VON. *Theory of Colours.* London, 1940.
GOLDWATER, R. *Primitivism in Modern Art.* New York, 1967.
———— and TREVES, M. *Artists on Art.* New York, 1945.
GREENBERG, C. *Art and Culture.* Boston, 1961.
HALL, J. B., and ULANOV, B., eds. *Modern Culture and the Arts.* New York, 1967.
HARRIS, A. S., and NOCHLIN, L. *Women Artists: 1550–1950.* Los Angeles County Museum of Art, 1976. E.C.
HARTT, F. *Art: A History of Painting, Sculpture, Architecture.* 2d ed. New York, 1985.
HAUSER, A. *The Social History of Art.* 4 vols. New York, 1957.
HENDERSON, L. D. *The Fourth Dimension and Non-Euclidian Geometry in Modern Art.* Princeton, 1983.
HERBERT, E. W. *The Artist and Social Reform: France and Belgium, 1885–1898.* New Haven, Conn., 1961.
HERBERT, R. L., ed. *The Art Criticism of John Ruskin.* New York, 1964.
————, ed. *Modern Artists on Art.* Englewood Cliffs, N.J., 1964.
————. *The Société Anonyme and the Dreier Bequest at Yale University.* New Haven, 1984.
HILDEBRAND, A. VON. *The Problem of Form in Painting and Sculpture.* New York, 1907.
HOFMANN, W. *Turning Points in Twentieth-Century Art.* New York, 1969.
HOLT, E. G., ed. *A Documentary History of Art.* 2 vols. New York, 1957–58.
————, ed. *From the Classicists to the Impressionists: Art and Architecture in the Nineteenth Century,* vol. 3. New York, 1966.
HONOUR, H., and FLEMING, J. *The Visual Arts: A History.* Englewood Cliffs, N.J., 1982.
JANSON, H. W. *History of Art.* 3d ed. New York, 1986.
JOHNSON, E. E. *Modern Art and the Object.* New York, 1976.

KAPLAN, A. *The New World of Philosophy.* New York, 1961.
KEPES, G. *The New Landscape in Art and Science.* Chicago, 1956.
————. *Education of Vision.* New York, 1965.
————. *The Nature and Art of Motion.* New York, 1965.
————. *Structure in Art and in Science.* New York, 1965.
————. *The Man-Made Object.* New York, 1966.
————. *Module, Proportion, Symmetry, Rhythm.* New York, 1966.
————. *Sign, Image, Symbol.* New York, 1966.
KERN, S. *The Culture of Time and Space: 1880–1918.* Cambridge, Mass., 1980.
KOZLOFF, M. *Renderings: Critical Essays on a Century of Modern Art.* New York, 1968.
KRAMER, H. *The Age of the Avant-Garde.* New York, 1976.
KUH, K. *The Artist's Voice.* Interviews. New York, 1962.
KUSPIT, D. B. *The Critic as Artist: The Intentionality of Art.* Ann Arbor, 1984.
LANGER, S. *Philosophy in a New Key.* New York and Toronto, 1951.
————. *Feeling and Form.* New York, 1956.
————. *Reflections on Art.* New York, 1961.
LEMAITRE, G. *From Cubism to Surrealism in French Literature.* Cambridge, Mass., 1947.
LIBERMAN, A. *The Artist in His Studio.* New York, 1960.
MILLON, H., and NOCHLIN, L., eds. *Art and Architecture in the Service of Politics.* Cambridge, Mass., 1978.
MOTHERWELL, R., gen. ed. *The Documents of Twentieth-Century Art.* A series of 16 books, New York.
PALMER, R. R., and COLTON, J. *A History of the Modern World.* New York, 1965.
PEVSNER, N. *Academies of Art: Past and Present.* London, 1940.
PHILIPSON, M., ed. *Aesthetics Today.* Cleveland and New York, 1961.
PINGEOT, A., et al. *Sculpture: The Adventure of Modern Sculpture in the Nineteenth and Twentieth Centuries.* New York, 1986.
PODRO, M. *The Critical Historians of Art.* New Haven, 1982.
POGGIOLI, R. *The Theory of the Avant-Garde.* Cambridge, Mass., 1968. G. Fitzgerald, translator.
READ, H. *The Philosophy of Modern Art.* London, 1952.
————. *Art Now.* Rev. ed. New York, 1960.
RODMAN, S. *Conversations with Artists.* New York, 1957.
ROSENBERG, H. *The Tradition of the New.* New York, 1959.
ROSENBLUM, R. *Modern Painting & the Northern Romantic Tradition: Friedrich to Rothko.* New York, 1975.
RUBIN, W., ed. *"Primitivism" in 20th-Century Art: Affinity of the Tribal and the Modern.* 2 vols. New York, MOMA, 1984. E.C.
RUSSELL, B. *A History of Western Philosophy.* New York, 1945.
RUTTER, F. *Evolution in Modern Art.* London, 1926.
SCHUG, A. *Art of the Twentieth Century.* New York, 1969.
SHAPIRA, T. *Painters and Politics: The European Avant-Garde and Society: 1900–1925.* New York, 1976.
SYPHER, W. *Rococo to Cubism in Art and Literature.* New York, 1960.
VALÉRY, P. *Aesthetics.* Vol. 13 of *Collected Works.* New York, 1964.
————. *Selected Writings.* New York, 1964.
VENTURI, L. *History of Art Criticism.* New York, 1964.
VOGT, A. M. *Art of the Nineteenth Century.* New York, 1973.

WILLIAMS, N. *Chronology of the Modern World: 1763 to the Present Time.* New York, 1967.
WORRINGER, W. *Abstraction and Empathy.* Cleveland and New York, 1967.

II. DICTIONARIES AND ENCYCLOPEDIAS

BENEZIT, E. *Dictionnaire critique et documentaire des peintres, sculpteurs, dessinateurs et graveurs.* 10 vols. Paris, 1976.
The Britannica Encyclopedia of American Art. Chicago, 1973.
CUMMINGS, P. *Dictionary of Contemporary American Artists.* 3d ed. New York, 1976.
EDOUARD-JOSEPH, R. *Dictionnaire biographique des artistes contemporains, 1910–1930.* 3 vols. Paris, 1930–36 and suppl. 1936.
EMANUEL, E., et al., eds. *Contemporary Artists.* 2d ed. New York, 1983.
Encyclopedia of World Art. 15 vols. New York, 1959–68.
HATJE, G., ed. *Encyclopedia of Modern Architecture.* New York, 1964.
HUYGHE, R., ed. *Larousse Encyclopedia of Modern Art from 1800 to the Present Day.* London, 1965.
LAKE, C., and MAILLARD, R., eds. *Dictionary of Modern Painting.* 2d ed. New York, 1964.
LUCIE-SMITH, E. *Lives of the Great Twentieth-Century Artists.* New York, 1986.
MAILLARD, R., ed. *New Dictionary of Modern Sculpture.* New York, 1970.
OSBORNE, H. *The Oxford Companion to 20th-Century Art.* Oxford, 1981.
PEVSNER, N., FLEMING, L., and HONOUR, H. *A Dictionary of Architecture.* Rev. enl. ed. Woodstock, N.Y., 1976.
Phaidon Dictionary of Twentieth-Century Art. London and New York, 1973.
SEUPHOR, M. *Dictionary of Abstract Painting, Preceded by a History of Abstract Painting.* New York, 1958.
THIEME, U., and BECKER, F., eds. *Allgemeines Lexikon der bildenden Künstler.* 37 vols. Leipzig, 1907–50.
VOLLMER, H. *Allgemeines Lexikon der bildenden Künstler ders XX. Jahrhunderts.* 5 vols. and suppl. Leipzig, 1953–62.

III. ARCHITECTURE, ENGINEERING, AND DESIGN

A. FROM THE ORIGINS OF MODERNISM TO THE 1970s

ANDREWS, W. *Architecture, Ambition, and Americans.* New York, 1955.
ARNHEIM, R. *The Dynamics of Architectural Form.* Berkeley and Los Angeles, 1977.
BACON, E. N. *Guide to Modern Architecture.* Princeton, N.J., 1963.
————. *Design of Cities.* New York, 1967.
BANHAM, R. *Theory and Design in the First Machine Age.* 2d ed. Cambridge, Mass., 1980.
————. *The New Brutalism.* New York, 1966.
Baubausbücher. 14 vols. Munich, 1925–26.
BEHRENDT, W. C. *Modern Building.* New York, 1937.
BENEVELO, L. *History of Modern Architecture.* 2 vols. Cambridge, Mass., 1971. H. J. Landry, translator.
BERNIER, G. and R., eds. *The Best in 20th-Century Architecture.* New York, 1965.
BESSET, M. *New French Architecture.* New York, 1967.
BILL, M. *Form: A Balance Sheet of Mid-Twentieth Century Trends in Design.* Basel, 1952.
BLAKE, P. *The Master Builders.* New York, 1960.
BROOKS, H. A. *The Prairie School.* Toronto, 1972.
CANTACUZINO, S. *Great Modern Architecture.* New York, 1966.
CONDIT, C. *The Rise of the Skyscraper.* Chicago, 1952.
CONRADS, U., and SPERLICH, H. G. *The Architecture of Fantasy.* New York, 1962.
CURTIS, W. J. R. *Modern Architecture Since 1900.* Oxford, 1982.
DREXLER, A. *The Architecture of Japan.* New York, MOMA, 1955. E.C.
————. *Transformations in Modern Architecture.* New York, MOMA, 1979. E.C.

———— and DANIEL, G. *Introduction to Twentieth-Century Design.* New York, MOMA, 1959. E.C.
ELDREDGE, H. W., ed. *Taming Megalopolis.* 2 vols. New York, 1967.
FLETCHER, B. *A History of Architecture on the Comparative Method.* London, 1963.
FRAMPTON, K. *Modern Architecture: A Critical History.* New York, 1980.
———— and FUTAGAWA, Y. *Modern Architecture 1851–1945.* New York, 1983.
FRANCISCONO, M. *Walter Gropius and the Creation of the Bauhaus in Weimar.* Urbana, Ill., 1971.
GALARDI, A. *New Italian Architecture.* New York, 1967.
GIEDION, S. *Mechanization Takes Command.* New York, 1948.
————. *A Decade of Contemporary Architecture.* 2d ed. New York, 1954.
————. *Space, Time, and Architecture.* 4th ed. Cambridge, Mass., 1963.
HAMILTON, G. H. *The Art and Architecture of Russia.* Harmondsworth, 1954.
HAMLIN, T. F. *Forms and Functions of Twentieth Century Architecture.* 4 vols. New York, 1952.
HATJE, G., HOFFMANN, H., and KASPAR, K. *New German Architecture.* New York, 1956.
HEYER, P. *Architects on Architecture.* New York, 1966.
HILBERSEIMER, L. *The Nature of Cities.* Chicago, 1955.
HITCHCOCK, H.-R. *Latin American Architecture Since 1945.* New York, MOMA, 1955. E.C.
————. *Architecture: Nineteenth and Twentieth Centuries.* 4th ed. Baltimore, 1977.
———— and DREXLER, A. *Built in U.S.A.: Post-War Architecture.* New York, MOMA, 1952. E.C.
———— and JOHNSON, P. *The International Style.* 2d ed. New York, 1966.
HOFMANN, W., and KULTURMANN, U. *Modern Architecture in Color.* New York, 1971.
HULTEN, B. *Building Modern Sweden.* Harmondsworth, 1951.
JACOBUS, J. *Twentieth-Century Architecture: The Middle Years 1940–65.* New York, 1966.
JENCKS, C. *Modern Movements in Architecture.* New York, 1973.
JENSEN, R. *High Density Living.* New York, 1966.
JOEDICKE, J. *A History of Modern Architecture.* New York, 1959.
JORDY, W. H. *Progressive and Academic Ideals at the Turn of the Twentieth Century.* New York, 1972.
JURGEN, J. *Architecture Since 1945.* New York, 1969.
KASPAR, K. *New German Architecture.* New York, 1956.
KULTERMANN, U. *New Architecture in the World.* New York, 1965.
LAVEDAN, P. *Histoire de l'urbanisme.* Vol. 3. Paris, 1952.
LE CORBUSIER (CHARLES-ÉDOUARD JEANNERET). *Towards a New Architecture.* London, 1952. F. Etchells, translator.
LOYER, F. *Architecture of the Industrial Age.* New York, 1983.
MADSEN, S. T. *Sources of Art Nouveau.* New York, 1956.
MARSCHALL, W. *Contemporary Architecture in Germany.* New York, 1962.
MEEKS, C. L. V. *The Railroad Station.* New Haven, Conn., 1956.
MIGNOT, C. *Architecture of the Nineteenth Century in Europe.* New York, 1984.
MILLON, H. A., ed. *Key Monuments of the History of Architecture.* New York, 1965.
MOCK, E. B. *Built in U.S.A. 1932–1944.* New York, MOMA, 1944. E.C.
MUMFORD, L. *The Culture of Cities.* New York, 1938.
————. *Roots of Contemporary American Architecture.* New York, 1952.
————. *The Brown Decades.* Rev. ed. New York, 1955.
————. *Sticks and Stones.* Rev. ed. New York, 1955.
————. *Technics and Civilization.* New York, 1963.
PETER, J. *Masters of Modern Architecture.* New York, 1958.
PEVSNER, N. *Pioneers of Modern Design.* 3d ed. Baltimore, 1974.
POMMER, R., ed. "Revising Modernist History: The Architecture of the 1920s and 1930s." *Art Journal,* Summer 1983 (special issue).

READ, H. *Art and Industry.* Bloomington, Ind., 1961.
RICHARDS, J. M. *Modern Architecture.* Baltimore, 1963.
RUDOFSKY, B. *Architecture Without Architects.* New York, MOMA, 1964. E.C.
SCHUYLER, M. *American Architecture and Other Writings.* New York, 1964.
SCULLY, V. *The Architecture of the American Summer: The Flowering of the Shingle Style.* New York, 1987.
————. *Modern Architecture.* Rev. ed. New York, 1974.
SELZ, P., and CONSTANTINE, M., eds. *Art Nouveau.* Rev. ed. New York, 1974.
SHARP, D. *Modern Architecture and Expressionism.* New York, 1967.
————, ed. *A Visual History of Twentieth-Century Architecture.* Greenwich, Conn., 1972.
SIEGEL, A., ed. *Chicago's Famous Buildings.* Chicago, 1965.
SILVER, N. *Lost New York.* New York, 1967.
SMITH, G. E. K. *Sweden Builds.* London, 1950.
————. *Switzerland Builds.* London, 1950.
————. *Italy Builds.* New York, 1955.
————. *The New Architecture of Europe.* Cleveland and New York, 1961.
STERN, R. A. M., GILMARTIN, G. F., and MELLINS, T. *New York 1930.* New York, 1987.
TAFURI, M., and DAL CO, F. *Modern Architecture,* I and II. New York, 1986.
TRACHTENBERG, A., and HYMAN, I. *Architecture: From Prehistory to Post-Modernism.* New York, 1986.
TUNNARD, C. *City of Man.* New York, 1953.
————. *American Skyline.* Boston, 1955.
———— and PUSHKAREV, B. *Man-Made America: Chaos or Control?* New Haven, Conn., 1963.
WINGLER, H. M. *The Bauhaus: Weimar, Dessau, Berlin, Chicago.* Cambridge, Mass., 1969.
ZEVI, B. *Towards an Organic Architecture.* London, 1950.
————. *Storia dell'Architettura Moderna.* 3d ed. Turin, 1955.

B. POST-MODERNISM IN ARCHITECTURE

BROLIN, B. C. *The Failure of Modern Architecture.* New York, 1976.
DAVIS, D. *Architecture: Essays on the Postmodern.* New York, 1977.
DREXLER, A. *Transformations in Modern Architecture.* New York, MOMA, 1979. E.C.
FRAMPTON, K. *A New Wave of Japanese Architecture.* New York, 1978.
JENCKS, C. *The Language of Post-Modern Architecture.* 4th ed. New York, 1984.
————, ed. *Post-Modern Classicism.* London, 1980.
————, and CHAITKIN, W. *Architecture Today.* New York, 1982.
KRIER, R. *On Architecture.* New York, 1982.
POMMER, R. "Some Architectural Ideologies After the Fall." *Art Journal,* Fall–Winter, 1980, pp. 353–61.
PORPHYRIOS, D. *Sources of Modern Eclecticism.* New York, 1982.
PORTOGHESI, P., et al. *The Presence of the Past: First International Exhibition of Architecture—Venice Biennale 1980.* London, 1980.
RAY, K., ed. *Contextual Architecture: Responding to Existing Style.* New York, 1980.
ROSSI, A. *Architecture of the City.* Cambridge, Mass., 1982.
RYKWERT, J. *The Necessity of Artifice.* New York, 1982.
SMITH, C. R. *Supermannerism: New Attitudes in Post-Modern Architecture.* New York, 1977.
TIGERMAN, S. *Versus: An American Architect's Alternatives.* New York, 1982.
VENTURI, R. *Complexity and Contradiction in Architecture.* New York, 1966.
————, SCOTT BROWN, D., and IZENOUR, S. *Learning from Las Vegas.* Rev. ed. Cambridge, Mass., 1977.

IV. PHOTOGRAPHY

ADAMS, R. *Beauty in Photography: Essays in Defense of Traditional Values.* Millerton, N.Y., 1981.
ADES, D. *Photomontage.* New York, 1976.

BARTHES, R. *Camera Lucida, Reflections on Photography.* New York, 1981.

BENJAMIN, W. "The Work of Art in the Age of Mechanical Reproduction," in W. Benjamin, *Illuminations.* Edited by H. Arendt. New York, 1969.

BRAIVE, M. F. *The Photograph: A Social History.* New York, 1966.

BRETELL, R., et al. *Paper and Light: The Calotype in Great Britain and France, 1839–1870.* Boston, 1984.

BUCKLAND, G. *Reality Recorded: Early Documentary Photography.* Greenwich, Conn., 1974.

BUERGER, J. E. *The Era of the French Calotype.* Rochester, International Museum of Photography at George Eastman House, 1982. E.C.

BUNNELL, P., ed. *A Photographic Vision: Pictorial Photography, 1889–1923.* Salt Lake City, 1980.

CAFFIN, CH. H. *Photography as a Fine Art.* Hastings-on-Hudson, N.Y., 1971 (facsimile ed.).

Camera Work: A Photographic Quarterly. Edited and published by A. Stieglitz, 1903–17. Reprint. New York, 1969.

COE, B. *Colour Photography: The First Hundred Years, 1840–1940.* London, 1978.

———, and GATES, P. *The Snapshot Photograph.* London, 1977.

COKE, V. D., ed. *One Hundred Years of Photographic History: Essays in Honor of Beaumont Newhall.* Albuquerque, 1975.

———. *The Painter and the Photographer: From Delacroix to Warhol.* Rev. ed. Albuquerque, 1972.

DAVAL, J.-L. *Photography: History of an Art.* New York, 1982.

EMERSON, P. H. *Naturalistic Photography for Students of the Art.* 1889, 3d ed. 1899. Reprint. New York, 1973.

FABIAN, R., and ADAM, H.-C. *Masters of Early Travel Photography.* New York, 1983.

FREUND, G. *Photography and Society.* Boston, 1980.

FRIEDMAN, J. S. *The History of Colour Photography.* London and New York, 1968.

GALASSI, P. *Before Photography: Painting and the Invention of Photography.* New York, MOMA, 1981. E.C.

GERNSHEIM, H. and A. *The History of Photography: From the Camera Obscura to the Beginning of the Modern Era.* New York, 1969.

GIDAL, T. N. *Modern Photojournalism: Origin and Evolution: 1910–1933.* New York, 1972.

GOLDBERG, V. *Photography in Print: Writings from 1916 to the Present.* New York, 1981.

GREEN, J., ed. *Camera Work: A Critical Anthology.* Millerton, N.Y., 1973.

———, ed. *The Snapshot.* Millerton, N.Y., 1974.

HALL-DUNCAN, N. *The History of Fashion Photography.* New York, 1977.

HARKER, M. *The Linked Ring: The Secession Movement in Photography in Britain, 1892–1910.* London, 1979.

HARTMANN, S. *The Valiant Knights of Daguerre: Selected Critical Essays on Photography and Profiles of Photographic Pioneers.* Edited by H. W. Lawton and G. Knox. Berkeley, 1978.

HOMER, W. I. *Alfred Stieglitz and the American Avant-Garde.* Boston, 1977.

———. *Alfred Stieglitz and the Photo-Secession.* Boston, 1983.

JAMMES, A., and JANIS, E. P. *The Art of French Calotype.* Princeton, 1983.

KOZLOFF, M. *Photography & Fascination.* Danbury, N.H., 1979.

LEWINSKI, J. *The Camera at War.* New York, 1978.

LYONS, N., ed. *Photographers on Photography: A Critical Anthology.* Englewood Cliffs, N.J., 1956.

MADDOW, B. *Faces: A Narrative History of the Portrait in Photography.* Boston, 1977.

MELLOR, D., ed. *Germany: The New Photography, 1927–33.* London, Arts Council of Great Britain, 1978. E.C.

NAEF, W. *Fifty Pioneers of Modern Photography: The Collection of Alfred Stieglitz.* New York, MMA, 1978. E.C.

——— and WOOD, J. N. *Era of Exploration: The Rise of Landscape Photography in the American West: 1860–1885.* Buffalo, Albright-Knox Gallery of Art, 1975. E.C.

NEWHALL, B. *The History of Photography: From 1839 to the Present.* 5th ed. New York, 1982.

———, ed. *Photography: Essays & Images.* New York, 1980.

PINNEY, R. *Advertising Photography.* New York, 1962.

ROSENBLUM, N. *A World History of Photography.* New York, 1984.

ROTZLER, W. *Photography as Artistic Experiment: From Fox Talbot to Moholy-Nagy.* Garden City, N.J., 1976.

SCHARF, A. *Art and Photography.* London and Baltimore, 1968, 1969.

———. *Pioneers of Photography.* New York, 1975.

SONTAG, S. *On Photography.* New York, 1973.

STOTT, W. *Documentary Expression and Thirties America.* New York, 1973.

STRYKER, R., and WOOD, N. *In This Proud Land: America 1935–1943 as Seen in FSA Photographs.* Greenwich, Conn., 1975.

SZARKOWSKI, J. *Looking at Photographs.* Boston and New York, 1973.

———. *The Photographer's Eye.* New York, 1977.

TRACHTENBERG, A., ed. *Classic Essays on Photography.* New Haven, 1980.

UPTON, B. and J. *Photography: Adapted from the Life Library of Photography.* 2d ed. Boston, 1980.

VAIZEY, M. *The Artist as Photographer.* New York, 1982.

WELLING, W. *Photography in America: The Formative Years, 1839–1900.* New York, 1978.

WITKIN, L. D., and LONDON, B. *The Photograph Collector's Guide.* Boston, 1979.

V. PAINTING AND SCULPTURE

A. MOVEMENTS

1. Nineteenth- and Twentieth-Century Painting and Sculpture

ARNASON, H. H. *Modern Sculpture from the Joseph H. Hirshhorn Collection.* New York, SRGM, 1962. E.C.

BARR, JR., A. H., ed. *Painting and Sculpture in the Museum of Modern Art: 1929–1967.* New York, MOMA, 1977.

BELL, C. *Since Cézanne.* New York, 1922.

CANADAY, J. *Mainstreams of Modern Art.* 2d ed. New York, 1981.

DENIS, M. *Théories, 1890–1910.* 4th ed. Paris, 1920.

DORIVAL, B. *Twentieth Century Painters.* 2 vols. New York, 1958.

DREIER, K., et al. *Collection of the Société Anonyme.* Yale University Art Gallery, New Haven, Conn., 1950.

ELSEN, A. E. *Modern European Sculpture, 1918–1945: Unknown Beings and Other Realities.* New York, 1979.

———. *Origins of Modern Sculpture: Pioneers and Premises.* New York, 1974.

GIEDION-WELCKER, C. *Contemporary Sculpture: An Evolution in Volume and Space.* Rev. ed. New York, 1961.

HAFTMANN, W. *Painting in the Twentieth Century.* Rev. ed. New York, 1979.

HAMILTON, G. H. *19th and 20th Century Art.* New York and Englewood Cliffs, N.J., 1970.

———. *Painting and Sculpture in Europe: 1880 to 1940.* Baltimore, 1967.

HOFMANN, W. *Die Plastik des 20. Jahrhunderts.* Frankfurt-am-Main, 1958.

———. *The Earthly Paradise: Art in the Nineteenth Century.* New York, 1961.

HUGHES, R. *Shock of the New.* New York, 1981.

HUNTER, S., and JACOBUS, J. *Modern Art: Painting, Sculpture, Architecture.* 2d ed. Englewood Cliffs, N.J., 1985.

JANSON, H. W. *Nineteenth-Century Sculpture.* New York, 1985.

LIEBERMAN, W. S., ed. *Modern Masters: Manet to Matisse.* New York, MOMA, 1975. E.C.

LYNTON, N. *The Story of Modern Art.* Ithaca, N.Y., 1980.

McCURDY, C. *Modern Art, a Pictorial Anthology.* New York, 1958.

NOVOTNY, F. *Painting and Sculpture in Europe: 1780–1880.* Baltimore, 1960.

OZENFANT, A. *Foundations of Modern Art.* 2d ed. New York, 1952.

POHRIBNY, A. *Abstract Painting.* Oxford, 1979.

RAYNAL, M., et al. *History of Modern Painting.* 3 vols. Geneva, 1949–50.

———. *Modern Painting.* Rev. ed. New York, 1960.

READ, H. *The Art of Sculpture.* New York and London, 1956.

———. *A Concise History of Modern Painting.* 3d ed. New York, 1975.

———. *A Concise History of Modern Sculpture.* New York and Washington, D.C., 1964.

RITCHIE, A. C. *Sculpture of the Twentieth Century.* New York, MOMA, 1952. E.C.

ROSENBLUM, R., and JANSON, H. W. *Nineteenth-Century Art.* Englewood Cliffs, N.J., 1984.

RUBIN, W., ed. *"Primitivism" in 20th-Century Art: Affinity of the Tribal and the Modern.* 2 vols. New York, MOMA, 1984. E.C.

RUSSELL, J. *The Meanings of Modern Art.* New York, MOMA, 1981.

SCHAPIRO, M. *Modern Art: 19th and 20th Centuries.* New York, 1978.

SELZ, J. *Modern Sculpture: Origins and Evolution.* New York, 1963.

SELZ, P. *Art in Our Times: A Pictorial History, 1890–1980.* New York, 1981.

SEUPHOR, M. *The Sculpture of This Century.* New York, 1960.

STANGOS, N., ed. *Concepts of Modern Art.* 2d ed. New York, 1981.

STEINBERG, L. *Other Criteria: Confrontations with Twentieth-Century Art.* New York, 1972.

TOMKINS, C. *The Bride and the Bachelors: The Heretical Courtship in Modern Art.* New York, 1965.

TRIER, E. *Form and Space (Sculpture of the Twentieth Century).* Rev. ed. New York, 1968.

TUCKER, W. *Early Modern Sculpture.* New York, 1974.

VALÉRY, P. *Degas, Manet, Morisot.* Vol. 12 of *Collected Works.* New York, 1964.

VENTURI, L. *Modern Painters.* 2 vols. New York, 1947–50.

———. *Four Steps Toward Modern Art.* New York, 1956.

WRIGHT, W. H. *Modern Painting: Its Tendency and Meaning.* New York and London, 1915.

2. Impressionism, Post-Impressionism, and Neo-Impressionism

BRETELL, R., and SCHAEFER, S. *A Day in the Country: Impressionism and the French Landscape.* Los Angeles County Museum of Art, 1985. E.C.

CLARK, T. J. *The Painting of Modern Life: Paris in the Art of Manet and His Followers.* New York, 1985.

DABROWSKI, M. *The Symbolist Aesthetic.* New York, MOMA, 1980. E.C.

DELEVOY, R. *Symbolists and Symbolism.* New York, 1978.

DURET, T. *Histoire des peintres impressionnistes.* Paris, 1906.

GERHARDUS, M. and D. *Symbolism and Art Nouveau.* Oxford, 1979.

GOLDWATER, R. *Symbolism.* New York, 1979.

HERBERT, R. L. *Neo-Impressionism.* New York, SRGM, 1968. E.C.

HIRSH, S., ed. "Symbolist Art and Literature." *Art Journal,* Summer 1985 (special issue).

JULLIAN, P. *Dreamers of Decadence: Symbolist Painters of the 1890s.* 2d ed. New York, 1977.

MOFFETT, C. S. *The New Painting: Impressionism, 1874–1886.* Fine Arts Museums of San Francisco, 1986. E.C.

REWALD, J. *The History of Impressionism.* 4th ed., rev. New York, 1980.

———. *Post-Impressionism from Van Gogh to Gauguin.* New York, 1979.

SHONE, R. *The Post-Impressionists.* London, 1980.

SIGNAC, P. *D'Eugène Delacroix au néo-impressionnisme.* Paris, 1899.

VENTURI, L. *Les Archives de l'impressionnisme (Lettres de Renoir, Monet, Pissarro, Sisley et autres. Memoires de Paul Durand-Ruel. Documents).* 2 vols. Paris and New York, 1939.

———. *Impressionists and Symbolists.* New York, 1950.

3. Art Nouveau and The Nabis

AMAYA, M. *Art Nouveau.* London, 1966.

CASSOU, J., LANGUI, E., and PEVSNER, N. *Gateway to the Twentieth Century*. New York, 1962.

CHASSE, C. *Les Nabis et leurs temps*. Lausanne and Paris, 1960.

HUMBERT, A. *Les Nabis et leur époque, 1888–1900*. Geneva, 1954.

KEMPTON, R. *Art Nouveau: An Annotated Bibliography*. Los Angeles, 1977.

MADSEN, S. T. *Sources of Art Nouveau*. New York, 1956.

The Nabis and Their Circle. Minneapolis Institute of Arts, 1962. E.C.

PEVSNER, N. *Art Nouveau in Britain*. London, The Arts Council, 1965. E.C.

RHEIMS, M. *L'Objet 1900*. Paris, 1964.

———. *The Flowering of Art Nouveau*. New York, 1966.

SCHMUTZLER, R. *Art Nouveau*. New York, 1964.

SELZ, P., and CONSTANTINE, M., eds. *Art Nouveau: Art and Design at the Turn of the Century*. New York, MOMA, 1959. E.C.

4. Fauvism

APOLLONIO, U. *Fauves and Cubists*. New York, 1959.

CRESPELLE, J. P. *The Fauves*. Greenwich, Conn., 1962.

DUTHUIT, G. *The Fauvist Painters*. New York, 1950.

ELDERFIELD, J. *The "Wild Beasts": Fauvism and Its Affinities*. New York, MOMA, 1976. E.C.

Le Fauvisme français et les débuts de l'expressionnisme allemand. Paris, Musée National d'Art Moderne, 1966. E.C.

LEYMARIE, J. *Fauvism, Biographical and Critical Study*. Paris, 1959.

REWALD, J. *Les Fauves*. New York, MOMA, 1952. E.C.

5. Cubism

APOLLINAIRE, G. *Les Peintres cubistes; méditations esthétiques*. Paris, 1913.

———. *The Cubist Painters*. New York, 1949.

ARNASON, H. H. *The Classic Tradition in Contemporary Art*. Minneapolis, Walker Art Center, 1953.

BARR, JR., A. H. *Cubism and Abstract Art*. New York, MOMA, 1936. E.C.

COOPER, D. *The Cubist Epoch*. London, Los Angeles County Museum of Art and MMA, 1970. E.C.

EDDY, A. J. *Cubists and Post-Impressionists*. Chicago, 1919.

Essential Cubism: 1907–1920. London, Tate Gallery, 1983. E.C.

FRY, E. *Cubism*. New York, 1966.

GLEIZES, A., and METZINGER, J. *Du Cubisme*. Paris, 1912.

———. *Cubism*. London, 1913.

GOLDING, J. *Cubism: A History and an Analysis, 1907–1914*. 2d ed. London, 1968.

GRAY, C. *Cubist Aesthetic Theories*. Baltimore, 1953.

HABASQUE, G. *Cubism: Biographical and Critical Study*. Paris and New York, 1959.

JANIS, H., and BLESH, R. *Collage*. Philadelphia and New York, 1962.

KAHNWEILER, D.-H. *The Rise of Cubism*. New York, 1949.

KOZLOFF, M. *Cubism/Futurism*. New York, 1973.

ROSENBLUM, R. *Cubism and Twentieth-Century Art*. Rev. ed. New York, 1976.

ROWELL, M., and ROBBINS, D. *Cubist Drawings: 1907–1929*. Houston, Janie C. Lee Gallery, 1982. E.C.

RUBIN, W. "Cézannism and the Beginning of Cubism," in W. Rubin, ed., *Cézanne: The Late Work*, pp. 151–202. New York, MOMA, 1977. E.C.

———. "From Narrative to 'Iconic' in Picasso: The Buried Allegory in *Bread and Fruitdish on a Table* and the Role of *Les Demoiselles d'Avignon*." *Art Bulletin*, Dec. 1983, pp. 615–49.

———. "Picasso," in W. Rubin, ed., *"Primitivism" in 20th-Century Art*, vol. I, pp. 241–343. New York, MOMA, 1984. E.C.

SPATE, V. *Orphism: The Evolution of Non-Figurative Painting in Paris: 1910–1914*. Oxford, 1979. E.C.

STEINBERG, L. "The Polemical Part." *Art in America*, March–April 1979, pp. 114–27.

———. "Resisting Cézanne: Picasso's *Three Women*." *Art in America*, Nov.–Dec. 1978, pp. 114–33.

WALLEN, B., and STEIN, D. *The Cubist Print*. Santa Barbara, University of California Art Museum, 1981. E.C.

6. German Expressionism

BARRON, S. *German Expressionist Sculpture*. Los Angeles County Museum of Art, 1980. E.C.

Expressionism: A German Intuition. New York, SRGM, 1980. E.C.

Le Fauvisme français et les débuts de l'expressionnisme allemand. Paris, Musée National d'Art Moderne, 1966. E.C.

KUHN, C. L. *German Expressionism and Abstract Art: The Harvard Collections*. Cambridge, Mass., 1957.

MYERS, B. S. *The German Expressionists: A Generation in Revolt*. New York, 1957.

Painters of the Brücke. London, The Tate Gallery, 1964. E.C.

PFISTER, O. *Expressionism in Art: Its Psychological and Biological Basis*. London, 1922.

REED, JR., O. P. *German Expressionist Art: The Robert Gore Rifkind Collection*. Los Angeles, Wight Art Gallery, Univ. of California, 1977. E.C.

RICHARD, L. *Phaidon Encyclopedia of Expressionism*. New York, 1978.

ROETHEL, H. K. *The Blue Rider*. New York, 1971.

SAMUEL, R., and THOMAS, R. H. *Expressionism in German Life, Literature, and the Theatre (1910–1924)*. Cambridge, 1939.

SELZ, P. *German Expressionist Painting*. Berkeley, Cal., 1957.

VOGT, P. *Expressionism: German Painting, 1905–1920*. New York, 1980.

ZIGROSSER, C. *The Expressionists: A Survey of Their Graphic Art*. New York, 1957.

7. Futurism

BRUNI, C., and DRUDI GAMBILLO, M., eds. *After Boccioni, Futurist Paintings and Documents from 1915 to 1919*. Rome, 1961.

CARRIERI, R. *Futurism*. Milan, 1963.

DRUDI GAMBILLO, M., and FIORI, T., eds. *Archivi del Futurismo*. 2 vols. Rome, 1958–62.

HANSON, A. C., ed. *The Futurist Imagination: Word + Image*. New Haven, 1983.

D'HARNONCOURT, A. *Futurism and the International Avant-Garde*. Philadelphia Museum of Art, 1980. E.C.

MARINETTI, F. T. *Das Manifest des Futurismus*. 2d ed., Herwarth Walden, ed. Berlin, 1912. E.C.

MARTIN, M. W., and HANSON, A. C., eds. "Futurism." *Art Journal*, Winter 1981 (special issue).

SANT'ELIA, A. "Manifesto of Futurist Architecture." *Architectural Review*, vol. 126, 1959.

TAYLOR, C. J. *Futurism: Politics, Painting, and Performance*. Ann Arbor, 1979.

8. Synchronism

LEVIN, G. *Synchronism and American Color Abstraction: 1910–1925*. New York, WMAA, 1978. E.C.

9. Abstraction-Constructivism

BARR, JR., A. H. *Cubism and Abstract Art*. New York, MOMA, 1936. E.C.

BARRON, S., and TUCHMAN, M. *The Avant-Garde in Russia, 1910–1930: New Perspectives*. Los Angeles County Museum of Art, 1980. E.C.

BIEDERMAN, C. *Art as the Evolution of Visual Knowledge*. Red Wing, Minn., 1948.

BOWLT, J., ed. and translator. *Russian Art of the Avant-Garde: Theory and Criticism, 1902–1934*. New York, 1976.

DABROWSKI, M. *Contrasts of Form: Geometric Abstract Art 1910–1980*. New York, MOMA, 1985. E.C. Introduction J. Elderfield.

ELLIOT, D. *Rodchenko and the Arts of Revolutionary Russia*. New York, 1979.

GUERMAN, M. *Art of the October Revolution*. New York, 1979.

LODDER, C. *Russian Constructivism*. New Haven, 1983.

MARTER, J. *Beyond the Plane: American Constructions 1930–1965*. Trenton, New Jersey State Museum, 1983. E.C.

MILNER, J. *Vladimir Tatlin and the Russian Avant-Garde*. New Haven, 1983.

RICKEY, G. *Constructivism: Origins and Evolution*. New York, 1967.

ROMAN, G. H., ed. "The Russian Avant-Garde." *Art Journal*, Fall 1981 (special issue).

ROWELL, M. *The Planar Dimension: Europe 1912–1932*. New York, SRGM, 1979.

——— and RUDENSTINE, A. *Art of the Avant-Garde in Russia: Selections from the George Costakis Collection*. New York, SRGM, 1981. E.C.

RUDENSTINE, A. Z., gen. ed. *Russian Avant-Garde Art: The George Costakis Collection*. New York, 1981.

10. De Stijl

BULHOF, F., ed. *Nijhoff, Van Ostaijen, "De Stijl": Modernism in the Netherlands and Belgium in the First Quarter of the Twentieth Century*. The Hague, 1976.

HAMMACHER, A. M. *Mondrian, De Stijl, and Their Impact*. New York, Marlborough-Gerson Gallery, Inc., 1964. E.C.

JAFFE, H. L. C. *De Stijl, 1917–1931: The Dutch Contribution to Modern Art*. Amsterdam, 1956.

——— et al. *De Stijl, 1917–1931: Visions of Utopia*. Minneapolis, Walker Art Center, 1982. E.C.

De Stijl. New York, MOMA, 1961. E.C.

TROY, N. J. *The "De Stijl" Environment*. Cambridge, Mass., 1983.

11. Bauhaus

BAYER, H., GROPIUS, W., and GROPIUS, I. *Bauhaus, 1919–1928*. 3d ed. Boston, 1959. New York, MOMA, 1938.

GROHMANN, W. *Painters of the Bauhaus*. London, Marlborough Fine Art Ltd., 1962. E.C.

ITTEN, J. *Design and Form: The Basic Course at the Bauhaus*. Rev. ed. New York, 1975.

PORTNER, P. *Experiment-Theater: Chronik und Dokumente*. Zurich, 1960.

Bauhausbücher. 14 vols. Munich, 1925–26.

WHITFORD, F. *Bauhaus*. London, 1984.

12. Dada and Surrealism

ADES, D. *Dada and Surrealism Reviewed*. London, Arts Council of Great Britain, 1978. E.C.

ARNASON, H. H. *Reality and Fantasy 1900–1954*. Minneapolis, Walker Art Center, 1954.

BARR, JR., A. H., ed. *Fantastic Art, Dada, Surrealism*. 2d ed., rev. New York, MOMA, 1937. E.C. With essays by G. Hugnet.

BRETON, A. *Le Surréalisme et la peinture*. New York, 1945. Updated by his *Le Surréalisme en 1947*. Paris, Galerie Maeght, 1947. E.C.

———. *Les Manifestes du surréalisme*. Rev. ed. Paris, 1955.

———. *What Is Surrealism? Selected Writings*. Edited by F. Rosemont. New York, 1978.

Dada 1966–67. Zürich, Kunsthaus, and Paris, Musée National d'Art Moderne, 1966–67. E.C.

FOSTER, S., and KUENZI, R. *Dada Spectrum: The Dialectics of Revolt*. Madison, Wis., 1979.

FOWLIE, W. *Age of Surrealism*. Bloomington, Ind., 1960.

GASCOYNE, D. *A Short History of Surrealism*. London, 1935.

HALSAM, M. *The Real World of the Surrealists*. New York, 1978. Introduction B. Rose.

HENNING, E. B. *The Spirit of Surrealism: 1919–1939*. Cleveland Museum of Art, 1979. E.C.

HERBERT, R. *The Société Anonyme and the Dreier Bequest at Yale University*. New Haven, 1984.

JEAN, M. *The History of Surrealist Painting*. New York, 1960.

LEVY, J. *Surrealism*. New York, 1936.

LIPPARD, L. R., ed. *Surrealists on Art*. Englewood Cliffs, N.J., 1970.

MOTHERWELL, R., gen. ed. *The Dada Painters and Poets: An Anthology*. New York, 1951.

NADEAU, M. *The History of Surrealism*. New York, 1965.

OESTERREICHER-MOLLOW, M. *Surrealism and Dadaism*. Oxford, 1979.

PICON, G. *Surrealists and Surrealism: 1919–1939*. New York, 1978.

RAYMOND, M. *From Baudelaire to Surrealism*. New York, 1950.

READ, H. *Surrealism*. London, 1936.

RICHTER, H. *Dada, Art, and Anti-Art.* New York, 1965.

RUBIN, W. S. *Dada, Surrealism, and Their Heritage.* New York, MOMA, 1968. E.C.

WALDBERG, P. *Surrealism.* New York, 1965.

13. Abstract Expressionism

ARNASON, H. H. *Abstract Expressionists and Imagists.* New York, SRGM, 1961. E.C.

ASHTON, D. *The New York School: A Cultural Reckoning.* New York, 1973.

BAUR, J. I. H. *The New Decade: 35 American Painters and Sculptors.* New York, WMAA, 1955. E.C.

GELDZAHLER, H. *New York Painting and Sculpture: 1940–1970.* New York, MMA, 1969. E.C.

GREENBERG, C. *Art and Culture: Critical Essays.* Boston, 1961.

GUILBAUT, S. *How New York Stole the Idea of Modern Art.* Chicago, 1983.

HESS, T. *Abstract Painting, Background and American Phase.* New York, 1951.

HOBBS, R. C., and LEVIN, G. *Abstract Expressionism: The Formative Years.* New York, WMAA, 1981. E.C.

LUCIE-SMITH, E. *Art Now: From Abstract Expressionism to Photorealism.* New York, 1977.

———. *Movements in Art Since 1945.* Rev. ed. London, 1975.

PONENTE, N. *Modern Painting: Contemporary Trends.* New York and Lausanne, 1960.

ROSENBERG, H. *The Tradition of the New.* New York, 1959.

SANDLER, I. *The New York School: The Painters and Sculptors of the Fifties.* New York, 1978.

———. *The Triumph of American Painting: A History of Abstract Expressionism.* New York, 1970.

SCHWARTZ, C. *The Abstract Expressionists and Their Precursors.* Nassau County Museum of Fine Art, 1981.

SEITZ, W. C. *Abstract Expressionist Painting in America.* Washington, D.C., National Gallery of Art, 1983. E.C.

SWEENEY, J. J. *Younger American Painters: A Selection.* New York, SRGM, 1954. E.C.

TUCHMAN, M., ed. *New York School, The First Generation: Paintings of the 1940s and 1950s.* Los Angeles County Museum of Art, 1965. E.C. With statements by artists and critics.

14. Postwar European Painting and Sculpture: The Forties and Fifties

ALVARD, J., and GINDERTAEL, R. V., eds. *Témoignages pour l'art abstrait.* Paris, 1952. Supplemented by *Témoignages pour la sculpture abstraite.* Paris, 1956. Foreword P. Guéguen.

BRION, M., et al. *Art Since 1945.* New York, 1958.

LEYMARIE, J. *Art Since Mid-Century: The New Internationalism.* 2 vols. Greenwich, Conn., 1971.

LUCIE-SMITH, E. *Art Now: From Abstract Expressionism to Photorealism.* New York, 1977.

———. *Movements in Art Since 1945.* Rev. ed. London, 1975.

PONENTE, N. *Modern Painting: Contemporary Trends.* New York and Lausanne, 1960.

RITCHIE, A. C. *The New Decade: Twenty-two European Painters and Sculptors.* New York, MOMA, 1955. E.C.

SWEENEY, J. J. *Younger European Painters: A Selection.* New York, SRGM, 1954. E.C.

15. Pop Art

AMAYA, M. *Pop Art . . . and After.* New York, 1965.

CALAS, N. and A. *Icons and Images of the Sixties.* New York, 1971.

GELDZAHLER, H. *New York Painting and Sculpture: 1940–1970.* New York, MMA, 1969. E.C.

HASKELL, B. *Blam! The Explosion of Pop, Minimalism, and Performance: 1958–1964.* New York, WMAA, 1984. E. C.

HENRI, A. *Total Art: Environments, Happenings, and Performance.* New York, 1979.

HULTEN, K. G. P. *The Machine: As Seen at the End of the Mechanical Age.* New York, MOMA, 1968. E.C.

HUNTER, S., et al. *New Art Around the World (Painting and Sculpture).* New York, 1966.

KAPROW, A. *Assemblage, Environments, and Happenings.* New York, 1966.

LEYMARIE, J. *Art Since Mid-Century: The New Internationalism.* 2 vols. Greenwich, Conn., 1971.

LIPPARD, L. R. *Pop Art.* New York, 1966.

LUCIE-SMITH, E. *Movements in Art Since 1945.* Rev. ed. London, 1975.

———. *Art Now: From Abstract Expressionism to Photorealism.* New York, 1977.

McCONNEL, G. *Assemblage: Three-Dimensional Picture Making.* New York, 1976.

MELLOW, J. R., ed. *The Art World.* New York, 1964 (*Arts Yearbook* 7).

MULAS, U., and SOLOMON, A. R. *New York: The New Art Scene.* New York, 1967.

Painting and Sculpture of a Decade (1954–64). London, Tate Gallery, 1964. E.C.

PELLEGRINI, A. *New Tendencies in Art.* New York, 1966.

PONENTE, N. *Modern Painting: Contemporary Trends.* New York and Lausanne, 1960.

POPPER, F. *Origins and Development of Kinetic Art.* Greenwich, Conn., 1968. S. Bann, translator.

RUSSELL, J., and GABLIK, S. *Pop Art Redefined.* New York, 1969.

SANDLER, I. *The New York School: The Painting and Sculpture of the Fifties.* New York, 1978.

Sculpture: A Generation of Innovation. Art Institute of Chicago, 1967. E.C.

SEITZ, W. C. *The Art of Assemblage.* New York, MOMA, 1961. E.C.

———, ed. *Contemporary Sculpture.* New York, 1965 (*Arts Yearbook* 8).

TUCHMAN, M., ed. *American Sculpture of the Sixties.* Los Angeles County Museum of Art, 1967. E.C.

16. Sixties Abstraction: Minimalism

ALLOWAY, L. *Systemic Painting.* New York, SRGM, 1966. E.C.

BARRETT, C. *Op Art.* New York, 1970.

GABLIK, S. "Minimalism," in N. Stangos, ed., *Concepts of Modern Art.* 2d ed., pp. 244–55.

GELDZAHLER, H. *New York Painting and Sculpture: 1940–1970.* New York, MMA, 1969. E.C.

GREENBERG, C. *Post-Painterly Abstraction.* Los Angeles County Museum of Art, 1964. E.C.

Hard-Edge. Paris, Galerie Denise René, 1964. E.C.

HUNTER, S., et al. *New Art Around the World: Painting and Sculpture.* New York, 1966.

LEYMARIE, J. *Art Since Mid-Century: The New Internationalism.* 2 vols. Greenwich, Conn., 1971.

LUCIE-SMITH, E. *Movements in Art Since 1945.* Rev. ed. London, 1975.

———. *Art Now: From Abstract Expressionism to Photorealism.* New York, 1977.

MELLOW, J. R., ed. *New York: The Art World.* New York, 1964 (*Arts Yearbook* 7).

MULAS, U., and SOLOMON, A. R. *New York: The New Art Scene.* New York, 1967.

NECOL, J., and DROLL, D. *Abstract Painting: 1960–1969.* New York, P.S.1, 1983. E.C.

NORDLAND, G. *Fourteen Abstract Painters.* Los Angeles, Frederick S. Wight Gallery, University of California, 1975. E.C.

Painting and Sculpture of a Decade (1954–64). London, Tate Gallery, 1964. E.C.

PELLEGRINI, A. *New Tendencies in Art.* New York, 1966.

POPPER, F. *Origins and Development of Kinetic Art.* Greenwich, Conn., 1968.

SANDLER, I. *The New York School: The Painters and the Sculptors of the Fifties.* New York, 1978.

SCHJELDAHL, P. "Minimalism," in *Art of Our Time: The Saatchi Collection,* vol. 1, pp. 11–17. London and New York, 1984.

SEITZ, W. C. *The Responsive Eye.* New York, MOMA, 1959. E.C.

———, ed. *Contemporary Sculpture.* 1965. New York, 1965 (*Arts Yearbook* 8).

"The Sixties in Abstract Painting: 13 Statements." *Art in America* Oct. 1983 (special issue).

TUCHMAN, M. *American Sculpture of the Sixties.* Los Angeles County Museum of Art, 1965. E.C.

17. The Post-Minimal Seventies: Conceptual Art, Performance, Earth and Site Works, Public Monuments

Art of Our Time: The Saatchi Collection. London and New York, 1984. Vol. 2: Essays by J.-C. Ammann, M. Auping, R. Rosenblum, P. Schjeldahl.

BATTCOCK, G., ed. *Idea Art: A Critical Anthology.* New York, 1973.

———, ed. *Art Since Pop: A Critical Anthology.* Woodbury, N.Y., 1978.

———, ed. *New Artists Video: A Critical Anthology.* New York, 1980.

BEARDSLEY, J. *Earthworks and Beyond: Contemporary Art in the Landscape.* New York, 1984.

BOCHNER, M. "Primary Structures." *Arts Magazine,* June 1966, pp. 32–35.

BURNHAM, J. *Beyond Modern Sculpture: The Effects of Science and Technology on the Sculpture of This Century.* New York, n.d.

———. *Great Western Salt Works.* New York, 1974.

CELANT, G. *Arte Povera.* New York, 1969.

———. *The Knot: Arte Povera at P.S. 1.* New York, P.S. 1, 1985. E.C.

DELAHOYD, M. *A New Beginning: 1968–1978.* Yonkers, N.Y., Hudson River Museum, 1985. E.C.

DOEZEMAN, M., and HARGROVE, J. *The Public Monument and Its Audience.* Cleveland Museum of Art, 1977. E.C.

FOOTE, N. "Situation Esthetics: Impermanent Art and the Seventies Audience." *Artforum,* Jan. 1980, pp. 22–29.

FRIEDMAN, M. *Works for New Spaces.* Minneapolis, Walker Art Center, 1971. E.C.

GLUECK, G. "Conceptual Art, Italian Style, Makes a Statement at P.S. 1." *New York Times,* Oct. 13, 1985, p. 29.

GOLDBERG, R. *Performance: Live Art 1909 to the Present.* New York, 1979.

GOTTLIEB, C. *Beyond Modern Art.* New York, 1976.

HENRI, A. *Total Art: Environments, Happenings, and Performance.* London, 1974.

HOBBS, R., ed. "Earthworks: Past and Present." *Art Journal,* Fall 1982 (special issue).

KOZLOFF, M. "9 in a Warehouse." *Artforum,* Feb. 1969, pp. 38–42.

KRAMER, H. *The Revenge of the Philistines: Art and Culture, 1972–1984.* New York, 1985.

KULTERMAN, U. *Art and Life.* New York, 1971. J. W. Gabriel, translator.

LEVIN, K. "Farewell to Modernism." *Arts Magazine,* Oct. 1979, pp. 90–92.

LINVILLE, K. "Sonsbeek: Speculations, Impressions." *Artforum,* Oct. 1971, pp. 54–61.

LIPPARD, L. R. *Six Years: The Dematerialization of the Art Object from 1966 to 1972.* New York, 1973.

———. *Overlay: Contemporary Art and the Art of Prehistory.* New York, 1983.

———. *Get the Message? A Decade of Art for Social Change.* New York, 1984.

LUCIE-SMITH, E. *Art in the Seventies.* Ithaca, N.Y., 1980.

MALLORY, R. "Computer Sculpture: Six Levels of Cybernetics." *Artforum,* May 1969, pp. 29–35.

McSHINE, K. *Information.* New York, MOMA, 1970. E.C.

MEYER, U. *Conceptual Art.* New York, 1972.

MORRIS, R. "Anti Form." *Artforum,* April 1968, pp. 33–35.

———. "Aligned with Nazca." *Artforum,* Oct. 1975, pp. 26–39.

MULLER, G., and GORGONI, G. *The New Avant-Garde: Issues for the Art of the Seventies.* New York and London, 1972.

NEUBERT, G. W. *Public Sculpture/Urban Environment.* Oakland Museum, 1974. E.C.

PATTON, P. "Other Voices, Other Rooms: The Rise of the Alternative Space." *Art in America,* July–Aug. 1977.

PINCUS-WITTEN, R. *Postminimalism: American Art of the Decade.* New York, 1977.

REDSTONE, L. G. and R. R. *Public Art: New Directions.* New York, 1981.

REICHARDT, J. *The Computer in Art.* New York and London, 1971.

ROBINS, C. *The Pluralist Era: American Art 1968–1981.* New York, 1984.

ROSENBERG, H. *Artworks and Packages.* New York, 1969.

————. *The De-Definition of Art: Action Art to Pop to Earthworks*. New York, 1972.

SANDLER, I., ed. "Modernism, Revisionism, Pluralism, and Post-Modernism." *Art Journal*, Winter 1980 (special issue).

SCHNEIDER, I., and KOSOT, B., eds. *Video Art*. New York, 1976.

SIMON, J.-P. *Video and Video: Four French Artists*. Berkeley, University Art Museum, 1979. E.C.

SMAGULA, H. J. *Currents: Contemporary Directions in the Visual Arts*. Englewood Cliffs, N.J., 1983.

SMITH, R. "Conceptual Art," in N. Stangos, *Concepts of Modern Art*. 2d ed., pp. 256–70. London, 1981.

SONFIST, A., ed. *Art in the Land: A Critical Anthology of Environmental Art*. New York, 1983.

TILLIM, S. "Earthworks and the New Picturesque." *Artforum*, Dec. 1968, pp. 42–45.

TOMKINS, C. *The Scene: Report on Post-Modern Art*. New York, 1974.

————. "Perception at All Levels." *The New Yorker*, Dec. 3, 1984, pp. 176–81. Article on new art in public spaces.

TUCKER, M., and MONTE, J. *Anti-Illusion: Procedures/Materials*. New York, WMAA, 1969. E.C.

WOODS, G., THOMPSON, P., and WILLIAMS, J., eds. *Art Without Boundaries*. New York, 1974.

18. The Pluralistic Seventies: The New Illusionism, Pattern and Decoration, and New Image Art

ALLOWAY, L. "The Renewal of Realist Criticism." *Art in America*, Sept. 1981, pp. 109–11.

ARMSTRONG, R., and MARSHALL, R. *Five Painters in New York: Brad Davis, Bill Jensen, Elizabeth Murray, Gary Stephan, John Torreano*. New York, WMAA, 1984. E.C.

Art of Our Time: The Saatchi Collection. London and New York, 1984. Vol. 4: Essays by M. Auping, P. Carlson, L. Cooke, H. Kramer, K. Levin, M. Rosenthal, P. Tuchman.

ARTHUR, J. *Realism/Photorealism*. Tulsa, Philbrook Art Center, 1980. E.C.

ASHBERY, J. "Decoration Days." *New York Magazine*, July 2, 1979, pp. 51–52.

BATTCOCK, G., ed. *Super Realism: A Critical Anthology*. New York, 1975.

BETTELHEIM, J. "Pattern Painting: The New Decorative, a California Perspective." *images & issues*, March 4, 1983, pp. 32–36.

BOURDON, D. "The Decorative Impulse." *Vogue*, Nov. 1979, p. 38.

BRENSON, M. "The Decorative Tradition." *New York Times*, April 20, 1984, p. C21.

BUCHLOH, B. H. D. *Formalism and Historicity—Changing Concepts in American and European Art Since 1945*. Chicago, 1977.

CHASE, L. "The Connotation of Denotation." *Arts Magazine*, Feb. 1974, pp. 38–41.

————. *Hyperrealism*. New York, 1975. Introduction Salvador Dali.

DELAHOYD, M. "Action and Abstraction." *Artforum*, Nov. 1980, pp. 62–63.

————. *A New Beginning: 1968–1978*. Yonkers, N.Y., Hudson River Museum, 1985. E.C.

FOSTER, H. "The Problem of Pluralism." *Art in America*, Jan. 1982, pp. 9–15.

GOLDIN, A. "Beyond Style." *Art & Artists*, Sept. 1968, pp. 32–35.

GOODYEAR, JR., F. H. *Contemporary American Realism Since 1960*. Boston, 1981.

GOTTLIEB, C. *Beyond Modern Art*. New York, 1976.

HENRY, G. "Painterly Realism and the Modern Landscape." *Art in America*, Sept. 1981, pp. 112–19.

HUGHES, R. "Ten Years that Burried the Avant-Garde." *The Sunday Times Magazine* (London), Dec. 30, 1979, pp. 16–21, 41–47.

HUNTER, S. "Post-Modernist Painting." *Portfolio*, Jan.–Feb. 1982, pp. 46–53.

————. *New Image, Pattern & Decoration: From the Morton G. Neuman Family Collection*. Kalamazoo Institute of Arts, 1983. E.C.

JENSON, R., and CONWAY, P. *Ornamentalism: The New Decorativeness in Architecture and Design*. New York, 1982.

KARDON, J. *Decorative Impulse*. Philadelphia, Institute of Contemporary Art, Univ. of Pennsylvania, 1979. E.C.

KENDALL, A., ed. *Real, Really Real, Superreal: Directions in Contemporary American Realism*. San Antonio Museum Association, 1981. E.C.

KRAMER, H. *The Revenge of the Philistines: Art and Culture: 1972–1984*. New York, 1985.

KUSPIT, D. B. "What's Real in Realism?" *Art in America*, Sept. 1981, pp. 84–95.

————. "The Emptiness of Pluralism: The End of the New." *Vanguard*, March 1984, pp. 14–16.

LEVIN, K. "The Ersatz Object." *Arts Magazine*, Feb. 1974, pp. 52–55.

LINDEY, C. *Superrealist Painting and Sculpture*. New York, 1980.

LUCIE-SMITH, E. *Super Realism*. Oxford, 1979.

————. *Art in the Seventies*. Ithaca, N.Y., 1980.

————. *The Real British: An Anthology of the New Realism in British Painting*. London, Fisher Fine Art Ltd., 1981. E.C.

LUKACS, G. *Essays on Realism*. Cambridge, Mass., 1981.

MARSHALL, R. *New Image Painting*. New York, WMAA, 1978. E.C.

————. *American Art Since 1970: Painting, Sculpture, and Drawings from the Collection of the Whitney Museum of American Art*. New York, WMAA, 1984. E.C.

MEISEL, L. K. *Photo-Realism*. New York, 1972. Foreword G. Battcock.

MEYER, R. *Arabesque*. Cincinnati, Contemporary Arts Center, 1978. E.C.

MONTE, J. K. *Twenty-Two Realists*. New York, WMAA, 1970. E.C.

PERREAULT, J. "Issues in Pattern Painting." *Artforum*, Nov. 1977, pp. 32–36.

————. "The New Decorativeness." *Portfolio*, June–July 1979, p. 46.

————. "Usable Art." *Portfolio*, July–Aug. 1981, pp. 60–63.

PERRONE, J. "Approaching the Decorative." *Artforum*, Dec. 1976, pp. 26–30.

————. "Sign and Design." *Arts Magazine*, Feb. 1982, pp. 132–39.

RAYMOND, H. D. "Beyond Freedom, Dignity, and Ridicule." *Art Magazine*, Feb. 1974, pp. 25–74.

RICKEY, C. "Art of Whole Cloth." *Art in America*, Nov. 1979, pp. 72–83.

————. "Of Crystal Palaces and Glass Houses." *Village Voice*, April 14, 1980.

————. "Decoration, Ornamentation, Pattern, and Utility: Four Tendencies in Search of a Movement." *Flash Art*, June–July, 1980, pp. 14–23.

————. "Pattern Painting." *Arts Magazine*, Sept. 1980, p. 17.

ROBINS, C. "Late Decorative: Art, Artifact, and the Ersatz." *Arts Magazine*, Sept. 1980, pp. 150–51.

————. *The Pluralist Era: American 1968–1981*. New York, 1984.

ROSENTHAL, M. "The Ascendance of Subject Matter and a 1960s Sensibility." *Arts Magazine*, Jan. 1982, pp. 92–94.

SANDLER, I. "Modernism, Revisionism, Pluralism, and Post-Modernism." *Art Journal*, Fall–Winter, 1980, pp. 245–347.

SEITZ, W. C. "The Real and the Artificial." *Art in America*, Nov.–Dec. 1972, pp. 58–72.

SMAGULA, H. J. *Currents: Contemporary Directions in the Visual Arts*. Englewood Cliffs, N.J., 1983.

SONDHEIM, A., ed. *Individuals: Post-Movement Art in America*. New York, 1976.

STEVENS, M. "The Dizzy Decade." *Newsweek*, March 26, 1979, pp. 88–94.

TOMKINS, C. "Matisse's Armchair." *The New Yorker*, Feb. 25, 1980, p. 108.

WALLIS, B., ed. *Art After Modernism: Rethinking Representation*. New York, 1984. Foreword M. Tucker.

ZIMMER, W. "Art for the Me-Decade." *Soho Weekly News*, March 1, 1979, pp. 39, 41.

"Photo-Realists: Twelve Interviews." *Art in America*, Nov.–Dec. 1972, pp. 73–89. Statements by Bechtle, Blackwell, Close, Cottingham, Estes, Eddy, McLean, Parrish, Levine, Posen, Salt, Goings.

19. The Appropriating Eighties: Neo-Expressionism and the New Abstraction

ARMSTRONG, R., and MARSHALL, R. *Five Painters in New York: Brad Davis, Bill Jensen, Elizabeth Murray, Gary Stephan, John Torreano*. New York, WMAA, 1984. E.C.

Art of Our Time: The Saatchi Collection. London and New York, 1984. Vol. 3: Essays by R. Fuchs, H. Kramer, P. Schjeldahl.

Art of Our Time: The Saatchi Collection. London and New York, 1984. Vol. 4: Essays by M. Auping, P. Carlson, L. Cooke, H. Kramer, K. Levin, M. Rosenthal, P. Tuchman.

BAKER, E. C. "Editorial: How Expressionist Is It?" *Art in America*, Dec. 1982 (special issue: "The Expressionism Question, I"), p. 5.

BENJAMIN, W. "The Work of Art in the Age of Mechanical Reproduction," in W. Benjamin, *Illuminations*, pp. 217–42. Edited by H. Arendt. New York, 1969.

BRENSON, M. "Artists Struggle with New Realities." *New York Times*, May 15, 1983, sect. 2, pp. 1, 30.

————. "Is Neo-Expressionism an Idea Whose Time Has Passed?" *New York Times*, Jan. 5, 1986, sect. 2, pp. 1, 12.

BROCK, B. "The End of the Avant-Garde? And So the End of Tradition: Notes on the Present 'Kulturkampf' in West Germany." *Artforum*, June 1981, pp. 62–67.

BUCHLOH, B. H. D. "Figures of Authority, Ciphers of Repression: Notes on the Return of Representation in European Painting." *October 16*, Spring 1981, pp. 39–68.

————. "Allegorical Procedures: Appropriations and Montage in Contemporary Art." *Artforum*, Sept. 1982, pp. 43–56.

————, GUILBAUT, S., and SOLKIN, D., eds. *Modernism and Modernity: The Vancouver Conference Papers*. Halifax, Nova Scotia, 1983.

CELANT, G. "The Italian Experience." Translated and reprinted from *Kunstforum International* (March 1980, pp. 125–33) in J. R. Lane and J. Caldwell, *Carnegie International*, pp. 21–25. Pittsburgh, Museum of Art, Carnegie Institute, 1985. E.C.

CLARKE, J. R. "Up Against the Wall, Transavanguardia!" *Arts Magazine*, Dec. 1982, pp. 76–81.

COMPTON, M. *The New Art*. London, Tate Gallery, 1983. E.C.

Contemporary Italian Masters. Chicago Council on Fine Arts and the Renaissance Society at the Univ. of Chicago, 1984. E.C. Essays by H. Geldzahler and J. R. Kirshner.

COWART, J. *Expressions: New Art from Germany, Georg Baselitz, Jörg Immendorff, Anselm Kiefer, Markus Lüpertz, A. R. Penck*. St. Louis Art Museum, 1983. E.C. Additional texts by S. Gohr and D. B. Kuspit.

CRIMP, D. "The Photographic Activity of Postmodernism." *October 15*, Winter 1980, pp. 91–101.

DAVIS, D. "Post-performancism." *Artforum*, Oct. 1981, pp. 31–39.

DE LOISY, J. "New French Painting." *Flash Art*, Jan. 1983, pp. 44–48.

DOUGLAS, D. *Artculture: Essays on the Postmodern*. New York, 1979.

"Expressionism Today: An Artist's Symposium." *Art in America*, Dec. 1982 (special issue "Expressionism, I"), pp. 58–119.

FOSTER, H., ed. *The Anti-Aesthetic: Essays on Postmodern Culture*. Port Tounsend, Wash., 1983.

————. "The Expressive Fallacy." *Art in America*, Jan. 1983 (special issue: "Expressionism, II"), pp. 80–83.

FREEMAN, P., et al., eds. *New Art*. New York, 1984.

GABLIK, S. "Report from New York: The Graffiti Question." *Art in America*, Oct. 1982, pp. 33–39.

————. *Has Modernism Failed?* New York, 1984.

GACHNANG, J. "Painting in Germany 1981." *Flash Art*, Feb. 3, 1983, pp. 33–37.

GALLOWAY, G. "Report from Germany: Taking Stock." *Art in America*, May 1986, pp. 28–39.

GREENFIELD-SANDERS, T. "The New Irascibles: Portfolio of Six Portraits." *Arts Magazine*, Sept. 1985, pp. 102–10. Entries by R. Pincus-Witten; drawings by M. Kostabi.

HERTZ, R. *Theories of Contemporary Art*. Englewood Cliffs, N.J., 1985.

HUGHES, R. "Careerism and Hype Amidst the Image Haze." *Time*, June 17, 1985, pp. 78–83.

HUNTER, S. *New Directions: Contemporary American Art.* Princeton University Art Museum, 1981. E.C.

Infotainment. New York, Nature Morte, 1985. E.C. Essays by G.W.S. Trow and T. Lawson.

JOACHIMIDES, C. M. *A New Spirit in Painting.* London, Royal Academy of Art, 1981. E.C. Essays by N. Rosenthal and N. Serota.

KARDON, J. *The East Village Scene.* Philadelphia, Institute of Contemporary Art, Univ. of Pennsylvania, 1984. E.C.

KRAMER, H. "Internationalism in the Eighties," in C. R. Lane and J. Caldwell, *Carnegie International,* pp. 84–87. Pittsburgh, Museum of Art, Carnegie Institute, 1985. E.C.

———. "Modernism and Its Demise." *New Criterion,* March 1986, pp. 1–7.

KRAUSS, R. *The Originality of the Avant-Garde and Other Modernist Myths.* Cambridge, Mass., 1985.

KRAUTHAMMER, C. *Cutting Edges: Making Sense of the Eighties.* New York, 1985.

LUCIE-SMITH, E. *American Art Now.* New York, 1985.

MADOFF, S. H. "A New Generation of Abstract Painters." *Art News,* Nov. 1983, pp. 78–84.

———. *Abstract/Issues.* New York, Sherry French/Tibor de Nagy/Oscarsson Hood, 1985. E.C.

———. "What Is Postmodern About Painting: The Scandinavia Lectures." Part 1, *Arts Magazine,* Sept. 1985, pp. 116–21; Part 2, *Arts Magazine,* Oct. 1985, pp. 62–63; Part 3, *Arts Magazine,* Nov. 1985, pp. 68–73.

———. *After Nature: Sculpture by Barl Breivik, Heide Fassnacht, Martin Puryear, Scott Richter, Mia Westerlund Roosen, Robert Therrien, and Steve Wood.* New York, Germans van Eck Gallery, 1986. E.C.

———. "The Return of Abstraction." *Art News,* Jan. 1986, pp. 80–85.

MARMER, N. "The New Culture: France '82." *Art in America,* Sept. 1982, pp. 115–23.

MARSHALL, R. *American Art Since 1970: Painting, Sculpture, and Drawings from the Collection of the Whitney Museum of American Art.* New York, WMAA, 1984.

MASHEK, J. *Smart Art (Part One).* New York, 1984.

McEVILLEY, T. "I Think Therefore I Art." *Artforum,* Summer 1985, pp. 74–84.

McGUIGAN, C. "New Art, New Money: The Marketing of an American Artist." *New York Times Magazine,* Feb. 10, 1985, pp. 20–35.

McSHINE, K. *An International Survey of Recent Painting and Sculpture.* New York, MOMA, 1984. E.C.

METZGER, R. T. "Expressionism: A Historical Perspective," in *American Neo-Expressionists.* Ridgefield, Conn., Aldrich Museum of Contemporary Art, 1984. E.C.

New Figuration in America. Milwaukee Art Museum, 1982. E.C.

NEWMAN, C. *The Post-Modern Aura: The Act of Fiction in an Age of Inflation.* Evanston, Ill., 1985.

NICKAS, R. "The Sublime Was Then (Search for Tomorrow)." *Arts Magazine,* March 1986, pp. 14–17.

OLIVA, A. B. "The Italian Trans-Avant-Garde." *Flash Art,* Oct. 11, 1979, pp. 17–20.

———. "La Transvanguardia Internazionale." *Flash Art,* Oct.–Nov. 1981, pp. 28–35.

———. *Trans Avant Garde International.* Milan, 1982.

OWENS, C. "The Allegorical Impulse: Toward a Theory of Postmodernism." Part 1: *October* 12 (Spring 1980), pp. 67–82; part 2: *October* 13 (Summer 1980), pp. 59–80.

———. "Honor, Power, and the Love of Women." *Art in America,* Jan. 1983 (special issue: "The Expressionism Question, II"), pp. 7–13.

PINCUS-WITTEN, R. *Entries (Maximalism).* New York, 1983.

PLOUS, P. *Neo York: Report on a Phenomenon.* Santa Barbara, University Art Museum, 1984.

PROBST, K. "A New Expression." *Horizon,* Jan. 2, 1984, pp. 38–46.

RABBINS, D. A. "The 'Meaning' of the 'New'—The 70s/80s Axis: An Interview with Diego Cortez." *Arts Magazine,* Jan. 1983, pp. 116–21.

RATCLIFF, C. "Art Stars for the Eighties." *Saturday Review,* Feb. 1981, pp. 12–14.

———. "On Iconography and Some Italians." *Art in America,* Sept. 1982, pp. 152–59.

———. "The Short Life of the Sincere Stroke." *Art in America,* Jan. 1983, pp. 73–79.

RAYNOR, V. "Neo-Expressionists or Neo-Surrealists?" *New York Times,* May 13, 1982, p. C27

ROSE, B. *American Painting, the Eighties: A Critical Interpretation.* New York, Grey Art Gallery and Study Center, New York Univ., 1979. E.C.

RUSSELL, J. "The Art of Italy Today." *New York Times,* April 11, 1982, pp. 1, 31.

———. "Modernism and Postmodernism: A New World Once Again." *New York Times,* Aug. 22, 1982.

———. "The New European Painters." *New York Times Magazine,* April 24, 1983, pp. 28–33.

SCHJELDAHL, P. "Treachery on the High Cs." *Village Voice,* April 27, 1982, p. 96.

———. "Fall in Style: The New Art and Our Discontents." *Vanity Fair,* March 1983, pp. 115ff.

SCHWABSKY, J. "After the Great Separation: On One Tendency in Recent Abstract Painting and Its Background." *Arts Magazine,* Nov. 1985, pp. 22–25.

SEROTA, N. *Transformations: New Sculpture from Britain.* London, British Council, 1983. E.C.

SMITH, R. "The Abstract Image." *Art in America,* March–April 1979, pp. 102–5.

———. "Appropriation über Alles." *Village Voice,* Jan. 11, 1983, p. 73.

TOMKINS, C. "Up from the I.R.T." *The New Yorker,* March 26, 1984, pp. 98–102.

TUCKER, M. "An Iconography of Recent Figurative Painting: Sex, Death, Violence, and the Apocalypse." *Artforum,* Summer 1982, pp. 70–75.

WALLIS, B., ed. *Art After Modernism: Rethinking Representation.* New York and Boston, 1984. Foreword M. Tucker.

WOLLHEIM, P. "The Politics of Meaning: Re-Reading Walter Benjamin." *Vanguard,* Feb. 3, 1986, pp. 22–26.

B. COUNTRIES

1. Austria

ADLMANN, J. E. *Vienna Moderne: 1898–1918.* New York, Cooper-Hewitt Museum, Smithsonian Institution, 1979. E.C.

CHIPP, H. B. *Viennese Expressionism 1910–1924.* Berkeley, University Museum, Univ. of California, 1963. E.C.

KALLIR, J. *Arnold Schoenberg's Vienna.* New York, Galerie Saint-Étienne, 1984. E.C.

NEBEHAY, C. M. *Ver Sacrum, 1898–1903.* New York, 1977.

POWELL, N. *The Sacred Spring: The Arts of Vienna, 1898–1918.* Greenwich, Conn., 1974.

SCHORSKE, C. E. *Fin-de-Siècle Vienna: Politics and Culture.* New York, 1980.

SOTRIFFER, H. *Modern Austrian Art.* New York, 1965.

VARNEDOE, K. *Vienna 1900: Art, Architecture, and Design.* New York, MOMA, 1986. E.C.

VERGO, P. *Art in Vienna, 1898–1918: Klimt, Kokoschka, Schiele, and Their Contemporaries.* New York, 1975.

WAISSENBERGER, R. *Vienna Secession.* New York, 1977.

2. France

BOIS, Y.-A. "Report from New York and Now—A French Wave?" *Art in America,* Sept. 1982, pp. 59–63.

DAULTE, F. *Le Dessin français de Manet à Cézanne.* Lausanne, 1954.

DORIVAL, B. *The School of Paris in the Musée D'Art Moderne.* New York, 1962.

FOCILLON, H. *La Peinture au XIXe siècle: Le Retour à l'antique. Le Romantisme (Manuels d'histoire de l'art).* Paris, 1927.

———. *La Peinture aux XIXe et XXe siècles: Du Réalisme à nos jours (Manuels d'histoire de l'art).* Paris, 1928.

FONTAINAS, A., and VAUXCELLES, L. *Histoire générale de l'art français de la Révolution à nos jours.* Paris, 1922.

FOSCA, F. *La Peinture française au XIXe siècle.* Paris, 1956.

FRANCASTEL, P. *La Peinture française du classicisme au cubisme.* Paris, 1955.

FRANCBLIN, C. "Free French." *Art in America,* Sept. 1982, pp. 128–31.

FRIEDLAENDER, W. *David to Delacroix.* Cambridge, Mass., 1952.

GAUSS, C. E. *The Aesthetic Theories of French Artists: 1855 to the Present.* Baltimore, 1949.

GORDON, J. *Modern French Painters.* London, 1923.

HUNTER, S. *Modern French Painting, 1855–1956.* New York, 1956.

HUYGHE, R. *French Painting: The Contemporaries.* New York, 1939.

MARCHIORI, G. *Modern French Sculpture.* New York, 1963.

MARMER, N. "The New Culture: France '82." *Art in America,* Sept. 1982, pp. 115–23.

RATCLIFF, C. "Report from New York: And Now—A French Wave?" *Art in America,* Sept. 1982, pp. 59–63.

ROGER-MARX, C. *La Gravure originale en France de Manet à nos jours.* Paris, 1939.

SAN LAZZARO, G. DI. *Painting in France, 1895–1949.* New York, 1949.

SLOANE, J. C. *French Painting Between the Past and the Present.* Princeton, N.J., 1951.

WILENSKI, R. H. *Modern French Painters.* London, 1954.

3. Germany

JOACHIMIDES, C. M., ROSENTHAL, N., and SCHMIED, W., eds. *German Art in the Twentieth Century: Painting and Sculpture, 1905–1985.* London, Royal Academy of Arts, 1985. E.C.

Kunst in der Bundesrepublik Deutschland: 1945–1985. Nationalgalerie, Staatliche Museen, Preussischer Kulturbesitz, West Berlin, 1985. E.C.

LEHMANN-HAUPT, H. *Art Under a Dictatorship.* New York, 1954.

LINCOLN, L., ed. *German Realism of the Twenties: The Artist as Social Critic.* Minneapolis Institute of Arts, 1980. E.C.

Neue Sachlichkeit and German Realism of the Twenties. London, Arts Council of Great Britain, 1978. E.C.

RITCHIE, A. C., ed. *German Art of the Twentieth Century.* New York, MOMA, 1957. E.C.

ROETHEL, H. K. *Modern German Painting.* New York, 1957.

THOENE, PETER [pseud.]. *Modern German Art.* London, 1938. Introduction H. Read.

WILLETT, J. *Art and Politics in the Weimar Period.* New York, 1978.

4. Great Britain

BERTRAM, A. *A Century of British Painting: 1851–1951.* London, 1951.

BOWNESS, A. *Contemporary British Painting.* London, 1968.

CORK, R. *Vorticism and Abstract Art in the First Machine Age.* London, 1976.

FARR, D. *English Art: 1870–1940.* Oxford, 1978.

FINCH, C. *Image as Language.* Harmondsworth, 1969.

FRIEDMAN, M., and BOWNESS, A. *London: The New Scene.* Minneapolis, Walker Art Center, 1965. E.C.

HAMMACHER, A. M. *Modern English Sculpture.* New York, 1966.

MELVILLE, R., and ROBERTSON, B. *The English Eye.* New York, Marlborough-Gerson Gallery, 1965. E.C.

NAIRNE, S., and SEROTA, N. *British Sculpture in the Twentieth Century.* London, Whitechapel Art Gallery, 1981. E.C.

New British Painting and Sculpture. Berkeley, University of California Art Museum, 1968. E.C.

RITCHIE. A. C. *Masters of British Painting: 1800–1950.* New York, MOMA, 1956. E.C.

ROBERTSON, B., RUSSELL, J., and THE EARL OF SNOWDOWN. *Private View: The Lively World of British Art.* London, 1965.

ROTHENSTEIN, J. *Modern English Painters.* 2 vols. London, 1952–56.

———. *British Art Since 1900: An Anthology.* London, 1962.

RUSSELL, J. *From Sickert to 1948: The Achievement of the Contemporary Art Society.* London, 1948.

SHONE, R. *The Century of Change.* Oxford, 1977.

5. Italy

BALLO, G. *Modern Italian Painting from Futurism to the Present Day.* New York, 1958.

CARRIERI, R. *Avant-Garde Painting and Sculpture (1890–1955) in Italy.* Milan, 1955.

PARMESI, L. *Arte Italiana, 1960–1982.* London, Hayward Gallery, 1982. E.C.

SALVINI, R. *Modern Italian Sculpture.* New York, 1962.

SOBY, J. T., and BARR, JR., A. H. *Twentieth-Century Italian Art*. New York, MOMA, 1949. E.C.

VENTURI, L. *Italian Sculptors of Today*. Rome, 1960. E.C.

WALDMAN, D., ed. *Italian Art Now: An American Perspective*. New York, SRGM, 1982.

ZERVOS, C., ed. "Un Demi-Siècle d'art italien." Paris, *Cahiers d'Art*, vol. 25, no. 1, 1950 (entire issue).

6. Japan

Contemporary Japanese Art: Fifth Japan Art Festival Exhibition. New York, SRGM, 1970. E.C.

ITO, N., et al. *Art in Japan Today II, 1970–1983*. Tokyo, 1984.

KUNG, D. *The Contemporary Artist in Japan*. Honolulu, 1966.

LIEBERMAN, W. S. *The New Japanese Painting and Sculpture*. New York, MOMA, 1966. E.C.

TAKASHINA, S., TONO, Y., and NAKAHARA, Y., eds. *Art in Japan Today*. Tokyo, 1974.

TAPIÉ, M., and HAGA, T. *Avant-Garde Art in Japan*. New York, 1962.

7. Russia

ELLIOTT, D. *Russian Art and Society: 1900–1935*. New York, 1986.

GRAY, C., and BURLEIGH-MOTLEY, M. *Russian Experiment in Art: 1863–1922*. Rev. ed. London and New York, 1986.

HAMILTON, G. H. *The Art and Architecture of Russia*. Harmondsworth, 1954.

8. Scandinavia

OSTBY, L. *Modern Norwegian Painting*. Oslo, 1949.

POULSEN, V. *Danish Painting and Sculpture*. Copenhagen, 1955.

SODERBERG, R. *Introduction to Modern Swedish Art*. Stockholm, Moderna Museet, 1962. E.C.

VARNEDOE, K. *Northern Light: Realism and Symbolism in Scandinavian Painting 1880–1910*. New York, Brooklyn Museum, 1982. E.C.

9. Spain

DYCKES, W. *Spanish Art Now*. Madrid, 1966.

MCCULLY, M. *El Quatre Gats: Art in Barcelona Around 1900*. Princeton University Art Museum, 1978. E.C.

New Spanish Painting and Sculpture. New York, MOMA, 1960. E.C.

SWEENEY, J. J. *Before Picasso, After Miró*. New York, SRGM, 1960. E.C.

10. Switzerland

From Hodler to Klee: Swiss Art of the Twentieth Century, Paintings and Sculptures. London, The Tate Gallery, 1959. E.C.

11. United States

AGEE, W. C. *The 1930's: Painting & Sculpture in America*. New York, WMAA, 1968. E.C.

ALLOWAY, L. *American Pop Art*. New York and London, WMAA, 1975. E.C.

———. *Topics in American Art Since 1945*. New York, 1975.

ANDERSEN, W. *American Sculpture in Process: 1930–1970*. Boston, 1975.

ARMSTRONG, T., et al. *200 Years of American Sculpture*. Boston, WMAA, 1976. E.C.

ASHTON, D. *American Art Since 1945*. New York, 1982.

BAIGELL, M. *Dictionary of American Art*. New York, 1979.

BAUR, J. I. H. *Revolution and Tradition in Modern American Art*. Cambridge, Mass., 1951.

BROWN, M. W. *American Painting from the Armory Show to the Depression*. Princeton, 1955.

———. *The Story of the Armory Show*. New York, 1963.

———. *One Hundred Masterpieces of American Painting from Public Collections in Washington, D.C.* Washington, D.C., 1983.

———, HUNTER, S., JACOBUS, J., ROSENBLUM, N., and SOKOL, D. M. *American Art: Painting, Sculpture, Architecture, Decorative Arts, Photography*. New York, 1979.

CARMEAN, JR., E. A. *American Art at Mid-Century: The Subjects of the Artist*. Washington, D.C., 1978. E.C. Essays by E. E. Rathbone and T. B. Hess.

CATHCART, L. *American Painting of the 1970s*. Buffalo, Albright-Knox Gallery, 1979. E.C.

DAVIDSON, A. A. *Early American Modernist Painting: 1910–1935*. New York, 1981.

DOTY, R., ed. *Photography in America*. New York, WMAA, 1974. E.C.

DWIGHT, E. H. *Armory Show 50th Anniversary Exhibition 1913–1963*. Utica, N.Y., Munson-Williams-Proctor Institute, 1963. E.C.

ELDRIDGE, C. D. *American Imagination and Symbolist Painting*. New York, Grey Gallery, New York University, 1980. E.C.

FINK, L. M., and TAYLOR, J. C. *Academy: The Academic Tradition in American Art*. Washington, D.C., National Collection of Fine Arts, 1975. E.C.

FRIEDMAN, M. L. *The Precisionist View in American Art*. Minneapolis, Walker Art Center, 1960. E.C.

GELDZAHLER, H. *American Painting in the 20th Century*. New York, MMA, 1965. Catalogue of the collection.

GOODRICH, L., and BAUR, J. I. H. *American Art of Our Century*. New York, WMAA, 1961. Catalogue of the collection.

GREEN, S. M. *American Art: A Historical Survey*. New York, 1966.

D'HARNONCOURT, R., and BARR, JR., A. H. *The New American Painting*. New York, MOMA, 1959. E.C.

HOMER, W. I. *Alfred Stieglitz and the American Avant-Garde*. Boston, 1977.

HUNTER, S. *Modern American Painting and Sculpture*. New York, 1959.

——— and JACOBUS, J. *American Art of the Twentieth Century: Painting, Sculpture, Architecture*. New York, 1973.

JANIS, S. *Abstract and Surrealist Art in America*. New York, 1944.

JOHNSON, E. H., ed. *American Artists on Art from 1940 to 1980*. New York, 1982.

LANE, J. R., and LARSEN, S., eds. *Abstract Painting and Sculpture in America: 1927–1944*. Pittsburgh, Museum of Art, Carnegie Institute, 1983. E.C.

MCSHINE, K. *The Natural Paradise: Painting in America, 1800–1950*. New York, MOMA, 1976.

MOTHERWELL, R., and REINHARDT, A., eds. *Modern Artists in America*. No. 1. New York, 1951.

NOVAK, B. *American Painting in the Nineteenth Century: Realism, Idealism, and the American Experience*. 2d ed. New York, 1979.

———. *Nature and Culture: American Landscape and Painting, 1825–1875*. New York, 1980.

RITCHIE, A. C. *Abstract Painting and Sculpture in America*. New York, MOMA, 1951. E.C.

Roots of Abstract Art in America 1910–1930. Washington, D.C., Smithsonian Institution, 1965. E.C.

ROSE, B. *American Art Since 1900*. Rev. ed. New York, 1975.

SANDLER, I. *The Triumph of American Painting: A History of Abstract Expressionism*. New York, 1970.

STEBBINS, JR., T. *A New World: Masterpieces of American Painting, 1760–1910*. Boston, Museum of Fine Arts, 1983. E.C.

TIGHE, M. A., and LANG, E. E. *Art America*. New York, 1977.

TSUJIMOTO, K. *Images of America: Precisionist Painting and Modern Photography*. San Francisco Museum of Modern Art, 1982. E.C.

WALDMAN, D. *Twentieth-Century American Drawing: Three Avant-Garde Generations*. New York, SRGM, 1976. E.C.

WECHSLER, J., and BERMAN, G. *Realism and Realities: The Other Side of American Painting, 1940–1960*. New Brunswick, N.J., Rutgers University Art Gallery, 1980. E.C.

YOUNG, M. S. *Early American Moderns: Painters of the Stieglitz Group*. New York, 1974.

———. *The Eight: The Realist Revolt in American Painting*. New York, 1973.

VI. ARTISTS, ARCHITECTS, AND PHOTOGRAPHERS

In addition to the publications listed here, additional sources for individual photographers can be found in Section IV.

AALTO: AALTO, A., and FLEIG, K., eds. *Alvar Aalto: Collected Works*. Zurich, 1963.

GUTHEIM, F. *Alvar Aalto*. New York, 1960.

JOHNSON, J. S. *Alvar Aalto: Furniture and Glass*. New York, MOMA, 1984. E.C.

PEARSON, P. D. *Alvar Aalto and the International Style*. New York, 1978.

QUANTRELL, M. *Alvar Aalto: A Critical Study*. New York, 1983.

ABBOTT: O'NEAL, H. *Berenice Abbott, American Photographer*. New York, 1982.

SZARKOWSKI, J. *Looking at Photographs*, p. 98. Boston and New York, 1973.

WITKIN, L. D., and LONDON, B. "Berenice Abbott," in *The Photograph Collector's Guide*, p. 65. Boston, 1979.

ACCONCI: KIRSHNER, J. R. *Vito Acconci: A Retrospective, 1969–1980*. Chicago, Museum of Contemporary Art, 1980. E.C.

PINCUS-WITTEN, R. "Vito Acconci and the Conceptual Performance." *Artforum*, April 1972, pp. 47–49.

ADAMS: NEWHALL, N. *Ansel Adams: The Eloquent Light*. San Francisco, 1963.

WITKIN, L. D., and LONDON, B. "Ansel Adams," *The Photograph Collector's Guide*, pp. 65–66. Boston, 1979.

AFRICANO: AUSTS, "Nicholas Africano at Holly Solomon." *Art in America*, Jan. 1983, p. 124.

BROOKS, V. "Nicholas Africano." *M.D.*, July 1984, pp. 37–42.

CAVALIERE, B. "Nicholas Africano," in E. Emanuel, et al., eds., *Contemporary Artists*. 2d ed., pp. 13–14. London and New York, 1983.

LARSON, K. "Nicholas Africano." *New York Magazine*, Sept. 24, 1984, p. 104.

AGAM: POPPER, F. *Agam*. 2d ed., rev. New York, 1983.

REICHARDT, J. *Yaacov Agam*. New York, Marlborough-Gerson Gallery, Inc., 1966. E.C. Text based on conversation with Agam.

AHEARN: GLUECK, G. "John Ahearn and Rigoberto Torres." *New York Times*, July 1, 1983, p. C19.

MCGILL, D. C. "Landscape of the Body." *New York Times*, Oct. 18, 1985, p. C28.

RICKEY, C. "John Ahearn: New Museum Windows." *Artforum*, March 1980, p. 75.

ROBINSON, W. "John Ahearn at Fashion/Moda." *Art in America*, Jan. 1980, p. 108.

SCHJELDAHL, P. "Anxiety as a Rallying Cry." *Village Voice*, Sept. 16, 1981, p. 86.

SIEGEL, J. "New Reliefs." *Arts*, April 1982, pp. 143–44.

ALBERS: ALBERS, F. *Interaction of Color*. New Haven and London, 1971.

Josef Albers at The Metropolitan Museum of Art: An Exhibition of His Paintings and Prints. New York, 1971. E.C.

BUCHER, F. *Josef Albers: Despite Straight Lines: An Analysis of His Graphic Constructions*. New Haven, Conn., 1961.

HAMILTON, G. H. *Josef Albers: Paintings, Prints, Projects*. New Haven, Conn., Yale University Art Gallery, 1956. E.C.

ANDERSON: ANDERSON, L. *United States*. New York, 1984.

GLUECK, G. "Laurie Anderson Now Starring at Museum." *New York Times*, July 27, 1984, p. C21.

GOLDBERG, R. "Performance: The Golden Years," in G. Battcock and R. Nickas, *The Art of Performance: A Critical Anthology*, pp. 84–87. New York, 1984.

SHEWEY, D. "The Performing Artistry of Laurie Anderson." *New York Times Magazine*, Feb. 6, 1983, p. 27.

STEWART, P. "Laurie Anderson: With a Song in My Art." *Art in America*, March–April 1979, pp. 110–13.

ANDRE: BOURDON, D. *Carl Andre: Sculpture, 1959–1977*. New York, 1978. Foreword B. Rose.

SEROTA, N. *Carl Andre: Sculpture, 1959–1978*. London, Whitechapel Art Gallery, 1978. E.C.

TUCHMAN, P. "An Interview with Carl Andre." *Artforum*, June 1970, pp. 55–61.

WALDMAN, D. *Carl Andre*. New York, SRGM, 1970. E.C.

ARCHIPENKO: ARCHIPENKO, A., et al. *Archipenko: Fifty Creative Years, 1908–1958.* New York, 1960.
KARSHAN, D. *Archipenko: The Sculpture and Graphic Art.* Boulder, Colo., 1975.
ARIKHA: BRENSON, M. "A World of Menace from Avigdor Arikha." *New York Times,* Sept. 16, 1983, p. C18.
———. "Fresh Visions Based on a Grand Tradition." *New York Times,* July 7, 1985, pp. 23, 26.
CHANNIN, R. "The Paintings of Avigdor Arikha: Composition and Meaning." *Art International,* Sept.–Oct. 1980, pp. 141–52.
GAMZU, H. *Avigdor Arikha: Paintings, 1957–1965 and 1968.* Tel Aviv Museum, 1973. E.C.
GLABERSON, B. "Arikha's Classicism." *Art World,* Oct. 1983, p. 4.
HUGHES, R. "Arikha's Elliptical Intensity." *Time,* July 30, 1979, p. 71.
ARMAJANI: DECHTER, J. "Siah Armajani." *Arts Magazine,* Jan. 1986, pp. 140–41.
KARDON, J. *Siah Armajani: Bridges, Houses, Communal Spaces, Dictionary for Building.* Philadelphia, Institute of Contemporary Art, Univ. of Pennsylvania, 1985. E.C.
MILLER, M. "Siah Armajani." *Art News,* Jan. 1986, p. 129.
PRINCENTHAL, N. "Master Builder." *Art in America,* March 1986, pp. 133–36.
ARMAN: HUNTER, S. *Arman's Apocalypse.* New York, Marisa del Re Gallery, 1984. E.C.
MARTIN, H. *Arman.* New York, 1973.
VAN DER MARCK, J. *Arman: Selected Works, 1958–1974.* La Jolla Museum, Cal., 1974. E.C.
——— and SCHJELDAHL, P. *Arman: Selected Activities.* New York, John Gibson Gallery, 1974. E.C.
ARP: ARP, H. *On My Way: Poetry and Essays, 1912–1947.* New York, 1948.
GIEDION-WELCKER, C. *Jean Arp.* New York, 1957. Documentation by M. Hagenbach.
RAU, B. *Jean Arp: The Reliefs, Catalogue of Complete Works.* New York, 1981.
READ, H. *The Art of Jean Arp.* New York, 1968.
SOBY, J. T., ed. *Arp.* New York, MOMA, 1958. E.C.
ATGET: ABBOTT, B. *The World of Atget.* New York, 1979.
COKE, V. D. *The Painter and the Photograph: From Delacroix to Warhol,* pp. 265–66. Albuquerque, N.M., 1972.
ROSENBLUM, N. *A World History of Photography,* pp. 278–79. New York, 1984.
SZARKOWSKI, J., and HAMBOURG, M. M. *The Work of Atget.* 4 vols. New York, 1981, 1982, 1984.
WITKIN, L. D., and LONDON, B. "Eugène Atget," in *The Photograph Collector's Guide,* p. 75. Boston, 1979.
AYCOCK: *Alice Aycock Projects: 1979–1981.* Tampa, Univ. of South Florida, 1981. E.C. Introduction E. Fry.
FRY, E. "The Poetic Machines of Alice Aycock." *Portfolio,* Nov.–Dec. 1981, pp. 60–65.
HALL, C. "Environmental Artists: Sources and Direction," in A. Sonfist, ed., *Art in the Land: A Critical Anthology of Environmental Art,* pp. 8–59. New York, 1983.
KUSPIT, D. "Aycock's Dream House." *Art in America,* Sept. 1980, pp. 84–87.
LARSON, K. "Alice in Duchamp-land." *New York Magazine,* May 25, 1981, p. 66.
MCDONOUGH, M. "Architecture's Unnoticed Avant-garde: Taking a Second Look at Art in the Environment," in Sonfist, ed., *Art in the Land: A Critical Anthology of Environmental Art,* pp. 233–52. New York, 1983.
BACON: ADES, D., and FORGE, A. *Francis Bacon.* New York, 1985.
ALLOWAY, L. *Francis Bacon.* New York, SRGM, 1963. E.C.
GELDZAHLER, H. *Francis Bacon: Recent Paintings, 1968–1974.* New York, MMA, 1975. E.C.
LEIRIS, M. *Francis Bacon: Full Face and in Profile.* New York, 1983.
RUSSELL, J. *Francis Bacon.* Rev. ed. New York, 1979.
BAILEY: GOODYEAR, JR., F.H. *Contemporary American Realism Since 1960,* pp. 153ff. Boston, 1981.
RUSSELL, J. "Recent Paintings by William Bailey." *New York Times,* April 23, 1982, p. C22.
STRAND, M. *William Bailey: Recent Paintings.* New York, Robert Schoelkopf Gallery, 1982. E.C.
BALDESSARI: BALDESSARI, J. *Ingres and Other Parables.* London, 1972.

DROHOJOWSKA, H. "No More Boring Art." *Art News,* Jan. 1986, pp. 62–69.
TUCKER, M., and PINCUS-WITTEN, R. *John Baldessari.* New York, New Museum, 1981. E.C. Interview by Nancy Drew.
BALLA: *Giacomo Balla.* Turin, Galleria Civica d'Arte Moderna, 1963. E.C. Documentation by E. Crispolti and M. Drudi Gambillo.
BALTHUS: REWALD, S. *Balthus.* New York, MMA, 1983. E.C.
BARLACH: JANSEN, E. *Ernst Barlach: Werke und Werkentwürfe aus fünf Jahrzehnten.* Berlin, Staatliche Museen, 1981. E.C.
SCHULT, F. *Ernst Barlach.* 2 vols. Hamburg, 1958–60.
BARTLETT: *Jennifer Bartlett: In the Garden.* New York, 1982. Introduction J. Russell.
Jennifer Bartlett: Rhapsody. New York, 1985. Introduction R. Smith; notes by the artist.
Jennifer Bartlett. Minneapolis, Walker Art Center, 1985. E.C. Essays by M. Goldwater, R. Smith, C. Tomkins. New York, 1985.
RUSSELL, J. "On Finding a Bold New Work." *New York Times,* May 16, 1976, sect. 2, pp. 1, 31.
———. "A Ferocious and Gleeful Intelligence at Work." *New York Times,* May 19, 1985, pp. 35–36.
TOMKINS, C. "Getting Everything In." *The New Yorker,* April 15, 1985, pp. 50–68.
BASELITZ: FUCHS, R. "Georg Baselitz," in *Art of Our Time: The Saatchi Collection,* vol. 3, pp. 9–11. London and New York, 1984.
KRAMER, H. "Georg Baselitz." *New York Times,* March 26, 1982, sect. 3, p. 21.
KUSPIT, D. B. "Acts of Aggression: German Painting Today, Part II." *Art in America,* Jan. 1983, pp. 91–99.
RUSSELL, J. "Georg Baselitz and His Upside-Downs." *New York Times,* April 8, 1983, p. C23.
———. "The New European Painters." *New York Times Magazine,* April 24, 1983, pp. 28–33.
BASQUIAT: GABLIK, S. "Report from New York: The Graffiti Question." *Art in America,* Oct. 1982, pp. 33–39.
LIEBMAN, L. "Jean-Michel Basquiat at Annina Nosei." *Art in America,* Oct. 1982, p. 130.
MCGUIGAN, C. "New Art, New Money: The Marketing of an American Artist." *New York Times Magazine,* Feb. 10, 1985, pp. 20ff.
MOUFARREGE, N. "Jean Michel Basquiat." *Flash Art,* Nov. 1984, p. 41.
BAUMEISTER: GROHMANN, W. *Willi Baumeister: Life and Work.* New York, 1965.
BAYER: DORNER, A. *The Way Beyond "Art": The Work of Herbert Bayer.* New York, 1947.
BAZIOTES: ALLOWAY, L. *William Baziotes: A Memorial Exhibition.* New York, SRGM. 1965. E.C. With statements by the artist.
William Baziotes: A Retrospective Exhibition. Newport Harbor Art Museum, 1978. E. C. Texts by B. Cavaliere and M. Hadler.
BEAL: GOODYEAR, JR., F. H. *Contemporary American Art: Realism since 1900,* pp. 118–21. Boston, 1981.
HENRY, G. "Jack Beal: A Commitment to Realism." *Art News,* Dec. 1984, pp. 94–100.
KRAMER, H. "Jack Beal's Unabashed Social Realism." *New York Times,* Feb. 10, 1980, p. D29.
KUSPIT, D. "What's Real in Realism." *Art in America,* Sept. 1981, pp. 83–94.
BEARDSLEY: READE, B. *Aubrey Beardsley.* New York, 1967.
BECKMANN: LACKNER, S. *Max Beckmann.* New York, 1985.
SCHULZ-HOFFMANN, C., and WEISS, J. C. *Max Beckmann: Retrospective.* St. Louis Art Museum, 1984. E.C.
SELZ, P. *Max Beckmann.* New York, MOMA, 1964. E.C. Additional texts by H. Joachim and P. T. Rathbone.
BEHRENS: CREMERS, P. *Peter Behrens: Sein Werk von 1900 bis zur Gegenwart.* Essen, 1928.
WINDOR, A. *Peter Behrens: Architect and Designer, 1879–1940.* New York, 1981.
BELLOCQ: SZARKOWSKI, J. *Storyville Portraits.* New York, 1970. Preface L. Friedlander.
BENGLIS: BOURDON, D. "Fling, Dribble, and Drip." *Life,* April 1970, pp. 62–66.
COHEN, R. "Lynda Benglis," in E. Emanuel, et al., eds., *Contemporary Artists,* 2d ed., pp. 86–88. London and New York, 1983.

KRAMER, H. "Grace, Flexibility, Esthetic Tact." *New York Times,* May 30, 1971, p. 19.
PERREAULT, J. "Celebrations Knotted and Dotted." *Village Voice,* May 16, 1974, p. 46.
PERRONE, J. "Lynda Benglis at Paula Cooper." *Art in America,* April 1981, pp. 92–101.
PINCUS-WITTEN, R. "Lynda Benglis: The Frozen Gesture." *Artforum,* Nov. 1974, pp. 54–59.
BENTON: BAIGELL, M. *Thomas Hart Benton.* New York, 1974.
BENTON, T. H. *An American in Art: A Professional and Technical Autobiography.* Lawrence, Kan., 1969.
BERMAN: LEVY, J., ed. *Eugène Berman.* New York, 1947.
BERNARD: MORNAND, P. *Emile Bernard et ses amis.* Geneva, 1957.
BEUYS: ADRIANI, G., KONNERTZ, W., and THOMAS, K. *Joseph Beuys: Life and Works.* Woodbury, N.Y., 1979.
SHARP, W. "An Interview with Joseph Beuys." *Artforum,* Dec. 1969, pp. 40–47.
TISDALL, C. *Joseph Beuys.* New York, SRGM, 1979. E.C.
BOCCIONI: BALLO, G. *Umberto Boccioni: La Vita e l'Opera.* Milan, 1964.
TAYLOR, J. C. *The Graphic Work of Umberto Boccioni.* New York, MOMA, 1961. E.C.
BOCHNER: PINCUS-WITTEN, R. "Bochner at MOMA: Three Ideas and Seven Procedures." *Artforum,* Dec. 1971, pp. 28–30.
BOFILL: BERGDALL, B. "Subsidized Doric." *Progressive Architecture,* Oct. 1982, pp. 74–79.
JAMES, W. A., ed. *Ricardo Bofill/Taller de Arquitectura: Buildings and Projects: 1960–1985.* New York, 1986.
NORBERG-SCHULZ, C. *Ricardo Bofill.* New York, 1985. Photography Y. Futagawa.
BONHEUR: ASHTON, D., and HARE, D. *Rosa Bonheur: A Life and a Legend.* New York, 1981.
BONNARD: *Bonnard: The Late Paintings.* Washington, D.C., Phillips Collection, 1984. E.C. Essays by J. Russell, S. A. Nash, J. Clair, A. Terrasse, H. Hahnloser-Ingold, J.-F. Chevrier.
Bonnard and his Environment. New York, MOMA, 1964. Texts by J. T. Soby, J. Elliott, M. Wheeler.
REWALD, J. *Pierre Bonnard.* New York, MOMA, 1948. E.C.
BOROFSKY: DANTO, C. "Jonathan Borofsky." *The Nation,* Feb. 2, 1985, pp. 121–24.
FREEDMAN, A. M. "Molecule Man Goes to a Museum." *Wall Street Journal,* Nov. 16, 1984, p. 28.
GIBSON, E. "The Borofsky Spectacle." *The New Criterion,* Feb. 1985, pp. 70–72.
GLUECK, G. "The Showmanship of Jonathan Borofsky in a Whitney Retrospective." *New York Times,* Dec. 28, 1984, p. C27.
KNIGHT, C. "Brainstorming with Borofsky." *Vanity Fair,* Sept. 1984, pp. 96–98.
LARSON, K. Review. *New York Magazine,* Jan. 29, 1985, p. 79.
MCGILL, D. C. "Borofsky Still Counting and Painting." *New York Times,* Dec. 28, 1984, p. C32.
ROSENTHAL, M., and MARSHALL, R. *Jonathan Borofsky.* New York, 1984.
RUSSELL, J. "Of Jonathan Borofsky." *New York Times,* Oct. 24, 1980, p. C23.
———. "Jon Borofsky Show." *New York Times,* Nov. 18, 1983.
ZIMMER, W. "Portrait of the Artist as a One-Man World." *New York Times,* Jan. 20, 1985, sect. 2, pp. 1, 27.
BOTERO: *Botero.* Munich, 1970. E.C. Baden-Baden, Staatliche Kunsthalle. Introduction K. Gallwitz et al.
RESTANY, P. *Botero.* New York, 1984.
BOURDELLE: JIANU, I. *Bourdelle.* New York, 1966.
Antoine Bourdelle. New York, The Charles E. Slatkin Galleries, 1961. E.C. Texts by P. R. Adams, J. Cassou, and J. Charbonneaux.
BOURGEOIS: BRENSON, M. "Louise Bourgeois." *New York Times,* May 23, 1986, p. C24.
GOROVOY, J. *The Iconography of Louise Bourgeois.* New York, 1980. E.C.
LIPPARD, L. "Louise Bourgeois: From the Inside Out." *Artforum,* March 1975, pp. 26–33.
RUBIN, W. "Some Reflections Prompted by the Recent

Work of Louise Bourgeois." *Art International*, April 20, 1969, pp. 17–20.

WYE, D. *Louise Bourgeois*. New York, MOMA, 1982. E.C.

BOURKE-WHITE: GOLDBERG, V. *Margaret Bourke-White*. New York, 1986.

SILVERMAN, J. *For the World to See: The Life of Margaret Bourke-White*. New York, 1983.

WITKIN, L. D., and LONDON, B. "Margaret Bourke-White," in *The Photograph Collector's Guide*, pp. 90–91.

BRADY: MEREDITH, R. *Mathew Brady's Portrait of an Era*. New York, 1982.

WITKIN, L. D., and LONDON, B. "Mathew Brady," in *The Photograph Collector's Guide*, pp. 92–93. Boston, 1979.

BRAGAGLIA: ROSENBLUM, N. *A World History of Photography*, p. 398. New York, 1984.

BRANCUSI: GEIST, S. *Brancusi*. New York, 1975.

———. "Brancusi," in W. Rubin, ed., *"Primitivism" in 20th-Century Art*, vol. 2, pp. 344–67. New York, MOMA, 1984. E.C.

GIEDION-WELCKER, C. *Brancusi: 1876–1957*. New York, 1959.

BRANDT: WITKIN, L. D., and LONDON, B. "Bill Brandt," in *The Photograph Collector's Guide*, p. 65. Boston, 1979.

BRAQUE: CHIPP, H. *Georges Braque: The Late Paintings, 1940–1963*. Washington, D.C., Phillips Collection, 1982. E.C.

COGNIAT, R. *Braque*. New York, 1986.

COOPER, D. *Braque, The Great Years*. Art Institute of Chicago, 1972. E.C.

HOFMANN, W. *Georges Braque: His Graphic Work*. New York, 1961.

HOPE, H. R. *Georges Braque*. New York, MOMA, 1949. E.C.

MANGIN, N. S., ed. *G. Braque: Catalogue de l'oeuvre: Peintures: 1928–57*. Paris, 1959.

MONOD-FONTAINE, I., and CARMEAN, JR., E. A. *Braque: The Papiers Collés*. Washington, D.C., National Gallery, 1982. E.C. Essay by A. Martin.

RICHARDSON, J. G. *Braque*. Greenwich, Conn., 1961.

RUBIN, W. "Cézannism and the Beginning of Cubism," in W. Rubin, ed., *Cézanne: The Late Work*, pp. 151–202. New York, MOMA, 1977. E.C.

———. "Pablo and Georges and Leo and Bill." *Art in America*, March 1979, pp. 114–27.

BRASSAÏ: DURRELL, L. *Brassaï*. New York, MOMA, 1968. E.C.

WITKIN, L. D., and LONDON, B. "Brassaï," in *The Photograph Collector's Guide*, pp. 94–95. Boston, 1979.

BRAUNER: HOFMANN, W. *Victor Brauner*. Amsterdam, Stedelijk Museum, 1965–66. E.C.

BRAVO: SULLIVAN, E. *Claudio Bravo*. New York, 1986.

WILLIAMS, S. "Claudio Bravo," in E. Emanuel et al., eds. *Contemporary Artists*, 2d ed., p. 133. London and New York, 1983.

BRETON: BRETON, A. *Le Surréalisme et la peinture*. New York, 1945. Updated by his *Le Surréalisme en 1947*. Paris, Galerie Maeght, 1947. E.C.

———. *Les Manifestes du surréalisme*. Rev. ed. Paris, 1955. *Homage to André Breton*. Milan, Galleria Schwarz, 1967.

BREUER: ARGAN, G. C. *Marcel Breuer*. Milan, 1955.

BLAKE, P. *Marcel Breuer: Architect and Designer*. New York, MOMA, 1949. E.C.

BROOKS: ARNASON, H. H. "James Brooks." *Art International*, March 1963, pp. 17–22.

HUNTER, S. *James Brooks*. New York, WMAA, 1963. E.C.

BURCHFIELD: BAUR, J. I. H. *Charles Burchfield*. WMAA, 1956. E.C.

BURDEN: BURDEN, C., and BUTTERFIELD, J. "Through the Night Softly," in G. Battcock and R. Nickas, *The Art of Performance: A Critical Anthology*, pp. 222–39. New York, 1984.

BUREN: BOURDON, D. "An Apocalyptic Paperhanger Shows His Stripes." *Village Voice*, Oct. 4, 1976, p. 10.

BUREN, D. "Notes on Work and Installation." *Studio International*, Sept.–Oct. 1975, pp. 124–29.

DEITCH, J. "Daniel Buren: Painting Degree Zero." *Arts*, Oct. 1976, pp. 88–91.

HUGHES, R. "Eight Cool Contemporaries." *Times*, Nov. 11, 1974, pp. 98, 100.

PERREAULT, J. "Daniel Buren." *Soho Weekly News*, Oct. 5, 1978, p. 95.

BURTON: SCHJELDAHL, P. "Scott Burton Chairs the Discussion." *Village Voice*, June 1, 1982, p. 86.

Scott Burton: Pair Behaviour Tableau. New York, SRGM, 1976. Text by L. Shearer. E.C.

Scott Burton. London, Tate Gallery, 1985. E.C.

SENIE, H. "Scott Burton," in *Sculpture for Public Spaces: Maquettes, Models, and Proposals*. New York, Marisa del Re Gallery, 1985. E.C.

TUCHMAN, P. "Scott Burton," in *Art of Our Time: The Saatchi Collection*. London and New York, 1984. Vol. 4, p. 22.

CALDER: ARNASON, H. H., and GUERRERO, P. E. *Calder*. Princeton, N.J., 1966.

——— and MULAS, U., eds. *Calder*. New York, 1971.

CALDER, A. *Calder: An Autobiography with Pictures*. New York, 1966.

LIPMAN, J. *Calder's Universe*. New York, 1977.

———. *Calder Creatures: Great and Small*. New York, 1985.

MESSER, T. M. *Alexander Calder: A Retrospective Exhibition*. New York, SRGM, 1964. E.C.

SWEENEY, J. J. *Alexander Calder*. New York, MOMA, 1951. E.C.

CALLAHAN: SZARKOWSKI, J., ed. *Callahan*. New York, 1976.

WITKIN, L. D., and LONDON, B. "Harry Callahan," in *The Photograph Collector's Guide*, p. 101. Boston, 1979.

CAMERON: FORD, C. *The Cameron Collection: An Album of Photographs by Julia Margaret Cameron Presented to Sir John Herschel*. New York and London, 1975.

GERNSHEIM, H. *Julia Margaret Cameron: Pioneer of Photography*. London and New York, 1975.

WITKIN, L. D., and LONDON, B. "Julia Margaret Cameron," in *The Photograph Collector's Guide*, p. 30. Boston, 1979.

CAPA: ROSENBLUM, N. *A World History of Photography*, pp. 475–76. New York, 1984.

SZARKOWSKI, J. *Looking at Photographs*, p. 146. Boston and New York, 1973.

CAPONIGRO: ROSENBLUM, N. *A World History of Photography*, p. 516. New York, 1984.

SZARKOWSKI, J. *Looking at Photographs*, p. 192. Boston and New York, 1973.

WITKIN, L. D., and LONDON, B. "Paul Caponigro," in *The Photograph Collector's Guide*, p. 107. Boston, 1979.

CARO: RUBIN, W. *Anthony Caro*. New York, MOMA, 1975. E.C.

WALDMAN, D. *Anthony Caro*. New York, 1982.

WHELAN, R. *Anthony Caro*. Harmondsworth, 1974. Additional texts by C. Greenberg, M. Fried, J. Russell, P. Tuchman.

CARRÀ: CARRÀ, C., et al. *Le Néoclassicisme dans l'art contemporain*. Rome, 1923.

PACCHIONI, G. *Carlo Carrà*. Milan, 1959.

CARTIER-BRESSON: CARTIER-BRESSON, H. *The World of Henri Cartier-Bresson*. New York, 1968.

Henri Cartier-Bresson: Photographs. Boston, 1979.

WITKIN, L. D., and LONDON, B. "Henri Cartier-Bresson," in *The Photograph Collector's Guide*. Boston, 1979.

CASSATT: BREESKIN, A. D. *Mary Cassatt: A Catalogue Raisonné of the Oils, Pastels, Watercolors, and Drawings*. Washington, D.C., 1970.

GETLEIN, F. *Mary Cassatt: Paintings and Prints*. New York, 1980.

CÉZANNE: ADRIANI, G. *Cézanne Watercolors*. New York, 1983.

———. *Paul Cézanne: The Watercolors, a Catalogue raisonné*. Boston, 1983.

———. *Cézanne: A Biography*. New York, 1986.

The Complete Paintings of Cézanne. Harmondsworth, 1985. Introduction I. Dunlop; notes and catalogue S. Orienti.

REWALD, J., ed. *Paul Cézanne: Letters*. New York, 1941.

RUBIN, W., ed. *Cézanne: The Late Work*. New York, MOMA, 1977. E.C. Essays by T. Reff, L. Gowing, L. Brion-Guerry, J. Rewald, F. Novotny, G. Monnier, D. Druick, G.H. Hamilton, W. Rubin.

SCHAPIRO, M. *Paul Cézanne*. 3d ed. New York, 1965.

SHIFF, R. *Cézanne and the End of Impressionism*. Chicago, 1984.

VENTURI, L. *Cézanne: Son art, son oeuvre*. 2 vols. Paris, 1936.

WECHSLER, J., ed. *Cézanne in Perspective*. Englewood Cliffs,

N.J., 1975.

CHADWICK: HODIN, J. P. *Chadwick*. New York, 1961.

READ, H. *Lynn Chadwick*. Amriswil, Switzerland, 1958.

CHAGALL: HAFTMANN, W. *Chagall*. New York, 1984.

———. *Marc Chagall: Gouaches, Drawings, Watercolors*. New York, 1984.

MEYER, F. *Marc Chagall*. New York, 1963.

MOURLOT, F. *Chagall: Lithographs*. 2 vols. New York, 1960–63.

CHAMBERLAIN: ROSE, B. "On Chamberlain's Interview." *Artforum*, Feb. 1972, pp. 44–45.

SYLVESTER, J. *John Chamberlain: A Catalogue Raisonné of the Sculpture, 1954–1985*. New York, 1986. Essay by K. Kertess.

CHIA: HUGHES, R. "Doing History as Light Opera." *Time*, May 16, 1983, p. 79.

KOHN, M. "Sandro Chia." *Flash Art*, Jan. 1983, pp. 63–64.

RAYNOR, V. "Neo-Expressionists or Neo-Surrealists." *New York Times*, May 13, 1983, p. C27.

RUSSELL, J. "The New Expressionist Painters." *New York Times Magazine*, April 2, 1983, p. 71.

SMITH, R. "Kieferland." *Village Voice*, Nov. 30, 1982, p. 113.

TULLY, J. "A New European Expression." *Horizon*, Jan.–Feb. 1984, p. 45.

CHILLIDA: SELZ, P., and SWEENEY, J. J. *Chillida*. New York, 1986.

SWEENEY, J. J. *Eduardo Chillida*. Houston, Museum of Fine Arts, 1966. E.C.

DE CHIRICO: OLIVA, A. B. *Warhol vs. De Chirico*. New York, Marisa del Re Gallery, 1985. E.C. Interview with A. Warhol; introduction C. Bruni Sakroischik.

PINCUS-WITTEN, R. *Giorgio de Chirico: Post-Metaphysical and Baroque Paintings, 1920–1970*. New York, Robert Miller Gallery, 1984. E.C.

RUBIN, W., ed. *De Chirico*. New York, MOMA, 1982. E.C. Essay by F. dell'Arco.

SOBY, J. T. *Giorgio de Chirico*. New York, MOMA, 1955. E.C.

CHRISTO: ALLOWAY, L. *Christo*. New York, 1969.

BOURDON, D. *Christo*. New York, 1972.

Christo: Valley Curtain, Rifle, Colorado, 1970–72. New York, 1973. Photography H. Shunk.

Christo: Surrounded Islands, Biscayne Bay, Greater Miami, Florida, 1980–1983. New York, 1985. Photography W. Volz; texts by D. Bourdon, J. Fineberg, J. Mulholland.

FINEBERG, J. "Theater of the Real: Thoughts on Christo." *Art in America*, Dec. 1979, pp. 92–99.

HOELTERHOFF, M. "Tropical Poetry: Christo's 'Surrounded Islands.'" *Wall Street Journal*, May 13, 1983, p. 29.

RATCLIFF, C. "Unwrapping Christo." *Saturday Review*, Dec. 1980, pp. 18–22.

SPIES, W., and VOLZ, W. *The Running Fence: Christo*. New York, 1977.

TOMKINS, C. "Onward and Upward with the Arts: Running Fence." *The New Yorker*, March 28, 1977, pp. 43–46.

——— and BOURDON, D. *Christo's Running Fence*. New York, 1978. Photography G. Gorgoni.

CLEMENTE: AUPING, M. *Francesco Clemente*. New York, 1985.

———. "Francesco Clemente," in *Art of Our Time: The Saatchi Collection*, vol. 4, pp. 32–33. London and New York, 1984.

GARDNER, P. "Gargoyles, Goddesses, and Faces in the Crowd." *Art News*, March 1985, pp. 52–59.

HUGHES, R. "Symbolist with Roller Skates." *Time*, April 22, 1985, p. 68.

LARSON, K. "The New Erraticism." *New York Magazine*, April 15, 1985, p. 102.

RUSSELL, J. "The New European Painters." *New York Times Magazine*, April 24, 1983, pp. 28–33.

CLERGUE: WITKIN, L. D., and LONDON, B. "Lucien Clergue," in *The Photograph Collector's Guide*, p. 111. Boston, 1979.

CLOSE: DYCKES, W. "The Photo as Subject: The Paintings and Drawings of Chuck Close." *Arts*, Feb. 1974, pp. 28–33.

FLAM, J. "Chuck Close Discovers Fingerpainting." *Wall Street Journal*, March 19, 1986, p. 28.

KRAMER, H. "Chuck Close: In Flight from the Realist Impulse." *New York Times*, Nov. 4, 1979, pp. D33, 35.

LEVIN, K. "Chuck Close: Decoding the Image." *Arts*, June 1978, pp. 146–49.

LYONS, L., and MARTIN, F. *Close Portraits.* Minneapolis, Walker Art Center, 1980. E.C.

MEISEL, L. "Chuck Close," in *Photorealism*, pp. 109–44. New York, 1980.

NEMSER, C. "An Interview with Chuck Close." *Artforum*, Jan. 1970, pp. 51–55.

COBURN: GERNSHEIM, H. and A., eds. *Alvin Langdon Coburn, Photographer: An Autobiography.* Rev. ed. New York, 1978.

WITKIN, L. D., and LONDON, B. "Alvin Langdon Coburn," in *The Photograph Collector's Guide*, p. 112. Boston, 1979.

COE: BRENSON, M. "Art of Protest Attempts to Shock and Mobilize." *New York Times*, April 19, 1985, p. C22.

BROOKS, V. "Sue Coe." *M.D.*, Sept. 1983, pp. 33–37.

LARSON, K. "Sue Coe." *New York Magazine*, May 20, 1985, p. 101.

PRINCENTHAL, N. "Sue Coe." *Art News*, Sept. 1985, pp. 135–36.

O'BRIEN, G. "Sue Coe, P.P.O.W. Gallery." *Artforum*, Feb. 1984, p. 75.

LE CORBUSIER (Charles-Edouard Jeanneret): BOESIGER, W. *Le Corbusier & Pierre Jeanneret: Oeuvre complète.* 6 vols. Zurich, 1937–57.

CHOAY, F. *Le Corbusier.* New York, 1960.

LE CORBUSIER. *The City of Tomorrow and Its Planning.* New York, 1929.

———. *Towards a New Architecture.* 2d ed. New York, 1946.

GARDINER, S. *Le Corbusier.* New York, 1975.

PAPADAKI, S., ed. *Le Corbusier: Architect, Painter, Writer.* New York, 1948.

CORNELL: ASHTON, D. *A Joseph Cornell Album.* New York, 1974.

McSHINE, K., ed. *Joseph Cornell.* New York, MOMA, 1980. E.C.

PORTER, F. *Joseph Cornell.* Pasadena Art Museum, 1966–67. E.C.

WALDMAN, D. *Joseph Cornell.* New York, SRGM, 1967. E.C.

COURBET: BOAS, G. *Courbet and the Naturalistic Movement.* Baltimore, 1938.

BOWNESS, A. *Gustave Courbet: 1819–1877.* London, Arts Council of Great Britain, 1978. E.C. Catalogue H. Toussaint.

CHU, P. T. D., ed. *Courbet in Perspective.* Englewood Cliffs, N.J., 1977.

MACK, G. *Gustav Courbet.* London, 1951.

Courbet. Philadelphia Museum of Art, Philadelphia, 1959. E.C.

CRAGG: CELANT, G. "Tony Cragg and Industrial Platonism." *Artforum*, Nov. 1981, pp. 40–46.

FEAVER, W. "The New British Sculpture." *Art News*, Jan. 1984, pp. 71–75.

NEWMAN, M. "New Sculpture in Britain." *Art in America*, Sept. 1982, pp. 104–14, 177–79.

———. "Discourse and Desire: Recent British Sculpture." *Flash Art*, Jan. 1984, pp. 48–55.

RUSSELL, J. "Tony Cragg." *New York Times*, March 21, 1986, p. 24.

CRAWFORD: ARNASON, H. H. *Ralston Crawford.* New York, 1963.

CUCCHI: GLUECK, G. "Apocalyptic Vision in Cucchi's Paintings." *New York Times*, Nov. 16, 1984, p. C22.

LEVIN, K. "Enzo Cucchi: Vitebsk Harar." *Village Voice*, Nov. 27, 1984, p. 80.

RUSSELL, J. "The New European Painters." *New York Times Magazine*, April 24, 1983, pp. 28–33.

WALDMAN, D. *Enzo Cucchi.* New York, 1983.

WARREN, R. "Enzo Cucchi." *Arts*, Jan. 1985, p. 38.

CUNNINGHAM: MANN, M. *Imogen Cunningham: Photographs.* Seattle, 1970.

WITKIN, L. D., and LONDON, B. "Imogen Cunningham," in *The Photograph Collector's Guide*, p. 115. Boston, 1979.

DAGUERRE: GERNSHEIM, H. and A. *L.J.M. Daguerre: The History of the Diorama and the Daguerreotype.* Reprint. New York, 1968.

DALI: DALI, S. *The Secret Life of Salvador Dali.* Enl. ed. New York, 1961.

DESCHARNES, R. *The World of Salvador Dali.* New York, 1962.

———. *Dali: The Work, the Man.* New York, 1984.

GERARD, M., ed. *Dali.* New York, 1968.

SOBY, J. T. *Paintings, Drawings, Prints: Salvador Dali.* 2d rev. ed. New York, MOMA, 1946. E.C.

Salvador Dali 1910–1965. New York, Gallery of Modern Art, 1965. E.C. With statement by the artist.

DARBOVEN: COPLANS, J. "Serial Imagery." *Artforum*, Oct. 1968, pp. 34–43.

CRIMP, D. "Hanne Darboven." *Art News*, Summer 1972, p. 100.

JAPPE, G. "Young Artists in Germany." *Studio International*, Feb. 1972, pp. 65–72.

LIPPARD, L. R. "Hanne Darboven: Deep in Numbers." *Artforum*, Oct. 1973, pp. 35–39.

THWAITES, J. A. "The Numbers Game." *Art and Artists*, Jan. 1972, pp. 24–25.

DAUMIER: ADHEMAR, J. *Honoré Daumier.* Paris, 1954.

REY, R. *Daumier.* New York, 1985.

DAVID: BROOKNER, A. *Jacques-Louis David.* London, 1980.

DOWD, D. L. *Pageant-Master of the Republic: Jacques-Louis David and the French Revolution.* Lincoln, Neb., 1848.

HAUTECOEUR, L. *Louis David.* Paris, 1954.

DE NANTEUIL, L. *David.* New York, 1985.

SCHNAPPER, A. *David.* New York, 1980.

DAVIE: BOWNESS, A. *Alan Davie.* London, 1967.

DAVIS, GENE: ROSE, B. "A Conversation with Gene Davis." *Artforum*, March 1971, pp. 50–54.

WASSERMAN, E. "Robert Irwin, Gene Davis, Richard Smith." *Artforum*, May 1968, pp. 47–49.

DAVIS, STUART: ARNASON, H. H. *Stuart Davis.* Minneapolis, Walker Art Center, 1957. E.C.

———. *Stuart Davis. 1894–1964. Memorial Exhibition.* Washington, D.C., Smithsonian Institution, 1965. E.C.

GOOSSEN, E. C. *Stuart Davis.* New York, 1959.

LANE, J. R. *Stuart Davis: Art and Art Theory.* Brooklyn Museum, 1978. E.C.

SIMS, P. *Stuart Davis.* New York, WMAA, 1980.

DEACON: COOKE, L. "Richard Deacon," in *Art of Our Time: The Saatchi Collection*, vol. 4, pp. 34–35. London and New York, 1984.

FRANCIS, R. *Richard Deacon.* London, Tate Gallery Publication, March 1985.

McEWEN, J. "Report from London." *Art in America*, Nov. 1984, p. 33.

NEWMAN, M. "New Sculpture in Britain." *Art in America*, Sept. 1982, pp. 104–14, 177–79.

DEGAS: BOGGS, J. S. *Portraits by Degas.* Berkeley, Cal., 1962.

GUÉRIN, M., ed. *Degas Letters.* Oxford, 1947.

LEMOISNE, P.-A. *Degas et son oeuvre.* 4 vols. Paris, 1946–48.

REFF, T. *Degas: The Artist's Mind.* New York, 1976.

REWALD, J., and MATT, L. VON. *Degas: Sculpture, the Complete Works.* New York, 1956.

RICH, D. C. *Degas.* New York, 1985.

SUTTON, D. *Edgar Degas: Life and Work.* New York, 1986.

DE KOONING: GAUGH, H. *Willem de Kooning.* New York, 1983.

HESS, T. B. *Willem de Kooning.* New York, MOMA, 1968. E.C.

LARSON, P., and SCHJELDAHL, P. *De Kooning: Drawings/Sculptures.* Minneapolis, Walker Art Center, 1974. E.C.

ROSENBERG, H. *De Kooning.* New York, 1974.

ROSENBLUM, R. "The Fatal Women of Picasso and De Kooning." *Art News*, Oct. 1985, pp. 98–103.

Willem de Kooning. New York, WMAA, 1983. E.C. Essays by P. Cummings, J. Merkert, C. Stoullig.

DELACROIX: BAUDELAIRE, C. *Delacroix, His Life and Work.* New York, 1927.

CASSOU, J. *Delacroix. (Les demi-dieux).* Paris, 1947.

HUYGHE, R. *Delacroix.* New York, 1963.

JOHNSON, L. *The Paintings of Eugène Delacroix: A Critical Catalogue, 1816–1831.* 2 vols. Oxford, 1981.

LASSAIGNE, J. *Eugène Delacroix.* New York, 1950.

TRAPP, F. A. *The Attainment of Delacroix.* Baltimore, 1971.

The Journal of Eugène Delacroix. New York, 1972. Introduction R. Motherwell.

DELAUNAY: DELAUNAY, R. *Du Cubisme à l'art abstrait, documents inédits.* Edited by P. Francastel. Paris, 1957.

Robert et Sonia Delaunay. Ottawa, National Gallery of Canada, 1965. E.C.

DELVAUX: DE BOCK, P. A. *Paul Delvaux.* Hamburg, 1965.

DE MARIA: ADRIAN, D. "Walter De Maria: Word and Thing." *Artforum*, Jan. 1967, pp. 28–29.

BEARDSLEY, J. *Earthworks and Beyond: Contemporary Art in the Landscape*, pp. 59–63. New York, 1984.

BOURDON, D. "Walter De Maria: The Singular Experience." *Art International*, Dec. 20, 1968, pp. 39–43, 72.

LEDER, D. "Walter De Maria: Mounds, Mines, Markers." *America*, March 15, 1980, pp. 219–20.

WORTZ, M. "Walter De Maria's 'Lightning Field.'" *Arts Magazine*, May 1980, pp. 170–73.

DEMUTH: RITCHIE, A. C. *Charles Demuth.* New York, MOMA, 1950. E.C. With a tribute to the artist by Marcel Duchamp.

DENIS: DENIS, M. *Théories 1890–1910.* 4th ed. Paris, 1920.

———. *Journal. 1884–1943.* 3 vols. Paris, 1957–59.

DERAIN: DIEHL, G. *Derain.* New York, 1964.

SUTTON, D. *André Derain.* London, 1959.

DESPIAU: GEORGE, W. *Despiau.* New York, 1959.

DE STAËL: GINDERTAEL, R. V. *De Staël: A Retrospective Exhibition.* Boston, Museum of Fine Arts, 1965. E.C.

DIBBETS: BOICE, B. "Jan Dibbets: The Photograph and the Photographed." *Artforum*, April 1973, pp. 45–49.

FUCHS, R. H. "Modes of Visual Experience: New Works by Jan Dibbets." *Studio International*, Jan. 1973, p. 37.

HALL, C. "Environmental Artists: Sources and Directions," in A. Sonfist, ed., *Art in the Land*, pp. 20–23. New York, 1983.

REISE, B. "Jan Dibbets: A Perspective Correction." *Art News*, Summer 1972, pp. 38–41.

DICKINSON: GOODRICH, L. *Edwin Dickinson.* New York, WMAA, 1965. E.C.

DIEBENKORN: ASHTON, D. *Richard Diebenkorn: Small Paintings from "Ocean Park."* Lincoln Neb., Sheldon Memorial Art Gallery, 1985. E.C.

BUCK, JR., R. T. *Richard Diebenkorn: Paintings and Drawings: 1943–1976.* Buffalo, Albright-Knox Art Gallery, 1976. E.C. Essays by L. Cathcart, G. Nordland, M. Tuchman.

DILLER: LARSON, P. *Burgoyne Diller: Paintings, Sculpture, Drawings.* Minneapolis, Walker Art Center, 1971. E.C.

TROY, N. J. "Burgoyne Diller," in J. R. Lane and S. Larsen, eds., *Abstract Painting in America: 1927–1944.* Pittsburgh, Museum of Art, Carnegie Institute, 1983. E.C.

DINE: GLENN, C. W. *Jim Dine Drawings.* New York, 1985.

GORDON, J. *Jim Dine.* New York, WMAA, 1970. E.C.

SHAPIRO, D. *Jim Dine: Painting What One Is.* New York, 1981.

DI SUVERO: MONTE, J. K. *Mark di Suvero.* New York, WMAA, 1975. E.C.

DIX: *Otto Dix: Gemälde und Graphik von 1912–1957.* Berlin, Deutsche Akademie der Künste, 1957. E.C.

DOISNEAU: WITKIN, L. D., and LONDON, B. "Robert Doisneau," in *The Photograph Collector's Guide*, p. 126. Boston, 1979.

VAN DONGEN: *Van Dongen.* Albi, Musée Toulouse-Lautrec, 1960. E.C.

DOVE: HASKELL, B. *Arthur Dove.* San Francisco Museum of Art, 1974. E.C.

JOHNSON, D. R. *Arthur Dove: The Years of Collage.* College Park, University of Maryland Art Gallery, 1967. E.C.

WIGHT, F. S. *Arthur G. Dove.* Berkeley and Los Angeles, 1958. E.C. Introduction D. Phillips.

DUBUFFET: ALLOWAY, L. *Jean Dubuffet. 1962–66.* New York, SRGM, 1966. E.C. With statement by the artist.

FRANZKE, A. *Dubuffet.* New York, 1981.

LOREAU, M. *Catalogue intégral des travaux de Jean Dubuffet.* 34 vols. Paris, 1964–ongoing.

SELZ, P. *The Work of Jean Dubuffet.* New York, MOMA, 1962. E.C. With texts by the artist.

Jean Dubuffet: A Retrospective. New York, SRGM, 1973. E.C. Introduction T. M. Messer; essay by M. Rowell; statements by the artist.

DUCHAMP: CLAIR, J. *Marcel Duchamp: Catalogue Raisonné.* Paris, Musée National d'Art Moderne, Centre Georges Pompidou, 1977. E.C.

D'HARNONCOURT, A., and McSHINE, K., eds. *Marcel Duchamp.* New York, MOMA and Philadelphia Museum of Art, 1973. E.C.

HAMILTON, R. *Almost Complete Works of Marcel Duchamp.* London, The Tate Gallery, Arts Council, 1966. E.C.

LEBEL, R. *Marcel Duchamp.* New York, 1959. With chapters by M. Duchamp, A. Breton, H. P. Roche.

MASCHEK, J., ed. *Marcel Duchamp in Perspective.* Englewood Cliffs, N.J., 1974.

PAZ, O. *Marcel Duchamp: Appearance Stripped Bare.* New York, 1978.

SCHWARZ, A. *The Complete Works of Marcel Duchamp.* New York, 1969.

DUCHAMP-VILLON: PACH, W. *Raymond Duchamp-Villon, sculpteur (1876–1918).* Paris, 1924. With writings by the artist.

SWEENEY, J. J. *Jacques Villon, Raymond Duchamp-Villon, Marcel Duchamp.* New York, SRGM, 1957. E.C. *Duchamp-Villon.* Paris, Galerie Louis Carré, 1963. E.C. *Duchamp-Villon. Le Cheval Major.* Paris, Galerie Louis Carré, 1966. E.C.

DUFY: GOGNIAT, R. *Raoul Dufy.* New York, 1962.

McEWEN, J. "The Other Raoul Dufy." *Art in America,* March 1984, pp. 120–27.

ROBERTSON, B., and WILSON, S., eds. *Raoul Dufy.* London, Hayward Gallery, 1983. E.C.

WERNER, A. *Raoul Dufy.* New York, 1970.

EAKINS: GOODRICH, L. *Thomas Eakins.* 2 vols. Cambridge, Mass., 1982.

SEWELL, D. *Thomas Eakins: Artist of Philadelphia.* Philadelphia Museum of Art, 1982. E.C.

EDDY: ABADIE, D. "Don Eddy," in E. Emanuel et al., eds., *Contemporary Artists.* 2d ed., p. 281. London and New York, 1983.

FOOT, N. "The Photo-Realists: Twelve Interviews." *Art in America,* Nov.–Dec. 1972, pp. 80–81 (artist's statement).

LUBELL, E. "Don Eddy." *Arts Magazine,* May 1976, p. 26.

MEISEL, L. K. "Don Eddy," in *Photorealism,* pp. 175–208. New York, 1978.

EIFFEL: BRESSET, M. *Gustave Eiffel. 1832–1923.* Milan, 1957.

ENSOR: FARMER, J. D. *Ensor.* New York, SRGM, 1976. E.C.

HAESAERTS, P. *James Ensor.* New York, 1959.

TANNENBAUM, L. *James Ensor.* New York, MOMA, 1951. E.C.

EPSTEIN: BUCKLE, R. *Jacob Epstein, Sculptor.* London, 1963. *J. Epstein: an Autobiography.* New York, 1955. Revised and extended version of *Let There Be Sculpture.* London, 1940.

ERNST: ERNST, M. *Beyond Painting, and Other Writings by the Artist and His Friends.* New York, 1948.

HUNTER, S., ed. *Max Ernst: Sculpture and Recent Painting.* New York, Jewish Museum, 1966. E.C. With introductory essays by L. R. Lippard, A. P. de Mandiargues, J. Russell, and a statement by the artist.

LIEBERMAN, W. S., ed. *Max Ernst.* New York, MOMA, 1961. E.C.

RUSSELL, J. *Max Ernst: Life and Work.* New York, 1967.

SPIES, W. *Max Ernst: Loplop, the Artist in the Third Person.* New York, 1983.

Max Ernst: A Retrospective. New York, SRGM, 1975. E.C.

ESTES: CANADAY, J. *Richard Estes: The Urban Landscape.* Boston, Museum of Fine Arts, 1978. E.C. Interview by J. Arthur.

MEISEL, L. K. "Richard Estes," in *Photorealism,* pp. 209–31. New York, 1978.

———. *Richard Estes: The Complete Paintings 1966–1985.* New York, 1986. With an essay by J. Perreault.

EVANS: SZARKOWSKI, J. *Walker Evans.* New York, MOMA, 1971. E.C.

WITKIN, L. D., and LONDON, B. "Walker Evans," in *The Photograph Collector's Guide,* p. 135. Boston, 1979.

FAHLSTRÖM: *Pentacle.* Olle Baertling, Oyvind Fahlström, Carl Fredrik Reuterswärd, Max Walter Svanberg, Olof Ultvedt. Paris, Musée des Arts Decoratifs, 1968. E.C.

FAUTRIER: RAGON, M. *Fautrier.* New York, 1958.

FEELEY: BARO, G. *Paul Feeley, 1910–1966: A Memorial Exhibition.* New York, SRGM, 1968. E.C.

FEININGER: HESS, H. *Lyonel Feininger.* New York, 1961.

MILLER, D. I., ed. *Lyonel Feininger.* New York, MOMA, 1944. With essays by A. J. Schardt and A. H. Barr, Jr., and excerpts from the artist's letters.

FERBER: ANDERSON, W. V. *Ferber.* Minneapolis, Walker Art Center, 1962. E.C.

GOOSEN, E. C., GOLDWATER, R., and SANDLER, I. *Three American Sculptors: Ferber, Hare, Lassaw.* New York, 1959.

FETTING: BUSCHE, E. "Violent Painting." *Flash Art,* Jan.–Feb. 1981, pp. 27–31.

KUSPIT, D. "Acts of Aggression: German Painting Today, Part II." *Art in America,* Jan. 1983, pp. 132–33.

LIEBMAN, L. "Rainer Fetting at Mary Boone." *Art in America,* Feb. 1982, pp. 140–41.

LUCIE-SMITH, E. "Rainer Fetting." *Art International,* Aug.–Sept. 1981, pp. 66–68.

RUSSELL, J. "Rainer Fetting." *New York Times,* Dec. 11, 1981, p. C26.

———. "The New European Painters." *New York Times Magazine,* April 24, 1983, pp. 28–33.

SARNOFF, R. *Rainer Fetting.* New York, Marlborough Gallery, 1984. E.C.

SEYMOUR, A. *Rainer Fetting.* London, 1982. E.C.

TULLY, J. "A New Expression." *Horizon,* Jan.–Feb. 1984, pp. 38–47.

FISCHL: "Expressionism Today: An Artists' Symposium." *Art in America,* Dec. 1982, pp. 60–62 (artist's statement).

FERGUSON, B. S. *Eric Fischl.* Saskatoon, Canada, Mendel Art Gallery, 1985. E.C. Essays by J.-C. Ammann, D. B. Kuspit, B. W. Ferguson.

FLAM, J. "Staring at Fischl." *Wall Street Journal,* Jan. 6, 1986, p. 18

STORR, R. "Desperate Pleasures." *Art in America,* Nov. 1984, pp. 124–30.

FISH: GOODYEAR, JR., F. J. *Contemporary American Realism Since 1960,* pp. 30, 153, 163. Boston, 1981.

RUSSELL, J. "Not So Much the Glasses as the Light." *New York Times,* Feb. 22, 1975.

SHIREY, D. "Through a Glass, Brightly." *Arts Magazine,* Feb. 1974, p. 27.

FLACK: ALLOWAY, L. *Audrey Flack: Vanitas.* New York, Louis K. Meisel Gallery, 1978. E.C.

Audrey Flack on Painting. New York, 1981. Introduction L. Alloway, foreword A. S. Harris.

MEISEL, L. K. "Audrey Flack," in *Photorealism,* pp. 241–72. New York, 1978.

NEMSER, C. "Conversation with Audrey Flack." *Arts Magazine,* Feb. 1974, pp. 34–38.

PERREAULT, J. *Audrey Flack: Light and Energy.* New York, Louis K. Meisel Gallery, 1983. E.C.

FLANAGAN, BARRY: COMPTON, M. *Barry Flanagan: Sculpture.* London, British Council, 1982. E.C.

COOKE, L. "Barry Flanagan," in E. Emanuel et al., eds., *Contemporary Artists,* 2d ed., pp. 306–7. London and New York, 1983.

FEAVER, W. "Putting on Hares." *Art News,* April 1982, pp. 181–82.

FLANNAGAN, JOHN: ARNASON, H. H. "John Flannagan: A Reappraisal." *Art in America,* Jan. 1960, pp. 64–69.

MILLER, D. I., ed. *The Sculpture of John B. Flannagan.* New York, MOMA, 1942. E.C.

FLAVIN: BAKER, K. "A Note on Dan Flavin." *Artforum,* Jan. 1972, pp. 38–40.

FRANCIS: SELZ, P. *Sam Francis.* New York, 1975.

FRANK: WITKIN, L. D., and LONDON, B. "Robert Frank," in *The Photograph Collector's Guide,* p. 144. Boston, 1979.

FRANKENTHALER: BELZ, C. *Frankenthaler, the 1950s.* Waltham, Mass., Rose Art Museum, 1981. E.C.

CHAMPA, K. S. "New Work of Helen Frankenthaler." *Artforum,* Jan. 1972, pp. 55–59.

GOOSSEN, E. C. *Helen Frankenthaler.* New York, WMAA and MOMA's International Council, 1969. E.C.

ROSE, B. *Frankenthaler.* New York, 1972.

WILKIN, K. *Frankenthaler: Works on Paper, 1949–84.* New York, SRGM, 1985. E.C.

FREUD: GOWING, L. *Lucien Freud.* New York, 1982.

RUSSELL, J. *Lucien Freud.* London, Hayward Art Gallery, 1974. E.C.

FREUND: FREUND, G. *Gisèle Freund, Photographer.* New York, 1985. Introduction C. Caujolle.

WITKIN, L. D., and LONDON, B. "Gisèle Freund," in *The Photograph Collector's Guide,* pp. 144–45. Boston, 1979.

FRIESZ: GAUTHIER, M., and CAILLER, P. *Othon Friesz.* Geneva, 1957.

FULLER: FULLER, B. *Ideas and Integrities.* Englewood Cliffs, N.J., 1963.

———. *Synergetics.* New York, 1975.

MARKS, R. W. *The Dymaxion World of Buckminster Fuller.* New York, 1960.

McHALE, J. R. *Buckminster Fuller.* New York, 1962.

GABO: GABO, N. *Of Diverse Arts.* New York, 1962.

MACAGY, D. *Plus by Minus: Today's Half-Century.* Buffalo, N.Y. Albright-Knox Art Gallery, 1968. E.C.

PEVSNER, A. *A Biographical Sketch of My Brothers–Naum Gabo and Antoine Pevsner.* Amsterdam, 1964.

Naum Gabo, Antoine Pevsner. New York, MOMA, 1948. E.C. Introduction H. Read; texts by R. Olson and A. Chanin.

Gabo: Constructions, Sculpture, Paintings, Drawings, Engravings. Cambridge, Mass., 1957. Introductory essays by H. Read and L. Martin.

Naum Gabo. London, Tate Gallery, 1966. E.C.

GAUDÍ: COLLINS, G. R. *Antoni Gaudí.* Masters of World Architecture Series. New York, 1960.

LE CORBUSIER. *Gaudí.* Barcelona, 1958. With photographs by Joachim Gomis.

HITCHCOCK, H.-R. *Gaudí.* New York, 1957.

SWEENEY, J. J., and SERT, J. L. *Antoni Gaudí,* New York, 1960.

GAUDIER-BRZESKA: EDE, H. S. *A Life of Gaudier-Brzeska.* London, 1930. American edition as *Savage Messiah.* New York, 1931.

LEVY, M. *Gaudier-Brzeska: Drawings and Sculpture.* London, 1965.

POUND, E. *Gaudier-Brzeska, a Memoir.* London, 1916.

GAUGUIN: ANDERSEN, W. *Gauguin's Paradise Lost.* New York, 1971.

GAUGUIN, P. *The Intimate Journals of Paul Gauguin.* Boston, 1985.

———. *Noa Noa: The Tahitian Journals.* O. F. Theis, translator. Mineola, N.Y., 1985.

Gauguin: Paintings, Drawings, Prints, Sculpture. Art Institute of Chicago, 1959. E.C.

Gauguin and the Pont-Aven Group. London, The Tate Gallery, 1966. E.C. Preface D. Sutton; catalogue R. Pickvance.

GOLDWATER, R. *Paul Gauguin.* New York, 1984.

GRAY, C. *Sculpture and Ceramics of Paul Gauguin.* Baltimore, 1963.

VARNEDOE, K. "Gauguin," in W. Rubin, ed., *"Primitivism" in 20th-Century Art,* vol. 1, pp. 179–209. New York, MOMA, 1984. E.C.

GÉRICAULT: BERGER, K. *Géricault und sein Werk.* Vienna, 1952. Eng. ed. Lawrence, Kan., 1955.

EITNER, L. *Géricault's Raft of the Medusa.* London, 1973.

———. *Géricault: His Life and Work.* London, 1983.

GIACOMETTI: HOHL, R. *Alberto Giacommetti: A Retrospective Exhibition.* New York, SRGM, 1974. E.C.

LORD, J. *Giacometti.* New York, 1985.

SELZ, P. *Alberto Giacometti.* New York, MOMA, 1965. E.C. With autobiographical statement by the artist.

SVENDSEN, L. A. *Alberto Giacommetti: Sculptor and Draftsman.* New York, The American Federation of Art, 1977. E.C.

GILBERT AND GEORGE: PLAGENS, P. "Gilbert & George: How English Is It?" *Art in America,* Oct. 1984, pp. 178–83.

RATCLIFF, C. *Gilbert & George: The Complete Pictures, 1971–1985.* New York, 1986.

RICHARDSON, B. *Gilbert & George.* Baltimore Museum of Art, 1984. E.C.

SCHWARZ, S. "We Are One." *The New Yorker,* Aug. 19, 1985, pp. 74–77.

GILLIAM: BEARDSLEY, J. *Modern Painters at the Corcoran: Sam Gilliam.* Washington, D.C., 1983. E.C.

GLACKENS: GLACKENS, I. *William Glackens and the Ashcan Group.* New York, 1957.

GLEIZES: GLEIZES, A., and METZINGER, J. *Du Cubisme.* Paris, 1912. Rev. ed. 1947.

ROBBINS, D. *Albert Gleizes, 1881–1953: A Retrospective Exhibition.* New York, SRGM, 1964. E.C.

GOINGS: CAVALIERE, B. "Ralph Goings," in E. Emanuel et al., eds., *Contemporary Artists,* 2d ed., pp. 342–43. London

and New York, 1983.

FOOT, N. "The Photo-Realists: Twelve Interviews." *Art in America*, Nov.–Dec. 1972, pp. 88–89 (artist's statement).

MEISEL, L. K. "Ralph Goings," in *Photorealism*, pp. 273–301. New York, 1978.

GOLUB: BRENSON, M. "A Golub Retrospective at the New Museum." *New York Times*, Sept. 28, 1984.

———. "From Leon Golub, Political Thugs Gallery." *New York Times*, Feb. 10, 1984, p. C20.

DANTO, A. "Golub." *The Nation*, Nov. 17, 1984, p. 531.

"Expressionism Today: An Artist's Symposium." *Art in America*, Dec. 1982, p. 64 (artist's statement).

HUGHES, R. "The Human Clay *in Extremis*." *Time*, Dec. 31, 1984, p. 67.

KUSPIT, D. B. *Leon Golub: Existentialist/Activist Painter.* Rutgers, N.J., 1985.

LARSON, K. "Power's Ugly Face." *New York Magazine*, Nov. 26, 1984, pp. 116–18.

LEVIN, K. "Power to the Painter." *Village Voice*, Feb. 28, 1984, p. 79.

SCHJELDAHL, P. "Red Planet." *Village Voice*, Oct. 26, 1982, pp. 96, 111.

GONCHAROVA: DABROWSKI, M. *Contrasts of Form: Geometric Abstract Art, 1910–1980*, p. 253. New York, MOMA, 1985. E.C.

Gontcharova—Larionov. Paris, Musée d'Art Moderne de la Ville de Paris, 1963. E.C.

Gontcharova, Larionov, Mansurov. Bergamo, Galleria Lorenzelli, 1966. E.C.

RUDENSTINE, A. Z., gen. ed. *Russian Avant-Garde Art: The George Costakis Collection*, pp. 106–9. New York, 1985.

GONZÁLEZ: KRAMER, H. "González." *New York Times Magazine*, March 6, 1983, pp. 44–47.

———. *Julio González.* New York, Galerie Chalette, 1961. E.C.

KRAUSS, R. *Julio González: Sculptures and Drawings.* New York, Pace Gallery, 1981. E.C.

RITCHIE, A. C. *Julio González.* New York, MOMA, 1956. E.C. With statements by the artist.

ROWELL, M. *Julio González: A Retrospective.* New York, SRGM, 1983. E.C.

WITHERS, J. *Julio González: Sculpture in Iron.* New York, 1983.

GORIN: *Jean Gorin.* Amsterdam, Stedelijk Museum, 1967. E.C.

GORKY: JORDAN, J. M. *Gorky: Drawings.* New York, M. Knoedler, 1969. E.C.

——— and GOLDWATER, R. *The Paintings of Arshile Gorky: A Critical Catalogue.* New York, 1982.

LADER, M. P. *Gorky.* New York, 1985.

LEVY, J. *Arshile Gorky.* New York, 1976.

RAND, H. *Arshile Gorky: The Implications of Symbols.* Montclair, N.J., 1980.

SCHWABACHER, E. K. *Arshile Gorky.* New York, 1957.

SEITZ, W. C. *Arshile Gorky: Paintings, Drawings, Studies.* New York, MOMA, 1962. E.C.

"Special Issue: Arshile Gorky." *Arts Magazine*, March 1976, pp. 62–110.

WALDMAN, D. *Arshile Gorky 1904–1948: A Retrospective.* New York, SRGM, 1981. E.C.

GOTTLIEB: DOTY, R., and WALDMAN, D. *Adolph Gottlieb.* New York, SRGM and WMAA, 1968. E.C.

HIRSCH, S., and MACNAUGHTON, M. D., eds. *Adolph Gottlieb: A Retrospective.* Washington, D.C., Corcoran Gallery of Art, 1982. E.C.

GOYA: LICHT, F., ed. *Goya in Perspective.* Englewood Cliffs, N.J., 1973.

———. *Goya: The Origins of the Modern Temper in Art.* New York, 1979.

GRAVES, MICHAEL: COLQUHOUN, A., and CARL, P. *Michael Graves.* New York, 1979.

GOLDBERGER, P. "Works of Michael Graves." *New York Times*, May 11, 1979, p. 20.

———. "Architecture of a Different Color." *New York Times Magazine*, Oct. 10, 1982, pp. 42–44, 48–52, 65–66.

HUXTABLE, A. L. "A Unified New Language of Design." *New York Times*, May 27, 1979, pp. 25, 37.

JENCKS, C. *The Language of Post-Modern Architecture.* 4th ed., pp. 6–7. New York, 1984.

TOMKINS, C. "Modern vs. Postmodern." *The New Yorker*, Feb. 17, 1986, pp. 58–66.

TRACHTENBERG, M., and HYMAN, I. *Architecture: From Prehistory to Post-Modernism*, pp. 572–73. New York, 1986.

WHEELER, K., et al., eds. *Michael Graves: Buildings and Projects, 1966–1981.* New York, 1982.

GRAVES, NANCY: BERMAN, A. "Nancy Graves: New Age of Bronze." *Art News*, Feb. 1986, pp. 57–64.

FRANK, E. "Her Own Way: The Daring and Inventive Sculptures of Nancy Graves." *Connoisseur*, Feb. 1986, pp. 54–61.

HESS, T. "Feel of Flying." *New York Magazine*, Feb. 28, 1977, pp. 58–60.

RICKEY, C. "A Project by Nancy Graves." *Artforum*, Summer 1983, pp. 48–52.

ROSE, B. "Nancy Graves." *Vogue*, June 1980, pp. 202–3.

SHAPIRO, M. E. "Nature into Sculpture: Nancy Graves and the Tradition of Direct Casting." *Arts*, Nov. 1984, pp. 92–96.

GREENBLAT: BRENSON, M. "Rodney Alan Greenblat." *New York Times*, March 22, 1985, p. C25.

GARDNER, P. "Rodney Alan Greenblat's Candy-Colored Cartooniverse." *Art News*, Jan. 1986, pp. 105–7.

STORR, R. "Rodney Alan Greenblat at Gracie Mansion." *Art in America*, Jan. 1984, p. 123.

GRIS: COOPER, D. *Juan Gris: Catalogue raisonné de l'oeuvre peinte.* Paris, 1977.

COOPER, D., ed. and translator. *Letters of Juan Gris (1913–1927).* London, 1956.

SOBY, J. T. *Juan Gris.* New York, MOMA, 1958. E.C.

GROOMS: *Red Grooms: A Retrospective, 1956–1984.* Philadelphia, Pennsylvania Academy of the Fine Arts, 1985. E.C.

Essays by J. E. Stein, J. Ashbery, J. K. Cutler.

RATCLIFF, C. *Red Grooms.* New York, 1984.

GROPIUS: GIEDION, S. *Walter Gropius.* London, 1954.

GROPIUS, W. *The New Architecture and the Bauhaus.* New York and London, 1935.

GROSZ: BAUR, J. I. H. *George Grosz.* New York, WMAA, 1954. E.C.

GROSZ, G. *George Grosz: An Autobiography.* N. Hodges, translator. New York, 1983.

HESS, H. *George Grosz.* New Haven, 1985.

GUSTON: ARNASON, H. H. *Philip Guston.* New York, SRGM, 1962. E.C.

ASHTON, D. *Yes, but . . . : A Critical Study of Philip Guston.* New York, 1976.

BRACH, P. "Looking at Guston." *Art in America*, Nov. 1980, pp. 96–101.

FRY, E., and ABLOW, J. *Philip Guston: The Late Works.* Sydney, Australia, 1984. E.C.

HUNTER, S. *Philip Guston: Recent Paintings and Drawings.* New York, Jewish Museum, 1966. E.C. Includes a dialogue by the artist and H. Rosenberg.

LYNTON, N. *Philip Guston: Paintings 1969–1980.* London, Whitechapel Art Gallery, 1982. E.C.

SCHJELDAHL, P. "Philip Guston," in *Art of Our Time: The Saatchi Collection*, vol. 3, pp. 12–14. London and New York, 1984.

HAACKE: BALDWIN, C. R. "Haacke: Refuse in Cologne." *Art in America*, Nov. 1974.

BURNHAM, J. "Hans Haacke's Cancelled Show at the Guggenheim." *Artforum*, June 1971, pp. 67–71.

FRY, E. "Hans Haacke at the Guggenheim: The Issues." *Arts Magazine*, May 1971, p. 17.

Hans Haacke Volume I. Oxford, Museum of Modern Art, 1978.

Hans Haacke Volume II. London, Tate Gallery, 1983.

KUHN, A. "Haacke and the Landlord." *Village Voice*, Dec. 1974.

MESSER, T. "Guest Editorial." *Arts Magazine*, June 1971, pp. 4–5.

MEYER, U. "Haacke," in *Conceptual Art*, pp. 132–35. New York, 1972.

HANSON: CAVALIERE, B. "Duane Hanson," in E. Emanuel, et al., eds., *Contemporary Artists.* 2d ed., pp. 283–84. London and New York, 1983.

LEVIN, K. "The Ersatz Object." *Arts Magazine*, Feb. 1974, pp. 52–55.

MASHEK, J. "Verist Sculpture: Hanson and De Andrea." *Art in America*, Nov.–Dec. 1972, pp. 90–99.

VARNEDOE, K. *Duane Hanson.* New York, 1985.

HARING: GABLIK, S. "Report from New York: The Graffiti Question." *Art in America*, Oct. 1982, pp. 33–39.

HARING, K. *Art in Transit.* New York, 1985. Introduction H. Geldzahler; photography Tseng Kwong Chi.

McGUIGAN, C. "New Art, New Money: The Making of an American Artist." *New York Times Magazine*, Feb. 10, 1985, pp. 20–35.

MOUFARREGE, N. A. "Cartoons and Laurels." *New York Native*, Feb. 1–14, 1982, p. 26.

PINCUS-WITTEN, R. *Keith Haring.* New York, Tony Shafrazi Gallery, 1982. E.C. Essays by J. Deitch and D. Shapiro.

RAYNOR, V. "Keith Haring." *New York Times*, Nov. 8, 1985.

HECKEL: VOGT, P. *Erich Heckel.* Recklinghausen, Germany, 1965.

Erich Heckel. Lugano, Galerie Roman Norbert Ketterer, 1966. E.C.

HEIZER: BEARDSLEY, J. *Earthworks and Beyond: Contemporary Art in the Landscape*, pp. 12–19. New York, 1984.

GRUEN, J. "Michael Heizer: You Might Say I'm in the Construction Business." *Art News*, Dec. 1977, pp. 96–99.

HEIZER, M. "The Art of Michael Heizer." *Artforum*, Dec. 1969, pp. 32–39.

HELD: GLASER, D. J. "Al Held's Strategy of Structural Conflict." *Arts Magazine*, Jan. 1983, pp. 82–83.

GREEN, E. *Al Held.* San Francisco Museum of Art, 1968. E.C.

SANDLER, I. *Al Held.* New York, 1984.

TUCKER, M. *Al Held.* New York, WMAA, 1974. E.C.

HENRI: ROSENBLUM, N. *A World History of Photography*, pp. 403–5. New York, 1984.

HEPWORTH: *Barbara Hepworth.* London, Tate Gallery, 1968. E.C. Texts by R. Alley, N. Gray, R. W. D. Oxenaar.

HODIN, J. P. *Barbara Hepworth.* London, 1961.

READ, H. *Barbara Hepworth: Carvings and Drawings.* London, 1952.

HESSE: LIPPARD, L. R. *Eva Hesse.* New York, 1976.

NEMSER, C. "An Interview with Eva Hesse." *Artforum*, May 1970, pp. 59–63.

PINCUS-WITTEN, R. "Eva Hesse: Post-Minimalism into Sublime." *Artforum*, Nov. 1971, pp. 32–44.

HILL: SCHWARZ, H. *David Octavius Hill: Master of Photography.* London, 1932.

HINE: ROSENBLUM, W. and N., and TRACHTENBERG, A. *America and Lewis Hine.* Millerton, N.Y., 1977.

HOCKNEY: GLAZEBROOK, M. *David Hockney: Paintings, Prints, and Drawings.* London, Whitechapel Art Gallery, 1970. E.C.

David Hockney by David Hockney. Edited by N. Stangos. New York, 1977. Introduction H. Geldzahler.

HOCKNEY, D. *Cameraworks.* New York, 1984. Essay by L. Weschler.

LIVINGSTON, M. *David Hockney.* New York, 1981.

HODGKIN: CARLSON, P. "Howard Hodgkin at Knoedler." *Art in America*, Oct. 1984, pp. 192–93.

COOKE, L. "Howard Hodgkin," in *Art of Our Time: The Saatchi Collection*, vol. 4, pp. 35–36.

GALLIGAN, G. "Howard Hodgkin: Forty Paintings." *Arts Magazine*, March 1985, pp. 122–25.

HARRISON, C. "Hodgkin's Moment." *Artscribe*, Dec. 1985–Jan. 1986, pp. 62–64.

HIGGINS, J. "In a Hot Country." *Art News*, Summer 1985, pp. 56–65.

McEWEN, J. "Finding Form at Fifty." *Sunday Times Magazine* (London), June 10, 1984, pp. 38–41.

———. "Late Bloomer." *Vanity Fair*, Nov. 1984, pp. 68–75.

RUSSELL, J. "Maximum Emotion with a Minimum of Definition." *New York Times*, April 15, 1984, sect. 2, p. 33.

HODLER: HIRSH, S. *Ferdinand Hodler.* New York, 1982.

SELZ, P. *Ferdinand Hodler.* Berkeley, University Art Museum, 1972. E.C. Additional texts by J. Bruschweiler et al.

HOFER: WITKIN, L. D., and LONDON, B. "Evelyn Hofer," in *A Photograph Collector's Guide*, pp. 164–65. Boston, 1979.

HOFMANN: GREENBERG, C. *Hans Hofmann.* Paris and London, 1961.

HOFMANN, H. *Search for the Real*. S. T. Weeks and B. H. Hayes, Jr., eds. Cambridge, Mass., 1967.

SEITZ, W. C. *Hans Hofmann*. New York, MOMA, 1963. E.C. With selected writings by the artist.

WIGHT, F. S. *Hans Hofmann: Retrospective Exhibition*. Los Angeles, The University Art Museum, 1957. E.C.

HOLLEIN: ANDERSEN, K. "The Art of Joyful Jam-Packing." *Time*, April 15, 1985, p. 106.

JENCKS, C. *The Language of Post-Modern Architecture*. 4th ed., pp. 142–45. New York, 1985.

MACK, M. "Extracting and Recombining Elements." *Progressive Architecture*, Dec. 1979, pp. 76–83.

TRACHTENBERG, M., and HYMAN, I. *Architecture: From Prehistory to Post-Modernism*, pp. 571–72. New York, 1986.

HOLT: BEARDSLEY, J. *Earthworks and Beyond: Contemporary Art in the Landscape*, pp. 103–6. New York, 1984.

CASTLE, T. "Nancy Holt: Siteseer." *Art in America*, March 1982, pp. 84–91.

HALL, C. "Environmental Artists: Sources and Directions," in A. Sonfist, ed., *Art in the Land*, pp. 8–59. New York, 1983.

HOLT, N. "Stone Enclosure: Rock Rings." *Arts*, June 1979, pp. 152–55.

SHAFFER, D. "Nancy Holt: Spaces for Reflections or Projections," in A. Sonfist, ed., *Art in the Land*, pp. 169–77. New York, 1983.

HOMER: GOODRICH, L. *Winslow Homer*. New York, WMAA, 1973. E.C.

WILMERDING, J. *Winslow Homer*. New York-Washington, D.C.-London, 1972.

Winslow Homer and the New England Coast. New York, WMAA, 1985. E.C.

HOPPER: GOODRICH, L. *Edward Hopper*. New York, WMAA, 1964. E.C.

———. *Edward Hopper*. New York, 1971.

LEVIN, G. *Edward Hopper: The Art and the Artist*. New York, WMAA, 1980. E.C.

HOYNINGEN-HUENE: EWING, W. A. *The Photographic Art of Hoyningen-Huene*. New York, 1986. Foreword G. Cukor.

HUEBLER: HUEBLER, D. *Location Pieces, Site Sculpture, Duration Works, Drawings, Variable Pieces*. Boston, Museum of Fine Arts, 1972. E.C.

KINGSLEY, A. "Douglas Huebler." *Artforum*, May 1972, pp. 74–78.

SIEGELANT, S., and WENDLER, J. W. *Carl Andre, Robert Barry, Douglas Huebler, Joseph Kosuth, Sol LeWitt, Robert Morris, Lawrence Weiner*. New York, 1968.

HUNDERTWASSER: HOFMANN, W. *Hundertwasser*. New York, 1976.

Hundertwasser: Recent Paintings. Paris, Galerie Karl Flinker, 1967. E.C.

HUNT: LANDOW, G. P. *William Holman Hunt and Typological Symbolism*. New Haven, 1979.

The Pre-Raphaelites, pp. 94–96. London, Tate Gallery, 1984. E.C.

William Holman Hunt. Liverpool, Walker Art Gallery, 1969. E.C.

INGRES: ALAIN. *Ingres (Les demi-dieux)*. Paris, 1949.

ROSENBLUM, R. *Ingres*. New York, 1967.

WILDENSTEIN, G. *Ingres*. London, 1954.

ITTEN: ITTEN, J. *The Art of Colour: The Subjective Experience and Objective Rationale of Colour*. New York, 1961.

———. *Design and Form: The Basic Course at the Bauhaus*. London, 1964.

JAUDON: *Valerie Jaudon*. West Berlin, Amerika-Haus, 1983. E.C. Introduction S. Hunter.

PERREAULT, J. "Allusive Depths: Valerie Jaudon." *Art in America*, Oct. 1983, pp. 162–65.

WESTFALL, S. "Valerie Jaudon." *Arts Magazine*, Dec. 1985, p. 125.

JAWLENSKY: WEILER, C. *Alexei Jawlensky*. Cologne, 1959.

JENNEY: CARLSON, P. "Neil Jenney at Oil and Steel." *Art in America*, April 1985, p. 206.

DELAHOYD, M. "Neil Jenney," in *A New Beginning*, p. 87. Yonkers, N.Y., Hudson River Museum, 1985. E.C.

GRIMES, N. "Neil Jenney." *Art News*, March 1985, p. 137.

KRAMER, H. "Neil Jenney—Elegance with a Political Twist." *New York Times*, May 17, 1981, pp. D45, 51.

LEVIN, K. "Issues and Images." *Village Voice*, Dec. 18, 1984, p. 122.

ROSENTHAL, M. *Neil Jenney: Paintings and Sculpture, 1967–1980*. Berkeley, University of California Museum of Art, 1981. E.C.

JENSEN: ARMSTRONG, R. "Bill Jensen," in *Five Painters*, pp. 26–98. New York, WMAA, 1984. E.C.

"Expressionism Today: An Artists' Symposium." *Art in America*, Dec. 1982, p. 73 (artist's statement).

GLUECK, G. "Bill Jensen." *New York Times*, Dec. 2, 1982.

KRAMER, H. "Bill Jensen," in *Art of Our Time: The Saatchi Collection*, vol. 4, p. 26. London and New York, 1984.

PARKS, A. "Bill Jensen and the Sound and Light Beneath the Lid." *Arts Magazine*, Nov. 1981, pp. 152–55.

PERREAULT, J. "Ryder on the Storm." *Soho News*, Nov. 11–17, 1981, p. 24.

JOHNS: CRICHTON, M. *Jasper Johns*. New York, WMAA, 1977. E.C.

FRANCIS, R. *Jasper Johns*. New York, 1984.

KOZLOFF, M. *Jasper Johns*. New York, 1974.

ROBERTSON, B. *Jasper Johns*. London, Hayward Gallery, 1978. E.C.

ROSENBLUM, R. *Jasper Johns: 1955–1960*. Columbia, S.C., Columbia Museum of Art, 1960. E.C.

SHAPIRO, D. *Jasper Johns Drawings: 1954–1984*. Edited by C. Sweet. New York, 1984.

SOLOMON, A. R. *Jasper Johns*. New York, Jewish Museum, 1964. Essay by J. Cage.

JOHNSON: FILLER, M. "High Rise, Part I." *Art in America*, Sept. 1984, pp. 153–65.

GOLDBERGER, P. "The New Age of Philip Johnson." *New York Times Magazine*, May 14, 1978, sect. 6, p. 27.

HITCHCOCK, H. R. *Philip Johnson, Architect: 1949–1965*. New York, 1966.

MILLER, M. *Johnson/Burgee, Architecture: Buildings and Projects*. New York, 1979.

POSNER, E. "Learning to Love Ma Bell's New Building." *Wall Street Journal*, Oct. 12, 1983, p. 26.

TOMKINS, C. "Forms Under Light." *The New Yorker*, May 23, 1977, pp. 43–80.

TRACHTENBERG, M., and HYMAN, I. *Architecture: From Prehistory to Post-Modernism*, pp. 573–75. New York, 1986.

JUDD: CONE, J. H. "Judd at the Whitney." *Artforum*, May 1968, pp. 36–39.

JUDD, D. *Complete Writings, 1959–1975*. Halifax and New York, 1975.

Donald Judd. Ottawa, National Gallery of Canada, 1975. E.C. Exhibition organized by B. Smith; essay by R. Smith.

KAHN: GIURGOLA, R. *Louis I. Kahn*. Boulder, Colo., 1975.

LOBELL, J. *Between Silence and Light: Spirit in the Architecture of Louis I. Kahn*. Boulder, Colo., 1979.

PROUN, J. *The Architecture of the Yale Center for British Art*. New Haven, 1977. Introduction E. P. Pillsbury.

SCULLY, V. *Louis I. Kahn*. New York, 1962.

TRACHTENBERG, M., and HYMAN, I. *Architecture: From Prehistory to Post-Modernism*, pp. 559–63. New York, 1986.

KANDINSKY: BARNETT, V. E. *Kandinsky at the Guggenheim*. New York, SRGM, n.d.

BOWLT, J. E., and LONG, R.-C. WASHTON. *The Life of Vasilli Kandinsky in Russian Art: A Study of "On the Spiritual in Art."* Newtownville, Mass., 1980.

DEROUET, C. *Kandinsky in Paris: 1934–1944*. New York, SRGM, 1985. E.C. Essay by V. E. Barnett.

LINDSAY, K. C., and VERGO, P. *Kandinsky: Complete Writings on Art*. 2 vols. Boston, 1982.

LONG, R.-C. WASHTON. *Kandinsky: The Development of an Abstract Style*. Oxford, 1980.

POLING, C. V. *Kandinsky: Russian and Bauhaus Years, 1915–1933*. New York, SRGM, 1983. E.C.

ROETHEL, H. K., and BENJAMIN, J. K. *Kandinsky*. New York, 1979.

———. *Kandinsky Catalogue Raisonné of the Oil-Paintings: Volume One, 1900–1915*. Ithaca, N.Y., 1982.

———. *Kandinsky Catalogue Raisonné of the Oil-Paintings, Volume Two, 1916–1944*. Ithaca, N.Y., 1984.

WEISS, P. *Kandinsky in Munich: The Formative Years*. Princeton, 1979.

———. *Kandinsky in Munich: 1896–1914*. New York,

SRGM, 1982. E.C. Essays by C. E. Schorske and P. Jelavich.

———, ed. *"Are We Ready to Memorialize Kandinsky?" Art Journal*, Spring 1983 (special issue). Articles by K. C. Lindsay, R. Heller, W. Venzmer, M. Strauss, E. J. Kimball, P. Weiss, T. Buddensieg, R.-C. Washton Long, S. A. Stein.

KÄSEBIER: HOMER, W. I. *A Pictorial Heritage: The Photographs of Gertrude Käsebier*. Wilmington, Del., 1979.

WITKIN, L. D., and LONDON, B. "Gertrude Käsebier," in *The Photograph Collector's Guide*, pp. 172–73. Boston, 1978.

KATZ: GLUECK, G. "Alex Katz: Painting in the High Style." *New York Times Magazine*, March 2, 1986, pp. 37–38.

MARSHALL, R. *Alex Katz*. New York, WMAA, 1986. E.C. With essay by R. Rosenblum.

McGILL, D. C. "How Alex Katz Puts Power on Canvas." *New York Times*, March 24, 1985, sect. 2, pp. 1, 33.

STOFFET, M. "Alex Katz." in E. Emanuel, et al., eds., *Contemporary Artists*. 2d ed., pp. 464–65. London and New York, 1983.

KELLY: COPLANS, J. *Ellsworth Kelly*. New York, 1973.

ELDERFIELD, J. "Color and Area: New Paintings by Ellsworth Kelly." *Artforum*, Nov. 1971, pp. 45–49.

GOOSSEN, E. C. *Ellsworth Kelly*. New York, MOMA, 1973. E.C.

SIMS, P., and PULITZER, E. R. *The Sculpture of Ellsworth Kelly*. New York, WMAA, 1983. E.C.

KEMENY: *Zoltan Kemeny 1907–1965*. Bergamo, Galleria Lorenzelli, 1967. E.C.

KERTÉSZ: DUCROT, N., ed. *André Kertész: Sixty Years of Photography, 1912–1972*. New York, 1972.

WITKIN, L. D., and LONDON, B. "André Kertész," in *The Photograph Collector's Guide*, pp. 173–74. Boston, 1979.

KIEFER: COWART, J. *Expressions: New Art from Germany*. St. Louis Art Museum, 1983. E.C. Additional texts by J. Gohr and D. Kuspit.

GRIMES, N. "Anselm Kiefer." *Art News*, Sept. 1985, pp. 131–32.

KUSPIT, D. B. "Acts of Aggression: German Painting Today, Part II." *Art in America*, Jan. 1983, pp. 99–100.

———. "Transmuting Externalization in Anselm Kiefer." *Arts Magazine*, Oct. 1984, pp. 84–86.

RUSSELL, J. "The New European Painters." *New York Times Magazine*, April 24, 1983, pp. 28–33.

———. "Anselm Kiefer's Paintings are Inimitably His Own." *New York Times*, April 21, 1985, pp. H33–34.

SCHJELDAHL, P. "Anselm Kiefer," in *Art of Our Time: The Saatchi Collection*, vol. 3, pp. 15–17. London and New York, 1984.

———. "Anselm Kiefer and the Exodus of the Jews." *Art & Text*, Summer 1985, pp. 5–11.

KIENHOLZ: SHIREY, D. *Edward and Nancy Reddin Kienholz: Human Scale*. San Francisco Museum of Modern Art, 1985. E.C. Essays by H. T. Hopkins, L. Weschler, E. Kienholz, R. Glower.

WESCHLER L. "The Subversive Art of Ed Kienholz." *Art News*, Sept. 1984, pp. 100–6.

KIRCHNER: DEUTCHE, R. "Alienation in Berlin: Kirchner's Street Scenes." *Art in America*, Jan. 1983, pp. 65–72.

GORDON, D. E. *Ernst Ludwig Kirchner*. Cambridge, Mass., 1968.

———. "Ernst Ludwig Kirchner: By Instinct Possessed." *Art in America*, Jan. 1983, pp. 65–72.

GORDON, D. E. "Kirchner in Dresden." *Art Bulletin*, Sept.–Dec. 1966, pp. 335–66.

GROHMANN, W. *E. L. Kirchner*. London, 1961.

KITAJ: HYMAN, T. "R. B. Kitaj: Decadence and Renewal," in *R. B. Kitaj*. New York, Marlborough Gallery, 1979. E.C.

KITAJ, R. B. *An Artist's Eye*. London, National Gallery, 1980. E.C.

LIVINGSTONE, M. *R. B. Kitaj*. New York, 1985.

SCHEAR, C. K. "Photomontage in the Early Work of R. B. Kitaj." *Arts*, Sept. 1984, pp. 74–77.

TUTEN, F. "Neither Fool, Nor Naïve, Nor Poseur—Saint: Fragments on R. B. Kitaj." *Artforum*, Jan. 1982, pp. 67–68.

KLEE: GIEDION-WELCKER, C. *Paul Klee*. New York, 1952.

GROHMANN, W. *Paul Klee*. New York, 1954.

HAFTMANN, W. *The Mind and Work of Paul Klee*. London,

1954.

JORDAN, J. *Paul Klee and Cubism*. Princeton, 1984.

KLEE, F., ed. *The Diaries of Paul Klee: 1898–1918*. Berkeley and Los Angeles, 1964.

KLEE, P. *On Modern Art*. London, 1948.

——. *The Thinking Eye: The Notebooks of Paul Klee*. 2d ed., rev. London, 1964.

Paul Klee, 1879–1940. New York, SRGM and Pasadena Art Museum, 1967. E.C. (Two catalogues.)

PINDELL, H. *Paul Klee Centennial: Prints and Transfer Drawings*. New York, MOMA, 1978. E.C.

SABARSKY, S. *Paul Klee: The Late Years, 1930–1940*. New York, Sabarsky Gallery, 1977. E.C.

SVENDSEN, L. A. *Paul Klee in the Collection of the Solomon R. Guggenheim Museum*. New York, SRGM, 1977.

VERDI, R. *Klee and Nature*. New York, 1985.

KLEIN: RESTANY, P. *Yves Klein*. New York, 1982.

KLIMT: COMINI, A. *Gustav Klimt*. New York, 1975.

NOVOTNY, F., and DOBAI, J. *Gustav Klimt*. Vienna, 1967. *Gustav Klimt and Egon Schiele*. New York, SRGM, 1965. E.C. Texts by T. M. Messer and J. Dobai.

KLINE: GORDON, J. *Franz Kline, 1910–1962*. New York, WMAA, 1968. E.C.

GAUGH, H. *Franz Kline: The Vital Gesture*. New York, 1985.

Franz Kline Memorial Exhibition. Washington, D.C., Washington Gallery of Modern Art, 1962. E.C.

KLINGER: VARNEDOE, J. K. T., with STREICHER, E. *Graphic Work of Max Klinger*. New York, 1977.

KOKOSCHKA: GORDON, D. E. *Oskar Kokoschka and the Visionary Tradition*. Bonn, 1981.

HODIN, J. P. *Oskar Kokoschka: The Artist and His Time*. Greenwich, Conn., 1966.

HOFFMAN, E. *Oskar Kokoschka: Life and Work*. London, 1947. With essays by Kokoschka; foreword H. Read.

Kokoschka: A Retrospective Exhibition of Paintings, Drawings, Lithographs, Stage Design, and Books. London, The Tate Gallery, 1962. E.C. With essays by E. H. Gombrich, F. Novotny, H. M. Wingler, et al.

Oskar Kokoschka. New York, Marlborough-Gerson Gallery, Inc., 1966. E.C.

SCHVEY, H. F. *Oskar Kokoschka, the Painter as Playwright*. Detroit, 1982.

KOLLWITZ: HINZ, R., ed. *Käthe Kollwitz: Graphics, Posters, Drawings*. New York, 1981. Foreword L. R. Lippard.

KLIPSTEIN, A. *The Graphic Work of Käthe Kollwitz: Complete Illustrated Catalogue*. New York, 1955.

KOLLWITZ, H., ed. *Käthe Kollwitz: Diary and Letters*. Chicago, 1955.

KOSUTH: KAISER, W. M. H. *Joseph Kosuth: Artworks and Theories*. Amsterdam, 1977.

KOUNELLIS: CELANT, G. *Arte Povera*. Milan, 1985.

NAYLOR, C., and PORRIDGE, C. "Jannis Kounellis," in E. Emanuel, et al., eds., *Contemporary Artists*, 2d ed., pp. 499–500. London and New York, 1983.

OLIVA, A. BONITA. *Europe-America: The Different Avant-Garde*. Milan, 1976.

KOZLOFF: FRIEDMAN, J. R. "Joyce Kozloff." *Arts Magazine*, Nov. 1979, p. 11.

PERRONE, J. "Two Ethnics Sitting Around Talking About Wasp Culture." *Arts Magazine*, March 1985, pp. 78–83.

TOMKINS, C. "Matisse's Armchair." *The New Yorker*, Feb. 25, 1980, pp. 108–13.

KRASNER: NOVAK, B. *Lee Krasner: Recent Works*. New York, Pace Gallery, 1981. E.C.

ROSE, B. *Krasner/Pollock, a Working Relationship*. New York, Grey Art Gallery, 1981. E.C.

——. *Lee Krasner: A Retrospective*. Houston, Museum of Fine Arts, 1983. E.C.

KÜHN: WITKIN, L. D., and LONDON, B. "Heinrich Kühn," in *The Photograph Collector's Guide*, p. 177. Boston, 1979.

KUPKA: CASSOU, J., and FEDIT, D. *Frank Kupka*. London, 1965.

Collection: L'Oeuvre de Kupka. Paris, Musée National D'Art Moderne, 1966. E.C.

František Kupka 1871–1957: A Retrospective. SRGM, New York, 1975. E.C.

KUSHNER: BLAU, D. "Robert Kushner." *Arts Magazine*, Dec. 1979, p. 3.

BECKER, R. "Robert Kushner." *Flash Art*, Nov. 1984, pp.

34–38.

LARSON, K. "Robert Kushner." *New York Magazine*, Dec. 19, 1983, p. 84.

MARSHALL, R. *Robert Kushner: Paintings on Paper*. New York, WMAA, 1984. E.C.

LACHAISE: KRAMER, H., et al. *The Sculpture of Gaston Lachaise*. New York, 1967.

NORDLAND, G. *Gaston Lachaise 1882–1935: Sculpture and Drawings*. Los Angeles County Museum of Art and New York, WMAA, 1964. E.C.

——. *Gaston Lachaise: The Man and His Work*. New York, 1974.

SIMS, P. *Gaston Lachaise*. New York, WMAA, 1980. E.C.

LA FRESNAYE: COGNIAT, R., and GEORGE, W. *Oeuvre complète de Roger de La Fresnaye*. Paris, 1950.

LANGE: ELLIOT, G. P. *Dorothea Lange*. New York, MOMA, 1966. E.C.

MELTZER, M. *Dorothea Lange, a Photographer's Life*. New York, 1978.

WITKIN, L. D., and LONDON, B. "Dorothea Lange," in *The Photograph Collector's Guide*, p. 178. Boston, 1979.

LARIONOV: DABROWSKI, M. *Contrasts of Form: Geometric Abstract Art, 1910–1980*, p. 261. New York, MOMA, 1985. E.C.

Gontcharova—Larionov. Musée d'Art Moderne de la Ville de Paris, 1963. E.C.

Gontcharova, Larionov, Mansurov. Bergamo, Galleria Lorenzelli, 1966. E.C.

RUDENSTINE, A. Z., gen. ed. *Russian Avant-Garde Art: The George Costakis Collection*, pp. 233–39. New York, 1985.

LARTIGUE: WITKIN, L. D., and LONDON, B. "Jacques Henri Lartigue," in *The Photograph Collector's Guide*, p. 179. Boston, 1979.

LAUFER: BELL, T. "Susan Laufer." *Arts Magazine*, Nov. 1984, p. 2.

COHEN, R. "Susan Laufer." *Artforum*, Dec. 1984, p. 84.

HEARTLEY, E. "Susan Laufer." *Art News*, Dec. 1985, p. 128.

HENRY, G. "Susan Laufer at Germans Van Eck." *Art in America*, Jan. 1985, pp. 140–41.

SOFER, K. "Susan Laufer." *Art News*, Dec. 1984, p. 152.

WESTFALL, S. "Susan Laufer." *Arts Magazine*, Jan. 1986, p. 132.

LAURENCIN: GERE, C. *Marie Laurencin*. New York, 1977.

LAURENS: GOLDSCHEIDER, C. *Laurens*. New York, 1959.

LAURENS, M., ed. *Henri Laurens, sculpteur: 1885–1954*. Paris, 1955.

Henri Laurens. New York. Curt Valentin Gallery, 1952. E.C. With artist's statement.

LÉGER: DE FRANCIA, P. *Fernand Léger*. New Haven, 1983.

DELEVOY, R. L. *Léger, Biographical and Critical Study*. Lausanne, 1962.

GREEN, C. *Léger and the Avant-Garde*. New Haven, 1976.

KUH, K. *Fernand Léger*. Urbana, Ill., Art Institute of Chicago, 1953. E.C.

"Fernand Léger." *Five Themes and Variations*. New York, SRGM, 1962. E.C.

Fernand Léger, 1881–1955. Paris, Musée des Arts Décoratifs, 1956. E.C. With texts by the artist.

SCHMALENBACH, W. *Léger*. New York, 1976.

LEHMBRUCK: HOFMANN, W. *Wilhelm Lehmbruck*. New York, 1959.

LESLIE: GOODYEAR, JR., F. H. *Contemporary American Realism Since 1960*, pp. 113–16. Boston, 1981.

KRAMER, H. "New Realism Writ Large by Leslie." *New York Times*, Nov. 17, 1978, p. C20.

ROSENBLUM, R. *Alfred Leslie*. Boston, Museum of Fine Arts, 1976.

LEVINE, LES: BURNHAM, J. "Les Levine: Business as Usual." *Artforum*, April 1970, pp. 40–43.

LEVINE, SHERRIE: CARR, C. "The Shock of the Old." *Village Voice*, Nov. 30, 1984, p. 103.

HEARTNEY, E. "Sherrie Levine." *Art News*, Feb. 1986, p. 120.

JONES, R. "Sherrie Levine at Baskerville + Watson." *Artscribe*, April 1986, pp. 75–76.

MAZORATI, G. "Art in the (Re)making." *Art News*, May 1986, pp. 91–99.

MELVILLE, S. W. "Not Painting: The New Work of Sherrie

Levine." *Arts Magazine*, Feb. 1986, pp. 23–25.

SMITH, R. "It's Not Faking Anything—It's Real Levine." *Village Voice*, Dec. 3, 1983, p. 107.

WESTFALL, S. "Sherrie Levine at Baskerville + Watson." *Art in America*, March 1986, pp. 145–46.

LEWIS: ROTHENSTEIN, J. *Wyndham Lewis and Vorticism*. London, Tate Gallery, 1956. E.C.

LEWITT: LEGG, A. *Sol LeWitt*. New York, MOMA, 1978. E.C.

LEWITT, S. *Sol LeWitt: Geometric Figures & Color*. New York, 1979.

LIBERMAN: *Alexander Liberman: Painting and Sculpture, 1950–1970*. Washington, D.C., Corcoran Gallery of Art, 1970. E.C.

LICHTENSTEIN: ABADIE, D. *Roy Lichtenstein: Dessins sans bande*. Paris, Centre National d'Art Contemporain et de Culture Georges Pompidou, 1975.

ALLOWAY, L., ed. *Roy Lichtenstein*. New York, 1972. Anthology of interviews with the artist.

——. *Roy Lichtenstein*. New York, 1983.

COWART, J. *Roy Lichtenstein: 1970–1980*. St. Lewis Art Museum, 1981. E.C.

KUSPIT, D. B. *Roy Lichtenstein: Recent Work*. Coral Gables, Fla., Lowe Art Museum, 1979. E.C.

Roy Lichtenstein: Landscape Sketches 1984–1985. New York, 1986. Introduction C. Glenn.

MORPHET, R. *Roy Lichtenstein*. London, Tate Gallery, 1968. E.C.

WALDMAN, D. *Roy Lichtenstein*. New York, 1972.

LINDNER: ASHTON, D. *Richard Lindner*. New York, 1970.

DIENST, R.-G. *Lindner*. New York, 1970. C. Cortis, translator.

KRAMER, H. *Richard Lindner*. Boston, 1975.

LIPCHITZ: ARNASON, H. H. *Jacques Lipchitz: Sketches in Bronze*. New York, 1969.

BORK, B. VAN. *Jacques Lipchitz: The Artist at Work*. New York, 1966. Critical evaluation A. Werner.

GOLDWATER, R. *Lipchitz*. New York, 1959.

HAMMACHER, A. M. *Jacques Lipchitz: His Sculpture*. New York, 1960. Introductory statement by the artist.

HOPE, H. R. *The Sculpture of Jacques Lipchitz*. New York, MOMA, 1954. E.C.

LIPCHITZ, J., with ARNASON, H. H. *My Life in Sculpture*. New York, 1972.

WIGHT, F. S. *Jacques Lipchitz: A Retrospective Selected by the Artist*. Berkeley, University Art Museum, 1963. E.C.

LIPSKI: HAPGOOD, S. "Donald Lipski." *Flash Art*, Dec. 1985–Jan. 1986, p. 46.

HEARTNEY, E. "Donald Lipski." *Art News*, Nov. 1985, pp. 146–47.

KUSPIT, D. B. *Donald Lipski*. New York, Germans Van Eck Gallery, 1985. E.C.

McGILL, D. C. "Mining the Scrap Heap." *New York Times*, Jan. 24, 1986, p. C24.

SCHWABSKY, B. "Donald Lipski." *Arts Magazine*, Nov. 1985, p. 140.

LIPTON: ELSEN, A. *Seymour Lipton*. New York, 1970.

LEAVITT, T. *Seymour Lipton: Recent Works*. New York, Marlborough Gallery, 1976. E.C.

LISSITZKY: DABROWSKI, M. *Contrasts of Form: Geometric Abstract Art 1910–1980*, p. 262. New York, MOMA, 1985. E.C.

ELLIOTT, D. *El Lissitzky: 1890–1941*. Oxford, Museum of Modern Art, 1977. E.C.

LISSITZKY-KÜPPERS, S. *El Lissitzky: Life, Letters, Texts*. Greenwich, Conn., 1968. Introduction H. Read.

MANSBACH, S. A. *Visions of Totality: László Moholy-Nagy, Theo van Doesberg, and El Lissitzky*. Ann Arbor, 1980.

ROWELL, M., and RUDENSTINE, A. Z. *Art of the Avant-Garde in Russia: Selections from the George Costakis Collection*, pp. 175–87, 314–15. New York, SRGM, 1981. E.C.

RUDENSTINE, A. Z., gen. ed. *Russian Avant-Garde Art: The George Costakis Collection*, pp. 242–50. New York, 1981.

LONG: BEARDSLEY, J. *Earthworks and Beyond: Contemporary Art in the Landscape*, pp. 40–44. New York, 1984.

COMPTON, M. *Some Notes on the Work of Richard Long*. London, British Council, 1976. E.C.

FOOTE, N. "Long Walks." *Artforum*, Summer 1980, pp. 42–47.

FUCHS, R. H. "Memories of Passing: A Note on Richard Long." *Studio International,* April 1974, pp. 172–73.

LONGO: BLINDERMAN, B. "Robert Longo's 'Men in the Cities': Quotes and Commentary." *Arts Magazine,* March 1981, pp. 92–93.

BRENSON, M. "Apocalyptic Pop in Mixed Media Show." *New York Times,* May 4, 1984, p. C26.

CARTER, H. "Robert Longo." *Arts Magazine,* Sept. 1984, p. 7.

DANOFF, S. M. *Robert Longo: Drawings and Reliefs.* Akron Art Museum, 1984. E.C.

GLUECK, G. "The Very Timely Art of Robert Longo." *New York Times,* March 10, 1985, pp. D1, 24.

HANDY, E. "Robert Longo." *Arts Magazine,* Sept. 1984, p. 32.

HOBBS, R. *Robert Longo Dis-illusions.* University of Iowa Museum of Art, 1985. E.C.

LEVIN, K. "Robert Longo: Metro Pictures." *Flash Art,* March–April 1981, p. 40.

LONGO, R. *Men in the Cities.* New York, 1986. Introduction and interview by R. Price.

OWENS, C. "Robert Longo at Metro Pictures." *Art in America,* March 1981, pp. 125–26.

RATCLIFF, C. *Robert Longo.* New York, 1985.

SMITH, R. "Appropriations über Alles." *Village Voice,* Jan. 11, 1983, p. 73.

ZIMMER, W. "City-City Bang-Bang!" *Soho News,* Jan. 21, 1981, p. 21.

LOOS: GRAVAGNUOLO, B. *Adolf Loos.* New York, 1983.

MUNZ, L. *Adolf Loos.* New York, 1966.

LÓPEZ-GARCIA: BRENSON, M. "Fresh Visions Based on a Grand Tradition."*New York Times,* July 7, 1985, pp. 23, 26.

———. "López-Garcia Work in First Show Since '68." *New York Times,* April 11, 1986, p. C23.

HUGHES, R. "The Truth in the Details." *Time,* Nov. 21, 1986, p. 83.

LOUIS: ELDERFIELD, J. *Morris Louis.* New York, MOMA, 1986.

FRIED, M. *Morris Louis.* New York, 1971.

Morris Louis, 1912–1962, Memorial Exhibition: Paintings from 1954–1960. New York, SRGM, 1963. E.C.

Morris Louis, 1912–1962. Boston, Museum of Fine Arts, 1967. E.C.

UPRIGHT. D. *Morris Louis: The Complete Paintings, a Catalogue Raisonné.* New York, 1985.

LÜPERTZ: BRENSON, M. "Markus Lüpertz." *New York Times,* Sept. 28, 1984, p. C29.

COWART, J. *Expressions: New Art from Germany.* St. Louis Art Museum, 1983. E.C. Additional texts by S. Gohr and D. Kuspit.

KUSPIT, D. B. "Acts of Aggression: German Painting Today, Part II." *Art in America,* Jan. 1983, pp. 91–99.

MACCONNEL: DELAHOYD, M. *A New Beginning,* pp. 94–95. Yonkers, N.Y., Hudson River Museum, 1985. E.C.

FRIEDMAN, J. R. "Kim MacConnel." *Arts Magazine,* June 1982, p. 21.

LEVIN, K. "Kim MacConnel." *Village Voice,* May 15, 1984, p. 76.

MADOFF, S. H. "Kim MacConnel at Holly Solomon." *Art in America,* Summer 1982, pp. 143–44.

PRINTZ, N. *Decoration and Representation.* Alberta College of Art, Alberta, Canada, 1982. E.C.

RICKEY, C. "Kim MacConnel." *Village Voice,* Feb. 25, 1980, p. 70.

MACDONALD-WRIGHT: *The Art of Stanton Macdonald-Wright: A Retrospective Exhibition.* Washington, D.C., Smithsonian Institution, 1967. E.C.

MACKINTOSH: BLISS, D. P. *Charles Rennie Mackintosh and the Glasgow School of Art.* Glasgow, 1961.

HOWARTH, T. *Charles Rennie Mackintosh and the Modern Movement.* New York, 1953.

PEVSNER, N. *Charles Rennie Mackintosh.* Milan, 1950.

MAGRITTE: BRETON, A. *Magritte: Le Sens propre.* Paris, Galerie Alexandre Iolas, 1964. E.C.

FOUCAULT, M. *This Is Not a Pipe.* Berkeley, Cal., 1983.

GABLIK, S. *Magritte.* New York, 1985.

SOBY, J. T. *René Magritte.* New York, MOMA, 1966. E.C.

TORCZYNER, H. *Magritte: Ideas and Images.* New York, 1977.

———. *Magritte: The True Art of Painting.* New York, 1985.

WALDBERG, P. *René Magritte.* Brussels, 1965.

MAILLOL: GEORGE, W. *Aristide Maillol.* New York, 1965.

REWALD, J. *Maillol.* London, 1939.

———. *The Woodcuts of Aristide Maillol.* New York, 1943.

RITCHIE, A. C., ed. *Aristide Maillol.* Buffalo, N.Y., Albright-Knox Art Gallery, 1945. E.C. With an introduction and survey of the artist's work in American collections.

MALEVICH: ANDERSEN, T., ed. *Essays on Art by K. S. Malevich.* 2 vols. London, 1971.

DABROWSKI, M. *Contrasts of Form: Geometric Abstract Art 1910–1980,* pp. 55–69, 263–64. New York, MOMA, 1985. E.C.

GRAY, C. *Kasimir Malevich, 1878–1935.* London, Whitechapel Art Gallery, 1959. E.C.

HULTEN, P., and MARTIN, J.-H. *Malevich.* Paris, Centre National d'Art Contemporain et de Culture Georges Pompidou, 1978. E.C.

MALEVICH, K. *The Non-Objective World.* Chicago, 1959.

RUDENSTINE, A. Z., gen. ed. *Russian Avant-Garde Art: The George Costakis Collection,* pp. 251–66, 425–26. New York, 1981.

MANET: CACHIN, F., MOFFETT, C. S., and BAREAU, J. W. *Manet: 1832–1883.* New York, MMA, 1983. E.C.

GORDON, R., and FORGE, A. *The Last Flowers of Manet.* New York, 1986.

HAMILTON, G. H. *Manet and His Critics.* New York, 1969.

HANSON, A. C. *Manet and the Modern Tradition.* New Haven, 1977.

MAUNER, G. *Manet, Peintre-Philosophe: A Study of the Painter's Themes.* University Park, Pa., 1975.

ORIENTI, S. *The Complete Paintings of Manet.* New York, 1967. Introduction P. Pool.

REFF, T. *Manet: Olympia.* New York, 1977.

———. *Manet and Modern Paris.* Washington, D.C., National Gallery of Art, 1982. E.C.

MANGOLD: BOURDON, D. "Cool Obdurate Art." *Village Voice,* Oct. 21, 1985.

KRAUSS, R. "Interview with Robert Mangold." *Artforum,* March 1974, pp. 36–38.

LIPPARD, L. R. "The Silent Art." *Art in America,* Jan.–Feb. 1967, p. 58

NECOL, J., and POIRIER, M. "The 60s in Abstract: 13 Statements and an Essay." *Art in America,* Oct. 1983, pp. 122–37.

STEVENS, M. *Robert Mangold: Paintings 1971–1984.* Akron Art Museum, 1984. E.C.

WALDMAN, D. *Robert Mangold.* New York, SRGM, 1971. E.C.

MAN RAY: PENROSE, R. *Man Ray.* Boston, 1975.

MAN RAY. *Self Portrait.* Boston, 1963.

Man Ray. Los Angeles County Museum of Art, 1966. E.C. Texts by the artist and his friends.

Works of Man Ray. London, ICA, 1959. E.C. Text by the artist.

MANZÙ: REWALD, J. *Manzù.* New York, 1967.

MAPPLETHORPE: AMAYA, M. *Robert Mapplethorpe Photographs.* Norfolk, Chrysler Museum, 1978. E.C.

HERSHKOVITS, D. "Shock of the Black and the Blue." *Soho News,* May 20, 1981, pp. 9–11.

LARSON, K. "Robert Mapplethorpe." *New York Magazine,* Jan. 1, 1981, pp. 57–58.

SQUIRES, C. "Mapplethorpe: Off the Wall." *Vanity Fair,* Jan. 1985, pp. 88–89.

MARC: LANKHEIT, K. *Franz Marc im Urteil seiner Zeit.* Cologne, 1960.

LEVINE, F. S. *The Apocalyptic Vision: The Art of Franz Marc as German Expressionism.* New York, 1979.

PROBST, R. *Franz Marc.* Munich, Städtische Galerie im Lenbachhaus, 1963. E.C.

MARCA-RELLI: AGEE, W. C. *Marca-Relli.* New York, WMAA, 1967. E.C.

ARNASON, H. H. *Conrad Marca-Relli.* New York, 1963.

GIRALT-MIRACLE, D. *Marca-Relli.* Barcelona, 1976.

MARCKS: *Gerhard Marcks: Skulpturen und Zeichnungen.* Cologne, Städtisches Museum Wallraf-Richartz, 1964. E.C.

MARDEN: CAVALIERE, B. "Brice Marden," in E. Emanuel et al., eds., *Contemporary Artists,* 2d ed., pp. 587–88. London and New York, 1983.

HESS, T. B. "Brice Marden." *New York Magazine,* March 19, 1973, p. 75.

LIPPARD, L. "The Silent Art." *Art in America,* Jan.–Feb. 1967, pp. 58–63.

SHEARER, L. *Brice Marden.* New York, SRGM, 1975. E.C.

STORR, R. "Brice Marden: Double Vision." *Art in America,* March 1985, pp. 118–25.

MARIN: CURRY, L. *John Marin/1870–1953.* Los Angeles, Los Angeles County Museum of Art, 1970. E.C.

NORMAN, D., ed. *Selected Writings of John Marin.* New York, 1949.

REICH, S. *John Marin: A Stylistic Analysis and Catalogue Raisonné.* 2 vols. Tucson, 1970.

John Marin. New York, MOMA, 1936. E.C. Texts by McBride, Hartley, Benson.

MARINI: MARINI, M. *Graphic Work and Paintings.* New York, 1960. Introduction P. Bardi.

TRIER, E. *The Sculpture of Marino Marini.* London, 1961.

MARTIN: ALLOWAY, L. "Agnes Martin." *Artforum,* April 1973, pp. 32–37.

CAVALIERE, B. "Agnes Martin," in E. Emanuel et al., eds., *Contemporary Artists,* 2d ed., p. 592. London and New York, 1983.

GRUEN, J. "Everything, Everything is About Feeling . . . Feeling and Recognition." *Art News,* Sept. 1976, pp. 91–94.

HESS, T. B. "Fresh-Air Fiends." *New York Magazine,* May 31, 1976, pp. 65–66.

KUSPIT, D. B. "Agnes Martin at Pace." *Art in America,* Jan. 1982, p. 139.

LINVILLE, K. "Agnes Martin: An Appreciation." *Artforum,* June 1971, pp. 72–73.

PERREAULT, J. "Martin-ized, or the Zen of Drawing Blanks." *Soho Weekly News,* Oct. 11, 1979, p. 42.

MASSON: HAHN, O. *Masson.* New York, 1965.

LEIRIS, N., and LIMBOUR, G. *André Masson and His Universe.* London-Geneva-Paris, 1947.

MATISSE: BARNES, A. C. *The Art of Henri Matisse.* New York, 1933.

BARR, JR., A. H. *Matisse: His Art and His Public.* New York, MOMA, 1951. E.C.

DIEHL, G. *Henri Matisse.* Paris, 1954. With documentation by A. Humbert.

ELDERFIELD, J. *The Cut-Outs of Henri Matisse.* New York, 1978.

———. *The "Wild Beasts": Fauvism and Its Affinities.* New York, MOMA, 1976. E.C.

FLAM, J. D. "Matisse and the Fauves," in W. Rubin, ed., *"Primitivism" in Twentieth-Century Art: Affinity of the Tribal and the Modern,* vol. 1, pp. 211–39. New York, MOMA, 1984. E.C.

GOWING, L. *Matisse.* New York, 1979.

JACOBUS, J. *Henri Matisse.* New York, 1973.

SCHNEIDER, P. *Matisse.* New York, 1984.

MATTA: RUBIN, W. *Matta.* New York, MOMA, 1957. E.C.

MEIER: FRAMPTON, K. *Richard Meier, Architect: Buildings and Projects, 1966–1976.* New York, 1976. Postscript J. Hejduk.

RYKWERT, J. *Richard Meier: 1964/1984.* New York, 1984.

MENDELSOHN: WHITTICK, A. *Eric Mendelsohn.* 2d ed. London, 1956.

METZKER: WITKIN, L. D., and LONDON, B. "Ray K. Metzker," in *The Photograph Collector's Guide,* p. 191. Boston, 1979.

MICHALS: WITKIN, L. D., and LONDON, B. "Duane Michals," in *The Photograph Collector's Guide,* pp. 192–94. Boston, 1979.

MIDDENDORF: KUSPIT, D. B. "Acts of Aggression: German Painting Today, Part II." *Art in America,* Jan. 1983, pp. 132–33.

LAWSON, T. "Helmut Middendorf." *Artforum,* Summer 1983, pp. 74–75.

RUSSELL, J. "The New European Painters." *New York Times Magazine,* April 24, 1983, pp. 28–33.

TULLY, J. "A New Expressionism." *Horizon,* Jan.–Feb. 1984, p. 41.

MIÈS VAN DER ROHE: BILL, M. *Ludwig Miès van der Rohe.* Milan, 1955.

DREXLER, A. *Ludwig Miès van der Rohe.* New York, 1960.

HILBERSEIMER, L. *Miès van der Rohe.* Chicago, 1956.

JOHNSON, P. *Miès van der Rohe.* 2d ed. New York, 1953.

SCHULZE F. *Miës van der Rohe: A Critical Biography.* Chicago, 1985.

SPAETH, D. A. *Miës van der Rohe.* New York, 1985. Preface K. Frampton.

SPEYER, A. J. *Miës van der Rohe: A Retrospective Exhibition.* Art Institute of Chicago, 1968. E.C.

TEGETHOFF, W. *Miës van der Rohe: The Villas and Country Houses.* New York, MOMA, 1985.

MILLET: FERMIGIER, A. *Jean-François Millet.* New York, 1977.

HERBERT, R. L. *Jean-François Millet.* London, Hayward Gallery, 1976. E.C.

MIRÓ: DUPIN, J. *Miró.* New York, 1962.

HUNTER, S. *Joan Miró: His Graphic Work.* New York, 1958.

SOBY, J. T. *Joan Miró.* New York, MOMA, 1959. E.C.

Joan Miró. Paris, Musée National d'Art Moderne, 1962. E.C.

Joan Miró. London, The Arts Council, 1964. E.C.

MISS: LINKER, K. *Mary Miss.* London, ICA, 1983. E.C.

PRINCENTHAL, N. "Mary Miss." *Art News,* Sept. 1984, p. 151.

MODERSOHN-BECKER: *The Letters and Journals of Paula Modersohn-Becker.* Translated and annotated by J. D. Radycki. Montclair, N.J., 1980. Introduction A. Comini.

PERRY, G. *Paula Modersohn-Becker: Her Life and Work.* New York, 1979.

MODIGLIANI: MODIGLIANI, J. *Modigliani: Man and Myth.* New York, 1958.

PFANNSTIEL A. *Modigliani et Son Oeuvre: Etude critique et catalogue raisonné.* Paris, 1956.

SOBY, J. T. *Modigliani: Paintings, Drawings, Sculpture.* 3d rev. ed. New York, MOMA, 1963. E.C.

WERNER, A. *Modigliani the Sculptor.* New York, 1962.

———. *Amedeo Modigliani.* New York, 1967.

WIGHT, F. S. *Modigliani: Paintings & Drawings.* Los Angeles County Museum of Art and Boston Museum of Fine Arts, 1961. E.C.

MODOTTI: CONSTANTIN, M. *Tina Modotti: A Fragile Life.* New York, 1983.

WITKIN, L. D., and LONDON, B. "Tina Modotti," in *The Photograph Collector's Guide,* p. 194. Boston, 1979.

MOHOLY-NAGY: CATON, J. H. *The Utopian Vision of Moholy-Nagy.* Ann Arbor, 1984.

HIGHT, E. M. *Moholy-Nagy: Photography and Film in Weimar Germany.* Wellesley College Museum, 1985. E.C.

MOHOLY-NAGY, L. *Vision in Motion.* Chicago, 1947.

———. *The New Vision and Abstract of an Artist.* New York, 1949.

MOLHOLY-NAGY, S. *Moholy-Nagy: Experiment in Totality.* New York, 1950. Introduction W. Gropius.

Moholy-Nagy. Amsterdam, Stedelijk Museum, 1967. E.C.

SENTIN, T. A. *László Moholy-Nagy.* London, ICA, 1980. E.C.

MONDRIAN: MONDRIAN, P. *Plastic Art and Pure Plastic Art and Other Essays.* New York, 1947.

SEUPHOR, M. *Piet Mondrian: Life and Work.* New York, 1957.

Piet Mondrian 1872–1944. London. Whitechapel Art Gallery, 1955. E.C. Includes the artist's essay, "Neo-Plasticism, General Principle of Plastic Equivalence" (1920).

Piet Mondrian, 1872–1944. Toronto Art Gallery, 1966. E.C. Texts by R. P. Welsh, R. Rosenblum, and M. Seuphor.

Piet Mondrian, 1872–1944: Centennial Exhibition. New York, SRGM, 1971. E.C.

MONET: GORDON, R., and FORGE, A. *Monet.* New York, 1983.

REWALD, J., and WEITZENHOFFER, F., eds. *Aspects of Monet: A Symposium on the Artist's Life and Times.* New York, 1986.

ROUART, D. *Claude Monet: Historical and Critical Study.* Lausanne, 1958.

SEITZ, W. C. *Claude Monet.* New York, 1960.

———. *Claude Monet: Seasons and Moments.* New York, MOMA, 1960. E.C.

STUCKEY, C., ed. *Monet: A Retrospective.* New York, 1985.

TUCKER, P. H. *Monet at Argenteuil.* New Haven, 1982.

WILDENSTEIN D. *Monet's Years at Giverny: Beyond Impressionism.* Introduction C. S. Moffet and J. N. Wood. New York, 1978.

MOORE, CHARLES W.: LITTLEJOHN, D. *Architect: The Life and Work of Charles W. Moore.* New York, 1984.

MOORE, HENRY: GROHMANN, W. *The Art of Henry Moore.* London, 1960.

JAMES R., ed. *Henry Moore on Sculpture.* London, 1966.

MOORE, H. *Sculpture and Drawings.* 2 vols. London, 1955–57.

PACKER, W. *Henry Moore, an Illustrated Biography.* London, 1985.

READ, H. *Henry Moore: A Study of His Life and Work.* New York, 1966.

RUSSELL, J. *Henry Moore.* Baltimore, 1973.

MOREAU: *Odilon Redon, Gustave Moreau, Rudolphe Bresdin.* New York, MOMA, 1961. E.C. With Moreau essay by D. Ashton.

MORISOT: MOSKOWITZ, I., ed. *Berthe Morisot: Paintings, Drawings, Pastels, Watercolors.* New York, 1960.

MORLEY: ALLOWAY, L. "Malcolm Morley," in M. André, ed., *Unmuzzled Ox 14,* vol. 4, no. 2, pp. 48–55.

KRAMER, H. "Malcolm Morley," in *Art of Our Time: The Saatchi Collection,* vol. 3, pp. 18–21. London and New York, 1984.

LEVIN, K. "Malcolm Morley: Post-Style Illusionism." *Arts Magazine,* Feb. 1973, pp. 60ff.

MORRIS: BURNHAM, J. "Robert Morris: Retrospective in Detroit." *Artforum,* March 1970, pp. 67–75.

MORRIS, R. "Anti Form." *Artforum,* April 1968, pp. 33–35.

Robert Morris: Selected Works, 1970–1981. Houston, Contemporary Arts Museum, 1981. E.C.

Robert Morris: Works of the Eighties. Chicago, Museum of Contemporary Art, 1986. E.C. Essays by E. F. Fry and D. P. Kuspit.

TUCKER, M. *Robert Morris.* New York, WMAA, 1970. E.C.

MOSKOWITZ: ADAMS, B. "Robert Moskowitz at the Hudson River Museum." *Art in America,* Nov. 1981, p. 169.

ROSENBLUM, R. *Robert Moskowitz.* New York, Blum Helman Gallery, 1983. E.C.

MOTHERWELL: ARNASON, H. H. "On Robert Motherwell and His Early Work." *Art International,* Jan. 1966, pp. 17–35.

———. *Robert Motherwell.* Rev. ed. New York, 1982.

———. "Robert Motherwell: The Years 1948 to 1965." *Art International,* April 1966, pp. 19–45.

———. *Robert Motherwell: Works on Paper.* New York, MOMA, 1967. E.C.

BUCK, R. T. *Robert Motherwell.* Buffalo, Albright-Knox Art Gallery, 1983. E.C. Essays by J. D. Flam and D. Ashton.

CARMEAN, JR., E. A., ed. *Robert Motherwell: The Reconciliation Elegy.* Geneva and New York, 1980.

GLUECK, G. "The Mastery of Robert Motherwell." *New York Times Magazine,* Dec. 2, 1984, pp. 68–72.

HUGHES, R. "Master of Anxiety and Balance." *Time,* Oct. 10, 1983, pp. 67–70.

KIMBALL, R. "The Motherwell Retrospective." *The New Criterion,* March 1985, pp. 31–40.

KRAUSS, R. "Robert Motherwell's New Paintings." *Artforum,* May 1969, pp. 26–28.

O'HARA, F. *Robert Motherwell.* New York, MOMA, 1965. E.C.

MUNARI: MUNARI, B. *Discovery of the Square.* New York, 1965.

———. *Discovery of the Circle.* New York, 1966.

MUNCH: BENESCH, O. *Edvard Munch.* London, 1960.

DEKNATEL, F. B. *Edvard Munch.* Boston, 1950.

Edvard Munch. New York, SRGM, 1965. E.C. Texts by S. Willoch, J. H. Langaard, L. A. Svendson.

Edvard Munch: Symbols and Images. Washington, D.C., 1978. E.C. Introduction R. Rosenblum; essays by A. Eggum, R. Heller, T. Nergaard, R. Stang, B. Torjusen, G. Wohl.

EGGUM, A. *Edvard Munch: Paintings, Sketches, and Studies.* New York, 1985.

ELDERFIELD, J. *The Masterworks of Edvard Munch.* New York, 1979.

HELLER, R. *Munch: His Life and Work.* Chicago, 1984.

MESSER, T. M. *Munch.* New York, 1973.

MURRAY: ARMSTRONG, R. *Five Painters in New York,* pp. 46–100. New York, WMAA, 1984. E.C. Introduction R. Marshall.

GARDNER, P. "Elizabeth Murray Shapes Up." *Art News,* Sept. 1984, pp. 46–55.

LARSON, K. "One From the Heart: Painter Elizabeth Murray Makes Her Own Trend." *New York Magazine,* Feb. 10, 1986, pp. 40–45.

LEVIN, K. "The Miniature Marauder." *Village Voice,* May 20–26, 1981, p. 90.

ROSENTHAL, M. "Jennifer Bartlett and Elizabeth Murray," in *Art of Our Time: The Saatchi Collection,* vol. 4., pp. 15–16.

RUSSELL, J. "Painting Is Once Again Provocative." *New York Times,* April 17, 1983, sect. 2, pp. 1, 31.

SMITH, R. "Elizabeth Murray at Paula Cooper." *Art in America,* March–April 1979, pp. 150–51.

———. "A Three-Sided Argument." *Village Voice,* Oct. 30, 1984, p. 107.

MUYBRIDGE: HAAS, R. B. *Muybridge's Man in Motion.* Berkeley and Los Angeles, 1976.

HENDRICKS, G. *Eadweard Muybridge—The Father of the Motion Picture.* New York, 1975.

WITKIN, L. D., and LONDON, B. "Eadweard Muybridge," in *The Photograph Collector's Guide,* p. 198. Boston, 1979.

NADAR: GOSLING, N. *Nadar.* New York, 1976.

NADELMAN: KIRSTEIN, L. *Elie Nadelman.* New York, 1973. *The Sculpture and Drawings of Elie Nadelman.* New York, WMAA, 1975. E.C.

NAKIAN: ARNASON, H. H. "Reuben Nakian." *Art International,* April 1963, pp. 36–43.

O'HARA, F. *Nakian.* New York, MOMA, 1966. E.C.

NAUMAN: DANIELI, F. A. "The Art of Bruce Nauman." *Artforum,* Dec. 1967, pp. 15–19.

LIVINGSTON, J., and TUCKER, M. *Bruce Nauman: Work from 1965 to 1972.* Los Angeles County Museum of Art and WMAA, 1972. E.C.

PINCUS-WITTEN, R. "Bruce Nauman: Another Kind of Reasoning." *Artforum,* Feb. 1972, pp. 30–37.

NEEL: HIGGINS, J. "Alice Neel in the Human Comedy." *Art News,* Oct. 1984, pp. 70–79.

HILLS, P. *Alice Neel.* New York, 1983.

NÈGRE: WITKIN, L. D., and LONDON, B. "Charles Nègre," in *The Photograph Collector's Guide,* p. 200. Boston, 1979.

NERVI: ARGAN, G. C. *Pier Luigi Nervi.* Milan, 1955.

HUXTABLE, A. L. *Pier Luigi Nervi.* New York, 1960.

NERVI, P. L. *The Works of Pier Luigi Nervi.* Stuttgart and New York, 1957.

———. *Aesthetics and Technology in Building.* Cambridge, Mass., 1965.

NEUTRA: NEUTRA, R. *Life and Human Habitat.* Stuttgart, 1956.

Richard Neutra, Buildings and Projects. Zurich, 1955.

ZEVI, B. *Richard Neutra.* Milan, 1954.

NEVELSON: FRIEDMAN, M. *Nevelson: Wood Sculptures.* Minneapolis, Walker Art Center, 1973. E.C.

GLIMCHER, A. B. *Louise Nevelson.* New York and Washington, D.C., 1972.

GORDON, J. *Louise Nevelson.* New York, WMAA, 1967. E.C.

Nevelson. New York, Pace Gallery, 1976. E.C.

NEWMAN: ALLOWAY, L. *Barnett Newman: The Stations of the Cross.* New York, SRGM, 1966. E.C.

HESS, T. B. *Barnett Newman.* New York, 1969.

———. *Barnett Newman.* New York, MOMA, 1971. E.C.

ROSENBERG, H. *Barnett Newman.* New York, 1978.

NICHOLSON: ALLEY, R. *Ben Nicholson.* London, 1963.

HODIN, J. P. *Ben Nicholson: The Meaning of His Art.* London, 1957.

NASH, S. A. *Ben Nicholson: Fifty Years of His Art.* Albright-Knox Art Gallery, 1978. E.C.

READ, H. *Ben Nicholson: Paintings, Reliefs and Drawings.* 2 vols. London, 1948–56.

NIEMEYER: PAPADAKI, S. *The Work of Oscar Niemeyer.* New York, 1950.

———. *Oscar Niemeyer: Works in Progress.* New York, 1956.

NOGUCHI: BEARDSLEY, J. *Earthworks and Beyond: Contemporary Art in the Landscape,* pp. 79–87, 102–5. New York, 1984.

GORDON, J. *Isamu Noguchi.* New York, WMAA, 1968. E.C.

GROVE, N. "Isamu Noguchi: Shapes of Space." *Arts,* Dec. 1984, pp. 111–15.

HUNTER, S. *Isamu Noguchi.* New York, 1978.

KRAMER, H. "The Purest of Living Sculptors." *New York Times,* May 21, 1978, pp. D33ff.

NOGUCHI, I. *A Sculptor's World.* New York and Evanston, 1968.

———. *Isamu Noguchi: The Sculpture of Spaces.* New York, WMAA, 1980. E.C. Foreword T. Armstrong.

NOLAND: MOFFETT, K. *Kenneth Noland.* New York, 1977.

WALDMAN, D. *Kenneth Noland: A Retrospective.* New York, SRGM, 1977. E.C.

NOLDE: HAFTMANN, W. *Emil Nolde.* New York, 1959.

———. *Emil Nolde: Unpainted Pictures.* New York, 1965.

SELZ, P. *Emil Nolde.* New York, MOMA, 1963. E.C.

O'KEEFFE: CASTRA, J. G. *The Life and Art of Georgia O'Keeffe.* New York, 1985.

GOODRICH, L., and BRY, D. *Georgia O'Keeffe.* New York, WMAA, 1970. E.C.

O'KEEFFE, G. *Georgia O'Keeffe.* New York, 1976.

TOMKINS, C. "The Rose in the Eye Looked Fine." *The New Yorker,* March 6, 1974, pp. 40–66.

OLDENBURG: FRIEDMAN, M. *Oldenburg: Six Themes.* Minneapolis, Walker Art Center, 1975. E.C.

FUCHS, R. D. *Claes Oldenburg: Large-Scale Projects, 1977–1980.* New York, 1980.

HASKELL, B. *Claes Oldenburg: Object into Monument.* Pasadena Art Museum, 1971. E.C.

JOHNSON, E. *Claes Oldenburg.* Baltimore, 1971.

ROSE, B. *Claes Oldenburg.* New York, MOMA, 1970. E.C.

OPPENHEIM: BOURGEOIS, J.-L. "Dennis Oppenheim: A Presence in the Countryside." *Artforum,* Oct. 1969, pp. 34–38.

OTTERNESS: BRENSON, M. "From Young Artists, Defiance Behind a Smiling Face." *New York Times,* Sept. 29, 1985, pp. C1, 33.

———. "Tom Otterness." *New York Times,* Sept. 13, 1985.

BROOKS, V. "Tom Otterness." *M.D.,* April 1983, pp. 271–75.

GLUECK, G. "Tom Otterness." *New York Times,* Jan. 28, 1983, p. C10.

LEVIN, K. "Tom Otterness." *Village Voice,* Sept. 24, 1985, p. 91.

ROBINSON, W. "Arcadian Hijinks." *Art in America,* Dec. 1985, pp. 95–97.

OUD: HITCHCOCK, H.-R. *J. J. P. Oud.* Paris, 1931.

VERONESI, G. *J. J. Pieter Oud.* Milan, 1953.

OZENFANT: OZENFANT, A. *Foundations of Modern Art.* London, 1931.

——— and JEANNERET, C.-E. *After Cubism.* Paris, 1918.

——— and ———. *La Peinture moderne.* Paris, 1927.

PAIK: HANHARDT, J. G. *Nam June Paik.* New York, WMAA, 1982. E.C. Essays by D. Ronte, M. Nyman, J. G. Hanhardt, D. A. Ross.

PASCIN: WERNER, A. *Jules Pascin.* New York, 1959.

PEARLSTEIN: BOWMAN, R. *Philip Pearlstein: The Complete Paintings.* New York, 1983.

NOCHLIN, L. "The Art of Philip Pearlstein," in *Philip Pearlstein.* Athens, Georgia Museum of Art, 1970. E.C.

SHAMAN, S. S. "An Interview with Philip Pearlstein." *Art in America,* Sept. 1981, pp. 120–26.

PENCK: BRENSON, M. "A. R. Penck: Works from the Past Twenty Years." *New York Times,* Jan. 20, 1984, p. C22.

COWART, J. *Expressions: New Art from Germany.* St. Louis Art Museum, 1983. E.C. Additional texts by S. Gohr and D. Kuspit.

KUSPIT, D. "Acts of Aggression: German Painting Today, Part II." *Art in America,* Jan. 1983, pp. 95, 100–1, 131.

STICH, S. "Pictorial, Personal, and Political Expression in the Art of A. R. Penck." *Arts Magazine,* Summer 1984, pp. 121–25.

PEREIRA: "Irene Rice Pereira," in J. R. Lane and S. C. Larson, eds., *Abstract Painting and Sculpture in America: 1927–1944,* pp. 205–7. New York, WMAA, 1983. E.C.

PERRET: ROGERS, E. *Auguste Perret.* Milan, 1955.

PEVSNER: MASSAT, R. *Antoine Pevsner et le Constructivisme.* Paris, 1956.

PEISSI, P., and GIEDION-WELCKER, C. *Antoine Pevsner.* Neuchâtel, 1961.

PEVSNER, A. *A Biographical Sketch of My Brothers— Naum Gabo and Antoine Pevsner.* Amsterdam, 1964.

Naum Gabo, Antoine Pevsner. New York, MOMA, 1948.

E.C. Introduction H. Read; texts by R. Olson and A Chanin.

PFAFF: AUPING, M. *Judy Pfaff: Installations, Collages, and Drawings.* Sarasota, John and Mable Ringling Museum of Art, 1981. E.C.

"Expressionism Today: An Artists' Symposium." *Art in America,* Dec. 1982, pp. 70–71 (artist's statement).

GLUECK, G. "Judy Pfaff's Neo-Expressionist Environment." *New York Times,* Jan. 21, 1983, p. C22.

KRANE, S. "Judy Pfaff: The Materialization of Ideas," in *Judy Pfaff: Collages and Constructions at Hallwalls and Installation: Rock/Paper/Scissors at Albright-Knox Art Gallery.* Buffalo, N.Y., 1982. E.C.

McGILL, D. C. "Pfaff's Riotous Calm Hits the Holly Solomon." *New York Times,* May 16, 1986.

SMITH, R. "Judy Pfaff: Undone and Done." *Village Voice,* Feb. 1, 1983, p. 93.

PICABIA: BORRAS, M. L. *Picabia.* New York, 1985.

BUCHLOH, B. "Parody and Appropriation in Francis Picabia, Pop, and Sigmar Polke." *Artforum,* March 1982, pp. 28–34.

CAMFIELD, W. A. *Francis Picabia: His Art, Life, and Times.* Princeton, 1979.

PICASSO: BARR, JR., A. H. *Picasso: Fifty Years of His Art.* New York, MOMA, 1946. E.C.

———, ed. *Picasso: 75th Anniversary Exhibition.* New York, MOMA, 1957. E.C.

BOECK, W., and SABARTES, J. *Picasso.* New York, 1965.

BOLLIGER, H., and GEISER, B. *Pablo Picasso: Fifty Years of His Graphic Work.* New York, 1956.

DAIX, P. *Picasso.* New York, 1965.

——— and BOUDAILLE, G. *Picasso: The Blue and Rose Periods.* Greenwich, Conn., 1967.

JAFFE, H. L. C. *Pablo Picasso.* London, 1964.

JARDOT, M. *Pablo Picasso Drawings.* New York, 1959.

KAHNWEILER, D.-H. *Les Sculptures de Picasso.* Paris, 1948.

———. *Picasso: Keramik, Ceramic, Céramique.* Hanover, 1957.

PENROSE, R. *Picasso: His Life and Work.* London, 1958.

———. *The Sculpture of Picasso.* New York, MOMA, 1967. E.C.

RICHARDSON, J., ed. *Picasso: An American Tribute.* New York, 1962.

RUBIN, W. "Cézannism and the Beginning of Cubism," in W. Rubin, ed., *Cézanne: The Late Work,* pp. 151–202. New York, MOMA, 1977. E.C.

———. "Pablo and Georges and Leo and Bill." *Art in America,* March 1979, pp. 114–27.

———, ed. *Pablo Picasso: A Retrospective.* New York, MOMA, 1980. E.C.

———. "Picasso," in W. Rubin, ed. *"Primitivism" in 20th-Century Art,* vol. 1, pp. 241–343. New York, MOMA, 1984. E.C.

SABARTES, J. *Picasso lithographe.* 4 vols. Monte Carlo, 1949–64.

SCHIFF, G. *Picasso: In Perspective.* Englewood Cliffs, N.J., 1976.

———. *Picasso: The Last Years, 1963–1973.* New York, SRGM, 1983.

STEINBERG, L. "Resisting Cézanne: Picasso's *Three Women.*" *Art in America,* Nov.–Dec. 1978, pp. 114–33.

———. "The Polemical Part." *Art in America,* March–April 1979, pp. 114–27.

ZERVOS, C. *Pablo Picasso: Oeuvres.* 19 vols. Paris, 1942–67.

Picasso: Sixty Years of Graphic Works. Los Angeles County Museum of Art, 1966. E.C.

Hommage à Pablo Picasso: Peintures, dessins, sculptures, céramiques. Paris, Grand Palais and Petit Palais, 1967. E.C. Organized by J. Leymarie.

Hommage à Pablo Picasso: Gravures. Paris, Bibliothèque Nationale, 1967. E.C.

PIPPIN: BEARDEN, R., and HENDERSON, H. *Six Black Masters of American Art.* Garden City, N.Y., 1972.

FINE, E. H. *The Afro-American Artist,* pp. 112–20. New York, 1973.

PISSARRO: *Pissarro,* London, Hayward Gallery, 1980. E.C. Essays by J. Rewald, R. Brettell, F. Cachin, J. Bailly-Herzberg, C. Lloyd, A. Distel, B. S. Shapiro.

PISSARRO, C. *Letters to His Son Lucien.* Edited by J.

Rewald. 2d ed. London, 1943.

PISSARRO, L. R., and VENTURI, L. *Camille Pissarro, son art–son oeuvre.* Paris, 1939.

REWALD, J. *Camille Pissarro.* 1963. Reprint. New York, 1977.

C. Pissarro. New York, Wildenstein & Co., 1965. E.C.

POLKE: BERLIND, R. "Sigmar Polke at Mary Boone/Michael Werner." *Art in America,* April 1985, pp. 201–2.

BRENSON, M. "Sigmar Polke, a Master of Illusion." *New York Times,* Jan. 11, 1985, p. C21.

FUCHS, R. "Sigmar Polke," in *Art of Our Time: The Saatchi Collection,* vol. 3, pp. 22–24. London and New York, 1984.

GINTZ, C. "Polke's Dissolve." *Art in America,* Dec. 1985, pp. 102–9.

KUSPIT, D. B. "Acts of Aggression: German Painting Today, Part II." *Art in America,* Jan. 1983, pp. 131–32.

LICHTENSTEIN, T. "Sigmar Polke." *Arts Magazine,* March 1985, pp. 37–38.

POLLOCK: BOZO, D., et al. *Jackson Pollock.* Paris, Centre Georges Pompidou, Musée National d'Art Moderne, 1982. E.C.

FRANK, E. *Jackson Pollock.* New York, 1982.

LIEBERMAN, W. S. *Jackson Pollock: The Last Sketchbook.* New York, 1982.

O'CONNOR, F. V. *Jackson Pollock.* New York, MOMA, 1967. E.C.

——— and Thaw, E.V., eds. *Jackson Pollock: A Catalogue Raisonné of Paintings, Drawings, and Other Works.* New Haven, 1978.

ROSE, B. *Jackson Pollock: Drawing into Painting.* New York, MOMA, 1980. E.C.

POONS: CHAMPA, K. S. "New Paintings by Larry Poons." *Artforum,* Summer 1968, pp. 39–42.

FRIED, M. "Larry Poons' New Paintings." *Artforum,* March 1972, pp. 50–52.

TUCHMAN, P. "An Interview with Larry Poons." *Artforum,* Dec. 1970, pp. 45–50.

POPOVA: DAROWSKI, M. *Contrasts of Form: Geometric Abstract Art 1910–1980.* p. 270. New York, MOMA, 1985. E.C.

PECK, G., and WEI, L. "Liubov Popova: Interpretations of Space." *Art in America,* Oct. 1982, pp. 95–104.

ROWELL, M., and RUDENSTINE, A. Z. *Art of the Avant-Garde in Russia: Selections from the George Costakis Collection,* pp. 15–26, 46–59, 147–56, 216–23, 226–27, 278–89, 292–300. New York, SRGM, 1981. E.C.

RUDENSTINE, A. Z., gen. ed. *Russian Avant-Garde Art: The George Costakis Collection,* pp. 344–420. New York, 1981.

PORTER, ELIOT: NAEF, W. J. *Intimate Landscapes: Photography by Eliot Porter.* New York, MMA, 1979.

WITKIN, L. D., and LONDON, B. "Eliot Porter," in *The Photograph Collector's Guide,* pp. 216–17, Boston, 1979.

PORTER, FAIRFIELD: ASHBERY, J., and MOFFETT, K. *Fairfield Porter: Realist Painter in an Age of Abstraction.* Boston, Museum of Fine Arts, 1982. E.C.

BALLIETT, W. "An Akimbo Quality." *The New Yorker,* March 14, 1983, pp. 140–47.

KRAMER, H. "Porter—'A Virtuoso Colorist.'" *New York Times,* Nov. 25, 1979, sect. 2, pp. 23, 32.

LARSON, K. "Fairfield Porter's Real-Life Pleasures." *New York Magazine,* June 18, 1984, pp. 76–77.

POUSETTE-DART: MONTE, J. K. *Richard Pousette-Dart.* New York, WMAA, 1974. E.C.

PURYEAR: BRENSON, M. "Puryear Postminimalism." *New York Times,* Aug. 10, 1984, p. C24.

DAVIES, H. M., and POSNER, H. *Martin Puryear.* Amherst, Univ. of Massachusetts, 1984. E.C.

MOSER, J. "Martin Puryear." *Art News,* Jan. 1986, p. 116.

SILVERTHORNE, J. "Martin Puryear." *Artforum,* Dec. 1984, pp. 82–83.

PUVIS DE CHAVANNES: D'ARGENCOURT, L., et al. *Puvis de Chavannes: 1824–1898.* Ottawa, National Gallery of Canada, 1977. E.C.

RAUSCHENBERG: CATHCART, L. *Robert Rauschenberg: Work from Four Series.* Houston, Contemporary Arts Museum, 1985. E.C. Appreciation by D. Barthelme.

FORGE, A. *Rauschenberg.* New York, 1969.

SOLOMON, A. R. *Robert Rauschenberg.* New York, Jewish

Museum, 1963. E.C.

TOMKINS, C. *Off the Wall: Robert Rauschenberg and the Art World of Our Time.* Garden City, 1980.

RAY-JONES: WITKIN, L. D., and LONDON, B. "Rony Ray-Jones," in *The Photograph Collector's Guide,* p. 218. Boston, 1979.

REDON: BACOU, R. *Odilon Redon.* 2 vols. Geneva, 1956.

BERGER, K. *Odilon Redon: Fantasy and Color.* New York, 1965.

Odilon Redon: Oeuvre graphique complet. 2 vols. The Hague, 1913.

Odilon Redon, Gustave Moreau, Rodolphe Bresdin. New York, MOMA, 1961. E.C. Essays on Redon by J. Rewald and H. Joachim.

REED: BELL, T. "David Reed." *Arts Magazine,* Feb. 1984, p. 5.

CARRIER, D. "Artifice and Artificiality: David Reed's Recent Painting." *Arts Magazine,* Jan. 1986, pp. 30–33.

WESTFALL, S. "David Reed at Protech." *Art in America,* March 1984, p. 164.

REINHARDT: LIPPARD, L. R. *Ad Reinhardt.* New York, 1981.

ROSE, B. *Art-as-Art: The Selected Writings of Ad Reinhardt.* New York, 1975.

REJLANDER: JONES, E. Y. *Father of Art Photography: O. G. Rejlander, 1813–1875.* Greenwich, Conn., 1973.

WITKIN, L. D., and LONDON, B. "Oscar Gustave Rejlander," in *The Photograph Collector's Guide,* p. 219. Boston, 1979.

RENGER-PATZSCH: WITKIN, L. D., and LONDON, B. "Albert Renger-Patzsch," in *The Photograph Collector's Guide,* p. 220. Boston, 1979.

RENOIR: BARNES, A. C., and DE MAZIA, V. *The Art of Renoir.* New York, 1935.

HAESAERTS, P. *Renoir, Sculptor.* New York, 1947.

PACH, W. *Renoir.* New York, 1960.

PERRUCHOT, H. *La Vie de Renoir.* Paris, 1964.

Renoir. London, Hayward Gallery, 1985. E.C. Essays by J. House, A. Distel, L. Gowing.

"Renoir: A Symposium." *Art in America,* March 1986, pp. 102–25. Statements by L. Nochlin, P. Schjeldahl, C. F. Stuckey, G. Stephan, M. Fried, C. Ratcliff, R. Rosenblum, M. Bochner, T. Crow, A. Fermigier, W. Robinson, B. Adams, P. Tucker, L. Tillman.

RENOIR, J. *Renoir, My Father.* Boston, 1962.

REWALD, J., ed. *Renoir: Drawings.* New York, 1958.

ROGER-MARX, C. *Les Lithographies de Renoir.* Monte Carlo, 1951.

WHITE, B. E. *Renoir: His Life, Art, and Letters.* New York, 1984.

RICHARDSON: HITCHCOCK, H.-R. *The Architecture of H. H. Richardson and His Times.* New York, 1936.

RICHIER: *Germaine Richier. 1904–1959.* Paris, 1966. Texts by J. Cassou, D. de la Souchère, G. Limbour, A. P. de Mandiargues.

RICHTER: BELL, J. "Gerhard Richter." *Art News,* Summer 1985, p. 117.

BUCHLOH, B. H. D. "Richter's Facture: Between the Synecdoche and the Spectacle," in *Gerhard Richter.* New York, Marian Goodman/Sperone Westwater Gallery, 1985. E.C.

DERFNER, P. "Gerhard Richter at Marian Goodman and Sperone Westwater." *Art in America,* Sept. 1985, p. 138.

VAN BRUGGEN, C. "Gerhard Richter: Painting as a Moral Act." *Artforum,* May 1985, pp. 82–91.

RIIS: ALLAND, SR., G. *Jacob A. Riis, Photographer and Citizen.* Millerton, N.Y., 1974.

WITKIN, L. D., and LONDON, B. "Jacob A. Riis," in *The Photograph Collector's Guide,* pp. 221–22. Boston, 1979.

RIPPS: BLISTENE, B. "Going to Live Down There." *Flash Art,* Summer 1980, p. 30.

KUSPIT, D. B. "Cosmetic Transcendentalism: Surface-Light in Torreano, Ripps, and Benglis." *Artforum,* Oct. 1979, pp. 38–40.

LANSING, G. L. "Rodney Ripps and the Constructivist Personage," in *Rodney Ripps.* New York, Holly Solomon Gallery, 1981. E.C.

ROBBINS, C. "Constructs: The Three-Dimensional Gesture." *Arts Magazine,* Sept. 1978, p. 156.

VERIN, H. "Rodney Ripps: An Interview." *Flash Art,* Summer 1980, pp. 28–29.

RIVERA: *Diego Rivera: A Retrospective.* Detroit Institute of Arts, 1986. E.C.

RIVERS: HARRISON, H. A. *Larry Rivers.* New York, 1984.

HUNTER, S. *Larry Rivers.* New York, 1972

ROUART, D. *Rivers.* New York, 1985.

ROBINSON: WITKIN, L. D., and LONDON, B. "Henry Peach Robinson," in *The Photograph Collector's Guide,* pp. 223–24. Boston, 1979.

ROCKBURNE: CRIMP, D. "Judd, LeWitt, Rockburne." *Art News,* March 1972, p. 71.

HESS, T. B. "Rules of the Game, Part II, Marden and Rockburne." *New York Magazine,* Nov. 11, 1974.

KUSPIT, D. B. "Dorothea Rockburne." *Artforum,* March 1983, p. 77.

LICHT, J. "Interview with Dorothea Rockburne." *Artforum,* March 1972, p. 28.

PERRONE, J. "Working Through, Fold by Fold." *Artforum,* Jan. 1, 1979, p. 44.

RODCHENKO: ELLIOTT, D., ed. *Rodchenko and the Arts of Revolutionary Russia.* New York, 1979.

KARGINOV, G. *Rodchenko.* London, 1979.

RODIN: DE CASO, J., and SANDERS, P. B. *Rodin's Sculpture: A Critical Study of the Spreckels Collection, California Palace of the Legion of Honor.* San Francisco, Fine Arts Museums, 1977.

ELSEN, A. E. *Rodin's "Gates of Hell."* Minneapolis, 1960.

———. *Auguste Rodin: Readings on His Life and Work.* Englewood Cliffs, N.J., 1965.

———, ed. *Rodin Rediscovered.* Washington, D.C., National Gallery, 1981. E.C.

RILKE, R. M. *Rodin.* Salt Lake City, 1979.

ROSENQUIST: GOLDMAN, J. *Rosenquist.* New York, 1986.

TUCKER, M. *James Rosenquist.* New York, WMAA, 1972. E.C.

ROSSO: BARR, M. S. *Medardo Rosso.* New York, MOMA, 1963. E.C.

ROSZAK: ARNASON, H. H. *Theodore Roszak.* Minneapolis, Walker Art Center, 1956. E.C.

Roszak: Lithographs and Drawings 1971–74. New York, Pierre Matisse Gallery, 1974. E.C.

Theodore Roszak—Recent Works. The Arts Club of Chicago, 1976. E.C. Essay by B. S. Myers (1974).

ROTHENBERG: "Expressionism Today: An Artist's Symposium." *Art in America,* Dec. 1982, pp. 65, 139 (artist's statement).

GLUECK, G. "Susan Rothenberg: New Outlook for a Visionary Artist." *New York Times Magazine,* July 22, 1984, pp. 16–22.

ROSENTHAL, M. "Susan Rothenberg," in *Art of Our Time: The Saatchi Collection,* vol. 4, pp. 16–18. London and New York, 1984.

STORR, R. "Spooks and Floats." *Art in America,* May 1983, pp. 153–58.

TUCHMAN, M. *Susan Rothenberg.* Los Angeles County Museum, 1983. E.C.

ROTHKO: ASHTON, D. *About Rothko.* New York, 1983.

ROSENBLUM, R. *Mark Rothko: Notes on Rothko, Surrealist Years.* New York, Pace Gallery, 1981. E.C.

———. *Modern Painting and the Northern Romantic Tradition: Friedrich to Rothko.* New York, 1975.

WALDMAN, D. *Mark Rothko, 1903–1970: A Retrospective.* New York, SRGM, 1978. E.C.

ROUAULT: COURTHION, P. *Georges Rouault.* New York, 1961.

ROUAULT, G. *Miserere.* Boston, 1963. Introduction A. Blunt; preface by the artist.

SOBY, J. T. *Georges Rouault: Paintings and Prints.* 3d ed. New York, MOMA, 1947. E.C.

VENTURI, L. *Rouault: Biographical and Critical Study.* Lausanne, 1959.

ROUSSEAU: BOURET, J. *Henri Rousseau.* Greenwich, Conn., 1961.

RICH, D. C. *Henri Rousseau.* New York, MOMA, 1946. E.C.

SALMON, A. *Henri Rousseau dit Le Douanier.* Paris, 1927.

VALLIER, D. *Henri Rousseau.* New York, 1962.

ROZANOVA: DABROWSKI, M. *Contrasts of Form: Geometric Abstract Art 1910–1980,* p. 273. New York, MOMA, 1985. E.C.

ROWELL, M., and RUDENSTINE, A. Z. *Art of the Avant-Garde in Russia: Selections from the George Costakis Collection,* pp. 138–45. New York, SRGM, 1981. E.C.

RUDENSTINE, A. Z., gen. ed. *Russian Avant-Garde Art: The George Costakis Collection,* pp. 453–61. New York, 1981.

RUSCHA: FAILING, P. "Ed Ruscha, Young Artist: Dead Serious About Being Nonsensical." *Art News,* April 1982, pp. 74–81.

HICKEY, D., and PLAGENS, P. *The Works of Edward Ruscha.* Foreword H. T. Hopkins. New York, 1982.

RICKIE, C. "Ed Ruscha, Geographer." *Art in America,* Oct. 1982, pp. 82–93.

RYMAN: PINCUS-WITTEN, R. "Ryman, Marden, Manzoni: Theory, Sensibility, Mediation." *Artforum,* June 1972, pp. 50–53.

SAARINEN, EERO: SAARINEN, A. *Eero Saarinen.* New Haven, Conn., 1968.

TEMKO, A. *Eero Saarinen.* New York, 1962.

Eero Saarinen on His Work. New Haven and London, 1962.

SAARINEN, ELIEL: CHRIST-JANER, A. *Eliel Saarinen.* Rev. ed. Chicago, 1979.

SAINT-GAUDENS: SAINT-GAUDENS, H., ed. *The Reminiscences of Augustus Saint-Gaudens.* 2 vols. London, 1913.

Augustus Saint-Gaudens: The Portrait Reliefs. Washington, D.C., The National Portrait Gallery, 1969. E.C. Introduction J. H. Dryfhout; catalogue J. H. Dryfhout and B. Cox.

SALLE: BRENSON, M. "David Salle Show at Mary Boone Gallery." *New York Times,* May 3, 1985, p. C25.

———. "Variety of Forms for David Salle." *New York Times,* March 23, 1984, p. C20.

"Expressionism Today: An Artists' Symposium." *Art in America,* Dec. 1982, p. 58 (artist's statement).

LARSON, K. "The Daring of David Salle." *New York Magazine,* May 20, 1985, p. 98.

RATCLIFF, C. "David Salle and the New York School," in *David Salle,* pp. 25–38. Museum Boymans-van-Beuningen, Rotterdam, 1983. E.C.

MCGILL, D. "Artist's Style Wins High Praise—and Rejection." *New York Times,* May 16, 1985, p. C23.

SCHJELDAHL, P. "David Salle's Objects of Disaffection." *Village Voice,* March 23, 1982, p. 83.

SCHWARZ, S. "David Salle." *The New Yorker,* April 30, 1984, pp. 104–11.

SMITH, R. "Quality Is the Best Revenge." *Village Voice,* April 3, 1984, p. 79.

SALOMON: HUNTER-SALOMON, P. *Erich Salomon: Portrait of an Age.* New York, 1967.

SAMARAS: GLIMCHER, A. *Lucas Samaras Photo-Transformations.* New York, 1975.

GRUEN, J. "The Apocalyptic Disguises of Lucas Samaras." *Art News,* April 1976, pp. 32–37.

GRUNDBERG, A. "Lucas Samaras: Polaroid Photographs, 1969–83." *New York Times,* July 20, 1984, sect. 3, p. 1.

KUSPIT, D. B. *Lucas Samaras.* Athens, 1986.

LEVIN, K. *Lucas Samaras.* New York, 1975.

———. *Lucas Samaras: The New Reconstructions.* New York, Pace Gallery, 1979. E.C.

RATCLIFF, C. "Modernism Turned Inside Out: Lucas Samaras' Reconstructions." *Arts,* Nov. 1979, pp. 92–95.

SAMARAS, L. *Samaras Album.* New York, WMAA and Pace Gallery, 1971.

———. *Lucas Samaras.* Edited by R. Doty. New York, WMAA, 1972. E.C.

SANDER: NEWHALL, B., and KRAMER, P. *August Sander: Photographer of an Epoch, 1904–1959.* Millerton, N.Y., 1980.

SANT'ELIA: BANHAM, P. R. "Sant'Elia." *Architectural Review,* vol. 117, 1955, and vol. 119, 1956.

SANT'ELIA. "Manifesto of Futurist Architecture." *Architectural Review,* vol. 126, 1959.

SARGENT: HILLS, P. *John Singer Sargent.* New York, 1986. With essays by L. Ayres, A. Boime, W. H. Gerdts, S. Olson, G. A. Reynolds.

RATCLIFF, C. *John Singer Sargent.* New York, 1982.

SCHAPIRO: BRADLEY, P. "Placing Women in History: Miriam Schapiro's Fan and Vestiture Series." *Arts Magazine,* Feb. 1979, pp. 148–49.

BROUDE, N. "Miriam Schapiro and Femmage: Reflections

on the Conflict Between Decoration and Abstraction in Twentieth-Century Art." *Arts Magazine,* Feb. 1980, pp. 83–87.

GOUMA-PETERSON, T. *Miriam Schapiro: A Retrospective, 1952–1980.* Ohio, College of Wooster, 1980. E.C.

———. "The Theater of Life and Illusionism in Miriam Schapiro's Recent Work." *Arts Magazine,* March 1986, pp. 38–43.

LAROSE, E. "Miriam Schapiro," in E Emanuel et al., eds., *Contemporary Artists,* 2d ed., pp. 823–25. London and New York, 1983.

SCHARF: GLUECK, G. "Kenny Scharf." *New York Times,* Dec. 7, 1984, p. C25.

MARZORATI, G. "Kenny Scharf's Fun-House Big Bang." *Art News,* Sept. 1985, pp. 73–81.

SMITH, R. "Aging Well Is the Best Revenge." *Village Voice,* June 14, 1983, p. 93.

SCHIELE: COMINI, A. *Egon Schiele.* New York, 1976.

KALLIR, O. *Egon Schiele: Oeuvre Catalog of the Paintings.* New York, 1966. Essays by O. Benesch and T. M. Messer.

SABARSKY, S. *Egon Schiele.* New York, 1985.

Gustav Klimt and Egon Schiele. New York, SRGM, 1965. E.C. Texts by T. M. Messer and J. Dobai.

SCHLEMMER: HILDEBRANDT, H. *Oskar Schlemmer.* Munich, 1952.

LEHMAN, A., and RICHARDSON, B., eds. *Oskar Schlemmer.* Baltimore Museum of Art, 1986. E.C.

SCHLEMMER, O. *The Theatre of the Bauhaus.* Middletown, Conn., 1961. Translation of *Die Bühne im Bauhaus,* Munich, 1925.

SCHMIDT-ROTTLUFF: GROHMANN, W. *Karl Schmidt-Rottluff.* Stuttgart, 1956.

SCHNABEL: DANTO, A. C. "Julian Schnabel." *The Nation,* Dec. 8, 1984, pp. 624–26.

"Expressionism Today: An Artists' Symposium." *Art in America,* Dec. 1982, pp. 66–67 (artist's statement).

GABLIK, S. "Julian Schnabel Paints a Portrait of God." *The New Criterion,* Jan. 1984, pp. 10–18.

GLUECK, G. "What One Artist's Career Tells Us of Today's Art World." *New York Times,* Dec. 2, 1984, sect. 2, pp. 1, 6.

KUSPIT, D. B. "The Rhetoric of Rawness: Its Effects on Meaning in Julian Schnabel's Paintings." *Arts Magazine,* March 1985, pp. 126–30.

LARSON, K. "Half-Empty Plates." *New York Magazine,* Oct. 25, 1982, pp. 86–87.

SCHIFF, G. *Julian Schnabel.* New York, Pace Gallery, 1984. E.C.

SCHJELDAHL, P. "The Ardor of Ambition." *Village Voice,* Feb. 23, 1982, p. 79.

SCHNEIDER: GINDERTAEL, R. V. *Gérard Schneider: Paintings.* Bergamo, Galleria Lorenzelli, 1967. E.C.

SCHÖFFER: *Nicolas Schöffer.* Neuchâtel, 1963. Introduction J. Cassou; texts by G. Habasque and J. Ménétrier.

SCHWITTERS: ELDERFIELD, J. *Kurt Schwitters.* New York, 1985.

SCHMALENBACK, W. *Kurt Schwitters.* New York, 1967.

SCULLY: COOKE, L. "Sean Scully," in *Art of Our Time: The Saatchi Collection,* vol. 4, pp. 37–38. London and New York, 1984.

HIGGINS, J. "Sean Scully and the Metamorphosis of the Stripe." *Art News,* Nov. 1985, pp. 104–12.

Sean Scully. Carnegie Institute, Pittsburgh, 1985. E.C. Essays by J. Caldwell, D. Carrier, A. Lighthill.

WESTFALL, S. "Sean Scully." *Arts Magazine,* Sept. 1985, p. 40.

SEGAL: SEITZ, W. C. *Segal.* New York, 1972.

TUCHMAN, P. *George Segal.* New York, 1984.

VAN DER MARCK, J. *George Segal.* Rev. ed. New York, 1979.

George Segal: Environments. Philadelphia, Institute of Contemporary Art, 1976. E.C. Essay by J. L. Barrio-Garay.

SERRA: BRENSON, M. "The Case in Favor of a Controversial Sculpture." *New York Times,* May 19, 1985, sect. 2, p. 1.

———. "Richard Serra Works Find a Warm Welcome in France." *New York Times,* Nov. 3, 1985, sect. 2, pp. 35, 40.

GLUECK, G. "What Part Should the Public Play in Choosing Public Art?" *New York Times,* Feb. 3, 1985, sect. 2, pp. 1, 27.

HOELTERHOFF, M. "Tilting Over the Arc: Art or Abomina-

tion?" *Wall Street Journal,* March 14, 1985, p. 23.

KRAUSS, R. E. *Richard Serra/Sculpture.* New York, MOMA, 1986. E.C. Essays by L. Rosenstock and D. Crimp.

PINCUS-WITTEN, R. "Richard Serra: Slow Information." *Artforum,* Sept. 1969, pp. 34–39.

TOMKINS, C. "Tilted Arc." *The New Yorker,* May 20, 1985, pp. 95–101.

SÉRUSIER: DENIS, M. *Sérusier, sa vie, son oeuvre.* Paris, 1943.

SÉRUSIER, P. *L'ABC de la peinture.* Paris, 1950. 1st ed. 1921; 2d ed. 1942, with a preface by M. Denis; 3d ed. 1950, with extracts of correspondence by Sérusier et al.

SEURAT: BROUDE, N. *Seurat in Perspective.* Englewood Cliffs, N.J., 1978.

DORRA, H., and REWALD, J. *Seurat: L'Oeuvre peinte, biographie, et catalogue critique.* Paris, 1959.

FRY, R., and BLUNT, A. *Seurat.* London, 1965.

HERBERT, R. L. *Seurat's Drawings.* New York, 1962.

HOMER, W. I. *Seurat and the Science of Painting.* Cambridge, Mass., 1964.

REWALD, J. *Georges Seurat.* 2d rev. ed. New York, 1946.

RICH, D. C., ed. *Seurat: Paintings and Drawings.* Art Institute of Chicago, 1958. E.C. Essay on Seurat's drawings by R. L. Herbert.

RUSSELL, J. *Seurat.* New York, 1965.

THOMSEN, R. *Seurat.* Salem, N.H., 1985.

SEVERINI: SEVERINI, G. *Du Cubisme au classicisme: Esthétique du compas et du nombre.* 4th ed. Paris, 1921.

———. *Témoignages: 50 ans de réflexion.* Rome, 1963.

Gino Severini. Rotterdam, Museum Boymans-van-Beuningen, 1963. E.C.

SHAPIRO: DELAHOYD, M. "Joel Shapiro," in *A New Beginning: 1968–1978,* pp. 104–5. Yonkers, N.Y., Hudson River Museum, 1985. E.C.

LARSON, K. "Ways with Wit." *New York Magazine,* Nov. 15, 1982, p. 98.

SMITH, R. *Joel Shapiro.* New York, WMAA, 1982. E.C. Essay by R. Marshall.

———. "Exercises for the Figure." *Village Voice,* Nov. 20, 1984, p. 107.

SHEELER: COKE, V. D. *The Painter and the Photograph,* pp. 213–19. Albuquerque, 1972.

MILLARD, III, C. W. "Charles Sheeler, American Photographer." *Contemporary Photographer,* vol. 6, no. 1 (1967). Special issue.

SHERMAN: COWART, J. "Cindy Sherman," in *Currents 20.* St. Louis Art Museum, 1983. E.C.

GRUNDBERG, A. "Cindy Sherman: A Playful and Political Post-Modernist." *New York Times,* Nov. 22, 1981, sect. 2, p. 35.

———. "Cindy Sherman's Dark Fantasies Evoke a Primitive Past." *New York Times,* Oct. 20, 1985.

———. "Lies for the Eyes." *Soho News,* Dec. 17, 1980, p. 28.

HAPGOOD, S. "Cindy Sherman." *Flash Art,* Jan. 1983, p. 63.

MARZORATI, G. "Imitation of Life." *Art News,* Sept. 1983, pp. 78–87.

MELVILLE, S. W. "The Time of Exposure: Allegorical Self-Portraiture in Cindy Sherman." *Arts Magazine,* Jan. 1986, pp. 17–24.

PERL, J. "Starring Cindy Sherman: Notes on the New Art World." *The New Criterion,* Jan. 1986, pp. 14–25.

SCHJELDAHL, P. *Cindy Sherman.* New York, 1984. Afterword by I. M. Danoff.

SICKERT: BROWSE, L. *Sickert.* London, 1960.

SIGNAC: LEMOYNE DE FORGES, M.-T., ed. *Signac.* Paris, Musée National du Louvre, 1963. E.C.

SIGNAC, P. *D'Eugène Delacroix au néo-impressionisme.* Paris, 1899 (also 1911).

SIMONDS: BEARDSLEY, J. *Earthworks and Beyond: Contemporary Art in the Landscape,* pp. 54–57. New York, 1984.

LINKER, K. "Charles Simonds' Emblematic Architecture." *Artforum,* March 1979, pp. 32–37.

LIPPARD, L., and SIMONDS, C. "Microcosm to Macrocosm/Fantasy World to Real World." *Artforum,* Feb. 1974, pp. 36–39.

NEFF, J. H. *Charles Simonds.* Chicago, Museum of Contemporary Art, 1981. E.C. Essays by J. Beardsley, D. Aba-

die, C. Simonds.

SINGER: FEINBERG, J. "Michael Singer: Ritual Series." *Arts Magazine,* June 1983, pp. 69–73.

LINKER, K. "Michael Singer: A Position In, and On, Nature," in A. Sonfist, ed., *Art in the Land,* pp. 183–90. New York, 1983.

WALDMAN, D. *Michael Singer.* New York, SRGM, 1984. E.C.

SISKIND: LYONS, N., ed. *Aaron Siskind, Photographer.* Rochester, 1965.

WITKIN, L. D., and LONDON, B. "Aaron Siskind," in *The Photograph Collector's Guide,* p. 235. Boston, 1979.

SMITH, DAVID: CARMEAN, JR., E. A. *David Smith.* Washington, D.C., National Gallery of Art, 1982. E.C.

CUMMINGS, P. *David Smith: The Drawings.* New York, WMAA, 1979. E.C.

DAY, H. T. *David Smith: Spray Paintings, Drawings, Sculpture.* Chicago, Arts Club of Chicago, 1983. E.C.

FRY, E.D., and McCLINTIC, M. *David Smith: Painter, Sculptor, Draftsman.* Washington, D.C., Hirshhorn Museum and Sculpture Garden, 1982. E.C.

KRAUSS, R. E. *Terminal Iron Works: The Sculpture of David Smith.* Cambridge, Mass., 1971.

———. *The Sculpture of David Smith: A Catalogue Raisonné.* New York, 1977.

MARCUS, S. E. *David Smith: The Sculptor and His Work.* Ithaca, N.Y., 1983.

McCOY, G. *From the Life of the Artist: A Documentary View of David Smith.* Washington, D.C., 1982.

WILKIN, K. *David Smith.* New York, 1984.

SMITH, MATTHEW: HENDY, P. *Matthew Smith.* London, 1962.

SMITH, TONY: *Tony Smith: Recent Sculpture.* New York, M. Knoedler & Co., 1971. E.C.

SMITH, W. EUGENE: JOHNSON, W. S., ed. *W. Eugene Smith: Master of the Photographic Essay.* Millerton, N.Y., 1981.

WITKIN, L. D., and LONDON, B. "W. Eugene Smith," in *The Photograph Coillector's Guide,* p. 238. Boston, 1979.

SMITHSON, R.: BEARDSLEY, J. *Earthworks and Beyond: Contemporary Art in the Landscape,* pp. 19–26. New York, 1984.

HOBBS, R. *Robert Smithson: Sculpture.* Ithaca, N.Y., 1981. Essays by L. Alloway, J. Coplans, L. R. Lippard.

HOLT, N., ed. *The Writings of Robert Smithson.* New York, 1979.

"Robert Smithson." *Arts Magazine,* May 1978, pp. 96–144. Special issue.

"Robert Smithson's Spiral Jetty." *Arts Magazine,* Oct. 1981, pp. 68–88. Special issue.

SMYTH: BLAU, D. "Ned Smyth at Holly Solomon." *Art in America,* March 1983, p. 151.

BOURDON, D. "Paradise Regained." *Village Voice,* Sept. 26, 1977, p. 73.

MEYER, R. K. "Ned Smyth's Stahahe Sphere and Solomon Palm Arcade," in *Arabesque.* Cincinnati, Contemporary Arts Center, 1978. E.C.

MORGAN, S., and SHOTTENKIRK, D. "Ned Smyth: An Interview." *Reallife,* Spring–Summer 1982, pp. 25–28.

Ned Smyth. New York, Holly Solomon Gallery, 1985. E.C. Texts by E. Frank and D. W. Thalacker.

SONNIER: PINCUS-WITTEN, R. "Keith Sonnier: Materials and Pictorialism." *Artforum,* Oct. 1969, pp. 39–45.

———. "Keith Sonnier: Video and Film as Color-Field." *Artforum,* May 1972, pp. 35–37.

SOTO: *Soto: A Retrospective Exhibition.* New York, SRGM, 1974. E.C.

SOULAGES: DORIVAL, B. *Soulages.* Paris, Musée National d'Art Moderne, 1967. E.C.

LEVITINE, G. *Some Comments on the Art of Pierre Soulages.* University of Maryland Art Gallery, 1972. E.C.

SWEENEY, J. J. *Soulages.* Neuchâtel, 1972.

Soulages 1970–1972. Paris, Galerie de France, 1972. E.C.

SOUTINE: CASTAING, M., and LEYMARIE, J. *Chaim Soutine.* New York, 1964.

SYLVESTER, D. *Chaim Soutine, 1894–1943.* London, The Arts Council, 1963. E.C.

TUCHMAN, M. *Soutine.* Los Angeles County Museum of Art, 1968. E.C.

WHEELER, M. *Soutine.* New York, MOMA, 1950. E.C.

SPENCER: *Niles Spencer.* Louisville, Ky., University of Ken-

tucky Art Gallery, 1965. E.C. Introduction R. B. Freeman; tribute by R. Crawford.

STEICHEN: LONGWELL, D. *Steichen: The Master Prints, 1895–1914.* New York and Boston, 1978.

STEICHEN, E. *A Life in Photography.* Garden City, N.J., 1963.

WITKIN, L. D., and LONDON, B. "Edward Steichen," in *The Photograph Collector's Guide,* p. 241. Boston, 1979.

STEINERT: ROSENBLUM, N. *A World History of Photography,* pp. 572–74. New York, 1984.

STEIR: BRENSON, M. "Pat Steir's Brueghel Series." *New York Times,* Dec. 14, 1984, p. C33.

———. "Expressionism Today: An Artists' Symposium." *Art in America,* Dec. 1982, pp. 74–75 (artist's statement).

GARDNER, P. "Pat Steir: Seeing Through the Eyes of Others." *Art News,* Nov. 1985, pp. 80–88.

McGILL, D. C. "Art People." *New York Times,* March 7, 1986, p. C19.

RATCLIFF, C. *Pat Steir: Paintings: Essay/Interview.* New York, 1986.

ZIMMER, W. "Pat Steir." *Soho News Weekly,* Dec. 1, 1981, p. 48.

STELLA, FRANK: BAKER, E. C. "Frank Stella, Revival and Relief." *Art News,* Nov. 1971, pp. 34–35, 87–89.

KRAMER, H. "Frank Stella's Brash and Lyric Flight." *Portfolio,* April–May 1979, pp. 48–55.

LEIDER, P. *Stella Since 1970.* Fort Worth Art Museum, 1978. E.C.

RATCLIFF, C. "Frank Stella's Portrait of the Artist as Image Administrator." *Art in America,* Feb. 1985, pp. 94–106.

RICHARDSON, B. *Frank Stella: The Black Paintings.* Baltimore Museum of Art, 1976. E.C.

ROSENBLUM, R. *Frank Stella.* Harmondsworth and Baltimore, 1971.

RUBIN, W. S. *Frank Stella.* New York, MOMA, 1970. E.C.

RUSSELL, J. "The Power of Frank Stella." *New York Times,* Feb. 1, 1985, pp. Cl, 20.

STELLA, F. "On Caravaggio." *New York Times Magazine,* Feb. 3, 1985, pp. 38–39.

STORR, R. "Frank Stella's Norton Lectures: A Response." *Art in America,* Feb. 1985, pp. 11–15.

TOMKINS, C. "The Space Around Real Things." *The New Yorker,* Sept. 10, 1984, pp. 53–97.

STELLA, JOSEPH: BAUR, J. I. H. *Joseph Stella.* New York, WMAA, 1963. E.C.

JAFFE, I. B. *Joseph Stella.* Cambridge, Mass., 1970.

STEPHAN: ARMSTRONG, R. "Gary Stephan," in *Five Painters,* pp. 62–76. New York, WMAA, 1984. E.C.

LAWSON, T. "Gary Stephan." *Flash Art,* Sept. 1981, p. 31.

RAYNOR, V. "Gary Stephan Show at Boone and Werner." *New York Times,* May 23, 1986, p. C26.

STORR, R. "Gary Stephan at Mary Boone." *Art in America,* May 1983, p. 163.

WESTFALL, W. "Gary Stephan at Marlborough." *Art in America,* Nov. 1984, p. 153.

STERN: JENCKS, C. *The Language of Post-Modern Architecture,* 4th ed., p. 155. New York, 1984.

MANDEVILLE, L. "Robert A. M. Stern: Custom of the Country." *Columbia,* Dec. 1985, pp. 16–23.

STERN, R. A. M. *New Directions in American Architecture.* Rev. ed. New York, 1977.

TRACHTENBERG, M. *Architecture: From Prehistory to Post-Modernism,* p. 572. New York, 1986.

VOGEL, C. "The Trend-Setting Traditionalism of Architect Robert A. M. Stern." *New York Times Magazine,* Jan. 13, 1985, pp. 40–43.

STIEGLITZ: GREENOUGH, S., and HAMILTON, J. *Alfred Stieglitz, Photographer and Writer.* Washington, D.C., and New York, 1983.

HOMER, W. I. *Alfred Stieglitz and the Photo-Secession.* Boston, 1983.

NORMAN, D. *Alfred Stieglitz: An American Seer.* New York, 1973.

WALDO, F., ed. *America and Alfred Stieglitz: A Collective Portrait (1934).* Rev. ed. Millerton, N.Y., 1979.

WITKIN, L. D., and LONDON, B. "Alfred Stieglitz," in *The Photograph Collector's Guide,* pp. 243–44. Boston, 1979.

STIRLING: *The Architecture of James Stirling: Four Works.* Minneapolis, Walker Art Center, 1978. E.C. Texts by C. Hodgetts and P. Papademetriou.

ARNELL, P., and BICKFORD, T. *James Stirling: Buildings and Projects.* New York, 1985. Essay by C. Rowe.

TRACHTENBERG, M. *Architecture: From Prehistory to Post-Modernism,* pp. 575–77. New York, 1986.

STRAND: *Paul Strand: A Retrospective Monograph, the Years 1915–1968.* 2 vols. Millerton, N.Y., 1971.

TOMKINS, C. *Paul Strand: Sixty Years of Photographs.* Millerton, N.Y., 1976.

WITKIN, L. D., and LONDON, B. "Paul Strand," in *The Photograph Collector's Guide,* p. 246. Boston, 1979.

SUDEK: BULLATY, S. *Sudek.* New York, 1978.

WITKIN, L. D., and LONDON, B. "Josef Sudek," in *The Photograph Collector's Guide,* p. 247. Boston, 1979.

SUGARMAN: DAY, H. T. *The Shape of Space: The Sculpture of George Sugarman.* Joslyn Art Museum, Neb., 1971. E.C.

SULLIVAN: MORRISON, H. *Louis Sullivan, Prophet of Modern Architecture.* New York, MOMA, 1935. E.C.

SULLIVAN, L. H. *Kindergarten Chats and Other Writings.* New York, 1947.

SZARKOWSKI, J. *The Idea of Louis Sullivan.* Minneapolis, 1956.

SULTAN: MADOFF, S. H. "Donald Sultan at Blum Helman." *Art in America,* Jan. 1983, p. 126.

RAYNOR, V. "Sultan's Tar-on-Tile Technique." *New York Times,* April 12, 1985, p. C26.

TOMKINS, C. "Clear Painting." *The New Yorker,* June 3, 1985, pp. 106–13.

TACK: GREEN, E. *Augustus Vincent Tack: 1870–1949: Twenty-Six Paintings from the Phillips Collection.* Austin, Univ. of Texas, 1972. E.C.

ROSENBLUM, R. *Modern Painting and the Northern Romantic Tradition: Friedrich to Rothko,* pp. 197–201, 289–92. New York, 1975.

TAEUBER-ARP: LANCHNER, C. *Sophie Taeuber-Arp.* New York, 1981.

TALBOT: ARNOLD, H. J. P. *William Henry Fox Talbot: Pioneer of Photography and Man of Science.* London, 1977.

BUCKLAND, G. *Fox Talbot and the Invention of Photography.* Boston, 1980.

WITKIN, L. D., and LONDON, B. "William Henry Fox Talbot," in *The Photograph Collector's Guide,* pp. 249–50. Boston, 1979.

TANGUY: SOBY, J. T. *Yves Tanguy.* New York, MOMA, 1955. E.C.

TANGUY, K. (S.). *Yves Tanguy: Un Recueil de ses oeuvres.* New York, 1963. Chronology by L. R. Lippard.

TÀPIES: PENROSE, R. *Tàpies.* New York, 1978.

PERMANYER, L. *Tàpies and the New Culture.* New York, 1986.

TAPIÉ, M. *Antoni Tàpies.* Barcelona, 1959.

Antoni Tàpies. New York, SRGM, 1962. E.C.

TCHELITCHEW: KIRSTEIN, L. *Pavel Tchelitchew.* New York, The Gallery of Modern Art, 1964. E.C.

SOBY, J. T. *Tchelitchew: Paintings, Drawings.* New York, MOMA, 1942. E.C.

TOBEY: ROBERTS, C. *Mark Tobey.* New York, 1959.

SEITZ, W. C. *Mark Tobey.* New York, MOMA, 1962. E.C.

TOMLIN: BAUR, J. I. H. *Bradley Walker Tomlin.* New York, WMAA, 1957. E.C.

TORRES-GARCIA: *Joaquin Torres-Garcia.* Amsterdam, Stedelijk Museum, 1961. E.C.

TOULOUSE-LAUTREC: COOPER, D. *Henri de Toulouse-Lautrec.* New York, 1956.

HUISMAN, P., and DORTY, M. G. *Lautrec by Lautrec.* New York, 1964.

JOURDAIN, F., and ADHEMAR, J. *T.-Lautrec.* Paris, 1952.

JOYANT, M. *Henri de Toulouse-Lautrec, 1864–1901.* 2 vols. Paris, 1926–27.

MACK, G. *Toulouse-Lautrec.* New York, 1938.

STUCKEY, C., and MAURER, N. E. *Toulouse-Lautrec: Paintings.* Art Institute of Chicago, 1979. E.C. Essay by M. G. Dortu.

Centenaire de Toulouse-Lautrec. Paris, Musée Toulouse-Lautrec, Albi. E.C.

TURNER: GOWING, L. *Turner: Imagination and Reality.* New York, MOMA, 1966. E.C.

TWOMBLY: BARTHES, R. *Cy Twombly: Paintings and Drawings 1954–1977.* New York, WMAA, 1979. E.C.

TWORKOV: BRYANT, E. *Jack Tworkov.* New York, WMAA, 1964. E.C.

UECKER: HONISCH, D. *Uecker.* New York, 1986.

UTRILLO: PETRIDES, P., ed. *Maurice Utrillo: l'oeuvre complet.* 2 vols. Paris, 1959–62.

Maurice Utrillo. Pittsburgh, Museum of Art, Carnegie Institute, 1963. E.C.

VAN DER ZEE: WITKIN, L. D., and LONDON, B. "James Van Der Zee," in *The Photograph Collector's Guide,* p. 261. Boston, 1979.

VAN DE VELDE: CASTEELS, M. *Henry van de Velde.* Brussels, 1932.

CURJEL, H. *Henry van de Velde, 1863–1957: Persönlichkeit und Werk.* Zurich, Kunstgewerbemuseum, 1958. E.C.

TEIRLINCK, H. *Henry van de Velde.* Brussels, 1959.

VAN DE VELDE, H. *Geschichte meines Lebens.* Munich, 1962.

Henry van de Velde, 1863–1957. Otterlo, The Netherlands, Kröller-Müller Rijksmuseum, 1964. E.C.

VAN DOESBURG: VAN DOESBURG, T. *New Movement in Painting.* Delft, 1917.

SWEENEY, J. J. *Theo van Doesburg.* New York, Art of This Century, 1947. E.C.

VAN GOGH: BARR, JR., A. H., ed. *Vincent Van Gogh.* New York, MOMA, 1935. E.C. With notes excerpted from the letters of the artist.

The Complete Letters of Vincent Van Gogh. 3 vols. Greenwich, Conn., 1958. Reprint 1979.

COOPER, D. *Van Gogh: Drawings and Watercolours.* New York, 1955.

DE LA FAILLE, J. B. *The Works of Vincent Van Gogh: His Paintings and Drawings.* Amsterdam and London, 1970.

HULSKER, J. *The Complete Van Gogh: Paintings, Drawings, Sketches.* New York, 1980.

NORDENFALK, C. A. J. *The Life and Work of Van Gogh.* New York, 1953.

PICKVANCE, R. *Van Gogh in Arles.* New York, MMA, 1984. E.C.

SCHAPIRO, M. *Vincent Van Gogh.* New York, 1950.

WELSH-OVCHAROV, B., ed. *Van Gogh in Perspective.* Englewood Cliffs, N.J., 1974.

———, ed. *Vincent Van Gogh: His Paris Period, 1886–1888.* Utrecht and The Hague, 1976.

VANTONGERLOO: BILL, M., ed. *Georges Vantongerloo.* London, Marlborough Fine Arts Ltd., 1962. E.C.

VANTONGERLOO, G. *Problems of Contemporary Art—Number 5: Paintings, Sculptures, Reflections.* New York, 1948.

VAN VELDE: BECKETT, S., and DUTHUIT, G. *Three Dialogues.* London, 1965.

PUTNAM, J., ed. *Bram van Velde.* New York, 1959. With statements by S. Beckett and G. Duthuit.

Bram van Velde. New York, Knoedler & Co., 1962. E.C. Text by J. van der Marck.

VASARELY: JORAY, M., ed. *Vasarely.* Neuchâtel, 1965.

VENTURI: GOLDBERGER, P. "Less is More—Mies van der Rohe; Less Is a Bore—Robert Venturi." *New York Times Magazine,* Oct. 17, 1971, pp. 34ff.

TRACHTENBERG, M. *Architecture: From Prehistory to Post-Modernism,* pp. 563–68. New York, 1986.

VENTURI, R. *Complexity and Contradiction in Architecture.* New York, 1966.

———, SCOTT BROWN, D., and IZENOUR, S. *Learning from Las Vegas.* Rev. ed. Cambridge, Mass., 1977.

VON MOOR, S. *Venturi, Rauch, and Scott Brown: Buildings and Projects, 1960–1985.* New York, 1986.

VILLANUEVA: MOHOLY-NAGY, S. *Carlos Raúl Villanueva and the Architecture of Venezuela.* Caracas, 1964.

VILLON: MOREL, A., et al. *Souvenir de Jacques Villon.* Paris, 1963.

VALLIER, D. *Jacques Villon: oeuvres de 1897 à 1956.* Paris, 1957.

WICK, P. A. *Jacques Villon, Master of Graphic Art (1875–1963).* Boston, Museum of Fine Arts, 1964. E.C.

VIOLLET-LE-DUC: GOUT, P. *Viollet-le-Duc: sa vie, son oeuvre, sa doctrine.* Paris, 1914.

VLAMINCK: GENEVOIX, M. *Vlaminck, l'homme.* Paris, 1954.

SELZ, J. *Vlaminck.* New York, 1963.

VUILLARD: RITCHIE, A. C. *Edouard Vuillard.* New York, MOMA, 1954. E.C.

ROGER-MARX, C. *Vuillard: His Life and Work*. New York, 1946.

⸻. *L'Oeuvre gravé de Vuillard*. Monte Carlo, 1948.

WACHSMANN: WACHSMANN, K. *The Turning Point of Building, Structure and Design*. New York, 1961.

WAGNER: LUX, J. A. *Otto Wagner*. Berlin, 1919.

WAGNER, O. *Einige Skizzen, Projekte und ausgeführte Bauwerke*. 4 vols. Vienna, 1890–1922.

WEBB: LETHABY, W. *Philip Webb and His Work*. London, 1935.

WEBER: GOODRICH, L. *Max Weber: Retrospective Exhibition*. New York, WMAA, 1949.

WEGMAN: DELAHOYD, M. "William Wegman," in *A New Beginning: 1968–1978*, pp. 110–11. Yonkers, N.Y., Hudson River Museum, 1985. E.C.

LARSON, K. "A Dog's Life." *New York Magazine*, Nov. 29, 1982, pp. 78–79.

LYON, C. "Man Snaps Dog." *Reader*, Jan. 1, 1982, p. 42.

LYONS, L., and LEVIN, K. *Wegman's World*. Minneapolis, Walker Art Center, 1982. E.C.

OWENS, C. "William Wegman's Psychoanalytic Vaudeville." *Art in America*, March 1983, pp. 100–109.

RICKEY, C. "Post-Modern Pup." *Village Voice*, Jan. 4, 1983, pp. 28–29.

WEGMAN, W., and WIEDER, L. *Man's Best Friend*. New York, 1982.

WEINER: FUCHS, R. H. *Lawrence Weiner: A Selection of Works with Commentary*. Eindhoven, Van Abbemuseum, 1976. E.C.

WELLIVER: GOODYEAR, JR., F. H., *Contemporary American Realism Since 1960*, pp. 23, 25, 30, 84, 88, 128, 131. Boston, 1981.

⸻. *Welliver*. New York, 1985. Introduction J. Ashbery.

HUGHES, R. "Neil Welliver's Cold Light." *Time*, Oct. 11, 1982, p. 85.

KUSPIT, D. B. "Terrestrial Truth: Neil Welliver." *Art in America*, April 1983, pp. 136–43.

SULLIVAN, B. "Neil Welliver." *Arts Magazine*, March 1985, p. 15.

WESTON: MADDOW, B. *Edward Weston: Fifty Years*. Millerton, N.Y., 1973.

WITKIN, L. D., and LONDON, B. "Edward Weston," in *The Photograph Collector's Guide*, pp. 269–70. Boston, 1979.

WHISTLER: CURRY, D. P. *James McNeill Whistler at the Freer Gallery of Art*. Washington, D.C., and New York, 1984. E.C.

LAVER, J. *Whistler*. London, 1930.

SUTTON, D. *Nocturne: The Art of James McNeill Whistler*. London, 1963.

YOUNG, A. McL. *James McNeill Whistler*. London, The Arts Council, 1960. E.C.

WHITE, CLARENCE H.: HOMER, W. I. *Symbolism of Light: The Photographs of Clarence H. White*. Wilmington, 1977.

WITKIN, L. D., and LONDON, B. "Clarence H. White," in *The Photograph Collector's Guide*, pp. 271–72. Boston, 1979.

WHITE, MINOR: WITKIN, L. D., and LONDON, B. "Minor White," in *The Photograph Collector's Guide*, pp. 272–73. Boston, 1979.

WILMARTH: *Christopher Wilmarth: Nine Clearings for a Standing Man*. Hartford, Wadsworth Atheneum, 1975. E.C.

GLUECK, G. "Christopher Wilmarth's 'Layers.'" *New York Times*, March 23, 1984, p. C18.

⸻. "Mallarmé Poems Inspire Glass Sculpture." *New York Times*, May 14, 1982, p. C20.

POIRIER, M. "Christopher Wilmarth: 'The Medium Is Light.'" *Art News*, Dec. 1985, pp. 68–75.

WINOGRAND: WITKIN, L. D., and LONDON, B. "Gary Winogrand," in *The Photograph Collector's Guide*, p. 274. Boston, 1979.

WINSOR: GRUEN, J. "Jackie Winsor: Eloquence of a Yankee Pioneer." *Art News*, March 1979, pp. 57–60.

JOHNSON, E. *Jackie Winsor*. New York, MOMA, 1979. E.C.

Jackie Winsor/Barry Ledoux: Sculpture. Cambridge, Mass., MIT, 1984. E.C.

KRAMER, H. "A Second Generation of Minimalists." *New York Times*, Feb. 4, 1979, sect. 2, p. 29.

RAYNOR, V. "Jackie Winsor." *New York Times*, March 19, 1982, p. C25.

WOOD: CORN, W. M. *Grant Wood: The Regionalist Vision*. New York, WMAA, 1983. E.C.

WOODROW: FEAVER, W. "The New British Sculpture." *Art News*, Jan. 1984, pp. 71–75.

NEWMAN, M. "New Sculpture from Britain." *Art in America*, Sept. 1982, pp. 104–14, 171–77.

AMMANN, J.-C. *Bill Woodrow*. Basel, Kunsthalle, 1985. E.C.

WRIGHT: GUTHEIM, F., ed. *Frank Lloyd Wright on Architecture: Selected Writings, 1894–1940*. New York, 1941.

HITCHCOCK, H.-R. *In the Nature of Materials: The Buildings of Frank Lloyd Wright, 1887–1941*. New York, 1942.

NADEN, C. J. *Frank Lloyd Wright, the Rebel Architect*. New York, 1968.

SCULLY, JR., V. *Frank Lloyd Wright*. New York, 1960.

WRIGHT, F. L. *An Autobiography*. New York, 1943.

⸻. *A Testament*. New York, 1957.

⸻. *The Solomon R. Guggenheim Museum*. New York, 1960.

⸻. *The Work of Frank Lloyd Wright*. New York, 1965.

WRIGHT, O. L. *Frank Lloyd Wright*. New York, 1966.

WYETH: *Andrew Wyeth*. Philadelphia, Pennsylvania Academy of the Fine Arts, 1966. E.C.

CORN, W. M. *The Art of Andrew Wyeth*. Fine Arts Museums of San Francisco, 1973. E.C.

ZADKINE: HAMMACHER, A. M. *Zadkine*. New York, 1959.

ZAKANITCH: PERREAULT, J. "Cultivated Canvas." *Art in America*, March 1982, pp. 96–101.

PERRONE, J. "Excess—A Dissenter." *Arts Magazine*, Oct. 1979, pp. 98ff.

RICKEY, C. "Decoration, Ornament, Pattern, and Utility: Four Tendencies in Search of a Movement." *Flash Art*, June/July 1979, pp. 19–23 (artist statements).

KARDON, J. *Robert S. Zakanitch*. Philadelphia, Institute of Contemporary Art, 1986. E.C.

ZUCKER: KERTESS, K. "Joe Zucker's Tales of Cotton." *Arts*, March 1980, pp. 161–65.

⸻. "The Paint(ing) Makes the Man," in *Joe Zucker*. New York, Holly Solomon Gallery, 1984. E.C.

KRANE, S. *Surfacing Images: The Paintings of Joe Zucker, 1969–1982*. Buffalo, N.Y., Albright-Knox, 1982. E.C.

MARSHALL, R. *New Image Painting*, p. 68 (artist's statement). New York, WMAA, 1978. E.C.

Index

Page numbers are in roman type. Figure numbers of black-and-white illustrations are in *italic type*. Colorplates are specifically so designated. Titles of works are in *italics*. Names of artists, architects, and photographers are in CAPITALS.

González, Jean, 305, 409
GONZÁLEZ, JULIO, 302, 303, 305–6, 417, 444, 663; *Cactus Man I*, 305; *435; Mask of Roberta in the Sun*, 305; *434; Montserrat*, 306; *436*
Good Morning #2 (Katz), 610; *978*
Goodrich, Lloyd, 363
Gore, Frederick Spencer, 353
GORIN, JEAN, 332, 333
Gorki, Maxim, 64
GORKY, ARSHILE, 291, 379, 387, 388, 389, 392, 395, 410, 494; *Betrothal II, The*, 388; *578; Liver Is the Cock's Comb, The*, 279, 388, colorplate 177
Gothic Revival architecture, 68, 70, 74, 78, 622
Gothic style, 275, 277, 497; architecture, 206, 209, 211, 312, 313, 315; and fantasy, 243, 245; and German Expressionism, 122, 123; in sculpture, 90, 97, 136
GOTTLIEB, ADOLPH, 382, 388, 405–6, 409, 487, 492; *Frozen Sounds Number 1, The*, 406; *598; Orb*, 406; *599; Voyager's Return*, 405; *597*
GOYA, FRANCISCO DE, 18–19, 20, 28, 67, 85, 88, 89, 125, 301, 483, 636, 651; *Disasters of War, The* (pl. 30), 18–19, 28, 60, 218; *15; St. Francis Borgia Exorcising an Impenitent*, 18–19, 218; *14*
Graded Exposure (Noland), 495, colorplate 245
Graffiti, graffiti artists, 432, 480, 492, 499, 653–58
Gramineous Bicycle…, The (Ernst), 243; *344*
Grand Metaphysical Interior (De Chirico), 223; *319*
Grand Vitesse, La (Calder), 525, colorplate 260
Grantchester Road (Hodgkin), 661; *1060*
GRANT, DUNCAN, 353
Graphic arts, 65, 67, 106, 135, 213, 221, 269; Art Nouveau, 75, 76–77, 81, 84; Bauhaus, 319, 324, 533; German Expressionism, 61, 122, 125–26, 130, 133; Pop Art, 450, 455, 461. *See also* Lithography; Poster design; Woodcuts
GRAVES, MICHAEL, 552, 695–96; Portland Public Services Building (Portland, Ore.), 695–96; *1095*, colorplate 318
GRAVES, MORRIS, 383; *Blind Bird*, 383; *569*
GRAVES, NANCY, 659, 662–64; *Camels VI, VII, VIII*, 663; *1061; Footscray*, 664, colorplate 309; *Zag*, 663; *1062*
Great American Nude #57 (Wesselmann), 460; *711*
Great Britain, 19; abstract art in, 351–58; Art Nouveau in, 75, 76–77; architecture, 70–72, 538–39, 698; Cubism in, 353, 354–55, 357; Expressionism in, 353, 356; Futurism in, 353, 354; Impressionism in, 45–46; landscape tradition, 19, 20, 30; photography in, 24, 26, 29, 66, 148; Pop Art in, 448–52; pre-W.W. II artists, 178, 354–58; sculpture, 357–58, 436–39, 525–27, 578, 632–33, 689–90. *See also* Pre-Raphaelites; Vorticism
Great Depression, 270, 311, 379, 386; and American scene painting, 372–75; documentary photography, 376–77
Great Figure, The (W. C. Williams), 372
Great Metaphysician, The (De Chirico), 223, colorplate 101
Great Parade, The (Léger), 178, colorplate 76
Great Red Dragon… (Blake), 76; *90*
Great Zoological Garden (Lache), 128, colorplate 54
Greece, ancient, 267, 558; architecture, 212; sculpture, 16, 52, 90, 94, 97, 134, 136, 138, 144, 167, 185, 189, 250, 336; vase painting, 107, 144, 145, 266, 268
Green, Red, and Orange (Rothko), 396, colorplate 186
Green Ballet (Jorn), 446; *685*
Greenberg, Clement, 387, 487–88, 489
GREENBLAT, RODNEY ALAN, 654, 657–58; *Guardian*, 675; *1055; Secret, The*, 657; *1056*
Green Box (Duchamp), 229
Green Coca-Cola Bottles (Warhol), 461, 612, colorplate 222
Green Oval Concept (Fontana), 487, 574, colorplate 231
Green Still Life (Picasso), 166–67, 168, 265, 267, colorplate 67
Green Stripe (Mme. Matisse) (Matisse), 102, 129–30, colorplate 34
Green Violinist, The (Chagall), 220, colorplate 98
Greuze, Jean-Baptiste, 28
Grillo (Basquiat), 655; *1052*
GRIS, JUAN, 167, 169, 173–74, 188, 254, 268, 289, 291, 332, 392; *Guitar with Sheet of Music*, 174, colorplate 71; *Place Ravignan, La (Still Life in Front of an Open Window)*, 174, colorplate 70; *Portrait of Picasso*, 173–74; *244*

GROOMS, RED, 475, 657; *Ruckus Manhattan*, 475; *730*
GROPIUS, WALTER, 208, 210, 212, 213, 214, 244, 311–15, 317, 318–19, 324, 326, 329, 358, 533, 534, 547, 550, 691; housing projects, 315, 316; theater architecture, 319, 541–42; Boston City Center project, 534; *831; Chicago Tribune Tower, 313, 317; *452; Fagus Shoe Factory (Alfeld, Ger.), 312–13, 317; *450; Harvard Graduate Center (Cambridge, Mass.), 534, 553; Impington College (Cambridgeshire, Eng.), 533; Model Factory, Werkbund Exhibition (Cologne), 313; *451; Workshop Wing, Bauhaus (Dessau, Ger.), 313; *454*
GROSS, CHAIM, 385
Grosses Schauspielhaus (Berlin; Poelzig), 214; *305*
GROSZ, GEORGE, 131, 241, 244–45, 247, 449, 651; *Dedication to Oskar Panizza*, 126, 244, colorplate 107; *Fit for Active Service*, 244; *345; Republican Automatons*, 244; *346*
Groupe de Recherche d'Art Visuel (GRAV), 519
Group *f*/64, 383
Group N (Padua), 517
Group of Four Trees (Dubuffet), 435; *648*
Group of 7 (Italy), 542
Group T (Milan), 517
Group III (Evocation) (Hepworth), 439; *663*
Group 0 (Zero) (Düsseldorf), 517
GRÜNEWALD, MATTHIAS, 85, 106, 243, 247; *Crucifixion* from *Isenheim Altarpiece*, 15–16, 245, 301, 436, 637; *8*
Guaranty Trust Building (Buffalo, N.Y.; Sullivan), 73, 78, 206; *87*
GUARDI, GIOVANNI ANTONIO, 16, 89
Guardian (Greenblat), 657; *1055*
Güell Park (Barcelona; Gaudí), 78, 280, 645; *98*
Guérin, Charles, 99, 151
Guernica (Picasso), 279, 301, 302, 442, 655; *424*
Guggenheim Museum (New York), 517, 575; Wright design, 533–34, 557; *829, 830; exhibitions: "American Abstract Expressionists and Imagists" (1961), 487; Picasso (1963–73), 635; "Systemic Painting" (1966), 488
Guifa e la berretta rossa (F. Stella), 500, 648; *778*
Guild House (Philadelphia; Venturi), 693; *1090*
Guilds, 22, 122
Guillaume, Paul, 290
GUIMARD, HECTOR: Métropolitain Station entrance (Paris), 81; *103*
Guitar (Picasso), 165, 167, 189; *224*
Guitar and Clarinet (Laurens), 172, colorplate 69
Guitar with Sheet of Music (Gris), 174, colorplate 71
GUSTON, PHILIP, 379, 388, 394, 623–24; *Blue Light*, 394, 624, colorplate 184; *Desert, The*, 394, 624; *591; Dial*, 394, 623, colorplate 183; *Studio, The*, 624; *996; Zone*, 394; *590*
Gutai Group (Japan), 472
GWATHMEY, CHARLES, 552
Gypsy, The (Dubuffet), 432, colorplate 206

HAACKE, HANS, 574–75; *Condensation Cube*, 561, 574; *897; Manet Project*, 574–75; *Schapolsky et al.…*, 575; *927*
Hadassah Medical Center Synagogue (Jerusalem): Chagall windows, 221
Hairdresser's Window (Sloan), 364, colorplate 162
HALL, TODD, AND LITTLETON: Sydney Opera House, 545; *855*
HALS, FRANS, 108, 361, 364
HAMILTON, RICHARD, 448, 449; *Just What Is It That Makes Today's Homes…*, 449; *687*
Hamlet in the Snow (Vlaminck), 104; *147*
Hammamet with the Mosque (Klee), 130, 218, colorplate 56
Hanging Construction (Rodchenko), 191; *276*
Hanover (Ger.), Dada in, 241–42
Hanover Merzbau (Schwitters), 242, 302, 479, 531; *342*
HANSON, DUANE, 609, 610, 653; *Football Player*, 444, 609; *974; Tourists*, 609, colorplate 274
Happenings, 302, 448, 453, 471–72, 497, 567
Harbor Mole (L. Feininger), 131, colorplate 57
Hard-Edge painting, 333, 335, 487, 488, 491, 493–97, 684
Hare on Bell with Granite Piers (B. Flanagan), 633; *1013*
HARING, KEITH, 653, 654; *New York Subway Drawing*, 654; *1050; One-Man Show*, 654; *1051*

Harlequin with Violin (Picasso), 267; *377*
Harmony in Red (Matisse), 107, colorplate 40
HARNETT, WILLIAM MICHAEL, 360; *After the Hunt*, 360; *518*
Harrison, Wallace K.: Metropolitan Opera House (New York), 556; *882; United Nations Headquarters (New York), 547; *860*
HARTLEY, MARSDEN, 365, 366, 667; *Portrait of a German Officer*, 366, colorplate 164
Hartley in London (Motherwell), 406; *602*
Hart Plaza (Detroit; Noguchi), 584; *946, 948*
HARTUNG, HANS, 417, 418; *Untitled*, 417, colorplate 198
Harvard University (Cambridge, Mass.), 553; architecture faculty, 533, 534, 691; Charles Eliot Norton lectures, 498–99; Rothko murals, 396; architecture: Carpenter Center for Visual Arts (Corbusier), 553, 555; *877; Graduate Center (Gropius), 534, 553; Married Student Housing (Sert), 553; *876*
Harvest (Beal), 614; *983*
Harvest Threshing (Gleizes), 174; *245*
Hatchet with Two Palettes, State #2 (Dine), 457; *706*
Hatshepsut (Queen of Egypt): Funerary Temple (Deir el-Bahari), 576, 698; *932*
HAUSSMANN, GEORGES-EUGÈNE, BARON, 558
HAUSSMANN, RAOUL, 241, 242, 332; *Mechanical Head*, 302; *428*
Hay Wain, The (Constable), 30, colorplate 3
Head: (Lipchitz), 169, 303; *235;* (Modigliani), 250; *355;* (Otterness), 653; *1048*
Head of a Man (Bacon), 435; *651*
Head of a Man on a Rod (A. Giacometti), 431; *635*
Head of a Tragic Clown (Rouault), 106; *150*
Head of a Woman (Fernande) (Picasso), 161, 165, 167, 185, 189; *217*
Head of a Woman (Picasso), 161, 173; *216*
Head of Henry van de Velde (Kirchner), 125–26; *163*
Head Surrounded by Sides of Beef (Bacon), 435, 451, 642, colorplate 208
Head with Three Annoying Objects (Arp), 273; *384*
HECKEL, ERICH, 121–22, 123–24, 126, 252; *Two Men at a Table*, 123; *158*
Hegel, G. W. F., 59
Heidegger, Martin, 688
HEIZER, MICHAEL, 576, 578; *Double Negative*, 576; *931*
HEJDUK, JOHN, 552
HELD, AL, 487, 488, 495–97, 660, 665; *Flemish IX*, 496; *774; Ivan the Terrible*, 495–96; *773; Mantegna's Edge*, 487, colorplate 246; *Mercury Zone II*, 496–97; *775*
Helen with Red Turban (Jawlensky), 129–30, colorplate 55
HÉLION, JEAN, 379, 415
Hello (Lindner), 452, colorplate 214
Helmholz, Herman von, 52, 500
Helm 1 (Lüpertz), 638; *1021*
HENRI, FLORENCE, 167; *Abstract Composition*, 167; *229*
HENRI, ROBERT, 364, 365; *Laughing Child*, 364; *526*
HEPWORTH, BARBARA, 273, 274, 324, 355, 358, 436–37, 439; *Ancestor II: Nine Figures on a Hill*, 439; *666; Group III (Evocation)*, 439; *663; Landscape Sculpture*, 358, colorplate 161; *Meridian*, 439; *665; Porthmeor: Sea Form*, 439; *664; Single Form*, 358; *515; Two Segments and Sphere*, 358; *514; Wave*, 355, 358; *516*
HERBIN, AUGUSTE, 131, 333; *Composition*, 333, colorplate 155; *Rain*, 333; *489*
Hercules the Archer (Bourdelle), 97; *133*
Here (Newman), 528; *818*
Here Everything Is Still Floating (Ernst), 243, 275; *343*
"Hérodiade" (Matisse), 256; *366*
Herzfelde, Wieland and Johann, 241
HESSE, EVA, 572; *Aught*, 572; *923*
Hide-and-Seek (Cache-cache) (Tchelitchew), 298, colorplate 140
Hide and Seek (Morisot), 51; *52*
High a Yellow (Olitski), 491, colorplate 237
Highland Park (Ill.): Willetts House (Wright), 206; *288*
HINE, LEWIS W., 365, 376; *Carolina Cotton Mill*, 365; *529*
HINMAN, CHARLES, 498; *Lode Star*, 498, colorplate 248
Hinterglasmalerei, 127
Hireling Shepherd, The (W. H. Hunt), 26, 30, 77, colorplate 5

Photo Credits

The author and publisher wish to thank the libraries, museums, galleries, and private collectors named in the picture captions for permitting the reproduction of works of art in their collections and for supplying the necessary photographs. Photographs from other sources are gratefully acknowledged below. Numbers in boldface refer to the illustration number.

Black-and-White Photographs

1 Archives Photographiques, Paris; **3** Fototeca Unione, Rome; **5** © ACL Brussels; **6, 10** Alinari, Florence; **13** Bulloz, J.-E., Paris; **14** Foto MAS, Barcelona; **18** Service documentation photographique de la Reunion des musées nationaux, Paris; **21** Caisse Nationale des Monuments Historiques, Paris; **24** Service documentation photographique de la Reunion des musées nationaux, Paris; **36** Lichtbildwerkstätte Alpenland, Vienna; **37** Service documentation photographique de la Reunion des musées nationaux, Paris; **40** Harold Morris; **41** Archives Photographiques, Paris; **42, 51** Service documentation photographique de la Reunion des musées nationaux, Paris; **53** Routhier, Studio Lourmel, Paris; **59** Oliver Baker, New York; **73** Edwin C. Smith, Essex; **74** Jean Roubier, Paris; **76** Archives Photographiques, Paris; **77** French Government Tourist Office, New York; **78** A.F. Kersting, London; **80** Wayne Andrews, Grosse Pointe, Michigan; **82, 83** T. & R. Annan, Ltd., Glasgow; **85** Bettmann Archives, Inc., New York; **87** Wayne Andrews, Grosse Pointe, Michigan; **89** Derrick E. Witty, Sunbury-on-Thames; **94** Foto Studio Minders, Ghent; **96** George Barrows; **97, 98** Foto MAS, Barcelona; **100** © A.C.L., Brussels; **102** Dr. Franz Stoedtner, Düsseldorf; **104–106** Foto Marburg, Marburg/Lahn; **107** Otto Vaering, Oslo; **113, 114** © A.C.L., Brussels; **119** © Spanganberg Verlag, Munich; **139** Service documentation photographique de la Reunion des musées nationaux, Paris; **141** M. Knoedler & Co., Inc., New York; **148** Rapho-Guillumette, Paris; **149** Service photographique de la Reunion des musées nationaux, Paris; **153** Foto Witzel, Essen; **155** Walter Klein, Düsseldorf; **157** Foto Witzel, Essen; **158** Kleinhempel, Hamburg; **185** Peter A. Juley & Son, New York; **187** Foto Witzel, Essen; **188** Fine Art Associates, Minneapolis; **198** Courtesy Witkin Gallery, New York; **208** VAAP, Moscow; **213** Galerie Louise Leiris, Paris; **214** Svetlana; **226** Courtesy Galerie Bruno Bischofberger, Zurich; **232** Galerie "IM Erker," St. Gallen; **237, 241** A. Studley, New York; **250** Geoffrey Clements, New York; **251** Jacques Mer, Antibes; **260** Charles Uht, New York; **261** Sherwin Greenberg, McGranahan & May, Inc., Buffalo, New York; **262** Courtesy Sotheby's Inc., New York; **264** Mario Perotti, Milan; **265** Gian Sinigaglia, Milan; **268, 275, 276** Alfred H. Barr, Jr., New York; **278** E. Irving Blomstrann, New Britain, Connecticut; **284** Studio Yves Hervochon, Paris; **288, 289** Wayne Andrews, Grosse Pointe, Michigan; **290** Hedrich-Blessing, Chicago; **293, 294** Buffalo and Erie County Historical Society; **295** Chicago Architectural Photographing Company; **296** Lucien Hervé, Paris; **299** G. Gherardi-A. Fiorelli, Rome; **300** Benevolo; **302** Foto van Ojen, The Hague; **307** German Information Center, New York; **308** Emil Gmelin, Dornach; **310** Doeser Fotos, Laren; **311** Foto van Ojen, The Hague; **312** Fototechnischer Dienst, Rotterdam; **317** Martin F.J. Coppens, Eindhoven; **321** Courtesy Robert Miller Gallery, New York; **325** Elizabeth Sax, Paris; **328** Courtesy Cordier & Ekstrom Inc., New York; **333** Geoffrey Clements, New York; **336** Courtesy Cordier & Ekstrom Inc., New York; **339** Jorg Anders; **342** Landesgalerie, Hanover; **347** Rheinisches Bildarchiv, Cologne; **357** S. Sunami, New York; **359** J.-E. Bulloz, Paris; **362** Oliver Baker, New York; **371, 374** Henri Mardyks; **377** Paul Rosenberg & Co., New York; **384** Etienne Bertrand Weill, Paris; **385** Geoffrey Clements, New York; **392** Magnum Photo Library, New York; **393** New York Public Library; **394** Colten Photos, New York; **398** UNESCO, Paris; **403** Oliver Baker, New York; **415** Courtesy Pierre Matisse Gallery, New York; **420** Foto Attualita, Venice; **421** Courtesy Susan Harder Gallery, New York; **422** Photo Researchers, New York; **427** Etienne Bertrand Weill, New York; **433** Chevojon Frères, Paris; **444, 445** Wayne Andrews, Grosse Pointe, Michigan; **446, 447** Hedrich-Blessing, Chicago; **448, 449** S.C. Johnson & Johnson, Inc., Racine, Wisconsin; **453, 456** Wayne Andrews, Grosse Pointe, Michigan; **457, 459** Lucien Hervé, Paris; **468** William Lescaze, New York; **469** E. Irving Blomstrann, New Britain, Connecticut; **472** L.W. Schmidt, Rotterdam; **477** Fotocollectie, Leiden; **482** Peter A. Juley & Son, New York; **487** Kleinhempel, Hamburg; **495** Photoatelier Gerlach, Vienna; **502** © London County Council; **532** Geoffrey Clements, Courtesy Dintenfass Gallery, New York; **538, 540** Geoffrey Clements, New York; **543** David Stansbury, Springfield, Massachusetts; **545** Oliver Baker, New York; **546** E. Irving Blomstrann, New Britain, Connecticut; **555** Courtesy Mrs. James Van Der Zee; **564** Peter A. Juley & Son, Courtesy Downtown Gallery, New York; **573** Arthur Siegel, Chicago; **575** Jerry Thompson; **578** Oliver Baker Associates; **579** Martha Jackson Gallery, New York;

581 Paulus Leeser, New York; **582** Courtesy Marlborough Gallery, New York; **583** Hans Namuth, New York; **589** Geoffrey Clements, New York; **590** Courtesy Egan Gallery of Modern Art, New York; **601** Courtesy Marlborough Gallery, New York; **602** Steven Sloman, New York; **603** Magnum Photo Library, New York; **607** Courtesy Pace/MacGill Gallery, New York; **608** Eric Sutherland, Minneapolis; **611** Courtesy Marlborough Gallery, New York; **613** University of Bridgeport, Connecticut, Public Relations Department; **614** Courtesy Pierre Matisse Gallery, New York; **616–618** Rudolph Burckhardt, New York; **623** Service documentation photographique de la Reunion des musées nationaux, Paris; **633** Courtesy Marlborough Gallery, New York; **645** Courtesy Pierre Matisse Gallery, New York; **648** Arthur Lavine, Courtesy The Pace Gallery, New York; **649** Rapho-Guillumette, Paris; **657** National Buildings Record, London; **662** Courtesy The Henry Moore Foundation, England; **665** David Farrell, The Oxebode, Gloucester, Courtesy The Barbara Hepworth Museum (Tate Gallery), England; **666** Courtesy Marlborough Fine Art, Ltd., London; **667** Courtesy the artist; **675** Marino Marini; **678** Ernest Nash, Rome; **682** Courtesy The Witkin Gallery, New York; **684** Courtesy Martha Jackson Gallery, New York; **687** Oliver Baker, New York; **691** Courtesy André Emmerich Gallery, New York; **694** Oliver Baker, New York; **695** Eric Pollitzer, New York; **696** Rudolph Burckhardt, New York; **699** Courtesy Leo Castelli Gallery, New York; **700, 701** Rudolph Burckhardt, New York; **702** Courtesy Leo Castelli Gallery, New York; **703** Courtesy Pace/MacGill Gallery, New York; **704** Courtesy Fraenkel Gallery, San Francisco/The Estate of Garry Winogrand; **705** Courtesy The Pace Gallery, New York; **706** Eric Pollitzer, New York; **707–709** Rudolph Burckhardt, New York; **710, 711** Eric Pollitzer, New York; **712, 713** Rudolph Burckhardt, New York; **714** Courtesy Sidney Janis Gallery, New York; **715** Eric Pollitzer, New York; **717** O.E. Nelson, New York; **719** Courtesy Louis K. Meisel Gallery, New York; **721** Allan Kaprow; **722** Robert R. McElroy, Courtesy Sidney Janis Gallery, New York; **723** Geoffrey Clements, New York; **724, 725** Courtesy Leo Castelli Gallery, New York; **728** Geoffrey Clements, New York; **733** Courtesy Allan Stone Gallery, New York; **735** Ferdinand Boesch, New York; **736** Courtesy The Pace Gallery, New York; **737** Courtesy The Pace Gallery, New York; **738** Peter Moore, New York; **739** Sculpture Now, Inc., New York; **742** Rudolph Burckhardt, New York; **743** Eric Pollitzer, New York; **746** Courtesy Galerie Iolas, Paris; **747** Thomas Cugini; **748** Attilio Bacci, Milan; **754** John Schiff, New York; **758** Liselotte Witzel, New York; **761** Geoffrey Clements, New York; **762** Courtesy André Emmerich Gallery, New York; **764** Courtesy Lawrence Rubin Gallery, New York; **766, 767** Geoffrey Clements, New York; **770** Greenberg-May Prod. Inc., New York; **771** Rudolph Burckhardt, New York, Courtesy André Emmerich Gallery, New York; **772** Geoffrey Clements, New York; **774** Courtesy André Emmerich Gallery, New York; **776** Rudolph Burckhardt, New York; **777** Courtesy Leo Castelli Gallery, New York; **780, 781** Geoffrey Clements, New York; **785** Armen Photographers, Newark, New Jersey; **790** David van Riper, Chicago; **795** Geoffrey Clements, New York; **796** Courtesy Sidney Janis Gallery, New York; **797** Courtesy John Weber Gallery, New York; **798** Courtesy Mary Boone Gallery, New York; **800** Rick Gardner; **802** Courtesy The Port Authority of New York and New Jersey; **811** Courtesy André Emmerich Gallery, New York; **815** Armando Salas, Portugal; **816** Marianne Goeritz, Mexico; **817** Courtesy The Witkin Gallery, New York; **818** Rudolph Burckhardt, New York; **820** Courtesy Studio Yves Hervochon, Paris; **822** Courtesy Waddell Gallery, New York; **823** Hickey & Robertson, Houston; **824** Courtesy Leo Castelli Gallery, New York; **827** Dwan, New York; **828** Douglas M. Parker Studio; **831** Courtesy Walter Gropius; **833** Der Senator für Bau-und Wohnungswesen; **834** G.E. Kidder-Smith, New York; **835** Lucien Hervé, Paris; **836** B. Moosbrugger, Zurich; **837** Rondal Partridge; **838, 839** © Ezra Stoller, New York; **840** Museum of Finnish Architecture, Helsinki; **841** Aerofilms, London; **842** Architectural Association, London; **844** Transacphoto, Grasse; **845** E. Bertrand Weill, Paris; **846** Ilse Buhs, Berlin; **848** Vasari e figlio, Rome; **851** Pirelli Company, Milan; **853** National Film Board, Canadian Consulate General, New York; **855** Australian News and Information Bureau, New York; **858** Ishimoto, Fujisawa City, Japan; **861** Hedrich-Blessing, Chicago; **862** © Ezra Stoller, New York; **864** Courtesy The Port Authority of New York and New Jersey; **866** © Richard Payne AIA 1985, Houston; **867** © 1974 Ezra Stoller/Esto, New York; **868** Marcel Breuer & Associates, New York; **869** Philip Johnson, New York; **870** Mrs. Frederick Kiesler, New York; **871** Ivan Pinter, Cosanti Foundation; **872** © The MIT Press, Cambridge, Massachusetts. Reprinted from *Arcology: The City in the Image of Man* by Paolo Soleri; **873** Julius Shulman, Los Angeles; **874** © 1979 Ezra Stoller/Esto, New York; **875** © Ezra Stoller, New York; **876** Harvard University News Office; **877** Harvard University News Office; **878** Stewarts Commercial Photographers, Colorado Springs; **879** Marcel Breuer & Associates, New York; **880** Malcolm Smith, New York; **881** © Ezra Stoller, New York; **882** Morris Warman,

New York; **883, 884, 887, 888** © Ezra Stoller, New York; **889** Marshall D. Meyers, A.I.A., Philadelphia; **892, 893** © Ezra Stoller, New York; **894** Buckminster Fuller, Carbondale, Illinois; **895** Canadian Government Tourist Bureau, New York; **896** Courtesy Xavier Fourcade Gallery, New York; **898** Courtesy Leo Castelli Gallery, New York; **900** Bernard Boyer, Courtesy the artist; **901** Robert E. Mates and Paul Katz, New York; **904** Bevan Davies, Courtesy The Sonnabend Gallery, New York; **908** Eric Pollitzer, New York; **911** Courtesy Howard Wise, New York; **912** Courtesy the artist; **914** Eric Pollitzer, New York; **915** Charles Hill, Courtesy Ronald Feldman Fine Arts Inc., New York; **918** Courtesy Holly Solomon Gallery, New York; **919** © Harry Shunk, Courtesy Holly Solomon Gallery, New York; **920** Rudolph Burckhardt, New York; **921** Courtesy Leo Castelli Gallery, New York; **922** Rudolph Burckhardt, New York; **923** Courtesy Xavier Fourcade Gallery, New York; **924** eeva-inkeri, Courtesy Paula Cooper Gallery, New York; **925** Courtesy Middendorf Gallery, Washington, D.C.; **927** Courtesy John Weber Gallery, New York; **929** Courtesy DIA Art Foundation, New York; **930** Peter Moore, Courtesy John Weber Gallery, New York; **931** Courtesy Xavier Fourcade Gallery, New York; **932** William Stevenson-Smith, Boston; **933** Courtesy John Weber Gallery, New York; **934** Sydney W. Newbery, Surrey, England, © Courtesy Anthony d'Offay Gallery, London; **935** Eric Pollitzer, Courtesy Leo Castelli Gallery, New York; **939, 940** John Cliett; **941** Courtesy John Weber Gallery, New York; **942** Courtesy Max Protetch Gallery, New York; **943** Courtesy John Weber Gallery, New York; **944** Courtesy Jeanne-Claude Christo; **946** Balthazar Korab Ltd., Troy, Michigan; **947** Courtesy The Renaissance Center Venture, Detroit; **948** Andrew Popper, New York; **949** Courtesy Leo Castelli Gallery, New York; **950** Geoffrey Clements, New York; **951** Susan Swider, New York; **958** eeva-inkeri, New York; **960, 961** Courtesy Marlborough Gallery, New York; **962** Courtesy Staempfli Gallery, New York; **963** Courtesy Coe Kerr Gallery, New York; **965** Geoffrey Clements, New York; **966** Courtesy The Pace Gallery, New York; **967** Al Mozell, New York, Courtesy The Pace Gallery, New York; **968** Courtesy O.K. Harris, New York; **969** Courtesy Louis K. Meisel Gallery, New York; **970** Bruce C. Jones, Courtesy Louis K. Meisel Gallery, New York; **971** Eric Pollitzer, New York; **972** Cuming-Wright-Watson Associates, Ltd., London, Courtesy the artist; **973** Robert E. Mates and Paul Katz, New York, Courtesy Nancy Hoffman Gallery, New York; **975** Eric Pollitzer, New York, Courtesy O.K. Harris, New York; **977** Edward Owen, Courtesy Middendorf Gallery, Washington, D.C.; **979** Courtesy Robert Miller Gallery, New York; **981** Geoffrey Clements, New York; **982, 983** eeva-inkeri, Courtesy Allan Frumkin Gallery, New York; **985** Michael Arthur, Courtesy Bernice Steinbaum Gallery, New York; **986** D. James Dee, Courtesy Bernice Steinbaum Gallery, New York, Courtesy Robert Miller Gallery, New York; **988** D. James Dee, New York; **989** © 1980 D. James Dee, New York; **990** D. James Dee, New York; **991** eeva-inkeri, Courtesy Sidney Janis Gallery, New York; **992** eeva-inkeri, Courtesy Barbara Gladstone Gallery, New York; **993** Courtesy Holly Solomon Gallery, New York; **994** D. James Dee, New York, Courtesy Holly Solomon Gallery, New York; **996** O.E. Nelson, Courtesy The David McKee Gallery, New York; **997** Roy M. Elkind, Courtesy The Willard Gallery, New York; **998** Gerard Murrell, Courtesy Holly Solomon Gallery, New York; **999** Gerard Murrell; **1000** Eric Pollitzer, New York; **1001** Courtesy Blum Helman Gallery, New York; **1002** Bill Jacobson, Courtesy Blum Helman Gallery, New York; **1003, 1004** Geoffrey Clements, New York; **1005** Geoffrey Clements, Courtesy Paula Cooper Gallery, New York; **1006** Courtesy Paula Cooper Gallery, New York; **1007, 1008** Geoffrey Clements, Courtesy Paula Cooper Gallery, New York; **1009** Courtesy Galerie Barbara Farber, Amsterdam; **1010, 1011** Geoffrey Clements, Courtesy Paula Cooper Gallery, New York; **1012** Courtesy The Pace Gallery, New York; **1013** Bill Jacobson Studio, Courtesy The Pace Gallery, New York; **1014** D. James Dee, Courtesy Holly Solomon Gallery, New York; **1015, 1016** Courtesy Robert Miller Gallery, New York; **1018** Courtesy Mary Boone/Michael Werner Gallery, New York; **1019** Zindman/Fremont, New York; **1022** Anne Gold, Aachen, Courtesy Michael Werner Gallery, Cologne; **1023** F. Rosenstiel, Cologne; **1025** Bill Jacobson Studio, Courtesy Marian Goodman Gallery, New York; **1027** Anthony J. Oliver, New York; **1028** Bill Jacobson Studio, Courtesy Marian Goodman Gallery, New York; **1029** Ellen Page Wilson, New York; **1030** Alan Zindman, Courtesy Sperone Westwater Gallery, New York; **1032** Zindman/Fremont, Courtesy Leo Castelli Gallery, New York; **1033, 1034** Zindman/Fremont, Courtesy Sperone Westwater Gallery, New York; **1035** Dorothy Zeidman, New York; **1038, 1039** Zindman/Fremont, Courtesy Mary Boone Gallery, New York; **1040** Pelka/Noble, New York; **1041** Pelka/Noble, Courtesy Metro Pictures, New York; **1044** David Reynolds, New York; **1045** Adam Reich, Courtesy Sally Baker, New York; **1046** eeva-inkeri, New York; **1048** Courtesy Brooke Alexander, New York; **1049** © Martha Cooper, Courtesy Brooke Alexander, New York; **1050** Tseng Kwong Chi, Courtesy Tony Shafrazi Gallery, New York; **1051** Ivan Dalla Tana, Courtesy Tony Shafrazi Gallery, New York; **1052** Zindman/Fremont, Courtesy Mary Boone Gallery, New York; **1053** Geoffrey Clements, New York; **1055, 1056** Adam Fuss; **1057** Courtesy The Sonnabend Gallery, New York; **1059** Geoffrey Clements, Courtesy Paula Cooper Gallery, New York; **1060** Courtesy Whitechapel Art Gallery, London; **1062** Ken Cohen Photography, Courtesy M. Knoedler & Co., Inc., New York; **1063** Bill Jacobson Studio, Courtesy Marian Goodman Gallery, New York; **1064** Julius Kozlowski, Courtesy Holly Solomon Gallery, New York; **1065** John Webb, London; **1066** Courtesy David McKee Gallery, New York; **1067** Steven Sloman, Courtesy Washburn Gallery, New York; **1068** Courtesy Wolff Gallery, New York; **1069** Courtesy Germans van Eck Gallery, New York; **1070** Courtesy Mary Boone Gallery, New York; **1071, 1072** Courtesy Pat Hearn Gallery, Inc., New York; **1073** Courtesy Wolff Gallery, New York; **1074** Courtesy Baskerville & Watson Gallery, New York; **1075** Courtesy Paula Cooper Gallery, New York; **1076** Geoffrey Clements, Courtesy Paula Cooper Gallery, New York; **1077** Dorothy Zeidman, New York; **1078** Courtesy Donald Young Gallery, Chicago; **1079** Eric Pollitzer, Courtesy Hirschl & Adler Modern, New York; **1080** Courtesy Sperone Westwater Gallery, New York; **1081** Photo by the artist, Courtesy Blum Helman Gallery, New York; **1082** Jerry L. Thompson, New York; **1083, 1084** Courtesy Max Protetch Gallery, New York; **1085** Bill Jacobson Studio, New York; **1087** Prudence Cuming Associates Ltd., London; **1088** Courtesy Venturi, Rauch & Scott Brown, Philadelphia; **1089** Rollin R. La France; **1090** Courtesy Venturi, Rauch & Scott Brown, Philadelphia; **1091** Peter Becker, Courtesy Charles Moore Associates; **1092** © Norman McGrath, New York; **1093** Courtesy Hans Hollein, Vienna; **1094** Franz Hobman, Courtesy Hans Hollein, Vienna; **1095** © Norman McGrath, New York; **1096, 1097** Courtesy Johnson/Burgee Arch., New York; **1098** © Norman McGrath; **1099, 1100** Courtesy Max Protetch Gallery, New York; **1101** © Jorg Peter Maucher, West Germany; **1102** © John Donut, London

Colorplates

3 John Webb, London; **9** Photographie Giraudon, Paris; **10** Services documentation photographique de la Reunion des musées nationaux, Paris; **11** Hubert Josse, Paris; **12** A.J. Wyatt, Philadelphia; **19** A.J. Wyatt, Philadelphia; **21** Thames & Hudson, Ltd., London; **22** Richard Nickel; **28** Galerie Welz, Salzburg; **29, 31** Eric Pollitzer, New York; **32** Ron Chamberlain, Warwick, New York; **33** George Kriloff, Tassin, France; **39** Elton Schnellbacher, Pittsburgh; **41** Svetlana; **44** Hans Hinz, Basel; **47** Clark Dean, Minneapolis; **53** Joachim Blauel, Munich; **54** Walter Kirchenberger, Dortmund; **56** Hubert Josse, Paris; **61** SRGM, New York; **62** David Heald; **64** H. Stebler, Bern; **65** Otto Vaering, Oslo; **68** David Heald; **69** Geoffrey Clements, New York; **70** A.J. Wyatt, Philadelphia; **71** Anna Wachsmann; **72** Rudolf Indlekofer, Basel; **73** The Museum of Modern Art, New York; **74, 78** A.J. Wyatt, Philadelphia; **79** Eric Pollitzer, New York; **80** Hubert Josse, Paris; **84** Eric Pollitzer, New York; **86** Giancarlo Sponga, Milan; **103** Geoffrey Clements, New York; **110** Edward Cornachio; **120** Dr. Franz Stoedtner, Düsseldorf; **121** Hans Hinz, Basel; **122** Eric Pollitzer, New York; **123** Hubert Josse, Paris; **127** A.J. Wyatt, Philadelphia; **128** Ezio Gribaudo, Turin; **130** Piaget, St. Louis; **132** Richard Nickel; **133** Geoffrey Clements, New York; **135** The Museum of Modern Art, New York; **136** Eric Pollitzer, New York; **137** Charles P. Mill, Philadelphia; **146** Galerie Louise Leiris, Paris; **147** P. Lorenzo, Nice; **149, 150, 152** SRGM, New York; **153** Marlborough Fine Art, Ltd., London; **155** SRGM, New York; **159** Charles P. Mill, Philadelphia; **160** Steven Sloman, New York; **161** Robert Mates, New York; **171, 174** Geoffrey Clements, New York; **181** Eric Pollitzer, New York; **183** Steven Sloman, New York; **185** Marlborough Gallery, New York; **191** Courtesy the artist; **192** Courtesy the artist; **194** Courtesy Daniel Wolf Gallery, New York; **196** SRGM, New York; **201** Robert E. Mates, New York; **203, 207** SRGM, New York; **213** Courtesy the artist; **214** Geoffrey Clements, New York; **218** Courtesy Leo Castelli Gallery, New York; **219** Paul Hester; **220** Courtesy Leo Castelli Gallery, New York; **222** Eric Pollitzer, New York; **223** Geoffrey Clements, New York; **224** Courtesy Leo Castelli Gallery, New York; **226** Edward Luce, Worcester, Massachusetts; **227** Courtesy The Pace Gallery, New York; **231** SRGM, New York; **233** Geoffrey Clements, New York; **234** Courtesy André Emmerich Gallery, New York; **235** Cleveland Museum of Art; **236** Geoffrey Clements, New York; **239** Courtesy André Emmerich Gallery, New York; **241** Jon Abbott, New York, Courtesy M. Knoedler & Co., Inc., New York; **242** Courtesy The Pace Gallery, New York; **246** Courtesy the artist; **249** Eric Pollitzer/SRGM, New York; **251** Courtesy Leo Castelli Gallery, New York; **252** Eric Landsberg, Courtesy Leo Castelli Gallery, New York; **257** Courtesy The Pace Gallery, New York; **258** Courtesy Mary Boone Gallery, New York; **259** Pedro E. Guerrero, New York; **261** Hayward Gallery; **262** Pedro E. Guerrero, New York; **263** Al Mozell, Courtesy The Pace Gallery, New York; **264** Courtesy The Sonnabend Gallery, New York; **265** Courtesy the artist; **266** Courtesy Middendorf Gallery, Washington, D.C.; **267** Gianfranco Gorgoni, Contact Press Images, New York; **268** Courtesy John Weber Gallery, New York; **269** Courtesy Jeanne-Claude Christo; **270** Courtesy Jeanne-Claude Christo; **271** Courtesy Hirschl & Adler Modern, New York; **272** Courtesy Louis K. Meisel Gallery, New York; **275** George Roos, Courtesy Marlborough Gallery, New York; **276** Eric Pollitzer, Courtesy Robert Miller Gallery, New York; **278** Courtesy Bernice Steinbaum Gallery, New York; **279** Steven Sloman, Courtesy Robert Miller Gallery, New York; **280** D. James Dee, Courtesy Holly Solomon Gallery, New York; **281** D. James Dee; **282** Allan Finkleman; **283** Cymie Payne, Courtesy Barbara Gladstone Gallery, New York; **284** Courtesy Holly Solomon Gallery, New York; **285** Charles Harrison, Courtesy The Willard Gallery, New York; **287** Courtesy Blum Helman Gallery, New York; **288** Eric Mitchell; **289** Geoffrey Clements, Courtesy Paula Cooper Gallery, New York; **290** D. James Dee, Courtesy Holly Solomon Gallery, New York; **291** Courtesy Xavier Fourcade Gallery, New York; **292** Courtesy Mary Boone Gallery, New York; **293** Anne Gold, Aachen; **294** Courtesy Mary Boone Gallery, New York; **296** Courtesy the artist; **297** D. James Dee, Courtesy Sperone Westwater Gallery, New York; **298** Courtesy Sperone Westwater Gallery, New York; **299** Beth Phillips, Courtesy The Pace Gallery, New York; **300** Zindman/Fremont, Courtesy Mary Boone Gallery, New York; **301** Geoffrey Clements, Courtesy Mary Boone Gallery, New York; **302, 303** Courtesy Metro Pictures, New York; **304** Courtesy Brooke Alexander Gallery, New York; **305** Eric Pollitzer, Courtesy Brooke Alexander Gallery, New York; **306** Ivan Dalla Tana, Courtesy Tony Shafrazi Gallery, New York; **307** eeva-inkeri, Courtesy Paula Cooper Gallery, New York; **308** Courtesy M. Knoedler & Co., Inc., New York; **309** Ken Cohen, Courtesy M. Knoedler & Co., Inc., New York; **310** Courtesy Marian Goodman Gallery/Sperone Westwater Gallery, New York; **311** D. James Dee, Courtesy David McKee Gallery, New York; **312** Courtesy Max Protetch Gallery, New York; **313** Courtesy Wolff Gallery, New York; **314** Bill Jacobson, Courtesy Wolff Gallery, New York; **315** Sarah Wells, Courtesy Baskerville & Watson Gallery, New York; **316–318** © Norman McGrath, New York; **319** Marvin Trachtenberg